Praise for previous editions

"Self provides solid, well-explained technical information throughout the book, all gained from years of experience and a thorough understanding of the entire topic . . . His book exudes skilful engineering on every page, and I found it a very refreshing, enjoyable, and inspirational read . . . If you have the slightest interest in audio circuit design this book has to be considered an essential reference. Very highly recommended."

Hugh Robjohns, *Sound on Sound* Magazine

"This book presents a large body of knowledge and countless insider-tips from an award-winning commercial audio designer . . . Douglas Self dumps a lifetime's worth of thoroughly-tested audio circuit knowledge into one biblical tome."

Joseph Lemmer, *Tape Op*

Small Signal Audio Design

Small Signal Audio Design is a highly practical handbook providing an extensive repertoire of circuits that can be assembled to make almost any type of audio system. This fully revised fourth edition offers wholly new content on internally balanced audio design, electret microphones, emitter-follower stability, microphony in capacitors, and much, much more.

This book continues the engaging prose style familiar to readers as you learn why mercury-filled cables are not a good idea, the pitfalls of plating gold on copper, and what quotes from *Star Trek* have to do with PCB design.

Learn how to:

- make amplifiers with apparently impossibly low noise

- design discrete circuitry that can handle enormous signals with vanishingly low distortion

- transform the performance of low-cost opamps

- build active filters with very low noise and distortion while saving money on expensive capacitors

- make incredibly accurate volume controls

- make a huge variety of audio equalisers

- use load synthesis to make magnetic cartridge preamplifiers that have noise so low it is limited by basic physics

- sum, switch, clip, compress, and route audio signals

- build simple but ultra-low noise power supplies

- be confident that phase perception is not an issue.

Including all the crucial theories, but with minimal mathematics, *Small Signal Audio Design* is the must-have companion for anyone studying, researching, or working in audio engineering and audio electronics.

Douglas Self studied engineering at Cambridge University then psychoacoustics at Sussex University. He has spent many years working at the top level of design in both the professional audio and hifi industries and has taken out a number of patents in the field of audio technology. He currently acts as a consultant engineer in the field of audio design.

Small Signal Audio Design

Fourth Edition

Douglas Self

Routledge
Taylor & Francis Group

NEW YORK AND LONDON

Designed cover image: © Douglas Self

Fourth edition published 2024
by Routledge
605 Third Avenue, New York, NY 10158

and by Routledge
4 Park Square, Milton Park, Abingdon, Oxon, OX14 4RN

Routledge is an imprint of the Taylor & Francis Group, an informa business

First edition published by Focal Press 2010
Third edition published by Routledge 2020

Library of Congress Cataloging-in-Publication Data
Names: Self, Douglas, author.
Title: Small signal audio design / Douglas Self.
Description: Fourth edition. | New York, NY : Routledge, 2024. | Includes bibliographical references and index.
Subjects: LCSH: Audio amplifiers—Design and construction. | Sound—Recording and reproducing. | Signal processing.
Classification: LCC TK7871.58.A9 S46 2024 (print) | LCC TK7871.58.A9 (ebook) | DDC 621.389/33—dc23/eng/20230824
LC record available at https://lccn.loc.gov/2023022154
LC ebook record available at https://lccn.loc.gov/2023022155

ISBN: 978-1-032-36627-2 (hbk)
ISBN: 978-1-032-36625-8 (pbk)
ISBN: 978-1-003-33298-5 (ebk)

DOI: 10.4324/9781003332985

Typeset in Times
by Apex CoVantage, LLC

To Julie, with all my love

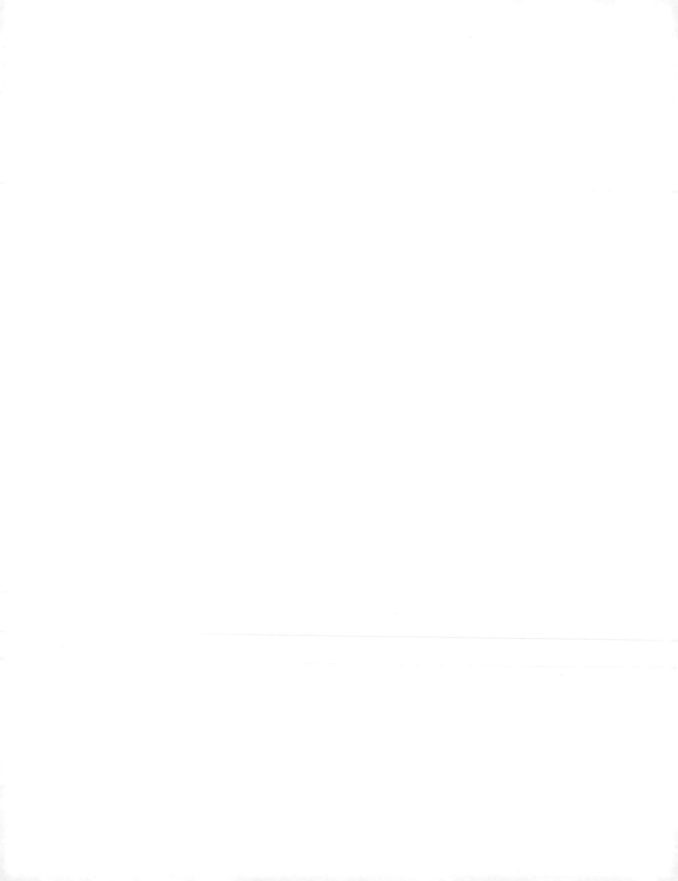

Contents

Preface . *xxv*

Acknowledgments . *xxix*

Chapter 1 The basics . 1

Signals . 1

Unbalanced and balanced signals . 2

Internally balanced design . 3

600-Ohm lines . 6

Amplifiers . 7

 Voltage amplifiers . 8

 Transconductance amplifiers. 8

 Current amplifiers . 8

 Transimpedance amplifiers . 8

Negative feedback . 9

Nominal signal levels and dynamic range 10

Frequency response . 11

Frequency response: cascaded stages . 13

Phase perception . 17

Gain structures. 19

Amplification then attenuation. 19

Attenuation then amplification. 20

Raising the input signal to the nominal level. 20

Active gain controls. 21

Noise . 21

 Johnson noise . 22

 Shot noise . 25

 1/f noise (flicker noise) . 25

 Popcorn noise . 26

 Summing noise sources. 26

Noise in amplifiers .27

Noise in bipolar transistors .29

Bipolar transistor voltage noise .30

Bipolar transistor current noise .30

Noise in JFETs .34

Noise in opamps .34

Noise gain .36

Low-noise opamp circuitry .36

Noise measurements .36

How to attenuate quietly .37

How to amplify quietly .39

How to invert quietly .40

How to balance quietly .40

Ultra-low noise design with multipath amplifiers .40

Ultra- low noise voltage buffers .41

The 32-times 5532 opamp power amplifier .43

Ultra-low noise amplifiers .45

Multiple amplifiers for greater drive capability .47

Chapter 2 Components . **51**

Conductors .51

Copper and other conductive elements .51

The metallurgy of copper .53

Gold and its uses .54

Tin and its uses .54

Cable and wiring resistance .55

Printed circuit boards (PCBs) .55

PCB track resistance .56

PCB track-to-track crosstalk .58

The 3-layer PCB .60

Impedances and crosstalk: a case history .60

Resistors .62

Through-hole resistors .63

Surface-mount resistors .63

Resistor series .65

Resistor accuracy: two resistor combinations .66

Resistor accuracy: three resistor combinations .70

Other resistor combinations .71

Resistor value distributions .73
The uniform distribution .74
Resistor imperfections .75
Resistor excess noise .76
Resistor non-linearity .78
Capacitors .81
Capacitor series .83
Capacitor non-linearity examined .83
Non-electrolytic capacitor non-linearity .83
Electrolytic capacitor non-linearity .88
Capacitor microphony .91
Inductors .91

Chapter 3 *Discrete transistor circuitry* . 95
Why use discrete transistor circuitry? .95
Bipolars and FETs .96
Bipolar junction transistors .96
The transistor equation .97
Transconductance .98
Beta .98
Unity-gain buffer stages .98
The simple emitter-follower .99
The constant-current emitter-follower .102
The push-pull emitter-follower .104
Emitter-follower stability .105
JFET source-followers .107
CFP-followers .109
CFP-follower stability .111
Improved unity-gain buffers .115
Gain stages .116
One-transistor shunt-feedback gain stages .116
One-transistor series-feedback gain stages .117
Two-transistor shunt-feedback amplifiers .119
Two-transistor shunt-feedback stages: improving linearity121
Two-transistor shunt-feedback stages: noise .125
Two-transistor shunt-feedback stages: bootstrapping .125
Two-transistor shunt-feedback stages as summing amplifiers126
Three-transistor cascode shunt-feedback stages .127

Two-transistor series-feedback gain stages . 132

Discrete opamp design. 134

Discrete opamp design: the input stage. 135

Discrete opamp design: the second stage . 137

Discrete opamp design: the output stage. 139

Chapter 4 Opamps and their properties . **143**

Introduction . 143

A very brief history of opamps . 143

Opamp properties: noise . 144

Opamp properties: slew rate . 145

Opamp properties: common-mode range . 147

Opamp properties: input offset voltage . 147

Opamp properties: bias current . 147

Opamp properties: cost . 148

Opamp properties: distortion. 149

Opamp internal distortion . 150

Slew rate limiting distortion . 150

Distortion due to loading. 151

Thermal distortion. 151

Common-mode distortion . 152

Common-mode distortion: bipolar input opamps. 153

Common-mode distortion: JFET opamps. 157

Selecting the right opamp . 159

Opamps surveyed: BJT input types . 159

The LM741 opamp . 160

The NJM4580 opamp . 161

The NJM8068 opamp . 162

The NE5532/5534 opamp . 162

5532 output loading in shunt feedback mode . 164

The 5532 with series feedback . 165

Common-mode distortion in the 5532 . 166

Reducing 5532 distortion by output stage biasing . 168

Which 5532?. 172

The 5534 opamp. 173

Deconstructing the 5532. 174

The LM4562 opamp . 177

The AD797 opamp . 180

The OP27 opamp. 180

The OP270 opamp. 182

The OP275 opamp. 182

Opamps surveyed: JFET input types . 184

The TL072 opamp. 185

The OPA2134 opamp . 187

The OPA604 opamp . 190

The OPA627 opamp . 190

Chapter 5 Opamps for low voltages. 195

High fidelity from low voltages. 195

Running opamps from a single +5 V supply rail . 195

Opamps for +5 V operation . 197

The NE5532 in +5 V operation . 197

The LM4562 in +5 V operation. 198

The AD8022 in +5 V operation . 199

The AD8397 in +5 V operation . 200

Opamps for 3.3 V single-rail operation . 204

Chapter 6 Filters . 207

Introduction . 207

Passive filters . 207

Active filters. 208

Lowpass filters . 208

Highpass filters . 208

Combined lowpass and highpass filters. 209

Bandpass filters . 209

Notch filters . 209

All-pass filters . 210

Filter characteristics. 210

Sallen & Key lowpass filters . 210

Sallen & Key highpass filters. 214

Amplitude peaking and Q in lowpass and highpass Sallen & Key filters 215

Sallen & Key bandpass filters . 217

Sallen & Key notch filters . 220

Distortion in Sallen & Key filters . 221

Mixed capacitors in low-distortion Sallen & Key filters . 223

Multiple-feedback bandpass filters .224

Other notch filters .225

Higher-order filters .226

Switched-slope filters. .227

Differential Filters .228

Chapter 7 Preamp architecture . ***231***

Passive preamplifiers .231

Active preamplifiers. .232

Amplification and the gain-distribution problem. .233

Active gain controls. .234

Active gain controls plus passive attenuators .234

Recording facilities .235

Tone controls .235

Chapter 8 Variable gain stages . ***237***

Amplifier stages with gain from unity upwards: single gain pot.237

Amplifier stages with gain from unity upwards: dual gain pot241

Combining gain stages with active filters .243

Amplifier stages with gain from zero upwards: single gain pot244

Amplifier stages with gain from zero upwards: dual gain pot.247

Switched-gain amplifiers. .249

Chapter 9 Moving-magnet inputs: levels and RIAA equalisation ***253***

Cartridge types. .253

The vinyl medium .253

Spurious signals. .254

Other vinyl problems .256

Maximum signal levels from vinyl .257

Moving-magnet cartridge sensitivities. .261

Overload margins and amplifier limitations .262

Equalisation and its discontents. .263

The unloved IEC amendment .264

The 'Neumann pole' .265

MM amplifier configurations. .265

Opamp MM input stages .267

Calculating the RIAA equalisation components .268

Implementing RIAA equalisation .268

Implementing the IEC amendment .271

RIAA series-feedback network configurations .272
 RIAA optimisation: C1 as a single E6 capacitor, 2xE24 .275
 RIAA optimisation: C1 as 3x10 nF capacitors, 2xE24 .277
 RIAA optimisation: C1 as 4x10 nF capacitors, 2xE24 .279
 RIAA optimisation: the Willmann Tables .279
 RIAA optimisation: C1 as 3x10 nF capacitors, 3xE24 .281
 RIAA optimisation: C1 as 4x10 nF capacitors, 3xE24 .282
Switched-gain MM RIAA amplifiers .284
Switched-gain MM/MC RIAA amplifiers .286
Open-loop gain and RIAA accuracy .287
Passive and semi-passive RIAA equalisation .287
MM cartridge loading and frequency response .291
MM cartridge-preamplifier interaction .292
MM cartridge DC and AC coupling .293
Noise in MM RIAA preamplifiers .293
Hybrid MM amplifiers .300
Balanced MM inputs .301
Noise in balanced MM inputs .301
Noise weighting .303
Noise measurements .303
Cartridge load synthesis for lower noise .304
Subsonic filters .306
 Subsonic filtering: Butterworth filters .306
 Subsonic filtering: elliptical filters .308
 Subsonic filtering by cancellation: the Devinyliser .311
Ultrasonic filters .311
A practical MM amplifier #3 .312

Chapter 10 *Moving-coil head amplifiers* .317
Moving-coil cartridge characteristics .317
The limits on MC noise performance .318
Amplification strategies .319
Moving-coil transformers .319
Moving-coil input amplifiers .321
An effective MC amplifier configuration .323
The complete circuit .325
Performance .326
Opamp arrays for MC preamps .327

Chapter 11 Tape replay . **329**

The return of tape. .329

A brief history of tape recording .330

The basics of tape recording .330

Multitrack recording .332

Tape heads .332

Tape replay. .334

Tape replay equalisation .335

Tape replay amplifiers .338

Replay noise: calculation. .340

Replay noise: measurements .342

Load synthesis .343

Noise reduction systems .343

Dolby HX-pro .345

Chapter 12 Guitar preamplifiers . **349**

Electric guitar technology .349

Guitar pickups .349

Pickup characteristics .351

Guitar wiring .351

Guitar leads .352

Guitar preamplifiers. .353

Guitar preamplifier noise: calculations .354

Guitar preamplifier noise: measurements .357

Guitar amplifiers and guitar effects .359

Guitar direct injection .360

Chapter 13 Volume controls . **363**

Volume controls. .363

Volume control laws .364

Loaded-linear pots .366

Dual-action volume controls .369

Tapped volume controls. .372

Slide faders .375

Active volume controls .377

The Baxandall active volume control .381

The Baxandall volume control law .383

A practical Baxandall active volume stage .384

Low noise Baxandall active volume stages.................................386

The Baxandall volume control: loading effects388

An improved Baxandall active volume stage with lower noise390

Baxandall active volume stage plus passive control392

The overlap penalty...395

Potentiometers and DC ...398

Belt-ganged volume controls...398

Motorised potentiometers ..399

Stepped volume controls ...400

Switched attenuator volume controls.....................................401

Relay-switched volume controls409

Transformer-tap volume controls.......................................410

Integrated circuit volume controls......................................410

Loudness controls ...411

The Newcomb and Young loudness control415

Chapter 14 Balance controls.................................. 421

The ideal balance law ...421

Balance controls: passive..423

Balance controls: active..426

Combining balance controls with other stages428

Switched balance controls ..428

Mono-stereo switches ...430

Width controls ..432

Chapter 15 Tone controls and equalisers 435

Introduction ..435

Passive tone controls ...436

Baxandall tone controls ..437

The Baxandall one-LF-capacitor tone control438

The Baxandall two-LF-capacitor tone control443

The Baxandall two-HF-capacitor tone control444

The Baxandall tone control: impedance and noise446

Combining a Baxandall stage with an active balance control..................449

One-band tone controls ..450

Switched-HF-frequency Baxandall controls................................451

Variable-frequency HF EQ ..454

Variable-frequency LF EQ...455

A new type of switched-frequency LF EQ .456

Variable-frequency HF and LF EQ in one stage .457

Tilt or tone-balance controls .464

Middle controls .466

 Fixed-frequency Baxandall middle controls .467

 Three-band Baxandall EQ in one stage .468

 Wien fixed middle EQ .472

 Wien fixed middle EQ: altering the Q .472

 Variable-frequency middle EQ .474

 Single-gang variable-frequency middle EQ .476

 Switched-Q variable-frequency Wien middle EQ479

Switchable peak/shelving LF/HF EQ .480

Parametric middle EQ .482

Graphic equalisers .485

Chapter 16 *Mixer architecture* . 491

Introduction .491

Performance factors .491

Mixer internal levels .492

Mixer architecture .492

The split mixing architecture .494

The in-line mixing architecture .495

A closer look at split format modules .497

 The channel module (split format) .497

 Effect-return modules .500

 The group module .500

 The master module .501

 Talkback and oscillator systems .503

The in-line channel module .504

Chapter 17 *Microphone preamplifiers* . 507

Microphone types .507

Microphone preamplifier requirements .508

Transformer microphone inputs .509

The simple hybrid microphone preamplifier .510

 Simple hybrid microphone preamplifier: noise .511

 Simple hybrid microphone preamplifier: distortion512

 Simple hybrid microphone preamplifier: CMRR514

Microphone and line input pads. .514

Why phantom power is +48 V .518

Simple hybrid microphone preamplifier: non-switched .518

The balanced-feedback hybrid microphone preamplifier (BFMA).519

The padless microphone preamplifier .520

Mic preamps for digital mixers .523

Capacitor microphone head amplifiers .524

Ribbon microphone amplifiers. .526

Chapter 18 Line inputs. 529

External signal levels. .529

Internal signal levels .529

Input amplifier functions .530

Unbalanced inputs .530

Balanced interconnections. .533

The advantages of balanced interconnections .534

The disadvantages of balanced interconnections. .534

Balanced cables and interference. .535

Balanced connectors .537

Balanced signal levels .537

Electronic vs transformer balanced inputs. .537

Common mode rejection .538

The basic electronic balanced input. .540

Common-mode rejection: the basic balanced input and opamp effects543

Common-mode rejection: opamp frequency response effects.544

Common-mode rejection: opamp CMRR effects .545

Amplifier component mismatch effects. .546

A practical balanced input .548

Variations on the balanced input stage. .551

Alternative unbalanced or balanced inputs .552

Combined unbalanced and balanced inputs .552

The Superbal input .553

Switched-gain balanced inputs .554

Variable-gain balanced inputs .556

Combined line input and balance control stage with low noise557

The Self variable-gain line input. .559

High input impedance balanced inputs .560

The inverting two-opamp input. .561

The instrumentation amplifier .562

 Instrumentation amplifier applications .563

 The instrumentation amplifier with 4x gain .564

 The instrumentation amplifier at unity gain .568

 The instrumentation amplifier and gain controls .568

 The instrumentation amplifier and the Whitlock bootstrap570

Transformer balanced inputs .571

Input overvoltage protection .572

Low-noise balanced inputs .573

Low-noise balanced inputs in action .578

Ultra low-noise balanced inputs. .578

Chapter 19 Line outputs . **583**

Unbalanced outputs .583

Zero-impedance outputs .584

Ground-cancelling outputs: basics. .591

Ground-cancelling outputs: zero-impedance output .593

Ground-cancelling outputs: CMRR. .594

Ground-cancelling outputs: send amplifier noise .595

Ground-cancelling outputs: into a balanced input. .596

Ground-cancelling outputs: history .597

Balanced outputs: basics .597

Balanced outputs: output impedance. .599

Balanced outputs: noise .599

Economical -6 dB balanced output .601

Quasi-floating outputs .602

Transformer balanced outputs .604

Output transformer frequency response. .605

Output transformer distortion .606

Reducing output transformer distortion. .607

Output impedance synthesis .611

Chapter 20 Headphone amplifiers . **613**

Driving heavy loads. .613

Driving headphones. .613

Special opamps .614

Multiple opamps .614

Opamp transistor hybrid amplifiers .616

Discrete Class-AB headphone amplifiers .618

Discrete Class-A headphone amplifiers. .622

Balanced headphone amplifiers .624

Chapter 21 Signal switching . **627**

Mechanical switches .627

Input-select switching: mechanical .627

The virtual contact: mechanical. .629

Relay switching .631

Electronic switching .631

Switching with CMOS analogue gate .632

 CMOS gates in voltage mode .633

 CMOS gates in current mode .640

 CMOS series-shunt current mode. .641

 Control voltage feedthrough in CMOS gates .643

 CMOS gates at higher voltages. .643

 CMOS gates at low voltages .645

 CMOS gates in other formats .646

Discrete JFET switching .646

 Series JFET switching in voltage mode .647

 Shunt JFET switching in voltage mode. .651

 JFETs in current mode .652

 Reducing distortion by biasing of JFETs .657

 JFET drive circuitry. .659

 Physical layout and offness. .660

 Dealing with the DC conditions .660

 A soft changeover circuit with JFETs. .661

 Control voltage feedthrough in JFETs .662

Discrete MOSFET switching. .662

Chapter 22 Mixer sub-systems . **665**

Mixer bus systems .665

Input arrangements .666

Equalisation. .666

Insert points .666

How to move a circuit block .668

Faders. .669

 Improving fader offness .670

Postfade amplifiers. .671

Direct outputs. .673

Panpots. .673

 Passive panpots .675

 The active panpot .680

 LCR panpots .681

Routing systems. .684

Auxiliary sends .688

Group module circuit blocks .688

 Summing systems: voltage summing .689

 Summing systems: virtual-earth summing .689

 Balanced summing systems .691

 Ground-cancelling summing systems .693

 Distributed summing systems .694

Summing amplifiers. .698

 Hybrid summing amplifiers. .699

 Balanced hybrid summing amplifiers .702

Balancing tracks to reduce crosstalk .704

The multi-function summing amplifier .705

PFL systems. .706

 PFL summing .708

 PFL switching .708

 PFL detection .708

 Virtual-earth PFL detection. .710

AFL systems .712

Solo-In-Place systems .712

Talkback microphone amplifiers .714

Line-up oscillators .715

The flash bus .718

Power supply protection .720

Console cooling and component lifetimes. .720

Chapter 23 Level indication and metering . **723**

Signal-present indication. .723

Peak indication. .724

The Log Law Level LED (LLLL) .726

Distributed peak detection. .728

Combined LED indicators .730

VU meters .730

PPM meters .732

LED bar-graph metering .732

A more efficient LED bar-graph architecture .734

Vacuum fluorescent displays .737

Plasma displays .737

Liquid crystal displays .738

Chapter 24 Gain-control elements . 739

A brief history of gain-control elements .739

JFETs .739

Operational transconductance amplifiers (OTAs) .742

Voltage-Controlled Amplifiers (VCAs) .743

Compressors and limiters .746

Attack artefacts .749

Decay artefacts .750

Subtractive VCA control .751

Noise gates .752

Clipping .754

Diode clipping .754

Active clipping with transistors .757

Active clipping with opamps .758

1) Clipping by clamping .758

2) Negative-feedback clipping .761

3) Feedforward clipping .764

Noise generators .767

Pinkening filters .768

Chapter 25 Power supplies . 771

Opamp supply rail voltages .771

Designing a ±15 V supply .772

Designing a ±17 V supply .775

Using variable-voltage regulators .776

Improving ripple performance .778

Ultra low-noise regulators .778

Dual supplies from a single winding .779

Power supplies for discrete circuitry .780

Larger power supplies .780

Mutual shutdown circuitry. .781

Very large power supplies .782

Microcontroller and relay supplies .782

+48 V phantom power supplies .783

Chapter 26 Interfacing with the digital domain . **787**

PCB layout considerations. .787

Nominal levels and ADCs .788

Some typical ADCs .789

Interfacing with ADC inputs .789

Some typical DACs .792

Interfacing with DAC outputs .792

Interfacing with microcontrollers .794

Chapter 27 Design and experimentation . **797**

The design sequence .797

Schematics. .798

Prototype board .798

Screening prototype boards .802

Stripboard. .802

PCBs . ˙.803

Safety. .803

Appendix . **805**

Index. **807**

Preface

Scientia potentia est

"Another damned thick book! Always scribble, scribble, scribble! Eh, Mr. Gibbon?"

Attributed to Prince William Henry, Duke of Gloucester, in 1781 upon receiving the second volume of The History of the Decline and Fall of the Roman Empire *from its author.*

This book deals with small-signal audio design: the amplification and control of audio in the analogue domain, where the processing is done with opamps or discrete transistors, usually working at a nominal level of a Volt or less. It constitutes a major update of the third edition. "Small-signal design" is the opposite term to the "large-signal design" which in audio represents power amplifiers driving loudspeakers, rather than the electricity distribution grid or lightning.

The publication of *Electronics for Vinyl* in 2018 allowed the vinyl-oriented material in this book to be much reduced, so the space freed can be used for new material. All the phono material that was in the second and third editions of *Small Signal Audio Design* is in *Electronics for Vinyl*, plus a great deal more. Therefore the chapters on moving-magnet inputs have been reduced to one (Chapter 9); this cannot give comprehensive coverage of a very big subject, but it does give the most important information with many pointers to where very much more can be found in *Electronics for Vinyl*. Chapter 9 also contains new information that has been acquired since *Electronics for Vinyl* was written.

Much has been added to this edition, so it is difficult to summarise, but the new material includes

- Chapter 1: Balanced and unbalanced signals; the deeper meaning
- Chapter 1: Internally balanced design
- Chapter 1: 600-Ohm lines
- Chapter 1: Opamp-based power amplifiers
- Chapter 1: Tin and its uses
- Chapter 1: Printed circuit board technology
- Chapter 1: Microphony in electrolytic capacitors
- Chapter 3: Emitter-follower stability
- Chapter 3: JFET source-followers

- Chapter 3: CFP-follower stability

- Chapter 3: Three-transistor shunt-feedback amplifiers with current-injection to the cascode stage

- Chapter 4: More opamp types examined

- Chapter 4: Opamp output biasing for reduced distortion, and how most people get it wrong

- Chapter 6 Amplitude peaking and Q in lowpass and highpass Sallen & Key filters

- Chapter 6 Sallen & Key bandpass filters

- Chapter 6 Sallen & Key notch filters

- Chapter 6 Distortion in Sallen & Key filters

- Chapter 6 Mixed capacitors in low-distortion Sallen & Key filters

- Chapter 6 Other notch filters

- Chapter 6 Higher-order filters

- Chapter 6: Switched-slope filters

- Chapter 10: Opamp arrays for MC preamps

- Chapter 12: Piezoelectric guitar pickups

- Chapter 13: Active gain controls plus passive attenuators

- Chapter 15: One-band tone controls

- Chapter 17: Electret microphones

- Chapter 17: The simple hybrid microphone preamp: noise, distortion, CMRR

- Chapter 17: Why phantom power is 48 V

- Chapter 17: Hybrid microphone preamplifier: mic/line without-switching

- Chapter 17: Mic preamps for digital mixers

- Chapter 18: Alternative unbalanced and balanced inputs

- Chapter 19: More on noise in balanced outputs

- Chapter 19: The −6 dB economical balanced output

- Chapter 19: Output impedance synthesis

- Chapter 21: Signal switching with MOSFETs

- Chapter 21: DG411 analogue gate series switching

- Chapter 25: Ultra low-noise regulators

- Chapter 27: The design sequence: schematics, prototype board, PCBs, safety

There is unquestionably a need for high-quality analogue circuitry. For example, a good microphone preamplifier needs a gain range from 0 to +80 dB if it is to get any signal it is likely to encounter up to a workable nominal value. There is clearly little prospect of ever being able to connect an A-to-D converter directly to a microphone. The same applies to other low-output transducers such as moving-coil and moving-magnet phono cartridges. If you are starting at line level, and all you need is a simple but high-quality tone control, there is little incentive to convert to digital via a relatively expensive ADC, perform the very straightforward arithmetic manipulations in the digital domain, then go back to analogue via a DAC; there is also the need to implement the actual controls as rotary encoders and have those overseen by a microcontroller. All digital processing involves some delay because it takes time to do the calculations; this is called the latency and can cause serious problems if more than one signal path is involved.

The total flexibility of digital signal processing certainly allows greater scope—you might contemplate how to go about implementing a 1-second delay in the analogue domain, for example—but there are many times when greater quality or greater economy can be obtained by keeping the signal analogue. Sometimes analogue circuitry connects to the digital world, and so a complete chapter of this book deals with the subtleties of analogue/digital interfacing.

Therefore analogue circuitry is often the way to go. This book describes how to achieve high performance without spending a lot of money. As was remarked in a review of my recent book, *Active Crossover Design*, duplicating this performance in the digital domain is not at all a trivial business. You can of course start off in analogue, and when you have identified the filter slopes, equalisation curves, and what-not that you want, it is relatively easy to move it over to the DSP world.

It is paradoxically true that ultimately analogue is actually digital, as an electric signal is the movement of a finite number of discrete electrons. This is not merely theoretical; the finite number of charge carriers causes random fluctuations that manifest themselves as shot noise, which is important in bipolar transistors; see Chapter 1.

I have devoted the first few chapters to the principles of high-quality small-signal design, moving on to first look closely at hifi preamplifiers and then mixing consoles. These two genres were chosen partly because they are of wide interest in themselves, but also because they use a large number of different functional blocks with very little overlap between them. They thus cover a very wide range of circuit functions that will be useful for all kinds of audio systems. You will find out how to adapt or design these building-blocks, and how to put them together to form a system without bad things happening due to loading or interaction. You should then be able to design pretty much anything in this field.

In the pursuit of high quality at low cost, there are certain principles that pervade this book. Low-impedance design reduces the effects of Johnson noise and current noise without making voltage noise worse; the only downside is that a low impedance requires an opamp capable of driving it effectively and sometimes more than one. The most ambitious application of this approach so far has been in the ultra-low noise Elektor 2012 preamplifier.

Another principle in this book is that of using multiple components to reduce the effects of random noise. This may be electrical noise, in which case the outputs of several amplifiers are averaged (very simply with a few resistors), and the noise from them is partially cancelled. Multiple amplifiers are also very useful for driving the low impedances just mentioned.

Alternatively it may be numerical noise, such as tolerances in a component value; making up the required value with multiple parts in series or parallel also makes errors partially cancel. This technique has its limits because of the square root way it works; four amplifiers or components are required to half the noise, sixteen to reduce it to a quarter and so on. Multiple parts also allow very precise non-standard values to be achieved; see Chapter 2.

These techniques are especially relevant at the time of writing. Pandemic and war have disrupted supply chains, and components that are even slightly exotic are hard to find and on long lead times. It is therefore very useful if you can get excellent performance from commonplace parts. To take one example, if you use four 5532 sections with their outputs averaged (very simply with a few low-value resistors) you effectively have an opamp with 6 dB lower noise than a single 5532 section.

There is also the principle of optimisation, in which each circuit block is closely scrutinised to see if it is possible to improve it by a bit more thinking rather than a bit more spending. One example is the optimisation of RIAA equalisation networks. There are four ways to connect resistors and capacitors to make an RIAA network, and I have shown that one of them requires smaller values of expensive precision capacitors than the others. This finding is presented in detail in Chapter 9, along with related techniques of optimising resistor values to get convenient capacitor values.

In many places hybrid amplifiers combining the virtues of discrete active devices and opamps are used. If you put a bipolar transistor before an opamp, you get lower noise but the loop gain of the opamp means the distortion is as good as the opamp alone. This is extremely useful for making microphone amplifiers, tape replay amplifiers, and virtual-earth summing amplifiers. If you reverse the order, with an opamp followed by bipolar transistors, you can drive much heavier loads, with the opamp gain once again providing excellent linearity. This latter technology, among others, is explained in Chapter 20 on headphone amplifiers.

However, what you most emphatically will *not* find here is any truck with the religious dogma of audio subjectivism: the directional cables, the oxygen-free copper, the World War I vintage triodes still spattered with the mud of the Somme, and all the other depressing paraphernalia of pseudo-science and anti-science. I have spent more time than I care to contemplate in double-blind listening tests—properly conducted ones, with rigorous statistical analysis—and every time the answer was that if you couldn't measure it you couldn't hear it. Very often if you could measure it you still couldn't hear it. However, faith-based audio is not going away any time soon because few people (apart of course from the unfortunate customers) have any interest in it so doing; you can bet your bottom diode on that. If you want to know more about my experiences and reasoning in this area, there is a full discussion in my book *Audio Power Amplifier Design (Sixth Edition)*.

A good deal of thought and experiment has gone into this book, and I dare to hope that I have moved analogue audio design a bit further forward. I hope you find it useful and enjoyable too.

I have a website at www.dself.dsl.pipex.com where I will be adding supplementary material to this book from time to time.

PCBs for some of the designs described here, such as phono input stages and complete preamplifiers, can be found at www.signaltransfer.freeuk.com.

Douglas Self

London, February 2023

Acknowledgments

My heartfelt thanks to Julie, without whom you wouldn't be reading this.

The basics

Signals

An audio signal can be transmitted either as a voltage or a current. The construction of the universe is such that almost always the voltage mode is more convenient; consider for a moment an output driving more than one input. Connecting a series of high-impedance inputs to a low-impedance output is simply a matter of connecting them in parallel, and if the ratio of the output and input impedances is high there will be negligible variations in level. To drive multiple inputs with a current output it is necessary to have a series of floating current-sensor circuits that can be connected in series. This can be done [1], as pretty much anything in electronics can be done, but it requires a lot of hardware and would very likely introduce performance compromises. The voltage-mode connection is just a matter of wiring inputs in parallel.

Obviously, if there's a current, there's a voltage, and vice versa. You can't have one without the other. The distinction is in the output impedance of the transmitting end (low for voltage mode, high for current-mode) and in what the receiving end responds to. Typically, but not necessarily, a voltage input has a high impedance; if its input impedance was only 600 Ω, as used to be the case in very old audio distribution systems, it is still responding to voltage, with the current it draws doing so a side issue, so it is still a voltage amplifier. In the same way, a current input typically, but not necessarily, has a very low input impedance. Current outputs can also present problems when they are not connected to anything. With no terminating impedance, the voltage at the output will be very high and probably clipping heavily; the distortion is likely to crosstalk into adjacent circuitry. An open-circuit voltage output has no analogous problem.

Current-mode connections are not common. One rare example is the Krell Current Audio Signal Transmission (CAST) technology which uses current-mode to interconnect units in the Krell product range. While it is not exactly audio, the 4–20 mA current loop format is widely used in instrumentation. The current-mode operation means that voltage drops over long cable runs are ignored, and the zero offset of the current (ie 4 mA = zero) makes cable failure easy to detect; if the current suddenly drops to zero, you have a broken cable.

The old DIN interconnection standard was a form of current-mode connection in that it had voltage output via a high output impedance of 100 kΩ or more. The idea was presumably that you could scale the output to a convenient voltage by selecting a suitable input impedance. The drawback was that the high output impedance made the amount of power transferred very small, leading to a poor signal-to-noise ratio. The concept is now wholly obsolete.

DOI: 10.4324/9781003332985-1

All modern systems use a low output impedance (typically less than 100 Ω) to drive one or more high impedance (typically 10 kΩ or more) inputs. The output is expected to drive a minimum load of 600 Ω, so up to 16 inputs could be driven at once in the unlikely event of that being necessary. The 600 Ω load figure is purely a hangover from history, as described later in this chapter. It is easily achieved with opamps.

Unbalanced and balanced signals

Given a standard voltage-mode connection, it may be either unbalanced or balanced. Unbalanced is simple and unequivocal; there is a signal wire and a ground wire, as in Figure 1.1a.

With a balanced connection there are three wires. This can actually mean at least two things. In what is sometimes called a 'true balanced' connection, one wire carries the signal in-phase (Hot), another wire carries the same signal but inverted in phase (Cold), and the third wire is ground. This requires a balanced output on the sending equipment to create signals at a phase of 180° to each other; see Figure 1.1b. In normal audio usage the inverting amplifier has unity gain (−1) so the balanced signal is twice the amplitude of the unbalanced signal. This is convenient because for an unbalanced output you just use the non-inverting amplifier, wired to an RCA (phono) connector, and ignore the inverting amplifier.

Alternatively, the second wire does not carry signal but simply reads the ground voltage of the sending equipment and sends it to the receiving equipment; see Figure 1.1c. In either case the receiving equipment subtracts the voltage on the Cold line from that on the Hot line, and this cancels out noise from currents flowing through the ground wire, depending on the accuracy of the subtraction. Better than −40 dB across the audio band is easy to obtain; this factor is called the common-mode rejection ratio (CMRR). The only difference is that in the first case the overall signal level applied to the line is doubled (while still using the same supply rails) and so the signal-to-noise ratio of the link will be improved by 6 dB. This is important as balanced receiving equipment is normally internally noisier than in the unbalanced case.

There is another way of cancelling noise on the ground wire. If, instead of subtracting the sending ground from the signal at the receiving end, you add the receiving ground voltage at the sending end, the overall effect is the same, and the receiving end sees a clean signal. Once again the third wire is just used for ground-sensing and does not carry signal. This is called a ground-cancel connection and is relatively little-known despite its great usefulness; see Figure 1.1d. It is not normally called a balanced connection. All the aforementioned types of connection are examined in great detail in the line input and line output chapters of this book (Chapter 18 and Chapter 19).

One of the themes of this book is the exploration of ideas to see how far they can be taken. The obvious question here is: if using three wires is much better than two wires, how about using four? This doesn't work because having subtracted an interfering signal, you can't subtract it again without undoing the improvement you have just achieved, so it's not clear what having more than two phases could accomplish. A three-phase operation is, of course, common in power engineering, and six-phase has been used, but that is to optimise power transmission efficiency and has nothing to do with noise rejection. Generating three phases at 120° to each other is easy with an alternator but rather hard in audio electronics. If you implement a 90° phase shift across

Figure 1.1 a) Unbalanced link, b) Balanced link with balanced output, c) Balanced link with unbalanced output, d) Ground-Cancel link.

the audio band, and also use that signal inverted to give −90°, you would have four-phase audio with 90° between each phase. Creating a 90° phase shift wideband is (I think) impossible to do directly, but you can design a network with two outputs that are 90° apart across the spectrum. Four-phase audio (or better still, polyphase audio) might sound well cool, but it is going to be hard to do in the first place, hard to undo at the other end of the link, and quite pointless. Somebody in the audio business is probably working on it now.

Internally balanced design

The ultimate expression of balanced design is to use two identical paths through a piece of equipment so the signal is balanced all the way through. This is often referred to as 'internally

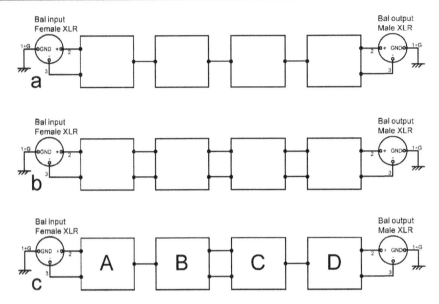

Figure 1.2 Three approaches to balancing: a) Unbalanced internally, b) Fully balanced internally, c) Balanced internally for a critical section of the signal path only.

balanced audio design' or more rarely, 'Fully balanced design'. While rather a rare technique, for reasons that will emerge, it does have its own Wikipedia page [2]. There is a useful discussion of the topic at [3].

In Figure 1.2a, there is a conventional piece of equipment with a balanced input and a balanced output. The balanced input converts the signal to single-ended as soon as possible, both to save components and achieve the best CMRR, and the signal passes through the rest of the signal path in this form. It is converted back to balanced only in the last stage of the equipment. A balanced output gives no direct reduction in noise or interference, but it does double the effective signal level and so increases the dynamic range of the interconnect by +6 dB, which is well worth having.

At Figure 1.2b the signal path is balanced all the way through so there are twice as many stages; each circuit block now represents two identical stages. The signal is never converted to single-ended.

At Figure 1.2c most of the signal path is unbalanced, but internally the signal is converted to balanced in Block B and then reconverted to single-ended in Block C for the rest of the signal path before it is finally rebalanced at the output; the classic application for this is large-scale mixers. The mix bus system is vulnerable to capacitive crosstalk and also often works at a large noise gain (see later in this chapter). A balanced mix bus systems addresses both issues; balanced buses will reject crosstalk, and a balanced system will be in theory be 3 dB quieter than an unbalanced equivalent.

If balanced is good, then fully balanced must be better, no? No. Here's why.

1) If the signal path is balanced all the way from input to output, never becoming single-ended, then for ground-noise reduction you are relying entirely on the CMRR of the balanced equipment that comes afterwards. If that equipment is unbalanced you will get no CMRR at all, and one of the paths in your full-balanced box will be ignored and is doing nothing useful whatever. A good CMRR is essential for rejecting ground noise.

2) If the signal path is balanced all the way from input to output, then the gain of the Hot (in-phase) path has to be matched very closely indeed to that of the Cold (phase-inverted) path, or the CMRR will be greatly degraded, even if the downstream equipment has a superb CMRR. This would be a major challenge with the simplest of circuitry, but when you consider something like a hifi preamp, where you have the cost of precision capacitors and the wide tolerances of pot tracks, it starts to look impossible. By contrast, the standard practice is to have a balanced input stage which converts the signal to single-ended as soon as possible. It can easily be optimised for a good CMRR as it involves relatively few components. If you are prepared to accept a preset CMRR adjustment, which will be set-and-forget at testing time, you should see better than −80 dB at low frequencies.

3) It is unarguable that the amount of circuitry is doubled, doubling manufacturing time, PCB area, and power consumption, and probably more than doubling the cost. For example, a four-gang pot is likely to cost more than twice the price of a two-gang pot because of much reduced demand and manufacturing quantities.

4) What about noise? It is one of the fundamental principles in this book that using two or more amplifiers and averaging their outputs gives a reduction in noise as the noise from the amplifiers is uncorrelated, but the signals are correlated. Thus two amplifiers give a 3 dB noise improvement, four amplifiers give 6 dB, and so on (see later in this chapter for more on this). Therefore two identical signal paths should give a 3 dB noise reduction when the Hot and Cold outputs are summed (which is the same as averaging, the latter just using half the gain). This summation is, however, going to be carried out by the piece of equipment downstream, assuming it is balanced in the conventional way.

 In the particular case of a magnetic cartridge RIAA stage, doubling it and requiring twice as many precision capacitors is not at all enticing. In fact it is not only utterly pointless, but actually harmful, as the noise performance will actually be degraded by about 1 dB with typical moving magnet (MM) cartridges, as I demonstrated in my book *Electronics for Vinyl* [4, 5]. This is because an MM or moving coil (MC) cartridge is a floating voltage source. There is no grounded centre-tap, so it cannot operate in a balanced mode.

5) What about distortion? This may be either increased or decreased depending on the distortion introduced by each semiconductor device. A worthwhile and dependable reduction in distortion by cancellation in the Hot and Cold paths is highly unlikely if you're using opamps. If you had some sort of discrete transistor design where the second harmonic was highly predictable, then you might be able to cancel it with a fully balanced design, but it would hardly be elegant design. And what about the other harmonics?

6) What about crosstalk? There are theoretical advantages, but in stereo equipment obtaining spectacularly good interchannel crosstalk (say better than −100 dB) is not very hard. The

situation is different in mixers where a lot of circuitry has to be packed into a very limited space; see Chapter 22 where local balancing (as in Figure 1.2c) is used in a mixer module without actually requiring any extra components at all. You will sometimes see statements like: "Internally balanced circuit design can offer better signal integrity by avoiding the extra amplifiers and/or transformers required for front-end unbalancing and back-end rebalancing." Well, possibly, if you have some really bad amplifiers. Probably better to use decent ones. And of course, hardly anyone uses transformers anymore. 'Can offer' are the tiresomely familiar audio weasel words that mean the author is not prepared to commit themselves. Why not, eh?

7) You also need to consider that anyone knowledgeable about audio will at once raise an eyebrow if told that 'the signal path is wholly balanced.' In my case, for the aforementioned reasons, I would have very dark suspicions as to whether the designer knew what he or she was doing.

Current examples of fully balanced professional audio products are manufactured by companies such as Millennia Media, 7th Circle Audio, Grace Design, and others. The Balanced Musical Concept (BMC) company [6] state that "All analogue circuitry is designed with a balanced signal path."

600-Ohm lines

When the first sizeable audio systems were setup, telephone technology was adopted because it was the only one available. The characteristic impedance of a telephone line on poles was usually about 600 Ω, and this was adopted despite the fact that even a huge audio installation would not have lengths anything like great enough to act as transmission lines (this is not the place to explain transmission line operation). The telephone origin of 600 Ω operation has sometimes been questioned, but if you plug typical telephone line dimensions, with 22 AWG wire, into the classic transmission line formulae, you do indeed get around 600 Ω [7]. The wire thickness affects the characteristic impedance, not for geometrical reasons, but because a thinner wire has more resistance per metre, and this affects the impedance. Using 26 AWG wire for the wire gives a 900-Ohm line.

It is generally accepted that you only need to think about a pair of conductors behaving as a transmission line when their length exceeds 1/10 of a wavelength at the highest frequency of concern. For a 1 kHz signal a wavelength is 300 kilometres, and at 20 kHz it is 15 kilometres. That would be a big recording studio. For any reasonable installation, transmission line technology is wholly irrelevant.

It is something of a mystery why early audio systems adopted transmission line technology. One hypothesis is that the telephone companies were the only people working with audio circuitry; the recording industry was still pretty much acoustic, with large hoods being placed over pianos to get sufficient signal to work a cutter head. So telephone technology was adopted, apparently without much thought. Much of the early audio work was done by Western Electric and Bell Labs, both branches of the Bell Telephone Company, who no doubt favoured the technology they knew.

The valve amplifiers in use could easily have been made to have very high impedance inputs, but lowering their output impedance was another matter; it meant adding a cathode-follower or a

step-down transformer, or both, which was expensive. But then you needed an output transformer anyway to match a valve anode circuit to 600 Ω.

The ghost of the 600 Ω line system still lingers faintly in modern audio. A decent line output is commonly expected to be able to drive a 600 Ω load with low distortion; easy enough, just reach for a 5532 opamp. The ability to drive 600 Ω means that if each input has a 10 kΩ bridging impedance, you can drive 16 of them wired in parallel. It is unlikely you will want to do that, but on the other hand, Bill Gates said 640 k of RAM should be enough for anybody. There is absolutely no question of 'matching' source and load impedances to optimise the power transfer. While this may be the case, inputs respond to voltage, not power.

The other place the spectre of 600 Ω persists is in the definition of 0 dBm = 1 mW in 600 Ω = 0.775 Vrms. As any pedant will tell you, dBm, strictly speaking, refers to power, and you should use dBu, which has the same definition but applies to voltage only. dBV works the same but is defined as 0 dBV = 1 Vrms. I always use dBu.

This was not the only impedance standard. For many years, CBS Radio used 150 Ω as their standard impedance, so their equipment would not work well with the rest of the industry without suitable 2:1 transformers at the impedance conversion point. A typical piece of mixer equipment such as the CBS 3B Studio Console [8] not only had 150 Ω inputs and outputs, but also used 150 Ω as its internal working impedance. The 150 Ω figure is roughly the impedance of a 20 AWG twisted pair with thick insulation, and this is likely its origin.

A 600 Ω line connection has an output impedance of 600 Ω at the sending end, and an input impedance of 600 Ω at the receiving end. Any matched-impedance system has equivalent source impedance and loading, which means that 6 dB of signal level is always lost, and so either noise or headroom compromised.

Amplifiers

At the most basic level, there are four kinds of amplifier because there are two kinds of signals (voltage and current) and two types of port (input and output). The handy word "port" glosses over whether the input or output is differential or single-ended. Amplifiers with differential input are very common—such as all opamps and most power amps—but differential outputs are rare and normally confined to specialised telecoms chips.

Table 1.1 summarises the four kinds of amplifiers.

TABLE 1.1 The four types of amplifiers

Amplifier type	Input	Output	Application
Voltage amplifier	Voltage	Voltage	General amplification
Transconductance amplifier	Voltage	Current	Voltage control of gain
Current amplifier	Current	Current	?
Transimpedance amplifier	Current	Voltage	Summing amplifiers, DAC interfacing

Voltage amplifiers

These are the vast majority of amplifiers. They take a voltage input at a high impedance and yield a voltage output at a low impedance. All conventional opamps are voltage amplifiers in themselves, but they can be made to perform as any of the four kinds of amplifier by suitable feedback connections. Figure 1.3a shows a high-gain voltage amplifier with series voltage feedback. The closed-loop gain is (R1+R2)/R2.

Transconductance amplifiers

The name simply means that a voltage input (usually differential) is converted to a current output. It has a transfer ratio $A = I_{OUT}/V_{IN}$, which has dimensions of I/V or conductance, so it is referred to as a transconductance amplifier. It is possible to make a very simple, though not very linear, voltage-controlled amplifier with transconductance technology; differential-input operational transconductance amplifier (OTA) ICs have an extra pin that gives voltage control of the transconductance, which when used with no negative feedback gives gain control; see Chapter 24 for details. Performance falls well short of that required for quality hifi or professional audio. Figure 1.3b shows an OTA used without feedback; note the current-source symbol at the output.

Current amplifiers

These accept a current in and give a current out. Since, as we have already noted, current-mode operation is rare, there is not often a use for a true current amplifier in the audio business. They should not be confused with current feedback amplifiers (CFAs), which have a voltage output, the 'current' bit referring to the way the feedback is applied in current-mode [9]. The bipolar transistor is sometimes described as a current amplifier, but it is nothing of the kind. Current may flow in the base circuit, but this is just an unwanted side effect. It is the *voltage* on the base that actually controls the transistor.

Transimpedance amplifiers

A transimpedance amplifier accepts a current in (usually single-ended) and gives a voltage out. It is sometimes called an I-V converter. It has a transfer ratio $A = V_{OUT}/I_{IN}$, which has dimensions of V/I or resistance. That is why it is referred to as a transimpedance or transresistance amplifier. Transimpedance amplifiers are usually made by applying shunt voltage feedback to a high-gain voltage amplifier. An important use is as virtual-earth summing amplifiers in mixing consoles; see Chapter 22. The voltage amplifier stage (VAS) in most power amplifiers is a transimpedance amplifier. They are used for I-V conversion when interfacing to DACs with current outputs; see Chapter 26. Transimpedance amplifiers are sometimes incorrectly described as 'current amplifiers.'

Figure 1.3c shows a high-gain voltage amplifier transformed into a transimpedance amplifier by adding the shunt voltage feedback resistor R1. The transimpedance gain is simply the value of R1, though it is normally expressed in V/mA rather than Ohms.

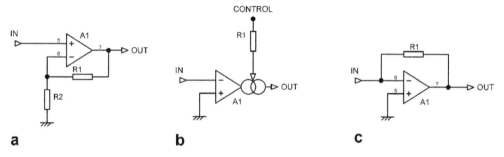

Figure 1.3 a) a voltage amplifier, b) a transconductance amplifier, c) a transimpedance amplifier.

Negative feedback

Negative feedback is one of the most useful and omnipresent concepts in electronics. It can be used to control gain, to reduce distortion and improve frequency response, and to set input and output impedances, and one feedback connection can do all these things at the same time. Negative feedback comes in four basic modes, as in the four basic kinds of amplifier. It can be taken from the output in two different ways (voltage or current feedback) and applied to the amplifier input in two different ways (series or shunt). Hence there are four combinations.

However, unless you're making something exotic like an audio constant-current source, (which you might well be if you're designing a tape machine) the feedback is always taken as a voltage from the output, leaving us with just two feedback types, series and shunt, both of which are extensively used in audio. When series feedback is applied to a high-gain voltage amplifier, as in Figure 1.3a, the following statements are true:

Negative feedback reduces voltage gain.

Negative feedback increases gain stability.

Negative feedback increases bandwidth.

Negative feedback increases amplifier input impedance.

Negative feedback reduces amplifier output impedance.

Negative feedback reduces distortion.

Negative feedback does not directly alter the signal-to-noise ratio.

If shunt feedback is applied to a voltage amplifier to make a transimpedance amplifier, as in Figure 1.3c, all the statements are still true, except since we have applied shunt rather than series negative feedback, the input impedance is reduced.

The basic feedback relationship is Equation 1.1 is dealt with at length in any number of textbooks, but it is of such fundamental importance that I feel obliged to include it here. The open-loop gain of the amplifier is A, and β is the feedback fraction, such that if in Figure 1.3a R1 is 2 kΩ and R2 is 1 kΩ, β is 1/3. If A is very high, you don't even need to know it; the 1 on the bottom becomes negligible, and the As on top and bottom cancel out, leaving us with a gain of almost exactly three.

$$\frac{Vout}{Vin} = \frac{A}{1 + A\beta} \qquad \text{Equation 1.1}$$

Negative feedback can, however, do much more than stabilising gain. Anything unwanted occurring in the amplifier, be it distortion or DC drift, or almost any of the other ills that electronics is heir to, is also reduced by the negative feedback factor (NFB factor for short). This is equal to

$$NFBfactor = \frac{1}{1 + A\beta} \qquad \text{Equation 1.2}$$

What negative feedback cannot do is improve the noise performance. When we apply feedback, the gain drops, and the noise drops by the same factor, leaving the signal-to-noise ratio the same. Negative feedback and the way it reduces distortion is explained in much more detail in one of my other books [10].

Nominal signal levels and dynamic range

The absolute level of noise in a circuit is not of great significance in itself—what counts is how much greater the signal is than the noise—in other words the signal-to-noise ratio. An important step in any design is the determination of the optimal signal level at each point in the circuit. Obviously a real signal, as opposed to a test sinewave, continuously varies in amplitude, and the signal level chosen is purely a nominal level. One must steer a course between two evils:

If the signal level is too low, it will be contaminated unduly by noise.

If the signal level is too high, there is a risk it will clip and introduce severe distortion.

The wider the gap between them the greater the dynamic range. You will note that the first evil is a certainty, while the second is more of a statistical risk. The consequences of both must be considered when choosing a level, and, if the best possible signal-to-noise is required in a studio recording, then the internal level must be high; if there is an unexpected overload you can always do another take. In live situations it will often be preferable to sacrifice some noise performance to give less risk of clipping. The internal signal levels of mixing consoles are examined in detail in Chapter 16.

If you seek to increase the dynamic range, you can either increase the maximum signal level or lower the noise floor. The maximum signal levels in opamp-based equipment are set by the voltage capabilities of the opamps used, and this usually means a maximum signal level of about 10 Vrms or +22 dBu. Discrete transistor technology removes the absolute limit on supply voltage and allows the voltage swing to be at least doubled before the supply rail voltages get inconveniently high. For example, +/–40V rails are quite practical for small-signal transistors and permit a theoretical voltage swing of 28 Vrms or +31 dBu. However, in view of the complications of designing your own discrete circuitry, and the greater space and power it requires, those nine extra dB of headroom are dearly bought. You must also consider the maximum signal capabilities of stages downstream—they might get damaged.

The dynamic range of human hearing is normally taken as 100 dB, ranging from the threshold of hearing at 0 dB SPL to the usual 'Jack hammer at 1 m' at +100 dB SPL; however hearing damage is generally reckoned to begin with long exposures to levels above +80 dB SPL. There is, in a sense, a physical maximum to the loudest possible sound. Since sound is composed of cycles of compression and rarefaction, this limit is reached when the rarefaction creates a vacuum because you can't have a lower pressure than that. This corresponds to about +194 dB SPL. I thought this would probably be instantly fatal to a human being, but a little research showed that stun grenades generate +170 to +180 dB SPL, so maybe not. It is certainly possible to get asymmetrical pressure spikes higher than +194 dB SPL, but it is not clear that this can be defined as sound.

Compare this with the dynamic range of a simple piece of cable. Let's say it has a resistance of 0.5 Ω; the Johnson noise from that will be −155 dBu. If we comply with the European Low Voltage Directive the maximum voltage will be 50 Vpeak = 35 Vrms = +33 dBu, so the dynamic range is 155 + 33 = 188 dB, which purely by numerical coincidence is close to the maximum sound level of 194 dB SPL.

In the field of music, louder is not always better. When the level exceeds a threshold, in the range 75–95 dB SPL, the human ear protects itself by with the stapedius reflex (also called the acoustic reflex) [11]. One of the tiny bones that couple the eardrum to the oval window of the cochlea is the stapedius, and when the reflex is triggered the muscle attached to it contracts and reduces the sound transmission by about 15 dB. I perceive it as a relatively sudden increase in intermodulation distortion as the music level increases, though it is not really the same subjective effect as amplifier distortion. Thus, quite apart from the consideration of hearing damage, which is important as it is irreparable and it doesn't get better, there is no point in being too loud. It is noticeable that in recent years professional audio has taken notice of this, and rock concerts are much better for it. Semi-pro practice is less admirable, and there is a venue pub near me where the SPLs are far above stapedius and well into the discomfort level, generating a hefty threshold shift [12] after an hour or so. I probably ought to do something about this.

Frequency response

The generally accepted requirement for the frequency response of audio equipment is that it should be flat from 20 Hz to 20 kHz. But how flat? A common spec 50 years ago would have been ±1 dB. You might wonder why a plus tolerance is required when we are usually talking about roll-offs; the reason is that valve amplifiers with output transformers may well show a peak at the HF end due to transformer resonance. There should never be any response peaking with solid-state equipment. Nowadays if you are aiming for quality kit, the amplitude tolerance is more likely as ±0.1 dB, which is far less than human perception can detect but easy to measure and still easy to attain with a little thought.

The frequencies are often altered to 22 Hz to 22 kHz because the leading testgear has measurement bandwidth so defined. It is a sad fact that with increasing chronological age, the upper reaches of the audio band are lost to us; this is called presbycusis [13]. I was intrigued to learn that birds, fish, and amphibians do not suffer presbycusis with ageing as they can regenerate their cochlear sensory cells; mammals including humans have genetically lost this extremely useful ability, and I call that downright careless.

You will sometimes hear people say that frequencies above 20 kHz are required for true reproduction, even though every conventional test shows that they cannot be perceived. Usually someone will mention the notorious 2000 paper by Tsutomu Oohashi in which he claimed that brain scans of subjects listening to the gamelan music of Bali (with much ultrasonic content) showed that ultrasonic frequencies caused changes in the brain although they were reported by the subjects as inaudible. The experimental methods described in the paper underwent much criticism and other researchers could not replicate the results. He never did any more work on the subject, and the general view is that the paper is a right load of—er, should be disregarded [14].

Another reason sometimes put forward for an over-extended frequency response is that it reduces the amount of phase shift undergone by signals towards the top of the audio band. There's a regrettable example at [15]. To illustrate, if the −3 dB cutoff frequency of a single roll-off is 40 kHz, the phase lag at 10 kHz is 14 degrees with respect to mid-band. If the cutoff is raised to 100 kHz the corresponding 10 kHz phase lag is only 5.7 degrees. This might have some weight if phase shift was perceptible, but since it isn't (see next section) the whole idea is invalid.

If 20 kHz is fine for the upper frequency limit, what about the bottom end? Things a bit simpler as we are dealing with the fundamental frequencies of musical instruments, which are well-known, unlike the harmonic content. For example a bass guitar with standard tuning has a bottom frequency of 41.2 Hz. This implies we will be fine with a 20 Hz limit and a standard bass guitar, but there are other instruments to be considered. Musical instrument ranges are more commonly described by note names; thus 41.2 Hz is E1, assuming the standard musical scale where the reference A4 is 440 Hz. There is a note-frequency conversion chart at [16].

E0 is one octave down at 20.6 Hz, and E2 is one octave up at 82.4 Hz. When five or six strings are used, on a bass guitar the lowest string is usually tuned to B0 (= 31 Hz).

The bottom note of a standard bowed double-bass is also E1. If that isn't low enough, there is the octobass, a giant double-bass that requires two people to operate it. Only seven have ever existed. One example has its three strings tuned to C0, G0, D1; the note C0 is 16.3 Hz, the bottom of the musical range and generally considered to be below the range of human hearing. You're only going to hear the harmonics. The fundamental pitch of a contrabass C1 tuba [17] is 32 Hz, and for a contrabass B1b tuba, 29 Hz. We must not, of course, neglect the subcontrabass tuba [18], though there are believed to be only five in existence in the whole world. One is tuned to F0 (= 21.8 Hz) as its bottom note. 20 Hz still looks like a realistic lower limit.

For real subsonics, the pipe organ is the way to go. A 32-foot organ stop has a bottom note of 'double pedal' C0 (16.35 Hz); these are rare as 32-foot pipes take up a lot of room. This is not the very bottom; there are two organs in the world that have complete 64-foot stops, the lowest note being 8.2 Hz, a 'note' sometimes called sub-subcontra-C or C-1. These are in the Sydney Town Hall, Australia, and the Atlantic City Convention Hall, United States. There is some more information on extreme organs at [19].

This discussion only relates to the low-frequency response of the electronics, where a response to 20 Hz or below is very easy to obtain. It is, of course, entirely another matter to find a loudspeaker system that is flat to 20 Hz or below.

Frequency response: cascaded stages

The typical audio path consists of several stages, all of which will have a high-frequency (HF) cutoff at some frequency. Many will also have a low-frequency (LF) cutoff, though sometimes stages are DC-coupled and so have no LF cutoff. It is instructive to see how the roll-offs add up. Bear in mind that the word 'cut-off' does not imply a sharp drop in response such as you would get from a high-order filter; even with the gentle 6 dB/octave slopes we are talking about here, the −3 dB point is still referred to as the cutoff frequency.

Take an audio path with N stages, each having the same cutoff frequency of f_s. This is hardly realistic but stay with me. In this case it is relatively simple to calculate the overall −3 dB cutoff frequency of the path; use Equation 1.3 for the high-frequency roll-off and Equation 1.4 for the roll-off at the bottom end.

$$f_{overall} = f_s\sqrt{2^{\frac{1}{n}} - 1}$$ Equation 1.3

$$f_{overall} = f_s \bigg/ \sqrt{2^{\frac{1}{n}} - 1}$$ Equation 1.4

Table 1.2 shows how this works for high-frequency cutoff, and Table 1.3 for the low-frequency cutoff. I have used 10 Hz and 20 kHz for the cutoffs of a single stage because they are nice round numbers: in practical design they would probably be lower and higher respectively, to obtain the desired bandwidth, as the tables show.

TABLE 1.2 HF cutoffs with N stages

Single	Stages	Overall
kHz	N	kHz
20	1	20
20	2	12.87
20	3	10.20
20	4	8.70
20	5	7.71
20	6	7.00
20	7	6.45
20	8	6.02
20	9	5.66
20	10	5.36
20	15	4.35
20	20	3.76

TABLE 1.3 LF cutoffs with N stages

Single	Stages	Overall
Hz	N	Hz
10	1	10.00
10	2	15.54
10	3	19.61
10	4	22.99
10	5	25.93
10	6	28.58
10	7	31.00
10	8	33.24
10	9	35.34
10	10	37.33
10	15	45.98
10	20	53.25

Table 1.2 makes it clear that two stages have a much lower bandwidth than each individual stage; three stages halve the HF cutoff frequency. Likewise in Table 1.3, three stages double the LF cutoff frequency. Clearly if you want a final HF cutoff of 20 kHz then with five identical stages you would need to select a higher cutoff for each stage at 20*(20/7.71) = 52 kHz or higher. Similarly at LF with five stages you would need to select a lower cutoff for each stage at 10/ (10/25.93) = 3.86 Hz or lower.

When you have the stages designed, the LF cutoff can sometimes be obtained by evaluating a simple RC time-constant. For anything more involved I strongly suggest you use a simulator. I have never enjoyed complex algebra, and it is horribly easy to make mistakes in it.

An alternative way to present this information is to directly calculate the stage cutoffs by working Equations 1.3 and 1.4 backwards. This can be done very simply using the Goalseek function in Excel. Table 1.4 shows that with 20 stages the individual cutoff frequency must be more than five times the desired overall cutoff frequency. Table 1.5 shows a similar result at the low end—with 20 stages the individual cutoff must be 1.88 Hz to get 10 Hz overall.

You may be thinking that it is pointless to extend these tables all the way up to 20 stages, but a signal path can easily be that long in a mixing desk, and such situations require careful design to stop roll-offs accumulating too much.

While the tables give a good insight into the way roll-offs accumulate, they do not represent a good design strategy. A lot of identical 6 dB/octave roll-offs give a slow and soggy composite roll-off, equivalent to a synchronous filter [20]. If we look at the LF cutoff, a better way is to have one relatively high cutoff frequency and the rest a good deal lower. We can then put the relatively high cutoff frequency in the first stage, where it will give some protection against subsonic disturbances. This is not, of course, an alternative to a proper highpass filter of second or higher order in cases where subsonics are a serious problem, such as microphone and vinyl cartridge amplifiers.

TABLE 1.4 Individual HF cutoffs for 20 kHz overall

Individual cutoff	No of stages	Overall cutoff freq
kHz	N	kHz
20.00	1	20
31.08	2	20
39.23	3	20
45.98	4	20
51.87	5	20
57.15	6	20
61.99	7	20
66.48	8	20
70.68	9	20
74.65	10	20
91.97	15	20
106.50	20	20

TABLE 1.5 Individual LF cutoffs for 10 Hz overall

Individual cutoff	No of stages	Overall cutoff freq
Hz	N	Hz
10.00	1	10
6.44	2	10
5.10	3	10
4.35	4	10
3.86	5	10
3.50	6	10
3.23	7	10
3.01	8	10
2.83	9	10
2.68	10	10
2.17	15	10
1.88	20	10

The LF response of each stage is likely to be set by a combination of a ±20% electrolytic capacitor and a ±1% resistor. The tolerance of the capacitor must be kept in mind, and the circuit designed for its minimum −20% extreme, because in this situation a more extended LF response is preferable to one that is curtailed early. Another very important point is that electrolytic capacitors generate distortion when they have a significant signal voltage across them, ie when they are implementing a roll-off. To reduce this effect to negligible proportions it is necessary to have a much greater time-constant than would be necessary simply to implement the required frequency response. This also suggests that to obtain a given cutoff frequency it is best to define it in the first stage, possibly using a relatively expensive but much more accurate non-electrolytic capacitor and then have much lower cutoff frequencies in the other stages.

As an example of this approach, see Figure 1.4a, where there are five identical stages giving an overall 10 Hz cutoff. From Table 1.5 we see that each stage needs to have a cutoff frequency of 3.86 Hz. There are no simple equations for calculating the combined effect of stages with differing cutoff frequencies, and I found the best method was to calculate the response of each stage separately on a spreadsheet and sum the dBs to get the overall response at any given frequency. If we decide that a 2 Hz cutoff in stages 2 to 5 is desirable, the first stage can be spreadsheet can be twiddled with Goalseek, and we find that the first-stage cutoff must be at the much higher frequency of 8.42 Hz to get the same overall 10 Hz cutoff, as in Figure 1.4b. Perhaps unexpectedly, this has a slower roll-off than five identical stages.

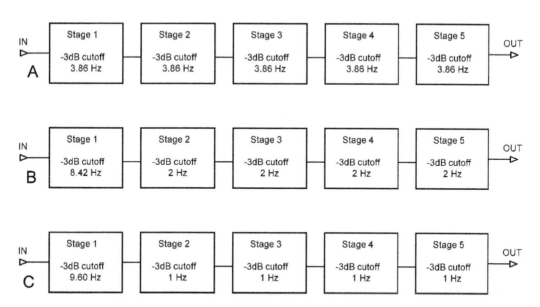

Figure 1.4 **Three ways to obtain an overall −3 dB LF cutoff frequency at 10 Hz using five stages. Putting the highest cutoff at the start, as in B and C, gives more protection against subsonic disturbances.**

Alternatively we could select a 1 Hz cutoff in stages 2 to 5, perhaps because we are troubled with capacitor distortion, and the first stage now needs a cutoff only slightly below 10 Hz, at 9.60 Hz; see Figure 1.4c. The roll-off is slightly slower than for the 2 Hz case.

Exactly the same considerations apply when dealing with the upper end of the frequency response, though it may be somewhat complicated if the HF cutoffs are partly due to opamp gain/bandwidth limitations. Figure 1.5a shows that if you have five identical stages, a cutoff of 92.13 kHz is needed to get −1 dB at 20 kHz. Figure 1.5b shows again the principle of putting the most restrictive stage first—now we put the *lowest* cutoff first to help keep out ultrasonic unpleasantness and have the higher cutoff frequencies later. In this case I have taken the cutoff attenuation as −1 dB at 20 kHz as −3 dB is certainly too low in most cases.

Spreadsheet calculation shows that if all five stages are identical, the common cutoff frequency must be 92.13 kHz, as in Figure 1.5a. If instead we set the −3 dB cutoff in stages 2 to 5 to 100 kHz, the cutoff frequency of the first stage can be twiddled with Goalseek, yielding 72.51 kHz, as in Figure 1.5b. Alternatively, we can set the −3 dB cutoff in stages 2 to 5 to 120 kHz, and the correct input stage −3 dB cutoff is now 56.0 kHz, giving rather more input protection, as in Figure 1.5c. Capacitor distortion should not be a problem at the HF end; the capacitors will be small and can be polystyrene or NP0 ceramic.

There is, of course, no requirement at either the LF or HF ends of the spectrum that any of the stages have the same cutoff frequency. The HF stage cutoffs are sometimes determined by the need to add a stabilisation capacitor; if none is needed then there may be nothing setting the cutoff of that stage but the finite opamp gain/bandwidth This is perfectly acceptable. When a capacitor is used, the exact HF cutoff frequency will be partly determined by the preferred values of the capacitors used and, of course, their tolerance.

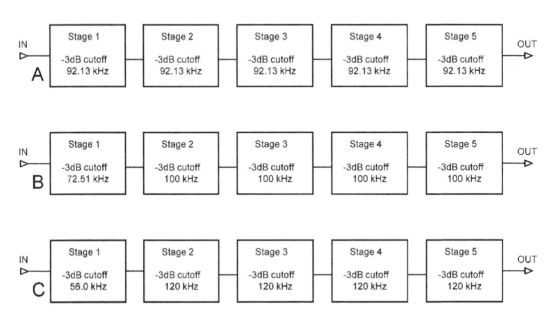

Figure 1.5 Three ways to obtain an overall −1 dB HF cutoff frequency at 20 kHz, using five stages. Putting the lowest cutoff at the start, as in B and C, gives more protection against ultrasonic disturbances. Be aware that while the overall response is −1 dB at 20 kHz, the cutoff frequencies for each are given at −3 dB.

Phase perception

You don't have any. Under realistic conditions human hearing cannot detect phase shift, which is just as well because most of what you hear will have been phase shifted all over the place by loudspeakers and subsequent room reflections. Being able to hear phase would probably be hopelessly distracting and from an evolutionary point of view it would be useless. It's not, as far as I can see, going to help you detect the tiger stalking you through the undergrowth, whereas stereo location with binaural hearing might. It's definitely 'might' because tigers, despite their large size, can move with terrifying stealth.

We are talking here about having one part of the audio spectrum phase shifted with respect to another. An example was given in the previous section; a −3 dB cutoff frequency of 40 kHz gives a phase lag at 10 kHz of 14 degrees relative to low frequencies. Raising the cutoff to 100 kHz reduces this to 5.7 degrees. Neither are perceptible.

If the phase shift is proportional to frequency, then the group delay is constant with frequency and this is a linear-phase system, as described earlier; we just get a pure time delay with no possible audible consequences. However, in most cases the phase shift is not remotely proportional to frequency and so the group delay varies with frequency. This is sometimes called phase distortion or group-delay distortion, which is perhaps not the ideal term as 'distortion' implies non-linearity to most people, while here we are talking about a linear process.

Most of the components in the microphone-recording-loudspeaker chain are minimum phase; in other words they impose only the phase shift that would be expected and which can be predicted from their amplitude/frequency response. One great exception to this is . . . the multi-way loudspeaker. Another great exception is the analogue magnetic tape recorder, which showed rapid phase changes at the bottom of the audio spectrum, usually going several times round the clock. In the 2011 first edition of my book on active crossover design, I wrote "Fortunately we don't need to worry about *that* anymore," but it appears I spoke too soon. There were several vintage multitrack tape recorders displayed at the Paris AES Convention in June 2016, and tape machine are now (2023) unquestionably having a revival. Even cassette tapes are having a revival [21], and there's a need for machines to play them on. Everybody was certain that the one format that would not be revived was the eight-track cartridge. Wrong; it happened in 2019, see [22]. Wax cylinders have already been revived once, by The Men Who Will Not Be Blamed for Nothing [23]. It seems unlikely that experiment will be repeated.

When digital audio began to appear, the possible perception of phase shifts caused by steep (typically ninth-order elliptical) anti-alias and reconstruction filters was very much a concern, as no such filtering had been used in audio paths before. That is true no longer, firstly because the rapid phase changes at the top of the audio band in fact proved to be inaudible and even more since oversampling technology eliminated the need for them altogether. Preis and Bloom examined this issue in 1983, when it was very much live, and they concluded "At 15 kHz (cutoff frequency) the cascade of up to 4 pairs of seventh-order elliptic filters introduced no perceptible effects."[24] That is some pretty serious filtering, much more than was actually required in practice. Mercifully no one has suggested reviving ninth-order elliptical anti-aliasing filters—so far as I am aware.

Whatever happens with tape recorders, we are certainly going to have multi-way loudspeaker systems around for the foreseeable future, and the vast majority of them have all-pass crossovers.

Clearly an understanding of what degradation—if any—this all-pass behaviour causes is vital to a general understanding of phase perception. Much experimentation has been done, as noted earlier, and there is only space for a very brief account here.

Some audio commentators have said that the possibility of phase being perceptible has been neglected by the audio establishment. This is wholly untrue. Searching on 'phase perception' in the archives of the *Journal of the Audio Engineering Society* brings up no less than 936 technical papers, the first dated 1956 and the last 2018. It is not a neglected subject.

One of the earliest findings on phase perception was Ohm's law. No, not that one, but Ohm's *other* law, which is usually called Ohm's acoustic law and was proposed in 1843 [25]. In its original form it simply said that a musical sound is perceived by the ear as a set of sinusoidal harmonics. The great researcher Hermann von Helmholtz extended it in the 1860s into what today is known as Ohm's acoustic law by stating that the timbre of musical tone depends solely on the number and relative level of its harmonics and *not* on their relative phases. This is a good start but does not ensure the inaudibility of an all-pass response.

An important paper on the audibility of midrange phase distortion was published by Lipshitz, Pocock & Vanderkooy in 1982 [26], and they summarised their conclusions as follows:

1) Quite small phase nonlinearities can be audible using suitable test signals.

2) Phase audibility is far more pronounced when using headphones instead of loudspeakers.

3) Simple acoustic signals generated in an anechoic environment show clear phase audibility when headphones are used.

4) On normal music or speech signals phase distortion is not generally audible.

At the end of the abstract of their paper the authors say: "It is stressed that none of these experiments thus far has indicated a present requirement for phase linearity in loudspeakers for the reproduction of music and speech." James Moir also reached the same conclusion [27].

An interesting paper on the audibility of second-order all-pass filters was published in 2007 [28], which describes a perception of "ringing" due to the exponentially decaying sinewave in the impulse response of high-Q all-pass filters (for example Q = 10). It was found that isolated clicks show this effect best, while it was much more difficult to detect, if audible at all, with test signals such as speech, music, or random noise. That is the usual finding in this sort of experiment—that only isolated clicks show any audible difference. While we learn that high-Q all-pass filters should be avoided in crossover design, I think most people would have thought that was the case anyway.

Siegfried Linkwitz, sadly no longer with us, did listening tests where either a first-order all-pass filter, a second-order all-pass filter (both at 100 Hz), or a direct connection that could be switched into the audio path [29]. These filters have similar phase characteristics to all-pass crossovers and cause gross visible distortions of a square waveform but are in practice inaudible. He reported, "I have not found a signal for which I can hear a difference. This seems to confirm Ohm's Acoustic Law that we do not hear waveform distortion."

If we now consider the findings of neurophysiologists, we note that the auditory nerves do not fire in synchrony with the sound waveform above 2 kHz, so unless some truly subtle encoding

is going on (and there is no reason to suppose that there is) then perception of phase above this frequency would appear to be inherently impossible.

Having said this, it should not be supposed that the ear operates simply as a spectrum analyser. This is known not to be the case. A classic demonstration of this is the phenomenon of 'beats.' If a 1000 Hz tone and a 1005 Hz tone are applied to the ear together, it is common knowledge that a pulsation at 5 Hz is heard. There is no actual physical component at 5 Hz, as summing the two tones is a linear process (if instead the two tones were multiplied, as in a radio mixer stage, there *would* be new components generated). Likewise non-linearity in the ear itself can be ruled out if appropriate levels are used. What the brain is actually responding to is the envelope or peak amplitude of the combined tones, which does indeed go up and down at 5 Hz as the phase relationship between the two waveforms continuously changes. Thus the ear is in this case acting more like an oscilloscope than a spectrum analyser. It does not however seem to work as any sort of phase-sensitive detector.

The conclusion we can draw is that for the purposes of designing analogue electronic circuitry, there is no need to consider phase perception.

Gain structures

There are some very basic rules for putting together an effective gain structure in a piece of equipment. Like many rules, they are subject to modification or compromise when you get into a tight corner. Breaking them reduces the dynamic range of the circuitry, either by worsening the noise or restricting the headroom; whether this is significant depends on the overall structure of the system and what level of performance you are aiming at. Three simple rules are

1) Don't amplify then attenuate.

2) Don't attenuate then amplify.

3) The signal should be raised to the nominal internal level as soon as possible to minimise contamination with circuit noise.

There are exceptions. For an example, see Chapter 10 on moving-coil disc inputs, where attenuation after amplification does not compromise headroom because of a more severe headroom limit downstream.

Amplification then attenuation

Put baldly it sounds too silly to contemplate, but it is easy to thoughtlessly add a bit of gain to make up for a loss somewhere else, and immediately a few dB of precious and irretrievable headroom are gone for good. This assumes that each stage has the same power rails and hence the same clipping point, which is usually the case in opamp circuitry.

Figure 1.6a shows a system with a gain control designed to keep 10 dB of gain in hand. In other words, the expectation is that the control will spend most of its working life set somewhere around its '0 dB' position where it introduces 10 dB of attenuation, as is typically the case for a fader on a mixer. To maintain the nominal signal level at 0 dBu we need 10 dB of gain, and a +10 dB amplifier (Stage 2) inserted just before the gain control. This is not a good decision. This

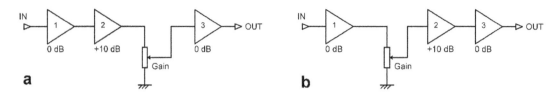

a **b**

Figure 1.6 a) Amplification then attenuation. Stage 2 will always clip first, reducing headroom. b) Attenuation then amplification. The noise from Stage 2 degrades the Signal-to-Noise (S/N) ratio. The lower the gain setting, the worse the effect.

amplifier will clip 10 dB before any other stage in the system and introduces what one might call a headroom bottleneck.

There are exceptions. As noted, the moving-coil phono head amp described in Chapter 10 appears to flagrantly break this rule, as it always works at maximum gain even when this is not required. But when considered in conjunction with the following RIAA stage, which also has considerable gain, it makes perfect sense, for the stage gains are configured so that the second stage always clips first, and there is actually no loss of headroom.

Attenuation then amplification

In Figure 1.6b the amplifier is now after the gain control, and noise performance rather than headroom suffers. If the signal is attenuated, any active device will inescapably add noise in restoring the level. Any conventional gain-control block has to address this issue. If we once more require a gain variable from +10 dB to off, ie minus infinity dB, as would be typical for a fader or volume control, then usually the potentiometer is placed before the gain stage as in Figure 1.6b because as a rule some loss in noise performance is more acceptable than a permanent 10 dB reduction in system headroom. If there are options for the amplifier stages in terms of a noise/cost trade-off (such as using the 5532 versus a TL072), and you can only afford one low-noise stage, then it should be Stage 2.

If all stages have the same noise performance this configuration is 10 dB noisier than the previous version when gain is set to 0 dB.

Raising the input signal to the nominal level

Getting the incoming signal up to the nominal internal level in one jump is always preferable as it gives the best noise performance. Sometimes it has to be done in two amplifier stages; typical examples are microphone preamps with wide gain ranges and phono preamps that insist on performing the RIAA equalisation in several goes (these are explored in their respective chapters). In these cases the noise contribution of the second stage may no longer be negligible.

Consider a signal path which has an input of −10 dBu and a nominal level of 0 dBu. The first version has an input amplifier with 10 dB of gain followed by two unity-gain circuit blocks A and

B. All circuit blocks are assumed to introduce noise at −100 dBu. The noise output for the first version is −89.2 dBu. Now take a second version of the signal path that has an input amplifier with 5 dB of gain, followed by block A, another amplifier with 5 dB of gain, then block B. The noise output is now −87.5 dB, 1.7 dB worse, due to the extra amplification of the noise from block A. There is also more hardware, and the second version is clearly an inferior design.

Active gain controls

The previous section should not be taken to imply that noise performance must always be sacrificed when a gain-control is included in the signal path. This is not so. If we move beyond the idea of a fixed-gain block and recognise that the amount of gain present can be varied, then less gain when the maximum is not required will reduce the noise generated. For volume-control purposes it is essential that the gain can be reduced to near-zero, though it is not necessary for it to be as firmly 'off' as the faders or sends of a mixer.

An active volume-control stage gives lower noise at lower volume settings because there is less gain. The Baxandall active configuration also gives excellent channel balance as it depends solely on the mechanical alignment of a dual linear pot—all mismatches of its electrical characteristics are cancelled out, and there are no quasi-log dual slopes to induce anxiety.

Active gain controls are looked at in depth in Chapters 8 and 13.

Noise

Noise here refers only to the random noise generated by resistances and active devices. The term is sometimes used to include mains hum, spurious signals from demodulated RF and other non-random sources, but this threatens confusion, and I prefer to call the other unwanted signals "interference." In one case, we strive to minimise the random variations arising in the circuit itself, in the other we are trying to keep extraneous signals out, and the techniques are wholly different.

When noise is referred to in electronics it means white noise, unless it is specifically labelled as something else, because that is the form of noise that most electronic processes generate. There are two elemental noise mechanisms which make themselves felt in all circuits and active devices. These are Johnson noise and shot noise, which are both forms of white noise. Both have Gaussian probability density functions. These two basic mechanisms generate the noise in both bipolar junction transistors (BJTs) and field effect transistors (FETs), though in rather different ways.

There are other forms of noise that originate from less fundamental mechanisms such as device processing imperfections which do not have a white spectrum; examples are 1/f (flicker) noise and popcorn noise. These noise mechanisms are described later in this chapter.

Non-white noise is given a colour which corresponds to the visible spectrum; thus red noise has a larger low-frequency content than white noise, while pink is midway between the two.

White noise has equal power in equal absolute bandwidth, ie with the bandwidth measured in Hz. Thus there is the same power between 100 and 200 Hz as there is between 1100 and 1200 Hz. It is the type produced by most electronic noise mechanisms [30].

Pink noise has equal power in equal ratios of bandwidth, so there is the same power between 100 and 200 Hz as there is between 200 and 400 Hz. The energy per Hz falls at 3 dB per octave as frequency increases. Pink noise is widely used for acoustic applications like room equalisation and loudspeaker measurement as it gives a flat response when viewed on a third-octave or other constant-percentage-bandwidth spectrum analyser [31].

Red noise has energy per Hz falling at 6 dB per octave rather than 3 dB. It is important in the study of stochastic processes and climate models but has little application in audio. The only place you are likely to encounter it is in the oscillator section of analogue synthesisers. It is sometimes called Brownian noise as it can be produced by Brownian motion, hence its alternative name of random-walk noise. Brown here is a person and not a colour [32].

Blue noise has energy per Hz rising at 3 dB per octave. Blue noise is used for dithering in image anti-aliasing but has, as far as I am aware, no application to audio. The spectral density of blue noise (ie the power per Hz) is proportional to the frequency. It appears that the light-sensitive cells in the retina of the mammalian eye are arranged in a pattern that resembles blue noise [33]. Great stuff, this evolution.

Violet noise has energy per Hz rising at 6 dB per octave (I imagine you saw that one coming). It is also known as "differentiated white noise" as a differentiator circuit has a frequency response rising at 6 dB per octave. The acoustic thermal noise of water has a violet spectrum, so it usually dominates hydrophone measurements at high frequencies. It is sometimes called purple noise.

Grey noise is pink noise modified by a psychoacoustic equal-loudness curve, such as the inverse of the A-weighting curve, to give the perception of equal loudness at all frequencies.

Green noise is generally considered to be the background noise of the natural world, ie the ambient noise in natural settings free from any man-made components. It is like pink noise but with more energy in the 500 Hz region. In graphics it is used for stochastic half-toning of images and consists of binary dither patterns composed of homogeneously distributed minority pixel clusters. I think we had better leave it there.

Black noise usually refers to absolute silence [34] but is sometimes used to mean a noise spectrum that is zero almost everywhere except for a few spikes. It can also refer to a kind of noise used to model the frequency of natural disasters; see [35].

Johnson noise

Johnson noise is produced by all resistances, including those real resistances hiding inside transistors (such as r_{bb}, the base spreading resistance). It is not generated by the so-called intrinsic resistances, such as r_e, which are an expression of the V_{be}/I_c slope and not a physical resistance at all. Given that Johnson noise is present in every circuit and often puts a limit on noise

performance, it seems surprising that it was not discovered until 1928 by John B Johnson at Bell Labs [36]. The reason is that Johnson noise is at a level that requires considerable amplification before it can be measured, and the amplifiers of the day were relatively noisy themselves, masking the Johnson noise.

The RMS amplitude of Johnson noise is easily calculated with the classic formula:

$$v_n = \sqrt{4kTRB}$$

<div align="right">Equation 1.5</div>

Where:

v_n is the RMS noise voltage T is absolute temperature in °K B is the bandwidth in Hz

k is Boltzmann's constant R is the resistance in Ohms

The only thing to be careful with here (apart from the usual problem of keeping the powers of ten straight) is to make sure you use Boltzmann's constant (1.380662×10^{-23}) and NOT the Stefan-Boltzmann constant ($5.67\ 10^{-08}$), which relates to black-body radiation and will give some spectacularly wrong answers. Often the voltage noise is left in its squared form for ease of summing with other noise sources. Table 1.6 gives a feel for how resistance affects the magnitude of Johnson noise. The temperature is 25°C, and the bandwidth is 22 kHz.

There is a new entry for ribbon microphones at the start of Table 1.6. The resistance of the ribbon is so small that getting associated other circuit resistances suitably low can be quite a problem. See Chapter 17.

Johnson noise theoretically goes all the way to daylight but in the real world is ultimately band-limited by the shunt capacitance of the resistor. Johnson noise is not produced by circuit reactances—ie pure capacitance and inductance. In the real world however, reactive components are not pure, and the winding resistances of transformers can produce significant Johnson noise; this is an important factor in the design of moving-coil cartridge step-up transformers. Capacitors with their very high leakage resistances approach perfection much more closely, and the capacitance has a filtering effect. They usually have no detectable effect on noise performance, and in some circuitry it is possible to reduce noise by using a capacitive potential divider instead of a resistive one [37].

The noise voltage is, of course, inseparable from the resistance, so the equivalent circuit is of a voltage source in series with the resistance present. While Johnson noise is usually represented as a voltage, it can also be treated as a Johnson noise current, by means of the Thevenin-Norton transformation, which gives the alternative equivalent circuit of a current-source in parallel with the resistance. The equation for the noise current is simply the Johnson voltage divided by the value of the resistor it comes from:

$$i_n = v_n/R$$

<div align="right">Equation 1.6</div>

When it is first encountered, this ability of resistors to generate electricity from out of nowhere seems deeply mysterious. You wouldn't be the first person to think of connecting a small

TABLE 1.6 Resistances and their Johnson noise

Resistance	Noise voltage	Noise voltage	Application
Ohms	uV	dBu	
0.1	0.006	−162.2 dBu	Ribbon microphones
1	0.018	−152.2 dBu	Moving-coil cartridge impedance (low output)
3.3	0.035	−147.0 dBu	Moving-coil cartridge impedance (medium output)
10	0.060	−142.2 dBu	Moving-coil cartridge impedance (high output)
47	0.13	−135.5 dBu	Line output isolation resistor
100	0.19	−132.2 dBu	Output isolation or feedback network
150	0.23	−130.4 dBu	Dynamic microphone source impedance
200	0.27	−129.2 dBu	Dynamic microphone source impedance (older)
600	0.47	−124.4 dBu	The ancient matched-line impedance
1000	0.60	−122.2 dBu	A nice round number
2500	0.95	−118.2 dBu	Worst-case output impedance of 10 kΩ pot
5000	1.35	−115.2 dBu	Worst-case output impedance of 20 kΩ pot
12500	2.13	−111.2 dBu	Worst-case output impedance of 50 kΩ pot
25000	3.01	−100.2 dBu	Worst-case output impedance of 100 kΩ pot
1 Meg (10^6)	19.0	−92.2 dBu	Another nice round number
1 Giga (10^9)	602	−62.2 dBu	As used in capacitor microphone amplifiers
1 Tera (10^{12})	19027	−32.2 dBu	Insulation testers read in tera-ohms
1 Peta (10^{15})	601,715	−2.2 dBu	I think I'll stop here

electric motor across the resistance and getting some useful work out—and you wouldn't be the first person to discover it doesn't work. If it did, then by the first law of thermodynamics (the law of conservation of energy) the resistor would have to get colder, and such a process is flatly forbidden by . . . the second law of thermodynamics. The second law is no more negotiable than the first law, and it says that energy cannot extracted by simply cooling down one body. If you could it would be what thermodynamicists call a perpetual motion machine of the second kind, and they are no more buildable than the common sort of perpetual motion machine.

It is interesting to speculate what happens as the resistor is made larger. Does the Johnson voltage keep increasing until there is a hazardous voltage across the resistor terminals? Obviously not or picking up any piece of plastic would be a lethal experience. Johnson noise comes from a source impedance equal to the resistor generating it, and this alone would prevent any problems. Table 1.6 ends with a couple of silly values to see just how this works; the square root in the equation means that you need a petaohm resistor (1 x 10^15 Ω) to reach even 600 mVrms of Johnson noise. Resistors are made up to at least 100 GΩ, but petaohm resistors (PΩ?) would really be a minority interest.

Shot noise

It is easy to forget that an electric current is not some sort of magic fluid but is actually composed of a finite though usually very large number of electrons, so current is in effect quantised. Shot noise is so-called because it allegedly sounds like a shower of lead shot being poured onto a drum, and the name emphasises the discrete nature of the charge carriers. Despite the picturesque description the spectrum is still that of white noise, and the noise current amplitude for a given average current is described by a surprisingly simple equation (as Einstein said, the most incomprehensible thing about the universe is that it is comprehensible) that runs thus:

Noise current $$i_n = \sqrt{2qI_{dc}B}$$ Equation 1.7

Where:

q is the charge on an electron (1.602×10^{-19} Coulomb) I_{dc} is the mean value of the current

B is the bandwidth examined

As with Johnson noise, often the shot noise is left in its squared form for ease of summing with other noise sources. Table 1.7 helps to give a feel for the reality of shot noise. As the current increases, the shot noise increases too, but more slowly as it depends on the square root of the DC current; therefore the *percentage* fluctuation in the current becomes less. It is the small currents which are the noisiest.

The actual level of shot noise voltage generated if the current noise is assumed to flow through a 100 Ohm resistor is rather low, as the last column shows. There are few systems which will be embarrassed by an extra noise source of even −99 dBu unless it occurs right at the very input. To generate this level of shot noise requires 1 amp to flow through 100 Ohms, which naturally means a voltage drop of 100V and a 100 watts of power dissipated. These are not often the sort of circuit conditions that exist in preamplifier circuitry. This does not mean that shot noise can be ignored completely, but it can usually be ignored unless it is happening in an active device where the noise is amplified.

1/f noise (flicker noise)

This is so-called because it rises in amplitude proportionally as the frequency examined falls. Unlike Johnson noise and shot noise, it is not a fundamental consequence of the way the universe

TABLE 1.7 How shot noise varies with current

Current	Current noise	Fluctuation	R	Voltage	Voltage
DC	nA RMS	%	Ohms	noise uV	noise dBu
1 pA	0.000084 nA	8.4%	100	8.4×10^{-6}	−219.3 dBu
1 nA	0.0026 nA	0.27%	100	0.000265	−189.3 dBu
1 uA	0.084 nA	0.0084%	100	0.0084	−159.3 dBu
1 mA	2.65 nA	0.00027%	100	0.265	−129.3 dBu
1 A	84 nA	0.000008%	100	8.39	−99.3 dBu

is put together but the result of imperfections in device construction. 1/f noise appears in all kinds of active semiconductors and also in some resistors. As frequency falls, the 1/f noise amplitude stays level down to the 1/f corner frequency, after which it rises at 6 dB/octave. For a discussion of flicker noise in resistors see Chapter 2.

Popcorn noise

This form of noise is named after the sound of popcorn being cooked rather than eaten. It is also called burst noise or bistable noise, and it is a type of low-frequency noise that is found primarily in integrated circuits, appearing as low level step-changes in the output voltage, occurring at random intervals. Viewed on an oscilloscope this type of noise shows bursts of changes between two or more discrete levels. The amplitude stays level up to a corner frequency, at which point it falls at a rate of $1/f^2$. Different burst-noise mechanisms within the same device can exhibit different corner frequencies. The exact mechanism is poorly understood but is known to be related to the presence of heavy-metal ion contamination, such as gold. As for 1/f noise, the only measure that can be taken against it is to choose an appropriate device. Like 1/f noise, popcorn noise does not have a Gaussian amplitude distribution.

Summing noise sources

When random noise from different sources is summed, the components do not add in a 2 + 2 = 4 manner. Since the noise components come from different sources, with different versions of the same physical processes going on, they are uncorrelated and will partially reinforce and partially cancel, so root-mean-square (RMS) addition holds, as shown in Equation 1.8. If there are two noise sources with the same level, the increase is 3 dB rather than 6 dB. When we are dealing with two sources in one device, such as a bipolar transistor, the assumption of no correlation is slightly dubious because some correlation is known to exist, but it does not seem to be enough to cause significant calculation errors.

$$Vntot = \sqrt{(Vn1^2 + Vn2^2 + ...)}$$
<div align="right">Equation 1.8</div>

Any number of noise sources may be summed in the same way, by simply adding more squared terms inside the square root, as shown by the dotted lines. When dealing with noise in the design process, it is important to keep in mind the way that noise sources add together when they are not of equal amplitude. Table 1.8 shows how this works in decibels. Two equal voltage noise sources give a sum of +3 dB, as expected. What is notable is that when the two sources are of rather unequal amplitude, the smaller one makes very little contribution to the result.

If we have a circuit in which one noise source is twice the RMS amplitude of the other (a 6 dB difference), then the quieter source only increases the RMS-sum by 0.97 dB, a change barely detectable on critical listening. If one source is 10 dB below the other, the increase is only 0.4 dB, which in most cases could be ignored. At 20 dB down, the increase is lost in measurement error. This mathematical property of uncorrelated noise sources is exceedingly convenient because it means that in practical calculations we can neglect all except the most important noise sources with minimal error. Since all semiconductors have some variability in their noise performance,

TABLE 1.8 The summation of two uncorrelated noise sources

dB	dB	dB sum
0	0	+3.01
0	−1	+2.54
0	−2	+2.12
0	−3	+1.76
0	−4	+1.46
0	−5	+1.19
0	−6	+0.97
0	−10	+0.41
0	−15	+0.14
0	−20	+0.04

it is rarely worthwhile to make the calculations to great accuracy. The same information is given graphically in Figure 1.7 (with rather more points calculated to give a smooth curve) and shows dramatically how quickly the contribution of the lesser noise source falls away.

Noise in amplifiers

There are basic principles of noise design that apply to all amplifiers, be they discrete or integrated, single-ended or differential. Practical circuits, even those consisting of an opamp and two resistors, have multiple sources of noise. Typically one source of noise will dominate, but this cannot be taken for granted, and it is essential to evaluate all the sources and the ways that they add together if a noise calculation is going to be reliable. Here I add the complications one stage at a time.

Figure 1.8 shows the most useful of circuit elements, A, the perfect noiseless amplifier (these seem to be unaccountably hard to find in catalogues). It is assumed to have a definite gain A without bothering about whether or not it is achieved by feedback, and an infinite input impedance. To emulate a real amplifier noise sources are concentrated at the input, combined into one voltage noise source and one current noise source. These can represent any number of actual noise sources inside the real amplifier. Figure 1.8 shows two equivalent ways of drawing the same situation.

It does not matter on which side of the voltage source the current source is placed; the 'perfect' amplifier has an infinite input impedance, and the voltage source has a zero-impedance, so either way all of the current noise flows through whatever is attached to the input.

Figure 1.9 shows the first step to a realistic situation, with a signal source now connected to the amplifier input. The signal source is modelled as a perfect zero-impedance voltage source with added series resistance Rs. Many signal sources are modelled accurately enough for noise calculations in this way. Examples are low-impedance dynamic microphones, moving-coil phono cartridges, and most electronic outputs. In others cases, such as moving-magnet phono cartridges

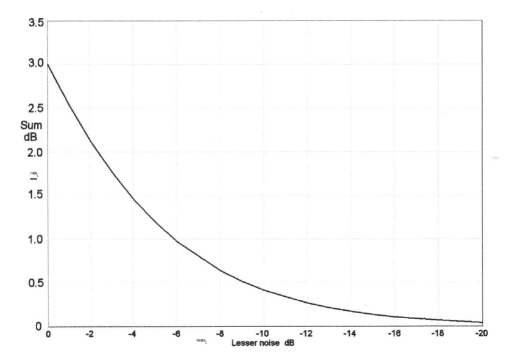

Figure 1.7 When one of the noise sources is much less than the other, its contribution to the total quickly becomes negligible.

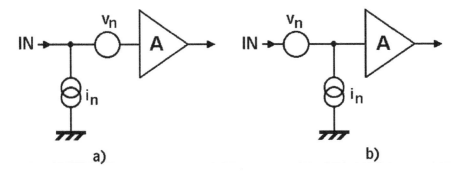

Figure 1.8 The noise sources of a perfect amplifier. The two circuits are exactly equivalent.

and capacitor microphone capsules, there is a big reactive component which has a major effect on the noise behaviour and cannot be ignored or treated as a resistor. The magnitude of the reactances tend to vary from one make to another, but fortunately the variations are not great enough for the circuit approach for optimal noise to vary greatly. It is pretty clear that a capacitor microphone will have a very high source impedance at audio frequencies and will need a special high-impedance preamplifier to avoid low-frequency roll-off; see Chapter 17 for details. It is perhaps less obvious that the series inductance of a moving-magnet phono cartridge becomes the dominating factor at the higher end of the audio band, and designing for the lowest noise with the 600 Ω or so series resistance alone will give far from optimal results. This is dealt with in Chapter 9.

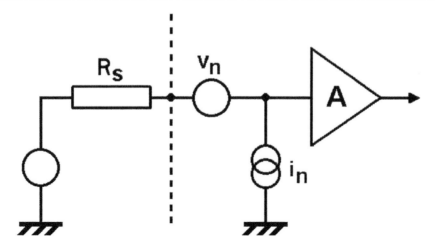

Figure 1.9 **The perfect amplifier and noise sources with a signal source now connected.**

There are two sources of voltage noise in the circuit of Figure 1.9:

1) The amplifier voltage noise source v_n at the input.

2) The Johnson noise from the source resistance Rs.

These two voltage sources are in series and sum by RMS addition as they are uncorrelated.

There is only one current noise component; the amplifier noise current source i_n across the input. This generates a noise voltage when its noise current flows through Rs (it cannot flow into the amplifier input because we are assuming an infinite input impedance). This third source of voltage noise is also added in by RMS addition, and the total is amplified by the voltage gain A and appears at the output. The noise voltage at the input is the equivalent input noise (EIN). This is impossible to measure, so the noise at the amplifier output is divided by A to get the EIN. Having got this, we can compare it with the Johnson noise from the source resistance Rs; with a noiseless amplifier there would be no difference, but in real life the EIN will be higher by a number of dB, which is called the noise figure (NF). This gives a concise way of assessing how noisy our amplifier is and if it is worth trying to improve it. Noise figures very rarely appear in hifi literature, probably because most of them wouldn't look very good. For the fearless application of noise figures to phono cartridge amplifiers see Chapters 9 and 10.

Noise in bipolar transistors

An analysis of the noise behaviour of discrete bipolar transistors, can be found in many textbooks, so this is something of a quick summary of the vital points. Two important transistor parameters for understanding noise are r_{bb}, the base spreading resistance, and r_e, the intrinsic emitter resistance. r_{bb} is a real physical resistance—what is called an *extrinsic* resistance. The second parameter r_e is an expression of the V_{be}/I_c slope and not a physical resistance at all, so it is called an *intrinsic* resistance.

Noise in bipolar transistors, as in amplifiers in general, is best dealt with by assuming a noiseless transistor with a theoretical noise voltage source in series with the base and a theoretical noise current source connected from base to emitter. These sources are usually described simply as the 'voltage noise' and the 'current noise' of the transistor.

Bipolar transistor voltage noise

The voltage noise v_n is made up of two components:

1) The Johnson noise generated in the base spreading resistance r_{bb}.

2) The collector current (I_c) shot noise creating a noise voltage across r_e, the intrinsic emitter resistance.

These two components can be calculated from the equations given earlier, and RMS summed thus:

Voltage noise density $v_n = \sqrt{4kTr_{bb} + 2(kT)^2 / (qI_c)}$ in V/rtHz (usually nV/rtHz) Equation 1.9

Where:

k is Boltzmann's constant (1.380662×10^{-23}) q is the charge on an electron (1.602×10^{-19} Coulomb)

T is absolute temperature in °K I_c is the collector current

r_{bb} is the base resistance in Ohms

The first part of this equation is the usual expression for Johnson noise and is fixed for a given transistor type by the physical value of r_{bb}, so the lower this is the better. The only way you can reduce this is by changing to another transistor type with a lower r_{bb} or using paralleled transistors. The absolute temperature is a factor; running your transistor at 25°C rather than 125°C reduces the Johnson noise from r_{bb} by 1.2 dB. Input devices usually run cool, but this may not be the case with moving-coil preamplifiers where a large I_c is required, so it is not impossible that adding a heatsink would give a measurable improvement in noise.

The second (shot noise) part of the equation decreases as collector current I_c increases; this is because as I_c increases, r_e decreases proportionally, following $r_e = 25/I_c$ where I_c is in mA. The shot noise, however, is only increasing as the square root of I_c, and the overall result is that the total v_n falls—though relatively slowly—as collector current increases, approaching asymptotically the level of noise set by first part of the equation. There is an extra voltage noise source resulting from flicker noise produced by the base current flowing through r_{bb}; this is only significant at high collector currents and low frequencies due to its 1/f nature and is not usually included in design calculations unless low-frequency quietness is a special requirement.

Bipolar transistor current noise

The current noise i_n, is mainly produced by the shot noise of the steady current I_b flowing through the transistor base. This means it increases as the square root of I_b increases. Naturally I_b increases with I_c. Current noise is given by

Current noise density $i_n = \sqrt{2qI_b}$ in A/rtHz (usual values are in pA) Equation 1.10

Where:

q is the charge on an electron I_b is the base current

So, for a fixed collector current, you get less current noise with high-beta transistors because there is less base current.

The existence of current noise as well as voltage noise means it is not possible to minimise transistor noise just by increasing the collector current to the maximum value the device can take. Increasing I_c reduces voltage noise but it increases current noise, as in Figure 1.10. There is an optimum collector current for each value of source resistance, where the contributions are equal. Because both voltage and current noise are proportional to the square root of I_c, they change slowly as it alters, and the combined noise curve is rather flat at the bottom. There is no need to control collector current with great accuracy to obtain optimum noise performance.

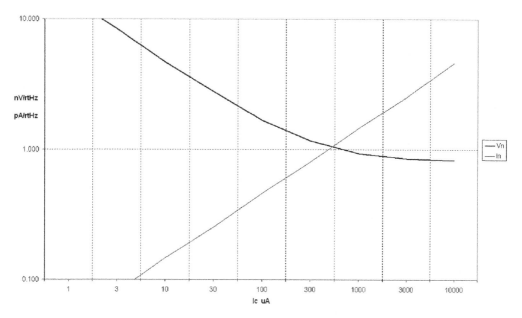

Figure 1.10 How voltage noise density V$_n$ and current noise density In vary with collector current I$_c$ in a generic transistor. As I$_c$ increases voltage noise asymptotes to a limit while current noise continuously increases.

I must emphasise that this is a simplified noise model. In practice both voltage and current noise densities vary with frequency. I have also ignored 1/f noise. However, it gives the essential insight into what is happening and leads to the right design decisions, so we will put our heads down and press on.

A quick example shows how this works. In a voltage amplifier we want the source impedances seen by the input transistors to be as low as possible to minimise Johnson noise and to minimise the effects of current noise. If we are lucky it may be as low as 100 Ω. How do we minimise the noise from a single transistor faced with a 100 Ω source resistance?

We assume the temperature is 25°C, the bandwidth is 22 kHz, and the r_{bb} of our transistor is 40 Ω (why don't they put this on spec sheets anymore?). The h_{fe} (beta) is 150. Set I_c to 1 mA, which is plausible for an amplifier input stage, step the source resistance from 1 to 100,000 Ω in decades, and we get Table 1.9.

Column 1 shows the source resistance, and column 2 shows the Johnson noise density it generates by itself. Factor in the bandwidth, and you get columns 3 and 4, which show the voltage in nV and dBu respectively.

Column 5 is the noise density from the transistor, the RMS sum of the voltage noise, and the voltage generated by the current noise flowing in the source resistance. Column 6 gives total noise density when we sum the source resistance noise density with the transistor noise density. Factor in the bandwidth again, and the resultant noise voltage is given in columns 7 and 8. The final column 9 gives the noise figure (NF), which is the amount by which the combination of transistor and source resistance is noisier than the source resistance alone. In other words, it tells how close we have got to perfection, which would be a noise figure of 0 dB. The results for the 100 Ω source show that the transistor noise is less than the source resistance Johnson noise; there is little scope for improving things by changing transistor type or operating conditions.

The results for the other source resistances are worth looking at. The lowest noise output (−134.9 dBu) is achieved by the lowest source resistance of 1 Ω, as you would expect, but the NF is very poor at 17.3 dB because the r_{bb} at 40 Ω is generating a lot more noise than the 1 Ω source. This gives you some idea why it is hard to design quiet moving-coil head amplifiers. The best noise figure and the closest approach to theoretical perfection is with a 1000 Ω source attained with a *greater* noise output than 100 Ω. As source resistance increases further, NF worsens again; a transistor with $I_c = 1$ mA has relatively high current noise and performs poorly with high source resistances.

TABLE 1.9 The summation of Johnson noise from the source resistance with transistor noise

1	2	3	4	5	6	7	8	9
Rsource	Rsource Johnson	Rsource Johnson BW	Rsource Johnson BW	Transistor noise incl in Rs	Transistor noise plus Rs Johnson	Noise in BW	Noise in BW	Noise Fig
Ohms	nV/rtHz	nV	dBu	nV/rtHz	nV/rtHz	nV	dBu	dB
1	0.128	19.0	−152.2	0.93	0.94	139.7	−134.9	17.3
10	0.406	60.2	−142.2	0.93	1.02	150.9	−134.2	8.0
100	1.283	190.3	−132.2	0.94	1.59	236.3	−130.3	1.9
1000	4.057	601.8	−122.2	1.73	4.41	654.4	−121.5	0.7
10000	12.830	1903.0	−112.2	14.64	19.46	2886.9	−108.6	3.6
100000	40.573	6017.9	−102.2	146.06	151.59	22484.8	−90.7	11.4

TABLE 1.10 How input device collector current affects noise output and noise figure

Rsource Ohms	I_c = 3 mA		I_c = 10 mA		I_c = 10 mA, 2SB737		I_c = 100 uA	
	Noise dBu	NF dB	Noise dBu	NF dB	Noise dBu	NF dB	Noise dBu	NF dB
1	−135.6	16.6	−135.9	16.3	−145.9	6.3	−129.9	22.3
10	−134.8	7.4	−135.1	7.1	−140.9	1.3	−129.7	12.5
100	−130.5	1.7	−130.3	1.9	−131.5	0.7	−127.9	4.3
1000	−120.6	1.6	−118.5	3.7	−118.6	3.6	−121.5	0.7
10 k	−105.3	6.9	−100.7	11.4	−100.7	11.4	−111.6	0.6
100 k	−86.2	16.0	−81.0	21.2	−81.0	21.2	−98.6	3.6

Since I_c is about the only thing we have any control over here, let's try altering it. If we increase I_c to 3 mA we find that for 100 Ω source resistance, our amplifier is only a marginal 0.2 dB quieter. See Table 1.10, which skips the intermediate calculations and just gives the output noise and NF.

At 3 mA the noise with a 1 Ω source is 0.7 dB better, due to slightly lower voltage noise, but with 100 kΩ the noise is higher by no less than 9.8 dB as the current noise is much increased.

If we increase I_c to 10 mA, this makes the 100 Ω noise worse again, and we have lost that slender 0.2 dB improvement.

At 1 Ω the noise is 0.3 dB better, which is not exactly a breakthrough, and for the higher source resistances things worse again, the 100 kΩ noise increasing by another 5.2 dB. It therefore appears that a collector current of 3 mA is actually pretty much optimal for noise with our 100 Ω source resistance.

If we now pluck out our 'ordinary' transistor and replace it with a specialised low-r_{bb} part like the much-lamented 2SB737, with its a superbly low r_{bb} of 2 Ω, the noise output at 1 Ω plummets by 10 dB, showing just how important low r_{bb} is for moving-coil head amplifiers. The improvement for the 100 Ω source resistance is much less at 1.0 dB.

If we go back to the ordinary transistor and reduce I_c to 100 uA, we get the last two columns in Table 1.10. Compared with I_c = 3 mA, noise with the 1 Ω source worsens by 5.7 dB, and with the 100 Ω source by 2.6 dB, but with the 100 kΩ source there is a hefty 12.4 dB improvement due to reduced current noise. Quiet BJT inputs for high source impedances can be made by using low collector currents, but JFETs usually give better noise performance under these conditions.

The transistor will probably be the major source of noise in the circuit, but other sources may need to be considered. The transistor may have a collector resistor of high value to optimise the stage gain, and this naturally introduces its own Johnson noise. Most discrete transistor amplifiers have multiple stages to get enough open-loop gain for linearisation by negative feedback, and an important consideration in discrete noise design is that the gain of the first stage should be high enough to make the noise contribution of the second stage negligible. This can complicate matters

considerably. Precisely the same situation prevails in an opamp, but here someone else has done the worrying about second-stage noise for you; if you're not happy with it all you can do is pick another type of opamp.

Noise in JFETs

Junction field effect transistors (JFETs) operate completely differently from bipolar transistors, and noise arises in different ways. The voltage noise in JFETs arises from the Johnson noise produced by the channel resistance, the effective value of which is the inverse of the transconductance (g_m) of the JFET at the operating point we are looking at. An approximate but widely accepted equation for this noise is

$$\text{Noise density} \qquad e_n = \sqrt{4kT\,\frac{2}{3g_m}} \quad \text{in V/rtHz (usually nV/rtHz)} \qquad \text{Equation 1.11}$$

Where:

k is Boltzmann's constant (1.380662×10^{-23}) T is absolute temperature in °K

FET transconductance goes up proportionally to the square root of drain current I_d. When the transconductance is inserted into Equation 1.11, it is again square-rooted, so the voltage noise is proportional to the fourth root of drain current and varies with it very slowly. There is thus little point in using high drain currents.

The only current noise source in a JFET is the shot noise associated with the gate leakage current. Because the leakage current is normally extremely low, the current noise is very low, which is why JFETs give a good noise performance with high source resistances. However, don't let the JFET get Hot because gate leakage doubles with each 10°C rise in temperature; this is why JFETs can actually show *increased* noise if the drain current is increased to the point where they heat up.

The g_m of JFETs is rather variable, but at $I_d = 1$ mA ranges over about 0.5 to 3 mA/V (or mMho) so the voltage noise density varies from 4.7 to 1.9 nV/rtHz. Comparing this with column 5 in Table 1.10, we can see that the BJTs are much quieter except at high source impedances, where their current noise makes them noisier than JFETs.

However, if you are prepared to use multiple devices, the lowest possible noise may be given by JFETs because the voltage noise falls faster than the effect of the current noise rises, when more devices are added. A low-noise laboratory amplifier design by Samuel Groner achieves a spectacularly low noise density of 0.39 nV/rtHz by using eight paralleled JFETs [38].

Noise in opamps

The noise behaviour of an opamp is very similar to that of a single input amplifier, the difference being that there are now two inputs to consider and usually more associated resistors.

An opamp is driven by the voltage difference between its two inputs, and so the voltage noise can be treated as one voltage v_n connected between them. See Figure 1.11, which shows a differential amplifier.

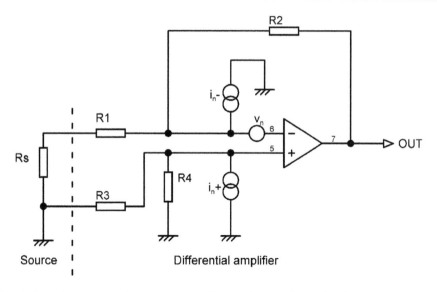

Figure 1.11 The noise sources in an opamp differential amplifier circuit.

Opamp current noise is represented by two separate current generators i_n+ and i_{n-}, one in parallel with each input. These are assumed to be equal in amplitude and not correlated with each other. It is also assumed that the voltage and current noise sources are likewise uncorrelated, so that RMS addition of their noise components is valid. In reality things are not quite so simple; there is some correlation, and the noise produced can be slightly higher than calculated. In practice the difference is small compared with natural variations in noise performance.

Calculating the noise is somewhat more complex than for the simple amplifier of Figure 1.9. You must

1) Calculate the voltage noise from the voltage noise density.

2) Calculate the two extra noise voltages resulting from the noise currents flowing through their associated components.

3) Calculate the Johnson noise produced by each resistor.

4) Allow for the noise gain (see next section) of the circuit when assessing how much each noise source contributes to the output.

5) Add the lot together by RMS addition.

There is no space to go through a complete calculation, but here is a quick example.

Suppose you have an inverting amplifier where the non-inverting input is grounded, so the effect of i_n+ disappears, as it has no resistance to flow through and cannot give rise to a noise voltage. This shunt-feedback stage has a 'noise gain' that is greater than the signal gain. The input signal is amplified by −1, but the voltage noise source in the opamp is amplified by two times because the voltage noise generator is amplified as if the circuit was a series-feedback gain stage.

Noise gain

The voltage noise of an amplifier puts a lower limit on its noise performance; this situation only occurs in a voltage-follower (buffer) where there are no circuit resistances to generate Johnson noise or turn current noise into voltage noise. In some circuits the gain applied to the voltage noise is higher than the gain applied to the signal; it can never be less. For an example see Figure 1.14a, which is a simple unity-gain inverting amplifier. Its signal gain is indeed unity, but its noise gain is two times or +6 dB. This is because the voltage noise is effectively a single voltage source in series with the differential inputs of the amplifier. It therefore sees a negative feedback factor (NFB) of 1/2, as R1 equals R2, and so its level at the output is doubled.

If a third 4k7 resistor was connected from the inverting input to ground, this would not change the signal gain, because the inverting input is at virtual-earth; however the voltage noise now sees an NFB network that gives a noise gain of three times or +9.5 dB. This can become a serious problem in large virtual-earth mixing systems, where the noise gain may be as high as +34 dB for 48 inputs, requiring a very low noise summing amplifier. This is examined in more detail in Chapter 22 on mixer sub-systems.

By the same mechanism, the distortion performance of an amplifier will be worsened by the same amount as the noise gain, due to the reduction in negative feedback, giving distortion gain.

Low-noise opamp circuitry

The rest of this chapter deals with designing low-noise opamp circuitry, dealing with opamp selection, and the minimisation of circuit impedances. It also shows how adding more stages can actually make the circuitry quieter. This sounds somewhat counter-intuitive, but as you will see, it is so.

When you are designing for low noise, it is obviously important to select the right opamp, the great divide being between bipolar and JFET inputs. This chapter concentrates mainly on using the 5532, as it is not only a low-noise opamp with superbly low distortion, but also a low-cost opamp, due to its large production quantities. There are opamps with lower noise, such as the AD797 and the LT1028, but these are specialised items, and the cost penalties are high. The LT1028 has a bias-cancellation system that increases noise unless the impedances seen at each input are equal, and since audio does not need the resulting DC precision, it is not useful. The new LM4562 is a dual opamp with somewhat lower noise than the 5532, but at present it also is much more expensive.

The AD797 runs its bipolar input transistors at high collector currents (about 1 mA), which reduces voltage noise but increases current noise. The AD797 will therefore only give lower noise for rather low source resistances; these need to be below 1 kΩ to yield benefit for the money spent. There is much more on opamp selection in Chapters 4, 5, and 9.

Noise measurements

There are difficulties in measuring the low noise levels we are dealing with here. The Audio Precision System One test system has a noise floor of −116.4 dBu when its input is terminated

with a 47 Ω resistor. When it is terminated in a short circuit, the noise reading only drops to −117.0 dBu, demonstrating that almost all the noise is internal to the audio precision (AP) and the Johnson noise of the 47 Ω resistor is much lower. The significance of 47 Ω is that it is the lowest value of output resistor that will guarantee stability when driving the capacitance of a reasonable length of screened cable; this value will keep cropping up.

To delve below this noise floor, we can subtract this figure from the noise we measure (on the usual RMS basis) and estimate the noise actually coming from the circuit under test. This process is not very accurate when circuit noise is much below that of the test system because of the subtraction involved, and any figure below −120 dBu should be regarded with caution. Cross checking against the theoretical calculations and SPICE results is always wise; in this case it is essential.

We will now look at a number of common circuit scenarios and see how low-noise design can be applied to them.

How to attenuate quietly

Attenuating a signal by 6 dB sounds like the easiest electronic task in the world. Two equal-value resistors to make up a potential divider, and *voila*! This knotty problem is solved. Or is it?

To begin with, let us consider the signal going into our divider. Wherever it comes from, the source impedance is not likely to be less than 50 Ω. This is also the lowest output impedance setting for most high-quality signal generators (though it's 40 Ω on my AP SYS-2702). The Johnson noise from 50 Ω is −135.2 dBu, which immediately puts a limit—albeit a very low one—on the performance we can achieve. The maximum signal-handling capability of opamps is about +22 dBu, so we know at once our dynamic range cannot exceed 135 + 22 = 157 dB. This comfortably exceeds the dynamic range of human hearing, which is about 130 dB if you are happy to accept 'instantaneous ear damage' as the upper limit.

In the scenario we are examining, there is only one variable—the ohmic value of the two equal resistors. This cannot be too low or the divider will load the previous stage excessively, increasing distortion and possibly reducing headroom. On the other hand, the higher the value, the greater the Johnson noise voltage generated by the divider resistances that will be added to the signal and the greater the susceptibility of the circuit to capacitive crosstalk and general interference pickup. In Table 1.11 the trade-off is examined.

What happens when our signal with its −135.2 dBu noise level encounters our 6 dB attenuator? If it is made up of two 1 kΩ resistors, the noise level at once jumps up to −125.2 dBu, as the effective source resistance from two 1 kΩ resistors effectively in parallel is 500 Ω. 10 dB of signal-to-noise ratio is irretrievably gone already, and we have only deployed two passive components. There will no doubt be more active and passive circuitry downstream, so things can only get worse.

However, a potential divider made from two 1 kΩ resistors in series presents an input impedance of only 2 kΩ, which is too low for most applications. 10 kΩ is normally considered the minimum

TABLE 1.11 Johnson noise from 6 dB resistive divider with different resistor values (bandwidth 22 kHz, temperature 25°C)

Divider R's value	Divider Reff	Johnson noise	Relative noise
100 Ω	50 Ω	−135.2 dBu	−27.0 dB
500 Ω	250 Ω	−128.2 dBu	−20.0 dB
1 kΩ	500 Ω	−125.2 dBu	−17.0 dB
5 kΩ	2.5 kΩ	−118.2 dBu	−10.0 dB
10 kΩ	5 kΩ	−115.2 dBu	−7.0 dB
50 kΩ	**25 kΩ**	**−108.2 dBu**	**0 dB REFERENCE**
100 kΩ	50 kΩ	−105.2 dBu	+3.0 dB

input impedance for a piece of audio equipment in general use, which means we must use two 5 kΩ resistors, and so we get an effective source resistance of 2.5 kΩ. This produces Johnson noise at −118.2 dBu, so the signal-to-noise ratio has been degraded by another 7 dB simply by making the input impedance reasonably high.

In some cases 10 kΩ is not high enough, and a 100 kΩ input impedance is sought, as in Figure 1.12a. Now the two resistors have to be 50 kΩ, and the noise is 10 dB higher again, at −108.2 dBu. That is a worrying 27 dB worse than our signal when it arrived.

If we insist on an input impedance of 100 kΩ, how can we improve on our noise level of −108.2 dBu? The answer is by buffering the divider from the outside world. The word 'buffer' indicates that the opamp does nothing apart from keeping the output load from affecting the circuitry upstream. Thus 'buffer' implies 'unity-gain buffer' almost always.

The output noise of a 5532 voltage-follower (buffer) is about −119 dBu with a 50 Ω input termination. If this is used to drive our attenuator, the two resistors in it can be as low as the opamp can drive. The 5532 has a most convenient combination of low noise and good load-driving ability, and the divider resistors can be reduced to 500 Ω each, giving a load of 1 kΩ and a generous safety margin of drive capability (pushing the 5532 to its specified limit of a 500 Ω load tends to degrade its superb linearity by a small but measurable amount). See Figure 1.12b.

The noise from the resistive divider itself has now been lowered to −128.2 dBu, but there is, of course, the extra −119 dBu of noise from the voltage-follower that drives it. This, however, is halved by the divider just as the signal is, so the noise at the output will be the RMS sum of −125 dBu and −128.2 dBu, which is −123.3 dBu. A 6 dB attenuator is actually the worst case, as it has the highest possible source impedance for a given total divider resistance. Either more or less attenuation will mean less noise from the divider itself.

So despite adding active circuitry that intrudes its own noise, the final noise level has been reduced from −108.2 to −123.3 dBu, an improvement of 15.1 dB.

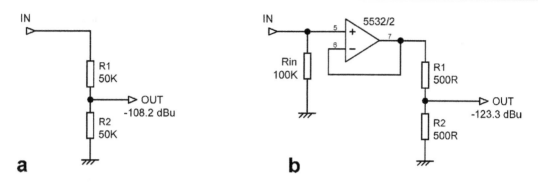

Figure 1.12 Two 6 dB attenuators with a 100 kΩ input impedance: (a) simple attenuator with high resistor values; and (b) buffered attenuator with low resistor values. Despite the extra noise from the 5532 voltage-follower, this version is 15 dB quieter.

How to amplify quietly

Okay, we need a low-noise amplifier. Let's assume we have a reasonably low source impedance of 300 Ω, and we need a gain of four times (+12 dB). Figure 1.13a shows a very ordinary circuit using half a 5532 with typical values of 3 kΩ and 1 kΩ in the feedback network, and the noise output measures as −105.0 dBu. The Johnson noise generated by the 300 Ω source resistance is −127.4 dBu and amplifying that by a gain of four gives −115.4 dBu. Compare this with the actual −105.0 dBu we get, and the noise figure is 10.4 dB—in other words the noise from the amplifier is three times the inescapable noise from the source resistance, making the latter essentially negligible. This amplifier stage is clearly somewhat short of noise-free perfection, despite using one of the quieter opamps around.

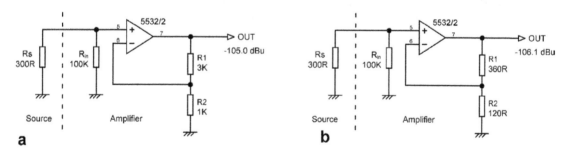

Figure 1.13 4 x amplifier a) with 'normal' feedback resistances; b) with low-impedance feedback arm resistances. Noise is only reduced by 1.1 dB.

We need to make things quieter. The obvious thing to do is to reduce the value of the feedback resistances; this will reduce their Johnson noise and also reduce the noise produced in them by the opamp current noise generators. Figure 1.13b shows the feedback network altered to 360 Ω and 120 Ω, adding up to a load of 480 Ω, pushing the limits of the lowest resistance the opamp can drive satisfactorily. This assumes, of course, that the next stage presents a relatively light load so that almost all of the driving capability can be used to drive the negative-feedback network; keeping tiny signals free from noise can involve throwing some serious current about. The noise output is reduced to −106.1 dBu, which is only an improvement of 1.1 dB and only brings the

noise figure down to 9.3 dB, leaving us still a long way from what is theoretically attainable. However, at least it cost us nothing in extra components.

If we need to make things quieter yet, what can be done? The feedback resistances cannot be reduced further, unless the opamp drive capability is increased in some way. An output stage made of discrete transistors could be added, but it would almost certainly compromise the low distortion we get from a 5532 alone. For one answer see the section on ultra-low noise design.

How to invert quietly

Inverting a signal always requires the use of active electronics (you *could* use a transformer but they are expensive). Assume that an input impedance of 47 kΩ is required, along with a unity-gain inversion. A straightforward inverting stage as shown in Figure 1.14a will give this input impedance and gain only if both resistors are 47 kΩ. These relatively high value resistors contribute Johnson noise and exacerbate the effect of opamp current noise. Also the opamp is working at a noise gain of two times so the noise output is high at −101.4 dBu.

The only way to improve this noise level is to add another active stage. It sounds paradoxical—adding more non-silent circuitry to reduce noise—but that's the way the universe works. If a voltage-follower is added to the circuit to give Figure 1.14b, then the resistors around the inverting opamp can be greatly reduced in value without reducing the input impedance, which can now be pretty much as high as we like. The "Noise buffered" column in Table 1.12 shows that if R1 and R2 are reduced to 2.2 kΩ the total noise output is lowered by 8.2 dB, which is a very useful improvement. If R1,R2 are further reduced to 1 kΩ, which is perfectly practical with a 5532's drive capability, the total noise is reduced by 9.0 dB compared with the 47 kΩ case. The "Noise unbuffered" column gives the noise output with specified R value but without the buffer, demonstrating that adding the buffer does degrade the noise slightly, but the overall result is still far quieter than the unbuffered version with 47 kΩ resistors. In each case the circuit input is terminated to ground via 50 Ω.

How to balance quietly

The design of low and ultra-low noise balanced amplifiers presents special difficulties. The topic is thoroughly examined in Chapter 18 on line inputs.

Ultra-low noise design with multipath amplifiers

Are the aforementioned circuit structures the ultimate? Is this as low as noise gets? No. In the search for low noise, a powerful technique is the use of parallel amplifiers with their outputs summed. This is especially useful where source impedances are low and therefore generate little noise compared with the voltage noise of the electronics.

If there are two amplifiers connected, the signal gain increases by 6 dB due to the summation. The noise from the two amplifiers is also summed, but since the two noise sources are completely uncorrelated (coming from physically different components) they partially cancel, and the noise level only increases by 3 dB. Thus there is an improvement in signal-to-noise ratio of 3 dB. This strategy can be repeated by using four amplifiers, in which case the signal-to-noise improvement is 6 dB. Table 1.13 shows how this works for increasing numbers of amplifiers.

TABLE 1.12 Measured noise from simple inverter and buffered inverter (5532)

R1, R2 value Ω	Noise unbuffered	Noise buffered	Noise reduction dB Ref 47k case
1 k	−111.0 dBu	−110.3 dBu	9.0
2k2	−110.1 dBu	−109.5 dBu	8.2
4k7	−108.9 dBu	−108.4 dBu	7.1
10 k	−106.9 dBu	−106.6 dBu	5.3
22 k	−104.3 dBu	−104.3 dBu	3.0
47 k	−101.4 dBu	−101.3 dBu Reference	0 dB

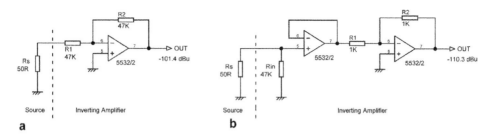

Figure 1.14 The noise from an inverter with 47 k$_\Omega$ input impedance: (a) unbuffered; b) buffered and with low-value resistors.

In practice the increased signal gain is not useful, and an active summing amplifier would compromise the noise improvement, so the output signals are averaged rather than summed, as shown in Figure 1.15. The amplifier outputs are simply connected together with low-value resistors; so the gain is unchanged but the noise output falls. The amplifier outputs are nominally identical, so very little current should flow from one opamp to another. The combining resistor values are so low that their Johnson noise can be ignored.

Obviously there are economic limits on how far you can take this sort of thing. Unless you're measuring gravity waves or something equally important, 256 parallel amplifiers may not be a viable choice.

Be aware that this technique does not give any kind of fault redundancy. If one opamp turns up its toes, the low value of the averaging resistors means the whole stage will stop working.

Ultra-low noise voltage buffers

The multiple-path philosophy works well even with a minimally simple circuit such as a unity-gain voltage buffer. Table 1.14 gives calculated results for 5532 sections, assuming the voltage noise density is the typical 5nV/√Hz. It is assumed the amplifier array is driven from a very low impedance so current noise has no effect. Calculation is used because the noise output is too low to measure reliably even with the best testgear. This shows how the noise output falls as more opamps are added. The distortion performance is not affected.

TABLE 1.13 How noise performance improves with multiple amplifiers

No of amplifiers	Noise reduction
1	0 dB ref
2	−3.01 dB
3	−4.77 dB
4	−6.02 dB
5	−6.99 dB
6	−7.78 dB
7	−8.45 dB
8	−9.03 dB
12	−10.79 dB
16	−12.04 dB
32	−15.05 dB
64	−18.06 dB
128	−21.07 dB
256	−24.58 dB

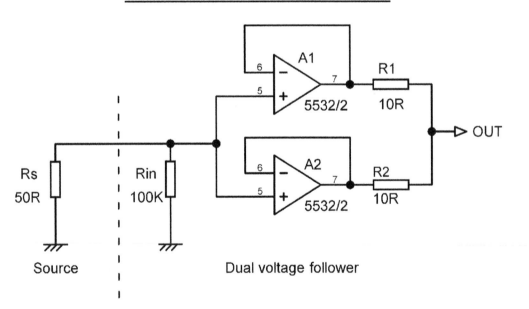

Figure 1.15 A double voltage-follower or buffer. The noise of this simple circuit is below that of the leading test equipment available.

The 10 Ω output resistors combine the opamp outputs and limit the currents that would flow from output to output as a result of DC-offset errors. AC gain errors here will be very small indeed as the opamps have 100% feedback. If the output resistors were raised to 47 Ω they would as usual give HF stability when driving screened cables or other capacitances, but the total output impedance is usefully halved to 23.5 Ω. Another interesting bonus of this technique is that we

TABLE 1.14 **Noise from parallel-array buffers using 5532 sections**

Number of opamp sections	Calculated noise out
1	−120.4 dBu
2	−123.4 dBu
3	−125.2 dBu
4	−126.4 dBu
8	−129.4 dBu
16	−132.4 dBu
32	−135.4 dBu
64	−138.4 dBu
128	−141.4 dBu

have doubled the output drive capability; this stage can easily drive 300 Ω. This can be very useful when using low-impedance design to reduce noise in the following stage.

The 32-times 5532 opamp power amplifier

The use of multiple buffers with their outputs averaged was taken to its logical conclusion (and perhaps beyond) in my Elektor 5532 power amplifier of 2010. This unusual but entirely practical design has a gain stage followed by a unity-gain power buffer composed of 64 5532-sections in parallel, ie 32 packages, working as voltage-followers. The outputs were combined by an array of 1 Ω resistors to give sufficient current to produce 16 Wrms into an 8 Ω load. 64 parallel amplifiers will reduce the voltage noise by $\sqrt{64} = 8$ times, (−18 dB), and if the output noise of a 5532 voltage-follower is taken as about −120.4 dBu, the noise from the power stage alone will be a subterranean −138 dBu. This is below any means of direct measurement. The current noise is, however, similarly multiplied, so a suitably low source impedance to drive the power buffer is very much required to feel the benefit, and a so-called zero-impedance stage was used. Like the voltage noise, the current noise partially cancels with multiple amplifiers, as it is uncorrelated. There is no global negative feedback around the buffer stage, which relies entirely on the 100% voltage feedback in the voltage-followers.

A bridged-output version of this amplifier used 128 5532 sections (64 packages) to double the current available, as an 8 Ω load driven in push-pull at each end looks like a 4 Ω load to each amplifier; the output power was then 64W into 8 Ω. That lowers the theoretical noise output to −141 dBu from each power buffer, which I think you will agree is impressive if not in itself very useful.

Such a power amplifier requires a voltage-gain stage in front of the unity-gain output buffers, as shown in Figure 1.16; the overall gain is +22.7 dB. Once again, I accept that 64W into 8 Ω is not exactly a small signal, but the techniques used in the voltage-gain stage are very relevant indeed. Some are not very obvious unless you have read the appropriate chapter of this book.

To minimise distortion:

1) Spread the required gain out over several stages so the negative feedback can be high in each one.

2) Distribute the gain so that the stages carrying the greatest output voltage have the lowest gain and the most negative feedback. Thus the first stage U1A,B has a gain of +10.7 dB, while the second stage U2A has a gain of only +6.0 dB.

3) The buffer U2B prevents R12 from loading U2A; its own distortion is low because as a voltage-follower it has 100% negative feedback.

4) The so-called zero-impedance output stage U3A also has a gain of +6.0 dB, but in this case the use of shunt feedback keeps distortion lower than with series feedback, as it avoids the common-mode distortion which would otherwise result from the high signal levels at this point. HF feedback is via C7 but LF feedback via R13; see Chapter 19.

5) The 64 unity-gain output buffers are driven from a zero-impedance output stage so that non-linearity in the input currents drawn by them cannot introduce distortion. I confess I never did any measurements to see how big the problem might be.

To minimise noise:

1) The balanced input stage is driven by unity-gain buffers IC4A and IC4B, so the following balanced stage can use much lower resistors than usual (820 Ω instead of 10 kΩ) which give less Johnson noise and reduce the effect of opamp current noise. This also allows the input impedances to be much higher than usual, preventing loading of external equipment and maximising the CMRR of the balanced link.

2) The balanced input stage is a dual balanced stage (IC5A, IC5B) amplifier that partially cancels the uncorrelated noise from each amplifier, giving a 3 dB noise reduction and, in a similar way, improves the CMRR slightly. The noise output of the balanced stage measures −112.5 dBu, an 8 dB improvement over conventional technology. See Chapter 18 for more.

3) The first voltage amplifier U1A,B is a double stage with the two outputs averaged by R6 and R9. This puts the quietest stage first in the amplifier chain. The noise output here measures −109.5 dBu when the stage fed direct from the unbalanced input, or −101.0 dBu when fed from the balanced input.

4) The second voltage amplifier U2A can have relatively low feedback resistors as buffer U2B prevents from being loaded by R12; this process could probably have been taken further, say using 1 kΩ resistors. The buffer U2B is unity-gain so its own noise output is low. The noise at the buffer output measures −103.2 dBu (unbalanced input) or −95.4 dBu (balanced input).

5) The zero-impedance output stage U3A uses relatively low resistors of 1 kΩ and 2 kΩ. The noise at its output measures −96.8 dBu (unbalanced input) or −89.3 dBu (balanced input).

6) The zero-impedance output stage U3B uses relatively low 1 kΩ resistors. The noise at its output measures −96.3 dBu (unbalanced input) or −89.0 dBu (balanced input). If instead a conventional 100 Ω series resistor was used, the aggregated current noise flowing in it would

give an extra −139.4 dBu. Not a lot to eliminate, but the zero-impedance stages are required anyway.

To minimise crosstalk:

1) The zero-impedance output stages eliminate the possibility of interchannel crosstalk. Also, an amplifier with 32 or 64 opamp packages inevitably has long stretches of tracking connecting to them all, and this will have significant stray capacitance to ground. The usual answer to this sort of thing is a series resistor in the output of the previous stage. However the high current noise means that even a small resistance could develop a significant noise voltage across it. A zero-impedance stage solves the problem.

This gives a good idea of what techniques to consider when designing high-quality signal paths. Note these are measured results for given specimens of 5532 and YMMV.

Note that the phase at the output of IC3A is inverted and only useful if you are bridging amplifiers. U3B is another zero-impedance stage that corrects the phase for normal operation.

It would be interesting to see if it would be possible to make a viable moving coil (MC) phono input or a microphone amplifier using multiple 5532s. If the best noise performance is required, it is not likely to be an economic approach; see Chapter 10 for the details.

Ultra-low noise amplifiers

We now return to the problem studied earlier: how to make a really quiet amplifier with a gain of four times. We saw that the minimum noise output using a single 5532 section and a 300 Ω source resistance was −106.1 dBu, with a not particularly impressive noise figure of 9.3 dB. Since almost all the noise is being generated in the amplifier rather than the source resistance, the multiple-path technique should work well here. And it does.

There is however, a potential snag that needs to be considered. In the previous section, we were combining the outputs of voltage-followers, which have gains very close indeed to unity because they have 100% negative feedback and no resistors are involved in setting the gain. We could be confident that the output signals would be near-identical, and unwanted currents flowing from one opamp to the other would be small despite the low value of the combining resistors.

The situation here is different; the amplifiers have a gain of four times, so there is a smaller negative feedback factor to stabilise the gain, and there are two resistors with tolerances that set the closed-loop gain for each stage. We need to keep the combining resistors low to minimise their Johnson noise, so things might get awkward. It seems reasonable to assume that the feedback resistors will be 1% components. Considering the two-amplifier configuration in Figure 1.17, the worst case would be to have R1a 1% high and R2a 1% low in one amplifier, while the other had the opposite condition of R1b 1% low and R2b 1% high. This highly unlikely state of affairs gives a gain of 4.06 times in the first amplifier and 3.94 times in the second. Making the further assumption of a 10 Vrms maximum voltage swing, we get 10.15 Vrms at the first output and 9.85 Vrms at the second, both applied to the combining resistors, which here are set at 47 Ω. The maximum possible current flowing from one amplifier output into the other is therefore 0.3 V/(47 Ω + 47 Ω), which is 3.2 mA; in practice it will be much smaller. There are no problems

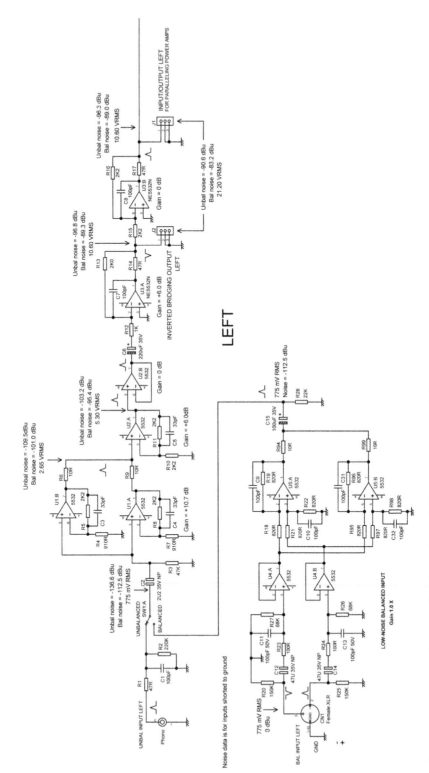

Figure 1.16 The gain stage for the voltage-follower power amplifier.

with linearity or headroom, and distortion performance is indistinguishable from that of a single opamp.

Having reassured ourselves on this point, we can examine the circuit of Figure 1.17, with two amplifiers combining their outputs. This reduces the noise at the output by 2.2 dB. This falls short of the 3 dB improvement we might hope for because of a significant Johnson noise contribution from source resistance, and doubling the number of amplifier stages again only achieves another 1.3 dB improvement. The improvement is greater with lower source resistances; the measured results with 1, 2, 3, and 4 opamps for three different source resistances are summarised in Table 1.15.

The results for 200 Ω and 100 Ω show that the improvement with multiple amplifiers is greater for lower source resistances, as these resistances generate less Johnson noise of their own.

Multiple amplifiers for greater drive capability

We have just seen that the use of multiple amplifiers with averaged outputs not only reduces noise but increases the drive capability proportionally to the number of amplifiers employed. This is highly convenient as heavy loads need to be driven when pushing hard the technique of low-impedance design. There is more on this in Chapter 15, relating to low-impedance Baxandall tone controls.

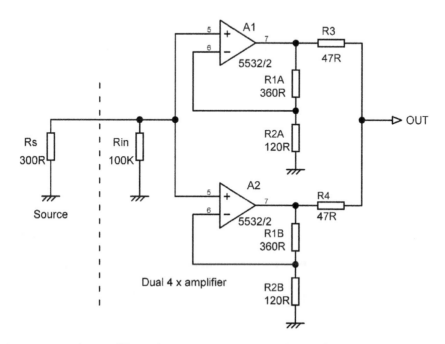

Figure 1.17 A 4 x gain amplifier using two opamps to reduce noise by an amount approaching 3 dB.

Using multiple amplifiers gets difficult when the stage has variable feedback to implement gain control or tone control. In this case the configuration in Figure 1.18 doubles the drive capability in a foolproof manner; I have always called it "mother's little helper." A1 may be enmeshed in as complicated a circuit as you like, but unity-gain buffer A2 will robustly carry out its humble duty of sharing the load. This is unlikely to give any noise advantage, as most of the noise will presumably come from the more complex circuitry around A1.

TABLE 1.15 Noise from multiple amplifiers with 4 x gain

Rs Ω	No of opamps	Noise out	Improvement
300	1	−106.1 dBu	0 dB ref
300	2	−108.2 dBu	2.2 dB
300	3	−109.0 dBu	2.9 dB
300	4	−109.6 dBu	3.5 dB
200	1	−106.2 dBu	0 dB ref
200	2	−108.4 dBu	2.2 dB
200	3	−109.3 dBu	3.1 dB
200	4	−110.0 dBu	3.8 dB
100	1	−106.3 dBu	0 dB ref
100	2	−108.7 dBu	2.4 dB
100	3	−109.8 dBu	3.5 dB
100	4	−110.4 dBu	3.9 dB

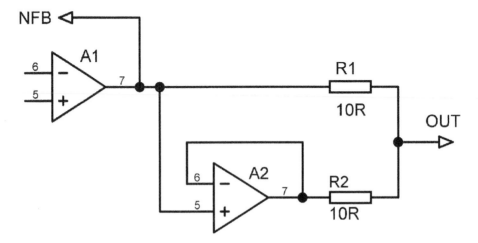

Figure 1.18 Mother's little helper. Using unity-gain buffer A2 to double the drive capability of any opamp stage.

It is assumed that A1 has load-driving capabilities equivalent to those of A2. This approach is more efficient than simply putting a multiple-buffer like that in Figure 1.15 after A1; that would make no use of the drive capability of A1. This technique was used to drive the input of a Baxandall volume control using 1 kΩ pots in the Elektor 2012 preamplifier design [39].

There is no reason why the averaging resistors R1 and R2 need to be the same. It may well occur that A1 is driving a low-impedance negative-feedback network that is a heavy load; in such a case it may be better to make R1 22 Ω, for example, keeping R2 at 10 Ω so that A2 does more of the work of driving the output.

References

[1] Smith, J. *Modern Operational Circuit Design*. Wiley-Interscience, 1971, p. 129

[2] https://en.wikipedia.org/wiki/Balanced_audio#Internally_balanced_audio_design Accessed Apr 2022

[3] https://forum.audiogon.com/discussions/balanced-but-not-fully-balanced Accessed Apr 2022

[4] Self, D. *Electronics for Vinyl*. Routledge, 2018, pp. 160–162

[5] Self, D. www.douglas-self.com/ampins/books/vinyl.htm Accessed Mar 2022

[6] http://bmc-audio.com/index.php/products.html Accessed Mar 2022

[7] www.canford.co.uk/TechZone/Article/CableImpedance Accessed Jan 2022

[8] www.technicalaudio.com/pdf/CBS_Labs/CBS_Labs_3B_Studio_Control_Console_extracted_from_Radio_Manual.pdf Accessed Mar 2022

[9] Intersil Application Note AN9420.1 *Current Feedback Amplifier Theory and Applications*, Apr 1995. https://www.academia.edu/3747671/Current_feedback

[10] Self, D. *Audio Power Amplifier Design*, 6th edition. Focal Press, 2013, Chapter 3, ISBN 978-0-240-52613-3

[11] Wikipedia. https://en.wikipedia.org/wiki/Acoustic_reflex

[12] Wikipedia. https://en.wikipedia.org/wiki/Auditory_fatigue

[13] Wikipedia. https://en.wikipedia.org/wiki/Presbycusis

[14] Oohashi, T., et al. "Inaudible High-Frequency Sounds Affect Brain Activity: Hypersonic Effect." *Journal of Neurophysiology*, Vol. 83, No. 6, June 2000

[15] McGowan, P. www.psaudio.com/pauls-posts/performance-above-20khz-matters/ Accessed June 2019

[16] https://pages.mtu.edu/~suits/notefreqs.html Accessed Apr 2022

[17] www.vsl.co.at/en/Brass_II/Contrabass_tuba Accessed Apr 2022

[18] https://en.wikipedia.org/wiki/Subcontrabass_tuba Accessed Apr 2022

[19] www.die-orgelseite.de/kurioses_e.htm#register Accessed Apr 2022

[20] Self, D. *The Design of Active Crossovers*, 2nd edition. Focal Press, 2018, pp. 190–193

[21] Loudersound.com. www.loudersound.com/features/forget-the-vinyl-revival-the-cassette-tape-revival-is-in-full-flow Accessed June 2019

[22] The Scotsman. www.scotsman.com/arts-and-culture/entertainment/forget-vinyl-it-s-time-for-the-8-track-revival-1-4913166 Accessed June 2019

[23] Wikipedia. https://en.wikipedia.org/wiki/The_Men_That_Will_Not_Be_Blamed_for_Nothing Accessed June 2019

[24] Preis, D. & Bloom, P. "Perception of Phase Distortion in Anti-Alias Filters." *Journal of the Audio Engineering Society*, Vol. 32, No. 11, Nov 1984

[25] Wikipedia https://en.wikipedia.org/wiki/Ohm%27s_acoustic_law Accessed June 2019

[26] Lipshitz, S. P., Pocock, M. & Vanderkooy, J. "On the Audibility of Midrange Phase Distortion in Audio Systems." *JAES*, Vol. 30, No. 9, Sept 1982, pp. 580–595

[27] Lipshitz, S. P., Pocock, M. & Vanderkooy, J. "James Moir Comment on 'Audibility of Midrange Phase Distortion in Audio Systems'." *JAES*, Dec 1983, p. 939

[28] Møller, H. et al. "On the Audibility of All-Pass Phase in Electroacoustical Transfer Functions." *JAES*, Vol. 55, No. 3, Mar 2007, pp. 113–134

[29] Linkwitz. www.linkwitzlab.com/phs-dist.htm (allpass audibility) Accessed June 2019

[30] Wikipedia. https://en.wikipedia.org/wiki/White_noise Accessed June 2019

[31] Wikipedia. https://en.wikipedia.org/wiki/Pink_noise Accessed June 2019

[32] Wikipedia. https://en.wikipedia.org/wiki/Brownian_noise Accessed June 2019

[33] Yellott, J. I., Jr. "Spectral Consequences of Photoreceptor Sampling in the Rhesus Retina." *Science*, Vol. 221, 1983, pp. 382–385

[34] Griffith, Martin. *Letter to Electronics World*, Apr 1996, p. 333

[35] Wikipedia. https://en.wikipedia.org/wiki/Colors_of_noise#Black_noise Accessed June 2019

[36] Johnson, J. "Thermal Agitation of Electricity in Conductors." *Physical Review*, Vol. 32, No. 97, 1928

[37] Chang, Z. Y. & Sansen, W. *Low-Noise Wideband Amplifiers in Bipolar & CMOS Technologies*, Kluwer, 1991, p. 106

[38] Groner, S. "A Low-Noise Laboratory-Grade Measurement Preamplifier." *Linear Audio*, Vol. 3, Apr 2012, p. 143

[39] Self, D. "Preamplifier 2012." *Elektor*, Vol. 4, Apr–June 2012, p. 16

Components

Conductors

It is easy to assume, when wrestling with electronic design, that the active devices will cause most of the trouble. This, like so much in electronics, is subject to Gershwin's law; it ain't necessarily so. Passive components cannot be assumed to be perfect, and while their shortcomings are rarely discussed in polite company, they are all too real. In this chapter I have tried to avoid repeating basic stuff that can be found in many places, to allow room for information that goes deeper.

Normal metallic conductors, such as copper wire, show perfect linearity for our purposes, and as far as I am aware, for everybody's purposes. Ohm's law was founded on metallic conductors, after all, not resistors, which did not exist as we know them at the time. George Simon Ohm published a pamphlet in 1827 entitled, "The Galvanic Circuit Investigated Mathematically" while he was a professor of mathematics in Cologne. His work was not warmly received, except by a perceptive few; the Prussian minister of education pronounced that "a professor who preached such heresies was unworthy to teach science." This is the sort of thing that happens when politicians try to involve themselves in science, and in that respect we have progressed little since then.

Although the linearity is generally effectively ideal, metallic conductors will not be perfectly linear in some circumstances. Poorly-made connections between oxidised or otherwise contaminated metal parts are capable of generating harmonic distortion at the level of several percent, but this is a property of the contact interface rather than the bulk material and usually means that the connection is about to fail altogether. A more subtle danger is that of magnetic conductors—the soft iron in relay frames causes easily detectable distortion at power amplifier current levels.

From time to time some of the dimmer audio commentators speculate that metallic conductors are actually a kind of 'sea of micro-diodes,' and that non-linearity can be found if the test signal levels are made small enough. This is both categorically untrue and physically impossible. There is no threshold effect for metallic conduction. I have myself added to the mountain of evidence on this by measuring distortion at very low signal levels [1]. Renardsen has some more information at [2].

Copper and other conductive elements

Copper is the preferred metal for conducting electricity in almost all circumstances. It has the lowest resistance of any metal but silver, is reasonably resistant to corrosion, and can be made mechanically strong; it's wonderful stuff. Being a heavy metal, it is unfortunately not that

DOI: 10.4324/9781003332985-2

common in the earth's crust, and so it is expensive compared with iron and steel. It is however cheap compared with silver. The price of metals varies all the time due to changing economic and political factors, but at the time of writing silver was 100 times more expensive than copper by weight. Given the same cross-section of conductor, the use of silver would only reduce the resistance of a circuit by 5%. Despite this, silver connection wire has been used in some very expensive hifi amplifiers; output impedance-matching transformers wound with silver wire are not unknown in valve amplifiers. Since the technical advantages are usually negligible such equipment is marketed on the basis of indefinable subjective improvements. The only exception is the moving-coil step-up transformer, where the use of silver in the primary winding might give a measurable reduction in Johnson noise.

Table 2.1 gives the resistivity of the commonly-used conductors, plus some insulators to give it perspective. The difference between copper and quartz is of the order of 10^{25}, an enormous range that is not found in many other physical properties.

TABLE 2.1 Properties of conductors and non-conductors

Material	Resistivity ρ (Ω-m)	Temperature coefficient per °C	Electrical usage
Silver	1.59×10^{-8}	0.0061	conductors
Copper	1.72×10^{-8}	0.0068	conductors
Gold	2.2×10^{-8}	0.0041	inert coatings
Aluminium	2.65×10^{-8}	0.00429	conductors
Tungsten	5.6×10^{-8}	0.0045	lamp filaments
Iron	9.71×10^{-8}	0.00651	barreters[*]
Platinum	10.6×10^{-8}	0.003927	electrodes
Tin	11.0×10^{-8}	0.0042	coatings
Mild steel	15×10^{-8}	0.0066	busbars
Solder (60:40 tin/lead)	15×10^{-8}	0.006	soldering
Lead	22×10^{-8}	0.0039	storage batteries
Manganin (Cu,Mn,Ni)[**]	48.2×10^{-8}	0.000002	resistances
Constantan (Cu,Ni)[**]	$49–52 \times 10^{-8}$	+/−0.00002	resistances
Mercury	98×10^{-8}	0.0009	relays
Nichrome	100×10^{-8}	0.0004	heating elements
(Ni,Fe,Cr alloy)			
Carbon (as graphite)	$3–60 \times 10^{-5}$	−0.0005	brushes
Glass	$1–10000 \times 10^{9}$. . .	insulators
Fused quartz	More than 10^{18}	. . .	insulators

[*] A barreter is an incredibly obsolete device consisting of thin iron wire in an evacuated glass envelope. It was typically used for current regulation of the heaters of RF oscillator valves, to improve frequency stability.

[**] Constantan and manganin are resistance alloys with moderate resistivity and a low temperature coefficient. Constantan is preferred as it has a flatter resistance/temperature curve, and its corrosion resistance is better.

There are several reasonably conductive metals that are lighter than copper, but their higher resistivity means they require larger cross-sections to carry the same current, so copper is always used when space is limited, as in electric motors, solenoids, etc. However, when size is not the primary constraint, the economics work out differently. The largest use of non-copper conductors is probably in the transmission line cables that are strung between pylons. Here minimal weight is more important than minimal diameter, so the cables have a central steel core for strength, surrounded by aluminium conductors.

It is clear that simply spending more money does not automatically bring you a better conductor; gold is a somewhat poorer conductor than copper, and platinum, which is even more expensive, is worse by a factor of six. Another interesting feature of this table is the relatively high resistance of mercury, nearly 60 times that of copper. This often comes as a surprise; people seem to assume that a metal of such high density must be very conductive, but it is not so. There are many reasons for not using mercury-filled hoses as loudspeaker cables, and their conductive inefficiency is just one. The cost and the insidiously poisonous nature of the metal are two more. Nonetheless . . . it is reported that the Hitachi Cable company has experimented with speaker cables made from polythene tubes filled with mercury. There appear to have been no plans to put such a product on the market. Restriction of hazardous substances (RoHS) compliance might be a bit of a problem.

We also see in Table 2.1 that the resistivity of solder is high compared with that of copper—nine times higher if you compare copper with the old 60/40 tin/lead solder. This is unlikely to be a problem as the thickness of solder the current passes through in a typical joint is very small. There are many formulations of lead-free solder, with varying resistivities, but all are high compared with copper.

One other point about solder. I have known people tin the ends of mains cables (ie solder them) so that the end slides easily into the screw-terminals (I should say I am talking about the magnificent UK mains plug here). This sounds harmless, but it is not. Under pressure the solder will creep, and the connection will come loose, possibly causing overheating and fire. Overheating increases the rate of creep, and we're talking positive feedback here. This danger is not the issue it once was because nowadays almost all mains cables come with a moulded-on plug, but it remains a subtle and non-obvious hazard.

The metallurgy of copper

Copper is a good conductor because the outermost electrons of its atoms have a large mean free path between collisions. The electrical resistivity of a metal is inversely related to this electron mean free path, which in the case of copper is approximately 100 atomic spacings.

Copper is normally used as a very dilute alloy known as electrolytic tough pitch (ETP) copper, which consists of very high purity metal alloyed with oxygen in the range of 100 to 650 ppm. In view of the wide exposure that the concept of oxygen-free copper has had in the audio business, it is worth underlining that the oxygen is deliberately alloyed with the copper to act as a scavenger for dissolved hydrogen and sulphur, which become water and sulphur dioxide. Microscopic bubbles form in the mass of metal but are completely eliminated during Hot rolling. The main use of oxygen-free copper is in conductors exposed to a hydrogen atmosphere at high

temperatures. ETP copper is susceptible to hydrogen embrittlement in these circumstances, which arise in the hydrogen-cooled alternators in power stations. Many metals are subject to hydrogen embrittlement, including steel, which makes it a difficult gas to deal with.

It has been stated many times that oxygen-free copper makes superior cables, etc. In the world of Subjectivist hifi this treated as a fact, but I am not aware that any hard evidence has ever been put forward, and I do not believe it. More information on the metallurgy of copper is given in [3], with an account of a comparison between copper and mercury, but the results are just those of 'listening tests,' and I do not agree at all with the conclusions drawn.

Gold and its uses

As stated earlier, gold has a higher resistivity than copper, and there is no incentive to use it as the bulk metal of conductors, not least because of its high cost. However it is very useful as a thin coating on contacts because it is almost immune to corrosion, though it is chemically attacked by fluorine and chlorine (if there is a significant amount of either gas in the air then your medical problems will be more pressing than your electrical ones). Other electrical components are sometimes gold-plated simply because the appearance is attractive. A carat (or karat) is a 1/24 part, so 24-carat gold is the pure element, while 18-carat gold contains only 75% of the pure metal. 18-carat gold is the sort usually used for jewellery as it retains the chemical inertness of pure gold but is much harder and more durable; the usual alloying elements are copper and silver.

18-carat gold is widely used in jewellery and does not tarnish, so it is initially puzzling to find that some electronic parts plated with it have a protective transparent coating which the manufacturer claims to be essential to prevent blackening. The answer is that if gold is plated directly onto copper, the copper diffuses through the gold and tarnishes on its surface. The standard way of preventing this is to plate a layer of nickel onto the copper to prevent diffusion, then plate on the gold. I have examined some transparent-coated gold-plated parts and found no nickel layer; presumably the manufacturer finds the transparent coating is cheaper than another plating process to deposit the nickel. However, it does not look so good as bare gold.

Tin and its uses

Tin is very useful stuff; there is an excellent Wikipedia page [4] on tin and its uses. Both through-hole (TH) and surface mount technology (SMT) components usually have copper leads which are hot-dipped or electroplated with a thin layer of tin which does not oxidise significantly at normal temperatures and solders easily. In contrast copper oxidises, and silver acquires a non-conductive coat of black silver sulphide. Tin-doped indium oxide (ITO) has the extremely useful property of being both electrically conductive and transparent and is used on touch screens.

Historically the greatest use of tin in electronics was in tin/lead solder; in 2006 52% of the tin produced was used in solder. Modern lead-free solders also contain tin; the most popular alloy is tin-silver-copper (Sn-Ag-Cu or SAC) [5]. When tin-based solders are use on gold-coated components they can dissolve the gold, forming brittle intermetallic joints. Tin-rich solders also dissolve silver, which may be unhelpful.

However tin does have some problems. At high temperatures, over time tin can form whiskers that create short-circuits [6]. In the 1980s it was found that adding a small amount, such as 2%, of lead prevented the growth of tin whiskers. Today this, of course, makes RoHS compliance difficult, and many recent studies have been made to find out how to control whisker formation with a pure tin coating.

Tin also has another special problem, called tin plague or tin pest [7]. Below 13.2°C, pure tin transforms from the familiar silvery and ductile metallic white tin to brittle non-metallic grey tin, which is non-conductive. As this happens the tin article turns into a grey powder. This is supposed to have caused the buttons of Napoleon's soldiers to disintegrate during his invasion of Russia, but this is untrue. Adding small amounts of antimony or bismuth prevents the conversion, and it is not considered a problem in electronics.

Cable and wiring resistance

Electrical cable is very often specified by its cross-sectional area and current-carrying capacity, and the resistance per meter is seldom quoted. This can, however, be a very important parameter for assessing permissible voltage drops and for predicting the crosstalk that will be introduced between two signals when they unavoidably share a common ground conductor. Given the resistivity of copper from Table 2.1; the resistance R of L metres of cable is simply

$$R = \frac{resistivity \cdot L}{area}$$

Equation 2.1

Note that the area, which is usually quoted in catalogues in square millimetres, must be expressed here in square metres to match up with the units of resistivity and length. Thus 5 metres of cable with a cross-sectional area of 1.5 mm2 will have a resistance of

$$(1.72 \times 10^{-8}) \times 5/(0.0000015) = 0.057 \text{ Ohms}$$

This gives the resistance of our stretch of cable, and it is then simple to treat this as part of a potential divider to calculate the voltage drop down its length.

Printed circuit boards (PCBs)

Printed circuit boards are the standard way of doing electronics, apart from a few valve amplifiers that still use tag-boards and point-to-point wiring. With modern technology they are cheap to make. Virtually all PCBs are now fibreglass (FR4) rather than the old FR-2 (phenolic cotton paper).

The standard thickness of fibreglass (FR4) PCBs is 1.6 mm, which normally gives more than enough mechanical strength. Other much less popular thicknesses are 0.4, 0.6, 0.8, 1.0, 1.2, and 2.0 mm. The difference between 1.6 and 2.0 mm may appear to be small, but stiffness increases as the cube of thickness, so a 2.0 mm PCB is almost twice as stiff and strong as the 1.6 mm version.

Standard PCB technology first gave us one layer, then two layers, and, after some time, four layers. Double-sided PCBs with plated-through holes (PTH) are commonplace, and 4-layer boards can be obtained for relatively little extra cost. This allows the use of power and ground planes, which are very useful but by no means essential for quality audio work; I don't recall ever using more than two layers. Multilayer boards are made by bonding together 2-layer boards, so there is never an odd number of layers. Computer motherboards commonly have eight or ten layers, while mobile phones often have 12 layers to allow greater circuit density. High density interconnects and backplanes often use 24 layers. The maximum number of layers obtainable is debatable, but Asian Circuits [8] say they can make 50-layer boards, and it is claimed that 70-plus is possible [9]. PCB manufacturers offering rapid turnaround often limit this to boards with a maximum of six layers.

PCB track resistance

It is also useful to be able to calculate the resistance of a PCB track for the same reasons. This is slightly less straightforward to do; given the smorgasbord of units that are in use in PCB technology, determining the cross-sectional area of the track can present some difficulty.

In the United States and the United Kingdom, and probably elsewhere, there is inevitably a mix of metric and imperial units on PCBs, as many important components come in dual-in-line packages which are derived from an inch grid; track widths and lengths are therefore very often in thousandths of an inch, universally (in the United Kingdom at least) referred to as "thou." Conversely, the PCB dimensions and fixing-hole locations will almost certainly be metric as they interface with a world of metal fabrication and mechanical CAD that (except in the United States) went metric many years ago. Add to this the UK practice of quoting copper thickness in ounces (the weight of a square foot of copper foil), and all the ingredients for dimensional confusion are in place. The conversion factor is 1 inch = 25.4 mm. When I was a lad I wondered why no one ever talked about the remaining decimal places; the answer is there aren't any. That is the exact conversion factor.

Standard PCB copper foil is known as one-ounce copper, having a thickness of 1.4 thou (= 35 microns). Two-ounce copper is naturally twice as thick; the extra cost of specifying it is small, typically around 5% of the total PCB cost, and this is a very simple way of halving track resistance. It can, of course, be applied very easily to an existing design without any fear of messing up a satisfactory layout. Four-ounce copper can also be obtained but is more rarely used and is therefore much more expensive. If a heavier copper than two-ounce is required, the normal technique is to plate two-ounce up to three-ounce copper. The extra cost of this is surprisingly small, in the region of 10% to 15%.

Given the copper thickness, multiplying by track width gives the cross-sectional area. Since resistivity is always in metric units, it is best to convert to metric at this point, so Table 2.2 gives area in square millimetres. This is then multiplied by the resistivity, not forgetting to convert the area to metres for consistency. This gives the "resistance" column in the table, and it is then simple to treat this as part of a potential divider to calculate the usually unwanted voltage across the track.

For example, if the track in question is the ground return from two 8 Ω speakers, this is the top half of a potential divider while the track is the bottom half (I am, of course, ignoring here the fact that loudspeakers are not purely resistive loads), and a quick calculation gives the fraction of the input voltage found along the track. This is expressed in the last column of Table 2.2 as

TABLE 2.2 Thickness of copper cladding and the calculation of track resistance

Weight oz	Thickness thou	Thickness micron	Width thou	Length inch	Area mm2	Resistance Ohm	Atten ref 8 Ω dB
1	1.38	35	12	3	0.0107	0.123	−36.4
1	1.38	35	50	3	0.0444	0.029	−48.7
2	2.76	70	12	3	0.0213	0.061	−42.4
2	2.76	70	50	3	0.0889	0.015	−54.7
4	5.52	140	50	3	0.178	0.0074	−60.7

attenuation in dB. This shows clearly that loudspeaker outputs should not have common return tracks or the interchannel crosstalk will be dire.

It is very clear from Table 2.2 that relying on thicker copper on your PCB as means of reducing path resistance is not very effective. In some situations it may be the only recourse, but in many cases a path of much lower resistance can be made by using 32/02 cable soldered between the two relevant points on the PCB.

PCB tracks have a limited current capability because excessive resistive heating will break down the adhesive holding the copper to the board substrate and ultimately melt the copper. This is normally only a problem in power amplifiers and power supplies. It is useful to assess if you are likely to have problems before committing to a PCB design, and Table 2.3, based on MIL-standard 275, gives some guidance.

Note that Table 2.3 applies to tracks on the PCB surface only. Internal tracks in a multilayer PCB experience much less cooling and need to be about three times as thick for the same temperature

TABLE 2.3 PCB track current capacity for a permitted temperature rise

Track temp rise	10°C		20°C		30°C	
Copper weight	1 oz	2 oz	1 oz	2 oz	1 oz	2 oz
Track width thou						
10	1.0 A	1.4 A	1.2 A	1.6 A	1.5 A	2.2 A
15	1.2 A	1.6 A	1.3 A	2.4 A	1.6 A	3.0 A
20	1.3 A	2.1 A	1.7 A	3.0 A	2.4 A	3.6 A
25	1.7 A	2.5 A	2.2 A	3.3 A	2.8 A	4.0 A
30	1.9 A	3.0 A	2.5 A	4.0 A	3.2 A	5.0 A
50	2.6 A	4.0 A	3.6 A	6.0 A	4.4 A	7.3 A
75	3.5 A	5.7 A	4.5 A	7.8 A	6.0 A	10.0 A
100	4.2 A	6.9 A	6.0 A	9.9 A	7.5 A	12.5 A
200	7.0 A	11.5 A	10.0 A	16.0 A	13.0 A	20.5 A
250	8.3 A	12.3 A	12.3 A	20.0 A	15.0 A	24.5 A

rise. This factor depends on laminate thickness and so on, and you need to consult your PCB vendor.

Traditionally, overheated tracks could be detected visually because the solder mask on top of them would discolour to brown. I am not sure if this still applies with modern solder mask materials, as in recent years I have been quite successful in avoiding overheated tracking.

PCB track-to-track crosstalk

The previous section described how to evaluate the amount of crosstalk that can arise because of shared track resistances. Another crosstalk mechanism is caused by capacitance between PCB tracks. This is not very susceptible to calculation, so I did the following experiment to put some figures to the problem.

Figure 2.1 shows the setup; four parallel conductors 1.9 inches long on a standard piece of 0.1 inch pitch prototype board were used as test tracks. These are perhaps rather wider than the

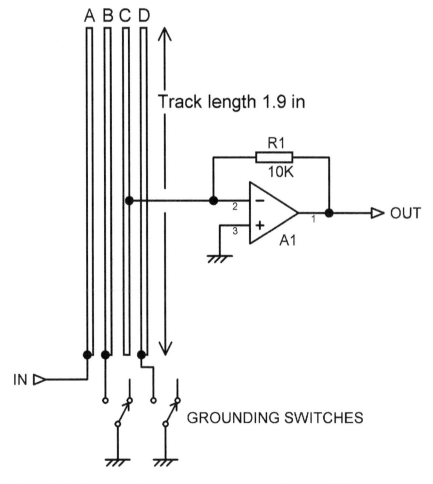

Figure 2.1 Test circuit for measuring track-to-track crosstalk on a PCB.

average PCB track, but one must start somewhere. The test signal was applied to track A, and track C was connected to a virtual-earth summing amplifier A1.

The tracks B and D were initially left floating. The results are shown as Trace 1 in Figure 2.2; the coupling at 10 kHz is −65 dB, which is worryingly high for two tracks 0.2 inch apart. Note that the crosstalk increases steadily at 6 dB per octave, as it results from a very small capacitance driving into what is effectively a short circuit.

It has often been said that running a grounded screening track between two tracks that are susceptible to crosstalk has a beneficial effect, but how much good does it really do? Grounding track B, to place a screen between A and C, gives Trace 2 and has only improved matters by 9 dB; not the dramatic effect that might be expected from screening. The reason, of course, is that electric fields are very much three-dimensional, and if you could see the electrostatic 'lines of force' that appear in physics textbooks you would notice they arch up and over any planar screening such as a grounded track. It is easy to forget this when staring at a CAD display. There are of course two-layer and multilayer PCBs, but the visual effect on a screen is still of several slices of 2-D. As Mr Spock remarked in one of the *Star Trek* films, "He's intelligent, but not experienced. His pattern indicates two-dimensional thinking."

Grounding track D, beyond receiving track C, gives a further improvement of about 3 dB; (Trace 3) this would clearly not happen if PCB crosstalk was simply a line-of-sight phenomenon.

To get more effective screening than this you must go into three dimensions too; with a double-sided PCB you can put one track on each side with ground plane opposite. With a 4-layer board it should be possible to sandwich critical tracks between two layers of ground plane, where they should be safe from pretty much anything. If you can't do this and things are really tough you may need to resort to a screened cable between two points on the PCB; this is of course expensive in assembly time. If components, such as electrolytics with their large surface area, are talking to each other, you may need to use a vertical metal wall, but this costs money. A more cunning plan is to use electrolytics not carrying signal, such as rail decouplers, as screening items.

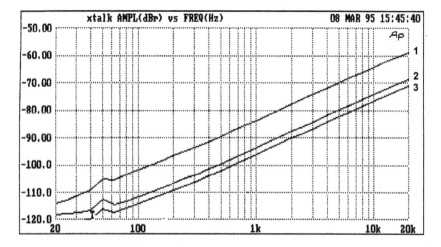

Figure 2.2 Results of PCB track-to-track crosstalk tests.

The internal crosstalk between the two halves of a dual opamp is very low according to the manufacturer's specs. Nevertheless, avoid having different channels going through the same opamp if you can because this will bring the surrounding components into close proximity and will permit capacitive crosstalk.

The 3-layer PCB

There are of course no 3-layer PCBs as such; PCBs come in 2-layer, 4-layer, and so on upwards in multiples of two. The desirability of three layers on a PCB appeared when people began to make flat mixers all on one big PCB; there were no longer screened-cable connections to and from the faders, as these are time-consuming and costly to fabricate and connect. All the connections had to be on the PCB for economy, but a 4-layer solution would have been wholly impractical due to the great cost at the time. Since the routing switches on a channel are almost always above the fader, the tracks to the fader had to cross the mix buses on both send and return. This naturally meant that on a 2-layer PCB there was significant capacitive crosstalk from the fader connections to the mix buses.

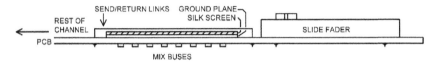

Figure 2.3 How to make a three-layer PCB.

I decided an answer to this problem was needed; at the time it was called the 3-layer PCB because it provided (to a limited extent) three layers of connectivity. Figure 2.3 shows how. The mixing buses were placed on the bottom side of a 2-layer PCB. The top copper layer was a ground plane completely covering the mix bus area, and on top of that two wire links provided the send and return paths to the fader. At the time this sort of thing was going on, solder-resist was not as tough as it is now, and so a band of solid screen-print ink (as used for the component ident) was placed under each link to prevent short-circuits at zero cost. Two wire links can be fitted much more quickly than a twin screened-cable connection; indeed they can be auto-inserted.

This technology is typically only required where signals cross the mix buses; no other part of the system is so vulnerable to capacitive crosstalk.

Impedances and crosstalk: a case history

Capacitive crosstalk between two opamp outputs can be surprisingly troublesome. The usual isolating resistor on an opamp output is 47 Ω, and you might think that this impedance is so low that the capacitive crosstalk between two of these outputs would be completely negligible, but . . . you would be wrong.

A stereo power amplifier had balanced input amplifiers with 47 Ω output isolating resistors included to prevent any possibility of instability although the opamps were driving only a few

cm of PCB track rather than screened cables with their significant capacitance. Just downstream of these opamps was a switch to enable biamping by driving both left and right outputs with the left input. This switch and its associated tracking brought the left and right signals into close proximity, and the capacitance between them was not negligible.

Crosstalk at low frequencies (below 1 kHz) was pleasingly low, being better than −129 dB up to 70 Hz, which was the difference between the noise floor and the maximum signal level (the measured noise floor was unusually low at −114 dBu because each input amplifier was a quadruple noise cancelling type as described in Chapter 18, and that figure includes the noise from an AP System 1). At higher frequencies things were rather less gratifying, being −96 dB at 10 kHz, as shown by the "47R" trace in Figure 2.4. In many applications this would be more than acceptable, but in this case the highest performance possible was being sought.

I therefore decided to reduce the output isolating resistors to 10 Ω, so the interchannel capacitance would have less effect (checks were done at the time and all through the prototyping and pre-production process to make sure that this would be enough resistance to ensure opamp stability—it was). This handily reduced the crosstalk to −109 dB at 10 kHz, an improvement of 13 dB at zero cost. This is the ratio between the two resistor values.

The third trace marked "DIS" shows the result of removing the isolating resistor from the speaking channel, so no signal reached the biamping switch. As usual, this reveals a further crosstalk mechanism at about -117 dB at 10 kHz, for reducing crosstalk, is proverbially like peeling onions. There is layer after layer, and even strong men are reduced to tears.

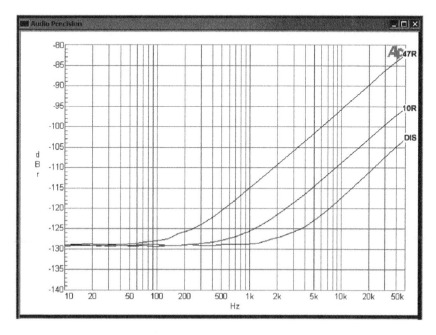

Figure 2.4 Crosstalk between opamp outputs with 47 Ω and 10 Ω output isolating resistors.

Resistors

There have been many types of resistors, including some interesting ones consisting of jars or tanks of liquid, which are good at absorbing large amounts of power, eg 0.5 MW for 30 seconds;[10] don't try that with SMT. The sort of resistors used in audio are often classified by the kind of material used in the resistive element, as this has the most important influence on the fine details of performance. The major materials and types are shown in Table 2.4.

These values are illustrative only, and it would be easy to find exceptions. As always, the official data sheet for the component you have chosen is the essential reference. The voltage coefficient is a measure of linearity (lower is better), and its sinister significance is explained later.

It should be said that you are most unlikely to come across carbon composition resistors in modern signal circuitry, but they frequently appear in vintage valve equipment so they are included here. They also live on in specialised applications such as switch-mode snubbing circuits, where their ability to absorb a high peak power in a mass of material rather than a thin film is very useful.

Carbon film resistors are currently still sometimes used in low-end consumer equipment, but elsewhere they have been supplanted by the other three types. Note from Table 2.4 that they have a significant voltage coefficient.

Metal film resistors are now the usual choice when any degree of precision or stability is required. These have no non-linearity problems at normal signal levels. The voltage coefficient is usually negligible.

Metal oxide resistors are more problematic. Cermet resistors and resistor packages are metal oxide and are made of the same material as thick film SM resistors. Thick film resistors can show significant non-linearity at opamp-type signal levels and should be kept out of high-quality signal paths.

Wirewound resistors are indispensable when serious power needs to be handled. The average wirewound resistor can withstand very large amounts of pulse power for short periods, but in this litigious age component manufacturers are often very reluctant to publish specifications on this capability, and endurance tests have to be done at the design stage; if this part of the system is built first then it will be tested as development proceeds. The voltage coefficient is usually negligible.

TABLE 2.4 **Characteristics of resistor types**

Type	Resistance tolerance	Temperature coefficient	Voltage coefficient
Carbon composition	±10%	+400 to −900 ppm/°C	350 ppm
Carbon film	±5%	−100 to −700 ppm/°C	100 ppm
Metal film	±1%	+100 ppm/°C	1 ppm
Metal oxide	±5%	+300 ppm/°C	variable but too high
Wirewound	±5%	±70% to ±250%	1 ppm

Resistors for general PCB use come in both through-hole (TH) and surface-mount (SM) types. TH resistors can be any of the types mentioned in the earlier table; SM resistors are always either metal film or metal oxide. There are also many specialised types; for example, high-power wirewound resistors are often constructed inside a metal case that can be bolted down to a heatsink.

Through-hole resistors

These are too familiar to require much description; they are available in all the materials mentioned earlier: carbon film, metal film, metal oxide, and wirewound. There are a few other sorts, such as metal foil, but they are restricted to specialised applications. Conventional TH resistors are now almost always 250 mW 1% metal film. Carbon film used to be the standard resistor material, with the expensive metal film resistors reserved for critical places in circuitry where low tempco and an absence of excess noise were really important, but as metal film got cheaper it took over many applications.

TH resistors have the advantage that their power and voltage rating greatly exceed those of surface-mount versions. They also have a very low-voltage coefficient, which for our purposes is of the first importance. On the downside, the spiral construction of the resistance element means they have much greater parasitic inductance; this is not a problem in audio work.

Surface-mount resistors

Surface-mount resistors come in two main formats, the common chip type, and the rarer (and much more expensive) MELF format. The values available range from zero-Ohm links, through sub-milliOhm values for current sensing, to an astonishing 50 giga-Ohms. That is an impressive range (ignoring the zero-Ohm link) of 5×10^{12}.

Chip surface-mount resistors come in a flat tombstone format, which varies over a wide size range; see Table 2.5.

MELF surface-mount resistors have a cylindrical body with metal endcaps, the resistive element is metal film, and the linearity is therefore as good as conventional resistors, with a voltage coefficient of less than 1 ppm. MELF is apparently an acronym for "metal electrode leadless face" though most people I know call them "metal ended little fellows" or something quite close to that.

Surface-mount resistors may have thin film or thick film resistive elements. The latter are cheaper and so more often encountered, but the price differential has been falling in recent years. Both thin film and thick film SM resistors use laser trimming to make fine adjustments of resistance value during the manufacturing process. There are important differences in their behaviour.

Thin film (metal film) SM resistors use a nickel-chromium (Ni-Cr) film as the resistance material. A very thin Ni-Cr film of less than 1 um thickness is deposited on the aluminium oxide substrate by sputtering under vacuum. Ni-Cr is then applied onto the substrate as conducting electrodes. The use of a metal film as the resistance material allows thin film resistors to provide a very low temperature coefficient, much lower current noise, and vanishingly small non-linearity. Thin film resistors need only low laser power for trimming (1/3 of that required for thick film resistors) and

TABLE 2.5 The standard surface-mount resistor sizes with typical ratings

Size L x W	Max power dissipation	Max voltage
2512	1 W	200 V
1812	750 mW	200 V
1206	250 mW	200 V
0805	125 mW	150 V
0603	100 mW	75 V
0402	100 mW	50 V
0201	50 mW	25 V
01005	30 mW	15 V

contain no glass-based material. This prevents possible micro-cracking during laser trimming and maintains the stability of the thin film resistor types.

Thick film resistors normally use ruthenium oxide ($RuO2$) as the resistance material mixed with glass-based material to form a paste for printing on the substrate. The thickness of the printing material is usually 12 um. The heat generated during laser trimming can cause micro-cracks on a thick film resistor containing glass-based materials which can adversely affect stability. Palladium/silver (PdAg) is used for the electrodes.

The most important thing about thick film surface-mount resistors from our point of view is that they do not obey Ohm's law very well. This often comes as a shock to people who are used to TH resistors, which have been the highly linear metal film type for many years. They have much higher voltage coefficients than TH resistors, at between 30 and 100 ppm. The non-linearity is symmetrical about zero voltage and so gives rise to third-harmonic distortion. Some SM resistor manufacturers do not specify voltage coefficient, which usually means it can vary disturbingly between different batches and different values of the same component, and this can have dire results on the repeatability of design performance.

Chip-type surface-mount resistors come in standard formats with names based on size, such as 1206, 0805, 0603, and 0402. For example, 0805, which used to be something like the 'standard' size, is 0.08 in by 0.05 in; see Table 2.5. The smaller 0603 is now more common. Both 0805 and 0603 can be placed manually if you have a steady hand and a good magnifying glass.

The 0402 size is so small that the resistors look rather like grains of pepper; manual placing is not really feasible. They are only used in equipment where small size is critical, such as mobile phones. They have very restricted voltage and power ratings, typically 50V and 100 mW. The voltage rating of TH resistors can usually be ignored, as power dissipation is almost always the limiting factor, but with SM resistors it must be kept firmly in mind.

Recently, even smaller surface-mount resistors have been introduced; for example several vendors offer 0201, and Panasonic and Yageo offer 01005 resistors. The latter are truly tiny, being about 0.4 mm long; a thousand of them weigh less than a twentieth of a gram. They are intended for

mobile phones, palmtops, and hearing aids; a full range of values is available from 10 Ω to 1 MΩ (jumper inclusive). Hand placing is really not an option.

Surface-mount resistors have a limited power dissipation capability compared with their through-hole cousins because of their small physical size. SM voltage ratings are also restricted, for the same reason. It is therefore sometimes necessary to use two SM resistors in series or parallel to meet these demands, as this is usually more economic than hand-fitting a through-hole component of adequate rating. If the voltage rating is the issue then the SM resistors will obviously have to be connected in series to gain any benefit.

Resistor series

Resistors are widely available in the E24 series (24 values per decade) and the E96 series (96 values per decade). There is also the E192 series, which as you might have guessed, has no less than 192 values per decade, but this is less freely available and not commonly used in audio design. Using the E96 or E192 resistor series over a product range means you have to keep an awful lot of different values in stock, and when non-standard values are required it is usually more convenient to use a series or parallel combination of two or three E24 resistors. There is much more on this later in this chapter. Some types of resistor such as wirewound may belong to more restricted series like E6.

It is common in US publications to see something like, "Resistor values have been rounded to the nearest 1% value," which usually means the E96 series has been used. E96 values seem to have been in frequent use in the United States decades before they became so in Europe, leading to much head-scratching over 'odd resistor values.' The value series from E3 to E96 is given in Appendix 1 at the back of this book.

There is a subtle trap built into the resistor series. If a resistor value exists in E6 or E12, then it will exist in E24. However, this does *not* follow for the E48 and E96 series. As an example, the 120 Ω value appears in both E12 and E24, but it does not occur in E48 or E96, where the nearest value is 121 Ω in both cases. Mysteriously, 120 Ω reappears in E192, which has 121 Ω as well. You need to be aware of this if you are changing resistor series. There actually seems to be little or no interest in manufacturing E48 resistors as such; they are a subset of E96 resistors.

There are some other aspects of the resistor series that are worth knowing. Circuit design often requires specific ratios of components; as an example, if you are designing a second-order highpass filter, you will need resistors in a 1:2 ratio; there are no such pairs in the E3, E6, or E12 series. The E24 series is much more helpful here because there are no less than six values which have an exact 2:1 ratio, such as 1 kΩ and 2 kΩ. All six pairs are shown in Table 2.6.

The E24 series also has four value pairs in an exact 1:3 ratio (eg 1 kΩ–3 kΩ), two pairs in a 1:4 ratio (eg 75 Ω–300 Ω), and six pairs in a 1:5 ratio (eg 2 kΩ–10 kΩ), which can be very useful in design. All these values are given in Appendix 1.

The E96 series sounds as though it would be even more fruitful of resistor pairs in integer ratios, and things start well with no less than 16 pairs in a 1:2 ratio. However there are no 1:3 pairs at all, and also no 1:4 pairs—none. You will recall that I said earlier that the E24 was *not* a subset

TABLE 2.6 E24: 6 value pairs in 1: 2 ratio

75	150
100	200
110	220
120	240
150	300
180	360

of E96. There are, however, in E96 a full 16 pairs in a 1:5 ratio. These are likewise listed in Appendix 1. I have not examined larger integer ratios as it seems relatively unlikely they will be useful in the design process.

Resistor accuracy: two resistor combinations

As noted in Table 2.4, the most common tolerance for metal film resistors today is 1%. If you want a closer tolerance then the next that is readily available is 0.1%; while there is considerable variation in price, roughly speaking the 0.1% resistors will be ten times as expensive.

When non-E24 values are required it is usually more convenient to use a series or parallel combination of two E24 resistors. I call this the 2xE24 format.

Using two or more resistors to make up a desired value has a valuable hidden benefit. If it is done correctly it will actually increase the average accuracy of the total resistance value so it is *better* than the tolerance of the individual resistors. This may sound paradoxical, but it is simply an expression of the fact that random errors tend to cancel out if you have a number of them. This also works for capacitors, and indeed any parameter that is subject to random variations, but for the time being we will focus on the concrete example of multiple resistors. Note that this assumes that the mean (ie average) value of the resistors is accurate. It is generally a sound assumption as it is much easier to control a single value such as the mean in a manufacturing process than to control all the variables that lead to scatter about that mean. This is confirmed by measurement.

Component values are usually subject to a Gaussian distribution, also called a normal distribution. It has a familiar peaky shape, not unlike a resonance curve, showing that the majority of the values lie near the central mean and that they get rarer the further away from the mean you look. This is a very common distribution, cropping up wherever there are many independent things going on that affect the value of a given component. The distribution is defined by its mean and its standard deviation, which is the square root of the sum of the squares of the distances from the mean—the RMS-sum, in other words. Sigma (σ) is the standard symbol for standard deviation. A Gaussian distribution will have 68.3% of its values within ±1 σ, 95.4% within ±2 σ, 99.7% within ±3 σ, and 99.9% within ±4 σ. This is illustrated in Figure 2.5, where the X-axis is calibrated in numbers of standard deviations on either side of the central mean value.

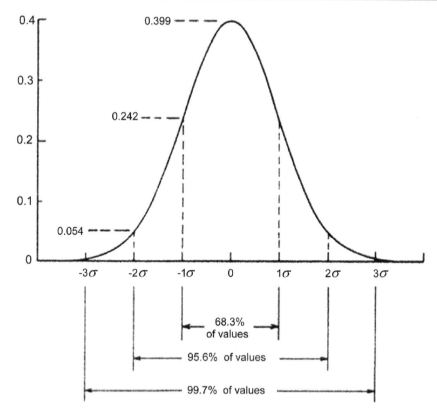

Figure 2.5 A Gaussian (normal) distribution with the X-axis marked in standard deviations on either side of the mean. The apparently strange value for the height of the peak is actually carefully chosen so the area under the curve is one.

If we put two equal-value resistors in series, or in parallel, (see Figure 2.6a and 2.6b) the total value has a proportionally narrower distribution that of the original components. The standard deviation of summed components is the RMS sum of the individual standard deviations, as shown in Equation 2.2. σ_{sum} is the overall standard deviation, and σ_1 and σ_2 are the standard deviations of the two resistors in series or parallel.

$$\sigma_{sum} = \sqrt{(\sigma_1)^2 + (\sigma_2)^2}$$ Equation 2.2

Thus if we have four 100 Ω 1% resistors in series, the standard deviation of the total resistance increases only by the square root of four, that is two times, while the total resistance has increased by four times; thus we have made a 0.5% close-tolerance 400 Ω resistor for four times the price, whereas a 0.1% resistor would be at least ten times the price and may give more accuracy than we need. There is a happy analogue here with the use of multiple amplifiers to reduce electrical noise; we are using essentially the same technique of RMS summation to reduce 'statistical noise.' The more resistors you combine, the more the values cluster together in the centre of the range.

The mathematics for series resistors is very simple (see Equation 2.2), but in other cases gets complicated very quickly. Equation 2.2 also holds for two parallel resistors as in Figure 2.6b, though this is mathematically much less obvious. I verified it by the use of Monte-Carlo methods [11]. A suitable random number generator is used to select two resistor values, and their combined value is calculated and recorded. This is repeated many times (by computer, obviously), and then the mean and standard deviation of all the accumulated numbers is recorded. This will never give the *exact* answer, but it will get closer and closer as you make more trials. For the series and parallel cases the standard deviation is $1/\sqrt{2}$ of the standard deviation for a single resistor. If you are not wholly satisfied that this apparently magical improvement in average accuracy is genuine, seeing it happen on a spreadsheet makes a convincing demonstration.

In an Excel spreadsheet, random numbers with a uniform distribution are generated by the function RAND(), but random numbers with a Gaussian distribution and specified mean and standard deviation can be generated by the function NORMINV(). Let us assume we want to make an accurate 20 kΩ resistance. We can simulate the use of a single 1% tolerance resistor by generating a column of Gaussian random numbers with a mean of 20 and a standard deviation of 0.2; we need to use a lot of numbers to smooth out the statistical fluctuations, so we generate 400 of them. As a check, we calculate the mean and standard deviation of our 400 random numbers using the AVERAGE() and STDEV() functions. The results will be very close to 20 and 0.2 but not identical and will change every time we hit the F9 recalculate key as this generates a new set of random numbers. The results of five recalculations are shown in Table 2.7, demonstrating that 400 numbers are enough to get us quite close to our targets.

To simulate two 10 kΩ resistors of 1% tolerance in series we generate two columns of 400 Gaussian random numbers with a mean of ten and a standard deviation of 0.1. We then set up a third column, which is the sum of the two random numbers on the same row, and if we calculate the mean and standard deviation using AVERAGE() and STDEV() again, we find that the mean is still very close to 20, but the standard deviation is reduced on average by the expected factor of $\sqrt{2}$. The result of five trials is shown in Table 2.8. Repeating this experiment with two 40 kΩ resistors in parallel gives the same results.

If we repeat this experiment by making our 20 kΩ resistance from a series combination of four 5 kΩ resistors of 1% tolerance, we generate four columns of 400 Gaussian random numbers with a mean of five and a standard deviation of 0.05. We sum the four numbers on the same row to get

TABLE 2.7 Mean and standard deviation of five batches of 400 Gaussian random resistor values

Mean kΩ	Standard deviation
20.0017	0.2125
19.9950	0.2083
19.9910	0.1971
19.9955	0.2084
20.0204	0.2040

TABLE 2.8 Mean and standard deviation of five batches of
400 Gaussian 10 kΩ 1% resistors, two in series

Mean kΩ	Standard deviation
19.9999	0.1434
20.0007	0.1297
19.9963	0.1350
20.0114	0.1439
20.0052	0.1332

a fifth column, and we calculate the mean and standard deviation of that. The result of five trials is shown in Table 2.9. The mean is very close to 20, but the standard deviation is now reduced on average by the a factor of $\sqrt{4}$, which is two.

I think this demonstrates quite convincingly that the spread of values is reduced by a factor equal to the square root of the number of the components used. The principle works equally well for capacitors or indeed any quantity with a Gaussian distribution of values. The downside is the fact that the improvement depends on the square root of the number of equal-value components used, which means that big improvements require a lot of parts, and the method quickly gets unwieldy. Table 2.10 demonstrates how this works; the rate of improvement slows down noticeably as the number of parts increases. The largest number of components I have ever used in this way for a production design is five. Constructing a 0.1% resistance from 1% resistors would require a hundred of them and is hardly a practical proposition. It would cost a lot more than just buying a 0.1% resistor.

You may be wondering what happens if the series resistors used are *not* equal. If you are in search of a particular value, the method that gives the best resolution is to use one large resistor value and one small one to make up the total, as this gives a very large number of possible combinations. However, the accuracy of the final value is essentially no better than that of the large resistor. Two equal resistors, as we have just demonstrated, give a $\sqrt{2}$ improvement in accuracy, and near-equal resistors give almost as much, but the number of combinations is very limited, and you may not be able to get very near the value you want. The question is, how much improvement in accuracy

TABLE 2.9 Mean and standard deviation of five batches of 400
Gaussian 5 kΩ 1% resistors, four in series

Mean kΩ	Standard deviation
20.0008	0.1005
19.9956	0.0995
19.9917	0.1015
20.0032	0.1037
20.0020	0.0930

TABLE 2.10 The improvement in value tolerance with number of equal-value parts

Number of equal-value parts	Tolerance reduction factor
1	1.000
2	0.707
3	0.577
4	0.500
5	0.447
6	0.408
7	0.378
8	0.354
9	0.333
10	0.316

can we get with resistors that are some way from equal, such as one resistor being twice the size of the other?

The mathematical answer is very simple; even when the resistor values are not equal, the overall standard deviation is still the RMS sum of the standard deviations of the two resistors, as shown in Equation 2.2; σ_1 and σ_2 are the standard deviations of the two resistors in series or parallel. Note that this equation is only correct if there is no correlation between the two values; this is true for two separate resistors but would not hold for two film resistors on the same substrate.

Since both resistors have the same percentage tolerance, the larger of the two has the greater standard deviation, and dominates the total result. The minimum total deviation is thus achieved with equal resistor values. Table 2.11 shows how this works; using two resistors in the ratio 2:1 or 3:1 still gives a worthwhile improvement in average accuracy.

The entries for 19.5 k + 500 and 19.9 k + 100 demonstrate that when one large resistor value and one small one are used to get a particular value, its accuracy is little better than that of the large resistor alone.

Resistor accuracy: three resistor combinations

The relatively small number of combinations of E24 resistor values that can approximate a given value means that it is difficult to pursue good nominal accuracy and effective tolerance reduction simultaneously. This can be completely solved by using three E24 resistors in parallel; I call this the 3xE24 format. As with 2xE24, a parallel rather than series connection makes PCB tracking easier. Resistors are relatively cheap, and it can be highly economic to use three rather than two to approach very closely a few critical values. The extra PCB area required is modest. However the design process is significantly harder. I used the Willmann tables to design the 3xE24 combinations in this book; this process is fully described in Chapter 9, where it is particularly relevant. The Willmann tables can be downloaded free of charge from my website [12].

TABLE 2.11 The improvement in value tolerance with non-equal value parts

Series resistor values Ω	Resistor ratio	Standard deviation
20 k single		0.2000
19.9 k + 100	199:1	0.1990
19.5 k + 500	39:1	0.1951
19 k + 1 k	19:1	0.1903
18 k + 2 k	9:1	0.1811
16.7 k + 3.3 k	5:1	0.1700
16 k + 4 k	4:1	0.1649
15 k + 5 k	3:1	0.1581
13.33 k + 6.67 k	2:1	0.1491
12 k + 8 k	1.5:1	0.1442
11 k + 9 k	1.22:1	0.1421
10 k + 10 k	1:1	0.1414

Other resistor combinations

So far we have looked at serial and parallel combinations of components to make up one value, as in Figure 2.6a and 2.6b. Other important combinations are the resistive divider in Figure 2.6c (frequently used as the negative-feedback network for non-inverting amplifiers) and the inverting amplifier in Figure 2.6f where the gain is set by the ratio R2/R1. All resistors are assumed to have the same tolerance about an exact mean value.

I suggest it is not obvious whether the divider ratio of Figure 2.6c, which is R2/(R1 + R2), will be more or less accurate than the resistor tolerance, even in the simple case with R1 = R2. However, the Monte-Carlo method shows that in this case partial cancellation of errors still occurs and the division ratio is more accurate by a factor of $\sqrt{2}$.

Figure 2.6 Resistor combinations: a) series, b) parallel, c) one-tap divider, d) two-tap divider, e) three-tap divider, f) inverting amplifier.

This factor depends on the divider ratio, as a simple physical argument shows:

- If the top resistor R1 is zero, then the divider ratio is obviously one with complete accuracy, the resistor values are irrelevant, and the output voltage tolerance is zero.

- If the bottom resistor R2 is zero, there is no output, and accuracy is meaningless, but if instead R2 is very small compared with R1 then the R1 completely determines the current through R2, and R2 turns this into the output voltage. Therefore the tolerances of R1 and R2 act independently, and so the combined output voltage tolerance is *worse* by their RMS sum $\sqrt{2}$.

Some more Monte-Carlo work, with 8000 trials per data point, revealed that there is a linear relationship between accuracy and the 'tap position' of the output between R1 and R2, as shown in Figure 2.7. Plotting against division ratio would not give a straight line. With R1 = R2 the tap is at 50%, and accuracy improved by a factor of $\sqrt{2}$, as noted earlier. With a tap at about 30% (R1 = 7 kΩ, R2 = 3 kΩ) the accuracy is the same as the resistors used. This assessment is *not* applicable to potentiometers as the two sections of the pot are not uncorrelated.

The two-tap divider (Figure 2.6d) and three-tap divider (Figure 2.6e) were also given a Monte-Carlo-ing, though only for equal resistors. The two-tap divider has an accuracy factor of 0.404 at OUT 1 and 0.809 at OUT 2. These numbers are very close to $\sqrt{2}/(2\sqrt{3})$ and $\sqrt{2}/(\sqrt{3})$ respectively. The three-tap divider has an accuracy factor of 0.289 at OUT 1, 0.500 at OUT 2, and 0.864 at

Figure 2.7 The accuracy of the output of a resistive divider made up with components of the same tolerance varies with the divider ratio.

OUT 3. The middle figure is clearly 1/2 (twice as many resistors as a one-tap divider so $\sqrt{2}$ times more accurate), while the first and last numbers are very close to $\sqrt{3}/6$ and $\sqrt{3}/2$ respectively. It would be helpful if someone could prove analytically that the factors proposed are actually correct.

For the inverting amplifier of Figure 2.6f, the accuracy of the gain is always $\sqrt{2}$ worse than the tolerance of the two resistors, assuming the tolerances are equal. The nominal resistor values have no effect on this. We therefore have the interesting situation that a non-inverting amplifier will always be equally or more accurate in its gain than an inverting amplifier. So far as I know, this is a new result.

Resistor value distributions

At this point you may be complaining that this will only work if the resistor values have a Gaussian (also known as normal) distribution with the familiar peak around the mean (average) value. Actually, it is a happy fact this effect does *not* assume that the component values have a Gaussian distribution, as we shall see in a moment. An excellent account of how to handle statistical variations to enhance accuracy is in [13]. This deals with the addition of mechanical tolerances in optical instruments, but the principles are just the same.

You sometimes hear that this sort of thing is inherently flawed because, for example, 1% resistors are selected from production runs of 5% resistors. If you were using the 5% resistors, then you would find there was a hole in the middle of the distribution; if you were trying to select 1% resistors from them, you would be in for a very frustrating time as they have already been selected out, and you wouldn't find a single one. If instead you were using the 1% components obtained by selection from the complete 5% population, you would find that the distribution would be much flatter than Gaussian and the accuracy improvement obtained by combining them would be reduced, although there would still be a definite improvement.

However, don't worry. In general this is not the way that components are manufactured nowadays, though it may have been so in the past. A rare contemporary exception is the manufacture of carbon composition resistors [14] where making accurate values is difficult, and selection from production runs, typically with a 10% tolerance, is the only practical way to get more accurate values. Carbon composition resistors have no place in audio circuitry because of their large temperature and voltage coefficients and high excess noise, but they live on in specialised applications such as switch-mode snubbing circuits, where their ability to absorb high peak power in bulk material rather than a thin film is useful, and in RF circuitry where the inductance of spiral-format film resistors is unacceptable.

So, having laid that fear to rest, what is the actual distribution of resistor values like? It is not easy to find out, as manufacturers are not exactly forthcoming with this sort of sensitive information, and measuring thousands of resistors with an accurate Digital Volt Meter (DVM) is not a pastime that appeals to all of us. Any nugget of information in this area is therefore very welcome.

Hugo Kroeze [15] reported the result of measuring 211 metal film resistors from the same batch with a nominal value of 10 kΩ and 1% tolerance. He concluded that

1) The mean value was 9.995 kΩ (0.05% low).

2) The standard deviation was about 10 Ω, ie only 0.1%. This spread in value is surprisingly small (the resistors were all from the same batch, and the spread across batches widely separated in manufacture date might have been less impressive).

3) All resistors were within the 1% tolerance range.

4) The distribution appeared to be Gaussian, with no evidence that it was a subset from a larger distribution.

I decided to add my own morsel of data to this. I measured 100 ordinary metal film 1 kΩ resistors of 1% tolerance from Yageo, a Chinese manufacturer, and very tedious it was too. I used a recently-calibrated 4.5 digit meter.

1) The mean value was 997.66 Ohms (0.23% low).

2) The standard deviation was 2.10 Ohms, ie 0.21%.

3) All resistors were within the 1% tolerance range. All but one was within 0.5%, with the outlier at 0.7%.

4) The distribution appeared to be Gaussian, with no evidence that it was a subset from a larger distribution.

These are only two reports, and it would be nice to have more confirmation, but there seems to be no reason to doubt that the mean value is very well controlled, and the spread is under good control as well. The distribution of resistance values appears to be Gaussian with no evidence of the most accurate specimens being selected out. Whenever I have attempted this kind of statistical improvement in accuracy, I have always found that the expected benefit really does appear in practice.

The uniform distribution

As I mentioned earlier, improving average accuracy by combining resistors does not depend on the resistance value having a Gaussian distribution. Even a batch of resistors with a uniform distribution gives better accuracy when two of them are combined. A uniform distribution of component values may not be likely, but the result of combining two or more of them is highly instructive, so stick with me for a bit.

Figure 2.8a shows a uniform distribution that cuts off abruptly at the limits L and –L and represents 10 kΩ resistors of 1% tolerance. We will assume again that we want to make a more accurate 20 kΩ resistance. If we put two of the uniform distribution 10 kΩ resistors in series, we get not another uniform distribution but the triangular distribution shown in Figure 2.8b. This shows that the total resistance values are already starting to cluster in the centre; it is possible to have the extreme values of 19.8 kΩ and 20.2 kΩ, but it is very, very unlikely.

Figure 2.8c shows what happens if we use more resistors to make the final value; when four are used the distribution is already beginning to look like a Gaussian distribution, and as we increase the number of components to 8 and then 16, the resemblance becomes very close.

Figure 2.8 How a uniform distribution of values becomes a Gaussian (normal) distribution when more component values are summed (after Smith).

Uniform distributions have a standard deviation just as Gaussian ones do. It is calculated from the limits L and −L as in Equation 2.3. Likewise, the standard deviation of a triangular distribution can be calculated from its limits L and −L as in Equation 2.4.

$$\sigma = \frac{1}{\sqrt{3}} L \qquad\qquad \text{Equation 2.3}$$

$$\sigma = \frac{1}{\sqrt{6}} L \qquad\qquad \text{Equation 2.4}$$

Applying Equation 2.3 to the uniformly-distributed 10 kΩ 1% resistors in Figure 2.8a, we get a standard deviation of 0.0577.

Applying Equation 2.4 to the triangular distribution of 20 kΩ resistance values in Figure 2.8b, we get 0.0816. The mean value has doubled, but the standard deviation has less than doubled, so we get an improvement in average accuracy; the ratio is √2, just as it was for two resistors with a Gaussian distribution. This is also easy to demonstrate with Monte-Carlo methods on a spreadsheet.

Resistor imperfections

It is well-known that resistors have inductance and capacitance and vary somewhat in resistance with temperature. Unfortunately there are other less obvious imperfections, such as excess noise and non-linearity; these can get forgotten because parameters describing how bad they are can often omitted from component manufacturer's data sheets.

Being components in the real world, resistors are not perfect examples of resistance and nothing else. Their length is not infinitely small and so they have series inductance; this is particularly true for the many kinds that use a spiral resistive element. Likewise, they exhibit stray capacitance between each end and also between the various parts of the resistive element. Both effects can be significant at high frequencies but can usually be ignored below 100 kHz unless you are using very high or low-resistance values.

It is a sad fact that resistors change their value with temperature. Table 2.4 shows some typical temperature coefficients. This is not likely to be a problem in small-signal audio applications, where the temperature range is small and extreme precision is not required unless you are designing measurement equipment. Carbon film resistors are markedly inferior to metal film in this area.

Resistor excess noise

All resistors, no matter what their resistive material or mode of construction, generate Johnson noise. This is white noise, its level being determined solely by the resistance value, the absolute temperature, and the bandwidth over which the noise is being measured. It is based on fundamental physics and is not subject to negotiation. In some cases it places the limit on how quiet a circuit can be, though the noise from active devices is often more significant. Johnson noise is covered in Chapter 1.

Excess resistor noise refers to the fact that some kinds of resistors, with a constant voltage drop imposed across them, generate excess noise in addition to their inherent Johnson noise. According to classical physics, passing a current through a resistor should have no effect on its noise behaviour; it should generate the same Johnson noise as a resistor with no steady current flow. In reality, some types of resistors do generate excess noise when they have a DC voltage across them. It is a very variable quantity but is essentially proportional to the DC voltage across the component, a typical spec being "1 uV/V" and it has a 1/f frequency distribution. Typically it could be a problem in biasing networks at the input of amplifier stages. It is usually only of interest if you are using carbon or thick film resistors—metal film and wirewound types should have very little excess noise. 1/f noise does not have a Gaussian amplitude distribution, which makes it difficult to assess reliably from a small set of data points. A rough guide to the likely specs is given in Table 2.12.

TABLE 2.12 Resistor excess noise

Type	Noise uV/V
Metal film TH	0
Carbon film TH	0.2–3
Metal oxide TH	0.1–1
Thin film SM	0.05–0.4
Bulk metal foil TH	0.01
Wirewound TH	0

(Wirewound resistors are normally considered to be completely free of excess noise.)

The level of excess resistor noise changes with resistor type, size, and value in Ohms; the relevant factors follow.

 Thin film resistors are markedly quieter than thick film resistors; this is due to the homogeneous nature of thin film resistive materials, which are metal alloys such as nickel-chromium deposited on a substrate. The thick film resistive material is a mixture of metal (often ruthenium) oxides and glass particles; the glass is fused into a matrix for the metal particles by high temperature firing. The higher excess noise levels associated with thick film resistors are a consequence of their heterogeneous structure due to the particulate nature of the resistive material. The same applies to carbon film resistors where the resistive medium is finely-divided carbon dispersed in a polymer binder.

A physically large resistor has lower excess noise than a small resistor because there is more resistive material in parallel, so to speak. In the same resistor range, the highest wattage versions have the lowest noise. See Figure 2.9.

A low ohmic value resistor has lower excess noise than a high ohmic value. Noise in uV per V rises approximately with the square root of resistance. See Figure 2.9 again.

A low value of excess noise is associated with uniform constriction-free current flow; this condition is not well met in composite thick film materials. However, there are great variations among different thick film resistors. The most readily apparent relationship is between noise level and the amount of conductive material present. Everything else being equal, compositions with lower resistivity have lower noise levels.

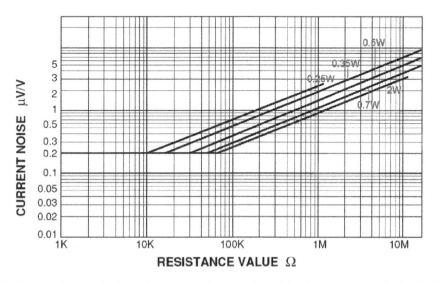

Figure 2.9 **The typical variation of excess resistor noise with ohmic value and physical size; this is for a range of carbon film resistors. The flat part of the plot represents the measurement floor, not a change in noise mechanism.**

Higher resistance values give higher excess noise since it is a statistical phenomenon related to the total number of charge carriers available within the resistive element; the fewer the total number of carriers present, the greater will be the statistical fluctuation.

Traditionally at this point in the discussion of excess resistor noise, the reader is warned against using carbon composition resistors because of their very bad excess noise characteristics. Carbon composition resistors are still made—their construction makes them good at handling pulse loads—but are not likely to be encountered in audio circuitry.

One of the great benefits of dual-rail opamp circuitry is that is noticeably free of resistors with large DC voltages across them. The offset voltages and bias currents are far too low to cause trouble with resistor excess noise. However, if you are getting into low-noise hybrid discrete/opamp stages, such as the MC head amplifier in Chapter 10, you might have to consider it.

To get a feel for the magnitude of excess resistor noise, consider a 100 kΩ 1/4W carbon film resistor with 10 V across it. This, from Figure 2.9, has an excess noise parameter of about 0.7 uV/V, and so the excess noise will be of the order of 7 uV, which is −101 dBu. This definitely could be a problem in a low-noise preamplifier stage.

Resistor non-linearity

Ohm's law is strictly a statement about metallic conductors only. It is dangerous to assume that it also invariably applies to 'resistors' simply because they have a fixed value of resistance marked on them; in fact resistors—whose main *raison d'etre* is packing a lot of controlled resistance in a small space—do not always adhere to Ohm's law very closely. This is a distinct difficulty when trying to make low-distortion circuitry.

Resistor non-linearity is normally quoted by manufacturers as a voltage coefficient, usually the number of parts per million (ppm) that the resistor value changes when one volt is applied. The measurement standard for resistor non-linearity is IEC 6040.

Through-hole metal film resistors show perfect linearity at the levels of performance considered here, as do wirewound types. The voltage coefficient is less than 1 ppm. Carbon film resistors are quoted at less than 100 ppm; 100 ppm is, however, enough to completely dominate the distortion produced by active devices if it is used in a critical part of the circuitry. Carbon composition resistors, probably of historical interest only, come in at about 350 ppm, a point that might be pondered by connoisseurs of antique equipment. The greatest area of concern over non-linearity is thick film surface-mount resistors, which have high and rather variable-voltage coefficients; more on this below.

Table 2.13 (calculated with SPICE) gives the THD in the current flowing through the resistor for various voltage coefficients when a pure sine voltage is applied. If the voltage coefficient is significant this can be a serious source of non-linearity.

A voltage coefficient model generates all the odd-order harmonics, at a decreasing level as order increases. No even-order harmonics occur as the model is symmetrical. This is covered in much more detail in my active crossover book [16].

TABLE 2.13 Resistor voltage coefficients and the resulting distortion at +15 and +20 dBu

Voltage	THD at	THD at
Coefficient	+15 dBu	+20 dBu
1 ppm	0.00011%	0.00019%
3 ppm	0.00032%	0.00056%
10 ppm	0.0016%	0.0019%
30 ppm	0.0032%	0.0056%
100 ppm	0.011%	0.019%
320 ppm	0.034%	0.060%
1000 ppm	0.11%	0.19%
3000 ppm	0.32%	0.58%

My own test setup is shown in Figure 2.10. The resistors are usually of equal value, to give 6 dB attenuation. A very low-distortion oscillator that can give a large output voltage is necessary; the results in Figure 2.11 were taken at a 10 Vrms (+22 dBu) input level. Here thick film SM and through-hole resistors are compared. The genmon trace at the bottom is the record of the analyser reading the oscillator output and is the measurement floor of the AP System 1 used. The THD plot is higher than this floor, but this is not due to distortion. It simply reflects the extra Johnson noise generated by two 10 kΩ resistors. Their parallel combination is 5 kΩ, and so this noise is at −115.2 dBu. The SM plot, however, is higher again, and the difference is the distortion generated by the thick film component.

For both thin film and thick film SM resistors non-linearity increases with resistor value and also increases as the physical size (and hence power rating) as the resistor shrinks. The thin film versions are much more linear; see Figures 2.12 and 2.13. Sometimes it is appropriate to reduce

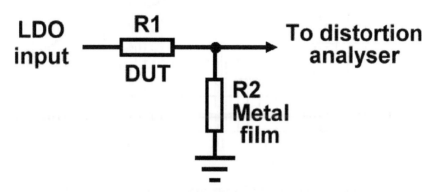

Figure 2.10 Test circuit for measuring resistor non-linearity. The not-under-test resistor R2 in the potential divider must be a metal film type with negligible voltage coefficient.

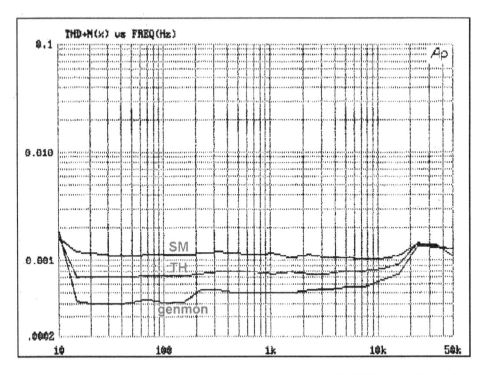

Figure 2.11 SM resistor distortion at 10 Vrms input, using 10 kΩ 0805 thick film resistors.

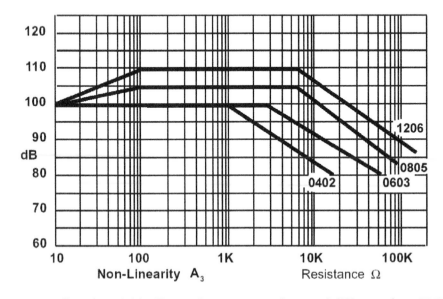

Figure 2.12 Non-linearity of thin film surface-mount resistors of different sizes. THD is in dB rather than percent.

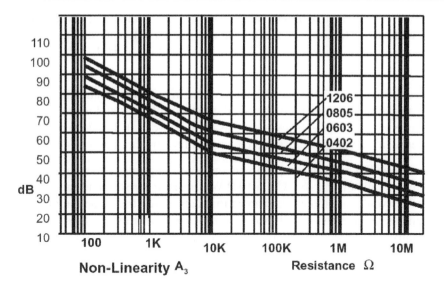

Figure 2.13 **Non-linearity of thick film surface-mount resistors of different sizes.**

the non-linearity by using multiple resistors in series. If one resistor is replaced by two with the same voltage coefficient in series, the THD in the current flowing is halved. Similarly, three resistors reduces THD to a third of the original value. There are obvious economic limits to this sort of thing, but it can be useful in specific cases, especially where the voltage rating of the resistor is a limitation.

Capacitors

Capacitors are diverse components. In the audio business their capacitance ranges from 10 pF to 100,000 uF, a ratio of ten to the tenth power. In this they handily out-do resistors, which usually vary from 0.1 Ω to 10 MΩ, a ratio of only ten to the eighth. However, if you include the 10 GΩ bias resistors used in capacitor microphone head amplifiers, this range increases to ten to the eleventh. There is, however, a big gap between the 10 MΩ resistors, which are used in DC servos, and 10 GΩ microphone resistors; I am not aware of any audio applications for 1 GΩ resistors.

Capacitors also come in a wide variety of types of dielectric, the great divide being between electrolytic and non-electrolytic types. Electrolytics used to have *much* wider tolerances than most components, but things have recently improved and ±20% is now common. This is still wider than for typical non-electrolytics which are usually ±10% or better.

This is not the place to reiterate the basic information about capacitor properties, which can be found from many sources. I will simply note that real capacitors fall short of the ideal circuit element in several ways, notably leakage, equivalent series resistance (ESR), dielectric absorption, and non-linearity.

Capacitor leakage is equivalent to a high value resistance across the capacitor terminals and allows a trickle of current to flow when a DC voltage is applied. It is usually negligible for non-electrolytics but is greater for electrolytics. It is still so low it is not likely to be a problem in audio electronics.

ESR is a measure of how much the component deviates from a mathematically pure capacitance. The series resistance is partly due to the physical resistance of leads and foils and partly due to losses in the dielectric. It can also be expressed as tan-δ (tan-delta). Tan-delta is the tangent of the phase angle between the voltage across and the current flowing through the capacitor.

Dielectric absorption is a well-known phenomenon: take a large electrolytic, charge it up, and then make sure it is fully discharged. Use a 10 Ω WW resistor across the terminals rather than a screwdriver unless you're not too worried about the screwdriver, the capacitor, or your eyesight. Wait a few minutes, and the charge will partially reappear, as if from nowhere. This 'memory effect' also occurs in non-electrolytics to a lesser degree; it is a property of the dielectric and is minimised by using polystyrene, polypropylene, NPO ceramic, or PTFE dielectrics. Dielectric absorption is invariably simulated by a linear model composed of extra resistors and capacitances; nevertheless dielectric absorption and distortion correlate across the different dielectrics.

Capacitor non-linearity is undoubtedly the least known of these shortcomings. A typical RC lowpass filter can be made with a series resistor and a shunt capacitor, and if you examine the output with a distortion analyser, you may find to your consternation that the circuit is not linear. If the capacitor is a non-electrolytic type with a dielectric such as polyester, then the distortion is relatively pure third harmonic, showing that the effect is symmetrical. For a 10 Vrms input, the THD level may be 0.001% or more. This may not sound like much, but it is substantially greater than the mid-band distortion of a good opamp. Capacitor non-linearity is dealt with at greater length later.

Capacitors are used in audio circuitry for three main functions, where their possible non-linearity has varying consequences:

1) Coupling or DC-blocking capacitors. These are usually electrolytics and, if properly sized, have a negligible signal voltage across them at the lowest frequencies of interest. The properties of the capacitor are pretty much unimportant unless current levels are high; power amplifier output capacitors can generate considerable mid-band distortion [17].

 Much nonsense has been talked about mysterious coupling capacitor properties, but it *is* all nonsense. For small-signal use, as long as the signal voltage across the capacitor is kept low, non-linearity is not normally detectable. The capacitance value is non-critical, as it has to be, given the wide tolerances of electrolytics.

2) Supply filtering or decoupling capacitors. These are electrolytics if you are filtering out supply rail ripple, etc, and non-electrolytics, usually around 100 nF, when the task is to keep the supply impedance low at high frequencies and so keep opamps stable. The capacitance value is again non-critical.

3) Setting time-constants, for example the capacitors in the feedback network of an RIAA amplifier. This is a much more demanding application than the other two. Firstly, the actual value is now crucially important as it defines the accuracy of the frequency response.

Secondly, there is by definition significant signal voltage across the capacitor, and so non-linearity can be a serious problem. Non-electrolytics are normally used; sometimes an electrolytic is used to define the lower end of the bandwidth, but this is a bad practice likely to introduce distortion at the bottom of the frequency range. Small value ceramic capacitors are used for compensation purposes.

In Subjectivist circles it is frequently asserted that electrolytic coupling capacitors (if they are permitted at all) should be bypassed by small non-electrolytics. There is no sense in this; if the main coupling capacitor has no signal voltage across it, the extra capacitor can have no effect.

Capacitor series

Capacitors are available in a much more limited range of values than resistors, often restricted to the E6 series, which runs 10, 15, 22, 33, 47, and 68. There are no values in that series that have an exact 2:1 ratio, which complicates the design of second-order lowpass active filters. If you can source capacitors in the E12 series, this gives much more freedom of design.

Capacitor non-linearity examined

When attempting the design of linear circuitry, everyone knows that inductors and transformers with ferromagnetic core material can be a source of non-linearity. It is, however, less obvious that capacitors and even resistors can show non-linearity and generate some unexpected and very unwelcome distortion. Resistor non-linearity has been dealt with earlier in this chapter; let us now examine the shortcomings of capacitors.

The definitive work on capacitor distortion is a magnificent series of articles by Cyril Bateman in *Electronics World* [18]. The authority of this work is underpinned by Cyril's background in capacitor manufacture (the series is long because it includes the development of a low-distortion THD test set in the first two parts).

Capacitors generate distortion when they are actually implementing a time-constant—in other words, when there is a signal voltage across them. The normal coupling or DC-blocking capacitors have no significant signal voltage across them, as they are intended to pass all the information through, not to filter it or define the system bandwidth. Capacitors with no signal across them do not generally produce distortion at small-signal current levels. This was confirmed for all the capacitors tested as shown later. However electrolytic types may do so at power amplifier levels where the current through them is considerable, such as in the output coupling capacitor of a power amplifier [19].

Non-electrolytic capacitor non-linearity

It has often been assumed that non-electrolytic capacitors, which generally approach an ideal component more closely than electrolytics and have dielectrics constructed in a totally different way, are free from distortion. It is not so. Some non-electrolytics show distortion at levels that are easily measured and can exceed the distortion from the opamps in the circuit. Non-electrolytic capacitor distortion is primarily third harmonic because the non-polarised dielectric technology is basically symmetrical. The problem is serious because non-electrolytic capacitors are commonly

used to define time-constants and frequency responses (in RIAA equalisation networks, for example) rather than simply for DC-blocking.

Very small capacitances present no great difficulty. Simply make sure you are using the COG (NP0) ceramic type, and so long as you choose a reputable supplier, there will be no distortion. I say "reputable supplier" because I did once encounter some allegedly COG capacitors from China that showed significant non-linearity [20].

Middle-range capacitors, from 1 nF to 1 uF, present more of a problem. Capacitors with a variety of dielectrics are available, including polyester, polystyrene, polypropylene, polycarbonate, and polyphenylene sulphide, of which the first three are the most common (note that what is commonly called "polyester" is actually polyethylene terephthalate, [PET]).

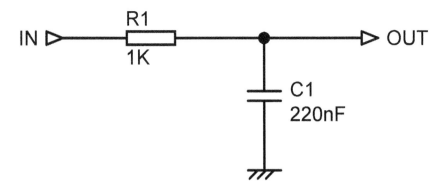

Figure 2.14 Simple lowpass test circuit for non-electrolytic capacitor distortion.

Figure 2.14 shows a simple lowpass filter circuit which, in conjunction with a good THD analyser, can be used to get some insight into the distortion problem; it is intended to be representative of a real bit of audio circuitry. The values shown give a pole frequency, or −3 dB roll-off point, at 710 Hz. Since it might be expected that different dielectrics give different results (and they definitely do), we will start off with polyester, the smallest, most economical, and therefore the most common type for capacitors of this size.

The THD results for a microbox 220 nF 100 V capacitor with a polyester dielectric are shown in Figure 2.15, for input voltages of 10, 15, and 20 Vrms. They are unsettling.

The distortion is all third-harmonic and peaks at around 300 to 400 Hz, well below the pole frequency, and even with input limited to 10 Vrms, it will exceed the non-linearity introduced by opamps such as the 5532 and the LM4562. Interestingly, the peak frequency changes with applied level. Below the peak, the voltage across the capacitor is constant, but distortion falls as frequency is reduced because the increasing impedance of the capacitor means it has less effect on a circuit node at a 1 kΩ impedance. Above the peak, distortion falls with increasing frequency because the lowpass circuit action causes the voltage across the capacitor to fall.

The level of distortion varies with different samples of the same type of capacitor; six of the aforementioned type were measured, and the THD at 10 Vrms and 400 Hz varied from 0.00128%

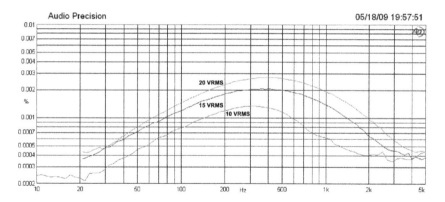

Figure 2.15 Third-harmonic distortion from a 220 nF 100 V polyester capacitor at 10, 15, and 20 Vrms input level, showing peaking around 400 Hz.

to 0.00206%. This puts paid to any plans for reducing the distortion by some sort of cancellation method. The distortion can be seen in Figure 2.15 to be a strong function of level, roughly tripling as the input level doubles. Third-harmonic distortion normally quadruples for doubled level, so there may well be an unanswered question here. It is, however, clear that reducing the voltage across the capacitor reduces the distortion. This suggests that if cost is not the primary consideration, it might be useful to put two capacitors in series to halve the voltage and the capacitance and then double up this series combination to restore the original capacitance, giving the series-parallel arrangement in Figure 2.16. The results are shown in Table 2.14, and once more it can be seen that halving the level has reduced distortion by a factor of three rather than four. The series-parallel arrangement obviously has limitations in terms of cost and PCB area occupied but might be useful in some cases.

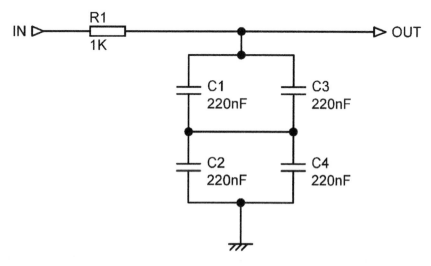

Figure 2.16 Reducing capacitor distortion by series-parallel connection.

TABLE 2.14 The reduction of polyester capacitor distortion by series-parallel connection

Input level Vrms	Single capacitor	Series-parallel capacitors
10	0.0016%	0.00048%
15	0.0023%	0.00098%
20	0.0034%	0.0013%

Clearly polyester gives significant distortion despite its extensive use in audio circuitry of all kinds.

An unexpected complication was that every time a sample was remeasured, the distortion was lower than before. I found a steady reduction in distortion over time if a test signal was left applied; 9 Vrms at 1 kHz halved the THD over 11 hours. This is a semi-permanent change as some of the distortion returns over time when the signal is removed. This effect may be of little practical use, but it does demonstrate that polyester capacitors are more complicated than they look. For much more on this see [21].

The next dielectric we will try is polystyrene. Capacitors with a polystyrene dielectric are extremely useful for some filtering and RIAA equalisation applications because they can be obtained at a 1% tolerance at up to 10 nF at a reasonable price. They can be obtained in larger sizes at an unreasonable or, at any rate, much higher price.

The distortion test results are shown in Figure 2.17 for a 4n7 2.5% capacitor; the series resistor R1 has been increased to 4.7 kΩ to keep the −3 dB point inside the audio band, and it is now at 7200 Hz. Note that the THD scale has been extended down to a subterranean 0.0001%, and if it was plotted on the same scale as Figure 2.15 it would be bumping along the bottom of the graph. Figure 2.17, in fact, shows no distortion at all, just the measurement noise floor, and the apparent rise at the HF end is simply due to the fact that the output level is decreasing because of the

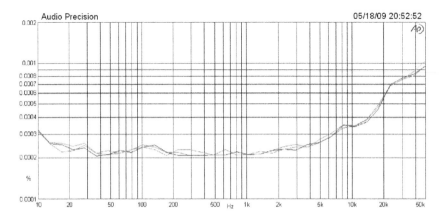

Figure 2.17 The THD plot with three samples of 4n7 2.5% polystyrene capacitors, at 10 Vrms input level. The reading is entirely noise.

lowpass action, and so the noise floor is relatively increasing. This is at an input level of 10 Vrms, which is about as high as might be expected to occur in normal opamp circuitry. The test was repeated at 20 Vrms, which might be encountered in discrete circuitry, and the results were the same—no measurable distortion.

The tests were done with four samples of 10 nF 1% polystyrene from LCR at 10 Vrms and 20 Vrms with the same results for each sample. This shows that polystyrene capacitors can be used with confidence; this is in complete agreement with Cyril Bateman's findings [22].

Having settled the issue of capacitor distortion below 10 nF, we need now to tackle capacitor values greater than 10 nF. Polyester having proven unsatisfactory, the next most common dielectric is polypropylene, and I might as well say at once that it was with considerable relief that I found these were effectively distortion-free in values up to 220 nF. Figure 2.18 shows the results for four samples of a 220 nF 250 V 5% polypropylene capacitor from RIFA. Once more the plot shows no distortion at all, just the noise floor; the apparent rise at the HF end is increasing relative noise due to the lowpass roll-off. This is also in agreement with Cyril Bateman's findings. Rerunning the tests at 20 Vrms gave the same result—no distortion. This is very pleasing, but there is a downside. Polypropylene capacitors of this value and voltage rating are physically much larger than the commonly used 63 or 100 V polyester capacitor and more expensive.

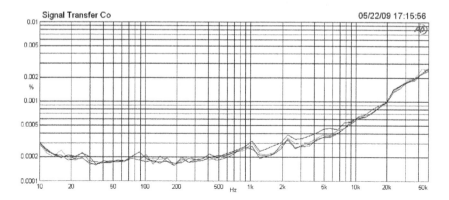

Figure 2.18 **The THD plot with four samples of 220 nF 250 V 5% polypropylene capacitors at 10 Vrms input level. The reading is again entirely noise.**

It was, therefore, important to find out if the good distortion performance was a result of the 250 V rating, and so I tested a series of polypropylene capacitors with lower voltage ratings from different manufacturers. Axial 47nF 160 V 5% polypropylene capacitors from Vishay proved to be THD-free at both 10 Vrms and 20 Vrms. Likewise, microbox polypropylene capacitors from 10 nF to 47 nF, with ratings of 63 V and 160 V from Vishay and Wima proved to generate no measurable distortion, so the voltage rating appears not to be an issue. This finding is particularly important because the Vishay range has a 1% tolerance, making them very suitable for precision filters and equalisation networks. The 1% tolerance is naturally reflected in the price.

The only remaining issue with polypropylene capacitors is that the higher values (above 100 nF) appear to be currently only available with 250 V or 400 V ratings, and that means a physically big component. For example, the EPCOS 330 nF 400 V 5% part has a footprint of 26 mm by 6.5 mm with a height of 15 mm. One way of dealing with this is to use a smaller capacitor in a capacitance multiplication configuration, so a 100 nF 1% component could be made to emulate 470 nF. It has to be said that the circuitry for this is only straightforward if one end of the capacitor is connected to ground.

When I first started looking at capacitor distortion, I thought that the distortion would probably be lowest for the capacitors with the highest voltage rating. I therefore tested some RF-suppression X2 capacitors, rated at 275 Vrms, which translates into a peak or DC rating of 389 V. These are designed to be connected directly across the mains and therefore have a thick and tough dielectric layer. For some reason manufacturers seem to be very coy about saying exactly what the dielectric material is, normally describing them simply as "film capacitors." A problem that surfaced immediately is that the tolerance is 10 or 20%, not exactly ideal for precision filtering or equalisation. A more serious problem, however, is that they are far from distortion-free. Four samples of a 470 nF X2 capacitor showed THD between 0.002% and 0.003% at 10 Vrms. Clearly a high voltage rating alone does not mean low distortion.

Electrolytic capacitor non-linearity

Cyril Bateman's series in *Electronics World* [22] included two articles on electrolytic capacitor distortion. It proved to be a complex subject, and many long-held assumptions (such as 'DC biasing always reduces distortion') were shown to be quite wrong. Distortion was in general a good deal higher than for non-electrolytic capacitors.

My view is that electrolytics should never, ever, under any circumstances be used to set time-constants in audio. There should be a time-constant early in the signal path, based on a non-electrolytic capacitor, that determines the lower limit of the bandwidth, and all the electrolytic-based time-constants should be much longer so that the electrolytic capacitors can never have significant signal voltages across them and so never generate measurable distortion. There is, of

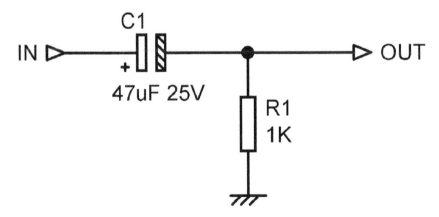

Figure 2.19 Highpass test circuit for examining electrolytic capacitor distortion.

course, also the point that electrolytics have large tolerances and cannot be used to set accurate time-constants anyway.

However, even if you obey this rule, you can still get into deep trouble. Figure 2.19 shows a simple highpass test circuit designed to represent an electrolytic capacitor in use for coupling or DC-blocking. The load of 1 kΩ is the sort of value that can easily be encountered if you are using low-impedance design principles. The calculated −3 dB roll-off point is 3.38 Hz, so the attenuation at 10 Hz, at the very bottom of the audio band, will be only 0.47 dB; at 20 Hz it will be only 0.12 dB, which is surely a negligible loss. As far as frequency response goes, we are doing fine. But . . . examine Figure 2.20, which shows the measured distortion of this arrangement. Even if we limit ourselves to a 10 Vrms level, the distortion at 50 Hz is 0.001%, already above that of a good opamp. At 20 Hz it has risen to 0.01%, and by 10 Hz it has a most unwelcome 0.05%. The THD is increasing by a ratio of 4.8 times for each octave fall in frequency, in other words increasing faster than a square-law. The distortion residual is visually a mixture of second and third harmonic, and the levels proved surprisingly consistent for a large number of 47 uF 25 V capacitors of different ages and from different manufacturers.

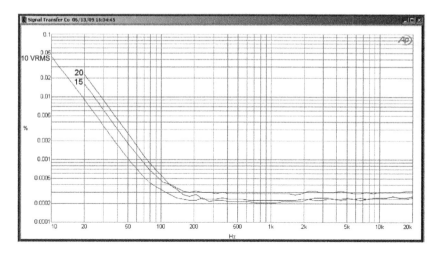

Figure 2.20 Electrolytic capacitor distortion from the circuit in Figure 2.18. Input level 10, 15, and 20 Vrms.

Figure 2.20 also shows that the distortion rises rapidly with level; at 50 Hz going from an input of 10 Vrms to 15 Vrms almost doubles the THD reading. To underline the point, consider Figure 2.21, which shows the measured frequency response of the circuit with 47uF and 1 kΩ; note the effect of the capacitor tolerance on the real versus calculated figures. The roll-off that does the damage, by allowing an AC voltage to exist across the capacitor, is very modest indeed, less than 0.2 dB at 20 Hz.

Having demonstrated how insidious this problem is, how do we fix it? Changing capacitor manufacturer is no help. Using 47 uF capacitors of higher voltage does not work—tests showed

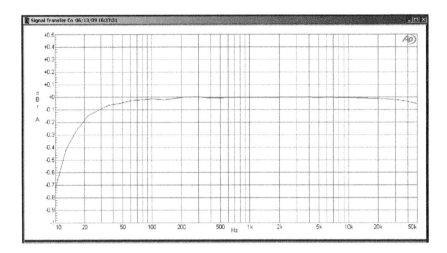

Figure 2.21 **The measured roll-off of the highpass test circuit for examining electrolytic capacitor distortion.**

there is very little difference in the amount of distortion generated. An exception was the sub-miniature style of electrolytic, which was markedly worse.

The answer is simple—just make the capacitor bigger in value. This reduces the voltage across it in the audio band, and since we have shown that the distortion is a strong function of the voltage across the capacitor, the amount produced drops more than proportionally. The result is seen in Figure 2.22, for increasing capacitor values with a 10 Vrms input.

Replacing C1 with a 100 uF 25 V capacitor drops the distortion at 20 Hz from 0.0080% to 0.0017%, an improvement of 4.7 times; the voltage across the capacitor at 20 Hz has been

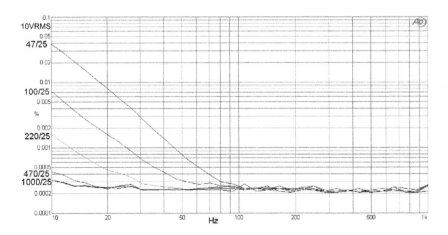

Figure 2.22 **Reducing electrolytic capacitor distortion by increasing the capacitor value. Input 10 Vrms.**

reduced from 1.66 Vrms to 790 mVrms. A 220 uF 25 V capacitor reduces the voltage across itself to 360 mV and gives another very welcome reduction to 0.0005% at 20 Hz, but it is necessary to go to 1000 uF 25 V to obtain the bottom trace, which is indistinguishable from the noise floor of the AP-2702 test system. The voltage across the capacitor at 20 Hz is now only 80 mV. From this data, it appears that the AC voltage across an electrolytic capacitor should be limited to below 80 mVrms if you want to avoid distortion. I would emphasise that these are ordinary 85°C rated electrolytic capacitors and in no sense special or premium types.

This technique can be seen to be highly effective, but it naturally calls for larger and somewhat more expensive capacitors and larger footprints on a PCB. This can be to some extent countered by using capacitors of lower voltage, which helps to bring back down the CV product and hence the can size. I tested 1000 uF 16 V and 1000 uF 6 V3 capacitors, and both types gave exactly the same results as the 1000 uF 25 V part in Figure 2.21 with useful reductions in CV product and can size. This does, of course, assume that the capacitor is, as is usual, being used to block small voltages from opamp offsets to prevent switch clicks and pot noises rather than for stopping a substantial DC voltage. More recent tests with capacitors from 10 to 220 uF suggests that there is in fact some correlation between higher rated voltage and lower distortion for these values at least.

The use of large coupling capacitors in this way does require a little care because we are introducing a long time-constant into the circuit. Most opamp circuitry is pretty much free of big DC voltages, but if there are any, the settling time after switch-on may become undesirably long.

More information on capacitor distortion in specific applications can be found in Chapter 19.

Capacitor microphony

It is a concern to some that audio quality may be impaired by microphony in the electronics, in other words the electronic components are in some way sensitive to mechanical vibration resulting from the ambient sound. This is plausible in valve circuitry, where the valve electrodes are thin and flexible. It is not plausible as affecting sound in semiconductors or most passive components; an exception may be those interleaved-plate variable capacitors for RF, but they don't show up in audio circuitry.

To get a feeling for this, take a microphone preamplifier, like those in Chapter 17. Set it to +80 dB gain and short the input. Connect the output to an amplifier and speaker. Now take a pencil and give one of the microphone preamplifier input capacitors a sharp tap; you will hear a dull thud from the speaker. This does not happen with the other components in the circuit. It is the only case of microphony I have ever encountered and is quite artificial. I think it demonstrates that normally microphony is not a problem.

Inductors

For several reasons, inductors are unpopular with circuit designers. They are relatively expensive, often because they need to be custom-made. Unless they are air-cored (which limits their inductance to low values) the core material is a likely source of non-linearity. Some types produce substantial external magnetic fields, which can cause crosstalk if they are placed close together,

and similarly they can be subject to the induction of interference from other external fields. In general they deviate from being an ideal circuit element much more than resistors or capacitors.

It is rarely, if ever, essential to use inductors in signal processing circuitry. Historically they were used in tone controls, before the Baxandall configuration swept all before it, and their last applications were probably in mid EQ controls for mixing consoles and in LCR filters for graphic equalisers. These too were gone by the end of the Seventies, being replaced by active filters and gyrators, to the considerable relief of all concerned (except inductor manufacturers).

The only place where inductors are essential is when the need for galvanic isolation, or enhanced EMC immunity, makes input and output transformers desirable, and even then they need careful handling; see Chapters 18 and 19 on line-in and line-out circuitry.

References

[1] Self, D. "Ultra-Low-Noise Amplifiers & Granularity Distortion." *JAES*, Nov 1987, pp. 907–915

[2] Michael Renardsen. www.angelfire.com/ab3/mjramp/wire.html Accessed Oct 2013

[3] Borwick, J., ed. *Loudspeaker and Headphone Handbook*, 2nd edition. Focal Press, 1994, pp. 246–247. ISBN 0 240 51371 1

[4] https://en.wikipedia.org/wiki/Tin Accessed July 2022

[5] https://en.wikipedia.org/wiki/Solder Accessed July 2022

[6] https://en.wikipedia.org/wiki/Whisker_(metallurgy) Accessed July 2022

[7] https://en.wikipedia.org/wiki/Tin_pest Accessed July 2022

[8] www.7pcbassembly.com/files/pcb-specifications.pdf Accessed Apr 2022

[9] Sanmina Co. www.sanmina.com/contract-manufacturing-design/printed-circuit-boards/technology/ Accessed June 2019

[10] https://en.wikipedia.org/wiki/Liquid_resistor Accessed July 2022

[11] Wikipedia. http://en.wikipedia.org/wiki/Monte_Carlo_method Accessed Oct 2013

[12] Self, D. www.douglas-self.com/ampins/Willmann/Willmann.htm Accessed Aug 2019

[13] Smith, Warren J. *Modern Optical Engineering*. McGraw-Hill, 1990, p. 484. ISBN0-07-059174-1

[14] Howard Johnson. www.edn.com/article/509250-7_solution.php Accessed Oct 2013

[15] Hugo Kroeze. www.rfglobalnet.com/forums/Default.aspx?g=posts&m=61096 Accessed Mar 2002

[16] Self, D. *The Design of Active Crossovers*. Newnes, 2018

[17] Self, D. *Audio Power Amplifier Handbook*, 5th edition. Newnes, 1996, p. 43

[18] Bateman, C. *Capacitor Sound*? Parts 1–6. Electronics World, July 2002–Mar 2003

[19] Self, D. *Audio Power Amplifier Design*, 6th edition. Newnes, 2013, p. 299. ISBN 978-0-240-52613-3

[20] Self, D. "Self-Improvement for Capacitors." *Linear Audio*, Vol. 1, Apr 2011, p. 156. ISBN 9-789490-929022

[21] Bateman, C. *Capacitor Sound?* Part 3. Electronics World, Oct 2002, p. 16, 18

[22] Bateman, C. *Capacitor Sound*? Part 4. Electronics World, Nov 2002, p. 47

Discrete transistor circuitry

This chapter deals with small-signal design using discrete transistors, mostly BJTs. JFET circuitry is briefly looked at to show why FETs are not a good idea unless you need a really high input impedance for a guitar input or a capacitor microphone. Many things found in standard textbooks are skated over quickly. This chapter concentrates on audio issues and gives information that I do not think appears anywhere else, including the distortion behaviour of various configurations.

Why use discrete transistor circuitry?

Circuitry made with discrete transistors is not obsolete. It is appropriate when

1) A load must be driven to higher voltages than an opamp can sustain between the supply rails. Opamps are mostly restricted to supply voltages of +/−18 or +/−20 Volts. Hybrid-construction amplifiers, typically packaged in TO3 cans, will operate from rails as high as +/−100 V, but they are very expensive and not optimised for audio use in parameters like crossover distortion. Discrete circuitry provides a viable alternative, but it must never be forgotten that excessive output signal levels may damage opamp equipment. Hifi is very rarely equipped with input voltage protection.

2) A load requires more drive current because of its low impedance than an opamp can provide without overheating or current limiting; eg any audio power amplifier.

3) The best possible noise performance is required. Discrete bipolar transistors can outperform opamps, particularly with low source resistances, say 500 Ω or less. The commonest examples are moving-coil head amps and microphone preamplifiers. These almost invariably use a discrete input device or devices, with the open-loop gain (for linearity) and load-driving capability provided by an opamp which may itself have fairly humble noise specs.

4) The best possible distortion performance is demanded. Most opamps have Class-B or AB output stages, and many of them (though certainly not all) show clear crossover artefacts on the distortion residual. A discrete opamp can dissipate more power than an IC and so can have a Class-A output stage, sidestepping the crossover problem completely.

5) When it would be necessary to provide a low-voltage supply to run just one or two opamps. The cost of extra transformer windings, rectifiers, reservoirs, and regulators will buy a lot of discrete transistors. For example, if you need a buffer stage to drive a power amplifier from a low impedance, it may be more economical and save space and weight to use a discrete

DOI: 10.4324/9781003332985-3

emitter-follower running from the same rails as the power amplifier. In these days of auto-insertion, fitting the extra parts on the PCB will cost very little.

6) Purely for marketing purposes, as you think you can mine a vein of customers that don't trust opamps.

7) At the time of writing (2022), the supply chains of electronic components are very much disrupted. One attraction of discrete BJT circuitry is that, to a large extent, a BJT is a BJT is a BJT (thank you, Gertrude Stein) for most small-signal devices, and so there is an immense flexibility in what parts you can use.

When studying the higher reaches of discrete design, the most fruitful source of information is paradoxically papers on analogue IC design. This applies with particular force to design with BJTs. The circuitry used in ICs can rarely be directly adapted for use with discrete semiconductors because some features such as multiple collector transistors and differing emitter areas simply do not exist in the discrete transistor world; it is the basic principles of circuit operation that can be useful. A good example is a paper by Erdi, dealing with a unity-gain buffer with a slew rate of 300 V/us [1]. Another highly informative discourse is by Barry Hilton [2], which also deals with a unity-gain buffer.

A little caution is required when a discrete stage may be driving not another of its own kind on the same supply rail, but opamp-based circuitry that is likely to be running off no more than ±18 V, as peak signal levels may drive the opamp inputs outside their rail voltages and cause damage. This normally only applies to discrete output stages but should be kept in mind whenever the supply rail is higher than +36 V for single rail and ±18 V for dual rail.

Bipolars and FETs

This chapter deals mainly with bipolar transistors. Their high transconductance and predictable operation make them far more versatile than FETs. The highly variable Vgs of a FET can be dealt with by expedients such as current-source biasing, but the low transconductance, which means low feedback and poor linearity, remains a problem. FETs have their uses when super-high input impedances are required, and an example of a JFET working with an opamp that provides loop gain can be found in Chapter 17 on microphone amplifiers.

Bipolar junction transistors

There is one thing to get straight first:

THE BIPOLAR JUNCTION TRANSISTOR IS A VOLTAGE-OPERATED DEVICE.

What counts is the base-emitter voltage, or V_{be}. Certainly a BJT needs base current to flow for it to operate, but this is really an annoying imperfection rather than the basis of operation. I appreciate this may take some digesting; far too many discussions of transistor action say something like "a small current flowing into the base controls a much larger current flowing into the collector." In fact the only truly current-operated amplifying device that comes to mind is the Hall-effect multiplier, and you don't come across those every day. I've certainly never seen one used in audio—could be a market niche there.

Transistor operation is thus: if the base is open-circuit, then no collector current flows, as the collector-base junction is effectively a reverse-biased diode, as seen in Figure 3.1. There is a little leakage through from the collector to the emitter, but with modern silicon BJTs you can usually ignore it.

When the base is forward biased by taking it about 600 mV above the emitter, charge carriers are launched into the base region. Since the base region is narrow, the vast majority shoot through into the collector to form the collector current I_c. Only a small proportion of these carriers are snared in the base and become the base current I_b, which is clearly a result and not the cause of the base-emitter voltage. I_b is normally just a nuisance.

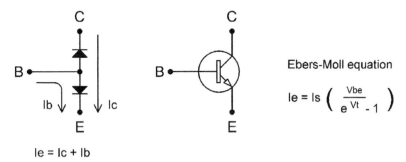

$$I_e = I_c + I_b$$

Ebers-Moll equation

$$I_e = I_s \left(e^{\frac{V_{be}}{V_t}} - 1 \right)$$

I_s is the reverse saturation current of the base-emitter diode (of the order of 10^{-15} to 10^{-12} Amp)

V_{be} is the base-emitter voltage

V_t is the thermal voltage kT/q (approx 26 mV at 25C room temperature).

k is Boltsmann's constant 1.381×10^{-23} Joule/K
T is absolute temperature in K
q is the electron charge 1.6022×10^{-19} Coulomb

Figure 3.1 Current flow through a bipolar transistor and the fundamental transistor equation.

The transistor equation

Every bipolar transistor obeys the Ebers-Moll transistor equation shown in Figure 3.1 with startling accuracy over nine or ten decades of I_c, which is a pretty broad hint that we are looking at the fundamental mechanism. In contrast, beta varies with I_c, temperature, and just about everything else you can think of. The collector current is to a first approximation independent of collector voltage—in other words it is a current-source output. The qualifications to this are

1) This only holds for Vce above, say, 2 V; this value depends on the device type and is higher for high-voltage BJTs like the MPSA42/92.

2) It is not a perfect current-source; even with a high Vce, I_c increases slowly with Vce. This is called the Early Effect, after Jim Early [3], and has nothing to do with timing or punctuality. It is a major consideration in the design of stages with high voltage gain. The same effect when the transistor is operated in reverse mode—a perversion that will not concern us here—has sometimes been called the Late Effect. Ho-ho.

Transconductance

Transconductance is the raw gain of the transistor, telling how much you need to change V_{be} to get a given change in I_c. It may be quoted in mA/V, or milliSiemens (mS), which is the same thing; mA/V is clearer. The transconductance can be derived from the aforementioned transistor equation by differentiating, and the result is

$$g_m = I_c/Vt = 38.46 \cdot I_c \qquad \text{which is approx} \qquad g_m = 40 \cdot I_c \qquad \text{Equation 3.1}$$

which is therefore equally accurate over nine or ten decades of I_c. Vt is the thermal voltage described in Figure 3.1. This delightfully simple equation tells us that for any BJT an I_c of 1 mA gives a g_m of 38.46 mA/V (or mS). Compare the 2N3819 JFET, which has a minimum g_m of 2 mA/V and a maximum g_m of 6.5 mA/V, and it's clear the BJT gives you a lot more gain to play with, meaning more negative feedback and so less distortion.

Beta

Beta (or h_{fe}) is the ratio of the base current I_b to the collector current I_c. It is not a fundamental property of a BJT. Never design circuits that depend on beta, unless of course you're making a transistor tester.

Here are some of the factors that affect beta. This should convince you that it is a shifty and thoroughly untrustworthy parameter:

- Beta varies with I_c. First it rises as I_c increases, reaching a broad peak, then it falls off as I_c continues to increase.

- Beta increases with temperature. This seems to be relatively little-known. Most things, like leakage currents, get worse as temperature increases, so this makes a nice change.

- Beta is lower for high-current transistor types.

- Beta is lower for high Vceo transistor types. This is a major consideration when you are designing the small-signal stages of power amplifiers with high supply rails.

- Beta varies widely between nominally identical examples of the same transistor type.

A very good refutation of the beta-centric view of BJTs is given by Barrie Gilbert in [4].

Unity-gain buffer stages

A buffer stage is used to isolate two portions of circuitry from each other. It has a high input impedance and low output impedance; typically it prevents things downstream from loading things upstream. The use of the word 'buffer' normally implies 'unity-gain buffer' because otherwise we would be talking about an amplifier or gain stage. The gain with the simpler discrete implementations is, in fact, slightly less than one. The simplest discrete buffer circuit block is the one-transistor emitter-follower; it is less than ideal both in its mediocre linearity

and its asymmetrical load-driving capabilities. If we permit ourselves another transistor, the Complementary-Feedback Pair (CFP) configuration gives better linearity. Both versions can have their load-driving performance much improved by replacing the emitter resistor with a constant-current source or a push-pull Class-A output arrangement.

If the CFP stage is not sufficiently linear, the next stage in sophistication is to combine an input differential pair with an output emitter-follower, using three transistors. This arrangement, often called the Schlotzaur configuration [5], can be elaborated until it gives a truly excellent distortion performance. Its load-driving capability can be enhanced in the same way as the simpler configurations.

The simple emitter-follower

The simplest discrete circuit block is the one-transistor emitter-follower (EF) This count of one does not include extra transistors used as current-sources, etc, to improve load-driving ability. It does not have a gain of exact unity, but it is usually pretty close. It is often called the common-collector configuration as the collector is connected to the supply rail, which is the same as ground so far as AC is concerned.

Figure 3.2 shows a simple emitter-follower with a 2k7 emitter resistor Re, giving a quiescent current of 8.8 mA with ±24 V supply rails. Biasing is by a high-value resistor R1 connected to 0 V. Note the polarity of the output capacitor; the output will sit at about −0.6 V due to the V_{be} drop, plus a little lower due to the voltage drop caused by the base current I_b flowing through R1.

The input impedance is approximately that of the emitter resistor in parallel with an external loading on the stage multiplied by the transistor beta:

$$\text{Rin} = \beta(\text{Re}\|\text{Rload}) \qquad\qquad \text{Equation 3.2}$$

Don't expect the output impedance to be as low as a opamp with plenty of NFB. The output impedance is approximately that of the source resistance divided by beta:

$$\text{Rout} = \text{Rs}/(\text{beta}) \qquad\qquad \text{Equation 3.3}$$

where Rs is the source impedance.

The gain of an emitter-follower is always slightly less than unity, because of the finite transconductance of the transistor. Essentially the intrinsic emitter resistance r_e (not be confused with the physical component Re) forms a potential divider with the output load. It is simple to work out the small-signal gain at a given operating point. The value of r_e is given by $25/I_c$ (for I_c in mA) Since the value of r_e is inversely proportional to I_c, it varies with large signals, and it is one cause of the rather imperfect linearity of the simple emitter-follower. Heavier external loading increases the modulation of I_c, increases the gain variation, and so increases distortion.

Figure 3.2 shows the emitter-follower with an AC-coupled load. Its load-driving capability is not very good. While the transistor can, within limits, source as much current as required into the load, the current-sinking ability is limited by the emitter resistor R2, which forms a potential

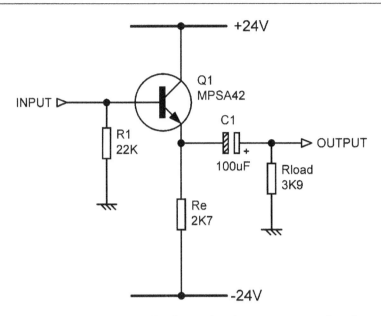

Figure 3.2 **The simple emitter-follower circuit running from ±24 V supply rails.**

divider with the load resistance Rload. With the values shown here, negative clipping occurs at about -10 V, severely limiting the maximum output amplitude. The circuit shows a high-voltage low-beta transistor type running from ±24 V rails, to give worst-case performance results and to exploit the ability of discrete circuitry to run from high-voltage rails.

The simple emitter-follower has several factors that affect its distortion performance:

- Distortion is reduced as the emitter resistor is reduced, for a given load impedance.

- Distortion is reduced as the DC bias level is raised above the mid-point.

- Distortion increases as the load impedance is reduced.

- Distortion increases monotonically with output level.

- Distortion does NOT vary with the beta of the transistor. This statement assumes low-impedance drive, which may not be the case for an emitter-follower used as a buffer. If the source impedance is significant then beta is likely to have a complicated effect on linearity—and not always for the worse.

Emitter-follower distortion is mainly second harmonic, except when closely approaching clipping. This is entirely predictable, as the circuit is asymmetrical. Only symmetrical configurations, such as the differential pair, restrict themselves to generating just odd harmonics and then only when they are carefully balanced [6]. Symmetry is often praised as desirable in an audio circuit, but this is subject to Gershwin's law: "It ain't necessarily so." Linearity is what we want in a circuit, and symmetry is not necessarily the best way to get it. The classic is example the audio power amplifier, where the best results are delivered by distinctly single-ended circuits; balanced configurations may look elegant on paper but in reality have some debilitating drawbacks.

Because the distortion is mostly second harmonic, its level is proportional to amplitude, as seen in Figure 3.3. At 2 Vrms with no load it is about 0.006%, rising to 0.013% at 4 Vrms. External loading always makes the distortion worse and more rapidly as the amplitude approaches the clipping point; the THD is more than doubled from 0.021% to 0.050% at 6 Vrms, just by adding a light 6k8 load. For these tests Re was 2k7, as in Figure 3.2. For both the EF and CFP circuits, distortion is flat across the audio band so no THD/frequency plots are given.

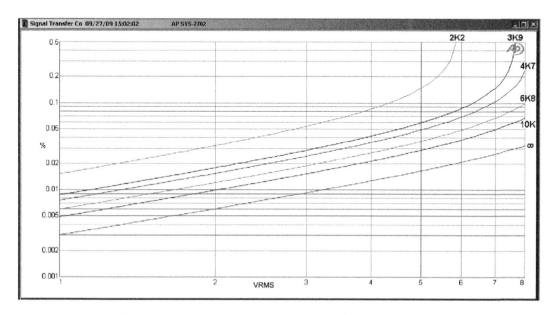

Figure 3.3 How various external loads degrade the linearity of the simple emitter-follower. Re = 2k7.

Insight into what's happening can be gained by using SPICE to plot the incremental gain over the output swing, as in Figure 3.4. As loading increases, the curvature of the gain characteristic becomes greater for a given voltage swing. It is obvious that the circuit is much more linear on the positive side of 0 V, explaining why emitter-followers give less distortion when biased above the mid-point. This trick can be very useful if the full output swing is not required.

Most amplifier stages are biased so the quiescent output voltage is at the mid-point of the operating region to allow the maximum symmetrical voltage swing. However, the asymmetry of the simple emitter-follower's output current-capability means that if there is significant loading, a greater symmetrical output swing is often possible if the stage is biased positive of 0 V.

If the output is loaded with 2k2, negative clipping occurs at −8 V, which allows a maximum output amplitude of only 5.6 Vrms. The unloaded output capability is about 12 Vrms. If the bias point is raised from 0V to +5 V, the output capability becomes roughly symmetrical, and the maximum loaded output amplitude is increased to 9.2 Vrms. Don't forget to turn the output capacitor around.

The measured noise output of this stage with a 40 Ω source resistance is a commendably low −122.7 dBu (22–22 kHz) but with a base-stopper resistor (see the "Emitter-follower stability" section) of 1 kΩ this degrades to −116.9 dBu. A higher stopper of 2k7 gives −110.4 dBu.

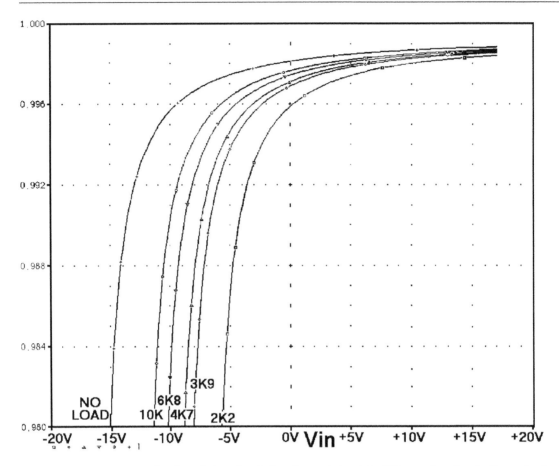

Figure 3.4 Incremental gain of the circuit in Figure 3.2 with different loads. A distortionless circuit would have constant gain and so give a horizontal lines. SPICE simulation.

The constant-current emitter-follower

The simple emitter-follower can be greatly improved by replacing the sink resistor Re with a constant-current source, as shown in Figure 3.5. The voltage across a current-source does not (to a good approximation) affect the current through it, so if the sink current is large enough a load can be driven to the full voltage swing in both directions.

The current source Q2 is biased by D1, D2, with the 22 kΩ resistor R3 powering the diodes. One diode cancels the V_{be} drop of Q2, while the other sets up 0.6 V across the 100 Ω resistor R2, establishing the quiescent current at 6 mA. This simple bias system works quite adequately if the supply rails are regulated but might require filtering if they are not. The 22 kΩ value is non-critical; so long as the diode current exceeds the I_b of Q2 by a reasonable factor (say ten times) there will be no problem.

Figure 3.6 shows that distortion is much reduced. With no external load, the 0.013% of the simple emitter-follower (at 4 Vrms) has become less than 0.0003%, the measurement system noise floor. This is because the amount by which the Q1 collector current is modulated is

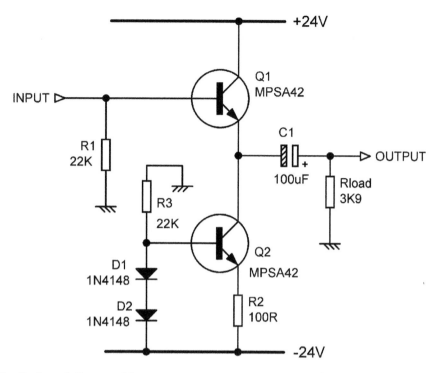

Figure 3.5 Emitter-follower with a constant-current source replacing the emitter resistor.

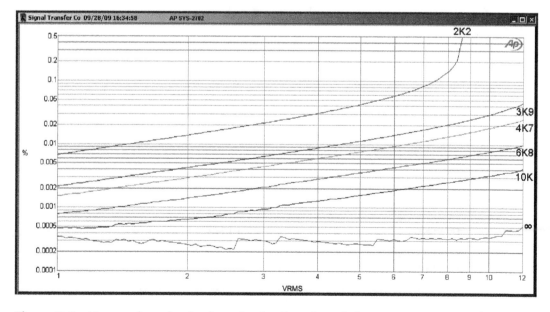

Figure 3.6 How various loads degrade the linearity of the current-source emitter-follower. Quiescent current 6 mA. Note X-axis scale change compared with Figure 3.3.

very much less. The linearity of this emitter-follower is still degraded by increasing loading but to a much lesser extent; with a significant external load of 4k7, the 0.036% of the simple emitter-follower (at 4 Vrms) becomes 0.006%. These are pretty dramatic improvements in linearity. The steps in the bottom (no load) trace are artefacts of the AP SYS-2702 measuring system.

The noise performance of this stage is exactly as for the aforementioned simple emitter-follower.

The push-pull emitter-follower

This is an extremely useful and trouble-free form of push-pull output; I have used it many times in preamplifiers, mixers, etc. I derived the notion from the valve-technology White cathode-follower, described by Nelson-Jones in a long-ago *Wireless World* [7]. The original reference is a British Patent taken out by Eric White in 1940 [8].

Figure 3.7 shows a push-pull emitter-follower. When the output is sourcing current, there is a voltage drop through the upper sensing resistor R5, so its lower end goes downwards in voltage. This is

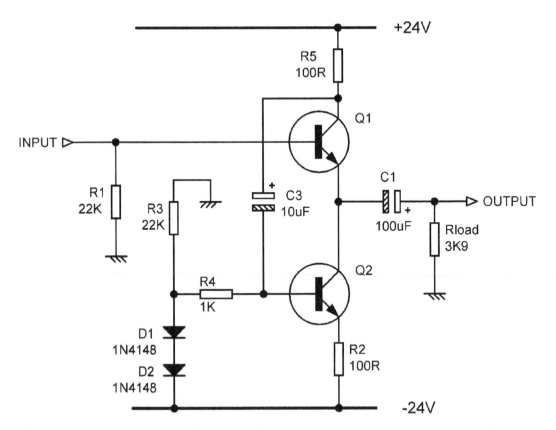

Figure 3.7 Circuit of push-pull emitter-follower. Quiescent current still 6 mA as before, but the load-driving capability is twice as great.

coupled to the current-source Q2 through C3 and tends to turn it off. Likewise, when the current through Q1 falls, Q2 is turned on more. This is essentially a negative-feedback loop with 100% negative feedback and an open-loop gain of unity, and so by simple arithmetic the current variations in Q1, Q2 are halved, and this stage can sink twice the current of the constant-current version described earlier while running at the same quiescent current. The effect of loading on linearity is once again considerably reduced, and only one resistor and one capacitor have been added.

This configuration needs fairly clean supply rails to work, as any upper-rail ripple or disturbance is passed directly through C3 to the current-source, modulating the quiescent current and disrupting the operation of the circuit.

Push-pull action further improves the linearity of load driving; the THD with a 4k7 external load is halved from 0.006% for the constant-current version (4 Vrms) to 0.003%, at the same quiescent current of 6 mA, as seen in Figure 3.8. This is pretty good linearity for such simple circuitry.

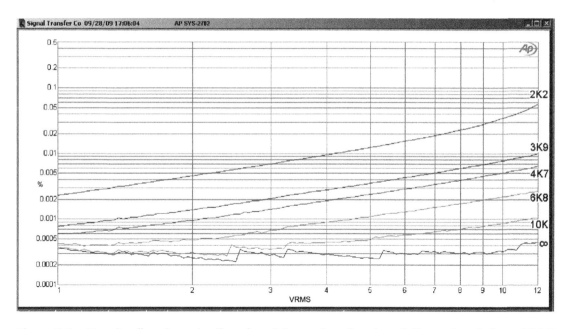

Figure 3.8 How loading degrades linearity of the push-pull emitter-follower. Loads from 10 kΩ to 2k2. Quiescent current 6 mA.

Emitter-follower stability

The emitter-follower is about as simple as an amplifier gets, and it seems highly unlikely that it could suffer from obscure stability problems. However, it can, and often does. Emitter-followers are liable to RF oscillation when fed from an inductive source impedance. This oscillation is often in the Very High Frequency (VHF) region, usually in the area 100–400 MHz and will be quite invisible on the average oscilloscope; however a sure sign of this problem is unusually high distortion that varies strongly when the transistor is touched with a probing finger. One way to stop this is to put a 'base-stopper' resistor directly in series with the base. This should come after the

bias resistor to prevent loss of gain. Depending on the circuit conditions, the resistor may be as low as 10 Ω or as high as 2k2. The latter generates −119.6 dBu of Johnson noise which in itself is inconvenient in low-noise circuitry, but the effects of the transistor noise current flowing through it are likely to be even worse. A typical example of their use is in the subsonic filter of my MRP4 preamp [9], a Sallen & Key filter using an emitter-follower with a constant-current source as in Figure 3.5. The stopper there is 2k2 which I now think too high. I was first conscious of this issue in 1976, and I was wary of it and designed cautiously. I don't recall doing any experiments then to see if the value could be reduced.

So I did some now. I set up the circuit of Figure 3.2 with ±24 V rails, adding a 22u35 V input blocking capacitor, omitting the 3k9 load resistor and adding a 47 Ω series output resistor to prevent instability due to output cable capacitance. It was built in my usual way: on prototype board with metre-long screened twisted-pair cables to the Audio Precision. The first result was wholly as expected. It was completely stable; capacitor output loads of up to 4n7 were applied, and it remained stable. To provoke oscillation it was necessary to insert an inductance in series with the input, placed just before the input capacitor; no output capacitor load was needed to cause instability. The added inductances ranged from 117 nH to 100 uH. Oscillation appeared at 172 nH but was cured by a base-stopper of only 10 Ω. Increasing the inductance to 294 nH required 47 Ω for stability, and 640 nH also required 47 Ω. The results are summarised in Table 3.1, which also covers current-source and push-pull emitter-followers, which tend to require larger base-stoppers for the same inductance. Note you do not need to use values like 1 kΩ unless there is enough wiring to give a substantial inductance such as 39 uH.

Ferrite beads are often recommended for stabilising emitter-followers, and Table 3.1 includes one case where a bead succeeded. In general, however, they do not do the job, and a 47 Ω resistor is much more certain and effective.

An interesting point here is that the screened input cable alone, despite being a metre long, did not cause oscillation. This is presumably because it acts as a transmission line at the frequencies we

TABLE 3.1 Emitter-follower stability. Bold figures denote high inductance

Configuration	Series inductance	Minimum base-stopper
Simple emitter-follower	172 nH	10 Ω
,,	294 nH	47 Ω
,,	640 nH	47 Ω
Current-source emitter-follower	172 nH	1 x ferrite bead
,,	172 nH	47 Ω
,,	294 nH	47 Ω
,,	640 nH	47 Ω
,,	**39 uH**	**1 kΩ**
,,	**100 uH**	**2k2**
Push-pull emitter-follower	172 nH	47 Ω
,,	294 nH	100 Ω
,,	640 nH	100 Ω

are dealing with and so does not look inductive. The very small inductances were made up of wire loops of differing diameter, resulting in odd inductance values. Wire loops do, of course, pick up some electromagnetic rubbish, but that is of no relevance to stability.

With the benefit of glorious vistas of hindsight, base-stoppers as low as 100 Ω are effective if you have normal signal path lengths. Values as high as 2k2 do not appear to be required unless you have some long leads with uH of inductance.

Base-stopper resistors are not shown in most of the diagrams here to aid clarity, but you should always be aware of the possible need for them. This also applies to the CFP configuration which is equally, if not more, susceptible to the problem.

For more information on this phenomenon see Feucht [10] and de Lange [11]. The best account of it in my opinion is by Hessman and Sokal [12] though their conclusions do not align exactly with mine as I found a capacitance loading the output was not necessary for instability to occur.

JFET source-followers

The vast majority of the circuits in this book use BJT transistors because you know where you are with them. Exceptions are JFETs used for signal switching and to obtain a very high input impedance for a capacitor microphone. But it is helpful to know what you are missing, and a brief study of JFETs puts BJTs into perspective. This section examines only one use of the JFET—as a source-follower, the equivalent of an emitter-follower—to contrast it with a BJT in the same role.

The first thing to realise is that the JFET is a very different device from the BJT. With Vgs = 0 V, the JFET is as fully on as it can be; the current passed is called Idss and varies a lot from sample to sample. You need to apply a negative voltage between gate and source (Vgs) to turn down the current and get it to do something useful. This is called depletion mode.

The second unsettling feature is that the Vgs required to get a given I_d is also variable. With BJTs it is feasible to measure one device and know that all the others will behave in a closely similar fashion (as is done with most of the configurations in this chapter), but JFETs are, by comparison, all over the place, and you need to measure multiple samples to get some idea of what's going on. Thus Table 3.2 gives the results for five samples (same batch) of the venerable 2N3819.

A third limitation is that most JFETs can only handle voltages that are low by BJT standard; the Vgs(max) for the 2N3819 is only 25 V.

And a fourth limitation . . . is that g_m is lower for JFETs: much lower and variable. A BJT with an I_c of 1 mA has a g_m of 38.46 mA/V precisely, whereas the JFET g_m for the 2N3819 is specified as between 2 and 6.5 mA/V. Most data sheets omit the typical value, but Vishay gives it as 5.5 mA/V.

Figure 3.9 shows a simple source-follower circuit; compare it with the simple emitter-follower in Figure 3.2. The supply rails have been drastically lowered to ±10 V because the maximum voltages for Vgs etc are only 25 V, and some safety margin is advisable; headroom is therefore reduced by 7.6 dB. A very important point is that the Idss of the 2N3819 varies from 2 mA to 20 mA, so if you want to be sure your circuit will always work you need to keep the I_d down to

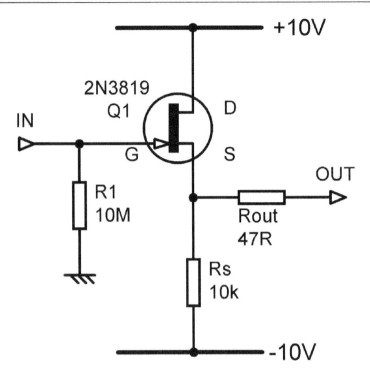

Figure 3.9 A simple JFET source-follower.

1 mA or less. Choosing 1mA sets Rs at 10 kΩ to get the output close to 0V when quiescent, giving the maximum output swing. The 10 M resistor is there to emphasise that the gate must have a DC path; many JFET preamps are driven by capacitor microphone capsules or piezo transducers, which are effectively insulators.

Table 3.2 shows that the gain is almost constant, though it is noticeably further from unity than the BJT emitter-follower. The THD at a very modest 1 Vrms in varies over a range of more than four times, which is not exactly helpful if you want predictable performance. This is due to variations in Idss and g_m. The Vgs that gives a 1 mA I_d varies over a 620 mV range, very different from the precise V_{be} of a BJT. No external load was used. The BJT simple emitter-follower gives a predictable 0.003% in the same unloaded conditions, which is five times better than the best JFET here. Figure 3.10 shows typical THD results.

The uncertainties of the Vgs cause few problems in source-followers, so long as you are doing audio and not looking for DC precision. It is a different matter with the common-source configuration (the equivalent of the BJT common-emitter configuration), and biasing can get complicated.

There is not space here to delve deeper into the use of FETs. Given their unpredictability I would steer clear of them unless a very high input impedance is essential and some form of linearisation applied, eg by putting them inside a negative-feedback loop.

TABLE 3.2 JFET source-follower results: 2N3819 1 Vrms in, 1 kHz

Sample	JFET #1	JFET #2	JFET #3	JFET #4	JFET #5
Gain x	0.953	0.951	0.952	0.950	0.951
THD 1 Vrms in	0.0319%	0.060%	0.0147%	0.0207%	0.0302%
Vs	+1.24 V	+1.04 V	+1.66 V	+1.55 V	+1.25 V

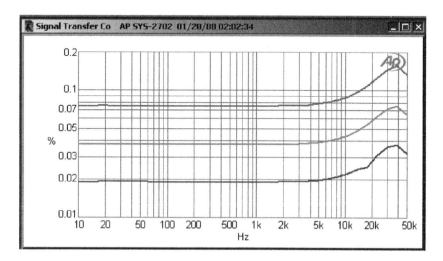

Figure 3.10 The distortion of the simple JFET source-follower at 0.5, 1, and 2 Vrms in. No load.

CFP-followers

The simple emitter-follower is lacking both in linearity and load-driving ability. The first shortcoming can be addressed by adding a second transistor to increase the negative feedback factor by increasing the open-loop gain. This also allows the stage to be configured to give voltage gain, as the output and feedback point are no longer inherently the same. This arrangement is usually called the complementary-feedback pair (hereafter CFP) though it is sometimes known as the Sziklai configuration. This circuit can be modified for constant-current or push-pull operation exactly as for the simple emitter-follower.

Figure 3.11 shows an example. The emitter resistor Re is the same value as in the simple emitter-follower to allow meaningful comparisons. The value of R4 is crucial to good linearity, as it sets the I_c of the first transistor. The value of 3k3 shown here is a good compromise.

This circuit is also susceptible to emitter-follower oscillation, particularly if it sees some load capacitance, and will probably need a base-stopper. If a 1 kΩ stopper does not do the job, try adding a series output resistor of 100 Ω close to the stage to isolate it from load capacitance.

Figure 3.12 shows the improved linearity; Figure 3.13 is the corresponding SPICE simulation. The measured noise output with a 100 Ω base-stopper is −116.1 dBu.

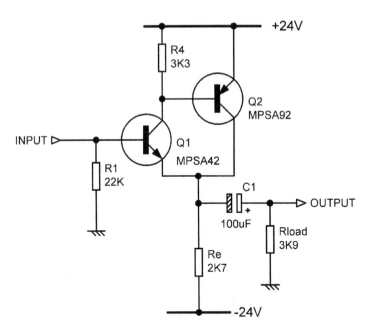

Figure 3.11 The CFP-follower. The single transistor is replaced by a pair with 100% voltage feedback to the emitter of the first transistor.

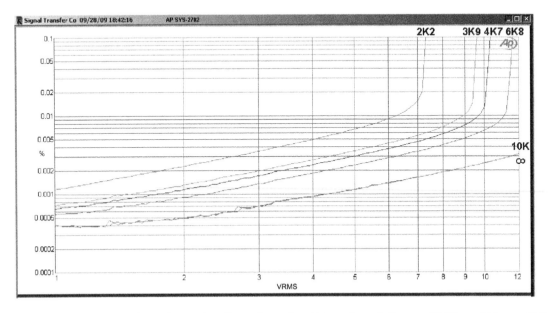

Figure 3.12 How loading affects the distortion of a CFP emitter-follower. THD at 6 Vrms, 6k8 load is only 0.003% compared with 0.05% for the simple EF. Re is 2K7.

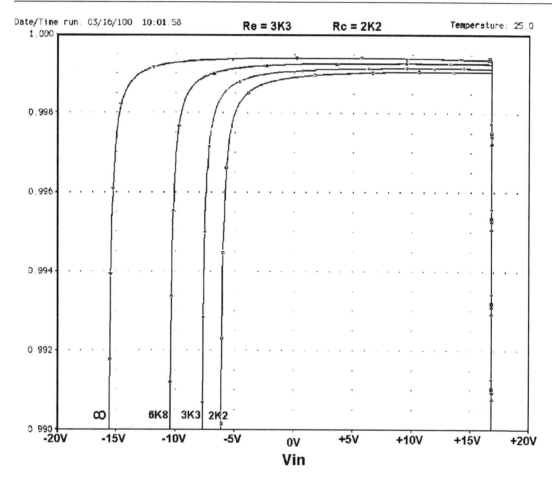

Figure 3.13 SPICE simulation of the CFP circuit in Figure 3.11 for different load resistances. The curves are much flatter than those in Figure 3.4, even though the vertical scale has been expanded.

If we replace Re with a 6 mA current-source, as in Figure 3.14, we once more get improved linearity and load-driving capability, as shown in Figure 3.15. The 6 Vrms, 6k8 THD is now only just above the noise at 0.0005% (yes, three zeros after the point: three-transistor circuitry can be rather effective).

Converting the constant-current CFP to push-pull operation as in Figure 3.16 gives another improvement in linearity and load driving. Figure 3.17 shows that now only the results for 2k2 and 3k9 loading are above the measurement floor.

CFP-follower stability

The CFP-follower was assessed for stability against RF oscillation in exactly the same way as the emitter-follower; the results are in Table 3.3. Comparing it with Table 3.1, the base-stoppers need to be higher for stability.

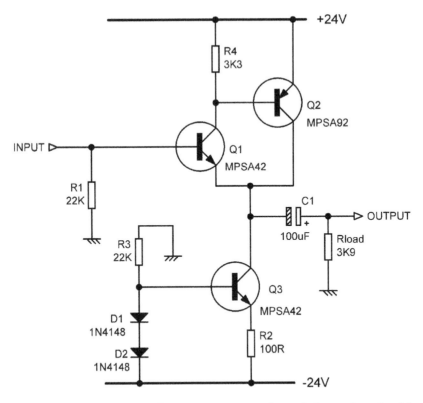

Figure 3.14 Constant-current CFP follower. Once more the resistive emitter load is replaced by a constant-current source to improve current-sinking.

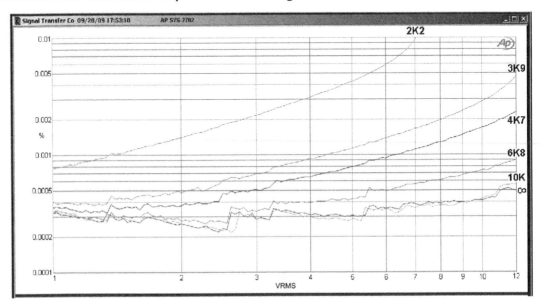

Figure 3.15 Distortion and loading effects on the CFP emitter-follower with a 6 mA current-source. The steps on the lower traces are artefacts caused by the measurement system gain-ranging as it attempts to measure the THD of pure noise. Note change of Y-axis scale.

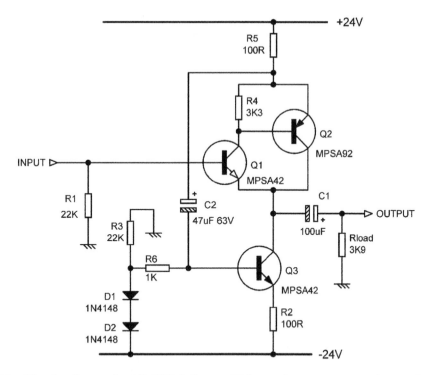

Figure 3.16 Circuit of a push-pull CFP follower. This version once more gives twice the load-driving capability for no increase in standing current.

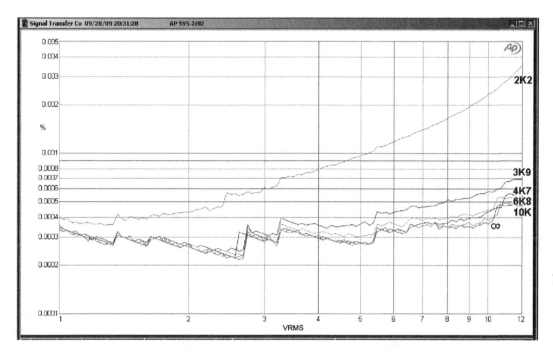

Figure 3.17 Distortion and loading effects on the push-pull CFP emitter-follower, still with 6 mA of quiescent current.

TABLE 3.3 CFP-follower stability

Configuration	Series inductance	Minimum base-stopper
Simple CFP	172 nH	100 Ω
,,	294 nH	100 Ω
,,	640 nH	220 Ω
Current-source CFP	172 nH	22 Ω
,,	294 nH	47 Ω
,,	640 nH	100 Ω
Push-pull CFP	172 nH	47 Ω
,,	294 nH	100 Ω
,,	640 nH	100 Ω

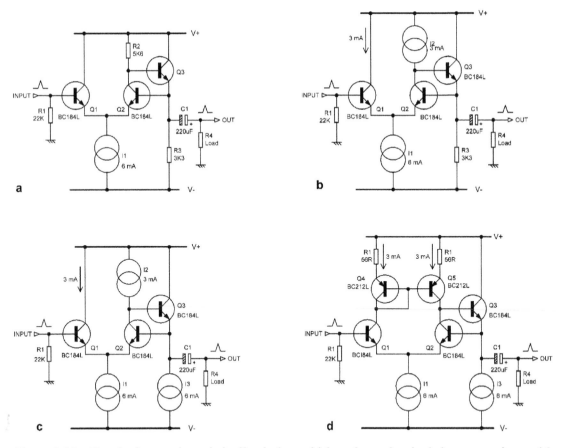

Figure 3.18 Developing a unity-gain buffer design, which replaces the single input transistor with a long-tail-pair: a) simple Schlotzhauer circuit; b) collector load R2 replaced with current-source; c) output current-source added; d) inserting current-mirror in input pair collectors.

Improved unity-gain buffers

There is often a need for a unity-gain buffer with very low distortion. If neither the simple emitter-follower, made with one transistor, nor the CFP configuration with two transistors are adequately linear, we might ponder the advantages of adding a third transistor to improve performance, without going to the complexity of the discrete opamps described later in this chapter (in our transistor count we are ignoring current-sources used to create the active output loads that so improve linearity into significant external loading).

One promising next step is a three-transistor configuration that is often called the Schlotzhauer configuration; see Feucht [5] and Staric & Margan [13]. The single input transistor in the CFP emitter-follower is now replaced with a long-tail-pair (LTP) with 100% feedback to Q1, as in Figure 3.18a. Because LTPs have the property of cancelling out their even-order distortion [6], you might expect a considerable improvement. You would be wrong; running on ±15 V rails we get 0.014% at 6 Vrms unloaded, almost flat across the audio band. The linearity is much inferior to the CFP emitter-follower. The open-loop gain, determined by measuring the error voltage between Q1, Q2 bases, is 249 times.

It's not a promising start, but we will persist! Replace the collector load R2 with a current-source of half the value of the tail current-source as in Figure 3.18b, and the linearity is transformed, yielding 0.00075% at 6 Vrms unloaded on ±15 V rails. Increasing the rails to ±18 V gives 0.00066% at 6 Vrms, and a further increase to ±24 V, as high-voltage operation is part of what discrete design is all about, gives 0.00042% at 6 Vrms (unloaded). It's the increase in the positive rail that gives the improvement. Reducing the measurement bandwidth from 80 kHz to 22 kHz for a 1 kHz signal eliminates some noise and gives a truer figure of 0.00032% at 6 Vrms. The open-loop gain is increased to 3400 times.

Adding loading to the buffer actually has very little effect on the linearity, but its output capability is clearly limited by the use of R3 to sink current, just as for a simple emitter-follower. Replacing R3 with a 6 mA constant-current source, as for previous circuits, much improves drive capability and also improves linearity somewhat. See Figure 3.18c. On ±30 V rails we get a reading of 0.00019% at 5 Vrms with a 2k2 load, and that is mostly the noise in a 22 kHz bandwidth.

Finally we remove current-source I2 and replace it with a simple current-mirror in the input pair collectors, as in Figure 3.18d, in the pious hope that the open-loop gain will be doubled and distortion halved. On ±30 V rails there is a drop in THD from 0.00019% to 0.00017% at 5 Vrms with a 2k2 load (22 kHz bandwidth), but that is almost all noise, and I am pushing the limits of even the magnificent Audio Precision SYS-2702. This goes to show that there are other ways of designing low-distortion circuitry apart from hefting a bucket of opamps.

Figure 3.19 shows the distortion plot at 5 Vrms. Using an 80 kHz bandwidth so the HF end is meaningful means the readings are higher and virtually all noise below 10 kHz. It also gives another illustration of the distortion generated by under-sized coupling capacitors. C1 started as 22 uF, but you can see that 220 uF is required to suppress distortion at 10 Hz with a 2k2 load, and 470 uF might be better.

SPICE analysis shows that the collector currents of the input pair Q1, Q2 are somewhat unbalanced by the familiar base current errors of a simple current-mirror. Replacing the simple

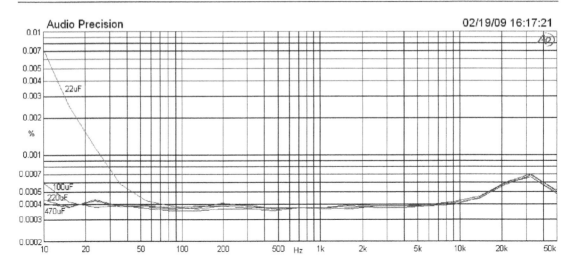

Figure 3.19 **THD plot for the final version of the buffer, at 5 Vrms with a 2k2 load. The rising LF curves illustrate the distortion generated by under-sized output capacitors. Bandwidth 80 kHz.**

current-mirror with the well-known Wilson improved mirror might get us further improvement, if we could measure it. Work in progress . . .

The circuit we have now could still be regarded as a much-enhanced emitter-follower, but it is probably more realistic to consider it as a two-stage discrete opamp, as it could be configured to give a closed loop of greater than unity.

Gain stages

This section covers any discrete transistor stage that can give voltage gain. It may be as simple as a single transistor or as complex as an opamp implemented with discrete components. A single transistor can give voltage gain in either series or shunt mode.

One-transistor shunt-feedback gain stages

Single-transistor shunt-feedback gain stages are inherently inverting and of very poor linearity by modern standards. It is often called the common-emitter configuration as the emitter is connected to a supply rail, which is the same as ground for AC. The circuit in Figure 3.20 is inevitably a collection of compromises. The collector resistor R4 should be high in value to maximise the open-loop gain; but this reduces the collector current of Q1, and thus its transconductance, and hence reduces open-loop gain once more. The collector resistor must also be reasonably low in value as the collector must drive external loads directly. Resistor R2, in conjunction with R3, sets the operating conditions. This stage has only a modest amount of shunt feedback via R3, and Q1 base can hardly be called a virtual-earth. However such circuits were once very common in low-end discrete preamplifiers, back in the days when the cost of an active device was a serious matter. Such stages are still occasionally found doing humble jobs like driving VU meters, but the cost advantage over an opamp section is small, if it exists at all.

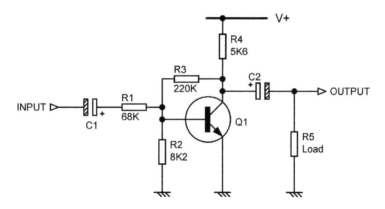

Figure 3.20 Circuit of single-transistor gain stage, shunt-feedback version. +24 V rail.

The gain of the stage in Figure 3.19 is at a first look 220 k/68 k = 3.23 times, but the actual gain is 2.3x (with no load) due to the small amount of open-loop gain available. The mediocre distortion performance that must be expected even with this low gain is shown in Figure 3.21.

One-transistor series-feedback gain stages

Single-transistor series-feedback gain stages are made by creating a common-emitter amplifier with an added resistor that gives series voltage feedback to the emitter. The gain is the ratio of the collector and emitter resistors, if loading is negligible. Note that unlike opamp-based series-feedback

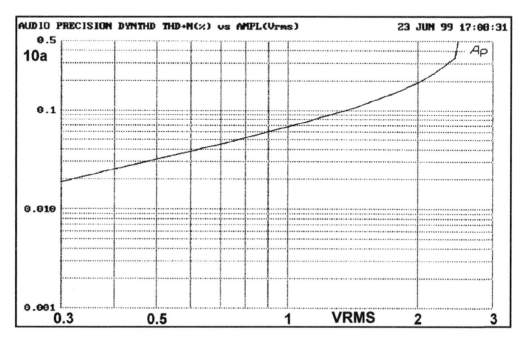

Figure 3.21 Single-transistor shunt-feedback gain stage, distortion versus level. +24 V rail. Gain is 2.3 times.

stages, this one is inherently inverting. To make a non-inverting stage with a gain more than unity requires at least two transistors because of the inversion in a single common-emitter stage.

This very simple stage shown in Figure 3.22 naturally has disadvantages. The output impedance is high, being essentially the value of the collector resistor R3. The output is not good at either sinking or sourcing current.

The distortion performance as seen in Figure 3.23 is indifferent, giving 0.3% THD at 1 Vrms out. Compare this with the shunt-feedback one-transistor gain stage earlier, which gives 0.07% under similar conditions.

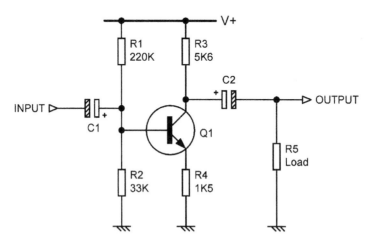

Figure 3.22 Circuit of single-transistor series-feedback gain stage. +24 V rail.

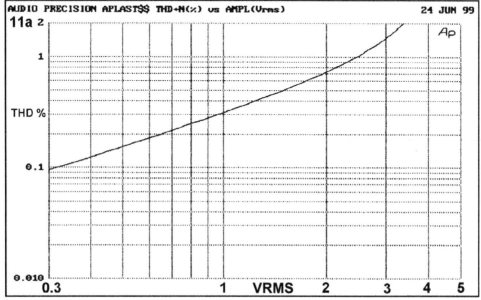

Single transistor series-feedback gain stage

Figure 3.23 Single-transistor series-feedback gain stage, distortion versus input level. +24 V rail. Gain is three.

Two-transistor shunt-feedback amplifiers

Before the advent of the opamp, inverting stages were required for tone controls and virtual-earth summing amplifiers. The one-transistor amplifier stage already described is very deficient in distortion and load-driving capability. A much better amplifier can be made with two transistors, as in Figure 3.24. The voltage gain is generated by Q1, which has a much higher collector resistor

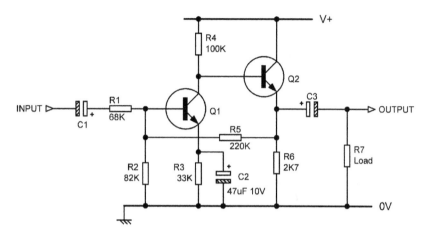

Figure 3.24 Two-transistor gain stage with shunt-feedback. +24 V rail. Gain is three.

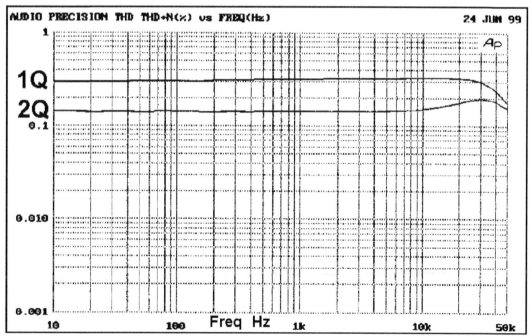

Figure 3.25 Distortion of two-transistor shunt stage versus freq (2Q). Distortion of one-transistor version (1Q) is also shown. The two-transistor version is only twice as good, which seems a poor return for the extra active device. +24 V rail.

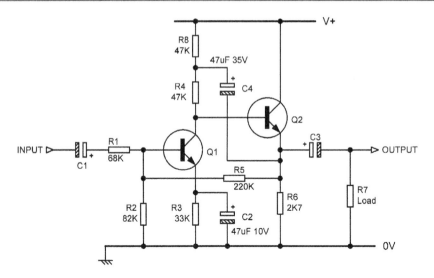

Figure 3.26 **Two-transistor shunt-feedback stage, with collector bootstrapping added to the first stage to improve linearity. Q1 collector current is 112 uA. +24 V rail.**

R4 and so much higher gain. This is possible because Q2 buffers it from external loading and allows a higher NFB factor. See Figure 3.25 for the distortion performance.

With the addition of bootstrapping, as shown in Figure 3.26, the two-transistor stage has its performance transformed. Figure 3.27 shows how THD is reduced by a factor of ten; 0.15% at 1 Vrms in, 3 Vrms out becomes 0.015%, which is much more respectable. The improvement

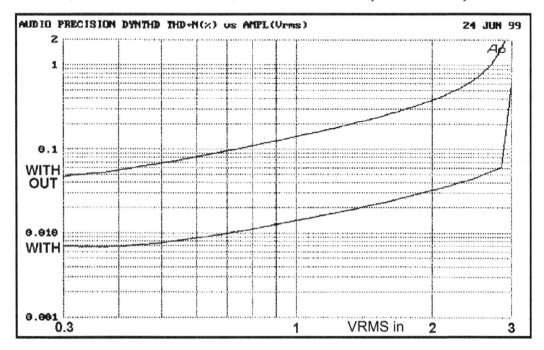

Figure 3.27 **Distortion of the two-transistor shunt stage versus level, with and without bootstrapping. X-axis is input level; output is three times this. +24 V rail.**

is due to the increased voltage gain of the first stage giving a higher NFB factor. THD is still approximately proportional to level, as the distortion products are mainly second harmonic. Clipping occurs abruptly at 2.9 Vrms in, 8.7 Vrms out; abrupt clipping onset is characteristic of stages with a high NFB factor. Stages like this were commonly used as virtual-earth summing amplifiers in mixing consoles before acceptable opamps were available at reasonable cost.

Figure 3.28 shows that the distortion is further reduced to 0.002% at 3 Vrms out if the impedance of the input and feedback networks is reduced by ten times. SPICE simulation confirms that this is because the signal currents flowing in R1 and R5 are now larger compared with the non-linear currents drawn by the base of Q1. There is also a noise advantage.

Figure 3.29 shows how output drive capability can be increased, as before, by replacing R6 with a 6 mA current-source. The input and feedback resistors R1, R5 have again been scaled down by a factor of ten. Push-pull operation can also be simply implemented as before. The EIN of this version is −116 dBu.

The constant-current and push-pull options can also be added to more complex discrete stages. Some good examples can be found in a preamplifier design of mine [14].

Two-transistor shunt-feedback stages: improving linearity

As is usual with discrete configurations, the quickest way to improve linearity is to crank up the supply voltage, if that is feasible. This obviously increases the power consumed by the circuitry, but this is not normally a major issue. Figure 3.30 shows the powerful effect of increasing the

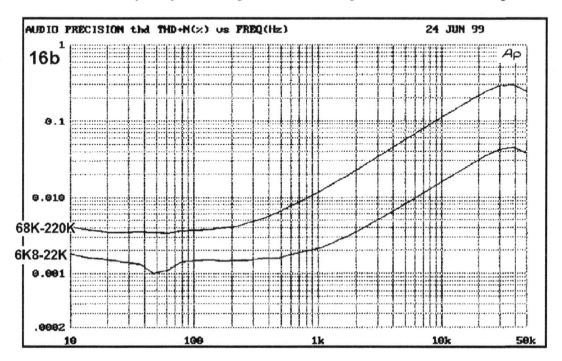

Figure 3.28 **The distortion is reduced by a further factor of at least five if the impedance of the input and feedback networks is reduced by ten times to R1 = 6k8 and R2 = 22 k. +24 V rail. Output 3 Vrms.**

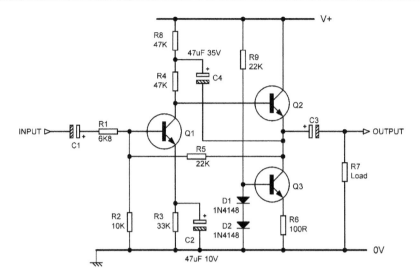

Figure 3.29 Two-transistor bootstrapped shunt-feedback configuration, with low-impedance feedback network, and with current-source output to enhance load-driving capability. +24 V rail.

rail voltage on both the LF and HF distortion regimes. It is interesting to note that this simple configuration shows HF distortion (mainly second harmonic) increasing at 6 dB/octave with frequency, despite the simplicity of the circuit and the apparent absence of compensation capacitance. Open-loop gain does, however, fall off at HF due to the internal C_{bc} of Q1, but

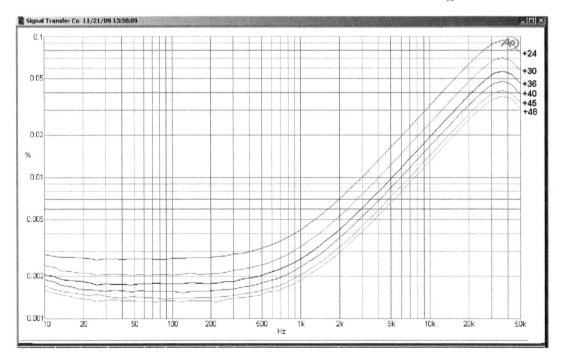

Figure 3.30 Distortion performance of two-transistor bootstrapped shunt-feedback stage with varying supply voltage. Output = 3.23 Vrms.

the major source of HF distortion is the non-linear nature of this C_{bc} which varies strongly in capacitance with the voltage across it. There is more on this vital point in the later section on discrete opamps.

Table 3.4 summarises how the distortion at 1 kHz drops quickly at first, as the supply voltage is increased, but the improvement slows down at higher voltages. The input was 1 Vrms and the output was 3.23 Vrms. These measurements were all taken with the emitter resistor R6 at 2k7, as shown in Figure 3.26. R1 was 6k8, and R5 was 22 kΩ, as for Figure 3.28 and in Figure 3.29.

TABLE 3.4 Reduction in distortion at 1 kHz for 3.23 Vrms out versus supply rail voltage

Supply voltage	THD 1 kHz	THD reduction ratio ref +24 V
+24 V	0.00435%	**1.00**
+30 V	0.00324%	**0.74**
+36 V	0.00262%	**0.60**
+40 V	0.00228%	**0.52**
+45 V	0.00201%	**0.46**
+48 V	0.00188%	**0.43**

In this configuration there are two stages, both of which have a certain curvature to their in/out characteristics. With discrete design you have some control over both of them, and there is always the possibility that you might be able to reduce distortion by altering the curvatures so that some degree of cancellation occurs in the distortion produced by each stage. This will be most effective on second-harmonic distortion.

A convenient way to alter the curvature of the second stage is to vary the value of the emitter resistor R6 in Figure 3.26. The results of doing this are shown in Table 3.5; the input level was 1 Vrms and the output level was 3.23 Vrms.

The second row shows the standard results, as obtained from Figure 3.26 with R6 set to 2k7. Our first experiment is to raise its value to 3k3, but this is clearly a step in the wrong direction as THD

TABLE 3.5 Reduction in distortion at 1 kHz for 3.23 Vrms out on changing R6 and supply rail voltage. Original value bolded

Supply voltage	R6 value	THD 1 kHz	THD reduction ratio
+24 V	3k3	0.00466%	1.09
+24 V	**2k7**	**0.00435%**	**1.00 (reference)**
+24 V	2k2	0.00378%	0.88
+24 V	2k0	0.00360%	0.84
+30 V	2k0	0.00287%	0.67
+36 V	2k0	0.00228%	0.53
+40 V	2k0	0.00204%	0.48
+45 V	2k0	0.00179%	0.42
+48 V	2k0	0.00167%	0.39

increases from 0.00435% to 0.00466%. We therefore try reducing R6 to 2k2 and get an immediate improvement to 0.00378%. Pressing on further, we reduce R6 to 2k0, and THD falls again, but this time by a smaller amount, giving 0.00360%. It looks as if further decreases will yield diminishing benefits, and the increased standing current in the emitter-follower may have serious consequences for power dissipation at higher supply voltages. Looking at the first four rows of the table, it is clear we get a useful improvement in distortion performance simply by changing one component value for no extra cost at all.

Since it appears we have gone about as far as we can in tweaking the output emitter-follower, we can consider a more radical step. As a general rule, any emitter-follower in a discrete transistor configuration can be inverted—in other words replaced by its complementary equivalent. This can be very useful when attempting to cancel the distortion from different stages, as just described. The result of this move is shown in Figure 3.31, where the output emitter-follower Q2 is now a PNP device.

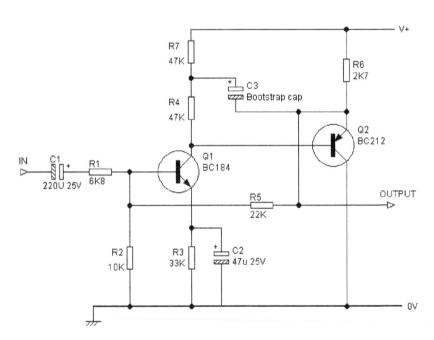

Figure 3.31 **Two-transistor shunt-feedback amplifier with the emitter-follower Q2 inverted. Note R1 and R5 have the reduced values.**

Unfortunately, we discover when we do the measurements that we have royally messed up an existing distortion cancellation rather than improved it, as shown in Table 3.6 (the "THD ratio" is based on the original configuration; the second row of Table 3.5 is the reference). The distortion with a +24 V supply rail is almost doubled, and clearly we are reinforcing the curvature of the two stages rather than partially cancelling it. Increasing the supply voltage still improves the linearity, as it almost always will.

TABLE 3.6 THD versus supply voltage with inverted emitter-follower. R6 = 2k7

Supply voltage	THD 1 kHz	THD ratio
+24	0.00850%	1.99
+30	0.00711%	1.66
+36	0.00589%	1.38
+40	0.00521%	1.22

TABLE 3.7 THD versus R6 value with inverted emitter-follower. R6 = 2k7

Supply voltage	R6 value	THD 1 kHz	THD ratio
+24	2K2	0.00882%	2.06
+24	2K7	0.00850%	1.99
+24	3K3	0.00806%	1.89

We can again attempt to improve the linearity by modifying the value of the output emitter resistor R6, but it really doesn't help very much. The deeply unimpressive results are seen in Table 3.7. The "THD ratio" reference is again the second row of Table 3.5.

Clearly in this case the conventional configuration with two NPN transistors is the superior one. It was and is the most common version encountered, so sometimes conventional is optimal.

Two-transistor shunt-feedback stages: noise

The noise output of the shunt-feedback circuit in Figure 3.29 with R1 = 6k8 and R5 = 22 kΩ is −99.5 dBu. To work out the EIN we need to know the actual noise gain at which the circuit works, not the closed-loop gain. The latter is simply (R5/R1), but the apparent noise gain is higher at (R5/R1)+1, which evaluates as +12.5 dB, as it would be for the equivalent opamp circuit. The noise gain is actually rather higher still because we must allow for the presence of the biasing resistor R2. This raises the true noise gain to +16.2 dB. In the typical application for this kind of circuit, that of virtual-earth summing amp, there would have been many input resistances R1, and the presence of R2 would have made relatively little difference to the overall noise performance.

Armed with the true noise gain, we can work out the EIN as −115.7 dBu, which is basically the noise performance of the first stage, as it implements all the voltage gain. It has to be said that I have so far made no attempt to optimise the noise performance of the circuit shown here. Increasing the first-stage collector current would probably reduce the noise with the feedback values shown.

Two-transistor shunt-feedback stages: bootstrapping

Choosing the right size for a bootstrap capacitor is not quite as straightforward as it appears. It looks as if quite a small value could be used because of the high impedance of the Q1 collector load. In Figures 3.25 and 3.28, the bootstrap capacitor C4 effectively sees only the 47 kΩ

impedance of R8 to the supply rail, and a 2u2 capacitor in conjunction with this gives −3 dB frequency of 1.54 Hz, which looks ample compared with 20 Hz.

But it is not. Figure 3.32 shows that this value gives an enormous rise in LF distortion, reaching 0.020% at 10 Hz. The reason for this steep rise is that bootstrapping as a means of gain enhancement requires the bootstrapped point to *accurately* follow the output of the voltage stage because even small deviations from unity-gain in the bootstrapping mean that the increase in Q1 collector impedance, and hence the overall open-loop gain, is seriously compromised. Note that there is no requirement for R4 and R8 to be the same value, but their sum, in conjunction with the voltage conditions, defines Q1 collector current. Figure 3.32 also shows that a 47 uF bootstrap capacitor is big enough to keep the distortion flat down to 10 Hz and going to 100 uF gives no further improvement.

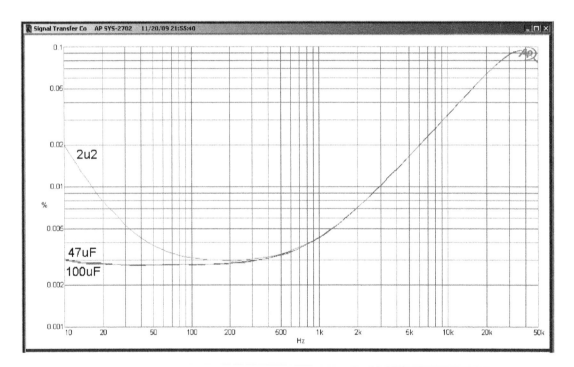

Figure 3.32 The 2u2 trace shows the effect of using too small a bootstrap capacitor. Output 3 Vrms, no external load.

Two-transistor shunt-feedback stages as summing amplifiers

Two-transistor shunt-feedback stages like those described earlier were used as virtual-earth summing amplifiers in mixers for many years. They were still in use in the early 1980s in mixer designs that were all-discrete to avoid the compromises in noise and distortion that came with the (affordable) opamps of the day. A two-transistor summing amplifier is simply the design of Figure 3.26 with a 22 kΩ feedback resistor R5, the 6k8 input resistor R1 representing a summing resistor from a mixer channel. The junction of the two was the virtual-earth bus.

We have seen that the distortion of the two-transistor configuration is not stunning by modern standards, though it can be improved. Another important parameter for a summing amplifier is the level of the bus residual, which is the signal voltage actually existing on the virtual-earth bus. Ideally this would be zero, but in the real world it is non-zero because the summing amplifier has a finite open-loop gain. In simpler mixers this can have serious effects on inter-bus crosstalk; this is discussed in more detail in Chapter 22.

Figure 3.33 shows the bus residual, relative to the summing amplifier output voltage, for three versions of the two-transistor configuration. With no bootstrapping, as in Figure 3.24, the bus residual is an unimpressive −52 dB. Adding conventional capacitor (AC) bootstrapping to increase the open-loop gain gives a much lower −66 dB, and DC-bootstrapping, as described in the third edition of this book, gives us −64 dB, indicating it is slightly less effective at raising the open-loop gain. This is probably because DC-bootstrapping falls further short of unity-gain than AC bootstrapping. These two traces show a rise at the HF end which does not appear on the −52 dB trace; this is almost certainly due to the open-loop gain falling off at HF due to the C_{bc} of Q1. There is also a rise in bus residual at the LF end, looking the same for all three cases. I suspect increasing C2 would remove that.

Three-transistor cascode shunt-feedback stages

If the aforementioned two-transistor shunt feedback circuits are not linear enough for the purpose in hand, and you don't want to go to the complexity of discrete opamps, a good compromise is to add

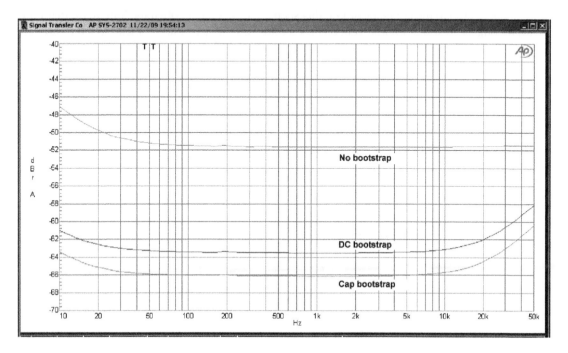

Figure 3.33 **The bus residual for non-bootstrapped, capacitor-bootstrapped, and DC-boot strapped two-transistor summing amplifiers. Measured relative to output voltage.**

a cascode transistor to the voltage amplifier section of the two-transistor circuit to increase the open-loop gain and prevent feedback through the non-linear C_{bc} of Q1. Another transistor, either constant-current or push-pull, can be added to the output stage to improve the load-driving capability.

Linearity is improved by current injection into the middle of the cascode via resistor R11 in Figure 3.34. This idea was inspired by an article called "Transistor Wide-band Cascade Amplifiers" by F Butler in *Wireless World* [15] and is sound (NB the title says cascade, not cascode). The current-injection resistor R11 is shown in the circuit diagram but not mentioned at all in the text; I thought it looked mysterious and interesting and soon discovered it was both; it much improved the distortion performance of the stage. The transistor types were not specified and neither was the value of R1, so the intended closed-loop gain was obscure—not very helpful.

The first time I put this configuration into practice was in the active volume-control stage in my 1979 design which I called a high-performance preamplifier as its distortion performance (if not its noise performance) was better than almost anything else around. It was published in *Wireless World* in February 1979 [16].

The distortion performance of the active volume control stage was a real issue because it had to give a closed-loop gain of up to ten times, at which the negative feedback available was obviously much reduced. I tried a standard two-transistor shunt circuit with the first stage collector bootstrapped and got 0.037% THD at 1 kHz and 0.30% at 10 kHz, both at 8 Vrms out. Definitely not good enough, especially the 10 kHz figure, but I balked at the complexity of a full discrete opamp stage.

I added a bootstrap to the collector of Q3; this seemed to be such an obvious thing to do that I did not even bother to test the original version. The dominant-pole capacitor C5 was added to give HF

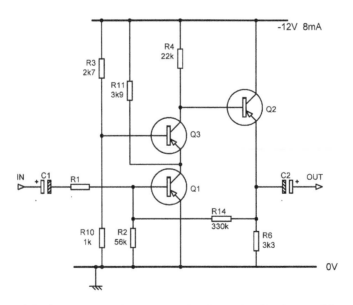

Figure 3.34 **The original three-transistor cascode shunt-feedback amplifier as published in** *Wireless World* **in 1965. Note negative supply rail and PNP transistors.**

stability ; see Figure 3.35. The bootstrapped cascode three-transistor stage with current-injection resistor R11 set to 2k2 gave 0.0046% at 1 kHz and 0.0088% at 10 kHz, (both 8 Vrms out again) and was a very acceptable compromise at the time. Without the current injection the THD was 0.011% at 1 kHz at 8 Vrms out, more than twice as much. Clearly there's a useful effect here. These historic measurements were made with the closed-loop stage gain set to 2.2 times. The single supply rail is +38 V, allowing comparison with opamps running from ±17 V. Note that the emitter-followers and CFP-followers earlier in this chapter use ±24 V rails.

The voltage gain stage Q1, Q3 is a cascode configuration with current-injection resistor R11. This allows the gain transistor Q1 to run at a higher current than the cascode transistor Q3. My explanation was and is that running Q1 at a higher collector current, because the injection current goes through it as well as the collector current I_c of Q3, increases its transconductance and so the variations in its own collector current.

There is a fixed voltage on the emitter of Q3 so the current through the injection resistor will be constant. This meant that the varying part of Q1 I_c all goes through Q3 to the high-impedance collector load, giving higher open-loop gain. The circuit of Figure 3.35 was rebuilt using BC182 transistors from the same batch as the original version in 1979. These had sat in a box for 43 years, and it was reassuring to find that they still worked as well as they ever did.

Don't start building Figure 3.35 until you have read the rest of this section. It has some rough edges:

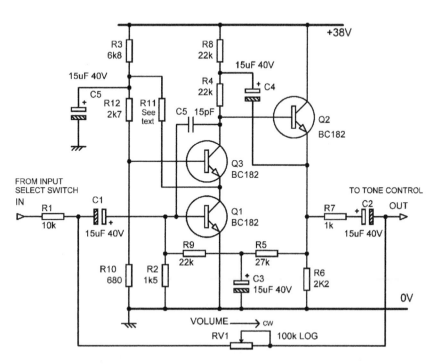

Figure 3.35 **My version of the three-transistor cascode shunt-feedback amplifier; as published in 1979.**

1) Something that now sticks out a mile, but at the time didn't, is the very low value of R2 compared with the values of R1 and RV1; it is clearly going to raise the noise gain considerably. The first thing I did on re-examining the circuit recently was to increase R2 to 7k5 and R9 to 220 k, which maintained the same bias conditions. Noise dropped by 5 dB at once, though there is more that could be done in this area.

2) The values in the bias chain R3, R12, R10 are too low; they drain almost 4 mA from the supply rail, which seems excessive.

3) The output resistor R7 inside the NFB loop was required to give HF stability with volume at zero; many non-opamp amplifiers object strongly to having their output connected directly to their inverting input. Not a problem here because the effect of R7 was neatly cancelled out in the following Baxandall tone control.

4) The values of the input resistor R1 and pot RV1 are too high. This was because the input of this stage was the line input of the preamplifier and needed a reasonably high impedance. This causes

 a) Excessive noise from the Johnson noise they create.

 b) Excessive noise due to Q1 input current noise flowing in them.

 c) Excess distortion due to the non-linear base current of Q1 flowing in them. It is explained in [17] how the input transistor of an amplifier stage draws a non-linear base current i_b, even though the closed-loop stage output may be completely linear, and the distortion this introduces can be reduced by reducing the impedance seen by the transistor base. For a shunt feedback amplifier this means scaling the value of the input resistor R1 and feedback resistor RV1 by the same ratio to maintain the closed-loop gain at the same value.

After the 5 dB reduction in noise gain noted earlier, the circuit was set to a closed-loop gain of 2.2 times (to allow comparison with historical measurements) by making R1 = 10kΩ and RV1 a fixed 22 kΩ resistor Rf. Distortion was now down to 0.0057% at 8 Vrms out, 1 kHz, because of the increased NFB factor. The impedance of the feedback network was then reduced by making R1 = 2k4, Rf = 5k1, and distortion dropped to 0.0038% (same conditions). Changing Rf and R1 to keep the gain the same and using three different injection currents yields Table 3.8. C2 was increased to 220 uF to maintain LF stability with the lower values. LF stability must always be checked with circuits like these that have separate AC and DC feedback paths.

These figures are not as tidy as they might be because reducing the impedance of the feedback network reduces the effect of i_b but also puts increased loading on the output stage; nevertheless it's pretty clear that whatever the value of Rf, adding one resistor can more than halve the distortion. It's a bargain.

I then decided to drag the circuit into something more like the present day by replacing the BC182 (h_{fe} spec 120 min, 500 max) at Q1 with a 2SC2240 BL (h_{fe} spec 350 min, 700 max), and things improved the THD for Rf = 4k3 dropped from 0.00335% to 0.00280% with no injection; as before increasing the injection current so R11 = 22 k again reduces the THD by more than half compared with no injection. See Table 3.9 where we (just) achieve a triple-zero THD in the rightmost column.

TABLE 3.8 THD versus Rf value and R11 injection resistor, 8 Vrms out 1 kHz

Rf	R11 no fit	R11 = 100 kΩ	R11 = 47 kΩ	R11 = 22 kΩ
5k1	0.00338%	0.00238%	0.00188%	0.00140%
4k7	0.00382%	0.00251%	0.00203%	0.00141%
4k3	0.00335%	0.00243%	0.00178%	0.00131%

TABLE 3.9 THD versus Rf value and R11 injection resistor, 8 Vrms out 1 kHz

Rf	R11 no fit	R11 = 100 kΩ	R11 = 47 kΩ	R11 = 22 kΩ
4k3	0.00280%	0.00213%	0.00162%	0.00120%
3k9	0.00340%	0.00215%	0.00161%	0.00099%

Transistor measurements showed that the real-life h_{fe} of samples was on average two times greater with the 2SC2240 BL. The improvement could be due to higher open-loop gain or a reduction in I_b or both. Transistors with high h_{fe} also show less noise as they have less base current and so less shot noise (see Chapter 2) and so are a good thing.

As noted earlier, the loading of the NFB network on the output stage is degrading the linearity. The standard answer, as widely practised in this chapter, is to replace the output emitter resistor R6 with a constant-current source. This was set to 6 mA and is identical to the current source in Figure 3.5. Table 3.10 shows that gets us squarely into the coveted triple-zero area. All the

TABLE 3.10 THD versus Rf value and R11 injection resistor, 8 Vrms out 1 kHz

Rf	R11 no fit	R11 = 100 kΩ	R11 = 47 kΩ	R11 = 22 kΩ
3k9			0.00065%	
3k3			0.00065%	

distortion seen on the THD residual was second harmonic and so proportional to signal level, so we can extrapolate down from 8 Vrms to see what the distortion would be at more practical operating level of 1 Vrms. The answer is 0.000081%, which I, for one, can live with.

A push-pull output stage as in Figure 3.7 was then tried, with a 6 mA quiescent current, and THD only dropped from 0.00065% to 0.00062%, which shows we have the effect of output loading under control.

The final circuit of Figure 3.36 shows R1 as 1k8, Rf as 3k9, and Q1 as 2SC2240BL and includes the current-source Q4 in the output stage. R7 is reduced to 470 Ω to increase output efficiency. The values in the bias chain have been increased so it now only draws 1.5 mA from the rail. The noise output is −111.8 dBu, which is an EIN of −118.6 dBu (22–22 kHz RMS). I am not claiming this version of the circuit is perfection because it could no doubt be optimised further, but I hope you'll agree it is pretty good for a relatively simple circuit.

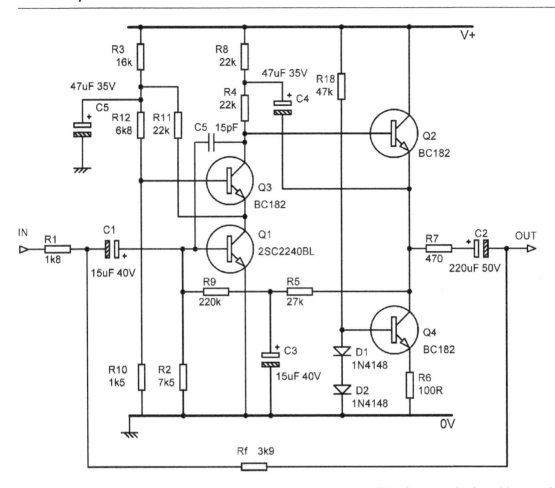

Figure 3.36 **The three-transistor cascode shunt-feedback amplifier improved, closed-loop gain is 2.2 times; 2022.**

The circuit is inherently inverting, which is an extremely useful circuit as most of the stages in a preamp, such tone controls and active volume controls, are inverting. The first 'operational amplifiers' (using valves) had only inverting inputs.

However, in some cases inverting is not wanted. It is hard to see how you could make a non-inverting version because Q1 is the voltage amplifier stage (VAS) and generates the full output swing; to get maximum output Q1 must have its emitter on the 0V rail.

The Butler article referred to here also prompted me to introduce the transistor version of the push-pull White cathode-follower; it is used not just in this chapter but many times in this book and in my various published designs—A useful article.

Two-transistor series-feedback gain stages

The circuit in Figure 3.37 clearly has a close family relationship with the CFP emitter-follower, which is simply one of these stages configured for unity gain. The crucial difference here is

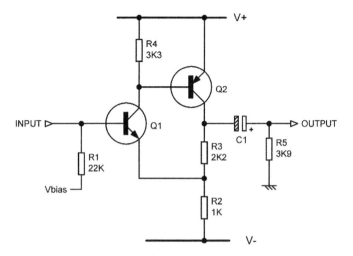

Figure 3.37 **Two-transistor gain stage, series-feedback. +24 V rail. Gain once more approximately three.**

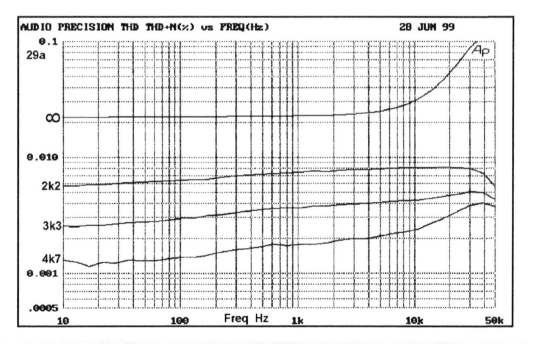

Figure 3.38 **Two-transistor series-feedback stage. THD varies strongly with value of R4. +24 V rail.**

that the output is separated from the input emitter, so the closed-loop gain is set by the R3–R2 divider ratio.

Only limited NFB is available, so closed-loop gains of two or three times are usually the limit.

It is less easy to adapt this circuit to improve load-driving capability because the feedback resistive divider must be retained. Figure 3.38 shows that distortion performance depends

strongly on the value of R4, the collector load for Q1. The optimal value for linearity and noise performance is around 4k7.

Discrete opamp design

When the previously described circuits do not show enough linearity or precision for the job in hand, or a true differential input is required, it may be time to use an opamp made from discrete transistors. The DC precision will be much inferior to an IC opamp and the parts count high compared with the other discrete configurations we have looked at, but the noise and distortion performance can both be very good indeed. A good example of discrete opamp usage is a preamplifier I designed a while back [18], though it must be said the opamps there could definitely be improved by following the suggestions in this section. It occurs to me this might have been the first true discrete opamp preamplifier; I am happy to debate the point with anyone. I am aware of the Meyer article entitled "Audio Pre-amplifier Using Operational Amplifier Techniques."[19] When I measured the distortion performance of Meyer's version of a discrete opamp in April 1975, I found the distortion performance was less than inspiring because the output is connected directly to the VAS collector and loading on this point is very bad for linearity; I measured 0.008% at 1 Vrms out with a flat closed-loop gain of 16 times and ±15 V supply rails (the rails used by Meyer). I don't call it a true discrete opamp preamplifier because it can't drive loads properly.

I was once told by someone who was paid enough to know better that discrete opamps made obtaining high-performance so trivially easy it was not worth doing; this was the same individual that utterly screwed up designing a simple two-transistor circuit. The statement is, of course, not true, as this section demonstrates. You need to know what you are about.

We may pause here to consider what a valve opamp preamplifier might be like. I envisage at least five valves to make some sort of opamp, implying 30-odd valves in a typical preamp—not appealing in a world short of energy.

A typical, though non-optimal, discrete opamp is shown in Figure 3.39. The long-tail pair first stage Q2, Q3 subtracts the input and feedback voltages. It is a transconductance amplifier, ie it turns a differential voltage input into a current output, which flows into the second amplifier stage Q4, Q5. This is a transadmittance amplifier; current in becomes voltage out. Its input is at low impedance (a sort of virtual-earth) because of local NFB through dominant-pole capacitor C3 and so is well-adapted to accepting the output current from the first stage. The third stage is a Class-A emitter-follower with current source, which isolates the second stage collector from external loads. The higher the quiescent current in this stage (here 6 mA as before) the lower the load impedance that can be driven symmetrically. The configuration is basically that of a power amplifier with a simplified small-scale output stage; a very great deal more information than there is space for here can be found in my power amplifier book [20].

The dominant-pole capacitor C3 is shown here as 15 pF, which is often large enough for stable small-signal operation. In a power amplifier it would probably be 100 pF because of the greater phase shifts in a full-scale output stage with power transistors. The closed-loop gain is here set to about 4 times (+12.5 dB) by R5, R6.

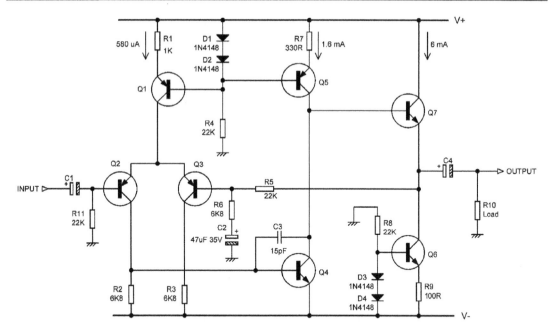

Figure 3.39 **A typical discrete opamp circuit with current-source output. Transistors are MPSA42 and MPSA92.**

The opamp in Figure 3.39 can be much improved by addressing the major causes of distortion in the circuit. These are

- Input stage: The current/voltage gain (transconductance) curve of the input stage peaks broadly at the centre of its characteristic, where the collector currents of Q2, Q3 are equal, and this is its most linear area. The distortion is a relatively small amount of third-harmonic. If the input pair is operated away from this point there is a rapid rise in second-harmonic distortion, which quickly swamps the third harmonic.

- Second stage: The transistor Q4 in conjunction with C3 converts current to voltage. It has the full output swing on its collector, and so I call it the Voltage Amplifier Stage (VAS). It has an internal collector-base capacitance C_{bc}, which varies with the collector-base voltage (Vcb) and so creates second-harmonic distortion at HF. Distortion at LF is at a much lower level and is due to the Early Effect in Q4.

- Output stage: The distortion of the Class-A output stage is negligible compared with that of the first two stages, providing it is not excessively loaded.

Discrete opamp design: the input stage

If the input pair is operated away from its balanced condition there is a rapid (12 dB/octave) rise in second-harmonic THD with frequency due to the roll-off of open-loop gain by C3. As a result, the value of R2 in Figure 3.39 is crucial. Global NFB establishes the V_{be} of Q4 (0.6 V) across R2,

so it needs to be approximately half the value of R1, which has 0.6 V across it to set the input stage tail current. The value of R3 has almost no effect on the collector current balance but is chosen to equalise the power dissipation in the two input transistors and so reduce DC drift. The critical importance of the value of R2 is demonstrated in Figure 3.40 where even small errors in R2 greatly increase the distortion. The collector currents of Q2, Q3 need to be matched to about 1% for minimum distortion.

Figure 3.39 has a small Miller capacitance C3 of 15 pF, and the large amount of NFB consequently available means that simply optimising R2 gives results almost indistinguishable from the testgear residual of an Audio Precision System-1. The circuit with R2 corrected is shown in Figure 3.41. An additional unrelated improvement shown is the inversion of the output stage so the biasing diodes D1, D2 can be shared and the component count reduced.

The good linearity obtained with the simple design of Figure 3.41 is only achieved because the closed-loop gain is moderate at four times, and the open-loop gain is high. In more demanding applications (including the front end of power amplifiers), the closed-loop gain will be higher (often 23 times) and the open-loop gain lower due to a typical Miller capacitance of 100 pF. This places much greater demands on the basic linearity of the circuit, and further improvements are valuable:

- The tail current of the input pair Q2, Q3 is increased from 580 uA to 4 mA, increasing the transconductance of the two transistors by roughly eight times. The transconductance is then reduced to its original value by inserting emitter degeneration resistors. Since

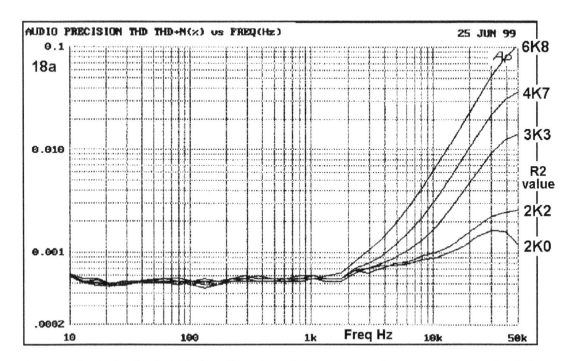

Figure 3.40 Reduction in high-freq distortion of Figure 3.39 as input stage approaches balance with R2 = 2 kΩ.

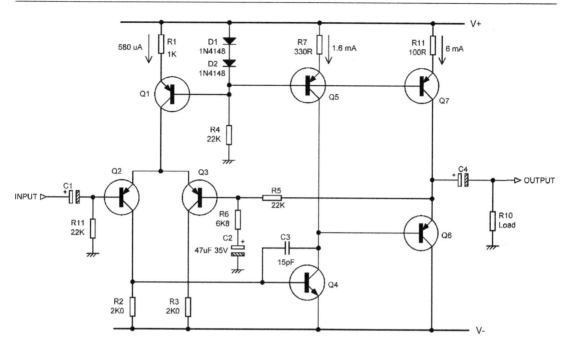

Figure 3.41 Improved discrete opamp with input stage balanced and output stage inverted to share the biasing diodes D1, D2. +20 dBu output, ±20 V rails.

the transconductance is now controlled much more by fixed resistors rather than the transistors, this greatly linearises the input stage.

- The collector resistors are replaced with a current-mirror that forces the collector currents of the input pair Q2, Q3 into accurate equality. This is more dependable than optimising R2 and also doubles the open-loop gain as the collector currents of both input transistors are now put to use. It also doubles the maximum slew-rate, because the maximum output current of the input stage is doubled.

These two enhancements give us the circuit shown in Figure 3.42. The input pair emitter degeneration resistors are R2, R3, and the current-mirror is Q4, Q5, which is itself degenerated by R4, R5 for greater accuracy. The distortion performance is the upper trace in Figure 3.44; this looks pretty poor compared with the lower trace in Figure 3.40, but as explained earlier our discrete opamp is now working under much more demanding conditions of high closed-loop gain and so a reduced NFB factor. Thanks to our efforts on the first stage, the distortion seen is coming entirely from the second stage Q6, so we had better sort it out.

Discrete opamp design: the second stage

As noted earlier, the dominant cause of second-stage (VAS) distortion is the non-linear C_{bc} of the VAS transistor, now labelled Q6. The local feedback around it is therefore non-linear, and

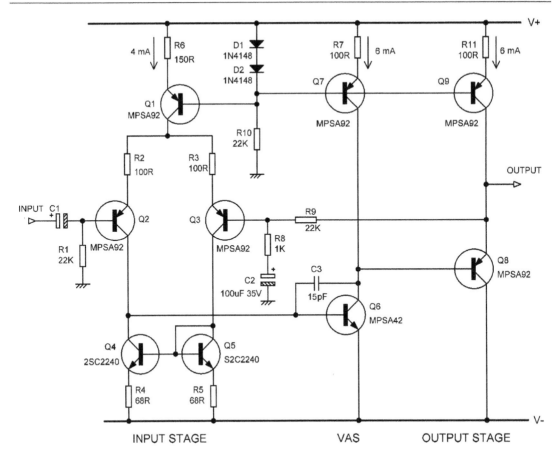

Figure 3.42 The improved discrete opamp with input pair degeneration R2, R3 and current-mirror Q4, Q5 added.

second-harmonic distortion is generated. A simple but extremely effective cure for this is to add an emitter-follower Q10 inside the local feedback loop of C3, giving us Figure 3.43. Note C3 has been increased to 100 pF, a typical value for a power amplifier small signal stage, and so there is less open-loop gain at HF, and greater demands are placed on the basic linearity of the circuit before overall negative feedback is applied. The non-linear local feedback through Q6 C_{bc} is now harmlessly absorbed by the low impedance at the emitter of Q10, and the linear component C3 alone controls the VAS behaviour. The result is the lower trace in Figure 3.44, which is indistinguishable from the output of the Audio Precision SYS-2702. Similar results can be obtained by instead cascoding Q6, but more parts are required, and the linearity is in general not quite so good.

In both Figures 3.42 and 3.43 the VAS current has been increased from 1.6 mA to 6 mA. This change has very little effect on the distortion performance but much increases the positive slew rate, marking it more nearly equal to the negative slew rate. The transistors are all MPSA42/92 high-voltage low-beta types (with the exception of the current-mirror) to underline the fact

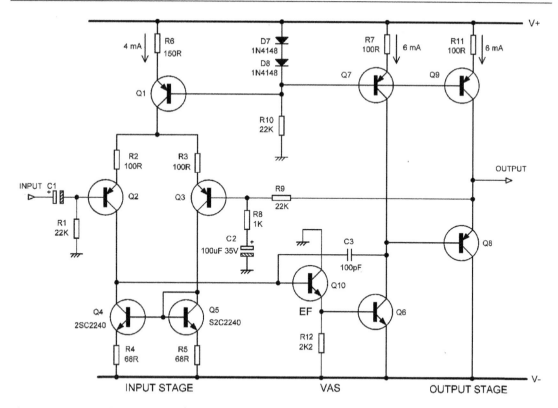

Figure 3.43 The improved discrete opamp of Figure 3.39 with emitter-follower Q10 added inside the VAS local feedback loop.

that high-beta devices are not required for low distortion. Do NOT use MPSA42 in the current-mirror as it has an unusually high minimum Vce for proper operation and so will work poorly here.

Discrete opamp design: the output stage

Figure 3.44 shows there is no need to worry about output stage distortion with moderate loading, as it is very low with even moderate levels of NFB. If the loading is so heavy that linearity deteriorates, the options are to increase the output stage standing current or to adopt a push-pull emitter-follower output stage, as described earlier in this chapter. The push-pull method is more efficient and will give better linearity.

For still heavier loads, a Class-AB output stage employing two complementary small-signal transistors can be used. The operation of such a stage is rather different from that of a power amplifier output stage, with crossover distortion and critical biasing being less of a problem. See Chapter 20 on headphone amplifiers for more on this.

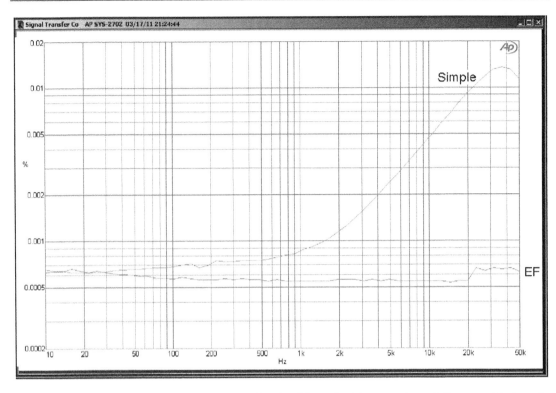

Figure 3.44 THD of the improved opamp circuit with and without emitter-follower added to the VAS. +20 dBu output, ±20 V rails.

References

[1] Erdi, G. "300V/us Monolithic Voltage Follower." *IEE Journal of Solid-State Circuits*, Vol. SC-14, No. 6, Dec 1979, p. 1059

[2] Williams, J., ed. *Analog Circuit Design: Art, Science & Personalities.* Butterworth-Heinemann, 1991, Chapter 21 by Barry Hilton, p. 193. ISBN 0-7506-9166-2

[3] Early, J. "Effects of Space-charge Layer Widening in Junction Transistors." *Proceedings of the IEEE*, Vol. 40, 1952, pp. 1401–1406

[4] Tomazou, C., Lidgey, F. J., & Haigh, D. G., ed. *Analogue Design: The Current-Mode Approach.* IEE Circuits & Systems Series 2, 1990, p. 12 et seq. ISBN 0 86341 215 7

[5] Feucht, D. *The Handbook of Analog Circuit Design.* Academic Press, 1990, p. 484 et seq. ISBN 0-12-254240-1

[6] Self, D. *Audio Power Amplifier Design Handbook*, 5th edition. Newnes, 1996, p. 78. ISBN 978-0-240-52162-6

[7] Nelson-Jones, L. "Wideband Oscilloscope Probe." *Wireless World*, Aug 1968, p. 276

[8] White, E. "Improvements in or Relating to Thermionic Valve Amplifier Circuit Arrangements." *British Patent No. 564, 250*, 1940

[9] Self, D. "A High-Performance Preamplifier Design." *Wireless World*, Feb 1979

[10] Feucht, D. L. *The Handbook of Analog Circuit Design*. Academic Press, 1990, p. 310 et seq. ISBN 0-12-254240-1

[11] de Lange, D. "Flat Wideband Buffers." *Electronics World*, Oct 2003, p. 19

[12] Chessman, M. & Sokal, N. "Prevent Emitter-follower Oscillation." *Electronic Design*, Vol. 24, No. 13, June 1976

[13] Staric, P. & Margan, E. *Wideband Amplifiers*. Springer, 2006, Chapter 5, p. 5.117 ISBN-10 0-387-28340-4 (HB) (Schlotzaur)

[14] Self, D. "A High-performance Preamplifier Design." *Wireless World*, Feb 1979

[15] Butler, F. "Transistor Wide-Band Cascade Amplifiers." *Wireless World*, Mar 1965, p. 124

[16] Self, D. "A High-Performance Preamplifier Design." *Wireless World*, Feb 1979

[17] Self, D. *Audio Power Amplifier Design*, 6th edition. Newnes, 2013, pp. 142–150. ISBN 978-0-240-52613-3

[18] Self, D. "An Advanced Preamplifier Design." *Wireless World*, Nov 1976

[19] Meyer, D. "Audio Pre-amplifier Using Operational Amplifier Techniques." *Wireless World*, July 1972, p. 309

[20] Self, D. *Audio Power Amplifier Design*, 6th edition. Newnes, 2013. ISBN 978-0-240-52613-3

Opamps and their properties

Introduction

Audio design has for many years relied on a very small number of opamp types; the TL072 and the 5532 dominated the audio small-signal scene for many years. The TL072, with its JFET inputs, was used wherever its negligible input bias currents and low cost were important. For a long time the 5534/5532 was much more expensive than the TL072, so the latter was used wherever feasible in an audio system, despite its inferior noise, distortion, and load-driving capabilities. The 5534/5532 was reserved for critical parts of the circuitry. Although it took many years, the price of the 5532 is now down to the point where you need a very good reason to choose any other type of opamp for audio work. Today better opamps are available but are markedly more expensive.

The TL072 and the 5532 are dual opamps; the single equivalents are TL071 and 5534. Dual opamps are used almost universally, as the package containing two is usually cheaper than the package containing one, simply because it is more popular.

There are however other opamps, some of which can be useful, and a selected range is covered here.

A very brief history of opamps

The opamp is today thought of as quintessentially a differential amplifier, responding to the difference of the input voltages while (hopefully) ignoring any common-mode component. The history of differential amplifiers goes back to that great man Alan Blumlein and his 1936 patent [1] for a pair of valves with their cathodes connected to ground through a common resistor. However, the first valve-based operational amplifiers, ie those intended to be capable of performing a mathematical operation, were in fact not differential at all, having only one input. That had to be an inverting input, of course, so you could apply negative feedback.

The first opamp to get real exposure in the United Kingdom was the Fairchild uA709, designed by the great Bob Widlar and introduced in 1965. It was a rather awkward item which required quite complicated external compensation and was devoid of output short-circuit protection. One slip of the probe and an expensive IC was gone. It was prone to latch-up with high common-mode voltages and did not like capacitive loads. I, for one, found all this most discouraging and gave up on the 709 pretty quickly. If you're going to quit, do it early, I say.

DOI: 10.4324/9781003332985-4

The arrival of the LM741 was a considerable relief. To my mind, it was the first really practical opamp, and it was suddenly possible to build quite complex circuitry with a good chance of it being stable, doing what it should do, and not blowing up at the first shadow of an excuse. I have given some details of it in this chapter for purely historical reasons. There is also an interesting example of how to apply the LM741 appropriately in Chapter 15.

The first IC opamps opened up a huge new area of electronic applications, but after the initial enthusiasm for anything new, the audio market greeted these devices with some scepticism. There were good reasons for this. The LM741 worked reliably; a snag with using it for audio was the leisurely slew rate of 0.5 V/usec, which made full output at 20 kHz impossible, but a bigger drawback was that it was obviously noisy. Up until about 1978, the only way to obtain good and cost-effective performance in a preamp was to stick with discrete transistor Class-A circuitry, and this became recognised as a mark of high quality. The advent of the TL072 and the 5532 changed this situation completely, but there is still sometimes marketing cachet to be gained from a discrete design.

An excellent and detailed history of operational amplifiers can be found in [2].

Opamp properties: noise

There is no point in regurgitating manufacturer's data sheets, especially since they are readily available on the internet. Here I have simply ranked the opamps most commonly used for audio in order of voltage noise (Table 4.1).

The great divide is between JFET input opamps and BJT input opamps. The JFET opamps have more voltage noise but less current noise than bipolar input opamps, the TL072 being particularly noisy. If you want the lowest voltage noise, it has to be a bipolar input. The difference, however, between a modern JFET input opamp, such as the OPA2134 and the old faithful 5532, is only 4 dB; but the JFET part is a good deal more costly. The bipolar AD797 seems to be out on its own here, but it is a specialised and expensive part. The LT1028 is not suitable for audio use because its bias compensation makes it noisy. The LM741 has no noise specs on its data sheets, and the 20 nV/rtHz is from measurements.

Several important new opamps have been released recently—the OPA828, OPA2156, OPA1622, and AD8656—which give lower noise and distortion in some applications. Another addition is the OPA1671, which is very economical of supply current but is only available in a single package. They have been added to the tables (NB, the AD8655 is the single version of the AD8656 dual opamp). The OPA1622 is notable for being able to drive loads down to 32 Ω at very low distortion but with the maximum output limited to 2 Vrms.

Both voltage and current noise increase at 6 dB/octave below the 1/f corner frequency, which is usually around 100 Hz. The only way to minimise this effect is to choose an appropriate opamp type.

Opamps with bias-cancellation circuitry are normally unsuitable for audio use due to the extra noise this creates. The amount depends on circuit impedances and is not taken into account in Table 4.1. The general noise behaviour of opamps in circuits is dealt with in Chapter 1.

TABLE 4.1 Opamps ranked by voltage noise density (typical)

Opamp	e$_n$ nV/rtHz	i$_n$ pA/rtHz	Input device type	Bias cancel?
LM741	20	??	BJT	No
TL072	18	0.01	FET	No
OPA604	11	0.004	FET	No
NJM4556	8	Not spec'd	BJT	No
OPA2134	8	0.003	FET	No
OP275	6	1.5	BJT+FET	No
OPA627	5.2	0.0025	FET	No
5532A	5	0.7	BJT	No
LM833	4.5	0.7	BJT	No
MC33078	4.5	0.5	BJT	No
OPA828	4	*	JFET	No
OPA2156	4	0.019	JFET	No
OPA1671	4	0.0047	FET	No
NJM8068	3.5	??	BJT	No
5534A	3.5	0.4	BJT	No
OP270	3.2	0.6	BJT	No
NJM4580	3	??	BJT	No
OP27	3	0.4	BJT	Yes
OPA1622	2.8	0.8	BJT	??
LM4562	2.7	1.6	BJT	No
LME49720	2.7	1.6	BJT	No
AD8656	2.7	*	JFET	??
AD797	0.9	2	BJT	No
LT1028	0.85	1	BJT	Yes

* No current-noise spec given by manufacturer's data sheet. Presumed negligible.

Opamp properties: slew rate

Slew rates vary more than most parameters; a range of 100:1 is shown here in Table 4.2. The slowest is the LM741, which is the only type not fast enough to give full output over the audio band. There are faster ways to handle a signal, such as current-feedback architectures, but they usually fall down on linearity. In any case, a maximum slew rate greatly in excess of what is required appears to confer no benefits whatever.

The 5532 slew rate is typically ±9 V/us. This version is internally compensated for unity-gain stability, not least because there are no spare pins for compensation when you put two opamps in an 8-pin dual package. The single-amp version, the 5534, can afford a couple of compensation pins and so is made to be stable only for gains of 3x or more. The basic slew rate is therefore

TABLE 4.2 Opamps ranked by slew rate (typical)

Opamp	Slew rate ±V/us
LM741	0.5
OP270	2.4
OP27	2.8
NJM4556	3
OPA1671	5
NJM4580	5
NJM8068	6.8
MC33078	7
LM833	7
5532A	9
OPA1622	10
AD8656	10
LT1028	11
TL072	13
5534A	13
OPA2134	20
LM4562	20
AD797	20
LME49720	20
OP275	22
OPA604	25
OPA2156	40
OPA627	55
OPA828	150

higher at ±13 V/us. Note the remarkable slew rate of the OPA828; it is technically impressive but gives no special benefits in audio use.

Compared with power amplifier specs, which often quote 100 V/us or more, these opamp speeds may appear rather sluggish. In fact they are not; even ±9 V/us is more than fast enough. Assume you are running your opamp from ±18 V rails, and that it can give a ±17 V swing on its output. For most opamps this is distinctly optimistic but never mind. To produce a full-amplitude 20 kHz sine wave you only need ±2.1 V/us, so even in the worst case there is a safety margin of at least four times. Such signals do not, of course, occur in actual use, as opposed to testing. More information on slew-limiting is given in the section on opamp distortion.

Opamp properties: common-mode range

This is simply the range over which the inputs can be expected to work as proper differential inputs. It usually covers most of the range between the rail voltages, with one notable exception. The data sheet for the TL072 shows a common-mode (CM) range that looks a bit curtailed at − 12 V. This bland figure hides the deadly trap this IC contains for the unwary. Most opamps, when they hit their CM limits, simply show some sort of clipping. The TL072, however, when it hits its negative limit, promptly inverts its phase, so your circuit either latches up or shows nightmare clipping behaviour with the output bouncing between the two supply rails. The positive CM limit is, in contrast, trouble-free. This behaviour can be especially troublesome when TL072s are used in highpass Sallen & Key filters.

Opamp properties: input offset voltage

A perfect opamp would have its output at 0V when the two inputs were exactly at the same voltage. Real opamps are not perfect, and a small voltage difference—usually a few milliVolts— is required to zero the output. These voltages are large enough to cause switches to click and pots to rustle, and DC blocking is often required to keep them in their place.

The typical offset voltage for the 5532A is ±0.5 mV typical, ±4 mV maximum at 25°C; the 5534A has the same typical spec but a lower maximum at ±2 mV. The input offset voltage of the newer LM4562 is only ±0.1 mV typical, ±4 mV maximum at 25°C.

Opamp properties: bias current

Bipolar-input opamps not only have larger noise currents than their JFET equivalents, they also have much larger bias currents. These are the base currents taken by the input transistors. This current is much larger than the input offset current, which is the difference between the bias current for the two inputs. For example, the 5532A has a typical bias current of 200 nA, compared with a much smaller input offset current of 10 nA. The LM4562 has a lower bias current of 10 nA typical, 72 nA maximum. In the case of the 5532/4 the bias current flows into the input pins from the positive rail as the input transistors are NPN.

Bias currents are a considerable nuisance; when they flow through variable resistors they make them noisy when moved. They will also cause significant DC offsets when they flow through high-value resistors.

It is often recommended that the effect of bias currents can be cancelled out by making the resistance seen by each opamp input equal. Figure 4.1a shows a 5532 shunt-feedback stage with a 22 kΩ feedback resistor. When 200 nA flows through this it will generate a DC offset of 4.4 mV, which is rather more than we would expect from the input offset voltage error.

If an extra resistance Rcompen, of the same value as the feedback resistor, is inserted into the non-inverting input circuit then the offset will be cancelled. This strategy works well and is done

almost automatically by many designers. However, there is a snag. The resistance Rcompen generates extra Johnson noise, and to prevent this it is necessary to shunt the resistance with a capacitor, as in Figure 4.1b. This extra component costs money and takes up PCB space, so it is questionable if this technique is actually very useful for audio work. It is usually more economical to allow offsets to accumulate in a chain of opamps and then remove the DC voltage with a single output blocking capacitor. This assumes that there are no stages with a large DC gain and that the offsets are not large enough to significantly reduce the available voltage swing. Care must also be taken if controls are involved because even a small DC voltage across a potentiometer will cause it become crackly, especially as it wears.

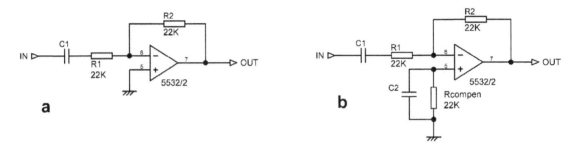

Figure 4.1 Compensating for bias current errors in a shunt-feedback stage. The compensating resistor must be bypassed by a capacitor C2 to prevent it adding Johnson noise to the stage.

FET-input opamps have very low bias current at room temperature; however it doubles for every 10°C rise. This is pretty unlikely to cause trouble in most audio applications, but a combination of high internal temperatures and high-value pots could lead to some unexpected crackling noises.

Opamp properties: cost

While it may not appear on the datasheet, the price of an opamp is obviously a major factor in deciding whether or not to use it.

Table 4.3 was compiled using prices for the SOT-8 surface-mount version, aggregated from a number of vendors such as Mouser, Digikey, RS, etc. Note that the price is per package and not per opamp section, and this can make a big difference. As always, thing are cheaper if you buy more of them; the 2,500 level prices are about half what they are for a one-off. The significance of 2,500 is that in many cases the devices come on a reel of that size. It is obviously only a rough guide, and YMMV. Purchasing in different countries may change the rankings somewhat, but the basic look of things will not alter too much.

The OPA627 is an outlier here; it is eye-wateringly expensive. This is probably because (as far as I can determine) it is the only laser-trimmed part here. Its DC precision is not useful in audio. One thing is obvious—the 5532 is still one of the great opamp bargains of all time.

DIL versions of the older opamps are still available, but the newer opamps are only manufactured in surface-mount packages. The OPA1622 is only available as a 10-pin VSON package—home soldering will be difficult.

TABLE 4.3 Opamps ranked by price in £ (GBP). Data for September 2019 and July 2022

Device	Format	1-off	10-off	100-off	2500-off
NJM4580	Dual			0.13	0.10
MC33078	Dual	0.47	0.40	0.28	0.17
TL072	Dual	0.48	0.41	0.26	0.19
NJM8068	Dual	0.49	0.43	0.33	0.19
TL052	Dual	0.52	0.42	0.27	0.19
NE5534	Single	0.70	0.59	0.45	0.28
NE5532	Dual	0.70	0.58	0.37	0.27
LM833	Dual	0.71	0.61	0.46	0.29
NE5532A	Dual	0.78	0.66	0.51	0.32
NE5534A	Single	0.78	0.66	0.51	0.32
OPA1671	Single	1.09	0.93	0.71	0.44
LM4562	Dual	1.30	1.11	0.96	0.96
LME49720	Dual	2.12	1.80	1.44	0.96
OPA604	Single	2.35	2.11	1.73	1.18
AD8656	Dual	2.83	2.53	2.07	1.46
OPA2156	Dual	2.86	2.58	2.10	1.44
OP27	Single	3.19	2.85	2.57	1.70
OPA2134	Dual	3.49	3.14	2.57	1.75
OP275	Dual	3.57	3.19	2.87	1.16
OP270	Dual	5.87	5.29	4.44	3.39
OPA828	Single	6.18	5.58	4.62	3.38
LT1028	Single	8.32	5.81	5.13	4.80
AD797	Single	8.92	8.09	6.59	5.52
OPA627	Single	20.33	18.76	16.02	14.54

Opamp properties: distortion

Relatively few discussions of opamp behaviour deal with non-linear distortion, perhaps because it is a complex business. Opamp 'accuracy' is closely related, but the term is often applied only to DC operation. Accuracy here is often specified in terms of bits, so '20-bit accuracy' means errors not exceeding one part in 2 to the 20, which is −120 dB or 0.0001%. Audio signal distortion is, of course, a dynamic phenomenon, very sensitive to frequency, and DC specs are of no use at all in estimating it.

Distortion is always expressed as a ratio and can be quoted as a percentage, as number of decibels, or in parts per million. With the rise of digital processing, treating distortion as the quantisation error arising from the use of a given number of bits has become more popular. Figure 4.2 hopefully provides a way of keeping perspective when dealing with these different metrics.

There are several different causes of distortion in opamps. We will now examine them.

dB	PERCENT	BITS	PPM
	50%	1	
−10	30	2	
	20		
−20	10%	3	100,000
	5	4	
			50,000
−30	3	5	30,000
	2	6	20,000
−40	1%		10,000
	0.5	7	5,000
−50	0.3	8	3,000
	0.2	9	2,000
−60	0.1%	10	1,000
	0.05	11	500
−70	0.03	12	300
	0.02		200
		13	
−80	0.01%		100
	0.005	14	50
−90	0.003	15	30
	0.002	16	20
−100	0.001%	17	10
	0.0005	18	5
−110	0.0003		3
	0.0002	19	2
−120	0.0001%	20	1
		21	0.5
−130		22	0.3
			0.2
		23	
−140	0.00001%		0.1
		24	

Figure 4.2 The relation between different ways of quoting THD—decibels, percentages, bit accuracy, and parts per million.

Opamp internal distortion

This is what might be called the basic distortion produced by the opamp you have selected. Even if you scrupulously avoid clipping, slew-limiting, and common-mode issues, opamps are not distortion free, though some types such as the 5532 and the LM4562 have very low levels. If distortion appears when the opamp is run with shunt feedback, to prevent common-mode voltages on the inputs and with very light output loading, then it is probably wholly internal and there is nothing to be done about it except to pick a better opamp.

If the distortion is higher than expected, the cause may be internal instability provoked by putting a capacitive load directly on the output or neglecting the supply decoupling. The classic example of the latter effect is the 5532, which shows high distortion if there is not a capacitor across the supply rails close to the package; 100 nF is usually adequate. No actual HF oscillation is visible on the output with a general-purpose oscilloscope, so the problem is likely to be instability in one of the intermediate gain stages.

Slew rate limiting distortion

While this is essentially an overload condition, it is wholly the designer's responsibility. If users whack up the gain until the signal is within a hair of clipping, they should still be able to assume that slew-limiting will never occur, even with aggressive material full of high frequencies.

Arranging this is not too much of a problem. If the rails are set at the usual maximum voltage, ie ±18 V, then the maximum possible signal amplitude is 12.7 Vrms, ignoring the saturation voltages of the output stage. To reproduce this level cleanly at 20 kHz requires a minimum slew rate of only ±2.3 V/usec. Most opamps can do much better than this, though with the OP27 (2.8 V/usec) you are sailing rather close to the wind. The old LM741 looks

as though it would be quite unusable, as its very limited 0.5 V/usec slew rate allows a full output swing only up to 4.4 kHz.

Horrific as it may now appear, audio paths full of LM741s were quite common in the early 1970s. Entire mixers were built with no other active devices, and what complaints there were tended to be about noise rather than distortion. The reason for this is that full-level signals at 20 kHz simply do not occur in reality; the energy at the HF end of the audio spectrum is well-known to be much lower than that at the bass end.

This assumes that slew-limiting has an abrupt onset as level increases, rather like clipping. This is in general the case. As the input frequency rises and an opamp gets closer to slew-limiting, the input stage is working harder to supply the demands of the compensation capacitance. There is an absolute limit to the amount of current this stage can supply, and when you hit it the distortion shoots up, much as it does when you hit the supply rails and induce voltage clipping. Before you reach this point, the linearity may be degraded but usually only slightly until you get close to the limit. It is not normally necessary to keep big margins of safety when dealing with slew-limiting. If you are employing the usual suspects in the audio opamp world—the TL072, the 5532, and the LM4562, with maximal slew rates of ±13, ±9, and ±20 V/usec respectively—you are most unlikely to suffer any slew rate non-linearity.

Distortion due to loading

Output stage distortion is always worse with heavy output loading because the increased currents flowing exacerbate the gain changes in the Class-B output stage. These output stages are not individually trimmed for optimal quiescent conditions (as are audio power amplifiers), and so the crossover distortion produced by opamps tends to be higher and can be more variable between different specimens of the same chip. Distortion increases with loading in different ways for different opamps. It may rise only at the high-frequency end (eg the OP2277), or there may be a general rise at all frequencies. Often both effects occur, as in the TL072.

The lowest load that a given opamp can be allowed to drive is an important design decision. It will typically be a compromise between the distortion performance required and opposing factors such as number of opamps in the circuit, cost of load-capable opamps, and so on. It even affects noise performance, for the lower the load resistance an amplifier can drive, the lower the resistance values in the negative feedback can be, and hence the lower the Johnson noise they generate. There are limits to what can be done in noise reduction by this method, because Johnson noise is proportional to the square root of circuit resistance and so improves only slowly as opamp loading is increased.

Thermal distortion

Thermal distortion is caused by cyclic variation of the properties of the amplifier components due to the periodic release of heat in the output stage. The result is a rapid rise in distortion at low frequencies, which gets worse as the loading becomes heavier.

Those who have read my work on audio power amplifiers will be aware that I am highly sceptical—in fact totally sceptical—about the existence of thermal distortion in amplifiers

built from discrete components [3]. The power devices are too massive to experience per-cycle parameter variations, and there is no direct thermal path from the output stage to the input devices. There is no rise, rapid or otherwise, in distortion at low frequencies in a properly designed discrete power amplifier.

The situation is quite different in opamps, where the output transistors have much less thermal inertia and are also on the same substrate as the input devices. Nonetheless, opamps do not normally suffer from thermal distortion; there is generally no rise in low-frequency distortion, even with heavy output loading. Integrated circuit power amplifiers are another matter, and the much greater amounts of heat liberated on the substrate do appear to cause serious thermal distortion, rising at 12 dB/octave below 50 Hz. I have never seen anything resembling this in any normal opamp.

Common-mode distortion

This is the general term for extra distortion that appears when there is a large signal voltage on both the opamp inputs. The voltage difference between these two inputs will be very small, assuming the opamp is in its linear region, but the common-mode (CM) voltage can be a large proportion of the available swing between the rails.

It appears to be by far the least understood mechanism and gets little or no attention in opamp textbooks, but it is actually one of the most important influences on opamp distortion. It is simple to separate this effect from the basic forward-path distortion by comparing THD performance in series and shunt feedback modes; this should be done at the same noise gain. The distortion is usually a good deal lower for the shunt feedback case where there is no common-mode voltage. Bipolar and JFET input opamps show different behaviours, and they are treated separately here. The test circuits used are shown in Figure 4.3.

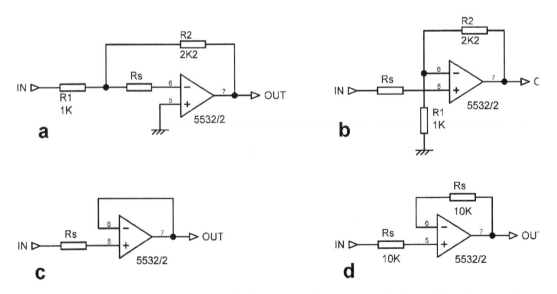

Figure 4.3 **Opamp test circuits with added source resistance Rs: a) shunt; b) series; c) voltage-follower; d) voltage-follower with cancellation resistor in feedback path.**

Common-mode distortion: bipolar input opamps

Figure 4.4 shows the distortion from a 5532 working in shunt mode with low-value resistors of 1 kΩ and 2k2 setting a gain of 2.2 times at an output level of 5 Vrms. This is the circuit of Figure 4.3a with Rs set to zero; there is no CM voltage. The distortion is well below 0.0005% up to 20 kHz; this underlines what a superlative bargain the 5532 is.

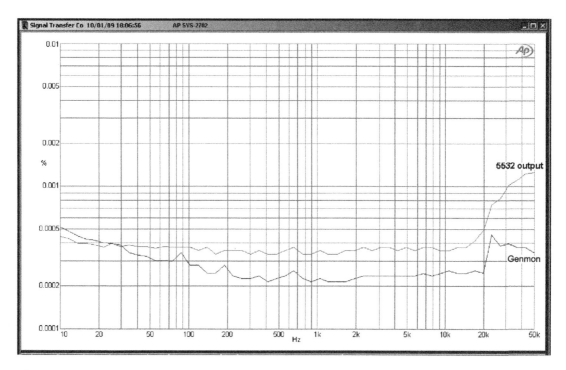

Figure 4.4 **5532 distortion in a shunt feedback circuit at 5 Vrms out. This shows the AP SYS-2702 genmon output (lower trace) and the opamp output (upper trace). Supply ±18 V.**

Figure 4.5 shows the same situation but with the output increased to 10 Vrms (the clipping level on ±18 V rails is about 12 Vrms), and there is now significant distortion above 10 kHz, though it only exceeds 0.001% at 18 kHz.

This remains the case when Rs in Figure 4.3a is increased to 10 kΩ and 47 kΩ—the noise floor is higher, but there is no real change in the distortion behaviour. The significance of this will be seen in a moment.

We will now connect the 5532 in the series feedback configuration, as in Figure 4.3b; note that the stage gain is greater at 3.2 times, but the opamp is working at the same noise gain. The CM voltage is 3.1 Vrms. With a 10 Vrms output we can see in Figure 4.6 that even with no added source resistance the distortion starts to rise from 2 kHz, though it does not exceed 0.001% until 12 kHz. But when we add some source resistance Rs, the picture is radically worse with serious mid-band distortion rising at 6 dB/octave and roughly proportional to the amount of resistance added. We will note it is 0.0085% at 10 kHz with Rs = 47 kΩ.

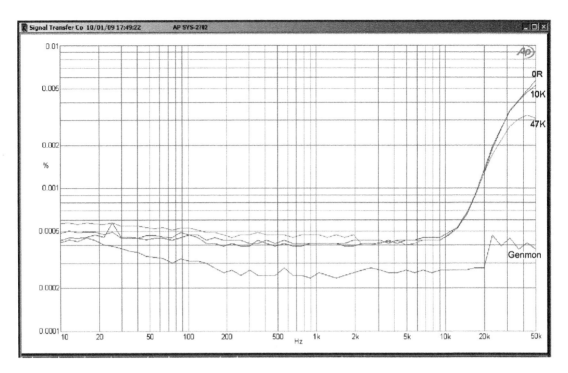

Figure 4.5 5532 distortion in the shunt feedback circuit of Figure 4.3b. Adding extra resistances of 10 kΩ and 47 kΩ in series with the inverting input does not degrade the distortion at all but does bring up the noise floor a bit. Test level 10 Vrms out. Supply ±18 V.

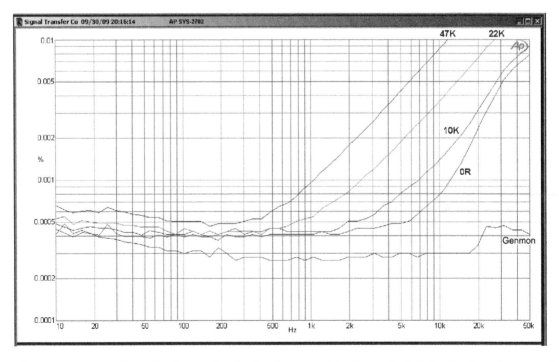

Figure 4.6 5532 distortion in a series feedback stage with 2k2 and 1 kΩ feedback resistors and varying source resistances. 10 Vrms output.

The worst case for CM distortion is the voltage-follower configuration, as in Figure 4.3c, where the CM voltage is equal to the output voltage. Figure 4.7 shows that even with a CM voltage of 10 Vrms, the distortion is no greater than for the shunt mode. However, when source resistance is inserted in series with the input, the distortion mixture of second, third, and other low-order harmonics increases markedly. It increases with output level, approximately quadrupling as level doubles. The THD is now 0.018% at 10 kHz with Rs = 47 kΩ, more than twice that of the aforementioned series-feedback amplifier, due to the increased CM voltage.

It is would be highly inconvenient to have to stick to the shunt feedback mode because of the phase inversion and relatively low input impedance that comes with it, so we need to find out how much source resistance we can live with. Figure 4.8 zooms in on the situation with resistance of 10 kΩ and below; when the source resistance is below 2k2, the distortion is barely distinguishable from the zero source resistance trace. This is why the lowpass Sallen & Key filters in Chapter 6 have been given series resistors that do not in total exceed this figure.

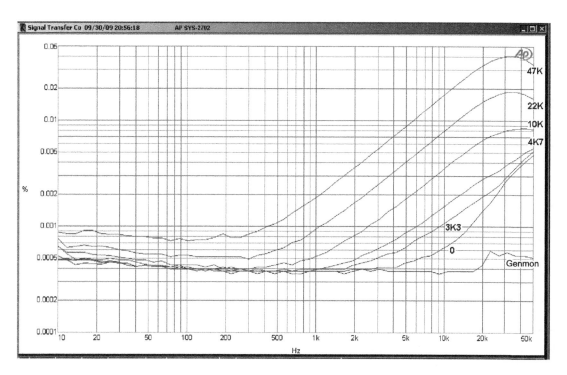

Figure 4.7 5532 distortion in a voltage-follower circuit with a selection of source resistances test level 10 Vrms. Supply ±18 V. The lowest trace is the analyser output measured directly, as a reference.

Close examination reveals the intriguing fact that a 1 kΩ source actually gives *less* distortion than no source resistance at all, reducing THD from 0.00065% to 0.00055% at 10 kHz. Minor resistance variations around 1 kΩ make no difference. This must be due to the cancellation of distortion from two different mechanisms. It is hard to say whether it is repeatable enough to be exploited in practice.

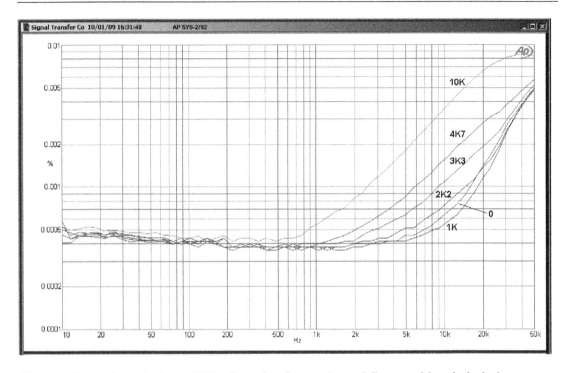

Figure 4.8 A closer look at 5532 distortion in a voltage-follower with relatively low source resistances; note that a 1 kΩ source resistance actually gives less distortion than none. Test level 10 Vrms. Supply ±18 V.

So, what's going on here? Is it simply due to non-linear currents being drawn by the opamp inputs? Audio power amplifiers have discrete input stages which are very simple compared with those of most opamps and draw relatively large input currents. These currents show appreciable non-linearity even when the output voltage of the amplifier is virtually distortion-free and if they flow through significant source resistances will introduce added distortion [4].

If this was the case with the 5532 then the extra distortion would manifest itself whenever the opamp was fed from a significant source resistance, no matter what the circuit configuration. But we have just seen that it only occurs in series-feedback situations; increasing the source resistance in a shunt-feedback does not perceptibly increase distortion. The effect may be present but if so it is very small, no doubt because opamp signal input currents are also very small, and it is lost in the noise.

The only difference is that the series circuit has a CM voltage of about 3 Vrms, while the shunt circuit does not, and the conclusion is that with a bipolar input opamp, you must have *both* a CM voltage and a significant source resistance to see extra distortion. The input stage of a 5532 is a straightforward long-tailed pair (see Figure 4.23) with a simple tail current source and no fancy cascoding, and I suspect that the Early Effect operates on it when there is a large CM voltage, modulating the quite high input bias currents, and this is what causes the distortion. The signal input currents are much smaller, due to the high open-loop gain of the opamp, and as we have seen appear to have a negligible effect.

Common-mode distortion: JFET opamps

FET-input opamps behave differently from bipolar-input opamps. Take a look at Figure 4.9, taken from a TL072 working in shunt and in series configuration with a 5 Vrms output. The circuits are as in Figure 4.3a and 4.3b, except that the resistor values have to be scaled up to 10 kΩ and 22 kΩ because the TL072 is nothing as good at driving loads as the 5532. This unfortunately means that the inverting input is seeing a source resistance of 10 k∥22 k = 6.9k, which introduces a lot of CM distortion—five times as much at 20 kHz as for the shunt case. Adding a similar resistance in the input path cancels out this distortion, and the trace then is the same as the "shunt" trace in Figure 4.9. Disconcertingly, the value that achieved this was not 6.9 k, but 9k1. That means adding −113 dBu of Johnson noise, so it's not always appropriate.

It's worth mentioning that the flat part of the shunt trace below 10 kHz is not noise, as it would be for the 5532; it is distortion.

A voltage-follower has no inconvenient medium-impedance feedback network, but it does have a much larger CM voltage. Figure 4.10 shows a voltage-follower working at 5 Vrms. With no source resistance the distortion is quite low, due to the 100% NFB, but as soon as a 10 kΩ source resistance is added we are looking at 0.015% at 10 kHz.

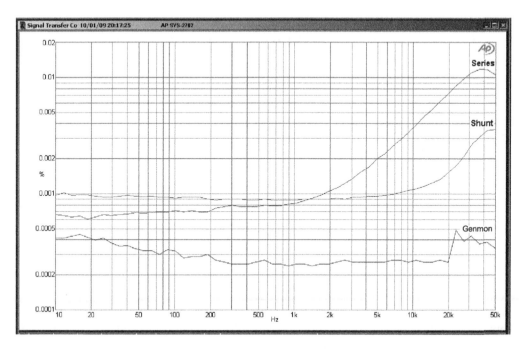

Figure 4.9 A TL072 shunt-feedback stage using 10 kΩ and 22 kΩ resistors shows low distortion. The series version is much worse due to the impedance of the NFB network, but it can be made the same as the shunt case by adding cancellation source resistance in the input path. No external loading. Test level 5 Vrms. Supply ±18 V.

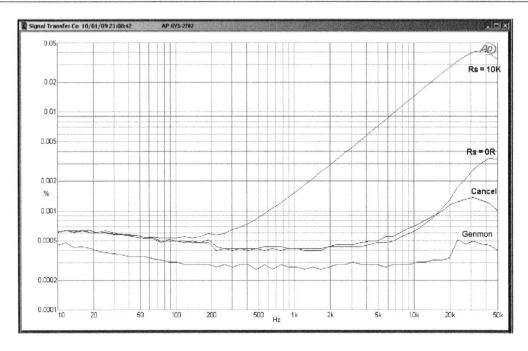

Figure 4.10 A TL072 voltage-follower working at 5 Vrms with a low source resistance produces little distortion (Rs = 0R) but adding a 10 kΩ source resistance makes things much worse (Rs = 10 k). Putting a 10 kΩ resistance in the feedback path as well gives complete cancellation of this extra distortion (Cancel). Supply ±18 V.

Once again, this can be cured by inserting an equal resistance in the feedback path of the voltage-follower, as in Figure 4.3d. This gives the "Cancel" trace in Figure 4.10. Adding resistances for distortion cancellation in this way has the obvious disadvantage that they introduce extra Johnson noise into the circuit. Another point is that stages of this kind are often driven from pot wipers, so the source impedance is variable, ranging between zero and 1/4 of the pot track resistance. Setting a balancing impedance in the other opamp input to a mid-value, ie 1/8 of the track resistance, should reduce the average amount of input distortion, but it is inevitably a compromise.

With JFET inputs the problem is not the operating currents of the input devices themselves, which are negligible, but the currents drawn by the non-linear junction capacitances inherent in field-effect devices. These capacitances are effectively connected to one of the supply rails. For P-channel JFETs, as used in the input stages of most JFET opamps, the important capacitances are between the input JFETs and the substrate, which is normally connected to the V-rail. See Jung [5].

According to the Burr-Brown data sheet for the OPA2134, "the P-channel JFETs in the input stage exhibit a varying input capacitance with applied CM voltage." It goes on to recommend that the input impedances should be matched if they are above 2 kΩ.

Common-mode distortion can be minimised by running the opamp off the highest supply rails permitted, though the improvements are not large. In one test on a TL072 going from ±15 V to ±18 V rails reduced the distortion from 0.0045% to 0.0035% at 10 kHz.

Selecting the right opamp

Until recently, the 5532 was pre-eminent. It is found in almost every mixing console and in a large number of preamplifiers. Distortion is very low, even when driving 600 Ω loads. Noise is very low, and the balance of voltage and current noise in the input stage is well-matched to moving-magnet phono cartridges; in many applications discrete devices give no significant advantage. Large-quantity production has brought the price down to a point where a powerful reason is required to pick any other device.

The 5532 is not, however, perfect. It suffers common-mode distortion. It has high bias and offset currents at the inputs, as an inevitable result of using a bipolar input stage (for low noise) without any sort of bias-cancellation circuitry. The 5532 is not in the forefront for DC accuracy, though it's not actually that bad. The offset voltage spec is 0.5 mV typical, 4 mV max, compared with 3 mV typical, 6 mV max for the popular TL072. I have actually used 5532s to replace TL072s when offset voltage was a problem, but the increased bias current was acceptable.

With horrible inevitability, the very popularity and excellent technical performance of the 5532 has led to it being criticised by Subjectivists who have contrived to convince themselves that they can tell opamps apart by listening to music played through them. This always makes me laugh because there is probably no music on the planet that has not passed through a hundred or more 5532s on its way to the consumer.

The LM4562 represents a real advance on the 5532. It is, however, still a good deal more expensive and is not perfect—it appears to be more easily damaged by excess common-mode voltages, and there is some evidence it is more susceptible to RF demodulation.

In some applications, such as low-cost mixing consoles, bipolar-style bias currents are a real nuisance because keeping them out of EQ pots to prevent scratching noises requires an inappropriate number of blocking capacitors. There are plenty of JFET input opamps around with negligible bias currents, but there is no obviously superior device that is the equivalent of the 5532. The TL072 has been used in this application for many years, but its HF linearity is not first-class and distortion across the band deteriorates badly as output loading increases. However, the opamps in many EQ sections work in the shunt-feedback configuration with no CM voltage on the inputs, and this reduces the distortion considerably. When low bias currents are needed with superior performance then the OPA2134 is often a good choice, though it is at least four times as expensive as the TL072.

Opamps surveyed: BJT input types

The rest of this chapter looks at some opamp types and examines their performance, with the 5532 the usual basis for comparison. The parts shown here are not necessarily intended as audio opamps, though some, such as the OP275 and the OPA2134, were specifically designed as such.

They have, however, all seen use, in varying numbers, in audio applications. Bipolar input opamps are dealt with first.

The LM741 opamp

The LM741 is only included here for its historical interest; in its day it was a most significant development, and to my mind, the first really practical opamp. It was introduced by Fairchild in 1968 and is considered a second-generation opamp—the 709 being first generation.

The LM741 had (and indeed has) effective short-circuit protection and internal compensation for stability at unity gain and was much easier to make work in a real circuit than its predecessors. It was clear that it was noisy compared with discrete circuitry, and you sometimes had to keep the output level down if slew-limiting was to be avoided, but with care it was usable in audio. Probably the last place the LM741 lingered was in the integrators of state-variable EQ filters, where neither indifferent noise performance nor poor slewing capability is a serious problem; see Chapter 15 for more details on this application. The LM741 is a single opamp. The dual version is the LM747.

Figure 4.11 shows a region between 100 Hz and 4 kHz where distortion rises at 6 dB/octave. This is the result of the usual dominant-pole Miller compensation scheme and not slew limiting. When slew limiting does begin, around 8 kHz, the slope increases and THD rises rapidly with frequency.

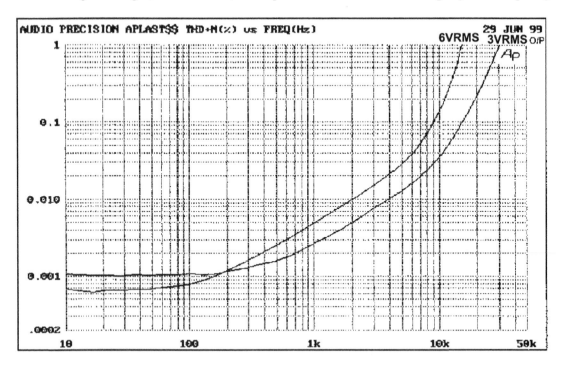

Figure 4.11 The THD performance of an LM741 working at a gain of 3x, on ±15 V rails, giving 3 Vrms and 6 Vrms outputs, with no load. At 6 Vrms, slew distortion exceeds 1% before 20 kHz is reached; there is visible slew limiting in the waveform. THD is, however, very low at 100 Hz due to the high NFB factor at low frequencies.

The NJM4580 opamp

The NJM4580 opamp is very widely used in Asian audio products; it is available at a low price in these markets. When lightly loaded it is comparable with the 5532 in distortion performance, but it is not very linear when driving 500 Ω loads; the performance is summarised in Figures 4.12 and 4.13, which are very similar. Note the high output level of 10 Vrms.

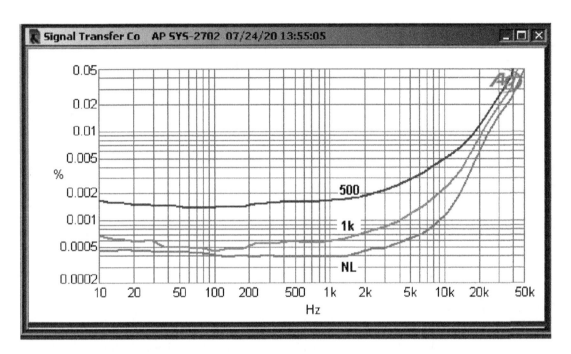

Figure 4.12 **THD performance of an NJM4580 working with shunt feedback at a gain of 2.2x, on ±18 V rails, giving 10 Vrms output, with no load, and 1 kΩ and 500 Ω external loads.**

For Figure 4.12 (shunt feedback), the input resistor was 1 kΩ and the feedback resistor 2k2; note the latter has to be driven by the opamp output as well the external load. For Figure 4.13 (series feedback), the lower feedback resistor was 1 kΩ and the upper feedback resistor 2k2. The noise performance of the NJM4580 is usually quoted as an input-referred noise voltage with RIAA equalisation (with a non-standard input load), and that is not very helpful. I have determined the input voltage noise density to be 3.0 nV/√Hz, which is better than the 5 nV/√Hz of the 5532A but comparable with the 5534. I have no data for the input current noise density; given the BJT input devices it will in many cases be significant. The internal circuitry is simple and is in the public domain, though the component values are not.

Unusually, the NJM4580 is available in a SIL 8-pin package, as well as DIL and SM packages.

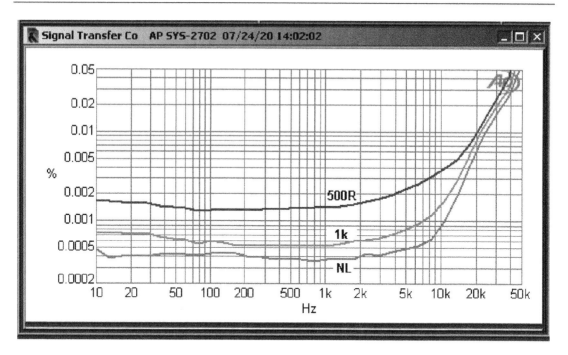

Signal Transfer Co AP SYS-2702 07/24/20 14:02:02

Figure 4.13 THD performance of an NJM4580 working with series feedback at a gain of 3.2x, on ±18 V rails, giving 10 Vrms output, with no load, and 1 kΩ and 500 Ω external loads.

The NJM8068 opamp

The NJM8068 opamp is a newer device than the NJM4580, but it does not exactly open new vistas of performance. It has less load-driving ability and markedly higher distortion under the same circuit conditions; see Figures 4.14 and 4.15. The input voltage noise density is specified as 3.5 nV/√Hz, the same as a 5534A, but this is a dual part so it may be better value for money; this seems to be its only advantage. There are, again, no specs for the input current noise density; since the input devices are BJT it will often be significant.

The NE5532/5534 opamp

The 5532 is a low-noise, low distortion bipolar dual opamp with internal compensation for unity-gain stability. The 5534 is a single version internally compensated for gains down to three times, and an external compensation capacitor can be added for unity-gain stability; 22 pF is the usual value. The 5532 achieves unity-gain stability by having degeneration resistors in the emitter circuits of the input transistors to reduce the open-loop gain, and this is why it is noisier than the 5534.

The common-mode range of the inputs is a healthy ±13 V, with no phase inversion problems if this is exceeded. It has a distinctly higher power consumption than the TL072, drawing approximately 4 mA per opamp section when quiescent. The DIL version runs perceptibly warm when quiescent on ±17 V rails.

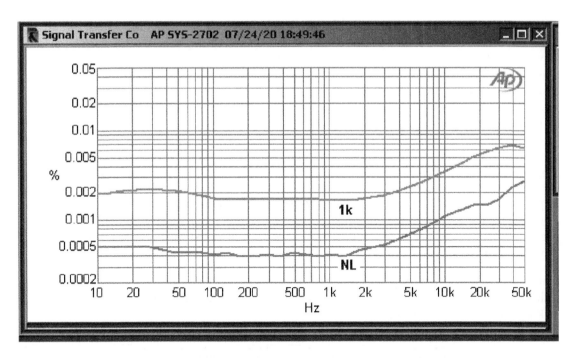

Figure 4.14 THD performance of an NJM8068 working with shunt feedback at a gain of 2.2x, on ±18 V rails, giving 10 Vrms output, with no load, and 1 kΩ external load.

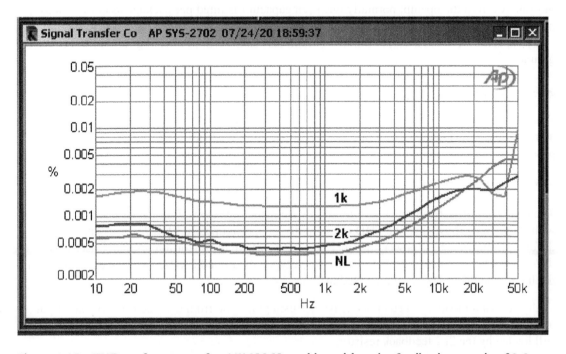

Figure 4.15 THD performance of an NJM8068 working with series feedback at a gain of 3.2x, on ±18 V rails, giving 10 Vrms output, with no load, and 1 kΩ and 2 kΩ external loads.

The 5534/5532 has bipolar transistor input devices. This means it gives low noise with low source resistances but draws a relatively high bias current through the input pins. The input devices are NPN, so the bias currents flow into the chip from the positive rail. If an input is fed through a significant resistance then the input pin will be more negative than ground due to the voltage drop caused by the bias current. The inputs are connected together with back-to-back diodes for reverse-voltage protection and should not be forcibly pulled to different voltages. The 5532 is intended for linear operation, and using it as a comparator is not recommended.

As can be seen from Figures 4.16 and 4.17, the 5532 is almost distortion-free, even when driving the maximum 500 Ω load. The internal circuitry of the 5532 has never been officially explained but appears to consist of nested Miller loops that permit high levels of internal negative feedback. The 5532 is the dual of the 5534 and is much more commonly used than the single as it is cheaper per opamp and does not require an external compensation capacitor when used at unity gain.

The 5532/5534 is made by several companies, but they are not all created equal. Those by Fairchild, JRC, and ON-Semi have significantly lower THD at 20 kHz and above, and we're talking about a factor of two or three here.

The 5532 and 5534 type opamps require adequate supply-decoupling if they are to remain stable; otherwise they appear to be subject to some sort of internal oscillation that degrades linearity without being visible on a normal oscilloscope. The essential requirement is that the V+ and V− rails should have a 100 nF capacitor between them at a distance of not more than a few millimetres from the opamp; normally one such capacitor is fitted per package as close to it as possible. It is *not* necessary and definitely undesirable to have two capacitors going to ground; every capacitor between a supply rail and ground carries the risk of injecting rail noise into the ground.

5532 output loading in shunt feedback mode

When a significant load is placed on a 5532 output, the distortion performance deteriorates in a predictable way. Figure 4.16 shows the effect on a shunt feedback amplifier (to eliminate the possibility of input common-mode distortion). The output of the opamp is, of course, always loaded by the feedback resistor, which is effectively connected to ground at its other end. The circuit is as Figure 4.1a with a load resistor to ground added.

There are two differing regimes visible. At low frequencies (below 10 kHz) the distortion is flat with frequency. Above this, the THD rises rapidly, at approximately 12 dB/octave. This is very different from Blameless power amplifier behaviour, where the distortion normally rises at only 6 dB/octave when it emerges from the noise floor, typically around 2 kHz. The increase in THD in the flat region (at 1 kHz) is summarised in Table 4.4.

With external no load, the THD trace is barely distinguishable from the Audio Precision output until we reach 10 kHz, where the THD rises steeply. In this condition, the opamp is, of course, still loaded by the 2k2 feedback resistor.

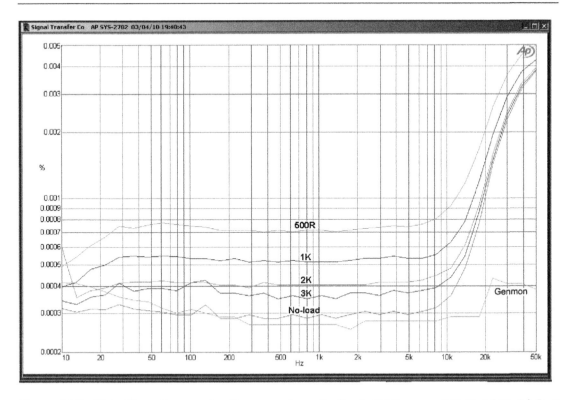

Figure 4.16 The effect of output loading on a shunt-feedback 5532 stage; 500 Ω, 1 kΩ, 2 kΩ, 3 kΩ, and No Load, plus genmon (bottom trace). Feedback resistors 1 kΩ and 2k2, noise gain 3.2 times. Output 9 Vrms. Supply ±18 V.

TABLE 4.4 THD at 1 kHz for varying external loads on a shunt-feedback 5532. Conditions as for Figure 4.16

External load resistance Ω	THD at 1 kHz
No external load	0.00030%
3 kΩ	0.00036%
2 kΩ	0.00040%
1 kΩ	0.00052%
500 Ω	0.00072%

The 5532 with series feedback

Figure 4.17 shows the distortion from a 5532 working in series-feedback mode. Note that the stage gain is greater at 3.2 times, but the opamp is working at the same noise gain as before and so has the same amount of negative feedback available to reduce distortion. The working conditions are, however, less favourable than with shunt feedback, as we shall see in the next section on

common-mode problems, and distortion now begins to rise from 5 kHz and reaches 0.0025% at 20 kHz, as opposed to 0.0014% at 20 kHz for the shunt version in Figure 4.16.

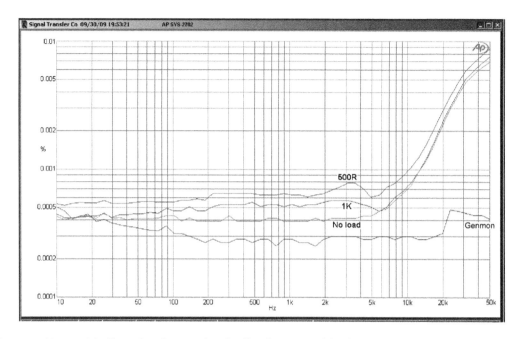

Figure 4.17 **5532 distortion in a series feedback stage with 2k2 and 1 kΩ feedback resistors, (gain 3.2 times) and zero source resistance. The output level is 10 Vrms with 500 Ω, 1 kΩ loads, and no load. The genmon trace is the output of the distortion analyser measured directly. Supply ±18 V.**

Figure 14.17 also shows the effect of loading the output. As for the shunt case, the increased distortion is mostly apparent in the flat LF section of the traces.

Common-mode distortion in the 5532

The relevant figures for this section are in the earlier section on general common-mode distortion in bipolar input opamps.

In a series-feedback amplifier with a gain of 3.2 times the CM voltage is 3.1 Vrms for a 10 Vrms output. See Figure 4.6. The trace labelled "0R" (ie no source resistance) is the same as the "No load" trace of Figure 4.17. The source resistance seen by the inverting input is not zero because of the impedance of the feedback network, but this is only 2k2 in parallel with 1 kΩ—in other words 687 Ω. Figure 4.6 implies that this will have only a very small effect but more on that later. When we add some source resistance Rs, the picture is radically worse with serious mid-band distortion rising at 6 dB/octave and roughly proportional to the amount of resistance added. We will note it is 0.0015% at 10 kHz with Rs = 10 kΩ. The horizontal low-frequency parts of the traces are raised by the Johnson noise from the source resistances and also by the opamp current noise flowing in those resistances.

The worst case for CM distortion is the voltage-follower configuration, as in Figure 4.1c, where the CM voltage is equal to the output voltage. Voltage-followers typically give low distortion because they have the maximum possible amount of negative feedback, and Figure 4.8 shows that even with a CM voltage of 10 Vrms, the distortion when driven from a low impedance is no greater than for the shunt mode. However, when source resistance is inserted in series with the input, the distortion mixture of second, third, and other low-order harmonics increases markedly; in the 3.2 times stage 10 kΩ of source resistance caused 0.0015% THD at 10 kHz, but with a voltage-follower we get 0.0035%. The distortion increases with output level, approximately quadrupling as level doubles. Figure 4.8 shows what happens with source resistances of 10 kΩ and below; when the source resistance is below 2k2, the distortion is close to the zero source resistance trace.

Close examination of Figure 4.8 reveals the intriguing fact that a 1 kΩ source actually gives *less* distortion than no source resistance at all, reducing THD from 0.00065% to 0.00055% at 10 kHz. Minor variations around 1 kΩ make no measurable difference. This effect is due to the 1 kΩ source resistance cancelling the effect of the source resistance of the feedback network, which is 1 kΩ in parallel with 2k2, ie 688 Ω. The improvement is small, but if you are striving for the very best linearity, the result of deliberately adding a small amount of source resistance appears to be repeatable enough to be exploited in practice. A large amount will compromise the noise performance, as seen in Figure 4.6, and this is another argument for keeping feedback network impedances as low as practicable without impairing distortion due to excessive loading.

This CM distortion behaviour is unfortunate because voltage-followers are very frequently required in active crossover design, primarily in Sallen & Key filters but also for general buffering purposes. The only cure is to keep the source impedances low, which is obviously a good idea from the noise point of view also. A total of 2 kΩ is about as high as you want to go, and this is why the lowpass Sallen & Key filters in Chapter 6 have been given series resistors that do not exceed this value.

So what exactly is going on here with common-mode distortion? Is it simply due to non-linear currents being drawn by the opamp inputs? Audio power amplifiers have discrete input stages which are very simple compared with those of most opamps and draw relatively large input currents. These currents show appreciable non-linearity even when the output voltage of the amplifier is virtually distortion-free and if they flow through significant source resistances will introduce added distortion [6].

If this was the case with the 5532 then the extra distortion would manifest itself whenever the opamp was fed from a significant source resistance, no matter what the circuit configuration. But as we saw earlier, it only occurs in series-feedback situations; increasing the source resistance in a shunt-feedback amplifier does not perceptibly increase distortion.

The only difference is that the series circuit has a CM voltage of about 3 Vrms, while the shunt circuit does not, and the conclusion is that with a bipolar input opamp, you must have *both* a CM voltage and a significant source resistance to see extra distortion. The input stage of a 5532 is a straightforward long-tailed pair with a simple tail current source and no fancy cascoding, and I suspect that the Early Effect is significant when there is a large CM voltage, modulating the quite high input bias currents, and this is what causes the distortion. The signal input currents are much smaller due to the high open-loop gain of the opamp and as we have seen appear to have a negligible effect.

Reducing 5532 distortion by output stage biasing

There is a useful, though relatively little-known (and where it is known, almost universally misunderstood) technique for reducing the distortion of the 5532 opamp. While the general method may be applicable to some other opamp types, here I concentrate on the 5532. This has a unique output stage and it must not be assumed that the relationships or results will be emulated by any other opamp type.

The principle is that if a biasing current of the right polarity is injected into the opamp output, then the output stage distortion can be significantly reduced. This technique is sometimes called 'output stage biasing' though it must be understood that the DC voltage conditions are not significantly altered; because of the high level of voltage feedback, the actual DC potential at the output is shifted by only a tenth of a milliVolt or so.

You may have recognised that this scheme is very similar to the Crossover Displacement (Class XD) system I introduced for power amplifiers, which also injects an extra current, either steady or signal-modulated, into the amplifier output [7]. It is not, however, quite the same in operation. In power amplifiers the main aim of crossover displacement is to prevent the output stage from traversing the crossover region at low powers. In the 5532, at least, the crossover region is not easy to spot on the distortion residual, the general effect being of second and third-harmonic distortion rather than spikes or edges. The 5532 output stage is not a conventional symmetrical Class-AB configuration; it is more linear when it is pulling down rather than pulling up, and the biasing current is compensating for this.

For the 5532, the current *must* be injected from the positive rail; currents from the negative rail make the distortion emphatically worse. This confirms that the output stage of the 5532 is in some way asymmetrical in operation, for if it was simply a question of suppressing crossover distortion by crossover displacement, a bias current of either polarity would be equally effective. The continued presence of the crossover region, albeit displaced, would mean that the voltage range of reduced distortion would be quite small and centred on 0 V. It is rather the case that there is a general reduction in distortion across the whole of the 5532 output range, indicating that the 5532 output stage is better at sinking current than sourcing it, and therefore injecting a positive current is effective at helping out.

Figure 4.18a shows a 5532 running in shunt-feedback mode with a moderate output load of 1 kΩ; the use of shunt feedback makes it easier to see what's going on by eliminating the possibility of common-mode distortion. With normal operation we get the upper trace in Figure 4.19, labelled "No bias." If we then connect a 3k3 current-injection resistor between the output and to the V+ rail, we find that the LF distortion (the flat bit) drops almost magically, giving the trace labelled "3k3," which is only just above the genmon trace. Since noise makes a significant contribution to the THD residual at these levels, the actual reduction in distortion is greater than it appears.

The optimum resistor value for the conditions shown (5 Vrms and 1 kΩ load) is about 3k3, which injects a 5.4 mA current into the output pin. A 2k2 resistor gives greater distortion than 3k3, in part due to the extra loading it imposes on the output; in AC terms the injection resistor is effectively in parallel with the output load. In fact, 3k3 seems to be close to the optimal value for a wide range of output levels and output loadings.

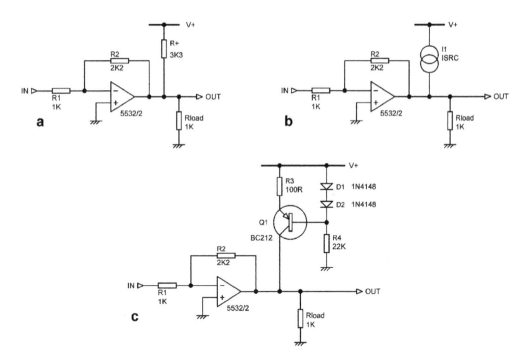

Figure 4.18 Reducing 5532 distortion in the shunt feedback mode by biasing the output stage with a current injected through a resistor R+ or a current source.

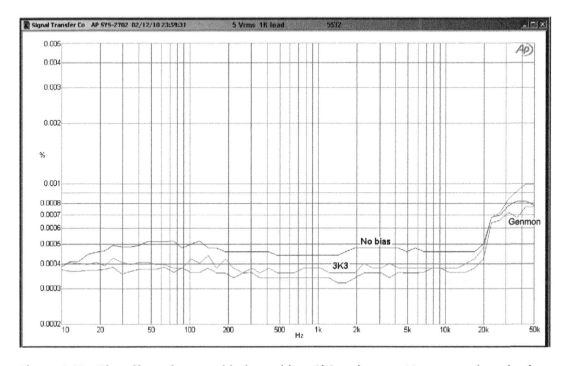

Figure 4.19 The effect of output biasing, with a 3k3 resistor to V+, on a unity-gain shunt-feedback 5532 stage. Output load 1 kΩ, input and feedback resistors are 2k2, noise gain 2.0 times. Output 5 Vrms. Supply ±18 V.

The extra loading that is put on the opamp output by the injection resistor is a disadvantage, limiting the improvement in distortion performance that can be obtained. By analogy with the canonical series of Class-A power amplifier outputs [8], a more efficient and elegant way to inject the required biasing current is by using a current-source connected to the V+ rail, as in Figure 4.18b. Since this has a very high output impedance, the loading on the opamp output is not increased. Figure 4.18c shows a simple but effective way to do this; the current source is set to the same current as the 3k3 resistor injects when the output is at 0V (5.4 mA), but the improvement in distortion is greater. There is nothing magical about this current; increasing the injection current to 8.1 mA gives only a small further improvement in the THD reading, and in some cases may make it worse; also the circuit dissipation is considerably increased, and in general I would not recommend using a current-source value of greater than 6 mA. Here in Table 4.5 there are typical figures for a unity-gain shunt amplifier as before, with the loading increased to 680 Ω to underline that the loading is not critical; output biasing is effective with a wide range of loads.

TABLE 4.5 Output biasing improvements with unity gain shunt feedback, 5 Vrms out, load 680 Ω, supply ±18 V

Injection method	THD at 1 kHz (22 kHz bandwidth)
None	0.00034%
3k3 resistor	0.00026%
5.4 mA current-source	0.00023%
8.1 mA current-source	0.00021%

As mentioned before, at such low THD levels the reading is largely noise, and the reduction of the distortion part of the residual is actually greater than it looks from the raw figures. Viewing the residual shows a dramatic difference.

You might be concerned about the C_{bc} of the transistor, which is directly connected to the opamp output. The 5532/5534 is actually pretty resistant to HF instability caused by load capacitance, and in the many versions of this configuration I tested I have had no problems whatever. The presence of the transistor does not reduce the opamp output swing.

Output biasing is also effective with series feedback amplifier stages in some circumstances. Table 4.6 shows it working with a higher output level of 9.6 Vrms and a 1kΩ load. The feedback resistors were 2k2 and 1 kΩ to keep the source resistance to the inverting input low.

TABLE 4.6 Output biasing improvements with 3.2 times gain, series feedback, 9.6 Vrms out, load 1 kΩ, supply ±18 V

Injection method	THD at 1 kHz (22 kHz bandwidth)
None	0.00037%
3k3 resistor	0.00033%
5.4 mA current-source	0.00027%
8.1 mA current-source	0.00022%

The output biasing technique is, in my experience, only marginally useful with voltage-followers, as the increased feedback factor with respect to a series amplifier with gain reduces the output distortion below the measurement threshold. Table 4.7 demonstrates this.

TABLE 4.7 Output biasing improvements for voltage-follower, 9.6 Vrms out, load 680 Ω, supply ±18 V

Injection method	THD at 1 kHz (22 kHz bandwidth)
None	0.00018% (almost all noise)
3k3 resistor	0.00015% (all noise)
5.4 mA current-source	0.00015% (all noise)
8.1 mA current-source	0.00015% (all noise)

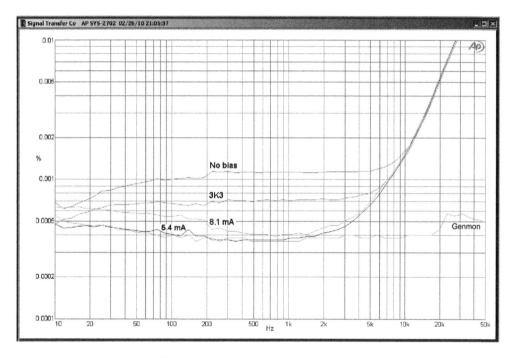

Figure 4.20 Reducing 5532 distortion with series feedback by biasing the output stage with a 3k3 resistor, or 5.2 or 8.1 mA current sources. Gain 14 times, no external load. Test level 5 Vrms out, supply ±18 V.

As a final example, Figure 4.20 shows that the output biasing technique is still effective with higher gains, here 14 times. The distortion with the 5.4 mA source is barely distinguishable from the testgear output up to 2 kHz. The series-feedback stage had its gain set by 1k3 and 100 Ω feedback resistors, their values being kept low to minimise common-mode distortion. It also underlines the point that in some circumstances an 8.1 mA current source gives worse results than the 5.4 mA version.

When extra common-mode distortion is introduced by the presence of a significant source resistance, this extra distortion is likely to swamp the improvement due to output biasing. In a 5532 amplifier stage with a gain of 3.2 times and a substantial source resistance, the basic output distortion with a 1 kΩ load at 9.6 Vrms, 1 kHz out was 0.0064%. A 3k3 output biasing resistor to V+ reduced this to 0.0062%, a marginal improvement at best, and an 8.1 mA current-source could only reduce it to 0.0059%.

Earlier I said that the practice of output stage biasing appears to be pretty much universally misunderstood, judging by how it is discussed on the internet. The evidence is that every application of it that my research has exposed shows a resistor (or current source) connected between the opamp output and the *negative* supply rail. This is very likely based on the assumption that displacing the crossover region in either direction is a good idea, coupled with a vague feeling that a resistor to the negative rail is somehow more 'natural.' However, the assumption that the output stage is symmetrical may be incorrect; as we have seen, it is certainly not true for the 5532/5534. For the 5532—which surely must be the most popular audio opamp by a long way—a pulldown resistor would be completely inappropriate as it *increases* rather than decreases the output stage distortion.

You may be thinking that this is an ingenious method of reducing distortion but rather clumsy compared with simply using a more linear opamp like the LM4562. This is true, but on the other hand, if the improvement from output biasing is adequate, it will be much cheaper than switching to a more advanced opamp that costs ten times as much, and may be currently hard to find.

Which 5532?

It is an unsettling fact that not all 5532s are created equal. The part is made by a number of manufacturers, and there are definite performance differences. While the noise characteristics appear to show little variation in my experience, the distortion performance does vary noticeably from one manufacturer to another. Although, to the best of my knowledge, all versions of the 5532 have the same internal circuitry, they are not necessarily made from the same masks, and even if they were there would inevitably be process variations between manufacturers.

The main 5532 sources at present are Texas Instruments, Fairchild Semiconductor, ON Semiconductor (was Motorola), NJR (New Japan Radio), and JRC (Japan Radio Company). I took as wide a range of samples as I could, ranging from brand-new devices to parts over 20 years old, and it was reassuring to find that without exception, every part tested gave the good linearity we expect from a 5532. But there were differences. I did THD tests on six samples from Fairchild, JRC, and Texas, plus one old Signetics 5532 for historical interest.

All tests were done using a shunt-feedback stage with a gain of unity, both input and feedback resistors being 2 kΩ; the supply rails were ±18 V. The output level was high at 10.6 Vrms, only slightly below clipping. No external load was applied, so the load on the output was solely the 2 kΩ feedback resistor; applying extra loading will make the THD readings worse. The test instrumentation was an Audio Precision SYS-2702.

For most of the manufacturers' distortion only starts to rise very slowly above the measurement floor at about 5 kHz and remains well below 0.0007% at 20 kHz. The exceptions were the six Texas 5532s, which surprisingly consistently showed somewhat higher distortion at high

frequencies. Distortion at 20 kHz ranged from 0.0008% to 0.0012%, showing more variation than the other samples as well as being generally higher in level. The low-frequency section of the plot, below 10 kHz, was at the measurement floor, as for all the other devices, and distortion is only just visible in the noise. Compared with other maker's parts, the THD above 20 kHz is much higher—at least 3 times greater at 30 kHz. Fortunately this should have no effect unless you have very high levels of ultrasonic signals that could cause intermodulation. If you do, then you have bigger problems than picking the best opamp manufacturer.

All of the measurements given in this book were performed using the Texas version of the 5532 to ensure worst-case results. If you use 5532s from one of the other manufacturers then your high frequency distortion results should be somewhat better.

The 5534 opamp

The single-opamp 5534 is somewhat neglected compared with the 5532, often being regarded as the same thing but inconveniently packaged with only one opamp per 8-pin DIL and in many cases requiring the expense of an external compensation capacitor. However, it can, in fact, be extremely useful when a somewhat better performance than the 5532 can give needs to be achieved economically, as it is between two and three times as expensive per opamp as the 5532 but about five times cheaper than the still somewhat exotic LM4562. The price ratio is likely to be nearer two when purchasing large quantities. There was once a 5533 which was basically a dual 5534, with external compensation and offset null facilities in a 14-pin DIL package, but it seems to have achieved very little market penetration—the only place I have ever seen one is on the equaliser board of the famous EMT turntable. However, Philips was still putting out spec sheets for it in 1994.

The 5534 has a very significant distortion advantage when gains of greater than unity are required because the lighter internal compensation means that an NFB factor three times greater can be applied with distortion reduced proportionally.

The 5534 also has lower noise than the 5532; its input voltage noise density is 3.5 uV/√Hz rather than 5 uV/√Hz. This means that in situations where the voltage noise dominates over the current noise—the sort of situation where you would want to use a BJT input opamp—the noise performance is potentially improved by 3.0 dB. Johnson noise from the circuit resistances is likely to reduce this difference in some cases.

Samuel Groner points out [9] that the higher voltage noise of the 5532 is almost certainly because the input pair has emitter degeneration resistors added to make unity-gain compensation easier. These are not shown on any internal schematic I have ever seen, but their presence is suggested by the fact that the 5532 has more voltage noise but much the same current noise and has a faster slew rate than a unity-gain compensated 5534 because its compensation capacitor can be smaller.

Figure 4.21 demonstrates the excellent linearity of an uncompensated 5534 with shunt feedback for 3.2 times gain and no external loading; distortion is 0.0005% at 20 kHz and 10 Vrms out. Compare this with Figure 4.17, which shows 0.0015% at 20 kHz for a 5532 section in the same situation. The 5534 distortion is reduced proportionally to the increased NFB factor, being three times less.

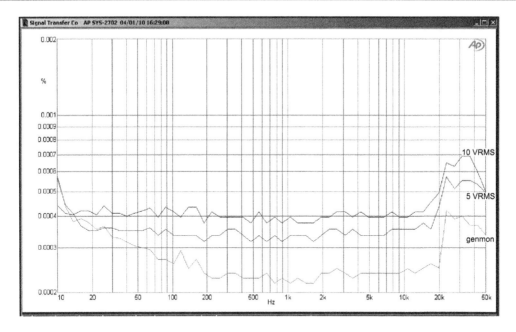

Figure 4.21 **Distortion from an uncompensated 5534 with shunt feedback with 3.2 times gain and no external loading, at 5 Vrms and 10 Vrms out. The genmon (testgear output) is also shown. Supply ±18 V.**

Figure 4.22 shows an uncompensated 5534 with series feedback for 3.2 times gain and no external loading; distortion is 0.00077% at 20 kHz and 10 Vrms out. Compare this with the "No-load" trace in Figure 4.18, which shows 0.0022% at 20 kHz for a 5532 section in the same situation. The reduction is again proportional to the increased NFB factor, being three times lower once more. Note that there is no source resistance added, so the 5534 is fed from a low impedance and will not exhibit CM distortion.

If the 5534 is used with external compensation to allow unity-gain stability, then the distortion advantage is lost but the better noise performance remains. The generally used value is 22 pF for unity-gain stability, though this does not, as far as I know, have any official seal of approval from a manufacturer. In fact I have often found that uncompensated 5534s were stable and apparently quite happy at unity-gain, but this is not something to rely on.

For a unity-gain shunt-feedback stage the opamp noise gain is two times. There appears to be no generally accepted value for the external compensation capacitor required in this situation, or other circuits requiring a 5534 to work at a noise gain of two, but I have always found that 10 pF does the job.

Deconstructing the 5532

To the best of my knowledge, virtually nothing has been published about the internal operation of the 5532. This is surprising given its unique usefulness as a high-quality audio opamp. I believe the secret of the 5532's superb linearity is the used of nested negative feedback inside the circuit, in the form of traditional Miller compensation.

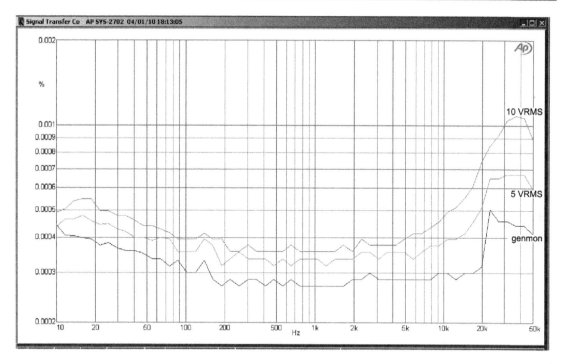

Figure 4.22 Distortion from an uncompensated 5534 with series feedback and 3.2 times gain, no external loading, at 5 Vrms and 10 Vrms out. Supply ±18 V.

Figure 4.23 shows the only diagram of the internal circuitry that has been released; the component and node numbers are mine. It has been in the public domain for at least 20 years, so I hope no one is going to object to my impertinent comments on it. The circuit initially looks like a confusing sea of transistors, and there is even a solitary JFET lurking in there, but it breaks down fairly easily. There are three voltage gain stages, plus a unity-gain output stage to increase drive capability. This has current-sensing overload protection. There is also a fairly complex bias generator which establishes the operating currents in the various stages.

In all conventional opamps there are two differential input signals which have to be subtracted to create a single output signal, and the node at which this occurs is called the "phase-summing point."

Q1, Q2 make up the input differential amplifier. They are protected against reverse-biasing by the diode-connected transistors across the input pins. Note there are no emitter degeneration resistors, which would linearise the input pair at the expense of degrading noise. Presumably high open-loop gain (note there are three gain stages, whereas a power amplifier normally only has two) means that the input pair is handling very small signal levels, so its distortion is not a problem.

Q3, Q4 make up the second differential amplifier; emitter degeneration is now present. Phase summing occurs at the output of this stage at Node 2. C1 is the Miller capacitor around this stage, from Node 2 to Node 1. Q5, Q6, Q7 are a Wilson current-mirror which provides a driven current-source as the collector load of Q4. The function of C4 is obscure, but it appears to balance C1 in some way.

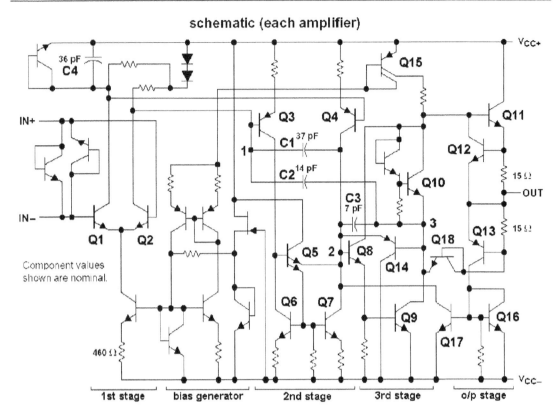

Figure 4.23 The internal circuitry of the 5534. Note absence of emitter resistors for Q1 and Q2.

The third voltage amplifier stage is basically Q9 with split-collector transistor Q15 as its current-source load. Q8 increases the basic transconductance of the stage, and C3 is the Miller capacitor around it, feeding from Node 3 to Node 2—note that this Miller loop does not include the output stage. Things are a bit more complicated here as it appears that Q9 is also the sink half of the Class-B output stage. Q14 looks very mysterious as it seems to be sending the output of the third stage back to the input; possibly it's some sort of clamp to ensure clean clipping, but to be honest I haven't a clue. Q10 plus associated diode generates the bias for the Class-B output stage, just as in a power amplifier.

The most interesting signal path is the semi-local Miller loop through C2, from Node 3 to Node 1, which encloses both the second and third voltage amplifiers; each of these have their own local Miller feedback, so there are two nested layers of internal feedback. This is probably the secret of the 5532's low distortion.

Q11 is the source side of the output stage, and as mentioned earlier, Q9 appears to be the sink. Q12, Q13 implement overcurrent protection. When the voltage drop across the 15 Ω resistor becomes too great, Q12 turns on and shunts base drive away from Q11. In the negative half-cycle, Q13 is turned on, which in turn activates Q17 to shunt drive away from Q8.

The biasing circuit shows an interesting point. Bipolar bias circuits tend not to be self-starting; no current flows anywhere until some flows somewhere, so to speak. Relying on leakage currents for starting is unwise, so here the depletion-mode JFET provides a circuit element that is fully on until you bias it off and can be relied upon to conduct as the power rails come up from zero.

More information on the internals of the 5534 can be found in [10].

The LM4562 opamp

The LM4562 is a new opamp, which first become freely available at the beginning of 2007. It is a National Semiconductor product. It is a dual opamp—there is no single or quad version. It costs about ten times as much as a 5532.

The input noise voltage is typically 2.7 nV/√Hz, which is substantially lower than the 4 nV/√Hz of the 5532. For suitable applications with low source impedances this translates into a useful noise advantage of 3.4 dB. The bias current is 10 nA typical, which is very low and would normally imply that bias-cancellation, with its attendant noise problems, was being used. However in my testing I have seen no sign of excess noise, and the data sheet is silent on the subject. No details of the internal circuitry have been released so far and quite probably never will be.

It is not fussy about decoupling, and as with the 5532, 100 nF across the supply rails close to the package should ensure HF stability. The slew rate is typically +/−20 V/us, more than twice as quick as the 5532.

The first THD plot in Figure 4.24 shows the LM4562 working at a closed-loop gain of 2.2x in shunt feedback mode, at a high level of 10 Vrms. The top of the THD scale is 0.001%, something you will see with no other opamp in this survey. The no-load trace is barely distinguishable from the AP SYS-2702 genmon output, and even with a heavy 500 Ω load driven at 10 Vrms there is only a very small amount of extra THD, reaching 0.0007% at 20 kHz.

Figure 4.25 shows the LM4562 working at a gain of 3.2x in series feedback mode, both modes having a noise gain of 3.2x. There is little extra distortion from 500 Ω loading.

For Figures 4.24 and 4.25 the feedback resistances were 2k2 and 1 kΩ, so the minimum source resistance presented to the inverting input is 687 Ω. In Figure 4.26 extra source resistances were then put in series with the input path (as was done with the 5532 in the section earlier on common-mode distortion), and this revealed a remarkable property of the LM4562—it is much more resistant to common-mode distortion than the 5532. At 10 Vrms and 10 kHz, with a 10 kΩ source resistance the 5532 generates 0.0014% THD (see Figure 4.6), but the LM4562 gives only 0.00046% under the same conditions. I strongly suspect that the LM4562 has a more sophisticated input stage than the 5532, probably incorporating cascoding to minimise the effects of common-mode voltages.

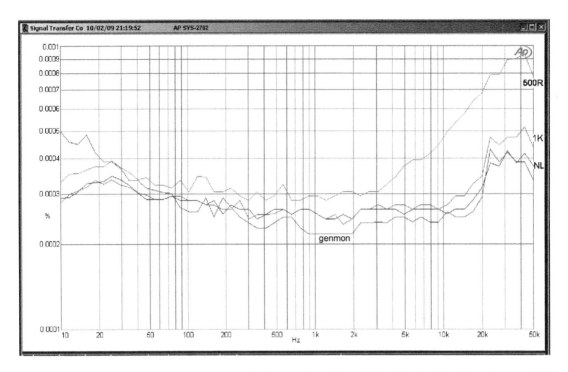

Figure 4.24 The LM4562 in shunt feedback mode, with 1 kΩ, 2k2 feedback resistors giving a gain of 2.2x. Shown for no load (NL) and 1 kΩ, 500 Ω loads. Note the vertical scale ends at 0.001% this time. Output level is 10 Vrms. ±18 V supply rails.

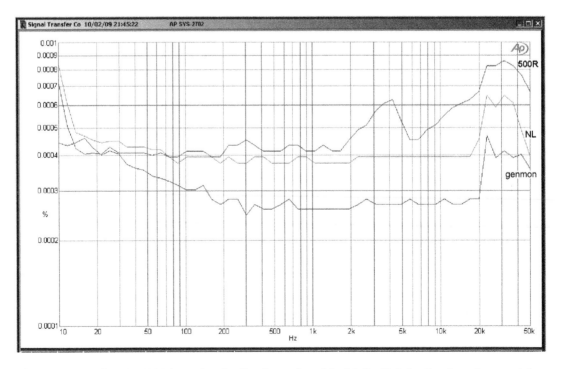

Figure 4.25 The LM4562 in series feedback mode, with 1 kΩ, 2k2 feedback resistors giving a gain of 3.2x. No load (NL) and 500 Ω load. 10 Vrms output. ±18 V supply rails.

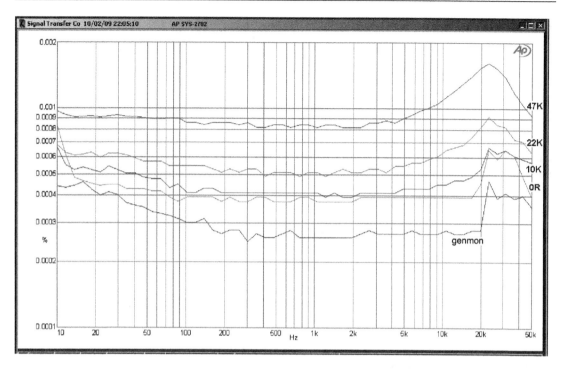

Figure 4.26 **The LM4562 in series feedback mode, gain 3.2x, with varying extra source resistance in the input path. The extra distortion is much lower than for the 5532. 10 Vrms out, +/−18 V supply rails.**

Note that only the rising curves to the right represent actual distortion. The raised levels of the horizontal traces at the LF end is due to Johnson noise from the extra series resistance.

The LM4562, in my experience, has an issue when it is working as a voltage-follower with 100% negative feedback. I have not heard about it anywhere else, and it may be just my batch of LM4562s, but in noise tests music and voices are audible in the noise floor. This can only be demodulation of RF, and I assume is due to some internal oscillation in the opamp allowing heterodyning; nothing is visible on a 100 MHz scope. It can be stopped by adding a 270 Ω resistor into the feedback path, though of course this not helpful if you are looking for the very lowest noise. It also appears not occur if there is even a tiny amount of gain in the stage; for example in my trials a 47 Ω resistor in the feedback path, with 1 kΩ to ground from the inverting pin (closed-loop gain = 1.047 times) gave no demodulation and may be a quieter solution if you don't need exactly unity gain. If 22 Ω in the feedback path is used instead, the voices return.

It has taken an unbelievably long time—nearly 30 years—for a better audio opamp than the 5532 to come along, but at last it has happened. The LM4562 is superior in just about every parameter, but it has much higher current noise. At present it also has a much higher price, but hopefully that will change.

The AD797 opamp

The AD797 (Analog Devices) is a single opamp with very low-voltage noise and distortion. It appears to have been developed primarily for the cost-no-object application of submarine sonar, but it works very effectively with normal audio—if you can afford to use it. The cost is something like 20 times that of a 5532. No dual version is available, so the cost ratio per opamp section is 40 times.

This is a remarkably quiet device in terms of voltage noise, but current noise is correspondingly high due to the high currents in the input devices. Early versions appeared to be rather difficult to stabilise at HF, but the current product is no harder to apply than the 5532. Possibly there has been a design tweak, or on the other hand my impression may be wholly mistaken.

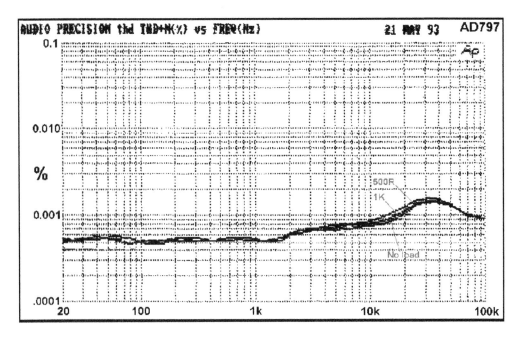

Figure 4.27 AD797 THD into loads down to 500 Ω, at 7.75 Vrms. Output is virtually indistinguishable from input. Series feedback, but no CM problems. Gain = 3.2x.

The AD797 incorporates an ingenious feature for internal distortion cancellation. This is described on the manufacturer's data sheet. Figure 4.27 shows that it works effectively.

The OP27 opamp

The OP27 from Analog Devices is a bipolar-input single opamp primarily designed for low noise and DC precision. It was not intended for audio use, but in spite of this it is frequently recommended for such applications as RIAA and tape head preamps. This is unfortunate, because

while at first sight it appears that the OP27 is quieter than the 5534/5532, as the e_n is 3.2 nV/rtHz compared with 4 nV/rtHz for the 5534, in practice it is usually slightly noisier. This is because the OP27 is in fact optimised for DC characteristics, and so it has input bias-current cancellation circuitry that generates common-mode noise. When the impedances on the two inputs are very different—which is the case in RIAA preamps—the CM noise does not cancel, and this appears to degrade the overall noise performance significantly.

For a bipolar input opamp, there appears to be a high level of common-mode input distortion, enough to bury the output distortion caused by loading; see Figures 4.28 and 4.29. It is likely that this too is related to the bias-cancellation circuitry, as it does not occur in the 5532.

The maximum slew rate is low compared with other opamps, being typically ±2.8 V/us. However, this is not the problem it may appear. This slew rate would allow a maximum amplitude at 20 kHz of 16 Vrms, if the supply rails permitted it. I have never encountered any particular difficulties with decoupling or stability of the OP27.

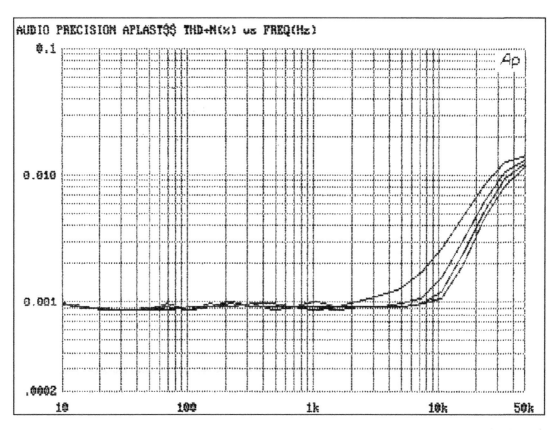

Figure 4.28 OP27 THD in shunt feedback mode with varying loads. This opamp accepts even heavy (1 kΩ) loading gracefully.

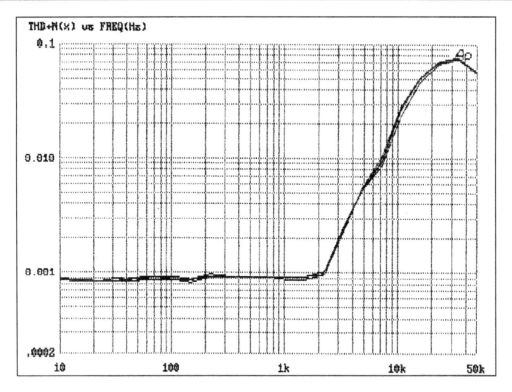

THD+N(%) vs FREQ(Hz)

Figure 4.29 OP27 THD in series feedback mode. The common-mode input distortion completely obscures the output distortion.

The OP270 opamp

The OP270 from Analog Devices is a dual opamp, intended as a "very low noise precision operational amplifier," in other words combining low noise with great DC accuracy. The input offset voltage is an impressively low 75 uV maximum. It has bipolar inputs with a bias current cancellation system; the presence of this is shown by the 15 nA bias current spec, which is 30 times less than the 500 nA taken by the 5534, which lacks this feature. It will degrade the noise performance with unequal source resistances, as it does in the OP27. The input transistors are protected by back-to-back diodes.

The OP270 distortion performance suffers badly when driving even modest loads. See Figures 4.30 and 4.31. The slew rate is a rather limited ±2.4 V/us, which is only just enough for a full output swing at 20 kHz. Note also that this is an expensive opamp, costing something like 25 times as much as a 5532; precision costs money. Unless you have a real need for DC accuracy, this part is not recommended.

The OP275 opamp

The Analog Devices OP275 is one of the few opamps specifically marketed as an audio device. Its most interesting characteristic is the Butler input stage which combines bipolar and JFET devices. The idea is that the bipolars give accuracy and low noise, while the JFETs give speed and "the sound quality of JFETs." That final phrase is not a happy thing to see on a datasheet from a major

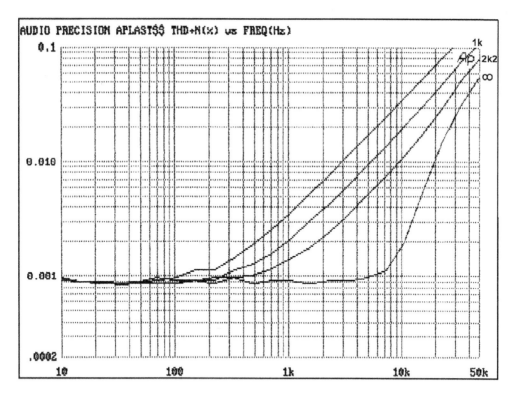

Figure 4.30 OP270 THD in shunt feedback mode. Linearity is severely degraded even with a 2k2 load.

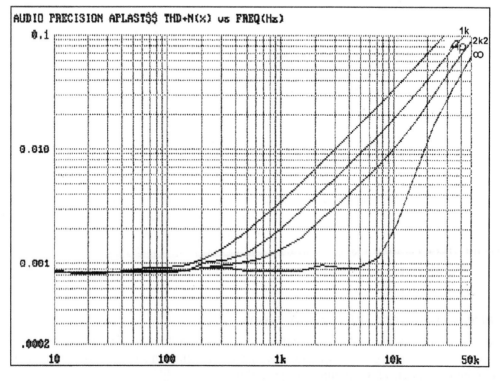

Figure 4.31 OP270 THD in series feedback mode. This looks the same as Figure 4.33 so CM input distortion appears to be absent.

manufacturer; the sound of JFETs (if any) would be the sound of high distortion. Just give us the facts, please.

The OP275 is a dual opamp; no single version is available. It is quite expensive, about six times the price of a 5532, and its performance in most respects is inferior. It is noisier, has higher distortion, and does not like heavy loads. See Figures 4.32 and 4.33. The CM range is only about 2/3 of the voltage between the supply rails, and I_{bias} is high due to the BJT part of the input stage. Unless you think there is something magical about the BJT/JFET input stage—and I am quite sure there is not—it is probably best avoided.

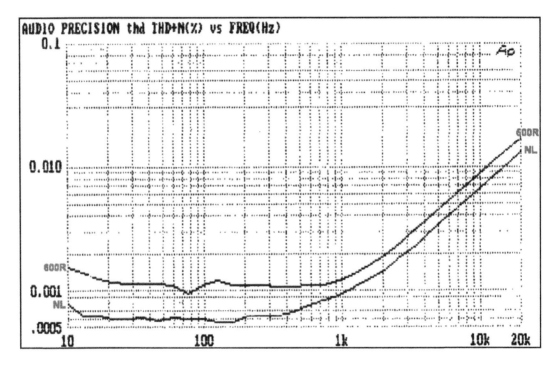

Figure 4.32 An OP275 driving 7.75 Vrms into No Load and 600 Ω. THD below 1 kHz is definitely non-zero with the 600 Ω load. Series feedback, gain 3.2x.

The THD at 10 kHz with a 600 Ω load is 0.0025% for shunt and 0.009% for series feedback; there is significant CM distortion in the input stage, which is almost certainly coming from the JFETs (I appreciate the output levels are not the same, but I think this only accounts for a small part of the THD difference). Far from adding magical properties to the input stage, the JFETs seem to be just making it worse.

Opamps surveyed: JFET input types

Opamps with JFET inputs tend to have higher voltage noise and lower current noise than BJT-input types and therefore give a better noise performance with high source resistances. Their very low bias currents often allow circuitry to be simplified.

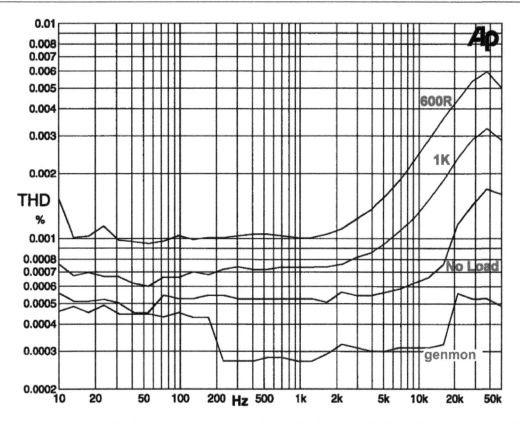

Figure 4.33 OP275 driving 5 Vrms into 1K and 600 Ω. Shunt feedback, gain 2.2x, but note the noise gain was set to 3.2x as for the series case. The genmon trace shows the distortion of the AP System 2 generator; the steps at 200 Hz and 20 kHz are artefacts generated by internal range-switching.

The TL072 opamp

The TL072 was one of the most popular opamps, having very high-impedance inputs, with effectively zero bias and offset currents; it is now pretty much obsolete. The JFET input devices give their best noise performance at medium impedances, in the range 1 kΩ–10 kΩ. It has a modest power consumption at typically 1.4 mA per opamp section, which is significantly less than the 5532. The slew rate is higher than for the 5532, at 13 V/us against 9 V/us. The TL072 is a dual opamp. There is a single version called the TL071 which has offset null pins.

However, the TL072 is not THD-free in the way the 5532 is. In audio usage, distortion depends primarily upon how heavily the output is loaded. The maximum loading on it is a trade-off between quality and circuit economy, and I would put 2 kΩ as the lower limit. I regard this opamp as obsolete for audio use unless the near-zero bias currents (which allow circuit economies by making blocking capacitors unnecessary), the low price, or the modest power consumption are dominant factors.

It is an unhappy quirk of this device that the input common-mode range does not extend all the way between the rails. If the common-mode voltage gets to within a couple of volts of the V-rail, the opamp suffers phase reversal, and the inputs swap their polarities. There may be really horrible clipping, where the output hits the bottom rail and then shoots up to hit the top one, or the stage may simply latch up until the power is turned off.

TL072s are relatively relaxed about supply rail decoupling, though they will sometimes show very visible oscillation if they are at the end of long thin supply tracks. One or two rail-to-rail decoupling capacitors (eg 100 nF) per few centimetres is usually sufficient to deal with this (what I call frugal decoupling), but normal practice is to not take chances and allow one capacitor per package as with other opamps.

Because of common-mode distortion, a TL072 in shunt configuration is always more linear. In particular, compare the results for 3k3 load in Figures 4.34 and 4.35. At heavier loadings the difference is barely visible because most of the distortion is coming from the output stage.

TL072/71 opamps are prone to HF oscillation if faced with significant capacitance to ground on the output pin; this is particularly likely when they are used as unity-gain buffers with 100%

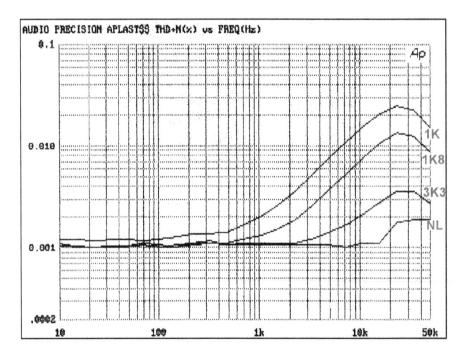

Figure 4.34 Distortion versus loading for the TL072, with various loads. Shunt feedback configuration eliminates CM input distortion. Output level 3 Vrms, gain 3.2x, rails +/−15 V. No output load except for the feedback resistor. The no-load plot is indistinguishable from that of the testgear alone.

Distortion always gets worse as the loading increases. This factor together with the closed-loop NFB factor determine the THD.

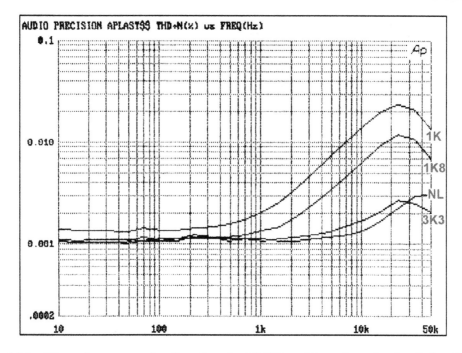

Figure 4.35 Distortion versus loading for the TL072, with various loads. Series feedback configuration output level 3 Vrms, gain 3.2x, rails +/−15 V. Distortion at 10 kHz is with no load is 0.0015% compared with 0.0010% for the shunt configuration. This is due to the 1 Vrms CM signal on the inputs.

feedback. A few inches of track can sometimes be enough. This can be cured by an isolating resistor, in the 47 to 75 Ω range, in series with the output, placed at the opamp end of the track.

The TL052 from Texas Instruments was designed to be an enhancement of the TL072, and so it is naturally compared with it. Most of the improvements were in the DC specifications. The offset voltage is 0.65 mV typical, 1.5 mV max, compared with the TL072's 3 mV typical, 10 mV max. It has half the bias current of the TL072. This is very praiseworthy but rarely of much relevance to audio. The distortion, however, *is* important, and this is worse rather than better. The TL052 achieved little market penetration, and I have removed it from this chapter.

The OPA2134 opamp

The OPA2134 is a Burr-Brown product, the dual version of the OPA134. The manufacturer claims it has superior sound quality due to its JFET input stage. Regrettably, but not surprisingly, no evidence is given to back up this assertion. The input noise voltage is 8 nV/√Hz, almost twice that of the 5532. The slew rate is typically ±20 V/us, which is ample. It does not appear to be optimised for DC precision, the typical offset voltage being ±1 mV, but this is usually good enough for audio work. I have used it many times as a DC servo in power amplifiers, the low bias currents allowing high resistor values and correspondingly small capacitors.

The OPA2134 does not show phase reversal anywhere in the common-mode range, which immediately marks it as superior to the TL072.

The two THD plots in Figures 4.36 and 4.37 show the device working at a gain of 3x in both shunt and series feedback modes. It is obvious that a problem emerges in the series plot, where the THD is higher by about three times at 5 Vrms and 10 kHz. This distortion increases with level, which immediately suggests common-mode distortion in the input stage. Distortion increases with even moderate loading; see Figure 4.38.

This is a relatively modern and sophisticated opamp. When you need JFET inputs (usually because significant input bias currents would be a problem), this definitely beats the TL072; it is, however, four to five times more expensive.

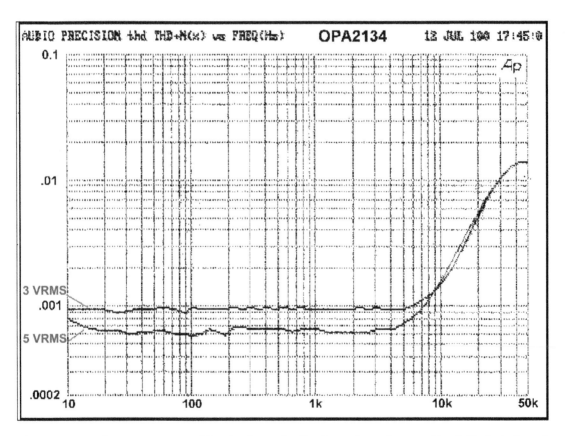

Figure 4.36 The OPA2134 working in shunt feedback mode, gain = 3. The THD is below the noise until frequency reaches 10 kHz; it appears to be lower at 5 Vrms simply because the noise floor is relatively lower.

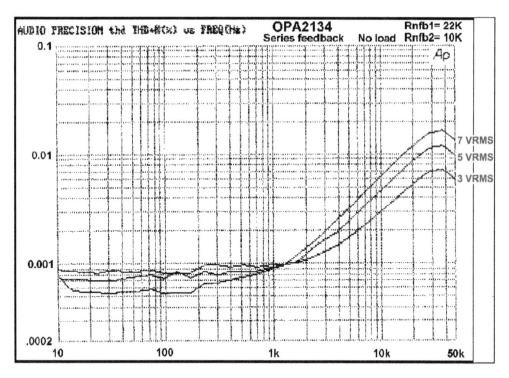

Figure 4.37 The OPA2134 in series feedback mode, gain = 3. Note much higher distortion at HF.

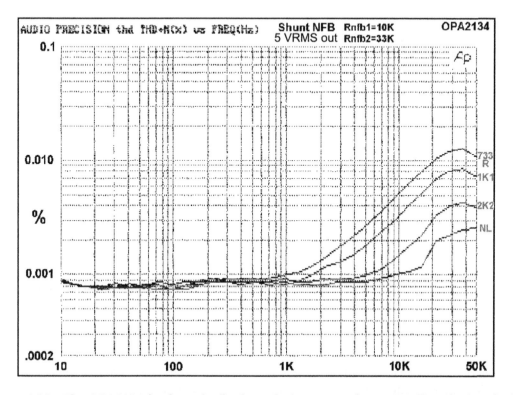

Figure 4.38 The OPA2134 in shunt feedback mode (to remove input CM distortion) and with varying loads on the output. As usual, more loading makes linearity worse. 5 Vrms out, gain = 3.3x.

The OPA604 opamp

The OPA604 from Burr-Brown is a single JFET input opamp which was specially designed to give low distortion. The simplified internal circuit diagram in the data sheet includes an enigmatic box intriguing labelled "Distortion Rejection Circuitry." This apparently "linearizes the open-loop response and increases voltage gain," but no details as to how are given; whatever is in there appears to have been patented so it ought to be possible to track it down. However, despite this, the distortion is not very low even with no load (see Figure 4.39) and is markedly inferior to the 5532. The OPA604 is not optimised for DC precision; the typical offset voltage is ±1 mV. The OPA2604 is the dual version, which omits the offset null pins.

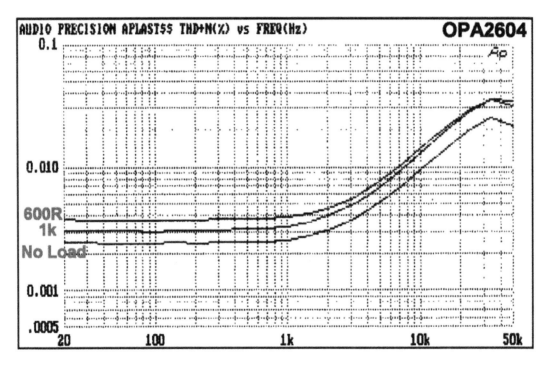

Figure 4.39 An OP2604 driving various loads at 7.75 Vrms. Series feedback, gain = 3.2x.

The data sheet includes a discussion that attempts to show that JFET inputs produce a more pleasant type of distortion than BJT inputs. This unaccountably omits the fact that the much higher transconductance of BJTs means that they can be linearised by emitter degeneration so that they produce far less distortion of whatever type than a JFET input [11]. Given that the OPA604 costs five times as much as a 5532, it is not clear under what circumstances this opamp would be good choice.

The OPA627 opamp

The OPA627 from Burr-Brown is a laser-trimmed JFET input opamp with excellent DC precision; the input offset voltage is typically ±100 uV. The distortion is very low, even into a 600 Ω load, though it is slightly increased by the usual common-mode distortion when series feedback is used.

The OP627 is a single opamp, and no dual version is available. The OPA637 is a decompensated version only stable for closed-loop gains of five or more. This opamp makes a brilliant DC servo for power amplifiers if you can afford it; it costs about 50 times as much as a 5532, which is 100 times more per opamp section and about 20 times more per opamp than the OPA2134, which is my usual choice for DC servo work.

The current noise i_n is very low, the lowest of any opamp examined in this book, apparently due to the use of Difet (dielectrically-isolated JFET) input devices, and so it will give a good noise performance with high source resistances. Voltage noise is also very respectable at 5.2 nV/√Hz, only fractionally more than the 5532.

The series feedback case barely has more distortion than the shunt one and only at the extreme HF end. It appears that the Difet input technology also works well to prevent input non-linearity and CM distortion. See Figures 4.40 and 4.41.

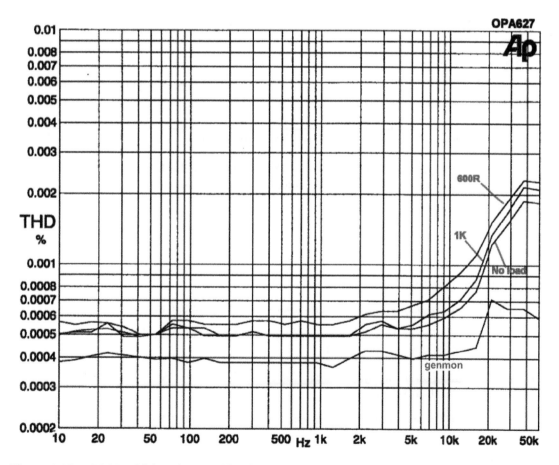

Figure 4.40 OP627 driving the usual loads at 5 Vrms. Series feedback, gain = 3.2x. Genmon is the testgear output.

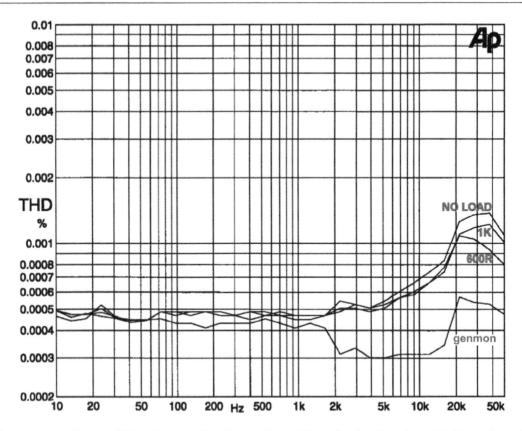

Figure 4.41 OP627 driving the usual loads at 5 Vrms. Shunt feedback, gain = 2.2, but noise gain = 3.2. Genmon trace shows the distortion produced by the AP System 2 generator alone.

References

[1] Blumlein, A. *British Patent No. 482,470*, 1936

[2] Jung, W., ed. *Op-amp Applications Handbook*. Newnes, 2006, Chapter 8

[3] Self, D. *Audio Power Amplifier Design Handbook*, 5th edition. Focal Press, 2009, pp. 186–189. ISBN 978-0-240-52162-6

[4] Self, D. *Audio Power Amplifier Design Handbook*, 5th edition. Focal Press, 2009, p. 96. ISBN 978-0-240-52162-6

[5] Jung, W., ed. *Op-amp Applications Handbook*. Newnes, 2006, Chapter 5, p. 399

[6] Self, D. *Audio Power Amplifier Design*, 6th edition. Newnes, 2013, pp. 142–150. ISBN 978-0-240-52613-3

[7] Self, D. *Audio Power Amplifier Design*, 6th edition. Newnes, 2013, pp. 449–462

[8] Self, D. *Audio Power Amplifier Design*, 6th edition. Newnes, 2013, pp. 423–426 (Class-A)

[9] Groner, S. *Operational Amplifier Distortion*, Oct 2009. www.sg-acoustics.ch/analogue_audio/index.html

[10] Huijsing, J. H. *Operational Amplifiers: Theory & Design.* Kluwer Academic, 2001, pp. 300–302. ISBN-13: 9780792372844

[11] Self, D. *Audio Power Amplifier Design*, 6th edition. Newnes, 2013, p. 500. ISBN 978-0-240-52613-3

Opamps for low voltages

High fidelity from low voltages

Nowadays there is considerable interest in audio circuitry that can run from +5 V, typically obtained from a USB port. It is expected that reasonable quality will be obtained; what might be called five-volt fidelity. Since there is only a single +5 V rail available, the maximum possible peak voltage is clearly ±2.5 V, equivalent to 1.77 Vrms or +7.16 dBu (this calculation obviously ignores opamp output saturation voltages). A slew rate of only 0.31 V/us is enough to give this maximum output at 20 kHz.

When the usual ±17 V rails are used, you get a maximum level of 12.02 Vrms or +23.81 dBu. Five-volt audio gives a maximum level that is 16.6 dB less, so the dynamic range is reduced by the same amount. If the same relative headroom is required, the nominal signal level will have to be correspondingly reduced by 16.6 dB, and the 5 V signal path will have a worse signal/noise ratio by 16.6 dB. Often a compromise between these two extremes is more appropriate. In this technology it is especially important to make sure that what dynamic range does exist is not compromised by deficiencies in design.

While +5 V was for many years the standard voltage for running digital circuitry, for some time now +3.3 V has been used to reduce power consumption and make larger processor ICs feasible. It is perhaps not very likely that applications will arise requiring quality audio circuitry to run off such a low supply, but the existence of opamps in Table 5.1 that are rated to operate down to 2.7 V and even 2.2 V shows that opamp manufacturers have this sort of thing in mind.

With a single +3.3 V rail the maximum possible peak voltage is ±1.65 V, equivalent to 1.17 Vrms or +3.55 dBu, ignoring output saturation voltages. This is 3.61 dB less than for a +5 V rail, so the dynamic range issue is that much more acute. A slew rate of only 0.21 V/us is enough to give the maximum output at 20 kHz.

The issues of +5 V operation are considered first, followed by those of +3.3 V operation.

Running opamps from a single +5 V supply rail

The vast majority of audio circuitry runs from dual supply rails; this has been the case ever since opamps became common in audio in the 1970s, and it was established that electrolytic capacitors could work satisfactorily and reliably without DC bias on them. When low voltages are used there is typically only one supply rail available, and it is necessary to bias the opamp outputs so they

DOI: 10.4324/9781003332985-5

TABLE 5.1 Low-voltage opamps, ranked in order of voltage noise density

Device	Supply voltage	Voltage noise 1 kHz	Current noise	CMRR type	Slew rate	Format	Price ratio 100-off
AD8022	5–24 V	2.3 nV/√Hz	1 pA/√Hz	−95 dB	50 V/us	Dual	1.72
LM4562	5–34 V	2.7 nV/√Hz	1.6 pA/√Hz	−120 dB	20 V/us	Dual	1.25
AD8656	2.7–5.5 V	4 nV/√Hz	No spec	−100 dB	11 V/us	Single	**1.00 ref**
AD8397	3–24 V	4.5 nV/√Hz	1.5 pA/√Hz	−90 dB	53 V/us	Dual	1.69
OPA2365	2.2–5.5 V	4.5 nV/√Hz	4 fA/√Hz	−100 dB	25 V/us	Dual	2.01
AD8066	5–24 V	7 nV/√Hz	0.6 fA/√Hz	−91 dB	180 V/us	Dual	1.83
AD8616	2.7–5 V	10 nV/√Hz	0.05 pA/√Hz	−100 dB	12 V/us	Dual	1.03
AD826	5–36 V	15 nV/√Hz	1.5 pA/√Hz	−80 dB	350 V/us	Dual	2.50
AD823	3–36 V	16 nV/√Hz	1 fA/√Hz	−75 dB	22 V/us	Dual	2.19

are halfway between the supply rail and ground. This is most economically done by an RC 'V/2 generator' which supplies bias to all the stages. This is sometimes called a 'half-rail generator.' There is no necessity that the bias point be *exactly* half of the supply rail. Some opamps clip earlier in one direction than the other, and a slight adjustment up or down of the half-rail may allow a larger symmetrical output swing. Having all the signal-carrying parts of the circuit displaced from ground means that DC-blocking capacitors are frequently required to keep DC out of volume controls and switches, counteracting any parts saving there may be in the power supply due to the single rail.

Figure 5.1 shows series and shunt feedback stages biased by a common V/2 generator R10, R11, C10. The shunt stage has a voltage gain of 2.2 times, set by R2 and R3. Capacitor C1 performs DC-blocking at the input; R1 ensures that the DC level at the input cannot float up due to leakage through this capacitor. Likewise a blocking capacitor C2 is required to prevent DC flowing through the load.

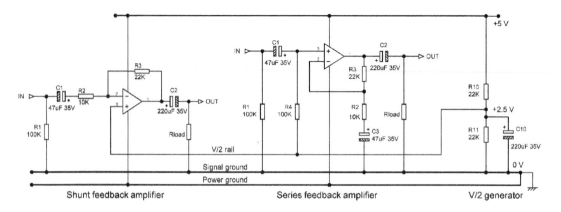

Figure 5.1 Opamps running from a single supply rail with a half-rail biasing generator shared between the two stages.

The series feedback stage has a voltage gain of 3.2 times, which means it works at the same noise gain as the shunt stage (see Chapter 22 for an explanation of noise gain), so comparative tests can be made in which the only difference is the common-mode voltage on the series stage opamp input pins. The series circuit requires an extra blocking capacitor C3 to prevent DC flowing through the feedback network and to reduce the gain to unity at zero frequency. An extra resistor R4 is needed to bias the stage input.

The V/2 generator typically uses a rather large capacitor to filter out disturbances on the supply rail. It is economical to share this with other stages, as shown in Figure 5.1. The low impedance of the filter capacitor should prevent interaction between stages, if they are not of high gain, but isolation will tend to fall with frequency. If a good crosstalk performance at LF is required in stereo circuitry it may be necessary to use separate V/2 generators for each channel.

One of the great advantages of dual-rail operation is that the opamp supply currents, which to some extent have the same half-wave rectified nature as those in a Class-B power amplifier, are inherently kept out of the signal ground. With single-rail operation the negative supply pin of an opamp will be at 0 V, but any temptation to connect it to signal ground must be stoutly resisted, or the half-wave rectified currents flowing will cause serious distortion. It is essential to provide a separate power ground, as shown in Figure 5.1, which only joins the signal ground back at the power supply.

Opamps for +5 V operation

Table 5.1 shows some candidates for low-voltage operation. The table has been restricted to those opamps capable of working from +5 V or lower. This therefore excludes the ubiquitous 5532 (with a minimum of 6 V) though it has been tested with results given in the text. Those opamps that have been tested are shown in bold.

Prices are per package, not per opamp section. This puts the single AD8656 at a serious price disadvantage. Prices as of 2013.

The NE5532 in +5 V operation

When an attempt is made to run the 5532 from a +5 V rail, the maximum output (with no load beyond the shunt feedback network) is only 845 mVrms (at 1% THD) compared with the 1.77 Vrms theoretically available. This is only 48% of the possible voltage swing—less than half—and the 5532 output stage is clearly not performing well at a task it was never intended to do. Shunt feedback was used to exclude any common-mode distortion in the opamp input stage, with a gain of 2.2 times, as in Figure 5.1. Distortion is high, even at lower levels such as 700 mVrms, but falls below the relatively high noise level at 500 mV out. Perhaps most importantly, using any IC outside of its specifications is very risky because one batch may work acceptably but another not at all.

The LM4562 in +5 V operation

The much newer LM4562 opamp has a supply specification reaching lower down to 5 V, so we expect better low-voltage performance. We get it too; the maximum output with no load is 1.16 Vrms, (1% THD), a more reasonable 65% of the possible voltage swing, but this is still very inefficient compared with the same opamp working from ±17 V rails.

The distortion performance for three output levels, with shunt feedback and a gain of 2.2 times as in Figure 5.1 is shown in Figure 5.2. The flat traces simply represent noise, and no distortion is visible in the THD residual except around 10–20 kHz for a 1.0 Vrms output. You will note that the relative noise levels, and hence the minimum measurable THD levels, are considerably higher than for opamps on ±17 V rails.

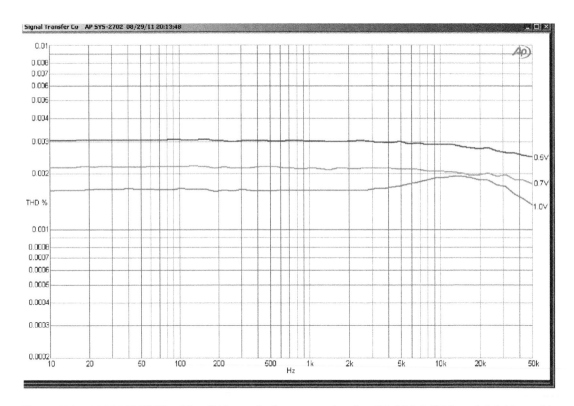

Figure 5.2 LM4562 THD with +5 V supply for output levels of 0.5 V, 0.7 V, and 1.0 Vrms. No external load.

The LM4562 is thus a possibility for +5 V operation, but the 3.7 dB loss in maximum output caused by that 65% when the dynamic range is already being squeezed is very unwelcome. There is also the point that the opamp is working right on the lower limit of its supply specs, which is not ideal. I found some evidence that the noise performance was impaired compared with ±17 V rails, with a noticeable incidence of burst noise. The NE5532 is at least cheap, but the

LM4562 is still relatively expensive. There may be, therefore, be no economic disadvantage in using specialised low-voltage opamps which are also expensive but designed for the job. We will examine some of them now.

The AD8022 in +5 V operation

The AD8022 from Analog Devices looks like a possible candidate, having an exceptionally low input noise density of 2.3 nV/√Hz that should allow maximisation of the dynamic range. It is a bipolar opamp with a wide supply range from +5 V to +24 V for single-rail operation, or ±2.5 V to ±12 V for dual rails; we would therefore still be operating at the lower limit of supply voltage. It is fabricated using a high-voltage bipolar process called XFCB.

Firstly, the maximum output is 1.18 Vrms (no load, 1% THD), 67% of the available voltage swing; this is only a tiny improvement on the LM4562. The distortion performance, using shunt feedback and a gain of 2.2 times, as in Figure 5.1, is not inspiring. According to the data sheet we can expect second harmonic at −80 dB (0.01%) and third harmonic at −90 dB (0.003%) with a 0.7 Vrms output into a 500 Ω load, flat with frequency. Figure 5.3 shows the measured results for various output levels; they are markedly worse than the data sheet suggests, for reasons unknown.

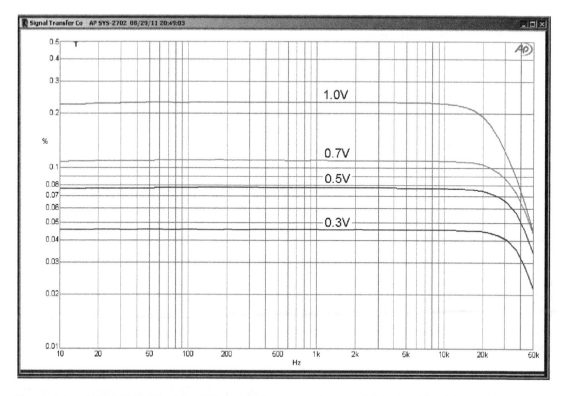

Figure 5.3 AD8022 THD with +5 V supply for output levels of 0.3 V, 0.5 V, 0.7 V, and 1.0 Vrms. Shunt feedback, no external load. 80 kHz bandwidth.

Note that we have changed the THD scale radically to accommodate the much higher levels, and the flat traces here really do represent distortion rather than noise. Several samples were tested with near-identical results.

These distortion levels are too high for any sort of quality audio, and the AD8022 will not be a good choice in most cases. No tests were therefore done on how distortion varies with output loading. However, for some applications it may be worth bearing in mind that its input noise density is exceptionally low at 2.3 nV/√Hz.

The AD8397 in +5 V operation

The AD8397 is another promising possibility because it claims a very voltage-efficient output stage and good load-driving capabilities. The input noise density is somewhat higher at 4.5 nV/√Hz, slightly better than a 5532 and slightly worse than a 5534. It is a bipolar opamp with a wide supply range from 3 V to 24 V (for single-rail operation) or ±1.5 V to ±12 V for dual rails; this means that at +5 V we are not operating at the lower supply voltage limit, which increases our confidence. It is fabricated using a complementary bipolar high voltage process called XFCB-HV.

The first good result is that the AD3897 really is voltage-efficient. The maximum output with no external load is 1.83 Vrms at 1% THD. This is actually *more* than the theoretical output of 1.77 Vrms because the 1% THD criterion relies on some clipping to create the distortion. If we instead use as our output criterion the first hint of disturbance on the THD residual, we get exactly 1.77 Vrms, which is 100% voltage efficiency! Brilliant work. Adding a 100 Ω load only reduces this to 1.72 Vrms.

The measured THD results, using shunt feedback and a gain of 2.2 times as in Figure 5.1, are shown in Figure 5.4 for various output levels (note that the noise gain is higher at 3.2x). The flat parts of the traces represent noise only, with detectable distortion only appearing above 10 kHz, except at 1.76 Vrms out. The measured relative noise levels obviously fall as the output voltage increases.

The unloaded distortion results are very encouraging, but how are they affected by an external load on the output? Hardly at all, as Figure 5.5 shows; the output level is close to the maximum at 1.5 Vrms, and the external loads go down to 220 Ω, well below the minimum 5532 load of 500 Ω. Shunt feedback was used.

The AD8397 data sheet refers to loads down to an impressively low 25 Ω, so we want to explore the linearity with loading a bit further. Figure 5.6 shows the measured THD results with No Load (NL) and external loads of 220 Ω, 150 Ω, and 100 Ω, again at an output of 1.5 Vrms. Not until the load falls to 150 Ω do we start to see significant distortion appearing above 1 kHz, and this promises that this opamp will work well with low-impedance designs that will minimise noise and optimise the dynamic range.

So far, so good. The next thing to investigate is the distortion performance using series feedback, which puts a significant common-mode signal on the input pins. The test circuit used is the series stage in Figure 5.1, which has a gain of 3.2 times, but the same noise gain (3.2x) as the shunt

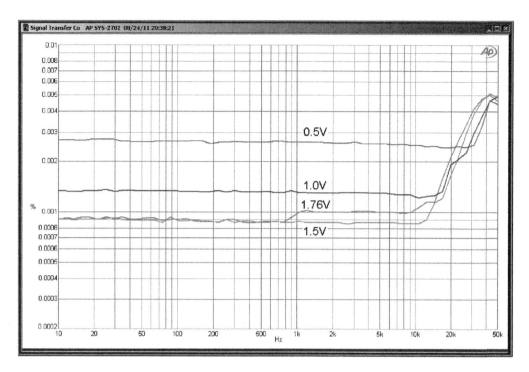

Figure 5.4 AD8397 THD with +5 V supply. Output levels of 0.5 V, 1.0 V, 1.5 V, and 1.76 Vrms. Shunt feedback, no external load.

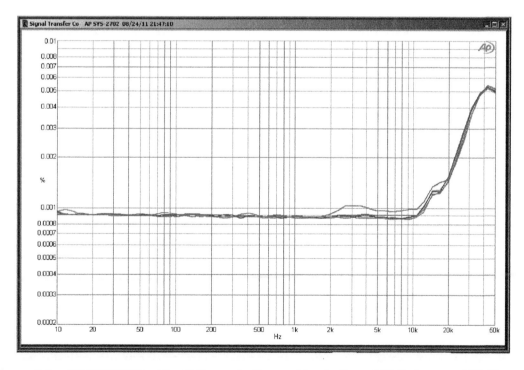

Figure 5.5 AD8397 THD with +5 V supply. External loads from 680 Ω down to 220 Ω at an output level of 1.5 VRMS. Shunt feedback.

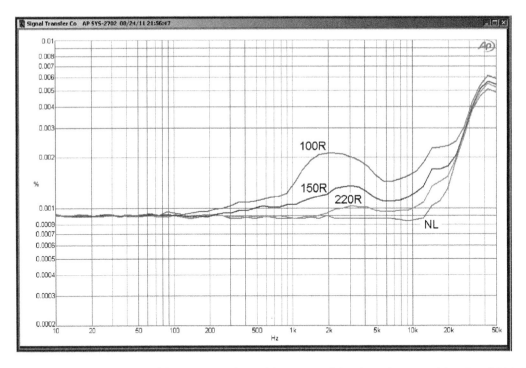

Figure 5.6 AD8397 THD with +5 V supply. With No Load (NL) and external loads of 220 Ω, 150 Ω, and 100 Ω at an output level of 1.5 Vrms. Shunt feedback, gain = 2.2x.

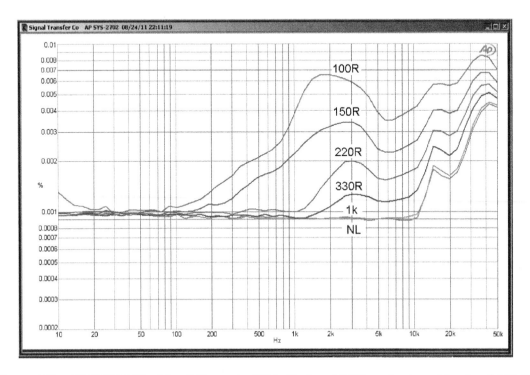

Figure 5.7 AD8397 THD with +5 V supply. With No Load (NL) and external loads of 330 Ω, 220 Ω, 150 Ω, and 100 Ω at an output level of 1.5 Vrms. Series feedback, gain = 3.2x.

circuit. Figure 5.7 shows the measured THD results with No Load (NL) and external loads of 220 Ω, 150 Ω, and 100 Ω, again at an output of 1.5 Vrms. The distortion behaviour is clearly worse with series feedback for loads of 220 Ω or lower; care will be needed if low impedances are to be driven from a series feedback stage using an AD8397.

The worst-case for common-mode voltage is the voltage-follower configuration, where the full output voltage is present on the input terminals, and this exposes a limitation of the AD8397. The output stage does a magnificent job of using the whole available voltage swing, but the input stage does not quite have a full rail-to-rail capability. This means that voltage-follower stages, where the input and feedback signals are equal to the output signal, have a limitation on output level set by the input stage rather than the output stage. The distortion performance is also significantly worse than for the case of series feedback with a gain of 3.2x. Figure 5.8 demonstrates that distortion rises quickly as the signal level exceeds 0.9 Vrms. If you want to make use of the full output swing, then voltage-followers should be avoided. A relatively small amount of voltage gain, for example 1.1 times, will reduce the signal levels on the input pins and allow the full output swing with low distortion.

Common-mode distortion is worsened when the opamp is fed from a significant source resistance. Our final test is to drive a voltage-follower through a 4k7 resistance. Figure 5.9 shows that distortion is much increased compared with Figure 5.8. We had about 0.0025% THD with a 1.05 Vrms signal, but adding the 4k7 in series with the input has increased that to 0.007%.

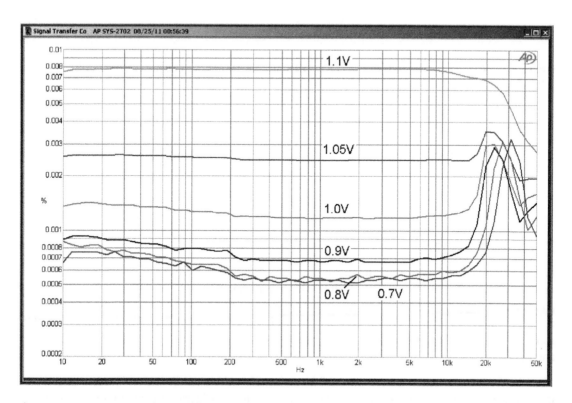

Figure 5.8 AD8397 voltage-follower THD with +5 V supply. No Load (NL) and input/output levels of 0.7 V, 0.8 V, 0.9 V, 1.0 V, 1.05 V, and 1.1 Vrms.

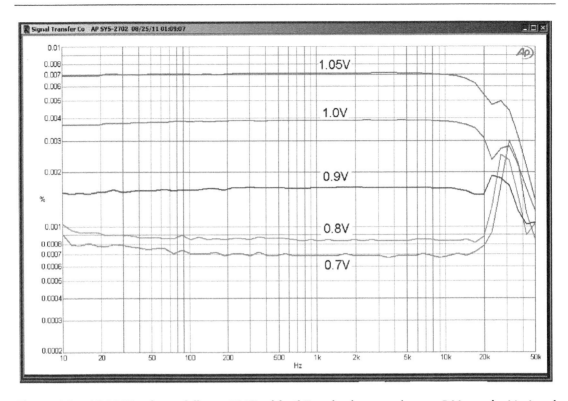

Figure 5.9 **AD8397 voltage-follower THD with 4k7 series input resistor. +5 V supply, No Load (NL) and input/output levels of 0.7 V, 0.8 V, 0.9 V, 1.0 V, and 1.05 Vrms.**

To conclude, the AD8397 is a useful opamp for +5 V operation; it is the best I have evaluated so far. It is however necessary to keep an eye on the effects of common-mode distortion and source resistance and be aware of the voltage limits of the input stage.

Opamps for 3.3 V single-rail operation

Firstly, forget about the NE5532. Its maximum output on a +3.3 V rail (with appropriate half-rail biasing) is only 240 mVrms (1% THD). This is a meagre 20% of the available voltage swing and is clearly very inefficient. There is considerable distortion and the residual shows nasty crossover spikes of the sort associated with under-biased power amplifiers. Finally, using any IC so far outside of its specifications is very dangerous indeed—one batch may work acceptably but another batch not at all.

The LM4562 works rather better from +3.3 V, giving 530 mVrms (1% THD). This is a slightly more respectable 45% of the available voltage swing, but the objection to using it outside of its specifications remains the THD at output levels up to 430 mVrms is around 0.01%, which is not very encouraging.

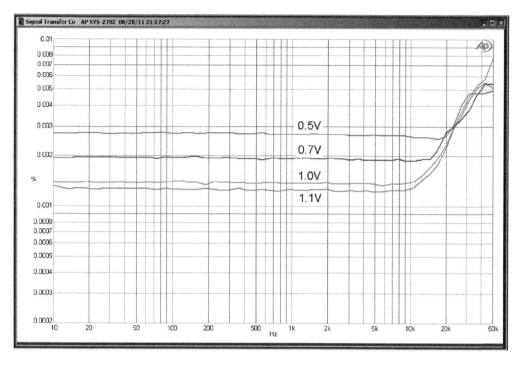

Figure 5.10 AD8397 THD with +3V3 supply. Output levels of 0.5 V, 0.7 V, 1.0 V, and 1.1 Vrms. Shunt feedback, no external load.

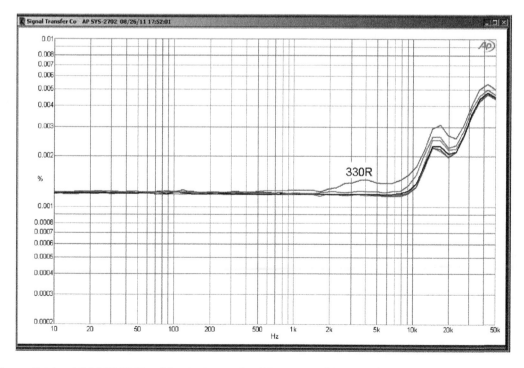

Figure 5.11 AD8397 THD with +3V3 supply with No Load (NL) and external loads of 4k7, 2k2, 1 k, 560 Ω, and 330 Ω at an output level of 1.1 Vrms. Shunt feedback, gain = 2.2x.

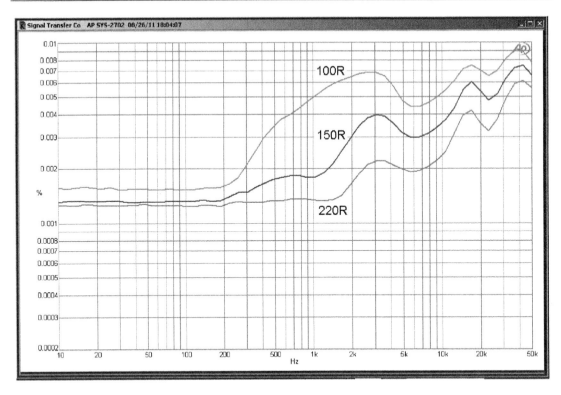

Figure 5.12 **AD8397 THD with +3V3 supply with external loads of 220 Ω, 150 Ω, and 100 Ω at an output level of 1.1 Vrms. Shunt feedback, gain = 2.2x.**

The AD8397, however, works well at +3.3 V. The maximum output is now 1.18 Vrms (1% THD). The measured THD results, using shunt feedback and a gain of 2.2 times, as in Figure 5.1, are shown in Figure 5.10 for differing output levels. The flat parts of the traces represent noise only, with detectable distortion only appearing above 10 kHz. Compare this with the +5 V results in Figure 5.4; there is little difference, though the maximum test level is, of course, less.

At +3.3 V the AD8397 still works well with quite heavy loading. Figure 5.11 shows that loads lighter than 560 Ω have very little effect on the distortion performance, while 330 Ω causes detectable distortion only above 2 kHz. Figure 5.12 demonstrates that heavier loads than this lead to significant distortion. The AD8022 was not evaluated for +3.3 V operation as its minimum supply voltage is +5 V.

Filters

Introduction

Analogue filter design is an enormous subject, and it is of course quite impossible to cover even its audio aspects in a single chapter. A much, much more detailed account is given in my book *The Design of Active Crossovers* [1], which gives practical examples of just about every filter type you can think of; get the second edition which is much more comprehensive. There are several standard textbooks on filter theory [2–4], and there would be no point in trying to create another one here. This chapter instead gives information on audio applications not found in the standard textbooks.

Filter design is at the root highly mathematical, and it is no accident that all of the common filter characteristics such as Bessel, Gaussian, Chebyshev, and Legendre are named after mathematicians. A notable exception is the Butterworth characteristic, probably the most popular and useful characteristic of all; Stephen Butterworth was a British engineer [5]. Here I am going to avoid the complexities of pole and zero placement, etc, and concentrate on practical filter designs that can be adapted for different frequencies by simply scaling component values. Most filter textbooks give complicated equations for calculating the amplitude and phase response at any desired frequency. This is much less necessary now that access can be assumed to a simulator, which will give all the information you could possibly want, much more quickly and efficiently than wrestling with calculations. Free simulator packages can be downloaded. Filters are widely used in different kinds of audio system, and I make frequent references to them in other chapters.

Filters are either passive or active. Passive or LCR filters use resistors, inductors, and capacitors only. Active filters use resistors, capacitors, and gain elements such as opamps; active filter technology is usually adopted with the specific intent of avoiding inductors and their well-known limitations. Nevertheless, there are some audio applications where LCR filters are essential.

Passive filters

Passive filters do not use active electronics, and this is a crucial advantage in some applications. They are not subject to slew rate limiting, semiconductor non-linearity, or errors due to falling open-loop gain, and this makes them the best technology for roofing filters. A roofing filter is one that stops out-of-band frequencies before they reach the first stage of electronics and so prevents RF demodulation and slew limiting. A classic application is the use in tape machines of parallel-LC circuits to keep bias frequencies out of record amplifiers. They are also used as bias traps in multitrack machines,

DOI: 10.4324/9781003332985-6

where recording may be happening on one track while the adjacent track is replaying, to keep the bias out of the replay amplifiers. There are more details in Chapter 11 on tape electronics.

Another application is in the measurement of Class-D power amplifiers, which emit copious quantities of RF that will greatly upset audio measuring equipment. The answer, as described by Bruce Hofer [6], is a passive LCR roofing filter. There are many excellent text books that describe LCR filter design, such as [2] and [3], and I am not going into it here. Bias traps are relatively easy to design as all you have to do is get the centre frequency right and have an appropriate Q.

Active filters

Active filters do not normally use inductors as such, though configurations such as gyrators that explicitly model the action of an inductor are sometimes used. The active element need not be an opamp; the Sallen & Key configuration requires only a voltage-follower, which in some cases can be a simple BJT emitter-follower. Opamps are usual nowadays, however. The rest of this chapter deals only with active filters.

Lowpass filters

Probably the most common use of lowpass filters is at the output of DACs to remove the high-frequency spurii that remain after oversampling; see Chapter 26 for more on this. They are also used to explicitly define the upper limit of the audio bandwidth in a system at, say, 50 kHz (see the example of a record-cutting amplifier in Chapter 9), though more often this is done by the casual accumulation of a lot of first-order roll-offs in succeeding stages. This is not a duplication of input RF filtering (ie roofing filtering) which, as described in Chapter 18 on line inputs, must be passive and positioned before the incoming signals encounter any electronics which can demodulate RF. Lowpass filters are also used in PA systems to protect power amplifiers and loudspeakers against ultrasonic oscillation in the system.

In what might be called the First Age of Vinyl, a fully-equipped preamplifier would certainly have a switchable lowpass filter, called, with brutal frankness, the "scratch" filter. This, having a slope of 12 or 18 dB/octave, faster than the tone-control stage, and rolling-off at a higher frequency around 5–10 kHz, was aimed at suppressing, or at any rate dulling, record surface noise and the inevitable ticks and clicks; see Chapter 9 for much more on this. Interestingly, preamplifiers today, in the Second Age of Vinyl, rarely have this facility, probably because it requires you to face up to the fact that the reproduction of music from mechanical grooves cut into vinyl is really not very satisfactory. Lowpass filters are, of course, essential to electronic crossovers for loudspeaker systems.

Highpass filters

Highpass filters are widely used. Preamplifiers for vinyl disc usage are commonly fitted with subsonic filtering, often below 10 Hz, to keep disturbances due to record warps and ripples from

reaching the loudspeakers. Subsonic noise may affect the linearity of the speaker for the worse as the bass unit is often moved through a substantial part of its mechanical travel; this is particularly true for reflex designs with no cone loading at very low frequencies. If properly designed, this sort of filtering is considered inaudible by most people. In the First Age of Vinyl, preamplifiers sometime were fitted with a 'rumble filter' which began operations at a higher frequency, typically 35 or 40 Hz, to deal with more severe disc problems and would not be considered inaudible by anyone. Phono subsonic filtering is comprehensively dealt with in Chapter 9 on moving-magnet preamplifiers.

Mixer input channels very often have a switchable highpass filter at a higher frequency again, usually 100 Hz. This is intended to deal with low-frequency proximity effect with microphones and general environmental rumblings. The slope required to do this effectively is at least 12 dB/octave, putting it outside the capabilities of the EQ section. Some mixer highpass filters are third-order (18 dB/octave), and fourth-order (24 dB/octave) ones have been used occasionally. Once again, highpass filters are used in electronic crossovers.

Combined lowpass and highpass filters

When both subsonic and ultrasonic filters are required they can sometimes be economically combined into one stage using only one opamp to give audio band definition. Filter combination is usually only practicable when the two filter frequencies are widely separated. There is more on this in Chapter 9 and much more in *The Design of Active Crossovers, Second Edition* [1].

Bandpass filters

Bandpass filters are principally used in mixing consoles and stand-alone equalisers (see Chapter 15). The Q required rarely exceeds a value of 5, which can be implemented with relatively simple active filters, such as the multiple-feedback type. Higher Qs or independent control of all the resonance parameters require the use of the more complex biquad or state-variable filters. Bandpass and notch filters are said to be 'tuneable' if their centre frequency can be altered relative easily, say by changing only one component value.

Notch filters

Notch filters are mainly used in equalisers to deal with narrow peaks in the acoustic response of performance spaces and in some electronic crossovers, for example [7]. They can also be used to remove a single interfering frequency; once a long time ago I was involved with a product that had a slide-projector in close proximity to a cassette player. Hifi was not the aim, but even so, the enormous magnetic field from the projector transformer induced an unacceptable amount of hum into the cassette tape head. Mu-metal only helped a bit, and the fix was a filter that introduced notches at 50 Hz and 150 Hz, working on the '1-bandpass' principle, of which more later.

All-pass filters

All-pass filters are so-called because they have a flat frequency response and so pass all frequencies equally. Their point is that they have a phase shift that *does* vary with frequency, and this is often used for delay correction in electronic crossovers. You may occasionally see a reference to an all-stop filter, which has infinite rejection at all frequencies. This is a filter designer's joke. It is probably the only filter design joke.

Filter characteristics

The simple second-order bandpass responses are basically all the same, being completely defined by centre frequency, Q, and gain. Highpass and lowpass filter characteristics are much more variable and are selected as a compromise between the need for a rapid roll-off, flatness in the passband, and a clean transient response. The Butterworth (maximally flat) characteristic is the most popular for many applications. Filters with passband ripple, such as the Chebyshev or the Elliptical types, have not found favour for in-band filtering, such as in electronic crossovers, but were once widely used for applications like ninth-order anti-aliasing filters; such filters have mercifully been made obsolete by oversampling. The Bessel characteristic gives a maximally flat group delay (maximally linear-phase response) across the passband and so preserves the waveform of filtered signals, but it has a much slower roll-off than the Butterworth.

Sallen & Key lowpass filters

The Sallen & Key filter configuration was introduced by R. P. Sallen and E. L. Key of the MIT Lincoln Laboratory as long ago as 1955 [8, 10]. It became popular as the only active element required is a unity-gain buffer, so in the days before opamps were cheap it could be effectively implemented with a simple emitter-follower or cathode-follower.

Figure 6.1 shows a second-order lowpass Sallen & Key (hereinafter S&K) filter with a −3 dB frequency of 624 Hz and a Q of 0.707 for a Butterworth response. Equations 6.1 and 6.2 are the pleasingly simple analysis equations for cutoff (−3 dB) frequency f_0 and Q.

$$f = \frac{1}{2\pi R\sqrt{C1C2}}$$
Equation 6.1

$$Q = \frac{1}{2}\sqrt{(C1/C2)}$$
Equation 6.2

These equations are only pleasingly simple because certain constraints have been placed on the components; R1 is equal to R2, and C1 is twice C2. That is why you almost always see S&K filters in this format. Removing those two conditions means that each component can be any value

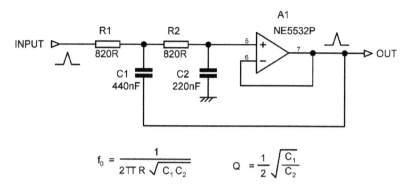

$$f_0 = \frac{1}{2\pi R \sqrt{C_1 C_2}} \qquad Q = \frac{1}{2}\sqrt{\frac{C_1}{C_2}}$$

Figure 6.1 The classic second-order lowpass Sallen & Key filter. Cutoff frequency is 624 Hz. Q = 0.707 (critically damped).

and so more complicated equations are required to design and analyse the circuit. See Equations 6.3 and 6.4.

$$f = \frac{1}{2\pi\sqrt{R1R2C1C2}}$$

Equation 6.3

$$Q = \frac{\sqrt{R1R2C1C2}}{C2(R1+R2)}$$

Equation 6.4

Note that these equations apply only for unity internal gain (ie the amplifier is acting as a voltage-follower). A little experimenting with these equations (I advise a spreadsheet) shows that deviating either from R1 = R2 or C1 = 2C2 gives a lower Q than 0.707, and this is another reason why these conditions are usually imposed.

The particular filter in Figure 6.1 was part of a fourth-order Linkwitz-Riley electronic crossover for a three-way loudspeaker, hence the odd cutoff frequency [9]. The main difference you will notice from textbook filters [10] is that the resistor values are rather low and the capacitor values correspondingly high. This is an example of low-impedance design, where low resistor values minimise Johnson noise and reduce the effect of the opamp current noise and common-mode distortion. The measured noise output is −117.4 dBu. This is after correction by subtracting the testgear noise floor.

It is important to remember that a Q of 1 does not give the maximally flat Butterworth response; what you need is Q = 0.707 ($\sqrt{2}/2$). S&K filters with a Q of 0.5 are used in second-order Linkwitz-Riley crossovers, but these are not favoured because the 12 dB/octave roll-off of the highpass filter is not steep enough to reduce the excursion of a driver when a flat frequency response is obtained [9]. If you do need a Q of exactly 0.5 then this can be obtained simply by making the capacitors equal as well as the resistors.

S&K lowpass filters can have a lurking problem. When implemented with some opamps, the response does not carry on falling for ever at the filter slope—instead it reaches a minimum and starts to come back up at 6 dB/octave. This is because the filter action relies on C1 seeing a low-impedance to ground, and the impedance of the opamp output rises with frequency due to falling open-loop gain and hence falling negative feedback. When the circuit of Figure 6.1 is built using a TL072, the maximum attenuation is −57 dB at 21 kHz, rising again and flattening out at −15 dB at 5 MHz. This type of filter should not be used to reject frequencies well above the audio band; a lowpass version of the multiple-feedback filter is preferred.

Lowpass filters used to define the top limit of the audio bandwidth are typically second-order with roll-off rates of 12 dB/octave; third-order 18 dB/octave filters are rather rarer, probably because there seems to be a general feeling that phase changes are more audible at the top end of the audio spectrum than the bottom. Either the Butterworth (maximally flat frequency response) or Bessel type (maximally flat group delay) can be used. It is unlikely that there is any real audible difference between the two types of filter in this application, as most of the action occurs above 20 kHz, but using the Bessel alignment does require compromises in the effectiveness of the filtering because of its slow roll-off. I will demonstrate.

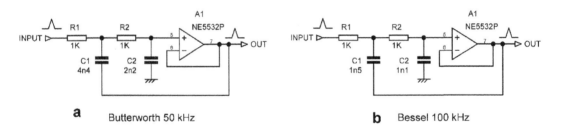

a Butterworth 50 kHz **b** Bessel 100 kHz

Figure 6.2 Second-order Sallen & Key lowpass circuits for ultrasonic filtering; a) Butterworth; b) Bessel. Both have a loss of less than 0.2 dB at 20 kHz.

The standard Butterworth filter in Figure 6.2a has its −3 dB point set to 50 kHz, and this gives a loss of only 0.08 dB at 20 kHz, so there is minimal intrusion into the audio band; see Figure 6.3. The response is a useful −11.6 dB at 100 kHz and an authoritative −24.9 dB at 200 kHz. C1 is made up of two 2n2 capacitors in parallel.

But let us suppose we are concerned about linear phase at high frequencies, and we decide to use a Bessel filter. The only circuit change is that C1 is now 1.335 times as big as C2 instead of 2 times, but the response is very different. If we design for −3 dB at 50 kHz again, we find that the response is −0.47 dB at 20 kHz; a lot worse than 0.08 dB and not exactly a stunning figure for your spec sheet. If we decide we can live with −0.2 dB at 20 kHz then the Bessel filter has to be designed for −3 dB at 72 kHz; this is the design shown in Figure 6.2b. Due to the inherently slower roll-off, the response is only down to −5.6 dB at 100 kHz and −14.9 dB at 200 kHz, as seen in Figure 6.3; the latter figure is 10 dB worse than for the Butterworth. The measured noise output for both versions is −114.7 dBu using 5532s (corrected for testgear noise).

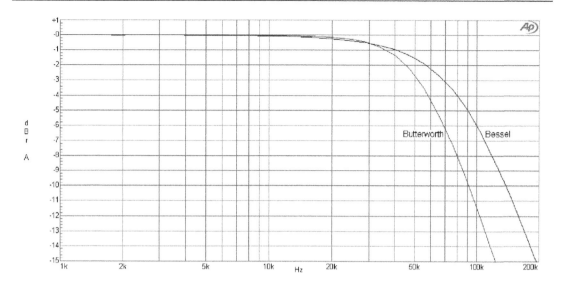

Figure 6.3 Frequency response of the 50 kHz Butterworth and 72 kHz Bessel filters in Figure 6.2.

TABLE 6.1 The frequency response of various ultrasonic filter options

Frequency	Butterworth 50 kHz	Bessel 50 kHz	Bessel 72 kHz	Bessel 100 kHz
20 kHz	−0.08 dB	−0.47 dB	−0.2 dB	−0.1 dB
100 kHz	−11.6 dB	−10.0 dB	−5.6 dB	−3.0 dB
200 kHz	−24.9 dB	−20.9 dB	−14.9 dB	−10.4 dB

If we want to keep the 20 kHz loss to 0.1 dB, the Bessel filter has to be designed for −3 dB at 100 kHz, and the response is now only −10.4 dB down at 200 kHz, more than 14 dB less effective than the Butterworth. These results are summarised in Table 6.1.

Discussions on filters always remark that the Bessel alignment has a slower roll-off but often fail to emphasise that it is a *much* slower roll-off. You should think hard before you decide to go for the Bessel option in this sort of application.

It is always worth checking how the input impedance of a filter loads the previous stage. In this case, the input impedance is high in the passband, but above the roll-off point it falls until it reaches the value of R1, which here is 1 kΩ. This is because at high frequencies C1 is not bootstrapped, and the input goes through R1 and C1 to the low-impedance opamp output which is effectively at ground. Fortunately this low impedance only occurs at high frequencies, where one hopes the level of the signals to be filtered out will be low.

Another important consideration with lowpass filters is the balance between the R and C values in terms of noise performance. R1 and R2 are in series with the input, and their Johnson noise will be added directly to the signal. The effect of the amplifier noise current flowing in these resistors

will also be added in. Here the two 1 kΩ resistors together generate −119.2 dBu of Johnson noise (22 kHz bandwidth, 25°C). The obvious conclusion is that R1 and R2 should be made as low in value as possible without causing excess loading (and 1 kΩ is not a bad compromise) with C1, C2 scaled to maintain the desired roll-off frequency. The need for specific capacitor ratios creates problems as capacitors are available in a much more limited range of values than resistors, usually the E6 series, running 10, 15, 22, 33, 47, and 68. C1 or C2 often has to be made up of two capacitors in parallel.

Full design details of lowpass filters of many types (Butterworth, Bessel, linear-phase, etc) up to sixth order are given in *The Design of Active Crossovers, Second Edition* [1].

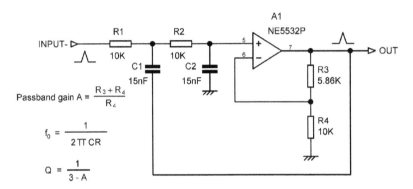

Passband gain $A = \dfrac{R_3 + R_4}{R_4}$

$f_0 = \dfrac{1}{2\pi CR}$

$Q = \dfrac{1}{3 - A}$

Figure 6.4 **Equal-capacitor second-order S&K lowpass Butterworth filter with a cutoff frequency of 1061 Hz. Gain must be 1.586 times for maximally flat response (Q = 0.707).**

A variation on the lowpass S&K filter that can avoid capacitor ratio difficulties is shown in Figure 6.4. The unity-gain buffer is replaced with a voltage gain stage; the gain set by R3 and R4 must be 1.586 times (+4.00 dB) for a Q of 0.707. This allows C1 and C2 to be the same value. An equal-resistor-value highpass filter can be made in exactly the same way. Depending on the system design, the gain may be inconvenient.

All the filters described so far in this section have two capacitors and are second-order (this equivalence works for many filters but not all), but it is also feasible to make a third-order filter in one stage; this is called the Geffen configuration. This used to be more important than it is now because the cost of an amplifier relative to the rest of the circuit has gone steadily downwards. It still saves parts, but the design process is complicated (involving solving equations rather than just plugging numbers into formulae), and there may be compromises on noise gain and component sensitivity. It is also possible to make a fourth-order filter in one stage. Designs for these are shown in Figure 6.18b.

Sallen & Key highpass filters

Figure 6.5 shows a second-order highpass S&K filter with a −3 dB frequency of 5115 Hz and a Q of 0.707 with its design equations; this was another part of the electronic crossover. The

capacitors are set to be equal while the resistors are set to a ratio of two. The measured noise output of this filter is −115.2 dBu (corrected).

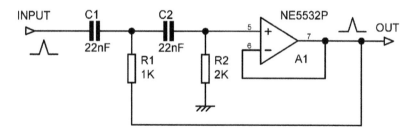

Figure 6.5 The classic second-order highpass Sallen & Key filter. Cutoff frequency is 5115 Hz. Q = 0.707.

As for the lowpass S&K filter, Equations 6.5 and 6.6 are only simple because of restrictions on the components; C1 is made equal to C2, and R2 is made twice R1. That is why you almost always see S&K highpass filters in this format. As for lowpass, it also gives the highest possible Q for unity internal gain.

$$f = \frac{1}{2\pi C\sqrt{R1R2}}$$

<div align="right">Equation 6.5</div>

$$\frac{1}{2}\sqrt{(R2/R1)}$$

<div align="right">Equation 6.6</div>

Removing those two conditions means that each component can be any value, and so more complicated equations are required to analyse the circuit; see Equations 6.7 and 6.8. The equation for frequency is the same as for the lowpass S&K, but the Q Equation 6.8 has the Rs and Cs swopped in the denominator.

$$f = \frac{1}{2\pi\sqrt{R1R2C1C2}}$$

<div align="right">Equation 6.7</div>

$$Q = \frac{\sqrt{R1R2C1C2}}{R1(C1+C2)}$$

<div align="right">Equation 6.8</div>

Note that these equations apply only for unity internal gain (ie the amplifier is acting as a voltage-follower).

Amplitude peaking and Q in lowpass and highpass Sallen & Key filters

All second-order lowpass and highpass show peaking in the frequency response when the Q is greater than 0.7071 ($1/\sqrt{2}$), and a clear appreciation of this is important as second-order filters are

very commonly used as the building-blocks for higher-order and more complex filters. The height of the peak (A_{max}) and the frequency of its maximum (f_p) relative to the filter cutoff frequency (f_0) are completely determined by the Q value chosen and nothing else and are related by these equations:

Lowpass and highpass:
$$A_{max} = \frac{Q}{\sqrt{1 - \frac{1}{4Q^2}}}$$
Equation 6.9

Lowpass only:
$$f_p = f_0 \sqrt{1 - \frac{1}{2Q^2}}$$
Equation 6.10

Highpass only:
$$f_p = f_0 \frac{1}{\sqrt{1 - \frac{1}{2Q^2}}}$$
Equation 6.11

The peaking caused by different Qs in lowpass and highpass filters are shown in Figures 6.6 and 6.7. Given the frequency response of a second-order filter, it is straightforward to work out its Q. Note that the peak amplitude can only be found for Q greater than or equal to $1/\sqrt{2}$; for lower Q values the results are meaningless as there is no peak to describe. Likewise the equations for f_p will only work for Q above $1/\sqrt{2}$ as the number in the big square root must be positive to give a real answer.

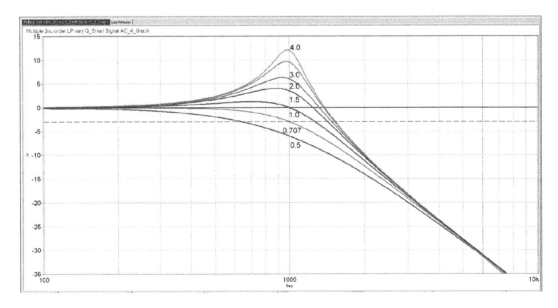

Figure 6.6 **Lowpass second-order amplitude response peaking for different values of Q.**

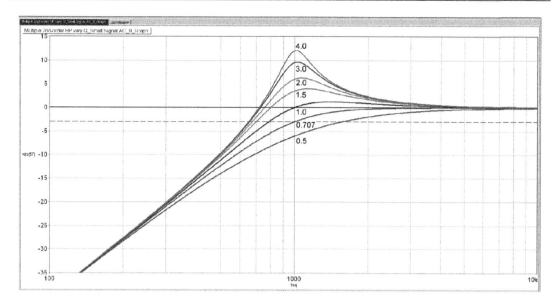

Figure 6.7 Highpass second-order amplitude response peaking for different values of Q.

Sallen & Key bandpass filters

The S&K bandpass filter languishes in obscurity compared with the lowpass and highpass versions. There may be good reasons for this, but they are not immediately obvious. Figure 6.8 shows a 1 kHz bandpass filter with a Q of 1.00; an internal gain of 2x is required for this value of Q. The internal gain controls the Q but does not affect the centre frequency.

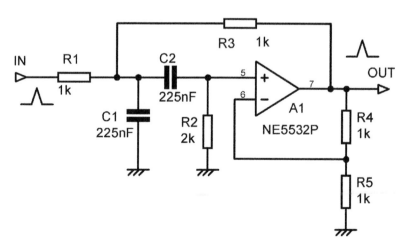

Figure 6.8 Sallen & Key bandpass filter with a centre frequency of 1 kHz and Q = 1.

As with the lowpass and highpass S&K filters, conditions are usually placed on the component values which much simplify the analysis equations. If R1 = R3 = R, and R2 = 2 x R1, and C1 = C2 = C, then Equations 6.12 and 6.13 hold:

$$f = \frac{1}{2\pi RC}$$

Equation 6.12

$$Q = \frac{1}{3-A}$$

Equation 6.13

Where A is the internal gain, equal to (R4+R5)/R5

If R1 R2 R3 C1 and C2 have arbitrary values,

$$f = \frac{1}{2\pi}\sqrt{\frac{R1+R3}{R1\,R2\,R3\,C1\,C2}}$$

Equation 6.14

$$Q = \frac{\sqrt{(R1+R3)\,R1\,R2\,R3\,C1\,C2}}{R1R3(C1+C2)+R2\,C2\left(R3-\frac{R4}{R5}R1\right)}$$

Equation 6.15

Figure 6.9 Sallen & Key bandpass filters with a centre frequency of 1 kHz.

Figure 6.9 shows two versions of an S&K bandpass where the condition R2 = 2*R1 does *not* apply; in this case all three resistors are set to 1 kΩ; the capacitors remain equal. Version a) is given by Wikipedia [10], while version b) is given by Frederiksen in *Intuitive Operational Amplifiers* [11]. The two circuits look very similar; the only difference is that C1 moves across to the other side of C2. Both look like obvious combinations of Sallen & Key lowpass and highpass filters, but the presence of R3 in both might not have been expected. The internal gain required for a given Q with version a) are shown in Table 6.2. Figures 6.10 and 6.11 show the response of version a) at varying Q's.

Both circuits have a centre frequency of 1 kHz and a centre gain of unity, but the Q of Figure 6.9b is slightly lower for the same internal gain. The design equation for frequency is the same (Equation 6.12), but the design equation for Q is different. Note that a Q of less than 0.5 is not possible because that corresponds to unity internal gain.

Other versions of the S&K bandpass filter can be designed with unequal capacitors; the rather cumbersome equations for the version in Figure 6.9b are given in [12]. See also [13].

TABLE 6.2 Q vs internal gain for S&K bandpass filter version a)

R4 Ω	R5 Ω	Internal gain	Calculated Q	Nominal Q
1000	1000	2.00	0.7071	$\sqrt{2}/2$
1586	1000	2.586	1.0000	1
2000	1000	3.00	1.4142	$\sqrt{2}$
2292	1000	3.29	1.999	2
2529	1000	3.53	3.000	3
2646	1000	3.65	4.000	4
2717	1000	3.72	4.999	5
2798	1000	3.80	7.000	7
2859	1000	3.86	9.999	10
2900	1000	3.90	14.142	$10\sqrt{2}$

For version a), the internal gain must be less than 4x because at that gain the Q becomes infinite, and the circuit oscillates.

Despite the 2x internal gain, for Q = $\sqrt{2}/2$ there is a maximum gain of unity to the amplifier output at the centre frequency. As Q increases the passband gain also increases, and for a modest Q of 1.41 ($\sqrt{2}$) there is a gain of 2.98x (9.5 dB) at the centre. This is not likely to be convenient in most systems, and very often it will be necessary to attenuate the input signal to prevent clipping of the

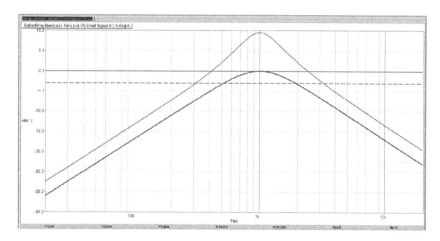

Figure 6.10 Response of Sallen & Key bandpass filter a) with a centre frequency of 1 kHz. Q is 0.707 and 1.41.

opamp. In the worst case this would mean adding a unity-gain buffer to drive an attenuator and then another buffer to drive the filter from a low impedance. But there is a better way . . .

Suppose we want an attenuation of 2x (−6 dB). This is easily contrived by replacing R1 with a 2 kΩ–2 kΩ divider which gives the required 6 dB loss but crucially maintains the impedance seen by the rest of the filter at 1 kΩ. Different attenuations are obtained by using a different divider ratio but keep the value of the parallel combination of the two divider resistors at 1 kΩ.

There is no phase shift at the centre frequency so the filter is non-inverting, which is what we might expect of a Sallen & Key filter.

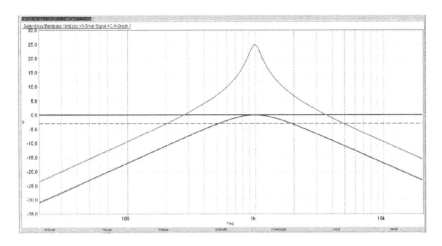

Figure 6.11 Response of Sallen & Key bandpass filter version a) with Q = 0.707 and version b) with Q = 5.15. Centre frequency 1 kHz.

Sallen & Key notch filters

There are two versions of the S&K notch filter, as shown in Figure 6.12. S&K notch filters are often disrespected in the literature. You will likely come across statements like "an excessive spread of component values," which seems to refer to a time when it was expected that all the

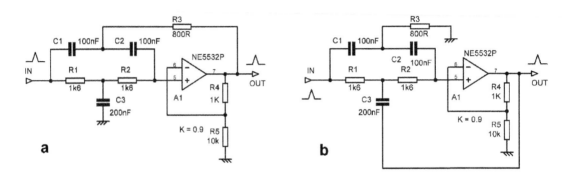

Figure 6.12 Sallen & Key notch filters with a centre frequency of 1 kHz.

passive components would be on thick film substrates. If you are using discrete components, you can ignore this criticism. The circuits look something like a twin-T filter (see the "Other notch filters" section), but here only one lower arm of the twin-T is driven from the amplifier.

The previously mentioned lowpass, highpass, and bandpass S&K filters all have well-known special cases which put design restrictions on the component values; this gives simpler equations and often the maximum Q for a given internal gain. For the S&K notch filter the conditions are R1 = R2 = 2R3 = R, and C1 = C2 = C3/2 = C. The equations are Equation 6.16 and Equation 6.17.

$$f = \frac{1}{2\pi RC}$$

Equation 6.16

$$Q = \frac{1}{4 - 2A}$$

Equation 6.17

I am not aware of any general equations that would describe this filter without the given design restrictions on the components. Some restrictions at least are required to produce a notch.

When simulating notch filters, assessing the notch depth can be tricky. You need a lot of frequency steps to ensure you really have hit bottom with one of them. For example, in one run, 50 steps/decade showed a −20 dB notch but upping it to 500 steps/decade revealed it was really −31 dB deep. In most cases having a stupendously deep notch is pointless. If you are trying to remove an unwanted signal then it only has to alter in frequency by a tiny amount, and you are on the side of the notch rather than the bottom, and the attenuation is much reduced. The exception to this is the THD analyser where a very deep notch (120 dB or more) is needed to reject the fundamental so very low levels of harmonics can be measured. This is achieved by continuously servo-tuning the notch so it is kept exactly on the incoming frequency.

Distortion in Sallen & Key filters

When they have a signal voltage across them, many capacitor types generate distortion. This unwelcome phenomenon is described in Chapter 2. It afflicts not only all electrolytic capacitors, but also some types of non-electrolytic. If the electrolytics are being used as coupling capacitors, then the cure is simply to make them so large that they have a negligible signal voltage across them at the lowest frequency of interest; less than 80 mVrms is a reasonable criterion. This means they may have to be ten times the value required for a satisfactory frequency response.

However, when non-electrolytics are used to set time-constants in filters, they obviously must have substantial signal voltages across them, and this simple fix is not usable. The problem is not a marginal one—the amounts of distortion produced can be surprisingly high. Figure 6.13 shows the frequency response of a conventional second-order Sallen & Key highpass filter as seen in Figure 6.5, with a −3 dB frequency of 520 Hz. C1, C2 were 220 nF 100 V polyester capacitors, with R1 = 1 kΩ and R2= 2 kΩ. The opamp was a 5532. The distortion performance is shown by the upper trace in Figure 6.14; above 1 kHz the distortion comes from the opamp alone and is very low. However you can see it rising rapidly below 1 kHz as the filter begins to act, and it has reached 0.015% by 100 Hz, completely overshadowing the opamp distortion; it is basically

third-order. The input level was 10 Vrms, which is about as much as you are likely to encounter in an opamp system. The output from the filter has dropped to −28 dB by 100 Hz, and so the amplitude of the harmonics generated is correspondingly lower, but it is still not a very happy outcome.

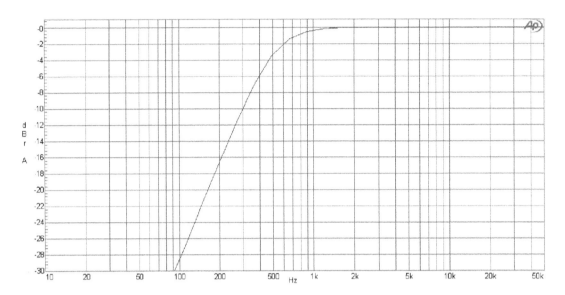

Figure 6.13 The frequency response of the second-order 520 Hz highpass filter.

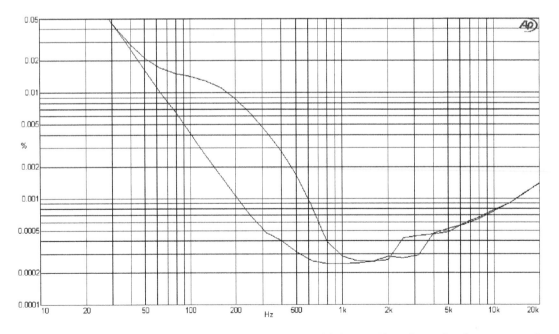

Figure 6.14 THD plot from the second-order 520 Hz highpass filter; input level 10 Vrms. The upper trace shows distortion from polyester capacitors; the lower trace, with polypropylene capacitors, shows noise only below 1 kHz.

As explained in Chapter 2, polypropylene capacitors exhibit negligible distortion compared with polyester, and the lower trace in Figure 6.14 shows the improvement on substituting 220 nF 250 V polypropylene capacitors. The THD residual below 500 Hz is now pure noise, and the trace is only rising at 12 dB/octave because circuit noise is constant but the filter output is falling. The important factor is the dielectric, not the voltage rating; 63 V polypropylene capacitors are also free from distortion. The only downside is that polypropylene capacitors are larger for a given CV product and more expensive.

Mixed capacitors in low-distortion Sallen & Key filters

You have seen in the previous section how capacitor distortion can wreak havoc in a second-order highpass filter; the results are much the same in a second-order lowpass filter. While this can be eliminated by using all polystyrene or polypropylene types, the latter in particular are expensive compared with polyester. It is, therefore, extraordinarily convenient to find that in single-stage filters, only *one* of the capacitors has a significant effect on the distortion behaviour. I modestly claim to have discovered this in 2011 [14]. I am not aware that anyone else has done any work on the topic.

The situation is summarised in Figure 6.15 for single-stage filters up to fourth-order, and it is not entirely as you might think. For the lowpass filters, the important capacitor is the inner of the two or the

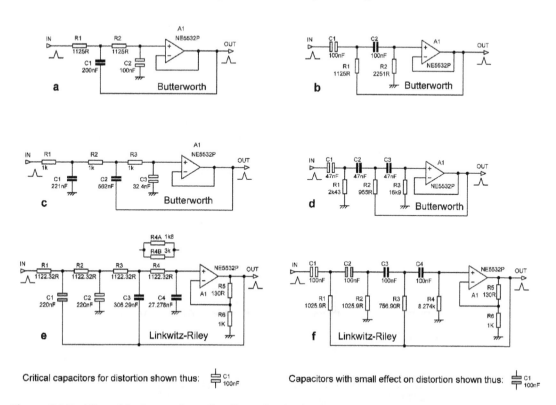

Figure 6.15 The critical capacitors for distortion in single-stage S&K filters, lowpass and highpass, second to fourth order. In each case one capacitor dominates the distortion performance and should be made polypropylene for best linearity. Cutoff is 1 kHz in each case.

three, but this breaks down in the fourth-order case. For the highpass filters, it is always the outermost capacitor that is the critical component. Only in the fourth-order filters do we see a capacitor that has a small but very real effect on linearity, as well as the capacitor that has a major effect.

Naturally, if you are making high-order filters in the more conventional multi-stage way by cascading second and first-order stages, you will need at least one linear (and expensive) capacitor per stage.

I have made strenuous efforts to find out the exact mechanism at work here by adding voltage-dependent non-linearity to the capacitor SPICE model, but the results I have obtained so far have been unconvincing.

Multiple-feedback bandpass filters

When a bandpass filter of modest Q is required, the multiple-feedback or Rauch type shown in Figure 6.16 has some advantages. The capacitors are equal and so can be made any preferred value. The opamp is working with shunt feedback and so has no common-mode voltage on the inputs, which avoids one source of distortion. It does, however, phase invert, which can be inconvenient.

The filter response is defined by three parameters—the centre frequency f_0, the Q, and the passband gain (ie the gain at the response peak) A. The filter in Figure 6.16 was designed for $f_0 = 250$ Hz, Q = 2, and A = 1 using the equations given, and the usual awkward resistor values emerged. The resistors are the nearest E96 value (ie 1xE96 format), and the simulated results come out as $f_0 = 251$ Hz, Q = 1.99, and A = 1.0024, which, as they say, is good enough for rock'n'roll.

The Q of the filter can be quickly checked from the response curve as Q is equal to the centre frequency divided by the −3 dB bandwidth, ie the frequency difference between the two −3 dB points on either side of the peak. This configuration is not suitable for Qs greater than about 10, as the filter characteristics become unduly sensitive to component tolerances. If independent control of f_0 and Q are required, the state-variable filter should be used instead.

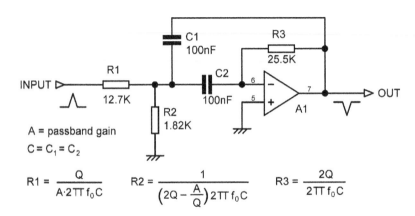

Figure 6.16 A bandpass multiple-feedback filter with $f_0 = 250$ Hz, Q = 2 and a gain of 1.

Similar configurations can be used for lowpass and highpass filters. The lowpass version does not depend on a low opamp output impedance to maintain stopband attenuation at high frequencies and so avoids the oh-no-it's-coming-back-up-again behaviour of S&K lowpass filters. It does, however, have higher noise gain and an inconvenient phase reversal. The highpass version has both those features, requires three capacitors rather than two, and also seems to have issues with HF distortion; it is not recommended.

Other notch filters

There are many ways to dig a deep notch in your frequency response. The width of a notch is described by its Q; exactly as for a resonance peak, the Q is equal to the centre frequency divided by the −3 dB bandwidth, ie the frequency difference between the −3 dB points on either side of the notch. The Q has no relation to the depth of the notch.

The best-known notch filter is the twin-T notch network shown in Figure 6.17a, invented in 1934 by Herbert Augustadt [15]. The notch depth is infinite with exactly matched components, but with ordinary ones it is unlikely to be deeper than 40 dB. It requires ratios of two in component values which do not fit in well with preferred values, and when used alone has a Q of only 0.25. It is therefore normally used with positive feedback via an opamp buffer A2, as shown. The proportion of feedback K and hence the Q-enhancement is set by R4 and R5, which here give a Q of 1. A great drawback is that the notch frequency can only be altered by changing three components (usually the resistors), so it is not considered tuneable.

Another way of making notch filters is the '1-bandpass' principle mentioned earlier. The input goes through a bandpass filter, typically the multiple-feedback type described earlier, and is then

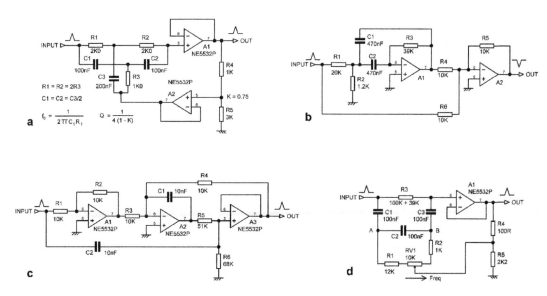

Figure 6.17 Notch filters: a) twin-T with positive feedback, notch at 795 Hz and a Q of 1; b) '1-bandpass' filter with notch at 50 Hz, Q of 2.85; c) Bainter filter with notch at 700 Hz, Q of 1.29; d) Bridged-differentiator notch filter tuneable 80 to 180 Hz.

subtracted from the original signal. The accuracy of the cancellation and hence the notch depth is critically dependent on the mid-band gain of the bandpass filter. Figure 6.17b shows an example that gives a notch at 50 Hz with a Q of 2.85. The subtraction is performed by A2, as the output of the filter is phase-inverted. The multiple-feedback filter is designed for unity passband gain, but the use of E24 values as shown means that the actual gain is 0.97, limiting the notch depth to −32 dB. The value of R6 can be tweaked to deepen the notch; the nearest E96 value is 10.2 kΩ, which gives a depth of −45 dB. The final output is inconveniently phase-inverted in the passband.

A notch filter that deserves to be better known is the Bainter filter [16, 17] shown in Figure 6.17c. It is non-inverting in the passband, and two out of three opamps are working at virtual-earth and will give no trouble with common-mode distortion. An important advantage is that the notch depth does not depend on the matching of components, but only on the open-loop gain of the opamps, being roughly proportional to it. With TL072-type opamps, the depth is from −40 to −50 dB. The values shown give a notch at 700 Hz with a Q of 1.29. The design equations can be found in [16].

A property of this filter that does not seem to appear in the textbooks is that if R1 and R4 are altered together, ie having the same values, then the notch frequency is tuneable with a good depth maintained, but the Q does change proportionally to frequency. To get a standard notch with equal gain either side of the crevasse R3 must equal R4. R4 greater than R3 gives a lowpass notch, while R3 greater than R4 gives a highpass notch; these responses are useful in crossover design [7]. Full design details are given in *The Design of Active Crossovers, Second Edition* [1].

But what if we need a notch filter that can be tuned with one control? Figure 6.17d shows a bridged-differentiator notch filter tuneable from 80 to 180 Hz by RV1. R3 must theoretically be six times the total resistance between A and B, which here is 138 kΩ, but 139 kΩ gives a deeper notch, about −27 dB across the tuning range. The downside is that Q varies with frequency from 3.9 at 80 Hz to 1.4 at 180 Hz.

Another interesting notch filter to look up is the Boctor, which uses only one opamp [18, 19]. Both the biquad and state-variable filters can be configured to give notch outputs.

Higher-order filters

Second-order filters, of whatever Q, will always finally roll-off at 12 dB per octave. To get a faster ultimate roll-off, we can use a third-order filter, which is a first-order filter (ie a simple RC time constant) cascaded with a second-order filter that has a Q of 1.0, causing a response peak. This peak combined with the slow first-order roll-off gives a flat passband and then a steep roll-off.

Figure 6.18a shows a third-order highpass Butterworth filter with a −3 dB frequency of 100 Hz, as might be used at the front end of a mixer channel. It is built the obvious way, with a first-order filter R1, C1 followed by a unity-gain buffer to give low-impedance drive to the following second-order filter. R2 and R3 now have a ratio of 4 to obtain a Q of 1.0. E24 resistor values are shown, and in this case they give an accurate response.

A more economical way to make a third-order filter is the Geffen configuration shown in Figure 6.18b, which saves an opamp section. The resistor values shown are the nearest E96 values to

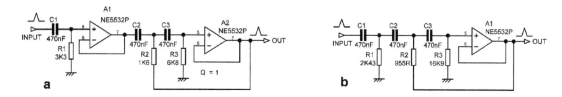

Figure 6.18 Two third-order Butterworth highpass filters with a cutoff frequency of 100 Hz.

the mathematically exact numbers (ie 1xE96 format) and give an extremely accurate response. The nearest E24 values are R1 = 2k4, R2 = 910 Ω, and R3 = 16 kΩ, giving a very small peaking of 0.06 dB at 233 Hz. Errors due to the capacitor tolerances are likely to be larger than this. The distortion performance may not be as good as for Figure 6.18a due to increased noise gain around cutoff. The design process is much more complicated, and the filter may prove to be more sensitive to component tolerances.

Fourth-order highpass filters are the steepest in normal use. They are made by cascading two second-order filters with Qs of 0.54 and 1.31. They can also be implemented in one stage as in Figure 6.18b, but again the design is complicated. Ready-made single-stage filter designs up to sixth order, lowpass and highpass, can be found in *The Design of Active Crossovers, Second Edition* [1].

Switched-slope filters

Some time back a requirement arose for a highpass filter with a 50 Hz cutoff that could be switched between no filtering, a first-order response, and a second-order response. It would, of course, be easy to design a first-order filter and a second-order filter and switch between them and a bypass path. That, however, does not seem a very elegant approach, using two opamps and three capacitors (the expensive parts). It occurred to me that it should be possible to have one filter and suitably switch the passive components. Unfortunately there are compromises; the slopes are exactly as required, but the either the cutoff frequency or the gain are not.

The first version in Figure 6.19a is a standard unity-gain S&K 50 Hz highpass filter when the switch is in the central position. It may not be desirable to have the steepest slope in the middle switch position, but it is a fact that centre-off toggle switches are cheap compared with other

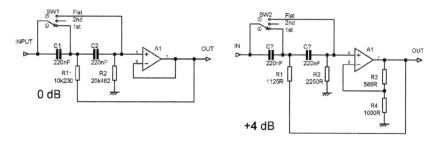

Figure 6.19 Switched-slope (first-order, second-order, and flat) highpass S&K filters.

ways of switching. With the switch in the 'Flat' position, C1 and C2 are shorted out, and R1 does nothing as it is fully bootstrapped. With the switch in the first-order position, only C1 is shorted out, and you get 6 dB/octave. The snag is that the first-order cutoff is at 35.5 Hz rather than 50 Hz, which may or may not be acceptable.

The second version in Figure 6.19b is an S&K filter with gain. If this internal gain is carefully chosen, in this case 1.58x (+4.0 dB), the cutoff frequencies for the two slopes are 50 Hz in each case. The snag is, of course, that you may not want 4 dB of gain at this point in your system.

I suspect that you could get constant cutoff frequency combined with unity gain by using a Bach filter, which decouples the two time-constants [20], but that requires two amplifiers so there would be no longer be a significant saving on parts cost or power consumption. I have, therefore, not pursued it further.

Differential filters

At first an active filter that is also a differential amplifier, and thereby carries out an accurate subtraction, sounds like a very exotic creature. Actually they are very common and are normally based on the multiple-feedback filter described earlier. Their main application is DAC output filtering in CD players and the like; more sophisticated versions are useful for data acquisition in difficult environments. Differential filters are dealt with in the section of Chapter 26 on interfacing with DAC outputs.

References

[1] Self, D. *The Design of Active Crossovers*, 2nd edition. Focal Press, 2018. ISBN 978-1-138-73302-2 (hbk); ISBN 978-1-138-73303-9 (pbk); ISBN 978-1-315-18789-1 (ebk)

[2] Williams, A. & Taylor, F. J. *Electronic Filter Design Handbook*, 4th edition. McGraw-Hill, 2006. ISBN 0-07-147171-5

[3] Van Valkenburg, M. *Analog Filter Design*. Holt-Saunders International Editions, 1982. ISBN 4-8338-0091-3

[4] Berlin, H. M. *Design of Active Filters with Experiments*. Blacksburg, 1978, p. 85

[5] Wikipedia. http://en.wikipedia.org/wiki/Stephen_Butterworth Accessed Oct 2013

[6] Hofer, B. "Switch-Mode Amplifier Performance Measurements." *Electronics World*, Sept 2005, p. 30

[7] Hardman, B. "Precise Active Crossover." *Electronics World*, Aug 2009, p. 652

[8] Sallen, R. P. & Key, E. L. "A Practical Method of Designing RC Active Filters." *IRE Transactions on Circuit Theory*, Vol. 2, No. 1, 1955–03, pp. 74–85

[9] Linkwitz, S. "Active Crossover Networks for Non-Coincident Drivers." *Journal of the Audio Engineering Society*, Vol. 24, Jan/Feb 1976, pp. 2–8

[10] Wikipedia. https://en.wikipedia.org/wiki/Sallen%E2%80%93Key_topology#Application:_bandpass_filter Accessed Nov 2020

[11] Frederiksen, M. T. *Intuitive Opamp Design*, Revised edition. McGraw-Hill, 1988, pp. 265, 266

[12] Analog.com. www.analog.com/media/en/training-seminars/tutorials/MT-222.pdf p2 Accessed Nov 2020

[13] www.d.umn.edu/~htang/ece3235_doc_F10/Active_Filter_Summary.pdf Accessed Nov 2020

[14] Self, D. *The Design of Active Crossovers*, 2nd edition. Focal Press, 2018, pp. 310–321

[15] Augustadt, H. "Electric Filter." *US Patent No. 2,106,785*, Feb 1938, assigned to Bell Telephone Labs

[16] Bainter, J. R. "Active Filter Has Stable Notch, and Response Can Be Regulated." *Electronics*, 2 Oct 1975, pp. 115–117

[17] Van Valkenburg, M. *Analog Filter Design*. Holt-Saunders International Editions, 1982, p. 346

[18] Boctor, S. A. "Single Amplifier Functionally Tuneable Low-pass Notch Filter." *IEEE Transactions on Circuits & Systems*, Vol. CAS-22, 1975, pp. 875–881

[19] Van Valkenburg, M. *Analog Filter Design*. Holt-Saunders International Editions, 1982, p. 349. ISBN 4-8338-0091-3

[20] Bhattacharyya, B., et al. "A Note on Bach's Low-Pass Active RC Filter." *Proceedings of the IEEE*, Vol. 64, No. 4, Apr 1976

Preamp architecture

Some sort of preamplifier or control unit is required in all hifi systems, even if its only function is to select the source and set the volume. You could even argue that the source-selection switch could be done away with if you are prepared to plug and unplug those rhodium-plated connectors, leaving a 'preamplifier' that basically consists solely of a volume control potentiometer in a box. I am assuming here that a selector switch will be required, and that gives us the 'passive preamplifier' (oxymoron alert!) in Figure 7.1a.

Passive preamplifiers

A device may have only one component, but it does not follow that it is easy to design, even though the only parameter to decide is the resistance of the volume pot. Any piece of equipment that embodies its internal contradictions in its very name needs to be treated with caution. The pot resistance of a 'passive preamplifier' cannot be too high because the output impedance, maximal at one quarter the track resistance when volume is set to −6 dB, will cause an HF roll-off in conjunction with the connecting cable capacitance. It also makes life difficult for those designing RF filters on the inputs of the equipment being driven, as described in Chapter 18.

On the other hand, if the volume pot resistance is too low, the source equipment will suffer excessive loading. If the source is valve equipment, which does not respond well to even moderate loading, the problem starts to look insoluble.

If, however, we can assume that our source equipment has a reasonable drive capability, we can use a 10 kΩ pot. Its maximum output impedance (at −6 dB) will be then be 2.5 kΩ. The capacitance of most audio cable is 50–150 pF/metre, so with a 2.5 kΩ source impedance and 100 pF/metre cable, a maximum length of 5 metres is permissible before the HF loss hits the magic figure of −0.1 dB at 20 kHz. A very rapid survey of current (2009) 'passive preamplifiers' confirmed that 10 kΩ seems to be the most popular value. One model had a 20 kΩ potentiometer and another had a 100 kΩ pot, which with its 25 kΩ source impedance would hardly allow any cable at all. I suspect that the only reason such a pot can appear acceptable is because in normal use it is set well below −6 dB. For example, if a 100 kΩ pot is set to −15 dB, the output impedance is reduced to 14 kΩ, which would allow just under a metre of 100 pF/metre cable to be used with HF loss still limited to −0.1 dB at 20 kHz. A high output impedance also makes an interconnection more susceptible to interference unless it is totally screened at every point on its length.

Consider also that many power amplifiers have RC filters at the input, not so much for EMC immunity, but more as a gesture against what used to be called "TID" but is actually just

DOI: 10.4324/9781003332985-7

old-fashioned slew limiting and highly unlikely in practice. These can add extra shunt capacitance to the input ranging from 100 pF to 1000 pF, apparently having been designed on assumption of near-zero source impedance, and this can cause serious HF roll-offs.

There is at least one passive preamplifier on the market that controls volume by changing the taps on the secondary of a transformer; this should give much lower output impedances. There is more on this approach in Chapter 13 on volume controls.

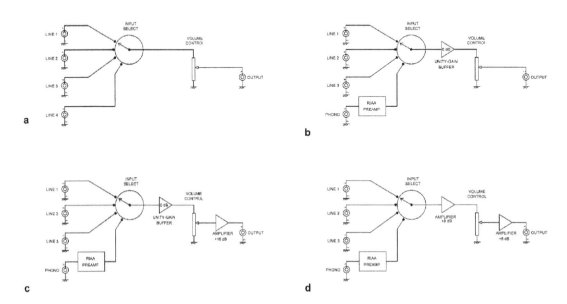

Figure 7.1 Preamplifier evolution: a) passive preamplifier; b) input buffer and phono amplifier added; c) amplification after the volume control added; d) amplification split into two stages, before and after volume control.

Active preamplifiers

Once we permit ourselves active electronics, things get much easier. If a unity-gain buffer stage is added after the selector switch, as in Figure 7.1b, the volume pot resistance can be reduced to much less than 10 kΩ, while presenting a high impedance to the sources. If a 5532 is used there is no technical reason why the pot could not be as low as 1 kΩ, which will give a much more usable maximum output impedance of only 250 Ω, and also reduce the Johnson noise from the pot by 10 dB. A phono preamplifier has also been added. Now we've paid for a power supply, it might as well supply something else.

This still leaves us with an 'amplifier' that has only unity line gain. Normally only CD players, which have an output of 2 Vrms, can fully drive a power amplifier without additional gain, and there are some high-power amplifiers that require more than this for full output. iPods appear to have a maximum output of 1.2 Vrms. Output levels for tuners, phono amps, and so on vary but may be as low as 150 mVrms from veteran equipment, while power amplifiers rarely have sensitivities lower than 500 mV. Clearly some gain would be good thing, so one option is adding

a gain stage after the volume control as in Figure 7.1c. The output level can be increased and the output impedance kept down to 100 Ω or much lower if required; see the section on so-called 'Zero-impedance outputs' in Chapter 19.

This amplifier stage introduces its own difficulties. If its nominal output level with the volume control fully up is taken as 1 Vrms for 150 mV in, which will let us drive most power amps to full output from most sources most of the time, we will need a gain of 6.7 times or 16.5 dB. If we decide to increase the nominal output level to 2 Vrms to be sure of driving most if not all exotica to its limits, we need 22.5 dB. The problem is that the gain stage is amplifying its own noise at all volume settings, and amplifying a proportion of the Johnson noise of the pot whenever the wiper is off the zero stop. The noise performance will therefore deteriorate markedly at low volume levels, which are the ones most used.

Amplification and the gain-distribution problem

One answer to this difficulty is to take the total gain and split it so there is some before and some after the volume control, so there is less gain amplifying the noise at low volume settings. One version of this is shown in Figure 7.1d. The question is—how much gain before and how much after? This is inevitably a compromise, and it might be called the gain-distribution problem. Putting more of the total gain before the volume control reduces the headroom as there is no way to reduce the signal level, while putting more after increases the noise output at low volume settings.

If you are exclusively using sources with a predictable output, of which the 2 Vrms from a CD player will be the maximum, the overload situation is well-defined, and if we assume that the pre-volume gain stage is capable of at least 8 Vrms out, then so long as the pre-volume control gain is less than four times there will never be a clipping problem. However, phono cartridges, particularly moving-coil ones, which have a very wide range of sensitivities, produce much less predictable outputs after fixed-gain preamplification, and it is a judgement call as to how much safety margin is desirable.

As an aside, it's worth bearing in mind that even putting a unity-gain buffer before the volume control, which we did as the first step in preamp evolution, does place a constraint on the signal levels that can be handled, albeit at rather a high level of 8 to 10 Vrms depending on the supply rails in use. The only source likely to be capable of putting out such levels is a mixing console with the group faders fully advanced. There is also the ultimate constraint that a volume control pot can only handle so much power, and the manufacturers ratings are surprisingly low, sometimes only 50 mW. This means that a 10 kΩ pot would be limited to 22 Vrms across it, and if you are planning to use lower resistance pots than this to reduce noise, their power rating needs to be kept very much in mind.

Whenever a compromise appears in engineering, you can bet that someone will try to find a way round it and get the best of both worlds. What can be done about the gain-distribution dilemma?

One possibility is the use of a special low-noise amplifier after the volume control, combined with a low-resistance volume pot as suggested earlier. This could be done either by a discrete

device and opamp hybrid stage or by using a multiple opamp array, as described in Chapter 1. It is doubtful if it is possible to obtain more than a 10 dB noise improvement by these means, but it would be an interesting project.

Another possible solution is the use of double gain controls. There is an input gain control before any amplification stage which is used to set the internal level appropriately, thus avoiding overload, and after the active stages there is an output volume control, which gives the much-desired silence at zero volume; see Figure 7.2a. The input gain controls can be separate for each channel, so they double as a balance facility; this approach was used on the Radford HD250 amplifier and also in one of my early preamplifier designs [1]. This helps to offset the cost of the extra pot. However, having two gain controls is operationally rather awkward, and however attenuation and fixed amplification are arranged, there are always going to be some tradeoffs between noise and headroom. It could also be argued that this scheme does not make a lot of sense unless some means of metering the signal level after the input gain control is provided, so it can be set appropriately.

If the input and output gain controls are ganged together, to improve ease of operation at the expense of flexibility, this is sometimes called a distributed gain control.

Active gain controls

The noise/headroom compromise is completely avoided by replacing the combination of volume-control-and-amplifier with an active gain control, ie an amplifier stage whose gain is variable from near-zero to the required maximum; see Figure 7.2b. We get lower noise at gain settings below maximum, and we can increase that maximum gain so even the least sensitive power amplifiers can be fully driven without impairing the noise performance at lower settings. We also get the ability to generate a quasi-logarithmic law from a linear pot, which gives excellent channel balance as it depends only on mechanical alignment. The only snags are that

a) Most active gain controls phase invert, though this can be corrected by suitable connection of a balanced input or balanced output stage, or adding a Baxandall tone control.

b) The noise out is very low but not zero at zero volume as it would be with a passive pot, since the noise gain cannot fall below unity and may be many times. A standard Baxandall active volume control with a maximum gain of 10 dB has a minimum noise gain at zero volume of 12 dB; see Chapter 13 for much more on this.

c) The gain control law may not be exactly what you want, and it can be hard to alter without losing the independence of gain from pot value.

The technology of active gain controls is dealt with fully in Chapter 13.

Active gain controls plus passive attenuators

In the previous section it was pointed out that while active gain controls have great advantages, they may have a non-optimal control law and do not give zero noise out at zero volume setting.

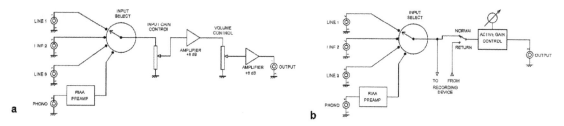

Figure 7.2 More preamp architectures: a) with input gain control and output volume control; b) with recording output and return input, and an active gain-control.

Both of these issues can be handily solved by adding a ganged passive attenuator after the active volume control and right at the end of the signal path. This means a quadruple pot for stereo, but they are not that hard to obtain. There is quite a bit to this technology, and it is dealt with in detail in Chapter 13 on volume controls.

Recording facilities

If a preamplifier is going to be used for recording, the minimum requirement is an output taken from before the volume control and tone controls (if any), and there is usually also a dedicated input for a signal coming back from the recorder which can be switched to for checking purposes. Back when recording was done on tape, the return signal could be taken from the replay heads and gave assurance that recording had actually happened. Now that recording is done on hard disc machines or PCs the return signal normally only assures you that the signal has actually got there and back.

Much ingenuity used to be expended in designing switching systems so you could listen to one source while recording another, though it is rather doubtful how many people actually wanted to do this; it demands very high standards of crosstalk inside the preamplifier to make sure that the signal being recorded is not contaminated by the source listened to.

Tone controls

Let us now consider adding tone controls. They have been unfashionable for a while, but this is definitely changing now. I think they are absolutely necessary, and it is a startling situation when, as frequently happens, anxious inquirers to hifi advice columns are advised to change their loudspeakers to correct excess or lack of bass or treble. This is an extremely expensive alternative to tone controls.

There are many possible types, as described in Chapter 15, but one thing they have in common is that they must be fed from a low-impedance source to give the correct boost/cut figures and predictable EQ curves. Another vital point is that most types, including the famous

Baxandall configuration, phase invert. Since there is now pretty much a consensus that all audio equipment should maintain absolute phase polarity for all input and outputs, this can be highly inconvenient.

However, as noted earlier, this phase inversion can very neatly be undone by the use of an active gain control, which also uses shunt feedback and so also phase inverts. The tone-control can be placed before or after the active gain control, but if placed afterwards it generates noise that cannot be turned down. Putting it before the active gain control reduces headroom if boost is in use, but if we assume the maximum boost used is +10 dB, the tone-control will not clip until an input of 3 Vrms is applied, and domestic equipment rarely generates such levels. It therefore seems best to put the tone control before the active gain control. This is what I did in my most recent preamplifier designs [2–5].

The classic Baxandall tone control gives cut and boost of bass and treble. Much greater flexibility is obtained if the turnover frequencies are switchable, or better still, continuously variable. Circuitry to perform this is described in Chapter 15.

References

[1] Self, D. "An Advanced Preamplifier." *Wireless World*, Nov 1976

[2] Self, D. "A Precision Preamplifier." *Wireless World*, Oct 1983

[3] Self, D. "Precision Preamplifier 96." *Electronics World*, July/Aug and Sept 1996

[4] Self, D. "A Low Noise Preamplifier with Variable-Frequency Tone Controls." *Linear Audio*, Vol. 5, 2013, pp. 141–162

[5] Self, D. "Preamplifier 2012." *Elektor*, Apr, May, June 2012

Variable gain stages

This chapter deals with amplifier stages that are required to have a variable gain, usually over a wide range of +20 dB, +30 dB, or more. It does not include volume controls, which typically only have a maximum gain of +10 dB or so and have their own chapter (Chapter 13). Nor does it include balanced microphone preamplifiers, which can have a variable gain range of 80 dB or more and also have their own chapter (Chapter 17).

These amplifier stages are very common in audio electronics. A typical application would be a guitar amplifier input which has to cover a range of playing styles and pickup sensitivities. Another major use is in compact mixers that have only one control performing the functions of both input gain control and channel fader.

The examples given in this chapter have a maximum gain of +30 dB. In some places it is assumed that ideally the gain law would be linear in dB. This not always the case; if the gain control will spend almost all its working life at mid settings, making the gain change faster at high and low settings will allow the middle gain range to be more spread out, giving easier adjustment.

Pot rotation is described here as the Mark on a scale calibrated 0–10, so Mark 5 is the middle setting and Mark 10 is the maximum. No provisions are made for turning anything up to 11 (Spinal Tap reference).

Amplifier stages with gain from unity upwards: single gain pot

In many cases a minimum gain of unity (0 dB) is quite acceptable, and this simplifies matters considerably. A series-feedback amplifier configuration can be used, which inherently has a minimum gain of unity and can also provide a high or very high input impedance. In contrast, a shunt-feedback amplifier can have gain adjustable down to zero but will have a relatively low input impedance, which may vary with the gain setting. This can be addressed by putting a unity-gain buffer in front of the gain control, but its noise is being added at the most sensitive part of the circuit, and this is usually not a very good idea.

If we require gain from unity upwards, this is best achieved by varying the amount of negative feedback. The simplest way to control the feedback factor is to make one of the resistors in the feedback network variable. Figure 8.1a shows how not to do it; this works OK at high gains, but at low gains the resistance of RV1 is low and in conjunction with R2 puts an excessive load on the opamp output. If the opamp is happy with a 1 kΩ load then R2 could be increased to 1 kΩ with the

DOI: 10.4324/9781003332985-8

value of RV1 increased proportionally. That will solve the loading problem but gives a relatively high impedance feedback network that will be noisy.

The method shown in Figure 8.1b is often a better choice. The variable resistor is now in the bottom arm of the feedback network. This means that the opamp output can never see a load less than R3 + R2. The downside is that at low gain settings the impedance seen by the inverting input is relatively high; at high gain settings it reduces to the value of R2. Thus the equivalent input noise is lower at high gains, keeping the noise output low.

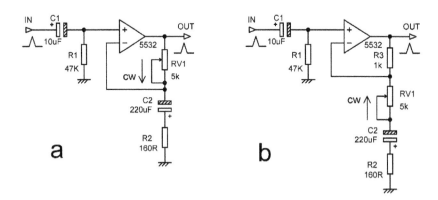

Figure 8.1 Variable-gain stages: a) is not workable with the values shown due to excessive loading on the opamp at low gains; b) has no loading problems.

If a linear pot is used for RV1, the gain law is a long way from linear in dB, as shown in Figure 8.2. When the control is turned clockwise, virtually nothing happens for the first 80% of rotation, and 20 of the 30 dB gain range is constricted into the last 10% of rotation. The obvious answer is to use an anti-log pot, where the resistance changes more rapidly at the start of rotation. This is demonstrated in Figure 8.2, where the gain laws are compared with the dotted ideal linear-in-dB line; the pot laws are anti-log C and anti-log D as used by Alps. Both are a considerable improvement on a linear pot, making the control usable, but the D-law is clearly the better of the two. However even the D-law is some 6 dB away from the ideal line for most of the pot rotation.

It appears as if the C-law may be implemented with two resistance slopes on the track, and the D-law with three, though this is speculative. Be aware that it is usually necessary to read the law of a pot from a rather small graph on the data sheet, so the accuracy is limited.

The gain does not go down as far as unity (0 dB) because this would require the maximum value of RV1 to be infinite. That is a limitation of this configuration, though in many cases a minimum gain of 1 or 2 dB would not be a big problem.

Both circuits in Figure 8.1 have the disadvantage that the gain depends on the track resistance of the pot, which is unlikely to have a tolerance closer than ±20%. This makes stereo gain control tricky—channel balance will be poor, especially if dual or triple slope pots are used.

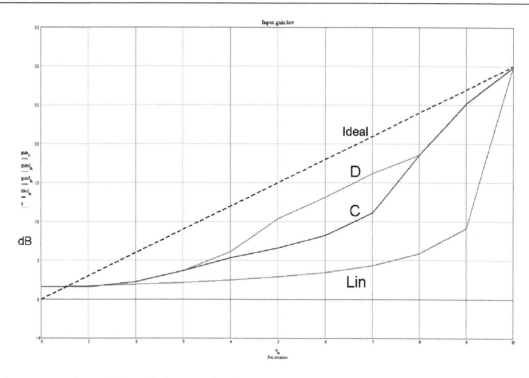

Figure 8.2 The gain law of Figure 8.1b, with linear-, C-, and D-laws.

A better gain control law can be obtained from a linear pot if it is arranged so that the entire track is always in the feedback network, with the wiper position deciding how much of it is in the upper feedback arm and how much in the lower. This is illustrated in Figure 8.3; Figure 8.3a uses the pot alone while Figure 8.3b has pot-loading resistor R3 added to give some control over the law shape.

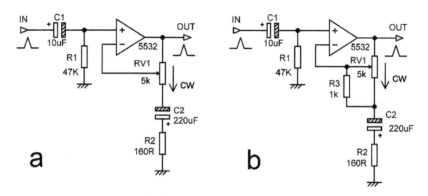

Figure 8.3 Variable-gain stages with improved law and a single pot.

The resulting gain laws for linear, C-law, and D-law pots are shown in Figure 8.4. Because both halves of the pot are controlling the gain, a linear pot gives a better law than when it is used only as a variable resistance. To a first approximation variations in track resistance will cancel out and not affect the gain. Also, now the gain can be reduced to exactly unity.

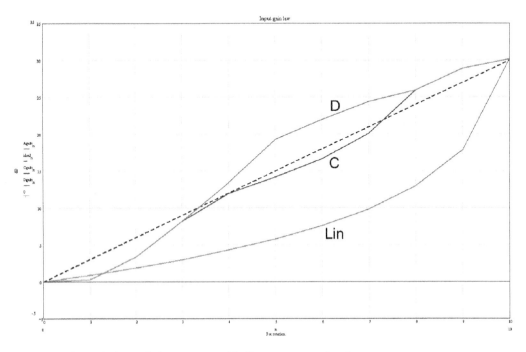

Figure 8.4 The gain law of Figure 8.3a with linear-, C-, and D-law pots.

As Figure 8.4 shows, the linear law gain increases by 12 dB in going from 9 to 10, whereas in Figure 8.2 it increases by 21 dB. The new law is more usable, but still a long way from the dashed linear-in-dB line. Using a C-law pot gives a much closer fit to the ideal line, the resulting gain law being only 2 or 3 dB away over most of the pot travel. Using a D-law pot now gives worse results, further away from and above the ideal line.

It may be that linear pots are preferred because they are more accurate than anti-log pots. In this case, the circuit of Figure 8.3b will be useful. The loading resistor R3 has no effect on the minimum or maximum gain but increases the gain in the centre portion of pot travel. This is demonstrated in Figure 8.5.

When the pot wiper is at the top of the track (ie minimum gain) R3 is connected from the opamp output to ground through R2 and so directly loads the opamp. This puts a minimum value on it if good opamp distortion performance is to be preserved. The lowest recommended value with a 5532 opamp is 620 Ω, but reducing R3 to this value does not greatly improve the gain law over R3 = 1 kΩ, as shown in Figure 8.5. With 620 Ω there is a good linear-in-dB law from 0 dB to +20 dB, but the last 10 dB of gain comes in too fast. In applications where this amount of gain is rarely needed, this may acceptable. The only way to improve it is to use C-law or D-law pots as demonstrated in Figure 8.4.

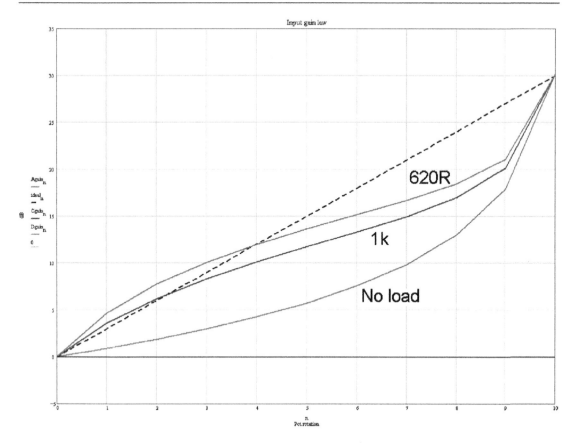

Figure 8.5 **The gain law of Figure 8.3b, with a linear pot unloaded, loaded with 1 kΩ and loaded with 620 Ω.**

Amplifier stages with gain from unity upwards: dual gain pot

If linear pots are preferred, a better approach to a linear-in-dB law can be obtained by using a dual pot, with the sections cascaded, as in Figure 8.6a. This gives a modified square-law gain characteristic (modified because of the loading effect of the second pot section on the first pot section), which fits very well with our 0–30 dB ideal line, especially when loading resistor R3 is added.

Figure 8.7 shows that the gain law for the circuit of Figure 8.6a is close to the dashed ideal line, being within 2 dB of it. Adding a 4k7 loading resistor R3 increases the gain slightly in the middle of the pot travel, and puts the gain law nicely on top of the ideal line. This is more than good enough for the normal use of audio equipment.

You might think that because there are two 5 kΩ pots it would be necessary to halve the value of R2 to get the same +30 dB maximum gain; this is not so. At maximum gain the first half of the pot is short circuited by the wiper position of the second half of the pot and plays no part in setting the gain.

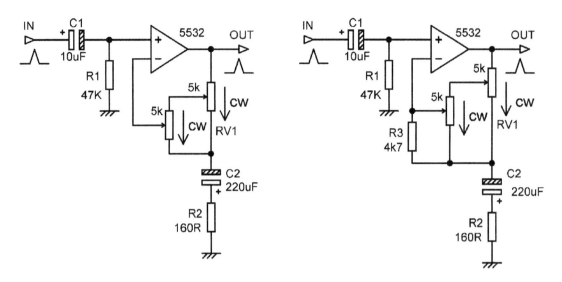

Figure 8.6 Variable-gain stages using dual pot, with and without loading resistor R3.

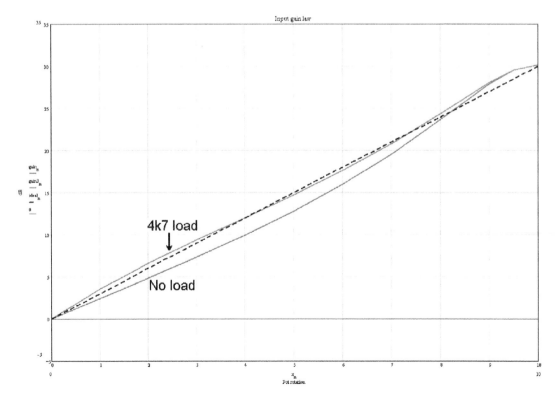

Figure 8.7 The gain law of Figure 8.6, with and without loading resistor R3.

Combining gain stages with active filters

Combining one stage with another so that less total parts are needed to perform two functions is certainly good practice economically, but rarely done unless really necessary because it is usually difficult to design a stage so that the two functions do not interact or interfere with each other. An application where a special effort to do it is worthwhile is the stereo input module of a mixing console, which has to fit approximately twice the amount of circuitry into the same space as a single channel. The facilities available often have to be simplified somewhat, if only to avoid unwelcome quadruple pots. Here I demonstrate combining a variable-gain stage with an active filter.

Figure 8.8 shows a second-order highpass filter with −3 dB cutoff at 50 Hz and a Q of 0.707 (Butterworth maximally flat) combined with a variable gain from unity to ten times (0 to +20 dB). This is the sort of gain range that might be found in one stage of a two-stage microphone amplifier, with the highpass filter being used to reduce mic proximity effect and environmental rumblings. The Sallen & Key filter is conventional except that both R2 and the inverting input of A1 are driven from the wiper of pot RV1; this means the filter characteristic does not change with the gain. The cutoff frequency is nominally 50 Hz but actually nearer 48 Hz as a result of using E24 resistors; this is of no consequence. The −3 dB point is, of course, with reference to the passband gain, whatever it might be set to be. The maximum gain is actually +20.8 dBu, which is as close as you can get with E24 resistors and E3 pot values; customers might complain about slightly too little gain range, but they won't complain about a little more than spec.

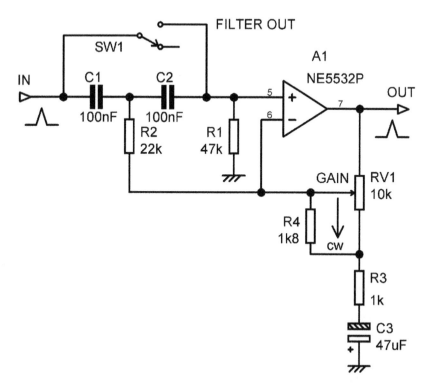

Figure 8.8 Second-order highpass filter (−3 dB at 50 Hz) combined with 0 to +20 dB gain stage.

Filters like this need to be switched out when not required; since the stage also gives gain it cannot simply be bypassed by a changeover switch. Instead SW1 performs this function very neatly, removing the filter action without affecting the gain control. Note that it is not necessary to switch both capacitors out separately; only one switch section is required, which is very desirable as it means a 2-c/o switch can be used for stereo rather than a more expensive 4-c/o part.

There will be a small offset voltage at the top of R1 due to the opamp bias current. It is assumed that there is a DC-blocking capacitor at the output of the previous stage so no current will flow through SW1 and there will be no clicks when it is operated.

Other combined stages described in this book are a combined balanced line input and balance control (see Chapter 18) and a tone-control combined with a balance control (Chapter 15).

Amplifier stages with gain from zero upwards: single gain pot

Sometimes a minimum gain of unity is unacceptable—it has to go down to zero. Such input stages are commonly used in compact mixers with only one control per channel performing the functions of both an input gain control and a channel fader. Therefore the stage must have not only a reasonably wide gain range, but that gain must go down to zero.

This means that an ideal gain law cannot simply be linear in dB because at one end it has to go down to −infinity dB. What we can do is have a linear-in-0 dB law down to a certain point, say the 20% point (Mark 2) and then make the gain fall rapidly to zero from there; see Figure 8.10.

The ideal line used here passes through 0 dB at Mark 2 and +30 dB at Mark 10. Its equation is

$$y = 3.75x - 7.5$$ Equation 8.1

The required functionality can be obtained with a single-gang pot, as shown in Figure 8.9; the wiper is grounded, so the left-hand part of the pot track controls the gain, while the right-hand part controls the attenuation introduced after the gain stage. As the control is turned counter-clockwise the resistance in series with R2 increases, while at the same time the loading on R4 is increased, increasing the attenuation.

The result for both C-law and D-law pots is shown in Figure 8.10, along with an ideal line that hits 0 dB gain at Mark 2 of rotation. Linear pots give a poor law. The C-law result is closer to the ideal line around the middle of pot travel, but the D version is not much worse. Both laws give a rapid gain increase between Mark 8 and Mark 9, but this may be no disadvantage if, as is likely in most cases, the upper gain extremes are less commonly used.

Note that the output is in general not at a low impedance; the maximum output impedance (at maximum gain) is 33 kΩ in parallel with 5 kΩ, which equals 4.34 kΩ. If the next stage requires a low-impedance drive (such as an EQ stage), then you will have to add a unity-gain buffer.

Ideally, as the control is turned counter-clockwise, the gain should reduce smoothly to unity, after which the attenuation starts from unity and increases until the output is zero. This is not feasible with an ordinary pot, though something could perhaps be contrived using special balance pots that

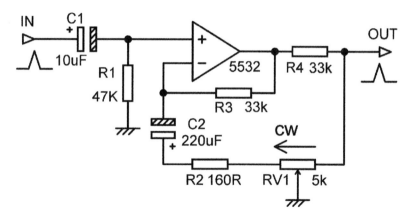

Figure 8.9 Variable-gain down to zero with single pot.

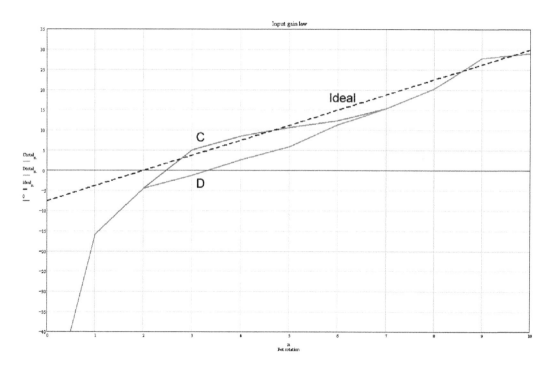

Figure 8.10 The gain law of Figure 8.9 with C-law and D-law pots.

have half the track made of low-resistance material (see Chapter 14). With the circuit here there is always a combination of gain and attenuation; they overlap. This reduces the headroom because it breaks the rule about not amplifying then attenuating. I have always called this the overlap penalty; it has nothing to do with football.

Assume that we have our gain control set halfway, ie at Mark 5. In this case the gain is +17.4 dB and the attenuation afterwards is −6.7 dB, giving an overall gain of +10.7 dB. But . . . the

amplifier will clip, assuming +22 dBu (10 Vrms) is its maximum output, when the input level is only +4.6 dBu. If there was no overlap penalty, then the maximum input would be 22–10.7 = + 11.3 dBu, which is 6.7 dB greater than +4.6 dBu. This demonstrates that the amount of headroom lost is the amount of attenuation.

Figure 8.11 shows the attenuation given by Figure 8.8, for C-law and D-law pots; the minimum loss of headroom is 1.6 dB, but it rapidly gets worse as the pot is turned counter-clockwise. The D-law gives more attenuation in the middle part of the pot travel, and so the headroom loss is more severe. If we consider Mark 3, the headroom loss is 12 dB with the C-law and 17.5 dB for the D-law. Thus if either gain plot in Figure 8.10 is acceptable, you should go for the C-law as it will give you 5.5 dB more headroom at this gain setting.

Apart from headroom issues, there is another disadvantage if this circuit is used in a stereo format. Log or anti-log pots have poor matching compared with linear ones due to the extra tolerances involved in making two or three-slope resistive pot tracks. Gain matching between two stereo channels is not likely to be good.

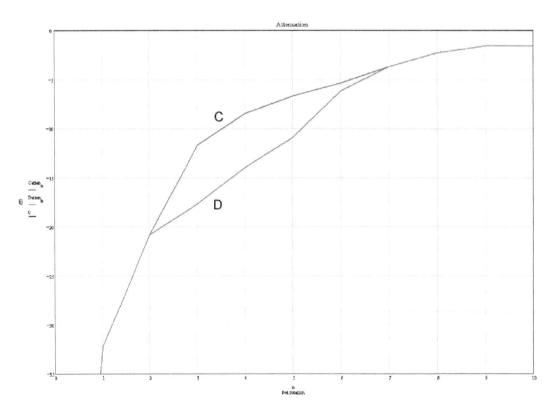

Figure 8.11 The attenuation equal to the loss of headroom in Figure 8.9 with C-law and D-law pots.

The offness with the pot fully counter-clockwise will not be very good compared with a simple passive pot because in pots the resistance between track and wiper is greater than the end

resistance where the track is connected to the terminals, and at Mark 0 all of the current from R4 flows through it to ground. With ordinary parts −65 dB should be achievable.

Amplifier stages with gain from zero upwards: dual gain pot

The loss of headroom and problems of stereo matching mentioned earlier caused me to look for a better way. There is no obvious way of doing anything else with a single pot, but if we allow ourselves a dual pot there are interesting possibilities, one of which is shown in Figure 8.12. A dual linear pot is used to reduce the stereo matching problems. The first half of the pot controls the feedback to the amplifier, varying the upper and lower feedback arms together, as in Figure 8.3 earlier. This gives a better control law than just varying one arm, but the gain is still too low in the middle, coming up fast at the end; see the 'Lin' trace in Figure 8.4. This is compensated for by the attenuation law implemented by the second half of the pot, which has a powerful pullup resistor R4 which reduces the attenuation at mid-travel and so reduces the headroom loss. It looks very much like half of a panpot (see Chapter 22). Be aware that R4 is connected almost directly from the amplifier output to ground at low gains, and the loading effect on the amplifier must be considered. If you are using 5532s then a 5 kΩ pot and a 1 kΩ pullup resistor are about as low as you want to go if a good distortion performance is to be preserved. This is demonstrated in Figure 8.13, where the upper trace is the gain and the lower trace the attenuation. The trace in the middle is the combination of the two.

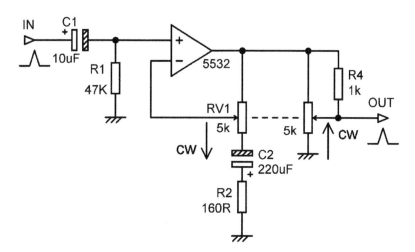

Figure 8.12 Variable-gain to zero with dual linear pot.

The attenuation is much less over most of the control range due to the effect of R4. Without R4 the attenuation would be −6 dB at Mark 5, with it the attenuation is only −2.5 dB. Compare 2.5 dB of headroom loss with 6.7 dB loss for the one-pot circuit of Figure 8.8. Comparing Figure 8.10 with Figure 8.12, the headroom loss is much reduced over all but the lowest gain settings.

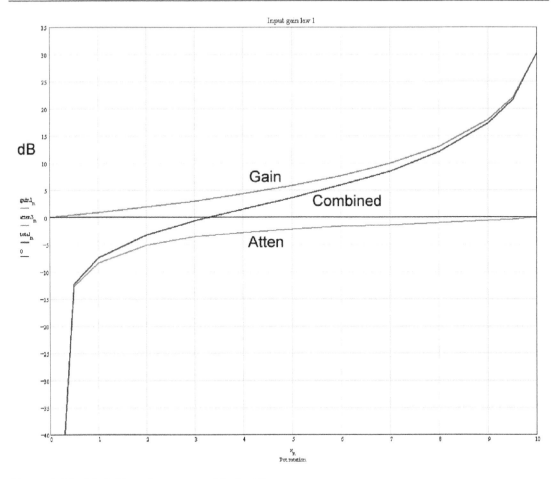

Figure 8.13 Variable-gain to zero with dual linear pot.

However . . . comparing Figure 8.9 with Figure 8.13, we can see that the combined gain law of the latter is much less of a linear-in-dB straight line, rising quite steeply from +12 dB at Mark 8 to +30 dB at Mark 10. We have said earlier that faster action at the control extremes is not necessarily a disadvantage, but this is too much. There is not much we can do with the attenuation stage, as it already has a pullup resistor R4, so we had better focus on the gain law.

This can be modified to pull the gain up in mid-travel by adding a pulldown resistor R3, as shown in Figure 8.14. This gives us the gain law in Figure 8.15, with the overall gain at mid-travel (Mark 5) increased from +3 dB to +11 dB. This gives a rather nicer overall gain law, though still with a rather quick rise at the high gain end, going from +17 dB at Mark 8 to +30 dB at Mark 10. This is about as far as we can go with this approach, as R3 is connected almost directly from the amplifier output to ground at low gains; at the same time R4 is putting its worst loading on the amplifier. What helps us here is that when the loading is at its very worst the gain is zero and no distortion will get through to the output.

Once again, how close the output can get to zero is limited by the wiper-to-track resistance of the attenuator pot, and something like -65 dB is likely.

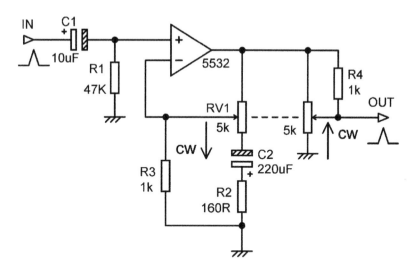

Figure 8.14 Variable-gain from zero to +30 dB with dual linear pot and law-bending resistor R3.

The stereo balance of two of these circuits will be much improved over that obtained with log and anti-log pots, but it will not be perfect. This is because while the fixed resistors can be chosen as 1% parts, the tolerance of linear pot tracks is rarely better than 20%. The only way to deal with this, assuming more accurate pots are not an option, is to use a configuration like the Baxandall volume control, in which the effect of pot track tolerances is completely cancelled out; see Chapter 13. Unfortunately the Baxandall control is a shunt-feedback configuration and does not offer a high input impedance. It's excellent for a volume control, having been used by me for gains up to +26 dB but not so good as an input stage.

Switched-gain amplifiers

In Chapter 9 we will see that the appropriate gain (at 1 kHz) for an MM input with pretensions to quality is between +30 and +40 dB, giving maximum inputs at 1 kHz of 316 and 100 mVrms respectively. Lower gains give an inconveniently low output signal and a greater headroom loss at HF due the need for a lower HF correction pole frequency. Higher gains give too low a maximum input.

The nominal output for 5 mVrms input (1 kHz) from a +30 dB stage is 158 mVrms, and from a +40 dB stage is 500 mVrms. Bearing in mind that the line signals between pieces of equipment are, in these digital days, usually in the range 1–2 Vrms, it is obvious that both 158 mVrms and 500 mVrms are too low. If we put a fixed-gain stage after the MM input stage, it will overload first, and the maximum inputs just quoted are no longer valid. It is therefore desirable to make

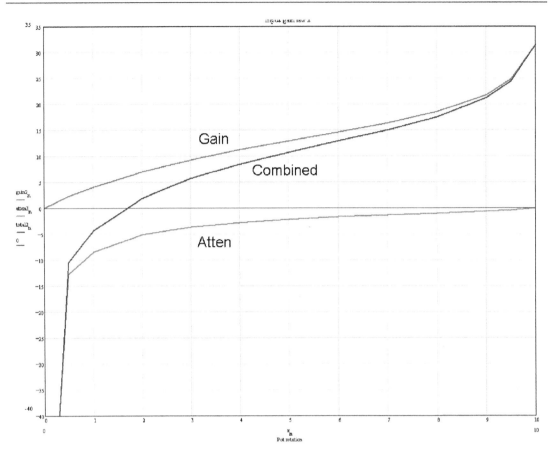

Figure 8.15 **The gain law of Figure 8.14, with dual linear pot and law-bending resistor R3.**

such a stage switchable in gain, to cope with differing conditions of cartridge sensitivity and recorded level. One of the gain options must be unity (0 dB) if the maximum MM inputs are to be preserved; having less than unity gain is pointless as the MM stage will clip first. It would, of course, be possible to have continuously variable gain controlled by a pot, but this brings in difficult issues of stereo level matching; these are described in Chapter 13 on volume controls. It is not, in my opinion, necessary to have finer control of the post-MM-input gain than 5 dB steps.

If we are dealing with just MM inputs then not many gain options are required. If we assume a +30 dB (1 kHz) MM stage with its nominal 158 mVrms output, then we need 6.3 times or +16 dB of gain to raise that level to 1 Vrms. This suggests that gain options of 0 dB, +5 dB, +10 dB, and +15 dB are all that are needed, with the lower gains allowing for more sensitive cartridges and elevated recording levels.

However, it will be seen in Chapter 10 that MC cartridges have a much wider spread of sensitivities than the MM variety, and if the MM input stage followed by the flat switched-gain

stage are going to be used to perform the RIAA equalisation after a flat +30 dB MC head amp, a further +20 dB gain option in the switched-gain stage is required to ensure that even the most insensitive MC cartridges can produce a full 1 Vrms nominal output.

The stage in Figure 8.16 is derived from my Elektor 2012 preamp [1] and gives the gain options specified earlier. The AC negative feedback is tapped from the divider R51–R60, which is made up of pairs of resistors to achieve the exact gain required and to reduce the effect of the resistor tolerances. The DC feedback for the opamp is always through R50 to prevent the opamp hitting the rails when switching the gain; the blocking capacitor C50 is more than large enough to prevent any frequency response irregularities in the audio band; in most cases a much smaller 1000/6V3 component will be fine. Assuming the source impedance is reasonably low, an LM4562 will give better noise and distortion results than a 5532 section.

The correct setting for the gain switch can be worked out by considering cartridge sensitivity specs and recording levels, but the latter are usually unknown, so some form of level indicator is very useful when setting up. A bar-graph meter seems a bit over the top for a facility that will not be used very often, and a single LED indication makes more sense. For this reason the Log Law

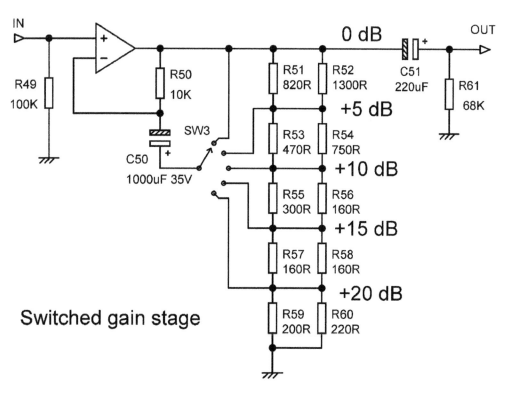

Figure 8.16 A flat gain stage with accurate switched gains of 0, +5, +10, +15, and +20 dB. Resistor pairs are used to get the exact gains wanted and to reduce the effect of tolerances.

Level LED was developed, giving about as much level information as can be had from one LED. It is fully described in Chapter 23 on metering. It is desirable that any level indication can be switched off as not everyone thinks that flashing lights add to the musical experience.

Reference

[1] Self, D. "Preamplifier 2012." *Elektor*, Apr, May, June 2012

Moving-magnet inputs

Levels and RIAA equalisation

The third edition of this book appeared after the publication of *Electronics for Vinyl* [1] which allowed the vinyl-oriented material in this book to be cut down and the space freed used for new stuff. All the phono material that was in the Second edition of *Small Signal Audio Design* is in *Electronics for Vinyl*, plus a great deal more. Therefore in this Fourth edition, as well as in the Third edition, the chapters on moving-magnet (MM) inputs have been reduced to one; this cannot and does not give comprehensive coverage of a very big subject, but it does provide the most important information with many pointers to where more (and usually very much more) can be found in *Electronics for Vinyl* (EFV). I hope you'll forgive me for making repeated references to it.

Cartridge types

This chapter deals with the design of preamplifiers for MM cartridge inputs, with their special loading requirements and need for RIAA equalisation. MM cartridges have been for many years less popular than moving-coil (MC) cartridges, but now seem to be staging a comeback. However it would be unusual nowadays to design a phono input that accepted MM inputs only. There are several ways to design a combined MM/MC input, but the approach that gives the best results is to design an MM preamp that incorporates the RIAA equalisation, and put a flat-response low-noise head amplifier in front of it to get MC inputs up to MM levels. A large part of this chapter is devoted to the tricky business of RIAA equalisation and so is equally relevant to MC input design; the RIAA just occurs one stage later. Other types of cartridges are the ceramic (wholly obsolete), strain-gauge cartridges, capacitance pickups, aka "FM pickups," or electrostatic pickups. The last three are around but are very much in a minority and are not dealt with here.

The vinyl medium

The vinyl disc dates back to 1948 when Columbia introduced microgroove $33\frac{1}{3}$ rpm LP records. These were followed soon after by microgroove 45 rpm records from RCA Victor. Stereo vinyl did not appear until 1958. The introduction of Varigroove technology, which adjusts groove spacing to suit the amplitude of the groove vibrations, using an extra look-ahead tape head to see what the future holds, allowed increases in groove packing density. This density rarely exceeded 100 grooves per inch in the 78 rpm format, but with Varigroove 180 to 360 grooves/inch could be used at $33\frac{1}{3}$ rpm.

DOI: 10.4324/9781003332985-9

While microgroove technology was unquestionably a considerable improvement on 78 rpm records, any technology that is 60 years old is likely to show definite limitations compared with contemporary standards, and indeed it does. Compared with modern digital formats, vinyl has a restricted dynamic range and poor linearity (especially at the end of a side) and is very vulnerable to permanent and irritating damage in the form of scratches. Even with the greatest care, scratches are likely to be inflicted when the record is removed from its sleeve.

Vinyl discs do not shatter under impact like the 78 shellac discs, but they are subject to warping by heat, improper storage, or poor manufacturing. Possibly the worst feature of vinyl is that the audio signal is degraded every time the disc is played, as the delicate high-frequency groove modulations are worn away by the stylus.

However, for reasons that have very little to do with logic or common-sense, vinyl is still very much alive. Even if it is accepted that as a music-delivery medium it is technically as obsolete as wax cylinders, there remain many sizeable album collections that it is impractical to replace with CDs and would take an interminable time to transfer to the digital domain. I have one of them. Disc inputs must therefore remain part of the audio designer's repertoire for the foreseeable future, and the design of the specialised electronics to get the best from the vinyl medium is still very relevant.

If discs are OK, why not cylinders? I thought the release on cylinder of the track "Sewer" in 2010 by the British steampunk band The Men That Will Not Be Blamed For Nothing [2] would be a unique event. It was a very limited edition, indeed; only 40 cylinders were produced, and only 30 were put on sale. But it was not a unique event; in 2013 Ghostwave released a track engraved on a beer bottle; special technology was required to cut the groove into glass [3]. Suzanne Vega has also been recording on cylinders [4].

Spurious signals

It is not easy to find dependable statistics on the dynamic range of vinyl, but there seems to be general agreement that it is in the range 50 to 80 dB, the 50 dB coming from the standard quality discs, and the 80 dB representing direct-cut discs produced with quality as the prime aim. My own view is that 80 dB is rather optimistic.

The most audible spurious noise coming from vinyl is that in the mid frequencies, stemming from the inescapable fact that the music is read by a stylus sliding along a groove of finite smoothness. The purely electronic noise will be much lower, unless you have a very peculiar (and probably-valve-based) phono amplifier. The *Radio Designer's Handbook* says that the groove noise (sometimes called surface noise) of vinyl is 60–62 dB below maximum recorded level, and this will be 20 dB or more above the electronic noise [5]. The best modern reference is Burkhard Vogel's book, which devotes Chapter 11 (no less than 22 pages) to groove noise [6]. He concludes that the best direct metal master (DMM) mother discs achieve a signal/noise ratio of −72 dB (A-weighted) and 2 dB more are lost in getting to the final pressing. Non-DMM discs will show −64 dB (A-weighted) or worse. This is for brand-new discs and is as good as it gets because groove noise increases as the record wears with playing. We are, therefore, looking at (or rather listening to) groove noise which is between −70 and −64 dB below nominal level, not

forgetting the A-weighting, and there is nothing that the designer of audio electronics can do about this.

As another data point, a very experienced vinyl enthusiast (60 years plus, going back to shellac) told me that he had never, ever, known noise fail to increase when the stylus was lowered onto the run-in groove [7].

This presents a philosophical conundrum; is it not a waste of time to strive for low electronic noise when the groove noise is much greater and the contribution of the electronic noise negligible? If obtaining a good electronic noise performance was difficult and expensive this argument would have more force, but it is simply not so. This chapter will show how to get within about 2 dB of the lowest noise physically possible using cheap opamps and a bit of ingenuity. There is also specmanship, of course. The lower the noise specification, the better the sales prospects? One might hope so.

Scratches create clicks that have a large high-frequency content, and it has been shown that they can easily exceed the level of the audio. It is important that such clicks do not cause clipping or slew limiting, as this makes their subjective impact worse.

The signal from a record deck also includes copious amounts of low-frequency noise, which is often called rumble; it is typically below 30 Hz. This can come from several sources:

1) Mechanical noise generated by the motor bearings and picked up by the stylus/arm combination. These tend to be at the upper end of the low-frequency domain, extending up to 30 Hz or thereabouts. This is a matter for the mechanical designer of the turntable, as it clearly cannot be filtered out without removing the lower part of the audio spectrum.

2) Room vibrations will be picked up if the turntable and arm system is not well isolated from the floor. This is a particular problem in older houses where the wooden floors are not built to modern standards of rigidity and have a perceptible bounce to them. Mounting the turntable shelf to the wall usually gives a major improvement. Subsonic filtering is effective in removing room vibration.

3) Low-frequency noise from disc imperfections. This can extend as low as 0.55 Hz, the frequency at which a 33⅓ rpm disc rotates on the turntable and is due to large-scale disc warps. Warping can also produce ripples on the surface, generating spurious subsonic signals up to a few Hertz at surprisingly high levels. These can be further amplified by a poorly controlled resonance of the cartridge compliance and the pickup arm mass. When woofer speaker cones can be seen wobbling—and bass reflex designs with no cone loading at very low frequencies are the worst for this—disc warps are usually the cause. Subsonic filtering is again effective in removing this. (As an aside, I have heard it convincingly argued that bass reflex designs have only achieved their current popularity because of the advent of the CD player, with its greater bass signal extension, but lack of subsonic output.)

The worst subsonic disturbances are in the region 8–12 Hz, where record warps are accentuated by resonance between the cartridge vertical compliance and the effective arm mass. Reviewing work by Happ & Karlov [8], Bruel & Kjaer [9], Holman [10, 11], Taylor [12], and Hannes Allmaier [13] suggests that in bad cases the disturbances are only 20–30 dB below maximum

signal velocities, and that the cart/arm resonance frequency at around 10 Hz should be attenuated by at least 40 dB to reduce its effects below the general level of groove noise. Holman, using a wide variety of cartridge-arm combinations, concluded that to accommodate the very worst cases, a preamplifier should be able to accept not less than 35 mVrms in the 3–4 Hz region. This is a rather demanding requirement, driven by some truly diabolical cartridge-arm setups that accentuated subsonic frequencies by up to 24 dB.

Since the subsonic content generated by room vibrations and disc imperfections tends to cause vertical movements of the stylus, the resulting electrical output will be out of phase in the left and right channels. The use of a central mono subwoofer system that sums the two channels will provide partial cancellation.

Other vinyl problems

The reproduction of vinyl involves other difficulties apart from the spurious signals mentioned earlier.

Distortion is a major problem. It is pretty obvious that the electromechanical processes involved are not going to be as linear as we now expect our electronic circuitry to be. Moving-magnet and moving-coil cartridges add their own distortion, which can reach 1 to 5% at high levels.

Distortion gets worse as the stylus moves from the outside to the inside of the disc. This is called 'end of side distortion' because it can be painfully obvious in the final track. It occurs because the modulation of the inner grooves is inevitably more compressed than those of the outer tracks due to the constant rotational speed of a turntable. I can well recall buying albums and discovering to my chagrin that a favourite track was the last on a side.

It is a notable limitation of the vinyl process that the geometry of the recording machine and that of the replay turntable do not match. The original recordings are cut on a lathe where the cutting head moves in a radial straight line across the disc. In contrast, almost all turntables have a pivoting tonearm about 9 inches in length. The pickup head is angled to reduce the mismatch between the recording and replay situations, but this introduces side forces on the stylus and various other problems, increasing the distortion of the playback signal. A recent article in *Stereophile* [14] shows just how complicated the business of tonearm geometry is. SME produced a 12-inch arm to reduce the angular errors; I have one, and it is a thing of great beauty, but I must admit I have never put it to use.

The vinyl process depends on a stylus faithfully tracking a groove. If the groove modulation is excessive, with respect to the capabilities of the cartridge/arm combination, the stylus loses contact with the groove walls and rattles about a bit. This obviously introduces gross distortion and is also very likely to damage the groove.

A really disabling problem is 'wow'; the cyclic pitch change resulting from an off-centre hole. Particularly bad examples of this used to be called 'swingers' because they were so eccentric that they could be visibly seen to be rotating off-centre. I understand that nowadays the term means something entirely different and relates to an activity which sounds as though it could only distract from critical listening.

Most of the problems that vinyl is heir to are supremely unfixable, but this is an exception; do not underestimate the ingenuity of engineers. In 1983 Nakamichi introduced the extraordinary TX-1000 turntable that measured the disc eccentricity and corrected for it [15]. A secondary arm measured the eccentricity of the run-out groove and used this information to mechanically offset the spindle from the platter bearing axis. This process took 20 seconds, which I imagine could get a bit tedious once the novelty has worn off. This idea deserved to prosper, but CDs were just arriving, and the timing was about as bad as it could be.

Flutter is rapid changes in pitch, rather than the slow ones that constitute wow. You would think that a heavy platter (and some of them are quite ridiculously massive) would be unable to change speed rapidly, and you would be absolutely right. But . . . the other item in the situation is the cartridge/arm combination, which moves up and down but does not follow surface irregularities because of the resonance between cartridge compliance and arm + cartridge mass. The stylus therefore moves back and forward in the groove, frequency-modulating the signal.

This and the other mechanical issues of turntables and arms are described in an excellent article by Hannes Allmaier [13], who makes the important point that the ear is most sensitive to flutter at around 4 Hz, uncomfortably close to the usual cart/arm resonance region of 8–12 Hz.

Maximum signal levels from vinyl

There are limits to the signal level possible on a vinyl disc, and the signal that a cartridge and its associated electronics will be expected to reproduce. The limits may not be precisely defined, but the way they work sets the ways in which maximum levels vary with frequency, and this is of great importance.

There are no variable gain controls on RIAA inputs because implementing an uneven but very precisely controlled frequency response and a suitably good noise performance are quite hard enough without adding variable gain as a feature. No doubt it could be done, but it would not be easy; there would be issues with channel balance, and the general consensus is that it is just not necessary for MM cartridges which have a range of sensitivities of only 7 dB. If you are using the same stage to RIAA equalise an MC cartridge, the situation is quite different, with sensitivities ranging over 36 dB. This is best dealt with by a switched-gain stage rather than fully variable gain.

The overload margin, or headroom, is therefore of considerable importance, and it is very much a case of the more the merrier when it comes to the numbers game of specmanship. The issue is a bit involved, as a situation with frequency-dependent vinyl limitations and frequency-dependent gain is often further complicated by a heavy frequency-dependent load in the shape of the feedback network, which can put its own limit on amplifier output at high frequencies. Let us first look at the limits on the signal levels which stylus-in-vinyl technology can deliver. In the diagrams that follow the response curves have been simplified to the straight-line asymptotes.

Figure 9.1a shows the physical groove amplitudes that can be put onto a disc. From subsonic up to about 1 kHz, groove amplitude is the constraint. If the sideways excursion is too great, the

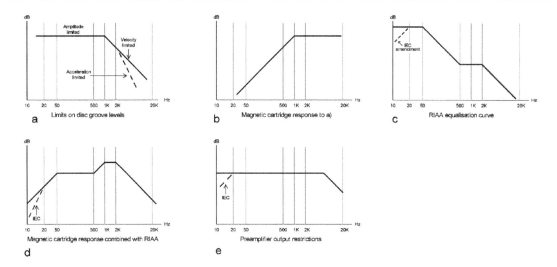

Figure 9.1 a) **The levels on a vinyl disc; b) the cartridge response combined with the disc levels; c) the RIAA curve; d) the RIAA combined with curve b; e) possible preamplifier output restrictions.**

groove spacing will need to be increased to prevent one groove breaking into another, and playing time will be reduced. Well before actual breakthrough occurs, the cutter can distort the groove it has cut on the previous revolution, leading to 'pre-echo' in quiet sections, giving a faint version of the music you are about to hear. Time travel may be fine in science fiction, but it does not enhance the musical experience. The ultimate limit to groove amplitude is set by mechanical stops in the cutter head.

There is an extra limitation on groove amplitude; out-of-phase signals cause vertical motion of the cutter, and if this becomes excessive it can cause it to cut either too deeply into the disc medium and dig into the aluminium substrate or lose contact with the disc altogether. An excessive vertical component can also upset the playback process, especially when low tracking forces are used; in the worst case the stylus can be thrown out of the groove completely. To control this problem the stereo signal is passed through a matrix that isolates the L-R vertical signal, which is then amplitude limited. This potentially reduces the perceived stereo separation at low frequencies, but there appears to be a general consensus that the effect is not audible. The most important factor in controlling out-of-phase signals is the panning of bass instruments (which create the largest cutter amplitudes) to the centre of the stereo stage. This approach is still advantageous with digital media as it means that there are two channels of power amplification to reproduce the bass information rather than one.

From about 1 kHz up to the ultrasonic regions, the limit is groove velocity rather than amplitude. If the disc cutter head tries to move sideways too quickly compared with its relative forward motion, the back facets of the cutter destroy the groove that has just been cut by its forward edges.

On replay, there is a third restriction—stylus acceleration, or to put it another way, groove curvature. This limits how well a stylus of a given size and shape can track the groove. Allowing

for this at cutting time places an extra limitation on signal level, shown by the dotted line in Figure 9.1a. The severity of this restriction depends on the stylus shape; an old-fashioned spherical type with a tip diameter of 0.7 mil requires a roll-off of maximum levels from 2 kHz, while a (relatively) modern elliptical type with 0.2 mil effective diameter postpones the problem to about 8 kHz. The limit, however, still remains.

Thus disc-cutting and playback technology put at least three limits on the maximum signal level. This is not as bad a problem as it might be because the distribution of amplitude with frequency for music is not flat with frequency; there is always more energy at LF than HF. This is especially true of the regrettable phenomenon known as rap music. For some reason there seems to be very little literature on the distribution of musical energy versus frequency, but a very rough rule is that levels can be expected to be fairly constant up to 1 kHz and then fall by something like 10 dB/ octave. The end result is that despite the limits on disc levels at HF, it is still possible to apply a considerable amount of HF boost, which when undone at replay reduces surface noise problems. At the same time the LF levels are cut to keep groove amplitude under control. Both functions are implemented by applying the inverse of the familiar RIAA replay equalisation at cutting time. More on the limitations affecting vinyl levels can be found on Jim Lesurf's website [16].

A reaction to the limitations of the usual 7-inch single was the 12-inch single, which appeared in the mid-1970s before CDs arrived. The much greater playing area allowed greater groove spacing and higher recording levels. I bought several of these, in the 45 rpm format, and I can testify that the greater groove speed gave a much clearer and less distorted high end, definitely superior to 33 rpm LPs.

Since MM input stages not intended for MC use do not normally have gain controls, it is important that they can accept the whole range of input levels that occur. A well-known paper by Tomlinson Holman [17] quotes a worst-case peak voltage from an MM cartridge of 135 mV at 1-kHz given by [18]. This is equivalent to 95 mVrms at 1-kHz. He says "this is a genuinely worst-case combination which is not expected to be approached typically in practice."

Shure are a well-known manufacturer of MM cartridges, and their flagship V15 phonograph cartridge series (the 15 in model name referred to the cartridges' 15-degree tracking angle) for many years set the standard for low tracking force and high tracking ability. Its development required much research into maximum levels on vinyl. Many other workers also contributed. The results are usually expressed in velocity (cm/s) as this eliminates the effect of cartridge sensitivity. I have boiled down the Shure velocity data into Table 9.1. I have included the acceleration of the stylus tip required for the various frequency/velocity pairs; this is not of direct use but given that the maximum sustained acceleration the human body can withstand with is around 3 g, it surely makes you think. Since the highest MM cartridge sensitivity for normal use is 1.6 mV per cm/s (see the next section), Table 9.1 tells us that we need to be able to handle an MM input of 1.6 x 38 = 61 mVrms. This is not far out of line with the 95 mVrms quoted by Holman, being only 3.8 dB lower.

The website of Jim Lesurf [16] also has many contemporary measurements of maximum groove velocities. The maximum quoted is 39.7 cm/s, which gives 1.6 x 39.7 = 63.5 mVrms. Rooting through the literature, the Pressure Cooker discs by Sheffield Labs were recorded direct to disc and are said to contain velocities up to 40 cm/s, giving us 1.6 x 40 = 64 mVrms. It is reassuring

TABLE 9.1 Maximum groove velocities from vinyl (after Shure)

	400 Hz	500 Hz	2 kHz	5 kHz	8 kHz	10 kHz	20 kHz
Velocity cm/s	26	30	38	35	30	26	10
Acceleration	66.5 g	96 g	487 g	1120 g	1535 g	1665 g	1281 g

TABLE 9.2 Maximum input, overload margin, and nominal output for various MM preamp gains, all at 1 kHz

Gain dB	Gain times	Max input mVrms	Overload margin dB	5 mVrms would be raised to:
50	316	32 mV	16 dB	1580 mVrms
45.5	188	53 mV	21 dB	942 mVrms
40	100	100 mV	26 dB	500 mVrms
35	56.2	178 mV	31 dB	281 mVrms
30	31.6	316 mV	36 dB	158 mVrms
25	17.8	562 mV	41 dB	89 mVrms
20	10	1000 mV	46 dB	50 mVrms

that these maxima do not differ very much. On the other hand, the jazz record *Hey! Heard The Herd* by Woody Herman (Verve V/V6 8558, 1953) is said to a peak velocity of 104 cm/s at 7.25 kHz [18], but this seems out of line with all other data. If it is true, the input level from the most sensitive cartridge would be 1.6 x 105 = 166 mVrms.

So we may conclude that the greatest input level we are likely to encounter is 64 mVrms, though that 166 mVrms should perhaps not be entirely forgotten.

The maximum input a stage can accept before output clipping is set by its gain and supply rails. If we are using normal opamps powered from ±17 V rails, we can assume an output capability of 10 Vrms. Scaling this down by the gain in each case gives us Table 9.2, which also shows the output level from a nominal 5 Vrms input. You will see shortly why the odd gain value of +45.5 dB was used.

If we want to accept a 64 mVrms input the gain cannot much exceed +40 dB. In fact a gain of +43.8 dB will just give clipping for 64 mVrms in. If we want to accept Woody Herman's 166 mVrms, then the maximum gain is +35.6 dB. I suggest a safety margin of at least 5 dB should be added, so we conclude that 30 dB (1 kHz) is an appropriate gain for an MM input stage; this will accept 316 mVrms from a cartridge before clipping. A recent review of a valve phono stage [19] described an MM input capability of 300 mVrms as "extremely generous," and I suggest that an input capability of around this figure will render you utterly immune to overload forever and be more than adequate for the highest quality equipment. The stage output with a nominal 5 mVrms input is only 158 mVrms, which is not enough to operate your average power amplifier, and so there will have to be another amplifying stage after it. This must have switched or variable gain or be preceded by a passive volume control, for otherwise it will clip before the first stage and reduce the overload margin.

While we must have a relatively low gain in the MM stage to give a good maximum signal capability, we do not want it to be too low, or the signal/noise ratio will be unduly degraded as the signal passes through later stages. It is one of the prime rules of audio that you should minimise the possibility of this by getting the signal up to a decent level as soon as possible, but it is common practice and very sensible for the MM output to go through a unity-gain subsonic filter before it receives any further amplification; this is because the subsonic stuff coming from the disc can be at disturbingly high levels.

Moving-magnet cartridge sensitivities

The level reaching the preamplifier is proportional to the cartridge sensitivity. Due to their electromagnetic nature MM cartridges respond to stylus velocity rather than displacement (the same applies to MC cartridges), so output voltage is usually specified at a nominal velocity of 5 cm/sec. That convention is followed throughout this chapter.

A survey of 72 MM cartridges on the market in 2012 showed that they fall into two groups—what might be called normal hifi cartridges (57 of them) and specialised cartridges for DJ use (15 of them). The DJ types have a significantly higher output than the normal cartridges—the Ortofon Q-Bert Concorde produces no less than 11 mV, the highest output I could find. It seems unlikely that the manufacturers are trying to optimise the signal-to-noise ratio in a DJ environment, so I imagine there is some sort of macho 'my cartridge has more output than yours' thing going on. Presumably DJ cartridges are also designed to be exceptionally mechanically robust. We will focus here on the normal cartridges, but to accommodate DJ types all you really need to do is allow for 6 dB more input level to the preamplifier.

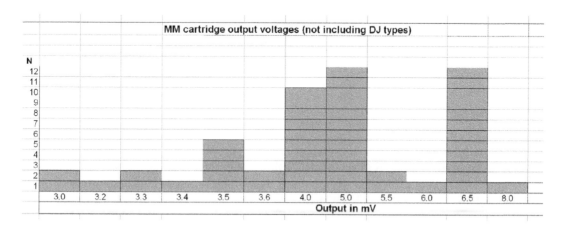

Figure 9.2 Output voltages for 57 MM cartridges at 5 cm/sec, excluding specialised DJ types.

The outputs of the 58 normal cartridges at a velocity of 5 cm/sec are summarised in the histogram of Figure 9.2. The range is 3.0 mV to 8.0 mV, with significant clumps around 4–5 mV and 6.5 mV. If we ignore the single 8.0 mV cartridge, the output range is restricted to 3.0 to 6.5 mV,

which is only 6.7 dB. This is a small range compared with the very wide one shown by MC cartridges and makes the design of a purely MM (non-MC) input simpler. There is no need for variable gain as a 6.7 dB range can be easily accommodated by adjustment of a volume control later in the audio path, without significant noise/headroom compromises.

Overload margins and amplifier limitations

The safety factor between a nominal 5 mVrms input and the clipping point may be described as either the input headroom in mVrms or the 'overload margin' which is the dB ratio between the nominal 5 mVrms input and the maximum input. Table 9.2 shows that an MM stage with a +35 dB gain (1 kHz) gives a output of 280 mV, an input overload level of 178 mVrms and an overload margin of 31 dB, which might be called very good. A +30 dB (1 kHz) stage gives a nominal 158 mV out, an input overload level of 316 mVrms, and an overload margin of 36 dB, which is definitely excellent, giving 5 dB more headroom.

The maximum input capability of an MM stage is not always defined by simple frequency-independent clipping at its output. Things may be complicated by the stage output capability varying with frequency. An RIAA feedback network, particularly one designed with a relatively low impedance to reduce noise, presents a heavier load as frequency rises because the impedance of the capacitors falls. This HF loading was very often a major cause of distortion and headroom-limitation in discrete RIAA stages that had either common-collector or emitter-follower output topologies with highly asymmetrical drive capabilities; for example an NPN emitter-follower is much better at sourcing current than sinking it. With conventional discrete designs the 20 kHz output capability, and thus the overload margin, was often reduced by 6 dB or even more. Replacing the emitter resistor of an emitter-follower with a current-source much reduces the problem, and the very slight extra complication of using a push-pull Class-A output structure can bring it down to negligible proportions; for more details see Chapter 10 on discrete MM input design in *Electronics for Vinyl* [1]. Earlier opamps, such as the TL072, also struggled to drive RIAA networks at HF and gave a very poor noise performance. It was not until the advent of the 5532 opamp, with its excellent load-driving capabilities, that the problem of driving low-impedance RIAA networks was solved; the noise performance was much better, too. However, if a low-impedance HF correction pole (more on this later) is being driven as well, there may still be some slight loss of output capability at 20 kHz.

Further headroom restrictions may occur when not all of the RIAA equalisation is implemented in one feedback loop. Putting the IEC amendment roll-off after the preamplifier stage, as in Figure 9.6, means that very low frequencies are amplified by 3 dB more at 20 Hz than they otherwise would be, and this is then undone by the later roll-off. This sort of audio impropriety always carries a penalty in headroom as the signal will clip before it is attenuated, and the overload margin at 20 Hz is reduced by 3.0 dB. This effect reduces quickly as frequency increases, being 1.6 dB at 30 Hz and only 1.0 dB at 40 Hz. Whether this loss of overload margin is more important than providing an accurate IEC amendment response is a judgement call, but in my experience it creates no trace of any problem in an MM stage with a gain of +30 dB (1 kHz). Passive-equalisation input architectures that put flat amplification before an RIAA stage suffer much more severely from this kind of headroom restriction, and it is quite common to encounter preamplifiers

that claim to be high-end, with a very high-end price-tag, but a very low-end overload margin of only 20 to 22 dB—a sad business indeed.

We have to be careful not to compromise the headroom at subsonic frequencies. We saw in the earlier section on spurious signals that Tomlinson Holman concluded that to accommodate the worst of the worst, a preamplifier should be able to accept not less than 35 mVrms in the 3–4 Hz region. If the IEC amendment is after the preamplifier stage, and C0 is made very large so it has no effect the RIAA gain in the 2–5 Hz region has flattened out at 19.9 dB, implying that the equivalent overload level at 1 kHz will be need to be 346 mVrms. The +30 dB (1 kHz) gain stage of Figure 9.6 has a 1 kHz overload level of 316 mVrms, which is only 0.8 dB below this rather extreme criterion; we are good to go. A +35 dB (1 kHz) gain stage would significantly reduce the safety margin.

At the other end of the audio spectrum, adding an HF correction pole after the preamplifier, to correct the RIAA response with low gains, also introduces a compromise in the overload margin, though generally a much smaller one. The 30 dB (1 kHz) stage in Figure 9.6 has a mid-band overload margin of 36 dB, which falls to +33 dB at 20 kHz. Only 0.4 dB of this is due to the amplify-then-attenuate action of the HF correction pole, the rest being due to the heavy capacitive loading on A1 of both the main RIAA feedback path and the pole-correcting RC network. This slight compromise could be eliminated by using an opamp structure with greater load-driving capabilities, so long as it retains the low noise of a 5534A.

An attempt has been made to show these extra preamp limitations on output level in Figure 9.1e, and comparing Figure 9.1d, it appears that in practice they are almost irrelevant because of the falloff in possible input levels at each end of the audio band.

To put things into some sort of perspective, here are the 1 kHz overload margins for a few of my published designs. My first preamplifier, the Advanced Preamplifier [20] achieved +39 dB in 1976, partly by using all-discrete design and ±24 V supply rails. A later discrete design in 1979 [21] gave a tour-de-force +47 dB, accepting over 1.1 Vrms at 1 kHz, but I must confess this was showing off a bit and involved some quite complicated discrete circuitry, including the push-pull Class-A output stages mentioned in *Self on Audio* [22]. Later designs such as the Precision Preamplifier [23] and its linear descendant the Precision Preamplifier '96 [24] accepted the limitations of opamp output voltage in exchange for much greater convenience in most other directions and still have an excellent overload margin of 36 dB.

Equalisation and its discontents

Both moving-magnet and moving-coil cartridges operate by the relative motion of conductors and magnetic field, so the voltage produced is proportional to rate of change of flux. The cartridge is therefore sensitive to groove velocity rather than groove amplitude, and so its sensitivity is expressed as X mV per cm/sec. This velocity-sensitivity gives a frequency response rising steadily at 6 dB/octave across the whole audio band for a groove of constant amplitude. Therefore a maximal signal on the disc, as in Figure 9.1a, would give a cartridge output like Figure 9.1b, which is simply 1a tilted upwards at 6 dB/octave. From here on the acceleration limits are omitted for greater clarity.

The RIAA replay equalisation curve is shown in Figure 9.1c. It has three corners in its response curve, with frequencies at 50.05 Hz, 500.5 Hz, and 2.122 kHz, which are set by three time-constants of 3180 μsec, 318 μsec, and 75 μsec. The RIAA curve was of US origin but was adopted internationally with surprising speed, probably because everyone concerned was heartily sick of the ragbag of equalisation curves that existed previously. It became part of the IEC 98 standard, first published in 1964, and is now enshrined in IEC 60098, "Analogue Audio Disk Records and Reproducing Equipment."

Note the flat shelf between 500 Hz and 2 kHz. It may occur to you that a constant downward slope across the audio band would have been simpler, required fewer precision components to accurately replicate, and would have saved us all a lot of trouble with the calculations. But . . . such a response would require 60 dB more gain at 20 Hz than at 20 kHz, equivalent to 1000 times. The minimum open-loop gain at 20 Hz would have to be 70 dB (3000 times) to allow even a minimal 10 dB of feedback at that frequency, and implementing that with a simple two-transistor preamplifier stage would have been difficult if not impossible (must try it sometime). The 500 Hz–2 kHz shelf in the RIAA curve reduces the 20 Hz–20 kHz gain difference by 12 dB to only 48 dB, making a one-valve or two-transistor preamplifier stage practical. One has to conclude that the people who established the RIAA curve knew what they were doing.

When the RIAA equalisation of Figure 9.1c is applied to the cartridge output of Figure 9.1b, the result looks like Figure 9.1d, with the maximum amplitudes occurring around 1–2 kHz. This is in agreement with Holman's data [10].

Figure 9.1e shows some possible output level restrictions that may affect Figure 9.1d. If the IEC amendment is implemented after the first stage, there is a possibility of overload at low frequencies which does not exist if the amendment is implemented in the feedback loop by restricting C0. At the high end, the output may be limited by problems driving the RIAA feedback network which falls in impedance as frequency rises. More on this later.

The unloved IEC amendment

Figure 9.1c shows in dotted lines an extra response corner at 20.02 Hz, corresponding to a time-constant of 7950 μs. This extra roll-off is called the "IEC amendment," and it was added to what was then IEC 98 in 1976. Its apparent intention was to reduce the subsonic output from the preamplifier, but its introduction is something of a mystery. It was certainly not asked for by either equipment manufacturers or their customers, and it was unpopular with both, with some manufacturers simply refusing to implement it. It still attracts negative comments today. The likeliest explanation seems to be that several noise reduction systems, for example dbx, were being introduced for use with vinyl at the time, and their operation was badly affected by subsonic disturbances; none of these systems caught on. You would think there must somewhere be an official justification for the amendment, but if there is I haven't found it.

On one hand critics pointed out that as an anti-rumble measure it was ineffective, as its slow first-order roll-off meant that the extra attenuation at 13 Hz, a typical cartridge-arm resonance frequency, was a feeble −5.3 dB; however at 4 Hz, a typical disc warp frequency, it did give a somewhat more useful −14.2 dB, reducing the unwanted frequencies to a quarter of their

original amplitude. On the other hand there were loud complaints that the extra unwanted replay time constant caused significant frequency response errors at the low end of the audio band, namely −3.0 dB at 20 Hz and −1.0 dB at 40 Hz. Some of the more sophisticated equipment allows the amendment to be switched in or out; a current example is the Audiolab 8000PPA phono preamplifier.

The 'Neumann pole'

The RIAA curve is only defined to 20 kHz, but by implication carries on down at 6 dB/octave forever. This implies a recording characteristic rising at 6 dB/octave forever, which could clearly endanger the cutting head if ultrasonic signals were allowed through. From 1995, a belief began to circulate that record lathes incorporated an extra unofficial pole at 3.18 μs (50.0 kHz) to limit HF gain. This would cause a loss of 0.17 dB at 10 kHz and 0.64 dB at 20 kHz and would require compensation if an accurate replay response was to be obtained. The name of Neumann became attached to this concept simply because they are the best-known manufacturers of record lathes.

The main problem with this story is that it is not true. The most popular cutting amplifier is the Neumann SAL 74B, which has no such pole. For protection against ultrasonics and RF it has instead a rather more effective second-order lowpass filter with a corner frequency of 49.9 kHz and a Q of 0.72 [25], giving a Butterworth (maximally flat) response rolling-off at 12 dB/octave. Combined with the RIAA equalization, this gives a 6 dB/octave roll-off above 50 kHz. The loss from this filter at 20 kHz is less than −0.1 dB, so there is little point in trying to compensate for it, particularly because other cutting amplifiers are unlikely to have identical filters.

MM amplifier configurations

There are many ways to make MM input stages, but a fundamental divide is the choice of series or shunt negative feedback. The correct answer is to always use series feedback, as it is about 14 dB quieter; this is because the cartridge loading resistor Rin has a high value and generates a lot of Johnson noise. In the series feedback circuit of Figure 9.3, Rin is in parallel with the cartridge, which shunts away the noise except at high frequencies. In the shunt feedback circuit of Figure 9.4 the input resistor R0 has to be 47 kΩ to load the cartridge correctly, and all its noise goes into the amplifier. The shunt RIAA network has to operate at a correspondingly high impedance and will be noisier. It is a difference that is hard to overlook.

In Figure 9.3, C0 has been given a low value that implements the IEC amendment. If the amendment is not required, C0 would be of the order of 220 uF.

The only drawback of the series-feedback configuration is that its gain cannot fall below unity. The RIAA curve is only defined to 20 kHz, but, as noted earlier, by implication carries on down at 6 dB/octave forever. If the stage has a gain of less than +35 dB (1 kHz) this causes the response to level out and causes RIAA errors in the top octaves. This can be completely cured by adding an HF correction RC time-constant just after the amplifier. See Figure 9.6.

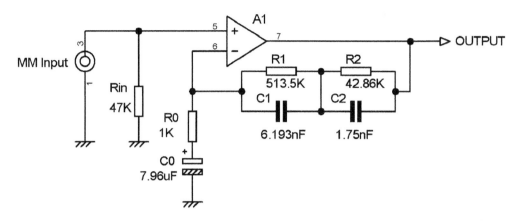

Figure 9.3 **Series-feedback RIAA equalisation configuration-A, IEC amendment implemented by C0. Component values for 35.0 dB gain (1 kHz). Maximum input 178 mVrms (1 kHz). RIAA accuracy is within ±0.1 dB from 20 Hz to 20 kHz, without using an HF correction pole.**

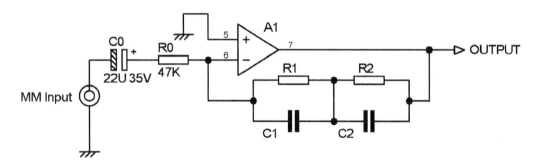

Figure 9.4 **Shunt-feedback RIAA configuration. This is 14 dB noisier than the series-feedback version.**

The shunt-feedback configuration has occasionally been advocated because it avoids the unity-gain problem, but it has the crippling disadvantage that with a real cartridge load, with its substantial inductance, it is about 14 dB noisier than the series configuration [26]. This is because the Johnson noise from R0 is not shunted away at LF by the cartridge inductance and because the current noise of A1 sees R0 + the cartridge inductance, instead of R0 in shunt with the cartridge inductance. A great deal of grievous twaddle has been talked about RIAA equalisation and transient response, in perverse attempts to render the shunt RIAA configuration acceptable despite its serious noise disadvantage.

Shunt feedback eliminates any possibility of common-mode distortion, but then at the signal levels we are dealing with that is simply not a problem, at least with bipolar input opamps. A further disadvantage is that a shunt-feedback RIAA stage gives a phase inversion that can be highly inconvenient if you are concerned to preserve absolute phase.

Remarkably, someone called Mohr managed to get a US patent for a variation of this idea in which the cartridge load is effectively a short circuit [27]. The patent is considered to be of no value. The fascinating thing about it is that while noise is barely mentioned, a reference is given to [26] as given earlier; this is H. P. Walker's famous article on noise in which the inherent inferiority of the shunt version was clearly demonstrated. Presumably Mohr never actually read it.

Opamp MM input stages

Satisfactory discrete MM preamplifier circuitry is not that straightforward to design, and there is a lot to be said for using a good opamp, which if well-chosen will have more than enough open-loop gain to implement the RIAA bass boost accurately and without introducing detectable distortion at normal operating levels. The 5534/5532 opamps have input noise parameters that are well suited to MM cartridges; better so than any other opamp I know of. They also have good low-distortion load-driving capability so the RIAA network impedances can be kept low.

Having digested this chapter so far, we are in a position to summarise the requirements for a good RIAA preamplifier. These are

1) Use a series feedback RIAA network, as shunt feedback is approximately 14 dB noisier.

2) Correct gain at 1 kHz. This sounds elementary, but getting the RIAA network right is not a negligible task.

3) RIAA accuracy. My 1983 preamplifier was designed for +/−0.2 dB accuracy from 20–20 kHz, the limit of the testgear I had at the time. This was tightened to +/−0.05 dB without using rare parts in my 1996 preamplifier.

4) Use obtainable components. Resistors will often be from the E24 series, though E96 is much more available than it used to be. Capacitors will probably be from the E6 or E12 series, so intermediate values must be made by series or parallel combinations.

5) R0 should be as low as its Johnson noise is effectively in series with the input signal. This is particularly important when the MM preamplifier is fed from a low impedance, which typically occurs when it is providing RIAA equalisation for the output of an MC preamplifier. With input direct from an MM cartridge with its high inductance, the effect of R0 on noise is weak.

6) The feedback RIAA network impedance to be driven must be suited to the opamp to prevent increased distortion or a limited output swing, especially at HF.

7) The resistive path through the feedback arm should ideally have the same DC resistance as input bias resistor Rin to minimise offsets at A1 output. This is a bit of a minor point as the offset would have to be quite large to significantly affect the output voltage swing (DC blocking is assumed, so the offset is not passed on to the next stage). Very often it is not possible to meet this constraint as well as other more important requirements.

Calculating the RIAA equalisation components

Calculating the values required for series feedback configuration is not straightforward. You absolutely cannot take Figure 9.3 and calculate the time-constants of R2, C2 and R3, C3 as if they were independent of each other; the answers will be wrong. Empirical approaches (cut-and-try) are possible if no great accuracy is required, but attempting to reach even ±0.2 dB by this route is tedious, frustrating, and generally bad for your mental health.

The definitive paper on this subject is by Stanley Lipshitz [28]. This heroic work covers both series and shunt configurations and much more besides, including the effects of low open-loop gain. It is relatively straightforward to build a spreadsheet using the Lipshitz equations that allows extremely accurate RIAA networks to be designed in a second or two; the greatest difficulty is that some of the equations are long and complicated—we're talking real turn-the-paper-sideways algebra here—and some very careful typing is required.

Exact RIAA equalisation cannot be achieved with preferred component values, and that extends to E24 resistors. If you see any single-stage RIAA preamp where the equalisation is achieved by two E24 resistors and two capacitors in the same feedback loop, you can be sure it is not very accurate.

My spreadsheet model takes the desired gain at 1 kHz and the value of R0, which sets the overall impedance level of the RIAA network. In my preamplifier designs the IEC amendment is definitely *not* implemented by restricting the value of C0; this component is made large enough to have no significant effect in the audio band, and the amendment roll-off is realised in the next stage, if at all.

Implementing RIAA equalisation

It can be firmly stated from the start that the best way to implement RIAA equalisation is the traditional series-feedback method. So-called passive (usually only semi-passive) RIAA configurations suffer from serious compromises on noise and headroom. For completeness they are dealt with towards the end of this chapter.

There are several different ways to arrange the resistors and capacitors in an RIAA network, all of which give identically exact equalisation when the correct component values are used. Figure 9.3 shows a series-feedback MM preamp built with what I call RIAA configuration-A, which has the advantage that it makes the RIAA calculations somewhat easier but otherwise is not the best; there will be much more on this topic later. Don't start building it until you've read the rest of this chapter; it gives an accurate RIAA response but is not otherwise optimised, as it attempts to represent a 'typical' design. We will optimise it later; we will lower the gain and reduce the value of R0 to reduce its Johnson noise contribution and the effect of opamp current noise flowing in it. Also note that details that are essential for practical use, like input DC-blocking capacitors, DC-drain resistors, and EMC/cartridge loading capacitors have been omitted to keep things simple; often the 47 kΩ input loading resistor is omitted as well. The addition of these components is fully described in the section on practical designs at the end of this chapter.

This stage is designed for a gain of 35.0 dB at 1 kHz, which means a maximum input of 178 mV at the same frequency. With a nominal 5 mVrms input at 1 kHz the output is 280 mV. The RIAA accuracy is within ±0.1 dB from 20 Hz to 20 kHz, and the IEC amendment is implemented by making C0 a mere 7.96 uF. You will note with apprehension that only one of the components, R0, is a standard value, and that is because it was used as the input to the RIAA design calculations that defined the overall RIAA network impedance. This is always the case for accurate RIAA networks. Here, even if we assume that capacitors of the exact value could be obtained, and we use the nearest E96 resistor values, systematic errors of up to 0.06 dB will be introduced. Not a long way adrift, it's true, but if we are aiming for an accuracy of ±0.1 dB it's not a good start. If E24 resistors are the best available, the errors grow to a maximum of 0.12 dB, and don't forget that we have not considered tolerances—we are assuming the values are exact. If we resort to the nearest E12 value (which really shouldn't be necessary these days), then the errors exceed 0.7 dB at the HF end. And what about those capacitors?

The answer is that by using multiple components in parallel or series we can get pretty much what value we like, and it is perhaps surprising that this approach is not adopted more often. The reason is probably cost—a couple of extra resistors are no big deal, but extra capacitors make more of an impact on the costing sheet. The use of multiple components also improves the accuracy of the total value, as described in Chapter 2. More on this important topic later in this chapter.

While the RIAA equalisation curve is not specified above 20 kHz, the implication is clear that it will go on falling indefinitely at 6 dB/octave. A series feedback stage cannot have a gain of less than unity, so at some point the curve will begin to level out and eventually become flat at unity gain.

Figure 9.5 shows the frequency response of the circuit in Figure 9.3, with its associated time-constants. T3, T4, and T5 are the time-constants that define the basic RIAA curve, while f3, f4, and f5 are the equivalent frequencies. This is the naming convention used by Stanley Lipshitz in his landmark paper [28] and is used throughout this book. Likewise, T2 is the extra time-constant for the IEC amendment, and T1 shows where its effect ceases at very low frequencies when the gain is approaching unity at the low-frequency end due to C0. At the high end, the final unity-gain frequency is f6, with associated time-constant T6, and because the gain was chosen to be +35 dB at 1 kHz, it is quite a long way from 20 kHz and has very little effect at this frequency, giving an excess gain of only 0.10 dB. This error quickly dies away to nothing as frequency falls below 20 kHz.

As noted earlier, the series-feedback RIAA configuration has what might be called the unity-gain problem. If the gain of the stage is set lower than +35 dB to increase the input overload margin, the 6 dB/octave fall tends to level out at unity early enough to cause significant errors in the audio band. Adding a HF correction pole (ie lowpass time constant) just after the input stage makes the simulated and measured frequency response exactly correct. It is NOT a question of bodging the response to make it roughly right. If the correction pole frequency is correctly chosen, its roll-off cancels *exactly* with the 'roll-up' of the final zero at f6.

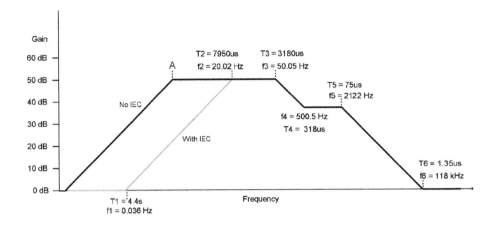

Figure 9.5 The practical response for series-feedback RIAA equalisation, with and without the IEC amendment which gives an extra roll-off at 20.02 Hz.

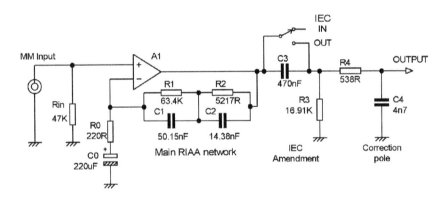

Figure 9.6 Series-feedback RIAA equalisation configuration-A, redesigned for +30.0 dB gain (1 kHz) which allows a maximum input of 316 mVrms (1 kHz). R0 has been set to 220 Ω to reduce RIAA network impedance. The switchable IEC amendment is implemented by C3, R3. HF correction pole R4, C4 is added to keep RIAA accuracy within ±0.1 dB 20 Hz to 20 kHz.

An HF correction pole is demonstrated in Figure 9.6, where several important changes have been made compared with Figure 9.3. The overall impedance of the RIAA network has been reduced by making R0 220 Ω to reduce Johnson noise from the resistors; we still end up with some very awkward values.

The IEC amendment is no longer implemented in this stage; if it was then the correct value of C0 would be 36.18 uF, and instead it has been made 220 uF so that its associated −3 dB roll-off does

not occur until 3.29 Hz. Even this wide spacing introduces an unwanted 0.1 dB loss at 20 Hz, and perfectionists will want to use 470 uF here, which reduces the error to 0.06 dB.

Most importantly, the gain has been reduced to +30 dB at 1 kHz to get more overload margin. With a nominal 5 mVrms input at 1 kHz the output will be 158 mV. The result is that the flattening-out frequency f6 in Figure 9.3 is now at 66.4 kHz, much closer in, and it introduces an excess gain at 20 kHz of 0.38 dB, which is too much to ignore if you are aiming to make high-class gear. The HF correction pole R4, C4 is therefore added, which solves the problem completely. Since there are only two components and no interaction with other parts of the circuit, we have complete freedom in choosing C4, so we use a standard E3 value and then get the pole frequency exactly right by using two resistors in series for R4–470 Ω and 68 Ω. Since these components are only doing a little fine-tuning at the top of the frequency range, the tolerance requirements are somewhat relaxed compared with the main RIAA network. The design considerations are a) that the resistive section R4 should be as low as possible in value to minimise Johnson noise and b) that the shunt capacitor C4 should not be large enough to load the opamp output excessively at 20 kHz. At this level of accuracy, even the finite gain open-loop gain of even a 5534 at HF has a slight effect, and the frequency of the HF pole has been trimmed to compensate for this.

Implementing the IEC amendment

The unloved IEC amendment was almost certainly intended to be implemented by restricting the value of the capacitor at the bottom of a series feedback arm, ie C0 in Figures 9.3 and 9.6. While electrolytic capacitors nowadays (2022) have relatively tight tolerances of ±20%, in the 1970s you would be more likely to encounter −20% +50%, the asymmetry reflecting the assumption that electrolytics would be used for non-critical coupling or decoupling purposes where too little capacitance might cause a problem but more than expected would be fine. This wide tolerance meant that there could be significant errors in the LF response due to C0. Figure 9.7 shows the effect of a ±20% C0 tolerance on the RIAA response of a preamplifier similar to Figure 9.6, with a gain of +30 dB (1 kHz) and C0 = 36.13 uF. The gain will be +0.7 dB up at 20 Hz for a +20% C0 and −1.1 dB down at 20 Hz for a −20% C0. The effect of C0 is negligible above 100 Hz, but this is clearly not a good way to make accurate RIAA networks.

To get RIAA precision it is necessary to implement the IEC amendment separately with a non-electrolytic capacitor, which can have a tolerance of ±1% if necessary. In several of my designs the IEC amendment has been integrated into the response of the subsonic filter that immediately follows the RIAA preamplifier; this gives economy of components but means that it is not practicable to make it switchable in and out. Unless buffering is provided the series resistance in the HF correction network can interfere with the subsonic filter action, causing an early roll-off that degrades RIAA accuracy in the 20–100 Hz region.

The best solution is a passive CR highpass network after the preamplifier stage. We make C0 large to minimise its effect and add a separate 7950 µs time-constant after the preamplifier, as shown in Figure 9.6, where R3 and C3 give the required −3 dB roll-off at 20.02 Hz.

Another problem with the 'small C0' method of the IEC amendment is the non-linearity of electrolytic capacitors when they are asked to form part of a time-constant. This is described

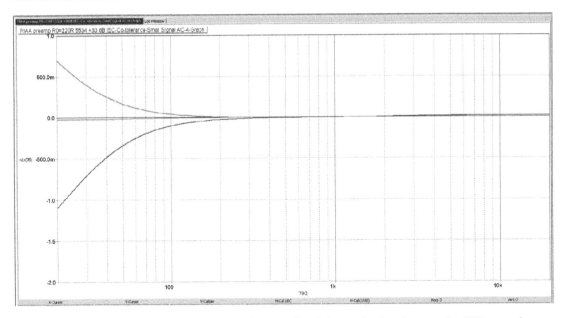

Figure 9.7 **The effect of a ±20% tolerance for C0 when it is used to implement the IEC amendment.**

in detail in Chapter 2. Since the MM preamps of the 1970s tended to have poor linearity at LF anyway because the need for bass boost meant a reduction in the LF negative feedback factor, introducing another potential source of distortion was not exactly an inspired move; on the other hand the signal levels are low. There is no doubt that even a simple second-order subsonic filter, switchable in and out, is a better approach to controlling subsonic disturbances. If a Butterworth (maximally flat) alignment was used, with a −3 dB point at 20 Hz, this would only attenuate by 0.3 dB at 40 Hz but would give a more useful −8.2 dB at 13 Hz and a thoroughly effective −28 dB at 4 Hz. Not all commentators are convinced that the more rapid LF phase changes that result are wholly inaudible, but they are; you cannot hear phase, as explained in Chapter 1. Subsonic filters are examined more closely at the end of this chapter.

RIAA series-feedback network configurations

So far we have only looked at one way to construct the RIAA feedback network. There are other ways because it does not matter how the time-constants are implemented, just that they are correct. There are four possible configurations described by Lipshitz in his classic paper [28]. These are shown in Figure 9.8; the same identifying letters have been used. Note that the component values have been scaled compared with the original paper so that all versions have a closed-loop gain of +45.5 dB at 1 kHz and all have R0 = 220 Ω to aid comparison.

All four versions are accurate to within ±0.1 dB when implemented with a 5534 opamp, but in the case of Figure 9.8a the error is getting close to −0.1 dB at 20 Hz due to the relatively high closed-

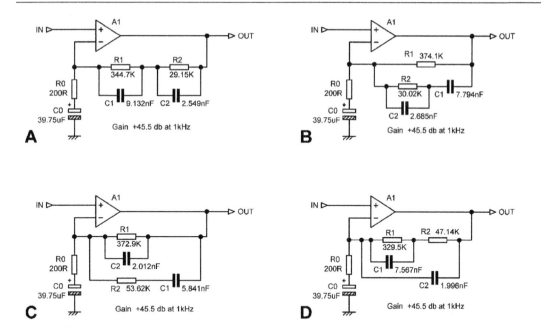

Figure 9.8 **The RIAA feedback configurations, with component values scaled so that R0 = 200 Ω and the gain is +45.5 dB at 1 kHz in each case. Note that the RIAA response of A and D here is not wholly accurate. Maximum input in each case is only 53 mVrms (1 kHz) which is not generally adequate.**

loop gain and the finite open-loop gain of the 5534. All have RIAA networks at a relatively high impedance. They all have relatively high gain and therefore a low maximum input. The notation R0, C0, R1, C1, R2, C2 is as used by Lipshitz; C1 is always the larger of the two. In each case the IEC amendment is implemented by the value of C0.

So there are the four configurations; is there anything to choose between them? Yes indeed. Firstly, each configuration in Figure 9.8 contains two capacitors, a large C1 and a small C2. If they are close-tolerance (to get accurate RIAA) and non-polyester (to prevent capacitor distortion) then they will be expensive; so if there is a configuration that makes the large capacitor smaller, even if it is at the expense of making the small capacitor bigger, it is well worth pursuing. The large capacitor C1 is probably the most expensive component in the RIAA MM amplifier by a large margin.

Configuration-A (which I have been using for years) makes the least efficient use of its capacitors since they are effectively in series, reducing the effective value of both of them. Configuration-C has its capacitors more in parallel, so to speak, and has the smallest capacitors for both C1 and C2. Configurations B and D have intermediate values for C1, but of the two D has a significantly smaller C2. Configuration-C is the optimal solution in terms of capacitor size and hence cost. To design it accurately for gains other than +45.5 dB (1 kHz) meant building a software tool for it

from the Lipshitz equations for configuration-C. This I duly did, though just as anticipated it was somewhat more difficult than it had been for configuration-A.

The scaling process slightly reduced the RIAA accuracy, so configuration A was recalculated from scratch using the Lipshitz equations; see Figure 9.9.

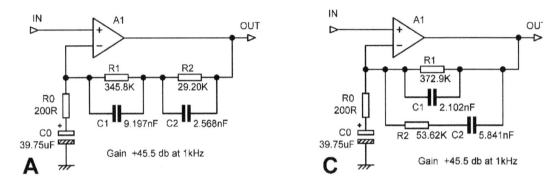

Figure 9.9 Configuration-A with values calculated from the Lipshitz equations to give accurate RIAA response. Configuration-C from Figure 9.8 shown for comparison; C1 in configuration-A is much larger than C1 in configuration-C, so the latter is superior. Gain +45.5 dB at 1 kHz for both.

While configuration-C in Figures 9.8 and 9.9 has come out as the most economical, our work here is not done. It will not have escaped you that a gain as high as +45.5 dB at 1 kHz is not going to give a great overload margin; it has only been used so far because it was the gain adopted in the Lipshitz paper. If we assume our opamp can provide 10 Vrms out, then the maximum input at 1 kHz is only 53 mVrms, which is mediocre at best. The gain of an MM input stage should not, in my opinion, much exceed 30 dB at 1 kHz (see the earlier example in Figure 9.6).

My Precision Preamplifier design [23] has an MM stage gain of +29 dB at 1 kHz, allowing a maximum input of 354 mVrms (1 kHz). The more recent Elektor Preamplifier 2012 [29] has an MM stage gain of +30 dB (1 kHz), allowing a maximum input of 316 mVrms; it is followed by a flat switched-gain stage which allows for the large range in MC cartridge sensitivity.

I used the new software tool for configuration-C to design the MM input stage in Figure 9.10, which has a gain of +30 dB (1 kHz). This design has an RIAA response, including the IEC amendment, that is accurate to within ±0.01 dB from 20 Hz to 20 kHz (it is assumed C0 is accurate). The relatively low gain means that an HF correction pole is required to maintain accuracy at the top of the audio band, and this is implemented by R3 and C3. Without this pole the response is 0.1 dB high at 10 kHz, and 0.37 dB high at 20 kHz. R3 is a non-preferred value as we have used the E6 value of 2n2 for capacitor C3.

In Figure 9.10 and in the examples that follow, I have implemented the IEC amendment by using the appropriate value for C0, rather than by adding an extra time-constant after the amplifier as in Figure 9.6. We noted earlier that using C0 for this is not the best method, but I have stuck with it here as it is instructive how the correct value of C0 changes as other alterations are made to the

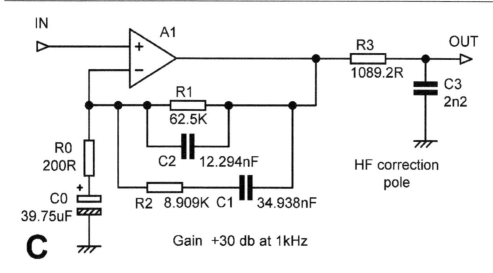

Figure 9.10 Configuration-C with values calculated from the Lipshitz equations to give +30.0 dB gain at 1 kHz and an accurate RIAA response within ±0.01 dB; the lower gain now requires HF correction pole R3, C3 to maintain accuracy at the top of the audio band.

RIAA network. In many cases the IEC amendment is just not wanted, and C0 will be 220 uF or 470 uF. It is assumed there will be a proper subsonic filter later in the signal path.

RIAA optimisation: C1 as a single E6 capacitor, 2xE24

Looking at Figure 9.10, a further stage of optimisation is possible after choosing the best RIAA configuration. There is nothing magical about the value of R0 at 200 Ω (apart from the bare fact that it's an E24 value), it just needs to be suitably low for a good noise performance, so it can be manipulated to make at least one of the capacitor values more convenient, the larger one being the obvious candidate. Compared with the potential savings on expensive capacitors here, the cost of a non-preferred value for R0 is negligible. It is immediately clear that C1, at 34.9 nF, is close to 33 nF. If we twiddle the new software tool for configuration-C so that C1 is exactly 33 nF, we get the arrangement in Figure 9.11. R0 has only increased by 6%, and so the effect on the noise performance will be quite negligible. All the values in the RIAA feedback network have likewise altered by about 6%, including C0, but the HF correction pole is unchanged; we would only need to alter it if we altered the gain. The RIAA accuracy of Figure 9.11 is still well within ±0.01 dB from 20 Hz to 20 kHz when implemented with a 5534.

The circuit of Figure 9.11 has two preferred value capacitors, C1 and C3, but that is the most we can manage. All the other values are, as expected, thoroughly awkward. The resistor values can be tackled by using the E96 series, but it may mean keeping an awful lot of values in stock. There are better ways . . .

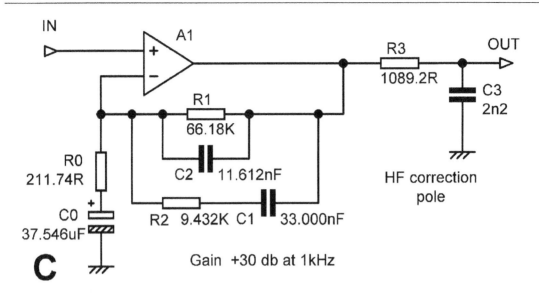

Figure 9.11 Configuration-C from Figure 9.10 with R0 tweaked to make C1 exactly the E6 preferred value of 33.000 nF. Gain is still 30.0 dB at 1 kHz, and RIAA accuracy within ±0.01 dB. The HF correction pole R3, C3 is unchanged.

In Chapter 2 I describe how to make up arbitrary resistor values by paralleling two or more resistors and how the optimal way to do this is with resistors of as nearly equal values as you can manage. If the values are equal, then the tolerance errors partly cancel, and the accuracy of the combination is $\sqrt{2}$ times better than the individual resistors. The resistors are assumed to be E24, and the parallel pairs were selected using a specially written software tool. I call this the 2xE24 format. The three-part combination for C2, which I have assumed restricted to E6 values, works out very nicely, with only three components getting us very close to the exact value we want. Table 9.3 gives the component combinations, and Figure 9.12 shows the practical circuit that results.

The criterion used when selecting the parallel resistor pairs was that the error in the nominal value should be less than half of the component tolerance, assumed to be ±1% in Table 9.3. R2 only just squeaks in, but its near-equal values will give almost all of the $\sqrt{2}$ (= 0.707) improvement possible. Remember that in Table 9.3 we are dealing here with nominal values, and the % error in the nominal value shown in the 'Error' column has nothing to do with the resistor tolerances. The effective tolerance of the combination for each component is shown in the rightmost column and all are an improvement on 1% except for C1, as it is a single component.

No attempt has been made here to deal with the non-standard value for C0. In practice C0 will be a large value such as 220 uF, so its wide tolerance will have no significant effect on RIAA accuracy. The IEC amendment will be implemented (if at all) by a later time-constant using a non-electrolytic, as shown earlier in Figure 9.6.

TABLE 9.3 Approximation to the exact values in Figure 9.11 by using parallel components, giving Figure 9.12

Component	Desired value	Actual value	Parallel part A	Parallel part B	Parallel part C	Nominal error	Effective tolerance
R0	211.74 Ω	211.03 Ω	360 Ω	510 Ω	-	−0.33%	0.72%
R1	66.18 kΩ	65.982 kΩ	91 kΩ	240 kΩ	-	−0.30%	0.78%
C1	33 nF	33 nF	33 nF	-	-	**0%**	1.00%
R2	9.432 kΩ	9.474 kΩ	18 kΩ	20 kΩ	-	+0.44%	0.71%
C2	11.612 nF	11.60 nF	4n7	4n7	2n2	−0.10%	0.60%
R3	1089.2 Ω	1090.9 Ω	2 kΩ	2.4 kΩ	-	+0.16%	0.71%

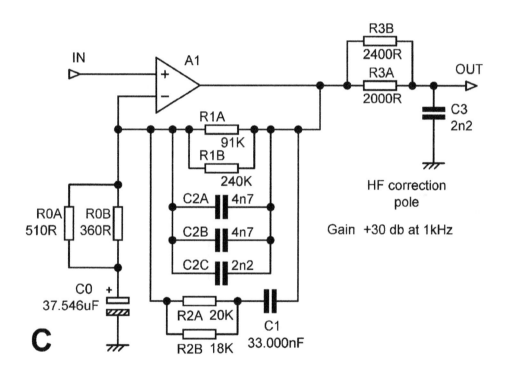

Figure 9.12 **Configuration-C from Figure 9.11 with the resistors now made up of optimal parallel E24 pairs to achieve the correct value. C2 is now made up of three parts A, B, and C. Gain +30.05 dB at 1 kHz, RIAA accuracy is worsened but still within ±0.048 dB.**

RIAA optimisation: C1 as 3x10 nF capacitors, 2xE24

We have just modified the RIAA network so that the major capacitor C1 is a single preferred value. The optimisation of the RIAA component values can be tackled in another way however; much depends on component availability. In many polystyrene capacitor ranges 10 nF is the

TABLE 9.4 Approximation to the exact values using C1 = 30 nF by using parallel components, giving
Figure 9.13

Component	Desired value	Actual value	Parallel part A	Parallel part B	Parallel part C	Nominal error	Effective tolerance
R0	232.9 Ω	233.3 Ω	430 Ω	510 Ω	-	−0.17%	0.71%
R1	72.64 kΩ	72.64 kΩ	91 kΩ	360 kΩ	-	−0.002%	0.82%
C1	30 nF	30 nF	10 nF	10 nF	10 nF	**0%**	0.58%
R2	10.375 kΩ	10.359 kΩ	13 kΩ	51 kΩ	-	−0.15%	0.82%
C2	10.557 nF	10.52 nF	4n7	4n7	1nF + 120 pF	−0.34%	0.64%
R3	1089.2 Ω	1090.9 Ω	2 kΩ	2.4 kΩ	-	+0.16%	0.71%

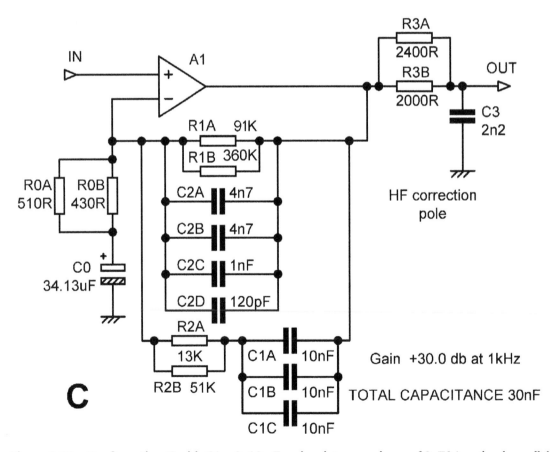

Figure 9.13 Configuration-C with C1 = 3x10 nF and resistors made up of 2xE24 optimal parallel
pairs. C2 is made up of four parts A, B, C, D. Gain +30.0 dB at 1 kHz, RIAA accuracy is within
±0.01 dB.

highest value that can be obtained with a tolerance of 1%; in other cases the price goes up rather faster than proportionally above 10 nF. Paralleling several 10 nF polystyrene capacitors is *much* more cost-effective than using a single precision polypropylene part.

To use this method we need to redesign the circuit of Figure 9.12 so that C1 is either exactly 30 nF or exactly 40 nF (there is a practical design using configuration-A with 5x 10 nF = 50 nF at the end of this chapter, underlining the fact that configuration-A makes less efficient use of its capacitance). The 40 nF version costs more than the 30 nF version but gives a total capacitance that is twice as accurate as one capacitor (because $\sqrt{4} = 2$) while the 30 nF version only improves accuracy by $\sqrt{3}$ (= 1.73) times. Using 40 nF gives somewhat lower general impedance for the RIAA network, but this will only reduce noise very slightly. Figure 9.13 and Table 9.4 shows the result for C1 = 30 nF, and Figure 9.14 and Table 9.5 shows the result for C1 = 40 nF. In both cases the resistors are made up of 2xE24 pairs. Since the gain is unchanged the values for the HF correction pole R3, C3 are also unchanged in each case.

In the +30 dB case we have been unlucky with the value of C2, which needs to be trimmed with a 120 pF capacitor to meet the criterion that the error in the nominal value will not exceed half the component tolerance. This configuration has been built with 1% capacitors and thoroughly measured, and it works exactly as it should. It gave a parts-cost saving of about £2 on the product concerned. That feeds through to a significant reduction in the retail price.

RIAA optimisation: C1 as 4x10 nF capacitors, 2xE24

The same process can be applied to the C1 = 4x10 nF version, giving the results in Table 9.5 and Figure 9.14.

This time we are much luckier with the value of C2; three 4n7 capacitors in parallel give almost exactly the required value and a healthy improvement in the effective tolerance 0.58%. On the other hand, we are very unlucky with R0, where 180 Ω in parallel with 6.2 kΩ is the most 'equal-value' solution that falls within our error criterion, and there is negligible improvement in the effective tolerance.

RIAA optimisation: the Willmann Tables

The 2xE24 examples given in the previous section use two resistors in parallel, and the relatively small number of combinations available means that the nominal value is not always as accurate as we would like; for example the 0.44% error in Table 9.3, which only just meets the rule that, "the nominal value of the combination shall not differ from the desired value by more than half the component tolerance." For the usual 1% parts this means within ±0.5%, and once that is achieved we can pursue the goal of keeping the values as near-equal as possible. Keep in mind that ±0.5% is the error in the nominal value, and the component tolerance, or the effective component tolerance when two or more resistors are combined, is another thing entirely and a source of additional error. It is usually best to use parallel rather than series combinations of resistors because it makes the connections on a PCB simpler and more compact.

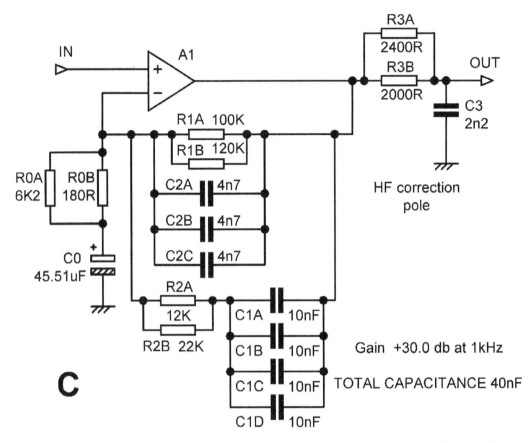

Figure 9.14 Configuration-C with C1 = 4x10 nF and resistors made up of 2xE24 parallel pairs. C2 is made up of three parts. Gain +30.0 dB at 1 kHz, RIAA accuracy is within ±0.01 dB.

TABLE 9.5 Approximation to the exact values for C1 = 40 nF by using parallel components, giving Figure 9.14

Component	Desired value	Actual value	Parallel part A	Parallel part B	Parallel part C	Parallel part D	Nominal error	Effective tolerance
R0	174.7 Ω	174.9 Ω	180 Ω	6.2 kΩ	-	-	+0.13%	0.97%
R1	54.65 kΩ	54.54 kΩ	100 kΩ	120 kΩ	-	-	+0.19%	0.71%
C1	40 nF	40 nF	10 nF	10 nF	10 nF	10 nF	**0%**	0.50%
R2	7.821 kΩ	7.765 kΩ	12 kΩ	22 kΩ	-	-	−0.22%	0.74%
C2	14.074 nF	14.1 nF	4n7	4n7	4n7	-	+0.18%	0.58%
R3	1089.2 Ω	1090.9 Ω	2 kΩ	2.4 kΩ	-	-	+0.16%	0.71%

The relatively small number of combinations of E24 resistor values also means that it is difficult to pursue good nominal accuracy and effective tolerance reduction at the same time. This can be addressed by instead using three E24 resistors in parallel, as noted in Chapter 2. I call this the 3xE24 format. Given the cheapness of resistors, the economic penalties of using three rather than two to approach the desired value very closely are small, and the extra PCB area required is modest. However the design process is significantly harder.

The process is made simple by using one of the resistor tables created by Gert Willmann. There are many versions, but the one I used lists in text format all the three-resistor E24 parallel combinations and their combined value. It covers only one decade, which is all you need, but it is naturally still a very long list, running to 30,600 entries, sorted by combined value. The complete Willmann Tables cover a wide range of resistor series, parallel/series connections, and so on. Gert Willmann has very kindly made the tables freely available, and the complete collection can be downloaded free of charge from my website at [30].

RIAA optimisation: C1 as 3x10 nF capacitors, 3xE24

I first applied the Willmann table process to Figure 9.11, which has +30 dB gain at 1 kHz and C1 set to exactly 33 nF. I started with R0, which has a desired value of 211.74 Ω. The appropriate Willmann table was read into a text editor and using the search function to find '211.74', it takes us straight to an entry at line 9763 for 211.74396741 Ω, made up of 270 Ω 1100 Ω and 9100 Ω in parallel. This nominal value is more than accurate enough, but since the resistor values are a long way from equal, there will be little improvement in effective tolerance; it calculates as 0.808%, which is not much of an improvement over 1%.

Looking up and down the Willmann table, better combinations that are more equal than others are easily found. For example, 390 Ω 560 Ω 2700 Ω at line 9774 has a nominal value only 0.012% in error, while the tolerance is improved to 0.667%, and this is clearly a better answer. On further searching the best result for R0 is 560 Ω 680 Ω 680 Ω at line 9754, which has a nominal value only −0.09% in error and an effective tolerance of 0.580%, very close to the best possible 0.577% (1/$\sqrt{3}$). This process needs automating, perhaps in Python.

TABLE 9.6 Table 9.4 redone using paralleled resistor triples, (3xE24) using C1 = 30 nF; see Figure 9.15

Component	Desired value	Actual value	Parallel part A	Parallel part B	Parallel part C	Nominal error	Effective tolerance
R0	211.74 Ω	211.03 Ω	560 Ω	680 Ω	680 Ω	−0.087%	0.58%
R1	66.18 kΩ	65.982 kΩ	180 kΩ	200 kΩ	220 kΩ	+0.062%	0.58%
R2	9.432 kΩ	9.474 kΩ	22 kΩ	33 kΩ	33 kΩ	−0.036%	0.59%
R3	1089.2 Ω	1090.9 Ω	2.7 kΩ	2.7 kΩ	5.6 kΩ	−0.13%	0.60%
C1	30 nF	30 nF	10 nF	10 nF	10 nF	**0.00%**	0.58%
C2	11.612 nF	11.60 nF	4n7	4n7	2n2	−0.10%	0.60%
C3	2n2	2n2	2n2	-	-	0.00%	1%

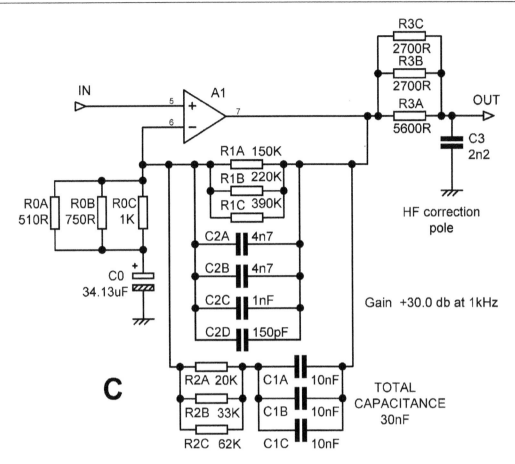

Figure 9.15 Configuration-C MM RIAA amplifier of Figure 9.13 (C1 = 3x10 nF) redesigned for 3xE24 parallel resistor combinations (A, B, C).

This process was applied to the C1 = 3x10 nF amplifier in Figure 9.13, and the results are shown in Table 9.6 and Figure 9.15. The effective tolerances are shown in the rightmost column, and you can see that all of them are quite close to the best possible value of 0.577% (1/√3). This is a direct result of the extra freedom in design given by the use of the 3xE24 format.

RIAA optimisation: C1 as 4x10 nF capacitors, 3xE24

I also applied 3xE24 to the C1 = 4x10 nF design in Figure 9.14, and the result is shown in Figure 9.16. The corresponding table is omitted to save space.

In *Electronics for Vinyl* [1] a comprehensive table of component values and combinations is given for a gain at 1 kHz of +30 dB, +35 dB, and +40 dB. In each case the same three options for C1 that we used for the +30 dB gain version here are offered, ie 3x10 nF, 1x33 nF, and 4x10 nF.

In the course of putting those tables together, 36 essentially random nominal resistor values were dealt with, and the average absolute error in nominal value if a single E96 resistor was used was 0.805%, for 2xE24 it was 0.285%, and for 3xE24 it was only 0.025%. So 2xE24 was three times better than 1xE96, and 3xE24 was ten times better again. You have to use the absolute value of the error as otherwise positive and negative errors tend to cancel out and give an unduly optimistic result. The RMS error could also be used, but it emphasises the larger errors, which may or may not be desirable.

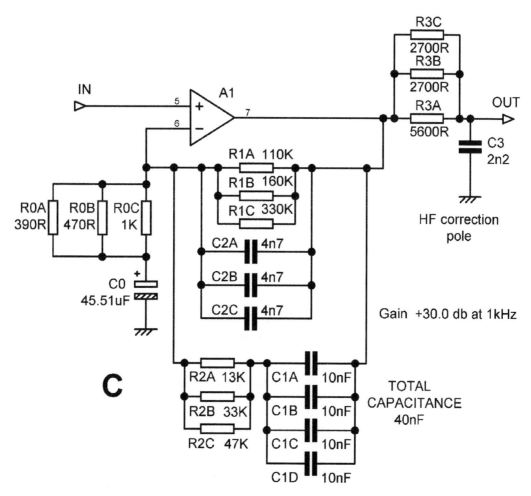

Figure 9.16 Configuration-C MM RIAA amplifier in Figure 9.14 (C1 = 4x10 nF) redesigned for 3xE24 parallel resistor combinations.

You may not agree that +30 dB (1 kHz) is the ideal gain for a phono amplifier. In Chapter 7 of *Electronics for Vinyl* [1] the component values are also given for +35 dB (1 kHz) and +40 dB (1 kHz). In each case the same three options for C1 that we used for the +30 dB gain version are

offered, ie 1x33 nF, 3x10 nF, and 4x10 nF. The nominal errors and effective tolerances are given for each component. Obviously this takes up a lot of room, and there is no space for it here.

Alternative optimisations of the RIAA networks shown here are possible. For example, we noticed that changing R0 from 200 Ω to 211.74 Ω had a negligible effect on the noise performance; worse by only 0.02 dB. That is well below the limits of measurement; what happens if we grit our teeth and accept a 0.1 dB noise deterioration? That is still at or below most measurement limits. It implies that R0 is 270 Ω, and the RIAA network impedance is therefore increased by 35%, so we could, for example, omit one of the 10 nF capacitors in Figure 9.14, naturally with suitable adjustments to other components, and so save some more of our hard-earned money.

To summarise, we have shown that there are very real differences in how efficiently the various RIAA networks use their capacitors, and it looks clear that using configuration-C rather than configuration-A will cut the cost of the expensive capacitors C1 and C2 in an MM stage by around 36% and 19% respectively, which I suggest is both a new result and well worth having. From there we went on to find that different constraints on capacitor availability lead to different optimal solutions for configuration-C.

Both my Precision Preamplifier 96 [23] and the more recent Elektor Preamplifier 2012 [29] have MM stage gains close to +30 dB (1 kHz), like the previous examples, but both use configuration-A, and five paralleled 10 nF capacitors are required.

I hope you will forgive me for not making public the software tools mentioned in this chapter. They are part of my stock-in-trade as a consultant engineer, and I have invested significant time in their development.

Switched-gain MM RIAA amplifiers

As noted earlier, it is not necessary to have a wide range of variable or stepped gain if we are only dealing with MM inputs, due to the limited spread of MM cartridge sensitivities—only about 7 dB. According to Peter Baxandall, at least two gain options are desirable [31].

However, as we have seen, the design of one-stage RIAA networks is not easy, and you might suspect that simply altering R0 away from the design point to change the gain is going to lead to some response errors. How right you are. Changing R0 introduces directly an LF RIAA error and indirectly causes a larger HF error because the gain has changed, and so the HF correction pole is no longer correct. Here are some examples where the RIAA components are calculated for a gain of +30 dB, with R0 = 200 Ω, and then the gain increased by a suitable reduction of R0:

1) For +30 dB gain switched to +35 dB gain (R0 reduced to 112.47 Ω)

 The RIAA LF error is +0.07 dB from 20 Hz–1 kHz

 The HF error is −0.26 dB at 20 kHz.

2) For +30 dB gain switched to +40 dB gain (R0 reduced to 63.245 Ω)

 The RIAA LF error is +0.10 dB from 20 Hz–1 kHz

 The HF error is −0.335 dB at 20 kHz.

These figures include the effect of finite open-loop gain when using a 5534A as the opamp; this increases the errors for the +40 dB gain option.

Thus for real accuracy we need to switch not only R0 but also R1 in the RIAA feedback path, and R3 in the HF correction pole; this would be very clumsy. If your RIAA error tolerance is a relaxed ±0.1 dB, switching R1 could be omitted, but two resistors still need to be switched. This assumes that the IEC amendment is performed by a CR network after the MM stage, as described earlier; this will be unaffected by changes in R0. Otherwise, if the IEC amendment is implemented by a small value of C0, you would need to switch that component as well to avoid gross RIAA errors below 100 Hz. All in all, switching the value of R0 is not an attractive proposition if you are looking for the good accuracy.

There is a better way. If the gain is altered not by changing the value of R0 but instead keeping R0 constant and having a variable tap on it, which feeds the inverting input of the amplifier, as in Figure 9.17, the loading of R0 on the rest of the RIAA network does not change with gain setting, and the RIAA response is accurate for all three settings.

You may be thinking ruefully that is all very well, but we still need to switch the HF correction pole resistor so we get the proper correction for each gain. And yet, most elegantly, that is not the case. When we move the switch from +30 to +35, the value of the bottom feedback arm R0 is no longer R0A + R0B + R0C but is reduced to R0B + R0C, increasing the gain. R0A is now in the upper arm of the feedback network, and this causes the frequency response at HF to flatten

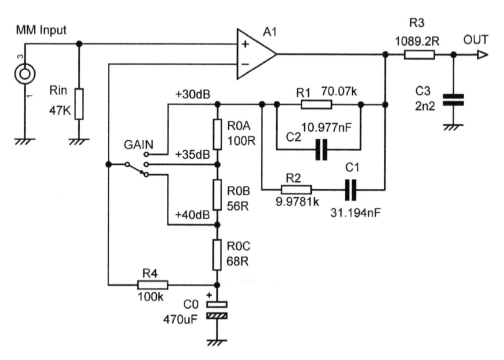

Figure 9.17 Configuration-C MM amplifier with gain switchable to +30 dB, +35 dB, and +40 dB (1 kHz).

out earlier than it would have done, in just the right way to keep the required HF correction pole unchanged. I won't bore you with the mathematics, but you can prove it for yourself in 2 minutes with SPICE simulation. Likewise switching to +40 dB leaves just R0C in the lower arm while R0A + R0B is in the upper arm. R4 maintains DC feedback when the switch is between contacts to prevent thunderous noises.

RIAA accuracy falls off slightly at LF for the +40 dB setting (−0.3 dB at 20 Hz) because of the finite value of C0. Its value can be increased considerably if desired as it has only the offset voltage across it, and a 6V3 part will be fine.

Switched-gain MM/MC RIAA amplifiers

There is a considerable saving in parts if the same RIAA amplifier stage can be used for both MM and MC cartridges. This approach was used in many Japanese amplifiers, for example the Pioneer A-8 (1981) and the Yamaha A-760, AX-500 (1987), AX-592, and AX-750. It implies that the gain of the stage must be increased by at least 20 dB in MC mode; which is rather more radical than the 5 or 10 dB gain changes examined in the previous section.

A typical arrangement is shown in Figure 9.18, which uses the same principle as Figure 9.17 with resistance removed from the bottom feedback arm being transferred to the top arm. The main difference is the very low value of R0B, which is essential as its Johnson noise is effectively in

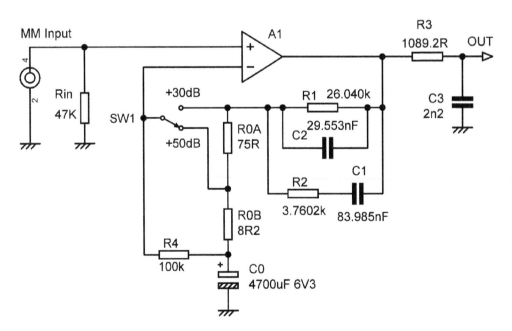

Figure 9.18 Configuration-C MM and MC amplifier with gain switchable from + 30 dB to + 50 dB (at 1 kHz).

series with the input, leading to a big C0 to maintain the LF response. R4 maintains DC feedback when the switch is between contacts to prevent horrible noises.

SPICE simulation shows that the RIAA accuracy is well within ±0.1 dB for the +30 dB setting. This is also true down to 40 Hz for the +50 dB setting, but the response then rolls-off due to the finite value of C0 being 0.3 dB down at 20 Hz. C0 is already about as large as is practicable at 4700 uF/6V3; at the time of writing the smallest I found was 25 mm high and 10 mm diameter. Improving the +50 dB LF response, or switching to a higher gain, will require C0 to be replaced by a short-circuit, and DC conditions maintained by a servo. This approach is described in Chapter 11 on MC amplifiers in *Electronics for Vinyl* [1].

If a BJT input device is used there is the problem that the collector current needs to be low to get low current noise, which is essential for a good MM noise performance; on the other hand the collector current needs to be high for low MC noise. The use of JFET input devices avoids this compromise because of the absence of current noise means a high drain current can be used in both cases; most of the amplifiers mentioned earlier used JFET input devices.

A significant complication is that the spread in sensitivity of MC cartridges is very much greater at about 36 dB than for MM cartridges (less than 10 dB) and having a single fixed MC gain is not very satisfactory.

Open-loop gain and RIAA accuracy

There is no point in having a super-accurate RIAA network if the active element does not have enough open-loop gain to correctly render the response demanded. This was a major problem for two and three-transistor discrete MM input stages, but one might have hoped that it would have disappeared with the advent of usable opamps. However, life is flawed, and gain problems did not wholly vanish. The TL072 was at one time widely used for MM inputs simply because of its affordability, even though its JFET input devices are a poor match to MM cartridge impedances, and its distortion performance was not of the best. However, there was another lurking problem—not enough open-loop gain.

Even the open-loop gain of a 5534A is not adequate for a closed-loop gain of +40 dB at 1 kHz if you are aiming for an accurate RIAA response, and the +35 dB (1 kHz) situation is marginal. For +30 dB (1 kHz) the errors due to limited open-loop gain are negligible compared with the expected tolerances of the passive RIAA components. We have already seen that if a wide range of cartridges and recording levels are to be accommodated, the minimum gain should be no more than +30 dB (1 kHz), so this works out quite nicely.

Passive and semi-passive RIAA equalisation

For many years, series-feedback RIAA preamplifiers as previously described were virtually universal, it being accepted by all that they gave the best noise, overload performance, and economy, especially of active components. However, human nature being what it is, some people will always want to do things the hard way, and this is exemplified by the fashion for passive (actually, semi-passive is more accurate) RIAA equalisation. The basic notion is to split the RIAA

equalisation into separate stages, and I have a dark and abiding suspicion that this approach may be popular simply because it makes the design of accurate RIAA equalisation much easier, as all you have to do is calculate simple time-constants instead of grappling with foot-long equations. But there is a price and it is a heavy one; the overload and/or noise performance is inevitably and seriously compromised.

Clearly a completely passive RIAA stage is a daft idea because a lot of gain is required somewhere to get the 5 mV cartridge signal up to a usable amplitude. The nearest you can get to completely passive is the scheme shown in Figure 9.19a, where the amplification and the equalisation are wholly separate, with no frequency-dependent feedback used at all. R2, R3, and C1 implement T3 and T4, while C2 implements T5. There is no inconvenient T6 because the response carries on falling indefinitely with frequency. This network clearly gives its maximum gain at 20 Hz, and at 1 kHz it attenuates by about 20 dB. Therefore, if we want the modest +30 dB gain at 1 kHz used in the previous example, the A1 stage must have a gain of no less than 50 dB. A 5 mVrms 1 kHz input would therefore result in 1.58 V at the output of A1. This is only 16 dB below clipping, assuming we are using the usual sort of opamps, and an overload margin of 16 dB is too small to be usable. It is obviously impossible to drive anything like a volume control or tone control stage from the passive network, so the buffer stage A2 is shown to emphasise that extra electronics are required with this approach.

The only way to improve the overload margin is to split the gain so that the A1 stage has perhaps 30 dB, while A2 after the passive RIAA network makes up the loss with 20 dB more gain. Sadly, this second stage of amplification must introduce extra noise, and there is always the point that you now have to put the signal through two amplifiers instead of one, so there is the potential for increased distortion.

The most popular architecture that separates the high and low RIAA sections is seen in Figure 9.19b. Here there is an active LF RIAA stage using feedback to implement T3 and T4 with R1, C1, R2 followed by R3, C2 which give a passive HF cut for T5. This is what I call an active-passive configuration. The values shown give an RIAA curve correct to within 0.04 dB from 20 Hz to 20 kHz. Note that because of the lack of time-constant interaction, we can choose standard values for both capacitors, but we are still left with awkward resistor values.

As always, amplification followed by attenuation means a headroom bottleneck, and this passive HF roll-off is no exception. Signals direct from disc have their highest amplitudes at high frequencies, so both these configurations give poor HF headroom, overload occurring at A1 output before passive HF cut can reduce the level. Figure 9.20 shows how the level at A1 output (Trace B) is higher at HF than the output signal (Trace A). The difference is Trace C, the headroom loss; from 1 dB at 1 kHz this rises to 14 dB at 10 kHz and continues to increase in the ultrasonic region. The passive circuit was driven from an inverse RIAA network, so a totally accurate disc stage would give a straight line just below the +30 dB mark.

A related problem in this semi-passive configuration is that the opamp A1 must handle a signal with much more HF content than the opamp in the single-stage series-feedback configuration, worsening any difficulties with slew-limiting and HF distortion. It uses two amplifier stages rather than one, and more precision components because of the extra resistor. Another difficulty is that A1 is more likely to run out of open-loop gain or slew rate at HF, as the response plateaus above

1 kHz rather than being steadily reduced by increasing negative feedback. Once again, a buffer stage A2 is required to isolate the final time-constant from loading.

A third method of equalisation is shown in Figure 9.19c, where the T5 roll-off is done by feedback via R5, C2 rather than by passive attenuation. This is not really passive in any way, as the equalisation is done in two active stages, but it does share the feature of splitting up the time-constants for easier design. As with the previous circuit, A1 is running under unfavourable conditions as it has to handle a larger HF content than in the series-feedback version, and there is now an inconvenient phase reversal. The values shown give the same gain and RIAA accuracy as the previous circuit, though in this case the value of R3 can be scaled to change the gain.

There are many other alternative arrangements that can be used for passive or semi-passive equalisation. There could be a flat input stage followed by a passive HF cut and then another stage to give the LF boost, as in Figure 9.19d, which has even more headroom problems and uses yet more parts. I call this a passive-active configuration. In contrast the 'all-in-one-go' series feedback configuration avoids unnecessary headroom restrictions and has the minimum number of stages.

Passive RIAA is not an attractive option for general use but comes into its own in the archival transcription of recordings, where there are dozens of different pre-RIAA equalisation schemes, and it must be possible to adjust the turnover frequencies f3, f4, and f5 independently.

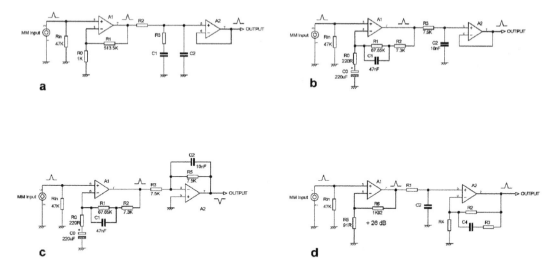

Figure 9.19 Passive and semi-passive RIAA configurations.

Peter Baxandall published a circuit in 1981 [31] with the configuration of Figure 9.19b that gave easy switched-gain control and allowed the use of preferred values, with only two of them in the E24 series. Like all of Peter's ideas, it is well worth studying and is shown in Figure 9.21. The gains are +20, +30, and +40 dB, accurate to within ±0.3 dB; the switchable gain largely avoids the headroom problems of passive RIAA equalisation. The networks R3 to R7 ensure that R1,C1 are always fed from the same 6k8 impedance. The RIAA accuracy is within ±0.03 dB between 1 kHz and 20 kHz in each case, falling off to about −0. 1 dB at 100 Hz. This is due to the way that

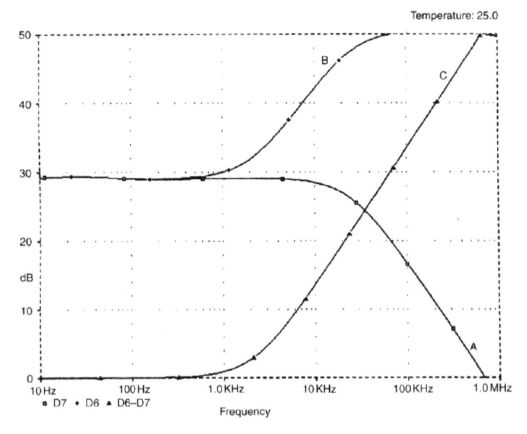

Figure 9.20 **Headroom loss with passive RIAA equalisation. The signal level at A1 (Trace B) is greater than at A2 (Trace A) so clipping occurs there first. Trace C shows the headroom loss, which reaches 18 dB at 20 kHz.**

R0 and C0 implement the IEC amendment, giving f2 = 21.22 Hz rather than the correct 20.02 Hz; that is as close as you can get with a single 750 Ω E24 resistor for R0. It results in a response 0.34 dB too low at 20 Hz. The correct value for R0 is 795 Ω, so f2 could be made much more accurate by using the parallel pair 1 kΩ and 3.9 kΩ, which is only 0.1% too high. However, there is the tolerance of C0 to be considered, and when Peter was writing (1981) that would have been larger than we would expect today, so 750 Ω was probably considered to be close enough.

One problem with this circuit suggests itself. When the gain switch is between contacts, A1 has no feedback and will hit the rails. Very likely, Peter was thinking of a make-before-break switch. The TDA1034B was an early version of the 5534 and was capable of driving the relatively low impedance of the R2–C2 combination with low distortion.

As so often happens, what you think is a recent trend has its roots in the distant past. An active-passive MM input stage was published in *Wireless World* in 1961 [32]. This had a two-transistor series-feedback amplifier which dealt with the LF equalisation, followed by a passive RC HF roll-off.

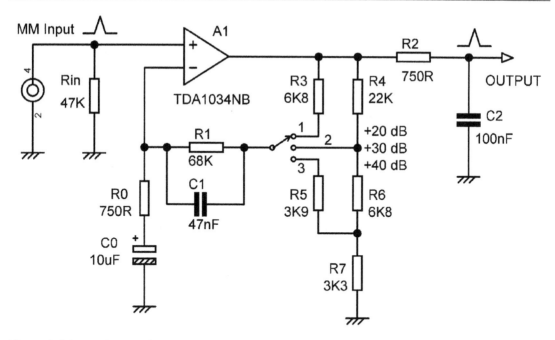

Figure 9.21 Active-passive RIAA stage with switched gain by Peter Baxandall.

MM cartridge loading and frequency response

The standard loading for a moving-magnet cartridge is 47 kΩ in parallel with a certain amount of capacitance, the latter usually being specified by the maker. The resulting resonance with the cartridge inductance is deliberately used by manufacturers to extend the frequency response, so it is wise to think hard before trying to modify it. Load capacitance is normally in the range 50 to 200 pF. Capacitance is often the subject of experimentation by enthusiasts, and so switchable capacitors are often provided at the input of high-end preamplifiers which allow several values to be set up by combinations of switch positions. The exact effect of altering the capacitance depends on the inductance and resistance of the cartridge, but a typical result is shown in Figure 9.22 where increasing the load capacitance lowers the resonance peak frequency and makes it more prominent and less damped. It is important to remember that it is the total capacitance, including that of the connecting leads, which counts.

Because of the high inductance of an MM cartridge, adjusting the load resistance can also have significant effects on the frequency response, and some preamplifiers allow this, too, to be altered. The only objective way to assess the effects of these modifications is to measure the output when a special (and expensive) test disc is played.

When loading capacitance is used it should be as near to the input socket as possible so it can contribute to filtering out RF before it radiates inside the enclosure. However its effectiveness for EMC purposes is likely to be much compromised if the capacitors are switched. Normal practice is that the smallest capacitor is permanently in circuit so it can be mounted right on the rear of the

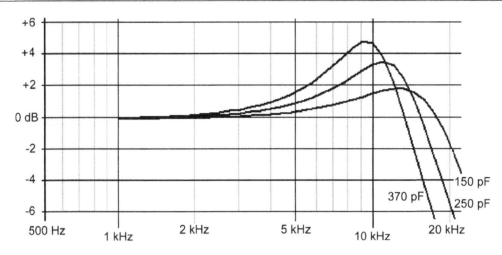

Figure 9.22 The typical effect of changing the loading capacitance on an MM cartridge.

input socket. A continuously variable loading capacitance could be made with an old-style tuning capacitor (two-section for stereo); looking back they were marvels of mass-produced precision engineering. The maximum value in an old medium-wave radio is often a rather convenient 500 pF. This would look well cool but naturally takes up a lot of space, and the variable-bootstrapping of a fixed capacitor (see the variable-frequency tone control in Chapter 15) would be much more compact.

The exact nature of this resonance does not have a consensus in the hifi community. There is also the possibility of what is usually called the 'cantilever resonance' which is a mechanical resonance between the effective tip mass of the stylus and the compliance of the vinyl it is tracking, the latter making up the spring part of the classic mass-and-spring system. The effective tip mass of the stylus is contributed to by the mass of the diamond tip, the cantilever, and the generator element on the other end, which may be a piece of iron, a magnet, or coils. It usually ranges from 0.2 to 0.7 milligrams. There is also the question of the contribution of the cantilever compliance, and the possibility of a torsional resonance of the cantilever [33]. You are probably thinking by now that this is a mass of electromechanical compromises that should be left alone, and you are probably right.

MM cartridge-preamplifier interaction

One often hears that there can be problems due to interaction between the impedance of the cartridge and the negative-feedback network. Most commentators are extremely vague as to what this actually means, but according to Tomlinson Holman [10], the factual basis is that it used to be all too easy to design an RIAA stage if you are using only two or three discrete transistors, in which the NFB factor is falling significantly with frequency in the upper reaches of the audio band, perhaps due to dominant-pole compensation to achieve HF stability (on the other hand, the amount of feedback is increasing with frequency due to RIAA

equalisation). Assuming a series-feedback configuration is being used, this means that the input impedance may fall with frequency, which is equivalent to having a capacitive input impedance. This interacts with the cartridge inductance and allegedly can cause a resonant peak in the frequency response in the same way that cable capacitance or a deliberately added load capacitance can do.

For this reason a flat-response buffer stage between the cartridge and the first stage performing RIAA equalisation was sometimes advocated. One design including this feature was the Cambridge Audio P50, which used a Darlington emitter-follower as a buffer; with this approach there is an obvious danger of compromising the noise performance because there is no gain to lift the signal level above the noise floor of the next stage.

MM cartridge DC and AC coupling

Some uninformed commentators have said that there should be no DC-blocking capacitor between the cartridge and the preamplifier. This is insane. Keep DC out of your cartridge. The signal currents are tiny (for MM cartridges 5 mV in 47 kΩ = 106 nA, while for MC ones 245 uV in 100 Ω = 2.45 uA; a good deal higher) and even a small DC bias current could interfere with linearity. I am not aware of any published work on how cartridge distortion is affected by DC bias currents, but I think it is pretty clear they will not improve things and may make them very much worse. Large currents might partially demagnetise the magnet, be it moving or otherwise, ruining the cartridge. Even larger currents due to circuit faults might burn out the coils, ruining the cartridge even more effectively. You may call a lack of blocking capacitors high-end, but I call it highly dangerous.

If I had a £15,000 cartridge (and they do exist, by Koetsu and Clearaudio) I would probably put two blocking capacitors in series—or three. Well, actually, I'd probably sell it and buy a car.

Noise in MM RIAA preamplifiers

Groove noise on a microgroove disc is between −70 and −64 dB (A-weighted) below the nominal level, as noted earlier. Later in this chapter you will see that a humble 5534A in a single amplifier stage gives a signal/noise ratio of −81.4 dBA (A-weighted) without load-synthesis, which is only 3.1 dB worse than a wholly noiseless amplifier. The groove noise will therefore be 11.4 dB above the amplifier noise; even if we had magic noiseless electronics the total noise level would only drop by 0.33 dB. This would be an argument against striving for low-noise amplifiers if it was an expensive pursuit, but it is not. All you need is a cheap opamp and a little ingenuity.

The basic noise situation for a series-feedback RIAA stage using an opamp is shown in Figure 9.23. The cartridge is modelled as a resistance Rgen in series with a significant inductance Lgen and is loaded by the standard 47 kΩ resistor Rin; this innocent-looking component causes more mischief than you might think. The amplifier A1 is treated as noiseless, its voltage noise being represented by the voltage generator Vnoise, and the current noise of each input being represented by the current generators Inoise+ and Inoise−, which are uncorrelated.

The contributions to the noise at the input of A1 are

1) The Johnson noise of the cartridge resistance Rgen. This sets the ultimate limit to the signal/ noise ratio. The proportion of noise from Rgen that reaches the amplifier input falls with frequency as the impedance of Lgen increases. Here the fraction reaching the amplifier falls from 0.99 at 36 Hz to 0.48 at 17.4 kHz.

2) The Johnson noise of the 47 kΩ input load Rin. Some of the Johnson noise generated by Rin is shunted away from the amplifier input by the cartridge, the amount decreasing with frequency due to the inductance Lgen. Here the fraction reaching the amplifier rises from 0.013 at 36 Hz to 0.52 at 17.4 kHz.

3) The opamp voltage noise Vnoise. Its contribution is unaffected by other components.

4) The noise voltage generated by Inoise+ flowing through the parallel combination of the cartridge impedance and Rin. This impedance increases with frequency due to Lgen. Here it increases from 619 Ω at 36 Hz to 24.5 kΩ at 17.4 kHz; the increase at the top end is moderated by the shunting effect of Rin. This increase has a major effect on the noise behaviour. For the lowest noise you must design for a higher impedance than you might think, and Gevel [34] quotes 12 kΩ as a suitable value for noise optimisation.

5) The Johnson noise of R0. For the values shown, and with A1 assumed to be 5534A, ignoring the Johnson noise of R0 improves the calculated noise performance by only 0.35 dB. The other resistors in the RIAA feedback network are ignored, as R0 has a much lower value and dominates the impedance seen.

6) The noise voltage generated by Inoise− flowing through R0. For normal values of R0, say up to 1000 Ω, this contribution is negligible, affecting the total noise output by less than 0.01 dB.

Contributions 1, 2, and 4 are significantly affected by the rising impedance of the cartridge inductance Lgen with frequency. On top of this complicated frequency-dependent behaviour is overlaid the effect of the RIAA equalisation. This would reduce the level of white noise by 4.2 dB, but we are not dealing with white noise—the HF part of the spectrum has been accentuated by the effects of Lgen, and with the cartridge parameters given RIAA equalisation actually reduces the noise amplitude by a rather larger 10.4 dB.

The model as shown does not include the input DC blocking capacitor Cin. This needs to be 47 uF, or preferably 100 uF, so that the voltage produced by the transistor noise current flowing through it is negligible.

Clearly this model has some quite complex behaviour. It could be analysed mathematically, using a package such as MathCAD, or it could be simulated by SPICE. The solution I chose is a spreadsheet mathematical model of the cartridge input, which I call MAGNOISE2.

Table 9.7 shows some interesting cases; output noise, EIN, and signal-to-noise ratio for a 5 mVrms input at 1 kHz are calculated for gain of +30.0 dB at 1 kHz. The IEC amendment is included. The cartridge parameters were set to 610 Ω + 470 mH, the measured values for the Shure M75ED 2. Bandwidth is 22 Hz–22 kHz, no A-weighting is used, and 1/f noise is not considered. Be aware that the 5534A is a low-noise version of the 5534, with a typical voltage noise density of 3.5 rather than

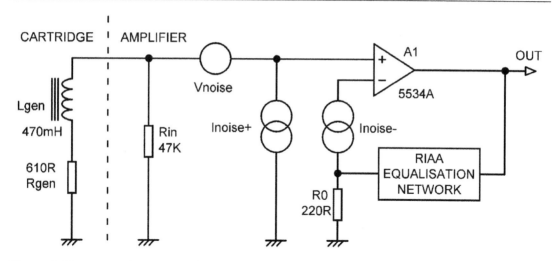

Figure 9.23 A moving-magnet input simplified for noise calculations, with typical cartridge parameter values (Shure ME75-ED2).

4 nV√Hz, and a typical current noise density of 0.4 rather than 0.6 pA/√Hz. The voltage noise and current noise densities used here are the manufacturer's 'typical' figures.

Firstly let us see how quiet the circuit of Figure 9.23 would be if we had miraculously noise-free electronics.

Case 0: We will begin with a completely theoretical situation with no amplifier noise and an MM cartridge with no resistance Rgen. Lgen is 470 mH. Rin is set to 1000 MΩ; the significance of that will be seen shortly. The noise out is a subterranean and completely unrealistic −136.8 dBu, and that is *after* +30 dB of amplification. This noise comes wholly from Rin and can be reduced without limit if Rin is increased without limit. Thus if Rin is set to 1000 GΩ the noise out is −166.8 dBu.

You may ask why the noise is going up as the resistance goes down, whereas it is usually the other way around. This is because of the high cartridge inductance, which means the Johnson noise of Rin acts as a current rather than a voltage, and this goes up as the Rin resistance goes down.

Case 1: We now switch on the Johnson noise from Rgen (610 Ω). We will continue to completely ignore the cartridge loading requirements and leave Rin at 1000 MΩ, at which value it now has no effect on noise. The output noise with these particular cartridge parameters is then −98.8 dBu (Case 1a). This is the quietest possible condition (if you can come up with a noiseless amplifier), but you will note that right from the start the signal/noise ratio of 85 dB compares badly with the 96 dB of a CD, a situation that merits some thought. And there is, of course, no groove noise on CDs. All of this noise comes from Rgen, the resistive component of the cartridge impedance. The only way to improve on this would be to select a cartridge with a lower Rgen but the same sensitivity or start pumping liquid nitrogen down the tone-arm. (As an aside, if you *did* cool your cartridge with liquid nitrogen at −196°C, the Johnson noise from Rgen would only be reduced by 5.8 dB, and if you are using a 5534A in the preamplifier, as in Case 10, the overall improvement would only be 0.75 dB. And, of course, the compliant materials would go solid, and the cartridge wouldn't work at all.)

TABLE 9.7 RIAA noise results from the MAGNOISE2 spreadsheet model under differing conditions, in order of quietness; cases 0 to 3 assume a noiseless amplifier and are purely theoretical; cartridge parameters 610 Ω + 470 mH, amplifier gain +30 dB at 1 kHz, unweighted

Case	Amplifier type	e_n nV/rtHz	i_n pA/rtHz	Rin Ω	R0 Ω	Noise output dBu	S/N ref 5 mV input dB	EIN dBu	NF ref Case 2 dB	Ref Case 10 dB
0	Noiseless amp, no Rgen	0	0	1000M	0	−136.8	−123.1	−166.8	−41.2	−44.3
1a	Noiseless amp	0	0	1000M	0	−99.4	−85.6	−129.4	−3.2	−6.3
1b	Noiseless amp	0	0	10M	0	−99.3	−85.5	−129.3		
1c	Noiseless amp	0	0	1M5	0	−98.9	−85.1	−128.9		
1d	Noiseless amp	0	0	1M	0	−98.7	−84.9	−128.7		
1e	Noiseless amp	0	0	1M5	220	−97.5	−83.7	−127.5		
1f	Noiseless amp	0	0	1M	220	−97.4	−83.6	−127.4		
2	**Noiseless amp**	**0**	**0**	**47 k**	**0**	**−95.6**	**−81.8**	**−125.6**	**0 dB ref**	**−3.1**
3	Noiseless amp	0	0	47 k	220	−94.9	−81.1	−124.9	0.7	−2.4
4a	2SK710 FET, I_d = 2 mA	0.9	0	47 k	220	−94.7	−80.9	−124.7	0.9	−2.2
4b	J310 FET, I_d = 10 mA	2	0	47 k	220	−94.2	−80.4	−124.2	1.4	−1.7
5a	2SB737 BJT, I_c = 70uA	1.75	0.39	47 k	220	−93.6	−79.8	−123.6	2.0	−1.1
5b	2SB737 BJT, I_c = 100uA	1.47	0.46	47 k	220	−93.4	−79.6	−123.4	2.2	−0.9
6	AD8656 *	2.7	0	47 k	220	−93.4	−79.6	−123.4	2.2	−0.9
7	2SB737 BJT, I_c = 200uA	1.04	0.65	47 k	220	−92.7	−78.9	−122.7	2.9	−0.2
8	OPA828 *	4	0	47 k	220	−92.7	−78.9	−122.7	2.9	−0.2
9	OPA2156	4	0.019	47 k	220	−92.7	−78.9	−122.7	2.9	−0.2
10	**5534A BJT**	**3.5**	**0.4**	**47 k**	**220**	**−92.5**	**−78.7**	**−122.5**	**3.1**	**0 dB ref**
10a	5534A BJT	3.5	0.4	47 k	470	−92.1	−78.3	−122.1	3.5	+0.4
11	OPA1642 JFET	5.1	0.0008	47 k	220	−91.8	−78.0	−121.8	3.8	+0.7
12	5534A BJT	3.5	0.4	47 k	1000	−91.4	−77.6	−121.4	4.2	+1.1
13	OPA1622	2.8	0.8	47 k	220	−91.4	−77.6	−121.4	4.2	+1.1
14	5532A BJT	5	0.7	47 k	220	−90.5	−76.5	−120.5	5.1	+2.0
15	OPA2134 JFET	8	0.003	47 k	220	−89.3	−75.5	−119.3	6.3	+3.2
16	LM4562 BJT	2.7	1.6	47 k	220	−87.9	−74.1	−117.9	7.7	+4.6
17	LME49720 BJT	2.7	1.6	47 k	220	−87.9	−74.1	−117.9	7.7	+4.6
18	OPA604 JFET	10	0.004	47 k	220	−87.9	−74.1	−117.9	7.7	+4.6
19	OP275 BJT+JFET	6	1.5	47 k	220	−87.3	−73.5	−117.3	8.3	+5.2
20	AD797 BJT	0.9	2	47 k	220	−86.6	−72.8	−116.6	9.0	+5.9
21	TL072 JFET	18	0.01	47 k	220	−83.4	−69.6	−113.4	12.2	+9.1
22	LM741 BJT	20	0.7 **	47 k	220	−82.4	−68.6	−112.4	13.2	+10.1

* No current-noise spec given by manufacturer's data sheet. Presumed negligible.

** No current-noise spec. Derived from measurements.

With lower, but still high, values of Rin the noise increases; with Rin set to 10 MΩ (Case 1b) the EIN is −128.7 dBu, a bare 0.1 dB worse. With Rin set to 1 MΩ (Case 1c) the EIN is now −128.2 dBu, 0.8 dB worse than the best possible condition (Case 1a). Cases 1e and 1f demonstrate that Ro has little effect even when there is no amplifier noise.

Case 2: It is, however, a fact of life that MM cartridges need to be properly loaded, and when we set Rin to its correct value of 47 kΩ things deteriorate sharply, the EIN rising by 3.2 dB (compared with Case 1a) to −125.6 dBu. That 47 kΩ resistor is not innocent at all. This case still assumes a noiseless amplifier and appears to be the appropriate noise reference for design, so the noise figure is taken as 0 dB (however, see the section on load synthesis later in this chapter, which shows how the effects of noise from Rin can be reduced by some non-obvious methods). Cases 1a, b, c therefore have negative noise figures but this has little meaning.

Case 3: We leave the amplifier noise switched off but add in the Johnson noise from R0 and the effect of Inoise− to see if the value of 220 Ω is appropriate. The noise only worsens by 0.7 dB, so it looks like R0 is not the first thing to worry about. Its contribution is included in all the cases that follow. The noise figure is now 0.7 dB.

We will now take a deep breath and switch on the amplifier noise.

Case 4: Here we use a single JFET. A 2SK710 with I_d = 2mA gives a noise figure of only 0.9 dB. If we use the J310, a device often recommended for this application [34] and set the drain current I_d to 10 mA, the voltage noise is about 2 nV√Hz. With JFETs the current noise is negligible, so the J310 is overall slightly quieter than the 2SB737 despite having slightly more voltage noise. The noise figure is 1.4 dB.

Case 5: In these cases a single discrete bipolar transistor is used as an input device, not a differential pair. This can give superior noise results to an opamp. The transistor may be part of a fully discrete RIAA stage or the front end to an opamp. If we turn a blind eye to supply difficulties and use the remarkable 2SB737 transistor (with Rb only 2 Ω typical) then some interesting results are possible. We can decide the collector current of the device, so we can to some extent trade off voltage noise against current noise, as described in Chapter 1. We know that current noise is important with an MM input, and so we will start off with quite a low I_c of 200 uA, which gives Case 7 in Table 9.7. The result is very slightly worse than the 5534A (Case 10). Undiscouraged, we drop I_c to 100 uA (Case 5b), and voltage noise increases but current noise decreases, the net result being that things are now 0.9 dB quieter than the 5534A. If we reduce I_c again to 70 uA (Case 5a), we gain another 0.2 dB, and we have an EIN of −123.6 and a noise figure of only 2.0 dB. Voltage noise is now increasing fast, and there is virtually nothing to be gained by reducing the collector current further. The 2SB737 is now obsolete. For information on replacements see Chapter 10.

We therefore must conclude that even an exceptionally good single discrete BJT with appropriate support circuitry will only gain us a 1.1 dB noise advantage over the 5534A, while the J310 FET gives only a 1.7 dB advantage, and it is questionable if the extra complication is worth it. You are probably wondering why going from a single transistor to an opamp does not introduce a 3 dB noise penalty because the opamp has a differential input with two transistors. The answer is that the second opamp transistor is connected to the NFB network and sees much more favourable noise conditions; a low and resistive source impedance in the shape of R0.

Case 6: The AD8656 is a relatively new opamp (released 2005) and gives the best noise results so far for an IC, due to its low voltage noise of 2.7 nV/√Hz. However it is only 0.9 dB quieter than the venerable (and cheap) 5534A. It makes you think . . .

Case 7: This is the 2SB737 with an I_c of 200 uA; see Case 5.

Case 8: The OPA828 is a new JFET-input opamp (released 2018).

Case 9: The OPA2156 is a new CMOS opamp (released 2018).

Case 10: Here we have a 5534A as the amplifying element, and using the typical 1 kHz specs for the A-suffix part, we get an EIN of −122.5 dBu and an NF of 3.1 dB. R0 is 220 Ω. Using thoroughly standard technology and one of the cheapest opamps about, we are within three decibels of perfection; the only downside is that the opportunities for showing off some virtuoso circuit design appear limited. Case 10 is useful as a standard for comparison with other cases, as in the rightmost column of Table 9.7.

How does the value of R0 affect noise? In Case 10a R0 is increased to 470 Ω, and the noise is only 0.4 dB worse; if you can live with that, the increase in the impedance of the RIAA feedback network allows significant savings in expensive precision capacitors. Reducing R0 from 220 Ω to 100 Ω is doable at some cost in capacitors but only reduces the noise output by 0.2 dBu. The value of R0 can be manipulated to get convenient capacitor values in the RIAA network because it has only a weak effect on the noise performance (see the section on RIAA equalisation).

We have seen that the presence of Lgen has a big effect on the noise contributions. If we reduce Lgen to zero, the noise out drops from −92.5 to −94.7 dBu. Halving it gives −93.8 dBu. Minimum cartridge inductance is good.

What about Rgen? With the original value of Lgen, setting Rgen to zero only reduces the noise from −92.5 to −93.5 dBu; the cartridge inductance has more effect than its resistance.

Case 11: The OPA1642 is a JFET-input opamp with noise densities of 5.1 nV/√Hz for voltage and a startlingly low 0.0008 pA/√Hz for current. This modern JFET technology gives another way to get low MM noise—accept a higher e_n in order to get a very low i_n. The OPA1642 gives an EIN of −121.8 dBu, beating the 5532 but not the 5534A with R0 = 220 Ω. At the time of writing the OPA1642 is something like 20 times more expensive than the 5532.

Case 12: We go back to the 5534A with R0 now raised substantially further to 1000 Ω, and the noise is only 1.1 dB worse than the 5534A 220 Ω case. This shows that the value of R0 is not critical.

Case 13: The OPA1622 is a relatively new (released 2016) BJT-input opamp. Its current-noise is twice that of the 5534A and its place in the table suffers accordingly.

Case 14: It is well-known that the single 5534A has somewhat better noise specs than the dual 5532A, with both e_n and i_n being significantly lower, but does this translate into a significant noise advantage in the RIAA application? Case 14 shows that on plugging in a 5532A the noise output increases by 2.0 dB, the EIN increasing to −120.5 dBu. The NF is now 5.1 dB, which looks a bit less satisfactory. If you want good performance then the inconvenience of a single package and an external compensation capacitor are well worth putting up with.

Case 15: Here we try out the FET-input OPA2134; the e_n is much higher at 8 nV√Hz, but i_n is very low indeed at 3 fA√Hz. The greater voltage noise does more harm than the lower current noise does good, and the EIN goes up to −119.3 dBu. The OPA2134 is therefore 3.2 dB noisier than the 5534A and 2.5 dB noisier than the 5532A, and it is not cheap. The noise figure is now 6.3 dB, which to a practised eye would show that something had gone amiss in the design process.

Case 16: The LM4562 BJT-input opamp gives significant noise improvements over the 5534/5532 when used in low-impedance circuitry because its e_n is lower at 2.7 nV√Hz. However, the impedances we are dealing with here are not low, and the i_n, at 1.6 pA√Hz is four times that of the 5534A, leading us to think it will not do well here. We are sadly correct, with EIN deteriorating to −117.9 dBu and the noise figure an unimpressive 7.7 dB. The LM4562 is almost 5 dB noisier than the 5534A and at the time of writing is a lot more expensive. Measurements confirm a 5 dB disadvantage.

Case 17: The LME49720 is a recent (released 2007) BJT-input opamp with the same voltage and current densities as the LM4562 and so gives the same EIN of −117.9 dBu, 5 dB noisier than the 5534A.

Case 18: The OPA604 is a FET-input opamp that is often recommended for MM applications by those who have not studied the subject very deeply. It has a high voltage-noise density of 10 nV/√Hz for voltage and a low 0.004 pA/√Hz for current-noise. This different balance of voltage and current noise gives the same EIN of 117.9 dBu as Case 17, 5 dB noisier than the 5534A.

Case 19: The OP275 has both BJT and FET input devices. Regrettably this appears to give both high voltage noise *and* high current noise, resulting in a discouraging EIN of −117.3 dBu and a noise figure of 8.2 dB. It is 5.2 dB noisier than a 5534A in the same circuit conditions. Ad material claims "excellent sonic characteristics" perhaps in an attempt to divert attention from the noise. It is expensive.

Case 20: The AD797 has very low voltage noise because of its large BJT input transistors, but current noise is correspondingly high, and it is noisy when used with an MM cartridge. And it is expensive, especially since it is a single opamp with no dual version. Definitely not recommended for MM; it is allegedly useful in submarines (for sonar).

Case 21: The TL072 with its FET input has very high voltage noise at 18 nV√Hz but low current noise. We can expect a poor performance. We duly get it, with EIN rising to −113.4 dBu and a very indifferent noise figure of 12.2 dB. The TL072 is 9.1 dB noisier than a 5534A, and 8.4 dB noisier than a 5532A. The latter figure is confirmed (within experimental error, anyway) by the data listed in the later section on noise measurements. There is no reason to use a TL072 in an MM preamp; it must be one of the worst you could pick.

Case 22: Just for historical interest I tried out the LM741. Voltage noise measures about 20 nV√Hz. I have no figures for the current noise, but I think it's safe to assume it won't be better than a 5532, so I have used 0.7 pA√Hz. Predictably the noise is the highest yet, with an EIN of −112.4 dBu, but it is a matter for some thought that despite using a really ancient part it is only 10 dB worse than the 5534A. The noise figure is 13 dB.

Hybrid MM amplifiers

In Table 9.7 the noise results are shown for single discrete devices as well as opamps. These cannot be used alone in a phono amplifier because the need for both substantial open-loop gain and good load-driving ability. The discrete device can be used as the first stage of a discrete amplifier, as described in Chapter 10, but it is more convenient to combine the discrete device with an opamp, which will give both the open-loop gain and the load-driving ability required at lower cost and using less PCB area. Either a BJT or a JFET may be used as the device, given suitable biasing. The 5532 or 5534 is once again a suitable opamp.

Figure 9.24 shows a basic arrangement. For optimal noise the I_c of Q1 will probably be in the range 50–200 uA, and most of this is supplied through emitter resistor R8. While there is always a DC path through the RIAA network because of the need to define the LF gain, trying to put all of the I_c through it would lead to an excessive voltage drop, which would appear as a big offset at the output. Instead the DC flowing through R1 in the RIAA network is just used for fine-tuning of Q1 operating conditions by negative feedback. This means that if R8 and Vbias are correctly chosen, there might be a few 100 mV of offset either way at the opamp output. This is not large enough to significantly affect the output swing, but it needs blocking; C5 is shown as non-polar to emphasise the point that the offset might go either way.

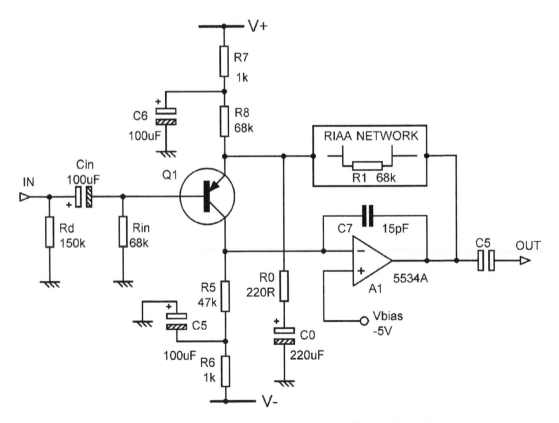

Figure 9.24 Basic arrangement of a hybrid MM phono amplifier with typical values. Note non-polar output blocking cap.

C7 around A1 gives dominant-pole compensation of the loop; the RIAA usually causes the closed-loop gain to fall to unity at high frequencies (but see the section on switched-gain phono amps) and achieving HF stability may require some experimentation with its value. The two supply rails are heavily filtered by R6, C5 and R7, C6 to keep out ripple and noise; no fancy low-noise supply is needed, 78/79 series regulators work just fine.

Balanced MM inputs

So far all the MM amplifiers considered have been of the usual unbalanced input type. There is a reason for this.

There is some enthusiasm out there for balanced MM inputs, on a 'me-too!' basis because balanced inputs are almost universally used in professional audio for excellent reasons. However, an MM cartridge and its short connecting lead (short to control shunt capacitance) are nothing like the average professional connection that links two pieces of powered equipment and so may have nasty currents flowing through its ground wire. The coils of an MM cartridge are floating, or should be; connecting one side to the turntable ground is likely to cause hum. How might common-mode interference, which is what balanced inputs reject, get into the cartridge or lead?

1) Electrical fields into the cartridge. Any sensible cartridge is electrically shielded, so balancing is not required. For electrically unscreened cartridges (there is one brand that is globally famous for humming), the coupling will not be identical for the two ends of the coil so it won't be a true common-mode signal; I dare say you could have a 'balanced' input in which you set the gain of Hot and Cold inputs separately so you could try to null the hum. Good luck getting that to stay nulled as the arm moves across the disc; this is really not an idea to pursue.

2) Magnetic fields into the cartridge. These will cause a differential voltage across the floating cart coil, just as for the signal, and will not be rejected in any way by a balanced input.

3) Electrical or magnetic coupling into the cable. Negligible with usual cable lengths and even half-sensible cable layout; ie keep it away from mains wiring and transformers. A balanced input is therefore not required.

These points were debated at length on DIYaudio and no evidence was offered that they were wrong. For this reason balanced MM inputs receive only limited attention here.

Noise in balanced MM inputs

When dealing with line inputs, a balanced input is much noisier than an unbalanced input (see Chapter 18). The conditions for an MM balanced input are quite different, but it still seems highly likely that it will be noisier because two (or more) amplifiers are used rather than one, and we don't want a noise penalty if there are no countervailing benefits. Let's find out . . .

Figure 9.25 depicts a balanced MM input made up of two 5534A stages with their outputs subtracted (or 'phase-summed'). All the noise sources are shown. The equal loading on each cartridge pin makes the coil appear balanced to the amplifiers; the 'ground' at the mid-point of the cartridge is purely notional with no physical connection there.

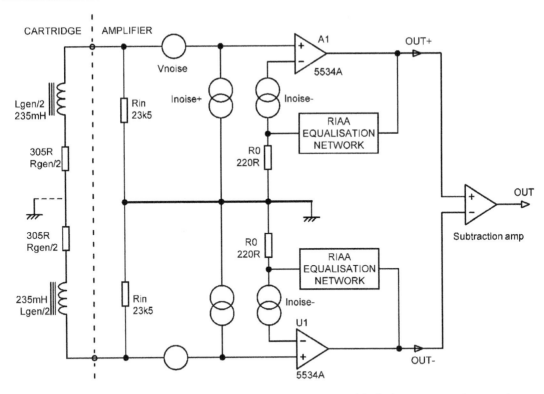

Figure 9.25 A balanced MM input using two 5534A stages with their outputs subtracted.

Therefore the 47 kΩ load is split into two 23.5 kΩ resistances; these give less Johnson noise by a factor of √2, and also the voltage produced by Inoise+ will be halved. The Vnoise is unaffected, and we now have two uncorrelated sources of it.

The unweighted noise output for a standard unbalanced 5534A amplifier in a +30 dB (1 kHz) amplifier is −92.51 dBu, as in Table 9.7. Cartridge parameters are 610 Ω + 470 mH. Reducing Rin to 23.5 kΩ, and changing the cartridge parameters to 305 Ω + 235 mH, as we are only dealing with half of the cartridge, reduces the noise output to −94.36 dBu. We then have to subtract the outputs of the two sides, which is equivalent to summing their noise. Neglecting the noise of the subtracting amplifier, which is quite realistic given the relatively high noise output of the input stages, the result is −91.36 dBu. This is only 1.1 dB noisier than an unbalanced input and would be quite acceptable if a balanced input solved other problems, but as noted earlier I've yet to hear any convincing argument that it does.

The arrangement of Figure 9.25 is an illustration of principle and is not claimed to be optimal. For one thing, there are two RIAA networks, and they are very likely the most expensive part of the circuit. They will have to be accurate for accurate RIAA and that may well be enough to give a good practical CMRR, if you can find a use for it. The arrangement uses two opamps, effectively

putting four input devices in series in the input circuit, though the two on the opamp inverting inputs see benign noise conditions because of the low resistance of R0. This could be addressed by using an instrumentation amplifier IC, but the possible noise advantage is small.

Noise weighting

The frequency response of human hearing is not flat, especially at lower listening levels. Some commentators therefore feel it is appropriate to use psychoacoustic weighting when studying noise levels. This is almost invariably ANSI A-weighting despite the fact that it is generally considered inaccurate, undervaluing low frequencies. ANSI B, C, and D-weightings are not used in audio. The ITU-R ARM 468 weighting (CCIR-468) is a later development and generally considered to be much better but is only rarely used in audio (ARM stands for average-responding meter). I prefer unweighted measurements as you are one step closer to the original data. Full details of both methods, with circuitry to implement them, are given in *Electronics for Vinyl* [1].

Noise measurements

In the past, many people who should have known better have recommended that MM input noise should be measured with a 1 kΩ load, presumably thinking that this emulates the resistance Rgen, which is the only parameter in the cartridge actually generating noise—the inductance is, of course, noiseless. This overlooks the massive effect that the inductance has in making the impedance seen at the preamp input rise with frequency, so that at higher frequencies most of the input noise actually comes from the 47 kΩ loading resistance. I am grateful to Marcel van de Gevel for drawing my attention to some of the deeper implications of this point [34].

The importance of using a real cartridge load is demonstrated in Table 9.8, where the noise performance of a TL072 and a 5532 are compared. The TL072 result is 0.8 dB too low, and 5532 result is 4.9 dB too low—a hefty error. In general results with the 1 kΩ resistor will always be too low by a variable amount. In this case you still get the right overall answer—ie you should use a 5532 for least noise—but the dB difference between the two has been exaggerated by almost a factor of two, by undervaluing the 5532 current noise.

Amplifier gain was +29.55 dB at 1 kHz. Bandwidth was 400–22 kHz to remove hum, RMS sensing, no weighting, cartridge parameters 610 Ω + 470 mH.

TABLE 9.8 Measured noise performance of 5532 and TL072 with two different source impedances

Zsource	TL072	5532	5532 benefit	5532 EIN
1 kΩ resistor	−88.0	−97.2 dBu	+9.8 dB	−126.7 dBu
Shure M75ED 2	−87.2	−92.3 dBu	+5.1 dB	−121.8 dBu

Cartridge load synthesis for lower noise

Going back to Table 9.7, you will recall that when we were examining the situation with the amplifier and feedback network noise switched off, adding in the Johnson noise from the 47 kΩ loading resistor Rin caused the output noise to rise by 3.2 dB. In real conditions with amplifier noise included the effect is obviously less dramatic, but it is still significant. For the 5534A (Case 10) the removal of the noise from Rin (but *not* the loading effect of Rin) reduces the noise output by 1.3 dB. Table 9.9 summarises the results for various amplifier options; the amplifier noise is unaffected, so the noisier the technology used, the less the improvement.

This may appear to be utterly academic because the cartridge must be loaded with 47 kΩ to get the correct response. This is true, *but it does not have to be loaded with a physical 47 kΩ resistor.* An electronic circuit that has the V/I characteristics of a 47 kΩ resistor, but lower noise, will do the job very well. Such a circuit may seem like a tall order—it will, after all, be connected at the very input, where noise is critical, but unusually, the task is not as difficult as it seems.

TABLE 9.9 The noise advantages gained by load synthesis with Rin = 1 MΩ and 1M5; R0 = 220 Ω from MAGNOISE2; NF is ref Case 2 in Table 9.7, with Rin = 1M5 (EIN = −128.9 dBu)

Case	Amplifier type	Rin = 47 kΩ		Rin = 1M		Synth advantage	Rin = 1M5		Synth advantage
		EIN dBu	NF dB	EIN dBu	NF dB	dB	EIN dBu	NF dB	dB
4a	2SK710 FET, I_d = 2 mA	−124.7	3.5	−127.1	1.1	2.9	−127.3	1.3	3.1
4b	J310 FET, I_d = 10 mA	−124.2	4.0	−126.3	1.9	2.5	−126.4	2.0	2.6
5a	2SB737 70uA	−123.6	4.6	−125.3	2.9	1.7	−125.4	3.0	1.8
5b	2SB737 100uA	−123.4	4.8	−125.1	3.1	1.7	−125.2	3.2	1.8
7	2SB737 200uA	−122.7	5.5	−124.1	4.1	1.4	−124.2	1.5	1.5
10	5534A	−122.5	5.7	−123.8	4.4	1.3	−123.9	1.4	1.4
14	5532A	−120.5	7.7	−121.3	6.9	0.8	−121.4	7.0	0.9
15	OPA2134	−119.3	8.9	−119.9	8.3	0.6	−119.9	8.3	0.6
16	LM4562	−117.9	10.3	−118.3	9.9	0.4	−118.4	10.0	0.5
21	TL072	−113.4	14.8	−113.5	14.7	0.1	−113.5	14.7	0.1

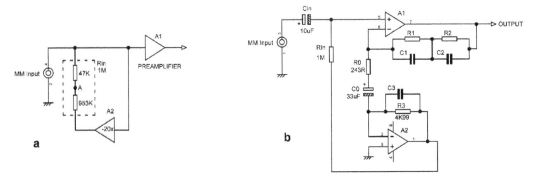

Figure 9.26 Electronic load synthesis: a) the basic principle; b) the Gevel circuit.

Figure 9.26a shows the basic principle. The 47 kΩ Rin is replaced with a 1 MΩ resistor whose bottom end is driven with a voltage that is phase-inverted and 20.27 times that at the top end. If we conceptually split the 1 MΩ resistor into two parts of 47 kΩ and 953 kΩ, a little light mathematics shows that with −20.27 times Vin at the output of A2, the voltage at the 47 kΩ–953 kΩ junction A is zero, and so as far as the cartridge is concerned it is looking at a 47 kΩ resistance to ground. However, the physical component is 1 MΩ, and the Johnson current noise it produces is less than that from a 47 kΩ (Johnson current noise is just the usual Johnson voltage noise applied through the resistance in question). The point here is that the apparent resistor value has increased by 21.27 times, but the Johnson noise has only increased by 4.61 times because of the square root in the Johnson equation; thus the current noise injected by Rin is also reduced by 4.61 times. The noise reduction gained with a 5534A (Case 10) is 1.3 dB, which is very close to the 1.5 dB improvement obtained by switching off the Rin noise completely. If a resistor larger than 1 MΩ is used slightly more noise reduction can be obtained but that would need more gain in A2, and we would soon reach the point where it would clip before A1, restricting headroom. With Rin =1M5, and with a gain of 21 times, we get a very good noise figure of 1.8 dB, though the lowest noise output comes from the 2SB737 at 70 uA.

The implementation made known by Gevel [34] is shown in Figure 9.26b. This ingenious circuit uses the current flowing through the feedback resistor R0 to drive the A2 shunt feedback stage. With suitable scaling of R3 (note that here it has an E96 value) the output voltage of A2 is at the right level and correctly phase-inverted. When I first saw this circuit I had reservations about connecting R0 to a virtual ground rather than a real one, and I thought that extra noise from A2 might find its way back up R0 into the main path. (I hasten to add that these fears may be quite unjustified, and I have not found time so far to put them to a practical test.) The inverting signal given by this circuit is amplified by 20.5 times rather than 20.27, but this has a negligible effect on the amount of noise reduction.

Because of these reservations, I tried out my version of load synthesis as shown in Figure 9.27. This uses the basic circuit of Figure 9.26a; it is important that the inverting stage A3 does not load the input with its 1 kΩ input resistor R4, so a unity-gain buffer A2 is added. The inverting signal is amplified by 20 times, not 20.27, but once again this has negligible effect on the noise reduction.

In practical measurements with a 5534A as amplifier A1, I found that the noise improvement with a real cartridge load (Shure M75ED 2, cartridge parameters 610 Ω + 470 mH) was indeed 1.3 dB, just as predicted, which is as nice a matching of theory and reality as you are likely to encounter in this world. There were no HF stability problems. Whether the 1.3 dB is worth the extra electronics is a good question; I say it's worth having.

When measuring the effect of load synthesis, it is highly convenient to be able to switch immediately between normal and synthesised modes. This can be done with one link, as in Figure 9.27. Adding link J1 loads the input with the physical 47 kΩ resistor Rin1 and at the same time short-circuits Rin2A and Rin2B to ground. The 953 kΩ resistor Rin2 is made up of two E24 resistors in parallel, giving a combined value only 0.26% below nominal.

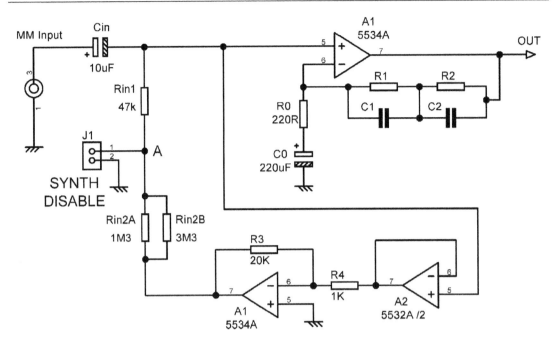

Figure 9.27 Electronic load synthesis: the Self circuit.

Subsonic filters

In the earliest parts of this chapter we have seen that the worst subsonic disturbances occur in the 2–4 Hz region, due to disc warps, and are about 8 dB less at 10 Hz. We have also seen that the IEC amendment gives only 14 dB of attenuation at 4 Hz, and in any case is often omitted by the manufacturer or switched out by the user. It is therefore important to provide authoritative subsonic filtering. We are aiming for frequencies around 10 Hz to be attenuated by at least 40 dB. What needs to be settled is what order and what kind of filter to use because some people at least will be concerned about the audibility of LF phase shifts and how far into the audio band the filter should intrude. There is nothing approaching a consensus on either point, so it can be a wise move to configure the subsonic filter so it can be switched out.

Subsonic filtering: Butterworth filters

Highpass filters used for RIAA subsonic are typically of the second-order or third-order Butterworth (maximally flat) configuration, rolling-off at rates of 12 dB/octave and 18 dB/octave respectively. Fourth-order 24 dB/octave filters are much less common, presumably due to needless worries about the possible audibility of rapid phase changes at the very bottom of the audio spectrum. The response of Butterworth filters from the second to the sixth order are shown in Figure 9.28. They are called all-pole filters, which effectively means the response is monotonic, always going downward once it has started to do so.

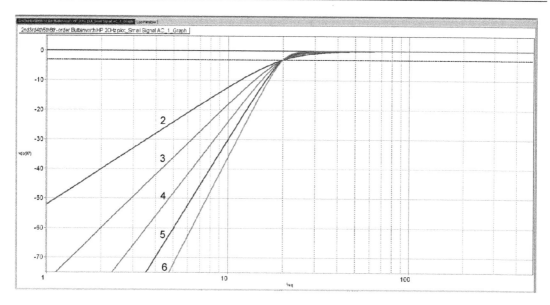

Figure 9.28 Frequency response of second to sixth-order Butterworth subsonic filters, all 3 dB down at 20 Hz.

The well-known Sallen & Key configuration is very handy for this sort of filter. A second-order Sallen & Key is simple to design; the two series capacitors C1 and C2 are made equal, and R2 is made twice the value of R1. Such a filter with a −3 dB point at 20 Hz is shown in Figure 9.29a. Other roll-off frequencies can be obtained simply by scaling the component values while keeping C1 equal to C2 and R2 twice R1. The response is 24.0 dB down at 5 Hz, by which time the 12 dB/octave slope is well-established, and we are well protected against disc warps. It is, however, only 12.3 dB down at 10 Hz, which gives little protection against arm resonance problems. Above the −3 dB roll-off point the response is still −0.78 dB down at 30 Hz, which is intruding a bit into the sort of frequencies we want to keep. We have to conclude that a second-order filter really does not bifurcate the condiment, and the faster roll-off of a third-order filter is preferable.

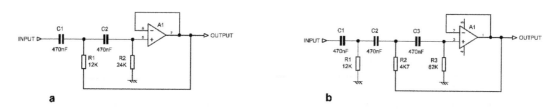

Figure 9.29 Subsonic filters: a) second-order and b) third-order Butterworth highpass filters, both 3 dB down at 20 Hz.

Third-order filters are a little more complex. In general they consist of a second-order filter cascaded with a first-order roll-off, using two opamp sections. It can, however, be done with just one, as in Figure 9.29b, which is a Geffen third-order Butterworth filter also with a −3 dB point at 20 Hz. The resistor value ratios are now a less friendly 2.53:1.00:17.55, and the circuit shown uses the nearest E24 values to this—which by happy chance come out as E12 values. The frequency response is shown in Figure 9.28, where it can be seen to be 18.6 dB down at 10 Hz, which should keep out any arm resonance frequencies. It is 36.0 dB down at 5 Hz so disc warp spurii won't have a chance. The 30 Hz response is now only down by an insignificant −0.37 dB, which demonstrates that how a third-order filter is much better than a second-order filter for this application. As before, other roll-off frequencies can be had by scaling the component values while keeping the resistor ratios the same.

Because of the large capacitances, the noise generated by the resistors in a highpass filter of this sort is usually well below the opamp noise. The capacitances do not, of course, generate any noise themselves. With the values used here, SPICE simulation shows that the resistors produce −125.0 dBu of noise at the output (22 kHz bandwidth, 25°C). The use of the LM4562 will reduce voltage-follower CM distortion compared with the 5534/5532 but may be noisier in some cases due to the higher current noise of the LM4562.

Capacitor distortion in electrolytics is (or should be) by now a well-known phenomenon. It is perhaps less well-known that non-electrolytics can also generate distortion in filters like these. This has nothing to do with Subjectivist musicality but is all too real and measurable. Details of the problem are given in Chapter 2 where it is concluded that only NP0 ceramic, polystyrene, and polypropylene capacitors can be regarded as free of this effect. The capacitor sizes needed for subsonic filters are large, if impedances and hence noise are to be kept low, which means it has to be polypropylene. As a result anything larger than 470 nF gets to be big and expensive, so that is the value used here. 220 nF polypropylene is substantially smaller and about half the price; use it if you can. There is more information on this and on highpass filters in general, in Chapter 6 on filters.

At the start of this section we decided that a really good subsonic filter should be down −40 dB around 10 Hz, but we're clearly not going to get it with either of the two all-pole filters examined so far. They are useful filters and very much better than nothing but do not meet this rather severe criterion. A seventh-order Butterworth should do it, with a small safety margin of 2 dB, but that means a four-stage filter which is a relatively complex design and may have problems with component sensitivities. Increasing the safety margin beyond 2 dB means an eighth-order Butterworth and that is getting into difficult territory.

Subsonic filtering: elliptical filters

As we've seen earlier in this chapter, ideally we would like the cart/arm resonance frequencies in the band 8–12 Hz to be attenuated by −40 dB, with 2–4 Hz also getting good suppression. All-pole filters can't do that without unduly encroaching on the passband and/or being unduly complex. An alternative approach is to use a notch filter that, in theory at least, gives infinite attenuation in the centre of the notch. To make a notch filter zeros are added to the filter poles; there isn't space to explain that further, but see any filter textbook.

Chebyshev filters have faster roll-off than Butterworth but introduce ripples into the passband response which are really unhelpful if you are looking for accurate RIAA equalisation. More useful is the Inverse Chebyshev, which also has a faster roll-off than Butterworth but still has a maximally flat passband with no ripples. There are one or more notches in the stopband, and one of them can be plonked exactly on 10 Hz. The price of this useful behaviour is that the stopband gain keeps bouncing back up again between the notches, but it will not exceed a level A0 chosen at the design stage; here it is −35 dB. However, when it comes to design information the Inverse Chebyshev highpass is the red-headed stepchild of filters, and so I had to design it as a more general elliptical filter with passband ripple set to zero, and this is (I think) exactly the same as an Inverse Chebyshev. The word 'elliptical' comes from the underlying mathematics, which is fearsome and has only the remotest connection with geometrical ellipses. Elliptical-shaped PCBs are not required.

There is little point in trying to guess exactly which cart/arm combination on the market gives the worst subsonics, so I put the notch at 10 Hz, with due attention paid to how much it attenuates from 8–12 Hz. A very narrow notch would not be useful as it cannot deal with cart/arm variations. You can always make a notch rumble filter by taking a third-order Butterworth and cascading it with a standard symmetrical 10 Hz notch filter, but it is not efficient and no way to design filters. A true filter cunningly fits together the various peakings and roll-offs of its cascaded stages to make the overall turnover and roll-off as clean and steep as possible.

EFV [1] contains much more explanation and detail; suffice it to say that after a lot of study I decided that a fourth-order classical (non-MCP) filter was a good compromise between parts cost and effectiveness. Even-order filters of this type are better because they have an ultimate roll-off of 12 dB/octave, giving better suppression of very low frequencies around 2–4 Hz, while odd-order filters only give an ultimate roll-off of 6 dB/octave.

Figure 9.30 shows the response of the fourth-order classical highpass elliptical filter with $A_0 =$ −35 dB. The −3 dB frequency is 21.0 Hz, very close to that of the third-order Butterworth. The −0.1 dB frequency is 30.5 Hz so there is minimum intrusion into the passband. The notch bandwidth at −35 dB is 8.5–10.9 Hz. The attenuations at some important frequencies are given in Table 9.10.

The response around 8–12 Hz is far superior for the elliptical filter, though its attenuation in the 2–4 Hz region is between 3 and 10 dB worse. If −50 dB at 2 Hz is not enough, an extra second-order highpass filter with a cutoff around 4 Hz would make the elliptical filter as good as the third-order Butterworth in the 1–4 Hz region. Alternatively, you could do something about that record deck.

The fourth-order elliptical filter consists of a second-order highpass filter A4 followed by a Bainter highpass-notch filter A1–A3. Putting the highpass stage first makes internal clipping in the Bainter filter less likely. Figure 9.31 uses 2xE24 resistor combinations and 220 nF capacitors. Polypropylene capacitors must be used to get the lowest distortion.

EFV contains a long chapter on subsonic filtering, including many kinds of Butterworth and elliptical filters up to sixth order. I think I can say without fear of successful contradiction that it is the most comprehensive treatment of subsonic filters ever published.

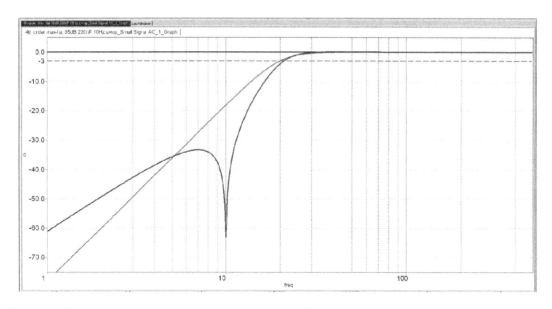

Figure 9.30 Frequency response of fourth-order elliptical subsonic filter with A0 = −35 dB, compared with a third-order Butterworth that is −3 dB at 20 Hz.

TABLE 9.10 Fourth-order elliptical filter attenuation compared with third and fourth-order 20 Hz Butterworths; the −70 dB entry for 10 Hz is the nominal notch depth

Freq	1 Hz	5 Hz	10 Hz	20 Hz	30 Hz	−3 dB freq	−0.1 dB freq
Elliptical fourth-order classic	−61 dB	−35.7 dB	−70 dB	−4.0 dB	−0.14 dB	21.0 Hz	30.5 Hz
third-order Butterworth	−78 dB	−36 dB	−18 dB	−3.0 dB	−0.37 dB	20 Hz	37 Hz
fourth-order Butterworth	−104 dB	−48 dB	−24 dB	−3.0 dB	−0.16 dB	20 Hz	32 Hz

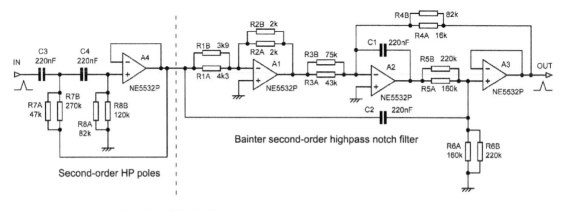

Figure 9.31 Fourth-order elliptical subsonic filter.

Subsonic filtering by cancellation: the Devinyliser

Since most of the low-frequency disturbances from a disc are due to up-and-down motion, they are reproduced as two out-of-phase signals by a stereo pickup cartridge. It has often been suggested that severe rumble overlapping the audio band can be best dealt with by reducing the stereo signal to mono at low frequencies, cancelling the disturbances but leaving the bass, which is usually panned towards the middle, relatively unaffected. This is usually done by cross-feeding the outputs of two lowpass filters between the channels. Several circuits have been published to perform this; one example is [35], but they have serious drawbacks. I showed that to do it properly requires compensating for phase shifts with all-pass filters to get good crossfeed filter slopes, and the highly successful result I call the Devinyliser, published in *Linear Audio* [36]. I gave a paper on it at the AES convention in Paris 2016; you can download the Powerpoint deck at [37]. You can buy a Devinyliser from the Signal Transfer Company [38]. The Devinyliser is fully explained in *EFV*.

Ultrasonic filters

Scratches and groove debris create clicks that have a large high-frequency content, some of it ultrasonic and liable to cause slew rate and intermodulation problems further down the audio chain. The transients from scratches can easily exceed the normal signal level. It is often considered desirable to filter this out as soon as possible (though, of course, some people are only satisfied with radio-transmitter frequency responses).

If an MM input stage is provided with an HF correction pole, in the form of an RC first-order roll-off after the opamp, this in itself provides some protection against ultrasonics as its attenuation continues to increase with frequency and it is inherently linear. The opamp ahead of it naturally does not benefit from this; while it might be desirable to put some ultrasonic filtering in front of the first active stage, it is going to be very hard to do this without degrading the noise performance. A passive LC filter might be a viable approach, but I am not aware that anyone has tried it.

If you want more ultrasonic filtering than that, likely choices are a second or third-order lowpass active filter, probably opamp-based, but if Sallen & Key filters are used then a discrete emitter-follower is an option, and this should be free from the bandwidth and slew rate limitations of opamps. If an ultrasonic filter is incorporated it is usually second-order, very likely due to misplaced fears of perceptible phase effects at the top of the audio band. If a Sallen & Key filter with an unsuitable opamp is used (such as the TL072), be aware that the response does not keeping going down forever but comes back up due to the non-zero output impedance of the opamp at high frequencies; the 5534/5532 has a lower output impedance and does not show this behaviour. The multiple-feedback (MFB) filter configuration is also free from this problem. The design of suitable lowpass filters to remove ultrasonics is fully explained in Chapter 6 on filters.

The combination of a subsonic filter and an ultrasonic filter is often called a bandwidth definition filter; and the two can be combined so that only one opamp is required; see *EFV* [1].

A practical MM amplifier #3

This is Number 3 of the five RIAA amplifier designs given in *EFV*, which range from basic to highly sophisticated.

The closely observed design given here is intended to demonstrate the various techniques discussed in this chapter and in Chapter 11 on MM amplifier noise and distortion in *Electronics for Vinyl* [1]. The MM amplifier shown in Figure 9.32 is based on the MM section of the Signal Transfer Company's MM/MC phono amplifier [39]. This practical design includes cartridge loading capacitor C1, input DC-blocking capacitor C2, and DC drain R1 which stops mighty thumps being caused by charge left on C2 if the input is unplugged. R1 in parallel with R2 makes up the 47 kΩ resistive input load. I have used this circuit for many years, and it has given complete satisfaction to many customers, though in the light of the latest knowledge it could be further optimised to economise on precision capacitors. It includes a typical subsonic filter which is designed with a slow initial roll-off that implements the IEC amendment, so a separate network is not required. A 5534A is used at the input stage to get the best possible noise performance. A 5534A without external compensation has a minimum stable closed-loop gain of about three times; that is close to the gain at 20 kHz here, so a touch of extra compensation is required for stability. The capacitor used here is 4.7 pF, which experience shows is both definitely required and also gives completely reliable stability. This is tested by sweeping a large signal from 20 kHz downwards; single-frequency testing can miss this sort of problem.

The resistors have been made more accurate by combining two E24 values. In this case they are used in series and no attempt was made to try and get the values equal for the maximum reduction of tolerance errors. That statistical work was done at a later date. The configuration-A RIAA network capacitances are made up of multiple 1% polystyrene capacitors for improved accuracy. Thus for the five 10 nF capacitors that make up C1, the standard deviation (square root of variance) increases by the square root of five, while total capacitance has increased five times, and we have inexpensively built an otherwise costly 0.44% close-tolerance 50 nF capacitor. You will note that 5x10 nF capacitors are required, whereas a configuration-C RIAA network can do the same job with 4x10 nF.

C2 is essentially composed of three 4n7 components and its tolerance is improved by √3, to 0.58%. Its final value is tweaked by the addition of C2D. An HF correction pole R3, C3 is fitted; here the resultant loss of HF headroom is only 0.5 dB at 20 kHz, which I think I can live with.

Immediately after the RIAA stage is the subsonic filter, a third-order Butterworth highpass filter which also implements the IEC amendment by using a value for R5 + R6, which is lower than that for maximal Butterworth flatness. The stage also buffers the HF correction pole R3, C3 from later circuitry and gives the capability to drive a 600 Ω load, if you can find one. A PCB for this design is available from the Signal Transfer Company [39].

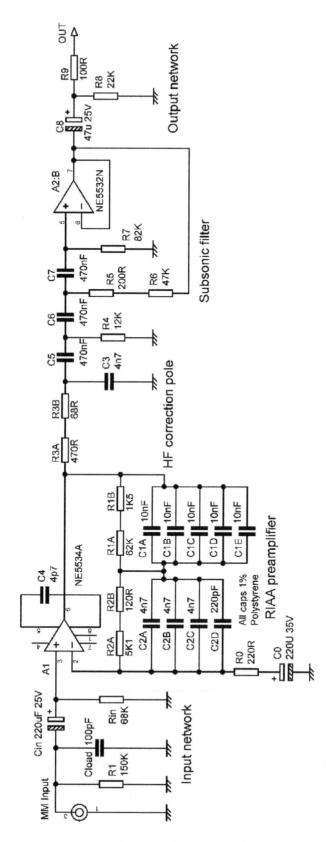

Figure 9.32 MM input with HF correction pole, and IEC amendment implemented by third-order subsonic filter. Based on Signal Transfer design. Gain +30 dB at 1 kHz

References

[1] Self, D. *Electronics For Vinyl*. Focal Press, 2018. ISBN 978-1-138-70544-9 hbk; ISBN 978-1-138-70554-6 pbk; ISBN 978-1-315-20217-4 ebk

[2] Wikipedia. https://en.wikipedia.org/wiki/The_Men_That_Will_Not_Be_Blamed_for_Nothing Accessed Aug 2019

[3] www.openculture.com/2013/06/beer_bottle_as_edison_cylinder_.html Accessed Aug 2019

[4] www.openculture.com/2012/02/suzanne_vega_the_mother_of_the_mp3_records_toms_diner_with_the_edison_cylinder.html Accessed Aug 2019

[5] Langford-Smith, F. *Radio Designer's Handbook*, 1953, Newnes Reprint, 1999, Chapter 17, p. 705. ISBN 0 7506 3635 1

[6] Vogel, B. *The Sound of Silence*, 2nd edition. Springer, 2011, p. 523. ISBN 978-3-642-19773-d

[7] Crossley, D. Personal communication, Nov 2016

[8] Happ, L. & Karlov, F. "Record Warps and System Playback Performance." *Presented at the 46th Convention of the Audio Engineering Society*, New York, 10–13 Sept 1973, Preprint no. 926

[9] Ladegaard, P. *Audible Effects of Mechanical Resonances in Turntables*. Bruel & Kjaer Application Note, 1977

[10] Holman, T. "New Factors in Phonograph Preamplifier Design." *Journal of the Audio Engineering Society*, May 1975, p. 263

[11] Holman, T. "Phonograph Preamplifier Design Criteria: An Update." *Journal of the Audio Engineering Society*, Vol. 28, May 1980, p. 325

[12] Taylor, D. L. "Measurement of Spectral Content of Record Warps." *Journal of the Audio Engineering Society*, Vol. 28, Dec 1980, p. 263

[13] Allmaier, H. "The Ins and Outs of Turntable Dynamics." *Linear Audio*, Vol. 10, Sept 2015, pp. 9–24

[14] Howard, K. www.stereophile.com/reference/arc_angles_optimizing_tonearm_geometry/index.html Accessed Aug 2019

[15] Smith & Miller. "Nakimichi TX-1000 Turntable." *Hi-Fi News*, Aug 2016, pp. 118–123

[16] Lesurf, J. www.audiomisc.co.uk/HFN/LP2/OnTheRecord.html Accessed Aug 2019

[17] Holman, T. "Dynamic Range Requirements of Phonographic Preamplifiers." *Audio*, July 1977, p. 74

[18] Huntley, C. "Preamp Overload." *Audio Scene Canada*, Nov 1975, pp. 54–56

[19] Miller, P. "Review of Canor TP306 VR+ Phono Stage." *Hi-Fi News*, Aug 2013, p. 25

[20] Self, D. "An Advanced Preamplifier Design." *Wireless World*, Nov 1976

[21] Self, D. "High Performance Preamplifier." *Wireless World*, Feb 1979

[22] Self, D. *Self on Audio* (collected articles). Focal Press, 2016. ISBN 978-1-138-85446-8 pbk; ISBN 978-1-138-85445-1 hbk; ISBN 978-1-315-72109-5 ebk

[23] Self, D. "A Precision Preamplifier." *Wireless World*, Oct 1983

[24] Self, D. "Precision Preamplifier 96." *Electronics World*, July/Aug and Sept 1996

[25] Howard, K. "Cut & Thrust: RIAA LP Equalisation." *Stereophile*, Mar 2009. See also www.stereophile.com/content/cut-and-thrust-riaa-lp-equalization-page-2 Accessed Aug 2019

[26] Walker, H. P. "Low-noise Audio Amplifiers." *Electronics World*, May 1972, p. 233

[27] Mohr, D. "Virtual Ground Preamplifier for Magnetic Phono Cartridge." *US Patent No. 4,470,020*, 4 Sept 1984

[28] Lipshitz, S. P. "On RIAA Equalisation Networks." *Journal of the Audio Engineering Society*, June 1979, p. 458

[29] Self, D. "Elektor Preamplifier 2012." *Elektor*, Apr, May, June 2012

[30] Self, D. www.douglas-self.com/ampins/Willmann/Willmann.htm Accessed Aug 2019

[31] Peter Baxandall Letter to Editor. "Comments on 'On RIAA Equalisation Networks'." *JAES*, Vol. 29, 1/2 Jan/Feb 1981, pp. 47–53

[32] Lewis, T. M. A. "Accurate Record Equaliser." *Wireless World*, Mar 1961, p. 121

[33] Kelly, S. "Ortofon S15T Cartridge Review." *Gramophone*, Oct 1966

[34] van de Gevel, M. "Noise and Moving-Magnet Cartridges." *Electronics World*, Oct 2003, p. 38

[35] Lawson, J. "Rumble Filter Preserves Bass." Letter to *Electronics & Wireless World*, Apr 1992, p. 317

[36] Self, D. "The Devinyliser." *Linear Audio*, Vol. 11, Apr 2016, pp. 77–103

[37] Self, D. www.douglas-self.com/ampins/Paris2016devinyliser.ppt Accessed Aug 2019

[38] Signal Transfer Company. www.signaltransfer.freeuk.com/devinyl.htm Accessed Aug 2019

[39] Signal Transfer Company SignalTransfer MM/MC Phono Amplifier. www.signaltransfer.freeuk.com/RIAAbal.htm Accessed Aug 2019

Moving-coil head amplifiers

Moving-coil cartridges are generally accepted to have a better tracking performance than moving-magnet cartridges because the moving element is a set of lightweight coils rather than a magnet which is inevitably made of a relatively dense alloy. Because the coils must be light, they consist of relatively few turns, and the output voltage is very low, typically in the range 100 to 550 uVrms at a velocity of 5 cm/sec, compared with 5 mVrms from the average moving-magnet cartridge. Fortunately this low output comes from a very low impedance, which, by various technical means, allows an acceptable signal-to-noise performance to be obtained.

Moving-coil cartridge characteristics

There is much greater variation in impedance and output across the available range of moving-coil cartridges than for moving-magnet cartridges. The range quoted earlier is already much wider but including the extremes currently on the market (2019) the output range is from 40 to 2500 uV, a remarkably wide span of 62 times or 36 dB. This is illustrated in Figure 10.1, which shows the results of a survey of 85 different MC cartridges (note that the ranges for the columns are wider at the right side of the diagram). When I first became involved in designing MC amplifiers in 1986, I compiled a similar chart [1], and it is interesting to note that the same features occurred—there are two separate clusters around 100–300 uV and 500–700 uV, and the lowest output is still 40 uV from an Audio Note cartridge (the loLtd model). The highest output of 2.5 mV comes from the Benz Micro H2, and this is only 6 dB below an MM cartridge.

Assuming that a conventional MM input stage is being used to raise 5 mV to nominal internal level and perform the RIAA equalisation, the Audio Note cartridge requires a gain of 125 times or +42 dB to reach 5mV. The cartridge cluster around 200 uV output needs 25 times or +28 dB, while the 500 uV cluster requires 10 times or +20 dB. If an amplifier is to cover the whole range of MC cartridges available, some form of gain switching is highly desirable.

Cartridge impedances also vary markedly, over a range from 1 Ω (Audio Note loLtd) to 160 Ω, (Denon DL-110 and DL160) with impedance increasing with output level, as you would expect—there are more turns of wire in the coils. The inductance of MC cartridges is very low, and their source impedance is normally treated as purely resistive. The recommended load impedances are also resistive (unlike the R-C combinations often used with MM cartridges) and are usually quoted as a minimum load resistance. Once more the variation is wide, from 3 Ω (Audio Note loLtd again) to 47 kΩ (Denon DL-110 and DL160 again), but a 100 Ω input load

DOI: 10.4324/9781003332985-10

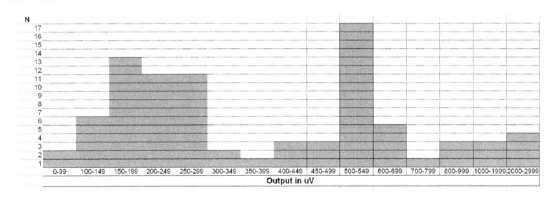

Figure 10.1 **The output levels for 85 moving-coil cartridges at 5 cm/sec (2009).**

TABLE 10.1 MC cartridge manufacturers
whose product data was used to compile
Figure 10.1

Audio Note	Immutable Music
Benz Micro	Koetsu
Cardas	Lyra
Clear Audio	Miyabi
Denon	Ortofon
Dynavector	Shelter
Goldring	Sumiko
Grado	van den Hul

will be high enough for most of the cartridges surveyed, and 500 Ω will work for almost all of them. The Audio Note IoLtd cartridge is unusual in another way—its magnetic field is produced not by permanent magnets but a DC-powered electromagnet, which presumably requires a very pure supply indeed. The manufacturers whose cartridges were included in the survey are listed in Table 10.1.

The limits on MC noise performance

Because MC cartridges can be modelled for noise purposes simply as their coil resistance, it is straightforward to calculate the best signal/noise ratio possible. Even if we assume a noiseless amplifier, the Johnson noise from the coil resistance sets an inescapable limit; comparing this with the cartridge nominal output gives the maximum signal/noise ratio. This was done for all the cartridges used to compile Figure 10.1, using the manufacturer's specs, and the answers varied from 63.9 to 90.8 dB, which is a pretty big spread (this does not include RIAA equalisation).

In practice things will be worse. Even if we carry on assuming a noiseless amplifier, there is resistance in the tone-arm wiring, which has to be very thin for flexibility, and a bit more in the cable connecting turntable to preamp. Calculating the same figures for MM cartridges is a good deal more complicated because of the significant cartridge inductance; see Chapter 9.

Amplification strategies

There are two ways to achieve the high gains required for these low-output cartridges. In the most common method a standard MM input stage, with RIAA equalisation, can be switched to either accept an MC input directly or the output of a specialised MC input stage which gives the extra gain needed; this may be either a step-up transformer or an amplifier configured to give low noise with very low source resistances. The large amount of gain required is split between two stages which makes it easier to achieve. Alternatively, a single stage can be used with switched-gain; but idea has its drawbacks:

1) Switchable gain can make accurate RIAA equalisation harder, but see Chapter 9 for some useful gain-switching options.

2) For good noise performance, a BJT input device operating current needs to be low for MM use (where it sees a high impedance) and high for MC use (where it sees a very low impedance). Making this operating current switchable would be a complicated business; using a JFET instead solves the problem, because it has negligible current noise. See Chapter 9.

3) Achieving the very high gain required for MC operation together with low distortion and adequate bandwidth will be a challenge. It is may not be possible with a single opamp, and so there is little likelihood of any saving on parts.

Moving-coil transformers

If you have a very low output voltage and very low impedance, an obvious way to deal with this is by using a step-up transformer to raise the voltage to the level where it can be appropriately applied to a moving-magnet amplifier stage, such as those discussed in Chapter 9. Such a transformer has most of the usual disadvantages such as frequency response problems and cost, though for hifi the use the size and weight is not a difficulty, and non-linearity should not be an issue because of the very low signal levels.

In this application the cost is increased by the need for very high immunity to hum fields. While it is relatively straightforward to make transformers that have high immunity to external magnetic fields, particularly if they are toroidal in construction, it is not cheap because the mu-metal cans that are required for the sort of immunity necessary are difficult to manufacture. The root of the problem is that the signal being handled is so very small. The transformer is usually working in a modern house which can have surprisingly large hum fields and generally presents a hostile environment for very-low-signal transformers, so very good immunity indeed is required; some manufacturers use two nested screening cans, separately grounded, to achieve this, as shown in Figure 10.2. An inter-winding electrostatic screen is usually fitted. A stereo MC input naturally requires *two* of these costly transformers.

MC transformers are designed with low primary winding resistances, typically 2 or 3 Ω, to minimise the Johnson noise contribution from the transformer. Some transformers have windings made of silver rather than copper wire, but the conductivity of silver is only 5% higher than that of copper, and the increase in cost is startling. At the time of writing one brand of silver-wound transformer costs more than £1200—each, not for a pair.

Because of the great variation in cartridge output levels and impedances some manufacturers (eg Jensen) offer transformers with two or three primary windings, which can be connected in series, parallel, or series-parallel to accommodate a wide variety of cartridges.

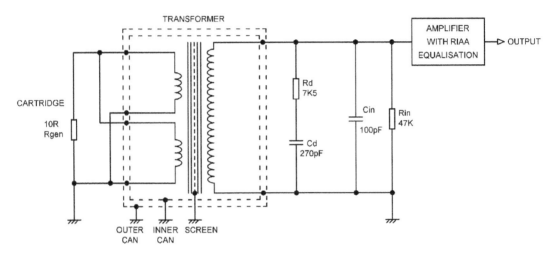

Figure 10.2 A typical MC step-up transformer circuit with twin primaries wired in parallel, dual screening cans, and Zobel network Rd, Cd across the secondary. Rin, Cin are the usual MM input loading components.

A transformer secondary must be correctly loaded to give the flattest possible frequency response, and this usually means that a Zobel R-C network must be connected across it, as explained in Chapter 18 on line inputs. This is Rd and Cd in Figure 10.2, where they have typical values. The values required depend not only on the transformer design but also somewhat on the cartridge impedance, and some manufacturers such as Jensen are praiseworthily thorough in giving secondary loading recommendations for a wide range of cartridge impedances.

The very wide variation in cartridge outputs means that the step-up ratio of the transformer must be matched to the cartridge to get an output around 5 mV that is suitable for an MM input amplifier. For example, Jensen offer basic step-up ratios from 1:8 to 1:37. The maximum ratio is limited not only by transformer design issues but by the fact that the loading on the secondary is, as with all transformers, transferred to the primary divided by the square of the turns ratio. A 1:37 transformer connected to the 47 kΩ input impedance of an MM stage will have an impedance looking into the primary of only 34 Ω; such a transformer would, however, only be used with a very low-impedance low-output cartridge, which should be quite happy with such a loading. It is, of course, possible to arrange the input switching so the 47 kΩ input load is on the MM socket side of the MC/MM switch; the MM amplifier can then have a substantially higher input impedance.

Moving-coil input amplifiers

The high cost of transformers means that there is a strong incentive to come up with an electronic solution to the amplification problem. The only thing that makes it possible to achieve a reasonable signal-to-noise ratio is that the very small signal comes from a very low source impedance.

MC head amplifiers come in many forms but almost all in use today can be classified into one of the topologies shown in Figure 10.3, all of which use series feedback. The configuration in Figure 10.3a is a complementary-feedback pair using a single input transistor chosen to have a low base series resistance R_b. The feedback network must also have a low impedance to prevent its Johnson noise from dominating the overall noise output, and this puts a heavy load on the second transistor. Typically a gain of 47 times will be implemented with an upper feedback resistor of 100 Ω and a lower resistor of 2 Ω, a total load on the amplifier output of 102 Ω. The combination of limited open-loop gain and the heavy load of the feedback network means that both linearity and maximum output level tend to be uninspiring, and the distortion performance is only acceptable because the signals are so small. An amplifier of this type is analysed in [2].

Figure 10.3b shows a classic configuration where multiple transistors are operated in parallel so that their gains add but their uncorrelated noise partly cancels. Two transistors gives a 3 dB improvement, 4 transistors 6 dB, and so on. The gain block A is traditionally one or two discrete devices that again have difficulty in driving the low-impedance feedback network. Attention is usually paid to ensuring proper current-sharing between the input devices. This can be done by adding low-value emitter resistors to swamp V_{be} variations; they are effectively in series with the input path and therefore degrade the noise performance unless each resistor is individually decoupled with a large electrolytic. Alternatively, each transistor can be given its own DC feedback loop to set up its collector current. For examples of this kind of circuitry see [3].

Figure 10.3c shows the series-pair configuration. This simple arrangement uses two complementary input transistors to achieve a 3 dB noise improvement without current-sharing problems as essentially the same collector current goes through each device. The collector signal currents are summed in R_c, which must be reasonably low in value to absorb collector current imbalances. There is no feedback so linearity is poor. The biasing arrangements are not shown.

Figure 10.3d is an enhancement of Figure 10.3a, with the input transistor inverted in polarity and the spadework of providing open-loop gain and output drive capability entrusted to an opamp. The much increased feedback gives excellent linearity, and less than 0.002% THD at full output may be confidently expected. However, problems remain. Rf_2 must be very low in value, as it is effectively in series with the input and will degrade the noise performance accordingly. If Rf_2 is 10 Ω (which is on the high side), C_f must be very large, for example 1000 uF to limit the LF roll-off to −1 dB at 30 Hz. Adopting a quieter 3.3 Ω for the Rf_2 position gives significantly lower noise but demands 4700 uF to give −3 dB at 10 Hz; this is not elegant and leads to doubts as to whether the ESR of the capacitor will cause trouble. C_f is essential to reduce the gain to unity at DC because there is +0.6 V on the input device emitter, and we don't want to amplify that by 50 times.

The +0.6 V offset can be eliminated by the use of a differential pair, as in Figure 10.3e. This cancels out the V_{be} of the input transistor TR_1 at the cost of some degradation in noise

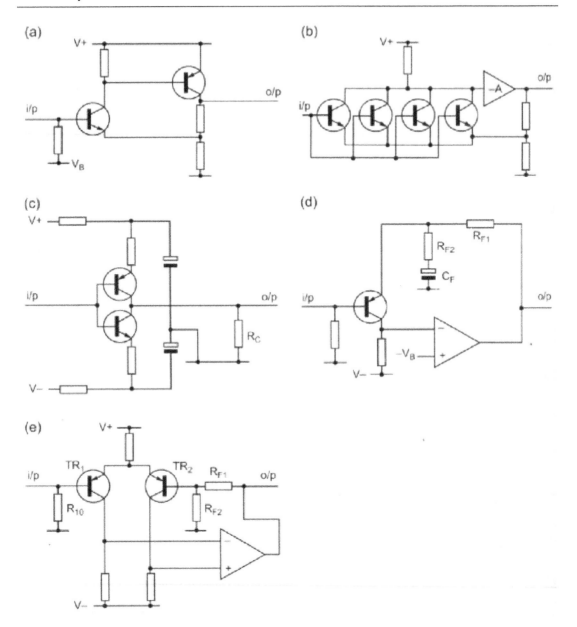

Figure 10.3 **The popular MC amplifier configurations.**

performance. The pious hope is that the DC offset is so much smaller that if C_f is omitted and the offset is amplified by the full AC gain, the output voltage swing will not be seriously reduced. The noise degradation incurred by using a differential pair was measured at about 2.8 dB; theory says 3.0 dB. Another objection to this circuit is that the offset at the output is still non-negligible, about 1 V, mostly due to the base bias current flowing through R10. A DC-blocking capacitor on the output is essential.

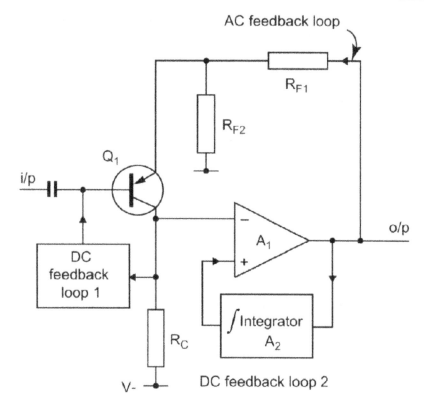

Figure 10.4 **Block diagram of the MC preamplifier, showing the two DC feedback loops.**

An effective MC amplifier configuration

Finding none of these configurations satisfactory, I evolved the configuration shown as a block diagram in Figure 10.4. There is no C_f in the feedback loop and indeed no very little overall DC feedback at all. The input transistor and the opamp each have their own DC feedback systems. The transistor relies on simple shunt negative feedback via DC loop 1; the opamp has its output held precisely to a DC level of 0V by the servo integrator A2 which acts as DC loop 2. This senses the mean output level and sets up a voltage on the non-inverting input of A1 that is very close to that at Q_1 collector, such that the output stays firmly at zero. The time-constant is made large enough to ensure that an ample amount of open-loop gain exists at the lowest audio frequencies. Too short a time-constant will give a rapid rise in distortion as frequency falls. Any changes in the direct voltage on Q1 collector are completely uncoupled from the output, but AC feedback passes through Rf_1 as usual and ensures that the overall linearity is near-perfect, as is often the case with transistor opamp hybrid circuits. Due to the high open-loop gain of A, the AC signal on Q1 collector is very small and so shunting AC feedback through DC loop 1 does not significantly reduce the input impedance of the overall amplifier, which is about 8 kΩ.

As we have seen, MC cartridges vary greatly in their output, and different amplifier gain settings are highly desirable. Usually it would be simple enough to alter Rf_1 or Rf_2, but here it is not quite

so simple. The resistance Rf$_2$ is not amenable to alteration, as it is kept to the low value of 3.3 Ω by noise considerations, while Rf$_1$ must be kept up to a reasonable value so that it can be driven to a full voltage swing by an opamp output. This means a minimum of 500 Ω for the 5534/2. It is intriguing that amplifiers whose output is measured in milliVolts are required to handle so much current.

These two values fix a minimum closed-loop gain of about 44 dB, which is much too high for all but the most insensitive cartridges. My solution was to use a ladder output attenuator to reduce the overall gain; this would be anathema in a conventional signal path because of the loss of headroom involved, but since even an output of 300 mVrms would be enough to overload virtually all MM amplifiers, we can afford to be prodigal with it. If the gain of the head amplifier

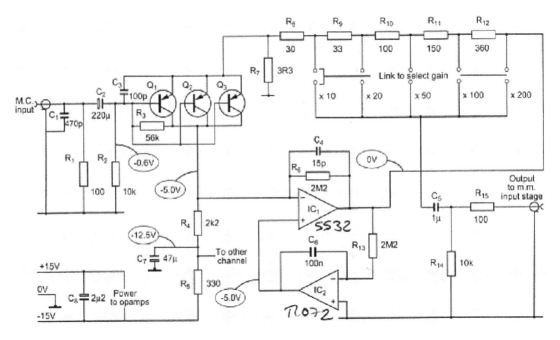

Figure 10.5 Circuit diagram of the MC preamplifier.

TABLE 10.2 Gain options and maximum outputs

Gain	Gain (dB)	Max output (RMS)
10 x	+20 dB	480 mV
20 x	+26 dB	960 mV
50 x	+34 dB	2.4 V
100 x	+40 dB	4.6 V
200 x	+46 dB	10 V

is set to be a convenient 200 times (+46 dB) then adding output attenuation to reduce the overall gain to a more useful +20 dB still allows a maximum output of 480 mVrms. Lesser degrees of attenuation to give intermediate gains allow greater outputs, and these are summarised in Table 10.2. For testing an Ortofon MC10 was used with +26 dB of gain, giving similar output levels to MM cartridges. This highly successful cartridge was in production for 30 years and has only recently been superseded; its impedance is 3.3 Ω.

A final constraint on the attenuator is the need for low output impedances so the succeeding MM input stage can give a good noise performance. The MM input should have been optimised to give its best noise figure with relatively high source impedances, but a low source impedance will still reduce its actual noise output. This means that an output attenuator will need low resistor values, imposing yet more loading on the unfortunate opamp. This problem was solved by making the attenuator ladder an integral part of the AC feedback loop, as shown in Figure 10.5. This is practicable because it is known that the input impedance of the following MM stage will be too high at 47 kΩ to cause significant gain variations.

The complete circuit

The complete circuit is shown in Figure 10.5 and closely follows Figure 10.4, though you will note that the input devices have suddenly multiplied themselves by three. Capacitor C1 is soldered on the back of the MC input phono sockets and is intended for EMC immunity rather than cartridge response modification. If the need for more capacitive or resistive loading is felt, then extra components may be freely connected in parallel with R1. If R1 is raised in value, then load resistances of 5 kΩ or more are possible, as the impedance looking into C_2 is about 8 kΩ. Capacitor C2 is large to give the input devices the full benefit of the low source impedance, and its value should not be altered. Resistors R2, R3 make up DC loop 1, setting the operating conditions of Q1, Q2, Q3 while R4 is the collector load, decoupled from the supply rail by C7 and R5, which are shared between two stereo channels.

Opamp IC1 is a half of a 5532, providing most of the AC open-loop gain, and is stabilised at HF by C4. R6 has no real effect on normal operation but is included to give IC1 a modicum of DC negative feedback and hence tidy behaviour at power-up, which would otherwise be slow due to the charging time of C2. IC2, half of a TL072, is the integrator that forms DC loop 2, its time-constant carefully chosen to give ample open-loop gain from IC1 at low frequencies, while avoiding peaking in the LF response that could occur due to the second time-constant of C2.

The ladder resistors R8–R12 make up the combined feedback network and output attenuator, the gain being selected by a push-on link in the prototype. A rotary switch could be used instead, but this should *not* be operated with the system volume up as this will cause loud clicks due to the emitter current (about 4 mA) of Q1–Q3 flowing through R7, which causes voltage drops down the divider chain. Note that the current through R7 flows down the ground connection back to the PSU. Output resistor R15 ensures stability when driving screened cables, and C5 is included to eliminate any trace of DC offset from the output.

The power supply rails do not need to be specially quiet, and a normal opamp supply is quite adequate.

Performance

The input transistor originally chosen was the 2N4403, a type that was acknowledged as superior for this kind of application for some years, due to its low R_b of about 40 Ω. A single device used in the circuit of Figure 10.5 gives an EIN of –138 dB with a 4 mA collector current and a 3.3 Ω source resistance. The Johnson noise from 3.3 Ω is –147.4 dBu, so we have a noise figure of 9.4 dB. It was then consistently found that putting devices in parallel without any current-sharing precautions whatsoever always resulted in a significant improvement in noise performance. On average, adding a second transistor reduced noise by 1.2 dB, and adding a third reduced it by another 0.5 dB, giving an EIN of –139.7 dBu and an NF of 7.7 dB. Beyond this further multiplication was judged unprofitable, so a triple-device input was settled on. The current-sharing under these conditions was checked by measuring the voltage across 100 Ω resistors temporarily inserted in the collector paths. With 3.4 mA as the total current for the array, it was found after much device-swapping that the worst case of imbalance was 0.97 mA in one transistor and 1.26 mA in another. The transistors were not all from the same batch. It appears that, for this device at least, matching is good enough to make simple paralleling practical.

A superior device for low source impedances was the purpose-designed 2SB737, with a stunningly low R_b of 2 Ω. Three of them improved the EIN to –141.0 dBu and the NF to 6.4 dB, albeit at significant cost. Sadly it is now obsolete (why, for heaven's sake?) but can still be obtained from specialised suppliers such as the Signal Transfer Company [4]. It is generally agreed that the best replacement for the 2SB737 is the Zetex ZTX951. Although its voltage noise performance is not specified, *The Art of Electronics (Third Edition)* gives the measured R_b of the ZTX951 as approximately 1.2 Ω, which is better than the 2SB737, though performance may not be so consistent. The ZTX851 is the NPN complement, with a measured R_b of approximately 1.4 Ω.

You will have spotted that R7, at 3.3 Ω, generates as much noise as the source impedance; this only degrades the noise figure by 1.4 dB, rather than 3 dB, as most of the noise comes from the transistors.

It would be instructive to compare this design with other MC preamplifiers, but it is not at all easy as their noise performance is specified in so many different ways that it is virtually impossible to reduce them all to a similar form, particularly without knowing the spectral distribution of the noise (this chapter uses unweighted noise referred to the input, over a 400 Hz–20 kHz bandwidth and with RIAA equalisation *not* taken into account). Nonetheless, I suggest that this design is

TABLE 10.3 MC head amp performance figures

Input overload level.	48 mVrms
Equivalent input noise.	–141.0 dBu, unweighted, without RIAA equalisation. (3.3 Ω source res)
Noise figure.	6.4 dB (3.3 Ω source res)
THD.	Less than 0.002% at 7 Vrms out (maximum gain) at 1 kHz Less than 0.004% 40 Hz–20 kHz
Frequency response.	+0, –2 dB, 20 Hz–20 kHz
Crosstalk.	Less than –90 dB, 1 kHz–20 kHz (layout dependent)
Power consumption.	20 mA at ±15 V, for two channels

quieter than most, being within almost 6 dB of the theoretical minimum and so with limited scope for further improvement. Burkhard Vogel has wrote an excellent article on the calculation and comparison of MC signal-to-noise ratios [5], and this has been much expanded and incorporated in his remarkable book *The Sound of Silence* and goes into more detail than there is space for here [6]. It is highly recommended.

The performance is summarised in Table 10.3. Careful grounding is needed if the noise and crosstalk performance quoted is to be obtained.

When connected to a RIAA-equalised MM stage as described in Chapter 9, the noise output from the MM stage is −93.9 dBu at 10 times MC gain and −85.8 dBu at 50 times. In the ten times case, the MC noise is actually 1.7 dB lower than for MM mode.

Note the noise figure is 6.4 dBu; there is definitely room for improvement.

Opamp arrays for MC preamps

Now and again I have pondered the possibility of making a rough-and-ready MC preamp by paralleling 5532 opamps; a technique that appears in many places in this book, especially Chapter 1. The 5532 is pretty much the only opamp that is cheap enough and quiet enough to make this practical. If we take a single 5532 section (half a package) and completely ignore the effects of current noise and Johnson noise in the multiple—feedback networks, the EIN is calculated as −120.4 dBu (22–22 kHz, RMS), which is a hefty 21 dB noisier than my aforementioned design. Four opamp sections (two packages), theoretically at least, reduces the EIN by 6 dB to −126.4 dBu, and 16 sections (eight packages) gets the EIN to −132.4 dBu, which is sort of a practical option and is starting to get in sight of our goal of −141 dBu (see Table 1.14 in Chapter 1). But to actually reach it we need 128 sections (64 packages), which is neither practical nor economic— don't forget that's just one channel, so stereo is 128 packages and really not on. And don't forget we have ignored current noise and Johnson noise. This is not a good route unless a mediocre noise performance is acceptable.

References

[1] Self, D. "Design of Moving-Coil Head Amplifiers." *Electronics & Wireless World*, Dec 1987, p. 1206

[2] Nordholt, E. H. and Van Vierzen, R. M. "Ultra Low Noise Preamp for Moving-Coil Phono Cartridges." *JAES*, Apr 1980, pp. 219–223

[3] Barleycorn, J. (a.k.a. S. Curtis). *HiFi for Pleasure*, Aug 1978, pp. 105–106

[4] Signal Transfer Company. www.signaltransfer.freeuk.com/

[5] Vogel, B. "The Sound of Silence." (Calculating MC preamp noise) Article in *Electronics World*, Oct 2006, p. 28

[6] Vogel, B. *The Sound of Silence*, 2nd edition. Springer-Verlag, 2011, Chapters 15, 16. ISBN 978-3-642-19774-1 hbk & ebk

Tape replay

The return of tape

When I was writing the first edition of *Small Signal Audio Design* in 2009, and indeed the second edition in 2015, it never occurred to me to include the technology of magnetic tape. It was gone and showed no signs of coming back. However, there were several vintage multitrack tape recorders displayed at the Paris AES Convention in June 2016, and reel-to-reel tape machines are now (2019, 2023) enjoying a revival. Perhaps that was inevitable after the vinyl revival, but few people predicted that cassette tapes would also come back to haunt us, and now they have [1]. Quite suddenly there is a need for new tape machines to play back old formats. I would have bet a lot of money that the one format which would never come back would be the dreadful eight-track cartridge. I would have lost that money because it happened in 2019, see [2]. Wax cylinders have already been revived once, by The Men Who Will Not Be Blamed For Nothing, though they might well be Blamed For That [3]. It seemed unlikely the experiment would be repeated, but see Chapter 9 . . .

Another format that is probably, and this time regrettably, not coming back, is the Elcaset [4], which looked like an enlarged compact cassette and used 1/4-inch tape running at 3.75 ips. An important feature was that a tape loop was pulled out of the Elcaset by the transport, reducing the effect of imprecise cassette mechanics. Much better quality compared with compact cassette was easily obtainable, and three-head operation was standard. The Elcaset was a collaboration between Sony, Panasonic, and Teac, introduced in 1976. Unfortunately at this time compact cassette quality was rapidly improving, due to the introduction of chromium tape and Dolby, and the system failed utterly in the marketplace, which is perhaps rather a pity as it was technically very sound, and it was abandoned in 1980. And despite what I said at the start of this paragraph, at the time of going to press, I discover that in 2017 Jeremy Hieden released an album called *Blue Wicked* on every obsolete format he could find, including Elcaset, making it the first ever prerecorded album on Elcaset. Apparently only Laserdisc defeated him. Note that Elcaset is the correct spelling, *not* Elcassette.

Tape is unmistakably coming back, like it or not, and so I have added this chapter. Tape technology is complicated, even if we confine ourselves to the replay part of the process, which I think is reasonable given the small number of people who are going to be designing new tape recorders from scratch and a perceptible trend towards playback-only tape machines for pre-recorded tapes. I will only go into the recording side where it is necessary to understand something on the replay side. Even so, a really comprehensive book on tape replay would be at least as long as *Electronics for Vinyl* [5], which has 327 pages just on vinyl replay. If it

DOI: 10.4324/9781003332985-11

comprehensively covered recording and tape transport as well, I think it would be a mighty tome. Wikipedia has some very good articles on tape technology, and I will give frequent references to these to keep the length of this chapter under control.

I should perhaps confess that while I have designed many amplifiers and many mixing consoles, to the point where I have lost count of both, I have only designed one tape recorder, back in the late 1970s. The replay amplifiers were all discrete-transistor technology, with some cunning crosstalk cancellation (see later). It had no Dolby-B noise reduction as licenses to use it were expensive. It was not exactly high-end hifi, but it worked alright, and we sold quite a few.

A brief history of tape recording

The first half-way practical magnetic recorder was built in 1898 by Poulsen. It used steel wire as the storage medium. The replay output was too low to be of use until valve amplifiers were introduced around 1909. Wire was later replaced by steel tape, the machines being called Blattnerphones after the inventor Louis Blattner; it was a difficult medium to handle, and the British Broadcasting Corporation considered them acceptable for voice but not music. Steel tape was replaced by paper tape coated with ferric oxide in 1930s, and this was in turn replaced by oxide-coated PVC tape. The introduction of AC bias to reduce noise and distortion was a vital step to making tape recorders useful; its history and application are described in the next section.

The basics of tape recording

This section is kept short to allow more room for consideration of the replay electronics. The tape recording process creates varying degrees of magnetisation on the tape by passing audio signal through the windings of the record head in contact with it; this by itself is not a very linear process, but the non-linearity is smoothed over by also applying a bias signal of higher frequency than the audio band being recorded.

The standard tape speeds are 30 ips, 15 ips, 7.5 ips, 3.75 ips, and 1.875 ips [6], where ips means inches per second; the metric equivalent of cm/sec is rarely used, probably because it results in lots of awkward numbers such as 7.5 ips = 19.05 cm/sec. The faster the tape speed, the better the quality. Thus 1.875 ips is mainly used in compact cassettes [7], which were originally designed for recording dictation where voice-only quality was acceptable. A lot of development work was required to make the compact cassette capable of producing decent audio. Even slower speeds exist, namely 15/16 ips and 15/32 ips are used in microcassettes [8], and these are just used for voice recording, though that should probably be '*were used*,' as digital voice recorders are much superior. Higher speeds of 60 and 120 ips were once used for analogue data recorders but have never been used in audio.

The basic setup is shown in Figure 11.1. Frequencies below 100 Hz are frequently boosted to offset losses in the record/replay process. The record head has significant inductance so to get a level response it must be driven from a high impedance; using a high-value resistor usually

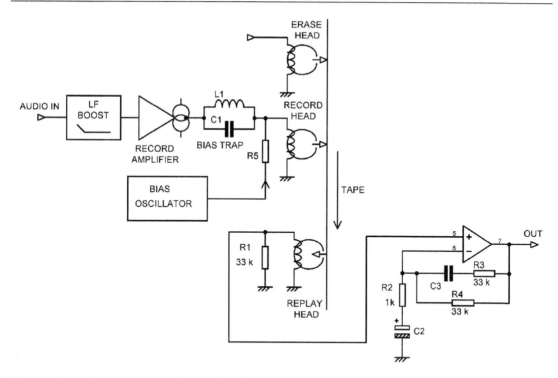

Figure 11.1 **The tape recording and replay process; when in use the erase head is driven from the bias oscillator.**

loses too much voltage swing, so an amplifier with a current source output is used. A record head has fewer turns than a replay head and so lower inductance, in order to minimise the extent of the problem. The bias signal is summed with the audio signal at the tape head. It is important to prevent the bias signal from being fed into the output of the record amplifier as it will wreck its linearity or maybe stop it working altogether. This is pretty much universally accomplished by putting a parallel-LC circuit in series with the output of the recording amplifier, as in Figure 11.1. Inductors are relatively uncommon nowadays in electronic circuitry, but here they are still the best option. For example, the Sony TC-A590/A790 introduced in 1996 still used passive LC bias traps; this technology is likely to continue.

Extraordinarily, the use of AC bias (as opposed to crude and unsatisfactory DC bias) goes back to a 1921 patent by Carlson and Carpenter [9], but the technique was forgotten and reinvented several times until being finally and solidly reinvented by Walter Weber in 1941, when a record amplifier went into parasitic oscillation [10]. The bias oscillator normally has a low output impedance which would shunt away the record amplifier signal, so the bias is injected either through a resistor (R5 in Figure 11.1) or a small capacitor, which may be an adjustable trimmer to set the bias level. The bias signal must be a clean sinewave with no DC component or noise and/or distortion will be compromised.

Multitrack recording

Multitrack recording is the foundation of modern music. There can be anywhere between 4 and 32 tracks on the tape, each of which can be recorded and played back separately, allowing each instrument a dedicated track. The beauty of this is that one mistake does not ruin the whole recording; only a single part need be done again (and again, and again, if necessary). The multitrack process is in two basic halves; recording individual tracks (often called 'tracklaying') and mixdown to stereo. One track is usually dedicated to time-code, which in the 4-track case leaves only three audio tracks and makes recording rather difficult. I call eight tracks the minimum; step forward the remarkable Fostex R8 (I have one).

When recording, normally only one or two parts are recorded at once, though it is quite possible to dedicate five or six tracks to a drum kit or a backing vocal section. The initial sound, whether captured by a microphone or fed in directly from a synthesiser line output, is usually processed as little as possible before committing it to tape; subsonic filtering and perhaps compression or limiting are used, but most effects are carefully avoided because they are usually impossible to undo later. You can easily add reverberation, for example, but just try removing it. It is clearly essential that all the new parts are performed in time with the material already on tape and also that the recording engineer can make up a rough impression of the final mix as recording proceeds. This is done by using the record head as a replay head when it's not recording, giving a 'sync' output that is time-aligned with what's being recorded by another section of the same head. Continually replaying already-recorded material is as important as recording it in the first place. The sync signal is not of the same quality as the replay head output; in particular the HF response will be lacking because the record head has a larger gap than the replay head, but it is quite good enough for keeping musicians playing in time.

When the tracklaying process is complete, it is mixdown time. There are 7, 15, or more separate tape tracks that must be mixed down to stereo. Major manipulations of sound are done at this mixdown stage; since the multitrack tape remains unaltered and the resulting stereo being recorded on a separate two-track machine, any number of experiments can be performed without doing anything irrevocable.

Tape heads

The electrical characteristics of tape heads are of crucial importance to correct operation, especially in the replay case where the head inductance has a big effect on the noise performance of the replay amplifier. Figure 11.1 shows a three-head tape recorder. This allows the recorded material to be played back almost immediately to monitor quality and means the record and replay heads can be optimised for their different roles. Cheaper machines have only two heads, the record and replay being done by a single head, and this is pretty much standard for cassette machines, as it is difficult to fit three heads into the openings in a cassette. However it can be done, and Nakamichi introduced the first three-head cassette decks, the 700 and the 1000 in 1973. Other manufacturers like Sony followed.

It is also possible to fit all three heads into one, giving a record/replay/erase head, sometimes called a Z-combo® head. The record/replay winding are on one half of the magnetic circuit and

the erase windings on the other, with an extra pole-piece in the middle [11]. This is suited to use with hard surfaces such as striped film and magnetic cards. It reduces the time delay between erase and record/replay to the minimum.

Tables 11.1 to 11.5 show typical head parameters, gathered from several reputable manufacturers. Where the output is not stated, it means the manufacturer didn't state it, for reasons unknown.

TABLE 11.1 Characteristics of multitrack heads (24-track on 2-inch tape), replay output at 15 ips, recorded at 12 dB below tape saturation at 1 kHz

Function	Inductance mH	DC resistance Ω	Replay output uV
Record	4	13	n/a
Replay	5	15	200
Replay	8	15	350
Replay	100	140	
Replay	650	650	200
Erase	0.17	3.0	n/a
Erase	1	12	n/a
Erase	1.5	18	n/a

TABLE 11.2 Characteristics of 1/4 inch record/playback heads, replay output at 7.5 ips, recorded 12 dB below tape saturation at 1 kHz

Inductance mH	DC resistance Ω	Replay output uV
20	30	350
100	100	800
200	190	1200
400	350	1600
500	315	1700
800	640	2200

TABLE 11.3 Characteristics of ¼ inch erase heads

Inductance mH	DC resistance Ω
0.2	2.2
0.8	9.0
8.0	45

TABLE 11.4 Characteristics of cassette record/playback heads

Inductance mH	DC resistance Ω	Replay output uV
20	50	750
80	110	
200	215	

TABLE 11.5 Characteristics of cassette erase heads

Inductance mH	DC resistance Ω
0.047	0.9
0.28	2.2
0.37	2.6
1	10
2	14
13	115

The majority of cassette machines are two-head, with the record and replay functions done by the same winding and core; they tend to have a relatively high inductance to get an adequate replay output voltage, but it is general lower than for 1/4-inch replay where three heads is more common. Likewise they have narrow gaps better suited to replay such as 50 micro-inches rather than the 200 micro-inches used for record-only cassette heads.

Cassette erase heads tend to have a lower inductance than 1/4-inch erase heads.

Many examples can be found in the Nortronics catalogue [11], which also has some good general information on tape recording and replay.

Tape replay

The replay head produces only a small voltage; it is made as large as possible by giving the head coil a large number of turns and consequently a larger inductance than the record head. The replay head has a narrower gap than a replay head.

There are several possible causes of HF loss on tape replay:

- Replay head gap width. At a sufficiently high frequency, the head gap will see a complete cycle of tape magnetisation, and there will be no output. At a much lower frequency the HF response will begin to droop in at the top of the audio band. This is commonly called gap loss.

- Azimuth error.If the vertical head gap is not exactly at right angles to the direction of tap travel, then the effective gap width is increased, leading to HF loss as described earlier.

- Spacing error. If the tape does not make good contact with the head, for example due to a build-up of oxide on the head face, the effective gap width is again increased, leading to HF loss as mentioned earlier.

All these issues depend on the relationship between the head gap and the wavelength on tape and so become more significant at lower tape speeds. Simple formulae for calculating the amount of loss are given in [11]. The problems are essentially mechanical and can be controlled by proper head design and regular maintenance and cleaning.

The HF response may also be affected by head resonance, which occurs between the head inductance and its internal stray capacitance, plus the external shunt capacitance from screened cable and added loading capacitors. The frequency must be comfortably above the desired audio HF response. Loading resistors, usually in the range 33 kΩ to 120 kΩ, are used to damp the resonance.

There also limitations on the minimum frequency that a replay head can reproduce. At low frequencies the magnetic field on the tape reaches the coil by other paths than just the gap, and partial reinforcements and cancellations put wobbles (that may be up to ±3 dB) in the response; these are sometimes called 'head bumps.' Ultimately the head output drops to zero as the recorded wavelength becomes much longer than the head gap. The longest wavelength is the mean of the lengths of the head pole and the window in the magnetic screening that allows the pole to contact the tape. A good low-frequency response requires a large window, which makes magnetic screening harder. The shape of the laminations in the head pole also affects the low-frequency response. The overall low-frequency loss is frequently called 'contour effect'; it occurs only on playback. It is well-described in [12].

Unlike vinyl discs, the maximum possible level from a tape is firmly set by magnetic saturation, and there is no need for large amounts of headroom in the replay circuitry to cope with excessive recording levels or transients from scratches. In anything but low-cost machines it is therefore often convenient to have a first preamplifier optimised for low noise and with a flat response that gets the signal up to a level where it is relatively immune from noise contamination in later circuitry. Equalisation and level control etc can therefore be done in separate stages, which simplifies the design process. Tape replay is also free from the subsonic disturbances created by vinyl (unless they are deliberately recorded—see Auto-Dolby in the "Noise reduction systems" section), and subsonic filtering is not normally considered necessary.

Tape replay equalisation

The signal produced by the replay head is proportional to the rate of change of the magnetic field it sees. The output therefore doubles with each doubling of frequency, and to undo this the basic replay equalisation is an integrator, ie a −6 dB/octave slope. This is modified by making the amplifier response level out at high frequencies, which is in effect HF boost. This compensates for the HF loss mechanisms listed earlier; the lower the tape speed the greater the losses and so the lower the frequency at which the gain is made to level out. The frequency is normally quoted as a time-constant, so a 90 µs time constant T is equivalent to a turnover frequency of $1/T = 1768$ Hz. The history of tape equalisation is very complicated [13], but Table 11.6 gives the most common values used.

There is also a levelling-off of gain at the low-frequency end, for all speeds except 30 ips, which compensates for bass boost on recording and improves the LF signal-to-noise ratio. See Figure 11.2.

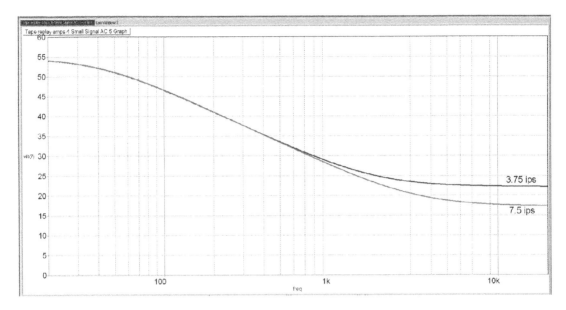

Figure 11.2 Tape replay equalisation responses from the amplifier in Figure 11.3 for 3.75 and 7.5 ips. The 15 ips response is below the curves shown, while the 1.875 ips response is above.

The equalisation for 3.75 ips is implemented in the replay amplifier of Figure 11.3. C3 performs the integration and is the central component on the equalisation feedback arm. The integration is limited by R2, which causes the gain to level out at HF. Similarly, R3 limits the increase in gain as frequency falls, giving a relative LF cut. R0 sets the overall gain in conjunction with the other feedback components. The gain of this circuit is +35 3 dB at 400 Hz; this frequency is chosen as it is in the 'integrating' part of the response and is therefore unaffected by the levelling-off at HF and LF.

$$R = \frac{1}{2\pi f_0 C}$$ Equation 11.1

TABLE 11.6 Tape replay NAB/IEC2 equalisation, including ferric and chrome cassette tapes

Tape speed ips	LF shelf μs	LF shelf Hz	HF shelf μs	HF shelf Hz
30	None	None	17.5	9095
15	3180	50	50	3183
7.5	3180	50	50	3183
3.75	3180	50	90	1768
1.875 Fe	3180	50	120	1326
1.875 Cr	3180	50	90	1768

The simple Equation 11.1 is frequently given for calculating the equalisation breakpoints. Plug in a preferred value for C3, which will give the desired gain at 400 Hz and calculate R2 and R3. Unfortunately the equation is not entirely accurate, as the value of R0 has a significant effect on the response. Your options are then a) do the complex algebra that completely describes the circuit (I'm not aware anyone has done this) or b) determine the approximate value for R2 or R3, with Equation 11.1, and then put the results into a SPICE simulator where the values of R2 and R3 can be fine-tuned to get exactly the desired break points; this is more my kind of approach to knotty problems. With values of R0 between 100 Ω and 1 kΩ, the corrections to R2 and R3 are unlikely to exceed ±20%. This crude but effective approach only works because the LF and HF levelling-out frequencies are far apart and do not significantly interact; it is not feasible with RIAA phono equalisation where the effects of the time-constants overlap (see Chapter 9).

In the case of 3.75 ips equalisation, the LF time-constant is 3180 μsec, equivalent to exactly 50 Hz. The HF time-constant is 90 μsec, equivalent to 1768 Hz. The calculate-and-tweak process gives R3 = 57k9 and R2 =1220 Ω. The nearest 1xE24 values are 56 kΩ and 1200 Ω. The value for R2 looks pretty close, but its nominal value is still 1.6% out, and R3 is 3.4% awry. The 1xE96 format for R2 gives 1210 Ω and 0.83% error, while R3 gives 57k6, which has 0.5% error.

The 2xE24 format is usually more accurate than 1xE96, so R3 and R2 were recalculated giving R3 = 110 k in parallel with 120 k and R2 = 2200 Ω in parallel with 2700 Ω, as shown in Figure 11.3. R2 has 0.64% error in the nominal value, and R3 has 0.88% error, which is not much of an improvement, but for both resistors the effective tolerance is reduced by almost √2. And you don't have to keep thousands of E96 values in stock.

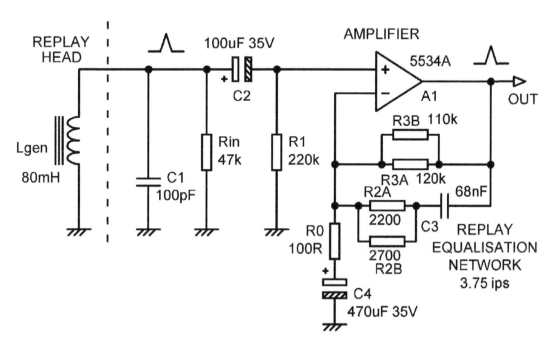

Figure 11.3 Tape replay amplifier with 2xE24 equalisation network for 3.75 ips.

TABLE 11.7 Component values for NAB/IEC2 equalisation at various tape speeds

Tape speed ips	R0	C3 nF	R2 exact Ω	R2A Ω	R2B Ω	R3 exact kΩ	R3A kΩ	R3B kΩ
30	680	10	650	1300	1300	1M	-	-
15	220	33	1270	2400	2700	130	180	470
7.5	100	68	633	1100	1500	57.9	110	120
3.75	100	68	1323	2200	2700	57.9	110	120
1.875 CrO2	100	68	1323	2200	2700	57.9	110	120
1.875 Fe	100	68	1675	2700	4300	57.9	110	120

Table 11.7 shows the results of this process for common tape speeds, with ferric and chrome options for the 1.875 ips cassette speed. The shelving frequencies are all accurate to within ±1%.

The amplifier in Figure 11.3 was designed to keep the impedance of the feedback network as low as possible to minimise Johnson noise and the effect of opamp current noise. First R0 was set to 100 Ω, which means that C4 has to be quite large at 470 uF to avoid it affecting the equalisation accuracy at 20 Hz and below. At the higher tape speeds of 15 and 30 ips the HF shelving is at so high frequency that R2 becomes too low and loads the opamp output excessively. For these speeds R0 is changed to 220 Ω, increasing the general impedance of the feedback network and allowing C4 to be reduced to 220 uF. This means C3 changes to 33 nF to maintain the same gain at 400 Hz.

A more radical change of impedance is required for the 30 ips case; here R0 is increased to 680 Ω, and C3 reduced to 10 nF to make the value of R2 acceptably high. The gain is still +35.3 dB at 400 Hz. There is no LF shelving at 30 ips, so the value of R3 should theoretically be infinite. The typical input bias current of a 5534A is 400 nA and 800 nA maximum; if we set R3 to 1 MΩ we get good accuracy down to 10 Hz, and a typical offset voltage across R3 of 400 mV. This appears at the opamp output but will not erode headroom much and preserves the simplicity of the amplifier, though the offset voltage will have to be DC-blocked at the output. If this is not acceptable then a DC servo will have to be used to control the operating conditions of A1. The 5532 (from Fairchild and Texas, anyway) has a lower typical bias current of 200 nA; the maximum is still 800 nA.

Tape replay amplifiers

Figure 11.3 shows a typical opamp-based replay amplifier which incorporates the equalisation circuitry in its feedback network. A1 is shown as a 5534A because it is quieter than any JFET opamps except rather expensive ones. Note that the input bias currents of a 5534 or 5532 are significant, and DC blocking between the opamp input and the head is very definitely required.

Figure 11.4 shows a hybrid discrete/opamp amplifier which uses the low noise of the discrete BJT combined with the open-loop gain and load-driving ability of the opamp A1. The design is based on amplifiers used by Studer in open-reel tape decks. Rin loads the replay head to tame head

resonance, and C1 fine-tunes the HF frequency response. The closed-loop gain is +38.4 dB flat across the audio band. The DC conditions are set by the potential divider R7–R8, running from a sub-rail filtered by R3 and C2. The voltage on the non-inverting input of A1 is approximately −6.5 V; negative feedback sets the inverting input to the same voltage, and so the voltage across R2 is 6.5 V, setting the collector current of Q1 to 95 uA. This low value reduces the current noise of Q1, which is important when the input loading has a high impedance. Also, Q1 is a high-beta device, which minimises the base current I_b and therefore the current noise (see Chapter 1 for more on this). C4 gives dominant-pole stabilisation of the feedback loop.

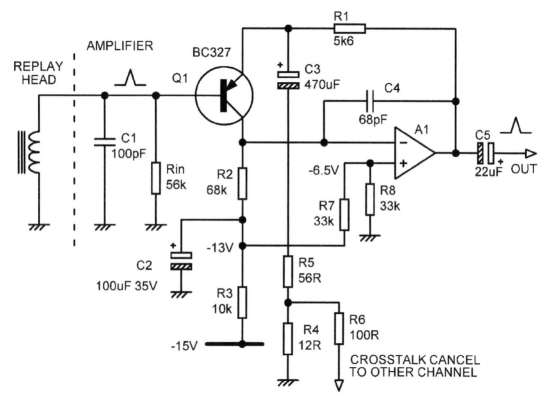

Figure 11.4 Hybrid discrete/opamp tape replay amplifier with flat response.

This amplifier implements crosstalk cancellation via R6; through this each stage of a stereo pair of amplifiers injects an inverted signal into the other, at a level also fixed by R4, R5. Here the crossfeed is flat with frequency; the amount is usually adjusted with a preset control. In other cases crosstalk rises with frequency, and R6 may be replaced with a small capacitor or a more complex R-C network to optimise the cancellation.

A notable feature is that the whole base current of Q1 flows through the replay head; presumably it is too low to cause head magnetisation problems. Hybrid circuitry like this often requires clamping circuitry so that a heavy base current is not drawn by Q1 during power turn-on and turn-off transients. Studer used safety-circuitry that switched off both supply rails if one of them was

lost to prevent unwanted head currents; Chapter 25 shows how to do this with a complete power-supply the Studer approach had separate lost-rail protection for each replay amplifier.

As for MM and MC phono cartridges, a tape head is a floating source, and so nothing can be gained by the use of balanced inputs. There should be no noise current flowing down the ground wire as it has no connection to anything except the head and the head screening, and so no voltage on the ground wire to cancel out. A balanced input would have the disadvantages of more noise and greater hardware complexity.

Replay noise: calculation

The first question is how low do we need the electronic noise to be? In the case of vinyl replay, the groove noise can be confidently expected to be at least 11 dB above the amplifier noise (see Chapter 9). How much the noise of blank tape passing over the replay head is above the preamplifier noise is a rather harder question to answer; it depends on tape coating formulation, tape speed, track width, tape thickness, head characteristics, noise reduction, and so on. So far as I can see it is safe to assume that if tape noise is not at least 6 dB above the electronic noise, you need to look at your tape preamplifier.

The theoretical noise model is shown in Figure 11.5; note its similarity to the noise models for a moving-magnet cartridge and amplifier (Chapter 9) and guitar pickup and amplifier (Chapter 12). The head parameters Lgen and Rgen are taken from Table 11.4 and are in the middle range for cassette replay heads.

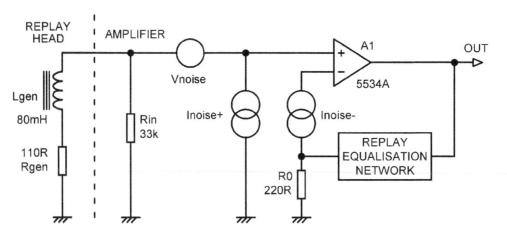

Figure 11.5 Tape replay noise model.

The contributions to the noise at the inputs of A1 are

1) The Johnson noise of the DC resistance of the replay head Rgen.

2) The Johnson noise of the 33 kΩ head load resistor Rin. Some of the Johnson noise generated by Rin is shunted away from the amplifier input by the tape head, the amount shunted away decreasing with frequency as the head inductance Lgen increases in impedance. Here the

fraction of Rin noise reaching the amplifier rises from 0.003 to 0.21 as frequency increases from 36 Hz to 17.4 kHz.

3) The opamp voltage noise Vnoise. This contribution is unaffected by other components.

4) The noise voltage generated by Inoise+ flowing through the parallel combination of the replay head impedance and Rin. This impedance increases with frequency due to Lgen. Here it increases from 111 Ω at 36 Hz to 6914 Ω at 17.4 kHz; the increase at the high frequency end is limited by the shunting effect of Rin. This increase in impedance makes Inoise+ significant and so has an important effect on the noise behaviour. For the lowest noise you must design for a higher impedance than you might think.

5) The Johnson noise of R0. For the values shown, and with A1 assumed to be 5534A, ignoring the Johnson noise of R0 improves the calculated noise performance by only 0.35 dB. The other resistors in the RIAA feedback network are ignored, as R0 has a much lower value, and so shunts their contribution to ground, but the replay equalisation frequency response must of course be modelled. More details of the very limited effect that R0 has on the noise performance in MM amplifiers are given in Chapter 9.

6) The noise voltage generated by Inoise− flowing through R0. For normal values of R0, say up to 1000 Ω, this contribution is negligible, affecting the total noise output by less than 0.01 dB.

Using my TAPENOISE mathematical model on Figure 11.3, without replay equalisation, gives Table 11.8. Values of Lgen = 100 mH and Rgen = 250 Ω were used to correspond with the heads used for measurements in the next section.

TABLE 11.8 Calculated equivalent input noise for Figure 11.3 with various devices as A1; Rin = 100 kΩ; cassette replay head: Lgen = 100 mH Rgen = 250 Ω; also some noise measurements

Device	Coil Lgen = 100mH EIN dBu	Coil Rgen = 250R Noise figure dB	Amp gain dB	Calc'd Noise out dBu	Meas'd Noise out dBu	Excess noise dB
Noiseless amp	−121.93	0.00	29.9	−92.03		
AD8656	−120.42	2.25	29.9	−90.52		
BC327 100 uA	−120.35	2.32	29.9	−90.45	−86.8	5.23
2SB737 70 uA	−119.85	2.82	29.9	−89.95		
OPA828	−119.11	3.56	29.9	−89.21		
OPA2156	−119.11	3.56	29.9	−89.21		
5534A	−118.56	4.11	29.9	−88.66	−86.2	3.01
OPA1622	−116.70	5.97	29.9	−86.80		
5532A	−116.05	6.62	29.9	−86.15	−85.8	2.86
OPA2134	−115.25	7.42	29.9	−85.35	−84.2	1.15
LM4562	−112.40	10.27	29.9	−82.50	−83.3	−0.8
TL072	−109.03	13.64	29.9	−79.13	−78.8	0.33
LM741	−107.90	14.77	29.9	−78.00		

If you compare the table with the similar tables for moving-magnet cartridges (Chapter 9) and guitar pickup (Chapter 12), you will see that the order of merit for the various devices is quite different. This is because the tape head inductance is much lower, and so the effect of device current noise is also much less.

The OPA2134 gave good results with a guitar pickup, but here its relatively high voltage noise drops it down the table with a noise figure (NF) of 7.4 dB. Using an inexpensive 5534A reduces the noise figure 4.1 dB; to improve on that you'll have to either shell out for some rather expensive new opamps or use a hybrid discrete/opamp amplifier. The much-lamented 2SB737 transistor gets the noise figure down to a rather impressive 2.8 dB, but its 2 Ω R_b is of no help here given the 250 Ω coil resistance of the head, and it is beaten by a BC327 (beta assumed to be 500) running at an I_c of 100 uA. Its high beta reduces current noise and drops the NF to 2.3 dB; clearly Studer knew what they were about when they chose it. The AD8656 wins with NF = 2.2 dB, but its high cost means that a BC327/5532 hybrid solution is very nearly as good and much cheaper.

Replay noise: measurements

As related in Chapter 12 on guitar electronics, measuring the noise performance of an amplifier whose input is loaded with a transducer sensitive to magnetic fields can be very difficult. The test amplifier used had a flat frequency response and was similar to Figure 11.3 but without equalisation. The replay head used had an inductance of 100 mH, measured by using it in a parallel resonance circuit with a 100 nF capacitor. The resistance was measured as 250 Ω using a digital ohmmeter; if you do this make sure to demagnetise the head before using it with tape.

The feedback network consisted of R3 = 10 kΩ and R0 = 330 Ω with C3 and R2 omitted, giving a flat gain of +30 dB (okay, 29.9 dB to be more precise). Some of the measured results are shown in the rightmost column of Table 11.8 for comparison with the calculated figures. The agreement is good for the TL072 but gets worse as the noise level decreases. This is not due to hum, as the measured noise was in no case significantly affected by switching in a 400 Hz filter, and further investigation is required. The amplifier and head were completely electrically shielded and connected by long leads to testgear approximately 2 metres away, to avoid hum from mains transformers.

The BC327 measurement was obtained using a hybrid amplifier closely resembling Figure 11.4. Interestingly, both TL072 and 5532 worked fine for A1, with no measurable difference in noise performance.

I measured five samples of each device I had to hand to check out the part-to-part variations; the results are in Table 11.9. All results except for the 5532 are admirably consistent; the 5532s were by various manufacturers including Fairchild, Philips, Texas, and Signetics.

TABLE 11.9 Noise measurements; cassette replay head: Lgen = 100 mH Rgen = 250 Ω

Manufacturer	Sample	dBu #1	dBu #2	dBu #3	dBu #4	dBu #5
Texas	5534A	−86.2	−86.2	−86.4	−86.5	−86.4
various	5532A	−86.4	−86.6	−85.8	−85.3	−85.8
Burr-Brown	OPA2134	−84.1	−84.2	−84.2	−84.3	−84.2
National	LM4562	−83.3	−82.8	−82.9	−83.3	−83.7
Texas	TL072	−78.8	−78.9	−79.1	−78.9	−80.7

Load synthesis

The noise performance of an MM phono preamplifier can be improved by 0.8 to 2.9 dB (depending on the noise performance of the basic amplifier) by means of load synthesis; see Chapter 9. This also applies to tape replay preamplifiers and even guitar pickup preamplifiers because both have the same situation of a large inductance that must be loaded with a high resistance to avoid LF roll-off. The idea is that a high-value resistor can be emulated by a very high-value resistor (which has lower current noise, which is what counts here) if the end that would normally be grounded is driven with an inverted signal, so it appears to be a lower value than it is.

The application of load synthesis to tape replay amplifiers is considered in [14], where its use with a cassette tape head loaded with a 36 kΩ resistor reduced the electronic noise by 5.9 dB (IEC weighted), which is notably better than the phono cartridge case. Nevertheless I am not aware it has ever been used in a commercial tape machine.

Noise reduction systems

It was clear that the basic noise performance of the compact cassette was too poor for anything resembling hifi, and in 1968 the Dolby-B system was unveiled [15] Dolby-A, a much more complex system for professional open-reel use, was introduced in 1966. Dolby-B was a compander system—the dynamic range on tape was reduced by boosting low-level HF content when recording and cutting it on replay, giving a noise reduction of up to 10 dB; this was enough to make cassettes acceptable. There were several other compander noise reduction systems, such as dbx [16], Telefunken's High Com [17], and Nakamichi's High Com II [18], but none were anything like as successful as Dolby-B.

The market acceptance of Dolby-B stemmed from two factors; firstly, the companding was done by processing low-level signals, with the high levels going through untouched, so artefacts would be less noticeable. Even so, a significant challenge was the need for an acceptably linear variable-gain element, in this case the JFET; voltage-controlled amplifiers (VCAs) were being introduced but were far too expensive for consumer gear. The Dolby system would probably have never

emerged without the invention of the JFET. Since the signal was only processed when it was at low levels, the non-linearity of the JFET was less important than it would have been otherwise. JFETs show considerable variation in their characteristics, and it was necessary to select them into batches and provide at least two adjustments by means of preset resistors.

Secondly, if you played a Dolby-B encoded tape without a decoder, it sounded brighter in the treble but was generally acceptable to listen to; given the variations in replay head azimuth about it often sounded better. I always used to play back Dolby-B cassettes without decoding in my car stereo, as the level-dependent HF boost helps in a noisy environment.

If a companding system is to operate without audible artefacts, the decoding process must be the exact inverse of the encoding process. It would be extremely hard to do this if the two processes were accomplished by different circuitry. An important feature of the Dolby system is that the encoding and decoding were performed by the same circuitry (or different instances of the same circuitry) so that only component tolerances could cause trouble. The heart of the Dolby-B system, as shown in Figure 11.6, is the sidechain, which is an HF-only compressor. As the signal level increases, the cutoff frequency of the lowpass filter is reduced, so that in Record mode a decreasing amount of HF is added into the straight-through signal. In replay the sidechain is reconnected so that the output signal is lowpass filtered and then subtracted from the straight-through path, reducing the HF gain and so improving the noise performance.

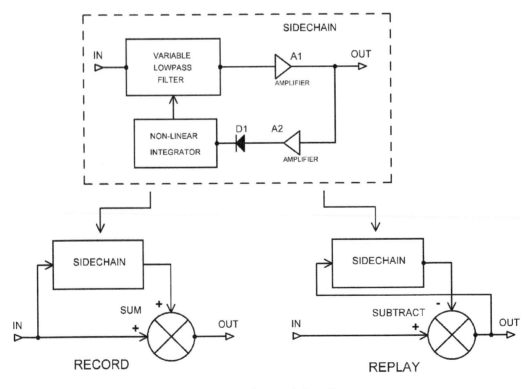

Figure 11.6 Block diagram of Dolby-B encoding and decoding.

Dolby-C [19] was a more ambitious consumer companding system introduced in 1980 and basically consisted of two Dolby-B characteristics, giving a noise reduction of about 15 dB (A-weighted). It does not give acceptable results without decoding. It arrived too late to have a major impact on consumer equipment but found its niche in semi-pro multitrack tape machines such as the Fostex R8, which gave eight tracks on 1/4-inch tape running at 15 ips. My R8 was the centre-piece of my 8-track recording studio, along with the first prototype of the Soundcraft Delta mixer. I still have both.

Bang & Olufsen came up with a technique they called "Auto-Dolby" which could detect if Dolby-B or Dolby-C was in use and select the correct decoding. You could have different Dolbys on the same tape. However, this only worked if the tape had been recorded on an Auto-Dolby machine in the first place because subsonic tones were added to the signal to indicate which Dolby was in use. This doesn't sound particularly useful, and not everyone (myself included) is happy with subsonic tones being added to their audio. The idea appears to have sunk without trace and rightly so.

Dolby-SR (SR stands for spectral recording) was Dolby's second professional noise reduction system, aimed at multitrack machines. It gave up to 25 dB of noise reduction at HF [20]. It was very complex, with multiple bands of companding, and never appeared in the consumer market.

Dolby-S was intended to be an advance on Dolby-C for consumer products. It was introduced in 1989, and Dolby claimed most people could not tell the difference between a CD and a Dolby-S cassette. Dolby-S is partly a development of Dolby-C and partly a simplified version of Dolby-SR; it uses one fixed LF band below 200 Hz and two bands working from 400 Hz upwards. The latter are divided into high and low level stages, with two 12 dB companders giving 24 dB noise reduction at HF when both are fully active. It gives 10 dB of noise reduction at LF. The timing was bad, and it has so far seen little use; however if we really are going to have a large-scale cassette revival its day may now have come.

Dolby HX-Pro

A completely different approach to noise reduction was the Dolby HX-Pro variable-bias system [21], where HX stands for headroom extension. HX alone represents the feedforward system developed by Ken Gundry at Dolby [22], and HX-Pro a superior feedback system invented later by Bang & Olufsen in 1980 [23] and licensed to Dolby. When a recording is made with a lot of HF content, it effectively adds to the bias signal and limits the HF levels that can be recorded. HX-Pro reduces the bias level in the presence of high-amplitude HF audio, allowing recording at a higher level for the same distortion and relatively reducing noise. On cassette tape the improvement is from 7 to 10 dB at 15 kHz [24].

Figure 11.7 shows the basic principle. The record amplifier has a current-source output (indicated by the two-circle symbol) so it can drive a constant current into the inductive record head at all frequencies. The usual LC bias trap to keep bias out of the record amplifier is shown. The voltage across the head, the sum of the audio, and bias signals are sensed by a high-impedance amplifier (to avoid upsetting the drive/head operation) and then integrated to provide a representation of the current through the head. This is then highpass filtered so the feedback loop only works at HF and applied to a rectifier and then an error amplifier which compares the total bias level detected with a desired reference level. This creates a correction signal to drive a VCA which

controls the amount of bias applied to the head. The feedback operation means that the system works automatically with different signal levels and music spectra. It is only necessary to set the reference to the right bias level for the type of tape being used.

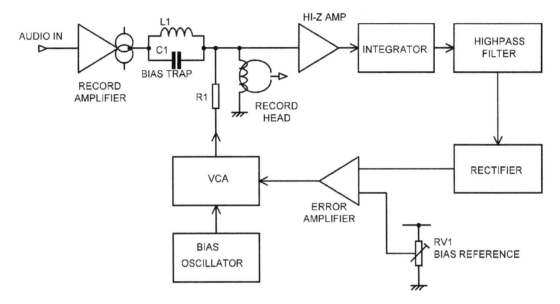

Figure 11.7 Block diagram of Dolby HX-Pro headroom extension system.

HX-Pro only operates when recording so no decoder is required. It has always struck me as one of the cleverest ideas applied to tape technology. It received wide acceptance as it did not manipulate the audio, and most HX-Pro machines have it permanently enabled though some have it as switchable on/off. As an example, the Revox C287 open-reel 8-track machine had HX-Pro but interestingly no companding noise reduction.

Two separate HX-Pro circuits are required for stereo recording, as the audio HF content will not be the same in both channels. Only one bias oscillator is used, both for economy and to prevent beat notes. In cassette decks the complete HX-Pro function was usually implemented by an IC, called the uPC1297CA; an example is the Sony TC-D707 (1992). The uPC1297CA was a stereo HX-Pro controller; each channel had a push-pull output to drive a step-up transformer that was connected to the record head.

References

[1] The Guardian. www.theguardian.com/music/2019/feb/23/cassette-tape-music-revival-retro-chic-rewind Accessed Sept 2019

[2] The Scotsman. www.scotsman.com/arts-and-culture/entertainment/forget-vinyl-it-s-time-for-the-8-track-revival-1-4913166 Accessed Sept 2019

[3]　Wikipedia. https://en.wikipedia.org/wiki/The_Men_That_Will_Not_Be_Blamed_for_ Nothing Accessed Aug 2019

[4]　Wikipedia. https://en.wikipedia.org/wiki/Elcaset Accessed Aug 2019

[5]　Self, D. *Electronics For Vinyl*. Focal Press, 2018. ISBN 978-1-138-70544-9 hbk; ISBN 978-1-138-70554-6 pbk; ISBN 978-1-315-20217-4 ebk

[6]　Wikipedia. https://en.wikipedia.org/wiki/Audio_tape_specifications Accessed Aug 2019

[7]　Wikipedia. https://en.wikipedia.org/wiki/Cassette_tape Accessed Aug 2019

[8]　Wikipedia. https://en.wikipedia.org/wiki/Microcassette Accessed Aug 2019

[9]　Carlson, W. L. & Carpenter, G. W. "Radio Telegraph System." *US Patent No. 1,640,881* (filed Mar 1921; issued Apr 1927)

[10]　Engel, F. www.richardhess.com/tape/history/Engel-Walter_Weber_2006.pdf Accessed Aug 2019

[11]　Nortronics. www.jrfmagnetics.com/Nortronics_pro/nortronics_silver/Nortronics_silver_ catalog.pdf Accessed Aug 2019

[12]　Camras, M. *Magnetic Recording Handbook*. Springer, 1988, pp. 204–206. ISBN-10: 0442262620; ISBN-13: 9780442262624

[13]　Pspatial Audio. http://pspatialaudio.com/tape%20equalisation%20correction.htm Accessed Aug 2019

[14]　Hoeffelman, J. M. & Meys, R. P. "Improvement of the Noise Characteristics of Amplifiers for Magnetic Transducers." *Journal of the Audio Engineering Society*, Vol. 26, No. 12, Dec 1978, p. 935

[15]　Wikipedia. https://en.wikipedia.org/wiki/Dolby_noise-reduction_system#Dolby_B Accessed Aug 2019

[16]　Wikipedia. https://en.wikipedia.org/wiki/Dbx_(noise_reduction) Accessed Aug 2019

[17]　Wikipedia. https://en.wikipedia.org/wiki/High_Com Accessed Aug 2019

[18]　Wikipedia. https://en.wikipedia.org/wiki/High_Com#High_Com_II Accessed Aug 2019

[19]　Wikipedia. https://en.wikipedia.org/wiki/Dolby_noise-reduction_system#Dolby_C Accessed Aug 2019

[20]　Wikipedia. https://en.wikipedia.org/wiki/Dolby_SR Accessed Aug 2019

[21]　Wikipedia. https://en.wikipedia.org/wiki/Dolby_noise-reduction_system#Dolby_HX/HX-Pro Accessed Aug 2019

[22]　Gundry, K. "Headroom Extension for Slow-Speed Magnetic Recording of Audio." *JAES Preprint 1534*, 64th Convention, New York, Nov 1979

[23]　Beoworld. www.beoworld.org/article_view.asp?id=145 Accessed Aug 2019

[24]　Jensen, J. "Recording with Feedback Controlled Effective Bias." *JAES Preprint 1852 (J-5)*, 70th Convention, New York, Oct/Nov 1981

Guitar preamplifiers

Electric guitar technology

The standard electric guitar technology uses the vibrations of a ferromagnetic string to modulate the magnetic field seen by the pickup windings. The field is only being modulated by a relatively narrow wire, and so the overall change in field is small. It is therefore necessary to use pick-up coils with a large number of turns to get a usable output voltage. This means the pickup has a large amount of inductance and a significant amount of series resistance because thin wire has to be used to physically fit in enough turns.

Electric guitars commonly have two or three pickups. In the case of three, one will be mounted just below the neck, one in the middle of the body, and one near the bridge. Guitars with four pickups are rarer but certainly exist, and there is at least one around with five pickups [1], though that is a result of modification. I could not locate one with six pickups; it would be hard to find space on the guitar body. The internal wiring of the guitar usually allows pickups to be selected, joined together, or operated in anti-phase. There is more on this in the following sections.

Guitar pickups

Pickups come in different types:

1) The standard pickup has a single coil surrounding the magnetic pole-pieces. It is sometimes called a normal pickup [2].

2) The humbucking pickup [3] discriminates against ambient hum fields. The standard pickup is rather susceptible to magnetic fields, as after all that is what it is meant to be. However, it responds not only to the magnetic signals created by the strings, but also external magnetic fields, which in practical terms means mains hum and buzz. Humbucking pickups have two windings, usually wired in series, placed around magnetic poles that alternate in polarity. The two coils are then connected in a phase relationship so that small-scale magnetic signals from the strings are reinforced, but large-scale disturbances, such as the ambient mains field in a room, affects both coils equally and is (to a first approximation) cancelled out. There are several ways to construct humbucking pickups [4], but in each the principle is the same.

There are also several ways in which a humbucking pickup can be connected; normally the two halves are simply connected in series. Figure 12.1 shows two more popular options. Figure 12.

DOI: 10.4324/9781003332985-12

1a is the split-coil approach, where a 'coil-cut' switch shorts out one half of the pickup. This is claimed to give a brighter sound, but of course the signal output is halved and the hum-cancelling feature entirely lost. Figure 12.1b is the series/parallel configuration; the parallel setting gives less output but a brighter tone. This time the hum-cancelling feature is retained.

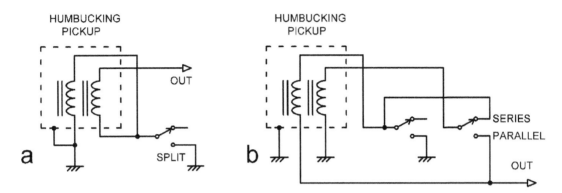

Figure 12.1 Alternate ways of connecting a humbucker pickup, assuming the two coils are brought out separately.

3) The third major magnetic category is the hexaphonic pickup, which has a separate magnet pole and coil for each string. It is hexaphonic because your standard (non-bass) guitar has six strings. It is also called a polyphonic pickup or (in Japan) a divided pickup and is typically used with a guitar synthesiser, in which the notes played are interpreted into MIDI commands; a process that is obviously much simpler if you have access to each string separately but is still a nontrivial task.

Alternatively the six outputs can be processed separately in purely analogue ways. Putting them through six separate fuzz circuits gives the hexfuzz effect, which sounds very different from the standard distort-the-lot fuzz effect. Here is an example [5] using a Roland GR-100 guitar synth to create the effect (an earlier model than the GR-700 mentioned later, released in 1981).

I am the proud owner of a Roland G707 guitar/synth-controller (in piano black) which has two normal humbucking pickups plus a hexaphonic pickup right down next to the bridge. The hex pickup was to drive the Roland GR-700 guitar synthesiser [6] via a 24-pin connector and multicore cable. Both were released in 1984. The humbucking pickups are loaded with 100 kΩ plus the usual guitar tone controls. The hexaphonic pickups are much more heavily loaded with 4k7 load resistors, presumably because a good high frequency response is unnecessary for determining the fundamental vibration rate of the string. The hexaphonic signals are then applied to a series-feedback amplifier with a preset-adjustable gain of between +17 dB and +31 dB. The opamp outputs are then sent straight down the multicore without any isolating resistors to fend off the effects of cable capacitance.

4) Magnetic pickups are no use with nylon strings, so acoustic guitars often use piezoelectric pickups, which are mounted under the bridge. They contain crystals that generate a voltage when subjected to a force. The output impedance is effectively a pure capacitance around 500

pF to 800 pF, and a high impedance input of at least 10 MΩ is required to avoid losses at low frequencies; 500 pF and 10 MΩ is −3 dB at 32 Hz, so a 20 MΩ input impedance would be better and is easily obtained with JFET input opamps.

Despite the high impedances, cable capacitance is not a major problem because its loading on the pickup capacitance gives a potential divider that is constant with frequency; several metres of cable will give a loss of around 6 dB, which may degrade the signal-to-noise ratio.

Pickup characteristics

Both standard and humbucking guitar pickups have several thousands of turns in the coil to get an adequate output, which also means a substantial series inductance. Typical values range from 1 H to 10 H; there are many variations in design. Compare this with a MM phono cartridge, which will have an inductance almost always in the limited range of 400 to 700 mH, while a moving-coil phono cartridge has negligible inductance. For both guitar pickups and MM cartridges, the inductance has a very great effect on the signal/noise ratio that is possible. The inductance of a pickup can be measured fairly simply; measuring its frequency response is a bit more involved because an air-cored transmitting coil is required to present a magnetic signal to the pickup. See [7].

Guitar pickups are always operated into a relatively high impedance to avoid the loss of high frequencies. A 10 H pickup loaded with 1.25 kΩ will roll-off by −3 dB at 20 kHz. Apart from the amplifier input impedance there will also be tone and volume controls loading the pickup. The amplifier is therefore designed for a high input impedance of the order of 500 kΩ to 1 MΩ, which is easily obtained either with opamps or discrete transistors.

Pickups have significant internal capacitance between the many turns, and this, in conjunction with any shunt capacitance, will resonate with the inductance. The frequency at which this occurs should be above the audio band.

Guitar wiring

Guitar wiring means the internal wiring of an electric guitar and usually includes tone and volume controls and often switches for selecting pickups and combining them in or out of phase to obtain different tone colours. For some reason there appears to be a near-universal assumption that anyone involved in guitar wiring is unable to read a circuit diagram, so wiring schemes are usually represented by drawing of actual components and wires. For me this makes it much harder to understand what is actually going on.

Figure 12.2 shows a single standard pickup and its associated wiring. The tone control is just a treble-cut control with its frequency of operation controlled by the pickup inductance and C1. The pots are very high in value compared with other kinds of audio circuitry to avoid loading the pickup, which would cut the high frequencies. Some manufacturers use 250 kΩ pots. The circuitry operates at high impedance and is therefore susceptible to hum from electric fields. The pickup will have an electrostatic screen which must be grounded, likewise for the metal bodies of the pots. The internal wiring must also be screened unless it is very short.

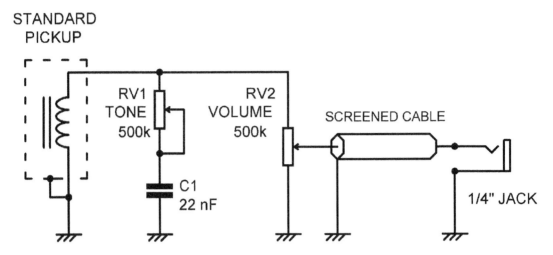

Figure 12.2 Simple guitar wiring for one pickup with tone and volume controls.

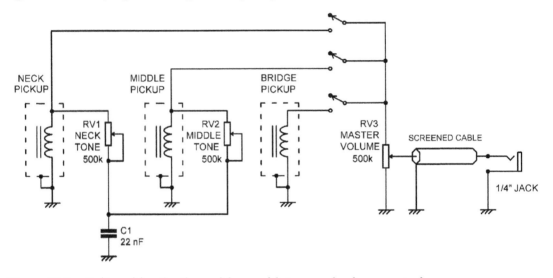

Figure 12.3 Guitar wiring for three pickups with tone and volume controls.

Adding a second or third pickup, as in Figure 12.3, greatly increase the possible arrangements. There will be switches to select which combination of pickups and pickup phase is used. These are shown as separate switches in the schematic but in practice are combined as 3-way or 5-way lever switches. These do not follow standard switch nomenclature, and things can get rather complicated, as usually wiring diagrams rather than schematics are provided, with the internals of the switch remaining enigmatic [8]. Note how the treble-cut capacitor C1 is shared between the tone controls. There is more on guitar wiring on Wikipedia [9].

Guitar leads

The pickup and internal guitar wiring are at high impedance, and only a small amount of shunt capacitance will cause losses at HF. Traditionally a guitar was connected to its amplifier by a long

curly lead to allow the player to move about, and this will typically have a capacitance between 52 and 190 pF/metre [10]. This can be effectively dealt with by having an active preamp in the guitar body (battery powered) with a low output impedance. Many guitarists now use radio links.

The classic way to reduce the effect of lead capacitance is the use of a driven guard screen, as in Figure 12.4 [11]. There is an extra screen between the grounded screening foil, and this is driven by a signal that is the same as is coming in on the Hot conductor from the pickup. Since there is no signal transfer between them (as there is no voltage difference between them), the capacitance causes no shunting effect. The outer screen is retained as a groundpath and to prevent crosstalk from the driven inner screen. There will be a substantial capacitance between the driven screen and the outer screen, and the stage A2 must be designed to remain stable in the face of this.

The inner guard screen is driven by a low-impedance version of the signal coming in. This could be accomplished by connecting the input of unity-gain buffer A2 to the input of A1, but this will increase the noise current flowing in the input circuit and should not be done. One way to drive A2 is from a suitably attenuated version of A1 output, as in Figure 12.4a. However since the attenuation of R1-R2 has to undo the gain of A1, it is neater to use R1-R2 to set the gain of A1 and drive A2 from the junction of R1-R2, which inherently gives unity gain; see Figure 12.4b.

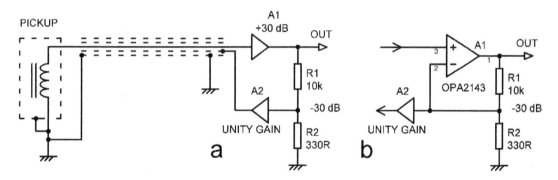

Figure 12.4 Guitar lead with a driven guard screen.

This seems to be a cheap simple way of rendering cable capacitance harmless. But I have so far been unable to find an example of its use, probably because of the difficulty in finding cable with two separate coaxial screens. One example of this approach (in this case an MM preamplifier rather than a guitar preamp) is the rack-mounting Neumann PUE74 phono amplifier [12], where the use of a driven guard allows the turntable to be a long way from the preamplifier without cable capacitance being an issue.

Guitar preamplifiers

Guitar preamplifiers need to have variable gain, suitably low noise and a high input impedance to prevent roll-off of HF content. Figure 12.5 shows a typical arrangement with gain variable from 0 to +30 dB; amplifier stages of this type are dealt with in detail in Chapter 8, where it is explained how to change the gain range from 0 to +30 dB to -infinity (-ish) to +30 dB by using a dual-gang pot. This means that if the amplifier has multiple inputs, only one control is required to go from full volume to no contribution to the mix. In Figure 12.5 The maximum gain is set by the value

of R4; the minimum gain with the arrangement shown is unity. R3 ensures that there is always feedback to the opamp if the pot wiper makes imperfect contact with the track.

Two jack inputs are shown, on the front and rear of the amplifier. If a jack is plugged into the front socket its normalling contact is opened and the rear socket disabled. If neither socket is in use the rear socket normalling shorts the amplifier input to ground, preventing the generation of a lot of noise from an open-circuit input.

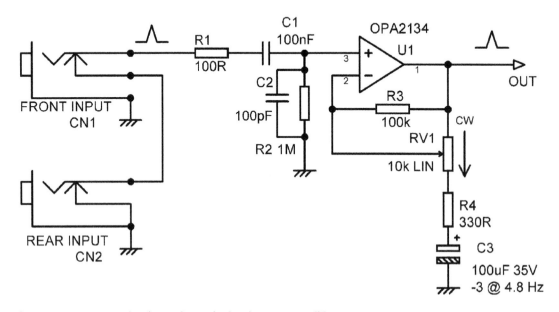

Figure 12.5 Input circuitry of a typical guitar preamplifier.

R1 and C2 make up a lowpass EMC filter to keep out RF. The opamp is shown as a OPA2134 because its FET input gives a good noise performance at high source impedance. The input impedance is set at 1 MΩ simply by the choice of R2, as the input impedance of the opamp is very high indeed.

Guitar preamplifier noise: calculations

The noise calculations for a guitar preamplifier are simple compared with the equivalent for MM cartridges or tape preamplifiers because there is no equalisation to complicate things. Later tone-control stages may, of course, make radical changes to the frequency response, but that is another issue altogether. Figure 12.6 shows the situation; the pickup parameters are intended to be 'average,' and the amplifier stage has a gain of +30 dB. A1 is here assumed noise to be noise free, with its voltage noise being represented by Vnoise and current noise by current-sources Inoise+ and Inoise−.

The contributions to the noise at the input of A1 are

1) The Johnson noise of the pickup series resistance Rgen. The proportion of noise from Rgen that reaches A1 input falls with frequency as frequency rises because the impedance of Lgen increases relative to Rin.

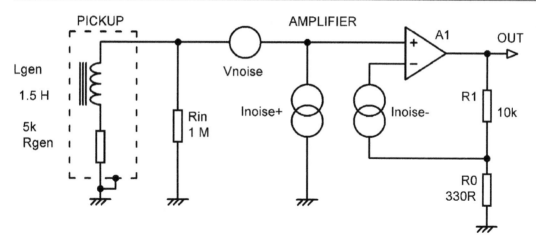

Figure 12.6 Noise model of a guitar preamplifier, with typical values.

2) The Johnson noise of the 1 MΩ input load Rin. Some of the Johnson noise generated by Rin is shunted away from the amplifier input by the pickup, the amount falling as frequency rises due to the impedance of the inductance Lgen rising.

3) The opamp voltage noise Vnoise. This contribution is unaffected by other components.

4) The noise voltage generated by Inoise+ flowing through the parallel combination of the total pickup impedance and Rin. This impedance increases as frequency rises due to Lgen.

5) The Johnson noise of R0. For the values shown, and with A1 assumed to be 5534A, ignoring the Johnson noise of R0 improves the calculated noise performance by only 0.35 dB. More details of the very limited effect that R0 has on noise performance in preamplifiers are given in Chapter 9.

6) The noise voltage generated by Inoise– flowing through R0. For normal values of R0, say up to 1000 Ω, in this case the contribution is negligible, affecting the total noise output by less than 0.01 dB.

These interactions get a bit complicated, so I built a mathematical model called GUITARNOISE in the form of an Excel spreadsheet, like MAGNOISE (Chapter 9) and TAPENOISE (Chapter 11). Some results from this are shown in Table 12.1. The noise is given as equivalent input noise (EIN), ie the equivalent noise at the input to A1; the output noise will naturally be 30 dB higher in each case. In the table I have used both very new devices, such as the OPA828, and also ancient ones like the TL072 and even the LM741.

You can see that the best devices are recent FET-input opamps (because current noise dominates with such a highly inductive input load), and they get very close to the best possible result because the Johnson noise from the 5 kΩ series resistance of the pickup is high. Things deteriorate somewhat when we get to the OPA2134 as it is an older part with quite high voltage noise by modern standards. Predictably the ancient TL072 is even worse by nearly 3 dB.

TABLE 12.1 Equivalent input noise for Figure 12.6 with various devices as A1; Rin = 1 MΩLgen = 1.5 H Rgen = 5 kΩ

Device	EIN dBu	Noise figure dB	Notes
Noiseless	**−110.44**	**0**	**Reference condition**
AD8656 *	−110.31	0.13	Released Apr 2005
OPA828 *	−110.17	0.27	Released Sept 2018
OPA2156	−110.10	0.34	Released Sept 2018
OPA2134	−109.44	1.00	Released 1996
TL072	−106.79	3.65	Old
2SB737 70uA	−101.73	8.71	Hybrid discrete-BJT/opamp
5534A	−101.40	9.04	
5532	−96.97	13.47	
LM741	−96.68	13.76	Current noise from measurements
OPA1622	−95.87	14.57	Released Nov 2015
LM4562	−89.97	20.47	

* No current-noise spec given by manufacturer's data sheet. Presumed negligible.

However, even that is better than any of the bipolar input devices further down the table. The 5534 is a reliably low-noise part in many low-impedance applications, and its balance of voltage and current noise is almost ideally suited to moving-magnet cartridges, but here the relatively high current noise, combined with a much higher input load inductance than either MM cartridges or tape heads, makes it 8 dB noisier than the OPA2134. However the OPA2134, at time of writing, is around five times the price.

The 2SB737 entry takes the voltage and current noise for a single bipolar transistor, the assumption being that it is combined with an opamp that supplies open-loop gain for linearisation and load-driving ability. This is about as good as bipolar technology is going to get, and it's still 5 dB noisier than the ancient TL072. The 5534 and 5532, which are so often the go-to opamps for low noise, do not work well here because they have relatively high current noise, and the input load impedance is high. Even the venerable 741 does better than the LM4562 opamp; the latter works very well with low impedances but is a really bad choice here. Be aware that the recent devices are only available in surface-mount packages (NB, the AD8655 is the single version of the AD8656 dual opamp). Factoring in cost and the availability of a DIP version, the OPA2134 is the recommended part here. I have used it very successfully in bass guitar amplifiers.

It is instructive to see how the noise performance varies with the parameters in Figure 12.6. If we use the OPA2134, then Table 12.2 shows how the EIN increases as pickup inductance increases. Table 12.3 demonstrates how the EIN increases as the pickup series resistance increases, as you would expect. The 'load synth advantage' column is explained further on.

Table 12.4 shows how EIN increases as the load resistance across the pickup Rin decreases.

Counter-intuitively, EIN worsens as the load resistance decreases; see Chapter 9 for explanation.

TABLE 12.2 How EIN increases with pickup inductance; Rin = 1 MΩ

Opamp	Coil Lgen Henrys	Coil Rgen Ohms	EIN dBu	20x load synth advantage dB
OPA2134	1	5000	−110.84	1.91
OPA2134	1.5	5000	−109.44	3.25
OPA2134	2	5000	−108.15	4.39

TABLE 12.3 How EIN increases with pickup series resistance; Rin = 1 MΩ

Opamp	Coil Lgen Henrys	Coil Rgen Ohms	EIN dBu	20x load synth advantage dB
OPA2134	1.5	1000	−110.28	4.42
OPA2134	1.5	5000	−109.44	3.25
OPA2134	1.5	10,000	−108.57	2.47

TABLE 12.4 How EIN increases as load resistance Rin decreases; Rgen = 5 kΩ

	Coil Lgen = Henrys	Rin Ohms	EIN dBu	20x load synth advantage dB
OPA2134	1.5	100,000	−107.40	6.75
OPA2134	1.5	500,000	−108.32	4.98
OPA2134	1.5	1,000,000	−109.44	3.25
OPA2134	1.5	2,000,000	−110.52	2.14
OPA2134	1.5	5,000,000	−111.57	1.06

Now, about those load-synthesis columns. Load synthesis is a way of decoupling the physical resistance of a resistor from its loading value. See Chapter 9 for how this works to reduce noise. The rightmost column of Tables 12.3 and 12.4 show how the advantage varies with pickup inductance and pickup series resistance. You can also see in the fourth column of Table 12.4 that EIN improves as the value of Rin increases. Using 20-times load synthesis (ie the actual resistor is 20 times the loading on the pickup) gives a loading effect of 1 MΩ but a noise-generating resistance of 20 MΩ, which is quieter. It gives a quite significant reduction in noise; with the values shown in Figure 12.6 there is a 3.25 dB improvement. The advantage increases with pickup inductance. Load synthesis is described in detail in Chapter 9.

Guitar preamplifier noise: measurements

Calculations are all very well, but sooner or later you will have to do some measurements and face up to the real world. As a baseline I took the circuit of Figure 12.5 (at maximum gain

of +29.9 dB) with a short-circuit across the input; GUITARNOISE gives an EIN for these conditions of −116.1 dBu. Measurements gave noise out of −85.7 dBu (usual conditions) and so an EIN= −115.6 dBu, which is about as close as you are likely to get in this imperfect world. Being a cautious person, I repeated the measurement with a 1 kΩ input termination. GUITARNOISE gives EIN= −115.1 dBu, while the measured EIN was −114.8 dBu. This is reassuring but a long way from the real highly inductive input loading.

Verifying the calculations leading to the earlier tables is very difficult because pickups are, of course, designed to pick up magnetic fields, and so they do, even in what would be thought to be an electrically quiet environment. Using standard (non-humbucking) pickups, the noise is utterly submerged in hum at 50 Hz and all its harmonics, I estimate by at least 30 dB. The ideal test load would be a tapped (to vary the inductance) toroidal inductor inside several nested mumetal boxes, but that is not a component often found on the shelf or indeed anywhere else.

My attempted solution was magnetic screening, so I got hold of a thick piece of steel pipe (apparently known as 'barrel' rather than 'pipe' in the construction business because of its greater thickness, resembling the barrel of a gun) and put the pickup inside it. The pipe section I used was 242 mm long, 47 mm outside diameter, 5 mm wall thickness. It came from a building site so is presumably ordinary mild steel. It is a substantial piece of metal weighing 1.1 kg, and you wouldn't want to drop it on your foot. See Figure 12.7 for the arrangement. I have to say that this did not work very well. Various standard (non-humbucking) pickups were tried, but the circuit noise was still completely dominated by 50 Hz hum and harmonics, by some 20 dB.

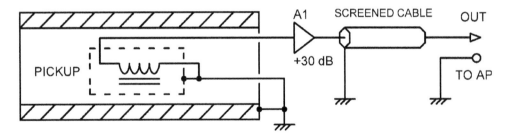

Figure 12.7 **A (failed) attempt at noise measurement, with magnetic screening by a length of steel pipe.**

Having failed with a standard pickup, the obvious recourse is to use a humbucking pickup. The one I obtained is an Entwhistle X2-B (neck version) [13], which has a DC resistance of 7870 Ω on one winding and 8450 Ω on the other; I have no idea why they are different. The inductance is unknown, but taking 1 Henry total (both coils) as a guesstimate, EIN calculates as −108.4 dBu, which gives −78.5 dBu at the amplifier output. An OPA2134 opamp was used.

The pickup is naturally about twice the size of a simple pickup and so regrettably would not fit into the same steel pipe. Using the amplifier in Figure 12.5, at its maximum gain of +30 dB, and just one half of the humbucker, the hum output was −45 dBu. Using both halves to get the humbucking action, the output was −59.9 dBu, which just goes to show that humbucking really works. However, this was still way above the noise level.

The pickup has its external metal bracket grounded, but for some reason only two of the twelve pole-pieces are grounded. Electric fields were clearly contributing to the effect of magnetic fields. Putting both the preamp and the pickup in a completely screened metal box solved this problem and reduced the hum level to −70.5 dBu in a 22–22 kHz bandwidth, and real white noise was now visible. There was no magnetic shielding. Switching in the 400 Hz third-order highpass filter in the AP reduced the reading to −78 dBu, and the GUITARNOISE calculation (more or less) aligns with measurement. The spectral distribution of noise and hum from the humbucking pickup and the effect of the 400 Hz filter are shown in Figure 12.8.

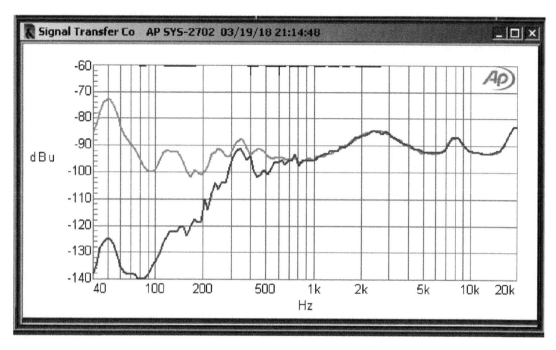

Figure 12.8 Spectral distribution of noise and hum from a humbucking pickup after +30 dB of amplification. The lower trace at left is with the 400 Hz filter engaged.

It would be very desirable to repeat this with a range of humbucking pickups, but buying them would soon get expensive. The conclusion so far is that it will be a real struggle to get the interference acquired from the pickup below the noise floor of the amplifier. Given this situation, it is questionable if anything will be gained by using the new and expensive FET-input opamps. The OPA2134 would seem appropriate for even high-end guitar amplifiers. It seems unlikely that load synthesis will give tangible benefits in this application and become popular for guitar inputs, but in audio you never know . . .

Guitar amplifiers and guitar effects

Electric guitars are traditionally operated into valve amplifiers, often with integral loudspeakers. The amplifier distortion and the frequency response of the speaker can radically alter the sound

to the extent that it is sensible to regard the guitar/amp combination as a single instrument. An alternative approach is to run the guitar directly into a mixing console without any amplification, (see the next section on "Guitar direct injection") and if desired put through an amplifier later.

Electric guitars are commonly used with effects boxes between guitar and amplifier. These exist in profusion but can be roughly classified thus:

- Altered dynamics: compressors, limiters, and swell (volume control) pedals.

- Added distortion: produced by fuzz-boxes, hard clipping. The hexafuzz, which as noted earlier, requires a hexaphonic pickup. Soft clipping using diodes, JFETs, or LEDs. My own contribution in 1975 was the Sound Folder, which made precisely zero penetration into the marketplace.

- Altered frequency response: the most popular of these effects is the wah-wah pedal, which moves a resonant peak up and down in frequency. Its popularity is due to the way it partially emulates the movement of formants [14] in human speech and singing. A more extreme version is the voice box (also called talk box or voice bag) where a tube from a small speaker in a box is placed in the mouth, and mouth movements move the resonances up and down. As several performers have found out the hard way, excessive bass levels tend to make you throw up.

- Modulation: this vague term covers phasing, flanging, tremolo (amplitude modulation), and vibrato (frequency modulation). It also covers the ring modulator, in which one sound is multiplied with another. The ring part refers to the ring of four diodes used in the original versions.

- Time manipulation: includes looping boxes, which allow a musical phrase to be repeated endlessly, straightforward delays, and reverberation.

- Altered pitch: digital pitch-shifters [15] and auto-tune [16] devices.

There are many possibilities, and a comprehensive outfit of effect boxes can easily add up to a dozen or more, and to avoid endless plugging and unplugging at gigs, they are usually fixed to a guitar pedalboard. Sometimes it is a good idea to make the last box in the chain a noise gate. According to the Guinness Book of Records the world's largest pedalboard holds 319 effects.

Guitar direct injection

Direct injection (or DI) refers to running the guitar output directly into a mixing console without the use of an amplifier. The problem is that the microphone input will not be likely to have an input impedance greater than 2 kΩ, which puts far too much loading on a pickup. A line input will have a higher input impedance, probably greater than 10 kΩ, but this is still far too low for a pickup.

There are passive and active DI boxes. A passive DI box contains a transformer with a suitably high turns ratio that makes the mixer input look like a high impedance to the pickup and usually converts the output to a balanced format. A typical arrangement is shown in Figure 12.9, using the Jensen JT-DB-E transformer, which is a specialised design for this application. The turns

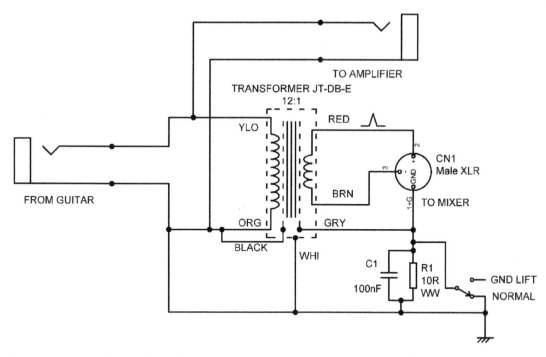

Figure 12.9 Passive DI box using transformer.

ratio is 12:1, giving an impedance transform ratio of 12 squared = 144 times. This turns the 1 kΩ input impedance of a mixer mic input into 144 kΩ, which is more like a reasonable load on a guitar pickup. The output is balanced and at a low impedance and so long cable runs can be used without capacitance losses or the ingress of interference.

Most DI boxes have a direct output that can be plugged into an amplifier while the clean signal is sent to the mixer. Most also have a ground-lift switch which separates the guitar ground from the mixer ground. This implies that there IS a guitar ground, which is of course essential for safety, or you may die standing up in a very literal manner. On the few occasions when I have been called upon to design in a ground-lift facility, I have always used a wirewound resistor for R1 so that it will not fail open-circuit on minor transients. The capacitor C1 ensures that RF still goes to ground when the switch is open. Some DI boxes include switched or variable attenuators to prevent overload of a mic input.

Active DI boxes do not use a transformer but instead an amplifier to buffer the pickup from the mixing console and provide a balanced output. They are usually battery powered to maintain ground isolation.

References

[1] Skow, V. https://wgsusa.com/ultimate-5-pickup-fender-stratocaster-worlds-most-versatile-guitar Accessed Sept 2019

[2] Wikipedia. https://en.wikipedia.org/wiki/Pickup_(music_technology) Accessed Sept 2019

[3] Wikipedia. https://en.wikipedia.org/wiki/Humbucker Accessed Sept 2019

[4] Wikipedia. https://en.wikipedia.org/wiki/Humbucker#Alternative_humbucker_designs Accessed Sept 2019

[5] YouTube. www.youtube.com/watch?v=Jodhm5mvvqE Roland GR-100 Accessed Aug 2019

[6] Joness, W. S. www.joness.com/gr300/G-707.html Accessed Aug 2019

[7] Hiscocks, P. www.syscompdesign.com/wp-content/uploads/2018/09/guitar-pickups.pdf Accessed Aug 2019

[8] Stewmac. www.stewmac.com/Pickups_and_Electronics/Components_and_Parts/Switches/ Accessed Sept 2019

[9] Wikipedia. https://en.wikipedia.org/wiki/Guitar_wiring Accessed Sept 2019

[10] Shootout. www.shootoutguitarcables.com/guitar-cables-explained/capacitance-chart.html Accessed Sept 2019

[11] Wikipedia. https://en.wikipedia.org/wiki/Driven_guard Accessed Sept 2019

[12] Vogel, B. *The Sound of Silence*, 2nd edition. Springer-Verlag, 2011, pp. 220–224. ISBN 978-3-642-19773-4 hbk; ISBN 978-3-642-19774-1 ebk (Neumann PUE 74 preamplifier)

[13] Entwhistle. www.entwistlepickups.com/pickup.php?puid=X2 Accessed Sept 2019

[14] Wikipedia. https://en.wikipedia.org/wiki/Formant Accessed Sept 2019

[15] Wikipedia. https://en.wikipedia.org/wiki/Pitch_shift Accessed Sept 2019

[16] Wikipedia. https://en.wikipedia.org/wiki/Auto-Tune Accessed Sept 2019

Volume controls

Volume controls

A volume control is the most essential knob on a preamplifier—in fact the unhappily named 'passive preamplifiers' usually consist of nothing else but a volume control and an input selector switch. Volume controls in one guise or another are also freely distributed on the control surfaces of mixing consoles, examples being the auxiliary sends and the faders.

A volume control for a hifi preamplifier needs to cover at least a 50 dB range, with a reasonable approach to a logarithmic (ie linear-in-dB) law, and have a channel balance better than ±1 dB over this range if noticeable stereo image shift is to be avoided when the volume is altered.

The simplest volume control is a potentiometer. These components, which are invariably called 'pots' in practice, come with various control laws, such as linear, logarithmic, anti-logarithmic, and so on. The control law is still sometimes called the 'taper,' which is a historical reference to when the resistance element was actually physically tapered, so the rate of change of resistance from track-end to wiper could be different at different angular settings. Pots are no longer made this way, but the term has stuck around. An 'audio-taper' pot usually refers to a logarithmic type intended as a volume control.

All simple volume controls have the highest output impedance at the wiper at the −6 dB setting. For a linear pot this is when the control is rotated halfway towards the maximum, at the 12 o'clock position. For a log pot it will be at a higher setting, around 3 o'clock. The maximum impedance is significant because it usually sets the worst-case noise performance of the following amplification stage. The resistance value of a volume control should be as low as possible given the loading/distortion characteristics of the stage driving it. This is sometimes called 'low-impedance design.' Lower resistances mean

1) Less Johnson noise from the pot track resistance.

2) Less noise from the current-noise component of the following stage.

3) Less likelihood of capacitive crosstalk from neighbouring circuitry.

4) Less likelihood of hum and noise pickup.

Voltage noise is not affected.

DOI: 10.4324/9781003332985-13

Volume control laws

What constitutes the optimal volume control law? This is not easy to define. One obvious answer is a strictly logarithmic or linear-in-dB law, but this is in fact somewhat less than ideal, as an excessive amount of the pot rotation is used for very high and very low volume settings that are rarely used. It is therefore desirable to have a law that is flatter in its central section but falls off with increasing rapidity towards the low volume end—see the fader law later in this chapter. Sometimes the law steepens at the high-volume end as well, but this is somewhat less common.

A linear pot is a simple thing—the output is proportional to the angular control setting, and this is usually pretty accurate, depending only the integrity of the mechanical construction. Since the track is uniform resistance, its actual resistance makes no difference to the proportionality of the output unless it is significantly loaded by an external resistance. Unfortunately, a linear volume control law is quite unsatisfactory. The volume is only reduced from maximum by 6 dB at the half-way rotation point, but the steepness of the slope accelerates as it is turned further down. This can be seen as Trace 1 in Figure 13.3. Linear pots are usually given the code letter "B". See Table 13.1 for more code letters.

Log pots are not, and do not attempt to be, precision attenuators with a fixed number of dB attenuation for each 10 degrees of shaft rotation. The track is not uniform but is made up of two or three linear slopes that roughly approximate a logarithmic law produced by superimposing two or three sections of track made with different resistivity material. If two slopes are used the overlap is towards the bottom end of the control setting, typically at 20% of full rotation; see Figure 13.1. The two materials of different resistivity have to match for the desired law to be obtained, and close matching is difficult to achieve, so log controls are rather less satisfactory in terms of accuracy; much more on that later. Looking at the log pot trace in Figure 13.1, we can see that the volume at half-rotation is now 20%, or 14 dB down, which is not really a great improvement on the 6 dB down we get with a linear pot. Log pots are usually given the code letter "A".

Anti-logarithmic pots are the same only constructed backwards so that the slope change is at the top end of the control setting; these are typically used as gain controls for amplifying stages rather than as volume controls. These pots are usually given the code letter "C".

There is a more extreme version of the anti-logarithmic law where the slope change occurs at 10% of rotation instead of 20%. These are useful where you want to control the gain of an amplifying stage over a wide range and still have something like a linear-in-dB control law. Typically they are used to set the gain of microphone input amplifiers, which can have a gain range of 50 dB or more. These pots are given the code "RD", which stands for reverse D-law; I don't think I have ever come across a non-reverse D-law. Some typical laws are shown in Figure 13.1.

TABLE 13.1 **Pot law identification letters**

ALPS Code letter	Pot characteristic
A	Logarithmic
B	Linear
C	Anti-logarithmic
RD	Reverse-log

Please note that the code letters are not adhered to quite as consistently across the world as one might hope. The codes given Table 13.1 are those used by ALPS, one of the major pot makers, but other people use quite different allocations; for example Radiohm, another major manufacturer, calls linear pots A and log pots B, but they agree that anti-log pots should be called C. Radiohm have several other laws called F, T, S, and X; for example, S is a symmetrical law apparently intended for use in balance controls. It clearly pays to check very carefully what system the manufacturer uses when you're ordering parts.

The closeness of approach to an ideal logarithmic law is not really the most important characteristic of a volume control; spreading out the most-used middle region is more useful. Of greater importance is the matching between the two halves of a stereo volume control. It is common for the channel balance of log pots to deteriorate quite markedly at low volume settings, causing the stereo image to shift as the volume is altered. You may take it from me that customers really do complain about this, and so a good deal of ingenuity has been applied in attempts to extract good performance from indifferent components.

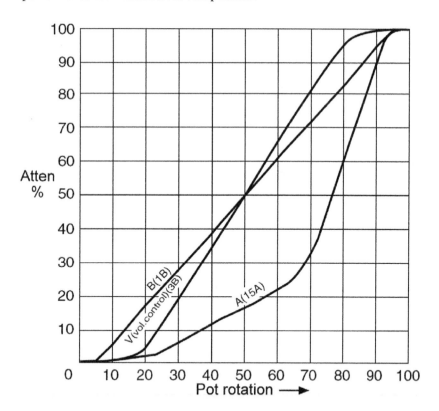

Figure 13.1 The control laws of typical linear and log pots.

An important point in the design of volume controls is that their offness—the amount of signal that gets through when the control is at its minimum—is not very critical. This is in glaring contrast to a level control such as an auxiliary send on a mixer channel (see Chapter 22), where the maximum possible offness is very important indeed. A standard log pot will usually have an

offness in the order of −90 dB with respect to fully up, and this is quite enough to render even a powerful hifi system effectively silent.

Loaded-linear pots

Since ordinary log pots are not very accurate, many other ways of getting a log law have been tried. Trace 1 in Figure 13.3 (for a linear pot with no loading) makes it clear that the use of an unmodified linear law for volume control really is not viable; the attenuation is all cramped up at the bottom end. However, a good approximation to a logarithmic law can be made by loading the wiper of a linear pot with a fixed resistor R1 to ground, as shown in Figure 13.2.

Adding a loading resistor much improves the law, but the drawback is that this technique really only works for a limited range of attenuation—in fact it only works well if you are looking

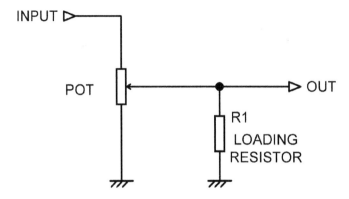

Figure 13.2 Resistive loading of a linear pot to approximate a logarithmic law.

for a control that varies from around 0 to −20 dB. It is therefore suitable for power amp level controls and aux master gain controls (see Chapter 22 for details of the latter) but is unlikely to be useful for a preamplifier gain control which needs a much wider logarithmic range. Figure 13.3 shows how the law varies as the value of the loading resistor is changed, and it is pretty clear that whatever its value, the slope of the control law around the middle range is only suitable for emulating the ideal log law labelled "20". The value of the loading resistor for each trace number is given in Table 13.2.

TABLE 13.2 The loading resistor values used with a 10 kΩ pot in Figure 13.3

Trace number	Loading resistor R1 value
1	None
2	4k7
3	2k2
4	1 kΩ

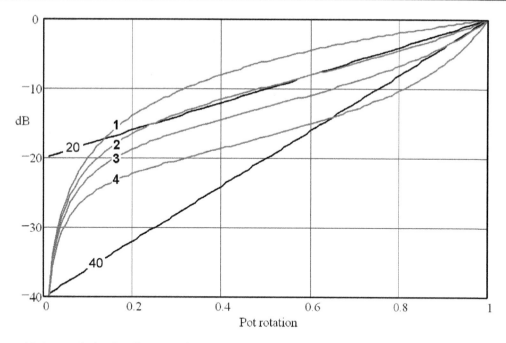

Figure 13.3 Resistive loading of a linear pot: the control laws plotted.

Figure 13.3 shows that with the optimal loading value (Trace 2), the error in emulating a 0 to −20 dB log range is very small, lying within ±0.5 dB over the range 0 to −16 dB; below this the error grows rapidly. This error for Trace 2 only is shown in Figure 13.4.

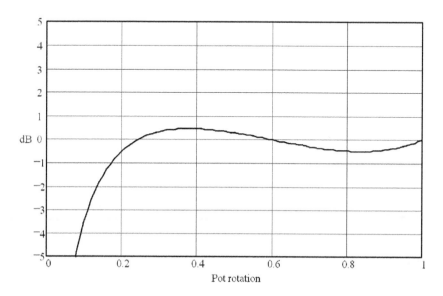

Figure 13.4 Loading of a linear pot: the deviation from an ideal 20 dB log law of Trace 2 in Figure 13.3.

Obtaining an accurate law naturally relies on having the right ratio between the pot track resistance and the loading resistor. The resistance of pot tracks is not controlled as closely as fixed resistors, their tolerance usually being specified as ±20%, so this presents a significant balance-shift problem. The only solution would seem to be making the loading resistor trimmable, and this approach has been used in a master volume control by at least one console manufacturer.

Figure 13.5 shows the effect on the control law of a ±20% pot track tolerance, with a loading resistor of 4k7 that is assumed to be accurate (Trace 2 in Figure 13.3). With the pot track 20% low in value, the loading resistor has less effect, and we get the dotted line above the solid (nominal) line. If it is 20% high the loading resistor has more effect, giving the lower dotted line. The error around the middle of control rotation is about ±0.7 dB, which is quite enough to give perceptible balance errors in a stereo volume control. If you are unlucky enough to have the two tracks 20% out in opposite directions, the error will be 1.4 dB.

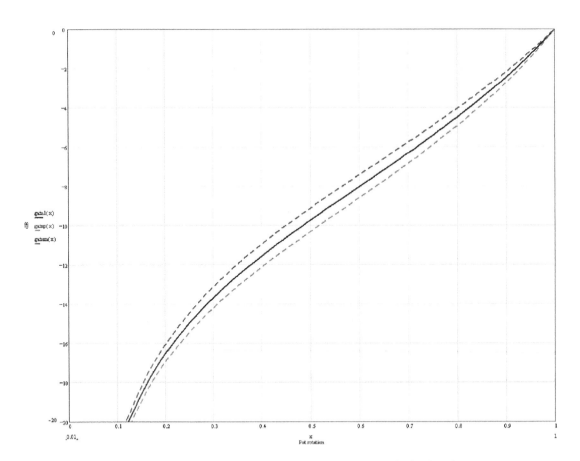

Figure 13.5 The effect of a ±20% pot track tolerance, with 4k7 resistive loading.

Another snag to this approach is that when the control is fully up, the loading resistor is placed directly across the input to the volume control, reducing its impedance drastically and possibly

causing unhappy loading effects on the stage upstream. However the main problem is that you are stuck with a 0 to −20 dB range, inadequate for a volume control on a preamplifier.

The following stage must have a high enough impedance to not significantly affect the volume control law; this obviously also applies to plain logarithmic pots and to all the passive controls described here.

Dual-action volume controls

In the previous section on loaded-linear pots, we have seen that the control law is only acceptably logarithmic over a limited range—too limited for effective use as a volume control in a preamplifier or as a fader or send control in a mixer. One way to fix this is the cascading of pots, so that their attenuation laws sum in dB. This approach does, of course, require the use of a four-gang pot for stereo, which may be objectionable because of increased cost, possible problems in sourcing, and a worsened volume-control feel. Nonetheless the technique can be useful, so we will give it a quick look.

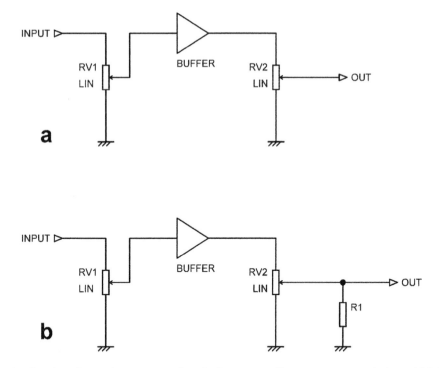

Figure 13.6 Dual-action volume controls: a) shows two linear pots cascaded, and b) is a linear pot cascaded with a loaded-linear pot.

It is assumed there is no interaction between the two pots, so the second pot does not directly load the wiper of the first. This implies a buffer stage between them, as shown in Figure 13.6. There is no need for this to be a unity-gain stage, and in fact several stages can be interposed between the two pots. This gives what is usually called a *distributed gain control*, which can be configured to give a better noise/headroom compromise than a single volume control.

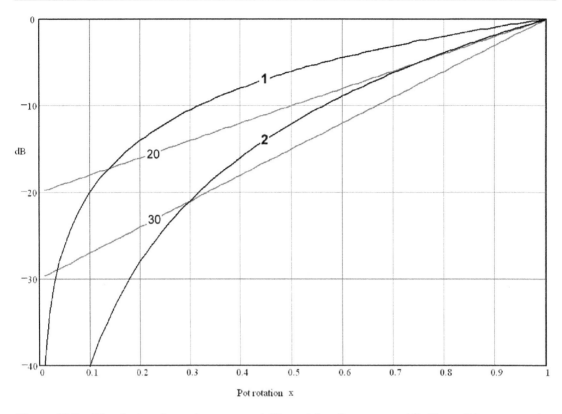

Figure 13.7 The dual-action volume control: Trace 1 is a linear pot, while Trace 2 is a square-law obtained by cascading two ganged linear pots with buffering between them.

Figure 13.7 shows a linear law (Trace 1) and the square-law (Trace 2) made by cascading two linear pots. 20 dB and 30 dB ideal log lines are shown for comparison, and it is pretty clear that while the square-law is much more usable than the linear law, it is still a long way from perfect. It does, however, have the useful property that, assuming the wiper is very lightly loaded by the next stage, the gain is dependent only upon control rotation and not the ratio between fixed 1% resistors and a ±20% pot track resistance. Figure 13.8 shows the deviation of the square-law from the 30 dB line; the error peaks at just over + 3 dB before it plunges negative.

A *much* better attempt at a log law can be made by cascading an unloaded linear pot with a loaded-linear pot; the resulting law is shown in Figure 13.9. Trace 1 is the law of the linear pot alone, and Trace 2 is the law of a loaded-linear 10 kΩ pot with a 2.0 kΩ loading resistor R1 from wiper to ground, alone. The combination of the two is Trace 3, and it can be seen that this gives a very good fit to a 40 dB ideal log line, and good control over a range of at least 35 dB.

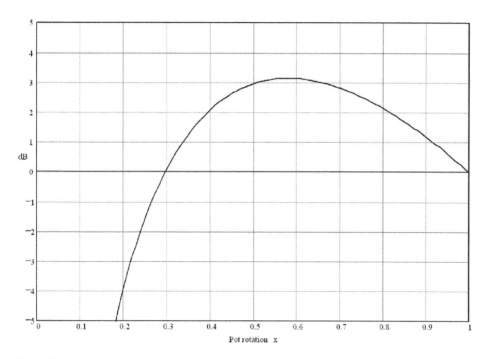

Figure 13.8 Dual-action volume control: the deviation of the square-law from the ideal 30 dB log line.

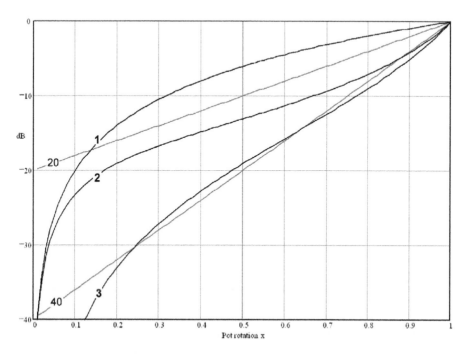

Figure 13.9 Dual-action volume control with improved law: linear pot cascaded with loaded-linear pot. Trace 3 is the combination of Traces 1 and 2 and closely fits the 40 dB log line.

Figure 13.10 shows the deviation of the combined law from the 40 dB line; the law error now peaks at just over ±1 dB. Unfortunately, adding the loading resistor means that once more the gain is dependent on the ratio between a fixed resistor and the pot track resistance.

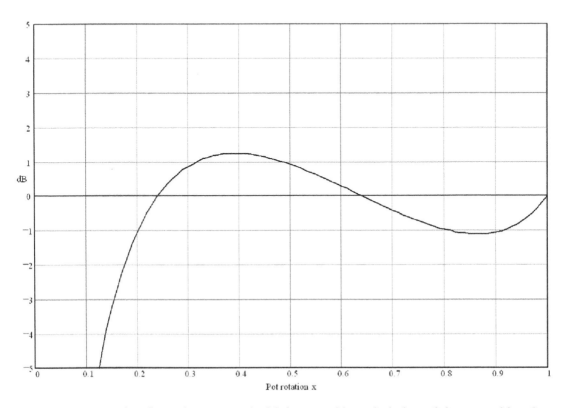

Figure 13.10 Dual-action volume control with improved law: deviation of the control law from the ideal 40 dB log line. Much better than Figure 13.8.

Passive volume controls of various types can, of course, also be cascaded with an active volume control stage, and this can be a good way to obtain a desired control law. This is dealt with later in this chapter.

Tapped volume controls

The control law of a linear pot can be radically altered if it has a centre-tap (see Chapter 22 for the use of tapped pots for LCR panning). This can be connected to a potential divider that has a low impedance compared with the pot track resistance, and the attenuation at the tap point altered independently of other parameters. Figure 13.11 shows both unloaded and loaded versions of the arrangement.

The unloaded version shown in Figure 13.11a is arranged so that the attenuation at the tap is close to −20 dB. This gives the law shown in Figure 13.12; it approximates to a 33 dB log line, but there is an abrupt change of slope as the pot wiper crosses the tapping point.

Note that the track resistance has to be a good deal higher than that of the fixed resistors so that they control the level at the tap. This means that with the values shown the source impedance at the wiper can be as high as 12.5 kΩ when it is halfway between the tap and one end, and this may degrade the noise performance, particularly if the following stage has significant current noise. A

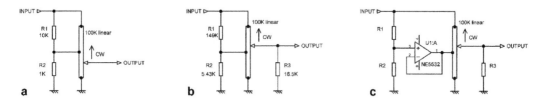

Figure 13.11 Tapped volume control: a) unloaded; b) loaded; c) with active control of tap voltage.

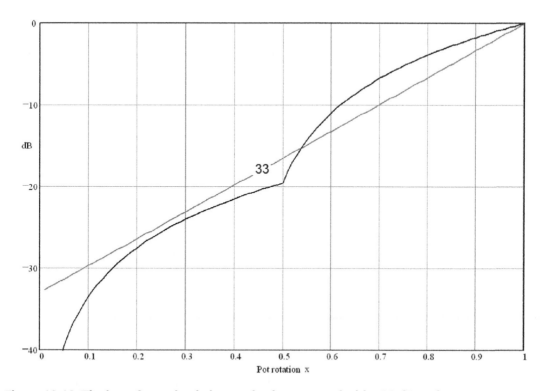

Figure 13.12 The law of an unloaded tapped volume control with −20 dB at the tap.

normal 10 kΩ pot, of whatever law, has a maximum output impedance of only 2.5 kΩ. To match this figure the values shown would have to be scaled down by a factor of five, so that R1 = 2 k, R2 = 200 Ω, and the track resistance is a more normal 10 kΩ. This scaling is quite practical, the load on the previous stage now being 1.62 kΩ.

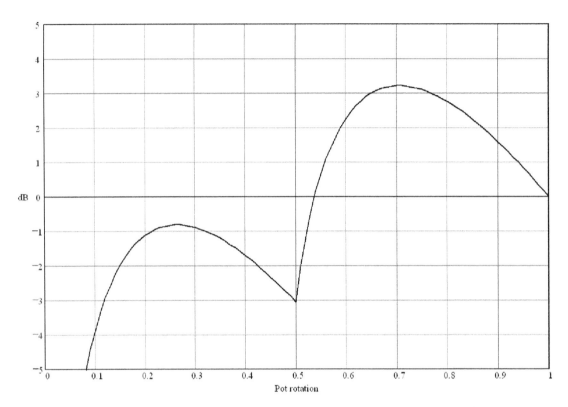

Figure 13.13 The deviation of the unloaded tapped volume control law from an ideal 33 dB log line.

The error is shown in Figure 13.13. This version of a tapped linear volume control covers a range of about 30 dB and almost keeps the errors within ±3 dB; but that abrupt change of slope at the tap point is somewhat less than ideal.

A much better approach to a log law is possible if a loading resistor is added to the wiper, as with the loaded-linear pot already examined. See Figure 13.11b for the circuit arrangement, and Figure 13.14 for the control law. If the resistors are correctly chosen, using the ratios given in Figure 13.11b, the law can be arranged to have no change of slope at the tapping, and the deviation from a 40 dB ideal line will be less than 1 dB over the range from 0 to −38 dB. The exact values of the resistors are given rather than the nearest preferred values. It is clear that this is a very effective way of giving an accurate law over a wide range, and it is widely used in making high-quality

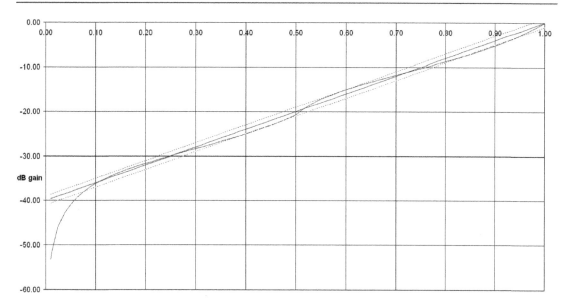

Figure 13.14 The law of a loaded and tapped volume control with −20 dB at the tap. The dotted lines show the width of a ±1 dB error band around the 40 dB ideal line.

slide faders, using multiple taps and a conductive plastic track. Note that the accuracy still depends on good control of the track resistance value compared with the fixed resistors.

If the value of the resistors connected to the tap is such that the loading effect on the previous stage becomes excessive, one possible solution is shown in Figure 13.11c, where the R1 and R2 are kept reasonably high in value, and a unity-gain opamp buffer now holds the tap point in a vice-like grip due to its low output impedance. The disadvantage is that the noise of the opamp, and of R1 in parallel with R2, is fed directly through at full level when the wiper is near the tap. Often this will be at a lower level than the noise from the rest of the circuitry, but it is a point to watch. Note that because of the low-impedance drive from the opamp, the values of the fixed resistors will need to be altered from those of Figure 13.11b to get the best control law.

If the best possible noise performance is required, then it is better to increase the drive capability of the previous stage and keep the resistors connected to the tap low in value; if this is done by paralleling opamps then the noise performance will be improved rather than degraded.

Slide faders

So far as the design of the adjacent circuitry is concerned, a fader can normally be regarded as simply a slide-operated logarithmic potentiometer. Inexpensive faders are usually made using the same two-slope carbon film construction as are rotary log volume controls, but the more expensive and sophisticated types use a conductive plastic track with multiple taps connected to a resistor ladder, as described in the previous section. This allows much better control over the fader law.

High-quality faders typically have a conductive plastic track, contacted by multiple gold-plated metal fingers to reduce noise during movement. A typical law for a 104 mm travel fader is shown in Figure 13.15. Note that a fader does not attempt to implement a linear-in-dB log scale; the attenuation is spread out over the top part of the travel and much compressed at the bottom. This puts the greatest ease of control in the range of most frequent use; there is very little point in giving a fader precise control over signals at −60 dB.

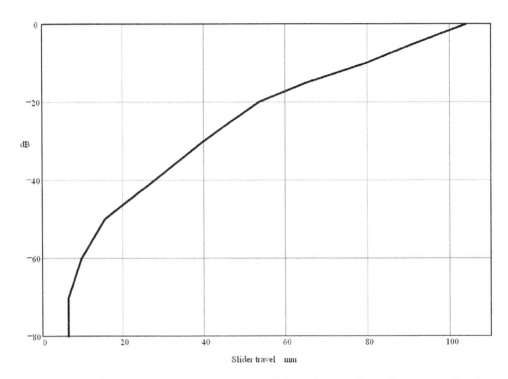

Figure 13.15 **A typical control law for a 104 mm fader, showing how the attenuation is spread out over the upper part of the travel.**

Figure 13.16a shows the straightforward construction used in smaller and less expensive mixers. There is some end resistance Ref at the bottom of the resistive track which compromises the offness, and it is further compromised by the voltage drop down the resistance Rg of the ground wire that connects the fader to the channel PCB. To fix this a so-called 'infinity-off' feature is incorporated into the more sophisticated faders.

Figure 13.16b shows an infinity-off fader. When the slider is pulled down to the bottom of its travel, it leaves the resistive track and lands on an end-section with a separate connection back to the channel module ground. No signal passes down this ground wire, and so there is no voltage drop along its length. This arrangement gives extremely good maximum attenuation, orders of magnitude better than the simple fader, though of course 'infinity' is always a tricky thing to claim.

Faders are sometimes fitted with fader-start switches; these are microswitches which are actuated when the slider moves from the 'off' position. Traditionally these started tape cartridge machines; now they may be used to trigger digital replay.

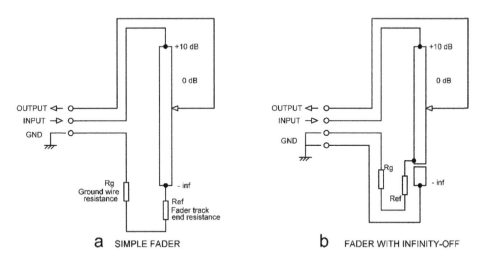

Figure 13.16 **A simple fader a) and a more sophisticated version at b) with an 'infinity-off' section to maximise offness.**

Active volume controls

Active volume controls have many advantages. As explained in the section on preamplifier architectures, the use of an active volume control removes the dilemma concerning how much gain to put in front of the volume control and how much to put after it. An active gain control must fulfil the following requirements:

1) The gain must be smoothly variable from a maximum, usually well above unity, down to effectively zero, which in the case of a volume control means at least −70 dB. This at once rules out series-feedback amplifier configurations as these cannot give a gain of less than one, unless combined with a following passive control. Since the use of shunt feedback implies a phase inversion, this can cause problems with the preservation of absolute polarity.

2) The control law relating shaft rotation and gain should be a reasonable approximation to a logarithmic law. It does not need to be strictly linear-in-decibels over its whole range; this would give too much space to the high-attenuation end, say around −60 dB, and it is better to spread out the middle range of −20 to −50 dB, where the control will normally be used. These figures are naturally approximate as they depend on the gain of the power amplifier, speaker sensitivity, and so on. A major benefit of active gain controls is that they give much more flexible opportunities for modifying the law of a linear pot than does the simple addition of a loading resistor, which was examined and found somewhat wanting earlier in this chapter.

3) The opportunity to improve channel balance over the mediocre performance given by the average log pot should be firmly grasped. Most active gain controls use linear pots and arrange the circuitry so that these give a quasi-logarithmic law. This approach can be configured to remove channel imbalances due the uncertainties of dual-slope log pots.

4) The noise gain of each amplifier involved should be as low as possible.

5) As for passive volume controls, the circuit resistance values should be as low as practicable to minimise Johnson noise and capacitive crosstalk.

Figure 13.17 shows a collection of possible active volume configurations, together with their gain equations. Each amplifier block represents an inverting stage with a large gain of -A, ie enough to give plenty of negative feedback at all gain settings. It can be regarded as an opamp with its non-inverting input grounded. Figure 13.17a simply uses the series resistance of a log pot to set the gain. While you get the noise/headroom benefits of an active volume control, the retention of a log pot with its two slopes and resulting extra tolerances means that the channel balance is no better than that of an ordinary passive volume control using a log pot. It may, in fact, be worse, for the passive volume control is truly a potentiometer, and if it is lightly loaded differences in track resistance due to process variations should at least partially cancel, and one can at least rely on the gain being exactly 0 dB at full volume. Here, however, the pot is actually acting as a variable resistance, so variations in its track resistance compared with the fixed R1 will cause imbalance; the left and right gain will not even be the same with the control fully up. Given that pot track resistances are usually subject to a ±20% tolerance, it would be possible for the left and right channel gains to be 4 dB different at full volume. This configuration is really not recommended.

Figure 13.17b improves on Figure 13.17a by using a linear pot and attempting to make it quasi-logarithmic by putting the pot into both the input and feedback arms around the amplifier. It is assumed that a maximum gain of 20 dB is required; it is unlikely that a preamplifier design will require more than that. The result is the law shown in Figure 13.18, which can be seen to approximate fairly closely to a linear-in-decibels line with a range of −24 to +20 = 44 dB. This is a result of the essentially square-law operation of the circuit, in which the numerator of the gain equation increases as the denominator decreases. This is in contrast to the loaded-linear pot case described earlier, which approximates to a 20 dB line.

The deviation of the control law from the 44 dB line is plotted in Figure 13.19, where it can be seen that between control rotations of 0.1 and 1, and a gain range of almost 40 dB, the maximum error is ±2.5 dB. This sort of deviation from an ideal law is not very noticeable in practice. A more serious issue is the way the gain heads rapidly south at rotations less than 0.1, with the result that volume drops rapidly towards the bottom of the travel, making it more difficult to set low volumes to be where you want them. Variations in track resistance tend to cancel out for middle volume settings, but at full volume the gain is once more proportional to the track resistance and therefore subject to large tolerances.

The configuration in Figure 13.17c also puts the pot into an input arm and a feedback arm, but in this case in separate amplifiers; the feedback arm of A1 and the input arm of A2. It requires two amplifier stages, but as a result the output signal is in the correct phase. When configured with R = 10 kΩ, R1 = 10 kΩ, R3 = 1 kΩ, and R4 =10 kΩ, it gives exactly the same law as Figure

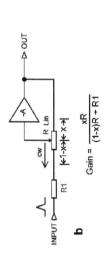

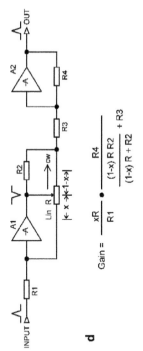

b

$$\text{Gain} = \frac{xR}{(1-x)R + R1}$$

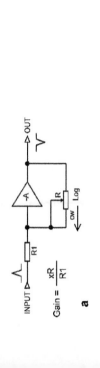

a

$$\text{Gain} = \frac{xR}{R1}$$

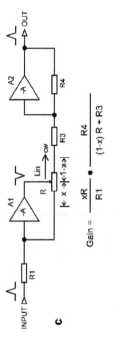

c

$$\text{Gain} = \frac{xR}{R1} \bullet \frac{R4}{(1-x)R + R3}$$

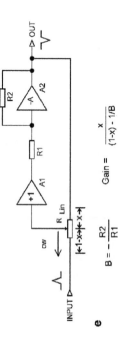

d

$$\text{Gain} = \frac{xR}{R1} \bullet \frac{R4}{\dfrac{(1-x)R\,R2}{(1-x)R + R2} + R3}$$

e

$$\text{Gain} = \frac{x}{(1-x) - 1/B}$$

$$B = -\frac{R2}{R1}$$

Figure 13.17 Active volume control configurations.

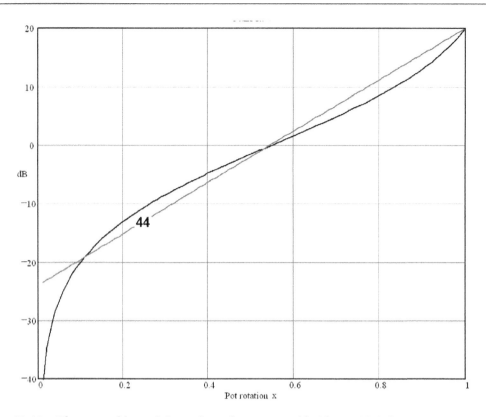

Figure 13.18 The control law of the active volume control in Figure 13.17b.

13.17b, with the same maximum error of ±2.5 dB. It therefore may seem as a pointless extra complication, but in fact the extra resistors involved give a greater degree of design freedom.

In some cases a linear-in-decibels line with a range of 44 dB, which is given by the active gain stages already looked at, is considered too rapid; less steep laws can be obtained from a modified version of Figure 13.17c, by adding another resistor R2 to give the arrangement in Figure 13.17d. This configuration was used in the famous Cambridge Audio P50 integrated amplifier, introduced in 1970. When R2 is very high, the law approximates to that of Figure 13.17c; see Trace 1 in Figure 13.20. With R2 reduced to 4 kΩ, the law is modified to Trace 2 in Figure 13.20; the law is shifted up, but in fact the slope is not much altered, and is not a good approximation to the ideal 30 dB log line, labelled "30". When R2 is reduced to 1 kΩ, the law is as Trace 3 in Figure 13.20 and is a reasonable fit to the ideal 20 dB log line, labelled "20". Unfortunately varying R2 can do nothing to help the way that all the laws fall off a cliff below a control rotation of 0.1, and in addition the problem remains that the gain is determined by the ratio between fixed resistors, for which a tolerance of 1% is normal, and the pot track resistance, with its ±20% tolerance. For this reason none of the active gain controls considered so far are going to help with channel balance problems.

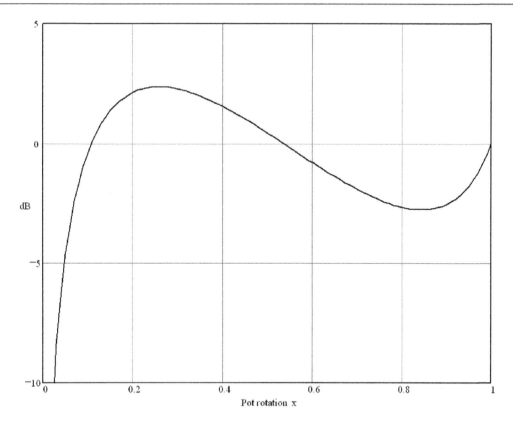

Figure 13.19 **The deviation of the control law in Figure 13.18 from an ideal 44 dB logarithmic line.**

The Baxandall active volume control

The active volume control configuration in Figure 13.17e is due to Peter Baxandall. Like so many of the innovations conceived by that great man, it authoritatively solves the problem it addresses [1]. Figure 13.21 shows the law obtained with a maximum gain of +20 dB; the best-fit ideal log line is now 43 dB. There is still a rapid fall-off at low control settings.

You will note that there are no resistor or track resistance values in the gain equation in Figure 13.17e; the gain is only a function of the pot rotation and the maximum gain set up by R1, R2. As a result quite ordinary dual linear pots can give very good channel matching. When I tried a number of RadioOhm 20 mm diameter linear pots, the balance was almost always within 0.3 dB over a 46 dB gain range, with occasional excursions to an error of 0.6 dB.

However, the one problem that the Baxandall configuration cannot solve is channel imbalance due to mechanical deviation between the wiper positions. I have only once found that the Baxandall configuration did not greatly improve channel balance; in that case the linear pots I

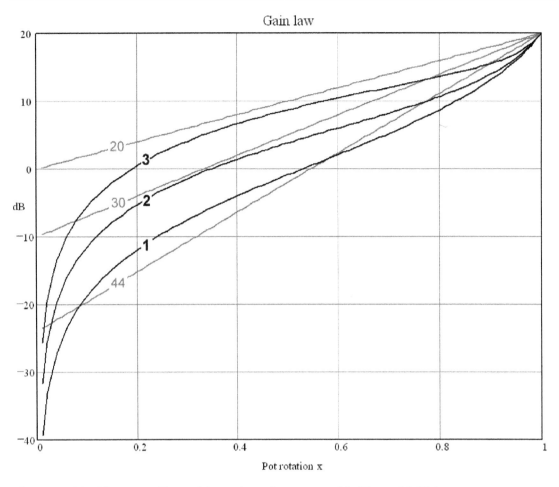

Figure 13.20 The control law of the active volume control in Figure 13.17d.

tried, which came from the same Chinese source as the log pots that were provoking customer irritation, had such poor mechanical alignment that the balance improvement obtained was small and not worth the extra circuitry. Be aware that there are some nasty dual pots out there that have appreciable backlash between the two sections, and clearly the Baxandall approach cannot help with that.

Note that all the active gain configurations require a low-impedance drive if they are to give the designed gain range; don't try feeding them from, say, the wiper of a balance control pot. The Baxandall configuration inherently gives a phase inversion that can be highly inconvenient if you are concerned to preserve absolute phase, but this can be undone by an inverting tone-control stage. Such as the Baxandall type . . .

An important point is that while at a first glance the Baxandall configuration looks like a conventional shunt feedback control, its action is modified by the limited gain set by R1 and R2. This means that the input impedance of the stage falls as the volume setting is increased but does

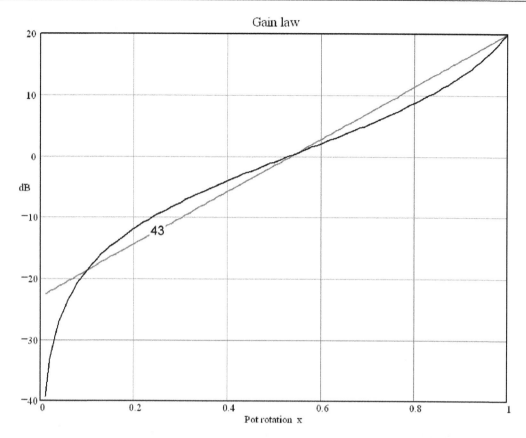

Figure 13.21 The control law of the +20 dB Baxandall active volume control in Figure 13.17e.

not drop to zero. With the values shown in Figure 13.23, input impedance falls steadily from a maximum of 10 kΩ at zero gain to a minimum of 1.27 kΩ at maximum gain. If the preceding stage is based on a 5532 it will have no trouble driving this. Another consequence of the gain of the A2 stage is that the signals handled by the buffer A1 are never very large. This means that R1, and consequently R2, can be kept low in value to reduce noise without placing an excessive load on the buffer.

All the active volume controls examined here, including the otherwise superior Baxandall configuration, give a gain law that falls very rapidly in the bottom tenth of control rotation. It is not easy to see that there is any cure for this.

The Baxandall volume control law

While the Baxandall configuration has several advantages, it is not perfect. One disadvantage is that the gain/rotation law is determined solely by the maximum gain, and it is not possible to bend it about by adding resistors without losing the freedom from pot-value dependence.

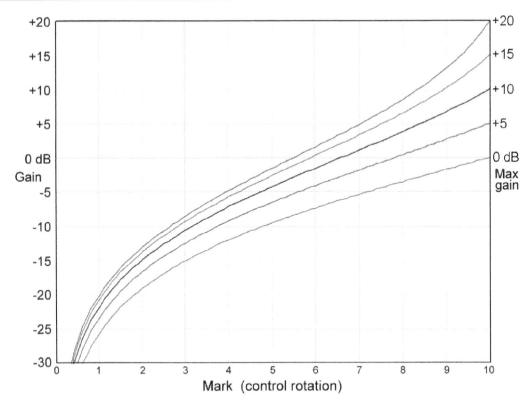

Figure 13.22 **The gain law of a Baxandall volume control stage depends only on the maximum gain; plotted here for maximum gains of 0, +5, +10, +15 and +20 dB.**

Figure 13.22 shows the control laws for different maximum gains. Pot rotation is described here as Marks from Mk 0 to Mk 10 for full rotation. No provision is made for rock bands seeking controls going up to Mk 11 [2]. Changing the maximum gain has a much smaller effect on the gain at the middle setting (Mk 5).

Very often a maximum gain of +10 dB is required in preamplifier design, giving us −4 dB with the volume control central. In this case the control law is rather flat, with only 14 dB change of gain in the top half of control rotation. The +10 dB law approximates closely to a linear-in-decibels line with a range of −18 to +10 = 28 dB. This has a shallower slope than the 43 dB log line shown in Figure 13.21 and is not ideal for a volume control law. Things can be much improved by combining it with a linear law; more on this later.

A practical Baxandall active volume stage

I have designed several preamplifiers using a Baxandall active volume control [3–6]. The practical circuitry I employed for [4] is shown in Figure 13.23; this includes DC-blocking arrangements to deal with the significant bias currents of the 5532 opamp. The maximum gain is set to +17 dB by the ratio of R1, R2, to amplify a 150 mV line input to 1 V with a small safety margin.

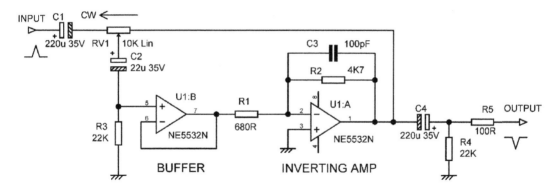

Figure 13.23 **A practical Baxandall active volume control with DC-blocking, as used in the Precision Preamplifier '96.**

TABLE 13.3 Noise performance of active gain control at various volume settings

Setting	Noise out
Zero gain	−114.5 dBu
Unity gain	−107.4 dBu
Full volume	−90.2 dBu

This active volume-control stage gives the usual advantages of lower noise at gain settings below maximum and excellent channel balance that depends solely on the mechanical alignment of the dual linear pot—all mismatches of its electrical characteristics are cancelled out. Note that in both the preamplifier designs referenced here all the pots were identical at 10 kΩ linear, apart from the question of centre detents, which are desirable only on the balance, and treble and bass boost/cut controls.

The component values given here are as used in the Precision Preamplifier '96 [4]. Compared with [3], noise has been reduced slightly by an impedance reduction on the gain-definition network R1, R2. The limit on this is the ability of buffer U1:B to drive R1, which has a virtual-earth at its other end. C3 ensures HF stability if there are excess phase shifts due to stray capacitance. C1 prevents any DC voltages from circuitry upstream from reaching the volume-control stage. The input bias current of U1:B will produce a small voltage drop across R3, and C2 prevents this from reaching the control pot. Since two terminals of the pot are DC-blocked, it is now permissible to connect the third terminal directly to the output of U1:A as no current can flow through the control. The offset voltage at the output of U1:B will be amplified by U1:A but should still be much too small to have any significant effect on available voltage swing, and it is prevented from leaving this stage by DC-blocking capacitor C4. R4 is a drain resistor to prevent voltage building up on the output due to leakage through C4, and R5 ensures stability by isolating the stage from load capacitance downstream, such as might be caused by the use of screened cable. Note that R4 is connected before R5 to prevent any loss of gain. The loss is, of course, very small in one stage, but it can build up irritatingly in a large system if this precaution is not observed. Table 13.3 gives the noise performance.

The figure at full volume may look a bit mediocre, but results from the use of +17 dB of gain; at normal volume settings the noise output is well below −100 dBu.

Low noise Baxandall active volume stages

One of the themes of this book is the use of multiple opamps to reduce noise, exploiting the fact that noise from uncorrelated sources partially cancels. The Baxandall volume stage lends itself very well to this technique, which is demonstrated in Figure 13.24. The first version at a) improves on the basic design in Figure 13.23 by using two inverting amplifiers instead of one and reducing the value of the pot from 10 kΩ to 5 kΩ. Bear in mind that the latter change reduces the input impedance proportionally, and it can fall to low values (1.2 kΩ in this case) with the volume control at maximum. The outputs of the two inverting amplifiers are averaged by the 10 Ω resistors R4 and R7, and the noise from them partially cancels. The noise from the unity-gain buffer U1:A is not reduced because it is reproduced identically by the two inverting amplifiers. C1 and R1 prevent the input bias current of the buffer from flowing through the pot wiper and causing rustling noises. This volume control stage was used in the variable-frequency-tone-control preamplifier published in Jan Didden's *Linear Audio*, Volume 5 [5].

Note that in Figure 13.24a there is a spare opamp section floating in space. If this is not required elsewhere in the signal path, pressing it into use as another inverting amplifier will usually give more noise reduction than doubling up the buffer.

Figure 13.24b shows a more sophisticated design for still lower noise, using four inverting amplifiers and four separate buffers. There is nothing to be gained by averaging the buffer outputs before applying the signal to the inverting amplifiers, as the partial cancellation of buffer noise is carried out later by the 10 Ω resistors R103, etc, just as for the inverting amplifier noise. Four inverting amplifiers have enough drive capability to make it feasible to reduce the volume pot right down to 1 kΩ for lower noise without any distortion problems. DC-blocking components were not deemed to be required at the buffer inputs because the bias currents are flowing through low resistances. This stage was used in my Elektor Preamplifier 2012 design [6], and as for all the stages in this preamplifier, a really serious attempt was made to make the noise as low as was reasonably practical. There are no great technical difficulties in using an even lower pot value, such as 500 Ω, but there are sourcing problems with dual-gang pots of less than 1 kΩ.

The measured noise performance for a single-inverting amplifier stage (Figure 13.23 with maximum gain reduced to +10 dB) and the stages in Figure 13.24 is summarised in Table 13.4. I think you will agree that the noise levels are very low, especially for the quad version. While the reduction in noise on adding amplifiers is not perhaps very dramatic, it is as bullet-proof as any electronic procedure can be.

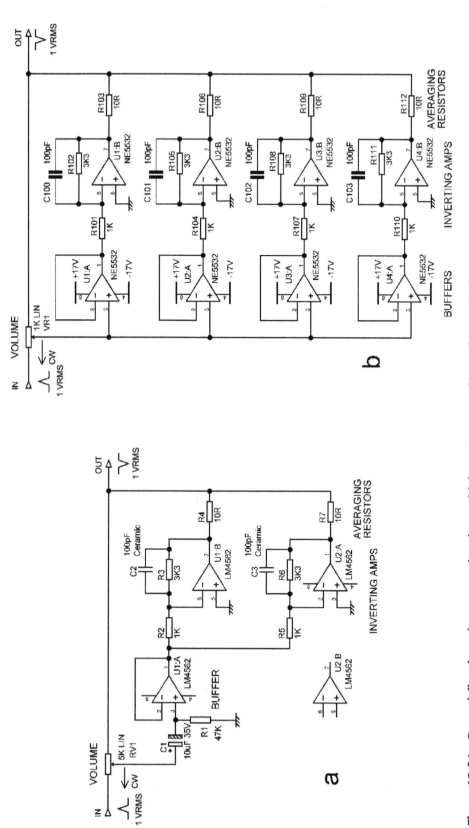

Figure 13.24 Baxandall active volume controls using multiple opamps to reduce noise. a) single buffer, dual inverting amps and 5 kΩ pot; b) quad buffer, quad inverting amps and 1 kΩ pot. Maximum gain +10 dB in both cases.

TABLE 13.4 Measured noise output from the volume control stages in Figure 13.24

Volume setting (Mark)	Single-amp control (+10 dB max)	Dual-amp control (Figure 13.24a)	Quad-amp control (Figure 13.24b)
10	−107.3 dBu	−109.0 dBu	−112.1 dBu
9	−109.4 dBu	−110.3 dBu	−114.1 dBu
8	−111.1 dBu	−112.4 dBu	−115.7 dBu
7	−112.7 dBu	−113.7 dBu	−117.1 dBu
6	−113.8 dBu	−114.7 dBu	−118.1 dBu
5	−115.0 dBu	−116.9 dBu	−119.4 dBu
4	−116.1 dBu	−115.7 dBu	−120.8 dBu
3	−117.1 dBu	−118.1 dBu	−122.1 dBu
2	−117.9 dBu	−118.4 dBu	−123.0 dBu
1	−118.8 dBu	−119.8 dBu	−124.2 dBu
0	−119.8 dBu	−121.4 dBu	−126.1 dBu

Readings corrected by subtracting −119.2 dBu testgear noise. Bandwidth 22 Hz–22 kHz, RMS sensing, unweighted.

The Baxandall volume control: loading effects

With circuits like the Baxandall volume stage that are not wholly obvious in their operation, it pays to keep a wary eye on all the loading conditions. We will take the dual amplifier volume control stage Figure 13.24a as an example. There are three loading conditions to consider.

Firstly, the input impedance of the stage. This varies from the whole pot track resistance at Mk 0, to a fraction of this at Mk 10, that fraction being determined by the maximum gain of the stage. It falls proportionally with control rotation as the volume setting is increased. Figure 13.25 shows how the minimum input impedance becomes a smaller proportion of the track resistance as the maximum gain increases. With a maximum gain of +10 dB the minimum input impedance is 0.23 times the track resistance, which for a 5 kΩ pot gives 1.2 kΩ. If the preceding stage is based on a 5532 or an LM4562 it will have no trouble at all in driving this load.

Secondly, the loading on the buffer stage U1:A. A consequence of the gain of the two inverting amplifiers U1:B, U2:A stage is that the signals handled by the unity-gain buffer U1:A are never very large; less than 3 Vrms if output clipping is avoided. This means that R2, R3 and R5, R6 can all be kept low in value to reduce noise without placing an excessive load on unity-gain buffer U1:A, which would cause increased distortion at high levels.

Thirdly, the loading on the inverting stages U1:B, U2:A. At Mk 10 the loading is a substantial fraction of the value of the pot, but it gets heavier as volume is reduced, as demonstrated in the rightmost column of Table 13.5. We note thankfully that the loading stays at a reasonable level over the mid volume settings. Only when we get down to a setting of Mk 1 does the load get down to a slightly worrying 383 Ω; however at this setting the attenuation is −21.6 dB, so even a maximum input of 10 Vrms would only give an output of 830 mV. We also have two opamps in

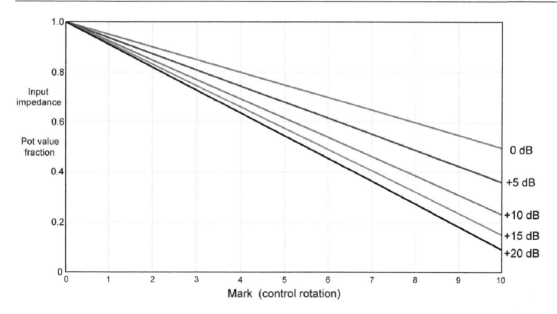

Figure 13.25 **The input impedance of the volume control stage as a proportion of the pot track resistance falls more rapidly when the stage is configured for higher maximum gains.**

parallel to drive the load, so the load on each one is an acceptable 766 Ω. Note that the loading considered here is only that of the pot on the inverting stages. The inverting opamps also have to drive their own feedback resistors R3 and R6, which are effectively grounded at the other end, and this should be taken into account when working out the total loading. U1:B, U2:A also have to drive whatever load is connected to the volume control stage output; it is likely to be the final stage in the preamplifier and may be connected directly to the outside world.

Table 13.5 shows the gain, impedances, and the noise output at the various control settings.

TABLE 13.5 **Volume stage gain, noise, input impedance, and gain stage loading versus control setting for Figure 13.24a**

Control position (Mk)	Gain dB	Noise output dBu	Input impedance Ω	Opamp load Ω
10	+10.37	−109.0	1162	3900
9	+6.98	−110.3	1547	3456
8	+4.03	−111.4	1929	3069
7	+1.29	−112.7		2687
6	−1.38	−113.7		2305
5	−4.11	−114.9	3083	1918
4	−7.07	−115.7		1534
3	−10.48	−117.1		1151
2	−14.83	−118.4		767
1	−21.61	−119.8		383
0	−infinity	−121.4	5000	

Corrected for AP noise at −119.2 dBu. Measurement bandwidth 22 Hz–22 kHz, RMS sensing, unweighted.

I haven't bothered to fill in all the entries for input impedance, as it simply changes proportionally with control setting as seen in Figure 13.25, ranging from the minimum of 1162 Ω to 5 kΩ, the resistance of the pot track.

Going back to the loading on the inverting opamps at low volume, we have 383 Ω at Mk 1, which is 766 Ω per opamp and no cause for alarm. However, I have heard doubts expressed about a possible rise in distortion at very low volume settings below this because the inverting amplifiers U1:B, U2:A then see even lower load impedances. The impedances may be low, but the current to be absorbed by the inverting stages is actually very limited because almost the whole of the pot track is in series with the input at low settings. To prove there is not a problem here, I set the volume to Mk 1 and pumped 20 Vrms in, getting 1.6 Vrms out. The THD residual was indistinguishable from the genmon output of the AP SYS-2702. In use the input cannot exceed about 10 Vrms as it comes from an opamp upstream.

To push things further, I set the volume to Mk 0.2, (ie only 2% off the end-stop) and pushed in 20 Vrms again to get only 300 mVrms out. The THD+N residual was 0.0007%, composed entirely of noise with no trace of distortion. I then replaced the 4562s in the U1:B, U2:A positions with Texas 5532s (often considered the worst make for distortion), and the results were just the same except the noise level was a bit higher giving a THD+N of 0.0008%. There is not a problem here.

An improved Baxandall active volume stage with lower noise

It may have occurred to you that the Baxandall volume control is difficult to improve upon, its only obvious disadvantage being the rather flat control law. However, consider Figure 13.23 and Figure 13.24a; in both cases a unity-gain buffer is used so the relatively low impedance of the inverting stages does not load the pot wiper. As I have written elsewhere, a unity-gain buffer that does nothing but buffer always strikes me as rather underemployed, but I did not take the thought further.

On the 14 June 2018 I received an email from Jake Thomas, who *did* take the thought further. He pointed out that all of the buffer noise was amplified by the full gain of the inverting stage. It is not a lot, as the voltage-follower is the most benign configuration for noise; the noise gain is unity, and there are no resistors to generate Johnson noise or have opamp current noise flowing through them. However, it is amplified by the full gain of the inverter. The inverter stage in itself is relatively noisy, as its voltage noise is amplified by a noise gain of the signal gain +1. To see how this works, look at row 1 of Table 13.6; current noise and Johnson noise are not included in the calculation as they are very low at the impedance levels used here. The use of 5532/2 opamps is assumed, and a single inverter opamp is used. Noise is calculated at maximum gain for simplicity.

In row 1 the voltage noise of the unity-gain buffer stage is calculated from the voltage noise density to be 0.74 uVrms in the usual 22 kHz 25°C conditions. The noise from the inverter stage alone is the same voltage multiplied by the noise gain; at the maximum gain of +10 dB

(3.3 times) this noise gain is 3.3 + 1 = 4.3 times. This works out to 3.19 uVrms. Taking this noise and adding it in RMS-fashion to the buffer noise multiplied by the inverter signal gain gives a total noise output of 4.02 uVrms, equal to −105.72 dBu. This fits in with measured results.

TABLE 13.6 Improving noise by moving gain from the inverter to the buffer stage, 5532/2 opamps

Row	Buffer Vn uV	Buffer noise gain x	Buffer noise o/p uV	Inverter gain x	Inverter noise gain x	Inverter noise o/p uV	Total noise o/p uV	Total noise o/p dBu	Advantage dB	Max gain dB
1	0.74	1	0.74	3.3	4.3	3.19	4.02	−105.70	0	10.37
2	0.74	1.6	1.19	2	3	2.22	3.25	−107.54	1.57	10.10
3	0.74	3.2	2.37	1	2	1.48	2.80	−108.85	2.88	10.10

The insight of Jake Thomas was that there was no reason that the buffer had to be unity gain; if it was given some voltage gain this would increase the signal level applied to the inverter, allowing its gain to be reduced. The noise gain of the non-inverting first stage is the signal gain and not the signal gain + 1, making the amplification process quieter. In row 2, the unity-gain buffer stage is changed to a non-inverting stage with a gain of 1.6 times by adding two feedback resistors, and the gain of the inverter is reduced to 2 times, bringing the total gain back to 3.2 times. This reduces the total noise output to −107.54 dBu, an improvement of 1.84 dB at the cost of two resistors. The non-inverting stage retains its buffering function, presenting a high input impedance to the pot wiper.

In row 3, we take things all the way and transfer all the gain to the first stage; the second stage becoming a unity-gain inverter, as shown in Figure 13.26. This improves the noise performance at maximum volume by another 1.31 dB, for a total advantage over the standard circuit of 2.88 dB, once more at the cost of only two resistors. One downside of this approach is that the first stage is non-inverting and so has a large common mode voltage on its inputs which may lead to increased distortion, depending on the opamp type.

Note that the maximum gain is slightly less for the two improved versions; it is as close as one gets using single E24 resistors. This has been allowed for when calculating the noise advantage.

Recalculating for the LM4562 opamp, which has a much lower voltage noise of 0.40 uVrms gives exactly the same numbers in the advantage column, as we are manipulating voltage noise in the same way. However, the total noise output is reduced to −111.05 dBu in row 1, −112.89 dBu in row 2, and −114.20 dBu in row 3. This is approximately a 6 dB improvement in each case.

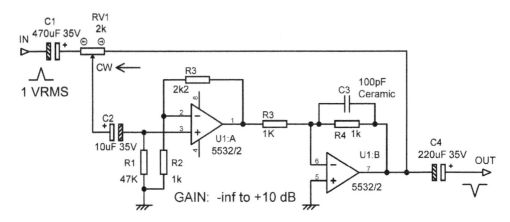

Figure 13.26 Baxandall active volume with gain transferred to first stage to reduce noise.

The principle is naturally not confined to stages with a maximum gain of +10 dB. Redoing the calculations for a maximum gain of +20 dB gives very similar results, with a maximum improvement (with all gain in the first stage) of 3.27 dB.

All credit goes to Jake Thomas for thinking this up. I am quite happy for this to be called the Baxandall-Thomas active gain control. Perhaps if we add a passive output attenuator (see the next section for why this is a very good idea) we might call it the Baxandall-Self-Thomas active gain control and take on the world.

Baxandall active volume stage plus passive control

One of the few disadvantages of the Baxandall volume control is that, unlike passive volume controls, the noise output is not absolutely zero when the volume is set to zero. Whatever the configuration, at least the voltage noise of the opamps will appear at the output. This limitation applies to all active volume controls. The only other real drawback of the Baxandall control is the control law, which as we saw earlier is rather too flat over its upper and middle ranges when configured for the popular maximum gain of +10 dB. The law cannot be modified with fixed resistors without introducing pot-dependence.

Both of these problems can be solved by putting a passive linear volume control after the active volume stage, with the two pots ganged together. This obviously means a four-gang control, but the benefits are worth it. The noise level is now really zero at Mk 0 because the wiper of the linear pot is connected to ground.

Furthermore, the combination of the linear law with that of the Baxandall control gives a steeper characteristic which approximates to a linear-in-decibels line with a range of −32 to +10 = 42 dB, which is much more usable than the 28 dB line of the Baxandall control alone. See Figure 13.27.

This arrangement is also free from pot-dependence, so the gain depends only on the angular setting of the ganged control. However, this will no longer hold if the wiper of the final passive pot is significantly loaded. In practice a high-input-impedance output buffer stage

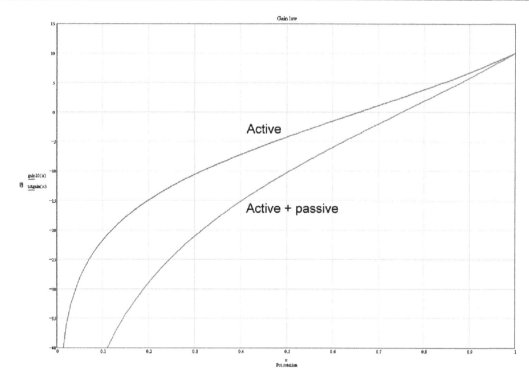

Figure 13.27 Baxandall active volume and active + passive control laws.

may be required, and this compromises the 'zero noise at zero volume' property. On the other hand, a unity-gain buffer opamp is working in the best possible conditions for low noise, having no feedback resistors to introduce Johnson noise or convert opamp current noise to voltage noise. The source impedance for the buffer is usually non-zero, as it is fed from the wiper of the passive pot, but this can be made low in value as the multiple inverting amplifiers in the Baxandall stage give plenty of drive capability. Multiple buffers in parallel with output averaging resistors would reduce the noise further; four buffers would reduce the zero-volume noise output by 6 dB. The passive pot does not have to be directly after the active volume control; intermediate stages could be inserted if required, giving a distributed volume control.

I have to say this idea is not exactly brand-new. I first used it in consultancy work in, I think, 1982.

A practical version of this arrangement is shown in Figure 13.28, where both pots are 2 kΩ. This gives a maximum output impedance of 500 Ω (with the control set halfway = Mk 5), which allows 24 metres of 100 pF/m cable before the HF response drops by 0.1 dB at 20 kHz. If this is adequate (and it certainly will be for most people) there is no need for an output buffer, whose presence would mean there would no longer be zero noise at zero volume. The same applies if you add an inverting stage to create a balanced input.

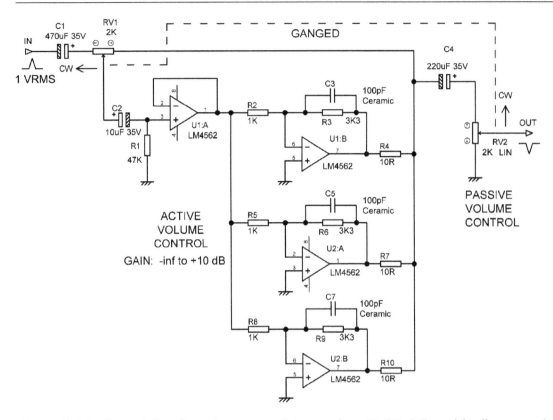

Figure 13.28 **Baxandall active volume control (max gain +10 dB) followed by linear passive output attenuator.**

In this case a 3-path Baxandall control is used, which has in itself an intermediate noise performance between the 2-path and 4-path versions in Table 13.4. Because of the three inverters, there is more than enough capability to drive RV1, RV2, and any likely external load. There is some more discussion of this approach in *Self on Audio* [7, 8].

While this technique gives a good volume law (and I have done quite a bit of knob-twiddling listening to confirm that), it does have some disadvantages. The extra expense of a four-gang pot is obvious, but there is another drawback which is slightly less so.

As noted earlier, the great advantage of an active gain control is that it only provides the amount of gain required. However, we have now added a stage of passive attenuation, so there will be some impairment of headroom. Assume that in the circuit of Figure 13.28 the volume control is set for unity total gain, a control setting of Mark 7.5; the active Baxandall stage will have a gain of + 2.4 dB, while the passive section will be attenuating by −2.4 dB. Therefore 2.4 dB of headroom is lost in the final attenuator.

The overlap penalty

Obviously, we would like to tailor the gain and attenuation laws so that the loss of headroom is as small as possible and exists over as small a range of volume settings as possible. The obvious way to do this is to arrange the gain law of the output attenuator so that as we turn down the volume it does not introduce any attenuation until the Baxandall stage has reached unity gain. The difference between this ideal state and reality (as in Figure 13.29) I call the overlap penalty as it results from the gain law overlapping with the attenuation law. It has nothing to do with the game of soccer or the arcane provisions of its offside rule. See Chapter 8 for another example.

However, we are limited to linear pots if we want to eliminate pot-dependency and retain channel matching that is as accurate as mechanical alignment permits. The Baxandall stage has its law fixed by its maximum gain and nothing else. Likewise, to avoid pot-dependency we cannot start pulling about the law of the output attenuator by adding fixed resistors (it is assumed in Figure 13.28 that RV2 faces an input impedance that is very high compared with the pot track resistance and so is unloaded). Therefore it is hard to see what can be done.

Or is it? The obvious but expensive solution is to replace both the pots in Figure 13.28 with switched resistor ladders, as described later in this chapter. The Baxandall stage and the output attenuator can then have whatever law you can think up, and it is straightforward to arrange things so the output attenuator is only attenuating when the Baxandall stage has unity gain or less. I designed a rather advanced preamplifier for a client that used this method with four ganged 48-way switch wafers, actuated either by a stepper motor or a manual knob. Since one position really MUST be used as a mechanical stop to avoid traumatic lurches from silence to full volume, we are left with 47 volume positions. Both the Baxandall and output attenuator ladders were composed of 47 Ω resistors to emulate linear pots, and no attempt was made to tweak the overall volume law. It seems to work very nicely as it is. This gave a total resistance in the Baxandall ladder of 2162 Ω and in the output attenuator 1410 Ω; there are fewer resistors in the latter because its top half does not attenuate, and the switch contacts there are simply wired together. These values are an implementation of low-impedance design and gave pleasingly low noise.

Figure 13.29 demonstrates how this method works. Above position 31, where the overall gain is unity, the 'passive' curve stays at 0 dB. Therefore the 'active' and 'active+ passive' curves are the same and overlaid in the diagram. Below position 31, the passive output attenuator begins to act, improving the volume control law and giving the much-desired condition of zero noise out at zero volume.

Or does it? As the design stands, the output is taken directly from the moving contact of the output attenuator. The maximum output impedance of 329 Ω occurs at position 17, half-way down the resistor ladder, as expected (not halfway down the control travel because the top half consists of links). Such a resistance produces Johnson noise at −126.9 dBu (usual conditions), which is not quite zero but will be negligible compared with the overall noise performance.

While this is a reasonably low output impedance, it is rather greater than the usual 47 Ω or 56 Ω recommended in this book and would not be suitable for driving long cables. To reduce it an

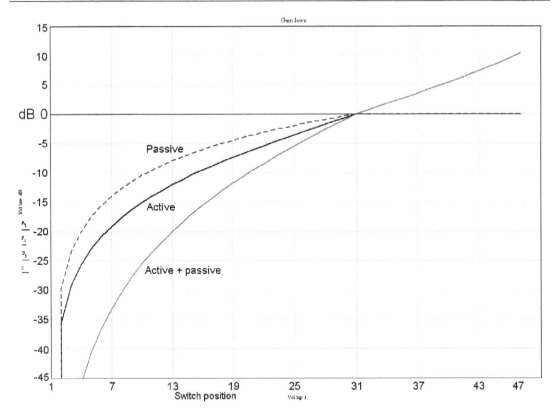

Figure 13.29 **Baxandall active volume and passive output attenuator arranged for zero overlap penalty.**

output buffer is necessary, which will introduce noise of its own that cannot be turned down to zero. This could be a zero-impedance buffer, as described in Chapter 19. The output is, of course, unbalanced; if a balanced output is required then both an output buffer and an inverter will be needed, with further compromise on the zero volume noise floor.

Let's put some numbers to this. In the preamplifier mentioned earlier, the output noise at zero volume measured −119.4 dBu (usual conditions) with the Audio Precision noise subtracted. Adding a unity-gain output buffer in the form of a 5532/2 voltage-follower increased this only to −116.8 dBu, which I hope you will agree is still extremely quiet. This is because a voltage-follower gives only the voltage noise of the opamp. A shunt mode 5532/2 inverter with 1 kΩ input and feedback resistors was further added, driven from the output buffer to avoid loading on the output attenuator, to give a balanced output. The output noise was then measured between the Hot output and the Cold (inverted) output and −111.8 dBu obtained. This is not quite so good and stems from the 2-times noise gain of the inverter and the opamp current noise flowing in the input and feedback resistors. It is still very quiet indeed, and it is good to know that supplying a low (or

zero) impedance output or a balanced output does not make a nonsense of having a very low-noise volume control system.

A quadruple bank of 48-way switches may be a near-perfect volume control in many ways, but it is unquestionably expensive. I began to wonder if there might be a way to produce suitably non-overlapping control laws using pots; the saving would be immense.

One possibility considered was the use of the special balance control pots that have one half of the track made of metal (giving no attenuation) and the other a standard resistive track; these are easily available, but the resistive track is usually a log law so balance accuracy may not be great. I am assuming here that you can separately specify that the active section of the quad-pot has a standard linear law or the active section will not work properly; a greater difficulty may be finding a balance control with linear resistive track and a suitably low resistance such as 1 kΩ. This method is illustrated in Figure 13.30. Having special pots made up of standard resistive tracks is usually not too much of a problem. Requests for non-standard tracks are, however, unlikely to be well received unless you promise to buy thousands.

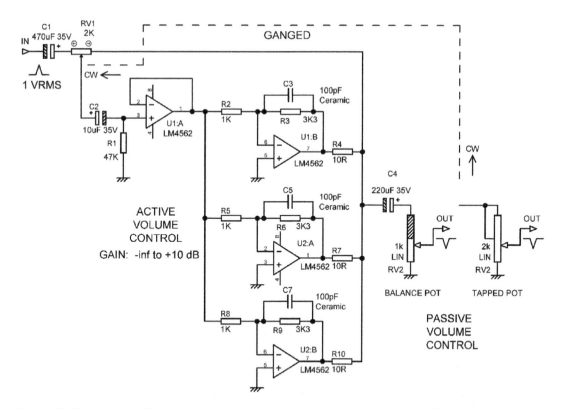

Figure 13.30 Baxandall active volume plus two pot-based methods for eliminating the overlap penalty.

If suitable balance control pots cannot be sourced, another possibility is to use centre-tapped pots. If you take a 2 kΩ centre-tapped pot and connect the tap to the top of the track, you have (up to point) emulated a 1 kΩ pot where the top half causes no attenuation. A snag is that the output impedance of the output attenuator is now no longer zero for all the upper half of its travel. The maximum output impedance now occurs with the wiper 3/4 of the way up and is therefore a quarter of 1 kΩ, which is 250 Ω. In the lower half of wiper travel, the maximum output impedance is likewise 250 Ω, at 1/4 of the way up. This is less than the 329 Ω maximum impedance given by the 48-position switched version and is unlikely to cause noise difficulties. This method is also illustrated in Figure 13.30.

In both cases the gain of the active stage should ideally be unity with the volume control at mid-point (Mark 5) to eliminate the overlap penalty. I'll say right away that I have not tried out either idea in practice due to the difficulty of obtaining one-off samples of odd pots.

Potentiometers and DC

As noted in the previous section, it is never a good idea to have DC flowing through any part of a potentiometer. If there is a DC voltage between the ends of the pot track, there will be rustling noises generated as the wiper moves up and down over minor irregularities in track resistance.

Feeding a bias current through a wiper to the next stage tends to create more serious noise because the variations in wiper contact resistance are greater. This tends to get worse as the track surface becomes worn. This practice is often acceptable for FET-input opamps like the TL072, but it is definitely not a good idea for bipolar opamps such as the 5532 because the bias current is much greater and so therefore is the noise on wiper movement. AC coupling is essential when using bipolar opamps. If you are using electrolytic capacitors, then make sure that the coupling time-constant is long enough for capacitor distortion to be avoided; see Chapter 2.

Belt-ganged volume controls

Sometimes if you want to use a particular fancy type of pot for volume control, you will find that dual versions for stereo are not available. One solution to this is to gang two pots together using toothed belts; it has been done. A possibly more extreme example is the Ayre AX-6 integrated amplifier [9, 10], which has two big Shallco switches (one for each channel) ganged by a toothed belt that is driven by a stepper motor, which is in turn controlled by a front panel rotary encoder. It is quoted as having 46 steps of volume control, suggesting a 48-position switch is being used, with presumably one position for a mechanical stop and one for 'off,' ie infinite attenuation or near enough.

The belt-coupled concept would be valid with pot-based volume controls but will it be accurate enough for good channel balance? When you consider that the printheads on inkjet and dot matrix printers all use toothed belts and achieve dot-placement accuracy better than a few thousandths of an inch all the time, it looks reasonably promising. It might not be quite as good as having two pots on the same solid shaft.

A rather crude way of ganging pots together with wooden levers was presented in *Electronics World* in 2002 [11]. I do not feel this is a promising route to pursue.

Motorised potentiometers

Motorised pots are simply ordinary pots driven by an attached electric motor, heavily geared down and connected to the control shaft through a silicone slipping clutch. This clutch allows manual adjustment of the volume when the motor is off and prevents the motor stalling when the pot hits the end of its travel; limit switches are not normally used. Motorised pots are now considerably cheaper than they used to be due to the manufacture of components in China that represent a very sincere homage to designs by ALPS and others, and they appear in lower to middle-range integrated amplifiers. Motorisation can be added to any control that uses a rotary pot.

In many ways they are the ideal way to implement a remote-controlled volume function. There is no variable gain electronics to add noise and distortion, manual control is always available if you can't find the remote (so-called because it is never to hand), and the volume setting is inherently non-volatile, as the knob stays where it was left when you switch off.

A disadvantage is that the 'feel' of a motorised pot is pretty certain to be worse than a normal control because of the need for the slipping clutch between the control shaft and the motor; a large-diameter weighted knob helps with this. The channel balance is, of course, no better than if the same pot was used as a manual control.

Since the motor has to be able to run in either direction, and it is simplest to run it from a single supply, an H-bridge configuration, as shown in Figure 13.31, is used to drive it. Normally all four transistors are off. To run the motor in one direction Q1 and Q4 are turned on; to run in the other direction Q2 and Q3 are turned on. The H-bridge and associated logic to interface with a microcontroller can be obtained in convenient ICs such as the BA6218 by Rohm. This IC can supply an output current of up to 700 mA. Two logic inputs allow four output modes: forward, reverse, idle (all H-bridge transistors off), and dynamic braking (motor shorted via ground). The logic section prevents input combinations that would turn on all four devices in the H-bridge and create (briefly) electronic mayhem.

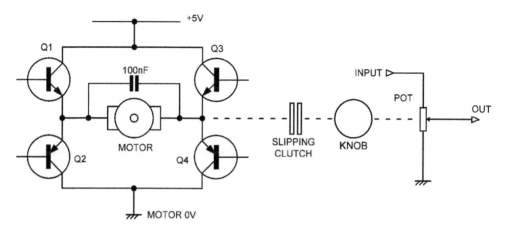

Figure 13.31 Control circuitry for a motorised volume control.

The absence of limit switches means that if continuous rotation is commanded (for example by sitting on the remote) there is the potential for the motor to overheat. It is a wise precaution to write the software so that the motor is never energised for longer than it takes to get from one extreme of rotation to the other, plus a suitable safety margin.

It would appear that there might be problems with electrical noise from the motor getting into the audio circuitry, but I have never encountered this myself. In the usual version the motor is screened with a layer of what appears to be GOSS (grain-oriented silicon steel) to keep magnetic effects under control, and the motor terminals are a long way from the audio terminals. A 100 nF capacitor across the motor terminals, and as close to them as practicable is always a good idea. It is a fact that GOSS was invented by Dr Norman P Goss. The motor should be driven from a separate non-audio supply unless you're really looking for trouble; motorised controls with 5 V motors are popular as they can run off the same +5 V rail as a housekeeping microcontroller. I have never had problems with motor noise interfering with a microcontroller.

Linear faders, as used on mixing consoles, are also sometimes motorised, not for remote control but to allow previously stored fader movements to be played back in an automatic mixdown system. A linear servo track next to the audio track allows accurate positioning of the fader. Motorisation has usually been done by adding a small electric motor to one end of the fader and moving the control knob through a mechanism of string and pulleys that is strongly reminiscent of an old radio dial. Such arrangements have not always been as reliable as one might have hoped.

Stepped volume controls

The great feature of potentiometer-based volume controls is that they have effectively infinite resolution, so you can set exactly the level you require. If, however, you are prepared to forego this and accept a volume control that changes in steps, a good number of new possibilities open up and in return promise much greater law accuracy and channel balance. The technologies available include rotary-switched resistive attenuators, relay-switched resistive attenuators, switched multi-tap transformers, and specialised volume-control ICs. These options are now examined.

The obvious question is how small a step is needed to give satisfactory control? If the steps are made small enough, say less than 0.2 dB, they are imperceptible, always providing there are no switching transients, but there are powerful economic reasons for not using more steps than necessary. 2 dB steps are widely considered acceptable for in-car entertainment (implemented by an IC), but my view is that serious hifi requires 1 dB steps.

I have designed several power amplifiers with a separate switch that introduces 20 dB of attenuation. Its main use is to give a set-up mode so that level errors with powerful amplifiers do not cause smoking loudspeakers. If you are using a standard Baxandall active volume control with its rather flat law, the attenuation switch can also be used to move operation to a more favourable part of the law curve.

Switched attenuator volume controls

For high-end products where the imperfections of a ganged-potentiometer volume control are not acceptable, much superior accuracy can be achieved by using switched attenuators to control level. It is well-known that the BBC for many years used rotary faders that were stud-switched attenuators working in 2 dB steps; some of these were still in use in 1961.

The normal practice is to have a large rotary switch that selects a tap on a resistor ladder; since the ladder can be made of 1% tolerance components the channel matching is much better than that of the common dual-gang pot. A stereo control naturally requires two resistor ladders and a two-pole switch. The snag is, of course, the much greater cost; this depends to a large extent on how many control steps are used. The resistor ladders are not too costly, unless exotic super-precision parts are used, but two-pole switches with many ways are neither cheap nor easy to obtain.

At the time of writing, one commercial preamp offers 12 5 dB steps; the component cost has been kept down by using separate switches for left and right channels, which is not exactly a triumph of ergonomics. Another commercial product has an 11 position ganged switched attenuator. In my opinion neither offer anything like enough steps.

The largest switches readily available are made up from 1 Pole 12-way wafers. The most common version has a break-before-make action, but this causes clicky transients due to the interruption of the audio waveform. Make-before-break versions can often be obtained, and these are much more satisfactory as the changes in level as the switch is rotated are much smaller, and the transients correspondingly less obtrusive. Make sure no circuitry gets overloaded when the switch is bridging two contacts.

Moving beyond 12-way, a relatively popular component for this sort of thing is a 24-position switch from the ELMA 04 range; this seems to be the largest number of ways they produce. A bit of care is needed in selecting the part required as one version has 10 μm of silver on the contacts with a protective layer of only 0.2 μm thick gold. This very thin layer is for protection during storage and transport only and in use will wear off quite quickly exposing the silver, which is then subject to tarnishing, with the production of non-conductive silver sulphide; this version should be avoided unless used in a sealed environment. Other versions of these switches have thick 3 μm gold on the contacts which is much more satisfactory. They can be obtained with one, two or four 24-way wafers, but they are not cheap. At the time of writing, (Jan 2013) two-wafer versions are being advertised by third parties at about $130 each, which means that in almost all cases the volume switch is going to cost a lot more than the rest of the preamplifier put together.

If 24 positions are not enough (which in my view is the case), 48-way switches are available from ELMA and Seiden, though in practice they have to be operated as 47-way because the mechanical stop takes up one position. This stop is essential, as a sudden transition from silence to maximum volume is rarely a good idea. 58-way switches are also available from Seiden. Shallco make switches with up to 48 positions in one, two, three, and four-pole formats, but their specs say this only gives 24 non-shorting (break-before-make) positions. It seems to be essentially a make-before-break product line, and this may complicate or simplify switched volume-control design depending on how you are doing it [12].

A switched attenuator can be made very low-impedance to minimise its own Johnson noise and the effect of the current noise of the following stage. The limiting factors are that the attenuator input must present a load that can be driven with low distortion from the preceding stage, and that the resistor values at the bottom of the ladder do not become too small for convenience. An impedance of around 1000 Ω from top to bottom is a reasonable choice. This means that the highest output impedance (which is at the −6 dB setting, a very high setting for a volume control) will be only 250 Ω. This has a Johnson noise of only −128.2 dBu (22 kHz bandwidth, 25°C) and is unlikely to contribute much to the noise output of a system. The choice of around 1000 Ω does assume that your chosen range of resistors goes down to 1 Ω rather than stopping at 10 Ω, though, if necessary, the lower values can, of course, be obtained by paralleling resistors.

Assuming you want to use an easily obtainable 12-way switch, a possible approach is to use 12 steps of 4 dB each, covering the range 0 to −44 dB. My view is that such steps are too large, and 2 dB is much more usable, but you may not want to spend a fortune on a rotary switch with more ways. In fact, 1 dB steps are really required so you can always get exactly the volume you want, but implementing this with a single rotary switch is going to be very difficult, as it implies something like a 60 or 70-way switch. My current preamplifier just happens to be a relay-switched Cambridge Audio 840E with some 90-odd 1 dB steps. I designed it.

There is no reason why the steps have to be equal in size, and it could be argued that the steps should be smaller around the centre of the range and larger at top and bottom to give more resolution where the volume control is most likely to be used. It does not really matter if the steps are not exactly equal—the vital thing is that they should be identical for the left and right channels to avoid image shift.

Figure 13.32a shows a typical switched attenuator of this sort, with theoretically exact resistor values; the size of each step is 4.00000 dB, accurate to five decimal places. In view of resistor tolerances, such accuracy may appear pretty pointless, apart from the warm feeling it produces, but it costs nothing to start off with more accuracy than you will need. The total resistance of the ladder is 1057 Ω, which is a very reasonable load on a preceding stage, so long as it is implemented with a 5532, LM4562, or similar.

A lot depends on what range of resistor values you have access to. When I began to design preamplifiers, E12 resistors (12 values per decade) were the norm, and E24 resistors (24 values per decade) were rather rare and expensive. This is no longer the case, and E24 is freely available. Figure 13.32b shows the same attenuator with the nearest E24 value used for each resistor. The attenuation at each tap is still very accurate, the error never exceeding 0.12 dB except for the last tap which is 0.25 dB high; this could be cured by making R12 a parallel combination of 6.8 Ω and 330 Ω and making R11 3.9 Ω, which reduces the last-tap error to 0.08 dB. To reduce the effect of tolerances R12 would be better made from two near-equal components; 12 Ω in parallel with 15 Ω is only 0.060% high in value.

The next most prolific resistor range is E96, with no less than 96 values in a decade—nobody seems interested in making an E48 range as such, though it is of course just a subset of E96. Using the nearest E96 value in the attenuator, we get Figure 13.32c, where the taps are accurate to within 0.04 dB; remember that this assumes that each resistor is exactly the value it should be and does not incorporate any tolerances. The improvement in accuracy is not enormous, and if you can get a tighter tolerance in the E24 range than E96, E24 is the preferred option.

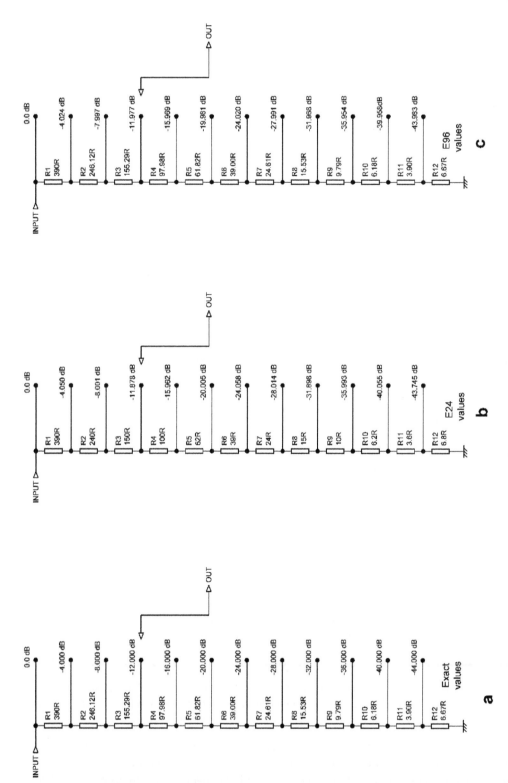

Figure 13.32 A 12-way switched attenuator volume control. a) gives the theoretical resistor values, b) is the best accuracy with E24 resistor values, and c) shows how the step errors are much reduced by using E96 values.

There is also an E192 resistor range, but it is rather rare, and there seems to be no pressing need to use so many different values in volume control attenuators.

Almost all the work in the design of a switched attenuator is the calculation of the resistor values in the ladder. Putting in likely component values and attempting to tweak them by hand is a most unpromising approach because all the values interact, and you will boil off your sanity. A systematic spreadsheet approach is the only way. This is probably the simplest:

1) Decide the approximate total resistance of the resistor ladder.

2) Decide the step size, say 4 dB.

3) Take a two resistor potential divider, where the sum of the resistors equals the desired total resistance, and choose exact values for a 4 dB attenuation; use the goal-seek tool to get the exact value for the bottom resistor (an exact E24 value at the top of the ladder is not essential, but it is convenient).

4) Now split the bottom resistor into two so that another 4 dB attenuator results. Check that the attenuation really is correct because an error will propagate through the rest of the process, and you will have to go back and do it all again from that point. Repeat this step until you have enough resistors in the ladder for the number of taps required.

5) When the table of resistor values is complete, for each resistor pick the nearest value from the E-series you are using. Alternatively select a parallel pair to get closer to the desired value, keeping the two resistors as near-equal as possible.

You will then have constructed something like the spreadsheet shown in Table 13.7, which gives the E24 resistor values shown in Figure 13.32b. The chosen value at the top of the ladder is 390 Ω. The spreadsheet has been set up to give more information than just the resistor value and the tap attenuation; it gives the voltage at each tap for a given input (10 V in this case) in column 5, the output impedance of each tap in column 6, the step size in dB in column 8, and the absolute error for each tap in column 9. It also gives the total resistance of the ladder, the current through it for the specified input voltage, and the resulting power dissipation in each resistor in column 7. The last parameter is unlikely to be a major concern in an audio attenuator, but if you're working with very low impedances to minimise noise, it is worth keeping an eye on.

The total resistance of the divider is 1046.6 Ω. With a 10 Vrms input 9.6 mA flows through the divider.

Before the design work begins you must consider the stages before and after the attenuator. It is strongly recommended that the attenuator input is driven from a very low impedance such as the output of an opamp with plenty of negative feedback so the source impedance can be effectively considered as zero and does not enter into the calculations. The loading on the output of the attenuator is more of a problem. You can either take loading on the output into account in the calculations, in which case the shunting effect of the load must be incorporated into step 3 mentioned earlier, or else make the input impedance of the next stage so high that it has a negligible effect.

As an example, the E24 network in Figure 13.32b was calculated with no allowance for loading on the output. Its highest output impedance is 253 Ω at Tap 3, so this is the worst case for both loading-sensitivity and noise. If a load of 100 kΩ is added, the level at this tap is only pulled down

TABLE 13.7 A spreadsheet that gives all the relevant information about a divider ladder for a switched attenuator; here a 12-way switch gives 4 dB steps, using single E24 resistors

1	2	3	4	5	6	7	8	9	10
	Nearest E24 value		dB Ref=0		Tap Z		Step	Tap error	Tap No.
	Ohms	ratio	dB	O/P V	Ohms	Power mW	dB	dB	1
R1	390					35.6			
		0.62736	−4.050	6.2736	244.672		4.0496	−0.0496	2
R2	240					21.9			
		0.39805	−8.001	3.9805	250.77		3.952	−0.0012	3
R3	150					13.7			
		0.25473	−11.878	2.5473	198.69		3.877	0.1216	4
R4	100					9.1			
		0.15918	−15.962	1.5918	140.08		4.084	0.0379	5
R5	62					5.7			
		0.09994	−20.005	0.9994	94.15		4.043	−0.0050	6
R6	39					3.6			
		0.06268	−24.058	0.6268	61.49		4.053	−0.0575	7
R7	24					2.2			
		0.03975	−28.014	0.3975	39.95		3.956	−0.0137	8
R8	15					1.4			
		0.02542	−31.898	0.2542	25.92		3.884	0.1020	9
R9	10					0.9			
		0.01586	−35.993	0.1586	16.34		4.095	0.0065	10
R10	6.2					0.6			
		0.00994	−40.055	0.0994	10.30		4.061	−0.0549	11
R11	3.6					0.3			
		0.00650	−43.745	0.0650	6.76		3.690	0.2546	12
R12	6.8					0.6			

by only 0.022 dB. A 100 kΩ input impedance for a following stage is easy to arrange, so the extra computation required in allowing for loading is probably not worthwhile unless for some very good reason the loading is much heavier. The Johnson noise of 253 Ω is still only −128.2 dBu.

If you feel you can afford 24-way switches, then there is rather more flexibility in design. You could cover from 0 to −46 dB in 2 dB steps, 0 to −57.5 dB in 2.5 dB steps, or 0 to −69 dB in 3 dB steps. There are infinite possibilities for adopting varying step sizes.

Table 13.8 shows the resistor values for 0 to −46 dB in 2 dB steps, Table 13.9 gives those for 0 to −57.5 dB in 2.5 dB steps, and Table 13.10 gives the values for 0 to −69 dB in 3 dB steps.

TABLE 13.8 Resistor values and accuracy for a 2 dB step switched attenuator with 24-way switch

Tap		Switched attenuator: 2 dB steps							
		Exact		Using E24 values			Using E96 values		
		Ohms	Step dB	Ohms	Step dB	Error dB	Ohms	Step dB	Error dB
1	R1	220.0000	0.0000	220	0.0000	0.0000	220	0.0000	0.0000
2	R2	174.7490	−2.0000	180	−2.0435	−0.0435	174	−2.0208	−0.0208
3	R3	138.8080	−4.0000	130	−4.1427	−0.1427	137	−4.0114	−0.0114
4	R4	110.2591	−6.0000	110	−6.0660	−0.0660	110	−5.9942	0.0058
5	R5	87.5819	−8.0000	82	−8.1104	−0.1104	86.6	−7.9967	0.0033
6	R6	69.5688	−10.0000	68	−10.0251	−0.0251	69.8	−9.9799	0.0201
7	R7	55.2605	−12.0000	56	−12.0124	−0.0124	54.9	−11.9914	0.0086
8	R8	43.8950	−14.0000	43	−14.0788	−0.0788	44.2	−13.9838	0.0162
9	R9	34.8670	−16.0000	33	−16.0850	−0.0850	34.8	−16.0046	−0.0046
10	R10	27.6958	−18.0000	27	−18.0166	−0.0166	27.4	−18.0107	−0.0107
11	R11	22.0000	−20.0000	22	−19.9959	0.0041	22.0	−19.9987	0.0013
12	R12	17.4749	−22.0000	18	−22.0272	−0.0272	17.4	−22.0077	−0.0077
13	R13	13.8808	−24.0000	13	−24.1361	−0.1361	13.7	−24.0093	−0.0093
14	R14	11.0259	−26.0000	11	−26.0577	−0.0577	11.0	−25.9916	0.0084
15	R15	8.7582	−28.0000	8.2	−28.1000	−0.1000	8.66	−27.9934	0.0066
16	R16	6.9569	−30.0001	6.8	−30.0120	−0.0120	6.98	−29.9758	0.0242
17	R17	5.5260	−32.0001	5.6	−31.9960	0.0040	5.49	−31.9863	0.0137
18	R18	4.3895	−34.0001	4.3	−34.0580	−0.0580	4.42	−33.9773	0.0227
19	R19	3.4867	−36.0001	3.3	−36.0588	−0.0588	3.48	−35.9964	0.0036
20	R20	2.7696	−38.0001	2.7	−37.9839	0.0161	2.74	−38.0004	−0.0004
21	R21	2.1999	−40.0001	2.2	−39.9548	0.0452	2.20	−39.9857	0.0143
22	R22	1.7475	−42.0000	1.8	−41.9753	0.0247	1.74	−41.9913	0.0087
23	R23	1.3881	−44.0000	1.5	−44.0701	−0.0701	1.37	−43.9886	0.0114
24	R24	5.3609	−46.0001	5.1	−46.3095	−0.3095	5.36	−45.9657	0.0343
				Total res =	1055	Ω	Total res =	1065	Ω
				Avg abs error =	0.0654	dB	Avg abs error =	0.0117	dB

TABLE 13.9 Resistor values and accuracy for a 2.5 dB step switched attenuator with 24-way switch

		Switched attenuator: 2.5 dB steps							
		Exact		Using E24 values			Using E96 values		
Tap		Ohms	Step dB	Ohms	Step dB	Error dB	Ohms	Step dB	Error dB
1	R1	220.0000	0.0000	220	0.0000	0.0000	220	0.0000	0.0000
2	R2	164.9809	−2.4999	160	−2.5471	−0.0471	165	−2.4997	0.0003
3	R3	123.7182	−4.9999	120	−5.0208	−0.0208	124	−4.9907	0.0093
4	R4	92.7756	−7.4999	91	−7.4864	0.0136	93.1	−7.4901	0.0099
5	R5	69.5719	−10.0000	68	−9.9726	0.0274	69.8	−9.9928	0.0072
6	R6	52.1715	−12.5000	51	−12.4441	0.0559	52.3	−12.4958	0.0042
7	R7	39.1231	−15.0000	39	−14.9066	0.0934	39.2	−14.9974	0.0026
8	R8	29.3382	−17.5000	30	−17.4130	0.0870	29.4	−17.4982	0.0018
9	R9	22.0005	−20.0000	22	−19.9969	0.0031	22	−19.9995	0.0005
10	R10	16.4981	−22.5000	16	−22.5429	−0.0429	16.5	−22.4952	0.0048
11	R11	12.3718	−25.0000	12	−25.0153	−0.0153	12.4	−24.9899	0.0101
12	R12	9.2775	−27.5000	9.1	−27.4790	0.0210	9.31	−27.4890	0.0110
13	R13	6.9572	−30.0000	6.8	−29.9627	0.0373	6.98	−29.9914	0.0086
14	R14	5.2172	−32.5000	5.1	−32.4310	0.0690	5.23	−32.4939	0.0061
15	R15	3.9123	−35.0000	3.9	−34.8893	0.1107	3.92	−34.9949	0.0051
16	R16	2.9338	−37.5000	3.0	−37.3900	0.1100	2.94	−37.4948	0.0052
17	R17	2.2000	−40.0000	2.2	−39.9658	0.0342	2.2	−39.9950	0.0050
18	R18	1.6498	−42.5000	1.6	−42.5014	−0.0014	1.65	−42.4892	0.0108
19	R19	1.2372	−45.0000	1.2	−44.9601	0.0399	1.24	−44.9818	0.0182
20	R20	0.9277	−47.5001	0.91	−47.4057	0.0943	0.931	−47.4783	0.0217
21	R21	0.6957	−49.9999	0.68	−49.8653	0.1347	0.698	−49.9771	0.0229
22	R22	0.5217	−52.4999	0.51	−52.3019	0.1981	0.523	−52.4748	0.0252
23	R23	0.3912	−54.9997	0.39	−54.7183	0.2817	0.392	−54.9694	0.0306
24	R24	1.1731	−57.4997	1.20	−57.1626	0.3374	1.18	−57.4608	0.0392
				Total res =	866	Ω	Total res =	881	Ω
				Avg abs error =	0.0816	dB	Avg abs error =	0.0113	dB

TABLE 13.10 Resistor values and accuracy for a 3 dB step switched attenuator with 24-way switch

Tap		Switched attenuator: 3 dB steps							
		Exact		Using E24 values			Using E96 values		
		Ohms	Step dB	Ohms	Step dB	Error dB	Ohms	Step dB	Error dB
1	R1	430.0000	0.0000	430	0.0000	0.0000	430	0.0000	0.0000
2	R2	304.4210	−3.0000	300	−2.9981	0.0019	301	−3.0066	−0.0066
3	R3	215.5135	−6.0000	220	−5.9437	0.0563	215	−5.9727	0.0273
4	R4	152.5719	−9.0000	150	−8.9930	0.0070	154	−8.9583	0.0417
5	R5	108.0126	−12.0000	110	−11.9281	0.0719	107	−11.9800	0.0200
6	R6	76.4671	−15.0000	75	−14.9622	0.0378	76.8	−14.9437	0.0563
7	R7	54.1346	−18.0000	56	−17.8769	0.1231	54.9	−17.9414	0.0586
8	R8	38.3243	−21.0000	39	−20.9466	0.0534	38.3	−20.9732	0.0268
9	R9	27.1315	−24.0000	27	−23.9857	0.0143	27.4	−23.9652	0.0348
10	R10	19.2077	−27.0000	20	−26.9606	0.0394	19.1	−26.9917	0.0083
11	R11	13.5980	−30.0000	13	−30.0906	−0.0906	13.7	−29.9736	0.0264
12	R12	9.6266	−33.0000	10	−32.9681	0.0319	9.53	−32.9950	0.0050
13	R13	6.8151	−36.0000	6.8	−36.0924	−0.0924	6.81	−35.9624	0.0376
14	R14	4.8248	−38.9999	4.7	−39.1209	−0.1209	4.87	−38.9497	0.0503
15	R15	3.4157	−42.0000	3.3	−42.0755	−0.0755	3.40	−41.9678	0.0322
16	R16	2.4181	−45.0000	2.4	−44.9831	0.0169	2.43	−44.9436	0.0564
17	R17	1.7119	−48.0000	1.8	−47.9476	0.0524	1.74	−47.9433	0.0567
18	R18	1.2119	−51.0001	1.2	−51.1090	−0.1090	1.21	−50.9841	0.0159
19	R19	0.8580	−54.0001	0.82	−54.1167	−0.1167	0.866	−53.9772	0.0228
20	R20	0.6074	−57.0002	0.62	−57.0034	−0.0034	0.604	−57.0068	−0.0068
21	R21	0.4300	−60.0003	0.43	−60.0776	−0.0776	0.432	−59.9949	0.0051
22	R22	0.3044	−63.0003	0.30	−63.1079	−0.1079	0.301	−63.0148	−0.0148
23	R23	0.2155	−66.0003	0.22	−66.0982	−0.0982	0.215	−65.9860	0.0140
24	R24	0.5224	−69.0003	0.51	−69.2132	−0.2132	0.523	−68.9771	0.0229
				Total res =	1473	Ω	Total res =	1470	Ω
				Avg abs error =	0.0701	dB	Avg abs error =	0.0281	dB

All three tables give the nearest E24 and E96 values and the resulting errors. Note the first two versions start off with a 220 Ω resistor at the top, but on moving from 2 dB to 2.5 dB steps, the resistors towards the bottom naturally get smaller to give the greater attenuation required, and the total ladder resistance falls from 1060 Ω to 866 Ω. To prevent the resistor values becoming inconveniently small and the total resistance too low, the 3 dB step version starts off with a higher value resistor of 430 Ω at the top; this increases the total resistance of the ladder to 1470 Ω and raises the maximum output impedance to 368 Ω at Tap 3. The Johnson noise of 368 Ω is naturally higher at −126.5 dBu, but this is still very low compared with the likely noise from amplifier stages downstream.

The exact values on the left hand of each table can be scaled to give the total divider resistance required, but it will then be necessary to select the nearest E24 or E96 value manually. If you are increasing all the resistances by a factor of ten, then the same E24 or E96 values with a zero added can be used. The average of the absolute error for all 24 steps is shown at the bottom of each section; note that simply taking the average error would give a misleadingly optimistic result because the errors are of random sign and would partially cancel.

If the available switches do not give enough steps, a possible solution is to use two rotary switches: one for coarse volume control and the other for vernier control, the latter perhaps in 1 dB steps or less. While straightforward to design, this is not exactly user-friendly. A buffer stage is usually desirable to prevent the second attenuator from loading the first one; the second attenuator may present a constant load, but it is a heavy one. With no buffer the total loading of the two attenuators could also present an excessive load to the stage before the first attenuator.

A rotary switch does not, of course, have the smooth feel of a good potentiometer. To mitigate this, a switched volume control may need a large-diameter weighted knob, possibly with some sort of silicone damping. Sharp detents and a small knob do not a good volume control make.

Relay-switched volume controls

If you need more steps than a switch can provide, it is relatively simple to come up with a system that emulates a rotary switch with as many as desired, using relays, a microcontroller, and an inexpensive shaft encoder; if you use need a relay for each step, and that will be an awful lot of relays.A better approach is to use relays in a ladder attenuator, which greatly reduces the relay count. This is dealt with in the next section. As soon as a microcontroller is introduced, then there is, of course, the possibility of infra-red remote control. The ultimate development in stepped volume controls is the relay ladder attenuator. This allows any number of steps to be employed.

The design of a ladder attenuator relay volume control is not as simple as it may appear. If you try to use a binary system, perhaps based on an R-2R network, you will quickly find that horrible transients erupt on moving from, say, 011111 to 100000. This is because relays have an operating time that is both long by perceptual standards and somewhat unpredictable. It is necessary to use logarithmic resistor networks with some quite subtle relay timing.

One of the highest expressions of this technology was the Cambridge Audio 840A integrated amplifier and 840E preamplifier. The latter used second-generation relay volume control

technology, using only 12 relays to give 1 dB steps over most of the control range. A rather unexpected feature of relay volume controls is that having purchased a very sophisticated preamplifier, where the precision relay control is the major unique feature, some customers then object to the sound of the relays clicking inside the box when they adjust the volume setting. You just can't please some people.

Transformer-tap volume controls

There are other ways of controlling volume than with resistors. At the time of writing (2023) there is at least one passive preamplifier on the market that controls volume by changing the taps on the secondary of a transformer. The unit I have in mind has only 12 volume steps, apparently each of 4 dB. These are very coarse steps for a volume control—unacceptably so, I would have thought; a 48 dB range also seems too small. 24-way switches are available (see the earlier "Switched attenuator volume controls" section), but they are expensive. There are several potential problems with this approach—transformers are well-known to fall much further short of being an ideal component than most electronic parts. They can introduce frequency response irregularities, LF distortion, and hum. They are relatively heavy and expensive, and the need for a large number of taps on the secondary puts the price up further. The multi-way switch to select the desired tap must also be paid for.

There are, however, some advantages. The output impedance of a resistive potential divider varies according to its setting, being a maximum at −6 dB. Assuming it is fed from a low impedance, a transformer volume control has a low impedance at every tap, greater than zero only by the resistance of the windings and handily lower than even a low-resistance pot. This gives lower Johnson noise and minimises the effect of the current noise of the following stage. The much-respected Sowter transformer company make a number of different volume-control transformers, of which the most representative is probably the 9335 model. This is basically a 1:1 transformer with taps on the secondary that give attenuation from 0 to −50 dB in 26 steps of 2 dB each. The DC resistance of both primary and secondary is 310 Ω. The total resistance of the windings is therefore 620 Ω, which is much lower than the value of the volume pots normally used. Note, however, that it is not much lower than the 1 kΩ pots I used in the Elektor preamplifier [6]. At the time of writing, 9335s cost £132 each. You need two for stereo.

Integrated circuit volume controls

Specialised volume-control ICs based on switched networks have been around for a long time but have only recently reached a level of development where they can be used in high-quality audio. Early versions had problems with excessively large volume steps, poor distortion performance, and nasty glitching on step changing. The best contemporary ICs are greatly improved; a modern example is the PGA2310 from Burr-Brown (Texas Instruments) which offers two independent channels with a gain range from +31.5 to −95.5 dB in 0.5 dB steps and is spec'd at 0.0004% THD at 1 kHz for a 3 Vrms input level. The IC includes a zero crossing detection function intended to give noise-free level transitions. The concept is to change gain settings on a zero crossing of the input signal and so minimise audible glitches. Gain control is by means of a three-wire serial

interface, which is normally driven by a rotary encoder and a microcontroller such as one of the PIC series. The Yamaha YAC523 has a similar specification but incorporates seven gain-controlled channels for AV applications.

A similar device is the Texas Instruments PGA2311; it is likewise stereo, and the main difference is that the analogue power supply is ±5 V rather than the ±15 V of the PGA2310, which must limit the headroom. At least one manufacturer uses both channels in parallel for lower noise—presumably 3 dB lower.

Volume ICs are available for operation off a single +5 V rail, allowing operation off a USB port, but the THD figures can be an order of magnitude worse than devices running from ±15 V. One example is the stereo MAX5486 which can run from a single +2.7 V to +5.5 V rail or dual ±2.7 V rails. Other low-voltage examples are the DS1669 digital potentiometer IC from Dallas Semiconductors and the M62429 from Renesas Electronics [13]. For suitable low-voltage opamps, see Chapter 5.

Loudness controls

It is an awkward but inescapable feature of human hearing that its frequency response varies with the level of the sound. As the level drops the perceived loudness of high and low frequencies falls faster than the middle frequencies. This is very clearly expressed by the well-known Fletcher & Munson curves [14], shown in Figure 13.33. Their work was repeated by Robinson & Dadson [15], whose results are sometimes considered to be more accurate and were the basis for the ISO equal-loudness curves. A great deal of information on these curves and the differences between them and on the whole subject of loudness controls can be found in the *Journal of Audio Engineering Society* papers by Newcomb and Young [16], and Holman and Kampmann [17]. More on their work later.

The graph shows what sound pressure level above the threshold of hearing is needed to get a constant result in phons, the unit of subjective loudness. The first disconcerting feature is that none of the curves are remotely flat—at 20 Hz the sensitivity of the ear is always much lower than at 1 kHz, no matter what the level. A vital point is that the slopes at the bass end increase as the level falls, as shown in column 2 of Table 13.11, which gives the average slope in dB per octave between 20 and 100 Hz. At 20 phons the slope is greater than that of a third-order filter, while at 100 phons it is less than that of a second-order filter.

This increase of slope means that if you have satisfactory reproduction at a given sound level, turning down the volume gives a subjective loss of bass, demonstrated by the increased SPLs required to get the same number of phons at 20 Hz in column 3. There are also some complicated but much smaller variations in the treble (see column 4). This effect used to be called 'scale distortion' in the 1950s, which is a less than satisfactory term, not least because it sounds as if it would be of interest only to aquarists. At the time there was intense debate as to whether attempting to compensate for it—by making the frequency response vary with the volume control setting, turning it into what became called a 'loudness control'—was the right thing to do or not. A switch to make the volume control into a loudness control was a common feature in the 1970s, though there was still much debate as to whether it was a useful approach, with hifi purists

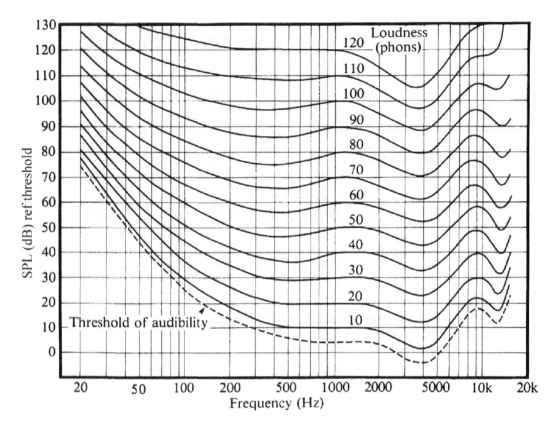

Figure 13.33 The Fletcher & Munson curves show the sound pressure level required to give a certain subjective loudness, which is measured in phons.

TABLE 13.11 Characteristics of the Fletcher & Munson curves

1	2	3	4
Loudness (phons)	Slope (dB/octave)	SPL at 20 Hz ref 1 kHz (dB)	SPL at 10 kHz ref 1 kHz (dB)
100	10.7	+28	+6
90	11.6	+30	+5
80	12.5	+34	+5
70	13.4	+37	+5
60	14.7	+42	+5
50	15.1	+46	+8
40	16.8	+50	+9
30	17.7	+57	+10
20	18.6	+61	+10
10	20.3	+68	+9

roundly condemning the notion. Loudness controls are currently out of fashion; if you're the kind of person that won't tolerate tone controls, you probably regard loudness controls as totally anathema. However, the wheel of fashion turns, and it is well worth looking at how they work.

Note that we are *not* trying to make the Fletcher & Munson curves flat. If we take the 100 phon level as an example, we will need some 42 dB of boost at 20 Hz, which is clearly not right. What we are trying to do is reduce the *differences* in perceived bass level with volume changes. Let us assume we have a 'flat' subjective response at a level of 100 phons, since it roughly corresponds to 100 dB SPL which is pretty loud, typically described as 'jackhammer at 1 metre.' Figure 13.34 shows the correction response we would need to bring the lower levels into line with the 100 phons curve. This was obtained by subtracting the 100 phon data from that for the other levels. The curves look a little wobbly as they cannot be read from the graph in Figure 13.33 with accuracy much better than 1 dB.

Clearly the correction shown above 1 kHz is neither large nor consistent. Holman and Kampmann state clearly that above 400 Hz correction is neither "necessary or desirable."[18] Correction

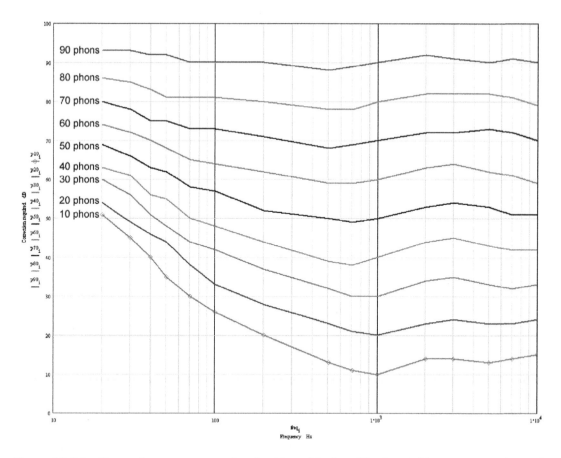

Figure 13.34 Correction curves to make the 10 to 90 phon Fletcher & Munson curves have the same response as the 100-phon curve.

below 1 kHz, however, is a different matter. Fortunately it consists of monotonic curves, though they do have varying slopes. For the higher levels the hinge point between sloping and flat is around 600 Hz, increasing as the level falls to about 1 kHz. The slope, averaged between 20 Hz and 1 kHz, varies between 0.5 dB/octave at 90 phons to 7.3 dB/octave at 10 phons. If we assume that 10 phons is too low a level to worry about, we find the 20-phons correction curve has a slope of only 5.8 dB, which promises that we could implement a useful compensation network using only simple first-order circuitry.

The Fletcher & Munson curves depend on the absolute level at the ear, and this obviously depends on amplifier gain, loudspeaker efficiency, room acoustics, and many other factors. Unless you set up your system for a defined SPL which you regard as 'flat,' loudness compensation is going to be a rather approximate business, and this is one argument frequently advanced against it.

Switchable loudness facilities were fitted to a large number of Japanese amplifiers in the 1970s and 1980s, but European and US manufacturers rarely used them. The circuitry used was virtually standard, with three typical versions by Denon, Pioneer, and Sansui shown in Figure 13.35. With the loudness switch set to "OUT" the capacitors do nothing, and we have a linear pot loaded down at its tap by R1, to approximate a logarithmic volume law (I assume that the pot must be linear; Japanese service manuals seem remarkably coy about the law of the pot, and only in one case have I found it confirmed as linear). When the loudness switch is set to "IN" C1 gives HF boost, and C2 gives LF boost by reducing the loading effect of R1.

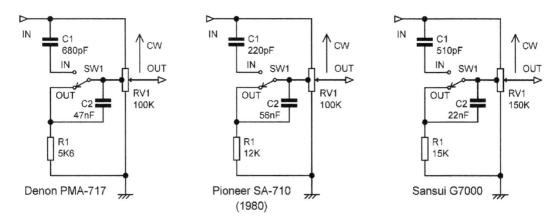

Figure 13.35 Three typical switchable loudness controls using a centre-tapped linear pot.

The simulated frequency response for the Denon circuit is shown in Figure 13.36. There are three notable features; firstly there is a lot of boost applied at HF, despite the fact that, as we saw earlier, no HF correction is actually wanted. The second is that the correction curves only change in shape over the bottom half of the control rotation, the response being fixed above that. Thirdly, there is a rather dramatic change in mid-band level between Marks 5 and 6, as the pot wiper approaches the centre-tap.

The almost universal inclusion of HF boost in these loudness circuits is a bit of a mystery. I can only assume that people took a quick look at the Fletcher & Munson curves and saw increases at the HF end but did not notice that the curves are essentially equally spaced, not varying in shape with level. I wonder if this unwanted HF boost was one of the reasons why loudness controls were so poorly regarded; in their heyday the primary source was vinyl, with bad distortion characteristics at HF. It seems likely that the HF boost would have accentuated this. For each of the three versions shown earlier, removing C1 removes the HF boost action.

These loudness controls must represent the widest ever use of centre-tapped pots, which are otherwise rarely encountered. Pioneer used a centre-tapped pot with a simple loading resistor to ground connected to the tap to emulate a logarithmic law; there was no loudness facility. See the Pioneer A-88X and the A-77X (1985).

A few other loudness schemes were used. The Sansui A60 and A80 amplifiers had separate loudness and volume pots, making for cumbersome operation.

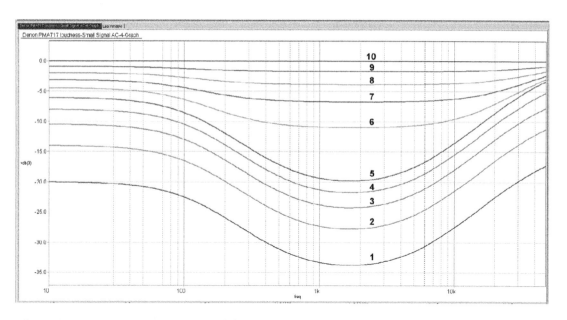

Figure 13.36 Frequency response of the Denon loudness control in Figure 13.35a. Complete pot rotation is from Marks 0–10, curve 0 not shown.

The Newcomb and Young loudness control

In 1976, Newcomb and Young published a very thoughtful paper on loudness controls [16]. They listed three important points about the Fletcher & Munson curves:

1) There is little change in slope above 1 kHz. In other words HF boost is not wanted, as I noted earlier.

2) The maximum LF boost required exceeds 6 dB/octave and cannot be provided by a single RC time constant.

3) The LF breakpoint moves upward in frequency as the SPL decreases.

To implement these three requirements they put forward an ingenious active loudness control that compensated at LF only; see Figure 13.37. There is still a requirement to have a gain control as well in the signal path so the SPL can be aligned with the loudness control to get the compensation right.

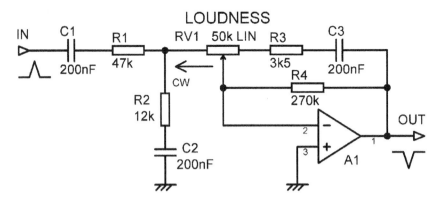

Figure 13.37 The Newcomb and Young active loudness control.

Since RV1 alters both the input and feedback arms around A1, it gives a quasi-log volume law. The tolerance of the pot tracks will affect the channel balance accuracy, as unlike in the Baxandall volume control, the track resistance errors are not eliminated. The increased slope is implemented by C2 in conjunction with C3.

The resulting loudness curves are shown in Figure 13.38; the component values are as given by Newcomb and Young and are of rather higher impedance than I would use. The slope of the −40 dB curve is significantly greater than 6 dB/octave; between 20 and 40 Hz it is 8 dB/octave. The first response breakpoint is set at an almost constant frequency by R2 and C2. The second −3 dB breakpoint moves up from 60 Hz at 0 dB loudness to 230 Hz at −40 dB loudness, due to the action of RV1, R3, and C3. The maximum flat gain is set by R4. Note that the 200 nF capacitors are from the E24 series and so may be hard to source, and the value of R3 at 3k5 is not in any of the standard resistor series, including E96; the nearest E96 value is 3k48. I suggest the impedances are scaled to make the capacitors 220 nF and the pot 47 kΩ.

The presence of R2, which is effectively connected to ground at all but the lowest audio frequencies, increases the noise gain of the circuit, especially when loudness is set to maximum, when R2 is connected directly to the summing point at A1 inverting input. At maximum loudness the noise gain is +15.1 dB, which is worryingly high; without R2 it would be only +5.8 dB. With R2 in place the noise gain is still +4.8 dB at the middle loudness setting; see Table 13.12 for full details.

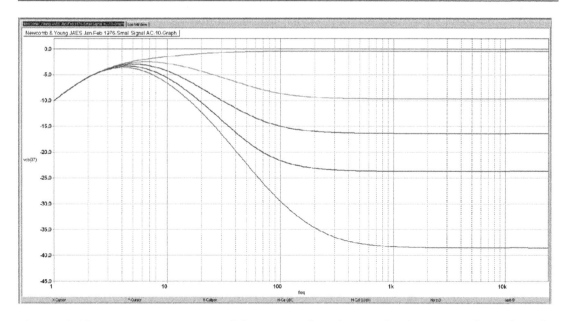

Figure 13.38 Frequency response of the Newcomb and Young loudness control at gains of 0, −10, −15, −25, and −40 dB.

TABLE 13.12 Noise gain versus loudness setting for the Newcomb and Young circuit

Control mark	Noise gain x	Noise gain dB
10	5.671	15.073
9	3.824	11.650
8	2.915	9.294
7	2.372	7.502
6	2.008	6.056
5	1.746	4.841
4	1.546	3.787
3	1.389	2.851
2	1.259	2.003
1	1.151	1.222
0	1.058	0.490

The relatively high value resistors in the design, common for the period, will increase the effect of A1 current noise and have will high Johnson noise themselves. Reducing the values by low-impedance design should be straightforward, but changing the noise gain characteristics would require complete redesign. The circuit is ingenious, but both the noise gain and channel balance accuracy will need close examination.

In 1978 Holman and Kampmann put forward [17] an in-depth analysis of alternative loudness curves such as Robson and Dadson [15] and curves produced by Stevenson. They looked at the Newcomb and Young circuit; new component values for R2 and C2 were derived but not actually disclosed in the paper. Not sure how that got past peer review. Also, a linear attenuating pot was placed after the circuit, ganged with the loudness pot, to improve the control law.

Interest in loudness controls has pretty much been negligible since then.

References

[1] Baxandall, P. "Audio Gain Controls." *Wireless World*, Nov 1980, pp. 79–81

[2] Reiner, R. (Director) *This is Spinal Tap* (Film, 1984)

[3] Self, D. "A Precision Preamplifier." *Electronics World*, Oct 1983

[4] Self, D. "Precision Preamplifier 96." *Electronics World*, July/Aug and Sept 1996

[5] Self, D. "A Low Noise Preamplifier with Variable-Frequency Tone Controls." *Linear Audio* (published by Jan Didden), Vol. 5, 2013, p. 141

[6] Self, D. "Preamplifier 2012." *Elektor*, Apr, May, June 2012

[7] Self, D. *Self on Audio*, 3rd edition. Focal Press, 2016, p. 66. ISBN 978-1-138-85446-8 pbk; ISBN 978-1-138-85445-1 hbk; ISBN 978-1-315-72109-5 ebk

[8] Self, D. *Self on Audio*, 3rd edition. Focal Press, 2016, p. 174

[9] Ayre. www.ayre.com/products/amplification/ax-5-twenty/ Accessed July 2019

[10] Bamford, J. & Miller, P. *Hifi News*, June 2014, pp. 24–27

[11] Fairbrother, J. "Gang your own pots" *Electronics World*, May 2002, p. 27

[12] Shallco. http://shallco.com/Industrial-Switch-Products/Additional-Switch-Products Accessed July 2019

[13] Renesas. www.renesas.com/eu/en/ Accessed Aug 2019

[14] Fletcher, H. & Munson, W. "Loudness, Its Definition, Measurement and Calculation." *Journal of the Acoustic Society of America*, Vol. 5, 1933, pp. 82–108

[15] Robinson, D. & Dadson, R. "A Re-Determination of the Equal-Loudness Relations for Pure Tones." *British Journal of Applied Physics*, Vol. 7, 1956, pp. 166–181

[16] Newcombe, A. & Young, R. "Practical Loudness: An Active Circuit Design Approach." *Journal of the Audio Engineering Society*, Vol. 24, No. 1, Jan/Feb 1976, p. 32

[17] Holman, T. & Kampmann, F. "Loudness Compensation: Use and Abuse." *Journal of the Audio Engineering Society*, Vol. 26, No. 7/8, July/Aug 1978, p. 526

[18] Holman, T. & Kampmann, F. "Loudness Compensation: Use and Abuse." *Journal of the Audio Engineering Society*, Vol. 26, No. 7/8, July/Aug 1978, p. 527

Balance controls

The ideal balance law

The job of a balance control on a preamplifier is to adjust the relative gain of the left and right channels and so alter the position of the stereo image to the left or right and do nothing else at all. As you would expect, increasing the left gain moves things to the left, and *vice versa*. The ideal law is therefore that of a stereo panpot in a mixing console. Two uncorrelated sound sources (and any signal will be uncorrelated once it has left the loudspeakers and bounced around the room a bit) add just like white noise sources and so give a combined signal that is 3 dB higher, and not 6 dB higher. The sine/cosine panpot law in Figure 14.1 is therefore appropriate for the balance control of a stereo signal because the level of the combined signals will not alter as the image is moved across the stereo stage from one side to the other (see panpots in Chapter 22). It is a constant-volume balance control.

I am aware I said in the first edition of this book that the panpot law was *not* the ideal balance law, so let me clarify that. The sine/cosine law is functionally ideal in terms of its operation but is not optimal in terms of electrical performance. Since the gain is −3 dB at the central position, there will be some compromise. If the 3 dB loss is made up by gain before the balance control, the headroom is reduced by 3 dB. If the loss is made up with 3 dB of gain after the balance control, the noise performance is likely to suffer. The only way to avoid this is to use an active balance control, which alters the gain of a stage rather than passively introducing attenuation.

A panpot in a mixing console reduces one of the signals to zero at each extreme of the pot rotation. There is no need to do this in a preamplifier. A balance control does not have to make radical changes to signal level to do its job. Introducing a channel gain imbalance of 10 dB is quite enough to shift the sound image completely to one side, so it appears to be coming from one loudspeaker only and there is nothing at all to be gained by having the ability to fade out one channel completely.

This means that the ideal balance control is not a mixer panpot as such, but a panpot effectively limited in its rotation so that neither end-stop is reached and the signal is never reduced to zero. This might be called a truncated-sine/cosine law. An example is shown in Figure 14.2, where the 20% of the control rotation at each end is not used, and the central 60% spread out to give more precise control. As a result the maximum attenuation, with the balance control hard over, is −10.4 dB, while the minimum attenuation is −0.41 dB. The attenuation at the centre is unchanged at −3.0 dB; a central detent on a balance control pot is highly desirable.

DOI: 10.4324/9781003332985-14

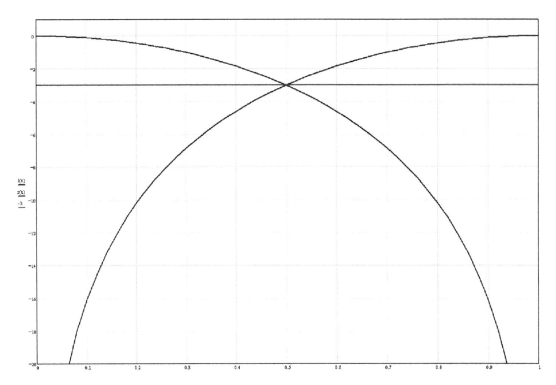

Figure 14.1 The sine/cosine law for a constant-volume stereo balance control.

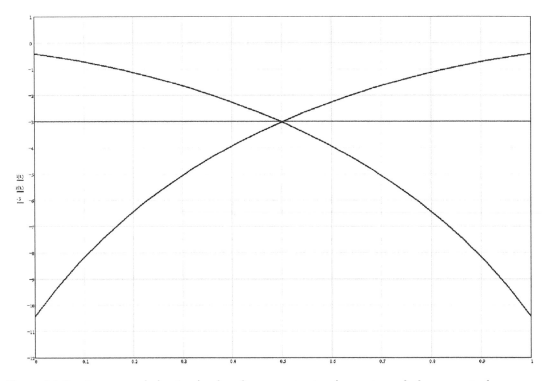

Figure 14.2 A truncated-sine/cosine law for a constant-volume stereo balance control.

In the case of a switched balance control, this is equivalent to using a 23-way switch (there must be an odd number to give a central position) and calculating it as part of a notional 37-way switch that has the extreme seven positions at each end inaccessible. This gives a greater number of steps over the range in which the control is actually used.

Since the balance control is usually a set-and-forget function that does not require readjustment unless the listening room is rearranged, it is not often considered when controls are being motorised. In fact, getting the balance exactly right by leaping up and down between sofa and preamplifier is rather more tiresome than manual adjustment of volume.

If we look at the issue purely from the point of electrical performance rather than functionality and ignore the desirability of a constant-volume balance control, the ideal balance law would have no attenuation when set centrally and when moved to left or right will attenuate only one channel without affecting the gain of the other. This can be done with special balance pots that are available from several manufacturers. If there *is* attenuation at the central position then it needs to be made up by extra amplification either before or after the balance control, and this means that either the overload margin or the noise performance will be compromised to some degree. As noted earlier, the only way to avoid this is to use an active balance control, which alters gain rather than attenuation.

Balance controls: passive

Figure 14.3 shows the various forms of passive balance control; only the right channel is shown in the first three cases. Anti-clockwise movement of the control is required to introduce attenuation into the right channel and shift the sound image to the left. In Figure 14.3a a simple pot is used. If this has a linear track it will give a 6 dB loss when set centrally, and when the two uncorrelated stereo channels are RMS-summed, there will be a 3 dB drop in the centre as the control is moved from hard left to hard right. See Figure 14.4 where no truncation of the balance law is used. This is a long way from being an ideal constant-volume balance control. An extra 3 dB of gain has to be built into the system to counteract the central loss, and the noise/headroom compromise is undesirable. If a log law is used for one channel and an anti-log law for the other, the central loss can be made smaller, say 3 dB or less. Such dual-slope pots are not noted for their accuracy, so the uncertainties of log law tolerancing mean it will not be possible to guarantee that the channel gains are identical when the control is centralised, and that's a serious problem.

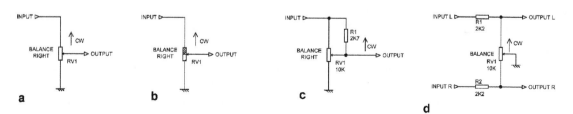

Figure 14.3 Passive balance controls.

Figure 14.4 The −3 dB central drop in overall volume when a linear balance law is used.

Special balance pots, as shown at Figure 14.3b, have half of each track, including the central position, made of a low resistance material so that neither channel is attenuated at the central setting. On moving the control clockwise the right channel wiper stays on the low-resistance section and gain stays at 0 dB, while the left wiper moves onto the normal log/anti-log section and the signal is attenuated. Since there is no central attenuation the combined signal level falls off at each side; this is not a constant-volume balance control.

The linear control in Figure 14.3a can be much improved by the addition of a pull-up resistor, as in Figure 14.3c, which reduces the attenuation at the central position. With a 10 kΩ, pot, a 3.6 kΩ pull-up resistor gives a central drop of very close to −3.0 dB, making the balance law approximately constant-volume.

The result is seen in Figure 14.5; we have the right combined volume at the centre, but the volume is up to 0.35 dB low elsewhere. This is not likely to be perceptible under any circumstances, and we have very simply created what is for all but the most demanding applications a constant-volume balance control.

We can make things even better by reducing the pull-up resistor to 3.0 kΩ, which spreads the volume error out over both sides of the 0 dB line, reducing the worst case volume error to 0.25 dB, as in Figure 14.6. You might think this improvement is mere pedantry, but if it is possible to make things work slightly better simply by changing a resistor value, I can think of no reason not to do it.

Figure 14.5 **Not quite constant-volume when a linear pot with a pullup resistor is used to approximate the sine/cosine law. Maximum error 0.35 dB.**

More information on what is essentially a panpot configuration can be found in Chapter 22, though there the emphasis is more on constant volume when panning a mono signal to stereo.

The economical method at Figure 14.3d was once popular as only a single pot section is required. Unfortunately it has the unavoidable drawback that the relatively high resistance between wiper and track causes serious degradation of the interchannel crosstalk performance. If the resistance values are reduced to lower Johnson noise, the track-wiper resistance is unlikely to decrease proportionally and the crosstalk will be worsened. With the values shown the loss for each channel with the control central is −3.2 dB. This loss can be reduced by decreasing the value of R1, R2 with respect to the pot, but this puts a correspondingly heavier load on the preceding stages when the control is well away from central.

Some preamplifier designs have attempted to evade the whole balance control problem by having separate but concentric volume knobs for left and right channels. The difficulty here is that almost all the time the volume only will require adjustment, and the balance function will be rarely used; it is therefore highly desirable that the left and right knobs are linked together in some sort of high-friction way so that the two normally move together. This introduces some awkward mechanical complications.

Figure 14.6 **Reducing the pullup resistor value from 3.6 kΩ to 3.0 kΩ reduces the maximum deviation from constant-volume to 0.25 dB.**

Balance controls: active

An active balance control is configured so that it makes a small adjustment to the gain of each channel rather than introducing attenuation, so that any noise/headroom compromise can be avoided altogether. Since all active preamplifiers have at least one gain stage, the extra complication is likely to be minimal. It is not elegant to add an extra active stage just to implement the balance function.

Figure 14.7a shows an active balance control that requires only a single-gang pot. However, it suffers from the same serious disadvantage as the passive version in Figure 14.3d; the wiper connection acts as a common impedance in the two channels and causes crosstalk. This kind of balance control cannot completely fade out one channel as it is not possible to reduce the stage gain below unity, and in fact even unity cannot be achieved with this configuration because whatever the setting, there is some resistance to ground making up the lower feedback arm. With the values shown the gain for each channel with the control central is +6.0 dB. With the control fully clockwise the gain increases to +9.4 dB and decreases to +4.4 dB with it fully anti-clockwise; the range is deliberately quite restricted. It is a characteristic of this arrangement that the gain increase on one channel is greater than the decrease on the other.

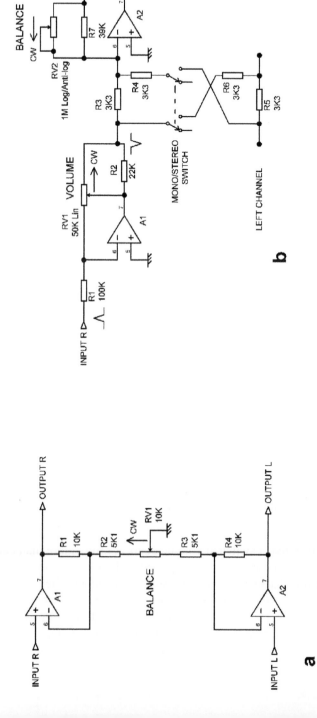

Figure 14.7 Active balance controls.

Combining balance controls with other stages

The balance control function is a very simple one; just control attenuation or gain over a rather limited range. I have always felt it is inelegant and uneconomic to design into a system a stage that does that and nothing else.

My earliest attempts in this direction were to combine the balance control with a Baxandall tone control, the balance pot varying the amount of output signal fed to the NFB side of the Baxandall network, with provision for minimising the source impedance variations. This might suggest a bit of approximate technology, but it actually worked rather well, with only a very small amount of interaction between balance setting and tone settings. It is fully described in Chapter 15.

More recently I have found it expedient to combine the balance control with a balanced (differential) line input amplifier. It is a pity that there are two different uses of the word "balance" in the same circuit block, but there's not much that can be done about it except to call the line input a "differential input" which is less common in audio usage. There is more on this combination later in this chapter and in Chapter 18 on line inputs.

Figure 14.7b shows an active balance control combined with an active gain control and mono/ stereo switching. This configuration was used in the original Cambridge Audio P-series amplifiers; in that application A1 was a simple two-transistor inverting stage, and A2 an even simpler single transistor. The left-hand section of volume control RV1 is the feedback resistance for A1, while the right hand section forms part of the input resistance to shunt stage A2, both changing to give a quasi-logarithmic law when the control is altered. The balance control RV2 is a variable resistance in the shunt feedback network of A2. The mono/stereo switch feeds the virtual-earth node of A2 with both channels via R3, R4 when in mono mode. The circuit has two inverting stages and so handily maintains the absolute phase of the output.

Switched balance controls

A balance control implemented with a pot is subject to inaccuracy due the loose tolerances of the pot track (20%) compared with the fixed resistors around it. This does not apply to the arrangements in Figure 14.3a and Figure 14.3b because here the pot is acting as a pure potentiometer, with its output determined only by the wiper position (this assumes that the next stage puts negligible loading on the pot). If Figure 14.3a has a linear track to avoid the inaccuracies of log and anti-log tracks, there is an excessive 6 dB loss when set centrally. The accuracy of the control in Figure 14.3b depends on whether the resistive (non-metal) part of the track is linear or log.

A switched balance control, like a switched volume control, offers more than enough accuracy for even very precise audio work and allows complete freedom in selecting the control law. As for volume controls, the drawbacks are much increased cost and a limited number of control steps. The latter is less of an issue for a balance control as it can have far fewer steps and still give all the control resolution for image position that is required. As with switched volume controls, the cost of the switch increases steeply with the number of steps. I suggest 24 steps is

enough for a truly world-class balance control, and such switches are readily available. One of the switch positions must correspond to the central setting, so we actually need an odd number of switch positions. The 24-way switch is therefore mechanically stopped down to 23 positions, with position 12 being the centre. The switch should be make-before-break to minimise glitching.

Table 14.1 shows a truncated-sine law, as described earlier; the maximum attenuation at each extreme is −10.4 dB. This is shown implemented in Figure 14.8.

TABLE 14.1 Gain at each switch position for a truncated-sine law balance control

Switch position	Sine law x	Gain dB	RMS summation dB
23	0.9537	−0.412	0.000
22	0.9397	−0.540	0.000
21	0.9239	−0.688	0.000
20	0.9063	−0.854	0.000
19	0.8870	−1.041	0.000
18	0.8660	−1.249	0.000
17	0.8434	−1.479	0.000
16	0.8192	−1.733	0.000
15	0.7934	−2.011	0.000
14	0.7660	−2.315	0.000
13	0.7373	−2.647	0.000
12	**0.7071**	**−3.010**	**0.000**
11	0.6756	−3.406	0.000
10	0.6428	−3.839	0.000
9	0.6088	−4.311	0.000
8	0.5736	−4.828	0.000
7	0.5373	−5.396	0.000
6	0.5000	−6.021	0.000
5	0.4617	−6.712	0.000
4	0.4226	−7.481	0.000
3	0.3827	−8.343	0.000
2	0.3420	−9.319	0.000
1	0.3007	−10.437	0.000

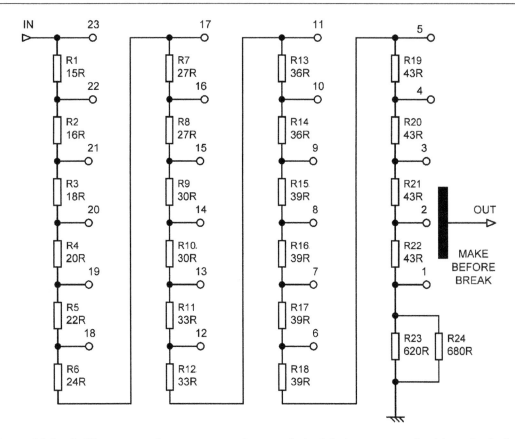

Figure 14.8 A 23-step passive constant-volume switched balance control with make-before-break wiper contact. Position 12 is the centre position.

Mono-stereo switches

It was once commonplace for preamplifiers to have mono-stereo switches, which allowed a mono source to be played over both channels of a stereo amplifier system. Most of these were configured so that the two channels were simply joined together somewhere in the middle of the preamp stages, which was not very satisfactory unless the unused input was terminated in a low impedance to minimise noise. More sophisticated switching allowed either the left or the right input only to be routed to both outputs.

Figure 14.9a shows a simple mono switch. As indicated here it was usually placed just before the balance or the volume control. The value of R1, R2 is a compromise; it should not be too high, as it is loaded by the balance pot and attenuation is introduced that will have to be undone somewhere else. If too low the path between the L and R inputs will have a low impedance that will excessively load the stages upstream when they are dealing with out-of-phase signal content. Another issue is interchannel crosstalk through the capacitance between the contacts when the switch is open.

The more sophisticated version in Figure 14.9b was very commonly used in Japanese preamplifiers. R1 and R2 are shorted out in stereo operation, so there is no loss of gain, and the

impedance at the switch contacts remains very low so capacitance does not cause crosstalk. There is, however, some small loss of gain in mono mode. It uses two switch sections, but since the mono switch was very often a 2-pole c/o push-switch anyway, there was no economic penalty.

For professional mono compatibility checking, no compromises in gain loss or crosstalk are acceptable. Figure 14.10 shows an active mono-switching stage that avoids these problems. Each shunt-feedback stage sums L and R signals in mono mode. There must be an exact 2:1 ratio of resistors to get the correct gains; 2 kΩ and 1 kΩ from the E24 series will work well in most cases. If the stage is fed from low impedances then the capacitances between the switch contacts have no effect. Note the phase inversion that can be inconvenient.

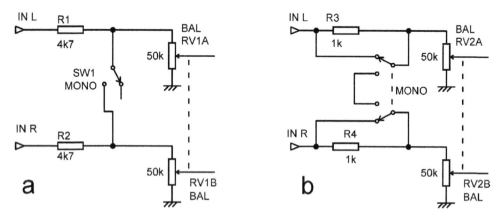

Figure 14.9 **Passive mono/stereo switching stage.**

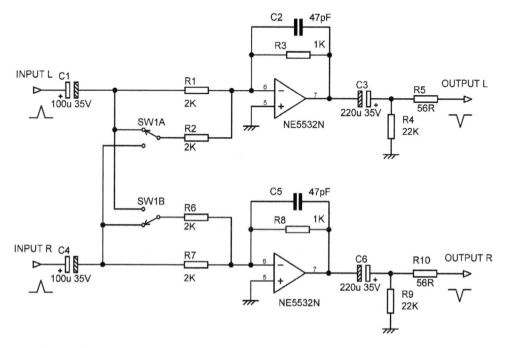

Figure 14.10 **Active mono/stereo switching stage. Note phase inversion.**

Since almost all modern sources are stereo if not multi-channel, mono-stereo switches are now rarely if ever fitted to preamplifiers. They are, however, still seen on mixing consoles to allow checking of mono compatibility.

Width controls

Another facility which has always been rare in preamps but is now almost unheard of is the width control. Summing a small proportion of each channel into the other reduces the width of the sound image, and this was sometimes advocated as a small width reduction would make the image less associated with the loudspeakers and so give a stronger illusion of acoustic reality. This, of course, runs directly counter to more contemporary views that very high levels of interchannel isolation are required to give a good stereo image. The latter is flat-out untrue; it was established long ago by the BBC in extensive testing before the introduction of FM stereo broadcasting that a stereo separation of 20 to 25 dB is enough to give the impression of full image width.

By cross-feeding antiphase signals, the width of a stereo image can be increased. A famous circuit published by Mullard back in 1972 [1] gave continuous variation between mono, normal, and enhanced-width stereo. It was stated that antiphase crossfeed of greater than 24% should not be used as it would cause the sound image to come apart into two halves. Figure 14.11 shows an up-to-date version that I have used in many mixing console designs, usually on stereo input modules. Centre-tap pots are required.

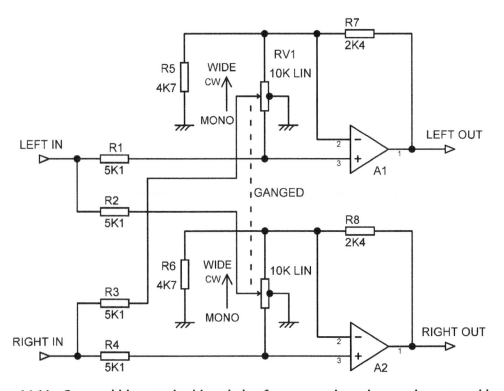

Figure 14.11 Stereo width control, with variation from mono through normal to extra-wide.

With the control central, the stereo width is unaltered, as the cross-feed through R2 and R3 is grounded via the centre-taps of the pot tracks. If there were no centre-taps we would be relying the limited mechanical accuracy of the dual pot to minimise the crossfeed, and this would not work well. With the pot fully anti-clockwise 100% of each channel is summed with the other, giving mono. With the pot fully clockwise a fraction of each channel is summed with the other in anti-phase, increasing stereo width. The pot should have a centre-detent to positively indicate the 'normal' position.

Reference

[1] Rose, M. J., ed. *Transistor Audio and Radio Circuits*, 2nd edition. Mullard, 1972, p. 180

Tone controls and equalisers

Introduction

Facilities that alter the shape of the frequency response are called tone controls when they are incorporated in hifi systems and equalisation (or EQ) in mixing consoles.

Tone controls have suffered at the hands of fashion for some years now. It has been claimed that tone controls cause an audible deterioration even when set to the flat position. This is usually blamed on 'phase shift.' For a long time tone controls on a preamp damaged its chances of street (or rather sitting-room) credibility, for no good reason. A tone-control set to 'flat'—assuming it really is flat—cannot possibly contribute any extra phase shift unless you have accidentally built in an all-pass filter, which would require truly surreal levels of incompetence. Even if you managed to do it, it would still be inaudible except possibly on artificial test signals such as isolated clicks. This is well-known; most loudspeaker crossovers have an all-pass phase response, and this is considered entirely acceptable. A tone-control set to flat really is inaudible.

My view is that hifi tone controls are absolutely indispensable for correcting room acoustics, loudspeaker shortcomings, or the tonal balance of the source material and that a lot of people are suffering sub-optimal sound as a result of this fashion. It is commonplace for audio critics to suggest that frequency-response inadequacies should be corrected by changing loudspeakers; this is an extraordinarily expensive way of avoiding tone controls.

The equalisation sections of mixers have a rather different function, being creative rather than corrective (from now on I am going to just call it EQ). The aim is to produce a particular sound, and to this end mixer EQ is much more sophisticated than that found on most hifi preamplifiers. There will usually be middle controls as well as bass and treble (which in the mixing world are more often called LF and HF), and these introduce a peak or dip into the middle range of the audio band. On more complex consoles the middle frequencies are infinitely variable, and the most advanced examples have variable-Q as well to control the width of the peak or dip introduced. No one has so far suggested that mixing consoles should be built without EQ.

It is not necessary to litter these pages with equations to determine centre frequencies and so on. In each case, altering the range of frequency controlled can be done very simply by scaling the capacitor values given. If a stage gives a peaking cut/boost at 1 kHz, but you want 2.5 kHz, then simply reduce the values of all the capacitors by a factor of 2.5 times. Scaling the associated resistors instead is a bit more complex; if you reduce the resistors too much, distortion will increase due to excessive loading on the opamps used. If you increase the resistors this may degrade the noise performance as Johnson noise and the effects of current noise will increase.

DOI: 10.4324/9781003332985-15

Another consideration is that potentiometers come in a very limited number of values, either multiples of 1, 2, and 5 or multiples of 1, 2.2, and 4.7 (the E3 series). Changing the capacitors is simpler and much more likely to be trouble-free.

Passive tone controls

For many years all tone controls were passive, simply providing frequency-selective attenuation. The famous *Radio Designer's Handbook* [1] shows that they came in a bewildering variety of forms; take a look at the chapter on "Tone compensation and tone control," which is 42 pages long with 90 references but does not include the Baxandall tone control; that is hidden away in an appendix at the back of the book (the final edition was published in 1953 but modern reprints are available). Some of the circuits are incredibly complex, requiring multi-section switches and tapped inductors to give quite limited tone control possibilities. Figure 15.1 shows one of the simpler arrangements [2], which is probably the best-known passive tone control configuration. It was described by Sterling [3], though I have no idea if he originally invented it. The arrangement gives about +/−18 dB of treble and bass boost and cut; the curves look something like those of a Baxandall control but with less symmetry.

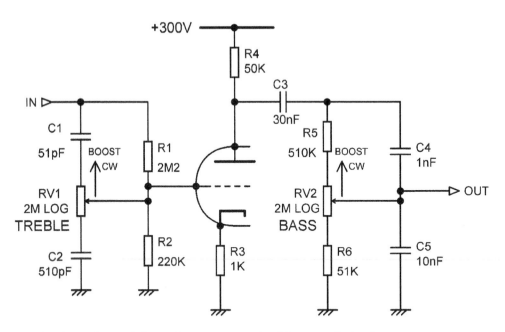

Figure 15.1 A pre-Baxandall passive tone control, with severe limitations.

Such circuitry has several disadvantages. When set to flat it gives a loss in each network of 20.8 dB, which means a serious compromise in either noise (if the make-up gain is after the tone-

control network) or headroom (if the make-up gain is before the tone-control network). In the days of valves, when these networks were popular, headroom may have been less of a problem, but given the generally poor linearity of valve circuitry, the increased levels probably gave rise to significantly more distortion.

Another problem is that if linear pots are used the flat position corresponds to 1/10 of the rotation. It is therefore necessary to use log pots to get the flat setting to somewhere near the centre of control travel, and their large tolerances in law and value mean that the flat position is actually rather variable and is unlikely be the same for the two channels of stereo.

This circuit counts as a passive tone control because the valve in the middle of it is simply providing make-up gain for the treble network and is not in a frequency-dependent feedback loop. In the published circuit there was another identical valve stage immediately after the bass network to make up the losses therein. There are some other interesting points about this valve-based circuit; it runs at a much higher impedance than solid-state versions, using 2 MΩ pots rather than 10 kΩ, a factor of 200 times, and it uses a single supply rail at an intimidating +300 V. Circuitry running at such high impedances is very susceptible to capacitive hum pickup, though this can be eliminated by careful metallic screening. There will also be a lot of Johnson noise from the high-value resistors.

Baxandall tone controls

The Baxandall bass and treble tone control swept all other versions before it. The original design, famously published in *Wireless World* in 1952 [4], was in fact rather more complex than the simplified version which has become universal. Naturally at that date it used a valve as the active component. The original schematic is rarely if ever displayed, so there it is in Figure 15.2. THD was quoted as less than 0.1% at 4 Vrms out up to 5 kHz.

The 1952 circuit specified a centre-tapped treble pot to give minimum interaction between the two controls, but such specialised components are almost as unwelcome to manufacturers as they are to home constructors, and the form of the circuit that became popular is shown in Figure 15.3; some control interaction is regarded as acceptable. The advantages of this circuit are its simplicity and its feedback operation, the latter meaning that there are no awkward compromises between noise and headroom, as there are in the passive circuit earlier. It also gives symmetrical cut and boost curves.

It is not commonly realised that the Baxandall tone control comes in several versions. Either one or two capacitors can be used to define the bass time-constants, and the two arrangements give rather different results at the bass end. The same applies to the treble control. The original Baxandall design used two capacitors for bass and one for treble.

In the descriptions that follow, I have used the term "break frequency" to indicate where the tone control begins to take action. I have defined this as the frequency where the response is +/−1 dB away from flat with maximum cut or boost applied.

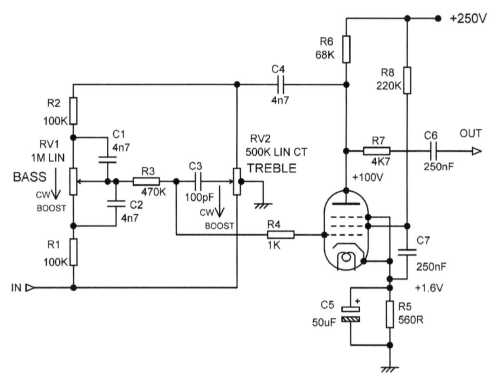

Figure 15.2 The original Baxandall tone control of 1952. The series output resistor R7 is to give stability with capacitive loads.

The Baxandall one-LF-capacitor tone control

This is probably the most common form of the Baxandall tone control used today, simply because it saves a capacitor or two. The circuit is shown in Figure 15.3. At high frequencies the impedance of C1 is small and the bass control RV1 is effectively shorted out, and R1, R2 give unity gain. At low frequencies RV1 is active and controls the gain, ultimately over a +/−16 dB range at very low frequencies. R1, R2 are end-stop resistors which set the maximum boost or cut.

At high frequencies, C2 has a low impedance and treble control RV2 is active, with maximum boost or cut set by end-stop resistor R4; at low frequencies C2 has a high impedance and so RV2 has no effect. The HF network can also be configured with two capacitors, with some advantages; more on that later.

The one-LF-capacitor version is distinguished by its fixed LF break frequency, as shown by the bass control response in Figure 15.4. The treble control response in Figure 15.5 is similar.

In these figures the control travel is in 11 equal steps of a linear pot (Central plus five steps on each side). The bass curves are +/−1.0 dB at 845 Hz, while the treble curves are +/−1.0 dB at 294 Hz. This sort of overlap is normal with the Baxandall configuration. Phase spikes are shown

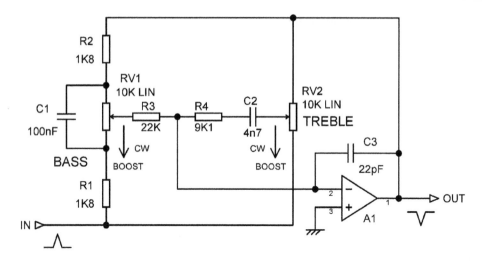

Figure 15.3 The one-LF-capacitor Baxandall tone control.

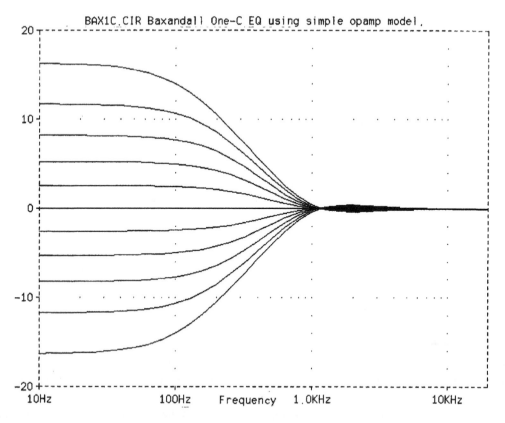

Figure 15.4 Bass control frequency responses. The effect of the LF control above the 'hinge point' at 1 kHz is very small.

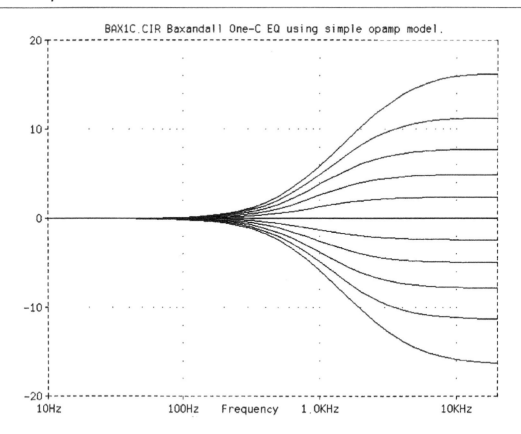

Figure 15.5 **Treble control frequency responses.**

at input and output to underline that this stage phase inverts, which can be inconvenient; phase spikes will be seen in most of the diagrams that follow in this chapter.

An HF stabilising capacitor C3 is shown connected around A1. This is sometimes required to ensure HF stability at all control settings, depending on how much stray capacitance there is in the physical layout to introduce extra phase shifts. The value required is best determined by experiment. This capacitor is not shown in most of the diagrams that follow to keep them as uncluttered as possible, but the likely need for it should not be forgotten.

It is important to remember that the input impedance of this circuit varies both with frequency and control settings, and it can fall to rather low values.

Taking the circuit values shown in Figure 15.3, the input impedance varies with frequency as shown in Figure 15.6, for treble (HF) control settings, and as Figure 15.7 for bass (LF) control settings. With both controls central the input impedance below 100 Hz is 2.9 kΩ. At low frequencies C1, C2 have no effect, and the input impedance is therefore half the LF pot resistance plus the 1k8 end-stop resistor, adding up to 6.8 kΩ. In parallel is 5 kΩ, half the impedance of the HF pot, as although this has no direct connection to the summing point (C2 being effectively

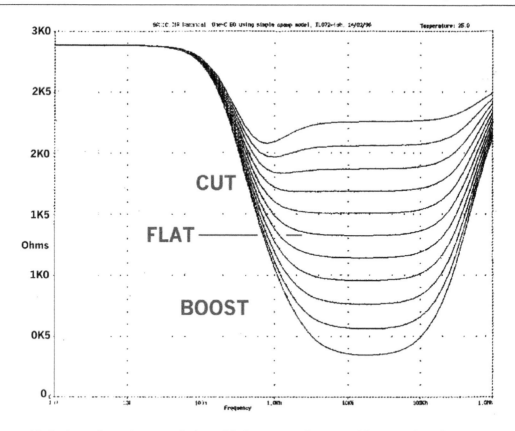

Figure 15.6 **Input impedance variation with frequency, for 11 treble control settings.**

open-circuit) its other end is connected to the output which is the input inverted. Hence the centre of the pot is approximately at virtual-earth. The parallel combination of 6.8 kΩ and 5 kΩ is 2.9 kΩ, and so this is the input impedance at LF.

At frequencies above 100 Hz (still with both controls central) the input impedance falls because C1 is now low impedance, and the LF pot is shorted out. The input impedance is now 1.8 kΩ in parallel with 5 kΩ, which is 1.3 kΩ. This is already a significant loading on the previous stage, and we haven't applied boost or cut yet.

When the HF control is moved from its central position, with the LF control central, the HF impedance is higher at full cut at 2.2 kΩ. It is, however, much lower at 350 Ω at full boost. There are very few opamps that can give full output into such a low impedance, but this is not quite as serious a problem as it first appears. The input impedances are only low when the circuit is boosting; therefore driving the input at the full rail capability is not relevant, for if you do the output will clip long before the stage driving it. Nonetheless, opamps such as the 5532 will show increased distortion driving too heavy a load, even if the level is a long way below clipping, so it is a point to watch.

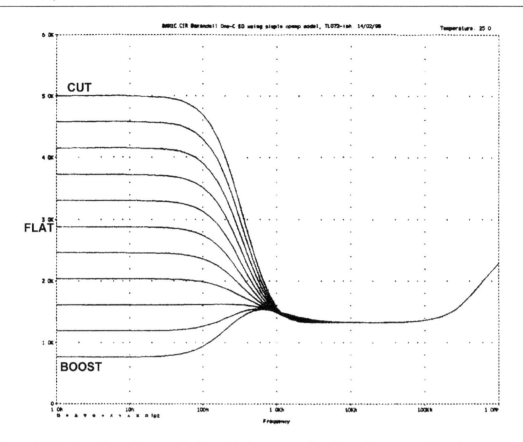

Figure 15.7 Input impedance variation with frequency, for eleven bass control settings

The input impedances can, of course, be raised by scaling the impedance of the whole circuit. For example, multiply all resistor values by four, and quarter the capacitor values to keep the frequency response the same. The downside to this is that you have doubled the Johnson noise from the resistors and quadrupled the effect of opamp current noise and so made the stage noisier.

When the LF control is moved from its central position, with the HF control central, the input impedance variations are similar, as shown in Figure 15.7. At full LF cut the input impedance is increased to 5.0 kΩ; at full LF boost it falls to 770 Ω at low frequencies. This variation begins below 1 kHz but is only fully established below 100 Hz.

The figure of 770 Ω requires some explanation. The incoming signal encounters a 1k8 resistor, in parallel with 5 kΩ, which represents half of the HF pot resistance, if we assume that its wiper is at virtual-earth. The value of this is 1.32 kΩ; so how in the name of reason can the input impedance fall as low as 770 Ω? The answer is that our assumption is wrong. The HF pot wiper is NOT at virtual-earth; it has a signal on it only 7 dB less than at the output, and this is in phase with the output, in other words in anti-phase with the input. This causes 'reverse bootstrapping' of the 5 kΩ resistance that is half of the HF pot and makes it appear lower in value than it is. A similar

'reverse bootstrapping' effect occurs at the Cold input of the standard differential amplifier balanced input stage; see Chapter 18.

At low frequencies, more of the input current is actually going into the HF section of the tone-control network than into the LF section. This highlights one of the few disadvantages of the Baxandall type of tone-control—the input impedances are reduced by parts of the circuit that are not actually doing anything useful at the frequency of interest. Other versions of the tone-control network have a somewhat better behaviour in this respect, and this is examined further on in this chapter.

These input impedances also appear as loading on the output of the opamp in the tone-control stage when the control settings are reversed. Thus at full LF boost there is a 770 Ω load on the preceding stage, but at full LF cut that 770 Ω loading is on the tone-control opamp.

The Baxandall two-LF-capacitor tone control

The two-capacitor version of the Baxandall tone control is shown in Figure 15.8, and while it looks very similar there is a big difference in the LF end response curves, as seen in Figure 15.9. The LF break frequency rises as the amount of cut or boost is increased. It is my view that this works much better in a hifi system as it allows small amounts of bass boost to be used to correct loudspeaker deficiencies without affecting the whole of the bass region. In contrast, the one-capacitor version seems to be more popular in mixing consoles, where the emphasis is on creation rather than correction.

The other response difference is the increased amount of 'overshoot' in the frequency response (nothing to do with overshoot in the time domain). Figure 15.9 shows how the use of LF boost causes a small amount of cut just above 1 kHz, and LF cut causes a similar boost. The amounts are small, and this is not normally considered to be a problem.

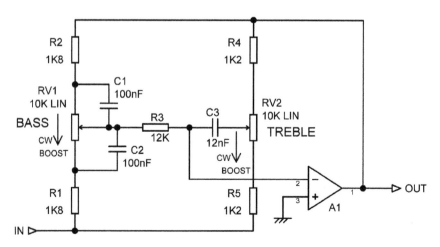

Figure 15.8 **The two-LF-capacitor Baxandall tone control.**

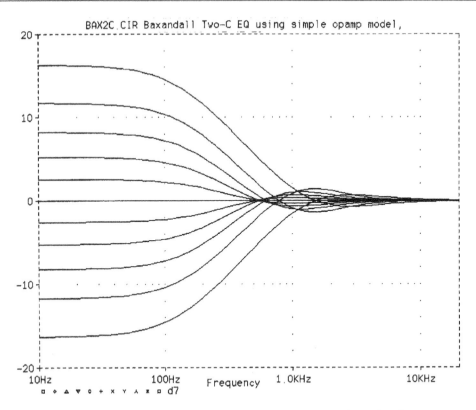

Figure 15.9 Bass control frequency responses for the two-capacitor circuit. Compare Figure 15.4.

Note that the treble control here has been configured slightly differently, and there are now two end-stop resistors, at each end of the pot, rather than one attached to the wiper; the frequency response is identical, but the input impedance at HF is usefully increased.

The input impedance of this version shows variations similar to the one-capacitor version. With controls central, at LF the input impedance is 3.2 kΩ; from 100 Hz to 1 kHz it slowly falls to 1.4 kΩ. The changes with HF and LF control settings are similar to the one-C version, and at HF the impedance falls to 370 Ω.

The Baxandall two-HF-capacitor tone control

The treble control can also be implemented with two capacitors, as in Figure 15.10.

The frequency responses are similar to those of one-HF-capacitor version, but as for the LF control, some 'overshoot' in the curves is introduced. There is a handy reduction in the loading presented to the preceding stage. With controls central, at LF the input impedance is 6.8 kΩ, which is usefully higher than the 2.9 kΩ given by the 1-HF capacitor circuit; from 100 Hz to 1 kHz it slowly falls to 1.4 kΩ.

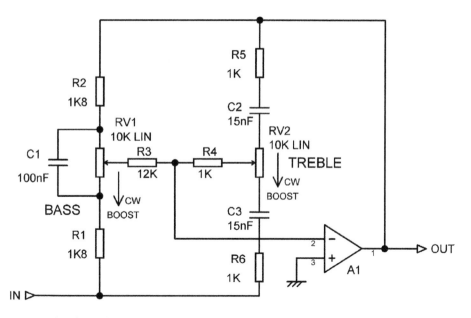

Figure 15.10 Circuit of the two-HF-capacitor version.

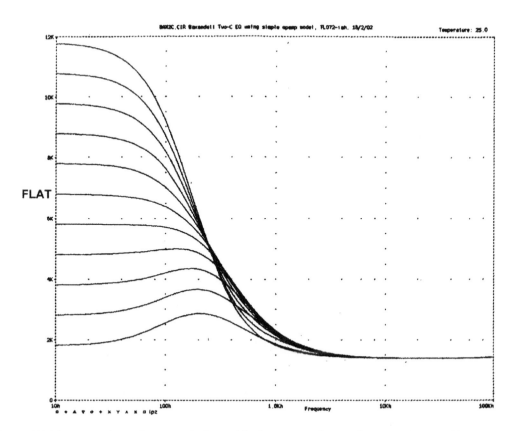

Figure 15.11 Input impedance variation with frequency, for 11 bass control settings; two-HF-capacitor version.

When the LF control is varied, at full cut the input impedance is increased to 11.7 kΩ, and at full boost it falls to 1.9 kΩ; see Figure 15.11. On varying the HF control, at full cut the input impedance is increased to 2.3 kΩ; at full boost it falls to 420 Ω. These values are higher because with this configuration C2, C3 effectively disconnect the HF pot from the circuit at low frequencies. In some cases the higher input impedance may justify the cost of an extra capacitor. The capacitors will also be about six times larger to obtain the same ±1 dB HF break frequency as the one-HF-capacitor version.

One disadvantage of the Baxandall tone control is that it inherently phase inverts. This is decidedly awkward because relatively recently the hifi world has decided that absolute phase is important; in the recording world keeping the phase correct has always been a rigid requirement. The tone-control inversion can, however, be conveniently undone by a Baxandall active volume control, which also phase inverts (see Chapter 13). If a balanced input stage is used then an unwanted phase inversion can be corrected simply by swapping over the Hot and Cold inputs.

A very important point about all of the circuits shown so far is that they assume a FET-input opamp (such as the TL072, or a more sophisticated FET part) will be used to minimise the bias currents flowing. Therefore all the pots are directly connected to the opamp without any explicit provision for preventing DC flowing through them. Excessive DC would make the pots scratchy and crackly when they are moved; this does not sound nice. It is, however, long-established that typical FET bias currents are low enough to prevent such effects in circuits like these; however there is still the matter of offset voltages to be considered. Substituting a bipolar opamp such as the 5532 will improve the noise and distortion performance markedly at the expense of the need to make provision for the much greater bias currents by adding DC-blocking capacitors.

The Baxandall tone control: impedance and noise

A major theme in this book is the use of low-impedance design to reduce Johnson noise from resistors and the effects of opamp input current noise flowing in them. Let's see how that works with the Baxandall tone control.

The Baxandall controls in Figure 15.12 all give ±10 dB boost and cut and are equivalent apart from employing 10 kΩ, 5 kΩ, 2 kΩ, and 1 kΩ pots with all other components scaled to keep the frequency responses the same. 1 kΩ is the lowest value in which dual-gang pots can be readily obtained.

Table 15.1 demonstrates that drastically reducing the impedance of the circuit by ten times reduces the noise output by 7.0 dB (controls set flat). Using an LM4562 section instead of a 5532 section shows a similar progression but with somewhat lower noise levels. The improvement on going from 2 kΩ to 1 kΩ pots is small (though reliable), and you may question if it is worth pushing things as far as 1 kΩ, given that as we saw earlier, Baxandall controls can show surprisingly low input impedance when boosting, with corresponding heavy loads on the opamp driving the negative feedback path when cutting. The situation becomes proportionally worse when the impedances are scaled down as we have just done. The design process here was driven by a desire to use 1 kΩ pots throughout in the very low noise Elektor Preamp 2012 [5].

In the 1 kΩ case a 5532 is only able to drive 6.7 Vms (±17 V rails) into the negative feedback path before clipping occurs. Clearly we need to either find some way of reducing the loading

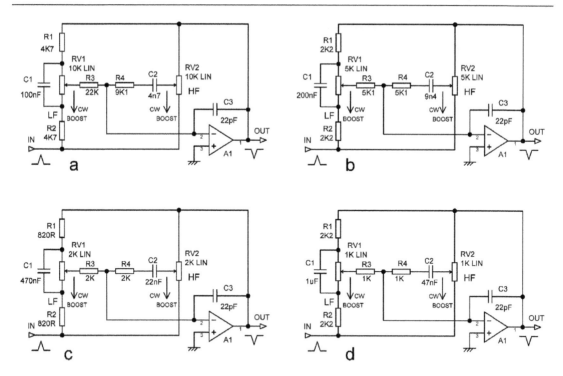

Figure 15.12 Equivalent Baxandall controls giving ±10 dB boost and cut, using 10 kΩ, 5 kΩ, 2 kΩ, and 1 kΩ pots.

TABLE 15.1 Noise output versus impedance level using 5532 opamp

Pot value	HF capacitor configuration	Noise output
10 kΩ	1-C	−105.6 dBu
5 kΩ	1-C	−108.9 dBu
2 kΩ	1-C	−112.2 dBu
1 kΩ	1-C	−112.6 dBu
1 kΩ	2-C (Figure 15.13)	−113.1 dBu

or increasing the drive capability. In the previous section I described how the Baxandall configuration with two HF capacitors is easier to drive than the one-capacitor version. Figure 15.12d is shown converted to two-HF-capacitor operation in Figure 15.13. The 5532 now clips at 8.8 Vrms, which is much better, but the opamp is still overloaded and will not give a good distortion performance. Note that the two HF capacitors are both much larger than the single HF capacitor in Figure 15.12d and will be relatively expensive. On the upside we get the side-benefit of yet lower output noise—see the bottom row of Table 15.1.

Elsewhere in this book I have described the great advantages of using multiple opamps in parallel to drive heavy loads. In this case it is not at all clear how the inverting opamp A1 can be

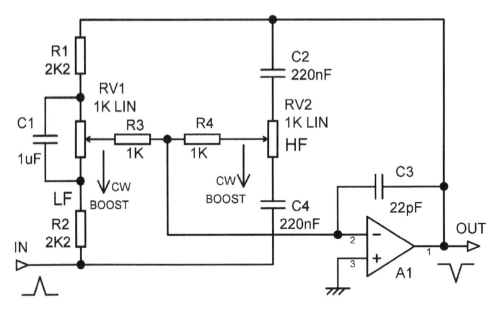

Figure 15.13 Baxandall control with 1 kΩ pots, converted to two-HF-capacitor configuration to reduce loading. Compare Figure 15.12d.

multiplied in parallel. My solution is to split the drive to the LF and HF control networks so that the LF section is driven by its own unity-gain buffer A2; see Figure 15.14. It is the LF section that is driven by the buffer, so that the HF section can be fed directly from A1 and will not suffer phase shift in A2 that might imperil stability. The output now clips at a healthy 10.8 Vrms, and THD is reduced to the low levels expected.

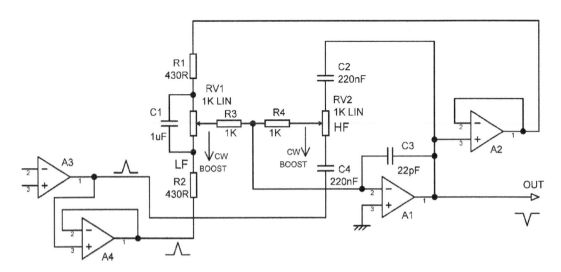

Figure 15.14 Split-Drive Baxandall control fed by two parallel opamps and with separate feedback drive to the LF and HF control networks.

This technique is to the best of my knowledge novel; it was used for the first time in the Elektor 2012 preamplifier (using LM4562s) with great success [5]. I call it a Split-Drive Baxandall stage.

The input side of the control also needs at least two opamps to drive it with low distortion. The arrangement here was also used in the Elektor preamp; it makes no assumptions about what A3 is up to (it was part of a balanced line input in the preamp) but simply uses A4 as a buffer to give separate drive to the input of the LF control network.

Combining a Baxandall stage with an active balance control

In 1983 I felt moved to design a new preamplifier. This was published in *Wireless World* as "A Precision Preamplifier." It seemed to me that a having a separate balance stage simply to introduce some quite small differences in interchannel gain was not a good idea. I therefore wondered which of the existing stages it could be grafted onto. The line-level part of the preamp consisted of a high-impedance unity-gain buffer, a Baxandall tone-control, and a Baxandall active volume-control; the buffer was a definite possibility (obviously it would have to be reconfigured so it could give gain), but the tone control seemed more promising and was clearly a bit of a design challenge. Now I like design challenges, though I am aware that not everybody does.

The basic idea is to vary the amount of negative feedback sent to the Baxandall network to change the stage gain without affecting the frequency response. It is only possible to increase the gain from unity, by reducing the feedback proportion, unless you accept the added complication of putting gain in the feedback path; that not only might cause stability problems, but it definitely makes a nonsense of combining stages to save on active circuitry. The problem boils down to making the source impedance seen by the feedback side of the Baxandall network as constant as possible with the movement of the balance control RV3, so it can be compensated for by putting the same impedance in series with the input. As shown in Figure 15.15, the value chosen here is 1

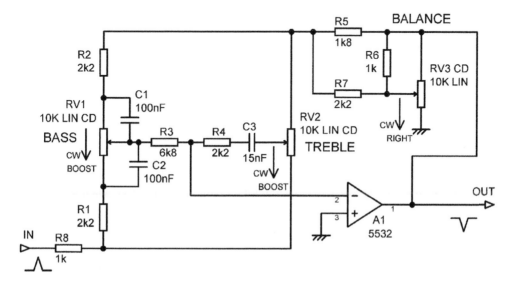

Figure 15.15 Baxandall control combined with active balance control.

kΩ. The three resistors R5, R6, R7 around RV3 make the output impedance of the network nearly constant, minimising interaction between the balance control and tone controls and also modify the balance control law to give only +0.8 dB of gain with balance central; it should be possible to fit this into a preamp gain structure somewhere. The gain with balance hard over is 0 dB or +5.2 dB. It could be argued the range should be greater, say 10 dB.

The balance network was designed by 'manual optimisation,' or in other words trial and error. Its output impedance varies from 990 Ω at the balance control extremes to 1113 Ω at the centre, a range of only 123 Ω; not bad, I feel. This could be reduced by reducing the value of R5 but only at the cost of increasing the loading on the opamp with the balance control fully clockwise. It works rather well as it is; with the treble control set to shelve at −4 dB, the difference in the response is only −0.2 dB as the balance control is moved from either extreme to the centre.

If we set the treble control to Mark −3 (ie with the treble wiper at the 2 kΩ–8 kΩ point on the track of the 10 kΩ pot) then the treble cut flattens out at −4.0 dB with balance control central. At either extreme balance setting the amount of cut is increased to −4.3 dB, as the impedance of the control and its associated network are at a minimum and therefore there is more negative feedback and so more treble cut. Similar results are obtained by setting the treble control back to flat and setting the bass control for +7.5 dB of bass boost. In this case the variation in boost with balance setting is only 0.2 dB. I suggest the control interaction is negligible in both cases.

This combined stage was used in the Precision Preamplifier design published in *Wireless World* in 1983; it was the MRP-10 in my own numbering system. I can say with absolute certainty that no comments on control interaction, negative or otherwise, were ever received.

A variation on this technique is occasionally useful. If for some reason you *have* to drive a simple Baxandall tone network (without balance control) from a substantial impedance (like R8 in Figure 15.15) the asymmetry that will produce in the control laws can be cancelled out by putting the same impedance in the feedback path.

One-band tone controls

Sometimes you need just an LF control or an HF control by itself. The LF control shown in Figure 15.16a uses the one-LF-capacitor format. The values shown in Figure 15.16a give a ±1 dB break frequency of 1 kHz (at max boost and cut), and the maximum boost and cut are ±15 dB at 20 Hz, set by end-stop resistors R1, R2. To obtain the same break frequency and a preamp-friendly ±10 dB max boost and cut at 20 Hz, R1 and R2 are increased to 4k7, and C1 is reduced to 100 nF.

In this case, DC feedback for the opamp operates through the pot, and there is no need to add the resistors R1, R2 seen in the HF stage of Figure 15.16b. This does, however, mean that the opamp bias current passes through the pot wiper, so a bipolar opamp may be noisy when the control is adjusted.

The HF control shown in Figure 15.16b uses the one-HF-capacitor format for component economy. The ±1 dB break frequency is 1 kHz (at max boost and cut), and the maximum boost and cut are ±15 dB at 20 kHz, set by end-stop resistor R3. This would be appropriate for a mixer input channel; for preamp use ±10 dB at 20 kHz is more likely to be desirable, and this can be

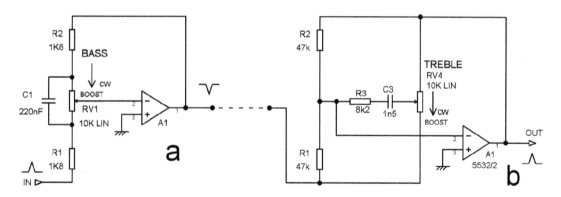

Figure 15.16 **(a) LF-only and (b) HF-only tone control stages, cascaded to correct phase.**

obtained by increasing R3 to 20 kΩ. Note that the opamp bias current does not pass through the pot wiper, so this control should be silent when moved.

It is important to remember that R1, R2 here do not just provide DC feedback to set the opamp operating conditions but also define the impedance level of the whole circuit; the lower they are the lower the end-stop resistor R3 must be and the bigger C1 must be for the same results. If R1, R2 are reduced to 4k7, then R3 must be reduced to 820 Ω, and C1 must be increased to 12 nF. This will much reduce the input impedance of the circuit, especially when boosting, and consideration of opamp drive capabilities is required.

In Figure 15.16, both types of stage are shown, cascaded together to emphasise that this is a good way to make a two-band EQ that does not phase invert. Also, inherently, there is no interaction at all between the HF and LF controls, which could well be a unique selling point in your sales literature.

The LF control in Figure 15.16a really requires a JFET input opamp because the bias current flows through the pot wiper. This is most inconvenient as it rules out popular opamps like the 5532. Figure 15.17 shows how to fix this; R3 and R4 are added to give DC feedback, and DC-blocking capacitor C2 keeps the bias current out of the pot. R1 and R2 must be reduced from 4k7 to 3k3 to obtain ±10 dB at 20 kHz; this is due to the effect of R3 and R4.

This circuit looks very much like that of a mid control.

Switched-HF-frequency Baxandall controls

While the Baxandall approach gives about as much flexibility as one could hope for from two controls, there is often a need for more. The most obvious elaboration is to make the break frequencies variable in some way.

The frequency response of the Baxandall configuration is set by its RC time-constants, and one obvious way to change the frequencies is to make the capacitors switchable, as in an early preamp design of mine [6]. Changing the R part of the RC is far less practical as it would require

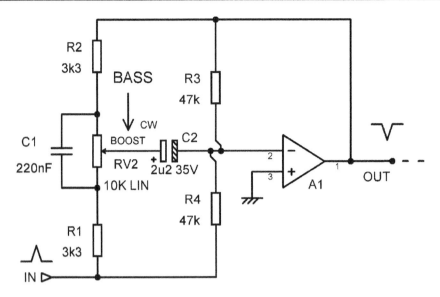

Figure 15.17 Baxandall LF-only tone control stage, with DC blocking to keep bias currents out of the pot.

changing the potentiometer values as well. If fully variable frequencies controlled by pots are wanted then a different configuration must be used, as described later in this chapter.

If a large number of switched frequencies (more than three) are wanted then a relatively expensive rotary switch is required, but if three will do, a centre-off toggle switch will certainly take up less panel space and probably be cheaper; you don't have to pay for a knob. This is illustrated in Figure 15.18, where C1 is always in circuit, and either C2 or C3 can be switched in parallel. This is an HF-only tone-control with ±1 dB break frequencies at 1 kHz, 3 kHz, and 5 kHz; most people will find frequencies higher than that to be a bit too subtle. A similar approach can be used with the two-HF-capacitor Baxandall control, but twice as much switching is required.

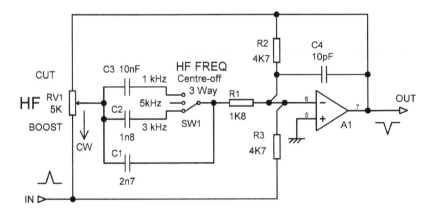

Figure 15.18 A Baxandall HF-only tone control with three switched turnover frequencies.

A disadvantage of the centre-off switch is that the maximum rather than the middle frequency is obtained at the central toggle position. If this is ergonomically unacceptable then C&K make a switch variant (Model 7411) [7] with internal connections that are made in the centre position, so that two switch sections will make up a 1-pole 3-way switch as in Figure 15.19. A stereo version is physically a 4-pole switch. This method is naturally more expensive than the centre-off approach.

The circuit of Figure 15.18 also demonstrates how an HF-only tone-control is configured, with R2 and R3 taking the place of the LF control and providing negative feedback at DC and LF. If this is cascaded with an LF-only control the second phase inversion cancels the first and both stages can bypassed by a tone-cancel switch without a phase change. The response is shown in Figure 15.20.

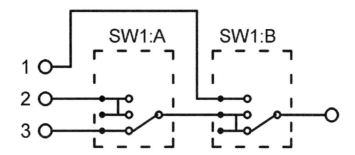

Figure 15.19 Making a 1-pole 3-way switch with two C&K 7411 switch sections.

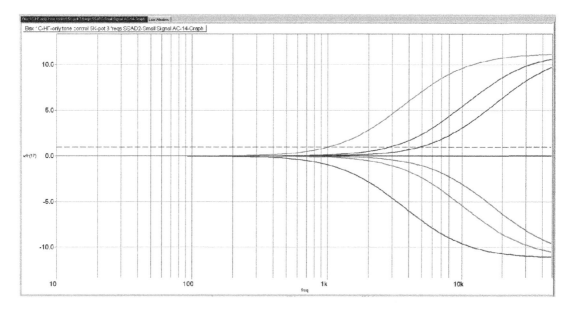

Figure 15.20 Frequency response of tone control with three switched HF 1 dB break frequencies, at 1, 3, and 5 kHz.

A similar approach can be used to switch the LF capacitor in a Baxandall control. The capacitor values tend to be inconveniently large for low break frequencies, especially if you are using low-value pots. A different tone control configuration gives more modest capacitor sizes—see the "Variable-frequency LF EQ" section.

Variable-frequency HF EQ

Since we are moving now more into the world of mixing consoles rather than preamplifiers, I shall stop using "bass" and "treble" and switch to "LF" and "HF," which, of course, mean the same thing. The circuit shown in Figure 15.21 gives HF equalisation only but with a continuously variable break frequency, and it is used in many mixer designs. It is similar to the Baxandall concept in that it uses opamp A1 in a shunt feedback mode so that it can provide either cut or boost, but the resemblance ends there.

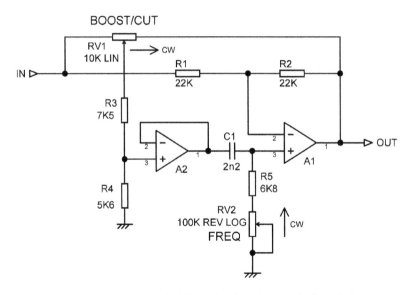

Figure 15.21 A variable-frequency HF shelving circuit. The ±1 dB break frequency range is 400 Hz–6.4 kHz.

R1 and R2 set the basic gain of the circuit to −1 and ensure that there is feedback at DC to establish the operating conditions. In many cases they can be reduced to say 2k2, which will give a useful reduction in noise. When the wiper of RV1 is at the output end, positive feedback partially cancels the negative feedback through R2 and the gain increases. When the wiper of RV1 is at the input end, the signal fed through A2 causes partial cancellation of the input signal, and gain is reduced.

The signal tapped off the pot RV1 is scaled by divider R3, R4, which set the maximum cut/boost. The signal is then buffered by voltage-follower A2 and fed to the frequency-sensitive part of the circuit, a highpass RC network made up of C1 and (R5 + RV2). Since only high frequencies are passed, this circuit has no effect at LF. The response is shown in Figure 15.22.

The frequency-setting control RV2 has a relatively high value at 100 kΩ because this allows for a 16:1 of variation in frequency, and a lower value would give excessive loading on A2 at the high frequency end. This assumes TL072 or similar opamps are used to avoid the need to deal with opamp input bias currents. If 5532 or LM4562 opamps are used there is considerable scope for reduction in the circuit impedances, resulting in lower noise. But watch out for input bias currents flowing through pots.

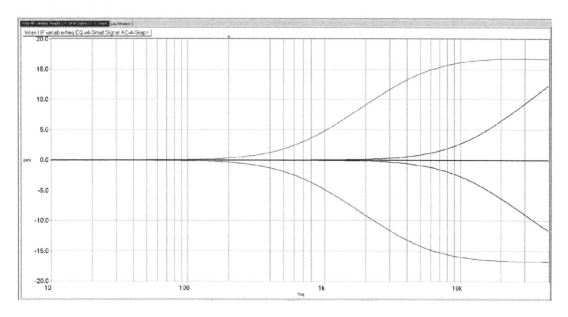

Figure 15.22 The response of the variable-frequency HF shelving circuit at extreme frequency settings. Maximum cut/boost is slightly greater than +/−15 dB.

A2 prevents interaction between the amount of cut/boost and the break frequency. Without it cut/boost would be less at high frequencies because R5 would load the divider R3, R4. In cheaper products this interaction may be acceptable, and A2 could be omitted. In EQ circuitry it is the general rule that the price of freedom from control interaction is not eternal vigilance but more opamps. The frequency range can be scaled simply by altering the value of C1. The range of frequency variation is controlled by the value of end-stop resistor R5, subject to restrictions on loading A2 if distortion is to be kept low.

The component values given are the E24 values that give the closest approach to +/−15 dB cut/boost at the control extremes. When TL072 opamps are used this circuit is stable as shown, assuming the usual supply rail decoupling. If other types are used a small capacitor (say 33 pF) across R2 may be required.

Variable-frequency LF EQ

The corresponding variable LF frequency EQ is obtained by swapping the positions of C1 and R5, RV2 in Figure 15.21 to give Figure 15.23. Now only the low frequencies are passed through, and so only they are controlled by the boost/cut control. The frequency response is shown in Figure 15.24.

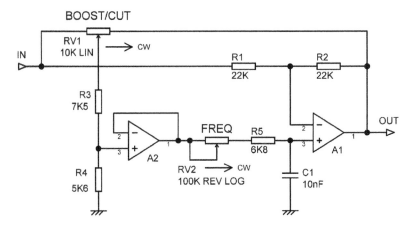

Figure 15.23 A variable-frequency LF shelving circuit. The ±1 dB break frequency range is 60 Hz–1 kHz. Boost/cut range of +/−15 dB is set by R3 and R4.

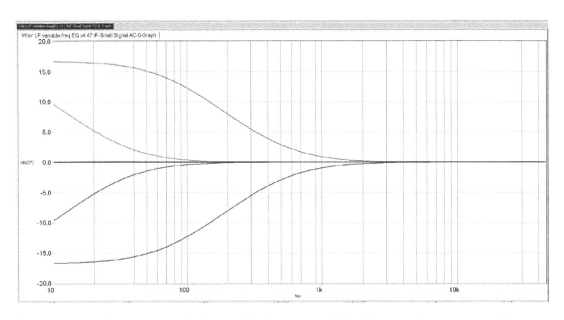

Figure 15.24 The response of the variable-frequency LF shelving circuit at extreme frequency settings. Maximum cut/boost is slightly greater than +/−15 dB.

A new type of switched-frequency LF EQ

In the circuit of Figure 15.23, R3 and R4 attenuate the signal before it passes through the unity-gain buffer A2. If a very low noise stage is required, it may be possible to put the attenuator after the buffer instead, in which case it will attenuate the buffer's noise by 7.4 dB. This is easier to do for a switched-frequency rather than a fully variable-frequency EQ. An example is Figure 15.25,

which has switched ±1 dB break frequencies at 100 Hz and 400 Hz and gives ±10 dB maximal cut and boost. With SW1 open, R3 and R4 attenuate the signal by the appropriate amount to give ±10 dB. Their combined impedance (R3 and R4 in parallel) gives the required 100 Hz frequency in combination with C1. When SW1 is closed, R5 is now in parallel with R3 and R6 is in parallel with R4; the attenuation is the same but the impedance is reduced so the break frequency increases to 400 Hz.

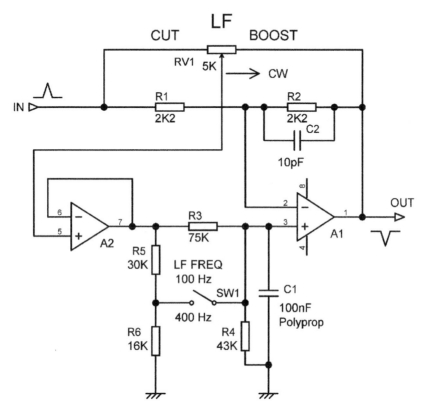

Figure 15.25 **Low-noise switched-frequency LF EQ with the attenuation after buffer A2.**

At first sight it appears that the relatively high values of R3, R4, R5, R6 would make the circuit very noisy. In fact the large value of C1 means that their noise is largely filtered out. In the first version measured R1 and R2 were 4.7 kΩ, and the output noise (flat) was −109.2 dBu using LM4562 for both opamp sections. Reducing R1, R2 to 2.2 kΩ as shown reduced this handily to −111.1 dBu, which is rather quiet.

Variable-frequency HF and LF EQ in one stage

In this section I describe how to combine variable-frequency LF and HF shelving EQ in one stage. This gives some component economy because opamp A1 can be shared between the two

functions. Despite this, the schematic in Figure 15.26 is a little more complex than you might expect from looking at the two circuits earlier because this is intended to be premium EQ with the following extra features:

- The response returns to unity gain outside the audio band. This is often called a return-to-flat (RTF) operation. The fixed RTF time-constants mean that the boost/cut range is necessarily less at the frequency extremes, where the effect of RTF begins to overlap the variable boost/cut frequencies.

- The frequency-control pots all have a linear law for better accuracy. The required logarithmic law is implemented by the electronic circuitry.

- There is an inbuilt tone-cancel switch that does not cause an interruption in the signal when it is operated.

- Low-impedance design is used to minimise noise.

The boost/cut range is +/−10 dB, the LF frequency range is 100 Hz–1 kHz, and the HF frequency range is 1 kHz–10 kHz. This design was used in my low-noise preamplifier published in Jan Didden's *Linear Audio* in 2012 [8], being developed from an earlier version used in the Precision Preamplifier '96 [9]. Very few hifi manufacturers have ever offered this facility. The only one that comes to mind is the Yamaha C6 preamp (1980–1981), which had LF and HF frequency variable by slider over wide ranges (they could even overlap in the 500 Hz–1 kHz range) and Q controls for each band as well. The Cello Sound Palette (1992) had a reputation as a sophisticated tone control, but it used six boost/cut bands at fixed frequencies that gave much less flexibility [10].

The variable boost/cut and frequencies make the tone-control much more useful for correcting speaker deficiencies, allowing any error at the top or bottom end to be corrected to at least a first approximation. It makes a major difference.

This control was developed for hifi rather than mixer use, and certain features of the tone control were aimed at making it more acceptable to those who think any sort of tone-control is an abomination. The control range is restricted to +/−10 dB, rather than the +/−15 dB which is standard in mixing consoles. The response is built entirely from simple 6 dB/octave circuitry, with inherently gentle slopes. The stage is naturally minimum-phase, and so the amplitude curves uniquely define the phase response. The maximum phase shift does not exceed 40 degrees at full boost, not that it matters because you can't hear phase shift anyway; see Chapter 1.

The schematic is shown in Figure 15.26. The tone-control gives a unity-gain inversion except when the selective response of the sidechain paths allow signal through. In the treble and bass frequency ranges where the sidechain does pass signal, the boost/cut pots RV1, RV2 can give either gain or attenuation. When a wiper is central, there is a null at the middle of the boost/cut pot, no signal through that sidechain, and the gain is unity.

If the pot is set so the sidechain is fed from the input then there is a partial cancellation of the forward signal; if the sidechain is fed from the output then there is a partial negative-feedback cancellation, or to put it another way, positive feedback is introduced to counteract part of the NFB. This apparently ramshackle process actually gives boost/cut curves of perfect symmetry.

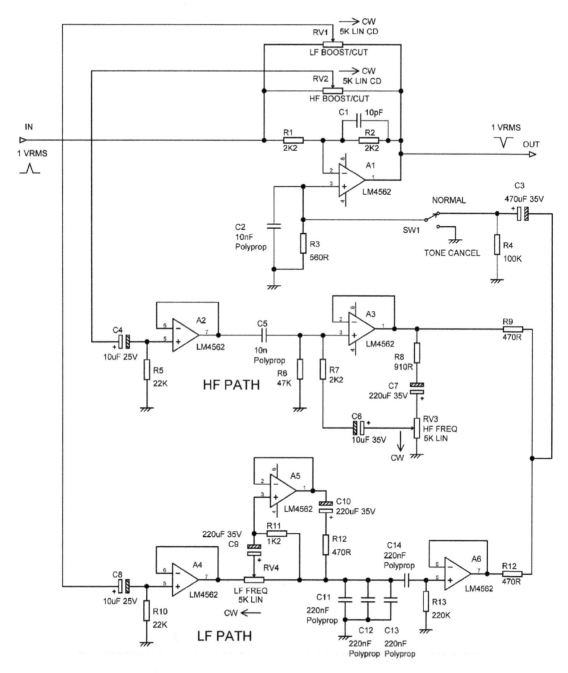

Figure 15.26 The tone-control schematic, showing the two separate paths for HF and LF control. All pots are 5 kΩ linear.

This is purely cosmetic because you can't use both sides of the curve at once, so it hardly matters if they are exact mirror-images.

The tone control stage acts in separate bands for bass and treble, so there are two parallel selective paths in the sidechain. These are simple RC time-constants, the bass path being a variable-frequency first-order lowpass filter, and the associated bass control only acting on the frequencies this lets through. Similarly the treble path is a variable highpass filter. The filtered signals are summed and returned to the main path via the non-inverting input, and some attenuation must be introduced to limit cut and boost. Assuming a unity-gain sidechain, this loss is 9 dB if cut/boost are to be limited to +/–10 dB. This is implemented by R9, R12, and R4. The sidechain is unity-gain and has no problems with clipping before the main path does, so it is very desirable to put the loss after the sidechain, where it attenuates sidechain noise. The loss attenuator is made up of the lowest value resistors that can be driven without distortion, to minimise the both the Johnson noise thereof and the effects of the current noise of opamp A1.

The tone-cancel switch disconnects the entire sidechain (five out of six opamps) from any contribution to the main path and usefully reduces the stage output noise by about 4 dB. It leaves only A1 in circuit. Unlike configurations where the entire stage is bypassed, the signal does *not* briefly disappear as the switch moves between two contacts. This minimises transients due to suddenly chopping the waveform and makes valid tone in/out comparisons much easier.

It is very convenient if all pots are identical. I have used linear 5 kΩ controls, so the tolerances inherent in a two-slope approximation to a logarithmic law can be eliminated. This only presents problems in the tone stage frequency controls, where linear pots require thoughtful circuit design to give the logarithmic action that fits our perceptual processes.

In the HF path, C5, R7 is the highpass time-constant, driven at low-impedance by unity-gain buffer A2. This prevents the frequency from altering with the boost/cut setting. The effective value of R7 is altered over a 10:1 range by varying the amount of bootstrapping it receives from A3, the potential divider effect, and the rise in source resistance of RV3 in the centre combining to give a reasonable approximation to a logarithmic frequency/rotation law. R8 is the frequency end-stop resistor that limits the maximum effective value of R7. C2 is the treble RTF capacitor— at frequencies above the audio band it shunts all the sidechain signal to ground, preventing the HF control from having any effect. The HF sidechain degrades the noise performance of the tone control by 2–3 dB when connected because it passes the HF end of the audio band. The noise contribution is greatest when the HF frequency is set to minimum, and the widest bandwidth from the HF sidechain contributes to the main path. This is true even when the HF boost/cut control is set to flat, as the HF path is still connected to A1.

In the LF path, A4 buffers RV1 to prevent boost/frequency interaction. The lowpass time-constant capacitor is the parallel combination of C11 + C12 + C13; the use of three capacitors increases the accuracy of the total value by $\sqrt{3}$. The associated resistance is a combination of RV4 and R11, R12. C14 and R13 make up the RTF time-constant for the LF path, blocking very low frequencies and limiting the lower extent of LF control action. The bass frequency law is made approximately logarithmic by A5; for minimum frequency RV4 is set fully CCW, so the input of A5 is the same as the C11 end of R12, which is thus bootstrapped and has no effect. When RV4 is fully CW, R11, R12 are effectively in parallel with RV4 and the turnover frequency is at a maximum. R11 gives

a roughly logarithmic law; its value is carefully chosen so that the centre of the frequency range is at the centre of the control travel. Sadly, there is some pot-dependence here. The LF path uses three opamps rather than two, but contributes very little extra noise to the tone stage because most of its output is rolled off by the lowpass action of C11, C12, C13 at HF, eliminating almost all its noise contribution apart from that of A6.

The measured responses for maximum boost and maximum cut at minimum, middle, and maximum frequency settings are shown in Figures 15.27 and 15.28.

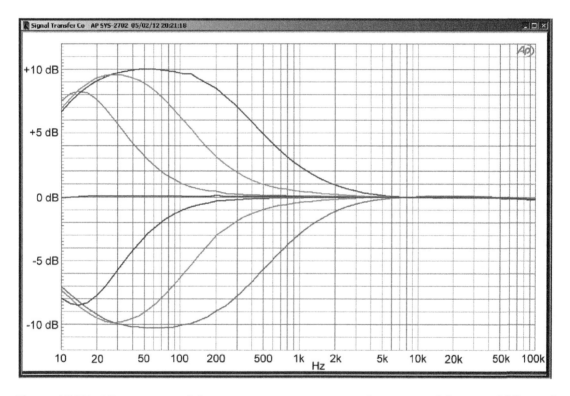

Figure 15.27 LF tone-control frequency response, max cut/boost, at minimum, middle, and maximum frequencies.

An important goal in the design of this tone control was low noise. Once the opamps have been chosen and the architecture made sensible in terms of avoiding attenuation then amplification, keeping noise gain to a minimum, and so on, the remaining way of improving noise performance is by low-impedance design. The resistances are lowered in value, with capacitances scaled up to suit by a factor that is limited only by opamp drive capability. The 5532 or LM4562 are good for this.

A complete evaluation of the noise performance is a lengthy business because of the large number of permutations of the controls. If we just look at extreme and middle positions for each control, we have maximum boost, flat, and maximum cut for both HF and LF and maximum, middle,

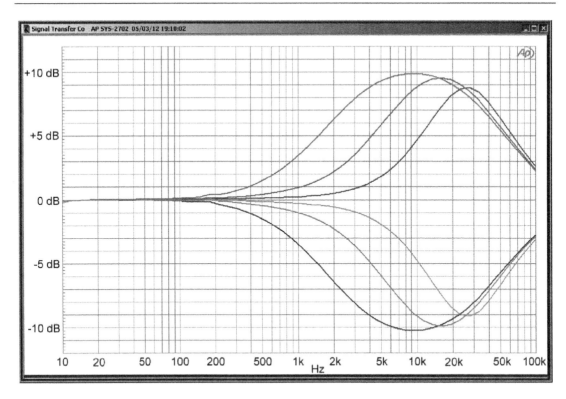

Figure 15.28 HF tone-control frequency response, max cut/boost, at minimum, middle, and maximum frequencies.

and minimum for the two frequency controls, yielding 3 x 3 x 3 x 3 = 81 permutations. The measurements given in Table 15.2 are therefore restricted to those that put the greatest demands on the circuitry, eg HF frequency at minimum.

Measuring the distortion performance of the tone-control is likewise a protracted affair, requiring the exploration of the permutations of the four controls. There were no surprises so I will not use up valuable space displaying the results; if there is interest I will put them on my website at douglas-self.com. Suffice it to say that THD at 9 Vrms in/out never gets above 0.001%. General THD levels are in the range 0.0003–0.0007%.

Be aware that circuits like this tone-control can show unexpected input impedance variations. A standard Baxandall tone-control made with 10 kΩ pots can have an input impedance that falls to 1 kΩ or less at high frequencies where the capacitors have a low impedance. It is not obvious, but the alternative tone-control configuration used here also shows significant input impedance variations.

Look at the circuit in Figure 15.26; the original value for R1 was 4k7 and the argument that follows here is based on that value. You might think that because the input terminal connects only to a 4k7 resistor and two 5 kΩ pots the input impedance cannot fall below their parallel combination, ie 4k7 ∥ 5k ∥ 5k = 1.63 kΩ. You would be wrong; the other end of the 4k7 resistor is connected to virtual ground, but the two 5 kΩ pots are connected to the stage output. When the controls are set flat or tone-cancel engaged, this carries an inverted version of the input signal.

TABLE 15.2 The noise output of the tone control at various settings

HF level	HF freq	LF level	LF freq	Noise out
Flat	Min	Flat	Max	−105.1 dBu
Flat	Mid	Flat	Max	−106.2 dBu
Flat	Max	Flat	Max	−107.2 dBu
Flat	Max	Flat	Mid	−106.8 dBu
Flat	Max	Flat	Min	−107.1 dBu
Flat	Min	Flat	Min	−105.6 dBu
Max boost	Min	Flat	Min	−100.5 dBu
Max cut	Min	Flat	Min	−107.4 dBu
Max cut	Min	Flat	Max	−107.6 dBu
Flat	Min	Max boost	Max	−103.8 dBu
Flat	Min	Max cut	Max	−105.9 dBu
Flat	Min	Max cut	Min	−105.6 dBu
Flat	Min	Max boost	Min	−105.0 dBu
Tone-cancel				−110.2 dBu

Not corrected for AP noise at −119.2 dBu (difference negligible).

Measurement bandwidth 22 Hz–22 kHz, RMS sensing, unweighted.

The effective value of the pots is therefore halved, with zero voltage occurring halfway along the pot tracks. The true input impedance when flat is therefore 4k7 ‖ 2.5k ‖ 2.5k = 987 Ω, which is confirmed by simulation.

When the tone-control is not set flat, but to boost, then at those frequencies the inverted signal at the output is larger than the input. This makes the input impedance lower than for the flat case; when the circuit is simulated it can be seen that the input impedance varies with frequency inversely to the amount of boost. Conversely, when the tone-control is set to cut, the inverted signal at the output is reduced, and the input impedance is higher than in the flat case. This is summarised in Table 15.3 with R1, R2 = 4k7.

Table 15.3 shows that the input impedance falls to the worryingly low figure of 481 Ω at maximum HF and LF boost. In this case the gain is +10 dB, and so the input voltage into this impedance cannot exceed 3 Vrms without the tone-control output clipping. This limits the current

TABLE 15.3 Input impedance of the tone control at various settings

HF level	HF freq	LF level	LF freq	Input impedance
Flat	Min	Flat	Mid	987 Ω
Flat	Mid	Max boost	Mid	481 Ω
Flat	Mid	Max cut	Mid	1390 Ω
Max boost	Mid	Flat	Mid	480 Ω
Max cut	Mid	Flat	Mid	1389 Ω

required of the preceding stage, and there are not likely to be problems with increased distortion if this is 5532 or LM4562-based.

As mentioned earlier, this tone control was developed from an earlier version designed some 16 years before. It is instructive to take a quick look at the improvements that were made:

- All opamps changed from 5532 to LM4562 to reduce noise and distortion.

- A general impedance reduction to reduce noise, including the use 5 kΩ linear pots throughout instead of 10 kΩ.

- Frequency-control laws improved so the middle of the frequency range corresponds with the middle position of the control.

- Three expensive 470 nF polypropylene capacitors in the LF path replaced with four of 220 nF, giving a cost reduction. The resulting impedance at C14 is quite high at low frequencies, and the pickup of electrostatic hum must be avoided.

- DC-blocking capacitor C10 added to the LF path frequency control to eliminate rustling noises.

- C3 increased from 220 uF to 470 uF to remove a trace of electrolytic capacitor distortion at 10 Hz and 9 Vrms out (with max LF frequency and max boost). Reduced from 0.0014% to less than 0.0007%.

The electrolytic capacitors in the tone-control are used for DC blocking only and have no part at all in determining the frequency response. It would be most undesirable if they did, both because of the wide tolerance on their value and the distortion generated by electrolytics when they have significant signal voltage across them. The design criterion for these capacitors was that they should be large enough to introduce no distortion at 10 Hz, the original values being chosen by the algorithm 'looks about right,' though I hasten to add this was followed up by simulations to check the signal voltages across them, and THD measurements to confirm all was well.

Tilt or tone-balance controls

A tilt or tone-balance circuit is operated by a single control and affects not just part of the audio spectrum but most or all of it. Typically the high frequencies are boosted as the low frequencies are cut, and vice versa. It has to be said that the name "tone-balance" is unfortunate as it implies it has something to do with interchannel amplitude balance, which it does not. A stereo 'tone-balance control' alters the frequency response of both channels equally and does not introduce amplitude differences between them, whereas a 'stereo balance control' is something quite different. It is clearer to call a tone-balance control a tilt control, and I shall do so.

Tilt controls are (or were) supposedly useful in correcting the overall tonal balance of recordings in a smoother way than a Baxandall configuration, which concentrates more on the ends of the audio spectrum. An excellent (and very clever) approach to this was published by Ambler in 1970 [11]. See Figure 15.29. The configuration is very similar to the Baxandall—the ingenious difference here is that the boost/cut pot effectively swaps its ends over as the frequency goes up. At low frequencies C1, C2 do nothing, and the gain is set by the pot, with maximum cut and boost set by R1, R2. At high frequencies, where the capacitors are effectively short-circuit,

R3, R4 overpower R1, R2 and the control works in reverse. The range available with the circuit shown is +/−8 dB at LF and +/−6.5 dB at HF. This may seem ungenerous, but because of the way the control works, 8 dB of boost in the bass is accompanied by 6.5 dB of cut in the treble, and a total change of 14.5 dB in the relative level of the two parts of the spectrum should be enough for anyone. The measured frequency response at the control limits is shown in Figure 15.30; the response is not quite flat with the control central due to component tolerances.

The need for one set of end-stop resistors to take over from the other puts limits on the cut/boost that can be obtained without the input impedance becoming too low; there is, of course, also the equivalent need to consider the impedance the opamp A1 sees when driving the feedback side of the network.

The input impedance at LF, with the control set to flat, is approximately 12 kΩ, which is the sum of R3 and half of the pot resistance. At HF, however, the impedance falls to 2.0 kΩ. Please note that this is not a reflection of the values of the HF end-stop resistors R3, R4, but just a coincidence. When the control is set to full treble boost, the input impedance at HF falls as low as 620 Ω. The impedance at LF holds up rather better at full bass boost, as it cannot fall below the value of R1, ie 6.8 kΩ.

The impedances of the circuit shown here have been reduced by a factor of ten from the original values published by Ambler to make them more suitable for use with opamps. The original (1970) gain element was a two-transistor inverting amplifier with limited linearity and load-driving capability. Here a stabilising capacitor C3 is shown explicitly, just to remind you might need one.

A famous example of the use of a tilt control is the Quad 44 preamplifier. The tilt facility is combined with a bass cut/boost control in one quite complicated stage, and it is not at all obvious if the design is based on the Ambler concept. Tilt controls have never really caught on and remain rare. One current example is the Classé CP-800 D/A preamplifier, reviewed by Stereophile in 2012 [12]. This gives a maximum of ±6 dB control at the frequency extremes and is implemented by DSP. In analogue use the signal has to be converted to 24-bit digital data, processed, then converted back to analogue, which to me seems somewhat less than elegant.

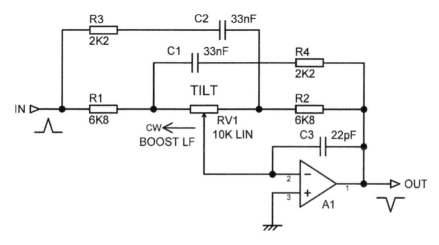

Figure 15.29 Tilt control of the Ambler type.

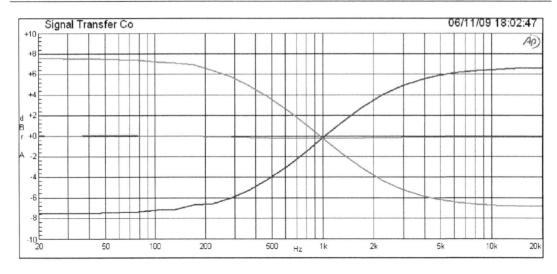

Figure 15.30 **Frequency response of Ambler tilt control.**

Middle controls

A middle control affects the centre of the audio band rather than the bass and treble extremes. It must be said at once that middle controls, while useful in mixers, are of very little value in a preamplifier. If the middle frequency is fixed, then the chances that this frequency and its associated Q corresponds with room shortcomings or loudspeaker problems is remote in the extreme. Occasionally middle controls appeared on preamps in the 1970s, but only rarely and without much evidence of success in the marketplace. One example is the Metrosound ST60 (1972), which had a 3-band Baxandall tone control—more on this later—with slider controls. The middle control had a very wide bandwidth centred on 1 kHz, and it was suggested that it could be used to depress the whole middle of the audio band to give the effect of a loudness control.

Middle controls come into their own in mixers and other sound-control equipment where they are found in widely varying degrees of sophistication. In recording applications middle controls play a vital part in 'voicing' or adjusting the timbres of particular instruments, and the flexibility of the equaliser, and its number of controls, defines the possibilities open to the operator. A 'presence' control is centred on the upper-middle audio frequencies so it tends to accentuate vocals when used; nowadays the term seems to be restricted to tone controls on electric guitars.

The obvious first step is to add a fixed middle control to the standard HF and LF controls. Unfortunately, this is not much more useful in a mixer than in a preamplifier. In the past this was addressed by adding more fixed middles, so a line-up with a high-middle and a low-middle would be HF-HMF-LMF-LF, but this takes up more front panel space (which is a very precious resource in advanced and complex mixers, and ultimately defined by the length of the human arm) without greatly improving the EQ versatility.

The minimum facilities in a mixer input channel for proper control are the usual HF and LF controls plus a sweep middle with a useful range of centre frequency. This also uses four knobs but is much more useful.

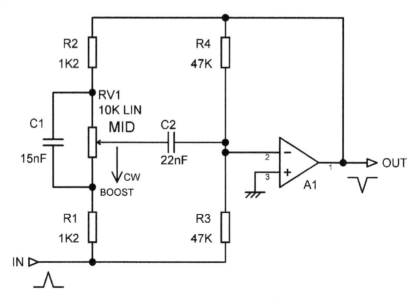

Figure 15.31 Fixed middle control of the Baxandall type. Centre frequency 1.26 kHz.

Fixed-frequency Baxandall middle controls

Figure 15.31 shows a middle version of a Baxandall configuration. The single control RV1 now has around it both the time constants that were before assigned to the separate bass and treble controls. R3 and R4 maintain unity gain at DC and high frequencies and keep the stage biased correctly.

As the input frequency increases from the bottom of the audio band, the impedance of C2 falls and the position of the pot wiper begins to take effect. At a higher frequency, the impedance of C1 becomes low enough to effectively tie the two ends of the pot together, so that the wiper position no longer has effect, and the circuit reverts to having a fixed gain of unity. The component values shown give a mid frequency of 1.26 kHz, at a Q of 0.8, with a maximum boost/cut of +/−15 dB. The Q value is only valid at maximum boost/cut; with less the curve is flatter and the effective Q lower. It is not possible to obtain high values of Q with this approach.

This circuit gives the pleasingly symmetrical curves shown in Figure 15.32, though it has to be said that the benefits of exact symmetry are visual rather than audible.

As mentioned earlier, in the simpler mixer input channels it is not uncommon to have two fixed mid controls; this is not the ideal arrangement, but it can be implemented very neatly and cheaply as in Figure 15.33. There are two stages, each of which has two fixed bands of EQ. It has the great advantage that there are two inverting stages so the output signal ends up back in phase. The first stage needs the extra resistors R5, R6 to maintain DC feedback.

There will inevitably be some control interaction with this scheme. It could be avoided by using four separate stages, but this is most unlikely to be economical for mixers with this relatively simple sort of EQ. To minimise interaction, the control bands are allocated between the stages to keep the frequencies controlled in a stage as far apart as possible, combining HF with LO MID, and LF with HI MID, as shown here.

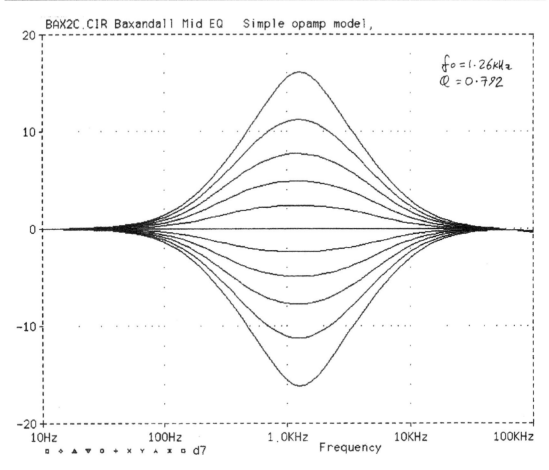

Figure 15.32 The frequency response of the Baxandall middle control in Figure 15.31

Three-band Baxandall EQ in one stage

The standard Baxandall tone control allows adjustment of two bands with one stage. When a three-band EQ is required, it is common practice to use one such stage for HF and LF and a following one to implement the middle control only. This has the advantage that the two cascaded inverting stages will leave the signal in the correct phase.

When this is not a benefit because a phase inversion is present at some other point in the signal path, it is economical to combine HF, MID, and LF in one quasi-Baxandall stage. This not only reduces component count but reduces power consumption by saving an opamp. The drawback is that cramming all this functionality into one stage requires some compromises on control interaction and maximum boost/cut. The circuit shown in Figure 15.34 gives boost/cut limited to +/−12 dB in each band. The pots are now 20 kΩ to prevent the input and feedback impedances from becoming too low. The bass control uses the 1-C configuration.

The frequency responses for each band are given in Figures 15.35, 15.36 and 15.37.

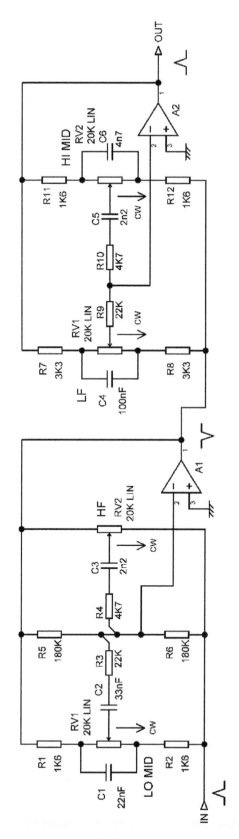

Figure 15.33 A 4-band Baxandall EQ using two stages only.

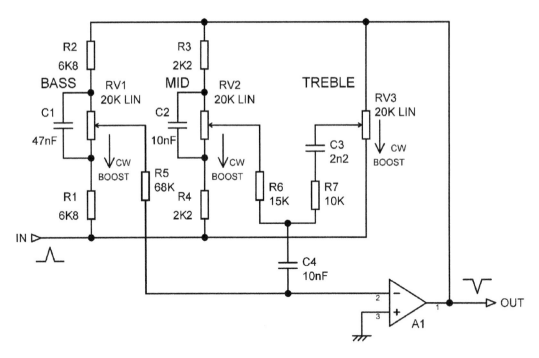

Figure 15.34 The circuit of a Baxandall three-band EQ using one stage only.

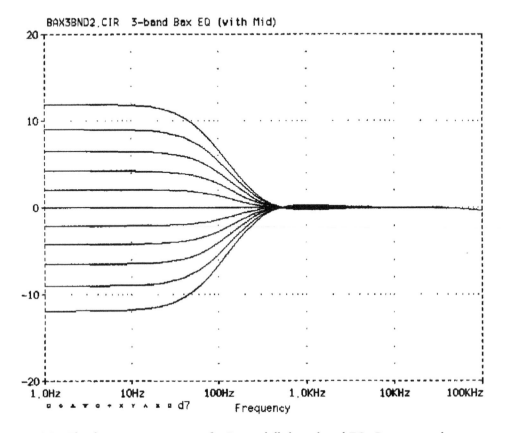

Figure 15.35 The frequency response of a Baxandall three-band EQ. Bass control.

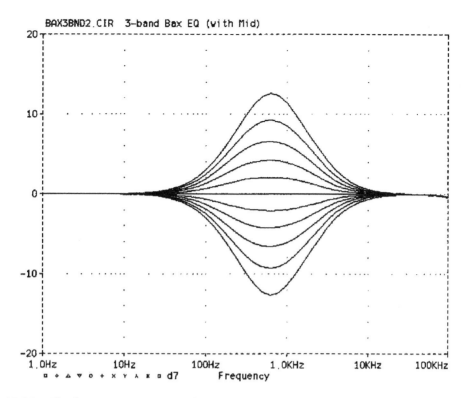

Figure 15.36 The frequency response of a Baxandall three-band EQ. Mid control.

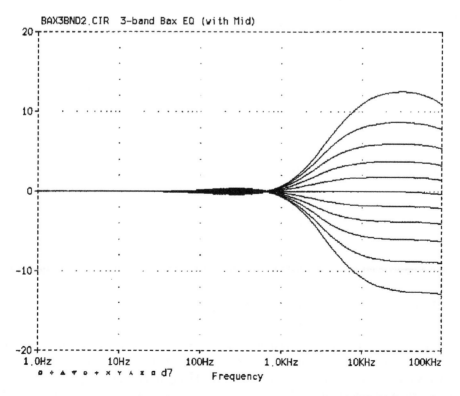

Figure 15.37 The frequency response of the Baxandall three-band EQ. Treble control.

Wien fixed middle EQ

An alternative way to implement a fixed middle control is shown in Figure 15.38. Here the signal tapped off from RV1 is fed to a Wien bandpass network R1, C1, R2, C2, and returned to the opamp non-inverting input. This is the same Wien network as used in audio oscillators.

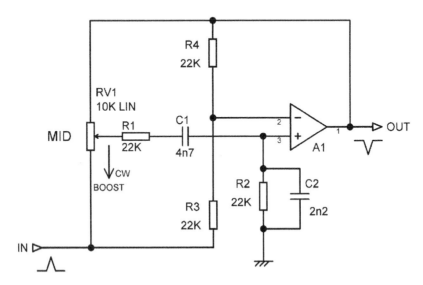

Figure 15.38 The Wien fixed middle circuit. Centre frequency is 2.26 kHz. The Q at max cut/boost is 1.4.

With the values shown the centre frequency is 2.26 kHz and the Q at max cut/boost is 1.4; it gives beautifully symmetrical response curves like those in Figure 15.36, with a maximal cut/boost of 15.5 dB.

Wien fixed middle EQ: altering the Q

The Q of resonance or peaking is defined as the centre frequency divided by the bandwidth between the two −3 dB points in the response. Strictly speaking Q only applies to a simple resonant circuit, where on either side of the peak the response falls away forever. Thus it is always possible to define the −3 dB bandwidth.

Mid EQs have a resonant peak (or dip) but on either side of the peak the response goes to unity gain rather than falling forever. Therefore for small amounts of boost/cut, say ±2 dB, it is impossible to quote a Q value as there *are* no −3 dB points. Normal practice is to simply quote the Q at maximum boost/cut, even though the control will rarely if ever be used there.

Conventional types of mid EQ have a Q that reduces as you move away from maximum cut or boost. For example, the mid EQ shown in Figure 15.38 has a Q of 1.4 at +15 dB boost, a Q of 0.82 at +10 dB boost, and a Q of 0.35 at +5 dB boost. The Q figures also apply to cut mode as the response curves are symmetrical.

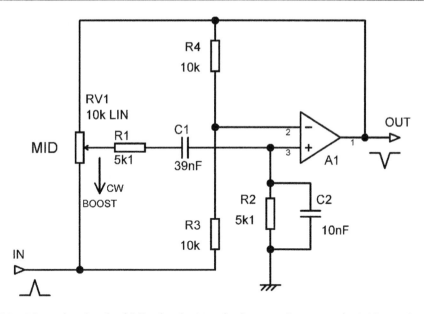

Figure 15.39 The Wien fixed middle circuit. Nominal centre frequency is 1.6 kHz, Q at max cut/ boost is 1.20.

Figure 15.39 shows another example of a fixed-frequency mid control; this time the nominal centre frequency is 1.6 kHz. The Q of the resonance is set by the ratio of the two capacitors C1 and C2; as C2 gets smaller the Q is reduced. To keep the same centre frequency C1 is increased as C2 is reduced. Sometimes R2 must be adjusted to maintain a ±15 dB boost/cut. There is not, so far as I am aware, a simple design equation for setting the Q, and Table 15.4 was constructed by twiddling simulator values. The procedure is thus:

1) Reduce the value of C2. This will increase the centre frequency.

2) Increase C1 to return the centre frequency to the original value.

3) If necessary adjust R2 to get about ±15 dB boost/cut.

4) Find the Q at max boost/cut and see if it is satisfactory.

 If not, try again with a different value for C2.

TABLE 15.4 Capacitor values for setting the Q of the mid control in Figure 15.39

Max Q	R1	C1	R2	C2	C1/C2 ratio
1.63	5k1	33n	5k1	12n	2.75
1.20	**5k1**	**39n**	**4k3**	**10n**	**3.90**
0.94	5k1	56n	3k9	8n2	6.83
0.86	5k1	68n	3k9	6n8	10.0
0.79	5k1	82n	3k9	5n6	14.6
0.69	5k1	100n	3k9	4n7	21.3

For Table 15.4 I used single E24 resistors and single E12 capacitors, and this does not allow the boost/cut, centre frequency, or Q to be very closely controlled. The component values therefore give a slightly variable response, as shown in Figure 15.40; the changes in Q are obvious but are accompanied by small shifts in maximum boost/cut and centre frequency. This approach keeps the component count down, but if intermediate Q values between those given prove to be really needed, we can always do a bit of paralleling, as in other cases where something needs to be set with some precision.

There are, of course, limits to how high a Q can be achieved with a simple circuit like this. A Q of 1.63 appears to be the maximum.

Thanks to Alex of Barefaced Audio, highly respected manufacturers of guitar cabinets and bass cabinets, for permission to publish the information in Figure 15.40.

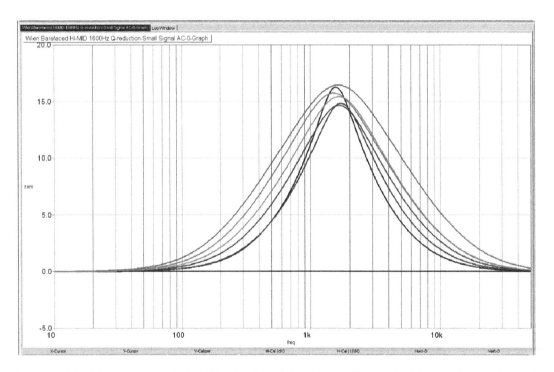

Figure 15.40 The response of the Wien fixed middle circuit of Figure 15.39 at various values of Q

Variable-frequency middle EQ

A fully variable-frequency middle control is much more useful and versatile than any combination of fixed or switched middle frequencies. In professional audio this is usually called a 'sweep middle' EQ. It can be implemented very nicely by putting variable resistances

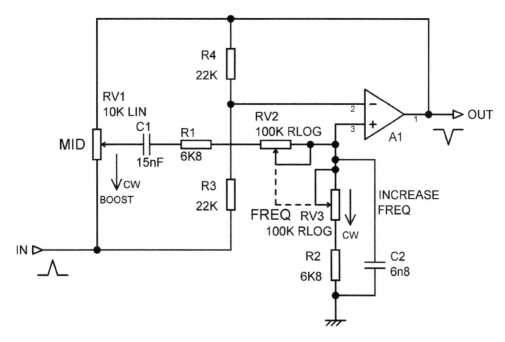

Figure 15.41 A Wien sweep circuit. The centre frequency range is 150 Hz–2.4 kHz (a 16:1 ratio).

in the Wien network of the stage previously described, and the resulting circuit is shown in Figure 15.41.

The variable load that the Wien network puts on the cut/boost pot RV1 causes a small amount of control interaction, the centre frequency varying slightly with the amount of boost or cut. This is normally considered acceptable in middle-range mixers. It could be eliminated by putting a unity-gain buffer stage between RV1 wiper and the Wien network, but in the middle-range mixers where this circuit is commonly used, this is not normally economical.

The Wien network here is carefully arranged so that the two variable resistors RV2, RV3 have four common terminals, reducing the number of physical terminals required from six to three. This is sometimes taken advantage of by pot manufacturers making ganged parts specifically for this EQ application. R1, C1 are sometimes seen swapped in position but this naturally makes no difference.

The combination of a 100 k pot and a 6k8 end-stop resistor gives a theoretical frequency ratio of 15.7 to 1, which is about as much as can be obtained using reverse-log Law C pots without excessive cramping at the high-frequency end of the scale. This will be marked on the control calibrations as a 16 to 1 range. The measured frequency responses at the control limits is shown in Figure 15.42. The frequency range is from 150 Hz to 2.3 kHz; the ratio being slightly adrift due to component tolerances. The maximum Q possible is 1.4, this only applying at maximum boost or cut.

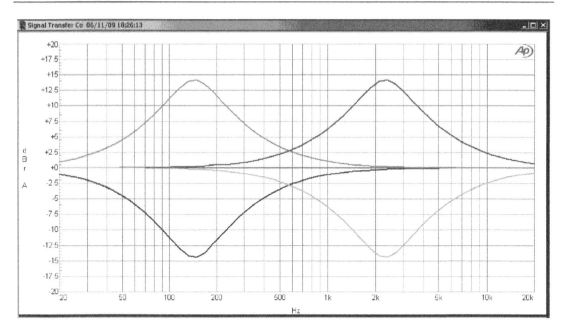

Figure 15.42 The measured response of the sweep middle circuit at control extremes. The cut/ boost is slightly short of +/−15 dB.

Single-gang variable-frequency middle EQ

The usual type of sweep middle requires a dual-gang reverse-log pot to set the frequency. These are not hard to obtain in production quantities but can be difficult to get in small numbers. They are always significantly more expensive than a single pot.

The problem becomes more difficult when the design requires a stereo sweep middle—if implemented in the usual way, this demands a four-gang reverse-log pot. Once again, such components are available, but only to special order, which means long lead-times and significant minimum order quantities. Four-gang pots are not possible in flat-format mixer construction where the pots are mounted on their backs, so to speak, on a single big horizontal PCB. The incentive to use a standard component is strong, and if a single-gang sweep middle circuit can be devised, a stereo EQ only requires a dual-gang pot.

This is why many people have tried to design single-gang sweep middle circuits, with varying degrees of success. It can be done, so long as you don't mind some variation of Q with centre frequency; the big problem is to minimise this interaction. I too have attacked this problem, and here is my best shot so far, in Figure 15.43.

This circuit is a variation of the Wien middle EQ, the quasi-Wien network being tuned by a single control RV2 which not only varies the total resistance of the R5, R7 arm, but also the amount of bootstrapping applied to C2, effectively altering its value. This time a unity-gain buffer stage A2

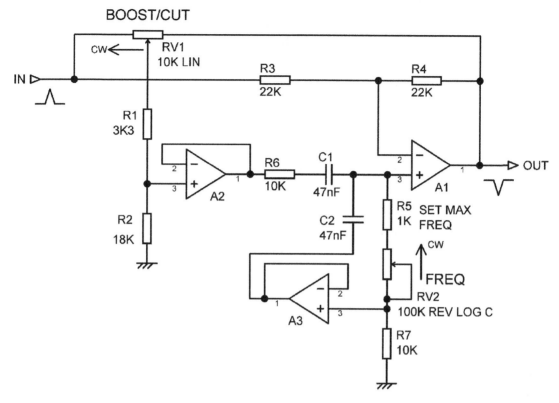

Figure 15.43 **My single-gang sweep middle circuit. The centre frequency range is 100 Hz–1 kHz.**

has been inserted between RV1 wiper and the Wien network; this helps to minimise variation of Q with frequency.

The response is shown in Figure 15.44; note that the frequency range has been restricted to 10:1 to minimise Q variation. The graph shows only maximum cut/boost; at intermediate settings the Q variations are much less obvious.

It is possible to make a yet more economical version of this, if one accepts somewhat greater interaction between boost/cut, and Q and frequency. The version shown in Figure 15.45 omits the unity-gain buffer and uses unequal capacitor values to raise the Q of the quasi-Wien network, saving an opamp section. R8 increases the gain seen by the Wien network and sets maximum boost/cut. The frequency range is still 10:1.

The response in Figure 15.46 shows the drawback—a higher Q at the centre of the frequency range than for the three opamp version. Once again the Q variations will be much less obvious at intermediate cut/boost settings.

The question naturally arises as to whether it is possible to design a single-gang sweep middle circuit where there is absolutely no variation of Q with frequency. Is there an 'existence theorem,' ie a mathematical proof that it can't be done? At the present time, I don't know . . .

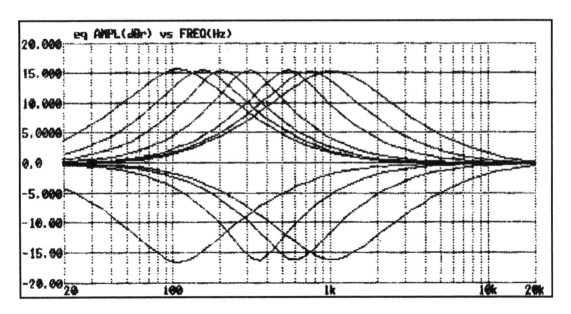

Figure 15.44 The response of the single-gang sweep middle circuit of Figure 15.41. Boost/cut is +/−15 dB and the frequency range is 100 Hz–1 kHz The Q varies somewhat with centre frequency.

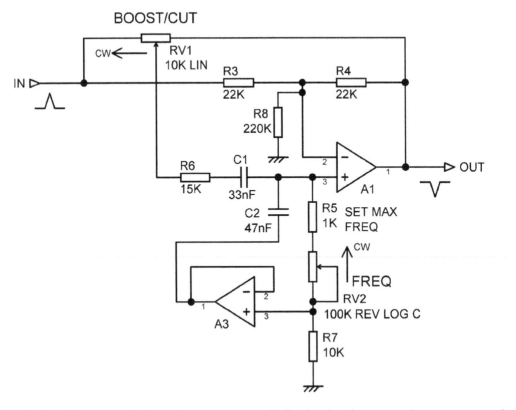

Figure 15.45 My economical single-gang sweep middle circuit. The centre frequency range has been changed to 220 Hz–2.2 kHz.

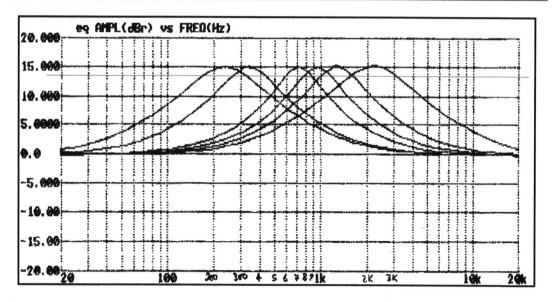

Figure 15.46 **The response of the economical single-gang sweep middle circuit. The response is +/−15 dB as before, but the frequency range has now been set to 220 Hz–2 kHz. Only the boost curves are shown; cut is the mirror-image.**

Switched-Q variable-frequency Wien middle EQ

The next step in increasing EQ sophistication is to provide control over the Q of the middle resonance. This is often accomplished by using a full state-variable filter solution, which gives fully variable Q that does not interact with the other control settings, but if two or more switched values of Q are sufficient, there are much simpler circuits available.

One of them is shown in Figure 15.47; here the Wien bandpass network is implemented around A2, which is essentially a shunt-feedback stage, with added positive feedback via R1, R2 to raise the Q of the resonance. When the Q-switch is in the LO position, the output from A2 is fed directly back to the non-inverting input of A1 because R7 is short circuited. When the Q-switch is in the HI position, R9 is switched into circuit and increases the positive feedback to A2, raising the Q of the resonance. This also increases the gain at the centre frequency, and this is compensated for by the attenuation now introduced by R7 and R8.

With the values shown the two Q values are 0.5 and 1.5. Note the cunning way that the Q-switch is made to do two jobs at once—changing the Q and also introducing the compensating attenuation. If the other half of a two-pole switch is already dedicated to a LED indicator, this saves having to go to a four-pole switch. On a large mixing console with many EQ sections this sort of economy is important.

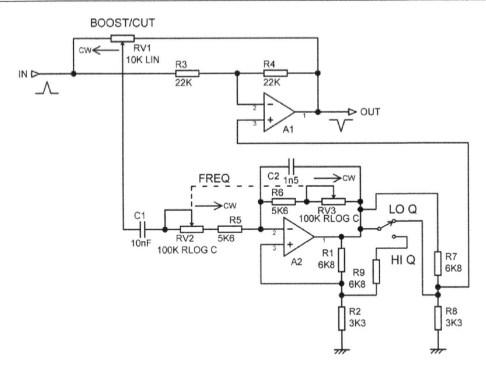

Figure 15.47 Variable-frequency switched-Q middle control of the Wien type.

Switchable peak/shelving LF/HF EQ

It is frequently desirable to have the highest and lowest frequency EQ sections switchable between a peaking (resonance) mode and shelving operation. The peaking mode allows relatively large amounts of boost to be applied near the edges of the audio band without having a large and undesirable amount occurring outside it.

Figure 15.48 shows one way of accomplishing this. It is essentially a switchable combination of the variable-frequency HF shelving circuit of Figure 15.21 and the sweep middle circuit of Figure 15.41; when the switches are in the PEAK position the signal tapped off RV1 is fed via the buffer A2 to a Wien bandpass network C2, RV2, R5, C3, R6, RV3, and the circuit has a peak/dip characteristic. When the switches are in the SHLV (shelving) position, the first half of the Wien network is disconnected and C1 is switched in, and in conjunction with R6 and RV3, forms a first-order highpass network fed by an attenuated signal because R2 is now grounded. This switched attenuation factor is required to give equal amounts of cut/boost in the two modes because the highpass network has less loss than the Wien network. R7 allows fine-tuning of the maximum cut/boost; reducing it increases the range.

As always we want our switches to work as hard as possible, and the lower switch can be seen to vary the attenuation brought about by R1, R2 with one contact and switch in C3 with the other. Unfortunately in this case two poles of switching are required. The response of the circuit at one frequency setting can be seen in Figure 15.49.

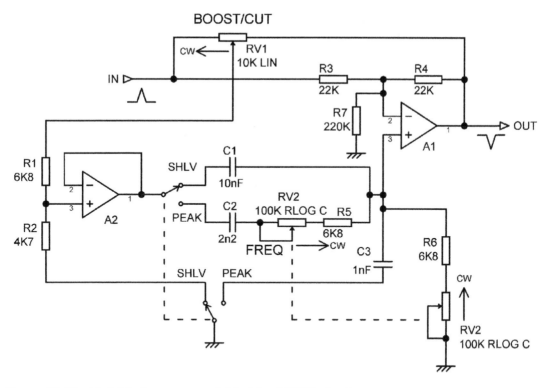

Figure 15.48 Variable-frequency peak/shelving HF EQ circuit.

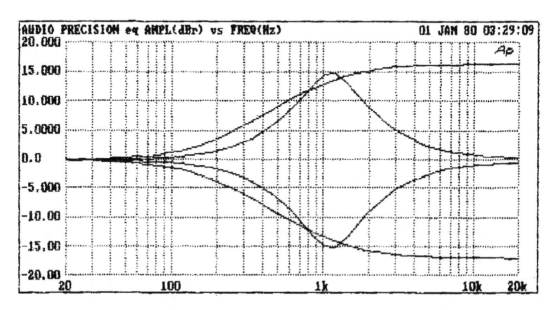

Figure 15.49 The response of the variable-frequency peak/shelving with R7 = 220 k; the cut/boost range is thus set to +/−15 dB.

When the peaking is near the edges of the audio band, this is called RTF (return-to-flat) operation or sometimes RTZ (return-to-zero dB) operation as the gain returns to unity (Zero dB) outside the audio band.

Parametric middle EQ

A normal second-order resonance is completely defined by specifying its centre frequency, its bandwidth or Q, and the gain at the peak. In mathematical language, these are the parameters of the resonance. Hence an equaliser which allows all three to be changed independently (proviso on that coming up soon) is called a parametric equaliser. Upscale mixing consoles typically have two fully parametric middle sections, and usually the LF and HF can also be switched from shelving to peaking mode when they become two more fully parametric sections.

The parametric middle EQ shown in Figure 15.50 is included partly for its historical interest, showing how opamps and discrete transistor circuitry were combined in the days before completely acceptable opamps became affordable. I designed it in 1979 for a now long-gone company called Progressive Electronics, which worked in a niche market for low-noise mixing consoles. The circuitry I developed was a quite subtle mix of discrete transistor and opamp circuitry which gave a significantly better noise performance than designs based entirely on the less-than-perfect opamps of the day; in time, of course, this niche virtually disappeared, as they are wont to do. This parametric middle EQ was used, in conjunction with the usual HF and LF controls, in a channel module called the CM4.

The boost/cut section used an opamp because of the need for both inverting and non-inverting inputs. I used a 741S, which was a completely different animal from the humble 741, with a much better distortion performance and slew rate; it was, however, markedly more expensive, and only used where its superior performance was really necessary. The unity-gain buffer Q1, Q2 which ensured a low-impedance drive to the state-variable bandpass filter was a discrete circuit block, as its function is simple to implement. Q1 and Q2 form a CFP emitter-follower. R13 was a 'base-stopper' resistor to make sure that the Q1, Q2 local feedback loop did not exhibit VHF parasitic oscillation. With the wisdom of hindsight, a 2k2 resistor directly in the signal path can only degrade the noise performance, and according to the stability information in Chapter 3, 220Ω would have been sufficient. The high input impedance of the buffer stage (set by R14) means that C6 can be a small non-electrolytic component.

The wholly conventional state-variable band-pass filter requires a differential stage U2, which once again is best implemented with an opamp, and another expensive 741S was pressed into service. The two integrators U3, U4 presented an interesting problem. Since only an inverting input is required, discrete amplifiers could have been used without excessive circuit complexity; a two or possibly three-transistor circuit (see Chapter 3) would have been adequate. However, the PCB area for this approach just wasn't there, and so opamps had to be used. To put in two more 741S opamps would have been too costly, and so that left a couple of the much-despised 741 opamps. In fact, they worked entirely satisfactorily in this case because they were in integrator stages. The poor HF distortion and slew rate were not really an issue because of the large amount of NFB at HF, and the fact that integrator outputs by definition do not slew quickly. The

indifferent noise performance was also not an issue because the falling frequency response of the integrators filtered out most of the noise. In my designs the common-or-garden 741 was only ever used in this particular application. Looking at the circuit again, I have reservations about the not inconsiderable 741 bias currents flowing through the two sections of the frequency-control pot RV2, which could make them noisy, but it seemed to work alright at the time.

The filter Q was set by the resistance of R6, R7 to ground. It does not interact with filter gain or centre frequency. The Q control could easily have been made fully variable by using a potentiometer here, but there was only room on the channel front panel for a small toggle switch. Note the necessity for the DC-blocking capacitor C3 because all the circuitry is biased at V/2 above ground.

The filtered signal is fed back to the boost/cut section through R17, and I have to say that at this distance of time I am unsure why that resistor was present; probably it was to cancel the effects of the input bias currents of U1. It could only impair the noise performance, and a DC-blocking cap might have been a better solution. Grounding the U1 end of R17 would give an EQ-cancel that also stops noise from the state-variable filter.

It is worth noting that the design dates back to when the use of single supply rails was customary. In part this was due to grave and widely-held doubts about the reliability of electrolytic coupling

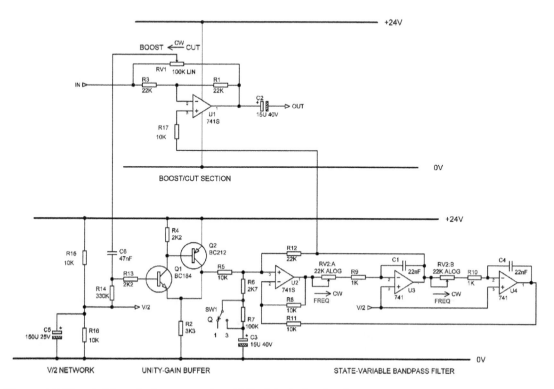

Figure 15.50 A historical parametric middle EQ dating back to 1979.

capacitors with no DC voltage across them, which would be the case if dual rails were used. As it happened, there proved to be no real problem with this, and things would have progressed much faster if capacitor manufacturers had not been so very wary of committing themselves to approving non-polarised operation. The use of a single supply rail naturally requires that the circuitry is biased to V/2, and this voltage was generated in the design shown by R15, R16, and C5; it was then distributed to wherever it was required in the channel signal path. The single rail was at +24 V, because 24 V IC regulators were the highest voltage versions available, and nobody wants to get involved with designing discrete power supply regulators if they can avoid it. This is obviously equivalent to a ±12 V dual-rail supply, compared with the ±15 V or ±17 V that was adopted when dual-rail powering became universal, and so gave a headroom that was lower by 1.9 dB and 3.0 dB respectively.

This design is included here because it is a good example of making use of diverse circuit techniques to obtain the best possible performance/cost ratio at a given point in time. It could be brought up to date quite quickly by replacing all the antique opamps and the discrete unity-gain buffer with 5532s or other more modern types.

Modern parametric equalisers naturally use all-opamp circuitry. Figure 15.51 shows a parametric EQ stage I designed back in 1991; it is relatively conventional, with a three-stage state-variable filter composed of A2, A3, and A4. There is, however, an important improvement on the standard circuit topology. Most of the noise in a parametric equaliser comes from the filter path. In this design the filter path signal level is set to be 6 dB higher than usual, with the desired return level being restored by the attenuator R6, R7. This attenuates the filter noise as well, and the result is a parametric section approximately 6 dB quieter than the industry standard. The circuit is configured so that despite this raised level, clipping cannot occur in the filter with any combination of control settings. If excess boost is applied, clipping can only happen at the output of A1, as usual.

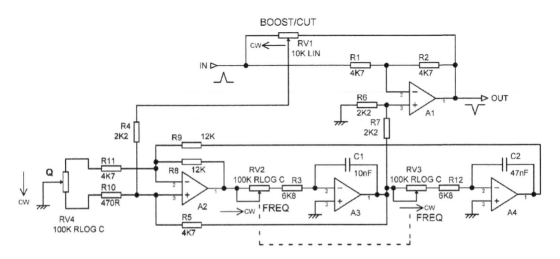

Figure 15.51 Variable-frequency variable-Q middle control. State-variable type.

Other features are the Q control RV4, which is configured to give a wide parameter range without affecting the gain. Note the relatively low values for the DC feedback resistors R1 and R2, chosen to minimise Johnson noise without causing excessive opamp loading.

This equaliser section has component values for typical low-mid use, with centre frequency variable over a wide range from 70 Hz to 1.2 kHz, and Q (at max boost) variable from 0.7 to 5. The cut and boost range is the usual +/−15 dB.

Graphic equalisers

Graphic equalisers are so-called because their cut/boost controls are vertical sliders, the assumption being that a graph of the frequency response will pass through the slider knob positions. Graphic equalisers can have any number of bands from 3 to 31, the latter having bands 1/3 of an octave wide. This is the most popular choice for serious room equalisation work as bands 1/3-octave wide relate to the perceptual critical bands of human hearing.

Graphic equalisers are not normally fitted to large mixing consoles but are often found on smaller powered mixers, usually in the path between the stereo mix and the power amplifiers. The number of bands provided is limited by the space on the mixer control surface and is usually in the range 7 to 10.

There is more than one way to make a graphic equaliser, but the most common version is shown in its basic concept in Figure 15.52, with some typical values. L1, C1, and R3 make up an LCR series resonant circuit which has a high impedance except around its resonant frequency; at this frequency the reactances of L1, C1 cancel each other out, and the impedance to ground is simply that of R3. At resonance, when the wiper of RV1 is at the R1 end, the LCR circuit forms the lower

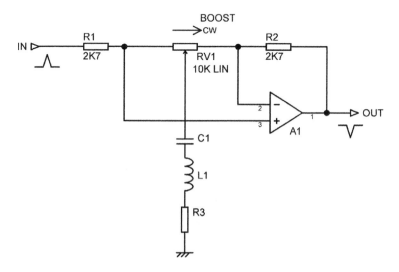

Figure 15.52 **The basic idea behind graphic equalisers; gain is unity with the wiper central.**

leg of an attenuator of which R1 is the upper arm; this attenuates the input signal and a dip in the frequency response is therefore created. When RV1 wiper is at the R2 end, an attenuator is formed with R2 that reduces the feedback factor at resonance and so creates a peak in the response. It is not exactly intuitively obvious, but this process does give symmetrical cut/boost curves. At frequencies away from resonance the impedance of the RLC circuit is high, and the gain of the circuit is unity.

The beauty of this arrangement is that two, three, or more LCR circuits, with associated cut/boost pots, can be connected between the two opamp inputs, giving us an equaliser with pretty much as many bands as we want. Obviously, the more bands we have, the narrower they must be to fit together properly. A good example of a classic LCR graphic design was published by Reg Williamson in 1973 [13].

As described in Chapter 2, inductors are in general thoroughly unwelcome in a modern design, and the great breakthrough in graphic equalisers came when the LCR circuits were replaced by gyrator circuits that emulated them but used only resistors, capacitors, and a gain element. It is not too clear just when this idea spread, but I can testify that by 1975 gyrators were the standard approach, and the use of inductors would have been thought risible.

The basic notion is shown in Figure 15.53; C1 works as a normal capacitor as in the LCR circuit, while C2 pretends to be the inductor L1. As the applied frequency rises, the attenuation of the highpass network C2–R1 reduces so that a greater signal is applied to unity-gain buffer A1 and it more effectively bootstraps the point X, making the impedance from it to ground increase. Therefore we have a circuit fragment where the impedance rises proportionally to frequency—which is just how an inductor behaves. There are limits to the Q values that can be obtained with this circuit because of the inevitable presence of R1 and R2.

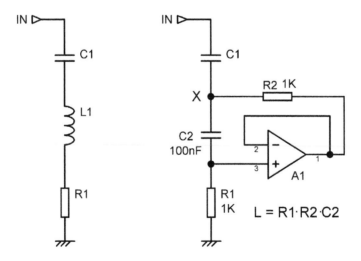

Figure 15.53 Using a gyrator to synthesise a grounded inductor in series with a resistance.

The sample values in Figure 15.53 synthesise a grounded inductor of 100 mH (which would be quite a hefty component if it was real) in series with a resistance of 2 kΩ. Note the surprisingly

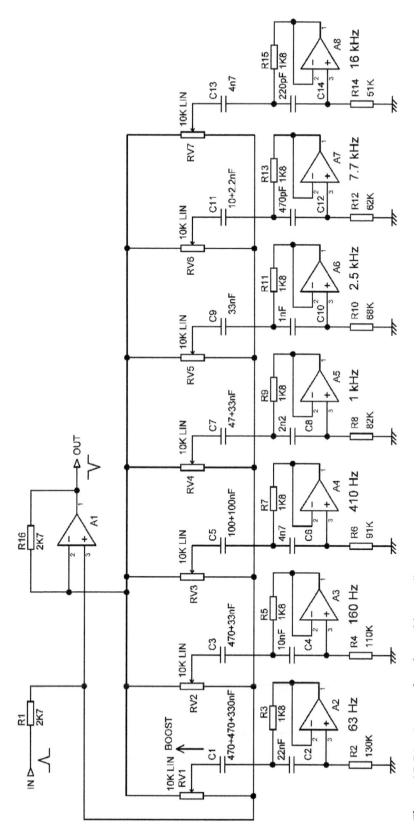

Figure 15.54 A seven-band graphic equaliser.

simple equation for the inductor value. Another important point is that the opamp is used as a unity-gain buffer, which means that the early gyrator graphic equalisers could use a simple emitter-follower in this role. The linearity was naturally not so good, but it worked and made graphic equalisers affordable.

A simple seven-band gyrator-based graphic equaliser is shown in Figure 15.54. The maximal cut/boost is +/−8 dB. The band centre frequencies are 63 Hz, 160 Hz, 410 Hz, 1 kHz, 2.5 kHz, 7.7 kHz, and 16 kHz. The Q of each band at maximum cut or boost is 0.9.

The response of each band is similar to that shown in Figure 15.36. The maximum Q value is only obtained at maximum cut or boost. For all intermediate settings the Q is lower. This behaviour is typical of the straightforward equaliser design shown here and is usually referred to as 'proportional-Q' operation; it results in a frequency response which is very different from what might be expected on looking at the slider positions.

There is, however, another mode of operation called "constant-Q" in which the Q of each band does not decrease as the cut/boost is reduced [14]. This is associated with the Rane Corporation. Constant-Q gives a frequency response that more closely resembles the slider positions, but the circuitry is more complex, essentially consisting of a bank of bandpass filters whose outputs are added to or subtracted from the input signal.

The graphic equaliser described here has a symmetrical response, also known as a reciprocal response; the curves are the same for cut and for boost operations. It is also possible to design an equaliser for an asymmetric or non-reciprocal response, in which the boost curves are as shown above, but the cut response is a narrow notch. This is often considered to be more effective when the equaliser is being use to combat feedback in a sound reinforcement system.

References

[1] Langford-Smith, F., ed. *The Radio Designers Handbook*, 4th edition 1953, reprinted Newnes, 1999, Chapter 15, pp. 635–677

[2] Langford-Smith, F., ed. *The Radio Designers Handbook*, 4th edition 1953, reprinted Newnes, 1999, Chapter 15, p. 668

[3] Sterling, H. T. "Flexible Dual Control System." *Audio Engineering*, Feb 1949

[4] Baxandall, P. "Negative-Feedback Tone Control." *Wireless World*, Oct 1952, p. 402

[5] Self, D. "Preamplifier 2012." *Elektor*, Apr, May, June 2012

[6] Self, D. "An Advanced Preamplifier." *Self on Audio*, 2nd edition, Newnes, 2016, p. 5. ISBN 0-7506-8166-7

[7] C&K Switches. www.ck-components.com/7000/toggle,10598,en.html Accessed Aug 2013

[8] Self, D. "A Low Noise Preamplifier with Variable-Frequency Tone Controls." *Linear Audio*, Vol. 5, 2013, pp. 141–162

[9] Self, D. "Precision Preamplifier 96." *Electronics World*, July/Aug and Sept 1996

[10] Cello. www.celloseattle.com/ctdocs/prodserve/peripherals/audiopalette.html Accessed Aug 2013

[11] Ambler, R. "Tone-Balance Control." *Wireless World*, Mar 1970, p. 124

[12] Stereophile. www.stereophile.com/content/class233-cp-800-da-preamplifier-page-2 Accessed June 2013

[13] Williamson, R. "Octave Equaliser." *Hi-Fi News*, Aug 1973

[14] Bohn, D. A. "Constant-Q Graphic Equalizers." *JAES*, Sept 1986, p. 611

Mixer architecture

Introduction

A large mixing console arguably represents the most demanding area of analogue audio design. The steady advance of digital media demands that every part of the chain that takes music from performer to consumer must be near-perfect, as the comfortable certainty that everything will be squeezed through the quality bottleneck of either analogue tape or vinyl disc now looks very old-fashioned.

The technical problems that must be overcome in a professional mixing console are many and varied and often unique to console design. A large number of signals flow in a small space, and they must be kept strictly apart until the operator chooses to mix them; crosstalk must be exceedingly low.

There may be 72 input channels or more, each with many stages that all have the potential to add distortion and noise to the precious signal. Even summing these signals together, while sounding trivially easy, is in practice a major challenge. The quality requirements, especially for recording consoles, are much more demanding than those for the most expensive hifi equipment, because degradation introduced at this stage can never be retrieved.

Performance factors

Two primary requirements of modern consoles are very low noise and minimal distortion. Since a comprehensive console must pass the audio through a large number of circuit stages (perhaps over 100 from microphone to final mixdown) great attention to detail is essential at each stage to prevent a build-up of noise and distortion; one of the most important trade-offs is the impedance of the circuitry surrounding the opamp, for if this is too high Johnson noise will be increased, while if it is too low an opamp will exhibit non-linearity in struggling to drive it.

The choice of opamp is also critical, for cost considerations discourage the global use of expensive ICs. In a console with many stages of signal processing, this becomes a major concern; nonetheless it is possible to keep the right-through THD below 0.002% at 20 dB above the normal operating level, so that at normal levels it is unmeasurable.

I will use the term mixer, mixing console, and mixing desk interchangeably where it will make the text less clunky. In the United States it is sometimes called simply "the Board." I hope I

DOI: 10.4324/9781003332985-16

can put "mixer" without anyone thinking I am referring to the front end of a radio or a kitchen appliance or indeed anything concrete-related. Throughout this chapter the various sections of the mixer—the channels, groups, master, etc—will be referred to as "modules," even if they are not constructed as separate physical modules.

In hifi, the preservation of absolute phase has only recently come to be considered necessary; with normal listening material it appears highly unlikely that it actually makes any audible difference, but it unquestionably looks good on the spec. In mixer design the meticulous preservation of phase is a rigid requirement to avoid the possible cancellation of signals. Both summing amplifiers and most EQ sections use shunt feedback and thus invert the signal, and it is sometimes necessary to include inverting stages that do nothing but get the phase straight again. It is a mark of good design to keep such stages to a minimum.

Mixer internal levels

The internal signal levels of any mixing console are always a compromise between noise and headroom. A higher level means that the signal is less compromised by circuit noise but makes inadvertent overload more likely, and *vice versa*. The levels chosen depend on the purpose of the console. If you are recording you only have to get it right once, but you do have get it exactly right, ie with the best possible signal-to-noise ratio, so the internal level is relatively high, very often −2 dBu (615 mVrms) which gives a headroom of about 22 dB. In broadcast work to air you only have one chance to get it right, and a mildly impaired signal-to-noise ratio is much preferable to a crunching overload, especially since the FM or DAB channel has limited noise performance anyway, so the internal levels are considerably lower. The Neve 51 Series broadcast consoles used −16 dBu (123 mVrms) which gives a much increased headroom of 36 dB at the cost of noise performance. At least one manufacturer has used balanced mixing buses to reduce the impact of the lower internal levels on signal-to-noise ratio.

As a sidelight on this issue, I might mention a mixer design I worked on some years ago. The decision was taken (no, not by me) to use an internal level of −6 dBu instead of the usual −2 dBu to improve headroom in live situations, the assumption being that 4 dB greater internal noise would go unnoticed. It most certainly did not, and vociferous complaints during beta-testing led to a rapid redesign to convert it back to the old −2 dBu level. Fortunately we were ready for this one, and the design had been arranged so that the internal level could be altered simply by changing resistor values.

An internal level of −2 dBu does have one unique advantage; doubling the level, as is done by most forms of balanced output stage, gets you directly to the professional +4 dBu level.

Mixer architecture

A mixing console has a number of input channels that can be summed into groups, and these groups again summed into a stereo mix as the final result. Small mixers often have no groups and mix directly to stereo.

The structure and signal flow of a mixing console depends very much on its purpose. A recording console needs track return sections to allow the creation of a monitor mix so that as a track is recorded, those already done can be played back at roughly the same levels they will have in the final mix; this is essential so new material can be synchronised with that already in existence. While it is quite possible to use a recording-oriented console for PA work, the reverse is much more difficult and usually impractical.

A sound reinforcement (PA) console does not need monitor sections, so it can be somewhat simpler, but it typically is fitted with a large number of effects returns. The output from a PA console at a large event is not likely to be in stereo—there will be multiple speakers, each of which requires an individual feed with different equalisation and delay requirements; sometimes there is a centre output.

In PA work there are often two mixers. The front-of-house (FOH) mixer usually resides in the middle of the audience or in a control room at the back. If the mixer is in the audience, the less room it takes up the better, as it is occupying seats that could have been paid for. Size is also very much an issue for mixers intended for installation in a control room, as access to these is often cramped and difficult.

The second type of PA mixer is the so-called monitor mixer. PA work makes much use of 'monitors,' ie small speakers, often wedge-shaped, that are placed close to the musician so that they can hear their output clearly without straining to pick it out of the main mix. Creating these foldback feeds on a separate mixer where basically each channel consists of a bank of aux sends (from 12 to 32 may be available) gives much greater flexibility than relying on the relatively few aux sends available on the FOH desk. The inputs to the monitor mixers are taken from the inputs to the FOH console by a splitter box, usually transformer-based, at the stage end of the 'snake' cable to the FOH console. Traditionally monitor mixers were placed just out of sight at the side of the stage so that disgruntled performers could signal to the hapless monitor engineer that the foldback mix was not to their liking. The widespread adoption of intercoms has given more flexibility in monitor desk placement.

Broadcast consoles are more specialised in their layout, and no one expects to be able to use them for recording or PA applications.

Recording consoles come in two different formats. The first and more traditional is called a split, separate-group, or European-style arrangement and has input channels arranged in one bank, typically to the left of the master section, with the groups banked to the right of it; on a large console there may be a further set of channels to the right of the groups.

The second format is called the in-line arrangement and has the channels and groups built into the same module. Normally there is a row of channel/group modules to both the left and right of a central master section. In-line consoles are more compact and make more efficient use of the electronic facilities, but they are conceptually more complex and somewhat harder to use. They are not popular in PA work where you need to do things quickly in real time without juggling a block diagram in your head.

In the sections that follow we will look at the internals of generic mixers that do not follow any particular design but are configured to bring out as many instructive points as possible.

The split mixing architecture

Figure 16.1 shows the basic arrangement of a split (separate-group) mixer.

Its design is oriented to recording but like many small and medium sized mixers it could also be used effectively for PA work.

Each channel has both a microphone and line-level input, with a wide-ranging gain control. Once it has been raised to the nominal internal level of the console, the signal is processed by the equalisation section, controlled in level by the channel fader, and then routed to a group or pair of groups or directly to the stereo L-R bus. The position of the channel signal in the overall stereo image is set by the panoramic potentiometer (universally known as a panpot) that controls the proportion of the signal sent to left and right. The channel also has auxiliary send controls that feed the channel signal to the auxiliary buses; sends taken off before the fader are called prefade and are normally used for foldback, ie helping the musician hear the sound they are producing. Sends taken off after the fader, so their level is dependent on the fader position, are called postfade sends and are normally used for adding effects such as reverberation that are expected to vary in level with the original signal.

The final feed from the channel to the buses is the prefade-listen (PFL); when the PFL switch is pressed the prefade channel signal is sent to the master module via the PFL bus, where it automatically replaces the normal stereo mix feed to the control-room monitor (CRM) loudspeakers.

The group/monitor modules contain both the group section and one or two monitor sections. The group consists of a summing amplifier that collects together all the signals sent to its group bus and passes it to the outside world via a fader and an output amplifier. When recording, this group signal is sent to one track of the recording machine. The monitor sections allow tracks which are already recorded to be played back to the stereo mix bus via a level control and a panpot so that a rough idea of what the final mix will sound like can be set up as early in the recording process as possible. One of the monitor sections will be switchable between the group output and the track return so the monitor mix can be made up of tracks that are being recorded as well as those which have already been laid down. This group/track switching is not shown in Figure 16.1 to aid clarity but is fully shown in Figure 16.4. Lack of space means that the monitor return sections usually have only simple EQ or none at all, but they almost always have a prefade aux send for foldback purposes. A postfade send is also extremely useful as the rough monitor mix is much more convincing if reverberation can be added as appropriate; this is called 'wet' monitoring. The monitor sections often each have a PFL switch.

When recording is finished and mixdown begins, the full facilities of the channels are required, and so the track return signal is now sent to the channel line input and the channel routed to the stereo mix bus. This is often a connection normalled through the line input jack, so that the input amplifier receives the track return signal at all times unless a jack is inserted. Back in the days of tape machines this facility was called 'tape normalling' but now 'track return normalling' describes it rather better. The monitor sections in the group/monitor modules are now no longer needed, but since they are routed to the stereo mix bus they can be used as extra effects returns.

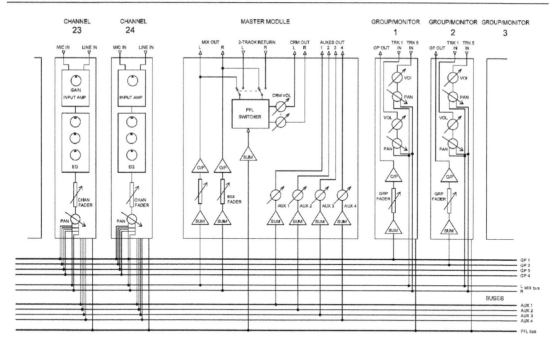

Figure 16.1 Block diagram of a split format mixer with four groups and four aux sends.

The master section contains the summing amplifiers for the stereo mix bus, which feed a stereo fader and suitable output amplifiers. These provide the final feed to the two-track recording device at mixdown. Normally this stereo output is also sent to a pair of meters and the control-room monitor (CRM) loudspeakers, the latter via a volume control, but the meters and CRM speakers can also be switched to monitor the return from the two-track recorder. When any PFL switch on the console is pressed, this is detected and the PFL signal (in mono) is fed to the meters and CRM speakers instead, so the signal quality and level from any channel can be assessed.

The master section also contains the summing and level controls for the aux send buses and may also incorporate talkback facilities and a line-up oscillator; these features are dealt with in more detail later in this chapter.

The in-line mixing architecture

Figure 16.2 shows the basic arrangement of an in-line mixer, essentially intended for recording. There are now no group/monitor modules, their functions being performed by what might be called channel/group/monitor modules. Only four group buses are shown for clarity, but in practice there would normally be a much higher number to make use of the in-line format.

The group summing amplifier is now part of the channel. It no longer has its own fader; instead the summing amp gain is controlled by a rotary 'bus trim' control so overload can be avoided. This is normally placed out of the way at the very top of the module. The group signal is sent out to the recording machine, and the track return comes back in, usually via a balanced amplifier. A

Track/Group switch SW2 selects either the group or the track return signal for the metering and the monitor path; as shown in the figure it consists only of a monitor fader and a monitor panpot which send the signal to the stereo mix bus to create a monitor mix. The monitor fader is normally a short fader mounted on the channel, as opposed to the long channel fader which is right at the front of the console. Sometimes a rotary monitor fader is fitted.

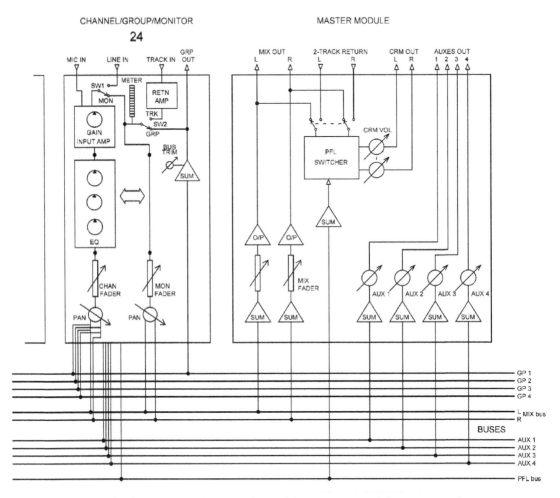

Figure 16.2 Block diagram of an in-line mixer with N groups and four aux sends.

There are two slightly differing approaches to the operation of an in-line module.

In the first approach, at mixdown switch SW1 now selects the track return signal rather than the line input, and the signal reaches the stereo mix bus via the full facilities of the channel. Sometimes additional switching allows the monitor path to be used as an extra effects return, as in split consoles. Typically the line input jack is pressed into service as the input connector for this purpose.

An alternative design approach is not to switch the source of the channel path to the track return at mixdown but instead to move the whole EQ section from the channel to the monitor path. This means that that the short monitor fader would have to be used for level adjustment, which is not ideal when there is a long fader right in front of you. This has particular force when fader automation is fitted, for it is normally only applied to the long fader. A switch called 'fader flip' is therefore fitted which swaps over the function of the two faders, allowing the long fader to be used at mixdown. This sort of approach involves a lot of reconfiguration when switching from record to mixdown mode, and on the more sophisticated consoles this is handled entirely by electronic switching, with global control from the master section, so that only one switch need be pressed to change the console mode. This second method always seems to me to be unnecessarily complex, but it has seen extensive use.

The master section shown in Figure 16.2 is identical to that shown for the split console in Figure 16.1.

A closer look at split format modules

We will now look in more detail at the channel, group, and master modules that make up a split mixing console.

The channel module (split format)

Figure 16.3 shows a typical input channel for a relatively simple split format mixing console. The input stage provides switchable balanced mic and line inputs; the mic input has an impedance of 1–2 kΩ, which provides appropriate loading for a 200 Ω mic capsule. If a +48 V phantom power facility to power microphones is provided, it is independently switchable on each channel. The line input will have a bridging impedance of not less than 10 kΩ. The mic preamplifier in particular will have a wide range of gain, such as 0 to 70 or 80 dB, while the line input tends to have a more restricted range such as +20 to –10 dB. The track return from the recording machine is shown connected through to the line input via the normalling contact of the line jack socket, so that mixdown with the full channel facilities can begin as soon as the mic/line switch is set to 'line,' so long as no jack has been inserted into the line input to break the normalling contact. The line input is shown as unbalanced in Figure 16.3 for clarity, but in practice it would usually be a balanced input using the tip and ring connections of the jack socket.

The input stage is followed immediately by a switchable highpass filter (usually –3 dB at 100 Hz) to remove low-frequency disturbances picked up by the microphone as soon as possible; if not filtered out these can eat up headroom. The filter is usually second or third-order, giving a roll-off of 12 or 18 dB per octave respectively.

The tone-control section (universally known in the pro audio business as EQ or equalisation) typically includes one or more mid-band resonance controls as well as the usual shelving Baxandall-type high and low controls. On all but the simplest mixers the EQ section can be switched out to allow before/after comparisons.

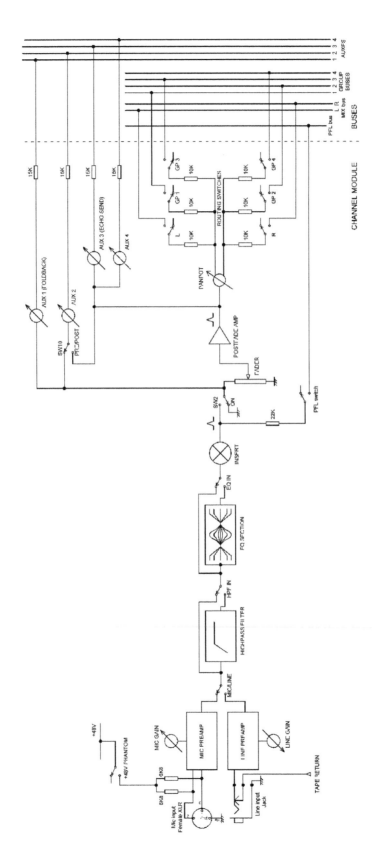

Figure 16.3 Block diagram of a typical channel module for a small mixer.

The larger and more sophisticated consoles incorporate dynamics sections into each channel. This is not shown Figure 16.3 to aid clarity. The dynamics facilities available vary but usually include compression, limiting, and sometimes noise-gating; some consoles have been produced with just the noise gate function, as it is easier to fit the required electronics into a limited space. A perennial problem with this sort of thing is finding panel room for the extra controls required; the permissible length of a module is limited by the reach of the human arm.

Next comes the insert point, though in some designs it may be configured so it can be placed ahead of the EQ and dynamics section instead. This is a jack or pair of jacks that allow external processing units to be plugged into the signal path. When nothing is plugged in the 'normalling' contacts on the jack socket allow the signal to flow through unchanged.

The PFL (prefade-listen) switch routes the post-insert signal to the master module and the monitor speakers independently of all other controls; a PFL-detect bus signals the master module to switch the studio monitoring speakers from the normal stereo mix bus to the PFL bus.

Next in the chain comes the channel-on switch. This may be either a simple mechanical switch or an electronic mute block. Note the PFL feed is taken off *before* the ON switch so the channel signal is always accessible. The channel level in the mix is controlled by a linear fader with a postfade amplifier typically giving 10 dB of gain, and the panpot sets the stereo positioning, odd group numbers being treated as left and even as right.

The channel shown has three auxiliary sends. The auxiliary sends of a console represent an extra mixing system that works independently of the main groups; the number and configuration of these sends have a large effect in determining the overall versatility of the console. Each send control provides a feed to a console-wide bus; this is centrally summed and then sent out of the console. Sends come essentially in two kinds. Prefade sends are taken from before the main channel fader and are therefore independent of its setting. Postfade sends take their feed from after the fader, so that the send level falls or rises according to the fader setting.

Prefade sends are normally used for 'foldback,' ie sending the artist a headphone feed of what he/she is perpetrating, which is important if electronic manipulation is part of the creative process and essential if the artist is adding extra material that must be in time with that already recorded. In the latter case, the existing tracks are played back to the artist via the prefade sends on the monitor sections.

Postfade sends are used as effects sends; their source is after the fader, so that the effect will be faded down at the same rate as the untreated signal, maintaining the same ratio. The sum of all feeds to a given bus is sent to an external effects unit and the output of this returned to the console. This allows many channels to share one expensive device, such as a high-quality digital reverb, and for this sort of purpose is much more appropriate than patching processors into the channel insert points.

There may be anything from one to 12 or more sends available. In the example shown the first send (Aux 1) is a dedicated prefade send which is typically used for foldback. The third (Aux 3) is a dedicated postfade send, typically used for effects such as reverb. The second send (Aux 2) can be switched so it is either prefade or postfade. In a recording console the greatest need for

foldback sends is during track laying, while effect sends are in greatest demand at mixdown; it is therefore common for some or all of the sends on a channel to be switchable prefade or postfade.

On more sophisticated consoles, it is often possible to switch every auxiliary send between pre and post to give maximal flexibility. Traditionally, this meant pressing a switch on every input module, since it is most unlikely that a mixture of pre and post sends on the same bus would be useful for anything. On a 64-input console this is a laborious process. More advanced designs minimise the effort by setting pre/post selection for each auxiliary bus with a master switch that controls solid-state pre/post switching in each module. An example of this approach is the Soundcraft 3200 recording console.

Effect-return modules

In complex mixdowns it may be necessary to return a large number of effects to the mix. While, as described earlier, it is often possible to press unused monitor sections or channel modules into service as effect returns, sometimes this just does not provide enough and specialised 'effects return' modules may be fitted. These usually have facilities intermediate between channels and monitor sections, and it is common to fit two and sometimes even four into the space occupied by a channel module. The returned effect, which may well now be in stereo, such as the output of a digital reverb unit for example, is usually added to the stereo mix bus via level and pan controls.

The group module

Figure 16.4 shows a typical group module for a recording desk. Each mix bus has its own summing amplifier; the summed group signal is then sent to an insert so external processing can be applied. The insert send is very often arranged for ground-cancelling operation for the simple reason that the summing amp inherently phase-inverts the signal, which must be returned to the correct polarity by another amplifier stage before it meets the outside world. This second stage can be arranged to be ground-cancelling at minimal expense. The operation of ground-cancelling outputs is described in Chapter 19.

The signal from the insert return goes to the group fader. Like that of the channel, it is a linear fader with a postfade amplifier typically giving 10 dB of gain. The signal then goes to an output amplifier suitable for driving the recording device, possibly via lengthy cables. On all but the cheapest designs this is a balanced output.

The second major function of the typical group module is to allow the creation of a monitor mix so that as a track is recorded, those already done can be played back at roughly the same levels they will have in the final mix; this is obviously essential to allow new material to be synchronised with that already in existence. Back in the days of tape recording machines, the monitor playback had to be done by the record head, as the playback head was physically displaced and so would have given a delayed signal; this meant the quality of the monitor mix was compromised as the record head was optimised for recording and not playback. With digital recording this is, of course, not a problem.

The monitor section typically consists of a balanced line input to prevent ground-loop problems with the recorder, some form of switching between the group and recorder return, so the track

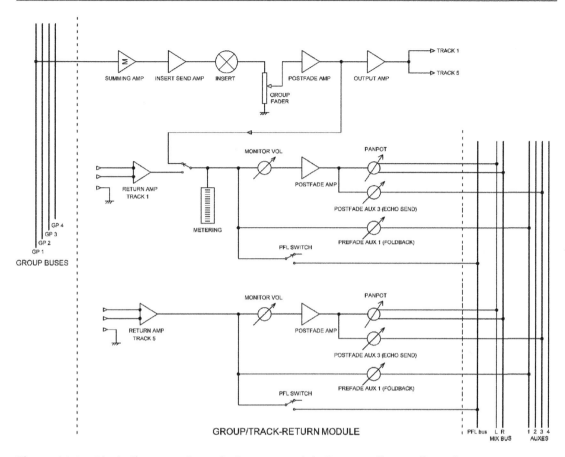

Figure 16.4 **Block diagram of a typical group module for a small recording mixer.**

being recorded can be incorporated into the monitor mix, and level and panpot controls. EQ is not often fitted for reasons of space, but aux sends for foldback and effects are standard, because adding reverb to the monitor mix makes it much more realistic. A PFL switch for each monitor section is usually provided.

Normally relatively few tracks are recorded at a time, so it is sensible to have more monitor sections than groups. For example, a 4-group mixer can be very effectively used with an 8-track recorder if Group 1 is connected to Track 1 and Track 5, Group 2 is connected to Track 2 and Track 6, and so on. The track to be recorded is selected at the recorder. To make use of this each group module will contain one actual group section and two monitor sections, which explains why there is not normally room for even basic EQ in the monitor sections.

The master module

Figure 16.5 shows the basics of a typical master section. It contains the summing amplifiers for the stereo mix bus with their associated insert send amplifiers and insert points. This is

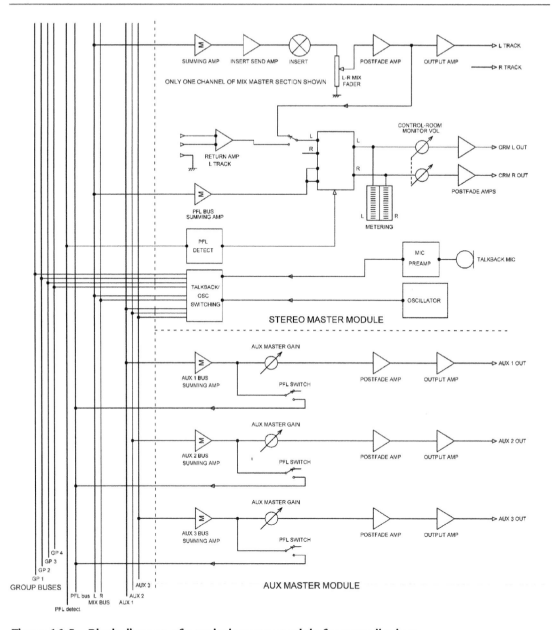

Figure 16.5 Block diagram of a typical master module for a small mixer.

followed by a stereo fader (sometimes implemented as two mono faders with the knobs mounted immediately next to each other), a +10 dB post amp, and a balanced or ground-cancelling output stage which feeds the two-track recorder during mixdown.

The stereo mix bus normally drives the L-R meters and the control-room monitor (CRM) loudspeakers, but a manual source-select switch allows this feed to be replaced by the return

signal from the two-track recorder for quality checking of the final stereo recording. Whenever a PFL switch anywhere on the console is pressed, the PFL-detect system responds and activates two solid-state switches that replace the stereo monitor signal with the PFL signal. The L-R meter feeds are taken off after the PFL switching so those meters can be used to check the level at whichever point in the system the PFL switch in question happens to be.

The master section also contains the summing and level controls for the aux send buses. The auxes may have dedicated meters or just a PFL switch each.

The master module will also carry any master status switches for globally changing things such as group/recorder switching for the monitor sections, pre/post operation of auxes, and so on.

Talkback and oscillator systems

The talkback system allows the mixing engineer to talk to the musicians in the studio or add spoken comments to the recording using a microphone mounted on the console. Back in the day it was considered cool to mount the talkback microphone on a flexible gooseneck, but these get in the way, and the modern approach is to have a small electret microphone mounted flush with the master module panel.

For talkback to the studio the microphone feed is routed to the aux buses, on the assumption that one or more of these will be in use for foldback and so will be connected to a loudspeaker in the studio area. Routing may also be provided to a dedicated talkback loudspeaker. In many cases there is a facility to route to the first two auxes only, as these will almost certainly be used for fold back purposes; see the typical system in Figure 16.6.

For recording identification the microphone feed is routed to the group buses. This facility, which allows the engineer to identify a recording by saying something like "Spinal Tap—take 147" is often called a 'Slate' facility, by analogy with the film industry.

When the talkback facility is used, there is a danger of acoustical feedback. If a microphone in the studio is active and routed through channel and group to the control-room monitors, the monitor speaker output will be picked up by the talkback microphone, fed to the studio . . . and away she goes. It is therefore normally arranged that pressing any of the talkback switches will attenuate or cut completely the monitor speaker signal. On larger consoles the amount of attenuation (or 'dim' as it is usually called in this context) is adjustable.

If the talkback microphone is mounted in the master panel, the distance between it and the engineer will vary as he or she moves. More sophisticated consoles sometimes incorporate a talkback compressor to reduce the level variations.

Many of the larger recording consoles include a 'Listen' facility whereby the control room can hear messages from the studio even if no microphone channels are faded up. A microphone is mounted somewhere out of the way (often suspended from the ceiling) and is routed to the monitors when the 'Listen' switch is pressed.

Most mixers of medium size and above incorporate a line-up oscillator which can be routed to all the groups and the stereo mix. This allows the mixer metering to be lined up with external level

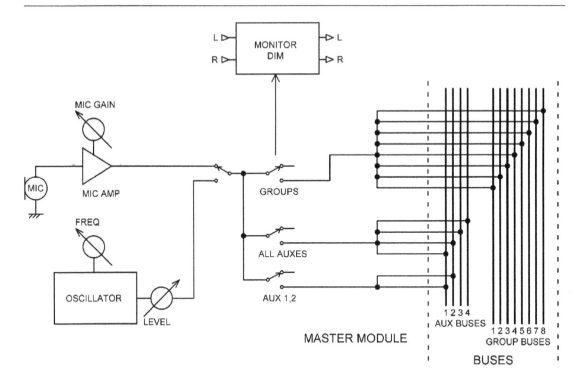

Figure 16.6 **Talkback and oscillator system with routing to aux and group buses.**

indication on the recorder. A fixed-frequency oscillator running at 1 kHz with a variable output level is the minimum facility; more advanced models have switched or fully variable frequency controls.

In the typical talkback/oscillator system of Figure 16.6, the line-up oscillator is shown sharing with the talkback system the bank of mix resistors that inject signal into the buses. On a large console this is quite a lot of resistors, and it would not be sensible to design them in twice. The only compromise is that it is not possible to use talkback and the oscillator at the same time, but then why would you want to? The default selection is talkback because this is used much more frequently than the oscillator.

The in-line channel module

Figure 16.7 shows a typical channel/group/monitor module for an in-line mixing console. This uses the first approach to in-line operation described earlier, where to enter mixdown mode the source of the channel path is switched to the track return, rather than bodily moving the EQ and other facilities into the monitor path.

The group fader no longer appears. More usefully, the summing amplifier gain can be varied by a rotary 'bus trim' control to prevent overload; it is highly desirable that this control alters the

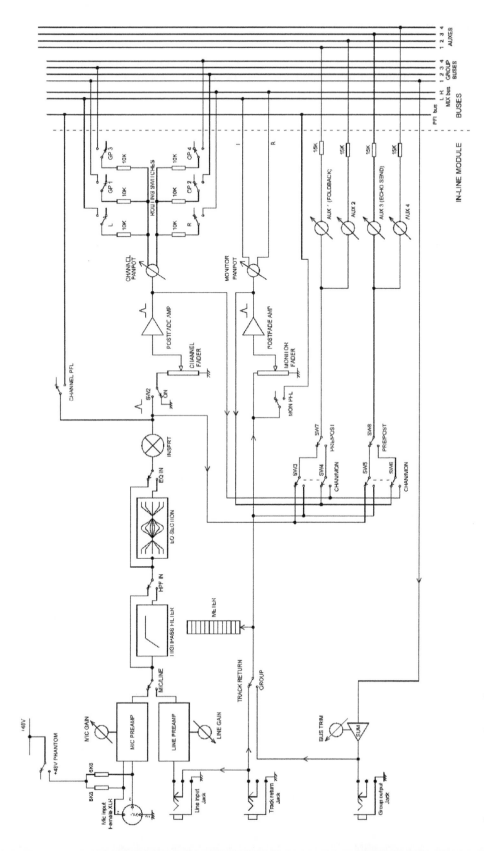

Figure 16.7 A channel/group/monitor module for an in-line recording console.

gain of the actual summing amplifier, rather than having a low-gain summing amplifier with a level control and post amplifier following it because the former gives greater protection against clipping and superior noise performance at low gain settings. The bus trim is rarely altered so it can be conveniently placed out of the way at the very top of the in-line module. The group signal from the summing amplifier is sent out to the recording machine, usually by means of a balanced or ground-cancelling output stage to prevent ground loops occurring with the multitrack recorder. The track return usually comes back via a balanced amplifier for the same reason. A Track-Return/Group switch selects either the group or the track return signal for the metering and the monitor path; as shown in the figure this path consists of a monitor fader (the 'short fader') and a monitor panpot which send the signal to the stereo mix bus to create a monitor mix. Note that every in-line module will have a meter, though it is not usual to provide meters for every channel on a split console. A monitor PFL switch is provided so that an individual track return or group can be conveniently listened to.

As in split consoles, it is convenient to connect the track return to the channel line input through normalling contacts on the line input jack, so switching to mixdown requires the minimum number of operations. As described earlier, in this form of in-line configuration the monitor path is redundant, as the channel fader and panpot are used to control the signal coming back from the multitrack recorder, and so there is usually a way in which the monitor path can be used as an extra effects return, as is commonly done in split consoles. Typically the line input jack is used as the input connector for this purpose; alternatively an extra insert point may be provided in the monitor path, into which an external line signal can be fed. These arrangements are not shown in Figure 16.7, which is quite complicated enough already; it is one of the drawbacks of the in-line system that it is conceptually more complex than the split console format.

The auxiliary send system is slightly more complex in an in-line module, in the interests of maximum flexibility of working. In the example shown, the sends can be switched in pairs to take their signal either prefade or postfade from either the channel or monitor path. This is implemented by means of the switches SW3–SW8. For example, during recording the effect sends can be switched to be monitor postfade, allowing wet monitoring. Many variations on this aux send are possible; on larger consoles there will be six or eight sends, and sometimes a stereo aux send with its own panpot is provided.

Microphone preamplifiers

Microphone types

There are many ways to make a microphone [1], but for our purposes there are four main types:

1) The dynamic microphone, which consists of a diaphragm that moves a coil of wire in a strong magnetic field. Output −80 to 0 dBu, the higher level only occurring when you put a microphone inside a bass drum. Phantom power is not required.

2) The capacitor microphone, where the diaphragm forms one plate of a capacitor with a constant charge applied via a very high value resistor—typically 10 GΩ (yes, 10,000 MΩ, a specialised part) so that variations in the capacitance cause voltage variations. There will be a head amplifier built into the microphone body that brings the output up to about the same as a dynamic mic, ie −80 to 0 dBu. Dynamic and capacitor microphones can therefore use the same input amplifiers. Phantom power or an internal battery is required.

3) The electret microphone is similar to the capacitor microphone except that the polarising charge is permanently embedded in a film material that can be used as a microphone diaphragm. Again the variations in capacitance must see a very high impedance so a JFET common-source amplifier is included in the mic package. The drain resistor is external so there is control over the amplifier gain. Electret microphones are usually considered to be of lower quality than their capacitor counterparts because a good electret material does not necessarily make a good diaphragm. Electret mics are commonly used for talkback in mixers.

4) The ribbon microphone, where the diaphragm is in the form of a very thin corrugated conducting ribbon in a strong magnetic field; it is essentially a dynamic mic with a single conductor instead of a coil. They have traditionally been regarded as delicate and very vulnerable to damage, as the ribbon is typically about 50 times thinner than the diameter of a human hair, but modern materials have helped somewhat with this. Ribbon microphones are ferociously expensive, costing thousands of dollars. Early ribbon mics were hefty items because of the need for permanent magnets weighing up to 6 pounds. (2.7 kg). The introduction of powerful neodymium magnets has allowed modern ribbon mics to be much lighter and more compact.

The output from the ribbon is very low (50–100 uV) and a step-up transformer is often used to get a usable level; a typical sensitivity (with transformer) would be −50 dBu/Pa (2.4 mV/Pa). The output impedance from the transformer is usually around 200–300 Ω, which works well with the usual microphone amplifier input impedance of 1–2 kΩ. A head amplifier is sometimes also built

into the microphone to give further amplification and reduce the output impedance. If so, phantom power is required.

Microphone preamplifier requirements

A microphone preamplifier is a serious design challenge. It must provide a gain variable from 0 to 70 dB or more to amplify deafening drum-kits or discreet dulcimers, generate minimal internal noise, and have a high-CMRR balanced input to cancel noise pickup in long cables. It must also be able to withstand +48 V DC of phantom power suddenly applied to its input while handling microvolt signals.

It is now rare to use input transformers to match a low-impedance (150–200 Ω) microphone to the preamplifier, since the cost and weight penalty is serious, especially when linearity at low frequencies and high levels is important. Both dynamic and capacitor microphones have a low output impedance of this order, the former because of the low number of turns used in the coil, the latter because active buffering of the extremely high capsule impedance is essential.

The low-noise requirement rules out the direct use of opamps, since their design involves compromises that make them at least 10 dB noisier than discrete transistors when faced with low source impedances. The answer, for at least the last 30 years, has been to use hybrid input stages that combine discrete input transistors to give low noise, combined with opamps to provide raw open-loop gain for linearisation, and load-driving capability.

To summarise the requirements of a microphone preamplifier:

1) Variable gain, usually from 0 to +70 dB. Some designs have a gain range extending to +80 dB. The bottom 20 dB section of the range is often accessed by switching in a 20 dB input attenuator.

2) Minimal noise. Taking the source impedance of a microphone as 200 Ω, the Johnson noise from that resistance is −129.6 dBu at 25°C, 20 kHz bandwidth. This puts an immediate limit on the noise performance; if you set up 70 dB of gain then the noise output from the preamplifier will be −59.6 dBu even if it is itself completely noiseless. Most mic preamplifiers approach to this at maximum gain, often having a noise figure as low as 1 or 2 dB but depart from it further and further as gain is reduced. In other words, the noise output does not fall as fast as it would if the preamp was noiseless because reducing the gain means increasing the effective resistance of the gain control network, so it creates more Johnson noise.

3) The input must have a high common-mode rejection ratio (CMRR) to reject interference and ground noise. The CMRR should ideally be high, be flat with frequency, and remain high as the input gain is altered over the whole range. In practice, CMRR tends to worsen as gain is reduced. Because of the need for a balanced input, microphone inputs are almost always female XLR connectors.

4) The input must have a constant resistive input impedance of 1 to 2 kΩ, which provides appropriate loading for a 200 Ω dynamic microphone capsule. This is also a suitable load for the internal head amplifiers of capacitor microphones.

5) The input must be proof against the sudden application (or removal) of +48 V DC phantom power. It must withstand this for many repeated cycles over the life of the equipment.

Transformer microphone inputs

For a long time transformer microphone inputs were the only real option. The cost and weight of a mic input transformer for every channel is considerable, especially at the quality end of the market because a large transformer core is needed to handle high levels at low frequency without distortion. Because of the low signal levels, mumetal screening cans were normally used to minimise magnetic interference, and this added to the cost and weight.

Step-up ratios from 1:5 to 1:10 were used, the higher ratios giving a better noise performance but more difficulties with frequency response because of the greater capacitance of a larger secondary winding. The impedance reflected to the input depends on the square of the step-up ratio, so with a 1:10 transformer the secondary had to be loaded with 100 kΩ to get the desired 1 kΩ at the primary input.

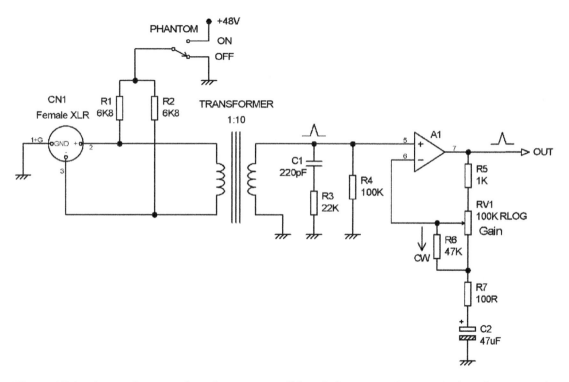

Figure 17.1 A transformer microphone preamplifier. Gain range +20 to +80 dB. The opamp is typically a 5532 or 5534.

Figure 17.1 has an amplifier gain range from to 0.3 to 60 dB to which is added 20 dB from the transformer ratio of 1:10, giving +20 to +80 dB of overall gain. R6, in conjunction with the reverse-log pot, shapes the control law so it is roughly logarithmic. R4 is the 100 kΩ secondary loading resistor, and C1, R3 form a Zobel network to damp the secondary resonance. In the mid-1970s, when opamps were still a dubious proposition for quality audio, the input amplifiers were very often discrete transistor stages using four or more transistors. Note R5, which prevents the gain from being reduced to exactly unity. Its presence is testimony to the fact that the discrete preamplifiers were difficult to stabilise at HF if the output and inverting input were directly connected together to get unity gain. R1 and R2 feed in phantom power when the switch is in the ON position.

Microphone transformer technology had, and still has, its own advantages. A balanced input with a good and constant CMRR was inherent. The step-up ratio, which gave 'gain for free' in electronic if not financial terms, and the associated impedance matching, meant that it was easy to design a quiet input stage. Transformers also gave good RF rejection and isolated the input preamplifier from phantom power voltages. For EMC reasons in particular, transformer microphones continued in use in broadcast mixing consoles long after they had disappeared from recording and PA equipment.

The simple hybrid microphone preamplifier

The cost incentive to develop an effective low-noise transformerless microphone input was considerable, and after much experimentation the arrangement shown in Figure 17.2 became pretty much standard for some years, being extensively used in mixers around the period 1978–1984 (in this period the more expensive consoles stuck to transformer microphone amplifiers). The circuit shown was used on a mixer that was produced in large quantities and is typical of its day. It is examined in some detail here because many facets of its operation, such as frequency response and noise, are equally relevant to more sophisticated configurations using overall negative feedback.

The difficulties of getting the noise low enough and the linearity good enough were at first formidable, but after a good deal of work (a lot of which I did) such stages became almost universal. Q1 and Q2 work as common-emitter stages, with the gain-control network R5, RV1, C3 connected between the emitters. As the resistance of this network is reduced, the differential gain increases but the common-mode gain remains low. The two signals at the collectors are then summed by the opamp. This does not have to be a low-noise type because the gain in the transistors means it is they which determine the noise performance at high gain, where it matters most, and the TL072 was universally used in this position, being at the time much cheaper than the 5532. That is no longer the case, and using a 5532 section for the opamp reduces the noise by some 3.5 dB at low gains; however as gain increases the improvement slowly falls away to nothing as the discrete transistors come to dominate the noise performance.

With appropriate choice of transistors (a type with low R_b) and collector current, preamplifiers of this type can give an equivalent input noise (EIN) of around −128.5 dBu at maximum gain, equivalent to a noise figure of only 2 dB with a 150 Ω load. The Johnson noise alone from 150 Ω is −130.4 dBu. The EIN rises as gain is reduced because the resistance of the gain-control network and its Johnson noise, and the effect of current noise through it, is increased. The noise output falls as gain is reduced but not as fast as the gain does.

The gain law is very non-linear with Rg (= R5 + RV1), a reverse-log D-law pot helps but there is still some cramping of the calibration at the high gain end, and preamplifier gain ranges of more than 50 dB are not really practicable with this simple arrangement.

Today this approach is generally considered obsolete for anything except budget mixer purposes because of its mediocre distortion performance. You will note that the input transistors have no overall feedback loop closed around them, and their nonlinearity creates significant distortion, especially at high gains.

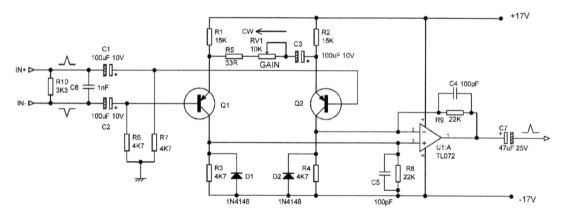

Figure 17.2 **The simple hybrid microphone preamplifier**

The two reverse-biased diodes in the transistor collector circuits are to prevent the opamp being damaged by having its input driven below the −17 V rail when phantom power is applied or removed. Note that the input coupling capacitors C1, C2 shown here are not intended to cope with the phantom voltage if used.

Whenever you use a TL072 consider the possibility of latchup due to the well-known common-mode phase reversal. That can't happen in the circuit of Figure 17.2 even with gross clipping of a balanced signal.

Simple hybrid microphone preamplifier: noise

The noise performance of the stage is best at maximum gain; see Table 17.1.

TABLE 17.1 **Measured noise vs gain for simple mic amp; Rg is the resistance set on the pot**

Rg Ω	Gain dB	Noise out dBu	EIN dBu	Noise figure dB
Infinity	+3.18	−91.1	−94.3	+36.2
10k	+15.22	−90.8	−106.0	+24.4
4k7	+20.42	−90.1	−110.5	+19.9
2k2	+26.24	−88.8	−115.0	+15.4
1k	+32.34	−87.0	−119.3	+11.1
680	+35.97	−85.4	−121.4	+9.1
330	+40.56	−83.2	−123.8	+6.7
220	+43.24	−81.8	−125.0	+5.4
100	+47.63	−78.9	−126.5	+3.9
47	+50.59	−76.9	−127.5	+2.9
0	+54.54	−73.6	−128.1	+2.6

This shows that at maximum gain the noise is only 2.6 dB greater than that of a perfect noiseless amplifier with a 150 Ω source resistance, so the noise figure (NF) is 2.6 dB. If the end-stop resistor R5 is reduced to 22 Ω then the NF is only reduced to +2.2 dB, so there's not much chance of a big improvement in that direction. In fact there's no chance at all of a big improvement when you are already only 2 dB away from perfection.

With Rg = 0, the input stage is running almost open-loop with very little negative feedback. This can be demonstrated by shorting the 33 Ω end-stop resistor R5. The gain does not shoot up but only rises to +58.94 dB, an increase of only 4.5 dB.

The noise sources in this configuration are the voltage noise of the two input transistors, the effect of their current noise flowing in the input loading, and the Johnson noise of the resistors. As gain is increased the lower noise from the transistors compared with the gain-setting resistors becomes more significant, and so the EIN falls and the NF gets better. See Figure 17.3. Using a 5532 opamp gives a significant improvement at low gains. The transistors should be low-R_b types for the lowest noise; the obsolete 2SB737 was very good for this; probably the best replacement for the 2SB737 is the Zetex ZTX951 with a measured R_b of approx 1.2 Ω.

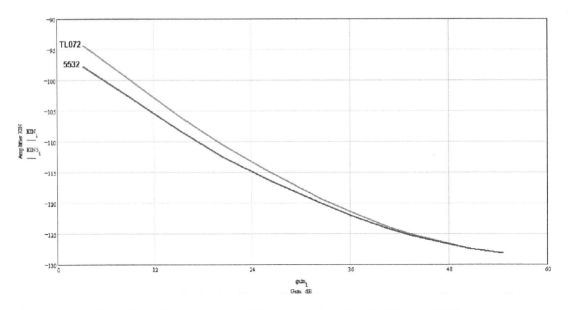

Figure 17.3 Simple hybrid mic preamp: EIN versus gain using TL072 and 5532 as the opamp.

Simple hybrid microphone preamplifier: distortion

The great drawback of the simple hybrid mic amp is that it is not very linear at high gains. This is demonstrated in Figure 17.4 for an 8 Vrms output, which is about as high as you would likely want to go. The plot shows very clearly that the distortion depends strongly on the gain. When gain is low Rg is high, the transistor emitters see a relatively high impedance and thus have a lot of local emitter negative feedback. At maximum gain the impedance seen by each emitter is reduced to 33/2 = 16.5 Ω, and there is little local feedback and so the non-linearity of the base-emitter junction makes itself felt.

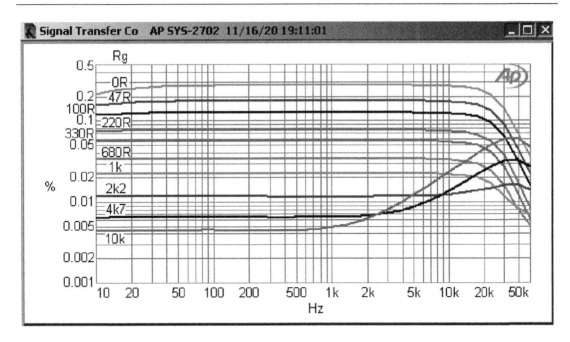

Figure 17.4 Simple hybrid microphone preamplifier: THD at 8 Vrms out.

In Figure 17.4 the flat parts of the traces are caused by visually-pure third-harmonic. At high gains the THD appears to fall at HF because the measurement bandwidth is 80 kHz to control noise, and so any frequency above 80/3 = 26.6 kHz will have its third harmonic attenuated; the THD is actually flat with frequency. At low gains THD increases at HF despite this effect, and inspection of the residual shows that a new second-harmonic component is increasing. This could easily be assumed to be down to the opamp, which as a TL072 is known to have imperfect distortion performance; however this is just not true.

If the TL072 is replaced with a 5532 section, then the THD performance shown in Figure 17.4 is—*completely unchanged*. It is clear that all the distortion comes from the transistor first stage. The 5532 will, however, reduce the noise at low gains and much improve the ability of the stage to drive circuitry downstream.

Because of the pure nature of the distortion residuals, it is possible to predict the distortion at any level from Figure 17.4. Second harmonic distortion doubles as level doubles, while third-harmonic distortion increases by a factor of four as level doubles. As an example, with Rg set to 1 kΩ, the THD measures 0.0238% at 8 Vrms out. If we drop the level to 4 Vrms out, the measured distortion is 0.00606%. The calculated distortion is 0.0238%/4 = 0.00595%, which is very close indeed to 0.00606%. The difference is caused by the extra contribution noise makes at lower levels; thus the measured distortion at 2 Vrms out was about 0.0033% and the residual was obviously noisy. At 1 Vrms, which is more like a normal operating level, the residual was visually-pure noise at a level of 0.005%, with no distortion visible at all.

In the worst case, at maximum gain with Rg set to 0 Ω, the distortion is 0.291% at 8 Vrms out, and a quarter of that is 0.0727%. The measured value at 4 Vrms out is 0.0728%, and you're

not going to get better agreement than that in this world. At 1 Vrms out the residual measured 0.0248%, but it was almost all noise with non-linearity barely visible.

This demonstrates why this simple configuration was as successful as it was. A plot like Figure 17.4 looks unimpressive, but at practical operating levels the distortion would mostly be below the noise, it was all low-order (third), and the chances of it ever being audible were small.

The frequency response of this configuration depends on the input capacitors C1, C2 and their associated bias resistors R5, R7, and the gain-control capacitor C3 (which prevents current flowing through the gain pot) in conjunction with Rg. C1, C2 with their bias resistors have a roll-off −3 dB at 0.34 Hz, which sounds over-generous. However this is very necessary for a good LF CMRR, as described in the next section.

The major influence is C3 in combination with Rg plus 33 Ω, and at maximum gain Rg is zero so this defines the worst-case LF response. 100 uF and 33 Ω as shown gives −3 dB at 19 Hz and −1 dB at 38 Hz, so it is a minimum value if you want a reasonable LF response. Increasing C3 to 470 uF gives −1 dB at 10 Hz and is more suitable for a high-performance application. C3 is not a large component; it needs only to withstand the difference between the V_{be}s of the two transistors which is a few milliVolts, and so a 6V3 part is quite adequate. In my tests I used a 470 uF 10 V part which was 8 mm in diameter and 12 mm high; no doubt smaller versions can be obtained.

Simple hybrid microphone preamplifier: CMRR

As noted earlier, the input capacitor and bias resistors give −3 dB at a very low 0.34 Hz. This is because the input capacitors are electrolytics with a relatively wide tolerance and mismatching between them will prevent a good LF common-mode rejection ratio (CMRR), unless their effect is pushed well below the audio bandwidth. This is illustrated in Figure 17.5, where the CMRR is worsening below 70 Hz.

You can see that the CMRR for Rg = 330 Ω has a significant notch around 14 kHz. This means that there are two common-mode error mechanisms working at that frequency, and they have cancelled each other out.

If the bias resistors are raised to 47 kΩ then the CMRR degradation is pushed to below 10 Hz, where it is of no interest. It is unlikely you will need to reject spurious signals below 50 Hz. This is illustrated in Figure 17.6, which shows the CMRR for all the gain options in Table 17.1.

This circuit is remarkable because it is a very simple solution to a demanding task, and yet it performs very well except for distortion at high gain and high level.

Microphone and line input pads

Microphone pads, or attenuators, are used when the output is too high for the mixing console input to cope with; this typically happens when you put a microphone inside a kick-drum. Attenuators are also used when for reasons of economy it is desirable to that the microphone input doubles up as a line input.

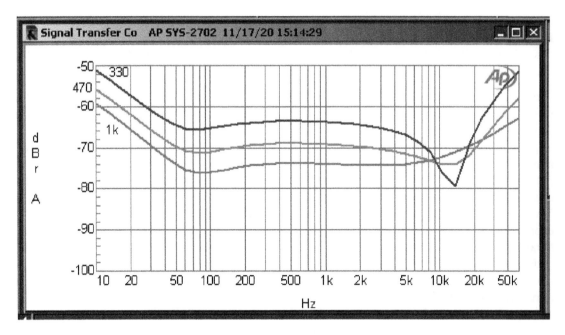

Figure 17.5 Simple hybrid microphone preamplifier CMRR performance for Rg = 330 Ω, 470 Ω, and 1 kΩ.

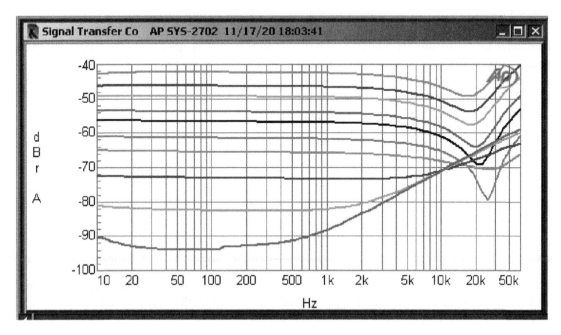

Figure 17.6 Simple hybrid microphone preamplifier CMRR performance for all Rg options in Table 17.1. Bias resistors raised from 4k7 to 47 kΩ.

On arriving at the input XLR, the microphone signal first encounters the phantom feed resistors, DC-blocking capacitors (usually rated at 63 V), a switchable 20 dB attenuator, and possibly a phase-invert switch that swaps over the inputs, before it reaches the preamplifier. A phase switch is illustrated in Figure 17.11.

A typical mic/line arrangement is shown in Figure 17.7. The preamplifier has a gain range of +20 to +70 dB. There is an input XLR and phantom feed resistors R1, R2. C1 and C2 are DC-blocking capacitors to stop the phantom voltage from getting into the preamplifier; these should be as large as possible to preserve LF CMRR; these are usually rated at 63 V. Next comes a 20 dB balanced attenuator made up of R3 to R6; note that the loading of the preamplifier input resistor R10 must be taken into account when designing the attenuator resistor values; one of the functions of this resistor is to prevent the preamplifier input from being open-circuited when the pad switch SW1 or the mic/line switch SW2 is between contacts. C3 and C4 are two further DC-blocking capacitors, which prevent the input terminals of the preamplifier, which are at +0.6 V, the V_{be} of the transistors, from causing clicks in the switching. C5, C6, and C7 increase EMC immunity and also keep the preamplifier from oscillating if the microphone input is left open-circuit at maximum gain. Such oscillation is not an indication that the preamplifier itself is unstable—it normally happens because the insert jacks, which carry the output signal from the preamplifier, are capacitively crosstalking to the microphone input, forming a feedback loop. Ideally the microphone input should be open-circuit stable not only with the input gain at maximum, but also with full treble boost set up on the EQ section. This can be challenging to achieve, but it is possible with careful attention to layout. I have done it many times.

In line mode, the microphone gain is, of course, much too high, and the usual practice is to use a 30 dB attenuator on the line input, which allows a high input impedance to be set by R7, R9 while R8 provides a low source impedance to minimise preamplifier noise. This pad alters the gain range to −10 to +40 dB, which is actually too wide for a line input, and some consoles have another switch section in the mic/line switch, which reduces the gain range of the preamplifier so that the overall range is a more useful −10 to +20 dB. The larger and more expensive consoles usually have separate line input stages which avoid the compromises inherent in using the microphone input as a line input.

There is an important point to be made about the two attenuators. You will have noticed that the microphone attenuator uses four resistors and has its centre connected to ground, whereas the line attenuator uses a more economical three resistors with no ground connection. The disadvantage of the three resistor version is that the wanted differential signal is attenuated, but the unwanted common-mode signal is not, and so the CMRR is much worsened. This does not happen with the four-resistor configuration because the ground connection means that both differential and common-mode signals are attenuated equally. There is no reason why the line attenuator here could not have been designed with four resistors—I just wanted to make the point.

The microphone amplifiers described have inherently a high CMRR at high gain, and a problem with attenuators like this is that both types degrade the overall CMRR quite seriously because of their resistor tolerances, even if 1% components are used.

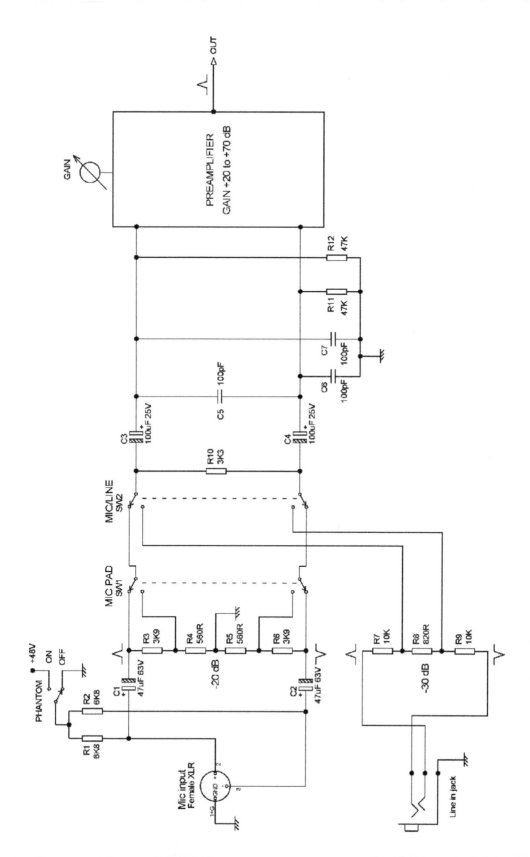

Figure 17.7 Mic and line attenuators at the input of a preamplifier.

Why phantom power is +48 V

The story goes thus, and as far as I am aware has never been denied. In 1966, a Neumann engineer made a visit to the Norwegian Broadcasting Corporation to talk about their new transistorised microphones. The broadcasters noted they needed to be powered and pointed out they had a ready-made supply at +48 V DC, which powered an emergency lighting system (very desirable in studios without windows), and so +48 V was decided on. This voltage was almost certainly provided by four 12 V car-type batteries, so the supply would have been clean.

Simple hybrid microphone preamplifier: non-switched

We've seen that a complete mic/line preamplifier uses quite a bit of switching in addition to the basic mic preamp. For economy this can be simplified. The mic/line switch can be done away with by the scheme in Figure 17.4a. Here a slightly different version of the basic mic preamplifier is used, with a gain range that extends higher because of the lower value of end-stop resistor R12, and with the preamplifier generally working at a lower impedance; that is not essential for the configuration here and is just there to show that the circuit is relatively flexible.

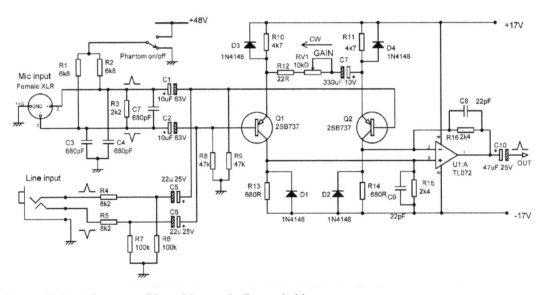

Figure 17.8 Mic preamplifier with no mic/line switching.

The circuit of Figure 17.8 has the mic and line inputs connected together with a resistive attenuator in the line path that gives 18 dB of attenuation because of the loading effect of R3 on R4, R5. Note: this circuit relies on only one connector being used at a time. If an unused mic is plugged in this will increase the line attenuation, as well as adding unwanted sounds to the line signal. If an unused line jack is plugged in, any noise on the input will be added to the mic signal. Since only one input is in use at a time, a combination XLR-jack connector can be used, saving weight and panel space, and that will ensure only one input is used.

Note input capacitors C5, C6 are the other way round from C1, C2.

The balanced-feedback hybrid microphone preamplifier (BFMA)

The microphone preamp architecture described in the previous section has the merit of simplicity, but because there is no global feedback loop around the input transistors, its distortion performance falls far short of the rest of a mixer, which typically consists of pure opamp circuitry with very low distortion. It is obviously undesirable practically, aesthetically, and in every other way for the very first stage in the signal chain to irretrievably mess up the signal, but this is what happened for several years. In the mid-1980s I decided to do something about this. Many methods of applying feedback to the input stage were tried, but foundered on the fact that if feedback was applied to one of the transistors, the current variations in the other were excessive and created distortion. The use of two feedback paths in anti-phase, ie balanced feedback, was my solution to this problem; this meant that one feedback path would have to be via an inverting amplifier with extra phase shifts that might imperil HF stability.

The basic concept is shown in Figure 17.9. Direct negative feedback to Q2 goes through R12, while the inverted feedback passes through the unity-gain inverting stage U1:B and goes through R11 to Q1. The gain-control network R5, RV1, and C3 is connected between the two feedback points at the Q1, Q2 emitters and sets the closed-loop gain by controlling the NFB factor. Distortion is pretty much eliminated, even at maximum gain.

The solution to the stability problem is to make sure that the direct HF feedback through C10 dominates that through C12, which has been through the inverter U1:A; this is aided by adding C4 to the inverter to control its HF response. This feedback is therefore not symmetrical at extreme HF, but this has no effect on the functioning of the circuit with audio signals.

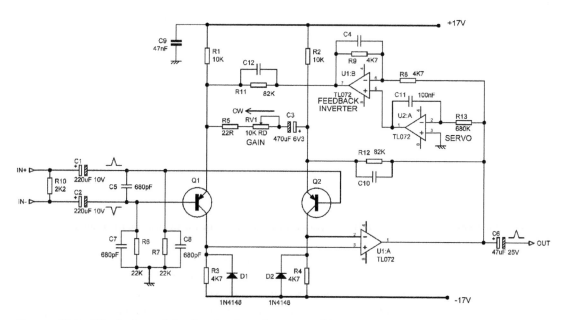

Figure 17.9 The balanced feedback microphone amplifier, known to its friends as the BFMA.

$$Gain = \frac{Rnfb + ((\frac{Rg}{2}\,Re)/(\frac{Rg}{2}+Re))}{2(\frac{Rg}{2}\,Re)/(\frac{Rg}{2}+Re)}$$

Equation 17.1

The closed-loop gain is given by Equation 17.1, which looks complicated but becomes clearer when you appreciate that the terms in brackets simply represent the parallel combination of the emitter resistor Re (R1, R2 in Figure 17.9) and half the resistance of the gain control network Rg. Rnfb is the value of R11, R12. The 2 on the bottom comes from the fact that we are only using one output of the amplifier—there is an inverted output from the inverter which could be phase—summed to give twice the gain. We don't do that because it is desirable to have as low a minimum gain as possible. With the values shown the gain range is +22 to +71 dB, which in conjunction with a switchable 20 dB pad gives a useful total range of about 0 to 70 dB.

In order to get enough maximum gain with reasonable values for R5 and C3, the feedback resistors R11, R12 have to be quite high at 82 kΩ. This means that the control of the DC level at the output is not very good. To solve this the DC servo integrator U2:A was added; R13 is connected to the preamplifier output and the integrator acts via the non-inverting input of the inverter opamp to keep the output at 0 V.

This technology was used on several consoles, such as the Soundcraft TS12, and later appeared in the Yamaha GA 24/12 and GA32/12 mixers in 1998, a very sincere form of flattery. It had a relatively short life at Soundcraft as I came up with something better—the padless microphone preamplifier described later in this chapter.

The padless microphone preamplifier

The ideal microphone preamplifier would have a gain range of 70 dB or thereabouts on a single control, going down to unity gain without the inconvenience of a pad switch. It was mentioned in the previous section that resistive pads degrade the overall CMRR and also the noise performance as an inevitable consequence of following a 20 dB pad with an amplifier having 20 dB of gain. In addition, space on a channel front panel is always in short supply and losing a switch would be very welcome. I therefore invented the padless microphone preamplifier. Looking at the mixer market today (2021), the idea seems to have caught on.

The concept is based on the balanced feedback mic amp described previously, but now the total gain is spread over two stages to give a smooth 0–70 dB gain range with the rotation of a single knob.

The first stage shown in Figure 17.10 is based on the BFMA circuit in Figure 17.9 but with the feedback resistors reduced to 2k7 to reduce the gain range. The gain-control network R5, RV1, and C3 has also been halved in resistance to reduce Johnson noise, and the net result is a gain range of +1.5 to +49 dB; as before a reverse-log D-law pot is used. The lower feedback resistors mean that no servo is required to correct the DC conditions. Note that the greater amount of NFB means that under overload conditions it is possible for the common-mode range of the opamp to

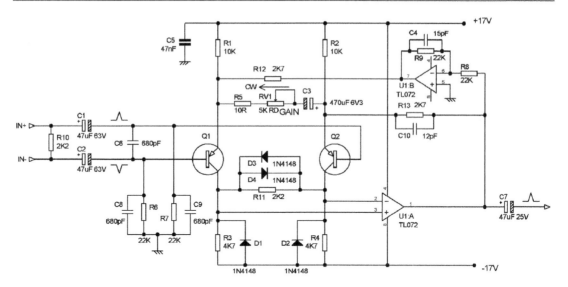

Figure 17.10 The padless balanced feedback microphone preamp: mic input stage.

be exceeded, leading to the well-known TL072 phase reversal and latchup. This is prevented by R11, D3, and D4, which have no effect on linearity in normal operation.

The second stage of the padless mic amp is shown in Figure 17.11. This consists essentially of a variable-gain balanced input stage as described in Chapter 18, configured for a gain range of 0 to +20 dB. The gain pot is once again a reverse-log D-law pot and the combination of the gain laws of the two stages gives a very reasonable law over the almost 70 dB range, though there is still a little cramping at the high-gain end.

The second stage is also used as a line input stage with a gain range of −10 to +20 dB. The mic/line switching used to do this may look rather complex, but it does a bit more than simply change sources. In Figure 17.11 switch SW1 is shown in the 'line' position. In 'mic' mode the first stage reaches the inverting input of the second via SW1-B; the output of the mic amp can be phase-inverted simply by swapping over its inputs. Line input resistors R1, R2 give reduced gain for line input working, and in mic mode they are shorted together by SW1-A to prevent crosstalk from line to mic, which is an important issue when track-normalling is incorporated—see Chapter 16. In several of my designs these resistors were placed on the input connector PCB rather than in the channel, to keep their high-voltage ends away from other circuitry and further reduce line to mic crosstalk. SW1-C shorts the junction of R1, R2 to ground, further improving mic/line crosstalk if the line input is not balanced. In mic mode SW1-D shorts the unused second stage non-inverting input to ground.

In line mode R1, R2 are connected to the second stage via SW1-B and SW1-C. In mic mode; SW1-D shorts R8 to ground so that the gain range of the second stage is increased to the required 30 dB. SW2 is a phase-invert switch which simply swaps over the input connections to the second stage.

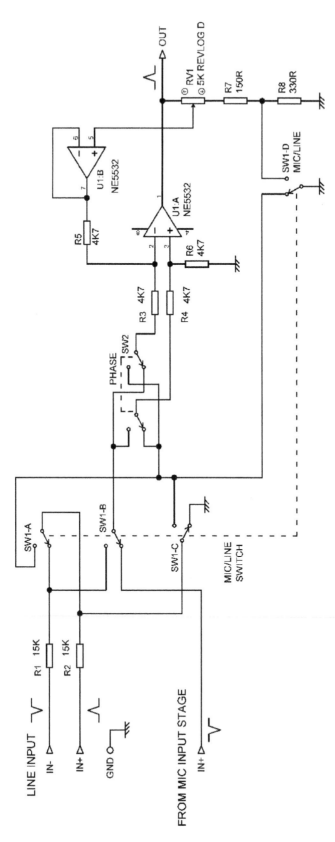

Figure 17.11 The padless balanced feedback microphone preamp: mic/line switching and second stage.

The padless mic amp gives both a good gain control law and lower noise at low gain settings. The noise performance versus gain for a typical example can be seen in Table 17.2; as described earlier, the EIN and noise figure worsen as the gain is turned down, due to the increased resistance of the gain network. A noise figure of 30 dB may appear to be pretty dire, but the corresponding noise output is only −98 dBu, and this will soon be submerged in the noise from following stages.

This effect can be reduced by reducing the impedance of the feedback and gain control network. This increases the power required to drive them, and because of the square root in the Johnson noise equation, a reduction by a factor of ten, which would need some serious electronics, would only give a 10 dB improvement, and that is at the low gain end where it is least needed. Specialised outboard mic amps with low-resistance feedback networks driven by what are in effect small power amplifiers have been developed but do not seem to have caught on.

Another advantage of the padless approach is that one pair of DC-blocking capacitors suffices, rated at 63 V as in Figure 17.10, and this improves the CMRR at low frequencies. The padless microphone preamplifier concept was protected by patent number GB 2242089 in 1991 and was used extensively over many ranges of mixing console.

TABLE 17.2 Noise performance versus gain of padless mic amp

Gain dB	Noise out dBu	EIN dBu	Noise figure dB
1.4	−98.2	−99.6	30.0
6.6	−95.4	−102.0	27.6
15.4	−90.5	−105.9	23.7
31.7	−83.1	−114.8	14.8
44.1	−77.5	−121.6	8.0
51.8	−72.7	−124.5	5.1
60.6	−65.7	−126.3	3.3
69.3	−58.7	−128.0	1.6

Mic preamps for digital mixers

Almost all audio functions can now be carried out with a combination of ADCs, DSPs, and DACs. But there is no sign of an ADC that can accept microVolt input signals and give a good noise performance. This is impossible with our current technology and is likely to be so for a very long time.

Typical practice is to use a mic preamp like the BFMA and run both outputs into an ADC with differential inputs, as in Figure 17.12. Preamp gain is controlled in steps by electronic switches U2, each with two associated gain resistors; there are two gain resistors so the switches are at their mid-point and see minimal signal levels for lowest distortion The switches may be analogue gates like the DG 411 or enhancement MOSFETs like the SN7002. Any number of them may be on or off to obtain intermediate gains.

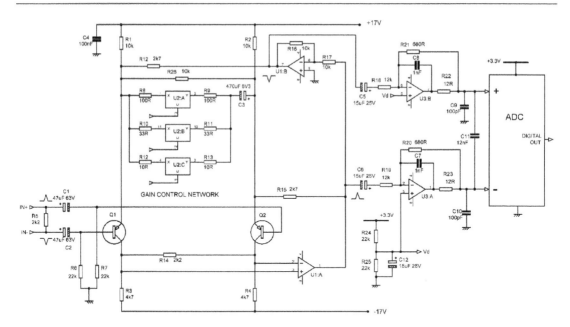

Figure 17.12 **Microphone preamp running into a differential ADC.**

A vital point is that the mic preamp will be running off at least ±15 V rails, while the ADC will be running of much lower rails (typically a single 3.3 V rail) and can only accept a much smaller voltage swing. Shunt-feedback stages U3A, B are therefore used to scale down the mic preamp output; these are biased to half of the ADC input range by Vd. An important consideration is that many ADCs require a capacitance across the inputs and to ground to source gulps of current when required; this is essential to get the specified distortion performance. A capacitor directly from opamp output to ground is an invitation to instability so zero-ohm output stages are used. These are described in detail in Chapter 19.

Capacitor microphone head amplifiers

A capacitor capsule has an extremely high output impedance, equivalent to a very small capacitor of a few picoFarads. It is in fact the highest impedance you are ever likely to encounter in the audio business, and certainly the highest I have ever had to deal with. For this reason there is invariably a head amplifier built into the microphone body; it has a modest amount of gain which makes the microphone output level compatible with dynamic mic preamplifiers as described earlier, and a low output impedance for driving cables. Special circuit techniques are required to combine low noise and very high impedance, working with a strictly limited amount of power. A while ago I designed the electronics for a new capacitor microphone by one of the well-known manufacturers, and the circuitry described here is a somewhat simplified version of that.

The first point is that the microphone capsule had an impedance of about 5 pF, so to get a −3 dB point of 10 Hz the total load impedance has to be no more than 3.2 GΩ (yes, that's 3200 MΩ). The capsule needs to be fed with a polarising voltage through a resistor, and the head amplifier needs

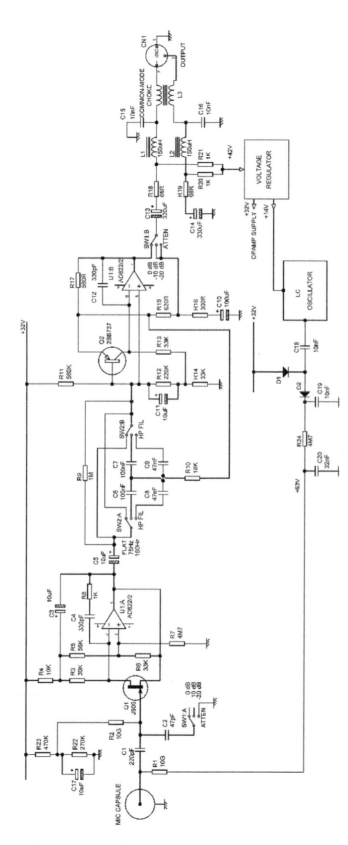

Figure 17.13 A typical head amp system for a capacitor microphone with phantom powering. All of this circuitry is fitted inside the body of the microphone.

a biasing resistor. In this design both were 10 GΩ, which mean that the input impedance of the amplifier itself had to be not less than 8.9 GΩ. Resistors with these astronomical values are exotic components that come in a glass encapsulation that must be manipulated with tweezers—one touch of a finger and the insulation properties of the glass are fatally compromised.

Figure 17.13 shows my capacitor mic head amp. R1 supplies the capsule polarising voltage and R2 biases the first stage, a unity-gain JFET source-follower augmented by opamp U1:A which provides the gain for a high NFB factor to linearise Q1. The drain of Q1 is bootstrapped via C3 to prevent local feedback through the gate-drain capacitance of the JFET from reducing the input impedance. R3, R5, R6 set the DC conditions for Q1.

The second stage is a low-noise amplifier with gain of +4 dB, defined by the ratio of feedback resistor R17 to R15 and R16. Like the first stage, it is a hybrid design that combines the low noise of low-R_b transistor Q2 with the open-loop gain and load-driving capability of an opamp. The stage also acts as a unity-gain follower making up a second-order Butterworth Sallen & Key highpass filter when C6, C7 or C8, C9 are switched in; the resistive elements are R10 and R14.

The system has two steps of attenuation; −10 and −20 dB. The first 10 dB step is obtained by using SW1:B to take the output from the junction of R15 and R16 instead of the normal stage output. The second 10 dB step results from switching C2 across the mic capsule, forming a capacitive attenuator that reduces the input to the first stage and prevents overload. The gains available are thus +4 dB, −6 dB, and −16 dB. The maximum sound pressure handling is +146 dB SPL, or +155 dB SPL with the −20 dB pad engaged.

The incoming +48V phantom power is tapped off by R20, R21 and fed to a discrete BJT regulator that gives +32 V to power the opamp and +14 V to run a small LC oscillator that pumps the +32 V rail up to the +63 V require to polarise the capsule. Total current consumption is 2.2 mA.

The noise output is −120.7 dBu (A-weighted), which may appear high compared with the moving-coil microphone amplifiers described earlier, but remember that a capacitor microphone puts out a high signal voltage so that the S/N ratio is actually very good. The mic capsule, being a pure reactance, generates no noise of its own, and its noise output comes only from the Brownian motion of the air against the capsule diaphragm and from the electronics. A larger diameter capsule means a better signal-to-noise ratio because more energy is absorbed from the coherent sound waves; the same applies to the Brownian motion but this partially cancels, just as with the use of multiple opamps for low noise [2].

Noise measurements of this technology require special methods. The impedances are so high that meaningful results can only be obtained by putting the circuitry inside a completely closed metal screening enclosure.

Ribbon microphone amplifiers

The output directly from a ribbon in its magnetic field (often referred to as the ribbon motor) is of the order of 50 to 100 microVolts (−86 dBu to −77.8 dBu). The level is inversely proportional to the ribbon mass and in directly proportional to the magnetic field strength. Ribbon width varies

from 1 to 6 mm. Microphone amplifiers rarely have more than 70 dB maximum gain, so to get the signal up to a usable level, a step-up transformer with a ratio of between 1:25 and 1:40 is used. Compare dynamic microphone amplifiers that use a transformer; there the ratio is rarely as high as 1:10. Ribbon mic transformers have more in common with moving-coil cartridge transformers, which also handle microvolt signals. Both have high step-up ratios and are often double shielded to keep out hum; see Chapter 10 for more details.

Ribbon transformers must have a very low resistance primary (such as 10 mΩ) so that the current through it will be as great as possible; it is being fed from a very low impedance, of the order of 0.1 Ω. The transformer secondary resistance will also be relatively low, typically less than 5 Ω. Toroidal construction helps to keep down the winding resistances and reject hum. The primary inductance also needs to be high to give an even frequency response.

The step-up ratio of a ribbon transformer is limited by the fact that the output impedance is increased by the square of the turns ratio. For a 1:40 transformer that is 1600 times, so a 0.1 Ω ribbon impedance becomes an output impedance of 160 Ω. Normal mic inputs usually have an input impedance in the 1 to 2 kΩ range, so a higher output impedance would lead to undesirable loading and losses. So-called active ribbon mics have a low-noise amplifier stage after the transformer, typically with 12 dB of gain and a very low output impedance for driving long cables.

A typical arrangement is shown in Figure 17.14, using a Lundahl LL2913 ribbon transformer [3]. This part has four primaries of 0.2 Ω resistance each, with a step-up ratio of 1:37 with all four connected in

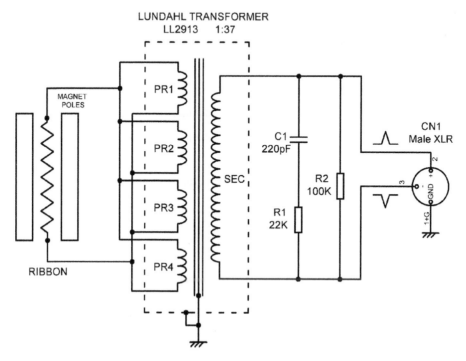

Figure 17.14 A ribbon microphone with a 1:37 step-up transformer.

parallel. The resistance of each primary is only 0.2 Ω; that of the secondary is 59 Ω. Note the ribbon has been turned 90° in the diagram to display the corrugations. R1 and C1 are a Zobel network, and R2 is a loading resistor to control any secondary resonance issues and give an even frequency response; the values shown are representative but need to be optimised for each transformer type.

Lundahl also make the specialised LL1297A transformer which can be configured for step-up ratios of 1:55 or 1:110. There are two primaries, each with a resistance of 0.05 Ω. Lundahl emphasise that this high ratio is intended for use in active ribbon mics [4].

Jensen is a well-known transformer manufacturer, but they do not appear to make a ribbon transformer as such. Their JT-346-AX transformer, intended for moving-coil phono use, has been used for ribbon applications by connecting the three primaries in parallel, which gives a step-up ratio of about 1:12, definitely on the low side. The resistance of each primary is relatively high at 5.7 Ω each, so it is not ideal for the job; but then it was not designed for it.

Both standard microphone amplifiers and moving-coil phono amplifiers can be built without the cost and weight of transformers; as a general rule in the audio business transformers are designed out wherever possible. The ribbon mic, however, presents a very severe challenge to that approach. It is addressed in the third edition of *The Art of Electronics* where the aim is a voltage noise density of less than 100 pV/$\sqrt{\text{Hz}}$. This was achieved with a simple differential pair, with each half of the 'pair' represented by up to 24 paralleled BJT devices [5].

References

[1] Wikipedia. https://en.wikipedia.org/wiki/Microphone Accessed Sept 2019

[2] Ono, K., et al. "Development of a Super-Wide-Range Microphone for Sound Recording." *JAES*, Vol. 56, No. 5, May 2008, pp. 372–380

[3] www.lundahltransformers.com/wp-content/uploads/datasheets/2913.pdf Accessed Sept 2019

[4] www.lundahltransformers.com/wp-content/uploads/datasheets/1927A.pdf Accessed Sept 2019

[5] Horovitz, P. & Hill, W. *The Art of Electronics*, 3rd edition. Cambridge University Press, 2015, pp. 505–509. ISBN 978-0-521-80926-9 hbk

Line inputs

External signal levels

There are several standards for line signal levels. The −10 dBV standard is used for a lot of semi-professional recording equipment as it gives more headroom with unbalanced connections—the professional levels of +4 dBu and +6 dBu assume balanced outputs which inherently give twice the output level for the same supply rails as it is measured between two pins with signals of opposite phase on them. See Table 18.1.

Signal levels in dBu are expressed with reference to 0 dBu = 775 mVrms; the origin of this odd value is that it gives a power of 1 mW in a purely historical 600 Ω load. The unit of dBm refers to the same level but takes the power in the load rather than the voltage as the reference—a distinction of little interest nowadays. Signal in dBV are expressed with reference to 0 dB = 1.000 Vrms.

These standards are well established, but that does not mean all equipment follows them. To take a current example, the Yamaha P7000S power amplifier requires +8 dBu (1.95 Vrms) to give its full output of 750 W into 8 Ω.

Internal signal levels

In any audio system it is necessary to select a suitable nominal level for the signal passing through it. This level is always a compromise—the signal level should be high so it suffers minimal degradation by the addition of circuit noi e as it passes through the system, but not so high that it is likely to suffer clipping before the gain control or generate undue distortion below the clipping level (this last constraint is not normally a problem with modern opamp circuitry, which gives very low distortion right up to the clipping point).

It must always be considered that the gain control may be maladjusted by setting it too low and turning up the input level from the source equipment, making input clipping more likely. The internal levels chosen are usually in the range −6 to 0 dBu (388 mV to 775 mVrms), but in some specialised equipment such as broadcast mixing consoles, where levels are unpredictable and clipping distortion less acceptable than a bit more noise, the nominal internal level may be as low as −16 dBu (123 mVrms). If the internal level is in the normal −6 to 0 dBu range, and the maximum output of an opamp is taken as 9 Vrms (+21.3 dBu), this gives from 27 to 20 dB of headroom before clipping occurs.

DOI: 10.4324/9781003332985-18

TABLE 18.1 Nominal signal levels

	Vrms	dBu	dBV
Semi-professional	0.316	−7.78	−10
Professional	1.228	+4.0	+1.78
German ARD	1.55	+6.0	+3.78

If the incoming signal does have to be amplified, this should be done as early as possible in the signal path to get the signal well above the noise floor as quickly as possible. If the gain is implemented in the first stage (ie the input amplifier, balanced or otherwise) the signal will be able to pass through later stages at a high level, so their noise contribution will be less significant. On the other hand, if the input stage is configured with a fixed gain, it will not be possible to turn it down to avoid clipping. Ideally the input stage should have variable gain. It is not straightforward to combine this feature with a balanced input, but several ways of doing it are shown later in this chapter.

Input amplifier functions

Firstly, RF filtering is applied at the very front end to prevent noise breakthrough and other EMC problems. It must be done before the incoming signal encounters any semiconductors where RF demodulation could occur and can be regarded as a 'roofing filter.' At the same time, the bandwidth at the low end is given an early limit by the use of DC-blocking capacitors, and in some cases overvoltage spikes are clamped by diodes. The input amplifier should present a reasonably high impedance to the outside world, not less than 10 kΩ, and preferably more. It must have a suitable gain—possibly switched or variable—to scale the incoming signal to the nominal internal level. Balanced input amplifiers also accurately perform the subtraction process that converts differential signals to single-ended ones, so noise produced by ground loops and the like is rejected. It's quite a lot of work for one stage.

Unbalanced inputs

The simplest unbalanced input feeds the incoming signal directly to the first processing stage of the audio chain. This is often impractical; for example, if the first stage was a Baxandall tone-control circuit then the boost and cut curves would be at the mercy of whatever source impedance was feeding the input. In addition, the input impedance would be low, and variable with frequency and control settings. Some sort of buffer amplifier which can be fed from a significant impedance without ill effect is needed.

Figure 18.1 shows an unbalanced input amplifier, with the added components needed for interfacing to the real world. The opamp U1:A acts as a unity-gain voltage-follower; it can be easily altered to give gain by adding two series feedback resistors. A 5532 bipolar type is used here for low noise; with the low source impedances that are likely to be encountered here, an

FET-input opamp would be 10 dB or more noisier. R1 and C1 are a first-order lowpass filter to remove incoming RF before it has a chance to reach the opamp and demodulate into the audio band; once this has occurred any further attempts at RF filtering are of course pointless. R1 and C1 must be as close to the input socket as physically possible to prevent RF from being radiated inside the box before it is shunted to ground, and so come before all other components in the signal path.

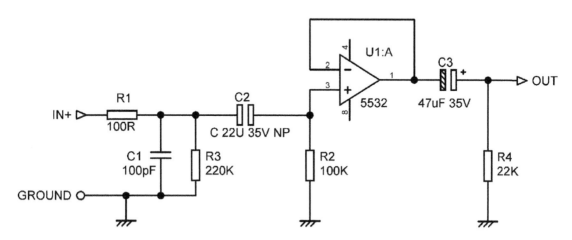

Figure 18.1 A typical unbalanced input amplifier with associated components.

Selecting component values for input filters of this sort is always a compromise because the output impedance of the source equipment is not known. If the source is an active preamplifier stage, then the output impedance will probably be around 50 Ω, but it could be as high as 500 Ω or more. If the source is an oxymoronic 'passive preamplifier,' ie just an input selector switch and a volume potentiometer, then the output impedance will be a good deal higher (at least one passive preamplifier tackles this problem by using a transformer with switched taps for volume control—see Chapter 13).

If you really want to use a piece of equipment that embodies its internal contradictions in its very name, then a reasonable potentiometer value is 10 kΩ, and its maximum output impedance (when it is set for 6 dB of attenuation) will be 2.5 kΩ, which is very different from the 50 Ω we might expect from a good active preamplifier. This is in series with R1 and affects the turnover frequency of the RF filter. Effective RF filtering is very desirable, but it is also important to avoid a frequency response that sags significantly at 20 kHz. Valve equipment is also likely to have a high output impedance.

Taking 2.5 kΩ as a worst-case source impedance and adding R1, then 2.6 kΩ and 100 pF together give us −3 dB at 612 kHz; this gives a 20 kHz loss of only 0.005 dB, so possibly C1 could be usefully increased; for example, if we made it 220 pF then the 20 kHz loss is still only 0.022 dB, but the −3 dB point is 278 kHz, much improving the rejection of what used to be called the Medium Wave. If we stick with C1 at 100 pF and assume an active output with a 50 Ω impedance in the source equipment, then together with the 100 Ω resistance of R1 the total is 150 Ω, which in conjunction with 100 pF gives us −3 dB at 10.6 MHz. This is rather higher than desirable, but it is

not easy to see what to do about it, and we must accept the compromise. If there was a consensus that the output impedance of a respectable piece of audio equipment should not exceed 100 Ω, then things would be much easier.

Our compromise seems reasonable, but can we rely on 2.5 kΩ as a worst-case source impedance? I did a quick survey of the potentiometer values that passive preamplifiers currently employ, and while it confirmed that 10 kΩ seems to be the most popular value, one model had a 20 kΩ potentiometer, and another had a 100 kΩ pot. The latter would have a maximum output impedance of 25 kΩ and would give very different results with a C1 value of 100 pF—the worst-case frequency response would now be −3 dB at 63.4 kHz and −0.41 dB at 20 kHz, which is not exactly helpful if you are aiming for a ruler-flat response in the audio band.

To put this into perspective, filter capacitor C1 will almost certainly be smaller than the capacitance of the interconnecting cable. Audio interconnect capacitance is usually in the range 50 to 150 pF/metre, so with our assumed 2.5 kΩ source impedance and 150 pF/metre cable, and ignoring C1, you can only permit yourself a rather short run of 3.3 metres before you are −0.1 dB down at 20 kHz, while with a 25 kΩ source impedance you can hardly afford to have any cable at all; if you use low capacitance 50 pF/metre cable you might just get away with a metre. This is just one of many reasons why 'passive preamplifiers' really are *not* a good idea.

Another important consideration is that the series resistance R1 must be kept as low as practicable to minimise Johnson noise; but lowering this resistance means increasing the value of shunt capacitor C1, and if it becomes too big then its impedance at high audio frequencies will become too low. Not only will there be too low a roll-off frequency if the source has a high output impedance, but there might be an increase in distortion at high audio frequencies because of excessive loading on the source output stage.

Replacing R1 with a small inductor to make an LC lowpass filter will give much better RF rejection at increased cost. This is justifiable in professional audio equipment, but it is much less common in hifi, one reason being that the unpredictable source impedance makes the filter design difficult, as we have just seen. In the professional world one *can* assume that the source impedance will be low. Adding more capacitors and inductors allows a 3 or 4-pole LC filter to be made. If you do use inductors then it is essential to check the frequency response to make sure it is what you expect and there is no peaking at the turnover frequency.

C2 is a DC-blocking capacitor to prevent voltages from ill-conceived source equipment getting into the circuitry. It is a non-polarised type as voltages from the outside world are of unpredictable polarity, and it is rated at not less than 35 V so that even if it gets connected to defective equipment with an opamp output jammed hard against one of the supply rails, no harm will result. R3 is a DC-drain resistor that prevents the charge put on C2 by the aforesaid external equipment from remaining there for a long time and causing a thud when connections are replugged; as with all input drain resistors, its value is a compromise between discharging the capacitor reasonably quickly and keeping the input impedance acceptably high. The input impedance here is R3 in parallel with R2, ie 220 kΩ in parallel with 100 kΩ, giving 68 kΩ. This is a good high value and should work well with just about any source equipment you can find, including valve technology.

R2 provides the biasing for the opamp input; it must be a high value to keep the input impedance up, but bipolar input opamps draw significant input bias current. The Fairchild 5532 data sheet

quotes 200 nA typical and 800 nA maximum; these currents would give a voltage drop across R2 of 20 mV and 80 mV respectively. This offset voltage will be reproduced at the output of the opamp, with the input offset voltage added on; this is only 4 mV maximum and so will not affect the final voltage much, whatever its polarity. The 5532 has NPN input transistors, and the bias current flows into the input pins, so the voltage at Pin 3 and hence the output will be negative with respect to ground by anything up to 84 mV.

Such offset voltages are not so great that the output voltage swing of the opamp is significantly affected, but they are enough to generate unpleasant clicks and pops if the input stage is followed by any sort of switching and enough to make potentiometers crackly. Output DC blocking is therefore required in the shape of C3, while R4 is another DC-drain resistor to keep the output at zero volts. It can be made rather lower in value than the input drain resistor R3 as the only requirement is that it should not significantly load the opamp output. FET-input opamps have much lower input bias currents, so that the offsets they generate as they flow through biasing resistors are usually negligible, but they still have input offset voltages of a few milliVolts, so DC blocking will still be needed if switches downstream are to work silently.

This input stage, with its input terminated by 50 Ω to ground, has a noise output of only −119.0 dBu over the usual 22–22 kHz bandwidth. This is very quiet indeed and is a reflection of the fact that R1, the only resistor in the signal path, has the low value of 100 Ω and so generates a very small amount of Johnson noise, only −132.6 dBu. This is swamped by the voltage noise of the opamp, which is basically all we see; its current noise has negligible effect because of the low circuit impedances.

Balanced interconnections

Balanced inputs are used to prevent noise and crosstalk from affecting the input signal, especially in applications where long interconnections are used. They are standard on professional audio equipment and are slowly but steadily becoming more common in the world of hifi. Their importance is that they can render ground loops and other connection imperfections harmless. Since there is no point in making a wonderful piece of equipment and then feeding it with an impaired signal, making an effective balanced input is of the first importance.

The basic principle of balanced interconnection is to get the signal you want by subtraction, using a three-wire connection. In some cases a balanced input is driven by a balanced output, with two anti-phase output signals; one signal wire (the Hot or in-phase) sensing the in-phase output of the sending unit, while the other senses the anti-phase output.

In other cases, when a balanced input is driven by an unbalanced output, as shown in Figure 18.2, one signal wire (the Hot or in-phase) senses the single output of the sending unit, while the other (the Cold or phase-inverted) senses the unit's output socket ground, and once again the difference between them gives the wanted signal. In either of these two cases, any noise voltages that appear identically on both lines (ie common-mode signals) are in theory completely cancelled by the subtraction. In real life the subtraction falls short of perfection, as the gains via the Hot and Cold inputs will not be precisely the same, and the degree of discrimination actually achieved is called the common-mode rejection ratio, (CMRR) of which we will hear much more later.

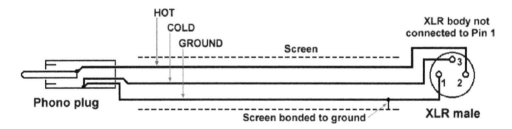

Figure 18.2 Unbalanced output to balanced input interconnection.

It is deeply tedious to keep referring to non-inverting and inverting inputs, and so these are usually abbreviated to 'Hot' and 'Cold' respectively. This does *not* necessarily mean that the Hot terminal carries more signal voltage than the Cold one. For a true balanced connection, the voltages will be equal. The Hot and Cold terminals are also often referred to as IN+ and IN−, and this latter convention has been followed in the diagrams here.

The subject of balanced interconnections is a large one, and a big book could be written on this topic alone; one of the classic papers on the subject is by Muncy [1]. To make a start, let us look at the pros and cons of balanced connections.

The advantages of balanced interconnections

- Balanced interconnections discriminate against noise and crosstalk, whether they result from ground currents or electrostatic or magnetic coupling to signal conductors.

- Balanced connections make ground loops much less intrusive and usually inaudible, so people are less tempted to start 'lifting the ground' to break the loop, with possibly fatal consequences. This tactic is only acceptable if the equipment has a dedicated ground-lift switch that leaves the external metalwork firmly connected to mains safety earth. In the absence of this switch the foolhardy and optimistic will break the mains earth (not quite so easy now that moulded mains plugs are standard), and this practice is, of course, highly dangerous, as a short-circuit from mains to the equipment chassis will result in live metalwork but dead people.

- A balanced interconnection incorporating a true balanced output gives 6 dB more signal level on the line, which should give 6 dB more dynamic range. However, this is true only with respect to *external* noise—as is described later in this chapter, a standard balanced input using 10 kΩ resistors is about 14 dB noisier than the unbalanced input shown in Figure 18.1.

- Balanced connections are usually made with XLR connectors. These are a professional 3-pin format and are far superior to the phono (RCA) type normally used for unbalanced connections. More on this later.

The disadvantages of balanced interconnections

- Balanced inputs are almost always noisier than unbalanced inputs by a large margin, in terms of the noise generated by the input circuitry itself rather than external noise. This may appear paradoxical but it is all too true, and the reasons will be fully explained in this chapter.

- More hardware means more cost. Small-signal electronics is relatively cheap; unless you are using a sophisticated low-noise input stage, of which more later, most of the extra cost is likely to be in the balanced input connectors.

- Balanced connections do not of themselves provide any greater RF immunity than an unbalanced input. For this to happen both legs of the balanced input would have to demodulate the RF in equal measure for common-mode cancellation to occur. This is highly unlikely, and the chances of it happening over a wide frequency range are zero. It remains vital to provide the usual passive RF filtering in front of any electronics to avoid EMC troubles.

- There is the possibility of introducing a phase error. It is all too easy to create an unwanted phase inversion by confusing Hot and Cold when wiring up a connector, and this can go undiscovered for some time. The same mistake on an unbalanced system interrupts the audio completely and leaves no room for doubt.

Balanced cables and interference

In a balanced interconnection two wires carry the signal, and the third connection is the ground wire which has two functions. Firstly it joins the grounds of the interconnected equipment together. This is not always desirable, and if galvanic isolation is required a transformer balancing system will be necessary because the large common-mode voltages are likely to exceed the range of an electronic balanced input. A good transformer will also have a very high CMRR, which will be needed to get a clean signal in the face of large CM voltages.

Secondly, the presence of the ground allows electrostatic screening of the two signal wires, preventing both the emission and pick-up of unwanted signals. This can mean

1) A lapped screen, with wires laid parallel to the central signal conductor. The screening coverage is not total and can be badly degraded as the screen tends to open up on the outside of cable bends. Not recommended unless cost is the dominating factor.

2) A braided screen around the central signal wires. This is much more expensive, as it is harder to make, but opens up less on bending than a lap screen. Even so, screening is not 100%. It has to be said that it is a pain to terminate in the usual audio connectors. Not recommended.

3) An overlapping foil screen, with the ground wire (called the drain wire in this context for some reason) running down the inside of the foil and in electrical contact with it. This is usually the most effective as the foil is a solid sheet and cannot open up on the outside of bends. It should give perfect electrostatic screening, and it is much easier to work with than either lap screen or braided cable. However, the higher resistance of aluminium foil compared with copper braid means that RF immunity may not be so good.

There are three main ways in which an interconnection is susceptible to hum and noise.

1) Electrostatic coupling

An interfering signal at significant voltage couples directly to the inner signal line, through stray capacitance. The stray capacitance between imperfectly-screened conductors will be a fraction

of a pF in most circumstances, as electrostatic coupling falls off with the square of distance. This form of coupling can be serious in studio installations with unrelated signals running down the same ducting.

The three main lines of defence against electrostatic coupling are effective screening, low impedance drive, and a good CMRR maintained up to the top of the audio spectrum. As regards screening, an overlapped foil screen provides complete protection.

Driving the line from a low impedance, of the order of 100 Ω or less, is also helpful because the interfering signal, having passed through a very small stray capacitance, is a very small current and cannot develop much voltage across such a low impedance. This is convenient because there are other reasons for using a low output impedance, such as optimising the interconnection CMRR, minimising HF losses due to cable capacitance, and driving multiple inputs without introducing gain errors. For the best immunity to crosstalk the output impedance must remain low up to as high a frequency as possible. This is definitely an issue as opamps invariably have a feedback factor that begins to fall from a low, and quite possibly sub-audio frequency, and this makes the output impedance rise with frequency as the negative feedback factor falls, as if an inductor were in series. Some line outputs have physical series inductors to improve stability or EMC immunity, and these should not be so large that they significantly increase the output impedance at 20 kHz. From the point of view of electrostatic screening alone, the screen does not need to be grounded at both ends or form part of a circuit [2]. It must, of course, be grounded at some point.

If the screening is imperfect, and the line impedance non-zero, some of the interfering signal will get into the Hot and Cold conductors, and now the CMRR must be relied upon to make the immunity acceptable. If it is possible, rearranging the cable-run away from the source of interference and getting some properly screened cable is more practical and more cost-effective than relying on very good common-mode rejection.

Stereo hifi balanced interconnections almost invariably use XLR connectors. Since an XLR can only handle one balanced channel, two separate cables are almost invariably used and interchannel capacitive crosstalk is not an issue. Professional systems, on the other hand, use multi-way connectors that do not have screening between the pins, and there is an opportunity for capacitive crosstalk here, but the use of low source impedances should reduce it to below the noise floor.

2) Magnetic coupling

If a cable runs through an AC magnetic field, an EMF is induced in both signal conductors and the screen, and according to some writers, the screen current must be allowed to flow freely or its magnetic field will not cancel out the field acting on the signal conductors, and therefore the screen should be grounded at both ends, to form a circuit [3]. In practice the magnetic field cancellation will be very imperfect and reliance is better placed on the CMRR of the balanced system to cancel out the hopefully equal voltages induced in the two signal wires. The need to ground both ends to possibly optimise the magnetic rejection is not usually a restriction, as it is rare that galvanic isolation is required between two pieces of audio equipment.

The equality of the induced voltages can be maximised by minimising the loop area between the Hot and Cold signal wires, for example by twisting them tightly together in manufacture. In

practice most audio foil-screen cables have parallel rather than twisted signal conductors, but this seems adequate almost all of the time. Magnetic coupling falls off with the square of distance, so rearranging the cable-run away from the source of magnetic field is usually all that is required. It is unusual for it to present serious difficulties in a hifi application.

3) Ground voltages

These are the result of current flowing through the ground connection and is often called 'common-impedance coupling' in the literature [1]. This is the root of most ground-loop problems. The existence of a loop in itself does no harm, but it is invariably immersed in a 50 Hz magnetic field that induces mains-frequency currents plus harmonics into it. This current produces a voltage drop down non-negligible ground-wire resistances, and this effectively appears as a voltage source in each of the two signal lines. Since the CMRR is finite a proportion of this voltage will appear to be a differential signal and will be reproduced as such.

Balanced connectors

Balanced connections are most commonly made with XLR connectors, though it can be done with stereo (tip-ring-sleeve) jack plugs. XLRs are a professional 3-pin format and are a much better connector in every way than the usual phono (RCA) connectors used for unbalanced interconnections. Phono connectors have the great disadvantage that if you are connecting them with the system active (inadvisable, but then people are always doing inadvisable things) the signal contacts meet before the grounds and thunderous noises result. The XLR standard has Pin 2 as Hot, Pin 3 as Cold, and Pin 1 as ground.

Stereo jack plugs are often used for line-level signals in a recording environment and are frequently found on the rear of professional power amplifiers as an alternative to an adjacent XLR connector, Both full-size and 3.5 mm sizes are used. Balanced jacks are wired with the tip as Hot, the ring as Cold, and the sleeve as ground. Sound reinforcement systems often use large multiway connectors that carry dozens of 3-wire balanced connections.

Balanced signal levels

Many pieces of equipment, including preamplifiers and power amplifiers designed to work together, have both unbalanced and balanced inputs and outputs. The general consensus in the hifi world is that if the unbalanced output is say 1 Vrms, then the balanced output will be created by feeding the in-phase output to the Hot output pin, and also to a unity-gain inverting stage, which drives the Cold output pin with 1 Vrms phase-inverted. The total balanced output voltage between Hot and Cold pins is therefore 2 Vrms, and so the balanced input must have a gain of 1/2 or −6 dB relative to the unbalanced input to maintain consistent internal signal levels.

Electronic vs transformer balanced inputs

Balanced interconnections can be made using either transformer or electronic balancing. Electronic balancing has many advantages, such as low cost, low size and weight, superior

frequency and transient response, and no low-frequency linearity problems. It may still be regarded as a second-best solution in some quarters, but the performance is more than adequate for most professional applications. Transformer balancing does have some advantages of its own, particularly for work in very hostile RF/EMC environments, but also serious drawbacks. The advantages are that transformers are electrically bullet-proof, retain their high CMRR performance forever, and consume no power even at high signal levels. They are essential if galvanic isolation between ground is required. Unfortunately transformers generate LF distortion, particularly if they have been made with minimal core sizes to save weight and cost. They are liable to have HF response problems due to leakage reactance and distributed capacitance, and compensating for this requires a carefully-designed Zobel network across the secondary. Inevitably they are heavy and expensive. Transformer balancing is therefore relatively rare, even in professional audio applications, and the greater part of this chapter deals with electronically-balanced inputs.

Common mode rejection

Figure 18.3 shows a balanced interconnection reduced to its bare essentials; Hot and Cold line outputs with source resistances Rout+, Rout−, and a standard differential amplifier at the input end. The output resistances are assumed to be exactly equal, and the balanced input in the receiving equipment has two exactly equal input resistances to ground R1, R2. The ideal balanced input amplifier senses the voltage difference between the points marked IN+ (Hot) and IN− (Cold) and ignores any common-mode voltage which are present on both. The amount by which it discriminates is called the common-mode rejection ratio or CMRR and is usually measured in dB. Suppose a differential voltage input between IN+ and IN− gives an output voltage of 0 dB; now reconnect the input so that IN+ and IN− are joined together and the same voltage is applied between them and ground. Ideally the result would be zero output, but in this imperfect world it won't be, and the output could be anywhere between −20 dB (for a bad balanced interconnection, which probably has something wrong with it) and −140 dB (for an extremely good one). The CMRR when plotted may have a flat section at low frequencies, but it very commonly degrades at high audio frequencies and may also deteriorate at very low frequencies. More on that later.

In one respect balanced audio connections have it easy. The common-mode signal is normally well below the level of the unwanted signal, and so the common-mode range of the input is not an issue. In other area of technology, such as electrocardiogram amplifiers, the common-mode signal may be many times greater than the wanted signal.

The simplified conceptual circuit of Figure 18.3, under SPICE simulation, demonstrates the need to get the resistor values right for a good CMRR, before you even begin to consider the rest of the circuitry. The differential voltage sources Vout+, Vout− which represent the actual balanced output are set to zero, and Vcm, which represents the common-mode voltage drop down the cable ground, is set to 1 V to give a convenient result in dBV. The output resulting from the presence of this voltage source is measured by a mathematical subtraction of the voltages at IN+ and IN− so there is no actual input amplifier to confuse the results with its non-ideal performance.

Let us begin with Rout+ and Rout− set to 100 Ω and R1 and R2 set to 10 kΩ. These are typical real-life values as well as being nice round figures. When all four resistances are exactly at their

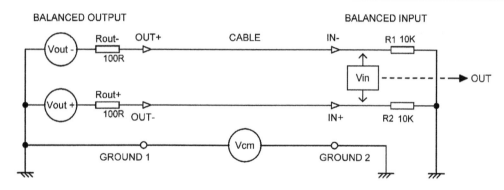

Figure 18.3 **A theoretical balanced interconnection showing how the output and input impedances influence CMRR.**

nominal value, the CMRR is in theory infinite, which my SPICE simulator rather curiously reports as exactly −400 dB. If one of the output resistors or one of the input resistors is then altered in value by 1%, then the CMRR drops like a stone to −80 dB. If the deviation from equality is 10%, things are predictably worse and the CMRR degrades to −60 dB, as shown in Table 18.2. That would be quite a good figure in reality, but since we have not yet even thought about opamp imperfections or other circuit imbalances and have only altered one resistance out of the four that will in real circuitry all have their own tolerances, it underlines the need to get thing right at the most basic theoretical level before we dig deeper into the circuitry. The CMRR here is naturally flat with frequency because our simple model has no frequency-dependent components.

The essence of the problem is that we have two resistive dividers, and to get an infinite CMRR they must have exactly the same attenuation. If we increase the ratio between the output and input resistors, by reducing the former or increasing the latter, the attenuation factor becomes closer to unity, so variations in either resistor value have less effect on it. If we increase the input impedance to 100 kΩ, which is quite practical in real life (we will put aside the noise implications of this for the moment), things are ten times better, as the Rin/Rout ratio has improved from 100 to 1000 times. We now get a CMRR of −100 dB with a 1% resistance deviation, and −80 dB with a 10% deviation. An even higher input impedance of 1 MΩ, which is perhaps a bit less practical, raises Rin/Rout to 10,000 and gives −120 dB for a 1% resistance deviation, and −100 dB for a 10% deviation.

We can attack the other aspect of the attenuation problem by reducing the output impedances to 10 Ω, ignoring for the moment the need to secure against HF instability caused by cable capacitance and also return the input impedance resistors to 100 kΩ. Rin/Rout is 10,000 once more, and as you might suspect the CMRR is once more −120 dB for a 1% deviation, and −100 dB for a 10% deviation. Ways to make stable output stages with very low output impedances are described in Chapter 19; a fraction of an Ohm at 1 kHz is quite easy to achieve.

In conventional circuits, the combination of 68 Ω output resistors and a 20 kΩ input impedance is often encountered; 68 Ω being about as low as you want to go if HF instability is to be absolutely guarded against with the long lines used in professional audio. The 20 kΩ common-mode input impedance is what you get if you make a basic balanced input amplifier with four 10 kΩ resistors. I strongly suspect that this value is so popular because it looks as if it gives standard 10 kΩ input impedances—in fact it does nothing of the sort, and the common-mode input impedance, which is

TABLE 18.2 How resistor tolerances affect the theoretical CMRR of the theoretical circuit in Figure 18.3

Rout+	Rout−	Rout deviation	R1	R2	R1, R2 deviation	Rin/Rout ratio	CMRR dB
100	100	0	10k	10k	0	100	Infinity
100	101	1%	10k	10k	0	100	−80.2
100	110	10%	10k	10k	0	100	−60.2
100	100	0	10k	10.1k	1%	100	−80.3
100	100	0	10k	11k	10%	100	−61.0
100	100	0	100k	101k	1%	1000	−100.1
100	100	0	100k	110k	10%	1000	−80.8
100	100	0	1M	1.01M	1%	10,000	−120.1
100	100	0	1M	1.1M	10%	10,000	−100.8
68	68	0	20k	20.2k	1%	294	−89.5
68	68	0	20k	22k	10%	294	−70.3

what matters here, is 20 kΩ on each leg; more on that later. It turns out that 68 Ω output resistors and a 20 kΩ input impedance give a theoretical CMRR of −89.5 dB for a 1% deviation of one resistor, which is quite encouraging. These results are summarised in Table 18.2.

The conclusion is simple; we need the lowest possible output impedances and the highest possible input impedances to get the maximum common-mode rejection. This is highly convenient because low output impedances are already needed to drive multiple amplifier inputs and cable capacitance, and high input impedances are needed to minimise loading and maximise the number of amplifiers that can be driven.

The basic electronic balanced input

Figure 18.4 shows the basic balanced input amplifier using a single opamp. To achieve balance R1 must be equal to R3 and R2 equal to R4. It has a gain of R2/R1 (= R4/R3). The standard one-opamp balanced input or differential amplifier is a very familiar circuit block, but its operation often appears somewhat mysterious. Its input impedances are *not* equal when it is driven from a balanced output; this has often been commented on [4]. Some confusion has resulted.

The source of the confusion is that a simple differential amplifier has interaction between the two inputs, so that the input impedance seen on the Cold input depends on the signal applied to the Hot input. Input impedance is measured by applying a signal and seeing how much current flows into the input, so it follows that the apparent input impedance on each leg varies according

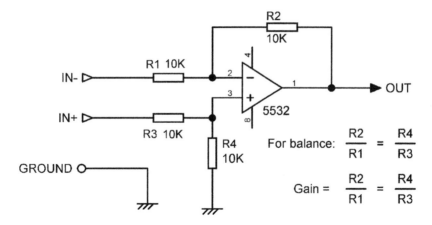

Figure 18.4 **The basic balanced input amplifier.**

to how the Cold input is driven. If the amplifier is made with four 10 kΩ resistors, then the input impedances on Hot and Cold are as Table 18.3.

Some of these impedances are not exactly what you might expect and require some explanation.

Case 1

The balanced input is being used as an unbalanced input by grounding the Cold input and driving the Hot input only. The input impedance is therefore simply R3 + R4. Resistors R3 and R4 reduce the signal by a factor of a half, but this loss is undone as R1 and R2 set the amplifier gain to two times, and the overall gain is unity. If the cold input is not grounded then the gain is 0.5 times. The attenuate-then-amplify architecture, plus the Johnson noise from the resistors, makes this configuration much noisier than the dedicated unbalanced input of Figure 18.1, which has only a single 100 Ω resistor in the signal path.

Case 2

The balanced input is again being used as an unbalanced input, but this time by grounding the Hot input, and driving the Cold input only. This gives a phase inversion, and it is unlikely you would want to do it except as an emergency measure to correct a phase error somewhere else.

TABLE 18.3 **The input impedances for different input drive conditions**

Case	Pins driven	Hot input res Ω	Cold input res Ω
1	Hot only	20 k	Grounded
2	Cold only	Grounded	10 k
3	Both (balanced)	20 k	6.66 k
4	Both common-mode	20 k	20 k
5	Both floating	10 k	10 k

The important point here is that the input impedance is now only 10 kΩ, the value of R1, because shunt negative feedback through R2 creates a virtual-earth at Pin 2 of the opamp. Clearly this simple circuit is not as symmetrical as it looks. The gain is unity, whether or not the Hot input is grounded; grounding it is desirable because it not only prevents interference being pickup on the Hot input pin, but also puts R3 and R4 in parallel, reducing the resistance from opamp Pin 3 to ground and so reducing Johnson noise and the effects of opamp current noise.

Case 3

This is the standard balanced interconnection. The input is driven from a balanced output with the same signal levels on Hot and Cold, as if from a transformer with its centre-tap grounded or an electronically balanced output using a simple inverter to drive the Cold pin. The input impedance on the Hot input is what you would expect; R3 + R4 add up to 20 kΩ. However, on the Cold input there is a much lower input impedance of 6.66 kΩ. This at first sounds impossible as the first thing the signal encounters is a 10 kΩ series resistor, but the crucial point is that the Hot input is being driven simultaneously with a signal of the opposite phase, so the inverting opamp input is moving in the opposite direction to the Cold input due to negative feedback, and what you might call anti-bootstrapping reduces the effective value of the 10 kΩ resistor to 6.66 kΩ. These are the differential input impedances we are examining, the impedances seen by the balanced output driving them. Common-mode signals see a common-mode impedance of 20 kΩ, as in Case 4.

You will sometimes see the statement that these unequal differential input impedances 'unbalance the line.' From the point of view of CMRR, this is not the case, as it is the CM input impedance that counts. The line is, however, unbalanced in the sense that the Cold input draws three times the current from the output that the Hot one does. This current imbalance might conceivably lead to inductive crosstalk in some multi-way cable situations, but I have never encountered it. The differential input impedances can be made equal by increasing the R1 and R2 resistor values by a factor of three, but this degrades the noise performance markedly and makes the common-mode impedances to ground unequal, which is a much worse situation as it compromises the rejection of ground voltages, and these are almost always the main problem in real life.

Case 4

Here both inputs are driven by the same signal, representing the existence of a common-mode voltage. Now both inputs shown an impedance of 20 kΩ. It is the symmetry of the common-mode input impedances that determines how effectively the balanced input rejects the common-mode signal. This configuration is of course only used for CMRR testing.

Case 5

Now the input is driven as from a floating transformer with the centre-tap (if any) unconnected, and the impedances can be regarded as equal; they must be because with a floating winding the same current must flow into each input. However, in this connection the line voltages are *not* equal and opposite: with a true floating transformer winding the Hot input has all the signal voltage on it while the Cold has none at all, due to the negative feedback action of the balanced input amplifier. This seemed very strange when it emerged in SPICE simulation, but a sanity-check with real components proves it true. The line has been completely unbalanced as regards crosstalk to other lines, although its own common-mode rejection remains good.

Even if absolutely accurate resistors are assumed, the CMRR of the stage in Figure 18.4 is not infinite; with a TL072 it is about −90 dB, degrading from 100 Hz upwards, due to the limited open-loop gain of the opamp. We will now examine this effect.

Common-mode rejection: the basic balanced input and opamp effects

In the earlier section on CMRR we saw that in a theoretical balanced line, choosing low output impedances and high input impedances would give very good CM rejection even if the resistors were not perfectly matched. Things are a bit more complex (ie worse) if we replace the mathematical subtraction with a real opamp. We quickly find that even if perfectly matched resistors everywhere are assumed, the CMRR of the stage is not infinite because the two opamp inputs are not at exactly the same voltage. The negative feedback error voltage between the inputs depends on the open-loop gain of the opamp, and that is neither infinite nor flat with frequency into the far ultra-violet. Far from it. There is also the fact that opamps themselves have a common-mode rejection ratio; it is high, but once more it is not infinite.

As usual, SPICE simulation is instructive, and Figure 18.5 shows a simple balanced interconnection with the balanced output represented simply by two 100 Ω output resistances connected to the source equipment ground, here called Ground 1, and the usual differential opamp configuration at the input end, where we have Ground 2.

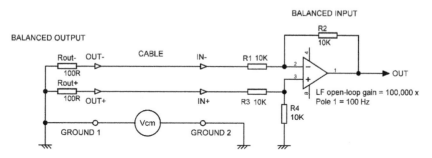

Figure 18.5 A simple balanced interconnection for SPICE simulation to show the effect that opamp properties have on the CMRR.

A common-mode voltage Vcm is now injected between Ground 1 and Ground 2, and the signal between the opamp output and Ground 2 measured. The balanced input amplifier has all four of its resistances set to precisely 10 kΩ, and the opamp is represented by a very simple model that has only two parameters; a low-frequency open-loop gain and a single pole frequency that says where that gain begins to roll-off at 6 dB per octave. The opamp input impedances and the opamp's own CMRR are assumed infinite, as in the world of simulation they so easily can be. Its output impedance is set at zero.

For the first experiments, even the pole frequency is made infinite, so now the only contact with harsh reality is that the opamp open-loop gain is finite. That is however enough to give distinctly non-ideal CMRR figures, as Table 18.4 shows.

TABLE 18.4 The effect of finite opamp gain on CMRR for the circuit of Figure 18.5

Open-loop gain	CMRR dB	CMRR ratio
10,000	−74.0	19.9×10^{-5}
30,000	−83.6	66.4×10^{-6}
100,000	−94.0	19.9×10^{-6}
300,000	−103.6	6.64×10^{-6}
1,000,000	−114.1	1.97×10^{-6}

With a low-frequency open-loop gain of 100,000, which happens to be the typical figure for a 5532 opamp, even perfect components everywhere will never yield a better CMRR than −94 dB. The CMRR is shown as a raw ratio in the third column so you can see that the CMRR is inversely proportional to the gain, and so we want as much gain as possible.

Common-mode rejection: opamp frequency response effects

To examine these we will set the low-frequency gain to 100,000 which gives a CMRR 'floor' of −94 dB and then introduce the pole frequency that determines where it rolls-off. The CMRR now worsens at 6 dB/octave, starting at a frequency set by the interaction of the low-frequency gain and the pole frequency. The results are summarised in Table 18.5, which shows that as you might expect, the lower the open-loop bandwidth of the opamp, the lower the frequency at which the CMRR begins to fall off. Figure 18.6 shows the situation diagrammatically.

Table 18.6 gives the open-loop gain and pole parameters for a few opamps of interest. Both parameters, but especially the gain, are subject to considerable variation; the typical values from the manufacturers' data sheets are given here.

Some of these opamps have very high open-loop gains but only at very low frequencies. This may be good for DC applications, but in audio line input applications, where the lowest frequency of CMRR interest is 50 Hz, they will be operating above the pole frequency and so the gain available will be less—possibly considerably so, in the case of opamps like the OPA2134. This is not, however, a real limitation, for even if a humble TL072 is used the perfect-resistor CMRR is about

TABLE 18.5 The effect of opamp open-loop pole frequency on CMRR for the circuit of Figure 18.5

Pole frequency	CMRR breakpoint freq
10 kHz	10.2 kHz
1 kHz	1.02 kHz
100 Hz	102 Hz
10 Hz	10.2 Hz

TABLE 18.6 Typical LF gain and open-loop pole frequency for some opamps commonly used in audio

Name	Input device type	LF gain	Pole freq	Opamp LF CMRR dB
NE5532	Bipolar	100,000	100 Hz	100
LM4562	Bipolar	10,000,000	below 10 Hz	120
LT1028	Bipolar	20,000,000	3 Hz	120
TL072	FET	200,000	20 Hz	86
OP27	FET	1,800,000	3 Hz	120
OPA2134	FET	1,000,000	3 Hz	100
OPA627	FET	1,000,000	20 Hz	116

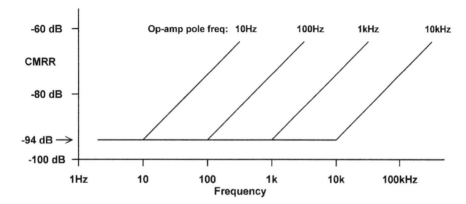

Figure 18.6 How the CMRR degrades with frequency for different opamp pole frequencies. All resistors are assumed to be perfectly matched.

−90 dB, degrading from 100 Hz upwards. This sort of performance is not attainable in practice. We will shortly see why not.

Common-mode rejection: opamp CMRR effects

Opamps have their own common-mode rejection ratio, and we need to know how much this will affect the final CMRR of the balanced interconnection. The answer is that if all resistors are accurate, the overall CMRR is equal to the CMRR of the opamp [5]. Since opamp CMRR is typically very high (see the examples in Table 18.6), it is very unlikely to be the limiting factor.

The CMRR of an opamp begins to degrade above a certain frequency, typically at 6 dB per octave. This is (fortunately) at a higher frequency than the open-loop pole and is frequently around 1 kHz. For example the OP27 has a pole frequency at about 3 Hz, but the CMRR remains flat at 120 dB until 2 kHz, and it is still greater than 100 dB at 20 kHz.

TABLE 18.7 How resistor tolerances affect the CMRR with some realistic opamp o/l gains

R1 Ω	R1 deviation	Gain x	CMRR dB
10 k	0%	100,000	−94.0
10.001 k	0.01%	100,000	−90.6
10.01 k	0.1%	100,000	−66.5
10.1 k	1%	100,000	−46.2
11 k	10%	100,000	−26.6
10 k	0%	1,000,000	−114.1
10.001 k	0.01%	1,000,000	−86.5
10.01 k	0.1%	1,000,000	−66.2
10.1 k	1%	1,000,000	−46.2
11 k	10%	1,000,000	−26.6

Amplifier component mismatch effects

We saw earlier in this chapter that when the output and input impedances on a balanced line have a high ratio between them and are accurately matched we got a very good CMRR; this was compromised by the imperfections of opamps, but the overall results were still very good—and much higher than the CMRRs measured in practice. There remains one place where we are still away in theory-land; we have so far assumed the resistances around the opamp were all exactly accurate. We must now face reality and admit that these resistors will not be perfect and see how much damage to the CMRR they will do.

SPICE simulation gives us Table 18.7. The situation with LF opamp gains of both 100,000 and 1,000,000 is examined, but the effects of finite opamp bandwidth or opamp CMRR are not included. R1 in Figure 18.5 is varied while R2, R3, and R4 are all kept at precisely 10 kΩ, and the balanced output source impedances are set to exactly 100 Ω.

Table 18.7 shows with glaring clarity that our previous investigations, which took only output and input impedances into account, and determined that 68 Ω output resistors and 20 kΩ input impedances gave a CMRR of −89.5 dB for a 1% deviation in either, were actually quite unrealistic, and even adding in opamp imperfections left us with unduly optimistic results. If a 1% tolerance resistor is used for R1 (and nowadays there is no financial incentive to use anything less accurate), the CMRR is dragged down at once to −46 dB; the same figure results from varying any other one of the four resistances by itself. If you are prepared to shell out for 0.1% tolerance resistors, the CMRR is a rather better −66 dB.

This shows that there really is no point in worrying about the gain of the opamp you use in balanced inputs; the effect of mismatches in the resistors around that opamp are far greater.

The results in the table give an illustration of how resistor accuracy affects CMRR, but it is only an illustration, because in real life—a phrase that seems to keep cropping up, showing how many factors affect a practical balanced interconnection—all four resistors will of course be subject

to a tolerance, and a more realistic calculation would produce a statistical distribution of CMRR rather than a single figure. One method is to use the Monte-Carlo function in SPICE, which runs multiple simulations with random component variations and collates the results. However you do it, you must know (or assume) how the resistor values are distributed within their tolerance window. Usually you don't know, and finding out by measuring hundreds of resistors is not a task that appeals to all of us. Fortunately, assuming a Gaussian distribution works well; see Chapter 2.

It is straightforward to calculate the worst-case CMRR, which occurs when all resistors are at the limit of the tolerance in the most unfavourable direction. The CMRR in dB is then

$$CMRR = 20\log\left(\frac{1+R2/R1}{4T/100}\right) \qquad \text{Equation 18.1}$$

Where R1 and R2 are as in Figure 18.5, and T is the tolerance in %.

This deeply pessimistic equation tells us that 1% resistors give a worst-case CMRR of only 34.0 dB, that 0.5% parts give only 40.0 dB and expensive 0.1% parts yield but 54.0 dB. Things are not however quite that bad in actuality, as the chance of everything being as wrong as possible is actually vanishingly small. I have measured the CMRR of more of these balanced inputs, built with 1% resistors, than I care to contemplate, but I do not ever recall that I ever saw one with an LF CMRR worse than 40 dB.

There are 8-pin SIL packages that offer four resistors that ought have good matching, if not accurate absolute values; be very, very wary of these as they usually contain thick film resistive elements that are not perfectly linear. In a test I did a 10 kΩ SIL resistor with 10 Vrms across it generated 0.0010% distortion. Not a huge amount perhaps, but in the quest for perfect audio, resistors that do not stick to Ohm's law are not a good start.

To conclude this section, it is clear that in practical use it is the errors in the balanced amplifier resistors that determine the CMRR, though both unbalanced capacitances (C1, C2 in Figure 18.9) and the finite opamp bandwidth are likely to cause further degradation at high audio frequencies. If you are designing both ends of a balanced interconnection and you are spending money on precision resistors, you should put them in the input amplifier, not the balanced output. The LF gain of the opamp, and opamp CMRR, have virtually no effect.

Balanced input amplifiers made with four 1% resistors are used extensively in the professional audio business, and almost always prove to have adequate CMRR for the job. When more CMRR is thought desirable, for example in high-end mixing consoles, one of the resistances is made trimmable with a preset, as in Figure 18.7. This means a bit of tweaking in manufacture, but the upside is that it is a quick set-and-forget adjustment that will not need to be touched again unless one of the four resistors needs replacing, and that is extremely unlikely. CMRRs at LF of more than 80 dB can easily be obtained by this method, but the CMRR at HF will degrade due to the opamp gain roll-off and stray capacitances.

Figure 18.8 shows the CMRR measurements for a trimmed balanced input amplifier. The flat line at −50 dB was obtained from a standard fixed resistor balanced input using four 1% 10 kΩ unselected resistors, while the much better (at LF, anyway) trace going down to −85 dB was

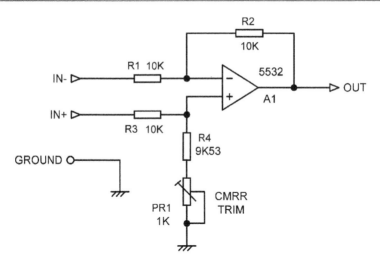

Figure 18.7 A balanced input amplifier, with preset pot to trim for best LF CMRR.

obtained from Figure 18.7 by using a multi-turn preset for PR1. Note that R4 is an E96 value so a 1k preset can swing the total resistance of that arm both above and below the nominal 10 kΩ. The CMRR is dramatically improved by more than 30 dB in the region 50–500 Hz where ground noise tends to intrude itself and is significantly better across almost all the audio spectrum.

The upward sloping part of the trace in Figure 18.8 is partly due to the finite open-loop bandwidth of the opamp and partly due to unbalanced circuit capacitances. The CMRR is actually worse than 50 dB above 20 kHz due to the stray capacitances in the multi-turn preset. In practice the value of PR1 would be smaller, and a one-turn preset with much less stray capacitance used. Still, I think you get the point; trimming can be both economic and effective.

Since the adjustment is somewhat critical, the amount of adjustment range should be limited to that necessary to cope with worst-case tolerance errors in all resistors, plus a safety margin.

Shock and vibration might affect preset adjustments in on-the-road mixing consoles. This can be prevented by using good-quality parts; multi-turn presets stay where they are put, but as noted their stray capacitance can be a problem, and they are relatively expensive parts to apply to every line input. If a preset suffers failure it is usually the wiper losing contact with the track; it is wise to arrange the preset connections so that if this occurs the CMRR will inevitably be degraded somewhat but its basic function will continue. See Figure 18.7; if the preset wiper becomes disconnected there is still a signal path through the preset track. If there was not the CMRR would be destroyed and a significant gain error introduced.

A practical balanced input

The simple balanced input circuit shown in Figure 18.4 is not fit to face the outside world without additional components. Figure 18.9 shows a fully-equipped version. Firstly, and most important, C1 has been added across the feedback resistor R2; this prevents stray capacitances from Pin 2

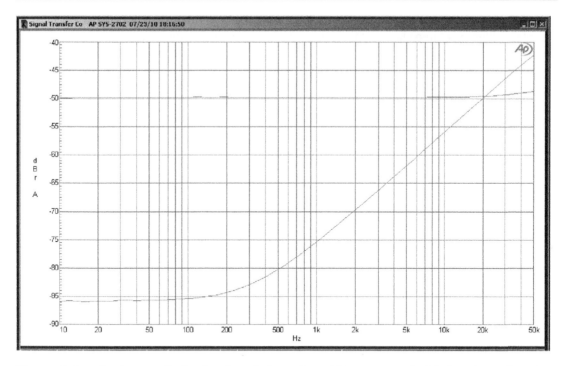

Figure 18.8 The CMRR of a fixed resistor balanced amplifier compared with the trimmed version. The opamp was a 5532 and all resistors were 1%. The trimmed version gives better than 80 dB CMRR up to 500 Hz.

to ground causing extra phase shifts that lead to HF instability. The value required for stability is small, much less than that what would cause an HF roll-off anywhere near the top of the audio band. The values here of 10 k and 27 pF give −3 dB at 589 kHz, and such a roll-off is only down by 0.005 dB at 20 kHz. C2, of equal value, must be added across R4 to maintain the balance of the amplifier, and hence its CMRR, at high frequencies.

C1 and C2 must not be relied upon for EMC immunity as C1 is not connected to ground, and there is every chance that RF will demodulate at the opamp inputs. A passive RF filter is therefore added to each input, in the shape of R5, C3 and R6, C4, so the capacitors will shunt incoming RF to ground before it reaches the opamp. Put these as close to the input socket as possible to minimise radiation inside the enclosure.

I explained earlier in this chapter when looking at unbalanced inputs that it is not easy to guess what the maximum source impedance will be, given the existence of 'passive preamplifiers' and valve equipment. Neither are likely to have a balanced output, unless implemented by transformer, but either might be used to feed a balanced input, and so the matter needs thought.

In the unbalanced input circuit resistances had to be kept as low as practicable to minimise the generation of Johnson noise that would compromise the inherently low noise of the stage. The situation with a standard balanced input is, however, different from the unbalanced case as there

have to be resistances around the opamp, and they must be kept up to a certain value to give acceptably high input impedances; this is why a balanced input like this one is much noisier. We could therefore make R5 and R6 much larger without a measurable noise penalty if we reduce R1 and R3 accordingly to keep unity gain. In Figure 18.9 R5 and R6 are kept at 100 Ω, so if we assume 50 Ω output resistances in both legs of the source equipment, then we have a total of 150 Ω, and 150 Ω and 100 pF give −3 dB at 10.6 MHz. Returning to a possible passive preamplifier with a 10 kΩ potentiometer, its maximum output impedance of 2.5k plus 100 Ω with 100 pF gives −3 dB at 612 kHz, which remains well clear of the top of the audio band.

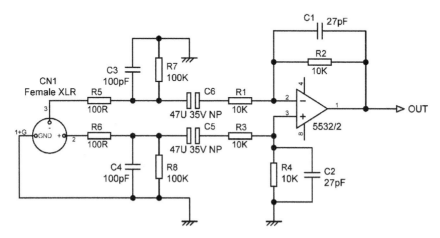

Figure 18.9 Balanced input amplifier with the extra components required for DC blocking and EMC immunity.

As with the unbalanced input, replacing R5 and R6 with small inductors will give much better RF filtering but at increased cost. Ideally a common-mode choke (two bifilar windings on a small toroidal core) should be used as this improves CMRR performance. Check the frequency response to make sure the LC circuits are well-damped and not peaking at the turnover frequency.

C5 and C6 are DC-blocking capacitors. They must be rated at no less than 35 V to protect the input circuitry and are the non-polarised type as external voltages are of unpredictable polarity. The lowest input impedance that can occur with this circuit when using 10 kΩ resistors, is, as described earlier, 6.66 kΩ when it is being driven in the balanced mode. The low-frequency roll-off is therefore −3 dB at 0.51 Hz. This may appear to be undesirably low, but the important point is not the LF roll-off but the possible loss of CMRR at low frequencies due to imbalance in the values of C5 and C6; they are electrolytics with a significant tolerance. Therefore they should be made large so their impedance is a small part of the total input impedance. 47 uF is shown here but 100 uF or 220 uF can be used to advantage if there is the space to fit them in. The low-end frequency response must be defined somewhere in the input system, and the earlier the better, to prevent headroom or linearity being affected by subsonic disturbances, but this is not a good place to do it. A suitable time-constant immediately after the input amplifier is the way to go, but remember that capacitors used as time-constants may distort unless they are NP0 ceramic, polystyrene, or polypropylene. See Chapter 2 for more on this.

R7, R8 are DC-drain resistors to prevent charges lingering on C5 and C6. These can be made lower than for the unbalanced input as the input impedances are lower, so a value of say 100 kΩ rather than 220 kΩ makes relatively little difference to the total input impedance.

A useful property of this kind of balanced amplifier is that it does not go mad when the inputs are left open-circuit—in fact it is actually *less* noisy than with its inputs shorted to ground. This is the opposite of the 'normal' behaviour of a high-impedance unterminated input. This is because two things happen; open-circuiting the Cold input doubles the resistance seen by the non-inverting input of the opamp, raising its noise contribution by 3 dB. However, opening the Hot input makes the noise gain drop by 6 dB, giving a net drop in noise output of approximately 3 dB. This, of course, refers only to the internal noise of the amplifier stage, and pickup of external interference is always possible on an unterminated input. The input impedances here are modest, however, and the problem is less serious than you might think. Having said that, deliberately leaving inputs unterminated is always bad practice.

If this circuit is built with four 10 kΩ resistors R and a 5532 opamp section, the noise output is −104.8 dBu with the inputs terminated to ground via 50 Ω resistors. As noted earlier, the input impedance of the Cold input is actually lower than the resistor connected to it when working balanced, and if it is desirable to raise this input impedance to 10 kΩ, it could be done by raising the four resistors to 16 kΩ; this slightly degrades the noise output to −103.5 dBu. Table 18.8 gives some examples of how the noise output depends on the resistor value; the third column gives the noise with the input unterminated and shows that in each case the amplifier is about 3 dB quieter when open-circuited. It also shows that a useful improvement in noise performance is obtained by dropping the resistor values to the lowest that a 5532 can easily drive (the opamp has to drive the feedback resistor), though this usually gives unacceptably low input impedances. More on that at the end of the chapter.

TABLE 18.8 Noise output measured from simple balanced amps using a 5532 section

R value Ω	50 Ω terminated inputs	Open-circuit inputs	Terminated/open difference
100 k	−95.3 dBu	−97.8 dBu	2.5 dBu
10 k	−104.8 dBu	−107.6 dBu	2.8 dBu
2k0	−109.2 dBu	−112.0 dBu	2.8 dBu
820	−111.7 dBu	−114.5 dBu	2.8 dBu

Variations on the balanced input stage

I now give a collection of balanced input circuits that offer advantages or extra features over the standard balanced input configuration. The circuit diagrams often omit stabilising capacitors, input filters, and DC-blocking capacitors to improve the clarity of the basic principle. They can easily be added; in particular bear in mind that a stabilising capacitor like C1 in Figure 18.9 is often needed to guarantee freedom from high-frequency oscillation, and C2, of equal value, must also be added to maintain balance at HF.

Alternative unbalanced or balanced inputs

It sometimes occurs that a piece of equipment needs to be built with either an unbalanced input OR a balanced input, but not both. It is straightforward to lay out both balanced and unbalanced input circuitry and only populate with components the input that is required. This however is rather wasteful of PCB area, and there is a better way. The circuit shown in Figure 18.10 uses input buffers in the balanced mode, allowing R3 to R6 to be low in value, much reducing noise; this technique is fully described later in this chapter. For balanced operation, the circuit is built as shown, with the UNBAL link omitted.

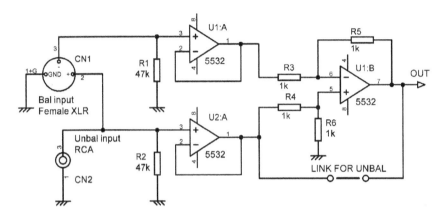

Figure 18.10 Input arrangement that can be configured for unbalanced or balanced operation, saving PCB area.

For unbalanced operation opamp U1 is omitted, leaving out the Cold (inverting) input buffer and the differential amplifier U1B. Resistors R1 and R3 to R6 are also omitted. The UNBAL link is fitted and the Hot (non-inverting) buffer U2A permits a high input impedance whatever the circuitry downstream. The arrangements for DC-blocking, EMC filtering, etc, are omitted for clarity. Typically the input connectors will be phono (RCA) or XLR types, and it may be possible to superimpose the two sets of pads to save more PCB area. Alternatively companies like Neutrik make an female XLR combined with a 1/4-inch stereo jack in the same body.

Combined unbalanced and balanced inputs

If both unbalanced and balanced inputs are required, it is extremely convenient if it can be arranged so that no switching between them is required. Switches cost money, mean more holes in the metalwork, and add to assembly time. Figure 18.11 shows an effective way to implement this. In balanced mode, the source is connected to the balanced input and the unbalanced input left unterminated. In unbalanced mode, the source is connected to the unbalanced input and the balanced input left unterminated, and no switching is required. It might appear that these unterminated inputs would pick up extra noise, but in practice this is not the case, as noted above. It works very well, and I have used it successfully in high-end equipment for two prestigious manufacturers.

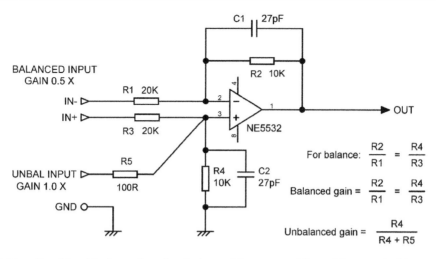

Figure 18.11 Combined balanced and unbalanced input amplifier with no switching required.

As described earlier, in the world of hifi, balanced signals are at twice the level of the equivalent unbalanced signals, and so the balanced input must have a gain of 1/2 or −6 dB relative to the unbalanced input to get the same gain by either path. This is done here by increasing R1 and R3 to 20 kΩ. The balanced gain can be greater or less than unity, but the gain via the unbalanced input is always approximately unity unless R5 is given a higher value to deliberately introduce attenuation in conjunction with R4.

There are two minor compromises in this circuit which need to be noted. Firstly, the noise performance in unbalanced mode is worse than for the dedicated unbalanced input described earlier in this chapter, because R2 is effectively in the signal path and adds Johnson noise. Secondly, the input impedance of the unbalanced input cannot be very high because it is set by R4, and if this is increased in value all the resistances must be increased proportionally and the noise performance will be markedly worse. It is important that only one input cable should be connected at a time because if an unterminated cable is left connected to an unused input, the cable capacitance to ground can cause frequency response anomalies and might in adverse circumstances cause HF oscillation. A prominent warning on the back panel and in the manual is a very good idea. Using a female XLR combined with a 1/4-inch stereo jack prevents this error.

The Superbal input

This version of the balanced input amplifier, shown in Figure 18.12, has been referred to as the "Superbal" circuit because it gives equal impedances into the two inputs for differential signals. It was publicised by David Birt of the BBC [6] but was apparently actually invented by M Law and Ted Fletcher at Alice in 1978. Ted Fletcher discusses the issue on his website at [7] and apparently the original idea goes back to 1972. With the circuit values shown the differential input impedance is exactly 10 kΩ via both Hot and Cold inputs. The common-mode input impedance is 20 kΩ as before.

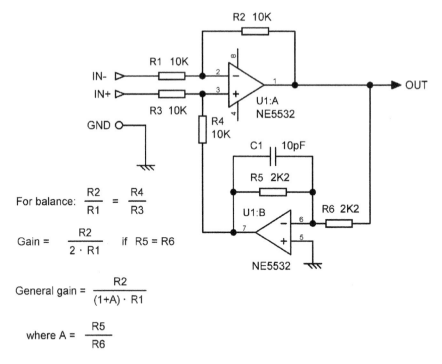

For balance: $\dfrac{R2}{R1} = \dfrac{R4}{R3}$

Gain $= \dfrac{R2}{2 \cdot R1}$ if R5 = R6

General gain $= \dfrac{R2}{(1+A) \cdot R1}$

where $A = \dfrac{R5}{R6}$

Figure 18.12 **The Superbal balanced input amplifier.**

In the standard balanced input R4 is connected to ground, but here its lower end is actively driven with an inverted version of the output signal, giving symmetry. The increased amount of negative feedback reduces the gain with four equal resistors to—6 dB instead of unity. The gain can be reduced below −6 dB by giving the inverter a gain of more than one; if R1, R2, R3 and R4 are all equal, the gain is 1/(A+1), where A is the gain of the inverter stage. This is of limited use as the inverter U1:B will now clip before the forward amplifier U1:A, reducing headroom. If the gain of the inverter stage is gradually reduced from unity to zero, the stage slowly turns back into a standard balanced amplifier with the gain increasing from −6 dB to unity and the input impedances becoming less and less equal. If a gain of less than unity is required it should be obtained by increasing R1 and R3.

R5 and R6 should be kept as low in value as possible to minimise Johnson noise; there is no reason why they have to be equal in value to R1, etc. The only restriction is the ability of U1:A to drive R6 and U1:B to drive R5, both resistors being effectively grounded at one end. The capacitor C1 will almost certainly be needed to ensure HF stability; the value in the figure is only a suggestion. It should be kept as small as possible because reducing the bandwidth of the inverter stage impairs CMRR at high frequencies.

Switched-gain balanced inputs

A balanced input stage that can be switched to two different gains while maintaining CMRR is very useful. Equipment often has to give optimal performance with both semi-pro (−7.8 dBu) and

professional (+4 dBu) input levels. If the nominal internal level of the system is in the normal range of −2 to −6 dBu, the input stage must be able to switch between amplifying and attenuating, while maintaining good CMRR in both modes.

The brute-force way to change gain in a balanced input stage is to switch the values of either R1 and R3, or R2 and R4, in Figure 18.4, keeping the pairs equal in value to maintain the CMRR; this needs a double-pole switch for each input channel. A much more elegant technique is shown in Figure 18.13. Perhaps surprisingly, the gain of a differential amplifier can be manipulating by changing the drive to the feedback arm (R2 etc) only, and leaving the other arm R4 unchanged, without affecting the CMRR. The essential point is to keep the source resistance of the feedback arm the same but drive it from a scaled version of the opamp output. Figure 18.13 does this with the network R5, R6, which has a source resistance made up of 6k8 in parallel with 2k2, which is 1.662 kΩ. This is true whether R6 is switched to the opamp output (low gain setting) or to ground (high gain setting), for both have effectively zero-impedance. For low gain the negative feedback is not attenuated but fed through to R2 and R7 via R5, R6 in parallel. For high gain R5 and R6 become a potential divider, so the amount of feedback is decreased and the gain increased. The value of R2 + R7 is reduced from 7k5 by 1.662 kΩ to allow for the source impedance of the R5, R6 network; this requires the distinctly non-standard value of 5.838 kΩ, which is here approximated by R2 and R7 which give 5.6 kΩ + 240 Ω = 5.840 kΩ. This value is the best that can be done with E24 resistors; it is obviously out by 2 Ω, but that is much less than a 1% tolerance on R2, and so will have only a vanishingly small effect on the CMRR.

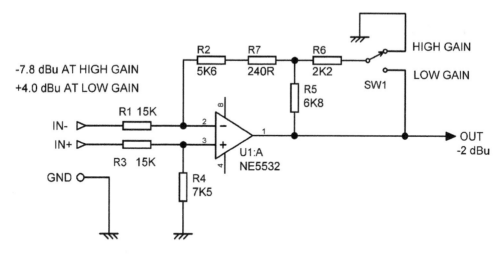

Figure 18.13 **A balanced input amplifier with gain switching that maintains good CMRR.**

Note that this stage can attenuate as well as amplify if R1, R3 are set to be greater than R2, R4, as shown here. The nominal output level of the stage is assumed to be −2 dBu; with the values shown the two gains are −6.0 and +6.2 dB, so +4 dBu and −7.8 dBu inputs, respectively will give −2 dBu at the output. Other pairs of gains can, of course, be obtained by changing the resistor values; the important thing is to stick to the principle that the value of R2 + R7 is reduced from the value of R4 by the source impedance of the R5, R6 network. With the values shown

the differential input impedance is 11.25 kΩ via the Cold and 22.5 kΩ via the Hot input. The common-mode input impedance is 22.5 kΩ.

This neat little circuit has the added advantage that nothing bad happens when the switch is moved with the circuit operating. When the wiper is between contacts you simply get a gain intermediate between the high and low settings, which is pretty much the ideal situation.

Variable-gain balanced inputs

The beauty of a variable-gain balanced input is that it allows you to get the incoming signal up or down to the nominal internal level as soon as possible, minimising both the risk of clipping and contamination with circuit noise. The obvious method of making a variable-gain differential stage is to use dual-gang pots to vary R2, R4 together, to maintain CMRR (varying R1, R3 would also alter the input impedances). This is very clumsy, and gives a CMRR that is both bad and highly variable due to the inevitable mismatches between pot sections. For a stereo input the required four-gang pot is an unappealing proposition.

There is, however, a way to get a variable gain with good CMRR, using a single pot section. The principle is essentially the same as for the switched-gain amplifier mentioned earlier; keep constant the source impedance driving the feedback arm, but vary the voltage applied. The principle is shown in Figure 18.14. To the best of my knowledge I invented this circuit in 1982; any comments on this point are welcome. The feedback arm R2 is driven by voltage-follower U1:B. This eliminates the variations in source impedance at the pot wiper, which would badly degrade the CMRR. R6 sets the maximum gain, and R5 modifies the gain law to give it a more usable shape. The minimum gain is set by the R2/R1 ratio. When the pot is fully up (minimum gain) R5 is directly across the output of U1:A so do not make it too low in value. If a centre-detent pot is used to give a default gain setting, this may not be very accurate as it partly depends on the ratio of pot track (no better than ±20% tolerance, and sometimes worse) to 1% fixed resistors.

This configuration is very useful as a general line input with an input sensitivity range of −20 to +10 dBu. For a nominal output of 0 dBu, the gain of Figure 18.14 is therefore +20 to −10 dB, with R5 chosen to give 0 dB gain at the central wiper position. An opamp in a feedback path may appear a dubious proposition for HF stability because of the extra phase shift it introduces, but here it is working as a voltage-follower, so its bandwidth is maximised and in practice the circuit is dependably stable.

This configuration can be improved. The maximum gain in Figure 18.14 is set by the end-stop resistor R6 at the bottom of the pot. The pot track resistance will probably be specified at ±20%, while the resistor will be a much more precise 1%. The variation of pot track resistance can therefore cause quite significant differences between the two channels. It would be nice to find a way to eliminate this, in the same way that the Baxandall volume control eliminates any dependency on the pot track. We could do this if we could get rid of the law-bending resistor R5 and also lose the end-stop resistor R6; the pot would then be working as a pure potentiometer with its division ratio controlled by the angular position of the wiper alone. If the gain range is restricted to around 10 dB, there is no very pressing need for law-bending and R5 can be simply omitted. However if we simply do away with the end-stop resistor R6 the gain is going to be

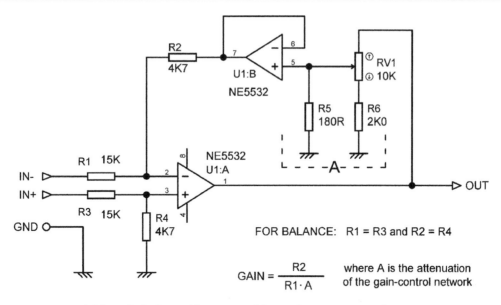

Figure 18.14 **Variable-gain balanced input amplifier: gain +20 to −10 dB.**

uncontrollably large with the pot wiper at the bottom of its track. We need a way to limit the maximum gain that keeps other resistors away from the pot; see the next section.

The noise outputs at various gains are given in Table 18.9. The inputs were terminated with 47 Ω resistors to ground.

Combined line input and balance control stage with low noise

This is a balanced low-noise input stage with gain variable over a limited range to implement the stereo balance control function. Maximum gain is +3.7 dB and minimum gain −6.1 dB, which may not sound much but is more than enough for effective stereo balance control. Gain with balance central is +0.2 dB, which I would suggest is close enough to unity for anyone.

The noise of the stage is reduced by low-impedance design. Compared with Figure 18.14, the input resistors R7, R8 have been reduced from 15 kΩ to 1 kΩ, and the feedback and attenuation arms to 500 Ω. This requires the addition of input buffers to give a reasonably high input impedance; in this case it is set to 50 kΩ but could easily be made higher. The schematic in Figure 18.15 shows the stage fully-equipped to meet the real world with EMC filtering R1, C1 and R2, C2, and non-polar DC-blocking capacitors C3, C4. R3, R4 are the DC-drain resistors.

TABLE 18.9 **Noise output from variable-gain balanced input stage (22–22 kHz, RMS)**

	Max gain	Unity gain	Min gain
5532	−99.7 dBu	−103.4 dBu	−109.3 dBu

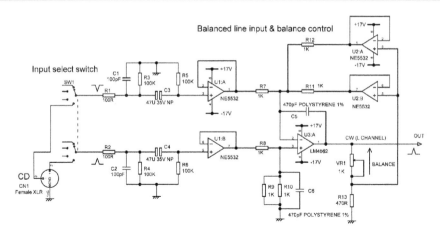

Figure 18.15 **Variable-gain balanced input amplifier. Gain here is +3.7 to −6.1 dB, with unity gain for control central.**

U3:A is the basic balanced amplifier; it is an LM4562 for low-voltage noise and good driving ability. The stage gain and its range is set by 1 kΩ pot VR1 and R13. The negative feedback to U3:A is applied through two parallel unity-gain buffers U2:A and U2:B so the variation in output impedance of the gain-control network will not degrade the CMRR.

The dual buffers reduce noise by partial cancellation of their own voltage noise and give also more drive capability so the feedback resistors can be low. In this stage combining the buffer outputs is simple, with no need for 10 Ω resistors, because the feedback resistance can be conveniently split into R11 and R12. The attenuation arm is then made up of two 1 kΩ resistors R9, R10 in parallel to exactly match R11, R12 and so give good CMRR. Resist the cheapskate temptation to use a single 470 Ω instead because that would degrade the CMRR significantly. The measured noise results are given in Table 18.10, with the inputs terminated with 47 Ω resistors to ground and with RMS-subtraction of the testgear noise floor. The top row shows the results with a 5532 for the basic balanced amplifier and only one buffer driving a 50 Ω feedback resistor. The middle row shows the relatively modest noise reduction achieved by using twin buffers and two 1 kΩ feedback resistors; this looks at first sight hardly worth it, but it is essential if we want the full improvement given by springing the money for an LM4562 as U3:A. The bottom row shows the final result, and is, I think you will agree, rather quiet.

This input/balance stage, with the twin buffers and the LM4562, was used in my Elektor 2012 preamp design, where all the pots were 1 kΩ for low noise [8]. It was designed before I had the

TABLE 18.10 **Noise output from input/balance stage (22–22kHz, RMS)**

	Max gain	Unity gain	Min gain
5532 1xFB buffer	−103.4 dBu	−107.0 dBu	−113.3 dBu
5532 2xFB buffer	−104.0 dBu	−107.6 dBu	−113.9 dBu
LM4562 2xFB buffer	−105.9 dBu	−109.4 dBu	−115.7 dBu

insight on pot-dependence described in the next section. Concerned about the effect of the pot-value tolerances, I measured a number of the pots used, which had a nominal ±20% tolerance and found the extreme values to be +5% and −7.8%. These led to worst-case gain errors of less than 0.1 dB, so I decided the problem was under control.

The Self variable-gain line input

I was just going to bed at dawn (the exigencies of the audio service, ma'am) when it occurred to me that the answer to the pot problem described in the previous section is to add a resistor that gives a separate feedback path around the differential opamp U1:A only. R7 in Figure 18.16 provides negative feedback independently of the gain control and so limits the maximum gain. It is not intuitively obvious (to me, at any rate) but the CMRR is still completely preserved when the gain is altered, just as for Figures 18.14 and 18.15. You will note in Figure 18.16 that two resistors R4, R8 are paralleled to get a value exactly equal to R2 in parallel with R7. It shows resistor values that give a gain range suitable for combining an active stereo balance control with a balanced line input, in one economical stage. The minimum gain is −3.3 dB and the maximum gain of +6.6 dB, The gain with the pot wiper central is +0.2 dB, which once more I suggest is close enough to unity for most of us. This concept eliminates the effect of pot track resistance on gain, and I propose to call it the Self Input. Alright?

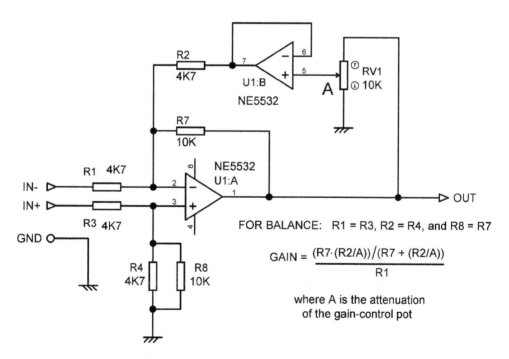

$$\text{GAIN} = \frac{(R7 \cdot (R2/A))/(R7 + (R2/A))}{R1}$$

Figure 18.16 The Self Input: a variable-gain balanced input amplifier free from pot-value dependence. Gain here is −3.3 to +6.6 dB, with unity gain for control central.

The gain equation looks more complex than for the previous example, but it is actually just a slight elaboration. The gain is now controlled by the ratio of R1 (=R3) to the parallel combination of R7 and R2, the latter being effectively scaled by the factor A introduced by the pot setting.

The Self Input stage in Figure 18.16 has reasonably high resistor values to allow direct connection to outside circuitry. As for the other configurations in this chapter, the noise performance can be much improved by scaling down all the resistor values and driving the inputs via a pair of unity-gain buffers; the low-value resistors reduce Johnson noise and the effect of opamp input current noise flowing through them; in this form it was used in my recent Linear Audio preamp design [9]. There is much more on reducing noise in this way later in this chapter.

High input impedance balanced inputs

We saw earlier that high input impedances are required to maximise the CMRR of a balanced interconnection, but the input impedances offered by the standard balanced circuit are limited by the need to keep the resistor values down to control Johnson noise and the effects of current noise. High-impedance balanced inputs are also useful for interfacing to valve equipment in the strange world of retro-hifi. Adding output cathode-followers to valve circuitry is expensive and consumes a lot of extra power, and so the output is often taken directly from the anode of a gain stage, and even a so-called bridging load of 10 kΩ may seriously compromise the distortion performance and output capability of the source equipment.

Figure 18.17 shows a configuration where the input impedances are determined only by the bias resistances R1 and R2. They are shown here as 100 kΩ but may be considerably higher if opamp

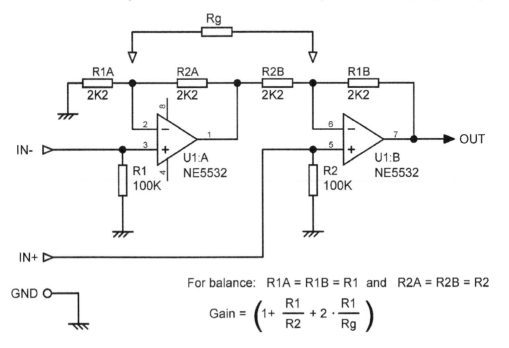

For balance: R1A = R1B = R1 and R2A = R2B = R2

$$\text{Gain} = \left(1 + \frac{R1}{R2} + 2 \cdot \frac{R1}{Rg}\right)$$

Figure 18.17 High input impedance balanced input.

bias currents permit. A useful property of this circuit is that adding a single resistor Rg increases the gain but preserves the circuit balance and CMRR. This configuration cannot be set to attenuate because the gain of an opamp with series feedback cannot be reduced below unity.

It is, of course, always possible to give a basic balanced input a high input impedance by putting unity-gain buffers in front of each input, but that uses three opamp sections rather than two. Sometimes, however, it is appropriate. Much more on that later.

We noted earlier that the simple balanced input is surprisingly quiet and well-behaved when its inputs are unterminated. This is not the case with this configuration, which because of its high input impedances will be both noisy and susceptible to picking-up external interference.

The inverting two-opamp input

The configuration depicted in Figure 18.18 has its uses because the Hot and Cold inputs have the same impedances for differential signals, as well as for common-mode voltages [10]. It is not suited to high input impedances at normal gains because high resistor values would have to be used throughout and they would generate excess Johnson noise, but if it is interfacing with a high voltage source so the gain must be well below unity, R1 and R3 can be made high in value, and R2, R4, R5 set low, the latter components keeping the noise down. The CMRR may degrade at HF because the Hot signal has gone through an extra opamp and suffered phase shift, interfering with the subtraction; this can be compensated for by the network R_c-1, R_c-2 and C1; the values needed depend on opamp type and must be checked by CMRR measurements.

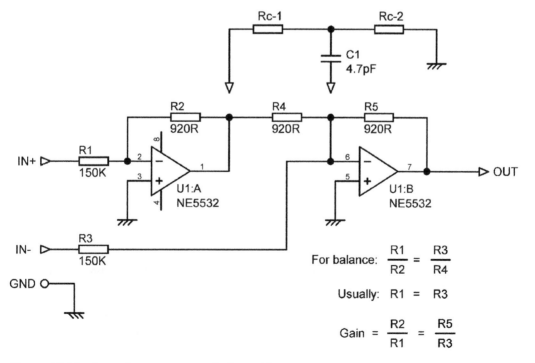

$$\text{For balance:} \quad \frac{R1}{R2} = \frac{R3}{R4}$$

$$\text{Usually:} \quad R1 = R3$$

$$\text{Gain} = \frac{R2}{R1} = \frac{R5}{R3}$$

Figure 18.18 Inverting two-opamp balanced input.

I have used this configuration for balanced input feeds from a 100 V loudspeaker line of the sort still in use for distributing audio over wide areas. The circuit values shown reduce the 100 V input to a nominal −2 dBu (615 mV) internal level. If this circuit is used for that purpose then effective input overvoltage protection on the inputs is essential as large voltage transients are possible on a loudspeaker line if parts of it are unplugged or plugged with signal present due to the inductance of the line matching transformers. This protection can be conveniently provided by the usual diode clamps to the supply rails; this is dealt with at the end of this chapter. The input resistors will be of high value in this application so there is very little possibility of excessive inputs overheating the resistors or 'pumping up' the opamp supply rails.

The instrumentation amplifier

Almost every book on balanced or differential inputs includes the three opamp circuit of Figure 18.19 and praises it as the highest expression of the differential amplifier. It is usually called the instrumentation amplifier configuration because of its undoubted superiority for data acquisition. Specialised ICs exist that are sometimes also called instrumentation amplifiers or in-amps; these are designed for very high CMRR data acquisition. They are expensive and in general not optimised for audio work.

The dual input stage U1:A, U1:B buffers the balanced line from the input impedances of the final differential amplifier U2:A, so the four resistances around the latter can be made much lower in value, reducing their Johnson noise and the effects of opamp current noise by a significant amount, while keeping the CMRR benefits of presenting high input impedances to the balanced line. However, the true beauty of the instrumentation amplifier, much emphasised because of its

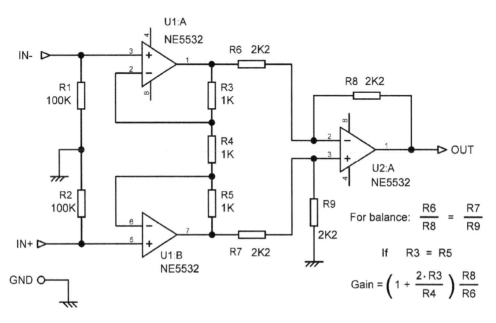

Figure 18.19 The instrumentation amplifier configuration. Gain here is 3 times.

unquestionable elegance, is that the dual input stage, with its shared feedback network R3, R4, R5, can be set to have a high differential gain by giving R4 a low value, but its common-mode gain is always unity; this property is *not* affected by mismatches in R3 and R5. The final amplifier then does its usual job of common-mode rejection, and the combined CMRR can be very good indeed (over 100 dB) if the first-stage gain is high.

This is all well and good, but it is not immediately obvious that the instrumentation amplifier configuration can usefully improve the CMRR of audio balanced line inputs. A data-acquisition application like ECG monitoring may need a gain of thousands of times; a good portion of this will be put into the first stage, allow a stunning CMRR to be achieved without using precision resistors. Unfortunately, the cruel fact is that in audio usage this much gain at an input is simply not wanted, except for microphone amplifiers. In a typical signal path comprised of opamps, the nominal internal level is usually between −6 and 0 dBu, and the line level coming in is at the professional level of +4 dBu; what is needed is 6 dB of attenuation rather than any gain. Gain at this point and attenuation later would introduce what can only be described as a headroom bottleneck. If the incoming level was the semi-pro −7.8 dBu a small amount of gain could be introduced.

So does this mean that the instrumentation amplifier configuration has no real advantages over an ordinary balanced amplifier with input buffers? No. Stand by for what I believe is a whole new way of looking at this stage.

Instrumentation amplifier applications

Firstly, there are some applications where gain in a balanced input amplifier is either essential or can be made use of. Active crossovers and power amplifiers are probably the two most common.

Active crossovers are commonly used with no volume control or only a limited-range gain trim between them and the power amplifiers, so that it can always be assumed that the power amplifier will clip first. As I pointed out in [11], under these conditions the crossover can be run at an internal level of 3 Vrms or more, with the output level dropped back to say 1 Vrms at the very output of the crossover by a low-impedance passive attenuator. This can give a very impressive noise performance because the signal goes through the chain of filters at a high level [12].

For a typical active crossover application like this, we therefore need an input stage with gain. If the nominal input is 0 dBu (775 mVrms) we want a gain of about four times to get the signal up to 3 Vrms (+11.8 dBu). We will not need a greater output than this because it is sufficient to clip the following power amplifiers, even after the passive attenuators. This demonstrates that you can break the rule 'Do not amplify then attenuate' so long as there is a more severe headroom restriction downstream and a limited gain control range.

If we use the strategy of input buffers followed by balanced amplifiers working at low impedances, as described later in this chapter (ie *not* an instrumentation amplifier as there is no network between the two input opamps), the required gain can be obtained by altering the ratio of the resistors in the balanced amplifier of a 1–1 configuration. With suitable resistor values (R1 = R3 = 560R, R2 = R4 = 2k2) the output noise from this stage (inputs terminated by 50 Ω) is −100.9 dBu, so its equivalent input noise (EIN) is −100.9–11.8 = −112.7 dBu, which is reasonably quiet. All noise measurements are 22–22 kHz, RMS sensing, unweighted, and 5532 opamps are used.

The other area for instrumentation amplifier techniques is that of power amplifiers with balanced inputs. The voltage gain of the power amplifier itself is frequently about 22 times (+26.8 dB) for its own technical reasons. If we take a power output of 100 W into 8 Ω as an example, the maximum output voltage is 28.3 Vrms, so the input level must be 28.3/22 = 1.29 Vrms. If the nominal input level is +4 dBu (1.23 Vrms) then a very modest gain of 1.05 times is required, and we will gain little from using an instrumentation amplifier with that gain in Stage 1. If, however, the nominal input level is 0 dBu (0.775 Vrms) a higher gain of 1.66 times is needed, but that is still only a theoretical CMRR improvement of 4.4 dB. However, we can again make use of the fact that a relatively small signal voltage is enough to clip the power amplifier, and we can amplify the input signal—perhaps by four times again—and then attenuate it, along with the noise from the balanced input amplifier.

The instrumentation amplifier with 4x gain

Since we need a significant amount of gain, the instrumentation amplifier configuration is a viable alternative to the input buffer-balanced amplifier approach, giving a CMRR theoretically improved by 11.8 dB, the gain of its first stage. It uses the same number of opamps—three. A suitable circuit is shown in Figure 18.20. This gives a gain of 3.94 times, which is as close as you can get to 4.00 with single E24 values. My tests show that the theoretical CMRR improvement really is obtained. To take just one set of results, when I built the second stage it gave a CMRR of −56 dB working alone, but when the first stage was added the CMRR leapt up to −69 dB, an improvement of 13 dB. These one-off figures (13 dB is actually better than the 12 dB improvement you would get if all resistors were exact) obviously depend on the specific resistor examples I used, but you get the general idea. The CMRR was flat across the audio band.

I do realise that there is an unsettling flavour of something-for-nothing about this, but it really does work. The total gain required can be distributed between the two stages in any way, but it should all be concentrated in Stage 1, as shown in Figure 18.20, to obtain the maximum CMRR benefit.

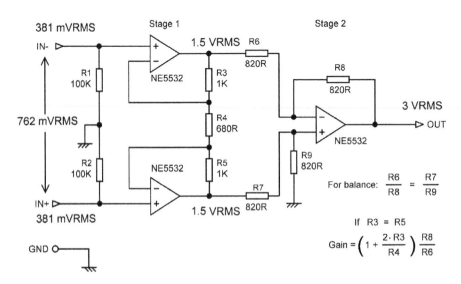

Figure 18.20 **Instrumentation-amplifier balanced input stage with gain of four times.**

What about the noise performance? Fascinatingly, it is considerably improved. The noise output of this configuration is usefully lower at −105.4 dBu, which is no less than 4.5 dB better than the −100.9 dBu we got from the more conventional 1–1 configuration described earlier. This is because the amplifiers in Stage 1 are working in better conditions for low noise than those in Stage 2. They have no significant resistance in series with the non-inverting inputs to generate Johnson noise or turn the opamp current noise into voltage noise. As they implement all the gain before the signal reaches Stage 2, the noise contribution of the latter is therefore less significant.

When noise at −105.4 dBu is put through a 10 dB passive attenuator to get back down to the output level we want, as might typically be done at the output of an active crossover, it will become −115.4 dBu, which I suggest is very quiet indeed.

The circuit in Figure 18.20 requires some ancillary components before it is ready to face the world. Figure 18.21 shows it with EMC RF filtering (R19, C1 and R20, C4), non-polarised DC-blocking capacitors (C2, C3), and capacitors C5, C6 to ensure HF stability. R21, R22 are DC-drain resistors that ensure that any charge left on the DC-blocking capacitors by the source equipment when the connector is unplugged is quickly drained away. These extra components are omitted from subsequent diagrams to aid clarity.

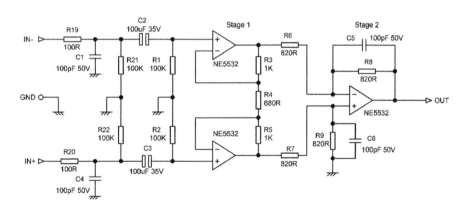

Figure 18.21 Practical instrumentation amplifier balanced input stage with gain of four times.

So here we are with all of the gain in the first stage, for the best CMRR, and this is followed by a unity-gain Stage 2. Now let's extend this thinking a little. Suppose Stage 2 had a gain of less than unity? We could then put more gain in Stage 1 *and* get a further free and guaranteed CMRR improvement, while keeping the overall gain the same. But can we do this without causing headroom problems in Stage 1?

The instrumentation amplifier in Figure 18.22 has had the gain of Stage 1 doubled to eight times (actually 7.67 times; 0.36 dB low, but as close as you can get with single E24 values) by reducing R4, while the input resistors R6, R7 to Stage 2 have been doubled in value so that stage now has a gain of 0.5 times, to keep the total gain at approximately four times.

In this case the theoretical CMRR improvement is once more the gain of Stage 1, which is 7.67 times, and therefore 17.7 dB. Stage 2 gave a measured CMRR of −53 dB working alone, but

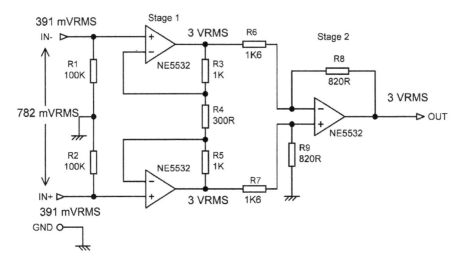

Figure 18.22 Instrumentation amplifier balanced input stage with gain of eight times in Stage 1 and 0.5 times in Stage 2.

when Stage 1 was added the CMRR increased to −70 dB, an improvement of 17 dB, significantly greater than the 14 dB improvement obtained when Stage 1 had a gain of four times. The noise output was −106.2 dBu, which is better than the four-times instrumentation amplifier by 0.8 dB and better than the more conventional 1–1 configuration by a convincing 5.3 dB. When the noise level of −106.2 dBu is put through the 10 dB passive attenuator to get back down to the level we want, this will become −116.2 dBu, which is even quieter than the previous version.

You may well be getting nervous about having a gain as high as eight times followed by attenuation; have we compromised the headroom? If we assume that as before, the maximum output we need is 3 Vrms, then with a total gain of four times we will have 0.775 Vrms between the two inputs, and the corresponding signal voltages at each output of Stage 1 are also 3 Vrms. These outputs are in anti-phase, and so when they are combined in Stage 2, with its gain of 0.5 times, we get 3 Vrms at the final output. This means that in balanced operation all three amplifiers will clip simultaneously, and the input amplifier can pass the maximum opamp output level before clipping. With the usual ±17 V supply rails this is about 10 Vrms.

So far so good; all the voltages are well below clipping. But note that we have assumed a balanced input, and unless you are designing an entire system, that is a dangerous assumption. If the input is driven with an unbalanced output of the same level, we will have 0.775 Vrms on one input pin and nothing on the other. You might fear we would get 6 Vrms on one output of Stage 1 and nothing on the other; that would still be some way below clipping but the safety margin is shrinking fast. In fact things are rather better than that. The cross-coupling of the feedback network R3, R4, R5 greatly reduces the difference between the two outputs of Stage 1 with unbalanced inputs. With 0.775 Vrms on one input pin, and nothing on the other, the Stage 1 outputs are 3.39 Vrms and 2.61 Vrms, which naturally sum to 6 Vrms, reduced to 3 Vrms out by Stage 2. The higher voltage is at the output of the amplifier associated with the driven input.

Maximum output with an unbalanced input is slightly reduced from 10 Vrms to 9.4 Vrms. This minor restriction does not apply to the earlier version with only four times gain in Stage 1.

This shows us that if we can assume a balanced input and stick with a requirement for a maximum output of 3 Vrms, we have a bit more elbow-room than you might think for using higher gains in Stage 1 of an instrumentation amplifier. Taking into account the possibility of an unbalanced input, we could further increase the gain by a factor of 10/3.39 = 2.95 times, on top of the doubling of Stage 1 gain we have already implemented. This gives a Stage 1 gain of 22.6 times. I decided to be conservative and go for a Stage 1 gain of 21 times; the gain of Stage 2 is correspondingly reduced to 0.19 times to maintain a total gain of four times. This version is shown in Figure 18.23; you will note that the feedback resistors R3, R4, R5 in Stage 1 have been scaled up by a factor of two. This is because Stage 1 is now working at a higher level; remember also that the resistors R3 and R5 are not the only load on Stage 1 because each of its opamp outputs is looking at the Stage 2 inputs driven in anti-phase, so its inverting input loading is heavier than it at first appears; see "The basic electronic balanced input" section for an explanation of why the inverting input of Stage 2 presents a lower impedance than is apparent. Leaving R3, R5 at 1 kΩ would significantly degrade the distortion performance; I found it increased the THD at 10 kHz from 0.0012% to 0.0019% for a 3 Vrms output.

When Stage 2 was tested alone its CMRR was −61 dB; clearly we have been lucky with our resistors. Adding on Stage 1 increased it to a rather spectacular −86 dB, an improvement of no less than 25 dB. This degrades to −83 dB at 20 kHz; this is the first time it has not appeared flat across the audio band. The theoretical CMRR improvement is 26.4 dB, without trim presets or selected components.

The output noise level remains at −106.2 dBu; we have clearly gained all the noise advantage we can by increasing the Stage 1 gain.

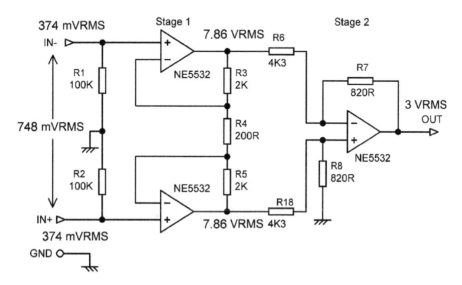

Figure 18.23 **Instrumentation amplifier balanced input stage with gain of 21 times in Stage 1 and 0.19 times in Stage 2. Maximum output 3 Vrms.**

Note that throughout this discussion I have assumed that there are no objections to running an opamp at a signal level not far from clipping, and in particular that the distortion performance is not significantly harmed by doing that. This is true for many modern opamps such as the LM4562, and also for the veteran 5532, when it is not loaded to the limit of its capability.

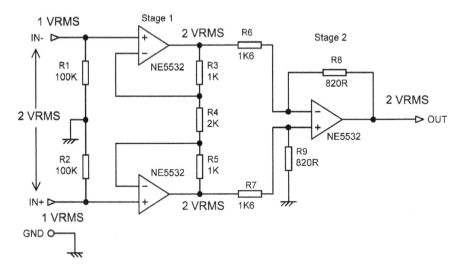

Figure 18.24 **Instrumentation amplifier balanced input stage with gain of two times in Stage 1 and 0.5 times in Stage 2 for overall unity gain.**

The instrumentation amplifier at unity gain

If you want a unity-gain input stage but also some CMRR improvement, some compromise is required.

Putting R3, R5 = 1 kΩ and R4 = 2 kΩ gives a Stage 1 gain of two times, which is undone by setting R6, R7 to 1k6 in Stage 2 to give a gain of 0.5 times. This will pass the full 10 Vrms maximum opamp level but only in balanced mode. In unbalanced mode Stage 1 will clip at the opamp connected to the driven input because when unbalanced the gain to this point from the input is 1.5 times. The maximum signal that can be handled in unbalanced mode is therefore about 7 Vrms. The resulting input amplifier is shown in Figure 18.24. A heavy load is placed on the Stage 1 amplifiers in this situation, and for the best distortion behaviour it might be better to make R3, R5 = 2 kΩ and R4 = 4 kΩ.

When I did the measurements, Stage 2 alone had a CMRR of −57 dB; adding on Stage 1 brought this up to −63 dB (this exact correspondence of theoretical and measured improvement is just a coincidence). You can therefore have 6 dB more CMRR free, gratis, and for absolutely nothing, so long as you are prepared to tolerate a loss of 3.5 dB in headroom if the stage is run unbalanced but with the same input voltage. The noise output is −111.6 dBu.

The instrumentation amplifier and gain controls

A typical hifi output gives 1 Vrms in unbalanced use, and 2 Vrms when run balanced, as the Cold output is provided by a simple inverter, the presence of which doubles the total output voltage.

Figure 18.25 shows the signal voltages when our unity-gain input stage is connected to a 2 Vrms balanced input. This sort of situation is more likely to occur in hifi than in professional audio; in the latter simulated 'floating transformer winding' outputs are sometimes found, where the total output voltage is the same whether the output is run balanced or unbalanced. These are described in Chapter 19.

In hifi use it may be possible to assume that the instrumentation amplifier will never be connected to a balanced output with a total signal voltage of more than 2 Vrms. If this is the case we can once more put extra gain into Stage 1, and undo it with stage 2, without compromising headroom. We are now dealing with a restriction on input level rather than output level. We will assume that the 2 Vrms input is required to be reduced to 1 Vrms to give adequate headroom in the circuitry that follows, so an overall gain of 0.5 times is required.

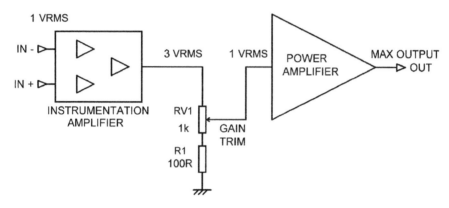

Figure 18.25 Maximum gain trim range possible avoiding headroom restriction in the instrumentation amplifier.

Finally we will look at how the range of gain control between the instrumentation amplifier and the power amplifier affects the headroom situation. Figure 18.25 shows one of the instrumentation amplifiers described earlier with a maximum output of 3 Vrms, the version in Figure 18.22 with a gain of eight times in Stage 1 and 0.5 times in Stage 2. This is followed by a ±10 dB gain trim network that is normally expected to work at the 0 dB setting, ie giving 10 dB of attenuation and so reducing the noise from the input stage. I should point out that with a linear pot this simple network does not give '0 dB' at the centre of the pot rotation; that point is more like 3/4 of the way down.

Since the maximum output of this stage is 10 Vrms with a balanced input (slightly less with an unbalanced input) clipping will always occur in the power amplifier first so long as the gain trim is set above −10 dB. At the −10 dB setting (which introduces 20 dB of actual attenuation) the input amplifier and the power amp will clip simultaneously; if more attenuation is permitted then there is the danger that the input amplifier will clip first, and this cannot be corrected by the gain trim. Note the low resistor values in the gain trim network to minimise Johnson noise and also the effect of the power amplifier input noise current. A low source impedance is also required by most power amplifiers to prevent input current distortion [13]. In the worst-case position

(approximately wiper central) the output impedance of the network is 275 Ω, and the Johnson noise from that resistance is −128.2 dBu, well below the noise from the input amplifier, which is −106.2 dBu−6 dB = −112.2 dBu, and also below the equivalent input noise of the power amplifier, which is unlikely to be better than −122 dBu.

The instrumentation amplifier and the Whitlock bootstrap

In some balanced applications the Hot and Cold source resistances may not be exactly the same. In a typical balanced link the output resistors of the sending equipment are likely to be in the range 47 Ω–100 Ω and of 1% tolerance, and when used with the 100 kΩ input bias resistors shown earlier the effect is likely to be negligible. However, if the source impedances are higher it is important to keep the common-mode impedance as high as possible to maximise the CMRR. It is going to be difficult to increase the input bias resistors without creating excessive DC offsets, but there is a very clever way of bootstrapping them, introduced by Bill Whitlock in an *Audio Engineering Society* paper in 1996 [14].

As noted earlier, the common-mode gain of the first stage of an instrumentation amplifier is always unity, no matter what differential gain is set by R3, R4, R5, so a common-mode bootstrapping signal can be derived by the two resistors R10, R11. The unity-gain buffer A4 then uses this to drive the mid-point of R1–R2, raising the common-mode impedance considerably. Figure 18:26 shows the unity-gain instrumentation amplifier of Figure 18.20 with bootstrapping

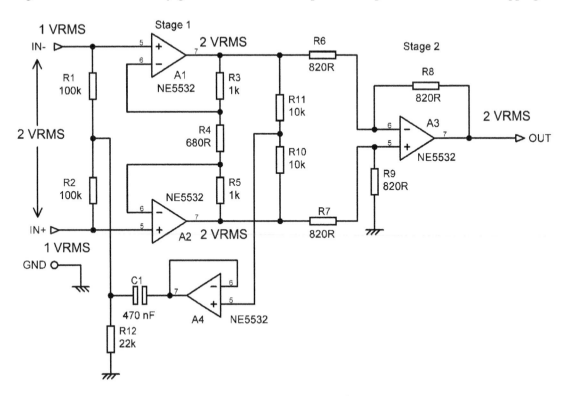

Figure 18.26 **The Bill Whitlock method of bootstrapping instrumentation amplifier input resistance to increase the common-mode input impedance.**

added; the component values are mine. R12 provides a DC path for biasing the opamps. Since C1 is not in the differential signal path, with the circuit as shown the frequency response extends down to DC; in practice input DC-blocking capacitors would be used.

The Whitlock bootstrap is used in the THAT1200 line receiver IC. EDN tested it and some of its competitors and you read about it here [15]. Note that the Whitlock bootstrap is the subject of a US patent [16], and if you plan to use it commercially you had better talk to THAT Corporation about licensing.

Transformer balanced inputs

When it is essential that there is no galvanic connection (ie no electrical conductor) between two pieces of equipment, transformer inputs are indispensable. They are also useful if EMC conditions are severe. Figure 18.27 shows a typical transformer input. The transformer usually has a 1:1 ratio and is enclosed in a metal shielding can which must be grounded. Good line transformers have an inter-winding shield that must also be grounded or the high-frequency CMRR will be severely compromised. The transformer secondary must see a high impedance as this is reflected to the primary and represents the input impedance; here it is set by R2, and a buffer drives the circuitry downstream. In addition, if the secondary loading is too heavy there will be increased transformer distortion at low frequencies. Line input transformers are built with small cores and are only intended to deliver very small amounts of power; they are *not* interchangeable with line output transformers. A most ingenious approach to dealing with this distortion problem by operating the input transformer core at near-zero flux was published by Paul Zwicky in 1986 [17].

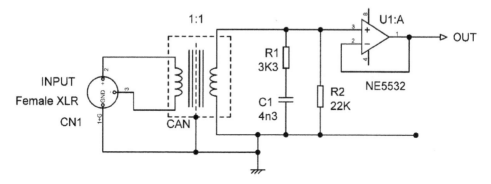

Figure 18.27 A transformer balanced input. R1 and C1 are the Zobel network that damps the secondary resonance.

There is a bit more to correctly loading the transformer secondary. If it is simply loaded with a high-value resistor there will be peaking of the frequency response due to resonance between the transformer leakage inductance and the winding capacitance. This is shown in Figure 18.28, where a Sowter 3276 line input transformer (a high-quality component) was given a basic resistive loading of 100 kΩ. The result was Trace A, which has a 10 dB peak around 60 kHz. This is bad not only because it accentuates the effect of out-of-band noise, but because it intrudes on the audio frequency response, giving a lift of 1 dB at 20 kHz. Reducing the resistive load R2 would damp the resonance, but it would also reduce the input impedance. The answer is to add a Zobel

network, ie a resistor and capacitor in series, across the secondary; this has no effect except high frequencies. The first attempt used R1 = 2k7 and C1= 1 nF, giving Trace B, where the peaking has been reduced to 4 dB around 40 kHz, but the 20 kHz lift is actually slightly greater. R1 = 2k7 and C1= 2 nF gave Trace C, which is a bit better in that it only has a 2 dB peak. Some more experimentation resulted in R1 = 3k3 and C1= 4.3 nF (3n3 + 1 nF) and yielded Trace D, which is pretty flat, though there is a small droop around 10 kHz. The Zobel values are fairly critical for the flattest possible response and must certainly be adjusted if the transformer type is changed.

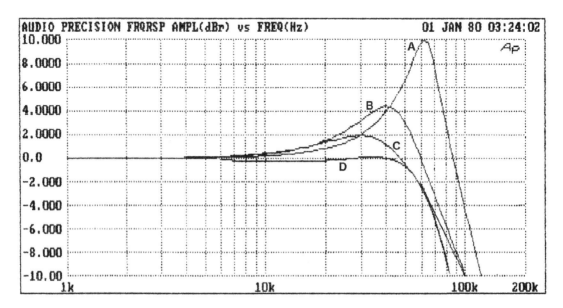

Figure 18.28 Optimising the frequency response of a transformer balanced input with a Zobel network.

Input overvoltage protection

Input overvoltage protection is not common in hifi applications but is regarded as essential in most professional equipment. The normal method is to use clamping diodes, as shown in Figure 18.29, that prevent certain points in the input circuitry from moving outside the supply rails.

This is straightforward, but there are two points to watch. Firstly, the ability of this circuit to withstand excessive input levels is not without limit. Sustained overvoltages may burn out R5 and R6 or pump unwanted amounts of current into the supply rails; this sort of protection is mainly aimed at transients. Secondly, diodes have a non-linear junction capacitance when they are reverse-biased, so if the source impedance is significant the diodes will cause distortion at high frequencies. To quantify this problem here are the results of a few tests. If Figure 18.29 is fed from the low impedance of the usual kind of line output stage, the impedance at the diodes will be about 1 kΩ and the distortion induced into an 11 Vrms 20 kHz input will be below the noise floor.

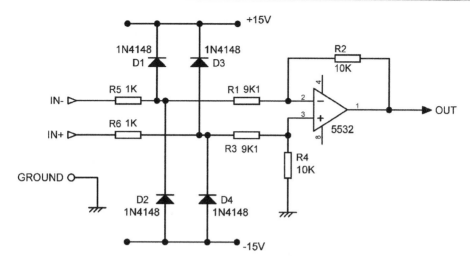

Figure 18.29 **Input overvoltage protection for a balanced input amplifier.**

However, if the source impedance is high so the impedance at the diodes is increased to 10 kΩ, with the same input level, the THD at 20 kHz was degraded from 0.0030% to 0.0044% by adding the diodes. I have thought up a rather elegant way to eliminate this effect completely; anybody interested?

Low-noise balanced inputs

So far we have not said much about the noise performance of balanced inputs, though we have noted several times that the standard balanced input amplifier with four 10 kΩ resistors as in Figure 18.30a is markedly noisier than an unbalanced input like that in Figure 18.1. The unbalanced input stage, with its input terminated by 50 Ω to ground, has a noise output of −119.0 dBu over the usual 22–22 kHz bandwidth. If the balanced circuit is built with 10 kΩ resistors and a 5532 section, the noise output is −104.8 dBu with the inputs similarly terminated. This is a big difference of 14.2 dB.

In the hifi world in particular, where an amplifier may have both unbalanced and balanced inputs, many people would feel that this situation is the wrong way round. Surely the balanced input, with its professional XLR connector and its much-vaunted rejection of ground noise, should show a better performance in all departments? Well, it does—except as regards internal noise—and a 14 dB discrepancy is both clearly audible and hard to explain away. This section explains how to design it away instead.

We know that the source of the extra noise is the relatively high resistor values around the opamp (see Table 18.8 earlier in the chapter), but these cannot be reduced in the simple balanced stage without reducing the input impedances below what is acceptable. The answer is to lower the resistor values but buffer them from the input with a pair of voltage-followers; this arrangement is shown in Figure 18.30b. 5532s are a good choice for this as they combine low-voltage noise with

low distortion and good load-driving capability. Since the input buffers are voltage-followers with 100% feedback, their gain is very accurately defined at unity and CMRR is not degraded; CMRR is still defined by the resistor tolerances and by the bandwidth of the differential opamp. I call this a 1–1 configuration, for reasons which will be made clear.

There is a limit to how far the four resistors can be reduced, as the differential stage has to be driven by the input buffers, and it also has to drive its own feedback arm. If 5532s are used a safe value that gives no measurable deterioration of the distortion performance is about 820 Ω, and a 5532 differential stage alone (without the buffers) and 4x 820 Ω resistors gives a noise output of −111.7 dBu, which is 6.6 dB lower than the standard 4x 10 kΩ version. Adding the two input buffers degrades this only slightly to −110.2 dB because we are adding only the voltage noise component of the two new opamps, and we are still 5.1 dB quieter than the original 4x 10 kΩ version. It is interesting point that we now have three opamps in the signal path instead of one, but we still get a significantly lower noise level.

This might appear to be all we can do; it is not possible to reduce the value of the four resistors around the differential amplifier any further without compromising linearity. However, there is almost always some way to go further in the great game that is electronics, and here are three possibilities. A step-up transformer could be used to exploit the low source impedance (remember we are still assuming the source impedances are 50 Ω), and it might well work superbly in terms of noise alone, but transformers are always heavy, expensive, susceptible to magnetic fields and of doubtful low-frequency linearity. We would also very quickly run into headroom problems; balanced line input amplifiers are normally required to attenuate rather amplify.

We could design a hybrid stage with discrete input transistors, which are quieter than those integrated into IC opamps, coupled to an opamp to provide raw loop gain; this can be quite effective but you need to be very careful about high-frequency stability, and it is difficult to get an improvement of more than 6 dB.

Thirdly, we could design our own opamp using all discrete parts; this approach tends to have less stability problems as all circuit parameters are accessible, but it definitely requires rather specialised skills, and the result takes up a lot of PCB area.

Since none of those three approaches are appealing, now what? One of the most useful techniques in low-noise electronics is to use two identical amplifiers so that the gains add arithmetically, but the noise from the two separate amplifiers, being uncorrelated, partially cancels. Thus we get a 3 dB noise advantage each time the number of amplifiers used is doubled. This technique works very well with multiple opamps, as expounded in Chapter 1; let us apply it and see how far it may be usefully taken.

Since the noise of a single 5532-section unity-gain buffer is only −119.0 dBu, and the noise from the 4x 820 Ω differential stage (without buffers) is a much higher −111.7 dBu, the differential stage is clearly the place to start work. We will begin by using two identical 4x 820 Ω differential amplifiers as shown in the top section of Figure 18.30c, both driven from the existing pair of input buffers. I call this a 1–2 configuration. This will give partial cancellation of both resistor and opamp noise from the two differential stages if their outputs are summed. The main question is how to sum the two amplifier outputs; any active solution would introduce another opamp, and

hence more noise, and we would almost certainly wind up worse off than when we started. The answer is however, beautifully simple. We just connect the two amplifier outputs together with 10 Ω resistors; the gain does not change but the noise output drops. We are averaging rather than summing. The signal output of both amplifiers is nominally the same, so no current should flow from one opamp output to the other. In practice there will be slight gain differences due to resistor tolerances, but with 1% resistors I have never experienced any hint of a problem. The combining resistor values are so low at 10 Ω that their Johnson noise contribution is negligible.

The use of multiple differential amplifiers has another advantage—the CMRR errors are also reduced in the same way that this the noise is reduced. This is similar to the use of multiple parallel capacitors to improve RIAA accuracy, as explained in Chapter 9.

We therefore have the arrangement of Figure 18.30c, with single input buffers (ie one per input) and two differential amplifiers, and this reduces the noise output by 2.3 dB to −112.5 dBu, which

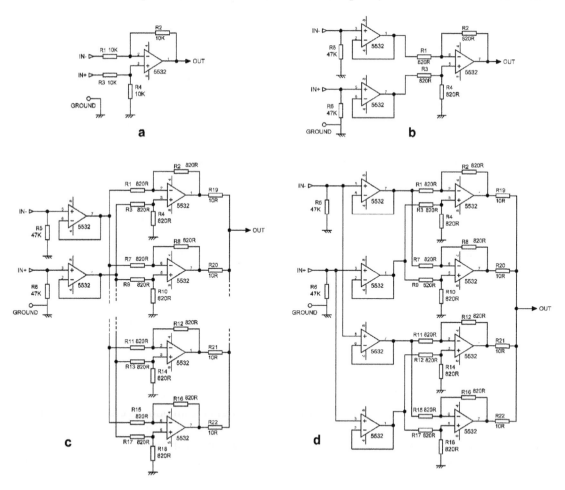

Figure 18.30 Low noise unity-gain balanced inputs using multiple 5532 buffers and differential amplifiers.

is quieter than the original 4x 10 kΩ version by an encouraging 7.4 dB. We do not get a full 3 dB noise improvement because both differential amplifiers are handling the noise from the input buffers, which is correlated and so is not reduced by partial cancellation. The contribution of the input buffer noise is further brought out if we take the next step of using four differential amplifiers (1–4 configuration). There is, of course, nothing special about using amplifiers in powers of two. It is perfectly possible to use three or five differential amplifiers in the array, which will give intermediate amounts of noise reduction. If you have a spare opamp section, then put it to work!

So leaving the input buffers unchanged, we use them to drive an array of four differential amplifiers. These are added on at the dotted lines in the lower half of Figure 18.30c. We get a further improvement, but only by 1.5 dB this time. The output noise is down to −114.0 dBu, quieter than the original 4x 10 kΩ version by 8.9 dB. You can see that at this point we are proceeding by decreasing steps, as the input buffer noise is starting to dominate, and there seems little point in doubling up the differential amplifiers again; the amount of hardware could be regarded as a bit excessive, and so would the PCB area occupied. The increased loading on the input buffers is also a bit of a worry.

A more fruitful approach is to tackle the noise from the input buffers by doubling them up as in Figure 18.30d, so that each buffer drives only two of the four differential amplifiers (2–4 configuration). This means that the buffer noise will also undergo partial cancellation and will be reduced by 3 dB. There is, however, still the contribution from the differential amplifier noise, and so the actual improvement on the previous version is 2.2 dB, bringing the output noise down to −116.2 dBu, which is quieter than the original 4x 10 kΩ version by a thumping 11.1 dB. Remember that there are two inputs, and 'double buffers' means two buffers per Hot and Cold input, giving a total of four in the complete circuit.

Since doubling up the input buffers gave us a useful improvement, it's worth trying again, so we have a structure with quad buffers and four differential amplifiers, as shown in Figure 18.31, where each differential amplifier now has its very own pair of buffers (4–4 configuration). This improves on the previous version by a rather less satisfying 0.8 dB, giving an output noise level of −117.0 dBu, quieter than the original 4x 10 kΩ version by 11.9 dB. The small improvement we have gained indicates that the focus of noise reduction needs to be returned to the differential amplifier array, but the next step there would seem to be using eight amplifiers, which is not very appealing. Thoughts about ears of corn on chessboards tend to intrude at this point.

This is a good moment to pause and see what we have achieved. We have built a balanced input stage that is quieter than the standard circuit by 11.9 dB, using standard components of low cost. We have used increasing numbers of them, but the total cost is still small compared with enclosures, power supplies, etc. On the other hand, the power consumption is clearly several times greater. The technology is highly predictable and the noise reduction reliable; in fact bullet-proof, since it is based on mathematics it will work anywhere, anytime, with any opamp. The linearity is as good as that of a single opamp of the same type, and in the same way there are no HF stability problems.

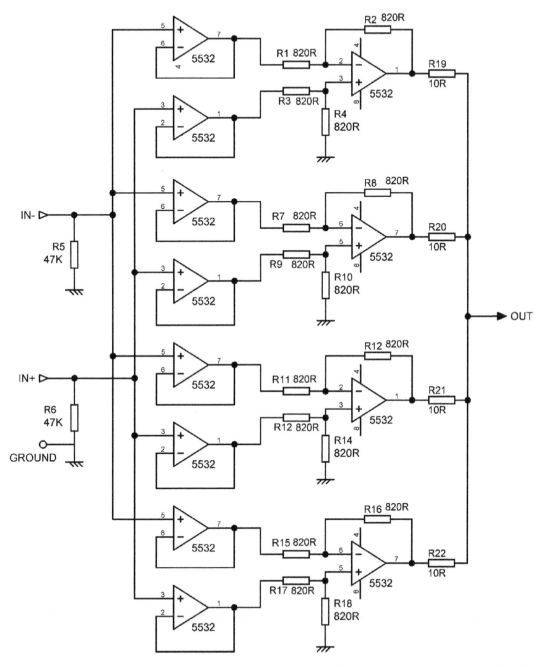

Figure 18.31 The final 5532 low noise unity-gain balanced input stage, with quad input buffers and four differential amplifiers. The noise output is only −117.0 dBu.

What we have not done is build a balanced input that is quieter than the unbalanced one—we are still 2.0 dB short of that target, but at least we have reached a point where the balanced input is not obviously noisier. The noise results are summarised in Table 18,12 at the end of the chapter.

Low-noise balanced inputs in action

Please don't think that this examination of low-noise input options is merely a voyage off into pure theory. It has real uses and has been applied in practice, for example in the Cambridge Audio 840W power amplifier, a design of mine which, I might modestly mention in passing, won a CES Innovation Award in January 2008. This unit has both unbalanced and balanced inputs, and conventional technology would have meant that the balanced inputs would have been significantly the noisier of the two. Since the balanced input is the 'premium' input, many people would think there was something amiss with this state of affairs. We therefore decided the balanced input had to be quieter than the unbalanced input. Using 5532s in an architecture similar to those outlined earlier, this requirement proved straightforwardly attainable, and the final balanced input design was both economical and quieter than its unbalanced neighbour by a dependable 0.9 dB. Two other versions were evaluated that made the balanced input quieter than the unbalanced one by 2.8 dB, and by 4.7 dB, at somewhat greater cost and complexity. These were put away for possible future upgrades.

The Signal Transfer Company [18] manufactures a low-noise balanced input card based on these principles which has 47 kΩ input impedances, unity gain, and a noise output of only −115 dBu.

Ultra low-noise balanced inputs

In the section on low-noise balanced inputs, we reclined briefly on our laurels, having achieved an economical balanced input stage with output noise at the extremely low level of −117.0 dBu. Regrettably this is still 2 dB noisier than a simple unbalanced input. It would be wrong to conclude from this that the resources of electronic design are exhausted. At the end of the noise reduction sequence we were aware that the dominant noise source was currently the differential amplifier array, and we shrank from doubling up again to use eight amplifiers because of issues of cost and the PCB area occupied. We will take things another step by taking a much more relaxed view of cost (as one does at the 'high-end') and see how that changes the game. We will, however, retain some concern about PCB area.

An alternative way to make the differential amplifier array quieter is simply to use opamps that are quieter. These will inevitably be more expensive—much more expensive—than the ubiquitous 5532. Because of the low resistor values around the opamps we need to focus on low-voltage noise rather than low current noise, and there are several that are significantly better than the 5532, as shown by the typical noise density figures in Table 18.11.

Clearly moving to the 5534A will give a significant noise reduction, but since there is only a single opamp per package, and external compensation is needed, the board area used will be much greater. Instead we will try the LM4562, a bipolar opamp which has finally surpassed the 5532 in performance. The input voltage noise density is typically 2.7 nV/√Hz, substantially lower than the

TABLE 18.11 Voltage and noise densities for low-noise balanced input opamp candidates

Opamp	Voltage noise density nV√Hz	Current noise density pA√Hz
5532	5	0.7
5534A	3.5	0.4
LM4562	2.7	1.6
AD797	0.9	2
LT1028	0.85	1

5 nV/√Hz of the 5532. For applications with low source impedances, this implies a handy noise advantage of 5 dB or more. The LM4562 is a dual opamp and will not take up more space. At the time of writing it is something like ten times more expensive than the 5532.

Step One: We replace all four opamps in the differential amplifiers with LM4562s. They are a drop-in replacement with no circuit adjustments required at all. We leave the quad 5532 input buffers in place. The noise output drops by an impressive 1.9 dB, giving an output noise level of −118.9 dBu, quieter than the original 4x 10 kΩ version by 14.1 dB, and only 0.1 dB noisier than the unbalanced stage.

Step Two: Replace the quad 5532 buffers with quad LM4562 buffers. Noise falls by only 0.6 dB, the output being −119.5 dBu, but at last we have a balanced stage that is quieter than the unbalanced stage, by a small but solid 0.5 dB.

One of the pre-eminent low-noise-with-low-source-resistance opamps is the AD797 from Analog Devices, which has a remarkably low-voltage noise at 0.9 nV/√Hz (typical at 1 kHz) but it is a very expensive part, costing between 20 and 25 times more than a 5532 at the time of writing. The AD797 has is a single opamp, while the 5532 is a dual, so the cost per opamp is actually 40 to 50 times greater, and more PCB area is required, but the potential improvement is so great we will overlook that.

Step Three: We replace all four opamps in the differential amplifiers with AD797s, putting the 5532s back into the input buffers in the hope that we might be able to save money somewhere. The noise output drops by a rather disappointing 0.4 dB, giving an output noise level of −119.9 dBu, quieter than the original 4x 10 kΩ version by 15.1 dB.

Perhaps putting those 5532s back in the buffers was a mistake? Our fourth and final move in this game of electronic chess is to replace all the quad 5532 input buffers with dual (not quad) AD797 buffers. This requires another four AD797s (two per input) and is once more not a cheap strategy. We retain the four AD797s in the differential amplifiers. The noise drops by another 0.7 dB yielding an output noise level of −120.6 dBu, quieter than the original 4x 10 kΩ version by 15.8 dB and quieter than the unbalanced stage by a satisfying 1.6 dB. You can do pretty much anything in electronics with a bit of thought and a bit of money.

You are probably wondering what happened to the LT1028 lurking at the bottom of Table 18.11. It is true that its voltage noise density is slightly better than that of the AD797, but there is a subtle snag. As described in Chapter 4, the LT1028 has bias-current cancellation circuitry which injects correlated noise currents into the two inputs. These will cancel if the impedances seen by the two

inputs are the same, but in moving-magnet amplifier use the impedances differ radically and the LT1028 is not useful in this application. The input conditions here are more benign, but the extra complication is unwelcome, and I have never used the LT1028 in audio work. In addition, it is a single opamp with no dual version.

This is not, of course, the end of the road. The small noise improvement in the last step we made tells us that the differential amplifier array is still the dominant noise source, and further development would have to focus on this. A first step would be to see if the relatively high current-noise of the AD797s is significant with respect to the surrounding resistor values. If so, we need to see if the resistor values can be reduced without degrading linearity at full output. We should also check the Johnson noise contribution of all those 820 Ω resistors; they are generating −123.5 dBu each at room temperature, but of course the partial cancellation effect applies to them as well.

All these noise results are also summarised in Table 18.12.

TABLE 18.12 A summary of the noise improvements made to the balanced input stage

Buffer type	Amplifier	Noise output	Improvement on previous version	Improvement over 4 x 10 kΩ diff amp	Noisier than unbal input by:
		dBu	dB	dB	dB
	5532 voltage-follower	−119.0			0.0 dB ref
None	Standard diff amp 10 k 5532	−104.8	0	0.0 dB ref	14.2
None	Single diff amp 820R 5532	−111.7	6.9	6.9	7.3
Single 5532	Single diff amp 820R 5532	−110.2	5.4	5.4	8.8
Single 5532	Dual diff amp 820R 5532	−112.5	2.3	7.4	6.5
Single 5532	Quad diff amp 820R 5532	−114.0	1.5	9.2	5.0
Dual 5532	Quad diff amp 820R 5532	−116.2	2.2	11.4	2.8
Quad 5532	Quad diff amp 820R 5532	−117.0	0.8	12.2	2.0
Quad 5532	Quad diff amp 820R LM4562	−118.9	1.9	14.1	0.1
Quad LM4562	Quad diff amp 820R LM4562	−119.5	0.6	14.7	−0.5
Quad 5532	Quad diff amp 820R AD797	−119.9	0.4	15.1	−0.9
Dual AD797	Quad diff amp 820R AD797	−120.6	0.7	15.8	−1.6

References

[1] Muncy, N. "Noise Susceptibility in Analog and Digital Signal Processing Systems." *JAES*, Vol. 3, No. 6, June 1995, p. 447

[2] Williams, T. *EMC for Product Designers*. Newnes (Butterworth-Heinemann) Pub, 1992, p. 176. ISBN 0 7506 1264 9

[3] Williams, T. *EMC for Product Designers*. Newnes (Butterworth-Heinemann) Pub, 1992, p. 173

[4] Winder, S. "What's The Difference?" *Electronics World*, Nov 1995, p. 989

[5] Graeme, J. *Amplifier Applications of Opamps*. McGraw-Hill, 1999, p. 16. ISBN 0-07-134643-0

[6] Birt, D. "Electronically Balanced Analogue-Line Interfaces." *Proceedings of the Institute of Acoustics Conference*, Windermere, UK, Nov 1990

[7] Fletcher, T. www.tfpro.com/phpbb/viewtopic.php?f=4&t=164 Accessed Jun 2019

[8] Self, D. "Preamplifier 2012." *Elektor*, Apr, May, June 2012

[9] Self, D. "A Low Noise Preamplifier with Variable-Frequency Tone Controls." *Linear Audio*, Vol. 5, 2013, pp. 141–162

[10] Jung, W., ed. *Op Amp Applications Handbook*. Newnes (Elsevier), 2006. ISBN 13 978-0-7506-7844-5; ISBN 10 0-7506-7844-5

[11] Self, D. *The Design of Active Crossovers*. Focal Press, 2011, p. 417. ISBN 978-0-240-81738-5

[12] Self, D. *The Design of Active*. Crossovers Focal Press, 2011, pp. 552–560. ISBN 978-0-240-81738

[13] Self, D. *Audio Power Amplifier Design*, 6th edition. Taylor & Francis, 2013, p. 142. ISBN 978-0-240-52613-3

[14] Whitlock, B. "A New Balanced Audio Input Circuit For Maximum Common-Mode Rejection in Real World Environments." *Preprint #4372 Presented at the 101st Convention of the Audio Engineering Society*, Los Angeles, CA, 8–11 Nov 1996

[15] Isrealsohn, J. www.thatcorp.com/datashts/A_Matter_of_Balance.pdf

[16] Whitlock, B. *US Patent No. 5,568,561*, 22 Oct 1996

[17] Zwicky, P. "Low-Distortion Audio Amplifier Circuit Arrangement." *US Patent No. 4,567,443*, 1986

[18] Signal Transfer Company. www.signaltransfer.freeuk.com/

Line outputs

Unbalanced outputs

There are only two electrical output terminals for an unbalanced output—signal and ground. However, the unbalanced output stage in Figure 19.1a is fitted with a three-pin XLR connector, to emphasise that it is always possible to connect the Cold wire in a balanced cable to the ground at the output end and still get all the benefits of common-mode rejection if you have a balanced input. If a two-terminal connector is fitted, the link between the Cold wire and ground has to be made inside the connector, as shown in Figure 18.2 in the chapter on line inputs.

The output amplifier in Figure 19.1a is configured as a unity-gain buffer, though in some cases it will be connected as a series feedback amplifier to give gain. A non-polarised DC-blocking capacitor C1 is included; 100 uF gives a −3 dB point of 2.6 Hz with one of those notional 600 Ω loads. The opamp is isolated from the line shunt capacitance by a resistor R2, in the range 47–100 Ω, to ensure HF stability, and this unbalances the Hot and Cold line impedances. A drain resistor R1 ensures that no charge can be left on the output side of C1; it is placed *before* R2, so it causes no attenuation. In this case the loss would only be 0.03 dB, but such errors can build up to an irritating level in a large system, and it costs nothing to avoid them.

If the Cold line is simply grounded as in Figure 19.1a, then the presence of R2 degrades the CMRR of the interconnection to an uninspiring −43 dB even if the balanced input at the other end of the cable has infinite CMRR in itself and perfectly matched 10 kΩ input impedances.

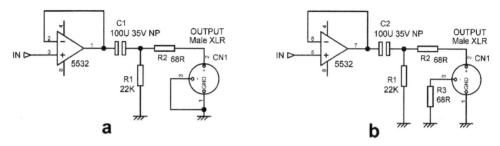

Figure 19.1 Unbalanced outputs: a) simple output, and b) impedance-balanced output for improved CMRR when driving balanced inputs.

DOI: 10.4324/9781003332985-19

To fix this problem, Figure 19.1b shows what is called an impedance-balanced output. There are now three physical terminals, Hot, Cold, and ground. The Cold terminal is neither an input nor an output, but a resistive termination R3 with the same resistance as the Hot terminal output impedance R2. If an unbalanced input is being driven, this Cold terminal can be either shorted to ground locally or left open-circuit; it makes no difference. The use of the word "balanced" is perhaps unfortunate as when taken together with an XLR output connector it implies a true balanced output with anti-phase outputs, which is absolutely *not* what you are getting. The impedance-balanced approach is not particularly cost-effective, as it requires significant extra money to be spent on an XLR connector. Adding an opamp inverter to make it a proper balanced output costs little more, especially if there happens to be a spare opamp half available, and it sounds much better in the specification.

Zero-impedance outputs

Both the unbalanced outputs shown in Figure 19.1 have series output resistors to ensure stability when driving cable capacitance. This increases the output impedance, which can impair the CMRR of a balanced interconnection and can also lead to increased crosstalk via stray capacitance in some situations. One such scenario that was fixed by the use of a so-called 'zero-impedance' output is described in Chapter 22 in the section on mixer insert points. Another reason to use as low an output impedance as possible is that many professional audio inputs are protected against overvoltage by clamping diodes at the input terminals. These have non-linear capacitance, and if they are not driven from low impedances distortion can be introduced. There is more on this in Chapter 18 on line inputs.

The output impedance is of course not exactly zero, but it is very low compared with the average series output resistor; it can easily be below 1 Ω over most of the audio band.

Figure 19.2a shows how the zero-impedance technique is applied to an unbalanced output stage with 10 dB of gain. Feedback at audio frequencies is taken from outside isolating resistor R3 via R2, while the HF feedback is taken from inside R3 via C2 so it is not affected by load capacitance and stability is unimpaired. Using a 5532 opamp, the output impedance is reduced from 68 Ω to

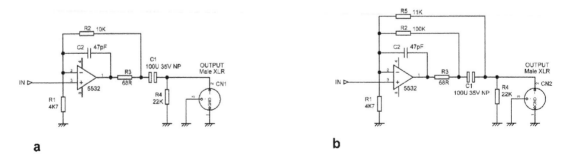

a b

Figure 19.2 Amplifiers with zero-impedance output. a) simple; b) with NFB around output capacitor.

0.24 Ω at 1 kHz—a dramatic reduction that would reduce capacitive crosstalk by 49 dB. Output impedance increases to 2.4 Ω at 10 kHz and 4.8 Ω at 20 kHz as opamp open-loop gain falls with frequency. The impedance-balancing resistor on the Cold pin has been replaced by a link to match the near-zero output impedance at the Hot pin. More details on zero-impedance outputs are given later in this chapter in the sections on balanced outputs.

There is no need for the output stage to have voltage gain for this to work, just a way to transfer the negative feedback point from outside to inside the series output resistor. Figure 19.3 shows versions in which a unity-gain voltage-follower is used.

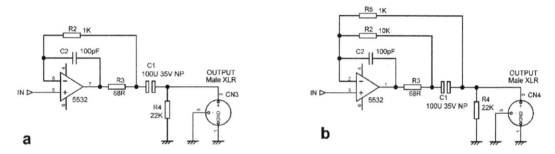

Figure 19.3 Voltage-followers with zero-impedance output. a) simple; b) with negative feedback around output capacitor.

The quickest way to measure normal output impedances is to load each output as heavily as is practical (say with 560 Ω) and measure the voltage drop compared with the unloaded state. From this the output impedance is simply calculated. However, in the case of zero-impedance outputs the voltage drop is very small and so measurement accuracy is poor.

A more sophisticated technique is the injection of a test signal current into the output and measuring the voltage that results. This is much more informative; the results for the Hot output in Figure 19.3a are given in Figure 19.4. A suitable current to inject is 1 mA RMS, defined by applying 1 Vrms to a 1 kΩ injection resistor. A 1 Ω output impedance will therefore give an output signal voltage of 1 mVrms, (−60 dBV) which can be easily measured; see Figure 19.4. Likewise −40 dBV represents 10 Ω, and −80 dBV represents 0.1 Ω; a log scale is useful because it allows a wide range of impedance to be displayed and gives convenient straight lines on the plot. The opamp sections were both LM4562.

Below 3 kHz the impedance increases steadily as frequency falls, doubling with each octave due to the reactance of the output capacitor. This effect can be reduced simply by increasing the size of the capacitor. In Figure 19.4 the results are shown for 220 uF, 470 uF, and 1000 uF output capacitors. For 1000 uF a broad null occurs reaching down to 0.03 Ω, and the output impedance is below 1 Ω between 150 Hz and 20 kHz. Bear in mind that output capacitors should be non-polarised types, as they may face external DC voltages of either polarity and should be rated at no less than 25 V; this means that a 1000 uF capacitor can be quite a large component.

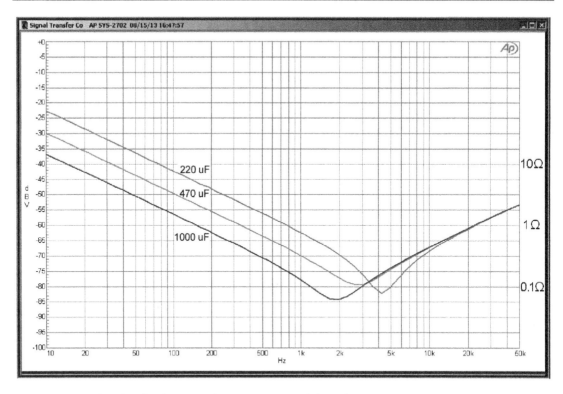

Figure 19.4 The signal voltage at the Hot output of the voltage-follower for 1mA RMS injection current and the output impedance modulus (in Ω). Three values of output capacitor 5532 R2 = 1 k Ω, C2= 100 pF.

In Figure 19.4 the modulus of the output impedance falls to below 0.1 Ω between 1 and 5 kHz. It is easy to assume that the steady rise above the latter frequency is due to the open-loop gain of the opamp falling as frequency increases, and indeed I did, until recently. However, an apparent anomaly in some measured results (it was Isaac Asimov who said that most scientific advances start with "hmmm . . . that's funny . . ." rather than "Eureka!") where a two-times change in noise gain (see the balanced output sections) gave identical output impedance plots, led me to dig a little deeper.

Figure 19.5 shows the output impedance with the output blocking capacitor removed; R2 is 1 k Ω.

I'm not entirely sure that the line at the bottom for no C at all should be dead flat, but at any rate the point is illustrated.

Figure 19.6 shows the effect of adding a 10 pF capacitor across the external compensation pins of the 5534. Now the 0 pF and 1 pF curves are close to that for 10 pF, but the 100 pF curve is still ten times higher. When this simulation is repeated using a TL072 (which has less open loop gain in the HF region) the curves are much closer together and the 100 pF passes through −60 dB at 10 kHz instead of −68 dB, so here the HF open-loop gain of the opamp really does define the

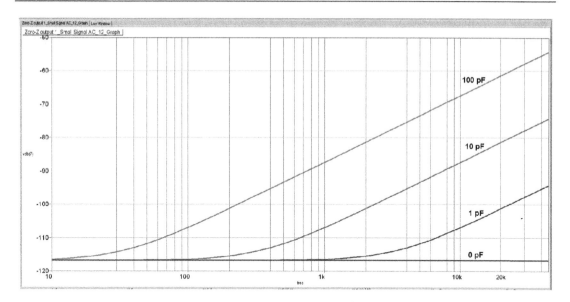

Figure 19.5 Output impedance with uncompensated 5534 varying C2.

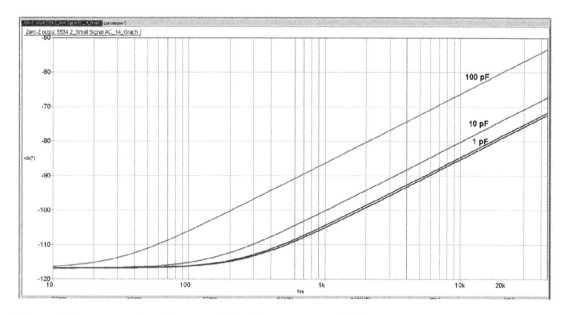

Figure 19.6 Output impedance with 10 pF-compensated 5534.

situation. Historically many output amplifiers were built with TL072s, due to the higher cost and power consumption of the 5534/2, but the values used were frequently R = 10 kΩ and C = 100 pF, so then the transition frequency between the feedback paths was still the defining factor for the HF output impedance.

The voltage-follower in Figure 19.3a is known to be stable with R = 1 k and C =100 pF; this gives an output impedance of 10 Ω at 20 kHz. While making C = 10 pF gives a useful reduction to 0.2 Ω, its stability needs to be checked. We will use 100 pF from here on.

We will now put back the output blocking capacitor and examine the output impedance at the low-frequency end. The situation is simpler at LF because the components are of known value (apart from the usual manufacturing tolerances) and performance is not significantly affected by variable opamp parameters.

Figure 19.7 shows the radical effect; the LF output impedance is now much higher and as expected, doubles for every halving of frequency. The middle trace is for an output capacitor of 470 uF which for size reasons (as a non-polarised electrolytic it is larger than the usual polarised sort) is probably the highest value you would want to use in practice; note how accurately it matches the measured impedance result for 470 uF in Figure 19.4. The 5534 is now uncompensated as it gives a better match of HF open-loop gain with the 5532s or LM4562s that will be used in practice

The voltage at 50 Hz, the lowest frequency of interest, is −44 dB, equivalent to an output impedance of 6.3 Ω, which is much higher than the impedance set by the opamp, and some way distant from zero-impedance. We can use a 1000 uF output capacitor instead, which reduces the output impedance at 50 Hz to 3.1 Ω, but the capacitor is now distinctly bulky. From here on we will stick with 470 uF.

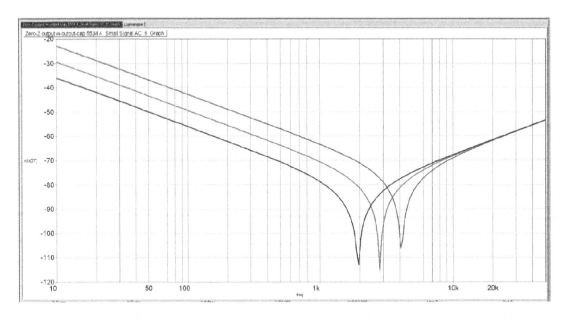

Figure 19.7 Output impedance with output cap 220, 470, and 1000 uF. 5534 R2 = 1 kΩ, C2 = 100 pF.

What do we do now if we want a lower LF output impedance? As is so often the case, in electronics as in life, you can use either brawn (big capacitors) or brains. The latter, once

again as is so often true, is the cunning application of negative feedback. The essence of the zero-impedance technique is to have two NFB paths, with one enclosing the output resistor, which could be called double-feedback. If we add a third NFB path, as in Figure 19.3b, then we can enclose the output capacitor as well and reduce the effects of its reactance; we'll call this triple-feedback. Figure 19.8 shows the dramatic results. The output impedance at 50 Hz drops from 6.3 Ω to 0.63 Ω, which has a much better claim to be zero-impedance. This ten-fold improvement continues up to about 400 Hz, where the triple-feedback output impedance plummets into a cancellation crevasse. We still get a useful reduction up to 2 kHz, but above that the double-feedback circuit has its own crevasse. As expected, the output impedances at HF are the same.

In Chapter 2 we saw how electrolytic coupling capacitors can introduce distortion even if the time-constant is long enough to give a flat LF response. In Figures 19.2b and 19.3b most of the feedback is now taken from outside C1, via R5, so it can correct capacitor distortion. The DC feedback goes via R2, now much higher in value, to maximise the negative feedback, and the HF feedback goes through C2 as before to maintain stability with capacitive loads. In Figure 19.2b R2 and R5 in parallel come to 10 kΩ so the gain is unchanged compared with the original version. In Figure 19.3b the gain is always unity, and the choice for the outer NFB path R5 as 1 kΩ and the middle path R2 as 10 kΩ is made simply on the grounds that the outer path has to overpower the middle path at low frequencies. There is the snag that the output is no longer DC-blocked because of the presence of R5. Figure 19.9 demonstrates the effect of varying R2; the higher it is the lower the output impedance at LF.

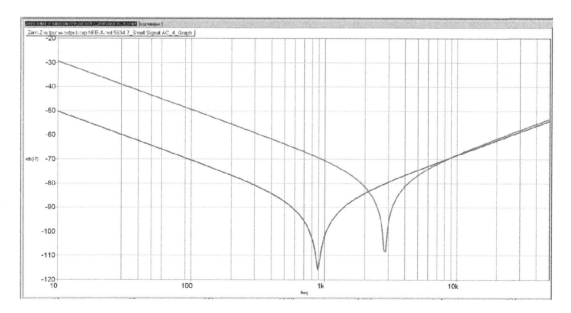

Figure 19.8 Output impedance with and without negative feedback around an output cap of 470 uF. 5534 R5 = 1 k, R2 = 10 k, C = 100 pF.

Any circuit with separate DC and AC feedback paths must be checked carefully for frequency response irregularities, which may happen well below 10 Hz. While simulator tests are very useful, real measurements are highly desirable in case there are issues with HF stability. At very low frequencies a function generator is more useful than an audio test set for this as their minimum output frequency is often 0.1 Hz. Another approach is to scale down all the capacitors by a factor of ten or 100 times so a conventional audio analyser can be used.

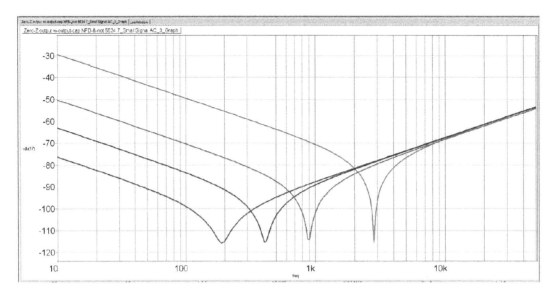

Figure 19.9 Output impedance with and without negative feedback around an output cap of 470 uF. Opamp = 5534, R5 = 1 k, R2 = 10 k, 47 k, 220 k, infinity. C = 100 pF.

The triple-feedback method has another advantage; it radically extends the frequency response, as it effectively multiplies the value of the output capacitor. A 470 uF output capacitor with a 600 Ω load (a largely fictitious worst case) has a −3 dB roll-off at 0.58 Hz; this is what we get with double feedback. The roll-off frequency is deliberately made very low to avoid capacitor distortion (see Chapter 2).

With triple-feedback as in Figure 19.3b, the −3 dB point drops to 0.035 Hz, which is lower than we need or want. This leads to the interesting speculation that we could reduce the output capacitor to 47 uF and still get satisfactory results for frequency response. I haven't tried this, and I am not sure what would happen with the capacitor distortion issue.

Since wiring resistances internal to the equipment are likely to be in the region 0.1 to 0.5 Ω there seems nothing much to be gained by reducing the output impedances any further than is achieved by this simple zero-impedance technique.

You may be thinking that the zero-impedance output is a bit of a risky business; will it always be stable when loaded with capacitance? In my wide experience of this technique, the answer

is yes, so long as you design it properly. If you are attempting something different from proven circuitry, it is always wise to check the stability of zero-impedance outputs with a variety of load capacitances. The stability of the circuits here was checked using a 5 Vrms sweep from 50 kHz to 10 Hz, with load capacitances of 470 pF, 1 nF, 2n2, 10 nF, 22 nF, and 100 nF. At no point was there the slightest hint of HF or LF instability. A load of 100 nF is, of course, grossly excessive compared with real use, being equivalent to about 1000 metres of average screened cable, and curtails the output swing at HF.

Ground-cancelling outputs: basics

This technique, also called a ground-cancel output or a ground-compensated output, appeared in the early 1980s in mixing consoles. It allows ground voltages to be cancelled out even if the receiving equipment has an unbalanced input; it prevents any possibility of creating a phase error by miswiring; it costs virtually nothing except for the provision of a three-pin output connector.

Ground-cancelling (GC) separates the wanted signal from the unwanted ground voltage by addition at the output end of the link, rather than by subtraction at the input end. If the receiving equipment ground differs in voltage from the sending ground, then this difference is added to the output signal so that the signal reaching the receiving equipment has the same ground voltage superimposed upon it. Input and ground therefore move together, and the ground voltage has no effect, subject to the usual effects of component tolerances. The connecting lead is differently

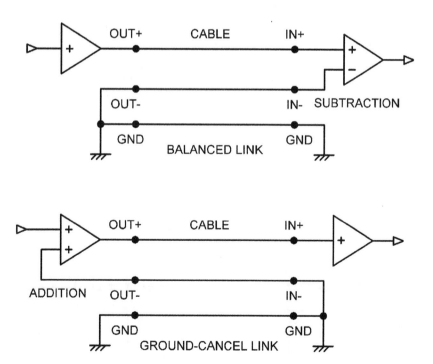

Figure 19.10 **A balanced link uses subtraction at the receiving end to null ground noise, while a ground-cancel link uses addition at the sending end.**

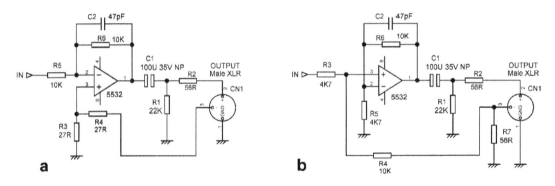

Figure 19.11 **a) Inverting ground-cancelling output; b) non-inverting ground-cancelling output.**

wired from the more common unbalanced-out balanced-in situation, as now the Cold line is to be joined to ground at the *input* or receiving end. This is illustrated in Figure 19.10, which compares a conventional balanced link with a GC link.

An inverting unity-gain ground-cancel output stage is shown in Figure 19.11a. The Cold pin of the output socket is now an input and has a unity-gain path summing into the main signal going to the Hot output pin to add the ground voltage. This path R3, R4 has a very low input impedance equal to the Hot terminal output impedance so if it *is* used with a balanced input, the line impedances will be balanced, and the combination will still work effectively. The 6 dB of attenuation in the R3-R4 divider is undone by the gain of two set by R5, R6. It is unfamiliar to most people to have the Cold pin of an output socket as a low impedance input, and its very low input impedance minimises problems caused by miswiring. Shorting it locally to ground merely converts the output to a standard unbalanced type. On the other hand, if the Cold input is left unconnected then there will be a negligible increase in noise due to the very low resistance of R3.

This is the most economical GC output and is very useful to follow an inverting summing amplifier in a mixer as it corrects the phase. However, a phase inversion is not always convenient, and Figure 19.11b shows a non-inverting GC output stage with a gain of 6.6 dB. R5 and R6 set up a gain of 9.9 dB for the amplifier, but the overall gain is reduced by 3.3 dB by attenuator R3, R4. The Cold line is now terminated by R7, and any signal coming in via the Cold pin is attenuated

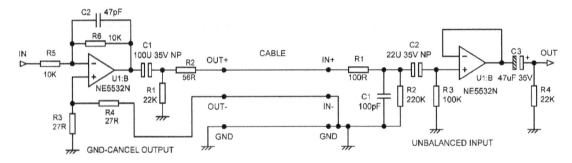

Figure 19.12 **The complete circuit of a GC link using an inverting ground-cancel output.**

by R3, R4 and summed at unity gain with the input signal. The stage must be fed from a very low impedance, such as an opamp output, for this to work properly. There is a slight compromise on noise performance here because attenuation is followed by amplification.

Figure 19.12 shows the complete circuit of a GC link using an inverting ground-cancel output stage. EMC filtering and DC-blocking are included for the unbalanced input stage.

Ground-cancelling outputs: zero-impedance output

Ground-cancelling outputs can also be made zero-impedance using the techniques described earlier; one version is shown in Figure 19.13. It is assumed that the stage is driven from a low impedance so R1 and R4 give the correct attenuation for cancellation.

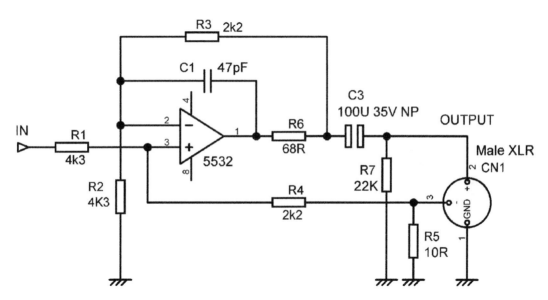

Figure 19.13 A ground-cancel output with zero-impedance output.

You may have probably already spotted a possible snag. The Hot output impedance is very close to zero, but the Cold input impedance R5 is 10 Ω, chosen so that it does not unduly attenuate the signal coming in, which probably arrives via a Cold wire that is unlikely to have a resistance of less than 0.1 Ω. That is going to limit the Ground-Cancel Rejection Ratio or GCRR to about 40 dB. What to do? Reducing R5 will make the reading of the ground signal at the receiving end less accurate. In fact there is not a problem here because a ground-cancel link, unlike a balanced link, does not need equal Hot and Cold line impedances to function optimally. If the error introduced by the 10 Ω value of R5 is too great, there is the possibility of adding a unity-gain buffer between the Cold pin and R4; this would allow a very high input impedance on the Cold input but would inevitably compromise the noise performance. I have never had cause to try this out in practice.

Ground-cancelling outputs: CMRR & GCRR

In a balanced link, the CMRR is a measure of how accurately the subtraction is performed at the receiving end and so how effectively ground noise is nulled. A GC link also has an equivalent CMRR that measures how accurately the addition is performed at the sending end. Figure 19.14 shows (for the first time, I think) how to measure the CMRR of a ground-cancelling link. It is slightly more complicated than for the balanced case. A better term is Ground-Cancel Rejection Ratio or GCRR.

In Figure 19.14, a 10 Ω resistor R17 is inserted into the ground of the interconnection. This allows the signal generator to move the output ground of the sending amplifier up and down with respect to the global ground, via R18. Quite a lot of power has to be supplied so that R17 can be kept low in value.

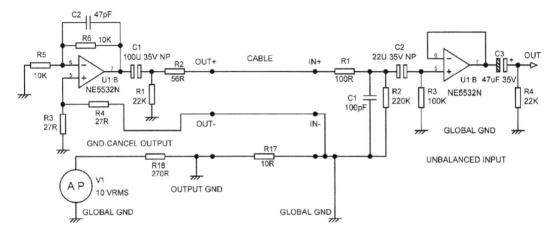

Figure 19.14 Measuring the GCRR of a GC link by inserting resistor R17.

If the send amplifier is working properly, the signal applied to OUT– will cancel the signal on the output ground, so that as far as the input of the receiving amplifier is concerned, it does not exist. Be clear that here we are measuring the GCRR of the sending amplifier, not the CMRR of the receiving amplifier.

Just as the CMRR of a balanced link depends on the accuracy of the resistors and the open-loop gain of the opamp in the receiving amplifier, the same parameters determine the GCRR of a ground-cancel send amplifier. The measured results from the arrangement in Figure 19.14 are given in Figure 19.15; the GCRR as built (with 1% resistors) was –50 dB, flat up to 10 kHz. The two lower traces were obtained by progressively trimming the value of R6 to minimise the output. If high GCRR is required a preset adjustment can be used, just as in balanced line input amplifiers.

Ground-cancelling outputs are an economical way of making ground loops innocuous when there is no balanced input, and it is rather surprising they are not more popular; perhaps it is because people

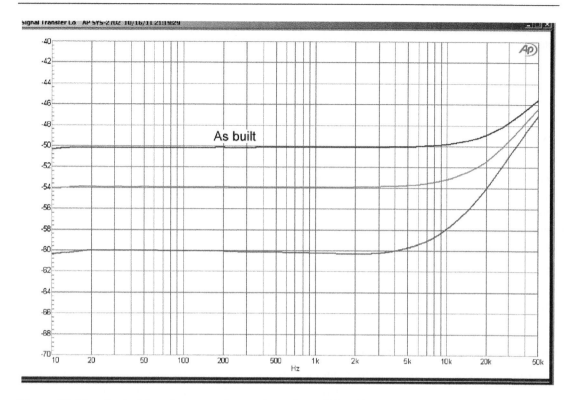

Figure 19.15 Optimising the ground-cancel send amplifier CMRR.

find the notion of an input pin on an output connector unsettling. In particular GC outputs would appear to offer the possibility of a quieter interconnection than the standard balanced interconnection because a relatively noisy balanced input is not required; see Chapter 18 on line inputs.

Ground-cancelling outputs: send amplifier noise

In Figure 19.14, the gain-setting resistors R5 and R6 have the relatively high value of 10 kΩ, for comparison with the 'standard' balanced input amplifier made with four 10 kΩ resistors. Reducing their value in accordance with the principles of low-impedance design gives useful reductions in noise, as shown in Table 19.1. A 5532 opamp was used.

TABLE 19.1 GC output noise improvement by reducing the value of R5, R6 (5532 opamp)

Value of R5, R6	Noise output	Improvement
10 kΩ	−107.2 dBu	0.0 dB
2k2	−111.3 dBu	−4.1 dB
1 kΩ	−112.2 dBu	−5.0 dB
560 Ω	−112.6 dBu	−5.4 dB

A very useful 4.1 dB reduction in noise is gained by reducing R5 and R6 to 2k2, at zero cost, but after that the improvements become smaller, for while Johnson noise and the effects of current noise are reduced, the voltage noise of the opamp is unchanged.

It is instructive to compare the signal/noise ratio with that of a balanced link. We will put 1 Vrms (+2.2 dBu) down a balanced link. The balanced output stage raises the level by 6 dB, so we have +8.2 dBu going down the cable. A conventional unity-gain balanced input made with 10 kΩ resistors and a 5532 section has a noise output of −104.8 dBu, so the signal/noise ratio is 8.2 + 104.8 = −113.0 dB.

In the ground-cancel case, if we use 1 kΩ resistors as in the third row of Table 19.1, the noise from the ground-cancel output stage is −112.2 dBu. Adding the noise of the 5532 buffer at the receiving end in Figure 19.14, which is −125.7 dBu, we get −112.0 dBu as the noise floor. The signal/noise ratio is therefore 2.2 + 112.0 = −114.2 dB. This is 1.2 dB quieter than the conventional balanced link, and it only uses two opamp sections instead of three.

The noise situation could easily be reversed by using a low-impedance balanced input with buffers to make the input impedance acceptably high, as described in Chapter 18, but we are then comparing a ground-cancel link using two opamp sections with a balanced link using four.

Ground-cancelling outputs: into a balanced input

The whole point of a ground-cancelling output is to make the use of balanced inputs unnecessary. However, life being what it is, sooner rather than later someone will plug a GC output into a balanced input. What will happen? At first there appears to be a danger that the ground-noise voltage will be subtracted twice, which will of course be equivalent to putting it back in anti-phase and gaining us absolutely nothing. In fact this is not the case, though the cancellation accuracy is compromised compared with the impedance-balanced case; the CM rejection will not exceed 46 dB, even with perfect resistor matching throughout. The situation is illustrated in Figure 19.16.

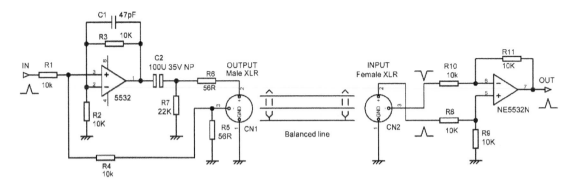

Figure 19.16 **Ground-cancel output connected to a conventional balanced input amplifier.**

When a ground-cancelling output is connected to a balanced input, the Hot balanced input is driven in the usual way, while the Cold input is connected to the sending ground via resistor R5. The high impedance of the Cold balanced input means that virtually no current flows through R5

as a result of ground voltages and so there is no ground-cancelling. The balanced input works as usual and will subtract the ground voltage from the Hot signal, but unless the ground-cancelling output impedance R6 is the same as the ground-cancel input resistance R5; the line impedances will be unequal and therefore will limit the CMRR, as noted earlier. The output and input impedances of a ground-cancelling output do not have to be the same for the ground-cancel to work, so it is unwise to assume they are. Since there will be unpredictable reductions in CMRR, it is wisest not to connect a ground-cancelling output to a balanced input, but it will work.

Ground-cancelling outputs: history

I first became aware of the ground-cancelling concept in the mid-1980s, when it appeared on some mixing consoles made in the United States. However, as is so often the case, you find out an idea is much older than you think. A ground-cancelling output was used in the dbx-160 compressor/limiter, which appeared in 1971. The instruction manual contained the following description:

"When the output is connected to an unbalanced load, special circuits in the 160's output stage sense any ground-loop current (hum). The ground-loop compensation then applies a precise correction signal to the 160 output, at the proper level and phase to reduce hum in the output signal by up to 40 dB."

I think it's clear that describes a ground-cancelling output. I would be glad to hear of any earlier use of the idea.

Balanced outputs: basics

Figure 19.17a shows a balanced output, where the Cold terminal carries the same signal as the Hot terminal but phase-inverted. This can be arranged simply by using an opamp stage to invert the normal in-phase output. The resistors R3, R4 around the inverter should be as low in value as possible to minimise Johnson noise and the effects of current noise because this stage is working at a noise gain of two, but bear in mind that R3 is effectively grounded at one end, and its loading, as well as the external load, must be driven by the first opamp. A unity-gain follower is shown for the first amplifier, but this can be any other shunt or series feedback stage as convenient. The feed to the inverter could also be taken from before the first amplifier.

The inverting output if not required can be ignored; it must *not* be grounded because the inverting opamp will then spend most of its time clipping in current limiting, probably injecting unpleasant distortion into the grounding system. Both Hot and Cold outputs must have the same output impedances (R2, R6) to keep the line impedances balanced and the interconnection CMRR maximised.

A balanced output has the advantage that the total signal level on the line is increased by 6 dB, which will improve the signal-to-noise ratio if a balanced input amplifier is being driven, as they are relatively noisy. It is also less likely to crosstalk to other lines even if they are unbalanced, as the currents injected via the stray capacitance from each line will tend to cancel; how well this works depends on the physical layout of the conductors. All balanced outputs give the facility of

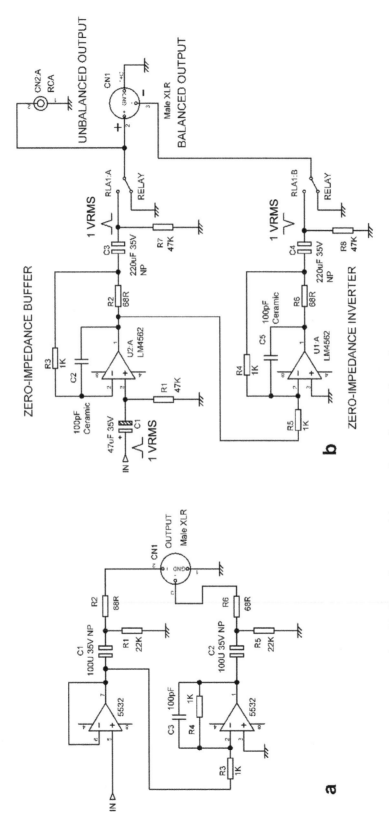

Figure 19.17 a) A conventional balanced output; b) a zero-impedance balanced output.

correcting phase errors by swapping Hot and Cold outputs. This is, however, a two-edged sword because it is probably how the phase got wrong in the first place.

There is no need to worry about the exact symmetry of level for the two output signals; ordinary tolerance resistors are fine. Such gain errors only affect the signal-handling capacity of the interconnection by a small amount. This simple form of balanced output is the norm in hifi balanced interconnection but is less common in professional audio, where the quasi-floating output described later in this chapter gives more flexibility.

Balanced outputs: output impedance

The balanced output stage of Figure 19.17a has an output impedance of 68 Ω on both legs because this is the value of the series output resistors; however, as noted earlier, the lower the output impedance the better, so long as stability is maintained. This balanced output configuration can be easily adapted to have two zero-impedance outputs, as shown in Figure 19.17b. The unity-gain buffer that drives the Hot output is as described earlier. The zero-impedance inverter that drives the Cold output works similarly, but with shunt negative feedback via R4. This diagram also shows the use of two sets of relay contacts for the muting of a balanced input.

The output impedance plot for the Cold output was identical to that of Figure 19.3a. This came as rather a surprise as the inverter here works at a noise gain of two times, as opposed to the Figure 19.3a buffer which works at a noise gain of unity, and so I expected it to show twice the output impedance above 5 kHz. This observation prompted me to investigate the effect of the feedback capacitor value, as described earlier.

Balanced outputs: noise

The noise output of the zero-impedance balanced output of Figure 19.17b was measured with 0 Ω source resistance, RMS response, unweighted; measured at two bandwidths to demonstrate the absence of hum; the opamp sections were both LM4562. See Table 19.2.

Bear in mind that the signal on the balanced output at is twice the level seen on just the Hot output, so the balanced results actually give a 6 dB better signal/noise ratio.

We will now look at the noise behaviour of a complete balanced link as in Figure 19.18a. As we saw in Chapter 18 on line inputs, the conventional balanced input amplifier made with a 5532

TABLE 19.2 Noise output of the zero-impedance balanced output of Figure 19.17b

Output	Noise out	Bandwidth
Hot output only	−113.5 dBu	(22–22 kHz)
Hot output only	−113.8 dBu	(400–22 kHz)
Balanced output (Hot and Cold)	−110.2 dBu	(22–22 kHz)
Balanced output (Hot and Cold)	−110.5 dBu	(400–22 kHz)

section and four 10 kΩ resistors is relatively noisy, and it is certainly the noisiest part of the balanced link shown here. The noise from this input amplifier alone is −105.1 dBu. We therefore expect that doubling the total level on the line by using a balanced output would give us a definite noise advantage approaching 6 dB.

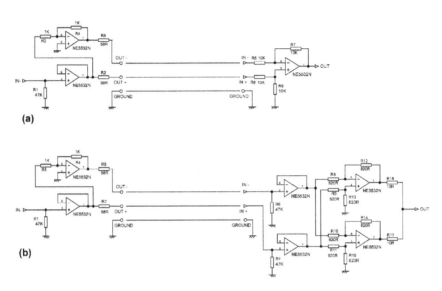

(a)

(b)

Figure 19.18 Balanced links: (a) with standard 0–1 balanced input amplifier; (b) with low-noise 1–2 configuration balanced input amplifier.

Assume the input voltage is 1 Vrms (+2.2 dBu). With the link balanced, the output level is 2 Vrms (+8.2 dBu), and with the signal switched off the output noise is −104.5 dBu. If the Cold line is then disconnected from the balanced output inverter and grounded instead, the output level drops to 1 Vrms (+2.2 dBu), but the output noise only falls slightly to −105.1 dBu. The signal/noise ratio of the link in balanced output mode is therefore 2.2 + 6 + 104.5 = 112.7 dB, but in unbalanced output mode is 2.2 + 105.1 = 107.3 dB, which is 5.4 dB worse.

Using a balanced output has thus improved the dynamic range of the whole link by a very useful 5.4 dB despite the extra noise from the balancing inverter which is greater than that of the output voltage-follower, as it is working at a noise gain of +6 dB. The noise from the balancing inverter alone (ie with R3 grounded) measured −115.1 dBu; this is well below the noise generated by the input amplifier, and so its contribution to the total noise is very small.

But supposing we don't want 2 Vrms at the output of the link? The 6 dB greater level may cause a headroom bottleneck. The 2x gain can be undone by halving the values of R7, R9 in the input amplifier, making them 5 kΩ. The output noise is now reduced to −108.6 dBu in balanced mode and −108.7 dBu unbalanced mode. You will note that the noise output has *not* dropped by a whole 6 dB. In balanced mode the signal/noise ratio of the link is now 2.2 + 108.6 = 110.8 dB, and in unbalanced mode it is 2.2−6 + 108.7 = 104.9 dB. The signal/noise ratios have fallen because the noise from the balanced input amplifier is more significant, but for the same reason the advantage

gained by utilising the balanced output inverter has increased from 5.4 to 5.9 dB. It cannot, of course, exceed 6 dB. The improvement occurs because we have reduced the gain of the balanced input amplifier that is the noisiest part of the link.

The chapter on line inputs explores ways of making a balanced input amplifier quieter. What happens if we use one of them? Figure 19.18b shows the same balanced output connected to a 1–2 format low noise input amplifier (ie each input has 1 buffer driving 2 parallel amplifiers). The noise from the input amplifier alone is reduced to −113.2 dBu, a handy improvement of 8.1 dB

With the link in balanced mode the overall noise output is −109.8 dBu, and in unbalanced mode there is now a significant drop to −113.1 dBu. The signal/noise ratio of the link in balanced output mode is now therefore 2.2 + 6 + 109.8 = 118.0 dB, but in unbalanced output mode is 2.2 + 113.1.1 = 115.3 dB, which is only 2.7 dB worse. As we would expect, the lower the noise from the input amplifier, the less benefit is gained by doubling the level in the link with fully balanced output.

It is an inherent problem with a balanced link of this kind that running it unbalanced causes a 6 dB drop in level, and it may be necessary to arrange for extra reserve gain in the system to allow for this.

Economical −6 dB balanced output

Quite recently the need arose in one of my consultancy projects for a balanced output that attenuated by 6 dB. To put another way, the usual +6 dB of gain you get with a standard balanced output is reduced to unity. Even more attenuation may be needed sometimes to reduce an elevated internal level to that intended for the outside world; this is particularly applicable to active crossovers.

The obvious way to do it is seen in Figure 19.19a. The inverting stage uses shunt feedback so its gain is reduced to −6 dB by making R1 twice the value of R3; no problem there. But the non-inverting stage uses series feedback and so cannot have a gain of less than unity; it is therefore

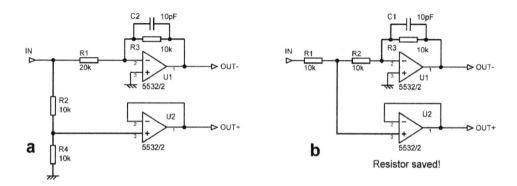

Figure 19.19 **(a) Standard balanced −6 dB output amplifier; (b) balanced −6 dB output amplifier saving a resistor.**

necessary to use the 6 dB attenuator R2, R4. The resistor values used here assume that the circuit should not present too heavy a load on the previous stage.

Looking at Figure 19.19a, it occurred to me, why put in a 6 dB attenuator when the halved signal you want is already there—halfway along R1. Since trying to make taps into the middle of physical resistors is not a sensible pursuit, R1 is split into R1 and R2, as in Figure 19.19b and we have saved a resistor. Not a radical cost reduction perhaps, but worth having if there is no downside. We have also increased the input impedance of the circuit from 10 kΩ to 20 kΩ, which may be useful if loading of the previous stage is an issue.

One possible snag presented itself. In Figure 19.19a the noise currents from the opamp inputs are quite separate and their effect easily calculated. But I anticipated that in Figure 19.19b the noise current from U2 will flow in R1 and R2, making U1 noisier. Likewise the noise current from U1 flowing in R1 and R2 will increase the noise output from U2. This is exactly what happens; see Table 19.3 The noise on both outputs has increased; by more on the + output.

TABLE 19.3 Noise measurements of the economical balanced output (22–22 kHz RMS)

Resistors	+ output dBu	– output dBu	Balanced output dBu
4	−114.0	−109.4	−106.6
3	−112.9	−108.7	−106.5

But . . . this is a balanced output. What has happened to the balanced output noise, ie that measured between the two outputs? As the rightmost column of Table 19.3 shows, it has barely altered; 0.1 dB is at the limits of noise measurement. This is because the extra noise generated by the current noise flowing in the shared resistors is common-mode and so does not contribute to a balanced noise measurement.

Naturally, if it is likely that the output will be used in unbalanced mode a lot, the extra 1.1 dB of noise is unwelcome. But bear in mind that these noise levels are so low that it is almost certain that the noise from upstream will swamp them entirely.

There is nothing magic about 6 dB of attenuation; with suitable resistor changes you can have any amount of attenuation you want, including fully-off (pointless, I know). The stage does not require to be driven from a low-impedance; as the junction between R1 and R2 will always tap off the correct fraction of the signal required.

The information given here is used with the full permission of the client concerned.

Quasi-floating outputs

The purely electronic output stage in Figure 19.20 emulates a floating transformer winding; if both Hot and Cold outputs are driving signal lines, then the outputs are balanced, as if a centre-tapped output transformer were being used, though clearly the output is not galvanically isolated

from ground. If, however, the Cold output is grounded, the Hot output doubles in amplitude so the total level hot-to-cold is unchanged. This condition is detected by the current-sensing feedback taken from the outside of the 75 Ω resistor R10, and the current driven into the shorted Cold output is automatically reduced to a low level that will not cause problems.

Similarly, if the Hot output is grounded, the Cold output doubles in amplitude and remains out of phase; the total hot-cold signal level is once more unchanged. This system has the advantage that it can give the same level into either a balanced or unbalanced input, given an appropriate connector at the input end. 6 dB of headroom is, however, lost when the output is used in unbalanced mode. It is most useful in recording studios where various bits of equipment may be temporarily connected; it is of less value in a PA system with a fixed equipment line-up.

When an unbalanced output is being driven, the quasi-floating output can be wired to work as a ground-cancelling connection, with rejection of ground noise no less effective than the true balanced mode. This requires the Cold output to be grounded at the remote (input) end of the cable. Under adverse conditions this might cause HF instability, but in general the approach is sound. If you are using exceptionally long cable, then it is wise to check that all is well.

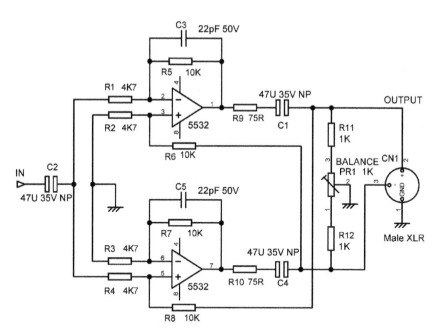

Figure 19.20 Quasi-floating balanced output.

If the Cold output is grounded locally, ie at the sending end of the cable, then it works as a simple unbalanced output, with no noise rejection. When a quasi-floating output stage is used unbalanced, the Cold leg *must* be grounded, or common-mode noise will degrade the noise floor by at least 10 dB, and there may be other problems with increased distortion.

Quasi-floating outputs use a rather subtle mixture of positive and negative feedback of current and voltage. This performs the required function quite well, but a serious drawback is that it accentuates the effect of resistor tolerances, and so a preset resistor is normally required to set the outputs for equal amplitude; the usual arrangement is shown in Figure 19.20. If it is not correctly adjusted one side of the output will clip before the other and reduce the total output headroom. This is a set-and-forget adjustment unless it becomes necessary to change any of the resistors in the circuit.

Transformer balanced outputs

If true galvanic isolation between equipment grounds is required, this can only be achieved with a line transformer, sometimes called a line isolating transformer. You don't use line transformers unless you really have to because the much-discussed cost, weight, and performance problems are very real, as you will see shortly. However they are sometimes found in big sound reinforcement systems (for example in the mic-splitter box on the stage) and in any environment where high RF field strengths are encountered.

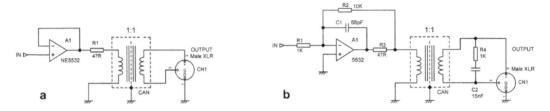

Figure 19.21 **Transformer balanced outputs; a) standard circuit; b) zero-impedance drive to reduce LF distortion, also with Zobel network across secondary.**

A basic transformer balanced output is shown in Figure 19.21a; in practice A1 would probably be providing gain, or doing something else useful, rather than just buffering. In good-quality line transformers there will be an inter-winding screen, which should be earthed to minimise noise pickup and general EMC problems. In most cases this does *not* ground the external can, and you have to arrange this yourself, possibly by mounting the can in a metal capacitor clip. Make very sure the can is grounded as this definitely does reduce noise pickup

Be aware that the output impedance will be higher than usual because of the ohmic resistance of the transformer windings. With a 1:1 transformer, as normally used, both the primary and secondary winding resistances are effectively in series with the output. A small line transformer can easily have 60 Ω per winding, so the output impedance is 120 Ω plus the value of the series resistance R1 added to the primary circuit to prevent HF instability due to transformer winding capacitances and line capacitances. The total can easily be 160 Ω or more, compared with say 47 Ω for non-transformer output stages. This will mean a higher output impedance and greater voltage losses when driving heavy loads.

DC flowing through the primary winding of a transformer is bad for linearity, and if your opamp output has anything more than the usual small offset voltages on it, DC current flow should be stopped by a blocking capacitor.

Output transformer frequency response

If you have looked at the section in Chapter 18 on the frequency response of line input transformers, you will recall that they give a nastily peaking frequency response if the secondary is not loaded properly due to resonance between the leakage inductance and the stray winding capacitances. Exactly the same problem afflicts output transformers, as shown in Figure 19.22; with no output loading there is a frightening 14 dB peak at 127 kHz. This is high enough in frequency to have very little effect on the response at 20 kHz, but this high-Q resonance isn't the sort of horror you want lurking in your circuitry. It could easily cause some nasty EMC problems.

The transformer measured was a Sowter 3292 1:1 line isolating transformer. Sowter is a highly respected company, and this is a quality part with a mumetal core and housed in a mumetal can for magnetic shielding. When used as the manufacturer intended, with a 600 Ω load on the secondary, the results are predictably quite different, with a well-controlled roll-off that I measured as −0.5 dB at 20 kHz.

The difficulty is that there are very few if any genuine 600 Ω loads left in the world, and most output transformers are going to be driving much higher impedances. If we are driving a 10 kΩ load, the secondary resonance is not much damped, and we still get a thoroughly unwelcome 7 dB

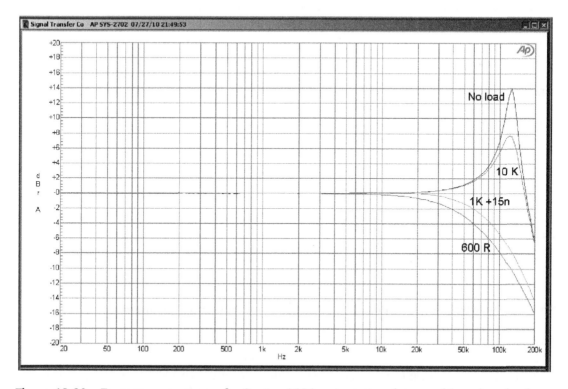

Figure 19.22 Frequency response of a Sowter 3292 output transformer with various loads on the secondary. Zero-impedance drive as in Figure 19.19b.

peak above 100 kHz, as shown in Figure 19.22. We could, of course, put a permanent 600 Ω load across the secondary, but that will heavily load the output opamp, impairing its linearity, and will give us unwelcome signal loss due in the winding resistances. It is also a profoundly inelegant way of carrying on.

A better answer, as in the case of the line input transformer, is to put a Zobel network, ie a series combination of resistor and capacitor, across the secondary, as in Figure 19.19b. The capacitor required is quite small and will cause very little loading except at high frequencies where signal amplitudes are low. A little experimentation yielded the values of 1 kΩ in series with 15 nF, which gives the much improved response shown in Figure 19.22. The response is almost exactly 0.0 dB at 20 kHz, at the cost of a very gentle 0.1 dB rise around 10 kHz; this could probably be improved by a little more tweaking of the Zobel values. Be aware that a different transformer type will require different values.

Output transformer distortion

Transformers have well-known problems with linearity at low frequencies. This is because the voltage induced into the secondary winding depends on the rate of change of the magnetic field in the core, and so the lower the frequency, the greater the change in the core field must be for transformer action [1]. The current drawn by the primary winding to establish this field is non-linear, because of the well-known non-linearity of iron cores. If the primary had zero resistance, and was fed from a zero source impedance, as much distorted current as was needed would be drawn, and no one would ever know there was a problem. But . . . there is always some primary resistance, and this alters the primary current drawn so that third-harmonic distortion is introduced into the magnetic field established and so into the secondary output voltage. Very often there is a series resistance R1 deliberately inserted into the primary circuit, with the intention of avoiding HF instability; this makes the LF distortion problem worse, and a better means of isolation is a low-value inductor of say 4 uH in parallel with a low-value damping resistor of around 47 Ω. This is more expensive and is only used on high-end consoles.

An important point is that this distortion does not appear only with heavy loading—it is there all the time, even with no load at all on the secondary; it is not analogous to loading the output of a solid-state power amplifier, which invariably increases the distortion. In fact, in my experience transformer LF distortion is slightly better when the secondary is connected to its rated load resistance. With no secondary load, the transformer appears as a big inductance, so as frequency falls the current drawn increases, until with circuits like Figure 19.21a, there is a sudden steep increase in distortion around 10–20 Hz as the opamp hits its output current limits. Before this happens the distortion from the transformer itself will be gross.

To demonstrate this I did some distortion tests on the same Sowter 3292 transformer that was examined for frequency response. The winding resistance for both primary and secondary is about 59 Ω. It is quite a small component, 34 mm in diameter and 24 mm high and weighing 45 gm, and is obviously not intended for transferring large amounts of power at low frequencies. Figure 19.23 shows the LF distortion with no series resistance, driven directly from a 5532 output (there were no HF stability problems in this case, but it might be different with cables connected to the secondary), and with 47 and 100 Ω added in series with the primary. The flat part to the right is the noise floor.

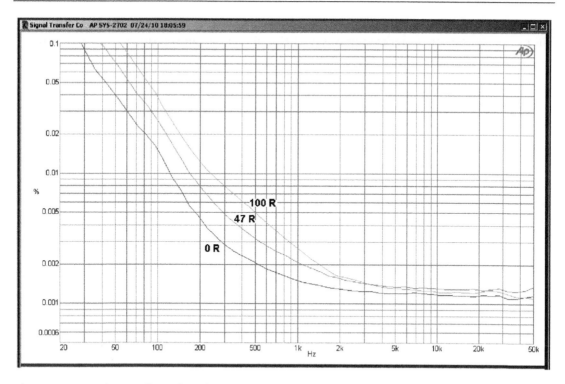

Figure 19.23 The LF distortion rise for a 3292 Sowter transformer, without (0R) and with (47 Ω and 100 Ω) extra series resistance. Signal level 1 Vrms.

Taking 200 Hz as an example, adding 47 Ω in series increases the THD from 0.0045% to 0.0080%, figures which are in exactly the same ratio as the total resistances in the primary circuit in the two cases. It's very satisfying when a piece of theory slots right home like that. Predictably, a 100 Ω series resistor gives even more distortion, namely 0.013% at 200 Hz, and once more proportional to the total primary resistance.

If you're used to the near-zero LF distortion of opamps, you may not be too impressed with Figure 19.23, but this is the reality of output transformers. The results are well within the manufacturer's specifications for a high-quality part. Note that the distortion rises rapidly to the LF end, roughly tripling as frequency halves. It also increases fast with level, roughly quadrupling as level doubles, and thus indicating third-harmonic distortion. Having gone to some pains to make electronics with very low distortion, this non-linearity at the very end of the signal chain is distinctly irritating. The situation is somewhat eased in actual use as signal levels in the bottom octave of audio are normally about 10–12 dB lower than the maximum amplitudes at higher frequencies.

Reducing output transformer distortion

In audio electronics, as in so many other areas of life, there is often a choice between using brains or brawn to tackle a problem. In this case "brawn" means a bigger transformer, such as the Sowter

3991, which comes in a can still 34 mm in diameter but now 37 mm high, weighing in at 80 gm. The extra mumetal core material improves the LF performance, but you still get a distortion plot very much like Figure 19.23 (with the same increase of THD with series resistance), except now it occurs at 2 Vrms instead of 1 Vrms. Twice the metal, twice the level—I suppose it makes sense. You can take this approach a good deal further with the Sowter 4231, a much bigger open-frame design tipping the scales at a hefty 350 gm. The winding resistance for the primary is 12 Ω and for the secondary 13.3 Ω, both a good deal lower than the previous figures.

Figure 19.24 shows the LF distortion for the 4231 with no series resistance, and with 47 and 100 Ω added in series with the primary. The flat part to the right is the noise floor. Comparing it with Figure 19.23 the basic distortion at 30 Hz is now 0.015% compared with about 0.10% for the 3292 transformer. While this is a useful improvement it is gained at considerable expense. Now adding 47 Ω of series resistance has dreadful results—distortion increases by about 5 times. This is because the lower winding resistances of the 4231 mean that the added 47 Ω has increased the total resistance in the primary circuit to 5 times what it was. Predictably, adding a 100 Ω series resistance approximately doubles the distortion again. In general bigger transformers have thicker wire in the windings, and this in itself reduces the effect of the basic core non-linearity, quite apart from the improvement due to more core material. A lower winding resistance also means a lower output impedance.

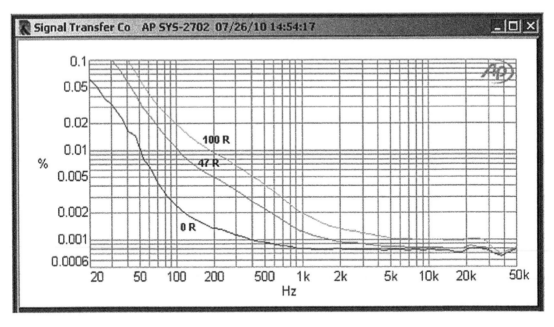

Figure 19.24 The LF distortion rise for the much larger 4231 Sowter transformer, without and with extra series resistance. Signal level 2 Vrms.

The LF non-linearity in Figure 19.22 is still most unsatisfactory compared with that of the electronics. Since the "My policy is copper and iron!" [2] approach does not really solve the problem, we'd better put brawn to one side and try what brains we can muster.

We have seen that adding series resistance to ensure HF stability makes things definitely worse, and a better means of isolation is a low-value inductor of say 4 uH paralleled with a low-value damping resistor of around 47 Ω. However inductors cost money, and a more economic solution is to use a zero-impedance output as shown in Figure 19.21b. This gives the same results as no series resistance at all, but with wholly dependable HF stability. However, the basic transformer distortion remains because the primary winding resistance is still there, and its level is still too high. What can be done?

The LF distortion can be reduced by applying negative feedback via a tertiary transformer winding, but this usually means an expensive custom transformer, and there may be some interesting HF stability problems because of the extra phase shift introduced into the feedback by the tertiary winding; this approach is discussed in [3]. However, what we really want is a technique that will work with off-the-shelf transformers.

A better way is to cancel out the transformer primary resistance by putting in series an electronically-generated negative resistance; the principle is shown in Figure 19.25, where a zero-impedance output is used to eliminate the effect of the series stability resistor. The 56 Ω resistor R4 senses the current through the primary and provides positive feedback to A1, proportioned so that a negative output resistance of twice the value of R4 is produced, which will cancel out both R4 itself and most of the primary winding resistance. As we saw earlier, the primary winding resistance of the 3292 transformer is approximately 59 Ω, so if R4 was 59 Ω we should get complete cancellation. But . . .

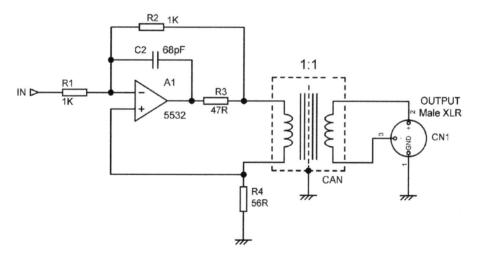

Figure 19.25 **Reducing LF distortion by cancelling out the primary winding resistance with a negative resistance generated by current-sensing resistance R4. Values for Sowter 3292 transformer.**

It is always necessary to use positive feedback with caution. Typically it works, as here, in conjunction with good old-fashioned negative feedback, but if the positive exceeds the negative (this is one time you do *not* want to accentuate the positive) then the circuit will typically latch up solid, with the output jammed up against one of the supply rails. R4 = 56 Ω in Figure 19.25

worked reliably in all my tests, but increasing it to 68 Ω caused immediate problems, which is precisely what you would expect. No input DC-blocking capacitor is shown in Figure 19.25, but it can be added ahead of R1 without increasing the potential latch-up problems. The small Sowter 3292 transformer was used.

This circuit is only a basic demonstration of the principle of cancelling primary resistance, but as Figure 19.26 shows it is still highly effective. The distortion at 100 Hz is reduced by a factor of five, and at 200 Hz by a factor of four. Since this is achieved by adding one resistor, I think this counts as a definite triumph of brains over brawn, and indeed confirmation of the old adage that size is less important than technique.

The method is sometimes called 'mixed feedback' as it can be looked at as a mixture of voltage and current feedback. The principle can also be applied when a balanced drive to the output transformer is used. Since the primary resistance is cancelled, there is a second advantage as the output impedance of the stage is reduced. The secondary winding resistance is, however, still in circuit, and so the output impedance is usually only halved.

If you want better performance than this—and it is possible to make transformer non-linearity effectively invisible down to 15 Vrms at 10 Hz—there are several deeper issues to consider. The definitive reference is Bruce Hofer's patent, which covers the transformer output of the Audio

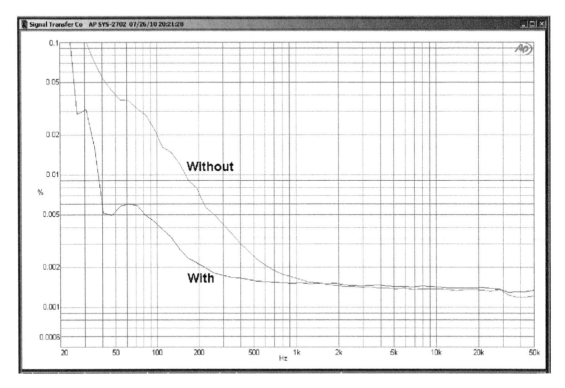

Figure 19.26 **The LF distortion rise for a 3292 Sowter transformer, without and with winding resistance cancellation as in Figure 19.25. Signal level 1 Vrms.**

Precision measurement systems [4]. There is also more information in the Analog Devices *Opamp Applications Handbook* [5].

Output impedance synthesis

Sometimes you need a defined output impedance, rather just the lowest impedance practicable. You might be driving a passive filter, which will definitely need a specific resistive source impedance, or possibly some extreme retro-tech mixer that works at 600 Ω. I will use 600 Ω as an example. The obvious way to do this is to put a series resistor of the desired impedance in series with the output, as in Figure 19.27; the inverting stage has a gain of two to give unity overall gain. The noise gain of the opamp stage is +10.1 dB, but the combination of the output impedance and the load reduce the noise by 6 dB, so the output noise measures −110.7 dBu. This is clearly a simple and foolproof solution, but half of the available voltage swing and 6 dB of headroom are lost. You won't get more than 5.2 Vrms out on ±17 V rails.

This is another of those problems, like transformer distortion, where either brains or brawn can be applied. Brawn, in this case, would mean a special output stage running from higher supply rails such ±35 V; perfectly doable, but it will require either special opamps or a discrete transistor stage, and the two extra rails will be expensive to provide.

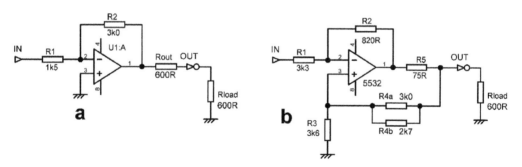

Figure 19.27 **Output stages with unity gain when loaded and a defined output impedance of 600 Ω.**

The brains option is to use a stage that emulates the desired output impedance; this is often called impedance synthesis. Figure 19.25b shows such a stage; it is essentially a shunt-feedback stage with the addition of the current-sensing resistor R5 and positive-feedback network R3, R4. When loading increases, the voltage at the output end of R5 drops so there is less positive feedback through R3, R4 and the output level is reduced by the right amount to simulate an output impedance of much greater value than R5. The level of positive feedback must be set accurately as it determines the output impedance; hence R4 is a 2xE24 parallel pair with an equivalent value of 1419 Ω. The circuit is reliably HF stable without adding little capacitors, and it does not go berserk if the output load is disconnected—instead the output voltage simply doubles, which is exactly what you would get with the circuit of Figure 19.25a.

The only drawback is that the noise output is −103.8 dBu, worse than the simple-minded but effective circuit by 6.9 dB. This is because there is no attenuation of the stage noise at the output.

It is also very likely that the noise gain of the impedance synthesis circuit is higher, but I have not yet confirmed this.

This circuit is phase-inverting. A non-inverting version may well be possible, but given the specialised nature of the application I have not pursued that further at present.

References

[1] Sowter, Dr G. A. V. "Soft Magnetic Materials for Audio Transformers: History, Production, and Applications." *Journal of AES,* Vol 35, No. 10, Oct 1987, p. 769

[2] Otto von Bismarck Speech, 1862 (Actually, he said *blood* and iron)

[3] Finnern, T. "Interfacing Electronics and Transformers." *AES preprint #2194 7ᵗh AES Convention*. Hamburg, Mar 1985

[4] Hofer, B. "Low-Distortion Transformer-Coupled Circuit." *US Patent No. 4,614,914,* 1986

[5] Jung, W., ed. *Opamp Applications Handbook*. Newnes, 2004, Chapter 6, pp. 484–491.

Headphone amplifiers

Driving heavy loads

This chapter focuses on techniques for driving loads heavier than can be handled by a single 5532 or LM4562 opamp—basically any impedance less than 500 Ω. This is typically a headphone load, the impedance of headphones varying widely from 600 Ω to 16 Ω or less, with sensitivity inversely related so the higher impedance models need more drive voltage. The need to drive impedances below 500 Ω is also likely to arise in very low-noise circuit designs, so that special measures have to be taken just to drive the next stage. A good example is my preamp 2012 design for Elektor [1]. It is assumed here that the heavy loads must be driven to the same high standards of noise and distortion that are required for lighter loading.

In writing this chapter I have become conscious that it would be easy to find enough material for a complete book on headphone amplifiers. Inevitably I have had to be very selective, but I think you will find plenty of new information here.

Driving headphones

The wide range of load impedances is accompanied by a wide range of sensitivity. Headphones of 600 Ω impedance require ten times or more voltage to achieve the same sound pressure level (SPL) than do those of 30 Ω impedance, though there is much variation. The sensitivity of most of the headphones currently on the market is covered by a range of +110 to +130 dB SPL per Volt. If a rather loud +110 dB SPL is taken as the maximum level required, voltages between 110 mV and 1.1 V will be needed. These are low voltages compared with the maximum of about 10 Vrms that can be obtained from standard ±17 V rails, and you may be thinking that it would be more efficient to run a headphone amplifier off much lower rails, such as ±5 V. While this is true, it is rarely done, as a) it is much easier to get low distortion with the standard rails; and b) extra power supply rails are expensive to provide.

The traditional solution to the wide impedance/sensitivity range is a resistor of the order of 50 Ω to 100 Ω in series with the amplifier output, which reduces the maximum output voltage available as the load impedance is reduced. This has a valuable safety function as applying the full voltage required for 600 Ω headphones to 30 Ω units will almost certainly wreck them, as well as generating SPLs that will cause hearing damage. The series resistor technique has been used extensively, despite the fact that it reduces the so-called 'damping factor' of the amplifier-headphone combination to about 0.3. The damping factor of a power amplifier-loudspeaker

DOI: 10.4324/9781003332985-20

combination is a meaningless ratio because the amplifier output impedance is a tiny fraction of the loudspeaker voice-coil resistance, so the latter utterly dominates the transient behaviour; here however, the amplifier output impedance is greater than that of the transducer and therefore could be expected to have a serious effect on its frequency response and transient behaviour. Nevertheless, this technique has been in wide use for many decades; there seems to be a general feeling that damping factor does not apply to headphones, though it is far from clear why this should be the case. It also seems to be the general view that capacitor-coupled outputs are acceptable for headphones but not full-scale power amplifiers. There is some technical justification for this because large electrolytic capacitors can introduce distortion when passing power-amplifier signal currents, even at mid-frequencies [2].

The series resistor approach has two other important advantages. Firstly, so long as the resistor has a sufficient power rating, the headphone amplifier is inherently short-circuit proof without any need for protection circuitry that might, if ill-conceived, degrade the distortion performance by premature operation. DC-offset protection may still be required. Secondly, with the series resistor, the amplifier should be stable into any conceivable load without the need for Zobel networks or output inductors.

A solution to the output impedance problem is to retain the series resistor but take the negative feedback from the load side of it. This will give a very low output impedance (see the zero-impedance outputs in Chapter 19) but retains the power-limiting action and inherent immunity to short-circuits. However, a Zobel network and output inductor are now likely to be required for reliable stability with all loads.

Special opamps

Opamps exist with a greater load-driving capability than the 5532, for example the NJM4556A from JRC is capable of driving 150 Ω, but it seems to have achieved little market penetration, possibly because its linearity even into light loads was distinctly inferior to the 5532 and LM4562. By 2009 none of the usual distributors were carrying it, and it is not clear if it is still in production.

A modern and more promising candidate is the OPA1622, released in 2016. It can drive directly loads down to 128 Ω to 6 Vrms, and 32 Ω to 2 Vrms, both at very low distortion (less than 0.0001% at 1 kHz, according to the data sheet). It can also drive 16 Ω at very low distortion, but the output is limited to about 700 mVrms. It is a BJT-input opamp with commendably low-voltage noise density (2.8 nV/$\sqrt{\text{Hz}}$) and current noise density comparable with the 5532 (0.8 pA/$\sqrt{\text{Hz}}$). On the downside it comes in a VSON SMT package that is not easy to handle, and it is currently very expensive; in 2019 it was £4.22 each at 10-off, in 2023 it was £5.43 for one-off.

Multiple opamps

In some circumstances paralleled opamp stages are the simplest answer. This is sometimes called an opamp array or multipath amplifier. There is much information on this in Chapters 1, 13, and 19, focusing mainly on the noise benefits; here I will concentrate on load-driving ability. In Figure 20.1

the upper trace shows a single 5532 section bravely attempting to drive 5 Vrms into 220 Ω. The distortion is very high for a 5532, and it is clearly running out of current capability. Adding a second section in parallel with the outputs coupled by 10 Ω resistors, as shown in Figure 1.15 in Chapter 1, drops the THD back to the familiar low levels. The gains of the paralleled voltage-follower stages are very closely equal, so the small series output resistors can allow for any microscopic differences, and no significant currents pass from opamp to opamp.

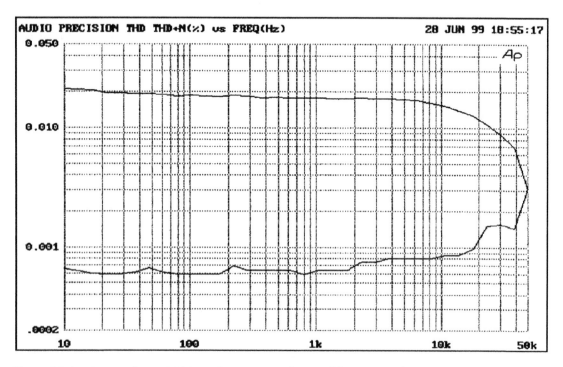

Figure 20.1 **One and two 5532 sections attempting to drive 5 Vrms into 220 Ω.**

This can be a very simple and cost-effective way to solve the problem of driving medium loads, and it can be extended by connecting more 5532 sections in a parallel, essentially without limit. Figure 20.2 shows four parallel 5532 sections driving 100 Ω to 5 Vrms with very little distortion. An array of 12 parallel 5532 sections can drive a 25 Ω load with 5 Vrms very effectively. Being me, I took the opamp array technique to its logical conclusion, and possibly beyond, in my power amplifier for Elektor [3], which used 32 opamp packages, giving 64 parallel sections of 5532 joined with 1 Ω sharing resistors. This can easily drive an 8 Ω loudspeaker to 15 Wrms, with the usual very low 5532 distortion. The opamp supply rails limit the power output, so another version was designed that used two of these amplifiers bridged to give about 60 W/8Ω; the number of opamps in each amplifier was doubled to cope with the doubled load currents, so there were 128-off 5532 sections in parallel, each with a 1 Ω sharing resistor. This project was completely straightforward to design and test, and I think demonstrates conclusively that you can use as many parallel opamps as you like.

Since the 5532 is usually the cheapest opamp available, using a number of them is not costly. The LM4562 will unquestionably give lower distortion, but at the time of writing is significantly more expensive.

The best linearity is given by separating the gain and load-driving functions, as shown in Figure 20.5 further on. The first opamp provides all the voltage gain, so the output amps can be operated as voltage-followers with 100% negative feedback to give the best linearity.

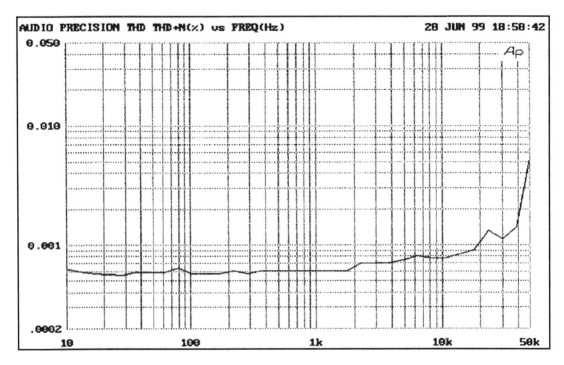

Figure 20.2 Four parallel 5532 sections driving 100 Ω with 5 Vrms. The THD plot is almost identical to two 5532 sections driving 220 Ω.

As described in Chapter 1, paralleled opamps not only increase drive capability but also reduce noise.

Opamp transistor hybrid amplifiers

When lower headphone impedances are to be driven, the number of multiple opamps required can become unwieldy, taking up an excessive amount of PCB area, and it becomes more economical to adopt a hybrid circuit. These are 'hybrid' circuits in that they combine IC opamps with discrete transistors; the name does not refer to thick film construction or anything like that. The usual approach is to add a discrete Class-AB output stage after the opamp. A Class-A output stage is perfectly feasible if ultimate quality is required, though the power consumption is naturally much higher, and the efficiency with real signals something like 1%. The discrete devices could

be either bipolar transistors or power FETs, but I invariably use bipolar transistors because their greater transconductance translates into better linearity, and they are totally predictable in every parameter that matters for this application.

I have always made it clear that Class-B and Class-AB in a power amplifier are not the same thing. Class-B is that unique quiescent condition where the distortion is a minimum. Class-AB is more highly biased so that it is effectively Class-A for small outputs, but above that extra distortion is generated as the output devices switch on and off. Here the situation is very different, instead of the driver-output device pairs of a power amplifier, there is a single transistor that turns on and off more gradually. There is here no real distinction between Class-B and AB and no need for critical biasing.

The arrangement in Figure 20.3a has been used for many years, dating back to when using a TL072 for the opamp made a significant cost saving. It is economical and dependable, and I have used it to drive headphones in low-cost mixing consoles. The output stage is the simplest possible version of Class-AB, but it really works quite well, though its distortion characteristics, as seen in Figure 20.4, are not of the highest standard. The output devices are TO92 small-signal types with high beta, and this is crucial to an acceptable distortion performance; the bias is set by D1, D2, and there is no adjustment. The gain is 3.2 times. Inserting extra stages into opamp feedback loops must be done with care to avoid adding extra phase shifts that may cause HF instability; here there are no problems, and no extra stabilising components are required. The output is AC coupled by C2 so that DC-offset protection is not required, and output resistor R7 takes care of short circuit protection and caters for the different drive voltages required by 600 Ω and 30 Ω headphones.

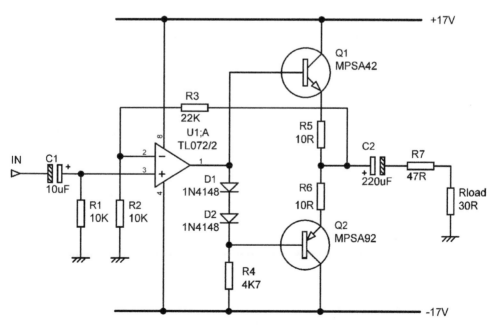

Figure 20.3 Traditional hybrid headphone amplifier combining a TL072 with a discrete Class-B output stage. Note the series output resistor R7, with typical value.

Figure 20.5 shows a more sophisticated version with lower distortion and greater output into lower impedances. I have deployed it in preamplifiers with a headphone output. There are three

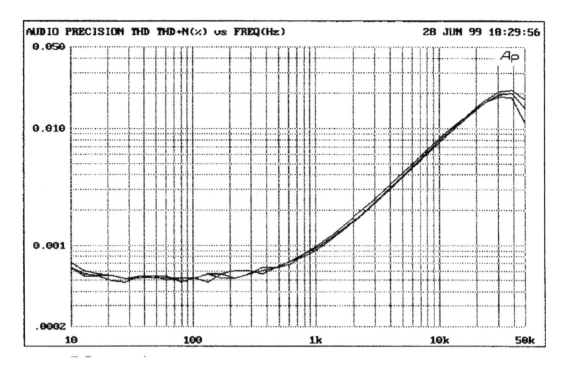

Figure 20.4 **THD against load for TL072 with discrete Class-B output stage. No-load, 470 Ω and 220 Ω loading. Gain 3x, output level 7.75 Vrms (before o/p series resistor).**

TO92 output pairs giving greater drive power; no heatsinks are required. The gain is higher than in Figure 20.3 at 5.4 times (+14.6 dB) and is provided by A1, allowing A2 to work at unity closed-loop gain so there is maximal negative feedback for correcting errors in the output stage. Bootstrapping is applied to R6, R7 to maintain a relatively constant current through bias components D1, R5. C3 aids stability; at very high frequencies the NFB is taken from before the output stage and does therefore not suffer phase shifts from it. This circuit is reliably HF stable with a 5532 for A2; an LM4562 in this position showed hints of instability, but this may be curable by adjusting C3. The noise output was measured at −107.0 dBu, so the EIN is −107.0– 14.6 = −121.6 dBu, which is pleasingly low.

The distortion performance is shown in Figure 20.6, without use of a series output resistor. The 5 Vrms trace is higher due to the relatively higher noise level with a smaller output.

Discrete Class-AB headphone amplifiers

The hybrid circuit of Figure 20.5 is relatively complicated, and one starts to wonder if a wholly discrete solution might be more economical. Figure 20.7 shows a discrete headphone amplifier

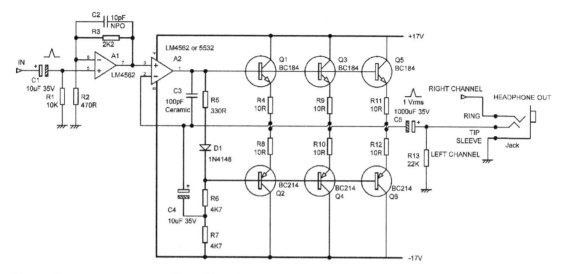

Figure 20.5 A more sophisticated hybrid headphone amplifier with the voltage gain provided by separate stage A1 and three output pairs.

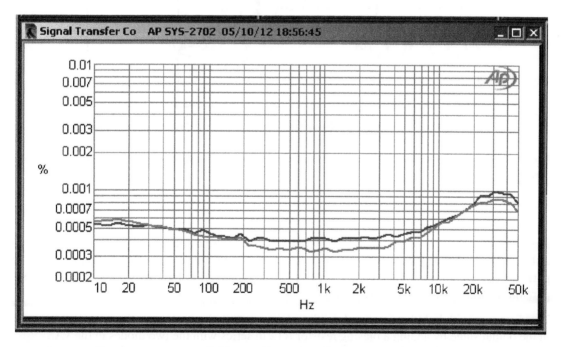

Figure 20.6 The hybrid headphone amplifier of Figure 20.5 driving a 60 Ω load. Upper trace 5 Vrms output, lower trace 9 Vrms output.

based on the discrete opamp designs of Chapter 3. The output stage is a simple complementary Class-AB configuration with fixed bias.

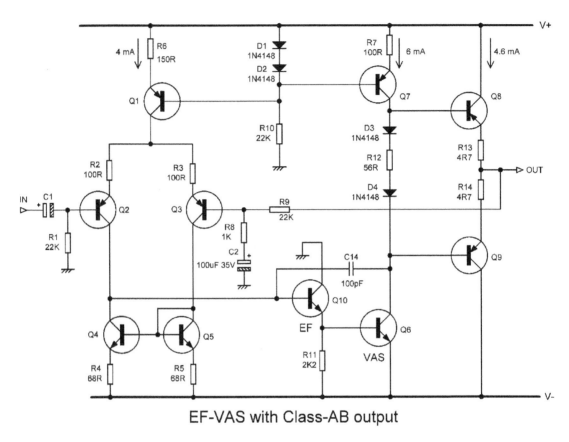

Figure 20.7 **Discrete headphone amplifier with Class-AB output stage. Output devices are MJE340/350.**

First we will look at the basic linearity with light loading. With a 3 kΩ load, the distortion residual at 1 kHz looks nothing like the characteristic crossover distortion seen in a power amplifier. It is pure third harmonic. This situation continues all the way up to 20 kHz, the residual remaining as pure third harmonic but increasing in relative level.

The distortion with light loading can be reduced dramatically by increasing the quiescent current in the output stage by adding a biasing resistor R12 in series with the two diodes in the VAS collector circuit, as shown Figure 20.7. The plot in Figure 20.8 demonstrates that HF distortion falls steadily as the value of the bias resistor increases, with no obvious sign of an optimal value. A 10 Ω resistor only gives a modest improvement, but 27 Ω reduces HF distortion by a factor of five, and 56 Ω seems to give most of the improvement that is attainable. The latter corresponds to a quiescent current of 4.6 mA in the output devices.

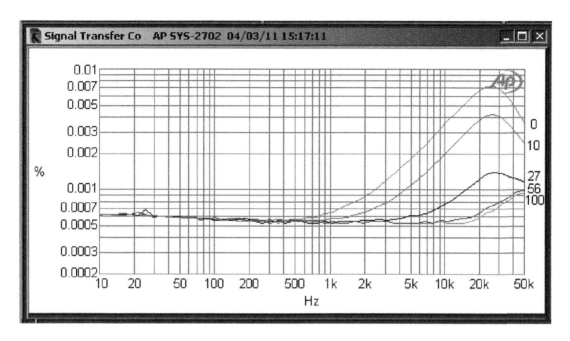

Figure 20.8 Effect of increasing output bias on discrete Class-AB amplifier with load of 3 kΩ.

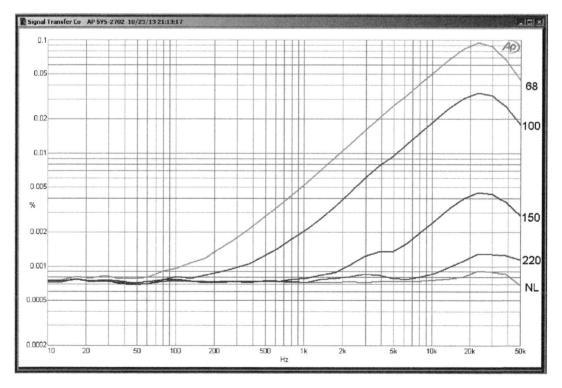

Figure 20.9 Distortion of discrete Class-AB amplifier driving into no load (NL), 220 Ω, 150 Ω, 100 Ω, and 68 Ω, +20 dBu output, ±20 V rails.

Figure 20.9 shows distortion remains low for a 220 Ω load but increases rapidly for heavier loading as the output stage is taken out of its Class-A region, and the THD residual becomes a complex mixture of higher harmonics, increasing at 6 dB/octave with frequency. Performance is inferior to the opamp and hybrid approaches. When comparing this with the other designs, be aware that the closed-loop gain is higher at 23 times.

Discrete Class-A headphone amplifiers

Because the power requirements of headphones are modest, it is quite practical to adopt an amplifier design that works in pure Class-A. This assumes that push-pull Class-A is used to get the maximum efficiency. Even so, with real music signals the efficiency is likely to be as low as 1% at full volume and even less at lower levels. Of such is Class-A.

Figure 20.10 shows different development of the discrete opamp using a Class-A output stage. The high quiescent dissipation means that TO-220 output transistors must be used; since these have relatively low beta they are paired with TO-92 driver transistors, the result looking rather like a full-scale power amplifier. The quiescent current is set at 90 mA by the bias generator Q9 and fixed resistors R12, R16, R17. No bias adjustment is required as in Class-A the quiescent current is not critical.

In the prototype a small vertical heatsink with a thermal resistance of 10 C/W (type SW38) was used for each output device, with the bias transistor Q9 mounted not just on the same heatsink but actually on top of output device Q12 for the best thermal coupling. The standard clip can

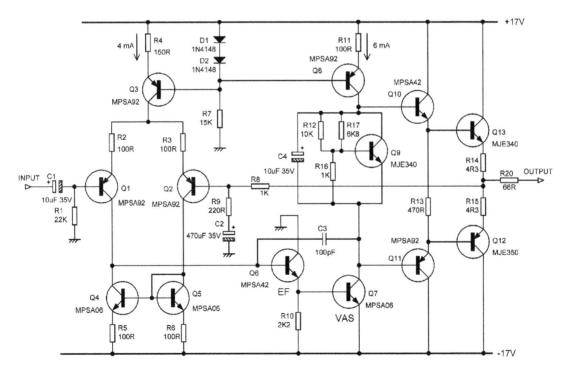

Figure 20.10 Class-A hybrid headphone amplifier with EF output stage.

still be used to hold the devices to the heatsink. From Cold turn-on to full operating temperature the quiescent remains within ±10%. A feedback control system could hold the quiescent current much more closely than this [4], but its complexity is hardly necessary at such modest powers. No short-circuit protection is required because the output resistance R20, made up of two 33 Ω 750 mW resistors in series, can safely absorb the power if the output is shorted.

The distortion driving a 30 Ω load at 3 Vrms out is shown in Figure 20.11. The THD at 10 kHz is 0.0008%, comfortably below 0.001%, and predominantly second harmonic. The maximum output is 3.3 Vrms, due to the effect of the output resistor.

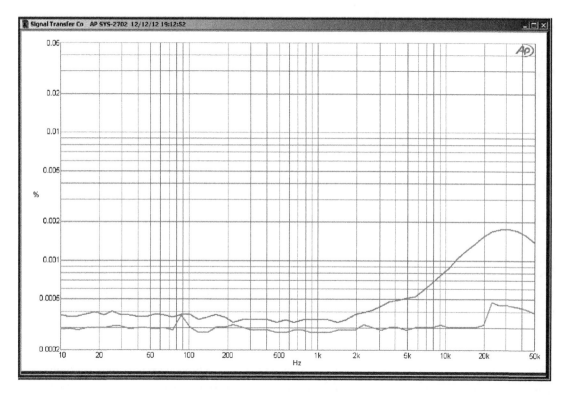

Figure 20.11 Class-A hybrid headphone amplifier distortion performance. The lower trace is the testgear residual.

Because of the high performance of this relatively simple circuit, I think it is worthwhile to look at the measurements in more detail than usual:

Gain

Measured gain	5.52 times	+14.83 dB	(no load)
Measured gain	4.97 times	+13.93 dB	(600 Ω load)
Measured gain	1.74 times	+4.81 dB	(30 Ω load)

Maximum output

10.5 Vrms	No load
9.4 Vrms	600 Ω load
3.3 Vrms	30 Ω load

Noise performance

Noise measurements bandwidth 22–22 kHz, unweighted, RMS sensing, input terminated with 40 Ω.

Noise out	−107.7 dBu	No output load
Equivalent Input Noise (EIN)	−122.5 dBu	
Noise out	−115.8 dBu	Output load 30 Ω
Equivalent Input Noise (EIN)	−120.6 dBu	

Noise out is lower with the 30 Ω load because, with the series output resistor, it forms an attenuator.

Power consumption

92 mA per amplifier from ±17 V rails (3.2 Watts)

Balanced headphone amplifiers

It is believed by a small minority that a balanced drive to headphones can be of advantage. It is difficult to think of any technical reason why this might be so, because the moving-coil speaker elements are not connected to anything except the cables feeding them, so the presence of a common-mode voltage is irrelevant.

Most headphones will need to be rewired for balanced use, as the typical arrangement for high-quality headphones is to have a 3-wire cable running from a 1/4-inch jack plug to one ear-piece, with a 2-wire cable running from there to the other ear-piece. This means that part of the ground connection is common to the left and right signals, and since it has some resistance it will cause interchannel crosstalk. Paradoxically, cheap headphones with a figure-of-eight cable that splits off to each ear-piece may be better in this respect because there are separate grounds to each ear-piece, and these only meet up at the jack plug, so there is the minimum amount of common ground resistance.

Four-pole jack plugs do exist (with tip, two rings, and sleeve), but these are usually in the 3.5 mm size for mobile phone use. There are also 5-pole versions specifically aimed at balanced headphone use; I haven't found a 6-pole jack. In hifi the connection to headphones wired for balanced use is normally made with two 3-pin XLR connectors.

References

[1] Self, D. *Preamplifier 2012*. Elektor, Apr, May, June 2012

[2] Self, D. *Audio Power Amplifier Design*, 6th edition. Focal Press, 2013, p. 107. ISBN 978-0-240-52613-3

[3] Self, D. *The 5532 OpAmplifier*. Elektor, Oct, Nov 2010

[4] Self, D. *Audio Power Amplifier Design*, 6th edition. Focal Press, 2013, pp. 429–432. ISBN 978-0-240-52613-3

Signal switching

The switching and routing of analogue signals is an important part of signal processing but not one that is easily implemented if accuracy and precision are required. This chapter focuses on audio applications, but the basic parameters such as isolation and linearity are equally relevant in many fields.

Mechanical switches

A mechanical switch normally makes a solid unequivocal connection when it is closed, and it is as 'on' as the resistance of its contacts and connections allows; these are small fractions of an Ohm and are unlikely to cause trouble in small signal audio design. Switches are, however, in general terms a good deal less 'off.' The insulation resistance may be measured in PetaOhms, but what does the damage is the inevitable capacitance between contacts. This is usually small in pF but quite large enough to dominate the degree of offness obtainable at high audio frequencies. Its effects naturally depend on the impedance at the 'receiving' side of the switch. For all the tests discussed here this was 10 kΩ.

Using an ALPS SPUN type push-switch, at 10 kHz the offness is only −66 dB, and grounding the unused side of the switch only the improves offness by about 2 dB. A graph of the result can be seen in Chapter 22; the offness naturally degrades by 6 dB/octave. Switch capacitance is an important issue in designing mixer routing systems.

In another test a miniature 3-way slide switch gave −70 dB at 10 kHz. Once again, grounding the unused contact at the end of the switch only gave a 4 dB improvement, and it is wise to assume that in general grounding unused switch sections will not help much.

Switch inter-contact capacitance is quite easy to determine; measure the offness, ie the loss of the RC circuit, and since R is known C can be calculated easily. Once it is known for a given switch construction, it is easy to calculate the offness for different loading resistances. Interestingly, the inter-contact capacitance of switches seems to be relatively constant, even though they vary widely in size and construction. This seems to be because the smaller switches have smaller contacts, with a smaller area, but on the other hand they are closer together.

Input-select switching: mechanical

Some time ago, Morgan Jones [1] raised the excellent point of crosstalk in the input-select switching of preamplifiers. If the source impedance is significant then this may be a serious

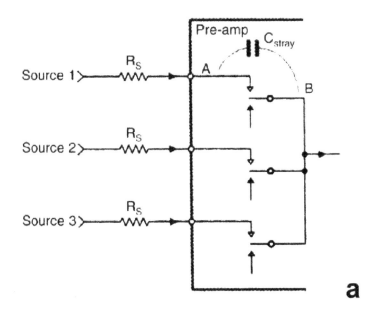

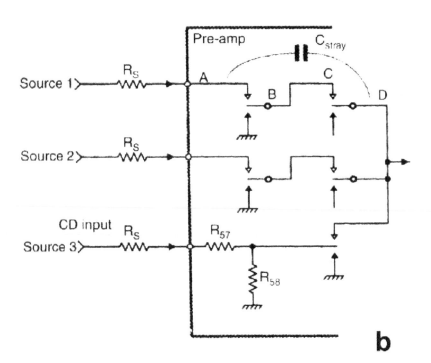

Figure 21.1 a) Two-changeover select switches give poor signal rejection due to switch capacitance Cstray; b) Using four-changeover switches improves offness by 21 dB at 10 kHz. Note CD input attenuator.

TABLE 21.1 Offness of various switch configurations (10 kHz)

	10 kHz
Simple rotary switch	–71 dB
Rotary with alternate contacts grounded	–76 dB
Two-changeover switch	–74 dB
Four-changeover switch	–95 dB

problem. While I agree that his use of a rotary switch with twice the required number of positions and grounding alternate contacts is slightly superior to the conventional use of rotary switches, measuring a popular Lorlin switch type showed the improvement to be only 5 dB. I am also unhappy with all those redundant 'Mute' positions between input selections, so when I design a preamp I normally choose interlocked push-switches rather than a rotary switch. A 4-changeover format can then be used to reduce crosstalk.

The problem with conventional input-select systems like Figure 21.1a is that the various input tracks necessarily come into close proximity, with significant crosstalk through capacitance Cstray to the common side of the switch, ie from A to B. Using two changeovers per input side (ie four for stereo) allows the intermediate connection B-C to be grounded by the NC contact of the first switch section and keeps the 'Hot' input A much further away from the common input line D, as shown in Figure 21.1b. Cstray is now much smaller.

The crosstalk data in Table 21.1 was gathered at 10 kHz, with 10 kΩ loading resistances.

The emphasis here is on minimising crosstalk between different sources carrying different signals, as interchannel (L–R) crosstalk is benign by comparison. Interchannel isolation is limited by the placement of left and right channels on the same switch, with the contact rows parallel, and limits L–R isolation to –66 dB at 10 kHz with a high 10 kΩ source impedance. Actual source impedances are likely to be lower, with both inter-source and inter-channel crosstalk proportionally reduced; so a more probable 1 kΩ source gives 115 dB of intersource rejection at 10 kHz for the 4-changeover configuration.

The third input of Figure 21.1b has a resistive attenuator intended to bring CD outputs down to the same level as other sources. In this case inter-source crosstalk can be improved simply by back-grounding the attenuator output when it is not in use, so only a 2-pole switch is required for good isolation of this input.

The virtual contact: mechanical

What do you do if you need a changeover switch—to select one of two signal sources—but only have a make contact? Here is a technique that can be a lifesaver when you have screwed up on ordering a switch with a long lead time or if you live in a Dilbertian world of last-minute spec changes.

Figure 21.2 demonstrates the principle. With the switch S open, source A goes through voltage-follower A and Rfeed to the output voltage-follower; this is the virtual normally-closed contact.

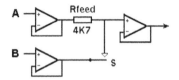

Figure 21.2 The virtual contact concept. When the switch S is closed the signal B overrides signal A.

With the switch closed, the much lower impedance output of voltage-follower B takes over and the contribution from A is now negligible. To give good rejection of A, the output impedance of follower B must be much, much lower than the value of Rfeed; so an opamp output must be used directly. Figure 21.3 shows how good the rejection of A can be using 5532 opamps as the voltage-followers. I used this technique in a series of power amplifiers in the early 2000s.

At first this technique looks a bit opamp-intensive. However, there is often no need to use dedicated voltage-followers if a similar low-impedance feed is available from a previous stage that uses an opamp with a large amount of negative feedback. Likewise, the output voltage-follower may often be dispensed with if the following load is reasonably high.

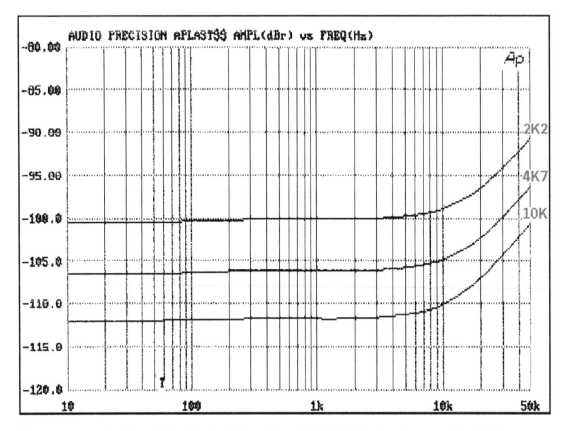

Figure 21.3 Rejection of signal A for 2k2, 4k7, and 10 kΩ Rfeed resistors, using 5532 opamps.

There is also the rejection of B when the switch is open to consider. The impedance of Rfeed mean there is the potential for capacitative crosstalk across the open switch contacts. The amount depends on the value if Rfeed and on switch construction.

If the offness of B is more important than the offness of A, then Rfeed should be a lower value to minimise the effects of the capacitance. Do not make Rfeed too low as A drives through it into effectively a short circuit when B is selected.

If the offness of A is more important, Rfeed should be higher to increase its ratio to the output impedance of B; be aware that making it too high may introduce excessive Johnson noise.

The rejection of A shown in Figure 21.3 worsens at high frequencies, as the dominant-pole of opamp B reduces its open-loop gain and the output impedance rises. The slopes are 6 dB/octave as usual.

This technique is particularly useful for switching between three sources with a centre-off toggle switch.

Relay switching

Any electronic switching technique must face comparison with relays, which are still very much with us. Relays give total galvanic isolation between control and signal, zero contact distortion, and in audio terms have virtually unlimited signal-handling capability. They introduce negligible series resistance, and shunt leakage to ground is usually also negligible. Signal offness can be very good, but as with other kinds of switching, this depends on intelligent usage. There will always be capacitance between open contacts, and if signal is allowed to crosstalk through this to nominally off circuitry, the offness will be no better than other kinds of switching.

Obviously relays have their disadvantages. They are relatively big, expensive, and not always as reliable as more than a hundred years of development should have made them. Their operating power is significant, though it can be reduced by circuitry that applies full voltage to pull in the relay and then a lower voltage to keep it closed. Some kinds of power relay can introduce disastrous distortion if used for switching audio because the signal passes through the magnetic soft-iron frame; however such problems are likely to be confined to the output circuits of large power amplifiers. For small signal switching the linearity of relay contacts can normally be regarded as perfect.

Electronic switching

Electronic switching is usually implemented with CMOS analogue gates, of which the well-known 4016 is the most common example, and these are examined first. However, there are applications where discrete JFETs or MOSFETs provide a better solution, so these are dealt with later in this chapter.

Switching with CMOS analogue gates

CMOS analogue gates, also known as transmission gates, are quite different from the CMOS logic gates in the 4000 series, though the underlying process technology is the same. Analogue gates are bilateral, which means that either of the in/out leads can be the input or output; this is emphatically not true for logic gates. The 'analogue' part of the name indicates that they are not restricted to fixed logic levels but pass whatever signal they are given with low distortion. The 'low' requires a bit of qualification, as will be seen later.

When switched on, the connection between the two pins is a resistance which passes current in each direction as usual, depending on the voltage between the two terminals. Analogue gates have been around for a long time and are in some ways the obvious method of electronic switching. They do have significant drawbacks, but these can be overcome by using them intelligently. The 4016 and 4066 provide four separate analogue gates in a 14-pin package.

Analogue gates like those in the 4016/66 are made up of two MOSFETs of opposite polarity connected back to back. The internal structure of a 4016 analogue gate is shown in Figure 21.4. The two transmission FETs with their protective diodes are shown on the right; on the left is the control circuitry. A and B are standard CMOS inverters whose only function is to sharpen up the rather soggy voltage levels that 4000-series CMOS logic sometimes provides. The output of B directly controls one FET, and inverter C develops the anti-phase control voltage for the FET of opposite polarity, which requires an inverted gate voltage to turn it on or off.

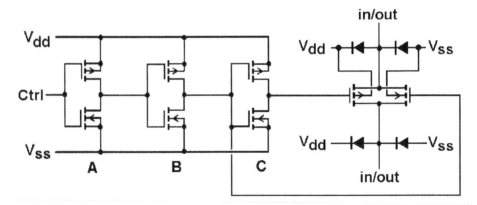

Figure 21.4 The internal circuitry of a 4000-series analogue gate.

MOSFETS are enhancement devices requiring a voltage to be applied to the gate to turn them on (in contrast JFETs work in depletion mode and require a gate voltage to turn them *off*); so as the channel approaches the gate voltage, the device turns off more. An analogue gate with only one polarity of FET would be of little use because Ron would become very high at one extreme of the voltage range. This is why complementary FETs are used; as one polarity finds its gate voltage decreasing, turning it off, the other polarity has its gate voltage increasing, turning it more on. It would be nice if this process cancelled out so the Ron was constant, but sadly it just doesn't work that way. Figure 21.5 shows how Ron varies with input voltage, and the peaky curve gives a strong hint that something is turning on as something else turns off.

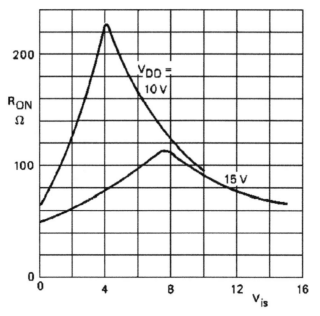

Typical R_{ON} as a function of input voltage.

Figure 21.5 **Typical variation of the gate series resistance Ron for the 4016. There is less variation with the +15 V supply.**

Figure 21.5 also shows that Ron is lower and varies less when the higher supply voltage is used; since these are enhancement FETs the on-resistance decreases as the available control voltage increases. If you want the best linearity then always use the maximum rated supply voltage.

Since Ron is not very linear, the smaller its value the better. The 4016 Ron is specified as 115 Ω typical, 350 Ω max, over the range of input voltages and with a 15 V supply. The 4066 is a pin-compatible version of the 4016 with lower Ron, 60 Ω typical, 175 Ω max under the same conditions. This option can be very useful both in reducing distortion and improving offness, and in most cases there is no point in using the 4016. The performance figures that follow all assume the use of the 4066 except where stated.

CMOS gates in voltage mode

Figure 21.6 shows the simplest and most obvious way of switching audio on and off with CMOS analogue gates. This series configuration is in a sense the 'official' way of using them; the only snag is that it doesn't work very well.

Figure 21.7 shows the measured distortion performance of the simple series gate using the 4016 type. The distortion performance is a long way from brilliant, exceeding 0.1% just above 2 Vrms. These tests, like most in this section, display the results for a single sample of the semiconductor in question. Care has been taken to make these representative, but there will inevitably be some small variation in parameters like Ron. This may be greater when comparing the theoretically identical products of different manufacturers.

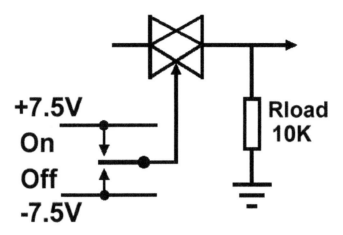

Figure 21.6 Voltage-mode series switching circuit using analogue gate.

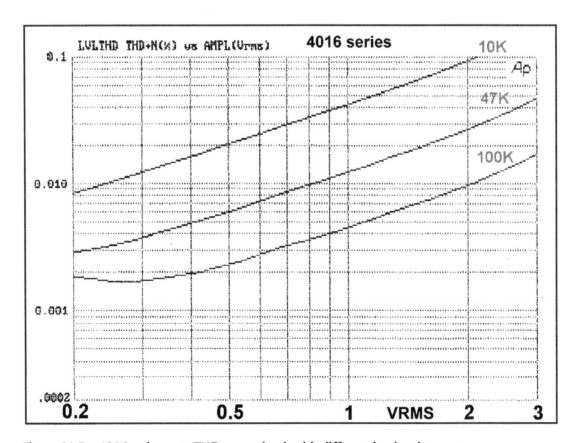

Figure 21.7 4016 series-gate THD versus level, with different load resistances.

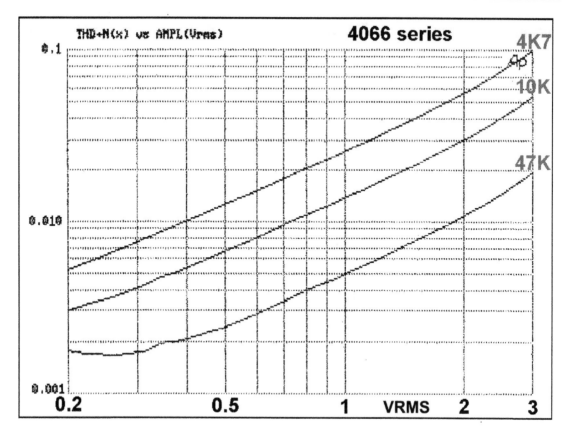

Figure 21.8 4066 THD versus level, with different load resistances.

Replacing the 4016 gate with a 4066 gives a reliable improvement due to the lower Ron. THD at 2 Vrms (10 kΩ load) has dropped to a third of its previous level (see Figure 21.8). There seems to be no downside to using 4066 gates instead of the more common and better-known 4016, and they are used exclusively from this point on, unless otherwise stated. Likewise, using multiple gates in parallel reduces distortion; see Figure 21.9.

The distortion is fairly pure second harmonic, except at the highest signal levels where higher-order harmonics begin to intrude. This is shown in Figures 21.8 and 21.9 by the straight line plots beginning to bend upwards above 2 Vrms.

Analogue gate distortion is flat with frequency as far as audio is concerned, so no plots of THD versus frequency are shown; they would just be a rather uninteresting set of horizontal lines.

This circuit gives poor offness when off, as shown by Figure 21.10. The offness is limited by the stray capacitance in the package feeding through into the relatively high load impedance. If this is 10 kΩ the offness is only −48 dB at 20 kHz, which would be quite inadequate for most applications. The load impedance could be reduced below 10 kΩ to improve offness—for example, 4k7 offers about a 7 dB improvement—but this degrades the distortion, which is already poor at 0.055% for 3 Vrms, to 0.10%.

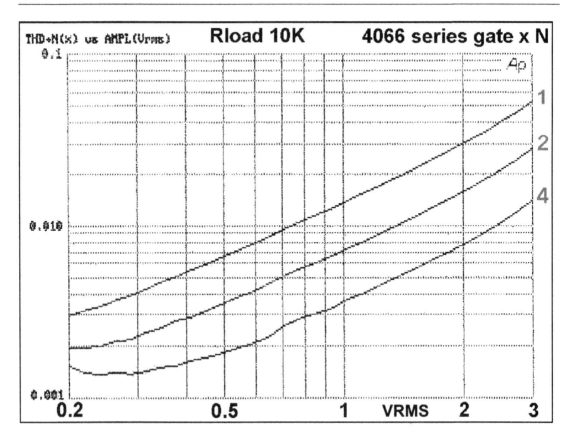

Figure 21.9 THD versus level, for different numbers of paralleled 4066 gates.

Using 4066 gates instead of 4016s does not improve offness in this configuration. The internal capacitance that allows signals to leak past the gate seems to be the same for both types. The maximum signal level that can be passed through (or stopped) is limited by the CMOS supply rails and conduction of the protection diodes. While it would in some cases be possible to contrive a bootstrapped supply to remove this limitation, it is probably not a good route to head down.

Figure 21.11 shows a CMOS three-way switch. When analogue gates are used as a multi-way-into-one switch, often called a multiplexer, the offness problem is much reduced because capacitative feedthrough of the unwanted inputs is attenuated by the low Ron looking back into the (hopefully) low impedance of the active input, such as an opamp output. If this is not the case then the crosstalk from nominally off inputs can be serious.

In this circuit the basic poor linearity is unchanged, but since the crosstalk problem is much less, there is often scope for increasing the load impedance to improve linearity. This makes Ron a smaller proportion of the total resistance. The control voltages must be managed so that only one gate is on at a time, so there is no possibility of connecting two opamp outputs together.

It may appear that if you are implementing a true changeover switch, which always has one input on, the resistor to ground is redundant and just a cause of distortion. Omitting it is, however, very

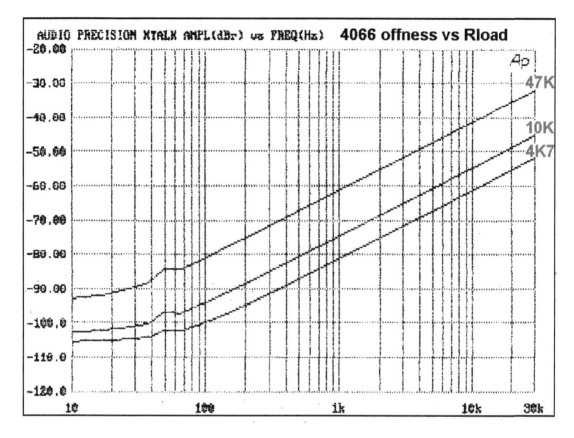

Figure 21.10 4066 offness versus load resistance. −49 dB at 20 kHz with a 10 kΩ load.

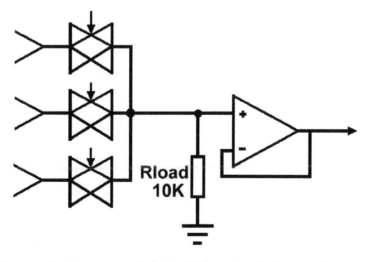

Figure 21.11 A one-pole, three-way switch (multiplexer) made from analogue gates.

risky because if all CMOS gates are off together even for an instant, there is no DC path to the opamp input, and it will register its displeasure by snapping its output to one of the rails. This does not sound nice.

Figure 21.12 shows the offness of a changeover system for two types of FET-input opamps. The offness is much improved to −87 dB at 20 kHz, an improvement of 40 dB over the simple series switch; at the high-frequency end, however, it still degrades at the same rate of 6 dB/octave. It is well-known that the output impedance of an opamp with negative feedback increases with frequency at this rate, as the amount of internal gain falls, and this effect is an immediate suspect. However, there is actually no detectable signal on the opamp output (as shown by the lowest trace) and is also not very likely that two completely different opamps would have exactly the same output impedance. I was prepared for a subtle effect, but the true explanation is that the falling offness is simply due to feedthrough via the internal capacitance of the analogue gate.

It now remains to explain why the OPA2134 apparently gives better offness in the flat low-frequency region. In fact it does not; the flat parts of the trace represent the noise floor for that particular opamp. The OPA2134 is a more sophisticated and quieter device than the TL072, and this is reflected in the lower noise floor.

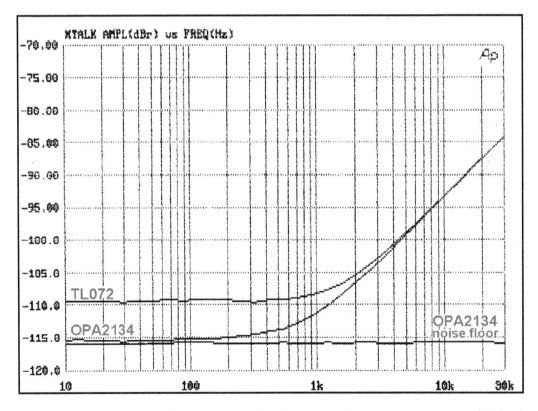

Figure 21.12 Voltage-mode changeover circuit offness for TL072 and OPA2134. 10 kΩ load.

There are two linearity problems. Firstly, the on-resistance itself is not totally linear. Secondly, and more serious, the on-resistance is modulated when the gates move up and down with respect to their fixed control voltages.

It will by now probably have occurred to most readers that an on/off switch with good offness can be made by making a changeover switch with one input grounded. This is quite true, but since much better distortion performance can be obtained by using the same approach in current mode, as explained later, I am not considering it further here.

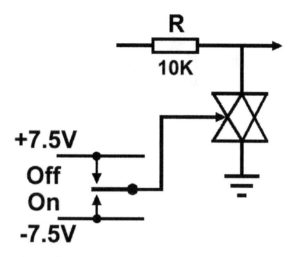

Figure 21.13 Voltage-mode shunt CMOS muting circuit.

Figure 21.13 shows a shunt muting circuit. This gives no distortion in the ON state because the signal is no longer going through the Ron of a gate. However the offness is limited by the Ron, forming a potential divider with the series resistor R; the latter cannot be very high in value or the circuit noise will be degraded. There is, however, the advantage that the offness plot is completely flat with frequency. Note that the ON and OFF states of the control voltage are now inverted.

Table 21.2 gives the measured results for the circuit, using the 4066. The offness can be improved by putting two or more of these gates in parallel, but since doubling the number N only gives 6 dB improvement, it is rarely useful to press this approach beyond four gates.

TABLE 21.2 Offness versus
number of shunt 4066 analogue
gates used, with R = 10 kΩ

N gates	Offness
1	−37 dB
2	−43 dB
4	−49 dB

CMOS gates in current mode

Using these gates in current mode—usually by defining the current through the gate with an input resistor and dropping it into the virtual-earth input of a shunt-feedback amplifier—gives much superior linearity. It removes the modulation of channel resistance as the gate goes up and down with respect to its supply rails, and, in its more sophisticated forms, can also remove the signal voltage limit and improve offness.

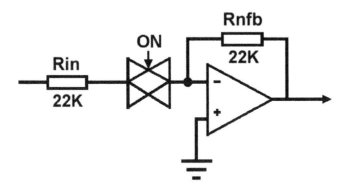

Figure 21.14 The simplest version of a current-mode on/off switch.

Figure 21.14 shows the simplest version of a current-mode on/off switch. An important design decision is the value of Rin and Rnfb, which are often equal to give unity gain. Too low a value increases the effect of the non-linear Ron, while too high a value degrades offness, as it makes the gate stray capacitance more significant and also increases Johnson noise. In many cases 22 kΩ is a good compromise.

Table 21.3 gives the distortion for +20 dBu (7.75 Vrms) in/out and shows that it is now very low compared with voltage-mode switchers working at much lower signal levels; compare the table data with Figures 21.8 and 21.9. The increase in THD at high frequencies is due to a contribution from the TL072 opamp. However, the offness is pretty poor and would not be acceptable for most applications. The problem is that with the gate off, the full signal voltage appears at the gate input and crosstalks to the summing node through the package's internal capacitance. In practical double-sided PCB layouts the inter-track capacitance can usually be kept very low by suitable layout, but the internal capacitance of the gate is inescapable.

TABLE 21.3 Distortion produced by a current-mode switch using 4016 gates, showing the gate contribution is small

	1 kHz	10 kHz	20 kHz
THD via 4016, +20 dBu	0.0025%	0.0039%	0.0048%
THD: 4016 shorted, +20 dBu	0.0020%	0.0036%	0.0047%
Offness	−68 dB	−48 dB	−42 dB

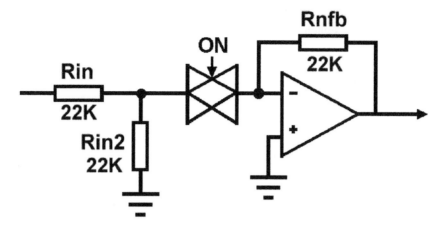

Figure 21.15 **Current-mode switch circuit with breakthrough prevention resistor Rin2.**

In Figures 21.14 and 21.15, the CMOS gate is powered from a maximum of ±7.5 V. This means that in Figure 21.14, signal breakthrough begins at an input of 5.1 Vrms. This is much too low for opamps running off their normal rail voltages, and several dB of headroom is lost.

Figure 21.15 shows a partial cure for this. Resistor Rin2 is added to attenuate the input signal when the CMOS gate is off, preventing breakthrough. There is no effect on signal gain when the gate is on, but the presence of Rin2 does increase the noise gain of the stage.

As with all shunt-feedback stages, this circuit introduces a phase inversion, which is sometimes convenient but usually not.

CMOS series-shunt current mode

We now extravagantly use two 4016/4066 CMOS gates, as shown in Figure 21.16.

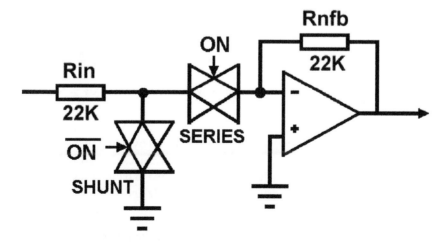

Figure 21.16 **A series-shunt current-mode switch.**

When the switch is on, the series gate passes the signal through as before; the shunt gate is off and has no effect. When the switch is off the series gate is off and the shunt gate is on, sending almost all the signal at A to ground so that the remaining voltage is very small. The exact value depends on the 4016/4066 specimen and its Ron value but is about 42 dB below the input voltage. This deals with the offness (by greatly reducing the signal that can crosstalk through the internal capacitance) and also increases the headroom by several dB, as there is now effectively no voltage signal to breakthrough when it exceeds the rails of the series gate.

Two antiphase control signals are now required. If you have a spare analogue gate it can generate the inverted control signal, as shown in Figure 21.17.

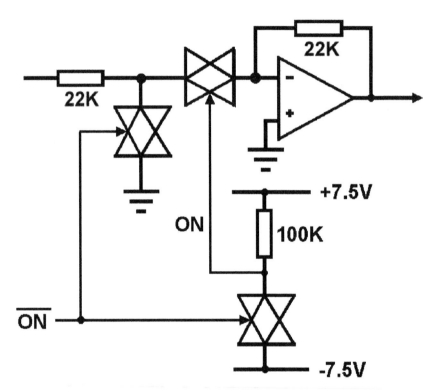

Figure 21.17 Generating antiphase control signals with a spare analogue gate.

The distortion generated by this circuit can be usefully reduced by using two gates in parallel for the series switching, as in Table 21.4; this gate-doubling reduces the ratio of the variable Ron to the fixed series resistor and so improves the linearity. Using two in parallel is sufficient to render the distortion negligible (the higher distortion figures at 10 kHz and 20 kHz are due to distortion generated by the TL072 opamp used in the measurements).

As before the input and output levels are +20 dBu, well above the nominal signal levels expected in opamp circuitry; measurements taken at more realistic levels would show only noise.

TABLE 21.4 Distortion levels with series-shunt switching

	1 kHz	10 kHz	20 kHz
THD via 4016 x 1, +20 dBu	0.0016%	0.0026%	0.0035%
THD via 4016 x 2, +20 dBu	0.0013%	0.0021%	0.0034%
THD 4016 shorted, +20 dBu	0.0013%	0.0021%	0.0034%
Offness 4016 x 1	−109 dB	−91 dB	−86 dB
Offness 4016 x 1, J111	< −116 dB	−108 dB	−102 dB

Discrete FETs have lower Ron than analogue gates. If a J111 JFET is used as the shunt switching element the residual signal at A is further reduced to about 60 dB below the input level with a consequent improvement in offness demonstrated by the bottom row in Table 21.4. This could also be accomplished by using two or more CMOS gates for the shunt switching.

Control voltage feedthrough in CMOS gates

When an analogue gate changes state, some energy from the control voltage passes into the audio path via the gate-channel capacitance of the switching FETs, through internal package capacitances, and through any stray capacitance designed into the PCB. Since the control voltages of analogue gates move snappily due the internal inverters, this typically puts a click rather than a thump into the audio. Attempts to slow down the control voltage going into the chip with RC networks are not likely to be successful for this reason. In any case, slowing down the control voltage change simply converts a click to a thump; the FET gates are moving through the same voltage range, and the feedthrough capacitance has not altered, so the same amount of electric charge has been transferred to the audio path—it just gets there more slowly.

The only certain way to reduce the effect of transient feedthrough is to soak it up in a lower value of load resistor. The same electric charge is applied to a lower resistor value (the feedthrough capacitance is tiny and controls the circuit impedance), so a lower voltage appears. Unfortunately reducing the load tends to increase the distortion, as we have already seen; the question is if this is acceptable in the intended application.

CMOS gates at higher voltages

Analogue gates of the 4016/4066 series have a voltage range of ±7.5 V, so they cannot directly switch signals from opamps running from the usual ±15 V or ±17 V rails. The classic device for solving this problem is the DG308 from Maxim. The absolute maximum supply rails are ±22 V, and the maximum signal range is specified as ±15 V. The Ron is typically between 60 and 95 Ω with ±15 V supply rails, comparable with a 4016 on ±7.5 V rails. The DG308 is *not* pin-compatible with the 4016/4066. The DG308 has been around for a long time, and it has always been significantly more expensive than 4016/4066. That situation continues today.

The DG411 is a more recent device that can run from ±18 V rails. Its Ron is quoted as 25 Ω typical. The DG412 and DG413 are very similar, differing only in the polarity of their control

logic. These devices are not pin-compatible with 4016/66. Figure 21.18 shows the distortion performance with the voltage-mode series switching circuit of Figure 21.6, with the control voltages suitably adjusted. Compare this with the results for the 4066 in Figure 21.8, noting that the load resistances go lower here; THD at 2 Vrms and 10 kΩ load is 0.03% for the 4066, and something like 0.0002% (mostly noise) for the DG411. This dramatic difference is because while the DG411 Ron is not particularly low, it is very flat across the range of signal voltages.

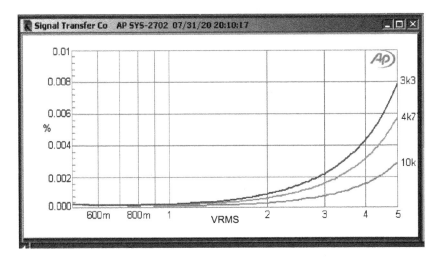

Figure 21.18 Distortion in voltage-mode of single DG411 gate at 5 Vrms, with ±18 V rails. Rload = 10 k, 4k7, and 3k3.

Using two DG411 gates in parallel exactly halves the distortion: see Figure 21.19. Note Y-axis scale change.

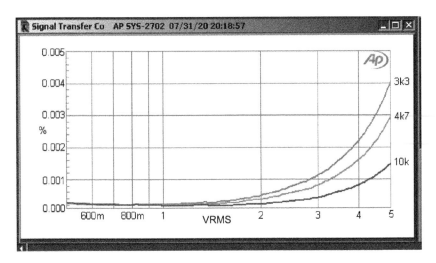

Figure 21.19 Distortion in voltage-mode of two paralleled DG411 gates at 5 Vrms, with ±18 V rails. Rload = 10k, 4k7, and 3k3. Note Y-axis scale change.

The offness of a voltage-mode switch depends on the amount of feedthrough via the internal IC and external stray capacitances. Compare Figure 21.10 for the 4066 with Figure 21.20; both show −55 dB at 10 kHz. The advantage of the DG411 here is that much lower loads can be used while still keeping distortion down, and the offness can be proportionally increased. Thus a 4k7 load gives 6 dB more offness than 10 kΩ.

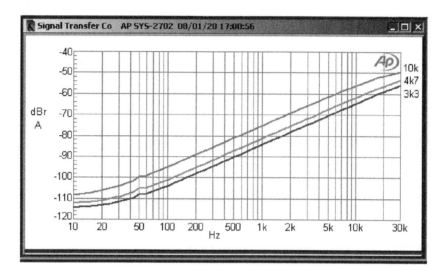

Figure 21.20 Offness of single DG411 gate at 5 Vrms input, with ±18 V rails. Rload = 10k, 4k7, and 3k3.

CMOS gates at low voltages

So far we have generally assumed that the CMOS analogue gates will be run from the maximum rated rail voltages of ±7.5 V to maximise the linearity of types such as the 4016/4066. As noted in Chapter 5, there is nowadays much interest in designing audio paths that can give decent quality when run from +5 V, the power typically being drawn from a USB port or similar digital source; what I call Five Volt Fidelity. The 4016/4066 gates work poorly under these conditions; the supply voltage is reduced to a third of the maximum, and this gives very bad linearity.

The answer is to use something designed for the job. The DG9424 from Vishay-Siliconix is rated for maximum supplies of ±6 V and works well running from a single 5 V supply. In this case its typical Ron is 3.4 Ω, which is much superior to the range of Ron shown for the 4016 in Figure 21.5. Once again a higher supply voltage means a lower Ron and less distortion; running the DG9424 from ±5 V reduces the typical Ron to 2 Ω and using the maximum ±6 V rails reduces it further to typically 1.8 Ω. This is a considerable advance on the older parts.

Figure 21.21 shows the distortion in series mode at various signal levels when driving a 10 kΩ load. When making the measurements I found that for outputs greater than 1.5 V and above 32 kHz the analogue switches entered a high-distortion mode that gave about 0.06% THD. Whether that is a typical finding I am not sure, but it is unlikely to cause problems unless you are handling high-level ultrasonic signals. I also found that distortion was at a minimum for a single +8 V

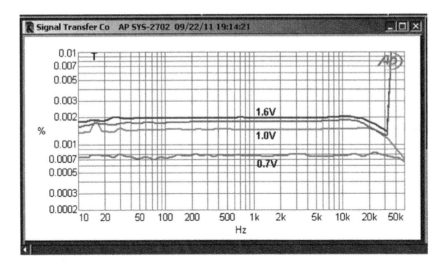

Figure 21.21 Distortion from DG9424 analogue gates powered from +5 V and driving a 10 kΩ load at various levels.

supply, which does not fit in well with the official Ron specs; the reason for this is currently unknown. The DG9424 is pin-compatible with the DG308.

CMOS gates in other formats

The 4016/4066 gives four separate analogue gates in a package. They were the first of their kind and things have naturally moved on. The ADG5208F is an 8-into-1 multiplexer, while the AD75019 is a highly impressive 16x16 crosspoint switch; in other words any of 16 input/outputs can be routed to 16 output/inputs, under serial data control. Both come from Analog Devices.

Discrete JFET switching

Having looked in detail at analogue switching using CMOS gates and having seen how well they can be made to work, you might be puzzled as to why anyone should wish to perform the same function with discrete JFETs. There are at least two advantages in particular applications.

Firstly, JFETs can handle the full output range of opamps working from maximum supply rails, so higher signal levels can often be switched directly without requiring opamps to convert between current and voltage mode.

Secondly, the direct access to the device gate allows relatively slow changes in attenuation (though still measured in milliseconds, for reasons that will emerge) rather than the rapid on-off action which CMOS gates give as a result of their internal control-voltage circuitry. This is vital in creating mute circuits that essentially implement a fast fade rather than a sharp cut and so do not generate clicks and thumps by abruptly interrupting the signal. A downside is that they require carefully-tailored voltages to drive the gates, and these cannot always be conveniently derived from the usual opamp supply rails.

Series JFET switching in voltage mode

The basic JFET series switching circuit is shown in Figure 21.22. With the switch open there is no other connection to the gate other than the bootstrap resistor Rboot; Vgs is zero, and so the FET is on. When the switch is closed, the gate is pulled down to a sufficiently negative voltage to ensure that the FET is biased off even when the input signal is at its negative limit.

The JFET types J111 and J112 are specially designed for analogue switching and are pre-eminent for this application. The channel on-resistances are low and relatively linear. This is a depletion-mode FET, which requires a negative gate voltage to actively turn it off. The J111 requires a more negative Vgs to ensure it is off than the J112, but in return gives a lower Rds(on) which means lower distortion.

The J111, J112 (and J113) are members of the same family—in fact they are the same device, selected for gate/channel characteristics, unless I am much mistaken. Table 21.5 shows how the J111 may need 10 V to turn it off but gives a 30 Ω on-resistance or Rds(on) with zero gate voltage. In contrast the J112 needs only 5.0 V at most to turn it off but has a higher Rds(on) of 50 Ω. The trade-off is between ease of generating the gate control voltages and linearity. The higher the Rds(on), the higher the distortion, as this is a non-linear resistance.

TABLE 21.5 Characteristics of the J111 JFET series

	J111	J112	J113
Vgs(off) min	−3.0	−1.0	−0.5 V
Vgs(off) max	−10	−5.0	−3.0 V
Rds(on)	30	50	100

FET tolerances are notoriously wide, and nothing varies more than the Vgs characteristic. It is essential to take the full range into account when designing the control circuitry.

Both the J111 and J112 are widely used for audio switching. The J111 has the advantage of the lowest distortion, but the J112 can be driven directly from 4000 series logic running from ±7.5 V rails, which is often convenient. The J113 appears to have no advantage to set against its high Rds(on) and is rarely used—I have never even seen one. The circuits below use either J111 or J112, as appropriate. The typical version used is shown, along with typical values for associated components.

Figure 21.22 has Source and Drain marked on the JFET. In fact, the J11x devices appear to be perfectly symmetrical, and it seems to make no difference which way round they are connected, so further diagrams omit this. As JFETs, in practical use they are not particularly static-sensitive.

The off voltage must be sufficiently negative to ensure that Vgs never becomes low enough to turn the JFET on. Since a J111 may require a Vgs of −10 V to turn it off, the off voltage must be 10 V below the negative saturation point of the driving opamp—hence the −23 V rail. This is not exactly a convenient voltage, but the rail does not need to supply much current and the extra cost in something like a mixing console is relatively small.

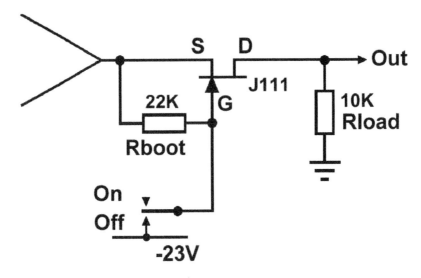

Figure 21.22 The basic JFET switching circuit, with gate bootstrap resistor.

To turn a JFET on, the Vgs must be held at zero volts. That sounds simple enough, but it is actually the more difficult of the two states. Since the source is moving up and down with the signal, the gate must move up and down in exactly the same way to keep Vgs at zero. This is done by bootstrap resistor Rboot in Figure 21.22. When the JFET is off, DC flows through this resistor from the source; it is therefore essential that this path be DC-coupled and fed from a low impedance such as an opamp output, as shown in these diagrams. The relatively small DC current drawn from the opamp causes no problems.

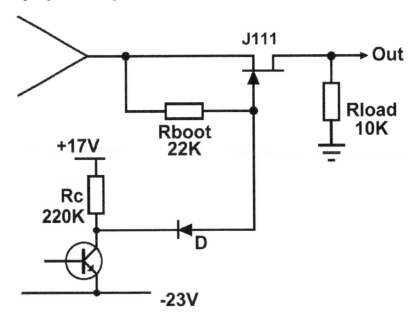

Figure 21.23 Using a transistor and diode for gate control.

Figure 21.23 is a more practical circuit using a driver transistor to control the JFET (if you had a switch contact handy, you would presumably use it to control the audio directly). The pull-up resistor Rc keeps diode D reverse-biased when the JFET is on; this is its sole function, so the value is not critical. It is usually high to reduce power consumption. I have used anything between 47 kΩ and 680 kΩ with success.

Sometimes DC-blocking is necessary if the opamp output is not at a DC level of 0 V. In this case the circuit of Figure 21.24 is very useful; the audio path is DC-blocked but not the bootstrap resistor, which must always have a DC path to the opamp output. Rdrain keeps the capacitor voltage at zero when the JFET is held off.

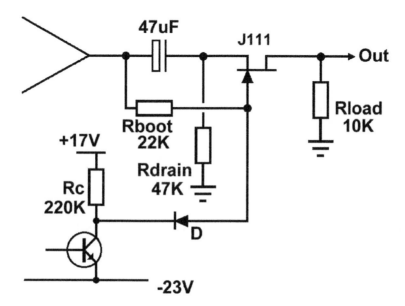

Figure 21.24 **The JFET switching circuit with a DC-blocking capacitor.**

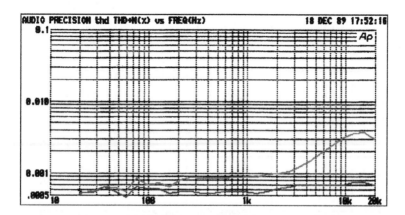

Figure 21.25 **The J111 distortion performance with a load of 10 kΩ. Lower trace is THD from the 5532 alone.**

Figure 21.25 shows the distortion performance with a load of 10 kΩ. The lower curve is the distortion from the 5532 opamp alone. The signal level was 7.75 Vrms (+20 dBu).

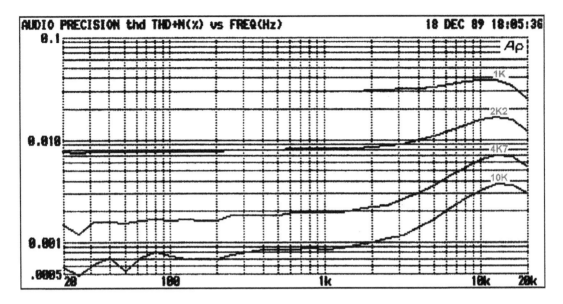

Figure 21.26 The J111 distortion performance versus loading; 10 kΩ to 1 kΩ.

Figure 21.26 shows the distortion performance with various heavier loadings, from 10 kΩ down to 1 kΩ. As is usual in the world of electronics, heavier loading makes things worse. In this case, it is because the non-linear Ron becomes a more significant part of the total circuit resistance. The signal level was 7.75 Vrms (+20 dBu).

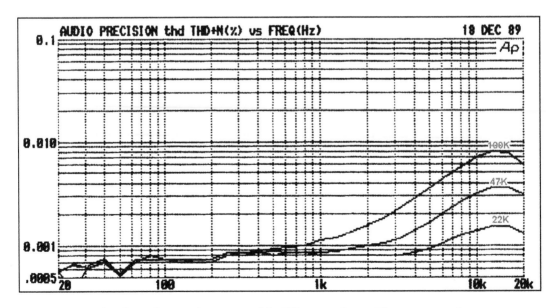

Figure 21.27 The distortion performance with different values of bootstrap resistor.

Figure 21.27 shows the distortion performance with different values of bootstrap resistor. The lower the value, the more accurately the drain follows the source at high audio frequencies and so the lower the distortion. The signal level was 7.75 Vrms (+20 dBu) once again. There appears to be no disadvantage in using a bootstrap resistor of 22 kΩ or so, except in special circumstances, as explained in what follows.

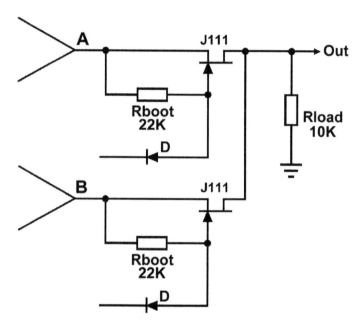

Figure 21.28 A JFET changeover switch.

Two series JFET switches can be simply combined to make a changeover switch, as shown in Figure 21.28. The valid states are A on, B on, or both off. Both on is not a good option because the two opamps will then be driving each other's outputs through the JFETs.

It is possible to cascade FET switches, as in Figure 21.29, which is taken from a real mixing console application. Here the main output is switched between A and B as before, but a second auxiliary output is switched between this selection and another input C by JFET3 and JFET4. The current drawn by the second bootstrap resistor Rboot2 must flow through the Rds(on) of the first FET and will thus generate a small click. Rboot2 is therefore made as high as possible to minimise this effect, accepting that the distortion performance of the JFET3 switch will be compromised at HF; this was acceptable in the application as the second output was not a major signal path. The bootstrap resistor of JFET4 can be the desirable lower value as this path is driven direct from an opamp.

Shunt JFET switching in voltage mode

The basic JFET shunt switching circuit is shown in Figure 21.30. Like the shunt analogue gate mute, it gives poor offness but good linearity in the ON state, so long as its gate voltage

is controlled so it never allows the JFET to begin conducting. Its great advantage is that the depletion JFET will be in its low-resistance state before and during circuit power-up and can be used to mute switch-on transients. Switch-off transients can also be effectively muted if the drive circuitry is configured to turn on the shunt FETs as soon as the mains disappears and keep them on until the various supply rails have completely collapsed.

I have used the circuit of Figure 21.30 to mute the turn-on and turn-off transients of a hifi preamplifier. Since this is an output that is likely to drive a reasonable length of cable, with its

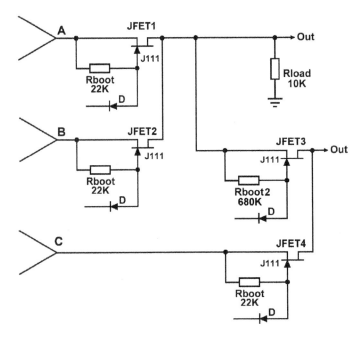

Figure 21.29 Cascaded FET switches.

attendant capacitance, it is important to keep R1 as low as possible to minimise the possibility of a drooping treble response. This means that the Rds(on) of the JFET puts a limit on the offness possible. The output series resistor R1 is normally in the range 47–100 Ω, when it has as its only job the isolation of the output opamp from cable capacitance. Here it has a value of 1 kΩ which is a distinct compromise—it is not suited for use with very long cables. Even with this value the muting obtained was not quite adequate at −27 dB so two J111s were used in parallel, giving a further −6 dB of attenuation. The resulting −33 dB across the audio band was sufficient to render the transients inaudible. The offness is not frequency dependent as the impedances are low and so stray capacitance is irrelevant.

JFETs in current mode

JFETS can be used in the current mode, just as for analogue gates. Figure 21.31 shows the basic muting circuit, with series FET switching only. Rin2 attenuates the signal seen by the FET when

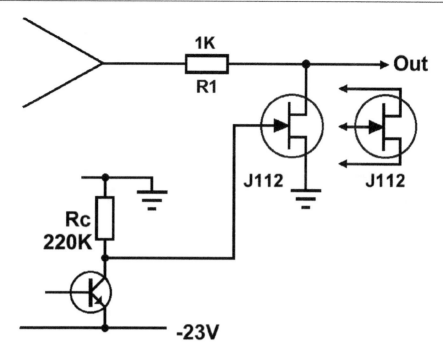

Figure 21.30 **The basic JFET shunt switching circuit. Adding more JFETs in parallel increases the offness, but each −6 dB requires doubling their number.**

it is off to prevent breakthrough; its presence means that the gain of the circuit is somewhat less than unity with the values shown, but the gain may be readily adjusted by altering the value of Rnfb. Figure 21.32 illustrates the distortion performance, and Figure 21.33 illustrates the offness of this circuit. Neither are startlingly good.

In designing a mute block, we want low distortion AND good offness at the same time, so the series-shunt configuration, which proved highly effective with CMOS analogue gates, is the obvious choice. The basic circuit is shown in Figure 21.34, the distortion performance is illustrated in Figure 21.35, and the offness in Figures 21.36 and 21.37. Capacitor C1 across the feedback resistor is usually required to ensure HF stability due to the FET capacitances hanging on the summing node at D.

Due to the shunt-feedback configuration, this circuit introduces a phase inversion. I have sometimes been forced to follow this circuit with another inverting stage that does nothing except get the phase right again. In this situation, it is sometimes advantageous to put the inverting stage *before* the mute block, so that any crosstalk to its sensitive summing node is muted with the signal by the following mute block.

The control voltages to the series and shunt JFETs are complementary as with the CMOS version, but now they can be slowed down by RC networks to make the operation gradual, as shown in Figure 21.35. The exact way in which the control voltages overlap is easy to control, but the Vgs/resistance law of the FET is not (and it is about the most variable FET parameter there is) and so

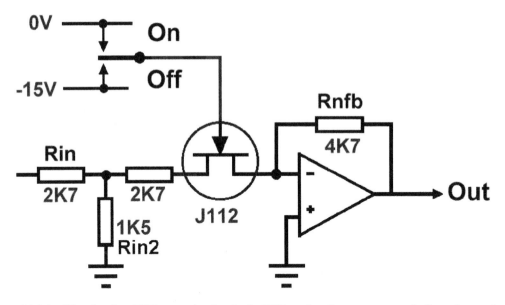

Figure 21.31 The simplest FET mute circuit: single-FET muting forces a crosstalk/linearity trade-off.

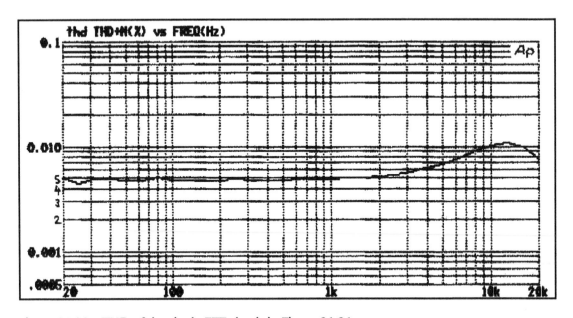

Figure 21.32 THD of the single-FET circuit in Figure 21.31.

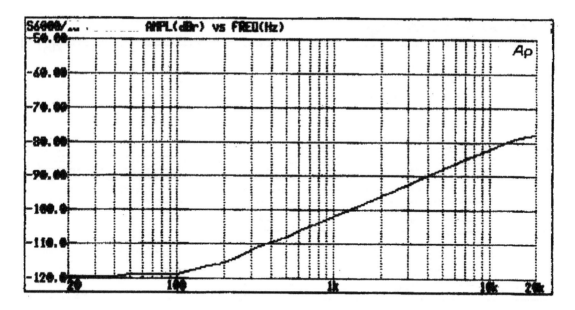

Figure 21.33 Offness of the single-FET circuit in Figure 21.31. It only manages −82 dB at 10 kHz.

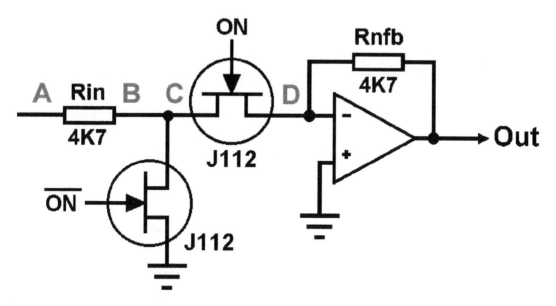

Figure 21.34 Series-shunt mode mute bloc circuit.

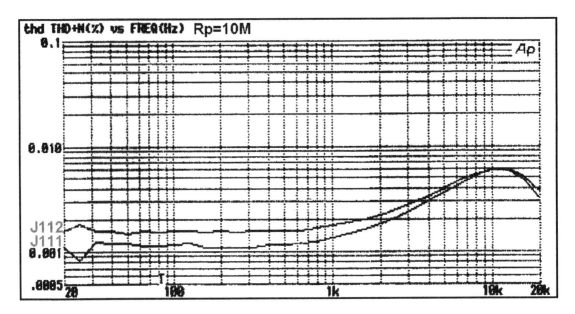

Figure 21.35 The THD of the mute bloc in Figure 21.38 with R = 4k7 and Rp = 10 MΩ. The increase in JFET distortion caused by using a J112 rather than a J111 is shown. The rising distortion above 1 kHz comes from the opamp.

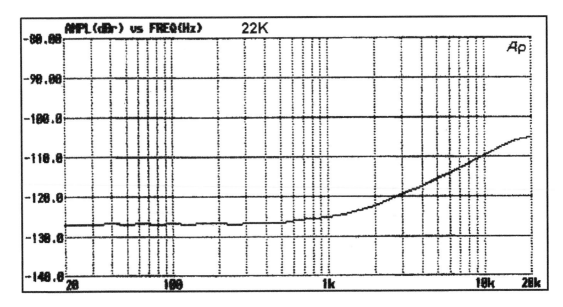

Figure 21.36 Offness of mute bloc in Figure 21.38 with Rin = Rnfb = 22 k.

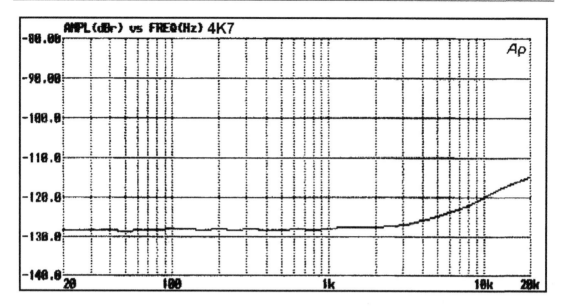

Figure 21.37 **Offness of mute bloc in Figure 21.38 with Rin = Rnfb = 4k7. Offness is better and the noise floor (the flat section below 2 kHz) has been lowered by about 2 dB.**

the overlap of FET conduction is rather variable. However, I should say at once that this system does work and works well enough to go in top-notch mixing consoles. As you go into the muted condition the series JFET turns off and the shunt JFET turns on, and if the overlap gets to be too much in error, the following bad things can happen:

1) If the shunt FET turns on too early, while the series JFET is still mostly on, a low-resistance path is established from the opamp VE point to ground, causing a large but brief rise in stage noise gain. This produces a 'chuff' of noise at the output as muting occurs.

2) If the shunt FET turns on too late, so the series JFET is mostly off, the large signal voltage presented to the series FET causes visibly serious distortion. I say 'visibly' because it is well-known that even quite severe distortion is not obtrusive if it occurs only briefly. The transition here is usually fast enough for this to be the case; it would not, however, be a practical way to generate a slow fade. The conclusion is that we should err on the side of distortion rather than noise.

Reducing distortion by biasing of JFETs

The distortion generated by this circuit block is of considerable importance because if the rest of the audio path is made up of 5532 opamps—which is likely in professional equipment—then this

stage can generate more distortion than the rest of the signal path combined and dominate this aspect of the performance. It is, therefore, worth examining any way of increasing the linearity that we can think of.

We have already noted that to minimise distortion, the series JFET should be turned on as fully as possible to minimise the value of the non-linear Rds(on). When a JFET has a zero gate-source voltage, it is normally considered fully on. It is, however, possible to turn it even more on than this.

The technique is to put a small positive voltage on the gate, say about 200–300 mV. This further reduces the Rds(on) in a smoothly continuous manner without forward biasing the JFET gate junction and injecting DC into the signal path. This is accomplished in Figure 21.38 by the simple addition of Rp, which allows a small positive voltage to be set up across the 680 kΩ resistor R1. The value of Rp is usually in the 10–22 MΩ range for the circuit values shown here.

Care is needed with this technique because if temperatures rise the JFET gate diode may begin to conduct after all, and DC will leak into the signal path, causing thumps and bangs. In my experience 300 mV is about the upper safe limit for equipment that gets reasonably warm internally, ie about 50°C. Caution is the watchword here, for unwanted transients are *much* less tolerable than slightly increased distortion.

As with analogue CMOS gates, an important consideration with this circuit is the impedance at which it works, ie the values of Rin and Rnfb. These are usually of equal resistance for unity gain so we will call their value R:

1) Raising R reduces distortion because it minimises the effect of Rds(on) variation in the series JFET.

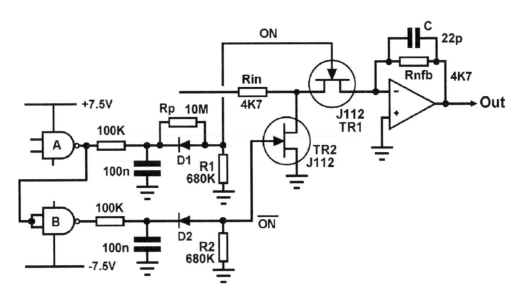

Figure 21.38 **Circuitry to generate drive voltages for series-shunt JFET mute bloc.**

2) Lowering R reduces the noise generated by the circuit and improves offness as it reduces the effect of stray capacitances. It also reduces the effect of control-voltage feedthrough via the gate-channel capacitances.

Figures 21.36 and 21.37 examine how the offness of the circuit is affected by using values of 4k7 and 22 kΩ. The latter gives −110 dB rather than −120 dB at 10 kHz. In my not inconsiderable experience with this circuit, R = 4k7 is the best choice when J112s are used. Values below 4k7 are not usual as distortion will increase as the JFET Rds(on) becomes a larger part of the total resistance in the circuit. The loading effect of Rin on the previous stage must also be considered.

JFET drive circuitry

The series-shunt mute bloc requires two complementary drive voltages, and these are most easily generated by 4000-series CMOS running from +/−7.5 V rails. NAND gates are shown here as they are convenient for interfacing with other bits of control logic, but any standard CMOS output can be used. It is vital that the JFET gates get as close to 0V as possible, ensuring that the series gate can be fully on and give minimum distortion, so the best technique is to run the logic from these +/− rails and use diodes to clamp the gates to 0 V.

Thus, in Figure 21.38, when the mute bloc is passing signal, the signal from gate A is high, so D1 is reverse-biased and the series JFET TR1 gate is held at 0V by R1, keeping it on (the role of Rp was explained above). Meanwhile, D2 is conducting as the NAND-gate output driving it is low, so the shunt JFET TR2 gate is at about −7 V, and it is firmly switched off. This voltage is more than enough to turn off a J112 but cannot be guaranteed to turn off a J111, which may require −10 V (see Table 21.5). This is one reason why the J112 is more often used in this application—it is simpler to generate the control voltages. When the mute bloc is off, the conditions are reversed, with the output of A low, turning off TR1, and the output of B high, turning on TR2.

When switching audio signals, an instantaneous cut of the signal is sometimes not what is required. When a non-zero audio signal is abruptly interrupted there is bound to be a click. Perhaps surprisingly, clever schemes for making the instant of switching coincide with a zero crossing give little improvement. There may no longer be a step-change in level, but there is still a step-change in slope, and the ear once more interprets this discontinuity as a click.

What is really needed is a fast fade over about 10 msec. This is long enough to prevent clicks without being so slow that the timing of the event becomes sloppy. This is normally only an issue in mixing consoles, where it is necessary for things to happen in real time. Such fast-fade circuits are often called 'mute blocks' to emphasise that they are more than just simple on-off switches. Analogue gates cannot be slowly turned on and off due to their internal circuitry for control-voltage generation, so discrete JFETs must be used. Custom chips to perform the muting function have been produced, but the ones I have evaluated have been expensive, single-source, and give less than startling results for linearity and offness; this situation is, of course, subject to change.

In Figure 21.38 the rate of control-voltage change is determined by the RC networks at the NAND-gate outputs. Ingenious schemes involving diodes to make the up/down rates different have been tried many times, but my general conclusion is that they give little if any benefit.

Physical layout and offness

The offness of this circuit is extremely good, providing certain precautions are taken in the physical layout. In Figure 21.39 there are two possible crosstalk paths that can damage the offness. The path C-D, through the internal capacitances of the series JFET, is rendered innocuous as C is connected firmly to ground by the shunt JFET. However, point A is still alive with full-amplitude signal, and it is the stray capacitance from A to D that defines the offness at high frequencies.

Given the finite size of Rin, it is often necessary to extend the PCB track B-C to get A far enough from D. This is no problem if done with caution. Remember that the track B-C is at virtual-earth when the mute bloc is on, and so vulnerable to capacitative crosstalk from other signals straying into the area.

Dealing with the DC conditions

The circuits shown so far have been stripped down to their bare essentials to get the basic principles across. In reality, things are (surprise) a little more complicated. Opamps have non-zero offset and bias voltages and currents, and if not handled properly these will lead to thumps and bangs. There are several issues:

1) If there is any DC voltage at all passed on from the previous stage, this will be interrupted along with the signal, causing a click or thump. The foolproof answer is of course a DC-blocking capacitor, but if you are aiming to remove all capacitors from the signal path, you may have a problem. DC servos can partly make up the lack, but since they are based on opamp integrators they are no more accurate than the opamp, while DC blocking is foolproof.

2) The offset voltage of the mute bloc opamp. If the noise gain is changed when the mute operates (which it is) the changing amplification of this offset will change the DC level at the output. The answer is shown in Figure 21.39. The shunt FET is connected to ground via

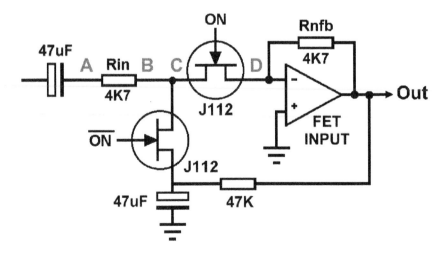

Figure 21.39 Circuit of JFET mute showing stray capacitances and DC handling.

a blocking capacitor to prevent gain changes. This capacitor does not count as 'being in the signal path' as audio only goes through it when the circuit is muted. Feedback of the opamp offset voltage to this capacitor via the 47 kΩ resistor renders it innocuous.

3) The input bias and offset currents of the opamp. These are much more of a problem and are best dealt with by using JFET opamps such as TL072 or OPA2134, where the bias and offset currents are negligible at normal equipment temperatures. All of the distortion measurements in this chapter were made with TL072 opamps in place ; OPA2134 would have given better results..

A soft changeover circuit with JFETs

This circuit (Figure 21.40) is designed to give a soft changeover between two inputs—in effect a fast crossfade. It is the same mute block but with two separate inputs, either or both of which can be switched on. The performance at +20 dBu in/out is summarised in Table 21.6.

The THD increase at 20 kHz is due to the use of a TL072 as the opamp. J112 JFETs are used in all positions.

This circuit is intended for soft-switching applications where the transition between states is fast enough for a burst of increased distortion to go unnoticed. It is not suitable for generating slow crossfades in applications like disco mixers, as the exact crossfade law is not very predictable.

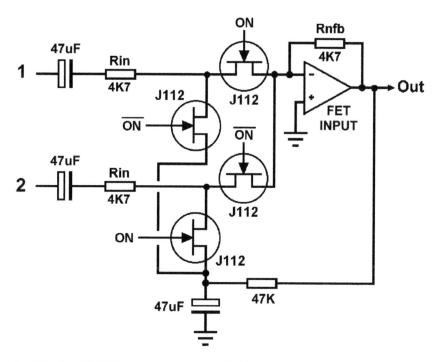

Figure 21.40 Circuit of JFET soft changeover switching.

TABLE 21.6 Distortion produced by JFET soft changeover switch

	1 kHz	10 kHz	20 kHz
THD +20 dBu	0.0023%	0.0027%	0.0039%
Offness	−114 dB	−109 dB	−105 dB

Control voltage feedthrough in JFETs

All discrete FETs have a small capacitance between the gate and the device channel, so changes in the gate voltage will therefore cause a charge to be transferred to the audio path, just as for CMOS analogue gates. As before, slowing down the control voltage change tends to give a thump rather than a click; the same amount of electric charge has been transferred to the audio path but more slowly. Lowering the circuit impedance reduces the effects of feedthrough, but halving it only reduces the amplitude of transients by 6 dB, and such a reduction is likely to increase distortion.

Discrete MOSFET switching

Audio switching with MOSFETs is often done with multiple MOSFETs in an IC (eg 4016/66, DG411, etc) but sometimes it is handy to use MOSFETs as single devices. A good example is the 2SN700/7002, which is a single N-channel enhancement FET. 2SN7000 is the TO-92 version and 2SN7002 is in SOT-32; the latter was used in my tests. Two MOSFETs must be used back-to-back to allow control of both polarities of input signal. Figure 21.41 shows voltage-mode switching, with an associated control-voltage driver. The equivalent circuit for 4016/66 is Figure 21.6 and for JFETs is Figure 21.22.

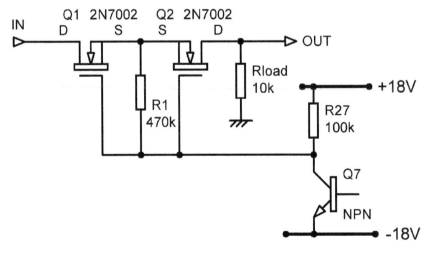

Figure 21.41 Voltage-mode audio switching with the 2SN700/7002 MOSFET.

The distortion performance of the 2SN7002 in voltage-mode is shown in Figure 21.42; distortion is flat with frequency. Compare with Figure 21.8 for the 4066, Figure 21.18 for the DG411, and Figure 21.26 for the J111. Of these three, the DG411 was by far the most linear, giving approximately 0.0018% at 4 Vrms with a 10 kΩ load resistance. The 2SN7002 reduces that to approximately 0.0001%, which is mostly noise. Linearity is summarised in Table 21.7.

TABLE 21.7 Summary of distortion from switching devices

Device	Figure	Level Vrms	Load	THD
4066	21.8	3	10 kΩ	0.055%
DG411	21.18	3	10 kΩ	0.0008%
J111	21.26	7.75	10 kΩ	0.0008%
2SN7002	21.42	3	10 kΩ	<0.0001%

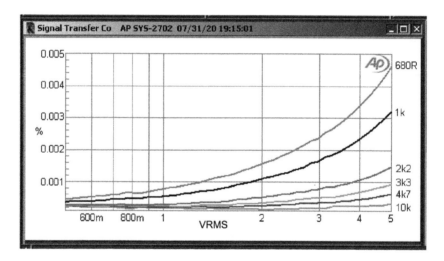

Figure 21.42 Distortion in voltage-mode of 2SN7002 pair at 5 Vrms, with ±18 V rails. Rload = 10 k to 680 Ω.

The 2SN7002 is a clear winner here, but the downside is you need two of them back-to-back.

The linearity of the 2SN7002 is also very good with lower load resistances; 2k2 can be driven at 3.8 Vrms before the THD exceeds 0.001%. The gate voltages for control were ±18 V as in Figure 21.41.

References

[1] Jones, M. "Designing Valve Preamps." *Electronics World*, Mar 1996, p. 193

Mixer sub-systems

This chapter deals with the specialised circuit blocks that make up mixing consoles. Some functions, such as microphone amplification, line input and output, and equalisation have already been explored in previous chapters. The other useful blocks are presented in the order that a signal encounters them as it goes through the console, but many of them are applicable to all the various kinds of module—input channels, groups, and master sections. For example, fader post-amplifiers and insert points will be found in all three types of module.

Mixer bus systems

In all but the smallest mixers there is a need to connect together all the modules so they have access to the mixing buses, power supply rails, and logic and control lines.

There are three basic ways of connecting together the modules. The smallest mixers are usually constructed on a single large PCB lying parallel to a one-piece front panel, and here 'modules' means repeated circuitry rather than physical modules. The all-embracing PCB minimises the money spent on connectors, and the time plugging them in during assembly, but there are obvious limitations to the size of mixer you can build in this way. A definite problem is the need to run summing buses laterally, as this results in them winding their way between controls and circuit blocks, threatening a mediocre crosstalk performance. The use of double-sided PCBs helps greatly with this, but very often there are still awkward points such as the need for the feed to and from the faders to cross over the mix bus area. This can easily wreck the crosstalk performance; one solution is to use what I call a three-layer board (see Chapter 2). The mix buses are on the bottom of the PCB, the top layer above it carries a section of ground plane, and the fader connections are made by wire links above that. Given a tough solder-resist, no further insulation of the links is necessary; if you have doubts then laying a rectangle of component-ident screen print under the links will give another layer of insulation without adding labour cost.

Medium-sized mixers are commonly made with separate modules, connected together with ribbon cable bearing insulation-displacement connectors (IDC). The advent of IDC ribbon cables (a long time ago, now) had a major effect on the affordability of mixing consoles. These cables naturally join Pin 1 to Pin 1 on every module, and so on, leading to a certain inflexibility in design.

Large mixers use a motherboard system, where each module plugs into a PCB at the bottom of the frame, which is typically divided into 'bins' holding eight or twelve modules. This provides (at

DOI: 10.4324/9781003332985-22

considerably increased expense) total flexibility in the running of buses and the interconnection of modules.

To me, it is a 'mixing bus' or a 'summing bus.' I realise that some of the world spells it "buss," and I am probably wasting my time pointing out that the latter is wrong, but I am still going to do it. The term dates from the dawn of electrical distribution, when circuits where connected together by copper bars called omnibus bars. This inevitably got shortened to 'bus-bars' and in mixing consoles it was further abbreviated to 'bus,' which somehow turned into 'buss." The *Oxford English Dictionary* says buss means "to kiss," (*archaic*), which seems somehow not quite appropriate. Unless of course you're recording Kiss. I have grave doubts if my protest here will make any difference to common usage, but sometimes you've just got to make a stand.

Input arrangements

Most mixer channels have both microphone and line inputs. On the lower-cost consoles these are usually switched to a single amplifier with a wide gain range, the line input being attenuated to a suitable level first. This approach is covered in Chapter 17 on microphone amplifiers. High-end consoles have separate line input amplifiers, removing some compromises on CMRR and noise performance. Dedicated line input amplifiers are dealt with in Chapter 18.

Equalisation

Mixer input channels have more or less sophisticated tone controls to modify the frequency response, either to correct imperfections or produce specific effects. This subject is fully dealt with in Chapter 15.

Insert points

The addition of effects for general use, such as reverberation, is normally handled by an effects send system. However, if a specific effect (say, flanging) is going to be used on one channel only then it is far more efficient and convenient to connect the external effects unit in series with the signal path of the channel itself. This is done by means of an insert point (usually just called an 'insert') which is a jack with normalling contacts arranged so that the signal flows to it and back to the channel again when nothing is plugged in. When a jack is inserted the normalling connection is broken, and the signal flows through the external unit. Inserts are also often fitted to groups.

Inserts come in two versions, illustrated in Figure 22.1. The single jack version is economical in panel space but is restricted to unbalanced operation. The two-jack version is superior because it allows the use of balanced send and returns, and in addition the OUT jack socket can be used as a direct output because inserting a jack in it does not break the signal path; only inserting a jack into the IN jack socket does that.

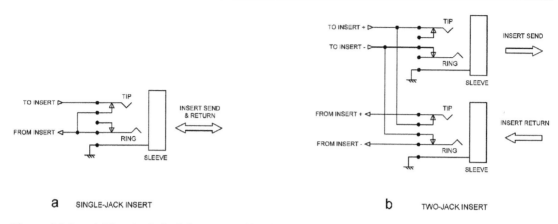

Figure 22.1 a) The single jack insert, and b) the two-jack insert.

When the mixer has a patchbay, the insert sends (and indeed, other console outputs) are likely to find their way there through a quite considerable length of ribbon cable, which has significant capacitance between its conductors. It is easy to get into a situation where the crosstalk performance of the console is limited by capacitive crosstalk between outputs, despite their low impedance. Output amplifiers commonly have a series resistor to isolate the amplifier from the capacitance of the cabling and prevent HF instability, and the minimum safe value of this resistor defines the output impedance, which is usually in the region of 47 to 100 Ω. Things get worse when the layers of ribbon cable are laid together in a 'lasagne' format; this is very often necessary because of the sheer number of signals going to and from the patchbay. In some cases layers of grounded screening foil are interleaved with the cables, but this is rather expensive and awkward to do and does not greatly reduce crosstalk between conductors in the same piece of ribbon. The only way to do this is to reduce the output impedance.

In a particular mixer design project, the crosstalk between the insert sends from the channels, with an output impedance of 75 Ω, was found to be −96 dB at 10 kHz. This may not sound like a lot, but I didn't get where I am today by designing consoles with measurable crosstalk, so something had to be done. An effective way to obtain a near-zero output impedance is shown in Figure 22.2. Here the main negative feedback for the opamp goes through R1, from the outside end of isolating resistor R2 and so reduces the output impedance, while the stabilising HF feedback is taken through C1 from the inside end where it is not subject to phase shift because of load capacitance. With this insert send stage the output impedance was reduced from 75 Ω to less than 1 Ω, and the crosstalk disappeared below the noise floor. Very similar circuitry can be used with stages that have gain. Arrangements like this must always be carefully checked to make sure that HF stability with a capacitive load really *is* maintained; this circuit is stable when driving a 22 nF load, which represents 220 metres of 100 pF/metre cable; see Chapter 19 for much more on this.

This arrangement is sometimes called a 'zero-impedance' output; the impedance is certainly much lower than usual but it is not of course actually zero.

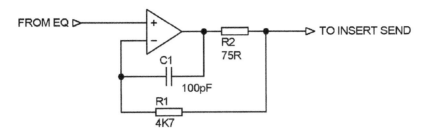

Figure 22.2 A typical non-inverting insert send amplifier with zero-impedance output.

In a group module, an inverting insert send amplifier is often used to correct the phase inversion introduced by the summing amplifier. A zero-impedance version of this is illustrated in the later section on summing amplifiers.

How to move a circuit block

In the more sophisticated and versatile mixers it is often possible rearrange the order of blocks in the signal path. A typical example is the facility to move an insert point from before to after the EQ section, depending on what sort of external processing is being plugged into the insert. Dynamics sections are also often movable to pre or post the EQ.

Figure 22.3 shows two ways to move a circuit block from one position to another in the signal path. The version at Figure 22.3a uses all the sections of a four-changeover switch to do the job. Normally the insert is before the EQ section, but when the switch, which would probably be labelled 'insert post' or whatever abbreviation of that can be fitted in, is pressed the signal passes along path A and reaches the EQ first; it then goes back through path B, through the insert, and then to the output along path C. However, the existence of two unused switch contacts gives us a broad hint that there may be a more efficient way to do it.

There certainly is; Figure 22.3b shows how to do it with only three changeovers. When the switch is pressed the signal passes along path A and reaches the EQ first, goes back through path B, to the insert, and then out via path C. You might think that this economy is quite pointless because either way you will need to use a physical four-changeover switch, but in fact the spare switch section in Figure 22.3b comes in very handy indeed to operate a switch status indicator LED. Alternatively the spare switch section can be connected in parallel with one of the other sections in the hope of improving reliability, but . . .

Paralleling switch sections sounds as though it would massively increase reliability, but it is actually not as useful as you might think. The classic switch problem is contamination of silver-plated contacts; the silver is converted to non-conductive silver sulphide by the action of hydrogen sulphide in the atmosphere. This can come from industrial pollution, but another source is diesel engine exhaust so virtually nowhere can be assumed to be free of it. If one set of contacts in a

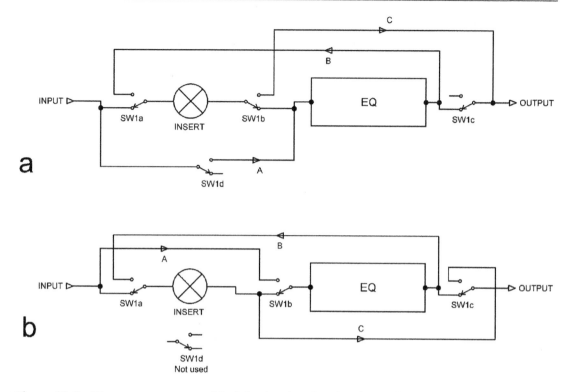

Figure 22.3 Two ways to move a block in the signal path. That at b) requires only three switch sections instead of four.

switch is affected then the other set right next to it is certain to be affected also, and paralleling the contacts is actually of little or no use. Sad but true.

Faders

So far as circuit design is concerned, a slide fader can normally be regarded as simply a logarithmic potentiometer, though in fact its internal construction may be quite complicated. The technology of faders is dealt with in Chapter 13 on volume controls and is not repeated here.

However, here is one anecdote that may yet have its uses. Connections to and from the fader are normally done by two individually screened cables. The send wire must be stopped from radiating, and the return wire stopped from both radiating and picking stuff up. The return wire will be quite susceptible to pick-up in some fader positions, and it should always be screened. However, I recall an application where there was no sensitive circuitry nearby and there was no need to screen the send wire. This was therefore an unscreened wire (coloured red to indicate send) that spiralled around the screened return wire. The spiralling was nothing to do with inductance—it just physically located the send wire. This saved quite a bit of time on making up fader connection harnesses.

Improving fader offness

This information is placed here rather than in Chapter 13 as it deals with circuitry around the fader rather than the fader itself.

For quite a long time in the mixer business, lower cost-bracket consoles used slide potentiometers rather than the precision faders made by people like Penny & Giles. These low-cost faders had a poor feel compared with the top-end faders, but their worst characteristic was poor offness due the resistance where the connection was made to the end of the carbon track. This was usually of the order of −90 dB, rather than the −120 dB or more you would expect from a top-end part. Low-cost faders did not use 'infinity-off' construction (see Chapter 13).

This meant that it was the fader that defined the general signal cleanliness of a mixing console; as described later in this chapter getting good routing offness had been sorted out several years earlier. While at Soundcraft I decided to do something about this. The key to the problem was that the offness of the faders used, while not very good, was quite consistent. This suggested that taking the signal from the top of the fader and feeding a tiny amount of it to the postfade amplifier in anti-phase would give a worthwhile amount of cancellation, and so it proved. Figure 22.4a shows two ways to implement the idea. The postfade amplifier has a very convenient 'inverting input' in that a high-value resistor can be connected to the negative-feedback arm as in Figure 22.4a. An appropriate choice for R5 improved the offness by a dependable 15 dB and often more across the audio band; there are no variations with frequency. Note that R5 was a fixed value and *not* adjusted-on-test, which would have been uneconomic; however periodic offness checks were undertaken to make sure the fader characteristics had not changed.

A more flexible method is shown in Figure 22.4b; the amount of anti-phase feedforward is now determined by two resistors, R5 and R4, which gives much more scope as both values can be

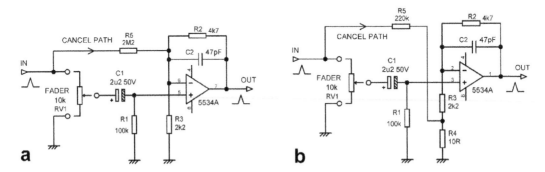

Figure 22.4 Improving the offness of a low-cost fader by cancellation: a) using a single feedforward resistor; b) using two resistors to give more control over the amount of anti-phase feedforward.

juggled to give on average good cancellation. I must emphasise that while this method can be highly effective, it does depend on consistency in the fader offness.

The first method was used in the Soundcraft Sapphyre input/output module, and the second was used on the Soundcraft Delta-SR mono input module and stereo input module (1992).

Postfade amplifiers

The postfade amplifier (sometimes called just the post amp) comes just after the fader, as its name implies. Its primary function is to allow the fader section to give gain. A +10 dB post amplifier, which is the most common amount of gain, allows the fader to be calibrated up to +10 dB. The 0 dB setting is then some way down the scale, and it is much easier to adjust the channel level up and down with respect to the rest of the mix. Without this feature, if a channel was fully faded up at 0 dB, to increase its relative level it would be necessary to pull all the other faders down. When you consider that a large mixer may have 64 channel faders you can see that this would be something of a nuisance.

The second function of the post amp is to buffer the fader from the heavy loading of panpot, mix resistors, and aux sends. The fader control law is carefully chosen for optimal controllability, and that law would be seriously distorted if all that loading came directly on the fader wiper.

It is important that the postfade amp has good noise performance because its noise contribution is not much reduced when the fader is pulled down, and it must also have a good load-driving capability at low distortion. For these two reasons, the 5534/2 opamp found a home in post amps quite early in its history, when its high cost ruled it out for most other circuit functions, which were still handled by TL072s. The other place that 5534/2s appeared early was in summing amplifiers, which often work at a high noise gain.

However, in budget designs TL072s or equivalent FET-input opamps are still used because they are not only cheaper themselves but allow several other parts to be omitted. In Figure 22.5a, the opamp input can be directly connected to the fader wiper because the input bias current is negligible and does not cause significant noise when the wiper is moved along the track. Note that the gain-determining resistors R2, R3 have to be quite high to minimise the loading on the opamp output. C3 improves stability.

In a more sophisticated design as in Figure 22.5b, the use of a 5534 with its significant bias current means that DC-blocking capacitor C1 is required to prevent unpleasant sounds when the fader is adjusted; in turn this means that R1 is required to bias the opamp. Another consequence flows from this; R1 has to have a relatively high value so it does not load the fader and distort its control law, and so the 5534 input bias current causes a relatively large offset voltage at the opamp input. The 5534 max bias current is 800 nA, which means a possible drop across R1 of −37.6 mV. The 5534 has NPN input devices, so the bias current flows into the input pins and so this voltage is negative; that is why C1 is the way round it is. This input offset appears multiplied by three at the post amp output, giving −113 mV. This is not enough to significantly affect the available output swing, but it does mean that C2 must be introduced to keep DC out of the panpot and postfade sends. Since the loading is quite heavy, C2 must be large to prevent it creating distortion (see Chapter 2). Note also the polarity of C2. We now have not only a more expensive opamp with a higher power consumption, but three extra components. Their number is multiplied

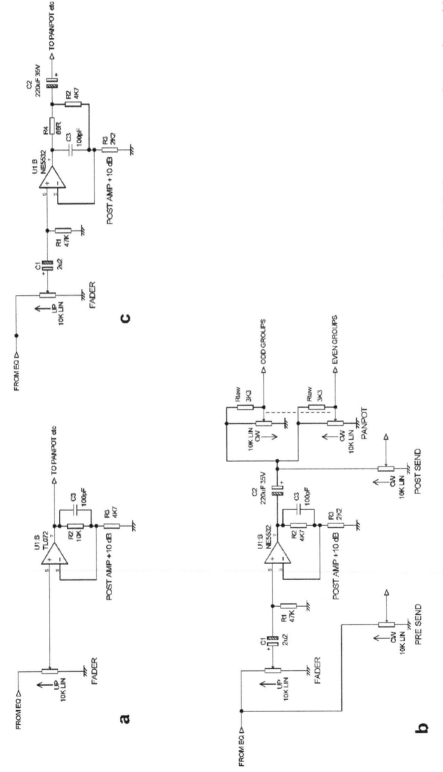

Figure 22.5 Three versions of a postfade amplifier. a) is the cheap and cheerful version, while b) is the more up-market version, with pre and post sends and the panpot section of a mixer channel shown. c) protects the opamp against capacitive loading while still giving a zero-impedance output.

by N, the number of channels, so you can see that the use of the 5534 as a post amp was actually a more serious cost decision than it might appear.

You will note that in Figure 22.5b the resistors R2, R3 in the feedback network have been reduced in value by a factor of about two to improve the noise performance. However they are still not particularly low in value, and it is true that the noise performance could be improved if they were reduced to say, 680 Ω and 330 Ω, which in itself would be well within the drive capability of a 5532. However, in simpler desks this opamp has to drive not only its own feedback network, but also the panpot, routing matrix, and the postfade sends and most of its drive capability has to be reserved for this duty.

Figure 22.5c shows a post amp utilising the zero-impedance approach described earlier for insert send amplifiers. In some layouts the panpot, routing, and postfade sends are physically spread out so that the stray capacitance seen by the post amp output is enough to imperil its stability. An output isolating resistor R4 cures the problem, but if simply stuck in the output line cause the level after it to vary as changing panpot and send settings alter the load on it. The feedback resistor R2 is therefore fed from after R4, preserving the zero-impedance output, but C3 is fed from before it, maintaining the HF stability.

Fader post amps almost invariably have a fixed gain; if they did not the carefully-designed fader law would no longer be obtained. However, there are places where making the gain effectively variable by the use of positive feedback allows the post amp to have a low gain when its associated control is at a low setting; this minimises the noise contribution of the post amp. There is more on this technique later in this chapter, in the section on Hybrid Summing Amplifiers.

Direct outputs

In more complex consoles, a direct out is available from each channel. This is a postfade signal, which can be fed directly to a recording device without sending it through the routing and summing systems. This gives a minimum signal path which will exhibit less noise and possibly less distortion. In all except the most elaborate consoles the direct out tends to be unbalanced and to save hardware; reliance is placed on the recording device having balanced inputs.

Many Soundcraft mixers used ground-cancelling direct outputs, giving most of the benefits of a balanced link when plugged into an unbalanced output, for the cost of a couple of resistors. See Chapter 19 on line outputs.

Panpots

The word 'panpot' is short for panoramic potentiometer. It is the control that places a monaural source in the desired place in the left–right stereo scene. It is an extremely fortunate property of human hearing that this can be done effectively simply by altering the proportion of the mono signal that is sent to the left and right channels of the stereo output. Changing the perception of up and down is considerably more complicated and outside the scope of mixer design.

The earliest attempt at 'panpotting' dates back to before the use of electrical amplification. In 1903 the French engineer Leon Gaumont was granted patents for loudspeaker systems to go with his sound-on-gramophone-disc talking films. Gaumont was the first to suggest placing loudspeakers behind the screen, with men carrying them about to follow the images on the screen. This procedure has never found favour in the sound industry, especially amongst those who might be asked to do the carrying.

To give smooth stereo panning without unwanted level changes, the panpot should theoretically have a sine/cosine characteristic, as shown in Figure 22.6; with this law both signals are attenuated by 3 dB when the panpot is set centrally. This is because when listening to stereo over loudspeakers, the signals that sum at each ear are not correlated, and so with equal amplitude the two signals give a result that is only 3 dB above the level of each of the components. The summation of two uncorrelated white noise sources to give a combined signal that is 3 dB, and not 6 dB, greater works on exactly the same principle. The sine/cosine law is therefore appropriate for stereo.

However, when you are listening in mono, such as via AM radio, the left and right signals have been summed when they are still in the electrical domain, and therefore are in phase and sum together arithmetically. In this case the pan law needs to be −6 dB down at the centre rather than −3 dB if level changes are to be avoided, so in this case a sine-squared/cosine-

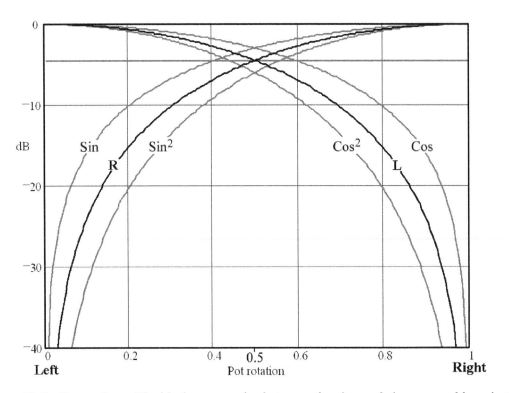

Figure 22.6 Panpot laws. The ideal compromise between the sine and sine-squared laws is the arithmetical mean of the two, shown here.

squared law is required. Since it is highly desirable to cope with both cases, the standard answer is to use a compromise between the two laws of −4.5 dB at the centre. This is entirely satisfactory in practice, not least because moving a component of the mix around during the performance is completely inappropriate for many forms of music, though it was popular in early 1970s rock, eg Wishbone Ash. I have yet to hear a music reviewer complain of "bad panpotting."

Figure 22.6 shows both the sine and sine-squared theoretical laws, and also the lines L, R which indicate the ideal compromise law; it is the arithmetical mean of sine and sine-squared and so is −4.5 dB down with the panpot central. So how do we obtain the compromise law we want?

Passive panpots

Figure 22.7 shows three different ways to make a panpot. Panpot circuits can be made with single pots with the wiper grounded, as shown in Figure 22.7a, but this has several disadvantages, not least the poor offness when panned hard over, caused by the current flowing through the wiper contact resistance to ground.

Potentiometers with an accurate sine/cosine law used to exist, which in theory allowed the use of the simple panpot circuit in Figure 22.7b, but they were always bulky and

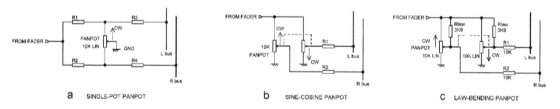

Figure 22.7 Three ways to make a panpot; c) uses a linear pot with law-bending resistors and is the most popular.

prohibitively expensive for audio use and seem to have disappeared altogether now that analogue computers are no longer at the cutting edge of technology. Hifi preamplifiers sometimes use a control with a 'balance law' for adjusting channel balance (see Chapter 14 for more on that), but this usually has no attenuation at all at the centre point and would make a poor panpot.

The traditional answer to the problem has always been to use dual linear pots and bend the linear law into an approximation of the compromise law we want by the use of fixed pull-up resistors connected to the wipers, as shown in Figure 22.7c. Here the panpot wipers are loaded with mix resistors of 10 kΩ, which being connected to virtual-earth buses are connected to ground as far as the panpot is concerned, and the pull-up resistors Rlaw are made 3k9 to give the desired 4.5 dB of attenuation at the centre position of the panpot.

There is an important factor in the design of panpot circuitry, and here a significant difference between low-cost and high-cost mixers intrudes. A low-cost mixer will drive the routing resistors

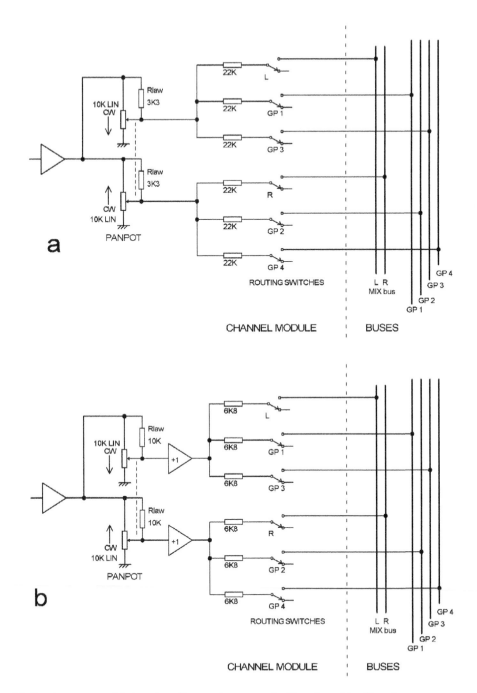

Figure 22.8 A panpot with law-bending resistors; unbuffered and buffered.

directly from the panpot wipers, as shown in Figure 22.8a, and the panpot law is affected by the loading to ground represented by the routing resistors; they work in opposition to the law-bending pull-up resistors, which therefore have to be reduced in value (here to 3k3) to get the mid-point attenuation back to −4.5 dB. As the wiper loading increases and the value of the pull-up resistors is decreased with respect to the panpot track, the more the resulting law tends to flatten out around the central position, as shown in Figure 22.9. Table 22.1 shows how the law-bend resistors change with loading when a 10 kΩ pot is used, and the resulting pan laws can be seen in Figures 22.9 and 22.10.

The distorted law that results from excessive loading gives a panpot that does little as it is moved through the central position and has an unpleasant 'dead' feeling; there are also level problems, as previously described. In addition, the lower the pull-up resistors, the greater loading they place on the stage upstream, which is usually the fader post amp; the loading is at its worst when the panpot is hard over to either side. This way of using a panpot presents a compromise on top of a compromise and puts a limit on the number of mix resistors that can be driven directly from a panpot.

Figure 22.10 shows the differences between the ideal compromise law and the actual law that results from law bending, for various wiper loadings as in Table 22.1. The amplitude error of the right output gets enormous as the loading increases; when the panpot begins to move away from hard left the level shoots up much too quickly.

Since the value of the pull-up resistor required to get the best approach to the required law depends on the loading on the panpot wiper, this is a very good reason to use routing methods that place a constant load on the panpot, regardless of the number of buses that are being routed to, as this at least allows the value of the law-bending resistors to be optimised at one value. More on this later.

TABLE 22.1 Wiper loading and pull-up resistor values in Figures 22.8 and 22.9

Trace in Figures 22.9, 22.10	Wiper loading	Pull-up resistor
1	15 k	5 k
2	4 k	2.2 k
3	3 k	1.8 k
4	2 k	1.2 k

A more sophisticated approach is used in high-cost mixers, which puts unity-gain (or near-unity gain) buffers between the panpot and the loading of the routing resistors, as shown in Figure 22.8b. Here there are two points to note; the panpot wipers now have a negligible loading to ground, and the pull-up resistors therefore have a much higher value of 10 kΩ, which will improve offness as less current goes through the wiper contact resistance. Also, the routing resistor values can be reduced, as they no longer load the panpot, and this reduces the Johnson noise generated in the summing system.

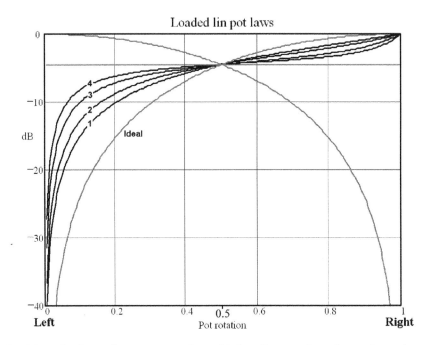

Figure 22.9 How the law of a panpot varies with loading on the wipers; in each case the law-bending resistors have been adjusted to give −4.5 dB at the centre. See Table 22.1.

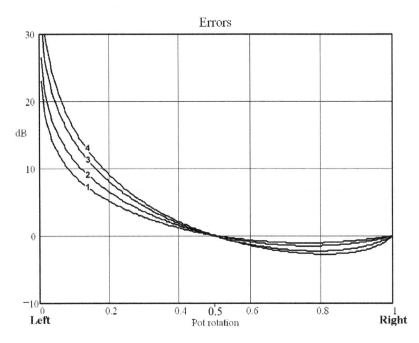

Figure 22.10 The difference between the ideal compromise law and the actual law that results from law bending. See Table 22.1.

This law-bending technique is a workable solution and has been very widely used, but unfortunately the addition of the law-bending resistor introduces another problem. A reasonable quality pot has an offness of about −90 dB with reference to fully up, due to the end-of-track resistance. The pull-up current from the law-bend resistors, however, passes through the wiper contact resistance, which is usually greater than the end-of-track resistance, and this extra resistance severely limits the attenuation the panpot can provide when set hard left or right, degrading the offness of the panpot from approximately −90 dB to −65 dB when it is hard over. The problem is made worse because when the wiper is at the bottom of the track, the whole of the signal voltage across the pot is also across the law-bend resistor, which is lower in resistance than the pot track and so passes more current through the wiper contact resistance. The exact value of offness obtained depends on the component values and the construction of the pot. The way this works is shown in Figure 22.11.

This reduction in offness is not really a problem in stereo use, as an attenuation of −65 dB is more than enough to pan a sound so it is subjectively completely to one side (in fact about −20 dB will do that), but it is a very serious issue for mixers that route to groups in pairs or in other words have one switch to route to Groups 1 and 2, another switch for Groups 3 and 4, and so on. Simpler mixers route to groups in pairs, as this makes good use of two-changeover switches, (and as mentioned before, the channels are by a long way the most cost-sensitive part of a mixer), but it means that if you are, say, routing to Group 1 by pressing the 1–2 switch and then panning hard left, then the signal being sent to Group 2 will only be −65 dB down. In bigger and more expensive consoles each group has its own routing switch, with the spare switch section typically used for an indicator LED, so panpot offness is not such an important issue.

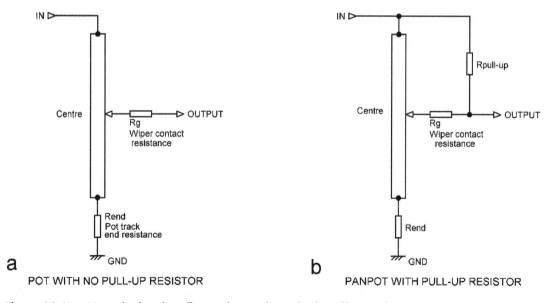

Figure 22.11 How the law-bending resistors degrade the offness of a panpot.

The active panpot

I think that it has been made clear that a conventional panpot is a bundle of compromises, and I decided in 1989 to do something about it. The active panpot was one of those ideas that strikes with such force that you remember exactly where and when it happened: in this case on the fifth floor of a tower block in Walthamstow, London. I had a glass of beer in my hand and had consumed half a pint. Ideas often strike at that point, but seldom after.

The active panpot shown in Figure 22.12 works by replacing the simple pull-up resistor with a negative-impedance-converter that modulates the law-bending effect in accordance with the panpot setting, making a closer approach to the sine law possible. This sounds intimidating but is actually very simple. The wiper of the left half of the panpot is connected to a series-feedback amplifier U1:A that gives a modest gain of about 2 dB, set by R2 and R3; the exact value shown in Figure 22.12 is 1.73 dB. The law-bending resistor R1 is driven from the output of this amplifier rather than the top of the panpot, and so, when the panpot wiper is at the lower end of its travel there is little or no signal to the amplifier, and therefore no pull-up action when it is not required. There is therefore no signal current flowing through the wiper contact resistance, so the left-right isolation using a good-quality pot is greatly improved from approximately –65 dB to –90 dB,

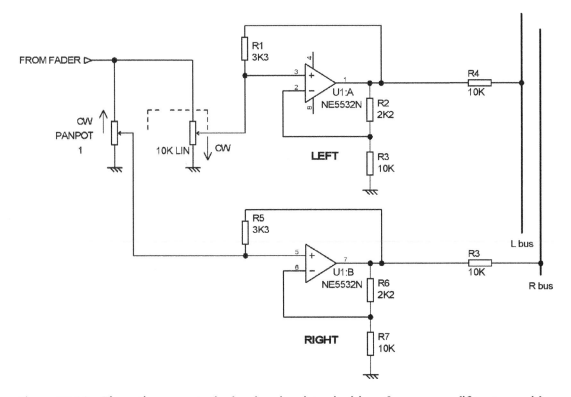

Figure 22.12 The active panpot: the law-bend resistor is driven from an amplifier stage with a gain of about 2 dB.

being now limited solely by the end-of-track resistance as shown earlier in Figure 22.11a. As an extra benefit, if the amplifier gain and the law-bend resistor are correctly chosen, is the pan law is much closer to the desired sin/sin² compromise law than can be obtained by the simple law-bending method described earlier; this is illustrated in Figure 22.13. This concept was protected by patent number GB 2214372 in 1989.

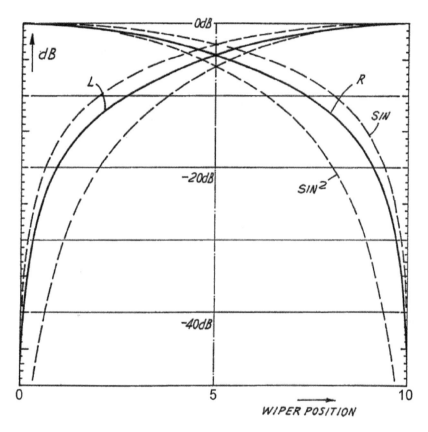

Figure 22.13 **The active panpot: the resulting law is much closer to the desired sin/sin²** **compromise. From patent number GB 2 214 372.**

The active panpot is obviously a more expensive solution, as we have added a dual opamp and four resistors to every channel. However, we get other benefits for our money as well as better pan offness and a better pan law; if the dual opamp is a 5532 (which it should be to keep the postfade noise down) then its good drive capability means that the value of the routing resistors can be reduced, which reduces both capacitive crosstalk and noise in the summing system.

LCR panpots

A relatively recent innovation in the world of panpots is the LCR panpot, where LCR stands for left-centre-right. This has three outputs; the left and right in general working the same way

as for a normal panpot. As the panpot is moved from extreme left, the centre output rises from zero, reaches a maximum with the panpot central, and then falls to zero again as the panpot reaches extreme right. The LCR panpot is used with speaker systems that have a central cluster as well as left and right speaker banks. This means that centrally panned signals are always heard as in the centre of the sound field, regardless of listening position, and this is useful when vocals or speech are combined with music, as typically occurs in religious installations. It is also used for panning to a discrete centre channel to create Surround and 5.1 mixes. A switch is normally provided by which the LCR pot can be converted to conventional L/R stereo operation.

There are two possible ways to handle LCR panning. In what I call the 'full-width' method, as shown in Figure 22.14, the left and right panpot outputs work much as they do in a normal stereo panpot, only falling to zero at the extreme end of control rotation.

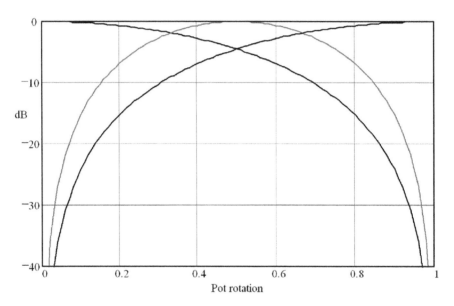

Figure 22.14 A full-width LCR panpot law. Left and right cross over at −4.5 dB in the centre as before, while C is 0 dB at the centre, but zero at each extreme.

The alternative is the 'half-width' method in which both left and right outputs fall to zero at the centre setting and stay there for further control rotation; this is shown in Figure 22.15. Both figures show laws which are a sin/sin^2 compromise as described earlier and are therefore 4.5 dB down at the centre—in the case of the half-width method these 'centres' are at pot positions of 25% and 75% rotation. Which LCR panning method is most appropriate depends on the application; some LCR panpot systems can switch between the full-width and half-width modes.

Figure 22.15 A half-width LCR panpot law. Left and right fall to zero at the centre setting and stay there for further control rotation. The crossover points between left and centre and right and centre are now at −4.5 dB.

Figure 22.16 shows a full-width LCR panpot arrangement. The L and R sections are as for a normal L-R panpot, but the C pot track is grounded at each end and fed with signal via its centre-tap; an LCR panpot always requires specially-designed pots with centre-taps on the tracks. These are available from major manufacturers like Alps, but they are inevitably made in small quantities and are relatively expensive.

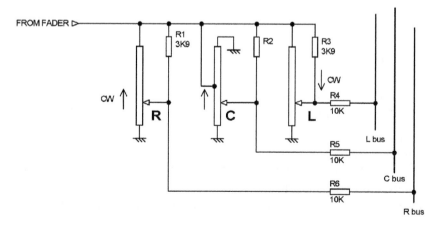

Figure 22.16 A full-width LCR panpot system.

Figure 22.17 shows a half-width LCR panpot. The L and R sections now are also centre-tapped (more expense!), and those taps are grounded so that the output falls to zero at the central control setting. The C pot track is grounded at both ends and fed with signal via its centre-tap as before.

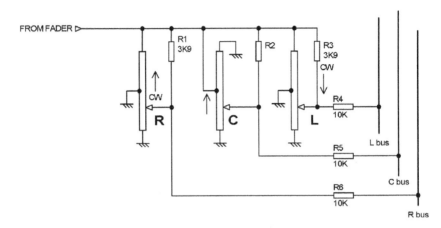

Figure 22.17 A half-width LCR panpot system. The L and R sections are now centre-tapped also.

LCR panpots, like ordinary panpots, give much superior performance in terms of offness and a better pan law when the active panpot system is applied to them. This is straightforward to do and is arranged exactly as for the stereo version.

Consoles with LCR panning systems include the Soundcraft Series 5, the Yamaha M2500–56, the D&R Orion, and the Amek 9098i. True LCR panning is not common as it is a relatively high-cost facility.

Routing systems

The routing system selects which mix bus the channel signal goes to. In a simple N into 2 stereo mixer the panpot does all the routing that is required, but as soon as more groups are introduced some sort of switching is required for bus selection.

Figure 22.18a shows the conventional routing system as commonly used up until about 1980. There are two problems with this method. Firstly, the capacitance between the switch contacts when they are open is significant, and this severely limits the crosstalk performance of the console. To get a feel for the problem, look at Figure 22.19 which shows the crosstalk performance of an ALPS SPUN two-changeover switch working into a mix bus with a 10 kΩ feedback resistor in the summing stage. This is a conventional push-switch with two parallel sections.

At 10 kHz the offness is only −66 dB, and at 20 kHz it is barely −60 dB. The problem is capacitive crosstalk across the switch contacts in the off position. Note that grounding the second switch section in the pious hope of improving things only reduces the crosstalk by 2 dB.

This problem can be completely eliminated by using the arrangement in Figure 22.18b, which is sometimes called the back-grounding system. The mix resistors are now connected to the channel ground when not in use, and so there is no possibility of capacitive crosstalk, so long as the switches, of which one contact still carries signal voltage, are not too close to the mix buses. But . . . this plan has a terrible drawback. The crosstalk performance is good, but back-grounding the mix resistors means that since relatively few routing switches are on at a time, most of the resistors are grounded, and the summing amp is working at or near maximum noise gain and always picks up the maximum possible ground noise.

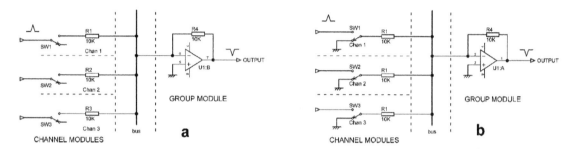

Figure 22.18 Two mediocre routing systems with virtual-earth summing, as used in the 1970s. a) Suffers from poor offness and b) has bad noise performance.

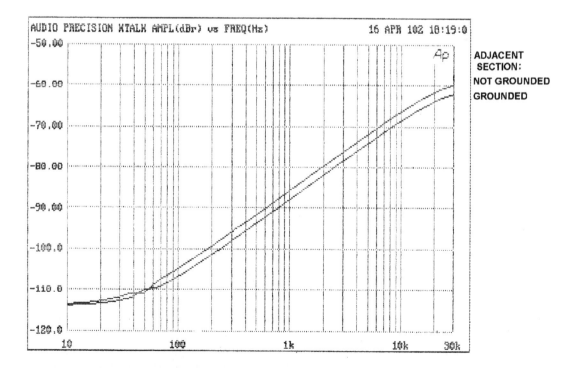

Figure 22.19 The poor high-frequency offness of a switch in a conventional routing system with a 10 kΩ summing feedback resistance.

It might be wise to take a moment here to explain the noise gain of a summing system; noise gain itself is dealt with in Chapter 1. A simple inverting amplifier with equal input and feedback resistors has a noise gain of two times, or 6 dB, because the noise referred to the amplifier input sees effectively a non-inverting amplifier with a gain of two, and so the noise at the output is twice that of the noise-generating mechanisms at the amplifier input. The important point is that the noise gain is greater than the signal gain, which is unity.

TABLE 22.2 Noise gain of a summing amp versus the number of mix resistors connected

Number of mix resistors	Noise gain times	Noise gain dB
1	2	6.02
2	3	9.54
4	5	13.98
8	9	19.08
12	13	22.28
16	17	24.61
24	25	27.96
32	33	30.37
48	49	33.80
56	57	35.12
64	65	36.26

If a second mix resistor of equal value is connected to the summing point, the amplifier input now sees effectively a non-inverting amplifier with a gain of three, and the noise gain is increased to almost 10 dB, though the signal gain via either mix resistor remains unity. The more channels that are routed to a mix bus, the worse the noise performance is, as summarised in Table 22.2. It is therefore clear that the arrangement in Figure 22.18b will be working at the worst-case noise gain all the time. Not only will the noise of the summing amp receive maximum amplification, but any ground noise in the console which puts the channel grounds at slightly different potentials will be picked up as effectively as possible. This is not a good plan, especially in large consoles.

Obviously a routing system that combined the advantages of the first two systems—good offness and minimum noise gain—would be a great improvement.

So, finally, here is the most satisfactory routing system. In the arrangement shown in Figure 22.20, the routing resistors are once more grounded when not being fed by the channel, but the topology has been turned around so that the grounded resistors are now connected to the channel rather than the mix bus. The switches rather than the routing resistors are connected directly to

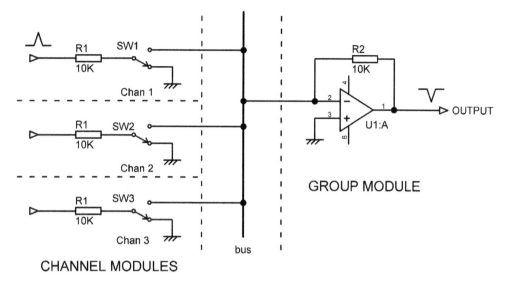

Figure 22.20 **The routing system that I introduced in 1979 which gives both good routing offness and optimal noise performance. Virtual-earth summing system also shown.**

the summing buses, and when a routing switch is not active, the feed from the routing resistor is grounded. So long as the Hot end of the mix resistor can be kept away from the mix buses, the offness is truly excellent. With a bit of care in the physical construction the offness can easily be better than −100 dB at 20 kHz. A possible objection is that all the grounded resistors put a heavier load on the channel circuitry upstream; this is quite true, but it has the countervailing advantage that the since each mix resistor is either grounded directly or connected to a virtual-earth mix bus, the loading remains constant, and so if, for example, the resistors are driven from an unbuffered panpot, you will get a predictable panning law, if not necessarily a very good one. This routing method retains the advantage of working the summing system at the minimum noise gain.

I have a difficulty here. To the best of my knowledge I invented this system in the backroom of a shop in Leyton, London in 1979. I recall being nervous about the apparently iffy business of having the routing switch at virtual-earth because of increased stray capacitance to ground from the virtual-earth bus, but in fact that caused no problems. However, since very little has been published about the details of mixer design, it being a proprietary art confined to a relatively small number of companies, it is not currently possible to say if I was the first to invent it.

The set of routing switches in each channel (often called the routing matrix) is relatively expensive and is, of course, multiplied by the number of channels. It is therefore common on all but the most expensive consoles for routing to be done in pairs; in other words the first switch routes the channel to Groups 1 and 2, the second to Groups 3 and 4, and so on. This is simple to do as many varieties of push-switch come in a two-changeover format as standard. If routing to only one group is required then the signal has to be steered to the appropriate bus with the panpot.

The offness of the panpot when set hard over is then crucial to obtaining good crosstalk figures; the active panpot scheme described earlier greatly improves this aspect of performance.

This system solves the electrical problems, but it relies on there being adequate physical separation between conductors carrying signal and the mix buses to keep the capacitance between them low. This can present some interesting topological challenges. The obvious way to arrange the routing matrix is to put the switches next to the front panel, with the mix resistors behind them. Assuming we are using a double-sided PCB, the tracks from the panpot to the mix resistors are on the other side of the board from the mix buses, but inevitably they have to cross over at some point, separated only by fibreglass. Back in the dark days when the cost penalty of double-sided PCBs was very serious, a single-sided PCB would be used with various convolutions of tracks and topside links used to get signals to the right places; this was inevitably a bundle of crosstalk compromises. Even a double-sided layout falls a long way short of perfection, as there is no screening between the panpot tracks and the mix bus tracks at the point where they cross. Keeping the track width to a minimum at this point reduces the capacitance between the tracks, but it remains the major limitation on crosstalk, ie 'routing offness.' If the routing resistors are through-hole, the pads and component leads on the same PCB side as the mix buses will also contribute to unwanted coupling.

The solution to this problem, introduced by me in the Series 6000 in 1987 at Soundcraft, was to reduce the size of the routing resistors from 1/4W to 1/8W, which made them small enough to fit between the actuators of the routing switches, right at the front edge of the PCB. This placed the mix resistors well away from the rear of the switches, which was the furthest extent of the mix buses, and likewise the panpot tracks could be run along the very front of the PCB. The use of a double-sided PCB allowed a ground plane to be placed on the other side of the mix buses. This form of construction was very successful, giving a major improvement in routing offness, and was later used in the famous 3200 console in 1988. Nowadays the mix resistors would probably be metal film SMD and could be fitted in very tight spaces at the front of the routing switches.

Auxiliary sends

These are straightforward. There is often a pre/post switch before the send pot so the send signal can be taken from before or after the fader. In many designs added flexibility is given in the form of push-on links so that other take-off points for the send signal can used, such as before the EQ section. Changing all these links on a large console is naturally not a light matter.

If there is an on/off switch for the send then it should disconnect the mix resistor from the bus, just as with the group routing switches described previously. This reduces summing noise dramatically if only a few auxes are in use and gives an offness much better than that at the end of the aux pot travel.

Group module circuit blocks

Most of the circuit blocks used in group modules carry out the same functions as they do in the input channel modules. The great exception is, of course, the summing amplifier,

which has a technology all of its own. Before diving into the details of practical summing amplifiers, it is advantageous to look at the various methods of performing that apparently simple but actually rather demanding task—adding signals together. The most fundamental function of a mixer, as its name suggests, is to combine two or more signals in the desired proportion. As with many areas of electronics, an extremely simple definition of the job to be done (addition—how hard can that be?) rapidly shows itself to have ever-deeper levels of complexity.

There are several intriguing techniques to look at:

Voltage summing

Virtual-earth summing

Balanced summing

Ground-cancel summing

Distributed summing

Summing systems: voltage summing

The earliest mixers used voltage summing, or passive summing as it sometimes called, as shown in Figure 22.21; note that only half of each panpot is shown, for clarity. The great drawback with this system is that there is a significant voltage on the mix buses, so that a signal can be fed onto the bus by one channel, and it can get back into another channel, as shown in the figure, from where it may, depending on the control settings, find its way onto another mix bus where it is definitely not wanted. This is demonstrated by the arrow A in the diagram. Channel 1 is feeding a signal onto Group 3 bus, and this is sidling back into Channel 2, which has both routing switches engaged and the panpot central, allowing the signal to turn round and get onto Group 1 bus. This sort of thing can, of course, be completely suppressed by suitable buffer stages after the panpot, and that is exactly what was done in the large consoles of the day. This means a lot of extra electronics, and this mixing system is not suitable for low or medium-cost designs. Another big snag is that since the mix buses have significant voltages on them, they must be carefully and expensively screened from each other to prevent capacitive crosstalk. Running the buses in a piece of low-cost ribbon cable is simply not an option.

You will have noted that all the routing switches are back-grounded, so there is a constant impedance from the mix bus to ground; this is essential as otherwise the gain of the summing system would vary with the number of channels routed to a bus. This in turn means that the amplifiers that get the low level on the bus back up to the nominal internal level are always working at substantial gain and are relatively noisy.

Summing systems: virtual-earth summing

Summing today is done almost universally by virtual-earth techniques, as shown above in Figure 22.20. An opamp or equivalent amplifier with shunt feedback is used to hold a long mixing

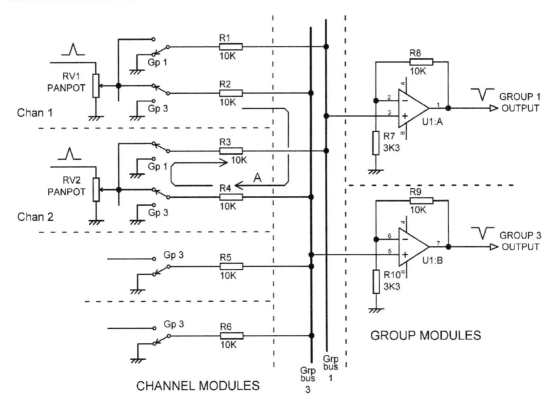

Figure 22.21 Voltage summing system as used in the 1960s.

bus at apparent ground, generating a sort of audio black hole; signals fed into this via mixing resistors apparently vanish, only to reappear at the output of the summing amplifier, as they have been summed in the form of current. The great elegance of virtual-earth mixing, as opposed to the voltage-mode summing technique in Figure 22.21, is that signals cannot be fed back out of the bus to unwanted places, as it is effectively grounded, and this can save massive numbers of buffer amplifiers in the input channels. The near-zero bus impedance also means that the gain does not alter as varying numbers of channels are routed to a bus. The appearance of the virtual-earth mixing concept was highly significant, as it essentially made low-cost mixing consoles viable.

There is, however, danger in being dazzled by this elegance into assuming that a virtual-earth is a perfect earth; it is not. A typical opamp-based summing amp loses open-loop gain as frequency increases, making the inverting input null less effective. The 'bus residual' (ie the voltage measurable on the summing bus) therefore increases with frequency and can cause inter-bus crosstalk in the classic situation with adjacent buses running down an IDC cable.

As we saw in the last section on routing, a virtual-earth summing system operates at quite a high noise gain when many inputs are routed to it. Minimising the noise is therefore of prime importance, and one obvious step is to keep the impedance of the summing system as low as possible to reduce Johnson noise in the mix resistors. I have been involved in more mixing console designs than I care to contemplate, of all sizes and types, and it is interesting to recall that the mix resistors were always in the range 22 kΩ to 4.7 kΩ, which seems like a rather narrow range of 4.7 to 1. There is a reason for this. 22 kΩ mix resistors are used in small budget consoles because a small number of them (say six) can be driven directly from a panpot without distorting its law unacceptably. Now consider a big expensive 32-group console where the panpot is buffered, but it has to drive 16 mix resistors on each side with the buffer and making them of very low resistance would present enormous loading. The mix resistors will therefore be something like 6.8 kΩ; the value has only been reduced by a factor of 3.23, and Johnson noise will only be reduced by the square root of this, or 5.1 dB.

Mix resistors lower than this are only used for the critical L-R mix buses, where there are only two to be driven, and 4.7 kΩ is a common value. It actually only gives an advantage of 1.6 dB over 6.8 kΩ. The lowest mixing resistors I am aware of are in fact 4.7 kΩ, and this value was used in the Neve VR consoles, which in their largest formats had a possible 144 inputs going to the L-R mix bus (72 modules each with two paths to the mix bus).

This consideration of resistance demonstrates the difficulty of reducing the Johnson noise beyond a certain point by reducing the summing impedance. Halving the mix resistors doubles the drive power required, but only improves the noise by a factor of the square root of two. Johnson noise is, of course, only one factor; there is also the noise from the summing amplifier itself. The current-noise component of this is reduced proportionally by reducing the bus impedance.

Apart from the noise performance, another advantage of a low summing system impedance is that it makes the mix buses less sensitive to capacitive crosstalk. Reducing mix resistors from 22 kΩ to 6.8 kΩ may only give a 5.1 dB improvement in noise, but it gives a 10 dB reduction in capacitive crosstalk.

Balanced summing systems

As a console grows larger, the mix bus system becomes more extensive, and therefore more liable to pick up internal capacitive crosstalk or external magnetic fields; the latter are poorly screened by the average piece of sheet steel. The increased physical size means longer ground paths with non-negligible signal voltage drops across them. An expensive but thoroughly effective answer to this the use of a balanced summing system. The basic idea is shown in Figure 22.22; only half of the channel panpot is shown, for clarity.

Each mix bus is now double, having a Hot (in-phase) and Cold (out of phase) bus, exactly like the Hot and Cold wires in a balanced line connection. These run physically as close together as possible. At the channel end, each side of the panpot has an inverting buffer A2 that drives a second set of mix resistors that feed the Cold mix buses. Two sections are now required for the

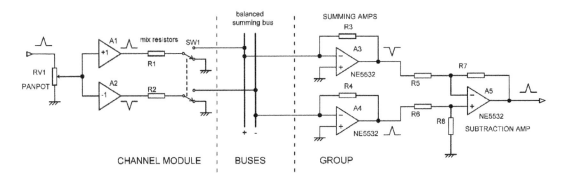

Figure 22.22 A balanced summing system.

routing switch SW1, which is fine as most push-switches are in a two-changeover format, but if you want switch status indication, which you normally will on a console large and sophisticated enough to employ balanced summing, four-changeover switches are needed—lots of them— and the cost jumps up. Each bus connects to a summing amplifier A3, A4 and their outputs are subtracted by A5 to cancel the common-mode signals.

A quite separate advantage of a balanced summing system is that it has a better noise performance because having two buses gives you 6 dB more signal, but only 3 dB more noise because the noise from the two summing amplifiers is uncorrelated and partially cancels. This gives you a 3 dB noise advantage that it would be difficult to get by other methods. Against this must be counted the extra noise from the channel inverters.

Because of the cancellation of capacitive crosstalk that occurs, the offness of the routing matrix can be made very good indeed. On the last console of this type that I designed the offness was a barely measurable −120 dB at 20 kHz.

As I just noted, probably all consoles of this type will have routing switch status indication, and so use four-changeover switches. This leaves a spare switch section doing nothing, and if you have followed this book so far you will have gathered it is not in my nature to leave a situation like that alone. In the last balanced console I designed, this fourth switch section was used to detect when *no* routing switches were active; this happens more often than you might think on a large desk. In this condition an FET switcher removed the signal feed to the buffers driving the mix resistors. This prevented a large number of grounded resistors being pointlessly driven, reducing power consumption significantly, and further improving routing offness.

It may have occurred to you that a considerable simplification would result if the channel inverters were done away with, and the Cold resistors simply connected to ground. The signal level in the summing system would be 6 dB lower, exacting a 3 dB noise penalty, but the rejection of ground voltages and the cancellation of capacitive crosstalk would be just as good. This is not a sound plan. Much of the cost of balanced summing lies in the doubled number of mix resistors, routing switch contacts, and mix buses. The saving on inverter cost of is relatively small. The

large currents flowing in the mix resistors are now unbalanced and are much more likely to cause troublesome voltage drops in ground connections.

A variation on this approach can, however, be very useful in specific applications; see the "Ground-cancel summing systems" section.

Ground-cancelling summing systems

Ground-cancel summing systems are very useful in auxiliary send systems where all sends are routed permanently to the bus. It gives some of the advantages of a balanced summing system at a tiny fraction of the cost, and it is particularly useful in consoles where the modules are connected together by ribbon cabling with a relatively high ground resistance. The basic principle is shown in Figure 22.23, which represents a single channel with two aux sends. The ground potential of each channel is read by a low-value resistor R3 and summed into the GC bus; this is not a virtual-earth bus as such, but it is at a very low impedance and is essentially immune to capacitive crosstalk. The GC bus is then used as the ground reference for the aux summing system, and by subtraction it gives excellent rejection of the channel ground potentials. If a channel is at the remote end of the ribbon cable then its ground resistance is relatively high and the local channel ground will carry a large signal potential, which is fed into the GC bus; conversely a channel at the near end of the ribbon cable will have a much lower ground potential, also fed into the GC bus. The end result is that good aux offness figures are obtained for both those channels. In such a system the aux offness is defined not by the grounding arrangements but by the offness of the aux send pot itself, typically −90 dB with reference to fully up.

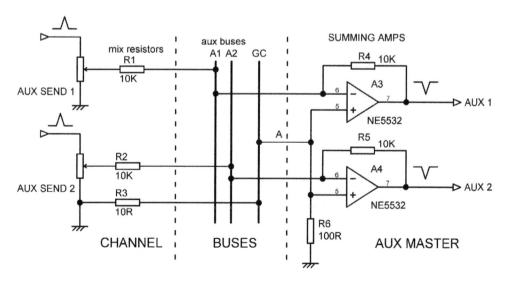

Figure 22.23 A typical ground-cancelling summing system for aux sends.

A couple of design points. The GC resistors R3 should be very low in value so that their Johnson noise contribution is negligible; the only requirement is that they are large with respect to the ground resistances to allow accurate subtraction. R6 is a safety resistor fitted in the aux master module so that it will keep working if the GC bus becomes disconnected. Without it the entire aux send system is dependent on the single connection A between the bus structure and the aux master module, and such a situation is not good practice. The only requirement is that R6 is high with respect to the total GC bus impedance so that the subtraction remains accurate. If an aux send has an on/off switch that disconnects the mix resistor from the bus, to minimise noise gain, the switch must also disconnect the GC resistor to maintain correct cancellation.

In some ribbon-cable consoles the grounding is reinforced by heavy (32/02) ground wires with push-on connectors plugged into every channel module or in some cases every fourth or fifth module. Even in this case the use of a ground-cancel summing system will normally give a worthwhile improvement.

Distributed summing systems

Distributed summing (sometimes called devolved summing or devolved mixing) is a deeply cunning way of improving the noise performance of a summing system, with reference to the noise from the summing amps themselves. In what follows the noise from an input channel and Johnson noise from the summing resistors are for the time being ignored.

In a distributed summing system the contributory signals are summed in two separate stages. Thus if you are summing together 24 channels, you might sum them in blocks of eight to get three sub-groups which are then summed together to get a single output, as shown in Figure 22.24a. Unlikely as it may seem, this two-layer summing system gives a definite noise advantage. Assume that every summing amplifier creates the same amount of input-referred voltage noise Vn; the result of this at the amplifier output then depends only the noise gain at which it is working. If we sum our 24 channels into one in the normal virtual-earth manner, the output noise will be 25 Vn, and that is our reference case. If we sum eight inputs together, the output noise will be only 9 Vn; three of these sub-mix outputs are now summed together, and you may have seen this coming—the signals sum arithmetically but the summing amp noise partially cancels, so the combined noise output is 9 Vn times $\sqrt{3}$, which is 15.6 Vn. To this we must add the noise of our second summing amp; this is working at a noise gain of only four, and so its own output noise contribution is 4 Vn. Adding the uncorrelated 15.6 Vn to 4 Vn RMS-fashion gives a total of 16.1 Vn, which is 1.55 times or 3.83 dB quieter than the straightforward all-in-one-go summation of 24 inputs into one. Clever, eh?

The downside to this is of course that a bit more hardware is required—we are using four summing amplifiers rather than one. This is, however, a trivial extra expense compared with the electronics involved in 24 input channels. A more serious potential problem with this approach is that there is now a hidden layer of summing amplifiers which might clip without there being any indication on the console control surface.

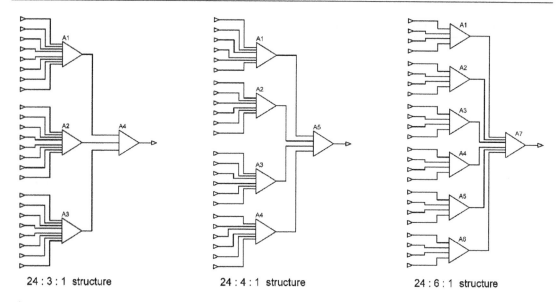

24 : 3 : 1 structure 24 : 4 : 1 structure 24 : 6 : 1 structure

Figure 22.24 Three different distributed summing schemes for 24 inputs. 24:6:1 is the quietest.

You are by now, I hope, pondering if there is anything special about the 24 into 3 into 1 (24:3:1) structure or whether other variations might be better; the answer is yes. Three different possibilities are shown in Figure 22.24. Summing the 24 inputs in batches of six into four sub-mixes and then summing them to one (24:4:1) gives an advantage of 4.51 dB, while summing four at a time into six sub-mixes and then summing to one (24:6:1) gives an advantage of 4.97 dB, and this is the optimal solution for 24 inputs.

The results are summarised in Table 22.3, which shows that there is not much difference between 24:6:1 and 24:8:1, except that the latter uses a bit more hardware and is a negligible 0.2 dB noisier. It is hard to see why anyone would want to use the 24:12:1 structure because of all those extra summing amps, but it is interesting to note that it still gives a theoretical noise improvement of 3.53 dB.

TABLE 22.3 The noise advantage of two-layer distributed summing with 24 inputs

No of inputs	No of sub-mixes	Noise advantage dB
24	2	2.56
24	3	3.83
24	4	4.51
24	6	4.97
24	8	4.76
24	12	3.53

TABLE 22.4 The noise advantage of two-layer distributed summing with 32 inputs

No of inputs	No of sub-mixes	Noise advantage dB
32	2	2.68
32	4	4.94
32	8	5.88
32	16	4.01

Table 22.4 illustrates the noise advantages with various forms of two layer summing for 32 inputs; the maximum advantage is now a very useful 5.88 dB, and once again the best results come from first summing the inputs in batches of four. There are less options this time because 32 has less factors than 24.

Table 22.5 shows the optimal structures giving minimum noise for various numbers of inputs; at first it looks as if there is something special about doing the first layer of summing in batches of four inputs, but as the total number of inputs reaches 72 the optimal number suddenly starts to rise.

The figures in Table 22.5 do show a rather unsettling irregularity; for example the optimal structure for 80 inputs is no quieter than that for 72 inputs. This seems to be because some numbers of inputs have more factors than others, and so give a greater choice of structures to choose from.

TABLE 22.5 The optimal two-layer summing structures for various numbers of inputs

Total no of inputs	No of inputs in each sub-mix	Optimal structure	Noise advantage dB
16	4	16:4:1	3.64
24	4	24:6:1	4.97
32	4	32:8:1	5.88
48	4	48:12:1	7.09
56	4	56:14:1	7.52
64	4	64:16:4	7.88
72	6	72:12:1	8.48
80	8	80:10:1	8.48
88	8	88:11:1	8.84
96	6	96:16:1	9.43
104	8	104:13:1	9.46
112	8	112:14:1	9.73
120	6	120:20:1	10.13
128	8	128:16:1	10.21
136	8	136:17:1	10.43
144	6	144:24:1	10.67

Two-layer distributed summing is particularly adapted to consoles built in sections, typically as bins of 8 or 12 modules. It avoids virtual-earth buses extending over large physical areas, which makes them more susceptible to magnetic fields and ground voltage drops, and can cause difficulties with HF stability. Each bin can now be connected by balanced low-impedance line connections, with the final summing done at whatever point is convenient. Both Neve and Focusrite have produced consoles with distributed summing systems in the past.

As I'm sure you have appreciated by now, I am a great one for following a train of thought until it derails at the points and scatters passengers all over the track. If two layers of distributed summing give a better noise performance, *would three layers be even better?* The answer is generally, yes, but not by much; basically it's not worth it. For example, the optimal two-layer structure 24:6:1 gives a noise advantage of 4.97 dB, while the optimal three-layer structure 24:8:2:1 gives 5.24 dB; the improvement over two layer summing is a very small 0.27 dB. Noise performance is actually very slightly *worse* for the 16-input case because you have added more summing amps creating noise, without enough partial cancellation going on to outweigh that.

See Table 22.6 for the optimal three-layer structures and their results. Note that in the three-layer structures the second figure denotes the *total* number of first-layer summing amps rather than the number feeding each summing amp in the second layer. The greatest advantage over two-layer distributed summing is 1.7 dB, and that is for a monster mixer with 144 paths to the mix bus; getting that improvement involves using 36 + 9 = 45 summing amplifiers, when the optimal two-

TABLE 22.6 The optimal three-layer summing structures for various numbers of inputs

Total no of inputs	Optimal structure	Noise advantage dB	Advantage over 2-layer summing dB
16	16:4:2:1	3.57	−0.07
24	24:8:2:1	5.24	0.27
32	32:8:2:1	6.24	0.36
48	48:16:4:1	7.99	0.90
56	56:14:7:1	8.33	0.81
64	64:16:4:1	9.06	1.18
72	72:18:9:1	9.27	0.79
80	80:20:5:1	9.97	1.49
88	88:22:11:1	10.00	1.16
96	96:32:8:1	10.74	1.28
104	104:26:13:1	10.59	1.13
112	112:28:14:1	11.33	1.60
120	120:40:8:1	11.62	1.49
128	128:32:8:1	11.87	1.66
136	136:34:17:1	11.51	1.08
144	144:36:9:1	12.35	1.68

layer process uses 24. That's almost twice as many, and we must regretfully conclude that three-layer distributed summing is of marginal utility at best.

Four-layer summing anyone? Probably not; you would need a quite enormous number of inputs to make such a structure even faintly worthwhile.

Summing amplifiers

Figure 22.25 shows a practical summing amplifier circuit using a 5534/2 opamp; the accompanying insert send amplifier is included because it gives a good example of how the summing amp phase inversion needs to be corrected before the signal sees the outside world again, and it also demonstrates how to apply the zero-impedance approach to an inverting stage. As mentioned before, the summing amplifiers were one of the first places that 5534/2s appeared in mixers because the potentially high noise gain makes their noise performance critical. The circuit is very straightforward but there are a few points to watch. Firstly, the DC-blocking capacitor C1 is essential to prevent the bias current of the 5534/2 from making the routing switches clicky. It needs to be bigger than might at first appear, because the relevant LF time constant is not C1 and the mix resistor R1 in the channel, but C1 and the parallel combination of all the mix resistors going to that bus. Thus for the 22 kΩ mix resistors and 100 μF capacitor shown, if there are eight input channels the LF −3 dB point will be at 0.59 Hz. Table 22.7 illustrates how this works, and you can see that in this case 100 μF is large enough for even a big mixer. If lower values of mix resistor are used then C1 must be scaled up proportionally.

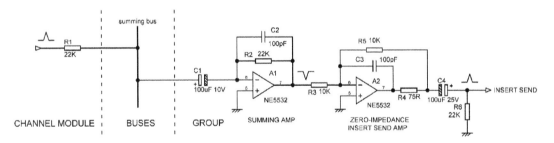

Figure 22.25 Simple opamp summing amplifier, followed by an inverting zero-impedance insert send amplifier that corrects the phase.

It may appear that C1 is still rather oversized for the job. This is not so. The signal in a mixing console passes through a large number of RC time constants on its journey from input to output, and even if each one causes only a tiny roll-off at the LF end, the cumulative effect on the frequency will be substantial. It is therefore essential that each LF roll-off is well below the normal audio band. The same considerations apply to HF roll-offs. See Chapter 1.

There is also the important point that electrolytic capacitors distort with even small signal voltages across them, as described in Chapter 2, and so they must be much larger than might otherwise be required.

TABLE 22.7 How the LF frequency response of the summing amp in Figure 22.25 varies with the number of 22 kΩ mix resistors connected to the bus

No of mix resistors	Total mix res to bus	−3 dB frequency
1	22 kΩ	0.072 Hz
8	2.75 kΩ	0.59 Hz
16	1.375 kΩ	1.18 Hz
24	917 Ω	1.74 Hz
32	687 Ω	2.33 Hz
40	550 Ω	2.90 Hz
48	458 Ω	3.44 Hz

There is yet another reason to make C1 large. A summing amplifier aspires to appear as a short-circuit to ground, and even if it is itself perfect, the presence of C1 means that the bus residual voltage will rise at low frequencies, possibly causing increased LF crosstalk.

The capacitor C2 across the summing amp feedback resistor R2 is another vital component; without it the stage is pretty well guaranteed to be unstable at HF. This is because the mix bus has an appreciable capacitance to ground, and this will destabilise the opamp by adding an extra phase shift to the feedback through R2. Adding C2 compensates for this; its value is normally determined by experiment. It clearly must not be so large that it gives an excessive HF roll-off with R2.

A balanced summing system as in Figure 22.22 can easily be made, using two separate summing amplifiers whose outputs are then subtracted. A more economical method which saves an opamp is shown in Figure 22.26; with equal resistor values the overall gain is −6 dB. The downside is that it does not generate two true virtual-earths. The two bus residuals are only low if symmetry holds in every part of the circuit, including the signal levels applied to the summing resistors. I built it with a 5532 and 1% resistors and the bus residuals were both −61 dB. (worsening above 1 kHz as usual due to opamp limitations). Changing either of the summing resistors or feedback resistors by 3% of their value increased this to −49 dB. Obviously, these are not true virtual-earths—more like virtual virtual-earths. This method was used for the main mix bus in the Mackie Onyx mixer, among others.

Hybrid summing amplifiers

It is well-known that at low source resistances, discrete bipolar transistors are normally quieter than opamps, the exception being specialised opamps like the AD797, which are usually ruled out on the grounds of cost. This applies to the normal run of low-cost transistors, though specialised types such as the 2SB737 are even better. While the advantage obtained varies with the number of summing resistors connected to the bus, and their value, in general a very desirable noise reduction of about 5 dB may be expected in a large console.

The hybrid combination of a discrete bipolar transistor input and an opamp to provide open-loop gain for linearisation and load-driving capability gives the arrangement shown in Figure

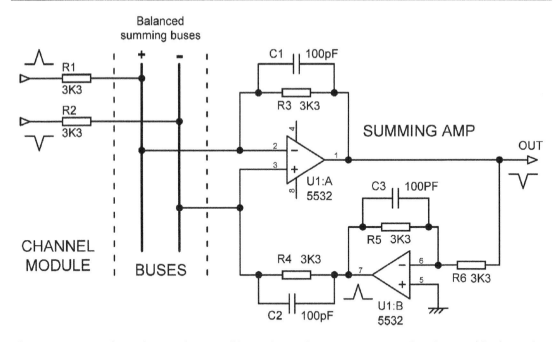

Figure 22.26 Balanced summing amplifier using only two opamps. A low bus residual requires complete symmetry of component values.

22.27. The summing bus is connected to the emitter of Q1 via the DC-blocking capacitor C1; the amplified signal from Q1 collector is passed to the opamp, which has a local feedback loop R3 which controls the DC conditions of Q1. The voltage set up on the non-inverting opamp input by bias network R7, R9, C5 determines the voltage at Q1 collector. C7 acts as a dominant-pole capacitor to give HF stability.

An outer layer of shunt feedback via R4 is used to minimise the effect of C1 in increasing the bus residual at LF, by putting C1 inside this outer feedback loop. C4 prevents the non-zero voltage at the opamp output from getting onto the bus via R4, and in the same way C6 is a DC-blocking capacitor which prevents the following stage from putting any DC offset voltages on to the bus. This arrangement is effective at doing what it is supposed to, but there are clearly several LF time-constants involved because of the various blocking capacitors, and with such schemes it is essential to check that there is no peaking or other irregularity in the frequency response at the bottom end.

While the one-transistor version gives a good noise performance, it is susceptible to rail noise getting into the emitter or collector circuits of the transistor, and very careful filtering and decoupling is required to prevent this putting a limit on the noise performance. Another potential problem is that there will be LF signal-related voltages on the supply rails due to the limited effectiveness of decoupling capacitors of reasonable size, and if these get into the summing amplifier they will compromise the LF crosstalk performance. An excellent fix for these issues is the use of a two-transistor circuit as in Figure 22.28. The two transistors are used in a balanced configuration that cancels out rail noise and makes the decoupling requirements much simpler; there is also no need for a biasing network as in the one-transistor version.

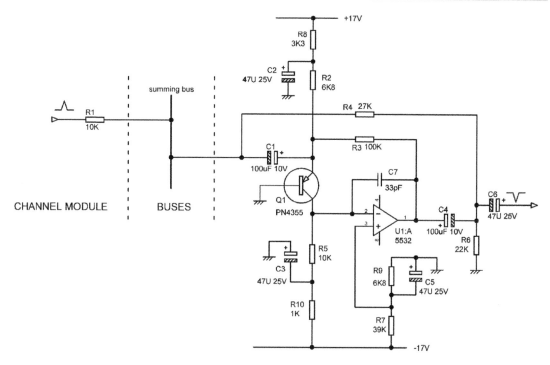

Figure 22.27 One-transistor hybrid summing amplifier.

There are one or two subtleties to be observed here; the shunt feedback must go to the same transistor as the VE bus, to prevent large current swings in the transistors that would cause distortion. This means that the feedback must be inverted to be in the right phase, which is done by U1:B. This introduces stability-threatening extra phase shifts, so HF stability capacitor C4 bypasses the feedback inverter and goes straight to the emitter of Q2. A very useful property of this arrangement is that the output is in phase and so can be fed directly to a group insert.

A more sophisticated version of this summing amplifier, which I thought up a while ago, is shown in Figure 22.29. Here the aux master level control RV1 not only acts as a normal gain control, but also alters the amount of negative feedback around the summing amplifier, effectively giving the stage variable gain. This can be extremely useful as aux summing amplifiers often have large numbers of inputs feeding them and are more liable to clipping than group summing amplifiers. It is extremely tedious to turn down dozens of aux sends to remedy the situation, so being able to reduce the aux summing amp gain is advantageous.

When RV1 is at minimum, the circuit is essentially that of Figure 22.28, with the main shunt feedback path through the inverter U1:B, and the HF stabilising path through C7. The value of the main feedback resistor R3 is chosen so the sum amp gain is low, in this case –6.8 dB, so overload is unlikely. When RV1 is turned up, a positive feedback signal is sent to the non-inverting input of U1:B via R11 and R12, and the partial cancellation that results reduces the output of the inverter, decreasing the overall amount of negative feedback and increasing the gain of the summing amplifier. The need for a post amplifier with make-up gain is therefore avoided, improving the noise performance.

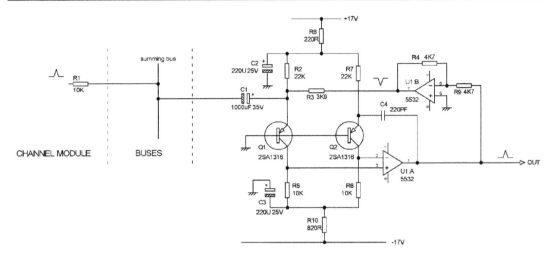

Figure 22.28 Two-transistor hybrid summing amplifier is better at rejecting noise and crosstalk from the supply rails.

This technique was used in the Soundcraft Delta mixing console, and I modestly propose that it might be one reason why it won a British Design Award in 1991. My collaborator in the design of the Delta was Mr Gareth Connor. This technology was also used in the Soundcraft Venue-2 mixing console.

Balanced hybrid summing amplifiers

In sophisticated consoles it is desirable to combine the benefits of balanced mixing with low-noise hybrid summing amplifiers. The obvious method of implementing this is to use two hybrid summing amplifiers and then subtract the result, but this uses quite a lot of hardware. A more elegant approach is to use a single balanced hybrid summing amplifier to accept the two antiphase mix buses simultaneously; this reduces noise as well as minimising parts cost and power consumption.

The circuit shown in Figure 22.30 is at first sight very similar to that in Figure 22.28, but with the crucial difference that two mix buses now feed into the stage, one to each transistor emitter. To prevent distortion-inducing variations in the transistor currents, and to maintain symmetry, it is therefore now necessary to also apply shunt feedback to both transistor emitters. The feedback to Q1 is taken via an inverter to get the phase right, as in Figure 22.28, but the other feedback path is simply resistor R12. As before, C4 gives HF stabilisation.

Note that the configuration is very similar to that of the balanced microphone amplifier described in Chapter 17 and gives low noise as well as excellent symmetry. This technology was used extensively in the Soundcraft 3200 recording console; once again, my valued collaborator in the design of the 3200 was Mr Gareth Connor.

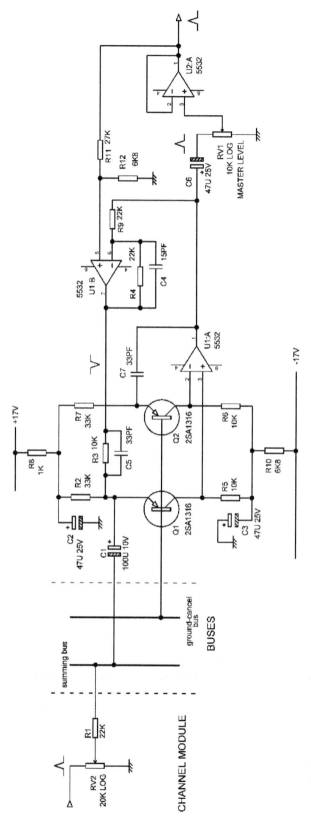

Figure 22.29 Two-transistor hybrid summing amplifier with positive feedback to enhance gain at high control settings only, improving headroom at low gain settings.

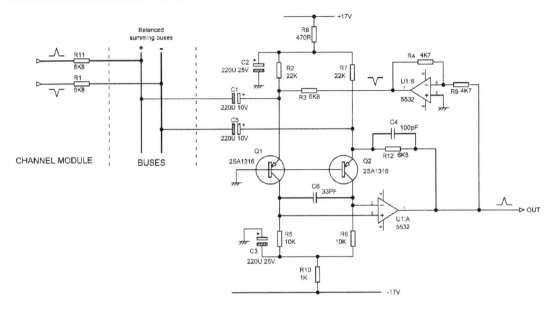

Figure 22.30 **Two-transistor balanced hybrid summing amplifier. Note the dual feedback paths via R3 and R12.**

Balancing tracks to reduce crosstalk

It is inherent in the two-transistor hybrid summing amplifiers described earlier, whether operated single-ended or balanced, that two anti-phase outputs are produced. There are also anti-phase inputs, though in single-ended operation the non-inverting input is not used. The anti-phase outputs can be very handy if it saves putting another stage in just to get the phase right (something I always deprecate). However, this feature can be further exploited to reduce crosstalk within a module.

A virtual-earth bus is very susceptible to capacitive crosstalk, and its most vulnerable time is when it gets onto the module where its summing amplifier lives. A typical group, aux master or mix master module will have much more circuitry on it, probably carrying unrelated signals we want to keep out of the mix buses. Physical separation helps, but on a crowded module it may not be possible to get enough of it. Making the track as narrow as practical also helps because it reduces the capacitance through which signals can crosstalk, but this is of limited effectiveness.

A highly effective approach is to run a second track parallel to the incoming mix bus, as close to it as the PCB design rules allow, and starting where it comes onto the PCB. There is no connection to the balancing track at this end, but the other end is connected to the non-inverting input of the summing amp, and any signal coupled to it is subtracted from the summing amp output signal. The effectiveness of the cancellation (which is exactly analogous to the common-mode rejection ratio of a balanced line input) depends on the details of the geometry of the crosstalk source(s) and the mix buses, on accurate feedback resistors in the summing amplifier, and on the balancing track being the same width as the mix bus track. There are too many variables for accurate predictions to be made, but it is straightforward to get a 20 dB improvement in crosstalk by this method.

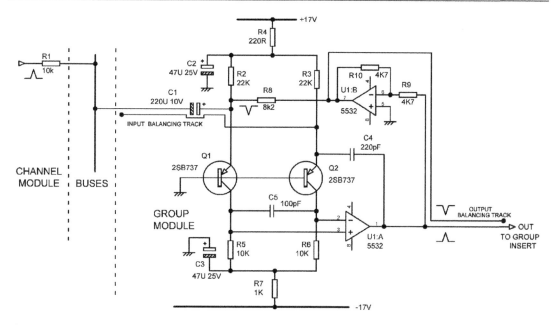

Figure 22.31 Input and output balancing tracks applied to a two-transistor balanced hybrid summing amplifier.

Figure 22.31 shows a single-ended summing amplifier using both input and output balancing tracks. Note how the input balance track snuggles around the DC-blocking cap C1.

Once our signal has been through the summing amplifier, it is at a very low impedance and is effectively immune to capacitive crosstalk, but now it has some voltage and so the potential to crosstalk to other virtual-earth buses and any other circuitry not at a low impedance. This can be much helped by running a balancing track from whichever of the anti-phase summing outputs is not in use. Once again, this parallels the summing amp output track, as close to it as possible, and has the same track width. Thus to a large extent signals radiated as an electric field from the output track are cancelled out. The exact amount of improvement depends on track geometry, etc, as for input balancing tracks.

Both balancing methods were used in the Soundcraft Sapphyre group module, to give just one example.

The multi-function summing amplifier

Figure 22.32 shows a summing amplifier that incorporates hybrid BJT-opamp technology, input and output balancing tracks, a zero-impedance output, and a ground-cancelling output, all in one stage. When people come up with a new idea, they often decide to add to it a number of other ill-advised ideas. Please don't think that this is some sort of doubtful throw-it-all-in demonstration like that. Figure 22.32 is the actual summing amplifier used with great success in the Soundcraft Sapphyre mixer. Manufacture has long ceased, but Sapphyres are still changing hands for remarkable sums of money.

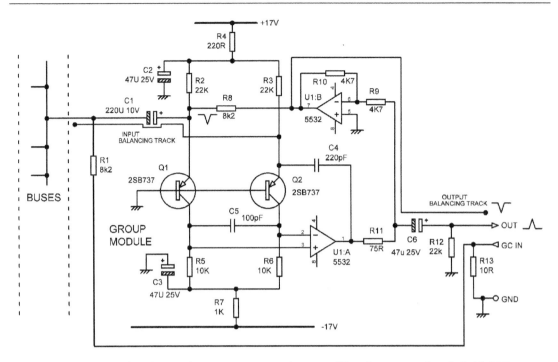

Figure 22.32 Soundcraft Sapphyre group summing amplifier, incorporating hybrid BJT-opamp technology for low noise, and an output that is both zero-impedance output and ground-cancelling.

The zero-impedance feature is obtained by taking the audio band negative feedback from the outside end of R11; the HF feedback goes directly through C4 from the inside end of R11 and gives stability in the face of capacitive loading on the output. The ground-cancelling feature is obtained by adding a ground-cancel input load resistor R13, and feeding the cancel signal back into the summing amp via R1, which in conjunction with R8 gives unity gain and good cancellation. These features are simple to add and do not interact with each other.

For more information on zero-impedance outputs and ground-cancelling outputs, see Chapter 19.

PFL systems

The prefade listen (PFL) facility goes back a long way in the history of mixers, almost certainly first appearing on broadcast consoles, where it proved extremely useful to be able to listen to a source before unleashing it on an unsuspecting public. It is also very handy in a recording environment, allowing you to listen to one source in isolation without undoing dozens of routing switches. It is invaluable for checking the level in a channel; the PFL feed takes over the main mix metering, which is usually much bigger and better than metering incorporated on a per channel basis, if indeed there is any at all. On most mixers there is only room for a peak light. As the name suggests, a PFL feed is taken from before the fader, so that the signal is heard at full level even if the fader is down. In the United States it is often called the 'solo' facility.

"PFL" is often used as a verb, as in "Could you PFL channel 23?". Interestingly, this request is always spelt out as P-F-L and the obvious pronunciation as "piffle" has never achieved favour. When any PFL switch is pressed, a circuit block in the master section switches the left and right monitor outputs so they reproduce the PFL signal in mono, as shown in Figure 22.33 The L/R meters are also taken over by the PFL system so they can be used to check channel prefade levels, allowing the adjustment of input gain when required. It is common to switch both meters over, though of course they both read the same thing. Historically the PFL switching was done with a relay, but this was taken over by electronic means, specifically 4016 analogue gates, at a relatively early date, as it is not essential for the switching to be absolutely click-free. The later availability of discrete FETs designed for analogue switching improved the linearity and much reduced (but did not wholly eliminate) the switching transients.

All that is required on each channel is a switch section to route the prefade-signal to the PFL bus, which is a simple virtual-earth bus that works in the same was as group buses, and another switch section to signal via a PFL-detect bus that a switch has been pressed and the monitor source must be changed over. The PFL-detect bus simply gathers together all the signals that indicate a PFL switch is pressed; it does not have to be a virtual-earth bus, but there are advantages in making it so, as described below. PFL switches are commonly fitted with indicator lights, even on quite small mixers, because otherwise it is necessary to hunt around the control surface if a PFL switch is inadvertently left pressed in. This does not make a third switch section (and therefore a four-changeover switch) necessary because the ingenious method shown in Figure 22.33 can be used. All the LEDs on a channel module are usually run in a chain from the positive to negative supply rails to minimise power consumption; so long as there are not too many LEDs a simple series resistor is usually all that is needed to give more or less constant-current operation of the chain. If the PFL indicator LED is put at the top of the

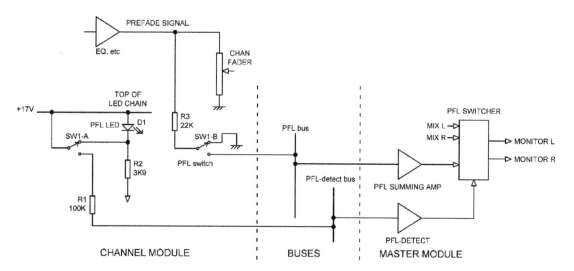

Figure 22.33 A PFL system; showing how to make a two-section PFL switch perform three functions at once.

chain, SW1-A removes the short-circuit from D1 and allows it to turn on, at the same time routing a DC signal into the PFL-detect bus via R1 Note that the switch section SW1-B that routes the signal to the PFL bus uses the same high-offness configuration described earlier).

This underlines the point that economy of design in a mixer channel is very important, because every extra component is multiplied by the number of channels. In the master section the need to design out every possible component is much less pressing.

PFL summing

There is nothing very difficult about the PFL summing amplifier. It is not necessary for it to have the best possible noise performance as it is only used for quick monitoring checks. The system shown in Figure 22.34 uses a dual opamp, the second half being used to restore the correct phase after the inversion produced by the summing amplifier. C1 provides DC blocking, while R2 keeps the PFL bus at 0V DC to prevent switch clicks. R3 sets the gain from channel to PFL summer as unity, and C2 prevents the bus capacitance from causing instability. R4 and R5 set the gain of the reinverting stage to unity. C3 provides DC blocking at the output to prevent clicks when the PFL switcher operates.

PFL switching

When the PFL system operates, the normal L-R mix is removed from the monitor outputs and is replaced by a mono feed from the PFL summing system. This is usually done by some form of electronic switching; see Chapter 21 on signal switching for more details.

PFL detection

In early consoles a DC voltage was simply switched into a PFL-detect bus that operated the PFL switching relay directly. Moving that amount of current around inside a mixer is simply asking for trouble with clicks crosstalking into the summing buses, and very soon a transistor relay driver was added so the voltage and current levels on the PFL-detect bus could be much lower. When solid-state PFL switching was introduced the transistor circuitry drove analogue gates or discrete FETs instead.

Two simple methods of PFL detection are shown in Figure 22.35. Figure 22.35a demonstrates how not to do it. When the PFL switch SW1 is closed, +17 V is applied to the PFL-detect bus, turning on Q1 and illuminating the "PFL ACTIVE" LED D1 and turning Q2 off. The problem is that the 34 V edge on the PFL-detect bus (which normally sits at −17 V) has an excellent chance of crosstalking into the other summing buses.

A better method is shown in Figure 22.35b. Here the resistor R1 has moved to the channel module, and the PFL-detect bus connects directly to the base of the detect transistor Q1. This ensures that the PFL-detect bus can never change by more than 0.6 V, which reduces the possibility of clicks crosstalking capacitively into adjacent summing buses; there should be a 35 dB advantage. A countervailing disadvantage is that the base of Q1 is vulnerable to destruction if the PFL-detect line gets shorted to ground. It is also slightly more expensive to implement as now there has to be a resistor R1 for the PFL switch on each channel.

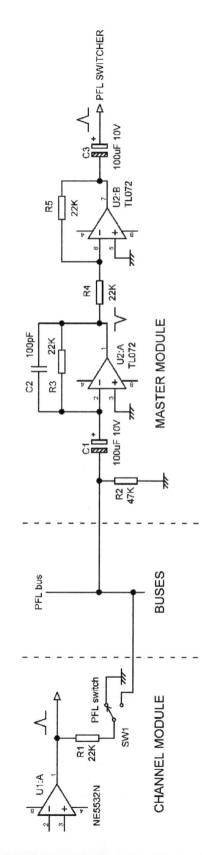

Figure 22.34 An example of a PFL summing system.

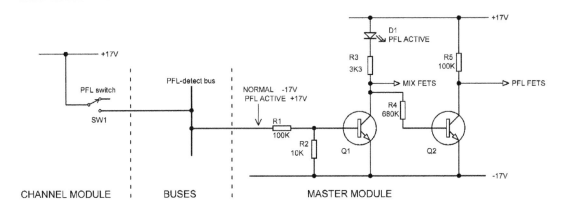

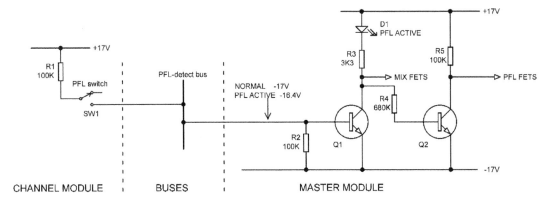

Figure 22.35 Two simple PFL-detect systems. The second version reduces the likelihood of clicks getting into other buses.

This method was workable when all mixers had mother boards, but the introduction of ribbon-cable interconnections between mixer modules put all the buses closer together, and increased the likelihood of PFL-detect clicks becoming audible.

Virtual-earth PFL detection

The ideal PFL-detection system would have no voltage edges on the detect bus at all. This can be done by detecting current instead of voltage—the PFL-detect line becomes a virtual-earth summing bus for DC signals. I thought this up in 1983.

Figure 22.36a shows the principle. U1 is simply a summing amplifier that works at DC. When no PFL switches are pressed, the output of U1:A sits at +10 V because of the bias from resistor R2, Q1 is held on via R4, and Q2 is held off. Negative feedback through R3 keeps the detect bus at 0 V; C1 prevents the bus capacitance to ground from causing instability. The "PFL ACTIVE" LED has moved to the collector of Q2 to allow for the logical inversion caused by the summing amplifier. When a PFL switch is pressed, the current injected into the detect bus by R1 overcomes

that from R2 and the output of U1 goes below 0 V, and Q1 turns off. Note that the signalling current is only 170 uA, so there is little possibility of inductive crosstalk. It could probably be significantly reduced without problems.

This simple version of the system will silently detect a single PFL button down, but will come unstuck if more are pressed, because U1 output will hit the −V rail and will no longer be able to maintain a virtual-earth on the detect bus. This situation is not uncommon, as it gives a rough submix of the channels pressed, and so it is wise to cater for any number of PFLs at once. The circuit of Figure 22.36a overcomes the problem by adding diode D1, which clamps the opamp output so that however many PFL switches are pressed, the opamp output will not hit the −V rail and negative feedback will continue to keep the PFL-detect bus very close to zero volts. The values of R4, and R5 must be carefully chosen so that the level-shift down to the −V rail works reliably, and Q1 will always switch correctly despite circuit tolerances.

Note that once again all the circuitry works between the +V and −V rails, so there is no chance of transients being injected into the ground system.

This arrangement has another less obvious advantage. It can handle signals in both directions. The ribbon-cable systems referred to earlier come in a number of fixed widths, so you can buy 40-way

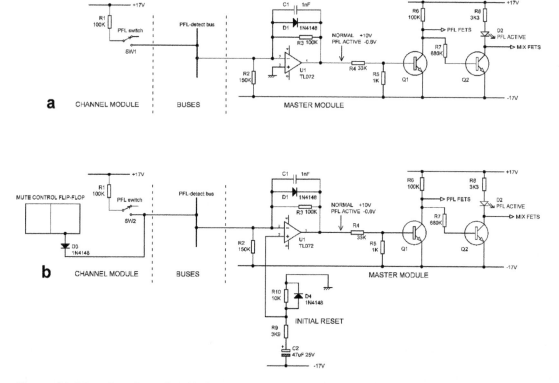

Figure 22.36 Virtual-earth PFL-detect systems. The second version uses the PFL-detect bus to reset channel mute status at power-up.

cable, but if you need 41 ways the next size up is 50-way. Since this increases the cost not only the cable itself, but of all the connectors on it and all the mating module connectors, increasing the cable size is not a decision taken lightly. In one mixer design there was a need to send an initial-reset signal to mute-control flip-flops on each module, and all 40-ways of the ribbon cable were committed. The only way to avoid 50-way cabling was to make the PFL-detect bus dual-function.

The idea is that by changing the reference voltage applied to the PFL-detection opamp, you can change the DC voltage that it maintains on the detect bus. In Figure 22.36b, at power-up, the initial-reset network R9, R10, C2 pulls the reference voltage going to the non-inverting input of U1 low for a brief period until C2 fully charges, and the PFL-detect bus is therefore also pulled low via R3, and this signal is coupled to each channel mute-control flip-flop by a diode D3; the flip-flop works between positive and negative supply rails so it can drive muting FETs directly. After the initial-reset period the PFL-detect bus settles at its normal level of 0V and D3 remains reverse-biased. D4 in the initial-reset network ensures rapid recovery when the power is switched off. Obviously the PFL system cannot function during the brief initial-reset period, but after that it works just as described before.

This is a good example of the ingenuity that is sometimes required to fit all the required functionality into a given size of ribbon cable.

AFL systems

AFL is a very similar concept to PFL, the difference being that an AFL feed is taken from after the fader, so that if a selection of AFL buttons are pressed, the resulting mix has the sources in the right proportion. A stereo AFL system goes one better by taking a stereo feed from after the panpot, so that the sources selected can be heard in their correct positions in the stereo field. Figure 22.37 shows the differing points in the channel from where PFL, AFL, and stereo AFL are taken. Stereo AFL requires a 4-pole switch; two sections route the stereo signal to the AFL buses, and one is required to signal the AFL-detect system. The detection of an AFL condition works in exactly the same way as PFL detection.

It is not common for mixers to be fitted with an AFL system only, as it is much less convenient for checking signal levels in the channel; it will only read the prefade level correctly if the channel fader is at 0 dB. More usually a solo system is fitted that can be switched from PFL to AFL at the master section. The channel module switch will route signals to both the PFL and AFL buses; these are summed by separate summing amplifiers, and which of the two resulting signals is switched to the monitors is selected by the PFL/AFL switch on the master section.

Solo-In-Place systems

PFL provides a mono look at a single channel. AFL preserves fader and perhaps pan position, but in both cases the signal that is heard is devoid of effects, which makes critical assessment difficult. A Solo-In-Place (SIP) system allows a channel or set of channels to be heard in isolation with all the effect sends working normally. This is done simply by muting all the channels except the ones

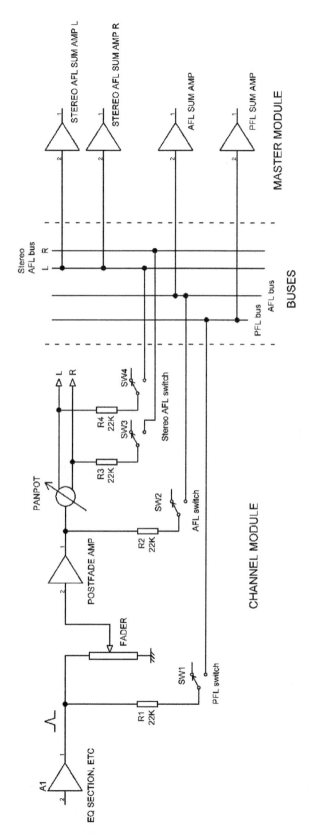

Figure 22.37 Comprehensive system with PFL and mono and stereo AFL.

you want to hear. This is obviously not applicable to PA work (except during set-up and sound checks) because it is what is called a 'destructive solo' in that the output of the mixer is disrupted while SIP is in use, unlike PFL and AFL systems which take over the monitor output but leave the group and LR mix outputs unaffected.

A SIP system requires an electronically-controlled mute on each channel. When the SIP button on a channel is pressed, every *other* channel is muted except that one. If two or more channels are soloed, they are left unmuted while the rest of the channels are muted.

The basic SIP system therefore has a SIP-detect bus, which works in just the same way as a PFL-detect bus. This determines when one or more SIP switches are pressed and activates a SIP mute bus that potentially mutes all the channels; however if the SIP switch on a channel is pressed it intercepts the mute signal and prevents it from operating on that channel. The basic scheme is shown in Figure 22.38.

SIP is a destructive solo, and you really, really don't want to trigger it during a live performance. Therefore a "Solo-Safe" switch is usually fitted in the master section to act as a safety-catch or Molly-guard and prevent accidental operation. When it is engaged, the solo system usually acts as a PFL system instead, which is safe to use during performance.

Talkback microphone amplifiers

Most contemporary talkback systems have a small electret microphone mounted flush with the master module panel. The microphones used typically have an internal head amplifier that buffers the high impedance of the electret element, and all else that is needed is an amplifier stage with variable gain over a wide range. A typical arrangement is shown in Figure 22.39; gain is variable from 0 to +55 dB by RV1, with C4 keeping it to unity at DC. Note that the microphone is powered through the filter network R1 and C1.

Figure 22.39 includes a couple of subtle but important design features. Firstly, the second changeovers of the talkback routing switches are connected into the feedback network so that when

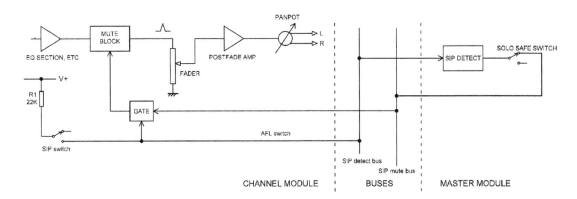

Figure 22.38 Solo-In-Place system.

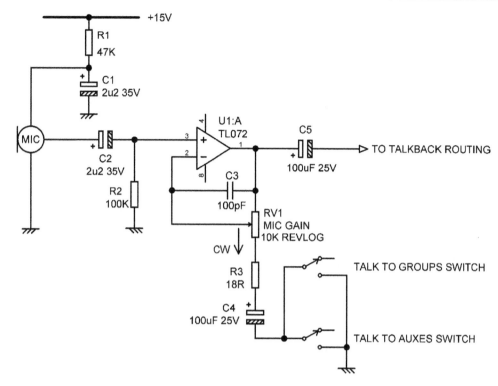

Figure 22.39 **A typical talkback microphone amplifier, with gain variable from to 0 to +55 dB.**

none of them are pressed, the amplifier gain is reduced to unity. This prevents the microphone amplifier from clipping continuously if the gain is turned up but talkback is not in use; the resulting distorted waveforms would almost certainly crosstalk crunchily into other parts of the master module, such as the L-R mix summing amplifiers, and this would not be a good thing.

Secondly, you will have noticed that the value of C4 looks rather small compared with the low value of the gain end-stop resistor R3, and in fact gives an LF roll-off that is -3 dB at 90 Hz. This is quite deliberate and is intended to control the amplitude of LF transients when the gain is set high.

Line-up oscillators

The oscillator output is not required to be a perfect sinewave; it only has to be good enough so that meter calibration is not affected. It also needs to look like a sinewave on an oscilloscope, or customer confidence will be undermined. Figure 22.40 shows a simple but dependable arrangement for a 1 kHz oscillator which does not require either expensive and fragile thermistors or complicated levelling circuitry.

It consists of a feedback loop containing a bandpass filter and a soft clipping circuit. The waveform at the output of bandpass filter U1:A is amplified by U1:B and then soft-clipped by D1 and D2. This symmetrical clipping introduces odd-order harmonics only, which are more

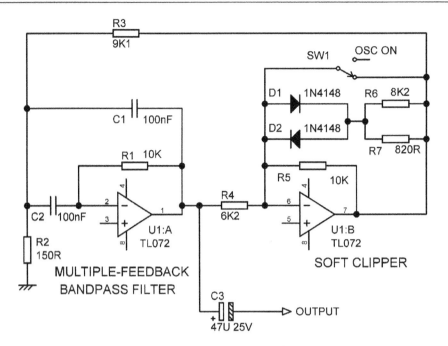

Figure 22.40 1 kHz oscillator with diode amplitude stabilisation.

easily filtered out when the signal is fed back to the multiple-feedback bandpass filter U1:A. The distortion is approximately 0.5%. Note that when the oscillator is not in use, it is not routed to the buses, but is also firmly stopped from oscillating at all by the closure of SW1. This is essential to remove any possibility of the oscillator crosstalking into the audio paths during normal operation. When SW1 is opened this oscillator ramps up in amplitude in a very neat manner.

You will note the use of E24 resistor values to get the frequency as close to 1.0 kHz as possible, and the parallel combination of R6 and R7 to give 745 Ω; this resistance is fairly critical for obtaining the minimum distortion, and the combination shown here gave dependably lower distortion than the E24 value of 750 Ω. The output level is dependent on the forward voltage of the two diodes and so there is some variation with temperature, but it is insignificant in this application.

A somewhat more sophisticated 1 kHz oscillator is shown in Figure 22.41. This is based on the classic state-variable filter. A2 and A3 are integrators, while A1 performs the various subtractions and additions needed. R8 gives positive feedback to A1 of the bandpass output at A2, starting the oscillation. As its amplitude increases, the gain transistor Q1 turns on more, allowing more negative feedback through to counteract the positive feedback until a stable operating amplitude is reached. Diodes D1-D4 form a full-wave rectifier so that only one transistor is need to handle both half-cycles. When SW1 is open, there is maximal negative feedback to A1 and the circuit does not oscillate, so there is no possibility of crosstalk. This function can be equally well performed by a JFET to ground, and it is common for sound reinforcement consoles to have a SAFE switch that disables the oscillator and also the solo-in-place system so they cannot be accidentally used during a performance.

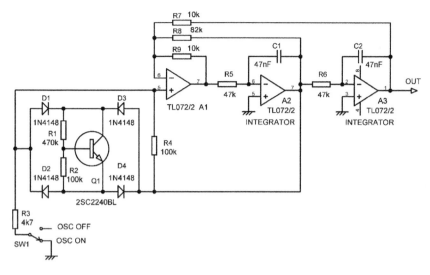

Figure 22.41 **1 kHz oscillator based on state-variable filter, with diode-transistor amplitude stabilisation.**

This oscillator is slightly more complicated than the previous version but has the advantage that it is more flexible in terms of setting the output voltage by adjusting R1 and R2 and also giving lower distortion due to the gentler amplitude control. An important point is that the output is taken from the second integrator, which in a state-variable filter gives a lowpass output. The extra filtering means that the distortion here is lower than at the bandpass output.

The next step up in oscillator sophistication is to provide two switched frequencies, usually 1 kHz and 10 kHz. The higher frequency was historically used for checking the azimuth adjustment of tape machine heads (when the azimuth of a tape head is maladjusted, the high frequency response falls off badly). Nowadays it is less useful but can still come in handy for quick frequency response checks. It is therefore very important that the output level is exactly the same for the two frequencies, and the oscillator shown in Figure 22.42 therefore has a more complex level-control loop.

The oscillator is based on the classic Wien bridge configuration, with the oscillation frequency controlled by R8, R9, C1 and R5, R6, C2. When running at 1 kHz R8, R9, and R5, R6 are in circuit. For 10 kHz SW1 is pressed and R5 and R9 are now shorted out, raising the operating frequency. The level control loop operation is as follows: when SW2 is pressed the short-circuit across R1 in the negative feedback loop R1, R2 which prevents oscillation is removed and the amplitude of oscillation ramps up. When it reaches the desired level, Zener diode D1 begins to conduct on positive peaks and turns on the common-base transistor Q1 (D1 also conducts on negative half-cycles, but Q1 does not respond and is protected from reverse-bias by clamp D2). The collector current of Q1 charges C3 and Q2 turns on, pulling down the gate of JFET Q3 and increasing its channel resistance, thus increasing the amount of negative feedback through R1, R2 and regulating the level. Q3 is a J112 FET, a type that is optimised for voltage-controlled resistance (VCR) operations. The network R3, R4 not only acts as the collector load for Q2, but also feeds half the Vds of Q3 to its own gate; this is a classic method of reducing even-order distortion in JFETs and is dealt with in more detail in Chapter 24. C3 and R10 set the time-

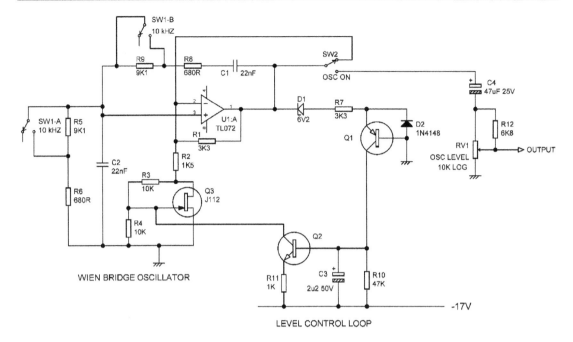

Figure 22.42 Switched 1 kHz/10 kHz oscillator with FET amplitude stabilisation.

constant of the control loop, and their values have a strong effect on oscillator distortion. Q1 and Q2 can be any high-beta transistor types.

Larger mixers often have more sophisticated oscillators with fully variable frequency and sometimes a choice of a squarewave output. Oscillator design is a massive subject on its own, and there is no space to get deeper into it here.

The flash bus

On a console of any size, it can be hard to find a single PFL button that is down, and so taking over the monitor path, even if the PFL switches are illuminated. All too often you might find yourself looking for a single indication in a sea of lit-up switches. Making the PFL LEDS a distinctive colour only helps a bit. I therefore persuaded Soundcraft that flashing the PFL LEDs at 2 Hz was a good idea. They would have to flash in synchrony, so the desk did not look like a demented Christmas-tree, and thus having individual oscillators for each LED was out of the question; it would also have been prodigal of parts. This is, of course, trivial if all your LEDs are controlled by digital means, but in an era when most consoles had no housekeeping microcontroller or other on-board computer, it was more of a challenge. Since analogue-only consoles (including some with hefty inductors in the EQ) are having a revival, this technology remains very relevant.

Clearly a common 'flash' signal would have to be distributed to each mixer module. Simple enough, but most of the mixers for which this technology was intended had their bus connection

made with IDC cable. This has a relatively high capacitance between conductors, and so sending a sharp-edged 5 V logic signal down it would have been a recipe for disaster. Be aware that grounding conductors in an IDC cable do not make them perfect screens; see the tests on PCB track-to-track crosstalk in Chapter 2. I therefore decided that the way to send the flash signal was as a 2 Hz sinewave. Experiment proved (and I don't think it could have been determined in any other way) that a low-distortion sinewave was not required; 1% THD was low enough to ensure no detectable crosstalk into the audio buses. Of course 2 Hz is well below audio and unlikely to capacitively couple into anything. Nonetheless this is not the sort of thing to leave to chance.

The master oscillator was therefore a simple two-opamp circuit with amplitude stabilisation by silicon diodes; see Figure 22.43. The first stage around A1 is a multiple-feedback bandpass filter and that around A2 is an inverting amplifier with diode limiting. This works just like the 1 kHz oscillator in Figure 22.40. It is important to use FET-input opamps (this is a good way to use up venerable TL072s) as the circuit impedances are high to keep the capacitors small. Electrolytics are used because the frequency is not critical and neither is the distortion content of the output; care is taken that they are correctly biased.

There is only one master flash oscillator but there is one or more PFL LED in every module. Therefore the LED control circuitry must be very simple to keep down both cost and the PCB area required. This is shown on the right of Figure 22.43. Resistors R10, R11, and Q1 are required to control the LED locally, and the only extra component in the channel module is one single resistor R9; it would be hard to make it more economical. Note that the sinewave amplitude is controlled so that reverse-bias precautions for the base of Q1 are not required. The output sinewave is centred around −17 V, as set by R3 and R4; since the emitter of Q1 sits on the −22 V rail (also used to power JFET switching, see Chapter 21) the flash bus oscillator must produce a signal just

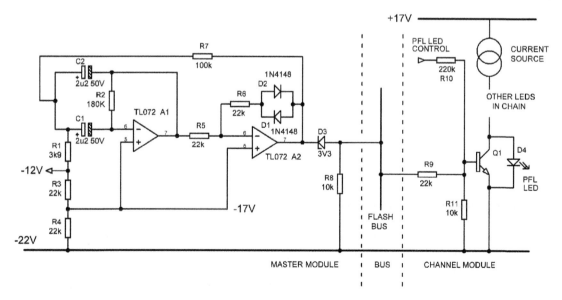

Figure 22.43 2 Hz flash bus oscillator with diode amplitude stabilisation.

above this rail, which is achieved by the level-shift network D3, R8. The two amplifiers A1, A2 are powered from the 0V and the −22 V rails.

When a channel PFL button is pressed, the voltage applied to R10 goes high and Q1 turns off, turning on the LED D4. The flash bus signal coming in through R9 overcomes that via R10 and periodically turns Q1 on, causing the LED to flash.

The flash bus technology was developed in 1983/84, and the first console to which it was applied was the TS24. It was still in use, virtually unchanged, in the Vienna-2 console which was released in November 1994.

Power supply protection

A large mixing console typically consists of many modules, and a fault that means a power rail shorted to ground or worse can occur in any of them. A properly designed power supply will have full short-circuit protection and should survive this, but until you fix it the whole console is out of action. You first have to locate the faulty module, and that will take time. At a live gig it means disaster.

For this reason, modular consoles normally have some sort of fusing that limits the effect of a shorted rail to one module. A very popular choice in the heyday of the analogue console was not to uses fuses as such, but the much cheaper approach of putting 10 Ω resistors in series with each rail. Rather than use expensive fusible resistors, ordinary 1/4 W types were used with their leads pre-formed to raise them above the PCB and so avoid it being damaged if ignition did occur.

In a complex module, the voltage drop across 10 Ω resistors becomes excessive, and there is also the question of how much signal voltage will exist on the inside of the resistor. Therefore two or three sets of fuse resistors are used to split up the power demand between them.

Console cooling and component lifetimes

Large mixing consoles have a lot of amount of electronics packed into a small space, both to reduce the size of the console so it is easier to install, and to bring all the controls within a reasonable reach. This means that natural convection cooling is often barely adequate. It is made more difficult by the fact that open cooling vents on the top of a console are not popular due the possibility of various beverages being poured into the works, with an excellent chance of catastrophic results. Elevated internal console temperatures are rarely high enough to cause semiconductor failures, but they have two bad consequences.

Firstly, over time the electrolytic capacitors will dry out, and drop in value. This loss of capacitance can be dramatic; a 100 uF component can fall to 10 nF. This in turn causes two further bad consequences: the LF response of the console degrades as coupling capacitors drop in value, and opamps go unstable as rail decoupling capacitors become ineffective. In a large studio console this can mean that its life is only 10 years before all the electrolytics need replacing. This 'recapping' procedure, is, as you might imagine, a lengthy and expensive process that can be done only by companies with specialised skills.

The average electrolytic capacitor has a temperature rating of 85°C. This does not mean that no capacitor degradation occurs below that temperature; degradation is happening all the time, but it accelerates rapidly as temperature rises, roughly doubling in speed with each 10°C increase. 85°C is the temperature at which capacitor life has dropped to a nominal 1000 hours, which is only 49 days, and so obviously they must be operated at a much lower temperature than that to get a reasonable equipment lifetime. Electrolytic capacitors rated at 105°C have recently fallen in price to the point at which they are a viable alternative, and at a given temperature this increases lifetime by a factor of four. The best recapping facilities use low-ESR 105°C capacitors exclusively for replacements, and in strategic places increase the value fitted so the life is longer before the value falls too low. This obviously requires an intimate knowledge of highly complex consoles and should only be undertaken by professionals such as GJC Designs [1].

Secondly, if silver contacts are used in switches or relays, the rate at which they are corroded by atmospheric hydrogen sulphide, creating non-conducting silver sulphide and causing the contacts to fail, also increases rapidly with temperature. Once again it roughly doubles in speed with each 10°C increase.

The obvious way to improve console cooling is to add fans to increase the air flow. Fans are very undesirable in consoles installed in recording studios because of the acoustic noise they generate and are rarely if ever used. They are, however, sometimes fitted in PA consoles, though still with considerable care to minimise the noise they create. When this is done by running the fan at low speeds, at the low end of its specified voltage range, great caution is needed. After a period of use the fan may stop altogether, as the bearings become worn, and how long this takes is not readily predictable. Sleeve bearings seem to be worse than ball bearings for this. The use of fans is to a large extent a last resort, and every effort should be made to induce adequate cooling by convection alone.

Reference

[1] GJC Designs. www.gjcdesigns.net/ Accessed Oct 2013

Level indication and metering

Signal-present indication

Some amplifiers and the more sophisticated mixers are fitted with a 'signal-present' indicator that illuminates to give reassurance that a channel is receiving a signal and doing something with it. The level at which it triggers must be well above the noise floor, but also well below the peak indication or clipping levels. Signal-present indicators are usually provided for each channel and are commonly set up to illuminate when the channel output level exceeds a threshold something like 20 or 30 dB below the nominal signal level, though there is a wide variation in this.

A simple signal-present detector is shown in Figure 23.1, based on an opamp rather than a comparator. The threshold is −32 dBu, which combined with the −2 dBu nominal level which it was designed for, gives an indication at 30 dB below nominal. Since an opamp is used which is internally compensated for unity gain stability, there is no need to add hysteresis to prevent oscillation when the signal lingers around the triggering point. U1 is configured as an inverting stage with the inverting input biased slightly negative of the non-inverting input by R4 in the bias chain R3, R4, R5. The opamp output is therefore high with no signal but is clamped by negative feedback through D1 to prevent excessive voltage excursions at the output which might crosstalk into other circuitry; C2 is kept charged via R6, and R7, so Q1 is turned on and LED1 is off. When an input signal exceeds the threshold the opamp output goes low, and C2 is rapidly discharged through R6 and D2. R6 limits the discharge current to a safe value; the overload protection of the opamp would probably do this by itself, but I have always been a bit of a belt-and-braces man in this sort of case. With C2 is discharged, Q1 turns off and LED1 illuminates as the 8 mA of LED chain current flows through it. When the input signal falls below the threshold the opamp output goes high again, and C2 charges slowly through R7, giving a peak-hold action. This is a unipolar detector; only one polarity of signal activates it.

The LED chain current is provided by a wholly conventional constant-current source Q3, which allows any number of LEDs to be turned on and off without affecting the brightness of other LEDs. In this case the clip-detect LED is shown just above the signal-present LED; since it is only illuminated when the signal-present LED is already on, the drive requirements for Q2 are simple, and it can be driven from exactly the same sort of capacitor-hold circuitry. The other LEDs in the chain (here assumed to be routing switch indicators) simply 'float' above the LEDs controlled by transistors. The LED chain is connected between the two supply rails so there is no possibility of current being injected into the ground. This gives a span of 34 V, allowing a large number of LEDs to be driven economically with the same current. The exact number depends on

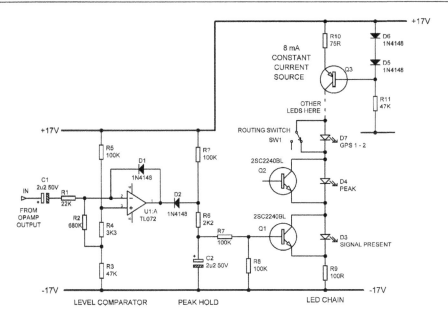

Figure 23.1 A simple unipolar signal-present detector, using an opamp. The threshold is −32 dBu. Other LEDs are run in the same constant-current chain.

their colour, which affects their voltage drop. It is of course necessary to allow enough voltage for the constant-current source to operate correctly, plus a suitable safety margin.

I have used this circuit many times in mixers and it can be regarded as well-proven.

A vital design consideration for signal-present indicators is that since they are likely to be active most of the time, the operation of the circuitry must not introduce distortion into the signal being monitored; this could easily occur by electrostatic coupling or imperfect grounding if there is a comparator switching on and off at signal frequency. Avoid this.

Peak indication

A mixer has a relatively complex signal path, and the main metering is normally connected only to the group outputs. The mix metering can be used to measure the level in other parts of the signal path by use of the PFL system (see Chapter 22) if fitted, but this can only monitor one channel at a time. It is therefore usual to guard against clipping by fitting peak level indication to every channel of all but the simplest consoles, and sometimes to effects-return modules also.

The peak indicator is driven by fast-attack, slow-decay circuitry so that even brief peak excursions give a positive display. It is important that the circuitry should be bipolar, ie it will react to both positive and negative peaks. The peak values of a waveform can show asymmetry up to 8 dB or more, being greatest for unaccompanied voice or a single instrument, and this is, of course, very often exactly what goes through a mixer channel. This level of uncertainty in peak detection is

not a good thing, so only the simplest implementations use unipolar peak detection. Composite waveforms, produced by mixing several voices or instruments together, do not usually show significant asymmetries in peak level.

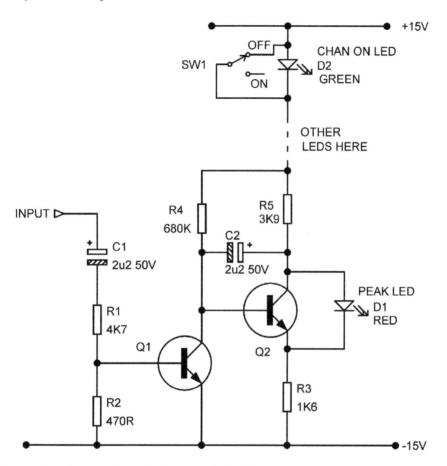

Figure 23.2 **A simple unipolar peak detector, including powering for the Channel-On LED.**

Figure 23.2 shows a simple unipolar peak LED driving circuit. This only responds to positive peaks, but it does have the advantage of using but two transistors and is very simple and cheap to implement. When a sufficient signal level is applied to C1, Q1 is turned on via the divider R1, R2; this turns off Q2, which is normally held on by R4, and Q2 then ceases to shunt current away from peak LED D1. C2 acts as a Miller integrator to stretch the peak hold time; when Q1 turns off again, R4 must charge C2 before Q2 can turn on again. Note that this circuit is integrated into the Channel-On LED supply with R5 setting the current through the two LEDs; the Channel-On LED is illuminated by removing the short placed across it by SW1. R5 is of high enough value, because it is connected between the two supply rails, for there to be no significant variation in the brightness of one LED when the other turns off. If for some reason this was a critical issue, R5 could be replaced by a floating constant-current source. Other LEDs switched in the same way can be included in series with the Channel-On LED.

This peak-detect circuit has a non-linear input impedance and must only be driven from a low-impedance point; preferably direct from the output of an opamp. The peak LED illuminates at an input of 6.6 Vpeak, which corresponds to 4.7 Vrms (for a sinewave) and +16 dBu. For typical opamp circuitry running off the usual supply rails this corresponds to having only 3 or 4 dB of headroom left. The detect threshold can be altered by changing the values of the divider R1, R2.

The Log Law Level LED (LLLL)

The Log Law Level LED or LLLL was evolved for the Elektor preamplifier project of 2012 to aid in the adjustment of a phono input with several different gain options. It is, to the best of my knowledge, a new idea. Usually a single LED level indicator is driven by an opamp or a comparator, and typically goes from fully-off to fully on with less than a 2 dB change in input level when fed with music (*not* steady sinewaves). It therefore only gives effectively one bit of information.

It would be useful to get a bit more enlightenment from a single LED. More gradual operation could be adopted, but anything that involves judging the brightness of an LED is going to be of doubtful use, especially in varying ambient lighting conditions. The LLLL, on the other hand, uses a comparator to drive the indicating LED hard on or hard off. It incorporates a simple log-converter so that that the level range from LED always-off to always-on is much increased, to about 10 dB, the on-off ratio indicating where the level lies in that range. In some applications, such as the Elektor preamplifier, it may be appropriate to set it up so that the level is correct when the LED is on about 50% of the time. This gives a much better indication.

The circuitry of the LLLL is shown in Figure 23.3. The U1:A stage is a precision rectifier circuit that in conjunction with R3 provides a full-wave rectified signal to U1:B; this is another precision rectifier circuit that establishes the peak level of the signal on C1. This buffered by U2:A and applied to the approximately log law network around U2:B. As the signal level increases, first D6 conducts, reducing the gain of the stage, and then at a higher voltage set by R9 and R10, D7 conducts and reduces the gain further. If sufficient signal is present to exceed the threshold set by R11 and R12, the output of open-collector comparator U3:A goes low and U3:B output goes high, removing the short across LED1 and allowing it to be powered by the 6 mA current-source Q1. As with other circuitry in this chapter, the LED current is run from rail to rail, avoiding the ground. Many other LEDs can be inserted in the constant-current LED chain. The LLLL has been built in significant numbers, and I have never heard of any problems with it.

If a stereo version of the LLLL is required, which will indicate the greater of the two input signals, the output of comparator U3:A is wire-OR'ed with the output of U3:C, which has the same function in the other channel; the circuitry up to this point is duplicated. A more elegant way to make a stereo version would be to combine the outputs of two peak rectifiers to charge C1. This would save a handy number of components, but I have not yet actually tried it out.

I have spent some time testing the operation of this scheme, using various musical genres controlled by a high-quality slide fader. I believe it is a significant advance in signalling level when there is only one LED available, but in the words of Mandy Rice-Davies, "Well, he would say that, wouldn't he."[1] Opinions on the value of the LLLL would be most welcome.

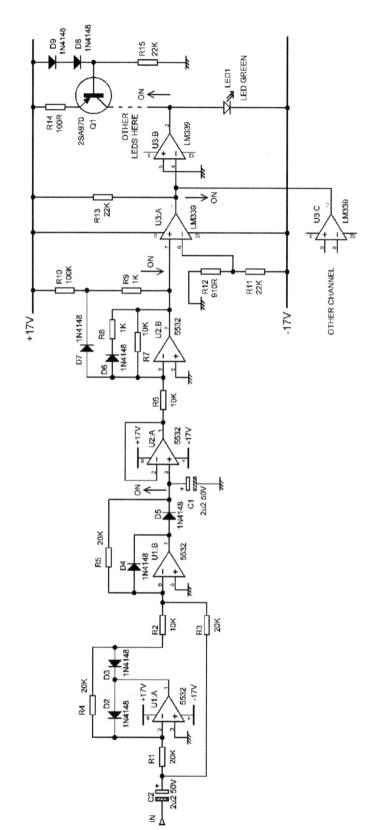

Figure 23.3 The Log Law Level LED or LLLL.

Distributed peak detection

When an audio signal path consists of a series of circuit blocks, each of which may give either gain or attenuation—and the classical example is a mixer channel with multiple EQ stages and a fader and post-fade amplifier—it is something of a challenge to make sure that excessive levels do not occur anywhere along the chain. Simply monitoring the level at the end of the chain is no use because a circuit block that gives gain, leading to clipping, may be followed by one that attenuates the clipped signal back to a lower level that does not trip a final peak-detect circuit. The only way to be absolutely sure that no clipping is happening anywhere along the path is to implement bipolar peak detection at the output of every opamp stage. This is, however, normally regarded as a bit excessive, and the usual practice in high-end equipment is to just monitor the output of each circuit block, even though each such block (for example a band of parametric EQ) may actually contain several opamps. It could be argued that a well-designed circuit block should not clip anywhere except at its output, no matter what the control setting, but this is not always possible to arrange.

A multi-point or distributed peak detection circuit that I have made extensive use of is shown in Figure 23.4. It can detect when either a positive or negative threshold is exceeded, at any number of points desired; to add another stage to its responsibilities you need only add another pair of diodes, so it is very economical. However, if one peak detector monitors too many points in the signal path, it can be hard to determine which of them is causing the problem. In most applications I have used the circuit to keep an eye on the output of the microphone preamplifier, the output of the EQ section, and the output of the fader post amplifier. This means that the location of the clipping can be pinpointed quite easily. If you pull down the fader to 0 dB or below and the peak LED goes out, the problem was at the post-fade amplifier. If that doesn't do the trick, switch out the EQ; this assumes of course that the EQ in/out switch removes the signal feed to the unused EQ section. I always arrange matters so if possible, as removing the EQ signal reduces power consumption and minimises the possibility of crosstalk. If that is not the case then you will have to back off any controls with significant boost and see if that works. Should the peak indication persist, it must be coming from the output of the microphone preamplifier, and you will need to reduce the input gain.

The operation is as follows. Because R5 is greater than R1, normally the non-inverting input of the opamp is held below the inverting input and the opamp output is low. If any of the inputs to the peak system exceed the positive threshold set at the junction of R4, R3, one of D1, D3, D5 conducts and pulls up the non-inverting input, causing the output to go high. Similarly, if any of the inputs to the peak system exceed the negative threshold set at the junction of R2, R6, one of D2, D4, D6 conducts and pulls down the inverting input, once more causing the opamp output to go high. When this occurs C1 is rapidly charged via D7. The output current limiting of the opamp discriminates against very narrow noise pulses. When C1 charges Q1 turns on, and illuminates D8 with a current set by the value of R7. R8 ensures that the LED stays off when U4 output is low, as it does not get close enough to the negative supply rail for Q1 to be completely turned off.

Each input to this circuit has a non-linear input impedance, and so for this system to work without introducing distortion into the signal path, it is essential that the diodes D1–D6 are driven directly from the output of an opamp or an equivalently low impedance. Do not try to drive them through

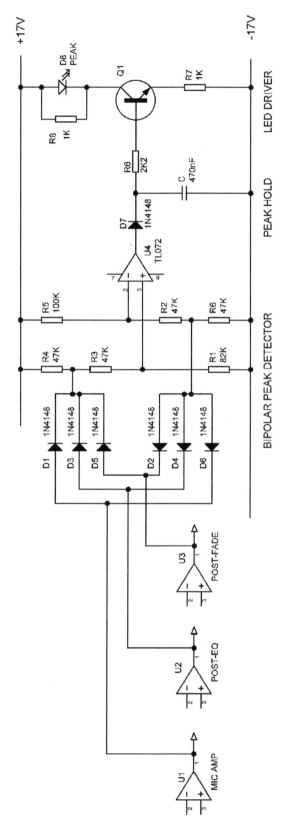

Figure 23.4 A multipoint bipolar peak detector, monitoring three circuit blocks.

a coupling capacitor as asymmetrical conduction of the diodes can create unwanted DC-shifts on the capacitor.

The peak-detect opamp U4 must be a FET-input type to avoid errors due to bias currents flowing in the relatively high value resistors R1–R6, and a cheap TL072 works very nicely here; in fact the resistor values could probably be raised significantly without any problems.

As with other non-linear circuits in this book, everything operates between the two supply rails so unwanted currents cannot find their way into the ground system.

Combined LED indicators

For many years there has been a tendency towards very crowded channel front panels, driven by a need to keep the overall size of a complex console within reasonable limits. One apparently ingenious way to gain a few more square millimetres of panel space is to combine the Signal-present and peak indicators into one by using a bi-colour LED. Green shows signal present, and red indicates peak. One might even consider using orange (both LED colours on) for an intermediate level indication.

Unfortunately, such indicators are hard to read, even if with normal colour vision. If you have red-green colour-blindness, the most common kind (6% of males, 0.4% of females), they are useless. Combining indicators like this is really not a good idea.

VU meters

VU meters are a relatively slow-response method of indicating an audio level in volume units. The standard VU meter was originally developed in 1939 by Bell Labs and the US broadcasters NBC and CBS. The meter response is intentionally a 'slow' measurement which is intended to average out short peaks and give an estimate of perceived loudness. This worked adequately when it was used for monitoring the levels going to an analogue tape machine, as the overload characteristic of magnetic tape is one of soft compression and the occasional squashing of short transient peaks is hard to detect aurally. Digital recorders overload in a much more abrupt and intrusive manner, making even brief overloads unpleasant, and the use of VU meters in professional audio has been in steady decline for many years.

The specifications, particularly of the dynamics, of a standard VU meter are closely defined in the documents British Standard BS 6840, ANSI C16.5–1942, and IEC 60268–17, but there are many cheap meters out there with "VU" written on them that make no attempt to conform with these documents. The usual VU scale runs from −20 to +3, with the levels above zero being red. 1 VU is the same change in level as 1 dB. The rise and fall times of the meter are both 300 msec so if a sine wave of amplitude 0 VU is applied suddenly, the needle will take 300 msec to swing over to 0 VU on the scale. A proper VU meter uses full-wave rectification so asymmetrical waveforms are measured correctly, but the cheap pretenders normally have a single series diode that only gives half-wave rectification. VU meters are calibrated on the usual measure-average-but-pretend-it's-RMS basis, so a VU meter gives a true reading of RMS voltage level only for a sinewave. Musical

signals are usually more peaky than sine waves so the VU meter will read somewhat lower than the true RMS value.

The 0 VU mark on the meter scale is "zero-reference level," but what that means in terms of actual level depends on the system to which it is fitted. In professional audio equipment 0 VU is +4 dBu, whereas in semi-pro gear it will be −10 dBV (= −7.8 dBu).

VU meters consist of a relatively low-resistance meter winding driven by rectifier diodes, with a series resistor added to define the sensitivity. The usual value is 3k6 which gives 0 VU = +4 dBu. They therefore present a horribly non-linear load to an external circuit, and a VU meter must never be connected across a signal path unless it has near-zero-impedance. This is particularly true for cheap ones with half-wave rectification. In practice a buffer stage is always used between a signal path and the VU meter to give complete isolation and to allow the calibration to be adjusted. Many mixers have a nominal internal level 6 dB below the nominal output level because the balanced output amplifiers inherently have 6 dB of again, and so the meter buffer amplifiers must also be capable of giving 6 dB of gain.

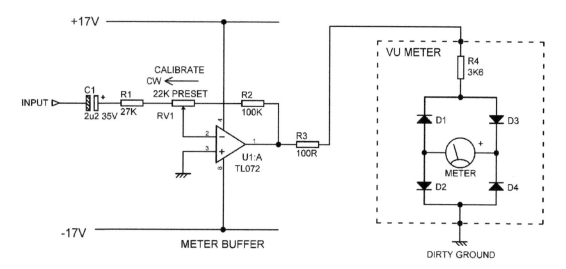

Figure 23.5 A very simple but effective design for a VU meter buffer stage.

Figure 23.5 shows an effective design for a meter buffer stage designed to work with a nominal internal level of −6 dBu, and which must therefore give 10 dB of gain to raise the meter signal to the +4 dBu that will give a 0 VU reading. C1 provides DC blocking because a VU meter will respond to DC as well as AC. R1 and R2 set the gain range to be +6 to +13 dB, which an ample range of adjustment. With the preset centralised, the gain is 9.3 dB. The resistor values are unusually high because presenting a high input impedance is here more important than the noise performance. An amplifier which was noisy enough to register directly on a VU meter would probably be better fitted to a life as a white noise generator. R3 is an isolating resistor to make sure that the capacitance of the cable to the VU meter, which may be quite lengthy if the meter is perched up in an overbridge, does not cause instability in the buffer amplifier; its presence in

series with the meter resistor R4 is allowed for when the calibration is set. The ground of the meter itself is labelled "Dirty Ground" to underline the point that the current through the meter will be heavily distorted by the rectification going on and must not be allowed to get into the clean audio ground.

Because of their slow response, VU meters are sometimes made with a peak LED projecting through the meter scale. This is driven by a peak-detect circuit of the sort described earlier in this chapter.

PPM meters

Peak programme meters (PPMs) are essentially peak-reading instruments that respond much more quickly than VU meters. They are always a good deal more expensive, partly because of the precisely defined and rather demanding characteristics of the physical meter itself—for example the needle has to be able to move much faster than a VU needle, but without excessive overshoot—and partly because they need much more complex drive circuitry. The PPM standard was originally developed by the BBC in 1938 as a response to the inadequacy of existing average-responding meters. PPMs have a distinctive scale with white legends and a white needle against a black background and are marked with from 1 to 7. This is a logarithmic scale giving 4 decibels per division, and the accurate and temperature-stable implementation of this characteristic is what makes the drive circuitry expensive.

Nonetheless PPMs are specifically designed *not* to catch the very fastest of transient peaks and are therefore sometimes called 'quasi-peak' meters. They only respond to transients sustained for a defined time; the specs give 'Type I' meters an integration time of 5 msec, while 'Type II' meters use 10 msec. The result is that transient levels normally exceed the PPM reading by some 4 to 6 dB. This approach encourages operators to somewhat increase programme levels, giving a better signal-to-noise performance. The assumption (which is generally well-founded) is that occasional clipping of brief transients is not audible. The existence of both Type I and II meters simply reflects differing views on the audibility of transient distortion.

PPMs exhibit a slow fallback from peak deflections, so it is easier to read peak levels visually. Type I meters should take 1.4 to 2.0 seconds to fall back 20 dB while Type II meters should take 2.5 to 3.1 seconds to fall back 24 dB. Type II meters also incorporate a delay of from 75 msec to 150 msec before the needle fallback is allowed to begin; this peak-hold action makes reading easier.

LED bar-graph metering

Bar-graph meters are commonly made up of an array of LEDs. An LED bar-graph meter can be made effectively with an active-rectifier circuit and a resistive divider chain that sets up the trip voltage of an array of comparators; this allows complete freedom in setting the trip level for each LED. A typical circuit which indicates from 0 dB to −14 dB in 2 dB steps with a selectable peak or average-reading characteristic is shown in Figure 23.6 and illustrates some important points in bar-graph design.

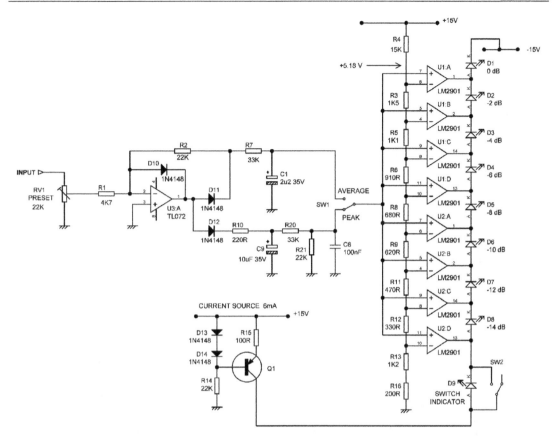

Figure 23.6 **LED bar-graph meter with selectable peak/average response.**

U3 is a half-wave precision rectifier of a familiar type, where negative feedback servos out the forward drop of D11, and D10 prevents opamp clipping when D11 is reverse-biased. The rectified signal appears at the cathode of D11 and is smoothed by R7 and C1 to give an average, sort-of-VU response. D12 gives a separate rectified output and drives the peak-storage network R10, C9 which has a fast attack and a slow decay through R21. Either average or peak outputs are selected by SW1 and applied to the non-inverting inputs of an array of comparators. The LM2901 quad voltage comparator is very handy in this application; it has low input offsets and the essential open-collector outputs.

The inverting comparator inputs are connected to a resistor divider chain that sets the trip level for each LED. With no signal input, the comparator outputs are all low and their open-collector outputs shunt the LED chain current from Q1 to −15 V, so all LEDs are off. As the input signal rises in level, the first comparator U2:D switches its output off, and LED D8 illuminates. With more signal, U2:C also switches off and D7 comes on, and so on, until U1:A switches off and D1 illuminates. The important points about the LED chain are that the highest level LED is at the bottom of the chain, as it comes on last, and that the LED current flows from one supply rail

down to the other and is not passed into a ground. This prevents noise from getting into the audio path. The LED chain is driven with a constant-current source to keep LED brightness constant despite varying numbers of them being in circuit; this uses much less current than giving each LED its own resistor to the supply rail and is universally used in mixing console metering. Make sure you have enough voltage headroom in the LED chain, not forgetting that yellow and green LEDs have a larger forward drop than red ones. The circuit shown has plenty of spare voltage for its LED chain, and so it is possible to put other indicator LEDs in the same constant-current path; for example D9 can be switched on and off completely independently of the bar-graph LEDs, and can be used to indicate Channel-On status or whatever. An important point is that in use the voltage at the top of the LED chain is continually changing in 2-Volt steps, and this part of the circuit must be kept well away from the audio path to prevent horrible crunching noises from crosstalking into it.

This meter can, of course, be modified to have a different number of steps, and there is no need for the steps to be the same size. It is as accurate in its indications as the use of E24 values in the resistor divider chain allows.

If a lot of LED steps are required, there are some handy ICs which contain multiple open-collector comparators connected to an in-built divider chain. The National LM3914 has 10 comparators and a divider chain with equal steps, so they can be daisy-chained to make big displays, but some law-bending is required if you want a logarithmic output. The National LM3915 also has ten comparators, but a logarithmic divider chain covering a 30 dB range in 3 dB steps.

A more efficient LED bar-graph architecture

The bar-graph meter shown in Figure 23.6 draws 6 mA from the two supply rails at all times, even if all the LEDs are off for long periods, which is often the case in recording work. This is actually desirable in a simple mixer as the ±15 V or ±17 V rails are also used to power the audio circuitry, and step-changes in current taken by the meter could get into the ground system via decoupling capacitors and suchlike, causing highly unwelcome clicks.

In larger mixers a separate meter supply is provided to prevent this problem, and this allows more freedom in the design of the meter circuitry. In the example I am about to recount, the meter supply available was a single rail of +24 V; this came from an existing power supply design and was not open to alteration, negotiation, or messing about with. A meter design with 20 LEDs was required and an immediate problem was that you cannot power 20 LEDs of assorted colours with one chain running from +24 V; two LED chains would be required and the power consumption of the meter, even when completely dormant, would be twice as great. I therefore devised a more efficient system, which not only saves a considerable amount of power, but also actually economises on components.

The meter circuit is shown in Figure 23.7, and I must admit it is not one of those circuit diagrams where the *modus operandi* exactly leaps from the page. However, stick with me.

There are two LED chains, each powered by its own constant-current source Q1, Q2. The relevant current source is only turned when it is needed. With no signal input, all LEDs are off; the

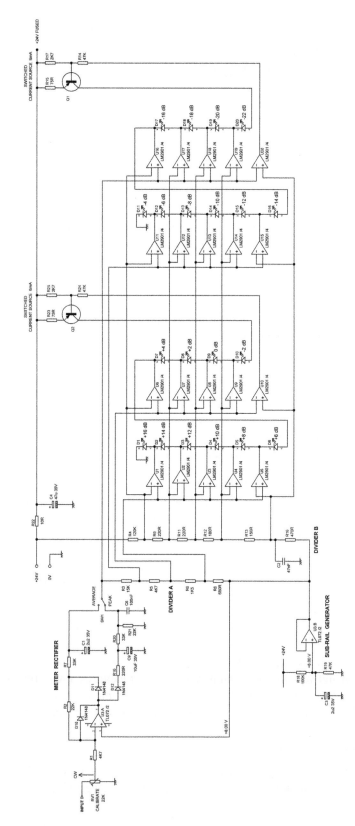

Figure 23.7 A more efficient LED bar-graph meter.

outputs of comparators U10 and U20 are high (open-collector output off) and both Q1 and Q2 are off. The outputs of all other comparators are low. When a steadily increasing signal arrives, U20 is the first comparator to switch, and LED D20 turns on. With increasing signal, the output of U19 goes high, and the next LED, D19, turns on. This continues, in exactly the same way as the conventional bar-graph circuit described earlier until all the LEDs in the chain D11–D20 are illuminated. As the signal increases further, comparator U10 switches and turns on the second current source Q2, illuminating D10; the rest of the LEDs in the second chain are then turned on in sequence as before. This arrangement saves a considerable amount of power, as no supply current at all is drawn when the meter is inactive and only half the maximum is drawn so long as the indication is below –2 dB.

There are ten comparators for each LED chain, 20 in all, so a long potential divider with 21 resistors would be required to provide the reference voltage for each comparator if it was done in the conventional way, as shown in Figure 23.6. However, looking at all those comparator inputs tied together, it struck me there might be a better way to generate all the reference voltages required, and there is.

The new method, which I call a "matrix divider" system, uses only ten resistors. This is more significant than it might at first appear because the LEDs are on the edge of the PCB, the comparators are in compact quad packages, and so the divider resistors actually take up quite a large proportion of the PCB area. Reducing their number by half made fitting the meter into a pre-existing and rather cramped meter bridge design possible without recourse to surface-mount techniques. There are now two potential dividers. Divider A is driven by the output of the rectifier circuit, while Divider B produces a series of fixed voltages with respect to the +8.0 V sub-rail. As the input signal increases, the output of the meter rectifier goes straight to comparators U16–U20, which take their reference voltages from Divider B and turn on in sequence as described earlier. Comparators U11–U15 are fed with the same reference voltages from Divider B, but their signal from the meter rectifier is attenuated by Divider A, coming from the tap between R3 and R5, and so these comparators require more input signal to turn on. This process is repeated for the third bank of comparators U6–U10, whose input signal is further attenuated, and finally for the fourth bank of comparators U1–U5, whose input is still further attenuated. The result is that all the comparators switch in the correct order.

Since in this application there was a only single supply rail, a bias generator is required to generate an intermediate sub-rail to bias the opamps. This sub-rail is set at +8.0 V rather than V/2 to allow enough headroom for the rectifier circuit, which produces only positive outputs; it is generated by R18, R19, and C3 and buffered by opamp section U3:B. The main +24 V supply is protected by a 10 Ω fusible resistor R22, so if a short-circuit occurs on the meter PCB the resistor will fail open and the whole metering system will not be shut down. This kind of per-module fusing is very common and very important in mixer design; it localises a possibly disabling fault to one module and avoids having the power supply shut down, which would put the whole mixer out of action. A small but vital point is that the supply for Divider B is taken from outside this fusing resistor; if it was not the divider voltages would vary with the number of LED chains powered, upsetting meter accuracy.

Once again the LM2901 quad voltage comparator is used, as it has low input offset voltages and the requisite open-collector outputs. Q1, Q2 can be any TO-92 devices with reasonable beta; their

maximum power dissipation, which occurs with only one LED on in the chain, is a modest 128 mW. This meter system was used at Soundcraft with great success.

Vacuum fluorescent displays

Vacuum fluorescent displays (VFDs) are sometimes used as bar-graph meters [2]. They are superior to LCDs as they emit a bright light and show good contrast. Their operation is similar to that of a triode valve; a metal oxide coated cathode gives off electrons when electrically heated, and their movement is controlled by wire grids. If they are directed to hit one of the multiple phosphor-coated anodes, it fluoresces, giving off light. The colour can be controlled by selecting appropriate phosphors. The cathode runs at a much lower temperature than in conventional valves and does not visibly glow. The cathode heating voltage is usually 2–3 V, and this is often supplied as a balanced centre-tapped drive to minimise brightness variations across the display. This voltage is inconveniently low and the current inconveniently high for many applications so an inverter with a transformer is used. The same transformer may be used to generate the anode voltage, usually +50 to +60 V.

VFDs require hefty tooling charges if you want a custom display, and their awkward power requirements make them more complicated to use than LEDs, especially because of the need for an electrically noisy inverter. One of the best-known applications of a VFD was in the classic Casio FX-19 scientific calculator [3] that appeared in 1976. I bought mine then, and it is still working perfectly; it is my calculator of choice because the display is brilliantly clear under all conditions. VFDs pre-dated LCDs, but they are still very much in use where high contrast is required. My Blu-Ray player has one.

Plasma displays

A plasma display [4] consists of a large number of gas-filled cells between two glass plates, which glow when energised with a high voltage. The cells are addressed by long electrode strips which run in the X-direction on one glass plate, and in the Y-direction on the other. When voltages are suitably applied, only the cell at the crossing point of one X and one Y electrode will glow. Plasma displays were used in the SSL 4000 and 5000 consoles and in the Neve V1, V2, V3, and VR consoles, amongst others. These were neon-filled, giving an orange glow. The plasma modules used by Neve combined PPM and VU characteristic bar-graphs in one module; each bar-graph was composed of 100 steps. They operate from 248 V DC, a voltage which requires considerable respect. That does not in itself make driving the displays difficult because such a voltage can be switched with a couple of MPSA42/92 transistors. This only needs to implemented once as the switching of the steps is done by a multiplexing process.

Since plasma televisions, working on the same basic principle but showing three colours, are available for reasonable prices (£340 for a 43-inch model in June 2013, down to £279 in 2020, for HD not 4K), you might be surprised to learn that a single-channel plasma display module for console use costs £250, presumably due to the small production quantities involved.

Liquid crystal displays

The ultimately versatile metering system is provided by making the meter display from a number of colour LCD display screens [5]. These can be of the size used in the smaller laptop computers, butted side-to-side to make something like a conventional meterbridge, or larger screens that can show three or more rows of bar-graphs at once. All the Calrec digital consoles currently have such metering. The advantages are obviously that you can display any kind of metering that you can think up, and the cost is low because the technology can be based on standard laptop screen displays and graphics chips, which are made in enormous quantities.

References

[1] http://en.wikipedia.org/wiki/Mandy_Rice-Davies Accessed Sept 2022

[2] http://en.wikipedia.org/wiki/Vacuum_fluorescent_display Accessed Sept 2022

[3] www.calculator.org/calculators/Casio_fx-19.html Accessed Sept 2022

[4] http://en.wikipedia.org/wiki/Plasma_display Accessed Sept 2022

[5] http://en.wikipedia.org/wiki/Liquid-crystal_display Accessed Sept 2022

Gain-control elements

A circuit block that gives voltage control of gain is a difficult thing to implement. The basic function is simply that of multiplication, but most of the practical techniques introduce significant distortion. In every case distortion and noise can be traded off by altering the operating level, but in some techniques the non-linearity is so great that a compromise that meets modern performance standards is simply not possible.

A brief history of gain-control elements

The difficulty of implementing a good voltage-variable gain element is testified to by the number of technologies that have been tried. A variable attenuator could be made by varying the current flow through diodes, which varied their effective resistance; the control-signal inevitably got mixed up with the audio signal, and linearity was poor. Optical combinations of filament bulbs and cadmium-sulphide photoresistors gave very good control-signal isolation, but operation was slow because of the thermal inertia of the filament. Later versions used LEDs and were much faster but the non-linearity of the photoresistors remained a limitation. Chopper systems, which turned the signal hard on and off at an ultrasonic frequency, with a variable mark-space ratio, and then reconstructed the signal with a lowpass filter, gave fast response and reasonable linearity. However it was difficult to get a wide control range and effectively removing all the switching frequencies required a fairly complicated filter. A long time ago I designed just such a variable attenuator, using 4016 analogue gates for the switching, and a clock frequency of 160 kHz. The gain was difficult to control below −40 dB, and it never made it to production, which on the whole was probably just as well.

Voltage-controlled amplifiers (VCAs) are the closest approach to an ideal gain-control element. The first VCA appeared in 1971, created by DBX Inc. They were initially very expensive, so other gain-control methods persisted for some time.

JFETs

The introduction of JFETs (junction-FETs as opposed to MOSFETs) as gain control devices was a great advance. These devices promised good isolation between control-voltage and signal, instantaneous operation, and lower distortion than existing methods. These advantages do exist, but there are some less desirable features, such as a highly non-linear gain/CV law that varies

DOI: 10.4324/9781003332985-24

significantly from specimen to specimen, as a result of process tolerances. Signal-CV isolation is absolute in the DC sense, the gate looking like a very-low-leakage reverse-biased diode, but there is always some gate-channel capacitance which means that fast edges on the control voltage can get through to the signal path.

The use of JFETs for on/off signal control rather than voltage-controlled attenuation is covered in Chapter 21 on signal switching.

A JFET used as a voltage-controlled attenuator is operated below pinch-off, ie at low values of Vds that allow it to operate more like a resistor than a constant-current source. Some JFET types are better than others for this job, the 2N5457 and the 2N5459 being particularly favoured in the mid-1970s.

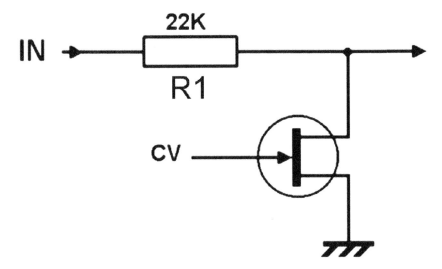

Figure 24.1 The basic voltage-controlled JFET attenuator circuit.

Figure 24.1 shows the most basic voltage-controlled JFET attenuator circuit. When N-channel FETs are used, as is normally the case, the control voltage must go negative of ground to turn off the JFET and give the minimum-attenuation condition. The maximum attenuation is limited by the Rds(on) of the JFET to about 45 dB for practical circuitry. The attenuation law is highly non-linear, and variable between specimens of the same JFET; to some extent this can be trimmed out by applying a constant DC bias to the control voltage, but minor variations in the shape of the control law still remain. One of the advantages of this circuit is that when there is no gain reduction, the JFET is biased hard off, and there is no extra distortion introduced, though there will be Johnson noise from the series resistor. This makes JFETs useful in limiter applications where gain reduction occurs only briefly and intermittently; JFETs are much cheaper than VCAs.

With the JFET conducting, the major non-linearity is second-harmonic distortion, which can be much reduced by adding half the drain-source voltage to the gate control voltage, via R2, R3 as in Figure 24.2. Note that it is half the drain-source voltage that is applied, not half of the input

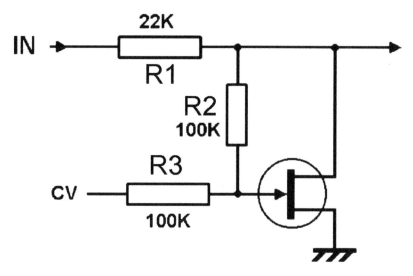

Figure 24.2 Second-harmonic distortion can be much reduced by adding half the drain-source voltage to the gate control voltage.

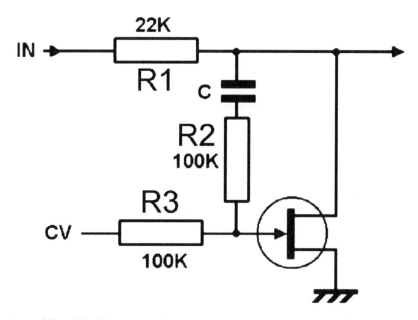

Figure 24.3 Adding blocking capacitor C prevents DC getting into the signal path but does nothing to stop transient feedthrough.

signal. The ratio is not critical—getting it right within 10% seems to give all the linearisation available. A serious problem with this circuit is the control-voltage feedthrough into the signal path. One answer is to add a DC-blocking capacitor C as in Figure 24.3; this stops DC, but does nothing to stop fast transient feedthrough.

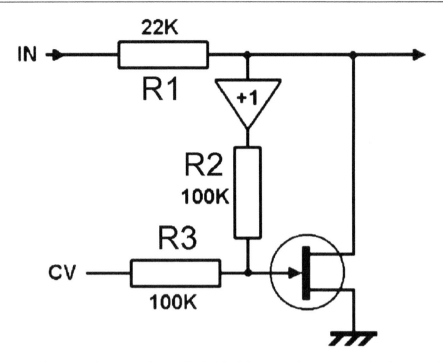

Figure 24.4 Using an active buffer instead of a blocking capacitor prevents both DC and transient feedthrough.

Another problem is that the presence of C adds an extra lowpass time-constant to the applied control voltage. In feedback limiters this can cause instability of the control loop, typically causing the gain reduction to suddenly snap to the maximum value, followed by a slow decay back to normal operating conditions. This is not a good thing. Both problems can be solved by using a unity-gain buffer amplifier to isolate the JFET gate network from the signal path, as shown in Figure 24.4.

Because of their unhelpful control laws, JFETs were most useful in feedback-type compressors and limiters, where the feedback loop linearised the law; more on that later. I produced a compressors/limiter design for *Wireless World* [1] when the application of FETs in this way was relatively new; it was published some years after I designed it. The linearity limitation remains, and JFETs are now rarely used in compressors and limiters (except for those which deliberately embrace obsolescent technologies), having been replaced by VCAs. They are, however, still useful in noise gates because as shown earlier, they can be configured so that when the noise gate is open, the JFET is firmly off and introduces no signal degradation at all. A JFET is much cheaper than a VCA.

Operational Transconductance Amplifiers (OTAs)

An operational transconductance amplifier (OTA) gives a current output for a voltage difference input, and the amount of current you get for a given input voltage is determined by the current

that is made to flow into a control port, giving a variable-gain capability. The output stage is a high-impedance current-source rather than the low-impedance voltage source of the conventional opamp, and the output current must be converted to a voltage, usually using a simple resistive load. Buffering is then needed to give a low-impedance output. Despite the name—operational transconductance amplifier—this device is not used like a conventional opamp when it is being used to give variable gain. There is no negative feedback around the device, as this would prevent the gain varying, and for acceptable linearity the differential input voltages should be kept to 20 mV or less. Distortion is mostly third harmonic and comes from the input pair transistors.

The best-known operational transconductance amplifier was the CA3080E, and a typical voltage-controlled gain circuit for it is shown in Figure 24.5. A1 is the OTA, R1 and R2 reduce the input level so it is suitable for the device input transistors, R3 is the I/V conversion resistor, and A2 is a conventional opamp acting as the output buffer. The THD is about 0.15% for a +5 dBu input level. Note the OTA symbol has a current source symbol attached to its output.

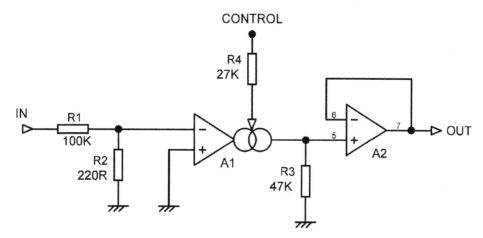

Figure 24.5 **A typical gain-control circuit using the 3080E operational transconductance amplifier.**

Another OTA called the LM13600, was introduced later by National Semiconductor; this is a dual part and has distortion-compensation diodes in the input stage, which are claimed to have improved linearity fourfold. I have to say that I found that the difference in practical applications was not that large. It also has built-in Darlington output buffers. The LM13600 has now been replaced by the LM13700; the CA3080E went out of production in 2005. The LM13700 is used in much the same way as the CA3080E.

Due to their poor noise/distortion performance OTAs are obsolete for most purposes. You are probably thinking that they belong in the history section of this chapter, but they are placed here because their flexibility and low cost has kept them very popular with builders of analogue synthesisers.

Voltage-Controlled Amplifiers (VCAs)

Voltage-controlled amplifier (VCA) is the name given to a specific kind of variable gain device. It is essentially a four-quadrant multiplier and is a current-in, current-out device, which therefore needs some support circuitry if it is to interface with the normal voltage-driven world.

Since the input port is a virtual-earth, converting the input voltage into an input current requires only a resistor; see R1 in the basic circuit of Figure 24.6. Converting the output current into an output voltage is less easy and requires a shunt-feedback amplifier A1, as it is essential to avoid signal voltages on the output port. This is a transadmittance amplifier (current-in, voltage out). An important advantage of this circuit is that is does NOT phase invert. It looks as if it does—the amplifier A1 certainly inverts—but so does the VCA internally, so the output remains in phase, which is of course essential for mixing console use.

Because of their log/anti-log operation, VCAs are characterized by an exponential control characteristic, so gain varies directly in decibels with control voltage. This is extremely convenient as it means that a linear fader can be used to control gain over a wide range; however this is in practice less than ideal as it spreads out the less important higher attenuation range too much. Special 'VCA-law' faders are made that squeeze the high-attenuation range so the normal operating range can be expanded.

The evolution of VCA technology starts in about 1970, based on the "Blackmer gain cell" developed by David Blackmer of dbx, Inc., and VCA history is a fascinating field in itself; see [2]. Another of the very early models was the Allison EGC-101, which gave improved linearity through Class-A operation [3]. The study of the internal operation of VCAs is also a big subject, and regrettably I don't have the space to go into the details here. An article in *Studio Sound* [4] gives a good deal of information on the internals. Other useful references on the technology are [5] and [6].

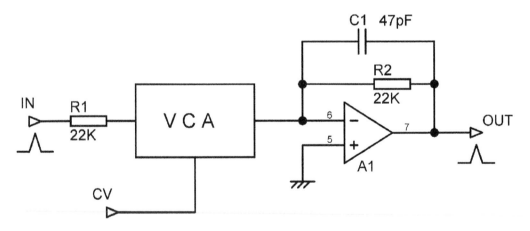

Figure 24.6 The basic gain-control circuit using a VCA.

For many years the 'standard' VCA was the DBX2150, of which I have deployed more than I care to contemplate in VCA sub-group systems and console automation; more modern ones are represented by parts like the THAT 2181. A typical application circuit suitable for both is shown in Figure 24.7.

You will note that a symmetry trim pot is required; this is set to minimise second harmonic generation. A THD analyser is required to make this adjustment, but on the positive side, once set it stays set and need never be touched again unless the VCA is replaced. Modern VCAs are very good; the THD at 1 Vrms with 0 dB gain can be as low as 0.002%. The off-isolation (or offness,

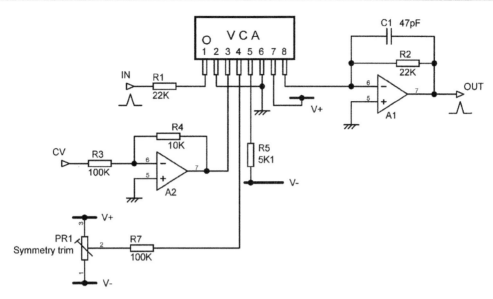

Figure 24.7 A typical gain-control circuit using the 2150 VCA. The 8-pin SIP package is almost always used for VCAs.

as I prefer to call it) can be as good as −110 dB at 1 kHz but will almost certainly be worse at higher frequencies as it depends on stray capacitance. This is why the SIP package is preferred; as shown in Figure 24.7, it keeps the input and output pins as far apart as possible. A crucial layout requirement is that the 'Hot' end of R1 is kept as far away as practicable from Pin 8 of the VCA, even if it means extending the track between R1 and VCA Pin 1. This track is at virtual-earth and susceptible to capacitive crosstalk so keep unrelated signals well away from it.

The control law (which is set by transistor physics, and is therefore dependable) is 6 mV/dB at the actual VCA control pin, and this is inconveniently low. A scaling amplifier A2 is therefore used so the control voltage has a more useful range, such as 0 to 10 V. The presence of this amplifier also gives the opportunity for control voltage filtering and changes of ground reference. The voltage applied to the control port must be at low impedance (basically an opamp output is the only source that will do) and absolutely free from contamination by any sort of signal or avoidable noise. Contamination with even a trace of the signal being controlled will cause excess distortion.

The capacitor C1 shown across the I-V conversion opamp feedback resistor is always required for HF stability, due to the destabilising capacitance seen looking into the VCA output port.

In other places in this book I have described how noise can be reduced by using multiple transistors or multiple opamps in parallel. This also works with VCAs; you simply put N of them in parallel and connect their outputs to a single shunt-feedback amplifier with a suitably reduced feedback resistor, as shown in Figure 24.8. Two VCAs give a 3 dB improvement and four a 6 dB benefit. There are, of course, limits as to how far you can go with this sort of thing; high-quality VCAs are relatively expensive. Four in parallel have been used in high-quality compressor/ limiters such as the Connor. Eight VCAs are employed by THAT Corporation in their 202 module which is used in high-end consoles such as those by SSL.

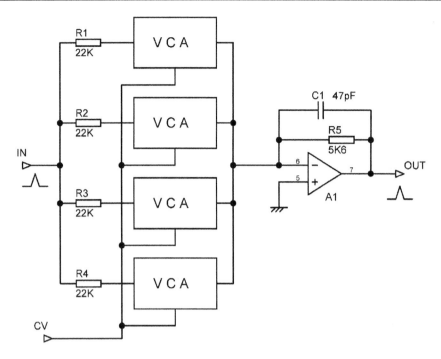

Figure 24.8 Using multiple VCAs in parallel to reduce noise. Each doubling of numbers theoretically reduces noise by 3 dB.

Compressors and limiters

Compressors and limiters are devices that control the dynamic range of a signal. The device acts like a rapid volume control that reduces the gain when the signal level becomes excessive.

A compressor reduces the general dynamic range of a signal for the majority of the time. A typical application is control of microphone levels when the talent does not make microphone technique their top priority. This means that it is applying some amount of gain reduction most of the time, so the gain-control element is active, and it is important that it is relatively distortion-free and without other audible defects.

A limiter, in contrast, has as its main function the prevention of overload and horribly audible clipping. When loudspeakers and AM transmitters are being driven it may actually prevent expensive equipment damage. Transmitters require the extra protection of a clipper circuit; see the separate section on these. Since a limiter operates relatively rarely (assuming the system is being operated correctly) it is less important that the gain-control element is distortion-free.

Figure 24.9 shows the relationships between input and output levels for compression and limiting. The compressor law begins gain reduction at a lower threshold level and has a moderate slope thereafter; the slope shown here is 3:1, which is typical. The limiter law has a higher threshold and only acts when overload is imminent; the slope is much flatter so that even very high signals levels cannot reach the overload point; the slope here is 10:1.

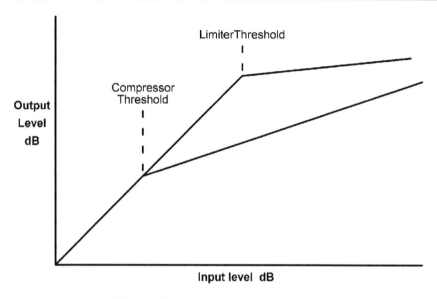

Figure 24.9 Compressor and limiter laws.

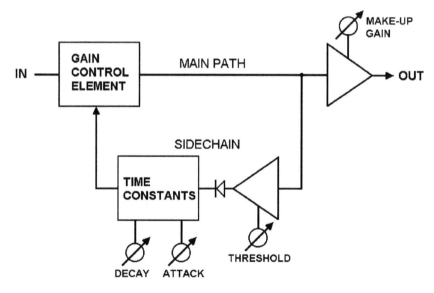

Figure 24.10 Block diagram of a feedback compressor/limiter.

Compressors and limiters do a similar job, using much the same hardware with different parameter settings, so the functions are often combined in a compressor/limiter. Figure 24.10 gives the block diagram of a feedback compressor/limiter. The output signal is amplified, and if it exceeds a certain threshold, applied to a rectifier with a fast-attack slow-decay characteristic. This part of the system is called the sidechain to emphasise that the signal does not pass through it. The

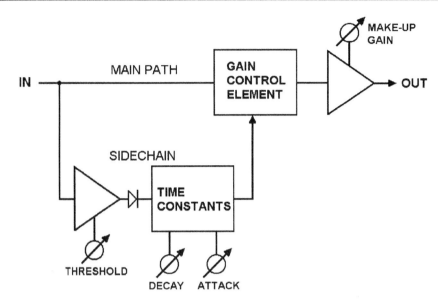

Figure 24.11 **Block diagram of a feedforward compressor/limiter.**

resulting control voltage is applied to the gain-control element, and as the signal level increases the gain is reduced, reducing the variations in output level. The sidechain may use either peak or RMS sensing; the latter is considered by some to relate better to our perception of loudness and give a less obtrusive effect.

The laws shown in Figure 24.9 have 'hard knees' as the gain laws change abruptly at the threshold. A 'soft knee' slowly increases the compression ratio as the level increases, giving a curve that gradually attains the desired compression ratio. A 'soft knee' is considered to make the change from uncompressed to compressed less audible, especially for higher compression ratios.

If the threshold is set low, and the sidechain gain also low, the system works as a compressor, the gain reduction acting to reduce the general dynamic range of the output signal, hopefully without obvious side-effects. If the threshold is set high and the sidechain gain is also high, we have instead a limiter. The signal will be untouched until it exceeds the threshold, and then gain reduction is applied strongly to prevent the output level significantly increasing.

Compressor/limiters can work in either feedforward or feedback modes, each of which has its own advantages and problems. In the feedback mode the compression law tends to be inherently linear because of the feedback around the level-control loop. The feedback configuration has the advantage that the output level set does not depend on the control-voltage law of the gain element.

With feedforward, as in Figure 24.11, the compression law depends on the control-voltage law of the gain element. If this is a VCA with a very predictable law, no problem. However, other gain elements such as FETs sometimes have their uses—with FETs the advantage that there is no signal degradation when there is no gain reduction. There is, however, also a highly non-linear control-voltage law to deal with, and it is not practical to bend this into a more desirable log law.

The way to solve this is shown in Figure 24.12, which assumes that two matched gain elements are easier to make than one with the required law. The sidechain path contains a feedback limiter and the control voltage this generates is fed to the second gain element, which acts in feedforward mode. Typically the gain elements are matched as well as possible by trimming.

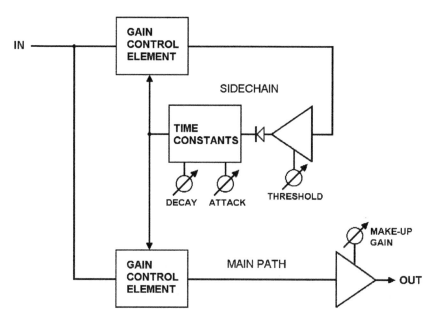

Figure 24.12 A combined feedforward/feedback compressor/limiter.

So far we have assumed that the sidechain dynamics consist only of two simple time-constants for attack and decay. In many cases this will give rise to objectionable effects and more sophisticated control measures have been developed to deal with the problems. Even if a gain-control element is completely linear when the control voltage is fixed, rapid CV changes put distortion into the waveform.

Attack artefacts

When a fast attack is used to control level (typically when the unit is being used as a limiter) and prevent overshoot, it tends to bite chunks out of the controlled waveform as a natural consequence of a rapid drop in gain. Isolated cases of this usually pass unnoticed but repeated occurrences are perceived as a crackling noise. This can be controlled by the use of dual attack times, with the faster time switched in if the signal peak exceeds criteria for amplitude and rate of rise, but the only complete solution to this problem is a delay-line compressor/limiter, as seen in Figure 24.13.

A delay in the signal path between the side-chain takeoff point and the gain element allows a feedforward sidechain to react relatively slowly and still have the gain reduced before the signal peak reaches the gain-control element. This is not possible with the feedback compressor/limiter

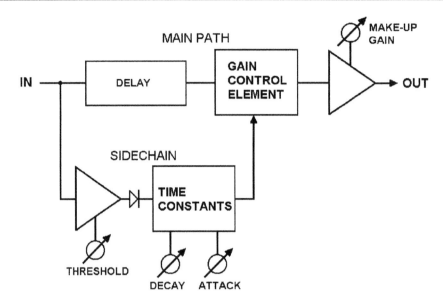

Figure 24.13 Block diagram of a feedforward compressor/limiter with delay.

configuration because the sidechain feed is taken *after* the gain-control element, and therefore after the delay. The difficulty is that the signal is delayed at all times; this will cause problems if it is being mixed with undelayed signals, and furthermore the delay section has to be of high quality as it passes the main signal, not just the sidechain information. A well-known BBC design of circa 1967 used a strictly analogue 320 uSec delay-line made up of ten LCR second-order all-pass filter sections [7]. This worked very well but is obviously an expensive technique. An active filter delay-line would be cheaper but still involves a significant amount of circuitry and a number of close-tolerance components. Nowadays a high-quality digital delay using 24-bit converters can be constructed relatively easily.

Decay artefacts

Since the sidechain contains either a peak or RMS detecting rectifier, the timing capacitor will have on it a ripple waveform resulting from cyclical charge and discharge, exactly as in a power supply reservoir capacitor. This waveform modulates the signal path gain and generates distortion; the effect can be severe. In most compressor/limiter usage the attack time has to be fast, but often the decay time can be made much longer, reducing the amplitude of the ripple and reducing distortion. However, in some applications the decay has to be short for rapid recovery from brief level excursions or the general level of the signal will be unduly depressed. An effective and widely-adopted solution to this problem is the use of dual time-constants. See Figure 24.14 for a simple implementation, where the short time-constant R1, C1 responds to short-term level changes while the long time-constant R2, C2 copes with the general trend.

Another elaboration is a hold circuit which prevents the decay from beginning if any attack events have occurred in, say, the preceding 20 msec. This helps to prevent sudden and obvious

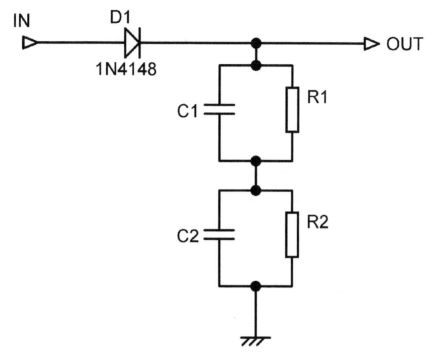

Figure 24.14 Dual decay time-constant circuit.

gain changes, often called by the highly descriptive term 'pumping.' If the noise background is significant, as with many live news recordings, then even slow gain changes produce a distracting effect called 'breathing' because that's just what it sounds like.

Subtractive VCA control

While modern VCAs are very good, they still introduce more noise and distortion than a typical well-designed chain of 5532 opamps, and as mentioned earlier, FETs are therefore still favoured for some compressor/limiter applications as they introduce no degradation when not bringing about gain reduction. However, the predictable characteristics of VCAs are very attractive, and it would nice to combine the advantages of both.

This can be done; whether I invented the technique first I have no idea, but it was all a long time ago. The concept, as shown in Figure 24.15, is not to send the signal through a VCA with 0 dB gain when no gain reduction is required, but to have the VCA normally hard off, and then turn it on to reduce the gain. When the VCA is off, the circuit acts as a simple unity-gain inverting amplifier, and there is minimal signal degradation.

Note that point about inverting—this circuit phase inverts although the standard VCA circuit does not. As the VCA gain is turned up, it lets more signal current through to the summing point of A1, and since this is out of phase, due to the internal inversion of the VCA, there is partial cancellation and the overall gain falls. When the VCA is set to 0 dB gain theoretically there is complete cancellation

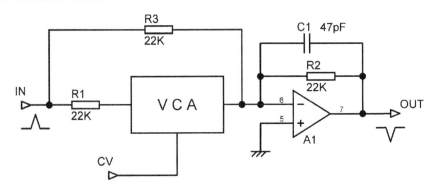

Figure 24.15 A VCA gain control arranged so that no signal passes through it when no gain reduction is occurring.

and the overall circuit is off. In practice the tolerances in R1, R3 and in the VCA set a limit to the practicable minimum gain, but the range is more than enough for effective dynamics control.

You may have spotted the potential snag. If the gain of the VCA goes above 0 dB (which corresponds with a control voltage of 0V) the overall gain will begin to rise again. With a feedback-type compressor/limiter this could be disastrous as the sidechain will try to reduce the gain, but it will simply increase it further, and the system will latch up solid. This can be prevented by the simple expedient of using an active-clamp circuit to prevent the control voltage rising even a millivolt above 0V. Note that because of the subtractive action the gain law is no longer linear in dBs, and so this plan is better suited to feedback compressor/limiters. I put this system into a production broadcast console in 1990, and it worked very well.

Noise gates

A noise gate allows a signal through only when it is above a set threshold: the gate is said to be open or on. When the signal level drops below the threshold the signal is either attenuated or stopped altogether, and the gate is closed or off. For effective noise reduction the level of the signal must be well above that of the noise; the threshold is set above the noise level so when there is no signal the gate closes. Noise gates are not actually often used to discriminate against noise as such, though they are very useful at the end of a string of guitar effects pedals. In recording they are more likely to be used to, for example, increase the isolation between the signals coming from a multi-mic'd drum kit. They are also used to provide the well-known 'gated reverb' effect where decaying reverb is cut off suddenly by a noise gate, giving a cleaner effect.

A noise gate is a rather different animal from a compressor/limiter. Its operation is much more on/off, and long time-constants are not normally used. This means that the non-linearity of an FET during intermediate degrees of gain reduction can be tolerated. In the traditional form of FET noise gate, as shown in Figure 24.16, and based on a design I did some years ago, FET distortion is reduced by attenuating the signal considerably—in this case by 32 dB—before applying it to the FET stage. This is done by R1, R4, and the signal is at a low impedance afterwards to keep noise down. The FET (actually two FETs here, to reduce Rds-ON and give a greater gain change) is at the bottom of the NFB network of a low-noise hybrid amplifier stage that restores the signal to its original level when

the FET is on. When the FET is off, the gain is reduced to unity. This would only give an offness of −32 dB, which is not enough, so the network R9, PR1, R8 is added, which lets a little signal through to what is effectively an inverting input to the amplifier stage; when PR1 is correctly adjusted there is effective cancellation and the offness can easily exceed −80 dB. FET distortion is further reduced by adding half the drain-source voltage to the gate control voltage via buffer A3, as described earlier.

The low-noise amplifier is a hybrid stage, combining the low-noise of the discrete input transistor Q1 with the open-loop gain and linearity of opamp A1. R2, R6 set up the DC conditions for Q1, while servo integrator A2 defines the DC operating point of A1, keeping its output at 0V on average. Q2 is a current-source that helps keep rail noise out of the collector circuit of Q1. The alert reader will spot the similarity between this stage and the moving-coil preamplifier stage in Chapter 10. The noise from the amplifier with the gate off is a rather quiet −106 dBu.

Many noise gates have a 'range control' that allows the offness to be reduced if a more subtle effect is required. This is RV1 in Figure 24.16, an ordinary log pot that has the bottom of its track, which would normally be grounded, connected instead to the noise gate output. Offness is reduced by advancing the control so that some of the signal gets through even when the gate is off.

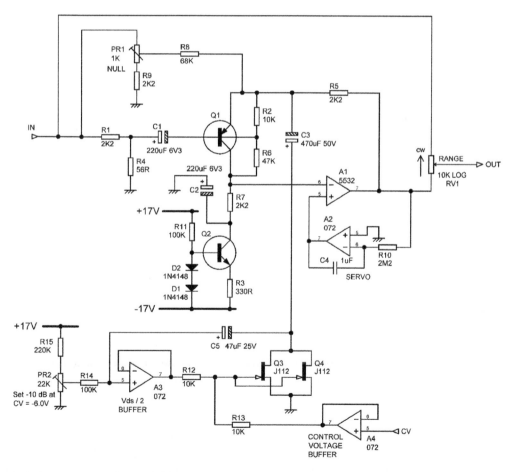

Figure 24.16 A typical FET noise gate.

The sidechain of a noise gate is similar to that of a compressor/limiter, but there is a greater emphasis on fast attack times of 50 usec or less, and special circuitry is used to charge the timing capacitor as quickly as possible.

Noise gates can also be made with VCAs, and this is the more usual method when a 'dynamics section,' which can act as either a noise gate or a compressor/limiter, is squeezed into a mixer channel.

Clipping

Since clipping and its attendant distortion is something we normally strive to avoid, it may be thought perverse to study ways in which to induce it. Clipping circuits do have their uses, however. One application is in the protection of AM transmitters, where even momentary excursions beyond 100% modulation are unacceptable because they lead to legal problems (sideband splatter causes the regulator to close you down) and technical problems (the transmitter blows up). Either way you're off the air. Limiters are the first line of defence, but they are liable to overshoot and maladjustment. A fixed-level clipping circuit, however, can absolutely prevent any signal exceeding its threshold. Clipping circuitry also has specialised uses in power amplifier design, where it can emulate the performance of a much more complex and expensive regulated power supply [8] or increase the flexibility of bridged amplifiers [9].

To set down some of the requirements for the perfect clipping circuit:

1) Clipping must be at well-defined symmetrical levels, constant with frequency and not dependent upon signal history.

2) The top of the clipped waveform should be absolutely flat, to give tight level control.

3) The clipping level must be arbitrarily settable, without steps.

4) There must be absolutely no degradation of the signal below the clipping threshold—or at any rate no more than would be caused by going through an ordinary single opamp stage.

This last requirement is actually much more demanding than it appears, but it is essential. Let us examine the problem. I appreciate that clean audio clipping may be a bit of a minority interest, but it will be highly instructive to see just what difficulties arise, and how they can be overcome.

Diode clipping

If you look up 'clipping circuits' in the average textbook, you will probably find something like Figure 24.17, where back-to-back diodes conduct when the signal exceeds their conduction threshold.

This fails to meet our requirements in several ways. Firstly, the gradual onset of conduction in the diodes means that the clipping is soft, infringing requirements 2 and 4. And finally, it breaks 3 as well because the clipping level can only be altered by changing the number of diode pairs used, giving 0.6 V steps.

Figure 24.18 shows the force of this, the result of using various numbers of pairs of 1N4148 silicon signal diodes. The lower line descending from left to right is the noise floor, getting relatively lower as the input level increases. With one pair of diodes distortion is already clearly above the noise floor for an input as low as 100 mVrms. The gradual increase in distortion after this as level increases shows that the clipping is distinctly soft and so introduces unacceptable

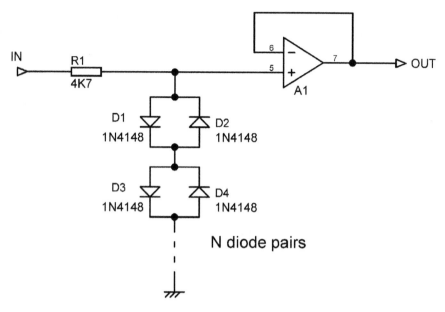

Figure 24.17 A simplest passive clipping circuit using diodes.

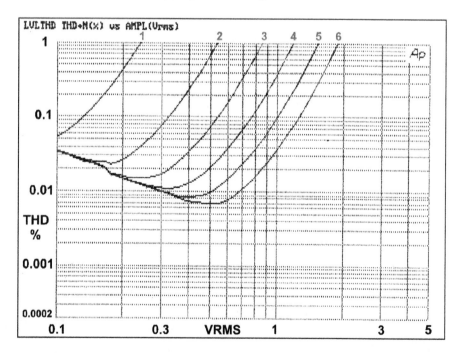

Figure 24.18 Distortion against input level for 1 to 6 pairs of clipping diodes. The uneven spacing of the curves as diode pairs are added is due to the logarithmic X-axis for input level.

distortion long before it effectively controls the level. An obvious extra snag is that a passive circuit like this has a significant output impedance; in most applications some sort of output buffering like A1 will be required.

The very gradual onset of clipping shown previously is due to the slow way in which the exponential conduction law of diodes begins. The clipping action can be made much sharper by connecting each diode to a suitable bias voltage so that it is firmly reverse-biased at low signal levels and only conducts when the signal is significantly above the bias voltage. The bias chain must have a low-impedance to give a steep clipping characteristic, and so diodes are also used to establish the voltages. It would, of course, be possible to generate near-zero-impedance supplies by using opamps to buffer resistive dividers (which also allow complete flexibility in setting the clipping threshold). However, if opamps are to be employed, there are better ways to use them, as we shall see later in this chapter.

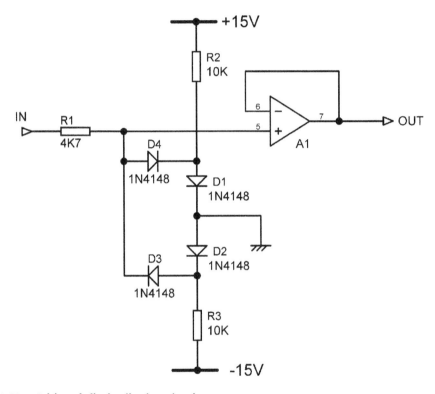

Figure 24.19 A biased diode clipping circuit.

A biased clipping circuit is shown in Figure 24.19, and the resulting distortion performance in Figure 24.20, for both one and two pairs of diodes in the biasing chain. The much steeper rise in distortion shows that the onset of clipping is much sharper; compare Trace 6 in Figure 24.18 with Trace 1 in Figure 24.20.

The clipping action of simple circuits like this is, however, still some way short of perfect, in that the clipped part of the waveform is not a dead flat horizontal line. Diodes do not suddenly become short-circuits when they start to conduct, and the clipped part of the waveform bulges upwards somewhat. Clearly we need active circuitry to sharpen up the diode action.

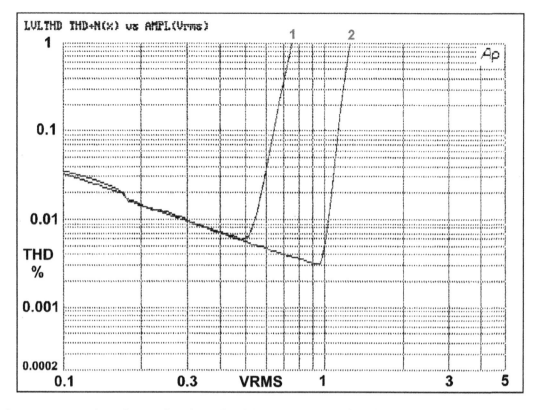

Figure 24.20 Distortion against input level for one or two pairs of diodes in the biasing chain of Figure 24.19.

Active clipping with transistors

The next step up in sophistication from simple diodes is the use of transistors for clipping. This is an active process, in that the voltage applied to the base turns on the collector current. It is not simply a matter of using the base-collector or base-emitter diodes to replace the simple diodes in the previous section.

Figure 24.21a shows a basic transistor clipper with NPN and PNP devices shunting the signal path, and Figure 24.22 shows the distortion performance. A buffer is required for a low-impedance output; trace A in Figure 24.22 shows the result without an output buffer, and trace B shows the result with it. In the latter case not only has the noise floor dropped, due to less pickup on what is now a low-impedance output, but the distortion at a given level has risen significantly, as the lowpass action of a capacitive screened cable driven from a medium impedance has been eliminated.

In the improved circuit of Figure 24.21b, the circuit is arranged so that extra drive is applied to the transistor bases via R2 because of the voltage drop across R1. This pulls down the clipped part of waveform in the centre and with a correct choice of values gives improved flatness. The circuit is based on a concept by Stefely. The distortion plot in Figure 24.23 is not very different.

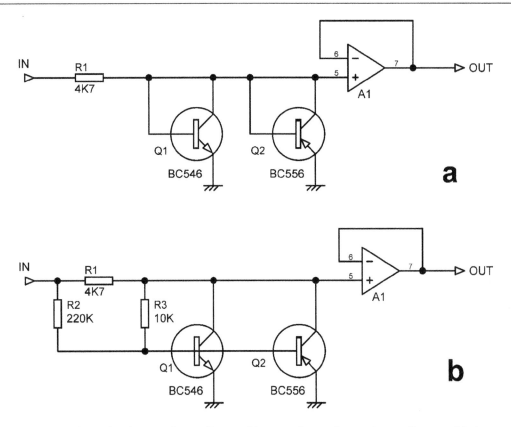

Figure 24.21 **a) A simple transistor clipper; b) An enhanced transistor clipper with increased base drive via R2.**

Active clipping with opamps

Opamps are noted for their versatility. However, using them to do precision clipping, with low distortion below the clipping point, is more difficult than it at first appears. Here I examine three ways of doing it, as the limitations of the first two approaches are highly instructive.

1) Clipping by clamping

The first attempt is the direct descendant of the diode clipping circuits examined earlier and uses two active clamps A1, A3 to constrain the voltage at point A, downstream of the 4k7 resistor, as shown in Figure 24.24. Normally this point is between the two clipping thresholds, so the inverting input of A1 is positive of Vt−, and the opamp output is saturated negatively. D1 is therefore firmly reverse-biased, and A1 has no effect on the voltage at A. Likewise, normally the inverting input of A2 is negative of Vt+, and D2 is held off.

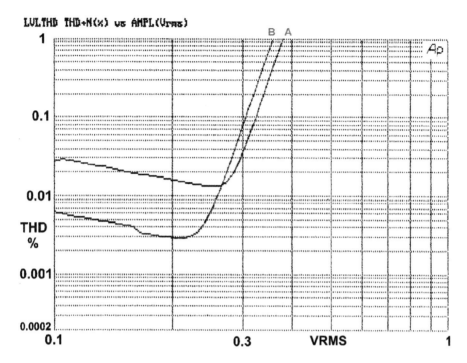

Figure 24.22 Distortion against input level for transistor clipper.

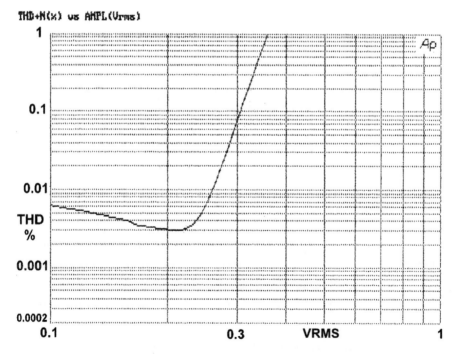

Figure 24.23 Distortion against input level for enhanced transistor clipper.

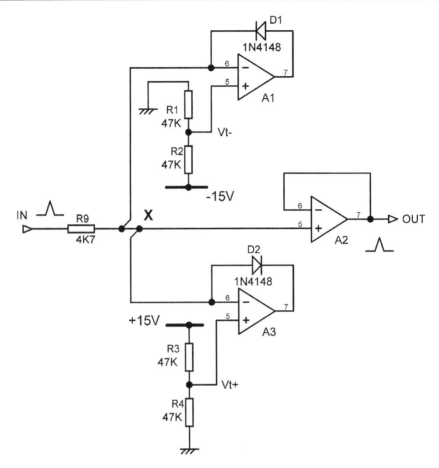

Figure 24.24 An active-clamp clipping circuit, with thresholds set at Vt+ and Vt−. Once again an output buffer A2 is essential to give a low output impedance.

When the voltage at X tries to exceed Vt+, the output of A2 swings negative, and D2 pulls down point A to prevent it. The diode imperfections are servoed out by the open-loop gain of A2, so the clipping threshold is exactly Vt+, neglecting opamp offsets and other minor errors. In the same way, if point X tries to go below Vt−, the output of A1 swings positive, and D1 conducts to clamp the output at this voltage. Like the aforementioned passive diode clipper, this circuit has a significant output impedance (4k7 in normal operation) and so buffer A2 is added to give a low output impedance.

The two clipping thresholds can be set to any desired voltage as they are derived from resistive dividers. They can, of course, be different, though an application where this might be useful is not that easy to visualise.

The active clamp circuit gives very clean clipping, but falls down badly on the distortion it adds to signals below the clipping threshold of 2.2 Vrms. Figure 24.25 shows that distortion reaches

an unacceptable 0.035% at 10 kHz and 2 Vrms; the 2 V trace is lower at LF because the relative noise floor is lower. This distortion occurs because point X is at a significant impedance and is connected to two opamps with JFET inputs, typically TL072s. These have non-linear capacitances to the IC substrate and cause distortion that worsens with frequency and level, as shown in Figures 24.25 and 24.26. See Chapter 4 for more details of this distortion mechanism. This effect could be eliminated by using opamps with bipolar inputs, but then the bias currents would have to be dealt with. One advantage of this circuit is that it does not phase invert, unlike most active clipper circuits.

Figure 24.26 shows that at 10 kHz distortion is beginning to appear when the input exceeds 300 mVrms and rises slowly until clipping begins just above 2 Vrms.

2) Negative-feedback clipping

Having found that clipping in the forward path has significant problems, we move to a configuration where this takes place in the negative-feedback loop, so the clipped output can be taken from an opamp output at low impedance. This makes interfacing with the next stage simpler.

The circuit in Figure 24.27 works as follows; with no input, point X sits at +5 V and point Y sits at −5 V. When the output heads positive, eventually Y is pulled positive of the 0V at the A1 inverting input,

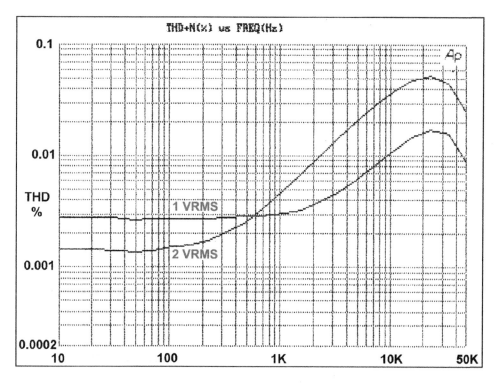

Figure 24.25 Distortion against frequency for the active-clamp clipping circuit.

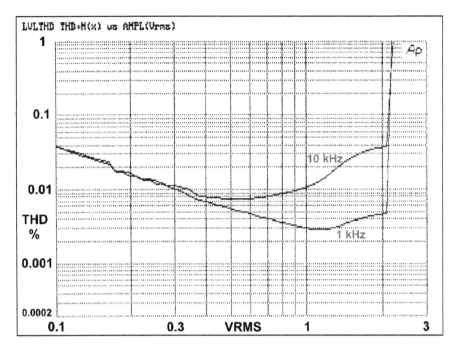

Figure 24.26 Distortion against input level for the active-clamp clipping circuit.

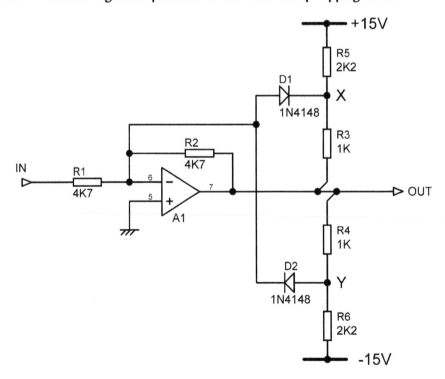

Figure 24.27 A negative-feedback clipper; the clipping threshold is set by the voltages at X and Y.

and D2 starts to conduct, reducing gain and giving clipping. Similarly, on sufficiently large negative output excursions D1 will conduct. The clipping characteristic is rather soft; the gain cannot be reduced entirely to zero above the threshold because of the diode forward impedance in series with the source resistance of the 2k2–1 kΩ bias network. The latter can be reduced by using lower resistance values, but this loads the opamp output excessively and draws more power from the supply rails.

This configuration gives less sub-threshold distortion than the previous circuit by a factor of roughly three at 10 kHz, but it is still a long way from our requirement for "absolutely no degradation of the signal" which some of you are by now probably thinking was a bit ambitious.

The distortion for a 3 Vrms input, which is well below the clipping threshold for this circuit, is shown by curve A in Figure 24.28, and it is instructive to wheel out the Scientific Method to find out what is going wrong with the linearity. The previous clamping-clipper circuit ran into trouble by driving non-linear opamp inputs from a non-zero-impedance; that cannot be happening here as both opamp inputs are at zero voltage, the inverting input so because there is always a healthy amount of shunt feedback.

So what might be the problem? We know that opamps have their linearity degraded by excessive output loading, and the two diode bias networks, being connected to rails that are effectively

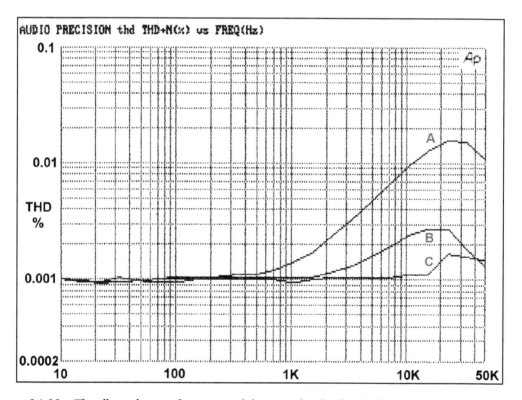

Figure 24.28 The distortion performance of the negative-feedback clipper against frequency for a 3 Vrms input. Plot A: basic distortion of Figure 24.27. Plot B: loading distortion eliminated by buffering A1 output. Plot C: with the diode chain disconnected.

at AC ground, represent a significant load of (2k2 + 1 kΩ) in parallel with (2k2 + 1 kΩ), which works out to a total load of 1.6 kΩ on the output. This is quite enough to degrade the linearity of most opamps (see Chapter 4), but the idea is still only a hypothesis and needs testing.

This can be done experimentally by means of the circuit in Figure 24.29, which uses a separate voltage-follower A2 to drive the two bias networks, the clean output being taken off before it. Our hypothesis looks good, as eliminating the loading on A1 has much reduced the distortion, giving Plot B in Figure 24.28. This however still falls somewhat short of perfect linearity.

The distortion remaining in Plot B is due to negative feedback through the non-linear diode capacitances while they are still reverse-biased, ie below the clipping threshold. This can be demonstrated by disconnecting the output of A2 so clipping is disabled and points X and Y do not move. The diodes are still connected to the summing point at the inverting input of A1, which also does not move, and we now get Plot C in Figure 24.28, which is essentially the testgear distortion plus a little circuit noise.

Putting extra opamps in a negative feedback loop is not something to be entered into lightly or unadvisedly because of the danger that accumulating phase shifts can make the loop unstable. However, it often works if the extra opamp is configured as a voltage-follower because the 100% local feedback in the follower makes its bandwidth as great as possible, and significantly greater than that of an inverting stage, which works at a noise gain of 2. Here it works dependably.

While this circuit is some way short of perfection, it can be useful sometimes, especially if there happens to be a spare opamp half left over to act as the buffer A2 in Figure 24.29. Don't forget that this circuit gives a phase inversion.

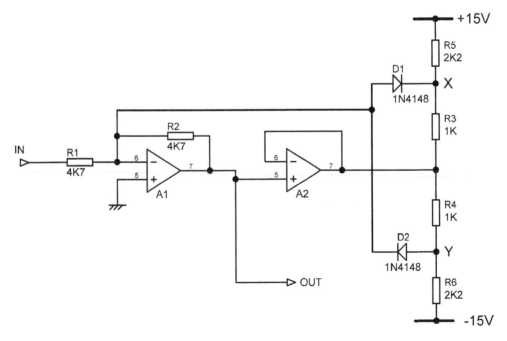

Figure 24.29 A modification of Figure 24.8 that removes the loading distortion from the signal path.

3) Feedforward clipping

The Attempt 2 negative-feedback clipper demonstrated one way to reduce sub-threshold distortion, but it also highlighted the difficulty of getting hard clipping and tight level control by using negative-feedback techniques. While feedback is a most powerful technique, it is not the only way; sometimes feedforward does it better.

The circuit of a feedforward clipper is shown in Figure 24.30. Below the clipping level it acts simply as a unity-gain inverting stage, with the forward path through R1. This configuration eliminates common-mode distortion in A2 during normal operation.

The clipping circuit consists of two shunt-feedback precision rectifiers A1, A3 that are biased by currents injected into their summing points via R2, R3 so they conduct only above the desired clipping threshold. A1 handles negative clipping; R2 injects 15 V/47 kΩ = 319 uA into the summing node of A1, and as long as this exceeds the current being pulled out of this node via R5 during negative inputs it will be counteracted by feedback through D2. When the current through R5 exceeds that injected by R2, the opamp output must go positive, so it can maintain its inverting input at ground by feedback through D1 and R6. As before, the gain of the opamp A1 is used to 'servo-out' the non-linearity of the diodes D1, D2.

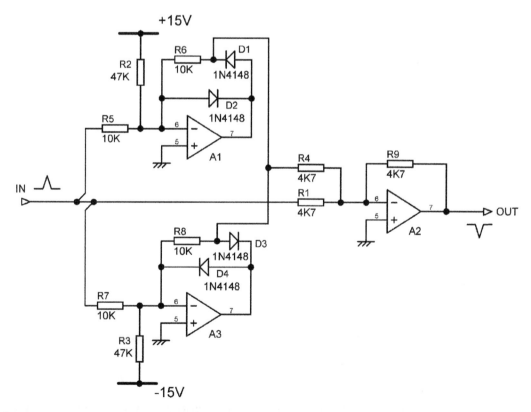

Figure 24.30 A feedforward clipping circuit. The clipping threshold is 2.25 Vrms with the values shown.

When D1 conducts, a clamped version of the input signal appears at the junction of R6 and D1, and a unity-gain but phase-inverted path is established through R4; the overall gain suddenly drops to zero as the two signal are cancelled at the summing point of A3, so the output cannot move any further and is clipped. The precision rectifier A3 acts in the same way for positive inputs.

Since A1 and A3 are never active at the same time, they can share the resistor R4, which makes for a very elegant circuit. The downside of this economy is that the active precision rectifier has to also drive the feedback resistance (R6 or R8) of the inactive precision rectifier, its other end being connected to virtual ground, and this will use up slightly more power. From this point of view the saving of a resistor is not quite as elegant as it looks; if power economy is paramount then separate cancellation resistors to each precision rectifier remove the problem.

As Figure 24.31 demonstrates, this circuit is a success. There is now no measurable distortion, even just below the clipping threshold (the step around 20 kHz is an artefact of the testgear used). The reason for this is that there are no opamp loading issues and no reverse-biased diodes with a distorted signal on one side connected to the audio path on the other side. The two clamp stages have zero output until the threshold is reached, with R4 being connected only to a virtual ground.

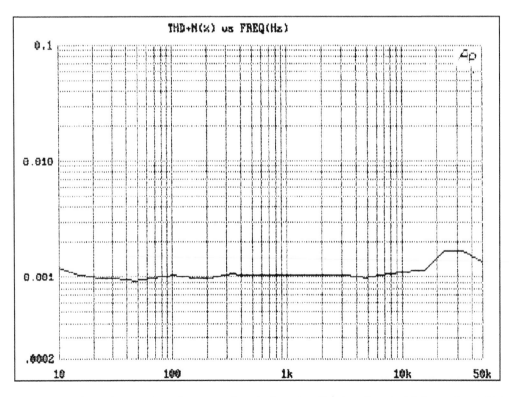

Figure 24.31 Distortion against frequency just below the clipping threshold. Input level 2 Vrms. This is once again the distortion of the testgear plus a little added noise.

With perfectly accurate resistors, and indeed perfect opamps, this circuit would give complete cancellation and the top of the clipped waveform would be absolutely flat. Cancellation processes have something of a dubious reputation in engineering circles because of the need for accurate matching of amplitude and phase to get a good cancellation. Where this depends on several factors—and particularly if semiconductor characteristics enter the equation—it can indeed be difficult to control. However, in this particular case the cancellation accuracy depends only on a few well-matched resistors. 1% tolerance is quite good enough, and most modern resistors are this accurate. The only consequence of mismatching is a very slight curvature of the clipped part of the waveform, and this is not normally enough to be troublesome.

As shown by the phase spikes in the diagram, this circuit gives a phase inversion, and this must be taken into account during the system design.

Noise generators

As with the introduction of deliberate clipping, it may seem perverse to go to a lot of trouble to generate noise when we have spent great efforts so far to minimise it. However, noise sources have their uses, for example in loudspeaker testing, room equalisation, and in analogue synthesisers. Noise comes, as is well-known, in various colours. This is not due to synaesthaesia, ("Tuesdays are red!") but a convenient way of describing the spectral content of various particularly useful kinds of noise; see Chapter 1.

White noise has equal power in equal bandwidth, so there is the same power between 100 and 200 Hz as there is between 1100 and 1200 Hz. It is the type of noise produced by most electronic noise mechanisms.

Pink noise has equal power in equal ratios of bandwidth, so there is the same power between 100 and 200 Hz as there is between 200 and 400 Hz. The energy per Hz falls at 3 dB per octave as frequency increases. Pink noise is very important as it gives a flat response when viewed on a third-octave or other constant-percentage-bandwidth spectrum analyser.

Red noise has its energy per Hz falling at 6 dB per octave; its main use is in synthesisers. There is more on noise of different colours in Chapter 1.

Most noise generators these days are digital, using calculations to produce pseudo-random white noise that is tightly defined in amplitude and spectral content. There are several ways to generate pseudo-random noise, of which the most common is the use maximal-length sequences. These sequences repeat eventually and need to be rather longer than you might think to avoid any audible patterns in the noise; 10 seconds is a good starting value. There are other ways to produce pseudo-random noise, such as Kasami codes, but that is rather outside the province of this analogue book, so instead we will take a quick look at analogue noise generation.

The most popular method is to use the white noise produced when a bipolar transistor is reverse-biased and works as a Zener diode, as shown in Figure 24.32. The collector is not connected to anything. This does the transistor no harm, so long as the current through it is limited, and

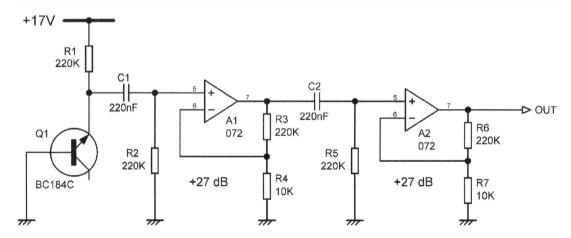

Figure 24.32 A white noise generator using a bipolar transistor as a Zener diode.

is surprisingly consistent, when you consider that this is not exactly the official way to use a transistor. I took a collection of ten BC184C transistors of varying pedigree and provenance, and found that with an emitter current of 36 uA the noise output varied between −61.5 dBu and −65.6 dBu, with one outlier at −56.9 dBu (bandwidth 22–22 kHz). The Zener voltage on the emitter was between 7.7 V and 8.9 V. When I tried a real Zener diode, of 6V2 voltage, the noise output was much less, around −85 dBu. This is presumably because Zeners are designed to produce minimal noise, though they still generate much more than simple silicon diodes; noise is distinctly unwanted in voltage reference applications.

The transistor noise output is well below a millivolt, and a good deal of amplification is needed to get it up to a useful level. Figure 24.32 shows a humble TL072 performing this service; there is of course absolutely no point in using a low noise opamp such as the 5532, and the low bias currents of the TL072 mean that high-value resistors can be used without DC offset troubles. Each stage has a gain of 27 dB. A point to remember is that the TL072 has limited open-loop bandwidth compared with more modern opamps, and if you try to take too much gain in one stage this will lead to a high-frequency roll-off. The last amplifier stage must not be allowed to clip as this will modify the energy spectrum. The output here is about 400 mVrms so clipping will statistically be very rare. Bear in mind there was a 4 dB variation in noise output for different transistor samples, and a preset gain trim may be needed for some applications.

Pinkening filters

Converting white noise into the much more useful pink noise is proverbially difficult because you can't make a filter with a true −3 dB/octave slope, as filter slopes come in multiples of 6 dB/octave only. The only solution when you need a pinkening filter is a series of overlapping lowpass and highpass time-constants that approximate to the required slope. The more pairs of time constants used, the more accurately the response approximates to a −3 dB/octave slope. Two possible versions are shown in Figure 24.33; that in a) uses three

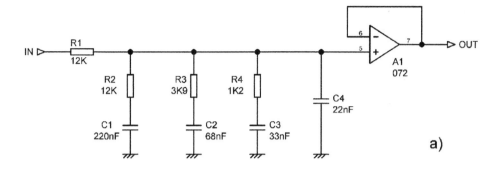

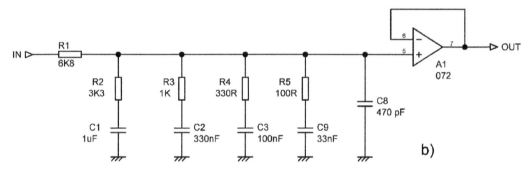

Figure 24.33 Two −3 dB/octave pinkening filters for turning white noise into pink noise.

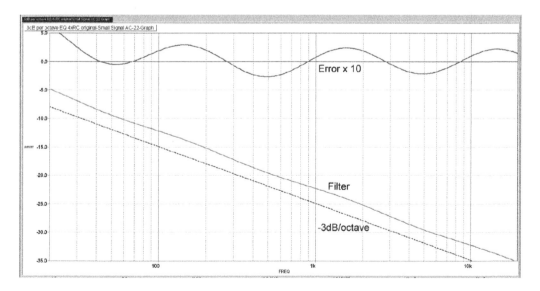

Figure 24.34 The simulated response of the 4x RC −3 dB/octave filter in Figure 24.33b. The error trace at top (multiplied by ten) shows a maximum error of +0.28 dB over the 20 Hz–20 kHz range.

pairs, with a final unmatched pole introduced by C4; that in b) has four pole-zero pairs, with a final unmatched pole. The closer the time constant spacing, the less the wobble on the frequency response.

The response of b), the more expensive and more accurate version, is shown in Figure 24.34. The measured curve is seen to be closely parallel to the −3 dB/octave line drawn below it on the graph. A still more accurate −3 dB/octave filter can be made by using seven RC networks that fit in with the E6 capacitor series; accuracy is within ±0.1 dB over a 10 Hz–20 kHz frequency range. For this and a great deal more on pinkening filters, and other filters with non-6 dB slopes, see my book *The Design of Active Crossovers* [10]. You need the second edition.

Red noise is rarely required, but if needed it can be made from white noise by passing it through a simple integrator, which has the necessary −6 dB/octave slope. Some sort of DC feedback will be required to stop the integrator output drifting.

References

[1] Self, D. "A High-Quality Compressor/Limiter." *Wireless World*, Dec 1975, p. 587

[2] Duncan, B. "VCAs Investigated." Parts 1–3, *Studio Sound*, June-Aug 1989

[3] Buff, P. (Allison Research). "The New VCA Technology." *DB*, Aug 1980, p. 32

[4] Bransbury, R. "Automation and the VCA." *Studio Sound*, Aug 1985, p. 80

[5] Frey, D. "The Ultimate VCA." AES Conference Preprint, Audio Engineering Society.

[6] Hawksford, M. "Topological Enhancements of Translinear Two-Quadrant Gain Cells." *JAES*, June 1989, p. 465

[7] Shorter, D. E. L., et al. "The Dynamic Characteristics of Limiters for Sound Programme Circuits." *BBC Engineering Monograph No.70*, Oct 1967

[8] Self, D. *The Audio Power Amplifier Design Handbook*, 6th edition. Newnes, 2013, p. 270. ISBN 978-0-240-52613-3

[9] Self, D. *The Audio Power Amplifier Design Handbook*, 6th edition. Newnes, 2013, p. 39. ISBN 978-0-240-52613-3

[10] Self, D. *The Design of Active Crossovers*, 2nd edition. Focal Press, 2018, pp. 415–421. ISBN 978-1-138-73302-2 hbk; ISBN 978-1-138-73303-9 pbk; ISBN 978-1-135-18789-1 ebk

Power supplies

"We thought, because we had power, we had wisdom." *Stephen Vincent Benet: Litany for Dictatorships, 1935*

Opamp supply rail voltages

It has been mentioned several times in the earlier chapters of this book that running opamps at the slightly higher voltage of ±17 V rather than ±15 V gives an increase in headroom and dynamic range of 1.1 dB for virtually no cost and with no reliability penalty. Soundcraft ran all the opamps in their mixing consoles at ±17 V for at least two decades, and opamp failures were almost unknown. This recommendation assumes that the opamps concerned have a maximum supply voltage rating of ±18 V, which is the case for the Texas TL072, the new LM4562, and many other types.

The 5532 is (as usual) in a class of its own. Both the Texas and Fairchild versions of the NE5532 have an absolute maximum power supply voltage rating of ±22 V (though Texas also gives a "recommended supply voltage" of ±15 V), but I have never made any attempt to make use of this capability. The 5532 runs pretty warm on ±17 V when it is simply quiescent, and my view (and that of almost all the designers I have spoken to) is that running it at any higher voltage is simply asking for trouble. This is a particular concern in the design of mixing consoles, which may contain thousands of opamps—anything that impairs their reliability is going to cause a *lot* of trouble. In any case, moving from ±17 V rails to ±18 V rails only gives 0.5 dB more headroom. Stretching things to ±20 V would give 1.4 dB more than ±17 V, and running on the ragged edge at ±22 V would yield 2.2 dB more than ±17 V, but you really wouldn't want to do it. Pushing the envelope like this is also going to cause difficulties if you want to run opamps with maximum supply ratings of ±18 V from the same power supply.

We will therefore concentrate here on ±17 V supplies for opamps, dealing first with what might be called 'small power supplies,' ie those that can be conveniently built with TO-220 regulators. This usually means an output current capability that does not exceed 1.5 Amps, which is plenty for even complicated preamplifiers, electronic crossovers, etc, but will only run a rather small mixing console; the needs of large consoles are dealt with later in this chapter.

An important question is how low does the noise and ripple on the supply output rails need to be? Opamps in general have very good power supply rejection ratios (PSRR), and some manufacturer's specs are given in Table 25.1.

DOI: 10.4324/9781003332985-25

TABLE 25.1 PSRR specs for common opamps

Opamp type	PSRR minimum dB	PSRR typical dB
5532	80	100
LM4562	110	120
TL072	70	100

TABLE 25.2 Typical additional supply rails for opamp-based systems

Supply voltage	Function
+5 V	Housekeeping microcontroller, relays
+9 V	Relays
+24 V	LED bar-graph metering systems, discrete audio circuitry, relays
+48 V	Microphone phantom power

The PSRR performance is actually rather more complex than the bare figures given in the table imply; PSRR is typically frequency-dependent (deteriorating as frequency rises) and different for the +V and −V supply pins. It is, however, rarely necessary to get involved in this degree of detail. Fortunately even the cheapest IC regulators (such as the venerable 78xx/79xx series) have low enough noise and ripple outputs that opamp PSRR performance is rarely an issue.

There is, however, another point to ponder; if you have a number of electrolytic-sized decoupling capacitors between rail and ground, enough noise and ripple can be coupled into the non-zero ground resistance to degrade the noise floor. Intelligent placing of the decouplers can help—putting them near where the ground and supply rails come onto the PCB means that ripple will go straight back to the power supply without flowing through the ground tracks on the rest of the PCB. This is of limited effectiveness if you have a number of PCBs connected to the same IDC cable, as in many small mixing desks, and in such cases low-ripple power supplies may be essential.

Apart from the opamp supply rails, audio electronics may require additional supplies, as shown in Table 25.2.

It is often convenient to power relays from a +9 V unregulated supply that also feeds the +5 V microcontroller regulator, see later in this chapter. The use of +24 V to power LED metering systems is dealt with in Chapter 23 on metering, and +48 V phantom supplies are examined at the end of this chapter.

Designing a ±15 V supply

Making a straightforward ±15 V 1 Amp supply for an opamp-based system is very simple and has been ever since the LM7815/7915 IC regulators were introduced (which was a long time ago). They are robust and inexpensive parts with both overcurrent and over-temperature protection and give low enough output noise for most purposes. We will look quickly at the basic circuit because it brings out a few design points which apply equally to more complex variations on the theme. Figure 25.1 shows the schematic, with typical component values; a centre-tapped transformer, a bridge rectifier, and two reservoir capacitors C1, C2 provide the unregulated rails that feed the

IC regulators. The secondary fuses must be of the slow-blow type. The small capacitors C7-C9 across the input to the bridge reduce RF emissions from the rectifier diodes; they are shown as X-cap types not because they have to withstand 230 Vrms but to underline the need for them to be rated to withstand continuous AC stress. The capacitors C3, C4 are to ensure HF stability of the regulators, which prefer a low AC impedance at their input pins, but these are only required if the reservoir capacitors are not adjacent to the regulators, ie more than 10 cm away. C5, C6 are not required for regulator stability with the 78/79 series—they are there simply to reduce the supply output impedance at high audio frequencies.

There are really only two electrical design decisions to be made; the AC voltage of the transformer secondary and the size of the reservoir capacitors. As to the first, you must make sure that the unregulated supply is high enough to prevent the rails dropping out (ie letting hum through) when a low mains voltage is encountered, but not so high that either the maximum input voltage of the regulator is exceeded, or it suffers excessive heat dissipation. How low a mains voltage it is prudent to cater for depends somewhat on where you think your equipment is going to be used, as some parts of the world are more subject to brown-outs than others. In the UK, the mains should not drop more than 6% below the nominal 230V, but it is wise to design for -10% or lower. You must consider both the minimum voltage drop across the regulators (typically 2 V) and the ripple amplitude on the reservoirs, as it is in the ripple troughs that the regulator will first 'drop out' and let through unpleasantness at 100 Hz.

In general, the RMS value of the transformer secondary will be roughly equal to the DC output voltage.

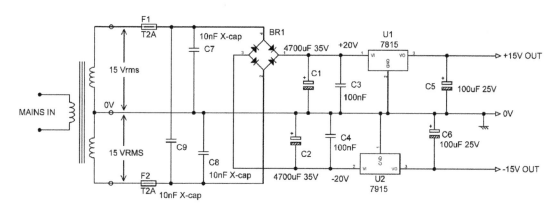

Figure 25.1 **A straightforward ±15 V power supply using IC regulators.**

The size of reservoir capacitor required depends on the amount of current that will be drawn from the supply. The peak-to-peak ripple amplitude is normally in the region of 1 to 2 Volts; more ripple than this reduces efficiency as the unregulated voltage has to be increased to allow for unduly low ripple troughs, and less ripple is usually unnecessary and gives excessive reservoir capacitor size and cost. The amount of ripple can estimated with adequate accuracy by using Equation 25.1.

$$Vpkpk = \frac{I \cdot \Delta t \cdot 1000}{C}$$

Equation 25.1

where:

Vpk-pk is the peak-to-peak ripple voltage on the reservoir capacitor

I is the maximum current drawn from that supply rail in Amps

Δt is the length of the capacitor discharge time, taken as 7 milliseconds

C is the size of the reservoir capacitor in microFarads

The "1000" factor simply gets the decimal point in the right place.

Note that the discharge time is strictly a rough estimate and assumes that the reservoir is being charged via the bridge for 3 msec and then discharged by the load for 7 msec. Rough estimate it may be, but I have always found it works very well.

The regulators must be given adequate heatsinking. The maximum voltage drop across each regulator (assuming 10% high mains) is multiplied by the maximum output current to get the regulator dissipation in Watts, and a heat sink selected with a suitable thermal resistance to ambient (in °C per Watt) to ensure that the regulator package temperature does not exceed, say, 90°C. Remember to include the temperature drop across the thermal washer between regulator and heatsink.

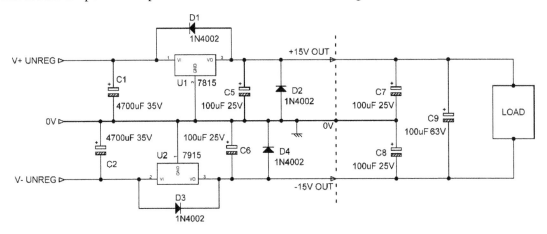

Figure 25.2 Adding protection diodes to a ±15 V power supply. The load has decoupling capacitors to both ground (C7, C8) and between the rails (C9); the latter can cause start-up problems DO NOT FIT C9.

Under some circumstances it is wise to add protective diodes to the regulator circuitry, as shown in Figure 25.2. The diodes D1, D3 across the regulators are reverse-biased in normal operation, but if the power supply is driving a load with a large amount of capacitance, it is possible for the output to remain higher in voltage than the regulator input as the reservoir voltage decays. D1, D3 prevent this effect from putting a reverse voltage across the regulators. Such diodes are not usually required with normal opamp circuitry, as the amount of rail decoupling, shown as C7, C8 in Figure 25.2, is usually modest.

The shunt protection diodes D2, D4 are also reverse-biased in normal operation. D2 prevents the +15 V supply rail from being dragged below 0V if the −15 V rail starts up slightly

faster, and likewise D4 protects the −15 V regulator from having its output pulled above 0V. This can be an important issue if rail-to-rail decoupling such as C9 is in use; such decoupling can be useful because it establishes a low AC impedance across the supply rails without coupling supply rail noise into the ground, as C7, C8 are prone to do. However, it also makes a low-impedance connection between the two regulators. D2, D4 will prevent damage in this case, but leave the power supply vulnerable to start-up problems; if its output is being pulled down by the −15 V regulator, the +15 V regulator may refuse to start. This is actually a very dangerous situation because it is quite easy to come up with a circuit where start-up will only fail one time in 20 or more, the incidence being apparently completely random, but presumably controlled by the exact point in the AC mains cycle where the supply is switched on, and other variables such as temperature, the residual charge left on the reservoir capacitors, and the phase of the moon. If even one start-up failure event is overlooked or dismissed as unimportant then there is likely to be serious grief further down the line. *Every power supply start-up failure must be taken seriously.*

Designing a ±17 V supply

There are 15 V IC regulators (7815, 7915), and there are 18 V IC regulators (7818, 7918), but there are no 17 V IC regulators. This problem can be effectively solved by using 15 V regulators and adding 2 Volts to their output by manipulating the voltage at the REF pin. The simplest way to do this is with a pair of resistors that divide down the regulated output voltage and apply it to the REF pin as shown in Figure 25.3a (the transformer and AC input components have been omitted in this and the following diagrams, except where they differ from those shown in Figure 25.1). Since the regulator maintains 15 V between the OUT and REF pin, with suitable resistor values the actual output with respect to 0V is 17 V. Using E24 resistors, R1 = 1 kΩ and R2 = 150 Ω gives a nominal output of +17.25 V, which is near enough for our purposes.

The snag with this arrangement is that the quiescent current that flows out of the REF pin to ground is not well controlled; it can vary between 5 and 8 mA, depending on both the input voltage and the device temperature. This means that R1 and R2 have to be fairly low in value so that this variable current does not cause excessive variation of the output voltage, and therefore power is wasted.

If a transistor is added to the circuit as in Figure 25.3b, then the impedance seen by the REF pin is much lower. This means that the values of R1 and R2 can be increased by an order of magnitude, reducing the waste of regulator output current and reducing the heat liberated. This sort of manoeuvre is also very useful if you find that you have a hundred thousand 15 V regulators in store, but what you actually need for the next project is an 18 V regulator, of which you have none.

What about the output ripple with this approach? I have just measured a power supply using the exact circuit of Figure 25.3b, with 2200 uF reservoirs, and I found −79 dBu (87 uVrms) on the +17 V output rail, and −74 dBu (155 uVrms) on the 17 V rail, which is satisfyingly low for inexpensive regulators and should be adequate for almost all purposes; note that these figures include regulator noise as well as ripple. The load current was 110 mA. If you *are* plagued by ripple troubles, the usual reason is a rail decoupling capacitor that is belying its name by coupling

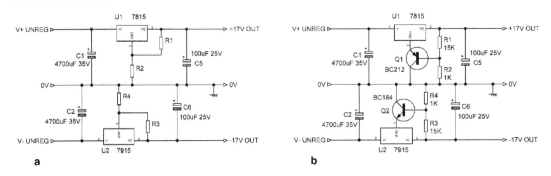

Figure 25.3 Making a ±17 V power supply with 15 V IC regulators. a) Using resistors is inefficient and/or inaccurate; b) adding transistors to the voltage-determining resistor network makes the output voltage more predictable and reduces the power consumed in the resistors.

rail ripple into a sensitive part of the ground system, and the cure is to correct the grounding rather than design an expensive ultra-low ripple PSU. Note that doubling the reservoir capacitance to 4400 uF only improved the figures to −80 dBu and −76 dBu respectively; just increasing reservoir size is not a cost-effective way to reduce the output ripple.

Using variable-voltage regulators

It is of course also possible to make a ±17 V supply by using variable output voltage IC regulators such as the LM317/337. These maintain a small voltage (usually 1.2 V) between the OUTPUT and ADJ (shown in figures as GND) pins and are used with a resistor divider to set the output voltage. The quiescent current flowing out of the ADJ pin is a couple of orders of magnitude lower than for the 78/79 series, at around 55 uA, and so a simple resistor divider gives adequate accuracy of the output voltage, and transistors are no longer needed to absorb the quiescent current. A disadvantage is that this more sophisticated kind of regulator is somewhat more expensive than the 78/79 series; at the time of writing they cost something like 50% more. The 78/79 series with transistor voltage-setting remains the most cost-effective way to make a non-standard-voltage power supply at present.

It is clear from Figure 25.4 that the 1.2 V reference voltage between ADJ and out is amplified by many times in the process of making a 17 V or 18 V supply; this not only increases output ripple, but also output noise as the noise from the internal reference is being amplified. The noise and ripple can be considerably reduced by putting a capacitor C7 between the ADJ pin and ground. This makes a dramatic difference; in a test PSU with a 650 mA load the output noise and ripple was reduced from −63 dBu (worse than 78xx series) to −86 dBu (better than 78xx series) and so such a capacitor is usually fitted as standard. If it is fitted, it is then essential to add a protective diode D1 to discharge C7, C8 safely if the output is short circuited, as shown in Figure 25.5.

The ripple performance of the aforementioned test PSU, with a 4700 uF reservoir capacitor and a 650 mA load, is summarised for both types of regulator in Table 25.3. Note that the exact ripple figures are subject to some variation between regulator specimens. Supply rail noise and ripple is often quoted in microVolts; see the last column of Table 25.3.

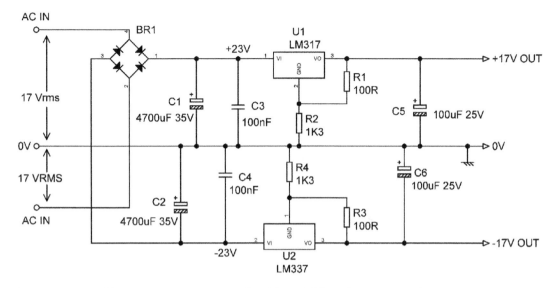

Figure 25.4 Making a ±17 V power supply with variable-voltage IC regulators.

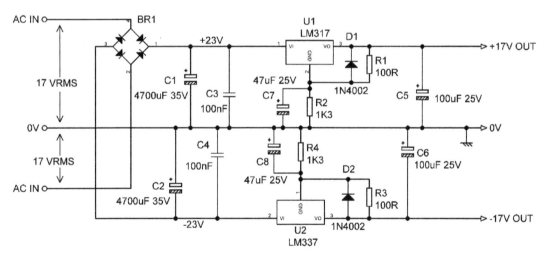

Figure 25.5 Ripple improvement and protective diodes for a variable-voltage IC regulator.

TABLE 25.3 Comparing the noise and ripple output of various regulator options at 650 mA load

	7815 + transistor dBu	LM317 dBu	LM317 uV
No C on LM317 ADJ pin	−73 dBu (all ripple)	−63 dBu (ripple & noise)	549 uV
47 uF on LM317 ADJ pin	−73 dBu (all ripple)	−86 dBu (ripple & noise)	39 uV
Input filter 2.2 Ω & 2200 uF	−78 dBu (ripple & noise)	−89 dBu (mostly noise)	27 uV
Input filter 2.2 Ω & 4400 uF	−79 dBu (mostly noise)	−90 dBu (all noise)	24 uV

Improving ripple performance

Table 25.3 shows that the best noise and ripple performance that can be expected from a simple LM317 regulator circuit is about −86 dBu (39 uVrms), and this still contains a visible ripple component. The reservoir capacitors are already quite large at 4700 uF, so what is to be done if lower ripple levels are needed? The options are

1) Look for a higher-performance IC regulator. They will cost more and there are likely to be issues with single sourcing.

2) Design your own high-performance regulator using discrete transistors or opamps. This is not a straightforward business if all the protection that IC regulators have is to be included. There can also be distressing issues with HF stability.

3) Add an RC input filter between the reservoir capacitor and the regulator. This is simple and pretty much bullet-proof and preserves all the protection features of the IC regulator, though the extra components are a bit bulky and not that cheap. There is some loss of efficiency due to the voltage drop across the series resistor; this has to be kept low and the capacitance large.

The lower two rows of Table 25.3 show what happens. In the first case the filter values were 2.2 Ω and 2200 uF. This has a −3 dB frequency of 33 Hz and attenuates the 100 Hz ripple component by 10 dB. This has a fairly dramatic effect on the output ripple, but the dB figures do not change that much as the input filter does not affect the noise generated inside the regulator. Increasing the filter capacitance to 4400 uF sinks the ripple below the noise level for both types of regulator.

Ultra low-noise regulators

If the supply rail noise levels quoted above are not good enough, there are other options. It needs to be said at once that most circuitry, especially that built with opamps which have good PSRR, really does not need very low levels of noise on the rails. This also assumes competent decoupling that does NOT couple rail noise into sensitive parts of the earth system.

However, if you decide you really do need ultra low-noise rails, designing your own discrete regulator is a major undertaking, as noted earlier. A better way is the relatively new (2016) LT3045 for positive rails. It has a low drop-out voltage and extra features such as a disable pin, power-good indication, and programmable current limiting. The noise is specified as 0.8 uVrms (10 Hz to 100 kHz), equivalent to -120 dBu, so it is more than an order of magnitude quieter than our best LM317 reading above of 24 uV. The data sheet says LT3045s can be paralleled for even lower noise (and more current), and they give two example circuits, so I think they mean it. Sharing/averaging resistors of 20 mΩ are recommended. However this is going to be an expensive choice, as you will need four regulators to drop the rail noise by 6 dB to obtain 0.4 uVrms, (-126 dBu) and the current 1-off price is around £6.50 at time of writing (2022). Noise levels this low are reminiscent of the EINs of microphone amplifiers.

One important issue is that the maximum input voltage is only +20 V, so if you're looking for a +15 V or +17 V rail you will need to use a LM317 pre-regulator rather than running the LT3045 directly from an unregulated supply. The LT3045 has too many features to describe here, but the data sheet is very comprehensive. Figure 25.6 shows an LT3045 supply giving +15 V (set by 100 uA through R2) at 150 mA max (limit set by R3). R4 and R5 set the Power Good threshold, if you are using that feature. The LT3094 is the equivalent regulator for negative rails.

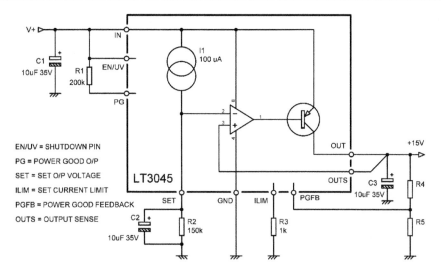

Figure 25.6 A +15 V 150 mA supply using an LT3045 regulator.

Dual supplies from a single winding

It is extremely convenient to use third-party 'wall-wart' power supplies for small pieces of equipment, as they come with all the safety and EMC approvals already done for you, though admittedly they do not look appropriate with high-end equipment.

The problem is that the vast majority of these supplies give a single AC voltage on a two-pole connector, so a little thought is required to derive two supply rails. Figure 25.7 shows how it is done in a ±18 V power supply; note that these voltages are suitable only for a system that uses 5532s throughout. Two voltage-doublers of opposite polarity are used to generate the two unregulated voltages. When the incoming voltage goes negative, D3 conducts and the positive end of C1 takes up approximately 0V. When the incoming voltage swings positive, D1 conducts instead and the charge on C1 is transferred to C3. Thus the whole peak-to-peak voltage of the AC supply appears across reservoir capacitor C3. In the same way, the peak-to-peak voltage, but with the opposite polarity, appears across reservoir C4.

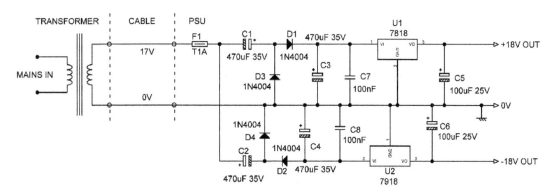

Figure 25.7 A ±18 V power supply powered by a single transformer winding.

Since voltage-doublers use half-wave rectification, they are not suitable for high current supplies. When choosing the value of the reservoir capacitor values, bear in mind that the discharge time in Equation 25.1 must be changed from 7 msec to 17 msec. The input capacitors C1, C2 should be the same size as the reservoirs.

Power supplies for discrete circuitry

One of the main reasons for using discrete audio electronics is the possibility of handling larger signals than can be coped with by opamps running off ±17 V rails. The use of ±24 V rails allows a 3 dB increase in headroom, which is probably about the minimum that justifies the extra complications of discrete circuitry. A ±24 V supply can be easily implemented with 7824/7924 IC regulators.

A slightly different approach was used in my first published preamplifier design [1]. This preamp in fact used two LM7824 +24 V regulators connected as shown in Figure 25.8 because at the time the LM7924 –24V regulator had not yet reached the market. The use of a second positive

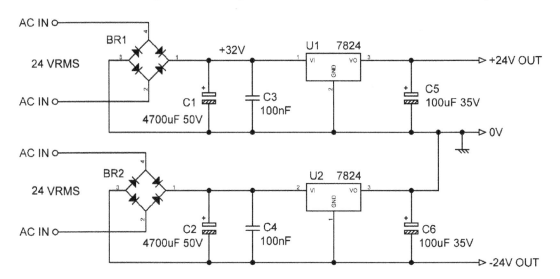

Figure 25.8 A ±24 V power supply using only positive regulators.

regulator to produce the negative output rail looks a little strange at first sight, but I can promise you it works. It can be very useful in the sort of situation described earlier; you have a hundred thousand +15 V regulators in store but no –15 V regulators . . . I'm sure you see the point.

Note that this configuration requires two separate transformer windings; it cannot be used with a centre-tapped secondary.

Larger power supplies

So what if you need more than 1 Amp of current? This will certainly be the case for all but the smallest mixing consoles. There are, of course, IC regulators with a greater current capability

than 1 Amp. The LM338K variable-voltage 5 Amp regulators come in a TO-3 package—which it has to be said is not the easiest format to mount. They were once widely used in mixing console power supplies but have been superseded by more modern devices such as the Linear Tech LT1083CK, which is a 7.5 Amp variable-voltage regulator that works very nicely and can be obtained in a TO-3P package. I have used lots of them in mixing console power supplies. An example of their use, incorporating a mutual shutdown facility, is shown in Figure 25.9.

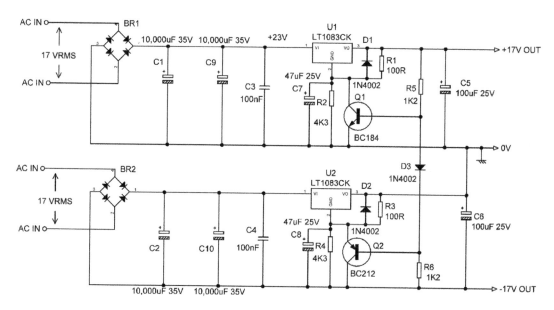

Figure 25.9 A high-current ±17 V power supply with mutual shutdown circuitry.

There is no negative version of the LT1083CK, so a +/− supply has to be made with two separate secondary windings, just as in Figure 25.8. When using any high-current regulator it pays to be rather cautious about the maximum rated current. Trying to use them too close to the maximum can cause start-up problems.

Mutual shutdown circuitry

It is an awkward quirk of 5532 opamps that if one supply rail is lost and collapses to 0V, while the other rail remains at the normal voltage, they can under some circumstances get into an anomalous mode of operation that draws large supply currents and ultimately destroys the opamp by overheating. To prevent damage from this cause, which could be devastating to a large mixing console, the opamp supplies are very often fitted with a mutual shutdown system. Mutual shutdown ensures that if one supply rail collapses because of overcurrent, over-temperature, or any other cause, the other rail will be promptly switched off. The extra circuitry required to implement this is shown in Figure 25.9, which is an example of a high-current supply using 7.5 Amp regulators.

The extra circuitry to implement mutual shutdown is very simple; R5, D3, R6 and Q1 and Q2. Because R5 is equal to R6, D3 normally sits at around 0V in normal operation. If the +17 V rail collapses, Q2 is turned on by R6, and the REF pin of U2 is pulled down to the bottom rail, reducing the output to the reference voltage (1.25 V). This is not completely off, but it is low enough to prevent any damage to opamps.

If the −17 V rail collapses, Q1 is turned on by R5, pulling down the REF pin of U1 in the same way. Q1 and Q2 do not operate exactly symmetrically, but it is close enough for our purposes.

Note that this circuit can only be used with variable output voltage regulators because it relies on their low reference voltages.

Very large power supplies

By "very large" I mean too big to be implemented with IC regulators—say 7 Amps and above. This presents a difficult problem, to which there are several possible answers:

1) Split up the system supply rails so that several IC regulators can be used. This is in my view the best approach. The amount of design work is relatively small; in particular the short-circuit protection has been done for you.

2) Use power transistors as series-pass elements controlled by opamps. This can be a surprisingly tricky technology. The feedback system has to be reliably stable, and the short-circuit protection has to be foolproof. Designing the latter is not too simple.

3) Switch-mode power supplies. Those found in PCs seem to be a mature technology and are very reliable. Custom designs, of the sort required for this application, are in my experience another matter. I have seen them explode. There is also the issue of RF emissions.

The first two methods obviously involve increased heat dissipation in proportion to their output current. This usually means that fan cooling is required to keep the heatsinks down to a reasonable size, which is fine for PA work but not welcome in a studio control room. There are no great technical difficulties to powering even a large console over a 20-metre cable (this is the recommended maximum for Neve consoles) so long as remote sensing is used to compensate for voltage drops. 20 metres is usually long enough to allow the power supply to be placed in another room.

The technology of very large audio supplies is a specialised and complicated business, and it would not be appropriate to dig any further into it here.

Microcontroller and relay supplies

It is very often most economical to power relays from an unregulated supply. This is perfectly practical as relays have a wide operating voltage range. If 9 V relays are used then the same unregulated supply can feed a +5 V regulator to power a microcontroller, as shown in Figure 25.10.

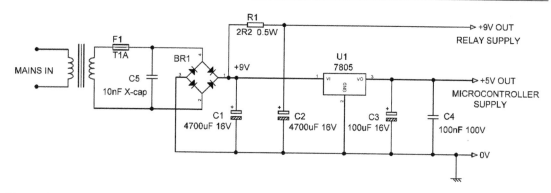

Figure 25.10 **A +5 V PSU with an RC smoothed +9 V relay supply.**

Hum induced by electrostatic coupling from an unregulated relay supply rail can be sufficient to compromise the noise floor; the likelihood of this depends on the physical layout, but inevitably the signal paths and the relay supply come into proximity at the relay itself. It is therefore necessary to give this rail some degree of smoothing, without going to the expense of another regulator and heatsink (there must be no possibility of coupling between signal ground and relay power ground; these must only join right back at the power supply). This method of powering relays is more efficient than a regulated rail as it does not require a voltage drop across a regulator that must be sufficient to prevent drop out and consequent rail ripple at low mains voltages.

Simple RC smoothing works perfectly well for this purpose. Relays draw relatively high currents, so a low R and a high value C are used to minimise voltage losses in R and changes in the relay supply voltage as different numbers of relays are energised.

The RC smoothing values shown in Figure 25.10 are typical but are likely to need adjustment depending on how many relays are powered and how much current they draw. R1 is low at 2.2 Ω and C2 high at 4700 uF; fortunately the voltage is low so C2 need not be physically large.

+48 V phantom power supplies

Making a discrete +48 V regulator with the necessary low amounts of noise and ripple is not too hard, but making one that is reliably short-circuit proof is a little more of a challenge, and by far the easiest way to design a +48 V phantom supply is to use a special high-voltage regulator called the TL783C, as shown in Figure 25.11. This extremely handy device can supply 700 mA, subject to power dissipation constraints.

It is a variable-voltage device, maintaining typically 1.27 V between the OUT and ADJ pins. It combines BJT circuitry with high-voltage MOS devices on the same chip, allowing it to withstand much higher voltages than standard bipolar regulators. Since MOS devices are not subject to

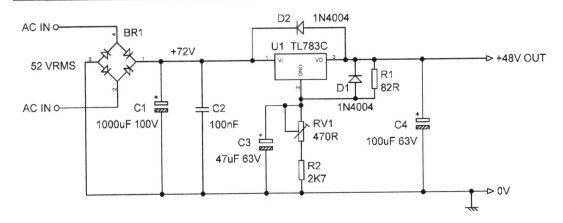

Figure 25.11 A +48 V phantom power supply using the TL783C regulator. Because of the large reference multiplication factor, a preset is required to set the output voltage exactly.

secondary-breakdown or thermal-runaway, the TL783 still gives full overload protection while operating with up to a 125 V voltage drop from the input to the output. The TL783 has current limiting, safe-operating-area (SOA) protection, and thermal shutdown. Even if the ADJ pin is accidentally disconnected, the protection circuitry stays operational. It is a very useful and reliable IC, and I have deployed thousands of them.

As with other variable-voltage regulators, the low voltage maintained between the OUT and ADJ pins needs to be amplified by a considerable ratio to get the desired output voltage, and so reference voltage tolerances are also amplified. In this case the amplification factor is as high as 37 times, and so a preset is used to adjust the output voltage to exactly +48 V. The filter capacitor C3 is essential for the same reason—without it the ripple is amplified along with the reference voltage.

The unregulated supply can be derived from a completely separate transformer secondary as in Figure 25.11 or alternatively by means of a voltage doubler. The latter is usually more economic, but obviously this depends on the cost of an extra transformer winding versus the cost of the extra capacitor in the doubler.

The arrangement of a voltage doubler phantom supply is shown in Figure 25.12. Note that the familiar voltage doubler circuit C13, C2, D5, D6 is actually working as a voltage-tripler because it is perched on the unregulated +23 V supply to the +17 V regulator. If it worked as a true voltage doubler, based on the 0V rail, it would generate insufficient unregulated voltage for the phantom regulator. Because of their inherently half-wave operation and relatively poor regulation, voltage doubler or voltage-tripler methods are not suitable for high-current phantom supplies.

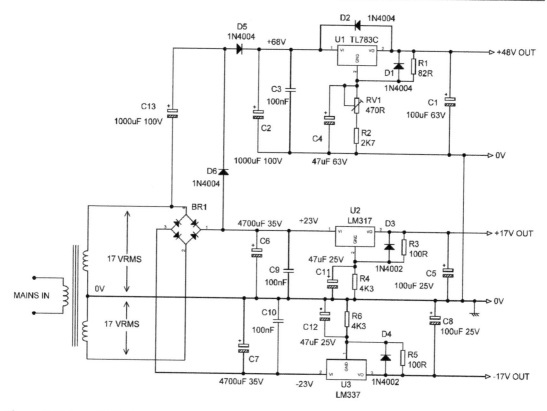

Figure 25.12 +48 V phantom power supply fed by a voltage doubler.

Reference

[1] Self, D. "An Advanced Preamplifier Design." *Wireless World*, Nov 1976

Interfacing with the digital domain

The advance of digital audio has greatly improved the fidelity of audio storage media, and generally made wonderful things possible, but sound waves remain stubbornly analogue, and so conversion from analogue to digital and vice versa is very necessary. Today's analogue to digital converters (ADCs) and digital to analogue to converters (DACs) have excellent performance, with 24-bit accuracy at a 192 kHz sampling rate a commonplace but to achieve this potential performance in an application there are a good number of factors that need to be appreciated. Some of them, such as the need for effective HF decoupling are relatively straightforward providing you follow the manufacturer's recommendations, but others, involving the actual interfacing to the analogue input and output pins, are a bit more subtle.

Having said that, contemporary ADCs and DACs are far easier to apply than their ancestors. Oversampling technology means that it is no longer necessary to put a ninth-order brickwall lowpass anti-aliasing filter in front of an ADC or place a ninth-order brickwall lowpass reconstruction filter after a DAC. If you've ever tried to design a ninth-order filter to a price, you will know that this is a very significant freedom. It has had a major effect in reducing the price of digital equipment, particularly in applications like digital mixers where a large number of ADCs and DACs are required.

ADC and DAC technology moves rapidly; the device examples I have chosen here (2013) will probably soon be out of date. The general principles I give should be more enduring and will be valid for the foreseeable development of the technologies.

PCB layout considerations

The PCB layout for both ADCs and DACs requires observance of certain precautions, which are basically the same for both functions. A double-sided (or, more likely, four-layer) PCB is necessary not only because of the large number of connections that have to be made in a small space, but also because it allows tracks that need to be isolated from each other to be put on opposite sides of the board. A most important consideration is to keep digital signals, particularly fast ones such as clocks, out of the analogue inputs, so use as much physical spacing between these as possible. Critical tracks on opposite sides of the board should be run at right angles to each other to minimise coupling through the PCB. Do not run digital tracks topside under the IC as they may couple noise directly into the die from underneath.

Separate analogue and digital ground planes should be used. Most conversion ICs have their analogue and digital interfaces at opposite ends or opposite sides of the package, facilitating

DOI: 10.4324/9781003332985-26

the use of separate ground planes. It is usually best to run the analogue ground plane under the IC to minimise the coupling of digital noise. The two ground planes must, of course, be connected together at some point, and this should be implemented by a single junction close to the IC. Some manufacturers (eg Analog Devices) recommend that the junction should be made through a ferrite bead to filter out high RF frequencies. A maximum-copper (minimum-etch) PCB layout technique is generally the best for ground planes as it gives the most screening possible.

The power supply tracks to the IC should be as wide as possible to give low impedance paths and reduce the voltage effects of current glitches on the power supply lines. Ideally a four-layer PCB (and such boards are now cheaper than they have ever been) should be used so that two layers can be devoted to power supply and ground planes.

Thorough decoupling is always important when using high speed devices such as ADCs and DACs. All analogue and digital supplies should be decoupled to analogue ground and digital ground respectively, using 0.1 µF ceramic capacitors in parallel with 10 µF electrolytic capacitors. Some manufacturers recommend using tantalum capacitors for this. To achieve the best possible decoupling, the capacitors should be placed as physically close to the IC as possible and solidly connected to the relevant ground plane.

When you are designing ADCs or DACs into a system, my experience is that significant time can be saved by doing preliminary testing on manufacturer's evaluation boards; this has particular force when you are using parts from a range you have not used before. Higher Authority may urge you to go straight to a PCB layout, but unless you are very sure what you are doing—if for example, you are cut-and-pasting from an existing satisfactory design—it is a relatively high-risk approach. Evaluation boards are usually expensive, as they are produced in small quantities, but in my view it is money very well spent.

Nominal levels and ADCs

The best use of the dynamic range of an ADC is only possible if it is presented with a signal of roughly the right amplitude. Too low a level degrades the signal-to-noise ratio as the top bits are not used, and too high a level will not only cause unpleasant-sounding digital clipping but can cause damage to the ADC if current flows are not limited. Analogue circuitry is therefore needed to scale the signal to the right amplitude.

A typical application of ADCs is in digital mixing consoles. These must accept both microphone and line input levels. Since the signal level from a microphone may very low (lute music) or very high (microphone in the kick-drum), an input amplifier with a wide variable gain range is required, typically 70 dB and sometimes as much as 80 dB. The signal level range of line signals is less but still requires a gain range of some 30 dB to cope with all conditions. It is therefore necessary for the operator to adjust the input gain, by reference to a level meter, so that good use is made of the available dynamic range without risking clipping. In live situations with unpredictable levels this is always something of a judgement call.

The signal level required at the ADC input to give maximum output, which is usually referred to as full-scale (FS), varies from manufacturer to manufacturer; this important point is brought out in the next section.

Some typical ADCs

There are a large number of ADCs on the market, and it is necessary to pick out just a few to look at. You will note that the various parts are actually very similar in their application. The inclusion of a device here does not mean that I am giving it any personal recommendation. All the devices mentioned are capable of 24-bit 192 kHz operation. In some cases the input voltage required for FS appears to exceed the supply voltage; this is not so, the quoted peak-to-peak voltage is the difference between two differential input pins.

And now in alphabetical order:

The Analog Devices AD1871 is a stereo audio ADC with two 24-bit conversion channels each giving 105 dB of dynamic range and each having a programmable gain amplifier (PGA) at the front end, a multibit sigma-delta modulator, and decimation filters. The digital details are rather outside our scope here and will not be alluded to further. The PGA has five gain settings ranging from 0 dB to 12 dB in 3 dB steps. The differential input required for full-scale is 2.828 V pk-pk and the input impedance is 8 kΩ. Like most of its kind, the AD1871 runs its analogue section from +5 V, but the digital section from +3.3 V to save power. This IC is unusual in that it is permissible to run the digital section from +5 V, which can save you a regulator.

The Analog Devices AD1974 is a quad ADC with four differential analogue inputs having a very useful CMRR of 55 dB (typical, at both 1 kHz and 20 kHz). These inputs are not buffered and require special interfacing that will be described later. A differential input of 5.4 V pk-pk is needed for FS; the input impedance is 8 kΩ. This IC runs from +3.3 V only.

The Burr-Brown PCM1802 is a stereo ADC with single-ended analogue voltage inputs with input buffer amplifiers. It requires 3.0 V pk-pk to reach full-scale and has with a resistive input impedance of 20 kΩ. The analogue section is powered from +5 V, the digital section from +3.3 V.

The Wolfson WM8782 is a stereo ADC with two single-ended analogue inputs with buffer amplifiers. It requires 2.82 V pk-pk (1.0 Vrms) to reach FS and the input impedance is 10 kΩ. The analogue section is powered from +5 V and the digital core from +3.3 V.

Interfacing with ADC inputs

The issues involved in interfacing with an ADC depend very much on how the ADC input is configured. As we saw in the previous section, some ADCs, such as the Burr-Brown PCM1802 and the Wolfson WM8782 have internal buffer amplifiers that present a relatively high impedance to the outside world (in this case 20 kΩ and 10 kΩ respectively). These inputs are very straightforward to drive. Such buffers are usually only found in ADCs made in a bipolar or BiCMOS process as making good low-noise low-distortion amplifiers in a straight CMOS technology is very difficult.

Others, such as the AD1974, do not have buffering and must be driven from special circuitry. In the case of the AD1974 and similar devices, the differential inputs must be driven from a differential signal source to get the best performance. The basic principle is shown in Figure 26.1. The input pins connect to switched internal capacitors, and these generate glitches. Each input

pin must be isolated from the opamp driving it by an external series resistor R5, R6 together with a capacitor C5, C6 connected from input to ground. This capacitor must not generate non-linearity when the voltage across it changes, so ceramic NPO or a polypropylene film types must be used; recommended values for the resistors and capacitors are usually given in the application notes. Note that since the external opamps are referenced to ground, and the ADC internals are referenced to half the +5 V rail, blocking capacitors C2, C3 are needed.

In some cases the input circuitry must be biased to half of the ADC supply rail by external circuitry. An example is the eight-channel AK5538 made by Asahi Kasei (see Chapter 17).

Adding external resistance will slow down the charging of input sampling capacitors. These must be allowed to charge for many time-constants if they are to get close enough to the final value to avoid degrading the performance. External resistance increases the time-constant and can degrade accuracy; manufacturers usually provide guidance as to how much external resistance is permissible for a given number of bits of accuracy.

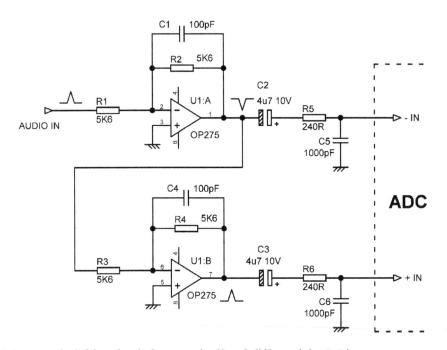

Figure 26.1 A typical drive circuit for an unbuffered differential ADC input.

A point that is obvious but easily overlooked is that the inputs must not be driven to excessive levels. This usually means that the input voltage should not go outside the supply rails by more than 300 mV; for example Wolfson specify this restriction for both the analogue and digital inputs of the WM8782 stereo ADC, and the other manufacturers quote similar ratings.

While ADC inputs invariably have clamp diodes for ESD protection that are intended to prevent the inputs moving outside the supply rails, these are small-dimensioned devices that may be destroyed by the output current capability of an opamp. This is why the input voltage should not go outside the

supply rails by more than 300 mV – this voltage will not cause a silicon diode to conduct significantly, even at elevated temperatures, The diodes can usually handle 5 mA but to subject them to anything more is to live dangerously. Obviously the manufacturer's absolute maximum ratings should be followed on this point, but not all manufacturers give a current rating for their clamp diodes.

Bullet-proof protection against input over-voltages is given by running the driving opamp from the same supply rails as the analogue section of the ADC, the opamp saturation voltages ensuring that the input can never reach the supply rails, never mind exceed them. This does however restrict your choice of opamp to types that is happy working on low supply voltages; these are likely to be more expensive than the popular audio opamps such as the 5534/5532, which will not give good performance from such low rails. See Chapter 5 for a survey of low-voltage opamps.

If you want to stick with the usual audio opamps, working from higher supply rails than the ADC, then an effective means of protection is the use of external clamping diodes, which in conjunction with a series resistance, will limit the voltage swing at the ADC input. The principle is shown in Figure 26.2; if the opamp output exceeds +5 V then D1 will conduct, while if it goes negative of 0V D2 will conduct, safely clamping the ADC input.

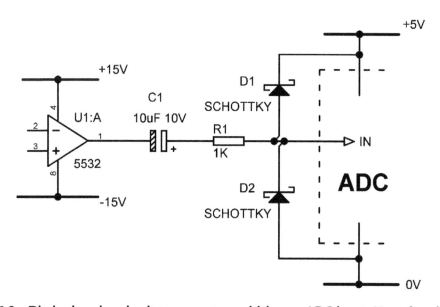

Figure 26.2 Diode clamping circuit to prevent overdriving an ADC input. Note that the diodes must be Schottky types.

A vital point here is that the clamp diodes must be of the Schottky type, so their forward voltage is substantially less than that of the conventional silicon diodes on-chip, for otherwise they will give little or no protection. The on-chip diodes will be warmer and would conduct before conventional external silicon diodes.

R1 must be large enough to limit the current in D1, D2 to safe levels, but not so large that it causes a roll-off with the ADC input capacitance. It must also not be so large that the non-linear capacitance of the diodes causes significant non-linearity; 1 kΩ should be safe in this respect.

Note that R1 is also useful in isolating the opamp output from the ADC input capacitance, which can otherwise erode stability margins.

Some typical DACs

Unlike ADCs, DACs come in two different types—voltage output and current output. Both types of output require some kind of lowpass filtering, but current-output DACs also need current-to-voltage (I-V) conversion stages. There are a large number of DACs on the market, and it is essential to be selective in examining a few typical devices. Once again, the inclusion of a device here does not mean that I am giving it my personal recommendation. All the devices mentioned here are capable of 24-bit operation.

And now in alphabetical order:

The Analog Devices AD1854 is a stereo audio DAC delivering 113 dB Dynamic Range and 112 dB SNR (A-weighted) at a 48 kHz sample rate. Maximum sample rate is 96 kHz. Differential analogue voltage outputs give a maximum output of 5.6 V pk-pk at full-scale and the output impedance is less than 200 Ω. It operates from a single +5 V supply rail, though there are separate supply pins for the analogue and digital sections.

The Texas PCM1794A is a stereo audio DAC supporting sample rates up to 192 kHz. It has differential analogue current outputs giving a maximum of 7.8 mA pk-pk at full-scale. The analogue section is powered from +5 V, the digital section from +3.3 V.

The Wolfson WM8740 is a stereo audio DAC supporting word lengths from 16 to 24 bits and sample rates up to 192 kHz. Differential analogue voltage outputs give a maximum output of 2.82 V pk-pk at full-scale. It can operate from a single +5 V supply rail, or the digital section can be run from +3.3 V to reduce power consumption.

Interfacing with DAC outputs

Modern DACs use oversampling so that brickwall reconstruction filters are not necessary at the analogue outputs. Nonetheless, some lowpass filtering is essential to remove high-frequency components that could cause trouble downstream from the output.

If you are using a DAC with a current output, the first thing you have to do is convert that current to a voltage. This is usually done with a shunt-feedback stage as shown in Figure 26.3, frequently called an I-V converter. The opamp most popular for this job (and in fact explicitly recommended for the Texas PCM1794A) is no less than our old friend the 5534/5532. The filter capacitors C1, C2 keep down the slew rate required at the outputs of the I-V converters and with their parallel resistors give a −3 dB roll-off at 88.2 kHz. The current output is simply scaled by the value of R1, R2 and results in a voltage output of 3.20 V peak for 3.9 mA peak out (half of the total 7.8 mA pk-pk FS output) and when the two anti-phase voltages are combined in the differential amplifier that follows the total output is 6.4 V peak or 4.5 Vrms. The differential amplifier has its own HF roll-off at 151 kHz to give further filtering, implemented by C3 and C4. The capacitors used must be linear; NP0 ceramic, polystyrene, or polypropylene are the only types suitable.

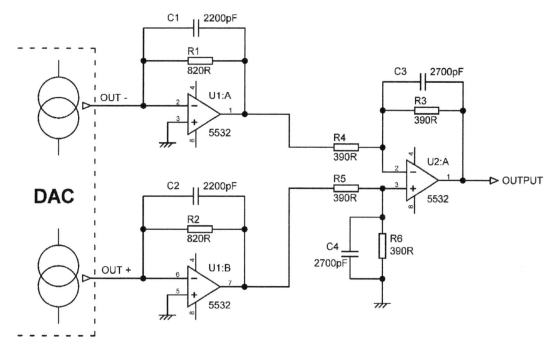

Figure 26.3 A typical output stage for a current-output DAC, with I-V converters and differential output filter.

Voltage output DACs are somewhat simpler to apply as there is no need for I-V converters and the outputs can drive an active lowpass filter directly. The output is usually differential to obtain enough voltage swing capability within the limited supply voltage available, so differential to single-ended conversion is still required, and this is often cunningly implemented in the form of a differential lowpass filter.

Figure 26.4 shows a typical differential lowpass filter system; it has a third-order Bessel characteristic with a corner frequency of 92 kHz. The outputs are combined, and the first two poles are implemented by the differential multiple-feedback filter around U1:A and the third pole is produced by the passive network R7, C5. Note that the circuitry uses E96 resistor values in order to obtain the desired accuracy. Multiple-feedback filters are often preferred for this kind of application because they do not suffer from the failure of attenuation at very high frequencies that afflicts Sallen & Key filters, due to the inability of the opamp to maintain a low impedance at its output when its open-loop gain, and hence its feedback factor, has fallen to a low value.

It must not be assumed from this that all DACs have differential outputs. For example the Wolfson WM8726, described as a 'low cost stereo DAC' has single-ended voltage outputs; it is recommended they are followed by second-order lowpass filters.

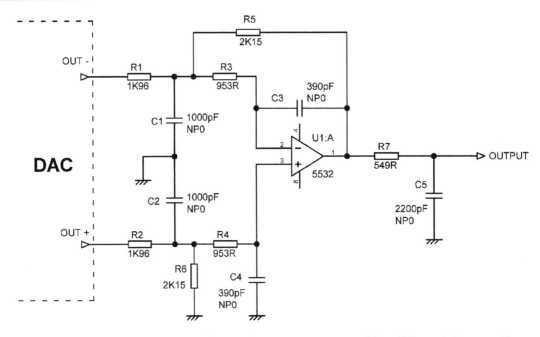

Figure 26.4 A typical output stage for a voltage output DAC, with a differential output filter.

Interfacing with microcontrollers

Having looked at interfacing with ADCs and DACs in digital audio, we turn to the important business of interfacing with microcontrollers. Much audio equipment keeps the signals wholly in the analogue domain but uses a microcontroller to handle humble but essential housekeeping tasks such as muting relay control at power-up and power-down, and input-select relay control. Volume control ICs keep the signal analogue but are controlled by serial data, generated when the microcontroller is driven from a rotary encoder connected to the volume knob. Input-select ICs (an array of high-voltage analogue gates) such as the Toshiba TC9163 likewise require serial data to control them. Many pieces of equipment have remote controls, so a microcontroller is essential to decode the incoming RC5 data and activate the correct bit of circuitry. LCD displays typically also take serial data, and with a large display the software can get complex. The microcontroller will also take the unit out of standby when a 12 V trigger is received.

PIC devices are very popular for this, and the 16F72 is used as an example here. There are many other microcontroller families; the same basic principles apply. The 16F72 is a capable but inexpensive device that incorporates flash program memory, timers, serial ports, and an 8-bit A/D converter, but here the three 8-bit I/O ports A, B, and C are used to illustrate a preamplifier application. Each port pin can be separately defined to be an input or an output.

Figure 26.5 is not necessarily a typical system but illustrates various techniques. The PIC output ports can drive LEDs directly, such as D5 with resistor R2 to set the current. LEDs D1 to D4

indicate which preamp input is selected, and since only one is ever on at a time they can share resistor R1. For loads such as relays that take more current than an output port can handle directly, a transistor Q1 can be used. Note the suppression diode across the relay coil.

The BA6218 control IC for the motorised volume control is driven by the two output pins RC4 and RC5. These are simple logic outputs and not a serial connection. See Chapter 13 for more on motorised volume controls.

Remote control commands are demodulated and filtered by the IR receiver U3, and the serial data output is applied to RC6. The IR commands are then decoded by software in the PIC.

The B port has a useful extra option. It can be set so that each pin has a 'weak-pullup' of 250 uA to the +5 V rail; this means that user-operated switches like SW1 do not need an external pullup resistor. When there are a large number of switches to be read a row-and-column matrix is much more economical of input pins.

The PIC clock frequency is set by ceramic resonator CER1. These components are much cheaper than quartz crystals, and their 0.5% frequency tolerance (crystals show 0.001%) is more than good enough for setting turn-on delays and so on.

Input port voltages must be clamped to ensure they do not exceed the permissible limits. The PIC has protective clamp diodes on all pins, but these have a limited current capability, and if you plan to use them for clamping as opposed to just static protection, a series resistor of around 47 kΩ is recommended, such as R5 on the MAINS FAIL input.

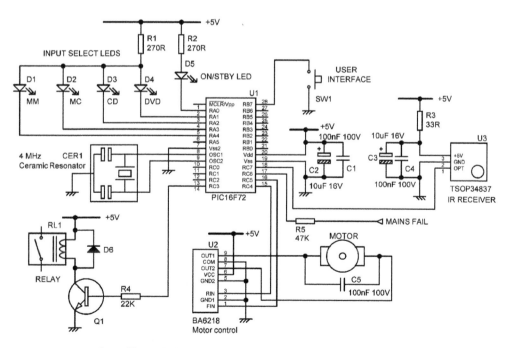

Figure 26.5 Examples of interfacing to a PIC 16F72 microcontroller for preamp housekeeping.

It is an important principle of interfacing that you should not rely on a low at an output port to prevent, say, the mute relay, from energising, perhaps by diverting the drive away from the base of the relay-control transistor. At power-up the output ports will be at high impedance. This is sometimes referred to as being 'tri-stated' as the high-impedance state is neither the high state nor the low state, but a third 'off' state. There may be momentary closure of the relay if it operates faster than the microcontroller can initialise itself and write a low to the output port.

More seriously, at power-down a mute relay must open as quickly as possible, to prevent thumps, *and it must stay off*. The mains-fail circuitry will detect power-down and signal this to the microcontroller, which will write a low to the output port to open the relay. But . . . the output ports will go high impedance when the microcontroller supply falls. Relays have a wide operating voltage range, so the mute relay will close again, letting through all sorts of unpleasant disturbances, and will not finally open until the supply drops below the hold-on voltage, which may take some time. This is a much more likely scenario than misoperation at switch-on.

Avoid configuring things so that either a high or a low on an output port must be asserted to prevent something operating.

Many microcontrollers have a Sleep mode which can be used to minimise the chance of electrical interference. I have never found it necessary to employ this in a piece of audio equipment; RF from the microcontroller getting into the audio has never been a problem. I do know of a case where it was done very successfully in an HF communications receiver, where the RF sensitivity is of course very much greater. Be aware that some microcontrollers take a surprisingly long time to come out of Sleep mode. Much the same is true of me.

Design and experimentation

I have spent a great deal of time on electronic experiments, and rightly or wrongly I think I can provide some helpful advice on how to go about it. Some suggestions may appear obvious, some may appear trivial, but I think most people will learn something here.

The design sequence

Step 1: Stipulate. Decide what you want to design. I am aware this sounds crashingly obvious, but I have been involved in many projects where the requirements were ever-changing and generally founded on sand. This obviously is going to cause delay as you grope towards what is really wanted, and it is going to be expensive if you are using consultants. A less obvious danger is that if in moving from version to version to version, it is easy to get confused and errors may creep in. Rigid version control is essential.

Ideally a formal specification document will be produced, and agreed upon before any design work gets done. The people that object to the non-negligible time this takes will be the same ones that introduce last-minute changes.

Step 2: Calculate. In the world of audio it is not often necessary to do complicated calculations. I have very rarely needed to use complex algebra to determine the behaviour of a circuit. Typically the equations get long very quickly and it is all too easy to make mistakes. Simple calculations, like determining the value of time-constants or resistors in a parallel are very conveniently done on a spreadsheet. I have one called UTILITY which does all the basic calculations; it has grown over the decades to include instant design of sixth-order filters. I have another for power amplifiers, which given power output and load impedance, pretty much does all of the design, down to the predicted lifetime of the power supply capacitors.

Step 3: Simulate. SPICE simulators are in my view absolutely essential. Professional ones are expensive, but free ones are downloadable, with LTspice being popular. I have used it, but I don't find the quality of the graphical output appealing. A common misuse of SPICE is to try and determine the distortion produced by a circuit. If this worked reliably it would save a lot of money on buying distortion analysers, but it doesn't. The two major weakness for our purpose are the simplistic ways in which SPICE handles transistor Early Effect and the variation of beta with collector current.

Step 4: Fabricate and Mensurate: There is no substitute for building it and measuring it. The best way to do this depends on exactly what you are designing. Small signal audio works perfectly on prototype board, but for power amplifiers it is best to go straight to PCB, recognising that

DOI: 10.4324/9781003332985-27

modifications before you get it absolutely right are almost inevitable. Getting a PCB of any complexity totally right first time is very hard, though I have managed it a number of times.

Schematics

There is not much information around about how to draw a good schematic, which is usually the input to the PCB part of the CAD package. Here is one important point; be careful with wire crossings; don't rely on wire dots (or blobs) to make it clear when wires are joined. These have tendency to disappear on photocopying. In Figure 27.1a this conventionally shows two connections crossing but not joining. DO NOT use it to represent a junction. Figure 27.1b shows the old-school way of indicating crossing but not joining; it leaves absolutely no doubt, but was abandoned because it took longer to draw in the days of manual draughtsmanship. Figure 27.1c shows a junction but the wire dot is vulnerable to disappearing; DO NOT do this; the scheme at Figure 27.1d is the way to do it. The plan at Figure 27.1e is useful when it is desirable to keep the two vertical connections in a straight line; for an example, see the headphone amplifier in Figure 20.5.

Figure 27.1 Wire crossings on schematics. a) is not a junction and c) is not a crossing.

This is not a purely theoretical danger; at one company I worked for this happened. A crossing and a junction were confused, and whole batch of PCBs had to be scrapped. No, it was not my schematic.

I draw transistors (be they BJT or FET) in the old-school way with a circle around the symbol. This means you can see at a glance how many active devices are involved; this was a big issue when active devices were expensive. It also means you can identify the configuration more easily.

One of the big changes in schematics (for many years referred to as circuit diagrams, which many would say was more descriptive) was the representation of resistors. From an early time, resistors were represented as zigzag lines, which may have something to do with historical graphite lines draw on slate. Around 1960, this symbol was replaced by a rectangle, which was much quicker to draw neatly with manual draughtsmanship. I am happy with either; one point is that zigzags are much quicker to draw when you're sketching a circuit with pencil on paper. Either are fine in CAD, where the symbols can be as complicated as you want to make them. If you want to represent resistors as rampant dragons, then you go ahead. If you must.

Prototype board

I am referring here to the sort of prototype board that has rows of spring contacts, typically connected together in rows of five or six, mounted under a perforated plastic cover. This is

sometimes called breadboard [1], or solderless-breadboard, because in the Old Days you would hammer nails into a bit of wood (like an actual breadboard) and wire things between them. I am glad to report I have never actually had to do this. Personally I call this protoboard, though I think that was once a proprietary name. Protoboard may also refer to PCBs with a matrix of isolated pads; these are useful for RF work, but not so much for audio.

Protoboard uses tin plated phosphor bronze or nickel silver alloy spring clips to hold the wires and components, and these should be treated with consideration if you want them to have a long life. Don't use connecting wires with jagged ends. If you are taking resistors from a bandolier, you will probably find that the ends of the leads are covered in glue. Pushing this into the board is not a good idea. It's no real hardship cutting the ends off, as the leads will probably be too long for convenient prototype board work anyway. I have been using these boards for many years and I have not yet found one to fail with unreliable contacts, or indeed fail at all. Some of my boards are 40 years old and still work fine.

Obviously the contacts can only handle a limited of current, but this can be surprisingly high; one specification I am looking at claims 3 to 5 Amps and a withstand voltage of 1000 V. In small signal audio you're not likely to be using currents like that, and if you think putting 1 kV onto your protoboard is a good plan you may be wrong. I have not built anything more powerful than a headphone amplifier on protoboard, though I have thus built the small-signal section of a power amplifier that way, with ±50 V or so on the protoboard. Not a problem.

Typically there is 2 to 5 pF of capacitance between adjacent contact rows, and this is rarely a problem in audio. One exception is if you have a discrete transistor amplifier, an extra 5 pF between the base and collector of the main gain transistor could be significant because of Miller effect. A cure is to spread out the transistor leads so there is room for a grounded contact row between the C and B of the VAS; this leaves you with some capacitance to ground, but pretty much prevents unwanted local feedback and Miller effect.

Connecting wires will be single strand and should not be too big in diameter, though my experience is that if the wire will go into the hole in the plastic it will not damage the contacts below. Some boards specify a wire size from 29 AWG to 20 AWG. My favourite connecting wire is the stuff used for wiring up telephone systems; it comes in many colours, plain or striped, which is very handy if you have a lot of connections to keep track of. At one time this wire could be literally picked up off the street when telephone engineers failed to clear up after a job. I use red for positive power, black for 0V, green for signal ground, and blue for negative. After that anything goes. Be very sure you use tinned copper wire, not bare copper wire. Bare copper oxidises quickly and will cause unreliable connections.

As time goes by you will build up a stock of wires of different lengths. It is handy to sort these into three or four batches and store them in boxes. Some protoboards come provided with a handy set of wire links of varying lengths.

You will need a stock of through-hole components. I have dedicated part of a wall to a plastic-drawer storage system that carries all the E24 resistor values from 1 Ω to 10 MΩ in metal film at 1%. You are not likely to need higher values unless you are designing preamplifiers for capacitor microphones. All other components, basically capacitors and semiconductors, live in

compartmented plastic boxes with hinged lids; these are very cheap to buy. Keep these boxes clipped shut unless you are actually taking a component out; or a careless elbow will result in picking hundreds of parts out of the carpet and sorting them. I suspect this is not much fun; I have not yet had to do it myself.

Very often protoboards are only used to build and measure one or two stages of a system that are new or causing anxiety. However, there are no real limits. At one company I built an 820 mm by 95 mm matrix of protoboard, with six supply rails, on which to build a complete input channel for a rather complicated new mixer which embodied a lot of new technology. It was extremely useful.

If you are dealing with a circuit that involves a variable resistor or pot, it can be very handy to make this out of a ladder of multiple fixed resistors, This allows accurate resetting. and also means, if you use 1% resistors, that the 'track' value will be accurate. Real pots often have a ±20% tolerance on track value. A typical application would be in a tone control where lots of intermediate settings need plotting. You therefore emulate a 10 kΩ pot with a ladder of ten 1 kΩ resistors in series. Using an even number of resistors means you have the equivalent of a central wiper setting. In some cases you only need a few plots and the ladder can be made of two or four resistors.

When you are experimenting, you are changing components all the time. The discarded components, being no longer of immediate interest, are dropped on the table. There is a clear danger of a dense layer of discarded components building up, and I can tell you that is irritating. There are two things you can do; tediously pick up each component, read the value, and refile them in their appropriate location; or you can save time by throwing them away. This is practical for resistors, which are the most numerous components and cost very little, but is less attractive for more costly parts like capacitors and semiconductors; fortunately there are relatively few of these in the average circuit. If you blow up a semiconductor then throw it in the bin at once before it gets mixed with the good ones.

When building your circuit, don't pack components too closely together because it makes changing them difficult. Leave some spare contact rows in case you need to add more parts. Resistors bent into a hairpin shape take up less space. Now and again you may need to sleeve resistor leads to prevent short-circuits, but this takes time and can usually be avoided if you allow a bit of elbow-room when building the circuit.

It is often worth investing in a number of protoboards, so a circuit can be left intact in case you need to go back to it. Writing a description on the underneath is recommended, for circuitry can look entirely opaque after a year or two has passed, and you don't want to have to work it out from scratch. It is highly convenient if each protoboard has a standard layout for power and signal connections. My method is shown in Figure 27.2, which shows a typical protoboard layout with supply and 0V rails running across top and bottom. In many cases these rails are divided into two or more sections which usually need to be linked as in the diagram.

Signal In is the three contact rows at the top left (shown cross-hatched). A screened cable terminating in a three-pin connector for Hot and Cold and ground plugs in here, and this system ground goes on to the board at this point only. A floating testgear output is assumed (as in Audio Precision equipment), and the Cold line is a reference for the Hot output and is shown here

connecting to the 0V rail at the point A. Hot and Cold should be routed to minimise the area of loop between them that could pick up hum fields.

Signal Out is the two contact rows B at upper right, next to the power connector (both shown cross-hatched). A screened cable terminating in a two-pin connector for Hot and Cold plugs in here. Ground is NOT connected here as a second ground would cause a ground loop. As before a balanced testgear input is assumed; Hot connects to whatever circuit node you are measuring, via the 47 Ω resistor R1, which isolates the circuit under test from the capacitance of the screened testgear input cable. Cold connects to the ground rail (unless of course you are measuring a balanced output) at a point C close to the circuitry. Again, the wires should be routed to minimise the area of loop between them that could pick up hum fields. A and C can be the same point if desirable. It is theoretically possible to use the output cable rather than the input cable to provide the single ground connection, but I have never done it that way.

Power In is the six contact rows at the top left. A three-way cable (mains cable works very well) from the bench PSU terminates in a six-pin connector; the cable should be at least a metre long so the PSU, which probably has a standard mains transformer creating a hum field, can be placed well away from what you are measuring. Both supply rails and 0V are duplicated, as many opamps, including the otherwise robust 5532, object strongly to losing one of their supply rails. Decoupling capacitors C1, C2 are fitted as standard. Note they are connected so that they cannot couple hum and noise from the supply rails into the 0V rail where it matters. Individual decoupling caps on each IC package are connected between V+ and V−, and also do not couple noise into the 0V rail

You will note that there are two 0V rails, at top and bottom. You need to be careful if you using both of them, because they are likely to have differing voltage drops down them and that could lead to trouble. My practice is to use the lower 0V for anything critical, and the upper for non-critical stuff.

Many of the more recent semiconductors are only available as SMT parts, but this does not mean they cannot be evaluated on prototype boards. I have made extensive use of them. Substituting passive TH parts for SMT is not likely to cause problems, so long as you keep an

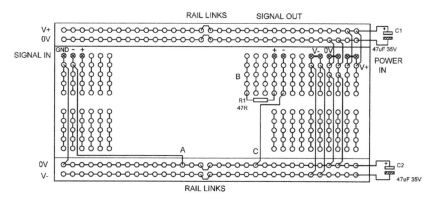

Figure 27.2 A typical standard layout for a prototype board.

eye on the current and voltage ratings of the SMT resistors. For semiconductors the answer is to use a chip carrier—a small PCB with SMT pads and TH pins for plugging into protoboard. These come in many forms. If you don't want to set up for SMT then you can usually find a nearby company who will fix the devices on a carrier for a modest sum. Chip carriers sometimes have pins of a size that only just fits into a protoboard, but this does not seem to cause any problems.

Screening prototype boards

Screening against electric fields is delightfully simple; any piece of metal does a near-perfect job. Ready-made protoboards come with their sections mounted together on a metal baseplate which can be grounded for screening. I use a lot of separate sections plugged together as needs be, so I addressed the issue by mounting a large aluminium plate under the table I use as a workbench. This is grounded to mains ground and effectively stops any hum coming up from underneath. However, when measuring low levels of noise, which is something I do a lot of, you need to stop mains electric fields from getting in from the top. There is a big source of electric hum, and it is YOU, assuming you have insulating shoes on. Putting a hand on the aforementioned screening plate causes the induced hum to drop dramatically. However, that is not wholly satisfactory for either hum or electrical safety. My solution is a biscuit tin (lid removed), which is big enough to cover the amount of protoboard likely to be used. This is fitted with a binding post for a banana (4 mm) plug and a (green) flying lead for grounding. Biscuit tins are varnished to stop them rusting, but this is a fragile layer and should not be relied upon to prevent short-circuits.

Screening against magnetic fields is not delightfully simple; it is difficult and expensive, often involving layers of mumetal. The best approach is to not set up the field in the first place; for example, don't put the mains transformer next to your phono stage, put it a separate box several feet away. Distance here is not free because you need to pay for another enclosure and a connecting cable. Likewise on your work bench there will probably be a power supply, an oscilloscope, and the audio measuring gear. Use long enough leads so these can be positioned well away from the circuit under test. I make life difficult for myself because my favourite oscilloscope (a Hewlett-Packard 54600B which I won in the Electronics World competition in 1994) has digital signal-handling, but a CRT display whose EHT transformer liberally radiates a high frequency around 16 kHz. I still use it because it has a lovely user interface; physical distance is the answer here.

Stripboard

Strip board consists of an insulating surface with parallel rows of copper conductors, drilled at a 0.1-inch spacing to accept component leads. The copper strips can be cut very easily with a hand-tool rather like a twist drill, so that each strip can accommodate multiple circuit nodes. It used to be very common for the first version of a circuit to be built on stripboard for measurement and evaluation, but this is rather time-consuming, and today PCB tooling costs are relatively

much lower, so it is common to go straight to a PCB. IC sockets are strongly recommended as stripboard will not stand up to much soldering and unsoldering. SMT components can be used with strip board if they are mounted on TH carriers, which you then plug into the IC sockets.

PCBs

Well, there you are with your prototype PCB, and it is not perfect. Of such is life. Connections you don't want can have their track cut with a scalpel or other sharp knife. The best way to do this is to scrape off the solder-resist (which can be quite tenacious), and then make two cuts close together on the track you want to sever. The isolated bit of track can usually be removed by heating it with a soldering iron to weaken its attachment to the PCB, and then pushing it sideways with the iron tip. In this way you know that the track has been completely cut; just cutting once does not give assurance that the connection has been completely broken. The next step is to scrape off some more solder-resist so you have enough bare copper track to solder a connection to. If extra components are needed, they are usually connected by air-wiring, which simply means components soldered to hang in the air and hold each other up. This gives minimal stray capacitances but this is usually not an issue in audio. It can however be very useful when you are working on capacitor microphone preamplifiers, where the circuit impedances are extremely high. See Chapter 17.

My experience is that old-fashioned lead/tin solder makes joints more easily than any of the lead-free formulations. So far as I can see it is entirely legal for experimentation which is never going to involve the general public, I have a large stock of it; you can have it when you pry it from my cold dead hands (though why wait for me to cool down?). Having said that, lead poisoning is no joking matter; it is insidious stuff. Basic precautions like washing your hands before eating are highly recommended.

There is more information on PCB technology in Chapter 2.

Safety

Small signal audio design is in general not a hazardous business. So long as you avoid valves, you are unlikely to encounter anything in audio circuitry higher than +/−18 V, unless it is +48 V microphone phantom power. The Low Voltage Directive adopted by the European Union covers DC voltages from 50 V to 1000 V, so +48 V phantom power just squeaks in.

However, sooner or later you are likely to be building or testing a mains power supply, and this is where you could get yourself killed. Plastic sole shoes are of course advisable to keep you insulated from ground, but the sad fact is that if you touch the mains it's all too likely your other hand will be resting on some grounded metalwork. Electric currents going from one hand to the other encounter your heart on the way through, and that can do for you. It is my practice to NEVER have exposed live terminals, not even for a few minutes. You can imagine why I feel strongly about that; I learnt the hard way.

Consider your attire. If you're dealing with solder, it is best to avoid synthetic fabrics that will melt and weld to your skin. Cotton is very resistant to heat, so the classical outfit of T-shirt and

jeans will repel solder droplets. In Britain at least, the drivers of steam engines wore moleskin trousers; moleskin is a particularly tough cotton material and does not actually exploit burrowing animals in any way.

About the only other hazard that comes to mind is dropping heavy transformers on your toes. If you are moving a lot of those about, safety boots will protect your feet.

Reference

[1] https://en.wikipedia.org/wiki/Breadboard Accessed June 2022.

Appendix

COMPONENT SERIES E3 TO E96			FOR THE DECADE 100 TO 1000				
E3	**E6**	**E12**	**E24**	**E96**	**E96**	**E96**	**E96**
100	100	100	100	100	178	316	562
			110	102	182	324	576
		120	120	105	187	332	590
			130	107	191	340	604
	150	150	150	110	196	348	619
			160	113	200	357	634
		180	180	115	205	365	649
			200	118	210	374	665
220	220	220	220	121	215	383	681
			240	124	221	392	698
		270	270	127	226	402	715
			300	130	232	412	732
	330	330	330	133	237	422	750
			360	137	243	432	768
		390	390	140	249	442	787
			430	143	255	453	806
470	470	470	470	147	261	464	825
			510	150	267	475	845
		560	560	154	274	487	866
			620	158	280	499	887
	680	680	680	162	287	511	909
			750	165	294	523	931
		820	820	169	301	536	953
			910	174	309	549	976
1000	1000	1000	1000				1000

E24: 6 pairs in 1:2 ratio				E24: 4 pairs in 1:3 ratio		E96: 16 pairs in 1:2 ratio	
100		200	100		300	100	200
110		220	110		330	105	210
120		240	120		360	113	226
150		300	130		390	137	274

180	360			140	280
750	1500	**E24: 2 pairs in 1:4 ratio**		147	294
		300	1200	158	316
		750	3000	162	324
				174	348
		E24: 6 pairs in 1:5 ratio		187	374
		150	750	196	392
		200	1000	221	442
		220	1100	232	464
		240	1200	590	1180
		300	1500	732	1464
		360	1800	750	1500

No pairs in 1:3 ratio
No pairs in 1:4 ratio
E96: 16 pairs in 1:5 ratio

Index

Note: Page numbers in *italics* indicate a figure and page numbers in **bold** indicate a table on the corresponding page.

1/f noise (flicker noise) 25–26, 30–31
2N4403 transistor 326
2N5457 transistor 740
2N5459 transistor 740
2SB737 transistor 33, **33**, 512; moving-magnet inputs 297–299, **297**, **304**; tape replay 341–342, **341**
3.3 V single-rail operation 204–205
4x gain 564–568
+5 V supply rail 195–206, *206*
±15 V power supply 772–775
±17 V power supply 775–776
32-times 5532 opamp power amplifier 43–45
+48 V phantom power supplies 518, 783–784, **785**
600-Ohm lines 6–7
4000 series analogue gates 632
4016 analogue gates 631–636, *633–634*, 641–643, 643–645, 707, 739
4066 analogue gates 632–635, *635–637*, **639**, 643–645, **663**

AC 89–91, 322–325, 330–331, 773–775; MM cartridge DC and AC coupling 293
active balance controls 426, *427*; and Baxandall stage 449–450
active clipping: feedforward 765–767; with opamps 758–761; transistors 757, *758*
active filters 208, 243–244
active gain controls 21, 234–235; plus passive attenuators 234–235
active panpot 680–681, 684
active preamplifiers 232–233, 426, 531
active volume controls 377–381
AD797 opamp 144, **145–146**, **149**, 180, 579–580, **580**
AD823 **196**
AD826 **196**

AD1854 DAC 792
AD1871 ADC 789
AD1974 ADC 789
AD75019 646
AD8022 **196**; in +5V operation 199–200, *199*
AD8066 **196**
AD8397 **196**; in +5 V operation 200–204, *202–206*
AD8616 **196**
AD8656 **196**
ADG5208F 646
AFL systems 712
all-pass filters 210
ALPS SPUN switch 627, 684
alternative unbalanced/balanced inputs 552
aluminium **52**, 53
Ambler concept 465, *466*
amplification: attenuation then 20, *20*; and the gain-distribution problem 233–234; moving-coil head amplifiers 319, 321; quiet 39–40; strategies 319; then attenuation 19–20, *20*; *see also* amplifiers
amplifiers 7; 32-times 5532 opamp power 43–45; amplifying stages 237–240, *241*, 244–249; an effective MC amplifier configuration 323–324; CA3080E 743; component mismatch effects 546–548; current 8; dual gain pot 241, *242*, 247–249; guitar 359–360; hybrid MM amplifiers 300–301; hybrid summing 699–702; instrumentation 562–571, *562*, 564–*570*; Johnson noise 23; limitations 262–263; line inputs 530; LM13600 743; MM amplifier configurations 265–267; moving-coil input amplifiers 321–322; multiple 47–49; Neumann SAL 74B amplifier 265,

318, 618; noise 27–29; post-fade 671–672; a practical MM amplifier 312, *313*; Radford HD250 234; single gain pot 237–240, 244–247; stereo power 60–61; summing 126–127, 698–706; switched-gain 249–252; tape replay 338–340; transconductance 8, *9*; transimpedance 8, *9*; types of **2**; ultra-low noise 45–47; voltage 3, *9*; *see also* headphone amplifiers; opamps; summing amplifiers
analogue to digital converters (ADCs) 787–792
attack artefacts 749–750
attenuation: amplification then 19–20, *20*; quiet 37–38, **38**, *39*; then amplification 20, *20*
attenuator volume controls 401–409
Audio Note cartridge 317
Audio Precision (AP) SYS-2702 measuring system 106, 115, 136, 138, 172, 177, 390
Audio Precision System One test system 36
Augustadt, Herbert 225
auxiliary sends: mixer sub-systems 688

bainter filters 208, *225*, 226
balance controls: active 426, *427*; combining balance controls with other stages 428; ideal balance law 421–423; mono-stereo switches 430–432; passive 423–425, *426*; switched 428–429, *430*; width controls 432–433
balanced cables 535–537
balanced connectors 537
balanced-feedback hybrid microphone preamplifier (BFMA) 519–520

balanced headphone amplifiers 624
balanced hybrid summing amplifiers 702, *703–704*
balanced inputs 551; alternative unbalanced/balanced inputs 552; cables and interference 535–537; combined line input and balance control stage with low noise 557–559; combined unbalanced/balanced 552–553; connectors 537; ground-cancelling outputs 596–597; high input impedance balanced inputs 560–561; instrumentation amplifier 562–571; interconnections 533–535; inverting two-opamp 561–562; MM 301; practical 548–551; self variable-gain line input 559–650; signal levels 537; superbal input 553–554; switched-gain 554–556; variable-gain 556–557
balanced interconnections 533–535; advantages of 534; disadvantages of 534–535
balanced line outputs 597–599; economical −6 db 601–602; noise 599–601; output impedance 599
balanced signal levels 537
balanced signals 2–3, *3*
balanced summing systems 691–693
balance, quiet 40
bandpass filters 209; multiple-feedback 224–225; Sallen-and-Key 217–220
bar-graph metering 732–737
Bateman, Cyril 83, 87, 88
Baxandall, Peter 284, 289–291, *291*, 381
Baxandall active volume control 381–383; improved volume stage with lower noise 390–392; loading

effects 388–390; low noise
Baxandall active volume
stages 386–388; passive
control 392–394; practical
Baxandall active volume
stage 384–386; volume
control law 383–384
Baxandall tone controls
437–438; combining a
Baxandall stage with an
active balance control
449–450; fixed-frequency
middle controls 467, *468*;
impedance and noise
444–449; one-band tone
controls 450–451; one-
LF-capacitor tone control
438–443; switched-HF-
frequency 451–454; three-
banded EQ in one stage 468,
469–471; two-HF-capacitor
tone control 444–446; two-
LF-capacitor tone control
443–444
BBC 401, 432, 553, 732, 750
belt-ganged volume controls
398
Benet, Stephen Vincent 771
Bessel filters 207, 210, 212,
212, 213, **213**, 214, 793
beta (h$_{fe}$) ratio 98
bias current 143, 147–148,
148, 159, 164, 182, 532
bipolar input opamps 153–156
bipolar junction transistors
(BJTs) 96–97, 159–160;
+48 V phantom power
supplies 783–784, *785*;
design and experimentation
798
bipolar transistors: current
noise 30–34; and FETs
96; noise 29–30; voltage
noise 30
Blackmer, David 744
black noise 22
blue noise 22
Boctor filter 226
bootstrapping: collector 120,
120, 126–127; junction
field-effect transistors 526,
647–651; supply rail 129
braided screen cables 535
bridged-differentiator notch
filter 225–256, *225*
bridging impedance 497
broadcast consoles 492, 706,
752
Brownian motion 22, 526
bus residual 127, *127*, 690,
699, *700*; trim control 495,
504–505, 506
Butler, F. 128
Butterworth filters 306

C1 275–284
CA3080E amplifier 743

cables: balanced 535–537;
braided screen 535–357;
mercury 53; overlapping foil
screen 535; ribbon 665–667,
689, 710, 712; wiring
resistance 55
Cambridge Audio 428; 840A
integrated amplifier 409;
840E preamplifier 402, 409;
840W power amplifier 578;
P50 integrated amplifier
293, 380
cancellation 311
capacitance: impedance and
crosstalk 60–61; Johnson
noise 23; PCB track-to-track
crosstalk 58–60, *58–59*;
resistors 62–63, 82–84,
547–548, 684
capacitors 81–92; blocking
82, 267–268, 550–551;
capacitor microphone head
amplifiers 524–526; ceramic
83, 788; decoupling 82, 186,
700, 720, 734, 772–775;
electrolytic capacitor
non-linearity 88–91; input
sampling 790; leakage 81;
microphony 91; mixed
223–224; non-electrolytic
capacitor non-linearity
83–88; non-linearity 83;
polyester 84–87, *85*, **86**,
221–222, *222*; polyethylene
terephthalate (PET) 84;
polypropylene 87–88,
87, 308–309; polystyrene
86–87, *86*; properties 81–82;
reservoir 772–726; series
83; tan-δ (tan-delta) 82
carbon **52**
carbon composition resistors
62, 73
carbon film resistors 62,
76–78, *77*
cartridges: cartridge–
preamplifier interaction 292;
cartridge types 253; DC/
AC coupling 293; frequency
response 291; impedances
292–298, 317–320,
323–324, 351–355; loading
291; load synthesis for
lower noise 304–305, *306*;
moving-coil cartridge
characteristics 317;
sensitivities 261–262
CAST *see* Current Audio
Signal Transmission
CBS (broadcaster) 730
CD players 228, 233, 255
ceramic capacitors 83, 788
channel modules: group
module circuit blocks
688–698; in-line 504–506;
routing *504*, 707; split
format 497–504

Chebyshev (elliptical) filter
207, 210
circuit block 4, 20–21, 668,
688–698, 728, *729*
clamping 758–761
clamping diodes 572, 584, 791
clipping: active clipping with
opamps 758–761; active
clipping with transistors
757, *758*; biased diode *755*;
by clamping 758–761; diode
754–767, *755*; feedforward
765–767; negative-feedback
761–764; opamps 529–530,
566, 723, 754–767,
758–761; soft 360,
715–716; transistors
100–101, 121, 767–768
CMOS analogue gates
632–633; control voltage
feedthrough 643; current
mode 640–641; at higher
voltages 643–645; at
low voltages 645–646;
series-shunt current mode
641–643; voltage mode
633–639
collector bootstrapping 120,
120, 126–127
Columbia (record label) 253
combined LED indicators
730
combined low-pass/high pass
filters 209
combined unbalanced/balanced
inputs 552–523
common-mode (CM)
distortion 152–159; bipolar
input opamps 153–157;
JFET opamps 157–159
common mode (CM) range for
opamps 147
common-mode rejection
538–540; basic balanced
input and opamp effects
543–544; basic electronic
balanced input 540–543;
line inputs 538–540; opamp
CMRR effects 545, **546**;
opamp frequency response
effects 544–45
common-mode rejection ratio
(CMRR) 2, 4–5; ground-
cancelling outputs 594–595;
simple hybrid microphone
preamplifier 514
complementary feedback pair
(CFP): configuration 99,
107, 109, 115; constant-
current 102–104, *103*;
emitter-followers 109–114;
parametric middle EQs
482–485; two-transistor
series feedback gain
132–134
component lifetimes in mixer
subsystems 720–721

components *see specific
components*
compressors 472
compressors/limiters 746–749;
attack artefacts 749;
decay artefacts 750–751;
subtractive VCA control
751–752
conductors 51–61; cables 55;
copper 51–53; gold 54;
PCB track resistance
56–58; properties 51, **52**;
silver 51–52, **52**; wire
resistance 55
Connor, Gareth 702
consoles: broadcast 492,
706, 752; cooling in mixer
subsystems 720–721
constantan **52**
control interaction 437, 450,
455, 467, 468
control law: balance controls
428; gain 234–235, 239,
247; gain-control elements
745, 748; microphone
preamplifiers 509, 523;
mixer sub-systems 671; tone
controls and equalisers 450;
volume controls 363–418,
372–375, 374–378,
380–383, 390, *393*, 395
control-room monitor (CRM)
494, 502
cooling: electronic 720–721;
fan 782
copper: balanced cables and
interference 535; conductors
53; metallurgy 53–54;
mixing bus systems 60, 666;
moving-coil transformers
52; PCB track resistance
56–58; properties 52, **52**
correlated noise 579
cost of opamps 148, **149**
crosstalk 60; balancing tracks
704–705; impedances
60–61; inductors 91–92,
536; input-select switching
627–629; inter-bus 127,
690; power amplifier 45
current amplifiers 8, *9*
Current Audio Signal
Transmission (CAST) 1
current-carrying capacity 55
current feedback amplifiers
(CFAs) 8
current-mode connections 1, 8
current-sharing 321, 326
current source: Johnson noise
23; transconductance
amplifiers 131, 742–743

DC: discrete JFET switching
660–601; drain resistors
268, 532, 551, 565;
MM cartridge DC
and AC coupling 293;

potentiometers 398; *see also* DC blocking capacitors

DC blocking capacitors: line inputs 552, 565; line outputs 583; microphone preamplifiers 520, 526; mixer sub-systems 671, 700; moving-magnet inputs 293–294, 312; opamps for low voltages 197; signal switching 660–601; tone controls and equalisers 464; variable gain stages 244

decay artefacts 750–751

decoupling capacitors 82, 186, 700, 720, 734, 772–775

design and experimentation: design sequence 797–798; printed circuit boards 803; prototype board 798–802; safety 803–4; schematics 798; stripboard 802–803

design sequence 797–798

"destructive solo" 714

DG411 analogue gate series switching 643–635

differential amplifier array 575, 578, 580

differential filters 228

digital to analogue converters (DACs) 8, 208, 228, 787–798, 792–794

digital domain interface: interfacing with ADC inputs 789–792; interfacing with DAC outputs 792–793; interfacing with microcontrollers 794–796; nominal levels and ADCs 788; PCB layout considerations 787–788; typical ADCs 789

digital mixers 523–524

DIN interconnection standard 1

diode clipping 754–756, 757

direct injection 360–361

direct outputs in mixer subsystems 673

discrete circuitry and power supplies 780

discrete class-A headphone amplifiers 618–622

discrete class-AB headphone amplifiers 618–622

discrete JFET switching: advantages 647; control voltage feedthrough in 662; current mode 652–657; DC conditions 660–601; drive circuitry 659; physical layout and offness 660; reducing distortion by biasing 657–659; series JFET switch in voltage mode 647–651; shunt JFET switch in voltage mode 651–652; soft changeover

circuit 661, **662**; voltage mode 651–652

discrete MOSFET switching 662–663

discrete opamp design 134–135; input stage 135–136; output stage 139, *140*; second stage 136–139

discrete transistor circuitry 95–96; beta 98; bipolar junction transistors 96–97; bipolars/FETs 96; discrete opamp design 134–135; reasons for use 95–96; transconductance 98; transistor equation 97; *see also* discrete transistor circuitry (gain stages)

discrete transistor circuitry (gain stages) 116; one-transistor series-feedback gain stages 117–118; one-transistor shunt-feedback gain stages 116–117; two-transistor series-feedback gain stages 132–134; two-transistor shunt-feedback gain stages 119–132

discrete transistor circuitry (unity-gain buffer stages) 98–99; CFP emitter-followers 109–114; constant-current emitter-follower 102–104; emitter-follower stability 105–107; improved unity-gain buffers 115–116; JFET source-followers 107–108, *109*, **109**; push-pull emitter-follower 104–105; simple emitter-follower 99–101, *102*

distortion 606–611; biasing 657–659; bipolar input opamps 153–156; common-mode distortion 152–159; JFET opamps 157–159; loading 151; opamp internal distortion 150; opamps 149–159; operational transconductance amplifiers 742–743; Sallen-and-Key filters 221–223; simple hybrid microphone preamplifier 512–514; slew-rate limiting distortion 150–151; thermal distortion 151–152

distributed gain control 234, 369

distributed peak detection 728–730

distributed summing systems 694–698

Dolby HX-Pro 345–346

dominant-pole compensation 292, 300–301

dual-action volume controls 369–372

dual gain pot 241, 247–249

dual supplies from a single winding (power) 779–780

dynamic range 10–11

dynamics section 499, 668, 754

E3 resistor 65

E6 capacitor 275–284

E6 resistor 65

E12 resistor 65

E96 resistor 65, 793

E24 resistor 65

E48 resistor 65

E192 resistor 65

Early Effect 97, 135, 156, 167

Early, Jim 97

Ebers-Moll transistor equation 97

economical −6 db balanced output 601–602

effects return (split-format) 506

efficient LED bar-graph architecture 734–737

Einstein, Albert 25

electret microphone 507

electric guitar *see* guitar preamplifiers

electrolytic capacitors 15, *85*, 88–91, *88–90*

electrolytic tough pitch (ETP) copper 53

electronic balanced line inputs 537–538

electronic cooling 720–721

electronic switching 631

electronic versus transformer balanced inputs 537–578

electrostatic coupling 535–576, 724, 783

Elektor 5532 power amplifier 43–45; bridged-output version 43; crosstalk 45; distortion 44; noise 44–45

emitter-follower (EF) circuits: CFP 109–114; constant-current 102–104, *103*; push-pull 104–105, 262; simple 99–101, 102–104, *102*, 107–109, 115; stability 105–107

endstop resistor *see under* resistors

equalisation 263–264; mixer sub-systems 666; tape replay 335–338

equalisers (EQs); graphic 485–458; new type of switched-frequency LF EQ 456–457; parametric middle EQ 482–485; single-gang variable-frequency middle EQ 476–478, *479*; switchable peak/shelving LF/HF EQ 480–482; switched-Q

variable-frequency Wien middle EQ 479, *480*; three-band Baxandall EQ in one stage 468, *469–471*; variable-frequency HF EQ 454–455; variable-frequency HF and LF EQ in one stage 457–463; variable-frequency LF EQ 455, *456*; variable-frequency middle EQ 474–475, *476*; Wien fixed middle EQ 472–474

equivalent input noise (EIN) 29; discrete transistor circuitry 121, 125; guitar preamplifiers 355–388; headphone amplifiers 618; line inputs 563; microphone preamplifiers 510, 523; moving-coil head amplifiers 326, 327; moving-magnet inputs 295–299, **303**; tape replay **341**; variable gain stages 238

equivalent series resistance (ESR) 81, 321, 721

evaluation boards 788

excess resistor noise 76–78, *77*

external signal levels 529

extrinsic resistance 30

fader flip 497

faders 669–671; linear 400, 499, 744; mixer sub-systems 670; short 496, 506; slide 375–377, 669, 726

fader-start switches 377

Fairchild uA709 opamp 143

fan cooling 782

feedforward 345, 670, *670*, 748, *750*; clipping 765–767

fibreglass 55

field-effect transistors (FETs); balanced summing systems 691–693; cascaded switches *652*; CMOS analogue gates 632–633, 638, 643, 652; design and experimentation 798; noise gates 752–754, *753*; *see also* junction field-effect transistors (JFETs)

filters 207; active 208; all-pass 210; Bainter 208, *225*, 226; bandpass 209; Bessel 207, 210, 212, *212*, *213*, **213**, 214, 793; Boctor 226; Butterworth 207, 210–214, 306–310; characteristics 210; Chebyshev (elliptical) 207, 210; combined low-pass/high pass 209; differential 228; higher-order 226–227; highpass 208–209; lowpass 208; multiple-feedback 224–225; notch 209, 225–226, *225*; passive 207–208; pinkening

768–770; roofing 207–208, 530; Sallen-and-Key 210–224; state variable 483–484, *484*; subsonic 271, 306–311; subsonic/ultrasonic combination 208–209, 312; switched-slope 227–228; third-order 212, 214, 221–222, 226–227; third order 311, 411, 497

First Age of Vinyl 208, 209

First Law of Thermodynamics 24

fixed-frequency Baxandall middle controls 467, *468*

flash bus 718–720

flicker noise *see* 1/f noise

foldback 493, 499–500, 503

four-layer summing 698

frequency response 11–12, 605; all-pass filters 210, 435; Ambler tilt control 465, *466*; Bessel filters 212–214, *212, 213*, **213**; Butterworth filters 82, *90*, 91, 207, 210–214, 265, 309, *310*, 464; cascaded stages 13–16; electrolytic capacitors 221; equalisation 263, 341–342; high-pass filters 214–216, *217*; MM cartridge 291; moving-coil transformers 319; negative feedback 451–452; non-electrolytic capacitors 15, 221; notch filters 225; opamps 210–212, 482–484, 544–545; output transformer 605–606; RIAA amplifiers 82; Sallen-and-Key filters 211–212, *213*, **213**, 215–216, 221, *222*; ultrasonic filters 213; vinyl 257; violet noise 22

front-of-house (FOH) mixer 493

fully balanced design *see* internally balanced design

gain-control elements: active clipping with opamps 758–761; clipping by clamping 758–761; compressors and limiters 746–749; diode clipping 754–756, *757*; feedforward clipping 765–767; history 739; junction field-effect transistors (JFETs) 739–742; negative-feedback clipping 761–764; noise gates 752–754; noise generators 767–768; operational transconductance amplifiers (OTAs) 742–743; pinkening

filters 768–770; voltage-controlled amplifiers (VCAs) 743–745, *746*

gain controls 568–570

gain-distribution problem 233–234

gain law: variable gain stages 237–240, *241, 242*, 244–245, *245*, 248, *251*; volume controls *384*, 395

gain stages 237–252; one-transistor series-feedback gain stages 117–118; one-transistor shunt-feedback 116–117; opamps 116; two-transistor series-feedback gain stages 132–134; two-transistor shunt-feedback 119–132, 175, 237–238

gain structures 19; active gain controls 21; amplification then attenuation 19–20; attenuation then amplification 20; raising the input signal to the nominal level 20–21

galvanic isolation 92, 535, 538, 604, 631

Gaumont, Leon 674

Gershwin's Law ("it ain't necessarily so") 51, 100

Gilbert, Barrie 88

glass **52**

gold **52**, 53–54, 401

gold plating 54

graphic equalisers 485–488; constant-Q 488; LCR filters 92; proportional-Q 488

green noise 22

grey noise 22

groove curvature 258–259, **260**

ground-cancelling outputs 591–593; into balanced input 596–597; CMRR 594–595; history 597; send amplifier noise 595–596; zero-impedance output 593

ground-cancelling summing systems 693–694

ground plane 56, 665, 688, 788–789

ground voltages 537, 591–592, 597, 692, 697

group modules: circuit blocks 688–690; split format 500–501

guitar preamplifiers 353–354; electric guitar technology 349; guitar amplifiers 359–360; guitar direct injection 360–361; guitar effects 359–360; guitar leads 352–353; guitar pickups 349–351; guitar wiring 351–352; pickup characteristics 351

headphone amplifiers: balanced 624; discrete class-A 618–622; discrete class-AB 618–622; driving headphones 613–614; driving heavy loads 613; multiple opamps 614–616; opamp-transistor hybrid 616–618; special opamps 614

heatsinks 618, 774, 782

heat sinks 63

heavy loads 47, 184, 321, 446, 568, 604, 613

hifi preamplifiers 363, 435, 652, 675

higher-order filters 226–227

high frequency (HF) correction pole 262, 269–271, *270*, 275–276, *275–276*, 284–286, 311–312, *313*

high-impedance inputs 1, 185

highpass filters 209; Sallen and Key 214–216, *217*

Hitachi Cable company 53

Hofer, Bruce 208, 610–611

Holman, Tomlinson 256, 259, 263, 292, 411, 418

hybrid microphone preamplifier 510–514, 518

hybrid MM amplifiers 300–301

hybrid summing amplifiers 699–702

hysteresis 723

ideal balance law 421–423

IEC 98 standard 264

IEC 60098 standard 264

IEC amendment 264–265; implementing 271–272

impedances 60–61; bridging 497, 560; crosstalk 533, 584–585, 627–629, 689–693, 704–705

inductance 73–76; guitar preamplifiers 349–351, 355–358; line outputs 605, 606; moving-coil head amplifiers 317–319; moving-magnet inputs 267, 291–298; tape replay 330–305, 341–343

inductors 91–92, 207–208, 486–488

input: amplifier functions 530; bias current 147; and ground-cancelling outputs 596–597; input-select switching 627–629; interfacing with ADC inputs 789–792; microphone and line input pads 514–516, *517*; mixer sub-systems 666; moving-coil input amplifiers 428; offset voltage 147; opamps 135–136, 147, 151, 153–156, 185–191,

267, 543–544, 561–562; overvoltage protection 572–573; sampling capacitors 790–792; selector switch 231–232, 363, 531; signal and nominal level 20–21; transformer microphone inputs 509–510; *see also* line inputs

input-select switching: mechanical 627–629

insert: points 499, 506, 666–668; return 500; send 499–500, 667–668, 673, 698, *698*

instrumentation amplifier 562–571

insulation-displacement connectors (IDCs) 665, 690, 719, 772

integrated circuits (ICs) 26, 400, 410; volume controls 410–412

integrated circuit volume controls 410–411

inter-bus crosstalk 127, 690

interfacing with digital domain: interfacing with ADC inputs 789–792; interfacing with DAC outputs 792–793; interfacing with microcontrollers 794–796; nominal levels and ADCs 788; PCB layout considerations 787–788; typical ADCs 789; typical DACs 792

interference 535–537

internally balanced audio design 3–6

internally balanced design 3–6

internal signal levels 10, 492, 529–530, 537

intrinsic emitter resistance 29, 99

intrinsic resistance 30

inversion, quiet 40, **41**, *41*

inverting two-opamp input 561–562

iron **52**

I-V converters 8, 792–793, *793*

JFET source-followers 107–108, *109*, **109**

JFETs *see* junction field-effect transistors (JFETs)

Johnson, John B. 22–23

Johnson noise 22–24, 76; bipolar transistor current noise 30–34; bipolar transistor voltage noise 30; guitar preamplifiers 354–355; how to amplify quietly 39–40; how to attenuate quietly 37–38, **38**, *39*; how to balance quietly 40; how

to invert quietly 40, **41**, *41*;
line inputs 265, 533,
553–554, 560–562;
microphone preamplifiers
510, 523; mixer sub-systems
691, 694; moving-coil
head amplifiers 319–320;
moving-magnet inputs
265–268, 270, 294–297,
304–305, *306*; noise in
amplifiers 27–29; noise
in bipolar transistors
29–30; noise gain 36;
noise in JFETs 34; noise
measurements 36–37;
opamps and their properties
148, 151, 157–158, 179;
preamplifier architectures
232–233; tape replay
338–341; ultra-low-noise
design with multipath
amplifiers 40–41
junction field-effect transistors
(JFETs) 34, **297**; CMOS
analogue gates 646–662;
common-mode distortion
157–159; control voltage
feedthrough in 662; in
current mode 652–657;
discrete switching 646–662;
drive circuitry 659; gain-
control elements 739–742;
input types 184–192;
mixer sub-systems 717;
noise in 34; opamps and
their properties 144, 147,
152, 157–159; series JFET
switch in voltage mode
647–651; shunt JFET switch
in voltage mode 651–652;
tape replay 343–344

larger power supplies 780–781
Late Effect 97
laws: ideal balance law
421–423; sine/sine
squared 674–685, *674*;
thermodynamics 24; volume
controls 364–366
LCD meter displays 738
lead **52**, 53
leads 352–353
leakage from capacitors 23,
81, 196
Left-Center-Right (LCR);
filters 92, 207; graphic
equalisers 92; graphic
equalizers 485–486; panpots
681–684
level indication: combined
LED indicators 730;
distributed peak detection
728–730; LED bar-graph
metering 732–734; liquid
crystal displays 738; Log
Law Level LED (LLLL)

251–252, 726, *727*; a more
efficient LED bar-graph
architecture 734–737; peak
indication 724–726; peak
programme meters 732;
plasma displays 737; signal-
present indication 723–724;
vacuum fluorescent displays
737; VU meters 730–72
light emitting diodes (LEDs)
707–708, 718–720, 723–724;
bar-graph metering
732–734; combined LED
indicators 730; Log Law
Level LED (LLLL) 726,
727; more efficient bar-
graph architecture 734–737
limiters 740, 746–749
linear faders 400, 499, 744
linearity 62–63; discrete
transistor circuitry 95–96,
98–100, *101*, *103*, 104–105,
109, 111, 115–116; gain-
control elements 739,
742–743, 765; line outputs
604, 614, 616, 617, 620;
opamps and their properties
145, 151, 159, 172–174, *183*;
signal switching 631, 633,
636–640, 642, 645, 647,
651; two-transistor shunt-
feedback stages 121–125
in-line channel module (mixer
architectures) 504–506
"Listen" facility 503
line inputs: alternative
unbalanced/balanced inputs
552; amplifier component
mismatch effects 546–548;
balanced cables and
interference 535–537;
balanced connectors 537;
balanced interconnections
533–5; balanced signal
levels 537; combined
line input and balance
control stage with low
noise 557–559; combined
unbalanced and balanced
inputs 552–553; common
mode rejection 538–540;
electronic balanced
540–543; electronic v.
transformer balanced
inputs 537–538; external
signal levels 529; input
amplifier functions 530;
input overvoltage protection
572–573; instrumentation
amplifier 562–571; internal
signal levels 529–530;
inverting two-opamp
input 561–562; line inputs
265, 560–562; low-
noise balanced 573–578;
microphone and line input
pads 514–516, *517*; opamp

CMRR effects 545, **546**;
opamp frequency response
effects 544–545; a practical
balanced input 548–551;
self variable-gain line input
559–560; superbal input
553–554; switched-gain
balanced inputs 554–556;
transformer balanced
571–572; ultra low-noise
balanced 578–580; variable-
gain balanced inputs
556–557
in-line mixing architectures
495–497
line outputs: balanced
597–602; ground-cancelling
591–597; heavy loads
568; output impedance
synthesis 611–612; output
transformer distortion
606–611; output transformer
frequency response 605–6;
quasi-floating 602–604;
transformer balanced 604;
unbalanced 583–584; zero-
impedance 584–591
line-up oscillators 715–718
Linkwitz-Riley electronic
crossover 211
Lipshitz, Stanley 18, 268,
272–275
liquid crystal displays 738
LM317/337 variable-voltage
IC regulators 776
LM338K variable-voltage
regulator 781
LM741 opamp 160
LM833 opamp **145–146**, *149*
LM3914 integrated circuit 734
LM4562 **196**
LM4562 opamp 177–179,
198–199, *198*
LM7815/7915 IC regulator
772
LM7824 fixed IC regulator 780
LM7924 fixed IC regulator 780
LM13600 amplifier 743
LM13700 amplifier 743
loaded-linear pots (volume
controls) 366–369
loading 151
load synthesis 343
Log Law Level LED (LLLL)
726, *727*
loudness controls 411–415
low-impedance design 27,
39, 43, 89; filters 211; line
inputs 557; line outputs 595;
tone controls and equalisers
446, 458, 461; volume
controls 363, 395, 417
low-noise: balanced line inputs
573–578; Baxandall active
volume stages 386–388;

operational amplifier
circuitry 36
lowpass filters 208; Sallen and
Key 210–14, 215–16
Low Voltage Directive 803
low voltages: AD8022 in
+5 V operation 199–200;
AD8397 in +5 V operation
200–204; CMOS analogue
gates 645–656; high fidelity
from 195; LM4562 in +5 V
operation 198–9; NE5532 in
+5 V operation 197; opamps
for +5 V operation 197;
opamps for 3.3 V single-rail
operation 204–205; running
opamps from a single +5 V
supply rail 195–197
LP records 253
LT1028 opamp 36, 144,
145–146, **149**, **545**,
579–580, **579**
LT1083CK variable-voltage
regulator 781

magnetic conductors 51
magnetic coupling 301, 534,
536–537
magnetic pickups 350–351
MAGNOISE model 355;
MAGNOISE2 295, **296**, **297**
manganin **52**
master module (split format)
501–503
master section 493, 495, 497,
707, 712
MathCAD software 295
MC33078 opamp **145–146**, **149**
mechanical switches 627
mercury: cables 53; properties
52, 53, 54
metal electrode face-bonded
(MELF) resistors 63
metal film resistors 62, 64,
73, 78
metal oxide resistors 62
metal oxide semiconductor
field-effect gates
(MOSFETs) 739; signal
switching 662–623
metering: combined LED
indicators 730; distributed
peak detection 728–730;
LCD meter displays 738;
LED bar-graph metering
732–734; Log Law Level
LED (LLLL) 726, *727*;
more efficient LED bar-
graph architecture 734–737;
peak indication 724–726;
peak programme meters
732; plasma displays 737;
signal-present indication
723–724; vacuum
fluorescent displays 737;
VU meters 730–732

mic/line preamplifier without-switching 518
mic/line switch 497, 521
microcontroller and relay supplies (power) 782–783
microgroove technology 253, 293
microphone capsules 27–28, 508, 524
microphone preamplifiers: +48 V phantom power supplies 518; balanced-feedback hybrid microphone preamplifier (BFMA) 519–520; capacitor head 524–526; digital mixers 523–524; electret 507; microphone and line input pads 514–516, *517*; microphone types 507–508; padless 520–523; requirements 508; ribbon 526–528; simple hybrid 510–514, 518; transformer microphone inputs 509–510
microphone transformer 510
microphony, capacitors 91
middle controls (tone) 466; fixed-frequency Baxandall middle controls 467, *468*; single-gang variable-frequency middle EQ 476–478, *479*; switched-Q variable-frequency Wien middle EQ 479, *480*; three-band Baxandall EQ in one stage 468, *469–471*; variable-frequency middle EQ 474–475, *476*; Wien fixed middle EQ 472–474
Miller compensation 160, 174
Miller effect 799
mixer architecture 491–506; internal levels 492; in-line 495–497; in-line channel 504–506; performance factors 491–492; split format modules 497–504; split mixing 494–495
mixer bus systems 665
mixer sub-systems: active panpot 680–681; AFL systems 712; auxiliary sends 688; balancing tracks to reduce crosstalk 704–705; circuit block 668; component lifetimes 720–721; console cooling 720–721; direct outputs 673; equalisation 666; faders 669–670; flash bus 718–720; group module circuit blocks 688–698; inputs 666; insert points 666–667; LCR panpots 681–684; line-up oscillators 715–718; mixer

bus 665; panpots 673–684; passive panpots 675–679; PFL systems 706–712; post-fade amplifiers 671–672; power supply protection 720; routing systems 684–688; solo-in-place systems 712–714; summing amplifiers 698–706; summing systems 689–698; talkback microphone amplifiers 714–715
Molly guard 714
monitor mix 493, 496, 500, 506
monitor mixer 493
mono-stereo switches 430–432
motorised potentiometers 399–400
moving-coil (MC) head amplifiers: amplification strategies 319; cartridges 317; complete circuit 325; effective MC amplifier configuration 323–324; input amplifiers 321–322; limits MC noise performance 318; opamp arrays for preamps 327; performance 326–328; transformers 319–320
moving-magnet (MM) inputs: amplifier configurations 265–267; balanced MM inputs 301; calculating the RIAA equalisation components 268; cartridge load synthesis for lower noise 304–305, *306*; cartridge sensitivities 261–262; cartridge types 253; equalisation 263–264; hybrid MM amplifiers 300–301; IEC amendment 264–265; implementing the IEC amendment 271–272; implementing RIAA equalisation 268–271; maximum signal levels from vinyl 257–261; MM cartridge DC and AC coupling 293; MM cartridge-preamplifier interaction 292; "Neumann pole" 265; noise in balanced MM inputs 301–303; noise measurements 303; noise in MM RIAA preamplifiers 293–299; noise weighting 303; opamp input stages 267; open-loop gain and RIAA accuracy 287; overload margins and amplifier limitations 262–263; passive and semi-passive RIAA equalisation

287–290; a practical MM amplifier 312, *313*; RIAA optimisation 275–284; RIAA series-feedback network configurations 272–275; spurious signals 254–255; subsonic filters 306–310; switched-gain MM/MC RIAA amplifiers 286; switched-gain MM RIAA amplifiers 284–285; ultrasonic filters 311; vinyl medium 253–254; vinyl problems 256–257
MRP4 preamp 106–107
Mr Spock (Star Trek) 59
multi-function summing amplifier 705–706
multipath amplifiers and ultra-low-noise 40–41
multiple amplifiers 47–479
multiple-feedback band-pass filters 224–245, 716
multiple-feedback filters 793
multitrack recording 332
mu-metal 209, 319
mute bloc 653, *655–658*, 659–660
mutual shutdown circuitry and power supplies 781–782

NBC (broadcaster) 730
NE5532/5532 197
NE5532/5534 opamp 162–177; 5532 output loading in shunt feedback mode 164, *165*, **165**; 5532 with series feedback 165–166; common-mode distortion in 5532 166–167; deconstructing 5532 174–177; reducing 5532 distortion 168–172; selection 172–173; single-opamp 5534 173–174
negative feedback (NFB) 9–10; clipping 761–764; discrete transistor circuitry 134–135; gain-control elements 761–764; line inputs 542; line outputs 585, 589–590, 609; microphone preamplifiers 520; mixer sub-systems 705–706; opamps and their properties 157–159
negative-impedance-converter 680
"Neumann pole" 265
Neumann SAL 74B amplifier 265
Newcomb and Young loudness control 415–418
nickel 54, 63, 77
NJM4556 opamp **145–146**
NJM4556A opamp 614

NJM4580 opamp 161, *162*
NJM8068 opamp 162
noise: active gain control 234–235, 373, 386–388, 390–394; amplifiers 27–29; in balanced MM inputs 301–303; Baxandall tone control 446–449; bipolar transistors 29–30; black 22; blue 22; cartridge load synthesis for lower noise 304–305, *306*; correlated 579; description 21; discrete class-AB headphone amplifiers 624; excess resistor 76–78; gates 752–754; generators 767–768; green 22; grey 22; improved Baxandall active volume stage with lower noise 390–392; junction field-effect transistors 34; limits on MC noise performance 318; measurements 303; in MM RIAA preamplifiers 293–299; opamps 34; pink 22, 767, *769*; power amplifier 44–45; red 22, 767, 770; replay noise 340–342; resistor excess noise 76–78; routing systems 685–687; send amplifier 595–596; shot 25; simple hybrid microphone preamplifier 511–512; summing systems 673, 692, 694, 697; violet 22; A-weighting 22, 254, 295, 303; weighting 303; white 22, 767–770; *see also* Johnson noise
noise (gain) 21–22, 36; in amplifiers 27–29; balanced output 599–601; bipolar transistor current noise 30–34; in bipolar transistors 29–30; bipolar transistor voltage noise 30; in JFETs 34; noise reductions systems 343–345; opamps 34–35, 144, **145**
noise gates 752–754
noise measurements 36–37
noise figure (NF) 29, 32, **33**; filters 221–222; microphone preamplifiers 512; moving-coil head amplifiers 325–326; moving-magnet inputs 275–284, *280*, **280**, **281**, *282–283*, 299; tape replay 341–342
nominal levels and ADCs 788
nominal signal levels 10–11
non-conductors **52**
non-electrolytic capacitor non-linearity 83–88
non-linearity: electrolytic capacitor 88–91;

non-electrolytic capacitor 83–88; resistor 78–81
normalling contacts 354, 497, 506, 666
notch filters 209, 225–226, *225*; Sallen-and-Key 220–221

offness: discrete JFET switching 660; faders 670–671; gain-control elements 753; mixer sub-systems 677–679, 684–688, 692–693; signal switching 627–631, **629**, 631–633, 635–640, 643, **643**, 644–655, 651–652, *653*, *655–657*, 659; volume controls 365–366, *377*
Ohm, George Simon 51
Ohm's law 18, 51, 64, 78, 547
one-band tone controls 450–451
one-capacitor LF control (Baxandall tone controls) 438–443
one-ounce copper 56
one-transistor: hybrid summing amplifiers 700, *701*; series-feedback gain stages 117–118; shunt-feedback gain stages 116–117
OP27 opamp **145–146**, **149**, 180–181, *181–182*, 545, **545**
OP270 opamp **145–146**, **149**, 182, *183*
OP275 opamp 182–184
OPA604 opamp **145–146**, **149**, 190, **297**, 299
OPA627 opamp **145–146**, 148, **149**, 190–192, **545**
OPA2134 opamp 144, **145–146**, **149**, 158–159, 187–189, 187–188, *189*, 191; guitar preamplifiers 355–357, 355–358, **356–357**; line inputs 544, **545**; moving-magnet inputs **297**, 299, **304**; signal switching *638*, 661; tape replay *341*, 342, **343**
OPA2365 **196**
opamps (distortion); arrays for MC preamps 327; bipolar input 153–156; common-mode 152–159; internal 150; JFET 157–159; loading 151; slew-rate limiting 150–151; power amplifier 43–45; thermal 151–152
opamps (operational amplifiers); for +5 V operation 197–206; for 3.3 V single-rail operation 204–205; active clipping 758–761; AD797 144, **145–146**, **149**, 180; AD8022

199–200; AD8397 200–204; bias current 147; BJT input 159–160; CMRR effects 545, **546**; common mode range 147; common mode rejection 543–544; cost 148, **149**; discrete 134–135; distortion 149–159; frequency response effects 544–545; high fidelity from low voltages 195; history 143–144; input 135–136; input offset voltage 147; JFET input 184–192; Johnson noise 23; line inputs 543–544; LM4562 177–179, 198–199; LM741 160; MM input stages 267; multiple 614–616; NE5532/5532 197; NE5532/5534 162–177; NJM4580 161, *162*; NJM8068 162; noise 34–35, 144, **145**; OP27 180–181, *182*; OP270 145–146, 149, 182, *183*; OP275 182–184; OPA604 **145–146**, **149**, 190; OPA627 **145–146**, 148, **149**, 190–192; OPA2134 144, **145–146**, **149**, 158–159, 187–189, 187–188, *189*, 191; opamp transistor hybrid amplifiers 616–618; running opamps from a single +5 V supply rail 195–197; Sallen-and-Key filters 210; selection 159; slew rate 145–146; special 614; supply rail voltages 771–772; TL052 **149**, 187; TL072 143–144, **145–146**, 147, **149**, 151, *157–158*, 159, 162, 185–188; *see also* opamps (distortion); *specific opamps by name*
open-loop gain: and RIAA accuracy 287
operational transconductance amplifiers (OTAs) 2; gain-control elements 742–743
oscillators 503–504, 715–718
OTAs *see* Operational transconductance amplifiers (OTAs)
output impedance 599; synthesis 611–612
overlap penalty 395–398
overlapping foil screen cables 535
overload margins 262–263

padless microphone preamplifiers 520–523
palladium/silver (PdAg) 64
panpots (panoramic potentiometers) 673–674;

active 680–681; full-width LCR 681–684, *682*; half-width LCR *683–684*; law bending 675–681; laws 674–684; Left-Center-Right (LCR) 681–684; mixer sub-systems 673–684; negative-impedance-converter 680; passive 675–679; sine/sine squared laws 674–675, *674*
parametric equalisers 482–485
parametric middle EQ 482–485
passive attenuators 234–235
passive balance controls 423–425, *426*
passive control: Baxandall active volume stage 392–394
passive DI box 360–361, *361*
passive filters 207–208
passive panpots 675–679
passive preamplifiers 231–232
passive/semi passive RIAA equalization 287–290
passive tone controls 436–437
PCB track-to-track crosstalk 58–60
PCM1794A stereo audio DAC 792
PCM1802 stereo ADC 789
peak detection, distributed 728–730
peak indication 724–726
peak programme meters (PPMs) 732
performance: discrete class-AB headphone amplifiers 624; MC head amplifiers 318, 326–327; mixer architecture 491–492; ripple 778
perpetual motion machine of the second kind 24
PFL systems 706–712
PGA2310 integrated circuit 410
phantom power 518, 783–784, *785*
phase perception 17–18
phono connectors 537
pickups 349–351; characteristics 351; magnetic 350–351; piezoelectric 350–351
piezoelectric pickups 350–351
pinkening filters 768–770
pink noise 22, 767, *769*
plasma displays 737
platinum **52**, 53
polyester capacitors 84–87, *85*, **86**, 221–222, *222*
polyethylene terephthalate (PET) capacitors 84
polypropylene capacitors 87–88, *87*, *222*, 223, 308–309, 464

polystyrene capacitors 86–87, *86*, 277, 312
popcorn noise 26
postfade amplifiers 499–500, 728; mixer sub-systems 670–672
postfade sends 494, 499, 671, 673
potentiometers: DC 365; motorised 399–400; *see also* panpots
power amplifiers: opamp 43–45
power consumption: discrete class-AB headphone amplifiers 624
power supplies: ±15 V 772–775; ±17 V 775–776; +48 V phantom 518, 783–784, *785*; discrete circuitry 780; dual supplies from a single winding 779–780; larger 780–781; microcontroller and relays 782–783; mutual shutdown circuitry 781–782; opamp supply rail voltages 771–772; protection 720; ripple performance 778; ultra low-noise regulators 778, *779*; variable-voltage regulators 776, *777*, **777**; very large 782; "wall-wart" 779
power supply rejection ratio (PSRR) 771–772, **772**
PPMs *see* peak programme meters (PPMs)
practical balanced inputs 548–551
practical MM amplifier 312, *313*
preamplifiers 231–236; active 232–233; active gain control 234–235; amplification 233–234; architecture 231–236; evolution *232*, 233–234; gain-distribution 233–234; hybrid microphone 510–514, 518; LM7824 780; microphone 507–508, 510–514, 520–523; MM cartridge–preamplifier interaction 292; noise in MM RIAA preamplifiers 293–299; padless microphone 520–523; passive 231–232; passive attenuators 234–235; recording 235; tone controls 235–236; tone-control stage 209; *see also* guitar preamplifiers
Precision Preamplifier 263, 284, 385, *385*, 450, 458
prefade listen (PFL); AFL 712–714; channel module

(split format) 707, 712, 719; detection 707, 708–710; master module 494, 499, 500, 506, 714; peak indication 724–726; simple *710*; split mixing 494–495; summing 708; systems 706–712; switching 708; virtual-earth detection 710–712

printed circuit boards (PCBs) 55–56; design and experimentation 803; digital domain interface 787–788; fibreglass 55; layout 787–788; mixer bus systems 665; plated-through holes 56; Signal Transfer Company 312; standard 56; three-layer 60; track current capacity **57**; track resistance 56–58; track-to-track crosstalk 58–60

Progressive Electronics 482

protection diodes 636, 774–775, *774*

prototype board: design and experimentation 798–802; screening 802; standard layout *801*

psychoacoustic weighting 303

public address (PA) 603

push-pull: CFP emitter-follower 109–211; emitter-follower 104–105

quasi-floating line outputs 602–604

quiet amplification 39–40

quiet attenuation 37–39

quiet balance 40

quiet inversion 40

Radford HD250 amplifier 234

radio frequency (RF); field strengths 604; filters 231, 530

rail bootstrapping *120*, *122*, 125–129, 636

RCA connectors 537

RCA Victor (record label) 253

recording facilities 235

Recording Industry Association of America/ RIAA; amplification 20; Audio Note cartridge 317–318; cartridge–preamplifier interaction 292; components 268; curve *258*, 265, 269, 288; implementing 267, 268–271; input signals 20, 262, 288, 319; inverse 259, 288, 309; noise in preamplifiers 293–299; non-electrolytic capacitors 82–83,

271, 308; optimisation 275–84; passive/semi passive 287–290; subsonic filters 308–309; *see also* Recording Industry Association of America/ RIAA (equalisation)

Recording Industry Association of America/ RIAA (equalisation); accuracy 287; amplifiers 284–286; differential amplifiers 575; moving-magnet input stages 268–271; overload margins 262–263; preamplifiers 293–299; series-feedback network configurations 272–275; signal levels from vinyl 257–261

red noise 22, 767, 770

relay supplies 782–783

relay-switched volume controls 409–410

relay switching 631

reservoir capacitors 750, 772–776, 779

resistances and Johnson noise 22–24, 29–36, 76; guitar preamplifiers 354–355; line inputs 553–554; moving-coil head amplifiers 319–320; moving-magnet inputs 295–296; preamplifier architectures 232

resistors 62–81; accuracy 66–71; carbon composition 62, **62**, 73, 78; carbon film 76–78; carbon film resistors 62, **62**, 73, 375; combinations 66–71; common-mode rejection ratio 538, 539–540, 542, 545, 583, 704; end stop 438, 440, 460, 475, 556–577; excess noise 76–78; imperfections 75–76; MELF 63; metal film 62, **62**, 64, 73, 76, 78, 688; metal oxide 62, **62**, **76**; noise 76–78; non-linearity 78–81; series 65–66; surface-mount 63–65; switched attenuators 401; temperature coefficient **62**, 63; thick film 62–64, 77–80, 547; thin film 62–63, 73, 77, 79–81; three-resistor combinations 70; through-hole 54; tolerances 66–74, 81–82, 276–281, 378, 401–402, 539–540, 546–548, 554–555; two-resistor combinations 66–70; uniform distribution 74–75; value distributions 73–74; voltage coefficients 62–63,

73, 78–81; wirewound 62, **62**, 76, 78

return-to-flat (RTF) tone-control 458, 460, 480, 482

RF filtering 530, 535, 550, 565

ribbon cable 665, 667, 693, 694, 712

ribbon microphone amplifiers 526–528

ripple performance (power supplies) 778

roofing filters 207–208, 530

routing systems: back-grounding 685; matrix 687; mixer sub-systems 684–688; offness 684–688; panpots 684–688

rumble 255, 264, 311

rumble filters 209

ruthenium oxide 64

safe-operating-area (SOA) 784

safety 803–804

Sallen and Key filters: bandpass 217–220; capacitor microphones 524; distortion 221–223; highpass 214–216, *217*; lowpass 210–214, 215–216; mixed capacitors in low-distortion 223–224; notch 220–221; subsonic filters 311

schematics 798

Schlotzaur configuration 99

screening 319–320, 535

'sea of micro-diodes' 51

Second Law of Thermodynamics 24

series-feedback: one-transistor 117–118; RIAA 272–275; two-transistor 132–134; *see also* individual circuits

servo integrator 520, 753

short fader 496, 506

shot noise 25, **25**

shunt-feedback: one-transistor 116–117; two-transistor 119–132; *see also* individual circuits

Shure M75ED 2 cartridge 295, **303**, 305

sidechain 748

signal-to-noise 1–2, 9–10, *20*, 37–38, 40

signal-present indication 723–724

signals 1–2; balanced signal levels 537; external signal levels 529; internally balanced design 3–6; internal signal levels 529–530; maximum signal levels from vinyl 257–261; nominal signal levels and dynamic range 10–11;

raising the input signal level to the nominal level 20–21; signal-present indication 723–724; spurious 254–255; unbalanced and balanced 2–3; warping 255; *see also* signal switching

signal switching: electronic switching 631; input-select switching 627–629; mechanical switches 627; MOSFETs 662–623; offness 660; relay switching 631; virtual contact 629–631; *see also* CMOS analogue gates

Signal Transfer Company 311, 312, 326, 578

silver 51–52, 401

simple emitter-follower (EF) discrete circuit-block 99–101, 102–104, *102*, 107–109, 115

simple hybrid microphone preamplifier; common-mode rejection ratio 514; distortion 512–514; mic/ line without-switching 518; noise 511–512

sine/cosine characteristic 421, *422*, 675

sine laws 429, **429**, 680

sine-squared laws *674*, 675

single gain pot 237–240, *241*, 244–247

single-gang sweep middle tone controls 476–479

single-gang variable-frequency middle EQ 476–478, *479*

single-jack insert 666–667

single jack insert *667*

"Slate" facility 503

slew limiting 145–146, 150–151, 207, 255, 288

slew rate 145–146; slew-rate limiting distortion 150–151

slide faders 375–377

soft clipping 360, 715

solder **52**, 53, 54

solo-in-place systems (SIP) 712–714

Soundcraft 3200 recording console 500, 702

sound reinforcement (PA) console 493

source-followers: JFET 107–108, *109*, **109**

SPICE simulation *102*, 109, *111*, 121, 286–287, 797

split format modules: channel 497–500; effect return 500; group 500–501; master 501–503; oscillators 503–504; talkback 503–504

split mixing (mixer architecture) 494–495

splitter box 493, 604
spurious signals 254–255
Star Trek 59
state-variable filters 209, 224, 226
steel 52, **52**, 53
stepped volume controls 401
stereo image 363, 365, 421, 432, 494
stereo power amplifiers 60–61
stripboard 802–803
stylus acceleration 258–259
subsonic filters/filtering 271, 306–310
subsonic/ultrasonic filters combination 208–209, 311
subtractive VCA control 751–2
summing amplifiers 698–706; balanced hybrid 702, *703–704*; hybrid 699–702; multi-function 705–706; two-transistor shunt-feedback stages as 126–127
summing noise sources 26–27
summing systems: balanced 691–693; bus residual 690, 699; distributed 694–698; four-layer 698; ground-cancelling 693–694; three-layer 665, 697, **697**; two-layer 694–697; virtual-earth summing 689–691; voltage summing 689, *690*; *see also* summing amplifiers
superbal input 553–554
supply rail voltages and opamps 195–197
supply-rail voltages and opamps 95–96, 636, 640, 643, 646, 652
surface-mount (SM) resistors 54, 63–65, 79, 148, 736
sweep middles tone controls 466
switchable peak/shelving LF/HF EQ 480–482
switched attenuator: resistors 401–409; volume controls 401–409
switched balance controls 428–429, *430*
switched-frequency LF EQ 456–457
switched-gain amplifiers 249–252; MM/MC RIAA 286; MM RIAA 284–285
switched-gain balanced inputs 554–556
switched-HF-frequency Baxandall controls 451–454
switched-Q variable-frequency Wien middle EQ 479, *480*
switched-slope filters 227–228
symmetrical clipping 715

talkback: microphone amplifiers 714–715; split format modules 503–504
tan-δ (tan-delta in capacitors) 82
tape replay: amplifiers 338–340; basics of tape recording 330–301; Dolby HX-Pro 345–346; history of tape recording 330; load synthesis 343; multitrack recording 332; noise reduction systems 343–345; the return of tape 329; tape heads 332–334; tape replay 334–342
tapped volume controls 372–375
temperature coefficient **52**, **62**, 63
thermal distortion 151–152
thermodynamics laws 24
Thevenin-Norton transformation 23
thick film resistors 62–64, 77–80, 547
thin film 62–64, 79–81
thin film resistors 73, 77
third-order filters 212, 214, 221–222, 226–267, 311, 359, 793
three-band Baxandall EQ 468, *469–471*
three-layer PCB 60
three-layer summing 665, 697, **697**
three-transistor cascode shunt-feedback stages 127–132
through-hole (TH) resistors 54, 63, 79, 688
TID 232; *see also* slew limiting
time-constants 82–83, 268–269, 288–289, 750–751
tin 52, **53**, 54–55
tin-doped indium oxide (ITO) 54
tin pest 54
tin plague 55
tin-silver-copper alloy 54
TL052 opamp **149**, 187
TL072 opamp 143–144, 145–146, 147, **149**, 151, *157–158*, 159, 162, 185–188; guitar preamplifiers 355–356; headphone amplifiers 617, *618*; line inputs 543, **545**; line outputs 586–587; moving-magnet inputs **297**, 299, 303, **304**; power supplies 771, **772**; signal switching *638*, 661; tape replay 341–343, **341**, **343**
TL783C high-voltage regulator 783, *783*
tolerances of resistors *see under* resistors

tone-balance controls 464–465, *466*
tone-cancel switch 458, 460
tone controls 435; Ambler concept 465, *466*; graphic equalisers 485–488; parametric middle EQs 482–485; passive 436–437; preamplifier architectures 235–236; return-to-flat (RTF) 460, 558; single-gang sweep middle 476–479; sweep middles 466, 474–475, 476–479; switchable peak/ shelving LF/HF EQ 480–482; switched-frequency LF EQ 456–457; tilt 464–465, *466*; tone-balance 464–465, *466*; variable frequency HF EQs 454–455; variable frequency LF EQs 455, *456*; variable frequency LF/HF EQs 457–464; Wien fixed middle EQ 472–474; *see also* Baxandall tone controls
total harmonic distortion (THD) 78–81, **79**, *80*, 84–89, *86–87*, *150*, 152, 155, 160, *161–163*, 164, **165**, 168, **170**, 172–173, *181–183*; discrete transistor circuitry 101, 105, 108, **109**, *110*, 111, *112*, 115–121, *116*, **123**, 124, **125**, 128–130, **131**, *133*, *140*; gain-control elements 743; headphone amplifiers 615, *616*, *618*, 622–623; microphone amplifiers 513; opamps for low voltages 197–206, *199–206*; signal switching *634–636*, *635–637*, 640, **643**, 644–645, 649, *654*, *656*, **663**; volume controls 389–390
track current capacity **57**
track resistance in printed-circuit boards 56–58
track-return/group switch 493, 506
track-to-track crosstalk 58–60
transconductance 98
transconductance amplifiers 8, 9
transformer balanced line inputs 537–538, 571–572
transformer balanced line outputs 604
transformer microphone inputs 509–510
transformers, moving-coil 319–320
transformer-tap volume controls 410
transimpedance amplifiers 8, 9

transistor equation 97
Transistor Wide-band Cascade Amplifiers 128
transmission gates 632
tungsten **52**
twin-T notch filter 225, *225*
two-layer summing 694–697
two-ounce copper 56
two-transistor hybrid summing amplifier 701–702, *702*
two-transistor series-feedback gain stages 132–134
two-transistor shunt-feedback gain stages 119–121; bootstrapping 125–126; cascode 127–132; improving linearity 121–5; noise 125; as summing amplifiers 126–127

ultra low-noise: amplifiers 45–7; balanced line inputs 578–580; multipath amplifiers 40–51, **42**, *42*; regulators 778, *779*; voltage buffers 41–53, **43**
ultrasonic filters 311
unbalanced line inputs 530–533, 583–584
unbalanced signals 2–3, *3*
uncorrelated noise 26–27, **27**, 321
unipolar peak detector *725*
unity 237–240, *241*
unity gain 568
unity-gain buffer stages 98–99; CFP emitter-followers 109–114; constant-current emitter-follower 102–104, *103*; emitter-follower stability 105–107; improved unity-gain buffers 115–116; JFET source-followers 107–108, *109*, **109**; push-pull emitter-follower 104–105; simple emitter-follower 99–101, *102*

vacuum fluorescent displays 737
variable-frequency LF/HF EQs 454–455, *456*, 457–464
variable-frequency middle EQ 474–475, *476*
variable-gain balanced inputs 556–557
variable gain stages 237–252; and active filters 243–244; dual gain pot 241, *242*, 247–249; single gain pot 237–240, *241*, 244–247; switched-gain amplifiers 249–252
variable-voltage regulators 776, *777*, **777**
Varigroove technology 253

VCAs *see* voltage controlled amplifiers (VCAs)
very large power supplies 782
vinyl 253–254, 335, 491; maximum signal levels from 257–261, *258*; problems 256–257
violet noise 22
virtual contact (signal switching); mechanical 629–631
virtual-earth PFL detection 710–712
virtual-earth summing 689–691
Vogel, Burkhard 254, 327
voltage amplifiers 8, *9*
voltage coefficient 62–63, **62**, 78, **79**, *79*, 81
voltage controlled amplifiers (VCAs); gain-control elements 742–743; subtractive control 751–752

voltage doubler 779–780, 784, *785*
voltage-followers 203, 573, 588, 616, 630
voltage-mode connection 1
voltage noise 29–36, 43, 144, **145**, 173, 180; guitar preamplifiers 354–355; line inputs 578–579; moving-magnet inputs 294–295; tape replay 341–342; volume controls 390–394
voltage summing 689, *690*
volume controls 363; active 377–381; attenuator volume controls 401–409; Baxandall active 381–383; belt-ganged 398; DC 398; dual-action 369–372; integrated circuit 410–411; laws 364–366, 383–384; loaded-linear pots 366–369; loudness controls 411–415; motorised 399–400;

Newcomb and Young loudness control 415–418; overlap penalty 395–398; potentiometers 398; relay-switched 409–410; slide faders 375–377; stepped 401; switched attenuator 401–409; tapped 372–375; transformer-tap 410
VU meters 730–732

Walker, HP 267
"wall-art" power supplies 779
warp signals 208, 255
A-weighting 22, 254, 295, 303
wet monitoring 506
White cathode-follower 104, 132
White, Eric 104
white noise 22, 767–770
Whitlock bootstrap 570–571
Widlar, Bob 143
width controls (balance) 432–433

Wien bridge configuration 717
Wien fixed middle EQ 472–744
Willmann Tables 70, 281
wirewound resistors 62
wiring 351–352
wiring resistance and cables 55
WM8726 stereo DAC 793
WM8740 stereo audio DAC 792
WM8782 stereo ADC 789

X2 capacitors 88
XLR connectors 508, 536, 537, 573, 583–584, 624

zero 244–249
zero-impedance outputs 584–591; ground-cancelling outputs 593
Zobel networks 320, *320*, 571–572, *604*, 606, 614
ZTX951 326, 512

Printed and bound by CPI Group (UK) Ltd, Croydon, CR0 4YY

17/10/2024

01775693-0001